One Hundred Years of Human Progress, Regression, Suffering and Hope

Conceived and Edited by Bruce Bernard

CENTURY

Φ

This sequence of photographs is an attempt to outline the history of the twentieth century as the camera (with a great variety of photographers attached) has seen it. It has by no means taken note of everything and its vision, particularly as a means of recording news events, has generally been of a Western orientation. Nevertheless it has observed a great deal of the world-wide human predicament over this period – the first century to have been examined from beginning to end by this long-sought instrument of useful and pleasurable, although also often harrowing, record. Those who have not seen much of the times at first hand, will, I hope, be really interested to see so many pictures, mainly of hard history, printed so well and shown together in such a quantity. Those of us who have come through a significant part of the century unscathed might accept this book as a welcome souvenir on leaving a territory which they have partly explored, but will never be able to visit again, and which will always seem to contain all the larger human problems set out in the clearest possible form. It has in some ways been the most thoughtless, but in other ways the most thoughtful, hundred years in human history – in which all kinds of moulds were broken and dies cast, but offering nothing to provide us with any firm grounds for either bright hope or black despair.

The generally refined art of nineteenth-century photography suffered a shock when mechanical replication of its pictures became widespread at the beginning of this century. Although the half-tone screen and block had been available in the late 1870s, the coarseness of its images must have seemed risible to the professional photographer, and none too impressive to the general public. Most illustrated magazines continued to make engravings from photographs rather than use the new half-tone process. When this process became more refined and was in general use in popular magazines and newspapers, the quality press and magazines still disdained it – they could see no way of using a gift that seemed to lose as much in quality as it offered in the prospect of gaining its images a wider currency. So artist-photographers, wedded to the magical results obtainable from the use of large-plate cameras and albumen or other beautiful methods of printing, took refuge in even more refined processes and the cultivation of an ever more painterly sensibility. Those with more mundane interests waited and worked impatiently to see how they could take advantage of the improved technology and new commercial opportunities. Their hopes were gradually realized as the development of mass-circulation magazines, together with the cheap roll of film and camera, created the new discipline of photojournalism.

At the turn of the century, the makers of stereocards would have been at least mentally prepared for this new development, as they had been most concerned with providing solid information. This can be seen in the two stereocards from 1899 that are reproduced here (pp. 18–19). But people had grown tired of stereo-viewing evenings by the family hearth, and this must have left a few competent picture-makers out of work and ready to join the media of the new age. However, there was inevitably a short period to begin with which was deficient in narrative images, and for the collection we found ourselves faced, before 1914, with fewer photographs of historic events and more of such whimsical subjects as elephants' tea parties and Sarah Bernhardt's travels.

Several photographers seemed to have grasped the idea of photojournalism early on. The wonderful picture of the Turkish Sultan Abdul Hamid from *L'Illustration* shows that the French were well aware of its future, as were the Germans and Austro-Hungarians. From Britain Horace Nicholls scented the right direction very early in the photographs he took of the Boer War, two of which are reproduced here. Later two *Daily Mirror* photographers, the Grant Brothers, came up with the excellent shots of the Young Turks in 1909 and the evacuation of the British from Antwerp in 1914. The powerful and atmospheric picture of the Japanese battle-cruiser *Hatsuse* in 1900 was not photojournalism. The photograph was made for the Vickers archives and was taken on a large-plate camera by a company photographer, who mostly took pictures of naval gun barrels and the firm's other products in Newcastle. This photograph has survived because the firm's management allowed only a hundred of many thousand glass negatives to be preserved in the late 1960s. We must always remember, while forgetting it as soon as possible, how many images have been lost or destroyed by accident, lack of appreciation (often by no means always justified) or destruction during wars.

The principle behind the selection of photographs for this book has been simply to look at everything relevant to the main narrative (and things that aren't) that I and my highly perceptive assistant could lay our hands on (or that I could find in my memory) and just discard what seemed irremediably dead or boring – while sneaking in a

few images from some of the 'master' photographers which would enrich the mixture without slackening the pace or demanding disproportionate attention. The conscious invocation of nostalgic feeling and the naturally popular 'feel good' photograph have been quite deliberately avoided.

Those over a certain age might deduce correctly that when very young I much enjoyed the great British pocket magazine *Lilliput*, edited by the same Stefan Lorant who started *Picture Post*, although my pairings have not been as predominantly humorous as they so famously were in *Lilliput*. The pairing of pictures, if done thoughtlessly, can seriously threaten the best qualities of both images brought together, but it can certainly be a means of mutual enhancement. With most pairings one must simply aim at giving each partner the breathing space it needs. In the happiest ones contrived here I feel I will always remember with satisfaction the quality of their relationships, while appreciating them perhaps a little more for themselves as well. Photographs on the 'highest' level are entirely self-sufficient, as are master drawings; but everyday news and documentary images can positively help each other, like dancing partners who achieve more exciting things together than alone. Or there are more serious musical analogies to be made to do with chords, keys, dissonances, etc. I would say that the spread with poor Clara Petacci's corpse and the entirely defeated German soldiers is a case in point. There is something a little heart-stopping – and, of course, extremely grim – about it; but horror is not what it is really about. It just seems to combine and, therefore, to better define, the extremities that had been reached.

I have deliberately avoided many, although by no means all, of the famous historical 'icons', or those that have been used to show any nation's indomitable spirit. Overuse has made them irritatingly unreal (or perhaps it was their very unreality that has led to their becoming overused), and I believe that they can deaden people's responses, making them feel complacent or superior, and discouraging them from seeking or seeing real feeling in the less familiar, more thought-provoking images. I have also avoided pictures in which the people seem to have been used only as puppets and to have no individuality as human beings. If I seem to have defied either of these principles, then it must have been for a reason. Something I have also been wary of has been the 'award-winning' image, although one or

two got in. The expression has become for me as much a warning as a recommendation and sometimes I fear (I hope without grounds) that some photographers might think about their prospects in that direction even as they look through the lens.

It would of course be impossible to tell even a fraction of the complete human story with an average of ten pictures a year, so this collection had to be highly selective, 'impressionistic' perhaps, and based on the strength of images. But it was on realizing the impossibility of covering anything more than the most important events, however much space I was given, that I decided to abandon any notion of strict or complete narrative. I went for images that moved me as living images or just as pictures that (often mysteriously) helped the main narrative ones. But with film stills, for instance, after indulging myself with Audrey Hepburn in *Roman Holiday* and the Gregory Peck I think I once wanted to be, I found that the actor appeared again (rather miscast) just because I liked the still of him defying God and the elements in *Moby Dick*. It went so well with *The Seven Samurai* that there had to be two Gregory Pecks. No John Wayne, Humphrey Bogart (except off-screen), Jean Gabin, Marlene Dietrich or Rita Hayworth – they were all in the line with many others – and Betty Hutton of all people had to represent *all Westerns* if you please. But I had come to feel that full coverage in that area wasn't at all important, and this got rid of a lot of unnecessary tension and unhappy juxtapositions. Curiously, though, I felt I had to include Charlie Chaplin, whom I like very little, because of the image, and I can't quite explain this any more than anything else. Two Muhammed Alis? No Pele? I give myself up and admit that only the main chronological structure of important events has saved me from total chaos and perversity.

Photogenic people are, by definition, more interesting to look at on a page, so Nikita Kruschev has been given the inordinate amount of space that he occupies so well. I was at first determined to be very mean with Richard Nixon but didn't quite succeed, and perhaps I shouldn't have given my favourite US presidential candidate, Adlai Stevenson, more than one page. Concerning Adolf Hitler I was very determined not to become part of his mostly unknowing posthumous propaganda machine, and I hope I've succeeded, although the one of him in tails may have let me down (but it went so well with its

partner). But above all, I hope the whole will leave an impression on the reader or spectator of having met some real people among the supporting players or extras. I also hope that the few jokes will not go amiss.

My main worry with this collection has been the number of violent or distressing images agitating to get in. The century has of course been quite horribly violent (compared with the nineteenth after 1815, that is), but the trouble is that pictures of man's inhumanity are very often the strongest and push others aside. They also arouse conflicting emotions in us. The best provoke our pity and human sympathy, but can also simultaneously make us feel satisfaction in our own detachment and safety – as well as the ever-threatening *schadenfreude* which is not always exorcized immediately it is felt. Some of the most violent spreads or combinations are, I believe, the best in the book, but others are a bit sickening. I would ask the readers' indulgence in this. These images cannot simply be diluted with gentler subject-matter or the 'feel good' ones already mentioned – it doesn't help at all. To underplay unpleasantness would have been wrong in any case, and *correct* balance has seemed impossible to strike. I had hoped the clouds would lift just a little in the 1980s and 1990s but they descended even further, so messages of hope must still be just around the corner.

I hope that this book, aided strongly by its historical background information, will provide both nourishment for thought and a stimulus for the imagination, and that it will encourage younger people to despise as well as hate and fear war and violence and any kind of exploitation or persecution of man or woman by woman or man. And also to realize that the best documentary photography is about the subject more than the photographer, though of course it must to some extent be both. I think that those two egotists Robert Capa and Don McCullin would agree with me, and I nominate the August Sander on page 231 as the one that proves it, and also as the best affirmation of humanity in this book. But what about McCullin's Biafran girl on page 738? There are surely a few more candidates, and I must leave it to the reader.

Bruce Bernard, 1999

1899–1914

High Hopes and Recklessness

By 1900 the 'Age of Progress' in Europe was coming to a close, although its ruling élites welcomed the new century as if ever-increasing prosperity was certain. A spirit of competitive and often frenzied expansion gripped Europe's leaders, fuelling an enormous stockpiling of arms, the formation of opposing military alliances and a scramble for territory, particularly in Africa. Hostilities erupted between Britain and the Boers, descendants of Dutch settlers in South Africa, and the ensuing war revealed the first cracks in the vast British Empire that had been at the height of its glory in the nineteenth century. Attempts by European powers to dominate affairs in China sparked a nationalist rebellion by the anti-Western Manchu Emperor. A six-nation European expeditionary force crushed the revolt and a decade later the last Manchu Emperor was forced to abdicate, ending nearly 2,000 years of continuous imperial tradition in China. Rival imperial ambitions sparked a fierce war between Russia and Japan, the latter an ancient country still largely unknown to most of the world. Russia's stunning defeat – the first in modern times by a European power at the hands of an Asian one – marked the beginning of Japan's intense expansionist drive in the Far East. Women in many parts of the world campaigned bravely for enfranchisement and social equality. Continuing government intransigence caused some suffragettes to resort to militancy to achieve their goals. The first powered flight, as well as other developments in transport and communications, shrank distances as never before, affecting all aspects of society. Millions of ordinary Europeans poured overseas in search of new opportunities, providing a vast labour resource for booming economies, particularly the US. The American-led construction of the Panama Canal demonstrated the extraordinary strength and ingenuity of a country fast emerging as the dominant political and economic power in the world. Thomas Edison, the American inventor, continued to inspire awe with his creative genius and countless scientific innovations. Russia lost two of its greatest writers – the novelist Leo Tolstoy and the dramatist Anton Chekhov. Paul Cézanne, the father of modern painting and one of the most influential artists of the twentieth century, died just as a new artistic movement was emerging, which led to Cubism and Abstraction. The Futurist artists captured the change and dynamism of the early twentieth century in their painting and sculpture. They advocated the complete upheaval and destruction of current society in their writing. Europe's leaders unwittingly fulfilled this vision in 1914 as national rivalries plunged the continent into a war unlike anything the world had ever seen.

Contemporary Voices

The time's come: there's a terrific thunder-cloud advancing upon us, a mighty storm is coming to freshen us up … It's going to blow away all this idleness and indifference, and prejudice against work … I'm going to work and in twenty-five or thirty years' time every man and woman will be working.

Anton Chekhov, *The Three Sisters*, 1901

From forge and farm and mine and bench,
Deck, altar, outpost lone –
Mill, school, battalion, counter, trench,
Rail, senate, sheepfold, throne –
Creation's cry goes up on high
From age to cheated age:
'Send us the men who do the work
'For which they draw the wage!'

When through the Gates of Stress and Strain
Comes forth the vast Event –
The simple, sheer, sufficing sane
Results of labour spent –
They that have wrought the end unthought
Be neither saint nor sage,
But only men who did the work
For which they drew the wage.

Rudyard Kipling, *The Wage-Slaves*, 1902

I remember my youth and the feeling that will never come back any more – the feeling that I could last forever, outlast the sea, the earth, and all men; the deceitful feeling that lures us on to joys, to perils, to love, to vain effort – to death; the triumphant conviction of strength, the heat of life in the handful of dust, the flow in the hearth that with every year grows dim, grows cold, grows small and expires – and expires, too soon, too soon – before life itself.

Joseph Conrad, *Youth*, 1902

A man who is good enough to shed his blood for his country is good enough to be given a square deal afterwards. More than than no man is entitled to, and less than that no man shall have.

Theodore Roosevelt, speech at Springfield, Illinois, 4 June 1903

Cusins: What on earth is the true faith of an Armorer?
Undershaft: To give arms to all men who offer an honest price for them, without respect of persons or principles: to aristocrat and republican, to Nihilist and Tsar, to Capitalist and Socialist, to Protestant and Catholic, to burglar and policeman, to black man, white man and yellow man, to all sorts and conditions, all nationalities, all faiths, all follies, all causes and all crimes.

George Bernard Shaw, *Major Barbara*, 1905

The home is the home of everybody of the nation. No nation can have a proper home unless women as well as men give their best to its building up and to making it what a home ought to be, a place where every single child born into it shall have a fair chance of growing up to be a fit, and a happy, and a useful member of the community.

Emily Pankhurst, 'The Importance of the Vote', lecture 24 March 1908

We will glorify war – the world's only hygiene –
militarism, patriotism, the destructive gesture of
freedom-bringers, beautiful ideas worth dying for
and scorn for woman.

F. T. Marinetti, artist's statement, 1909

The moment is supreme, yet I surprised myself by
feeling no exultation. Below me is the sea; the
motion of the waves is not pleasant. I drive on. Ten
minutes pass. I turn my head to see if I am
proceeding in the right direction. I am amazed.
There is nothing to be seen – neither the destroyer,
nor France, nor England. I am alone. I am lost.

Then I saw the cliffs of Dover! Away to the west
was the spot where I had intended to land. The
wind had taken me out of my course. I turned and
now I was in difficulties, for the wind here by the
cliffs was much stronger, and my speed was reduced
as I fought against it. My beautiful aeroplane
responded. I saw an opening and found myself over
dry land. I attempted a landing, but the wind
caught me and whirled me round two or three
times. At once I stopped my motor, and instantly
my machine fell straight on the ground. I was safe
on shore. Soldiers in khaki ran up, and also a
policeman. Two of my compatriots were on the
spot. They kissed my cheeks. I was overwhelmed.

Louis Blériot, interview, 25 July 1909

To the Grafton Gallery to look at what are called
the post-Impressionist pictures sent over from
Paris. The exhibition is either an extremely bad
joke or a swindle … Nothing but gross puerility
which scrawls indecencies on the wall of a privy.
The drawing is on the level of an untaught child of
seven or eight years old, the sense of colour that of
a tea-tray painter, the method that of a schoolboy
who wipes his fingers on a slate after spitting on
them … In all the 300 or 400 pictures there was not
one worthy of attention even by it singularity, or
appealing to any feeling but of disgust. I am wrong.
There was one picture signed Gaugin which at a
distnace had a pleasing effect of colour. Examined
closer I found it to represent three figures of brown
people, probably South Sea Islanders, one of them
a woman suckling a child, all repulsively ugly, but
of a good general dark colouring, such as one sees
in old pictures blackened by candle smoke. One of
the figures wore a scarlet wrapper, and there was a
patch of green sky in the corner. Seen from across
the room the effect of colour was good. Apart from
the frames, the whole collection should not be
worth £5.

Wilfred Scawen Blunt, diary, 15 November 1910

It was a gala evening at the Grand Syaris Hotel, and a special dinner was being served in the Amethyst dining-hall. The Amethyst dining-hall had an almost European reputation ... Monsieur Aristide Saucourt was the chef ... For the first time in the history of the Grand Sybaris Hotel, he was presenting to its guests the dish which he had brought to that pitch of perfection which amounts almost to scandal. *Canetons à la mode d'Amblève*. In thin gilt lettering on the creamy white of the menu; how little those words conveyed to the bulk of the imperfectly educated diners. And yet how much specialized effort had been lavished, how much carefully treasured lore had been ungarnered, before those six words could be written. In the Department of Deux-Sèvres, ducklings have lived peculiar and beautiful lives and died in the odour of satiety to furnish the main theme of the dish; *champignons*, which even a purist for Saxon English would have hesitated to address as mushrooms, had contributed their languorous atrophied bodies to the garnishing ... And now the moment had arrived for the serving of the great dish, the dish which world-weary Grand Dukes and market-obsessed money magnates counted among their happiest memories.

Saki, *The Chronicles of Clovis*, 1911

Our souls, which are only now beginning to awaken after the long reign of materialism, harbour seeds of desperation, unbelief, lack of purpose. The whole nightmare of the materialistic attitude, which has turned the life of the universe into an evil, purposeless game, is not yet over. The awakening soul is still deeply under the influence of this nightmare. Only a weak light glimmers, like a tiny point in an enormous circle of blackness.

Vassily Kandinsky, *Concerning the Spiritual in Art*, 1912

You cannot think of the greatness of America without at once bringing to your minds the names of Morgan, Rockefeller, Vanderbilt, Carnegie and the other industrial kings of the Republic – if I may be permitted the paradox. You may not know of even one German general or admiral, but you cannot think of Germany without conjuring up the titanic figures of Krupp or Ballin, Rathenau or Henkel Donnersmarck; and it is these men, these captains of industry, men who turn hundreds of thousands of unskilled labourers into skilled workmen for the benefit of their country, who add to the strength and power, the prosperity and dignity of the modern State. Today they form a bodyguard around the constitution of a country similar to that which a century or so ago gathered around the former kings with the difference that the nobility of industry has replaced the nobility of birth.

Hugo Hirst (chairman of the General Electric Company), 'The Higher Aspect of Business', lecture at Christ's College, Cambridge, 30 January 1914.

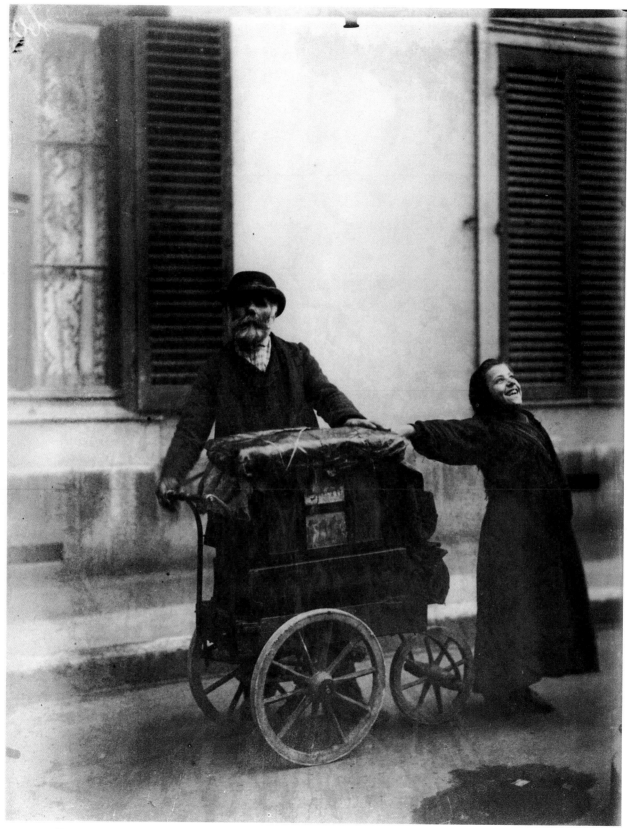

These Parisian performers photographed by Eugene Atget seem to sense a brave new century – and not without reason.

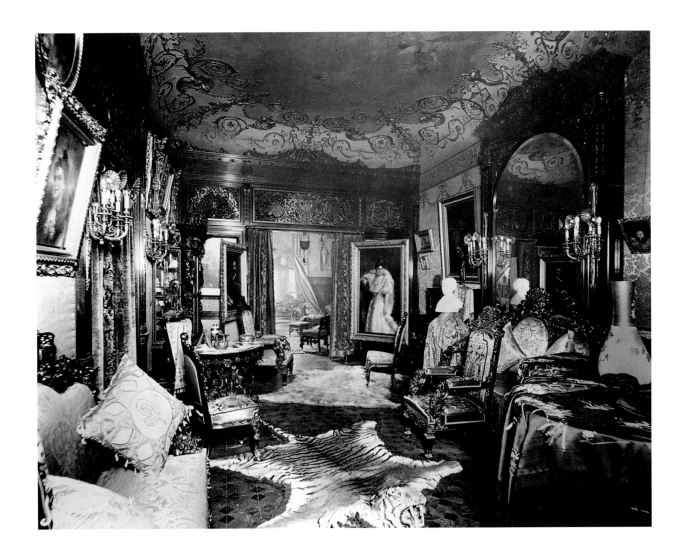

A desirable New York residence – although it was not only in the United States that the pursuit of wealth was becoming entirely uninhibited.

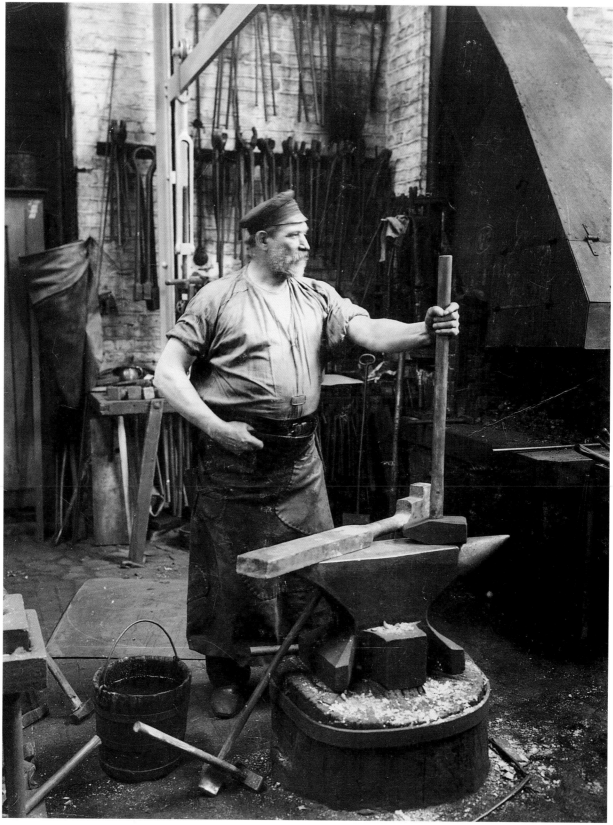

A sanguine German blacksmith who had witnessed all of his new nation's history.

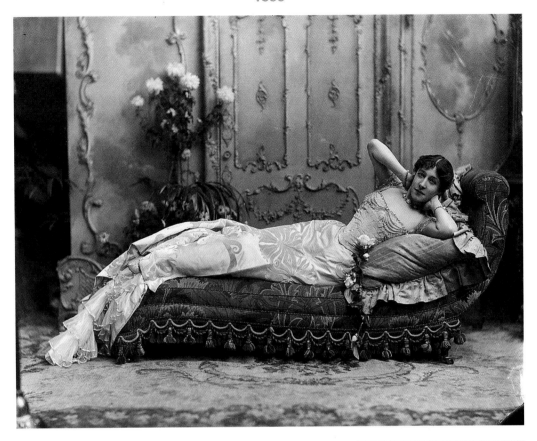

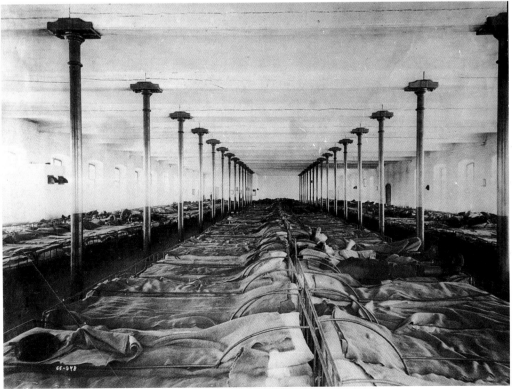

At forty-six, Lillie Langtry – once mistress of Edward, Prince of Wales – takes her ease.
A Russian weavers' dormitory awaiting the rest of its occupants.

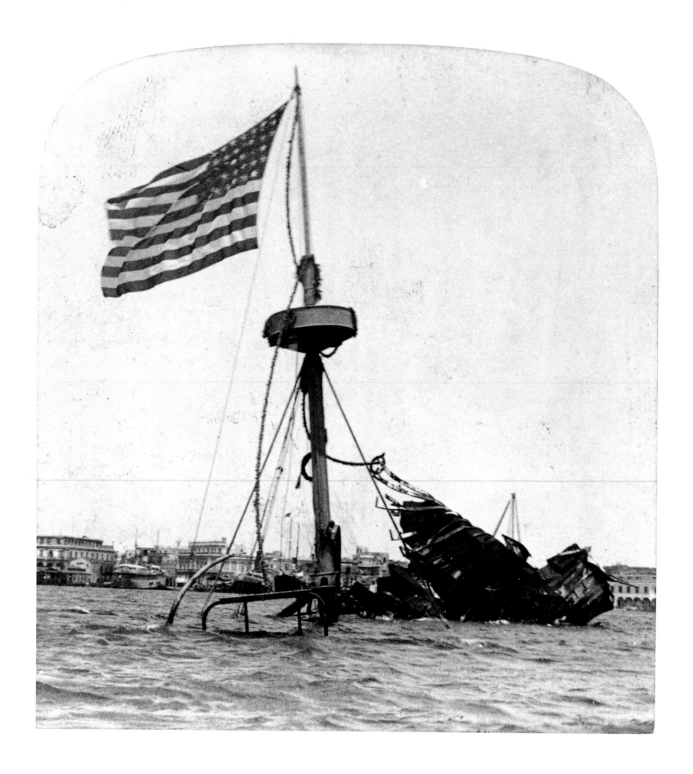

The wreck of the USS *Maine* in Havana, whose sinking in 1898 provoked the Spanish-American war.

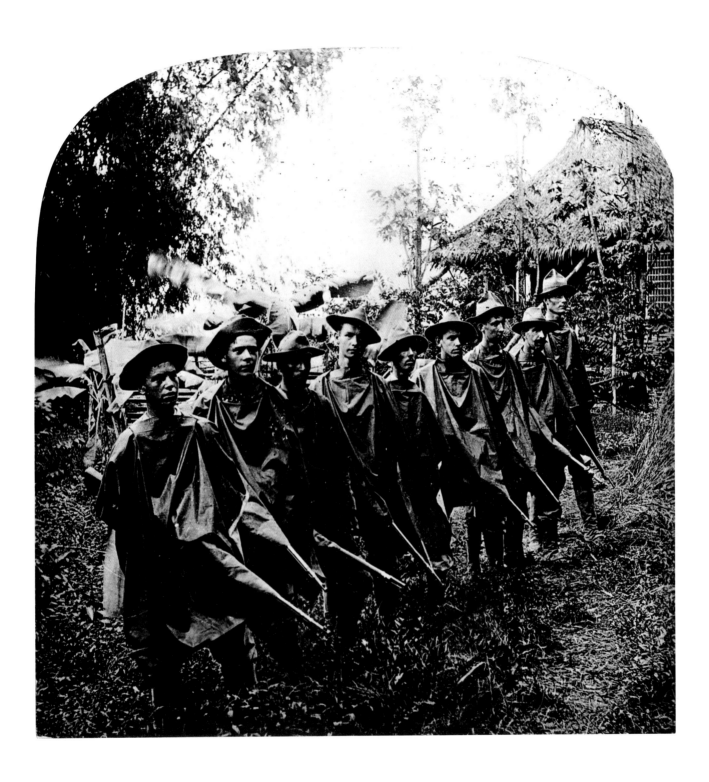

The presence of American troops in the Philippines foreshadows their future close involvement in the Far East.

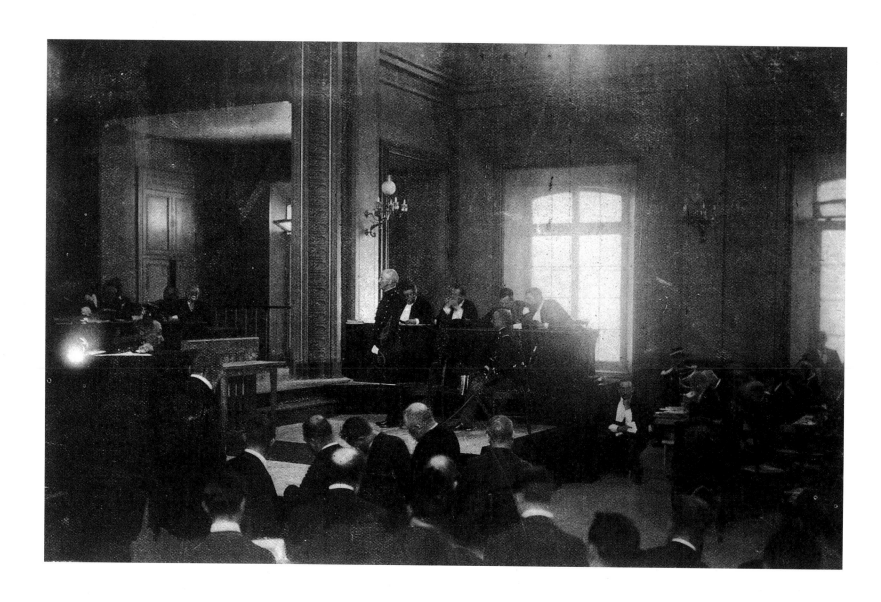

Captain Dreyfus in court in Rennes, moving towards his historic vindication.

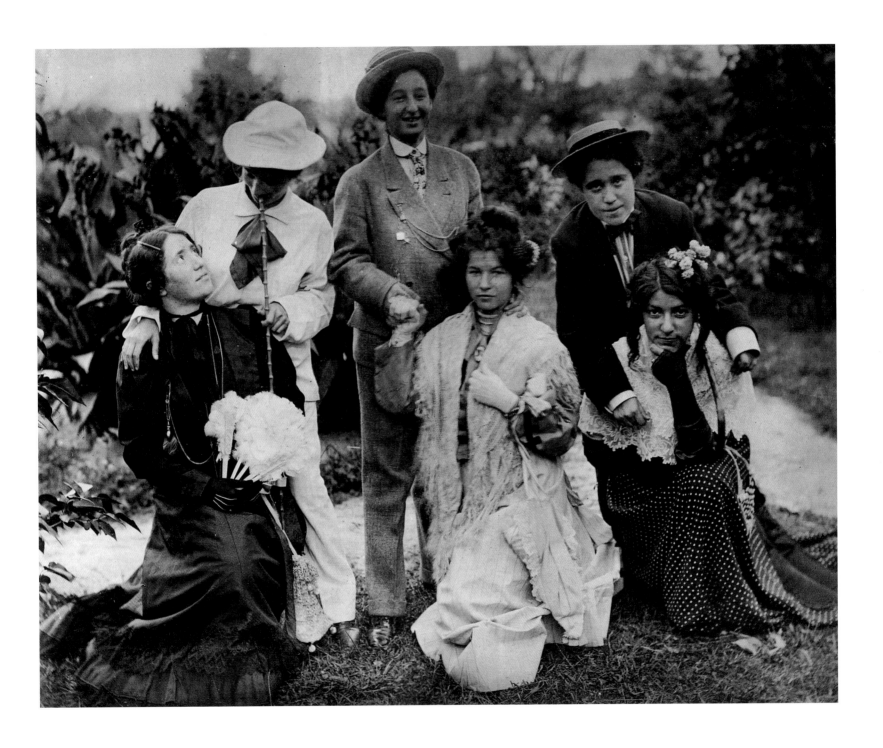

American 'New Women' approach the coming century with high spirits.

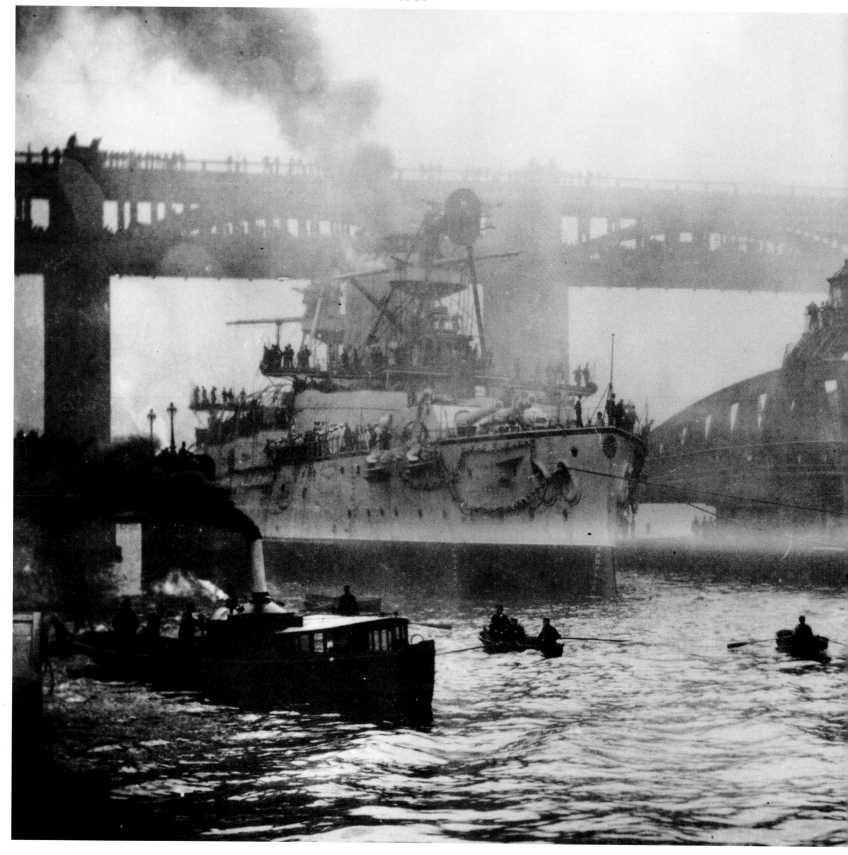

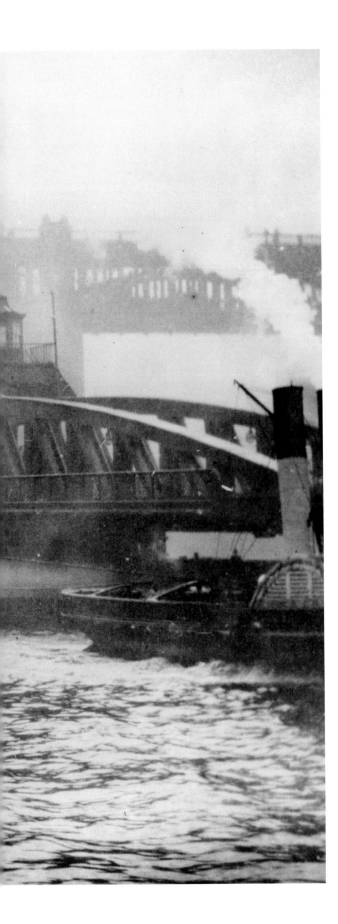

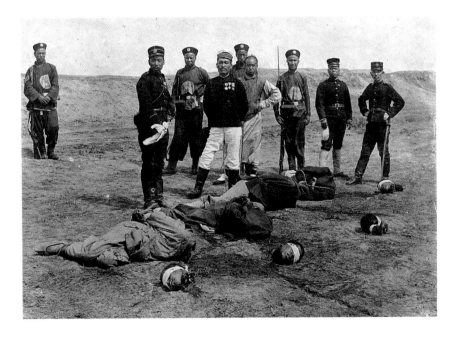

Built on the Tyne River in Britain for friendly Japan, the battle cruiser *Hatsuse* is ready to threaten Russia.
The Boxer Rising in China – Japanese swords at work for European interests.

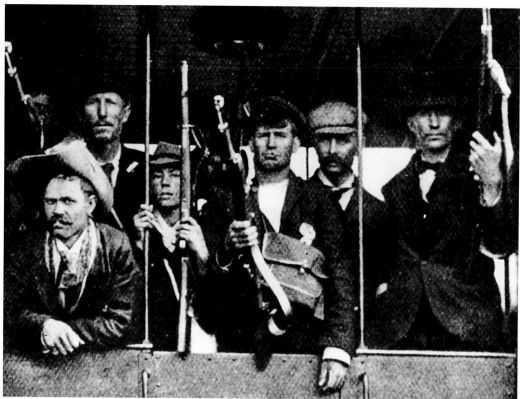

Thanking the Irish for dying in Africa – Queen Victoria visits Dublin during the last year of her reign.
Boer guerrillas show their disregard for conventional military dress and deportment.

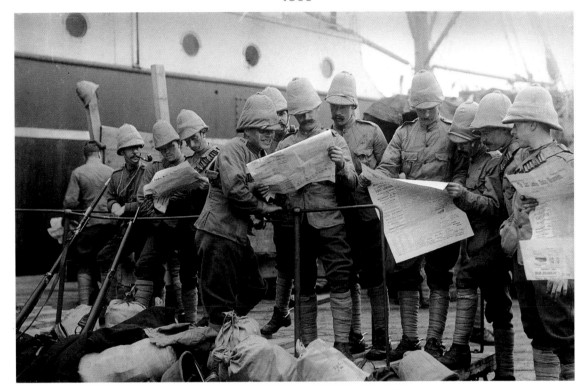

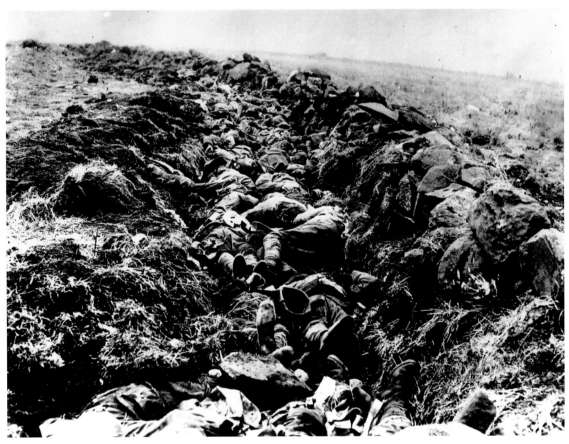

Confident British soldiers read the newspapers on their way to subdue the Boers ...
... but at Spion Kop Afrikaner tactics wiped them out.

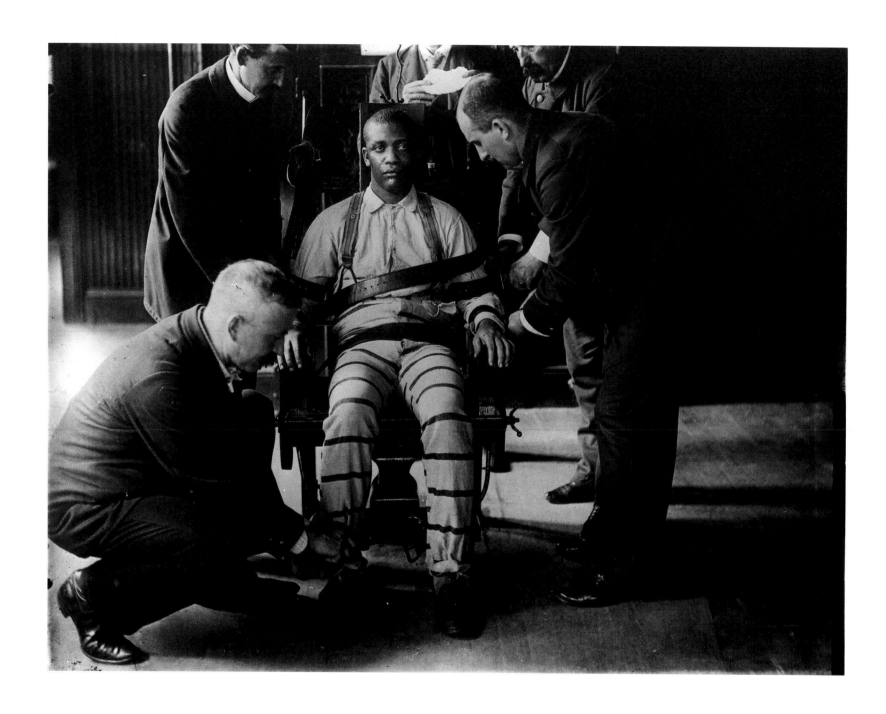

America's relentless modernity. An unnamed man faces death in the electric chair at Sing Sing, a New York state prison.

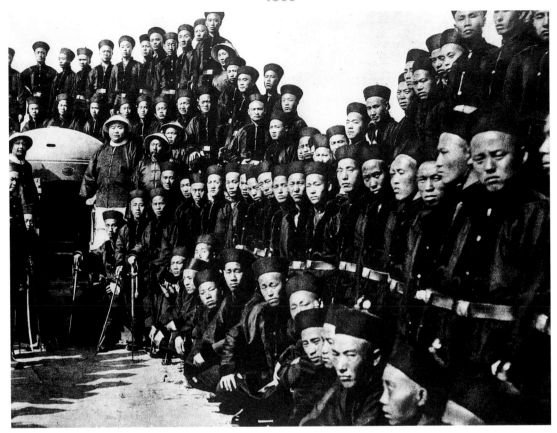

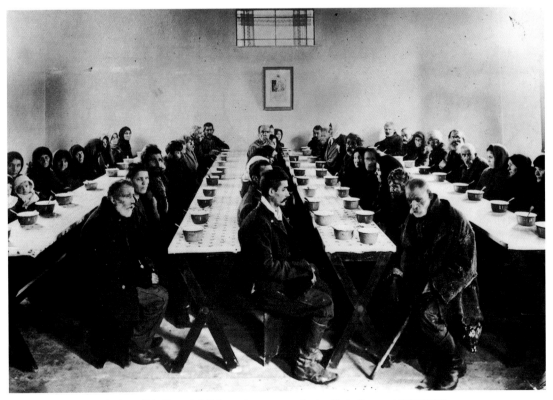

Cadets of the Imperial Chinese Army, many sharing their Empress' xenophobia.
The Daily Bread Institute in Bucharest shows poverty dependent on charity.

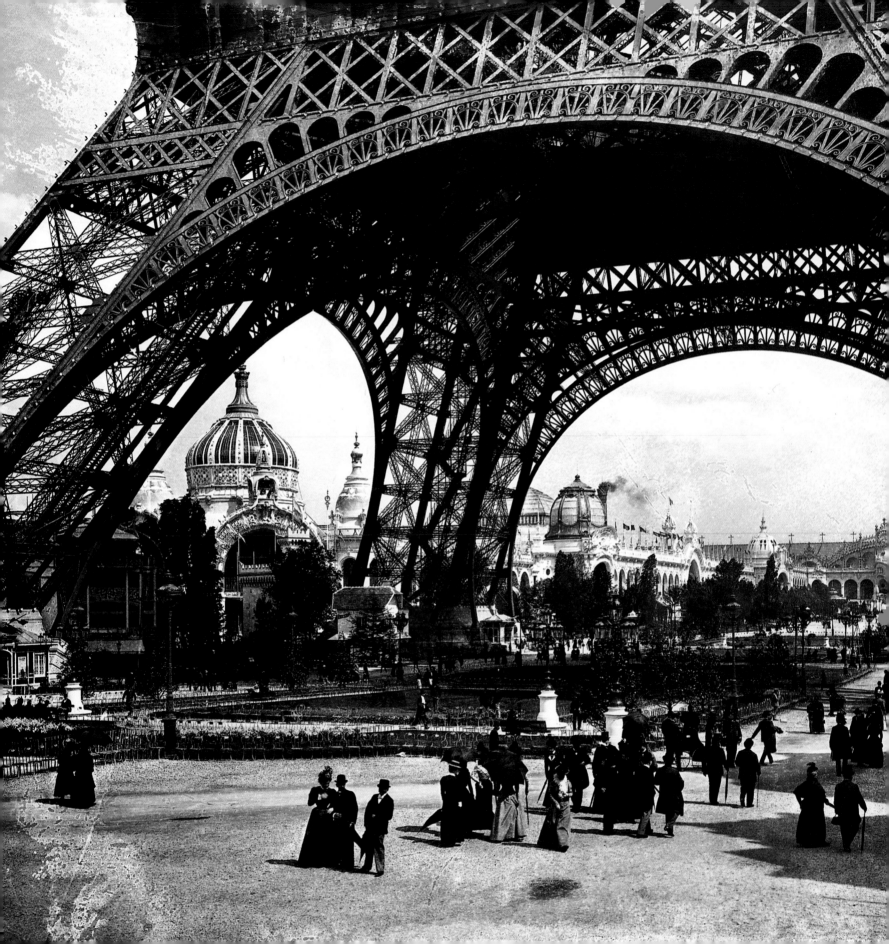

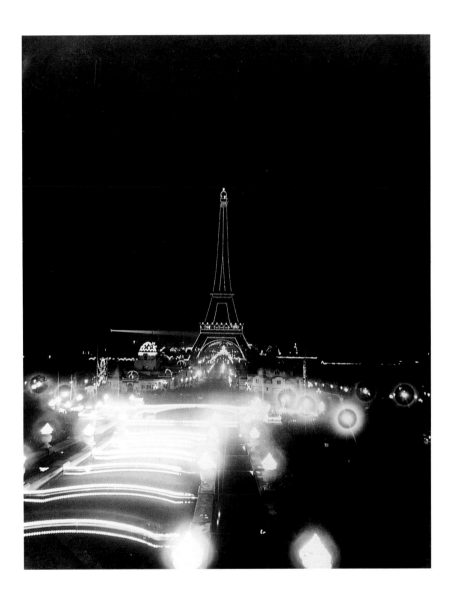

The Paris *Exposition* opened the new century with a brash commercial confidence which was echoed worldwide.
Electric lights on the Eiffel Tower set a style for the future.

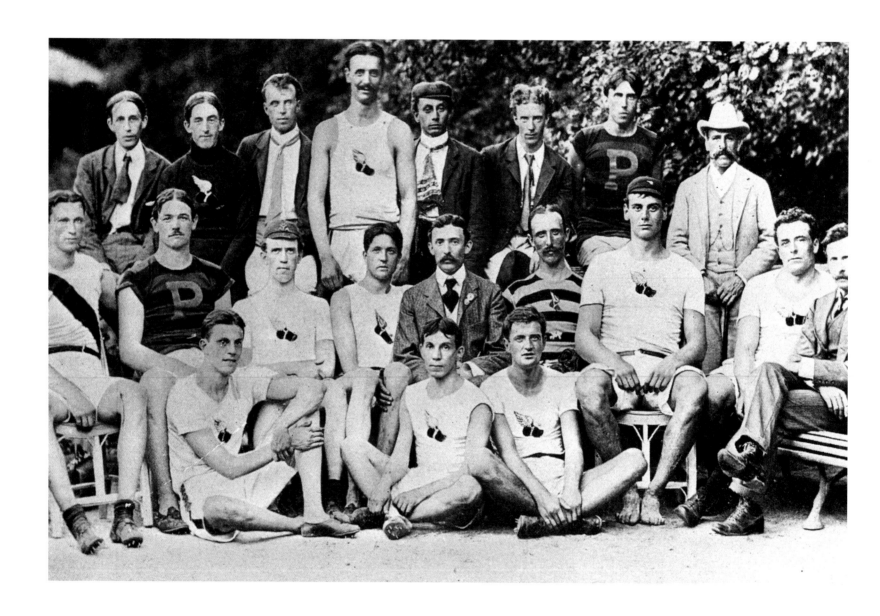

These American contestants in the Paris Olympics were no match for the winning nations, Britain and France.

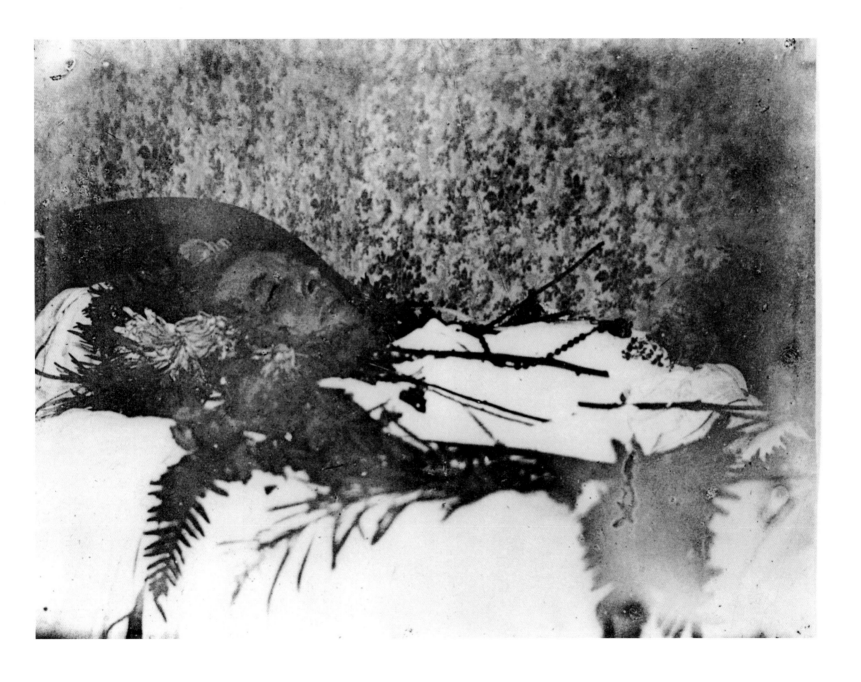

Oscar Wilde on his Paris deathbed. His wit illuminates human behaviour now as sharply as it ever did.

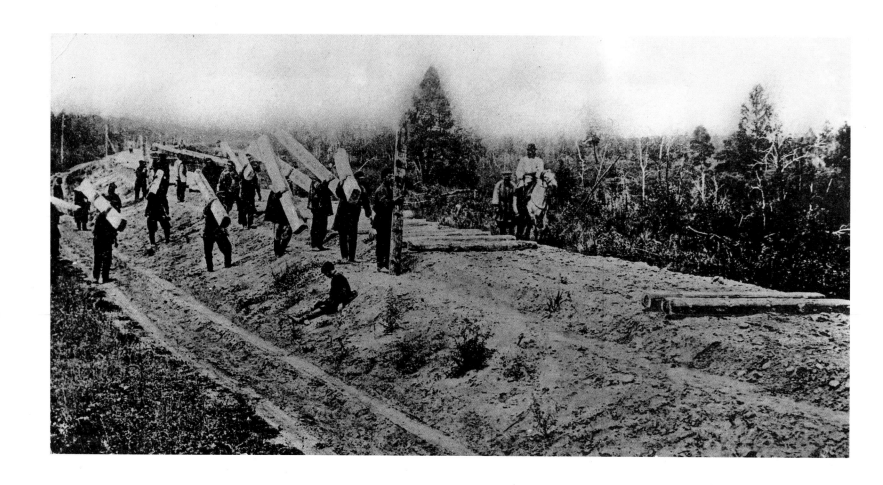

Russians at work on the Trans-Siberian Railway which would span an even larger continent than America.

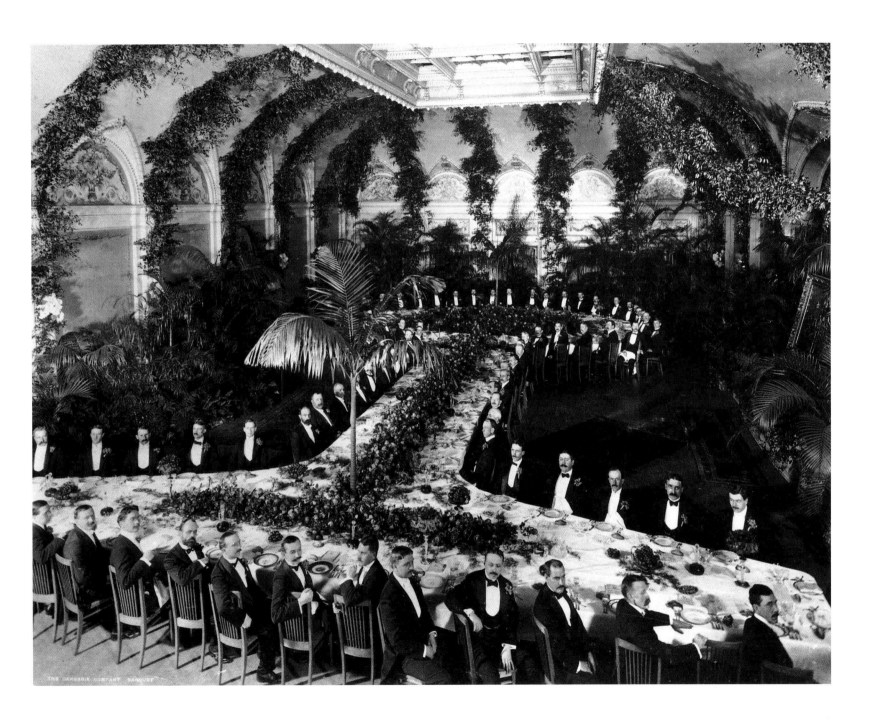

Andrew Carnegie's henchmen eating at a giant rail-section table in Pittsburgh.

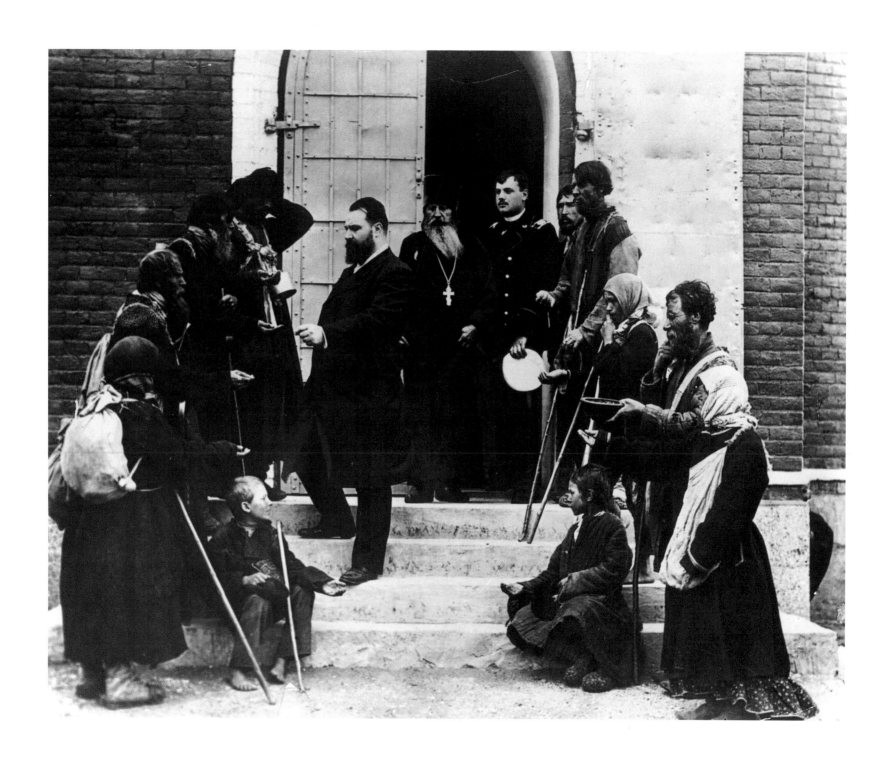

Possibly staged with instructive intent, a Russian photograph illustrates a social structure impossible to maintain or justify.

Качаловъ. Литовцева.

Anton Chekhov's *The Three Sisters* is produced at the Moscow Art Theatre.

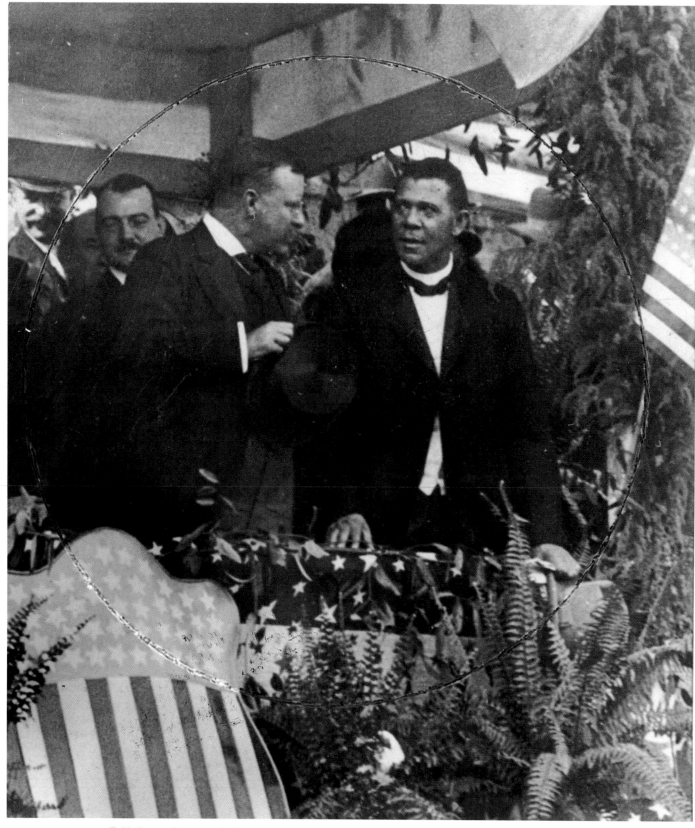

Teddy Roosevelt provocatively visiting Booker T. Washington at his progressive college for African-Americans.

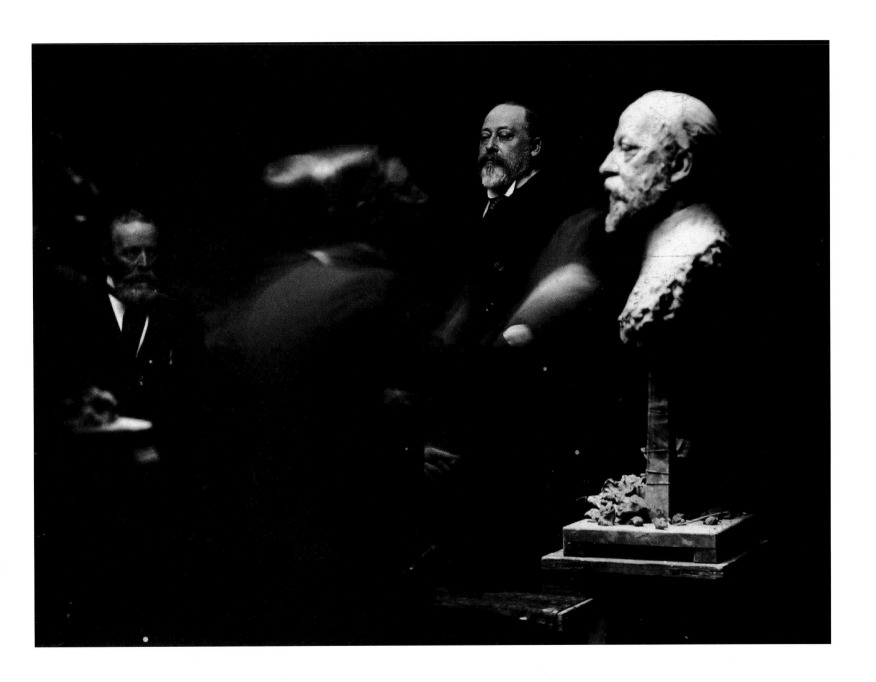

On succeeding to the British throne at fifty-nine, Edward VII was sculpted by Sydney March.

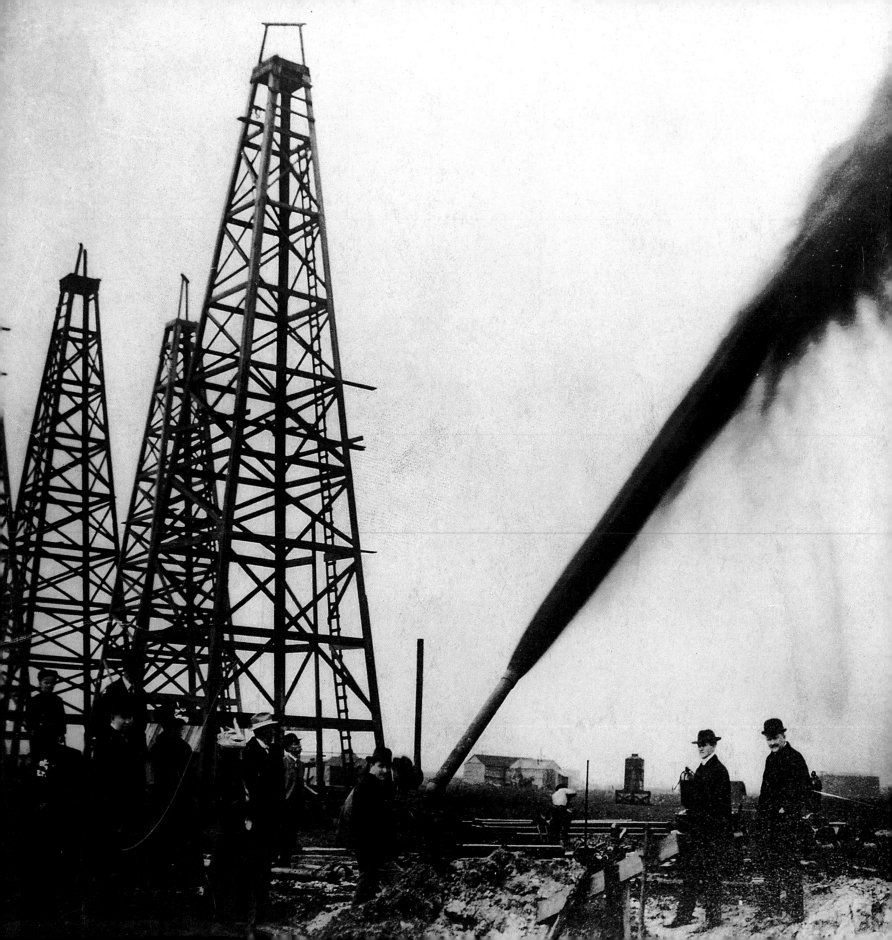

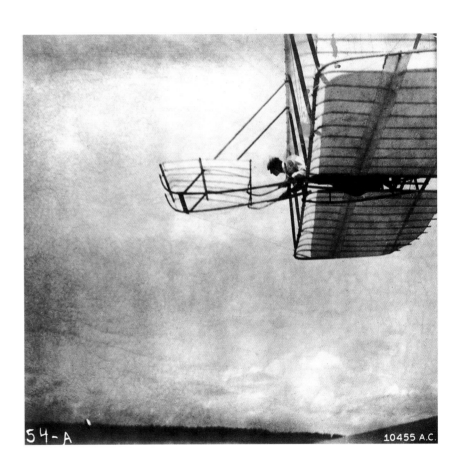

54-A

10455 A.C.

Texas oil gushing. It would soon fuel universal human mobility
– and create enormous wealth as well as pollution.
The Wright brothers' glider confidently awaits its engine.

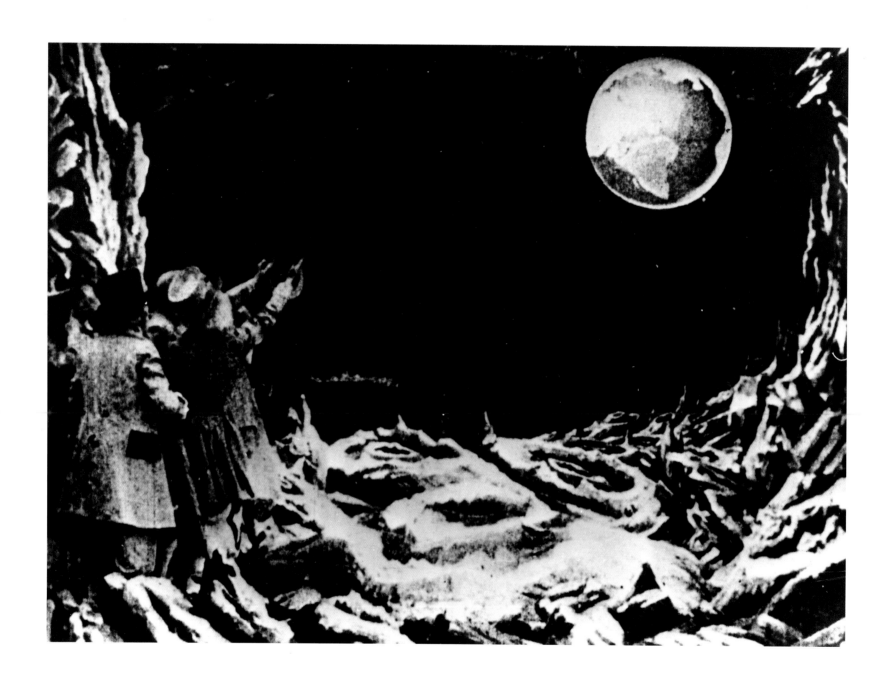

Georges Méliès' early sci-fi film *A Trip to the Moon* pre-dated the real thing by only sixty-seven years.

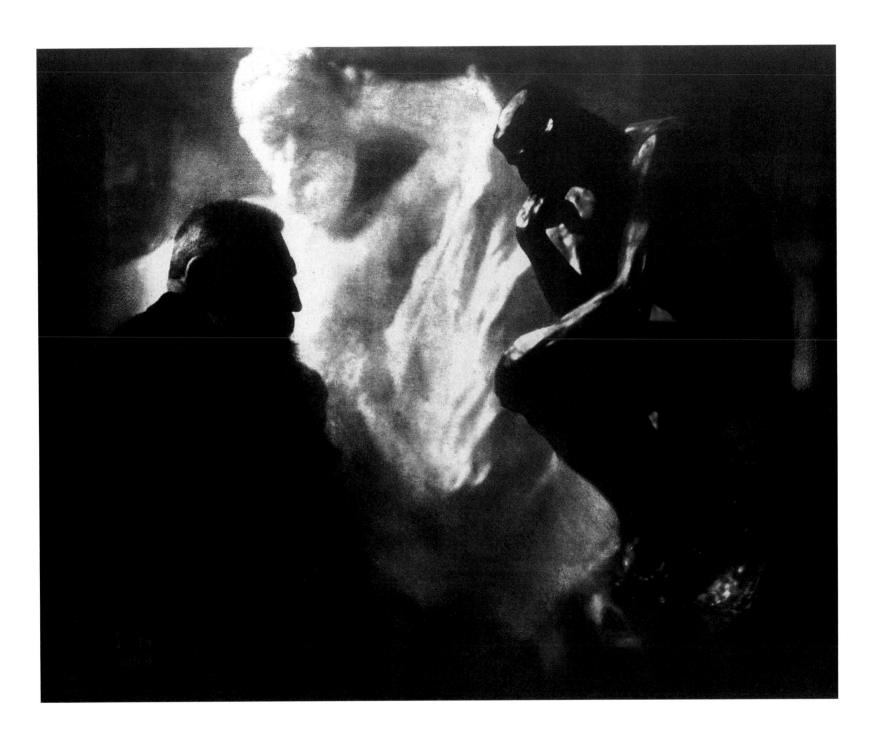

August Rodin with his great symbolic figure *The Thinker* photographed by the American Edward Steichen.

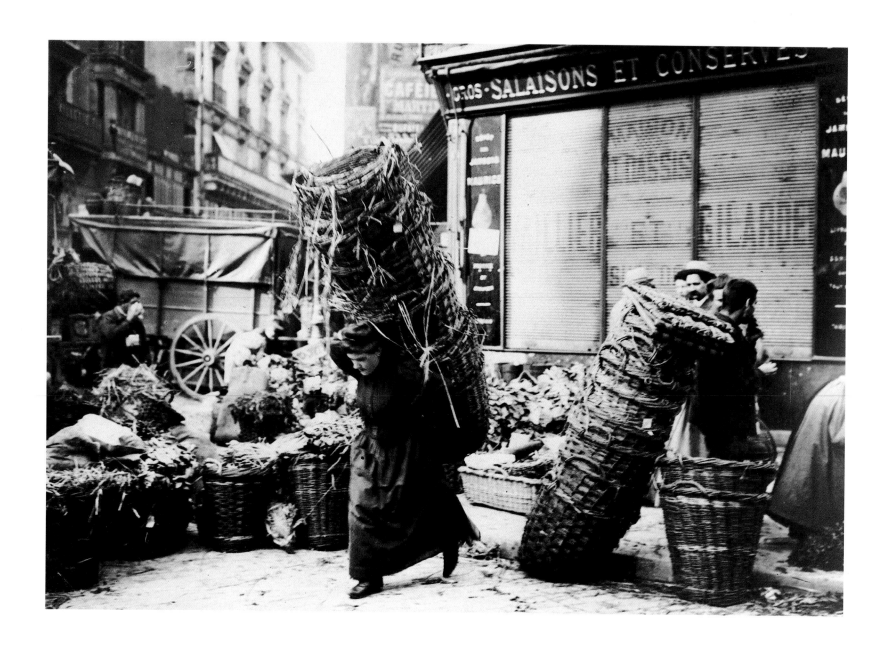

Daily toil at Les Halles, the great Paris food market, photographed by Paris-based American photographer Harry Ellis.

A good family turnout for speeches at a coal miners' meeting during the great Pennsylvania strike.

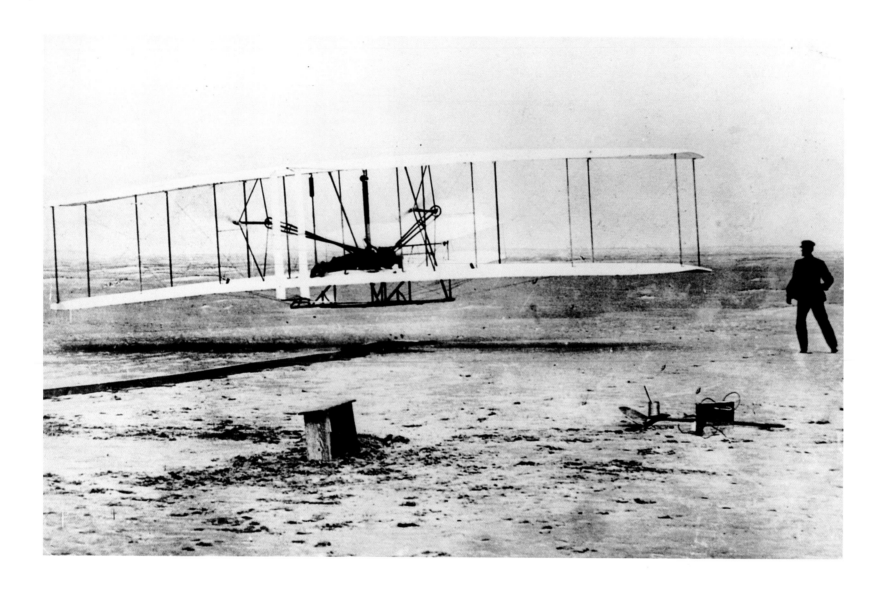

Orville Wright's first powered flight at Kitty Hawk, North Carolina. The achievement would radically change life and death on earth.

The Great Train Robbery – almost certainly the first blank cartridge fired at a movie audience.

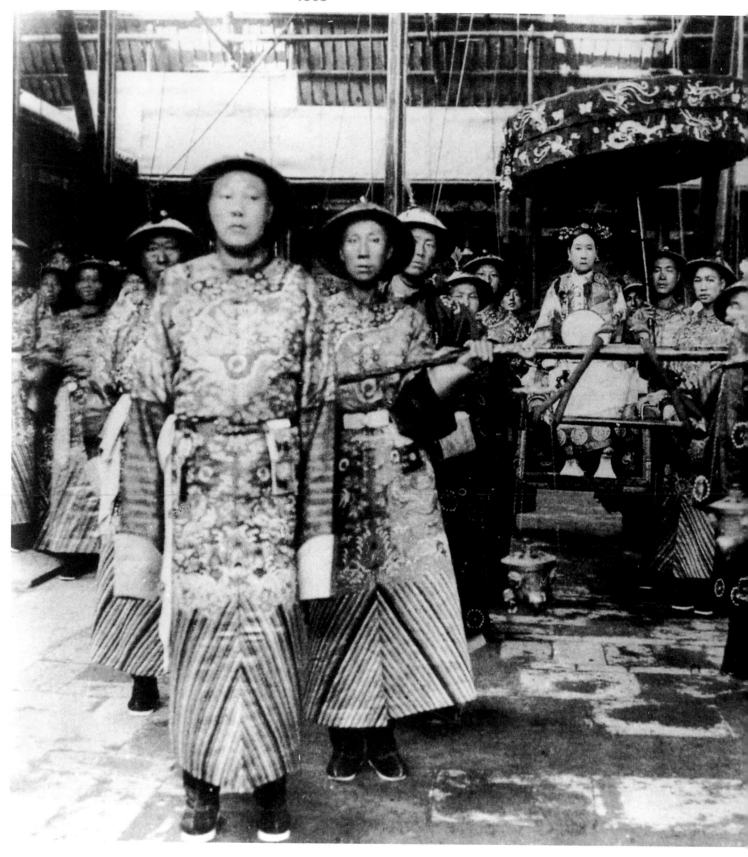

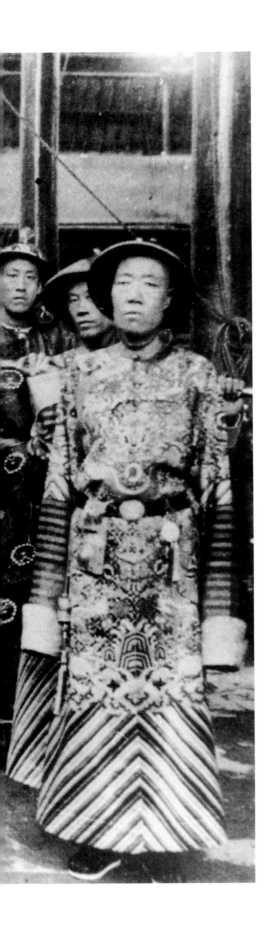

Cixi, the Dowager Empress of China, with her eunuchs and retinue. The Manchu dynasty had only ten years to go.

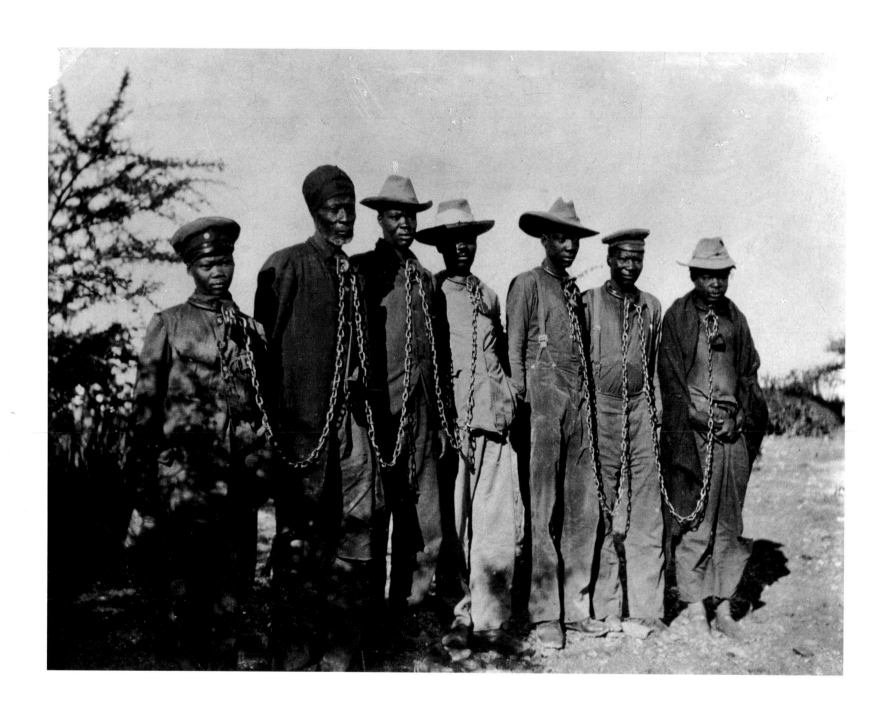

In German South West Africa the Herero revolt against their masters was brutally supressed.

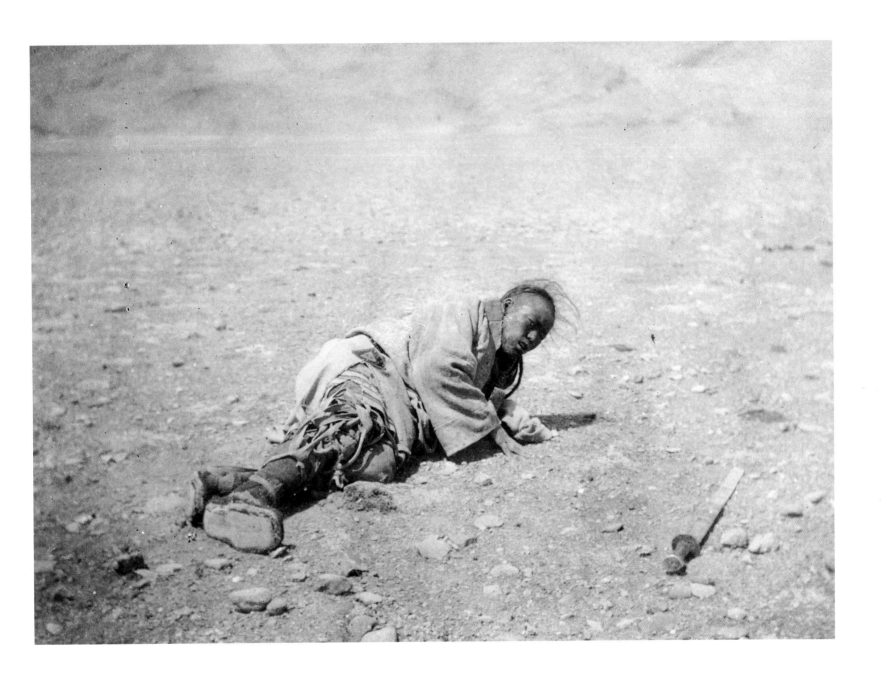

One casualty of the British invasion of Tibet. Suspicions of Russian intentions there cost hundreds of native lives.

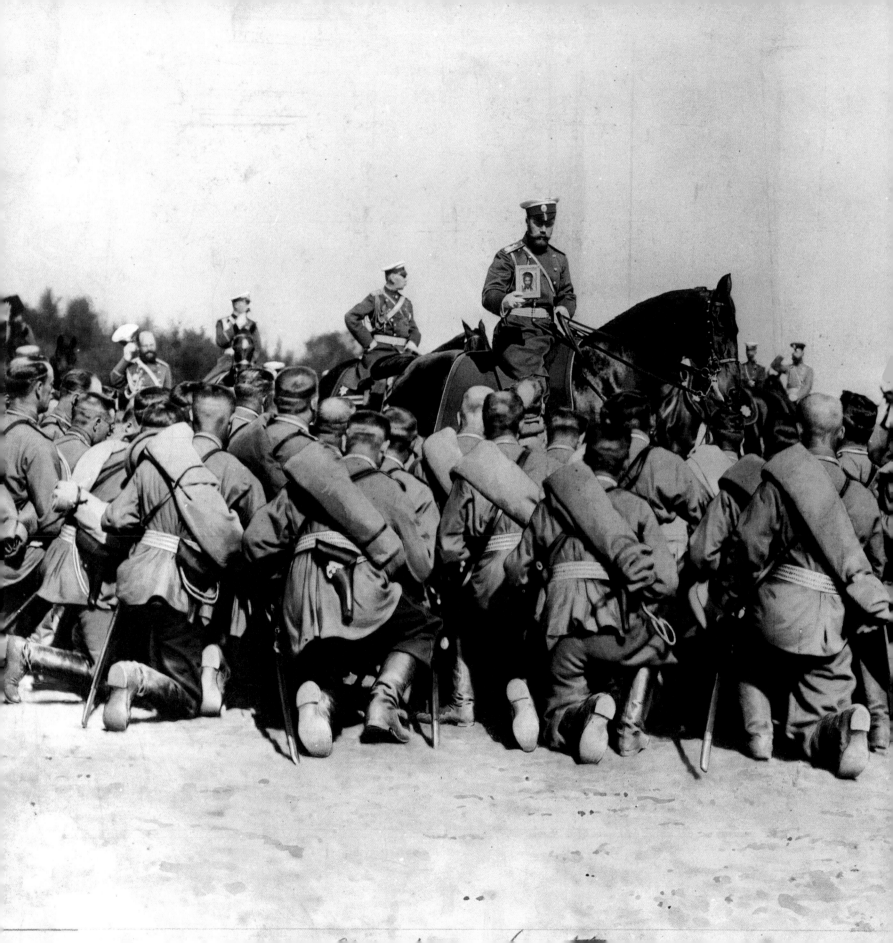

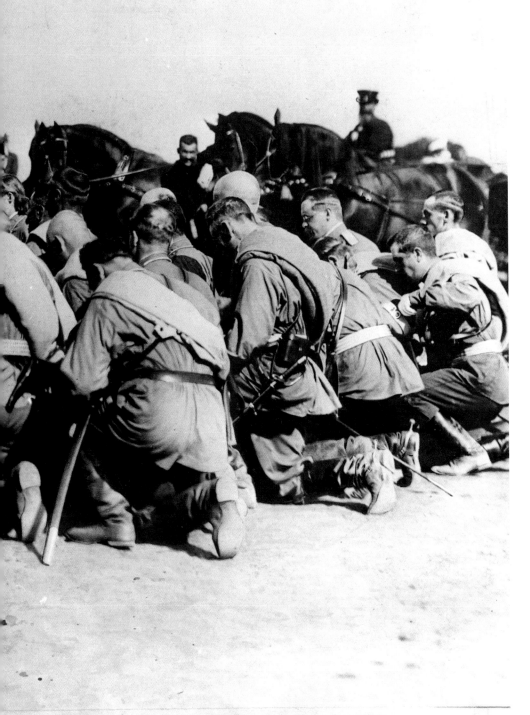

The Tsar blessing his troops with an icon of a being he acknowledged
to be greater even than himself.

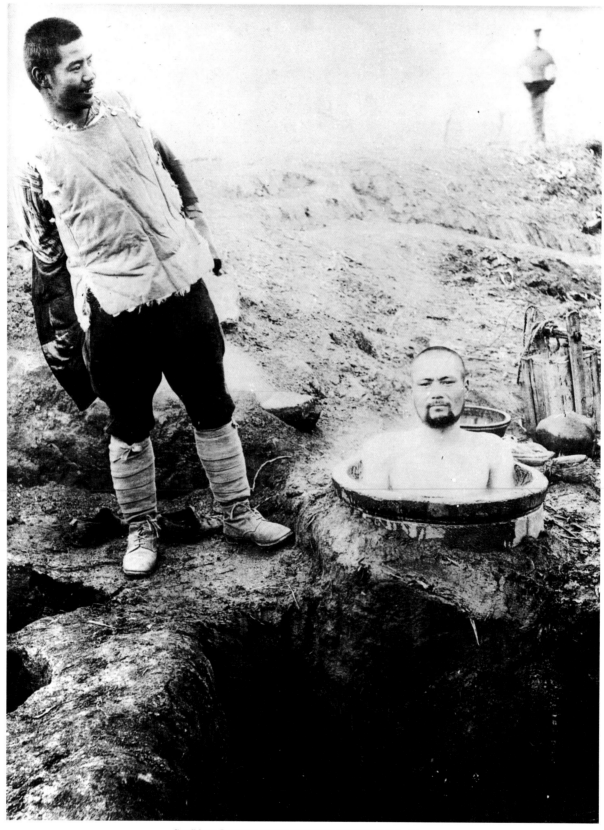

Confident Japanese troops enjoying a bath between battles.

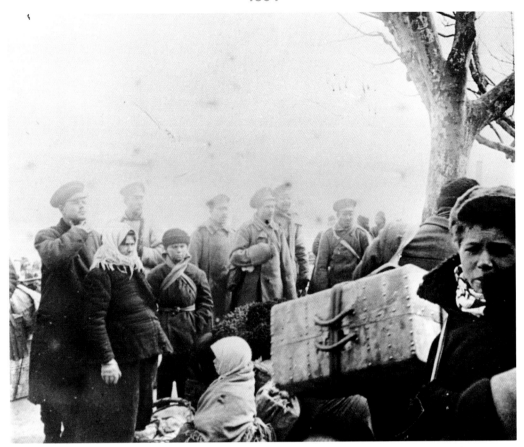

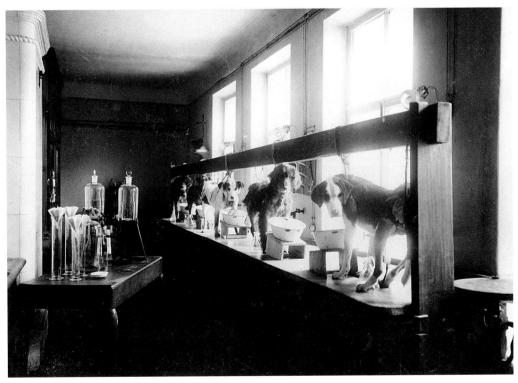

Russians fleeing Shanghai as the Japanese reach the city.
The laboratory of Russian scientist Ivan Pavlov, who discovered conditioned reflexes through dogs' responses to chosen stimuli.

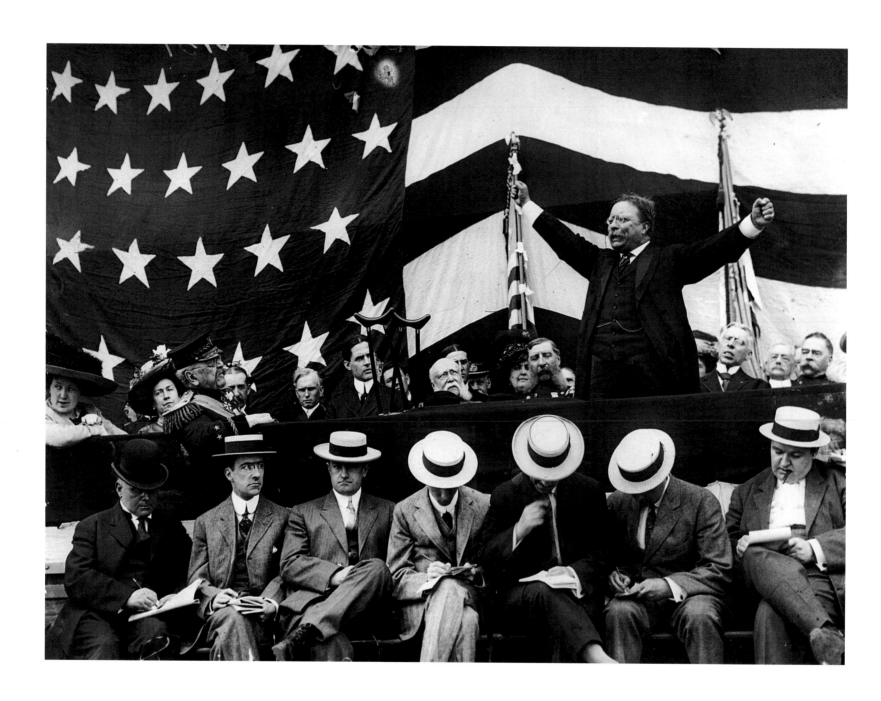

Teddy Roosevelt – an ebullient, egotistical and also progressive president.

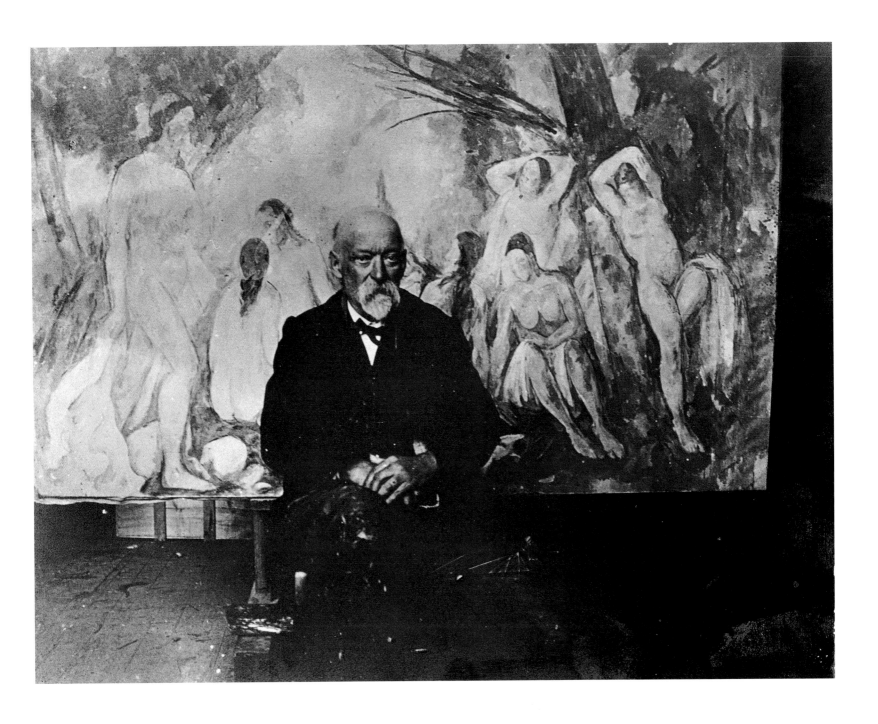

Paul Cézanne looking content with a late *Grandes Baigneuses* – a rare emotion captured by friend and painter Emile Bernard.

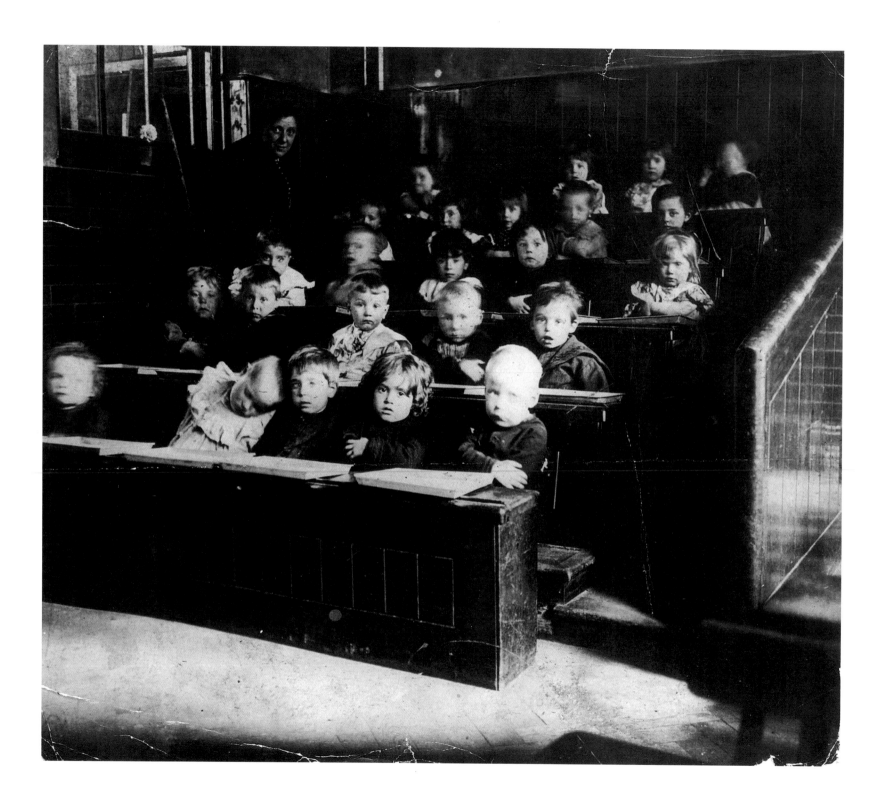

A touching image of a London classroom.

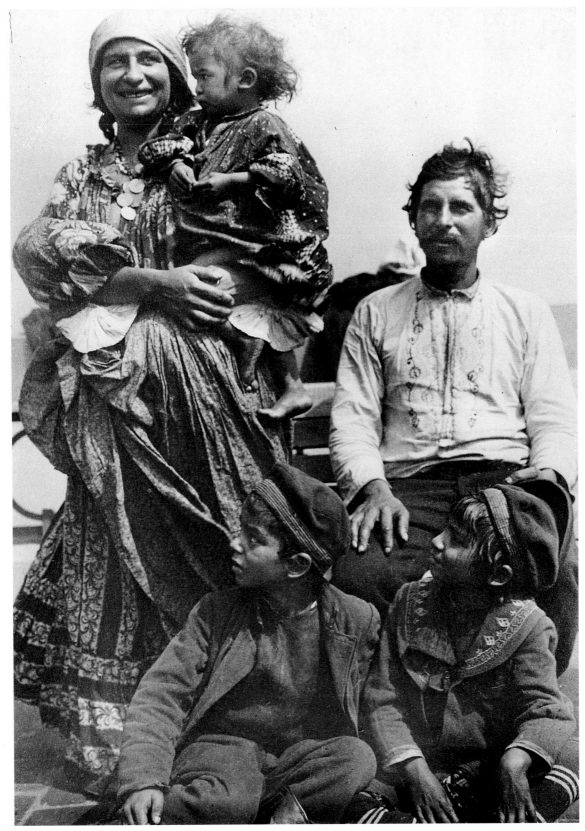

Serbian Gipsy immigrants arriving at Ellis Island seem confident of their admission and of their future.

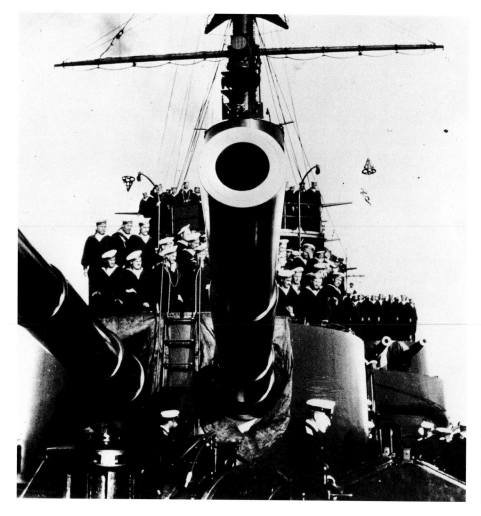

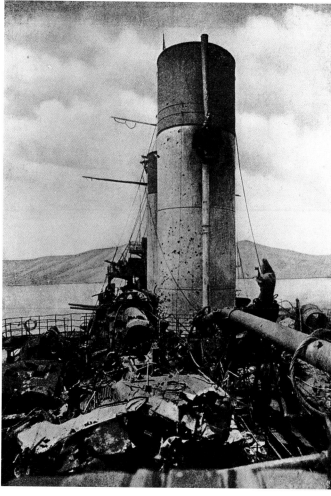

A Russian warship looks deceptively invincible before meeting the Japanese ...
... while another bears witness to the fire power and skill which brought Russia such a crushing defeat.

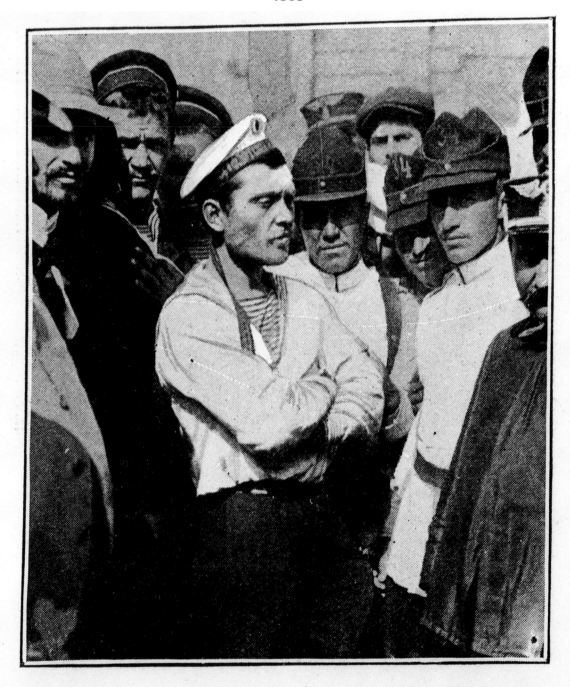

Matsushenko, who is said to have been the leader of the mutiny, found himself ultimately opposed to the rest of the mutinous crew of the Kniaz Potemkin. He wished to blow up the ship, but as all the rest were anxious to surrender to the Roumanians, he had to give way. It is said that when the mutiny broke out Matsushenko himself killed ten officers.

MATSUSHENKO, THE RINGLEADER OF THE MUTINY

Report of the mutiny on the Russian battleship *Potemkin*, immortalized by Sergi Eisenstein in his groundbreaking film.

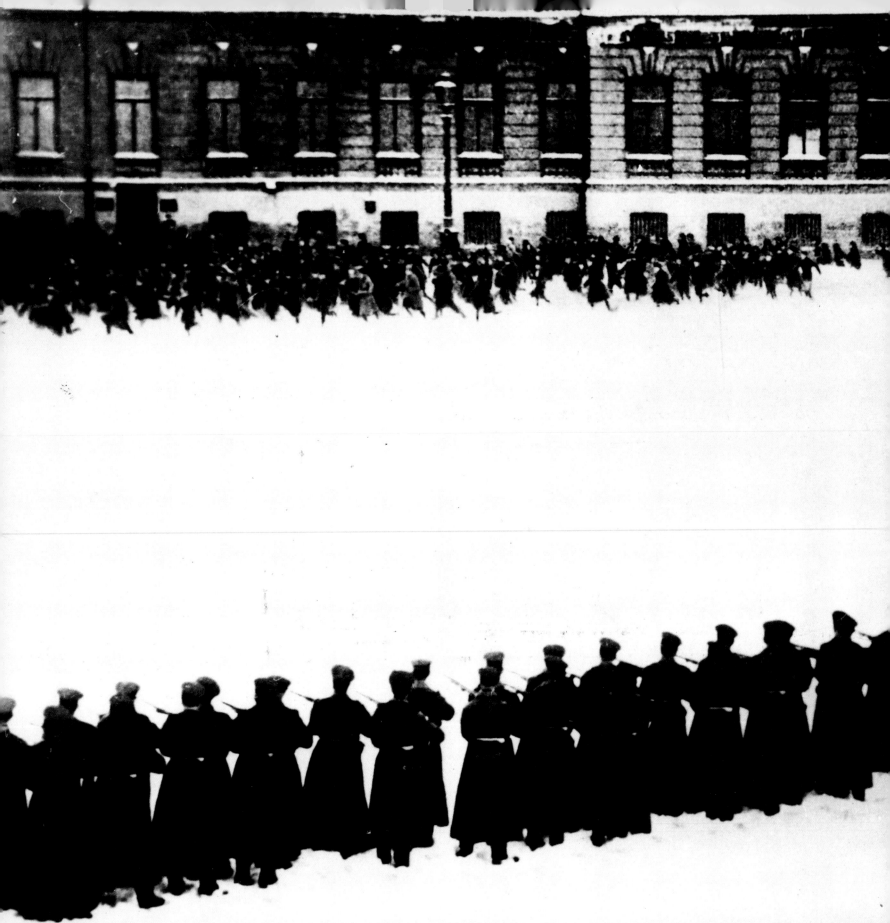

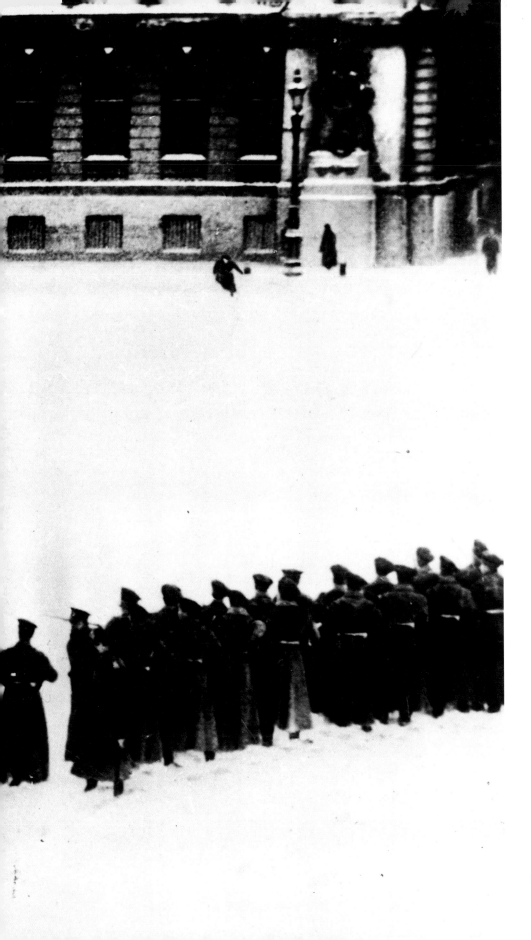

Bloody Sunday in Russia. On 22 January a petition was taken for
humble presentation to the Tsar at the St Petersburg Winter Palace.
Its bearers were mown down.

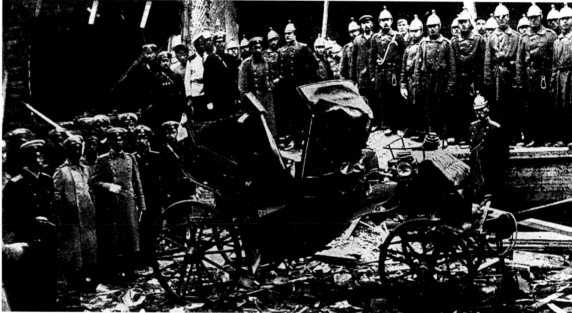

Father Gapon, who may have betrayed his St Petersburg flock, is hanged for his role on Bloody Sunday.
Peter Stolypin, Russia's progressive Prime Minister, escapes assassination for the time being.

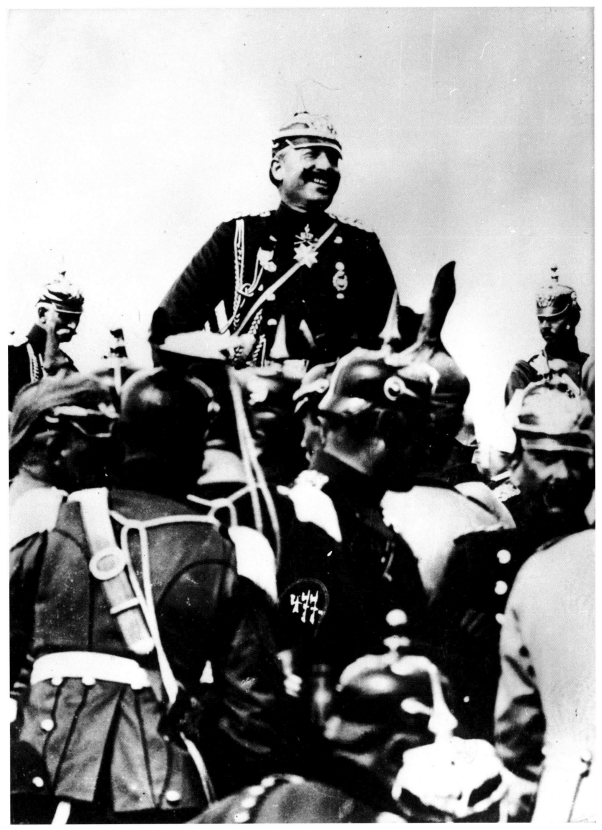

A foretaste of quick victories? Kaiser Wilhelm II on manoeuvres.

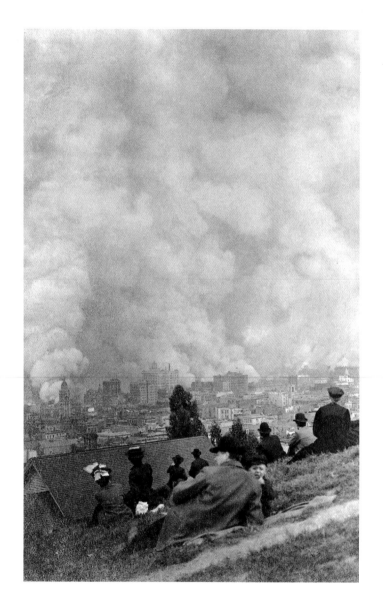

San Francisco burning after the great earthquake – a memorable image by Arnold Genthe.

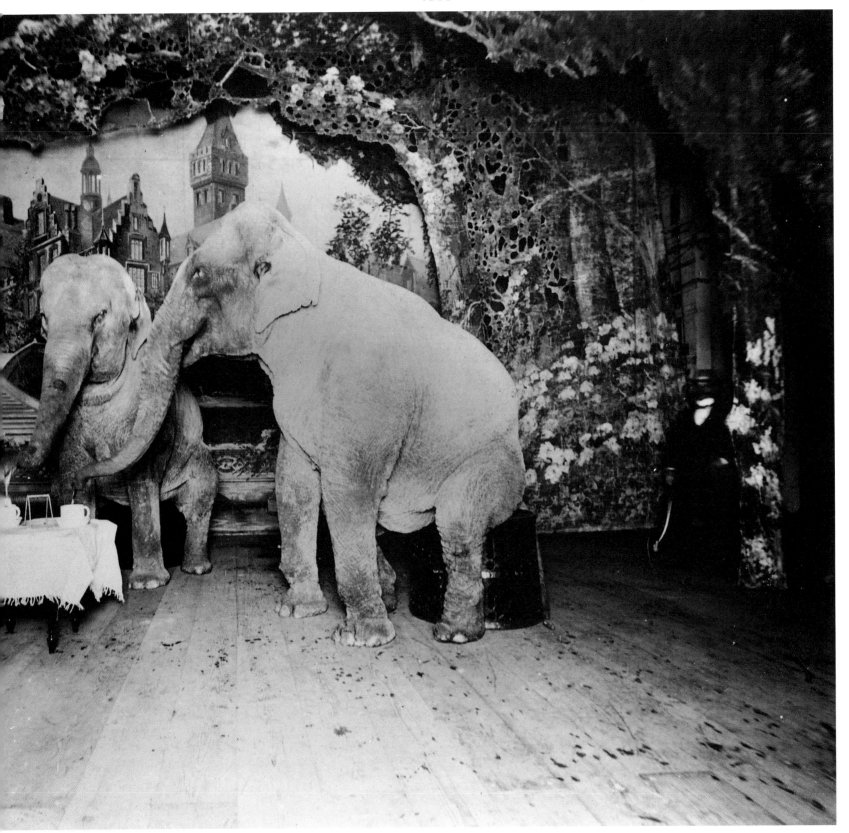

Elephants taking tea in Paris. To induce delicacy in great beasts was once seen as a major human triumph.

French actress Sarah Bernhardt takes her talents to America and stops off at Niagara Falls ...

... later performing *Phèdre* at Berkeley some 5,000 kilometres (3,000 miles) further on.

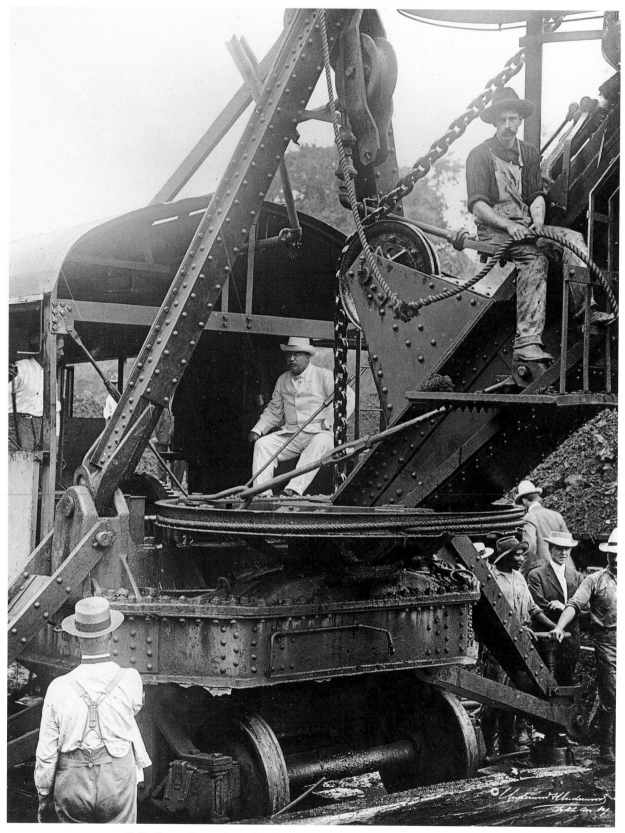

Teddy Roosevelt on a steam shovel glories in his grandest project: the Panama Canal.

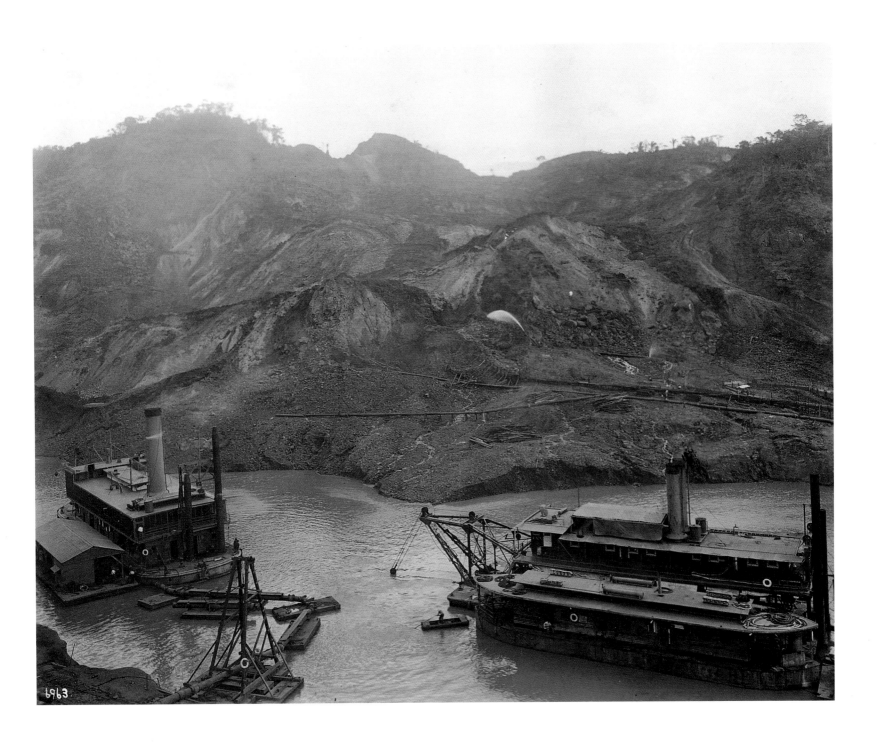

Man and machinery nearing success in the Panamanian mire. The first attempt in 1889 had been a catastrophe.

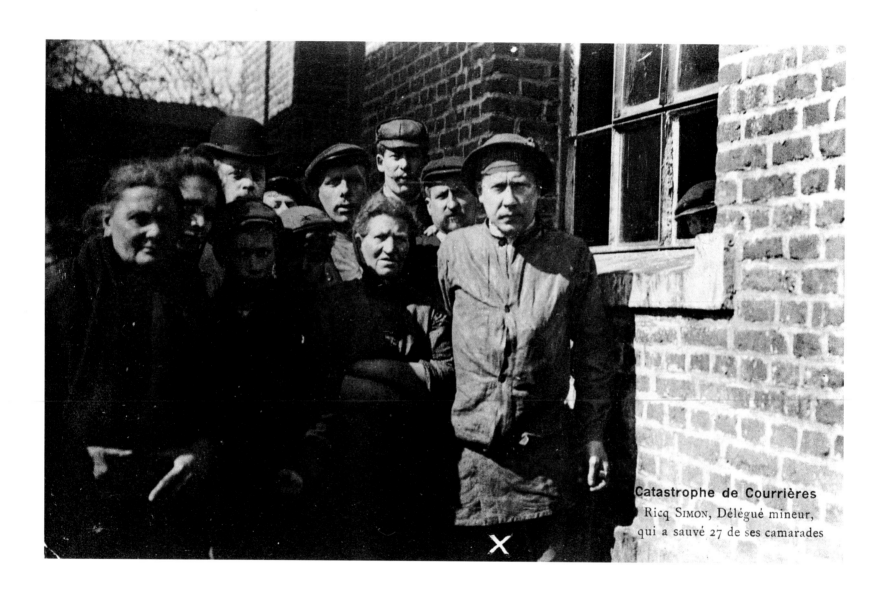

Catastrophe de Courrières
Ricq SIMON, Délégué mineur,
qui a sauvé 27 de ses camarades

Mining disasters killed thousands each decade – this one at Courrières killed 1,230. Heroes like Ricq Simon (far right) were always to be found.

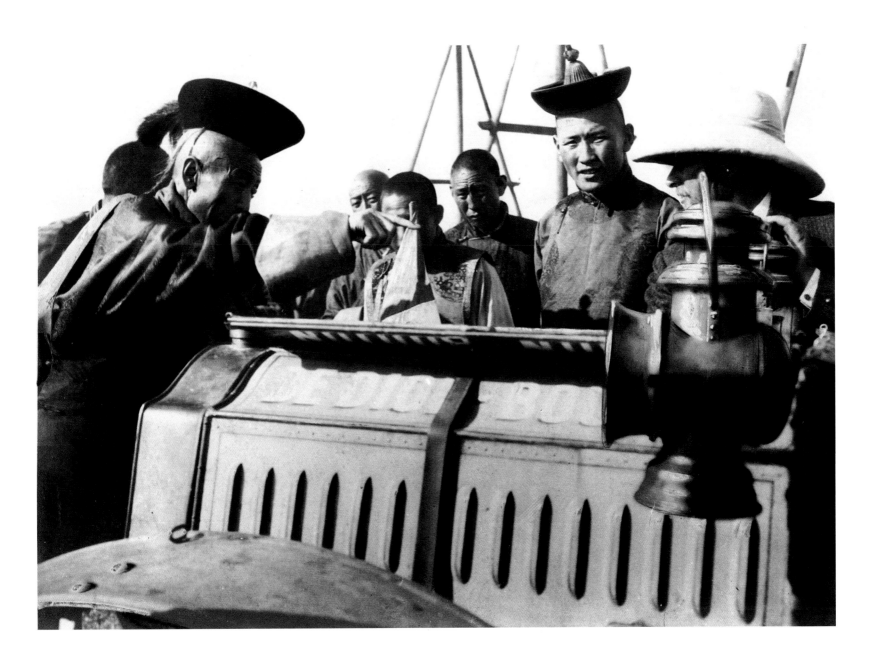

The Peking-to-Paris automobile race excited everyone along its route, although the Chinese suspected espionage.

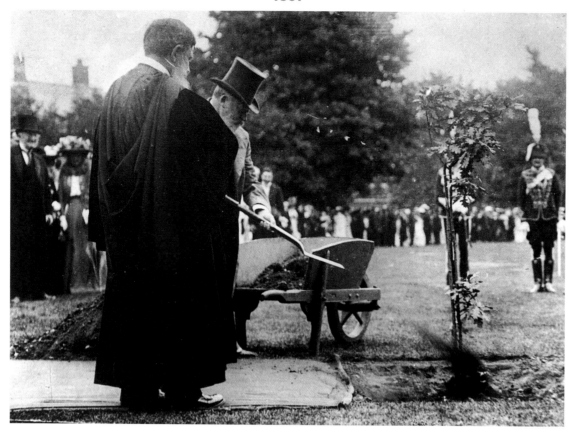

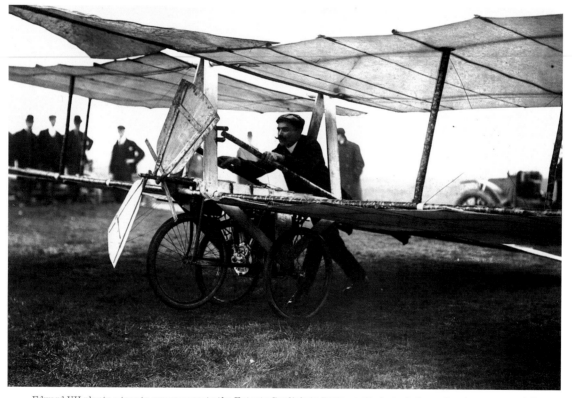

Edward VII plants a tree to commemorate the Entente Cordiale in Paris – a city he had always found very congenial.
The meticulous work of the Wright brothers spawned many non-flying machines – A.M. Guillon tries his out on Epsom Downs, England.

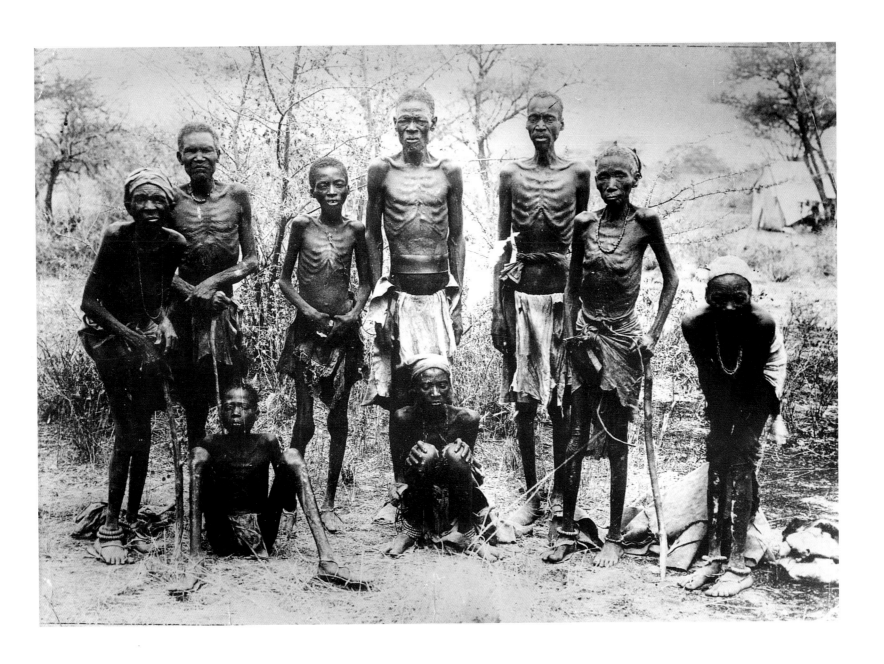

South West African Hereros who fled from their German rulers and starved. An early photograph of such suffering – with thousands more to come.

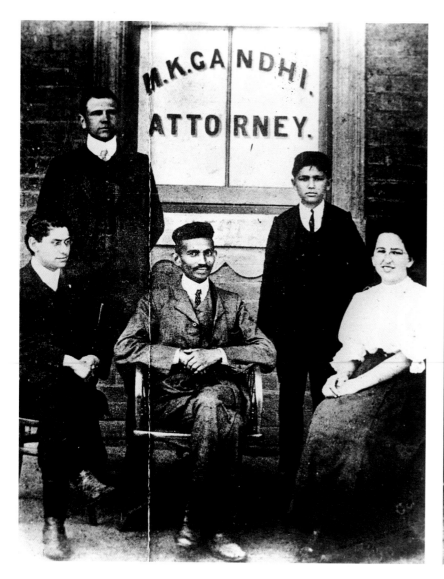

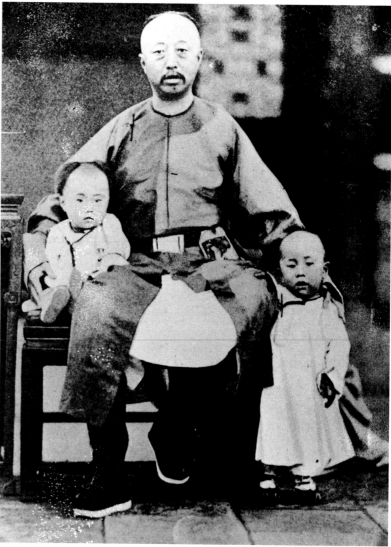

Mahatma Gandhi outside his law practice in South Africa. Born in India, he would return there to fulfil his destiny.
Pu Yi, the last Chinese Emperor, on his father, the Regent's, knee.

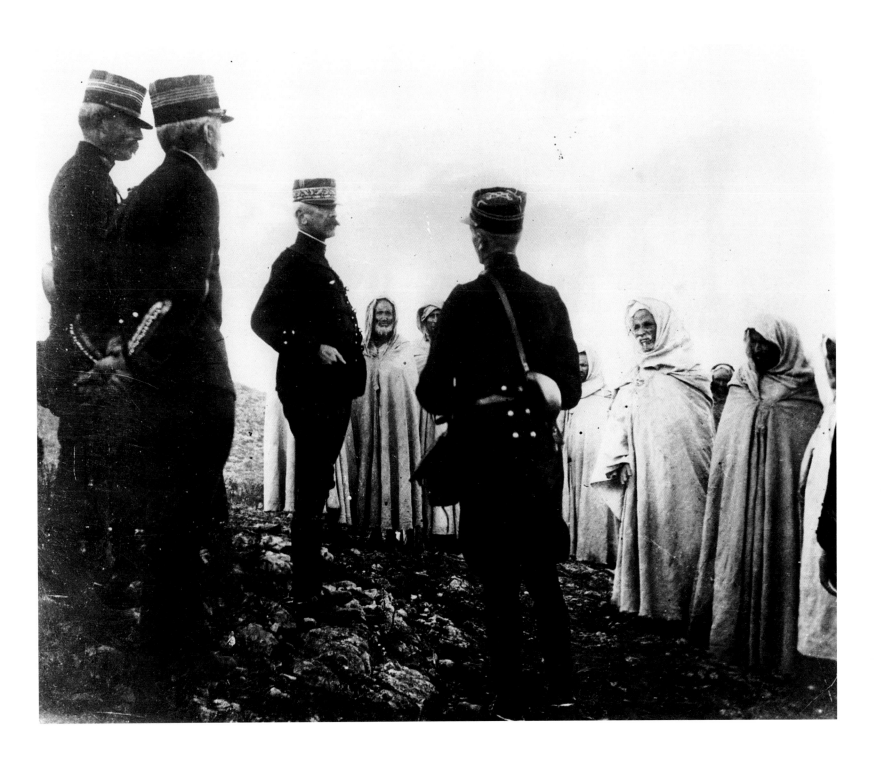

Colonel, later General Lyautey, campaigning against rebel Arabs. He was the soul of French imperialism's more enlightened aspects.

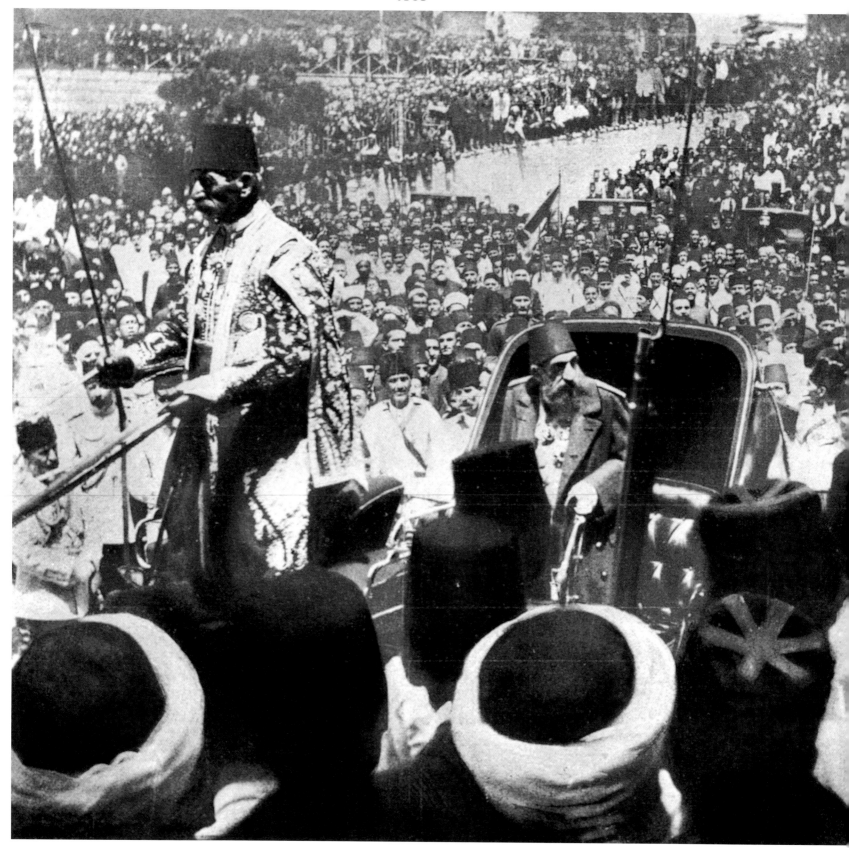

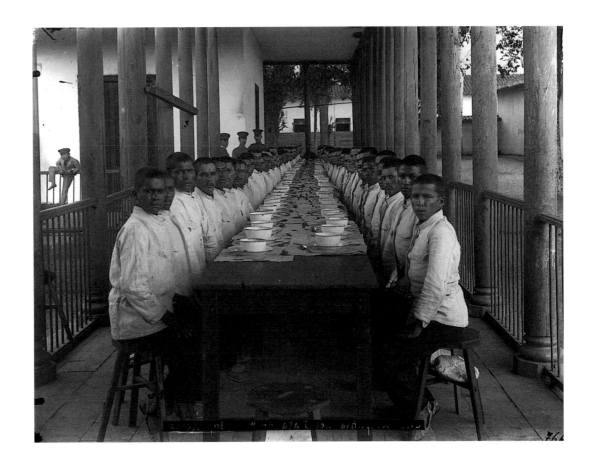

Abdul Hamid II, Sultan of Turkey, in a rare public appearance – and even more rare photograph.
Part of a Colombian infantry battalion seated in their mess – a fine photograph of military order.

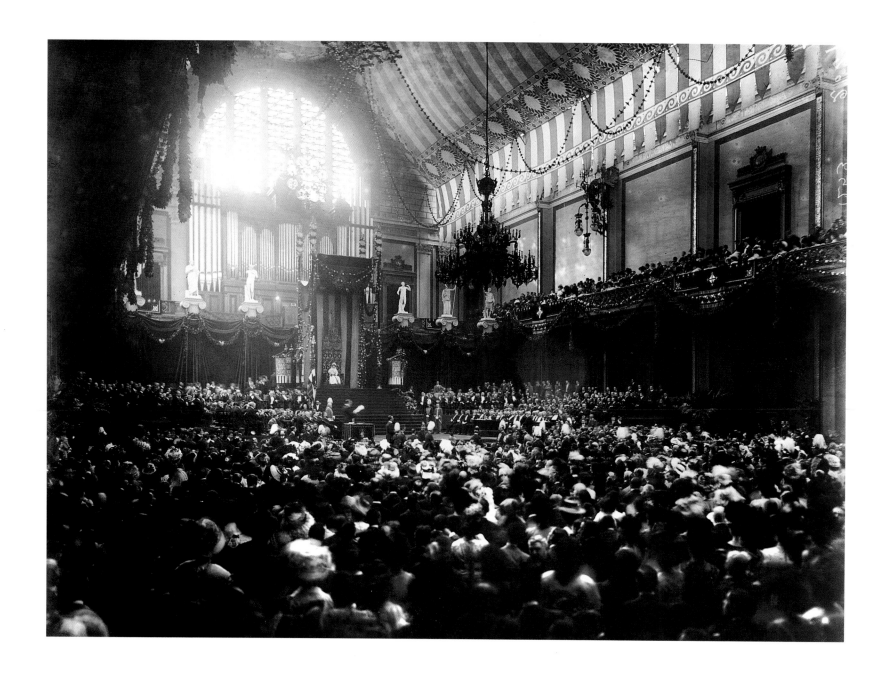

The fiftieth anniversary of the revival of the Floral Games in Barcelona.

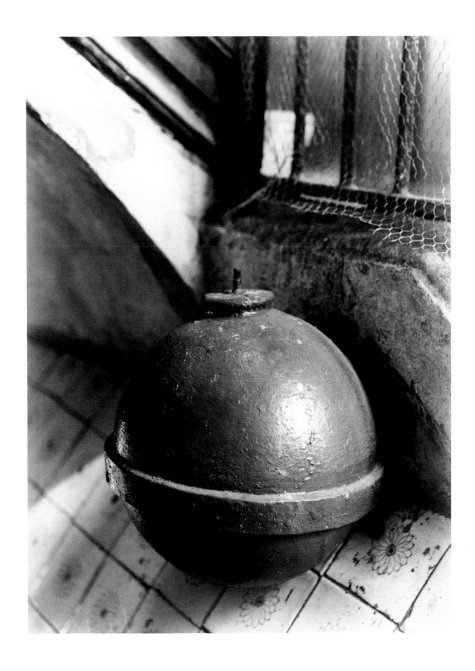

A bomb made by anarchists in Barcelona proves that the cartoonists have not deceived us.

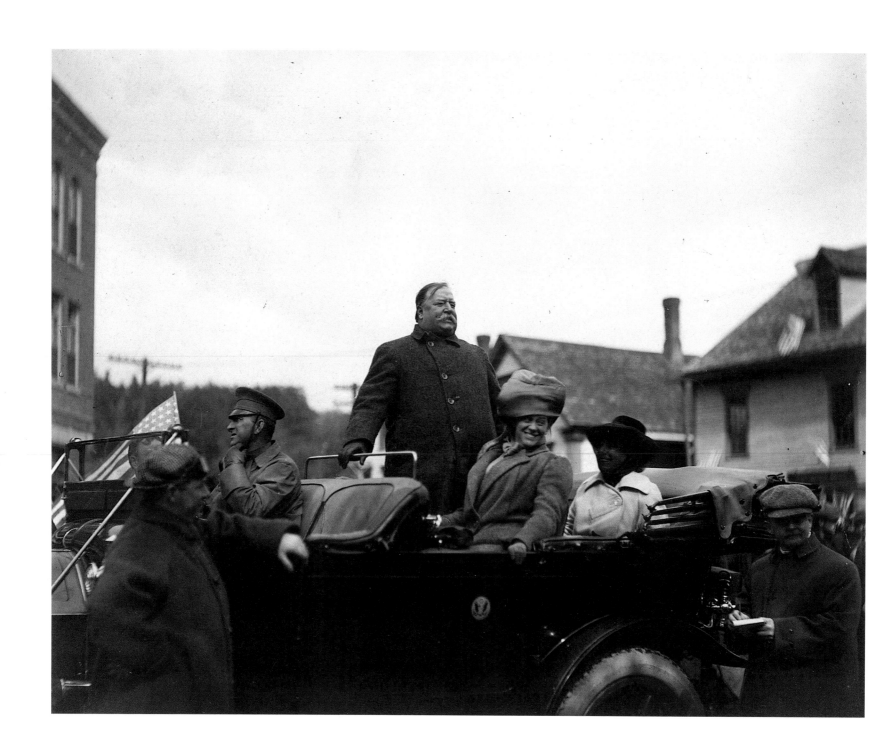

William Howard Taft successfully campaigning to succeed Teddy Roosevelt in 1909.

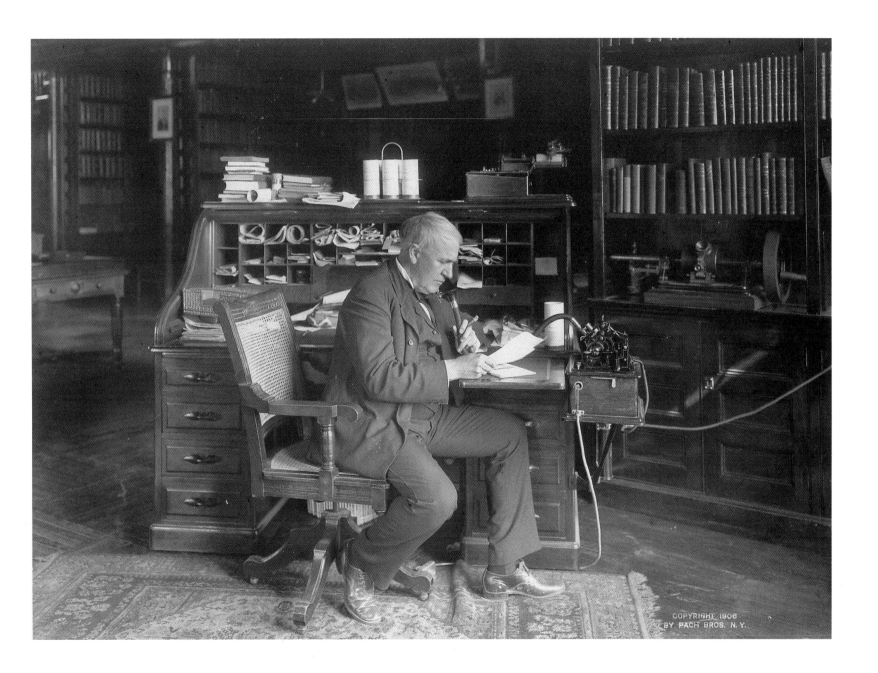

Thomas Edison, prolific inventor and archetypal American spirit, posing with his Dictaphone.

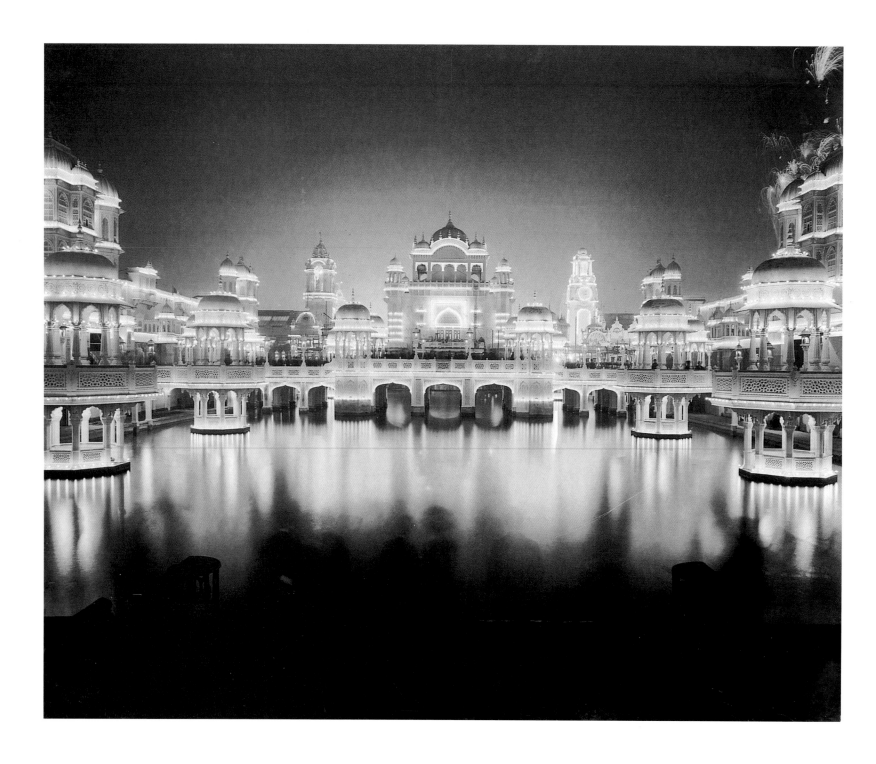

The Franco-British exhibition at White City in west London – a lavish celebration of a re-alliance.

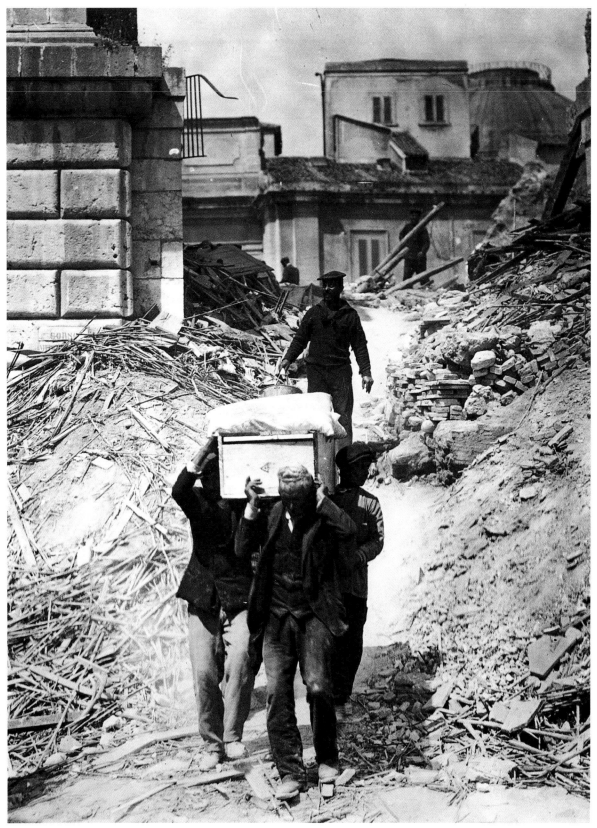

A year after the Messina earthquake of 1908 in Sicily which killed 200,000, bodies were still being recovered from the ruins.

Innocent fun from sibling affection – the Tsarevitch and Grand Duchess Anastasia on a palace balcony.

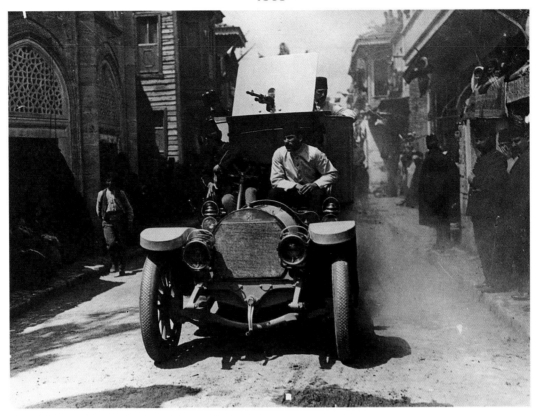

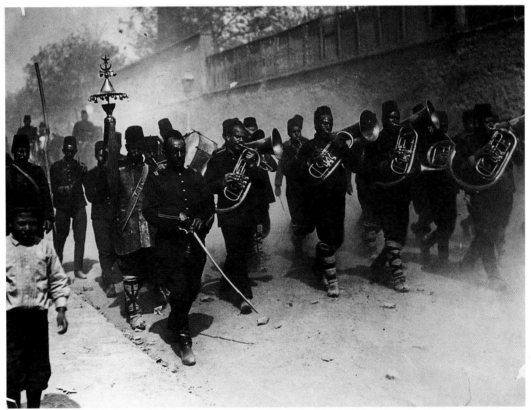

The Young Turks triumphantly enter Istanbul – then Constantinople – harbingers of both national progress and fragmentation.

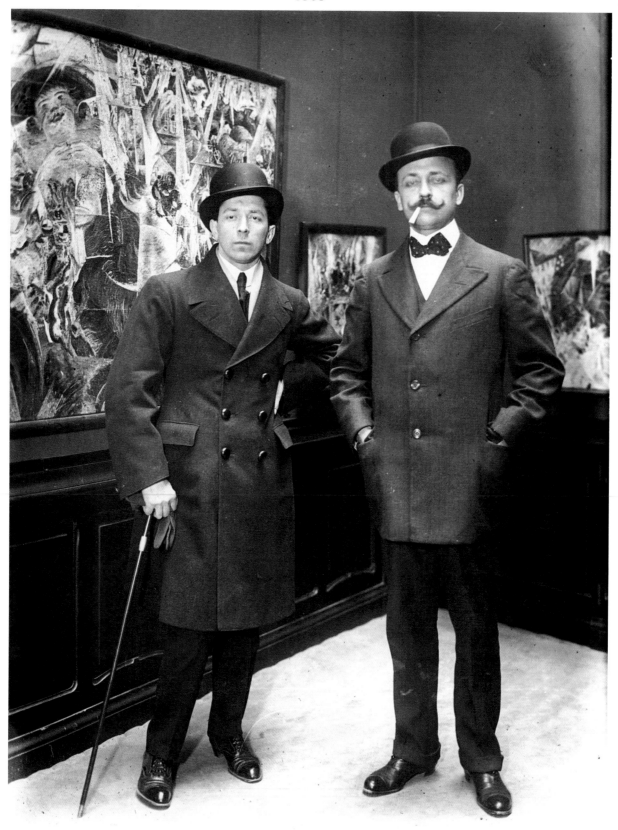

The Italian Futurists Marinetti and Boccioni, writer and artist respectively, at an inaugural show of their work in Paris.

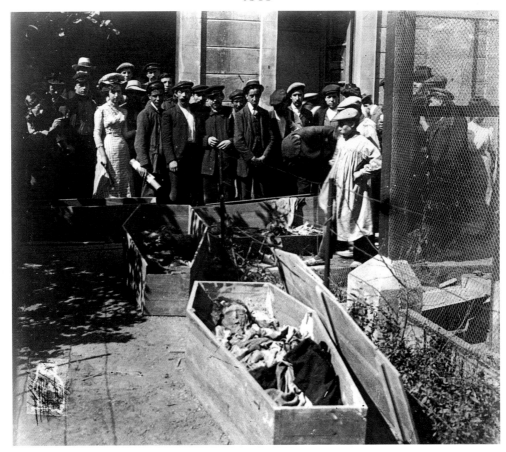

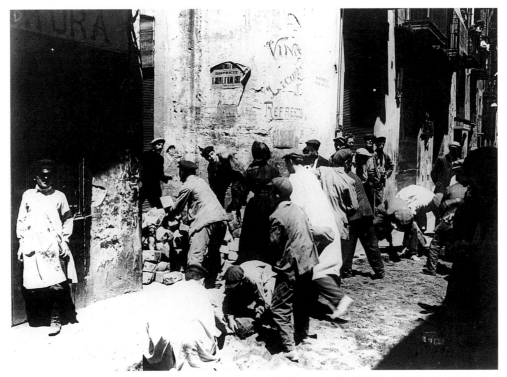

The bones of nuns and others treated with gross irreverence during the *Semana Trágica* – a week of failed anticlerical and left-wing revolt in Barcelona.
Barcelona revolutionaries building a barricade.

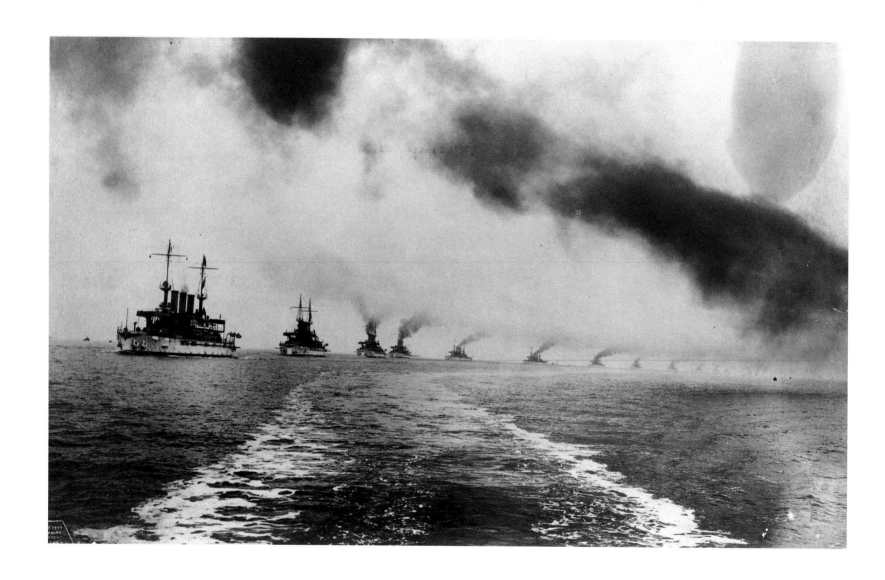

The return of the Great White Fleet – Teddy Roosevelt's portentous but effective message to the world.

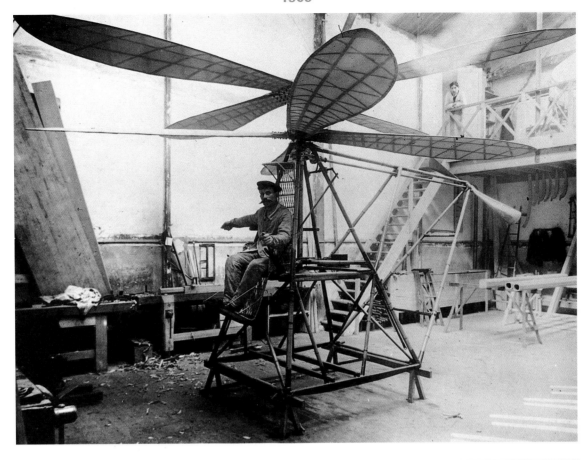

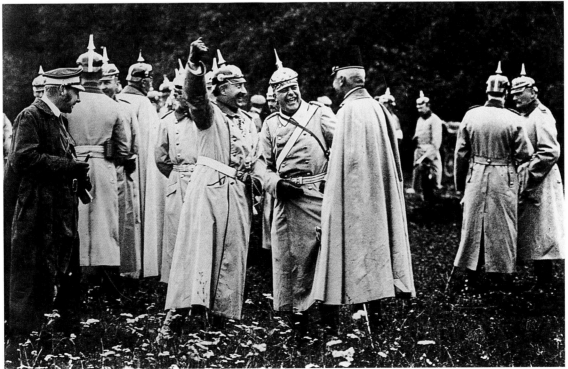

Vuitton with his beautiful but useless helicopter.
The Kaiser continues his manoeuvres, this time with a British guest, the Earl of Lonsdale (far left).

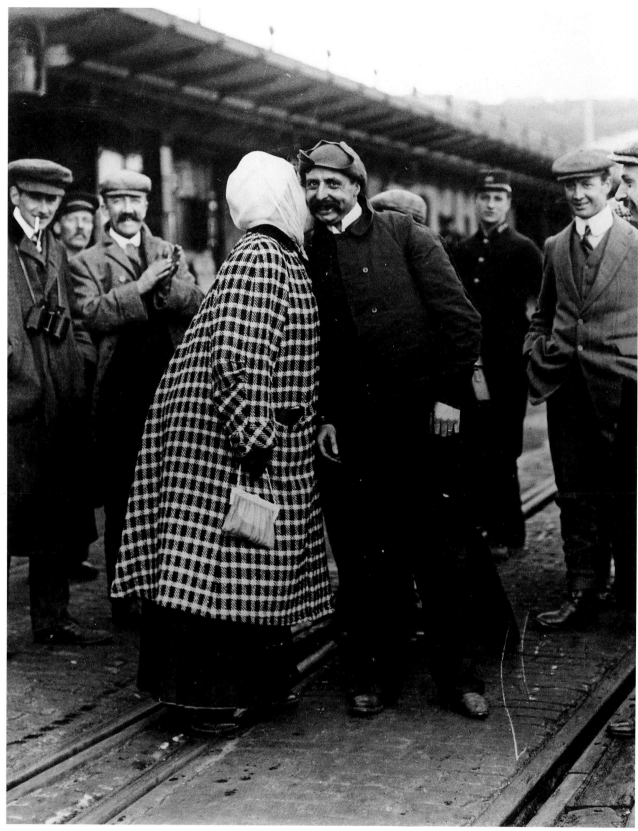

Louis Blériot, triumphant after making the first English Channel crossing by air, being greeted by his wife.

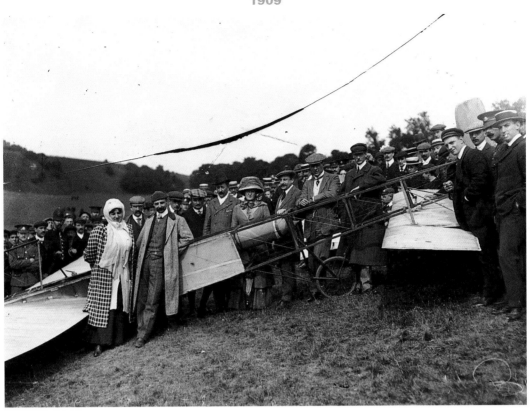

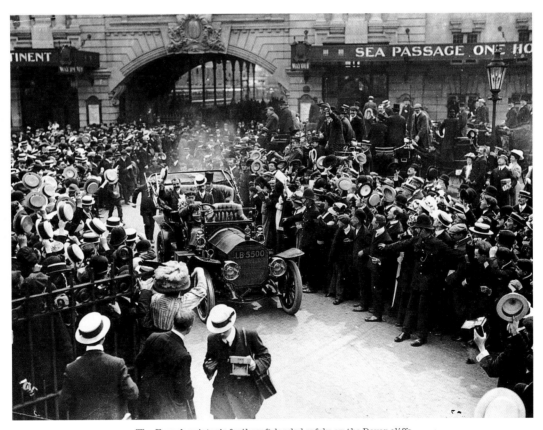

The French aviator's frail craft landed safely on the Dover cliffs.
An 'entente cordiale' reception for Blériot in London as well as £1,000 *Daily Mail* prize money.

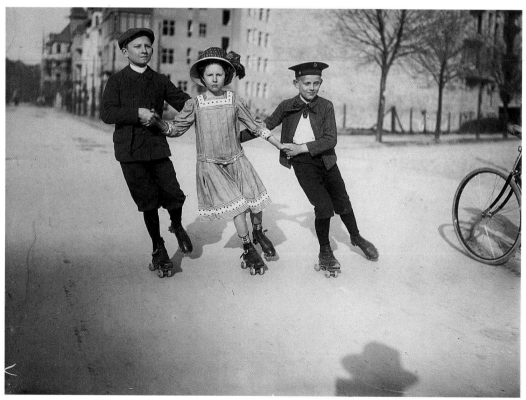

A Paris seamstress quite happily on strike, being taken away by a policeman.
Berlin children take to the streets on roller-skates.

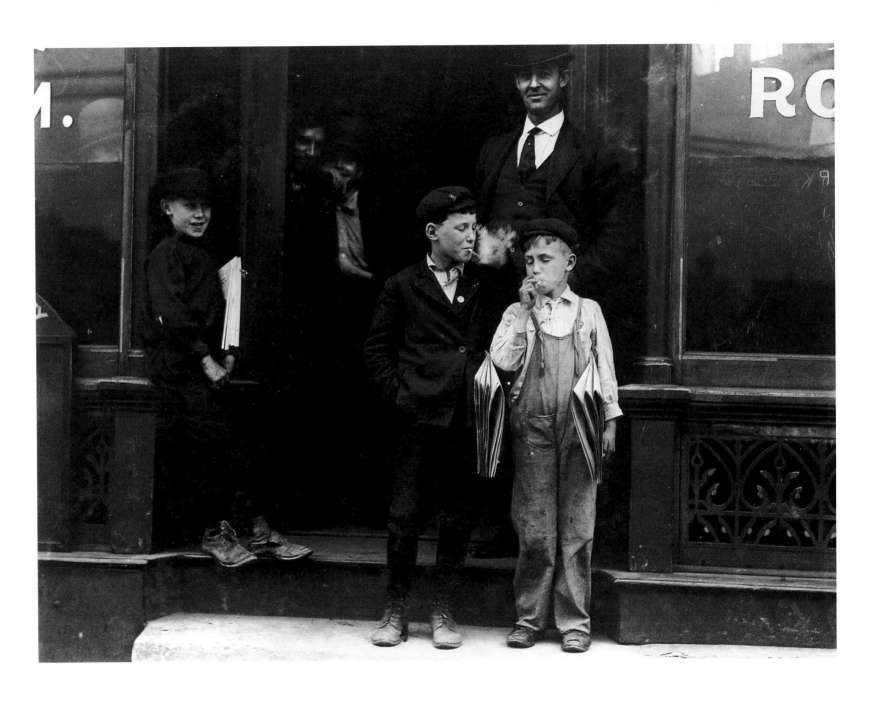

American newsboys savouring the pleasure of cigarettes without inhibition.

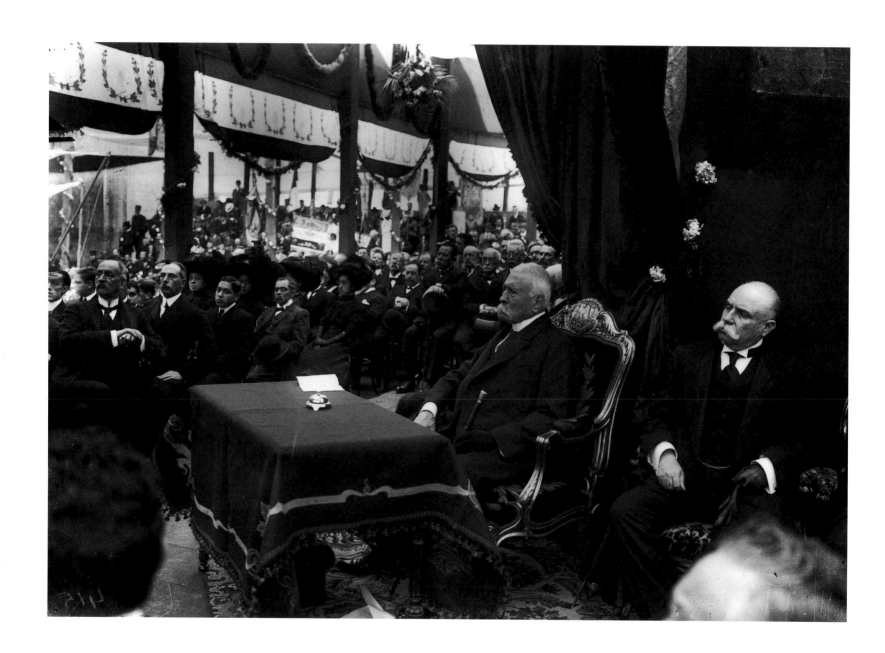

President Porfirio Díaz of Mexico commemorating Benito Juárez, his famous predecessor.

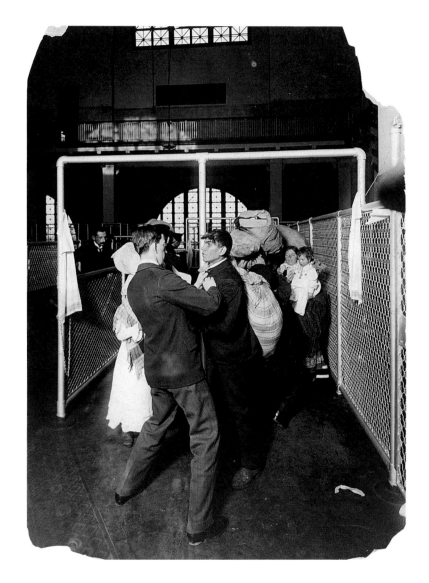

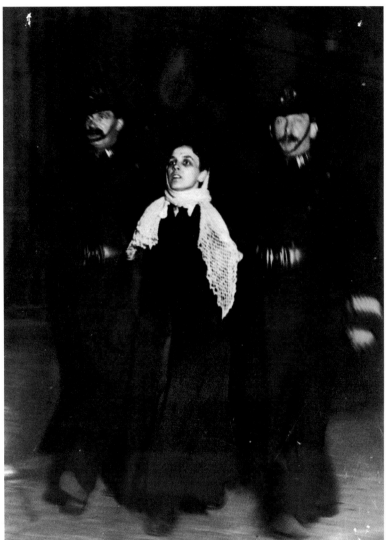

Testing for trachoma on Ellis Island – positive diagnosis of contagious disease could bar immigrants from entry.
An untypical British suffragette.

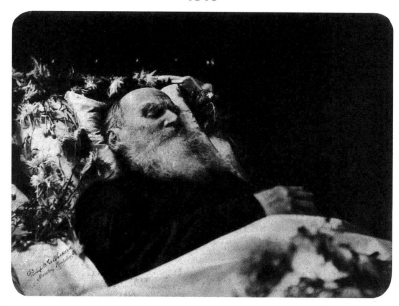

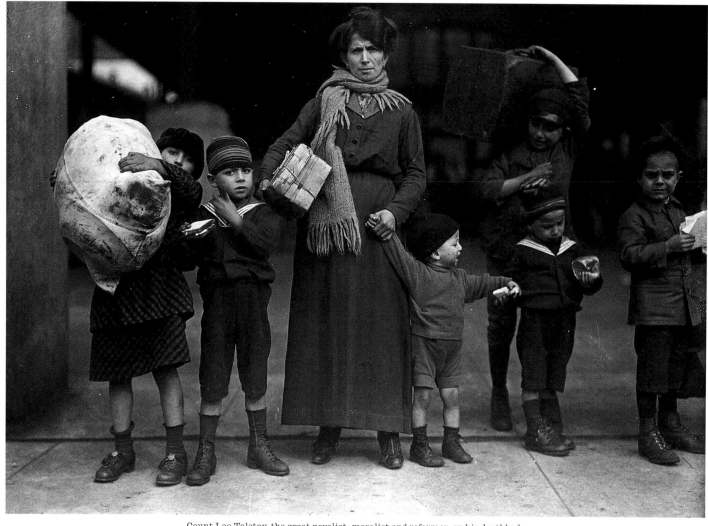

Count Leo Tolstoy, the great novelist, moralist and reformer, on his deathbed.
An unidentified and perhaps fatherless family on their arrival in the New World.

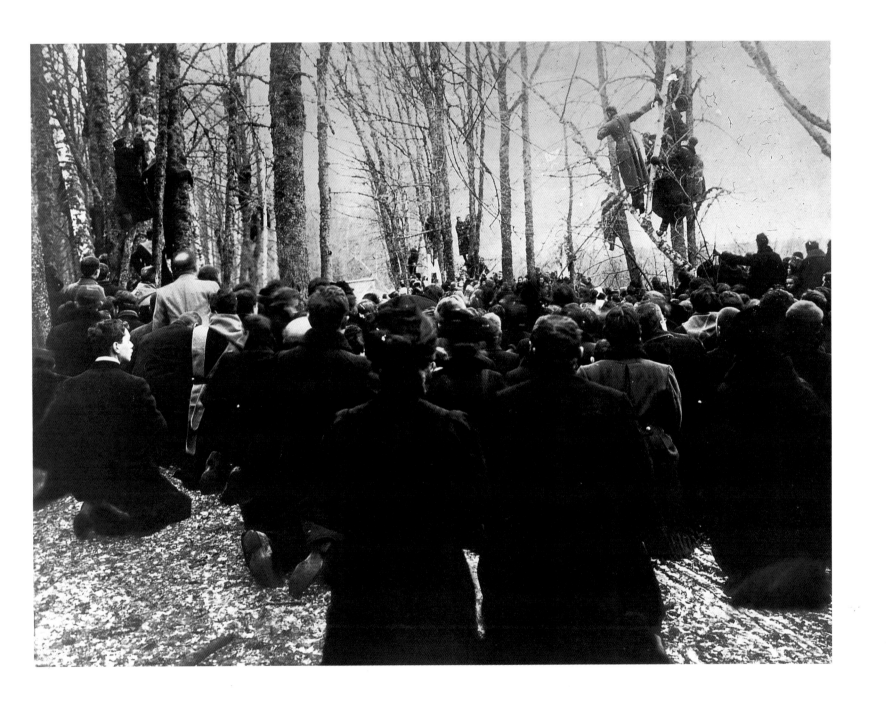

The burial of Tolstoy on his estate – still recognized as a giant of literature.

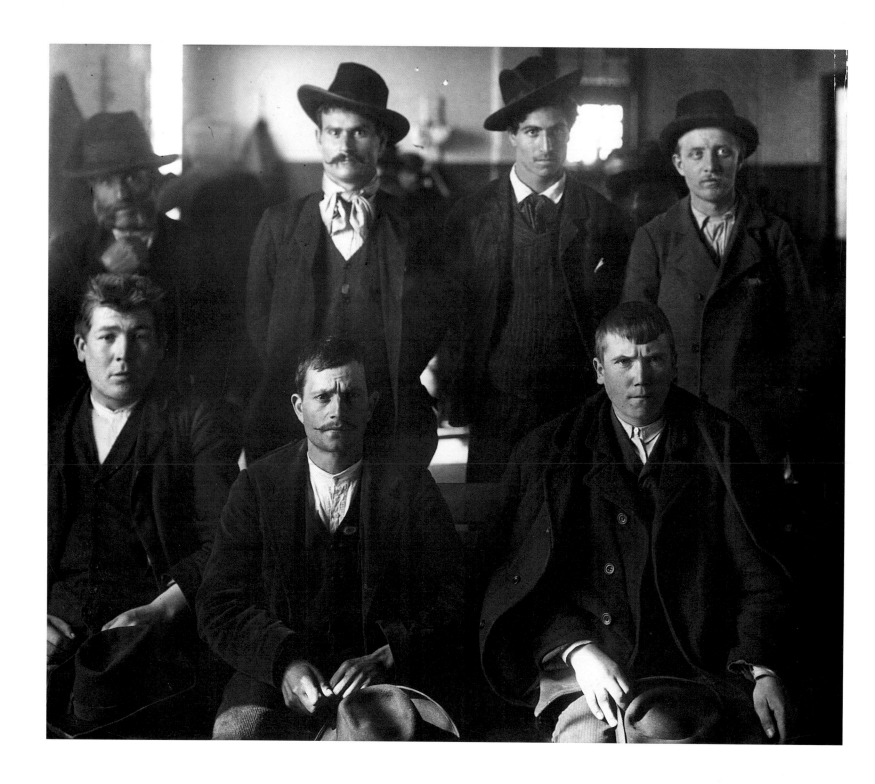

Found unfit to be Americans for whatever reason, European deportees on Ellis Island await repatriation.

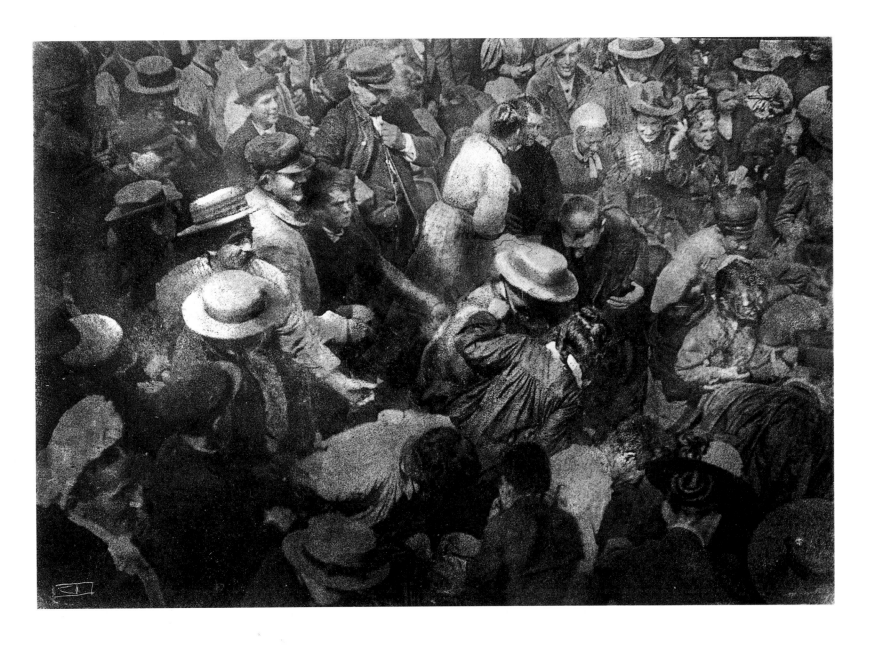

In sharp contrast to the fight which is the subject of his photograph, Robert Demachy has used a sophisticated printing technique.

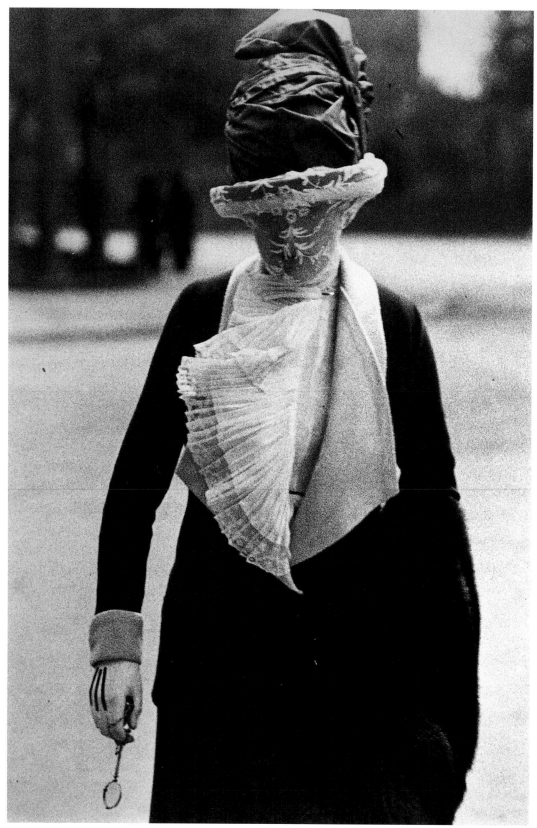

Jacques-Henri Lartigue made photographic masterpieces from the age of nine – this one was taken at seventeen near the Bois de Boulogne.

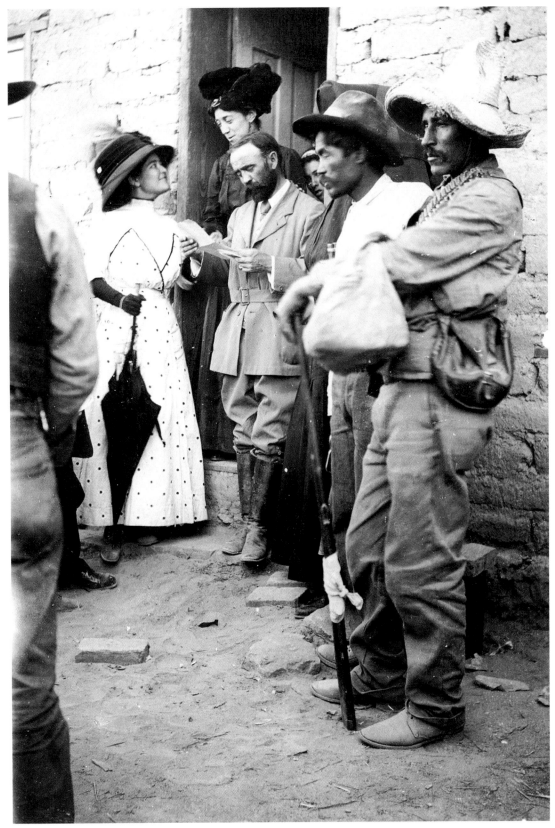

The unworldly President Madero of Mexico with his wife and a certain Miss Campo.

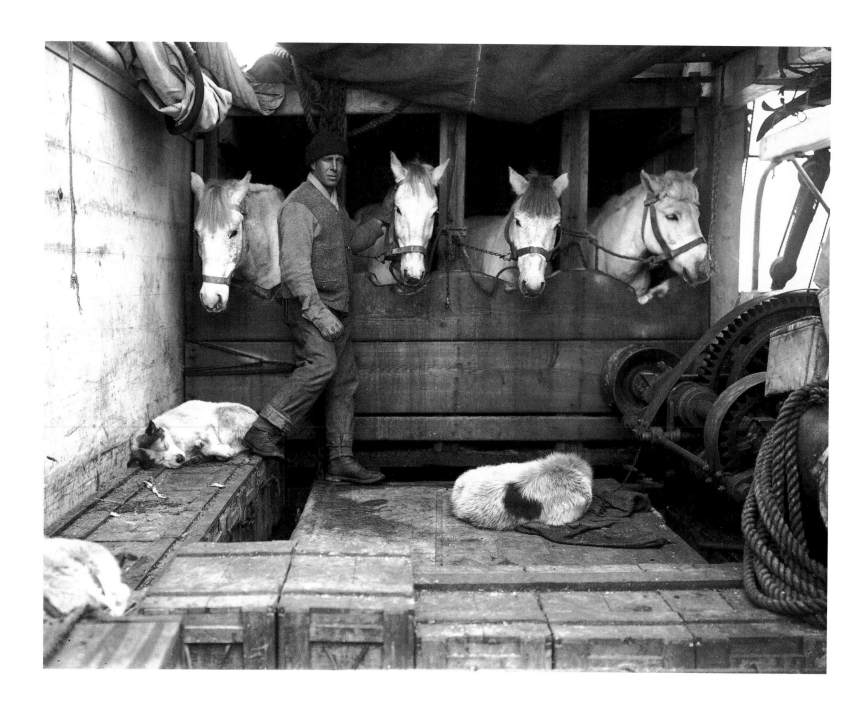

Captain Oates, tragic hero of Captain Scott's Antarctic expedition, looking after their Siberian ponies.

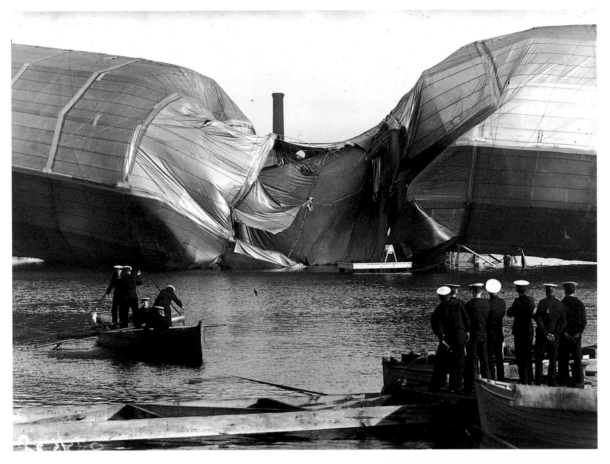

A wrecked British Navy airship, the *Mayfly*, demonstrates the fragility of all such craft.
A polar explorer's home from home – Amundsen's boat the *Fram* was far from shipshape.

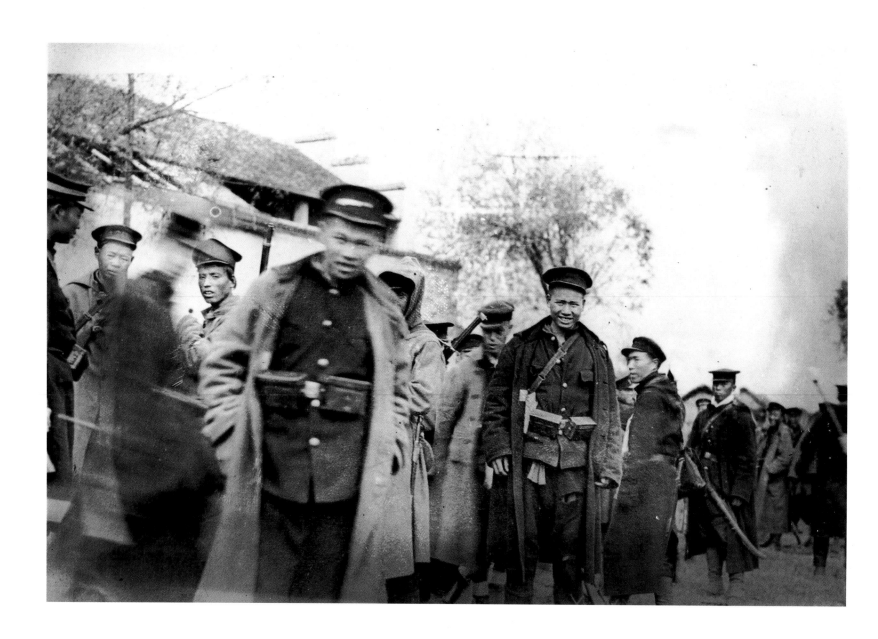

Chinese republican soldiers seem quite familiar with cameras in a picture which foreshadows modern photojournalism.

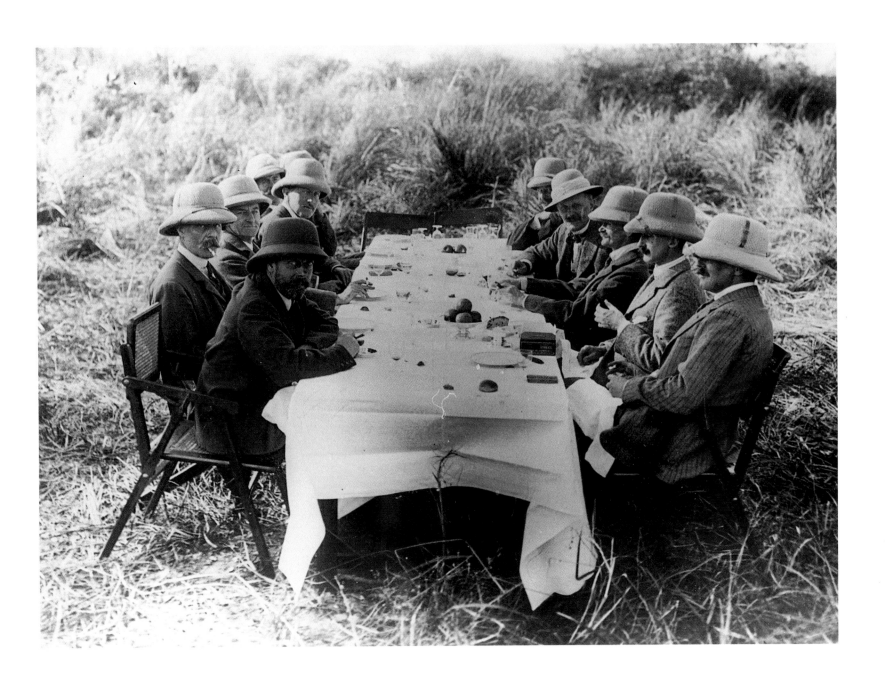

George V escapes the ceremony of his Durbar to shoot tigers and eat al fresco in India.

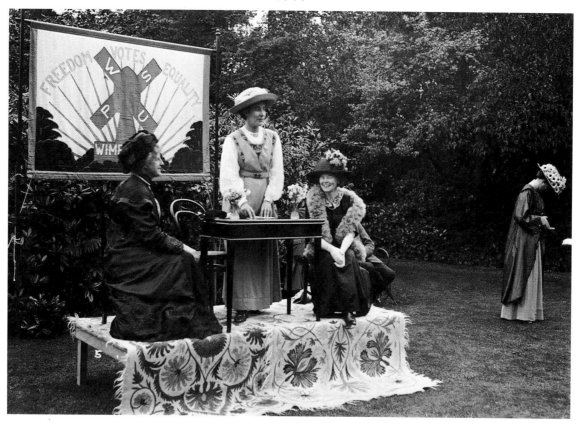

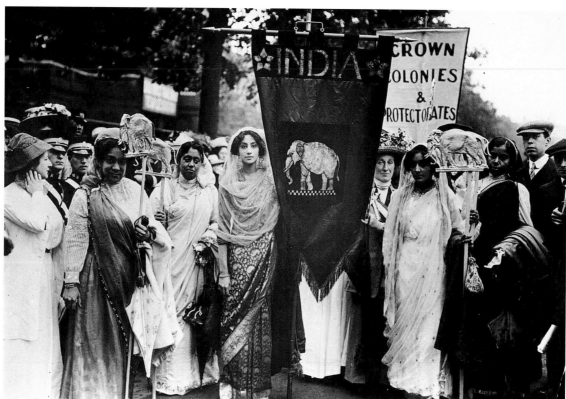

Suffragettes awaiting their guests at a genteel rally in Wimbledon, London.
Indian ladies on a women's coronation procession in London seem more interested in national independence than women's suffrage.

American Harriet Quimby becomes the first woman to qualify for a pilot's licence.

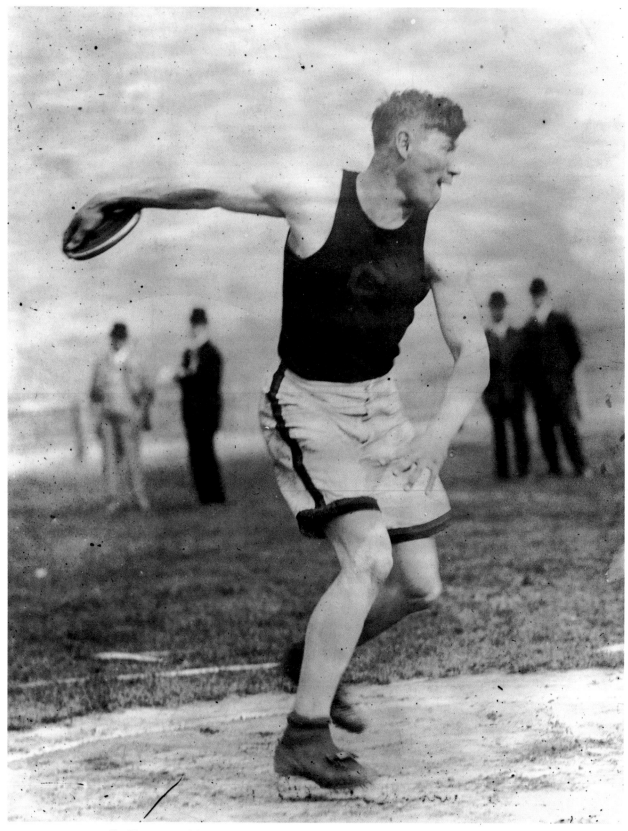

Jim Thorpe, one of the greatest of all athletes, throwing the discus at the Stockholm Olympics.

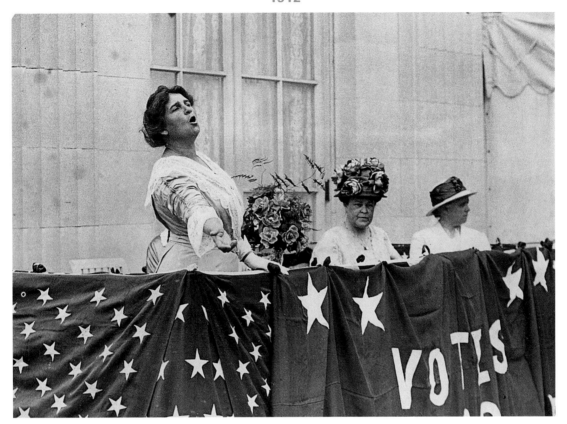

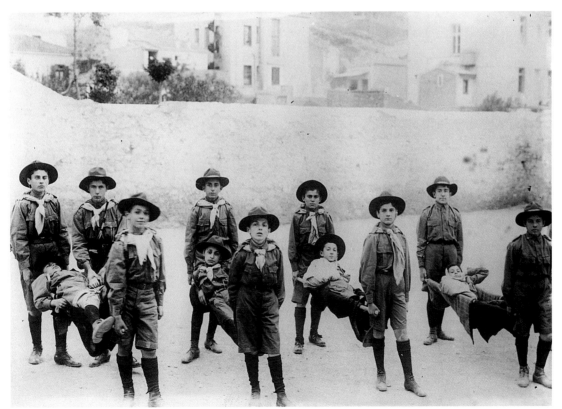

Maud Ballington Booth – a formidable American champion of many progressive causes, including women's suffrage.
Greek boy scouts in the infancy of the British-born movement, learning rescue techniques during the Balkan Wars.

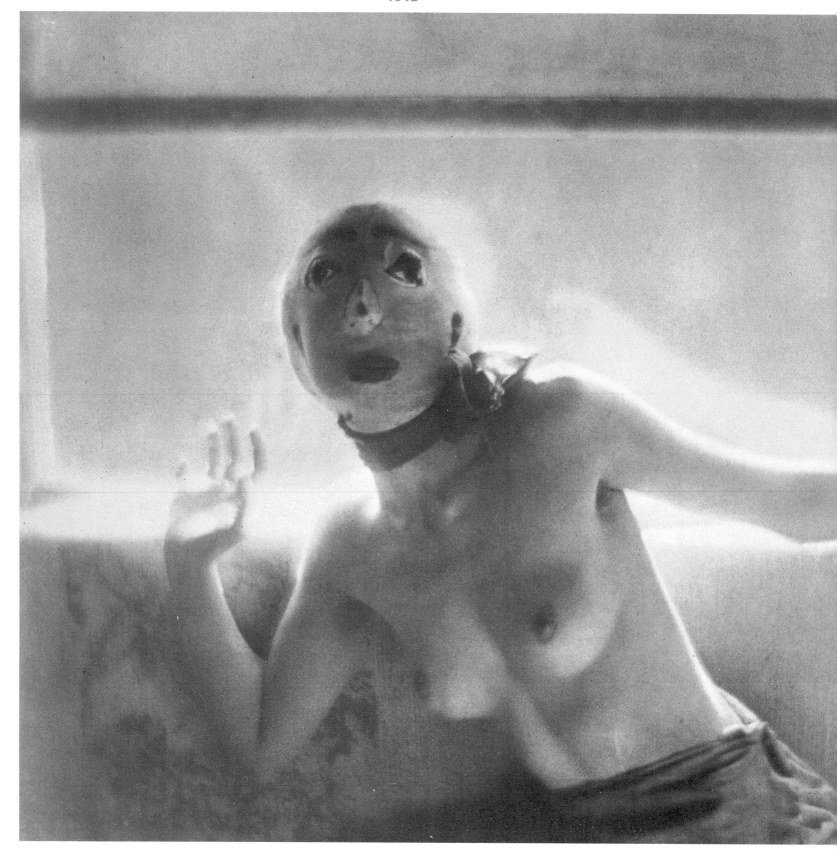

Dance Study by Baron de Meyer. This very elegant photographer of women, fashion and the
dancer Nijinsky, here offers us an image of overwhelming strangeness and beauty inspired by the *Ballet Russe*.

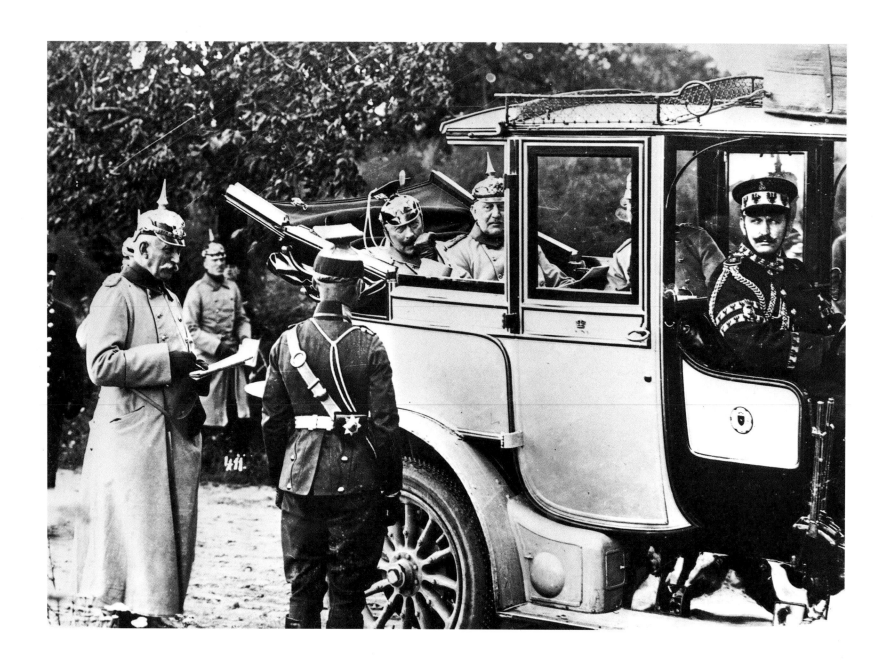

The Kaiser (seated in the carriage) on manoeuvres once more with his Commander-in-Chief von Moltke – and also a lookalike chauffeur.

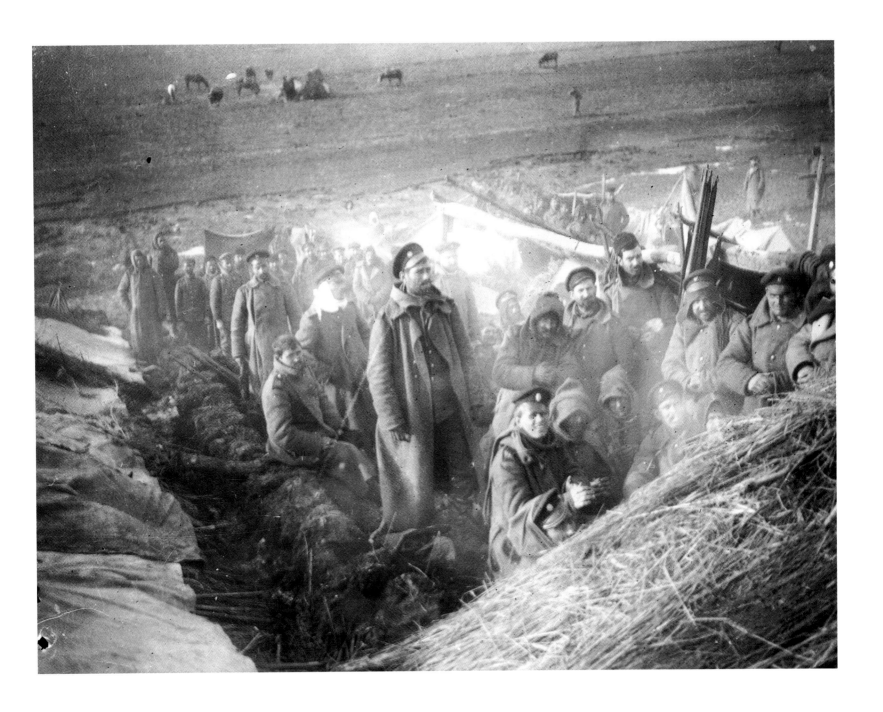

Bulgarian soldiers warming themselves during a lull in the fighting in the first Balkan War.

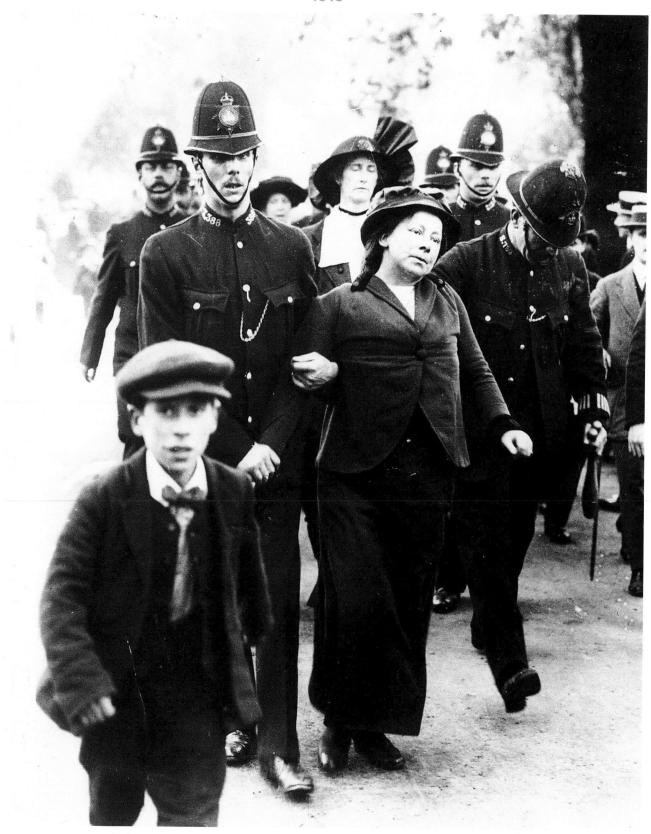

Under arrest – a British working-class suffragette followed by ladies from the vocal middle class.

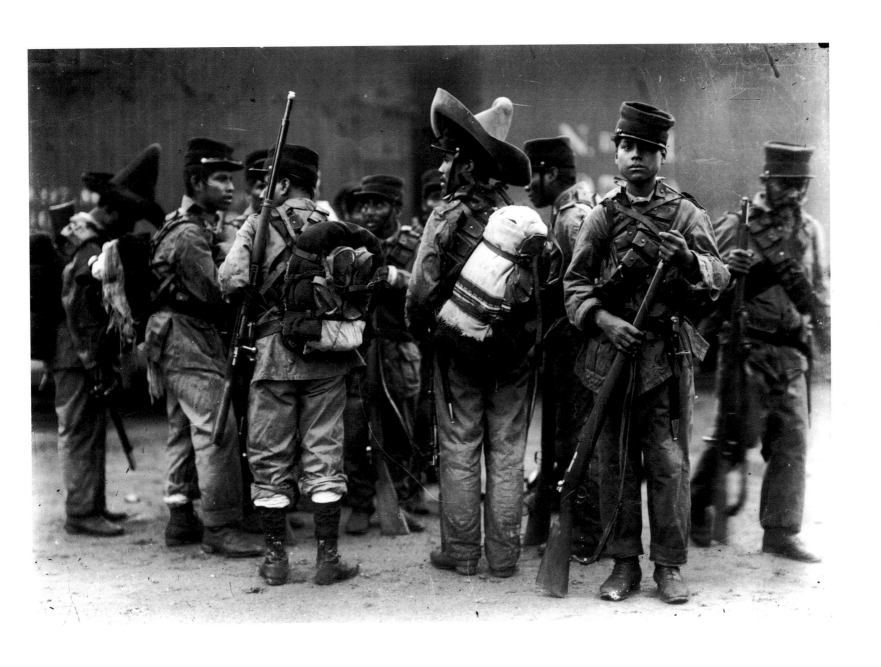

President Huerta's federal troops on their way to defeat by Venustiano Carranza's rebels after President Madero's death.

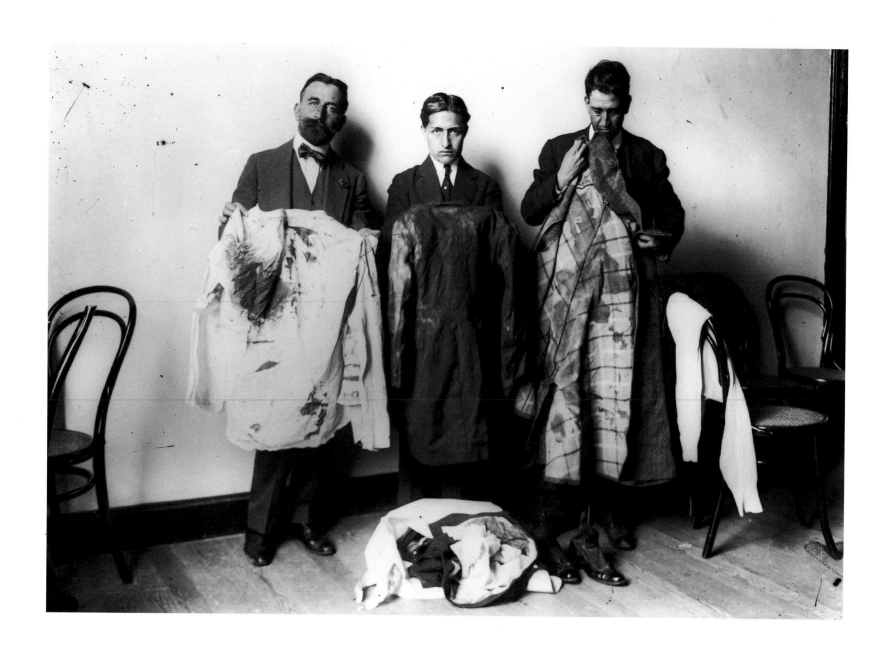

Former Mexican president Madero's bloodstained clothing held by shocked associates after his assassination.

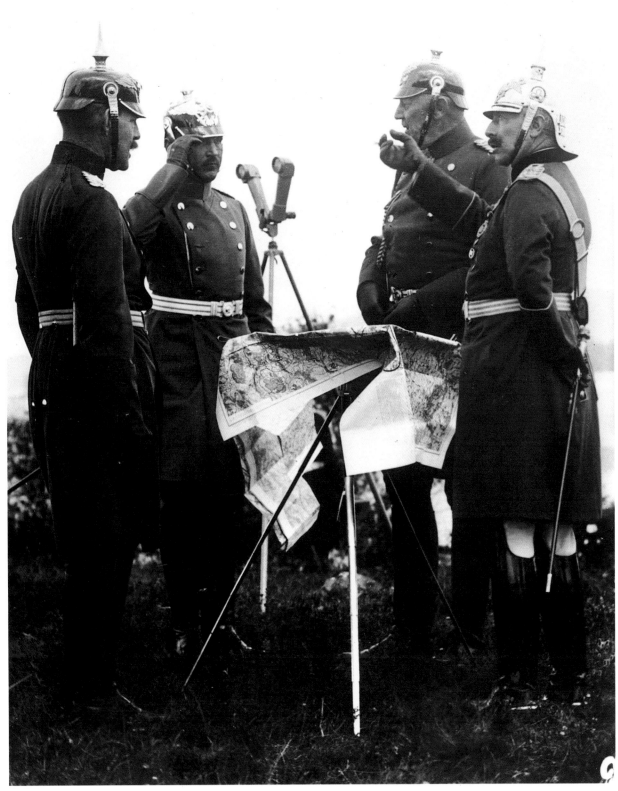

The Kaiser's vanity had provoked many war-manoeuvre photographs and would soon play its part in a world catastrophe.

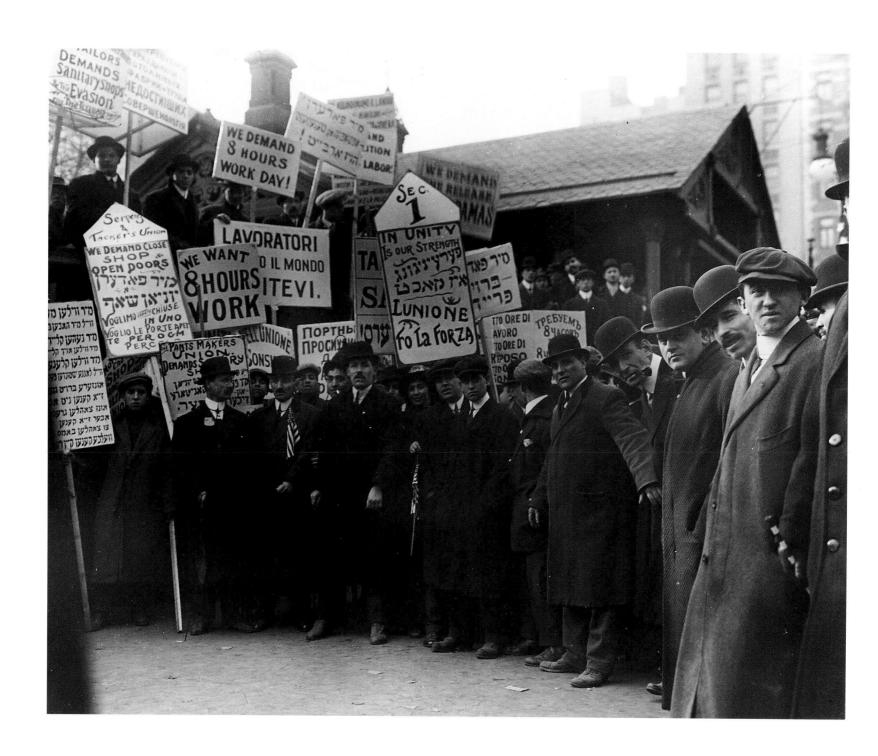

The garment workers' strike in New York City makes a telling display of their varied origins.

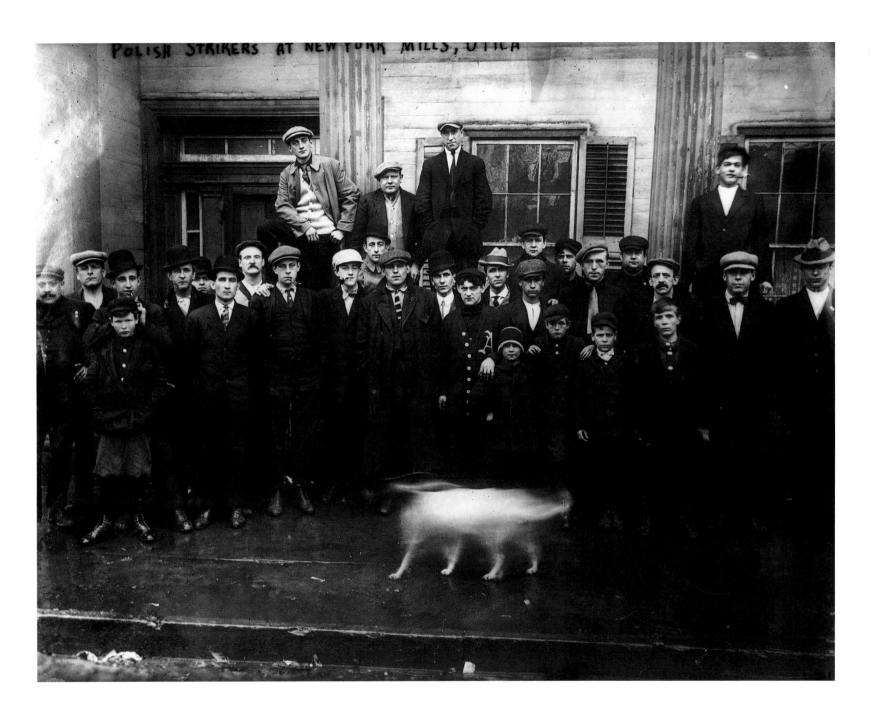

Polish mill workers on strike in Utica, New York. Many problems for immigrant labourers sprang from employers' impatience with their poor knowledge of English.

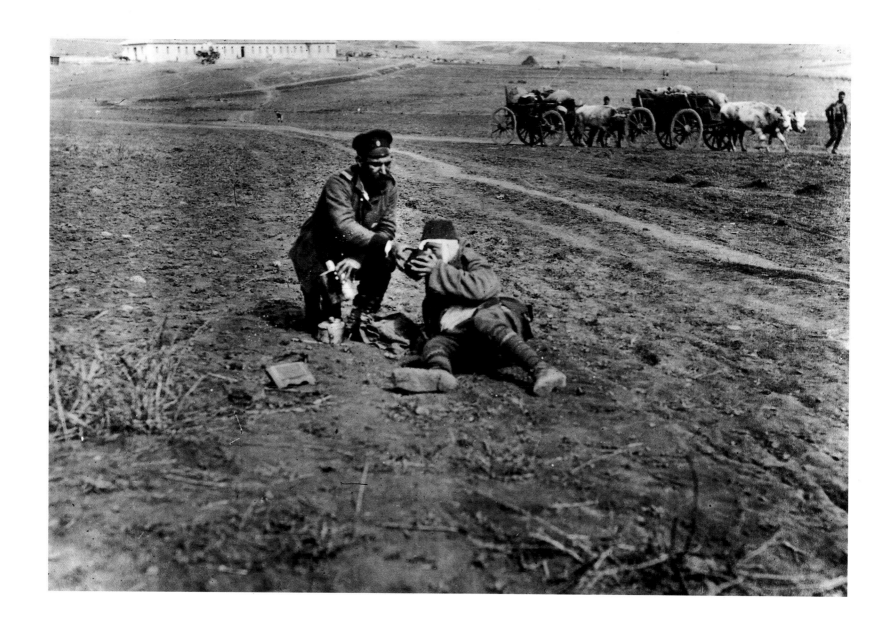

A Bulgarian soldier giving a drink to a wounded Turk – a common propaganda image.

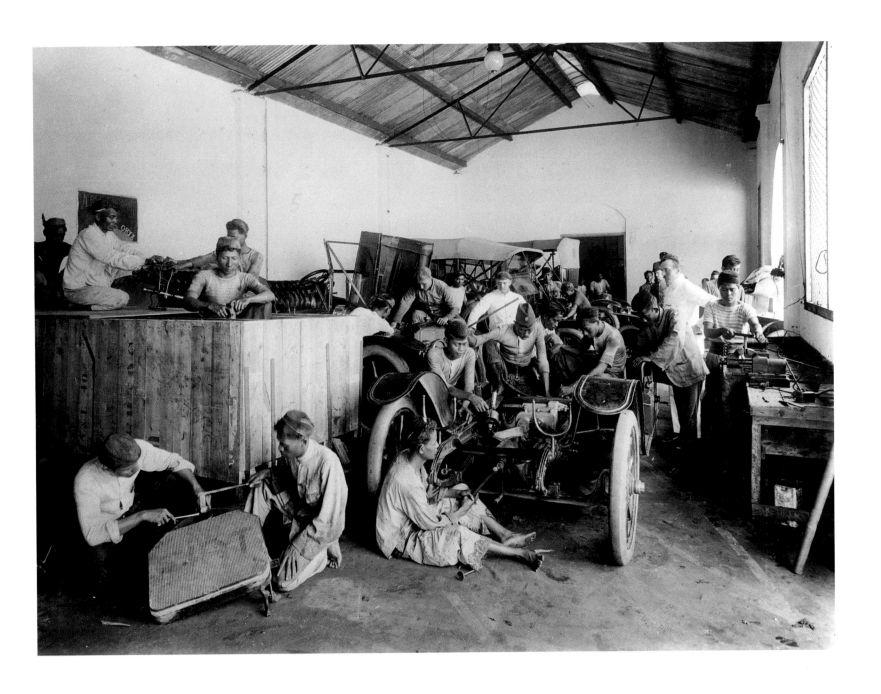

The automobile conquering the Orient – a Fiat depot in Jakarta, Dutch East Indies.

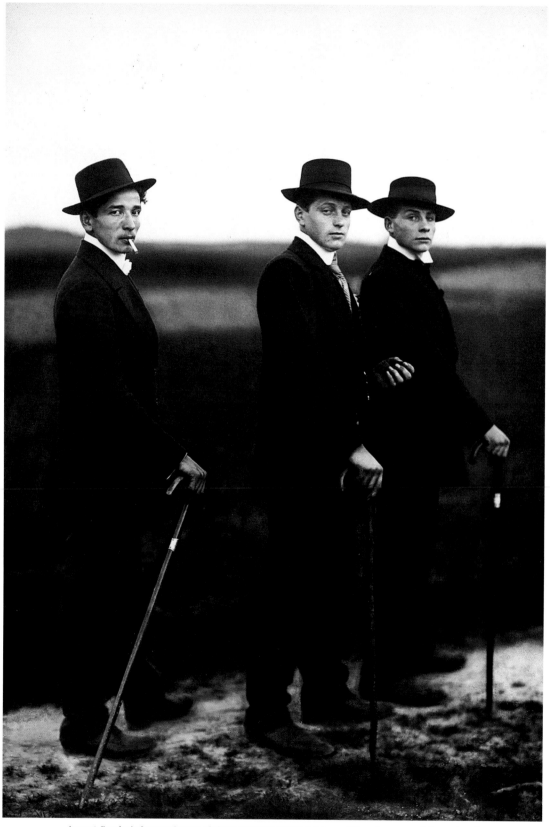

August Sander's famous image of three young German farmers off to a dance – and then where?

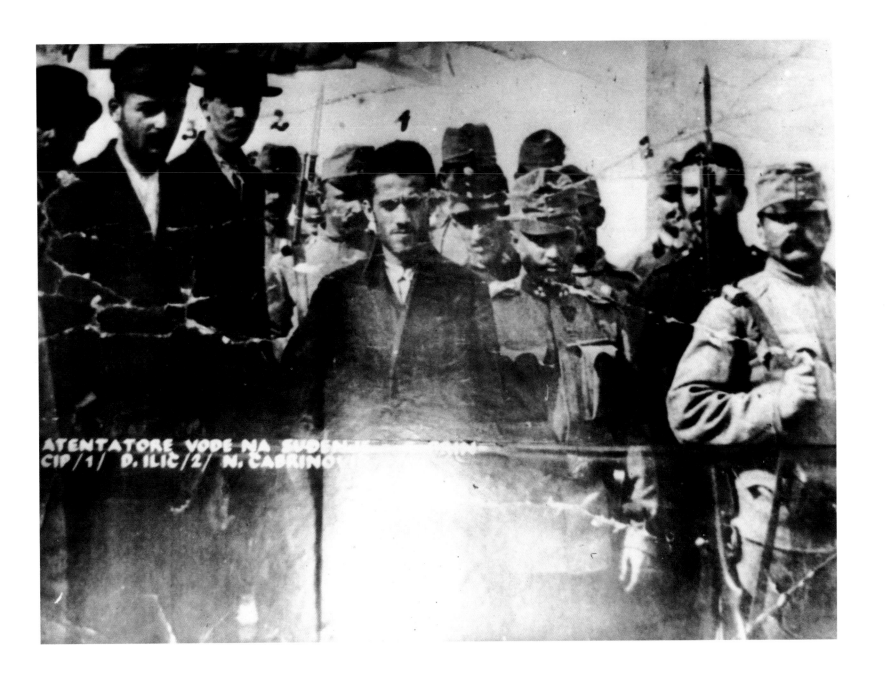

Three young Serbs who sparked a world war with an assasination – Cabrinovic (3), Ilitch (2) and Princip who fired the gun (1), going for trial in Belgrade.

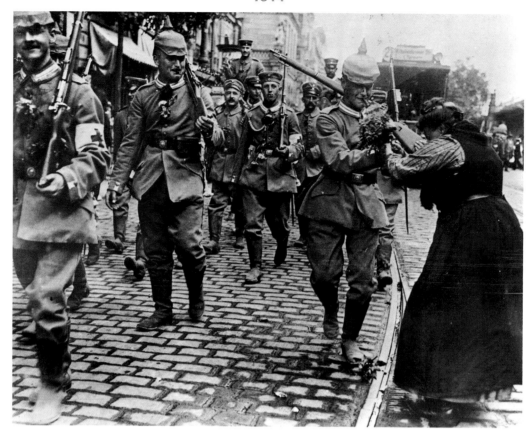

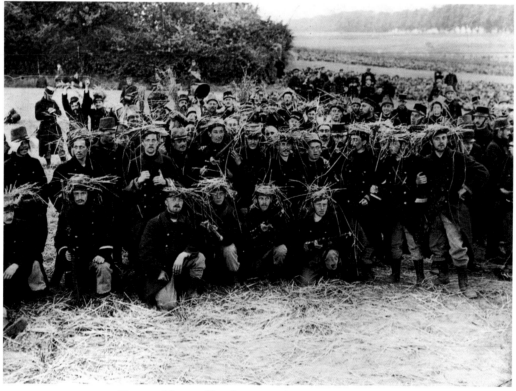

Cigars and flowers affirm German confidence in a quick victory.
Belgian soldiers seem to have improvised their camouflage for a battle of the farmyards.

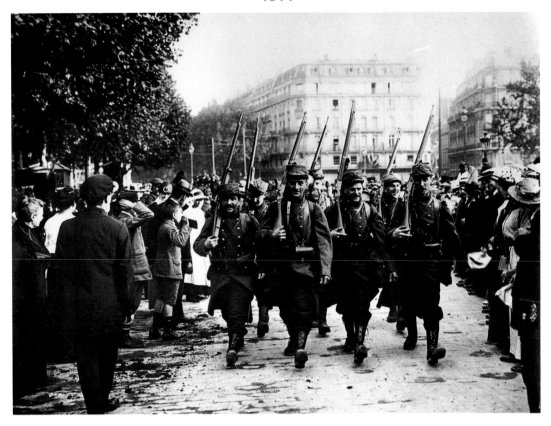

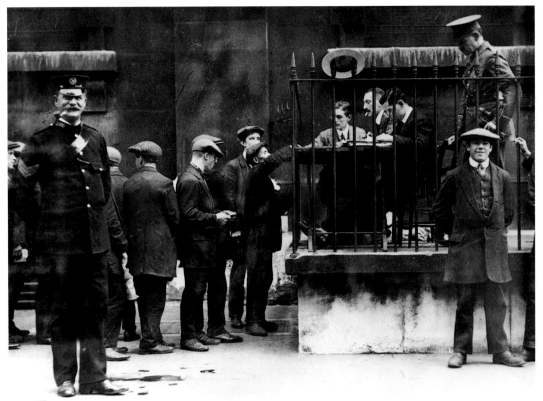

These French troops could be rehearsing their victory parade – but their tragic miscalculation was shared by all.
Londoners line up to join the army at Trafalgar Square.

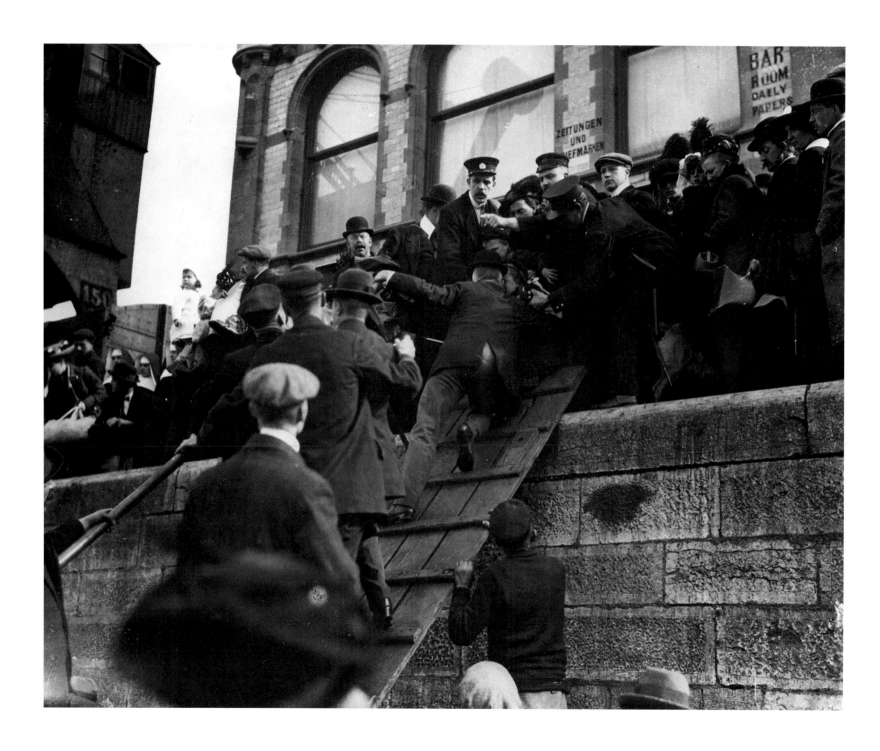

Taken by surprise by the Germans' rapid approach to Antwerp, some of the fleeing British community panic as they seek boats and families.

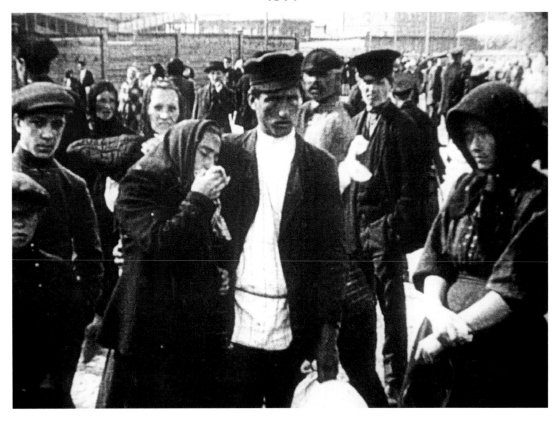

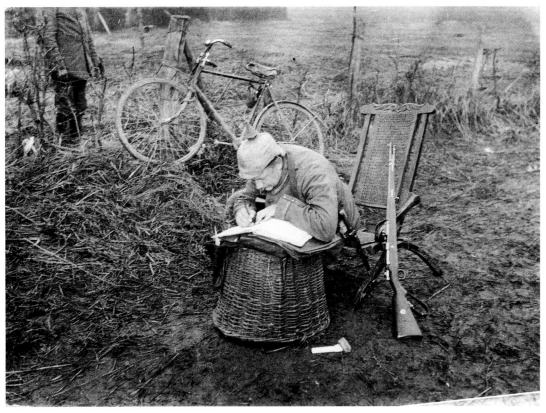

Russians feeling the wrench of parting.
A German soldier writing home from Belgium – with doubtless no mention of his army's brutality there.

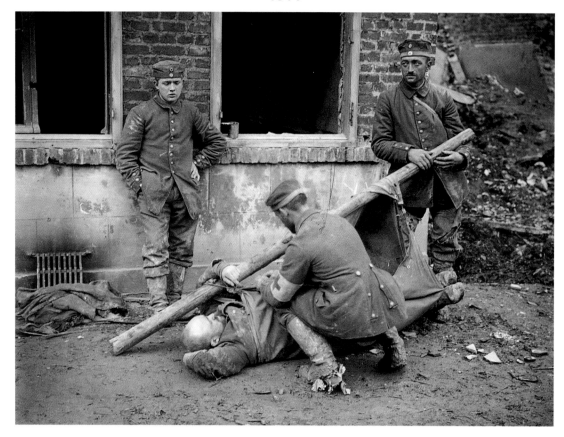

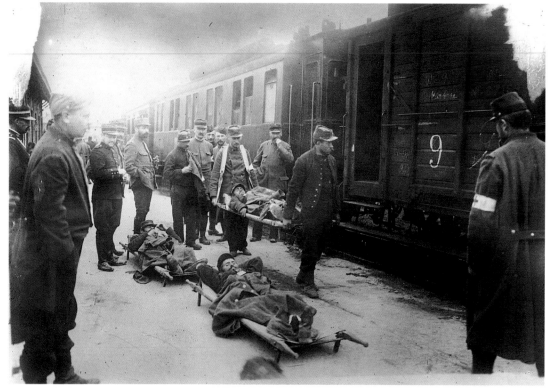

A clumsily fashioned stretcher belies the notion of total German efficiency.
French wounded at Rheims railway station where there seems to be a curious lack of urgency.

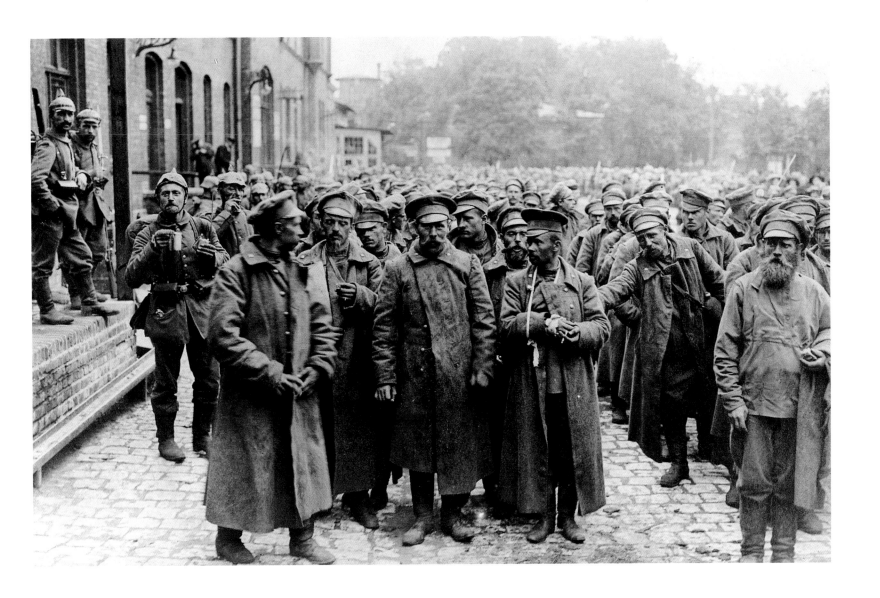

A notably relaxed atmosphere at Tilsit station where Russian prisoners wait with their captors.

French cavalry used Paris taxis in their victorious move at the River Marne.

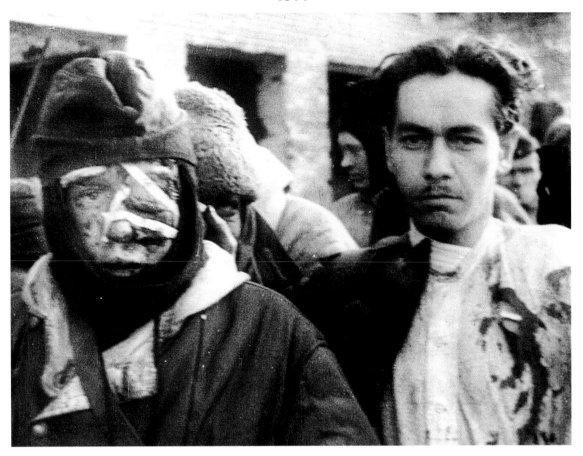

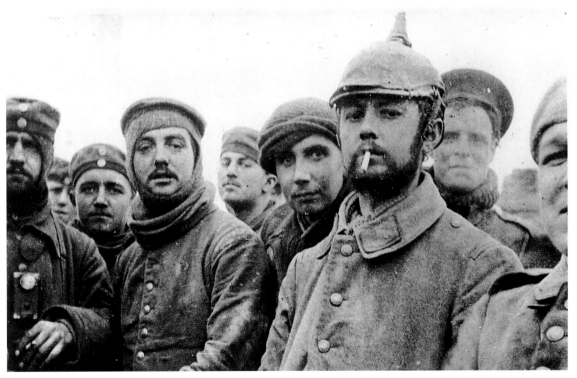

Russian wounded show a stoicism which dated back to before Napoleon's invasion – and which would persist.
The famous Christmas truce between British and German troops – temporary friends perhaps wary of the camera.

All pictures are referenced by page number.

1899

14. *Organ Grinder* by Eugene Atget. Europeans could be forgiven for feeling light-hearted at the dawn of the century. Europe was at its presumptuous, confident peak: its cities were the envy of the world and its empires spanned the globe. War between these major powers seemed a distant possibility.

15. The drawing-room of the Edward Lauterbach residence, New York City. Waves of immigration from Italy and Eastern Europe during the latter part of the nineteenth century helped power a booming economy in which thousands of New Yorkers amassed large personal fortunes. By 1900 approximately 80 per cent of New York's population were immigrants or the children of immigrants. It was at this time that America's largest city became a metropolis, moving from national to world stature in finance, business and the arts.

16. This blacksmith was one of some 2 million Germans who were still working in traditional artisanal enterprises at the turn of the century. The pre-industrial sector was more entrenched in Germany than in Britain or France at the time, but the same cannot be said for the rest of the economy. In his lifetime this blacksmith had witnessed the euphoria of military triumph in the Franco-Prussian War (1870–71) and the emergence of Germany as a unified, modern European nation-state. By 1900 Germany had risen to become an industrial colossus and the most powerful state on the continent.

17 top. British beauty and actress Lillie Langtry striking a pose as Mrs Trevelyan, a character from Sydney Grundy's comic satire *The Degenerates* (1899). Daughter of the Dean of the Isle of Jersey in the Channel Islands, Langtry was one of the most famous women of her time. Known as 'The Jersey Lily', she caused a sensation among the upper classes by becoming the first society woman to have a career on the stage. Eventually she acquired many distinguished admirers, including the Prince of Wales, subsequently King Edward VII.

17 bottom. In the 1890s Russia's industrial growth approached 10 per cent a year, and textiles was the largest industry. Peasants fleeing intolerable conditions in the countryside often made their way to the industrial cities and found work in huge factories such as this textile plant in the region of Ivanovo. But urban life proved just as difficult for most. This, combined with the unfamiliar pace of factory work and an awareness of continuing rural hardship, caused waves of strikes and demonstrations to break out. By 1905 workers in Ivanovo had set up the first soviet – a council of workers that demanded the right to assemble freely to discuss their grievances and elect representatives.

18. The sinking of the USS *Maine* which had been sent to Cuba to protect US citizens and property after rioting against Spanish colonial rule swept across the island. The mysterious explosion of the American battleship on 15 February 1898 precipitated US intervention in the Cuban struggle for independence. When war broke out between Spain and the US in 1898, newspapers had not yet turned to photography for reporting topical events. Stereographs (of which this and the image on the opposite page are examples) were the closest thing to the news for most Americans. These are three-dimensional images which were produced by looking through a stereoscope.

19. American soldiers during the Philippine campaign of the Spanish-American war. A US naval squadron went into Manila Bay in the Philippines and destroyed the anchored Spanish fleet in a quick, one-sided battle on 18 December 1898. The Filipinos suffered greatly during the US occupation of their country which followed. In response, an unsuccessful guerrilla campaign was waged against the US (1899–1902), foreshadowing similar struggles in other South-East Asian states against foreign domination in future decades.

20. Alfred Dreyfus, seen standing in the central area of the military court in Rennes, France, declaring his innocence on 7 August 1899. Five years earlier the young French army officer had been tried in secret and convicted of treason for passing secrets to Germany. Suspicion had fallen on him because he was Jewish. Prominent writers and French intellectuals began a campaign, which included the publication of Emile Zola's famous letter '*J'accuse*', to have Dreyfus exonerated. The controversy flared into a national crisis, dividing French society into Dreyfusards and anti-Dreyfusards. It was not until 1906 that a civilian court finally reversed the verdict.

21. A group of upper-middle-class American women at the Woodbine Settlement School, New Jersey. To these women wearing men's clothing was one of the few ways that they could openly express their sexuality and desire for more autonomy during this period. By the late nineteenth century, distinct limits on female participation in the workplace, coupled with a general tendency across society to view women only in their traditional roles as wives, mothers and homemakers, fuelled a minor backlash among small groups of women in Europe and America. Gatherings of the 'Old Maids' Convention – as these women ironically referred to themselves – reflected the less aggressive forms of opposition to male domination which preceded the vigorous and sometimes militant women's movements in the West over the next two decades.

1900

22. A Japanese battleship built by the British, leaving Newcastle-upon-Tyne. Shipbuilding was one of the few heavy industries in which Britain still maintained an international supremacy at the turn of the century. British naval technology helped Japan, then a British ally, to develop the fastest and most powerful fleet in the Far East. The British and continental Europeans still regarded Japan as a small, albeit clever nation with no great imperial ambitions in the Far East.

23. A Japanese officer wipes blood from his sword after beheading several Boxer rebels in Tungshun, China. Foreign interference in China's affairs and attempts by European powers to monopolize trade in the country, sparked a peasant uprising known as the Boxer Rebellion. The protest was led by members of a secret society (named Boxers by Westerners) which had strong links with the Imperial Court. Foreign legations and religious missions in Peking were attacked. Popular unrest followed, most notably in Tianjin. A six-nation expeditionary force – including soldiers from America, Europe and Japan – arrived in August to crush the rebellion.

24 top. Reports of gallantry among Irish troops fighting for Britain in the Boer War prompted Queen Victoria to visit Ireland and express her gratitude. For many people there was no greater symbol of British expansionism and imperialism than the Queen. She died before the Boers finally surrendered, but the war in South Africa exposed many worrying cracks in the vast British Empire which she had helped to build.

24 bottom. Boer commandoes confronting the might of Imperial Britain. Hostilities between the British and Boer descendants of Dutch settlers in southern Africa erupted in 1899, after the British tried to extend their rule in the region from the Cape Colony and Natal to include the independent Boer republics of the Transvaal and Orange Free State. The conflict was caused by the discovery of vast gold mines, especially in the Transvaal. The Boers' military strength lay in a citizens' army, composed primarily of farmers called *trekboers*. Small commando units, often including fathers and sons, were formed to carry out raids on isolated British garrisons and towns. Determined fighters and great marksmen, the Boers were also better prepared than the British to deal with the harsh conditions of southern Africa.

25 top. *Troops reading the latest news, Boer War*, taken by Horace Nicholls. British troops on their way to the war.

25 bottom. Dead soldiers lying in the British trench after the battle at Spion Kop, Natal, South Africa, 24 January 1900. Some 1,200 British men lost their lives in the battle, the worst defeat suffered by a British army since the Crimean War. Photographs of the dead taken by the Boers were published throughout the world and caused uproar in Britain. As a result of this popular unrest, Britain sent massive numbers of troop reinforcements to South Africa soon afterwards.

26. First used in 1890, the electric chair became the preferred method of legal execution in America at the turn of the century. Condemned persons were strapped to a wired chair and then fitted with electrodes, thus enabling an

electric current to flow through their body until they died. Its proponents believed that the electric chair was more humane than previous methods of execution. Other than the US, only China and the Philippines would ever use this technique.

27 top. The Emperor's Army at a Chinese Officers School in Tianjin, China. The Boxers' attempt to expel foreigners from China attracted widespread support among Chinese soldiers. The anti-Western Manchu Emperor and Dowager Empress Cixi exhorted soldiers to join the rebellion, but divisions in the army between supporters and enemies of the imperial family prevented full mobilization. As a result, a six-nation European expeditionary force had little trouble suppressing the uprising. China was forced to pay reparations and allow foreign troops onto its soil.

27 bottom . A scene in the Daily Bread Institute in Bucharest, Romania. Widespread poverty had generally been viewed as an inevitable consequence of finite resources, and few attempts to ameliorate the conditions of the poor had been undertaken by governments or religious organizations. By the beginning of the twentieth century however, the provision of a free, hot meal to those in need became accepted in many parts of the world as a basic minimum protection that all 'civilized' societies had an obligation to maintain.

28. A view of the Champ-de-Mars, the main site of the *Exposition Universelle*, from beneath the Eiffel Tower, Paris. Nothing on the scale of the Paris *Exposition* of 1900 had ever been staged before. Presented as a balance sheet of the century which had drawn to a close, visitors poured into the city to witness a spectacular showcase of European cultural and technological achievements. The exhibition's huge number of colonial exhibits also gave people glimpses, mostly for the first time, of native life in distant parts of Europe's empires.

29. The Eiffel Tower lit up by night at the Paris *Exposition*. Despite initial opposition on aesthetic grounds, the 300-metre (1,000-foot) tower ultimately won over most Parisians. It was the ideal symbol for an exhibition that glorified the apparently indomitable confidence

of turn-of-the century Europe. By 1900, ten years after its construction, the Eiffel Tower was still the tallest building in the world. It would remain so until 1930.

30. Members of the US team at the Olympic Games in Paris, 1900. Four years earlier, Frenchman Baron Pierre de Courbertin's dream of staging a contemporary version of ancient Greece's major athletic contest was finally realized when the first Olympic Games of the modern era were held in Athens. At the second Games in Paris, held in connection with the *Exposition*, the host country led the field with twenty-nine gold medals. The event itself was a rather haphazard affair. Entries for the various competitions were unlimited and rarely included each nation's best performers.

31. Oscar Wilde's body in the Hôtel d'Alsace (now Hôtel Guy-Louis Duboucheron) in Paris, 30 November 1900. Writer of comic masterpieces such as *Lady Windermere's Fan* (1892) and *The Importance of Being Earnest* (1895), Wilde had left England for France after his release from prison in 1897. The Irish poet and dramatist had been imprisoned for two years for his homosexuality following a sensational criminal trial. Bankrupt and living under the alias Sebastian Melmoth, Wilde spent his last years in Paris, hoping to resuscitate his writing career. He died suddenly at the age of forty-six of an acute brain inflammation.

1901

32. Construction of the Trans-Siberian Railway began along various sections of the planned route from Moscow to Vladivostok in 1891. Russia had won rights to build part of the railway across Chinese-held Manchuria. Tsar Nicholas II, keen to mould Russia into a great Eurasian power, believed this would establish a vital link to draw Siberia into a single economic entity with the fertile plains of northern China. The completion of the Moscow-Vladivostok rail link in 1904 did indeed open up vast areas of the Russian Far East to settlement and industrialization.

33. The United States Steel Company Dinner at the Shenley Hotel Ballroom in Pittsburgh, Pennsylvania, 9 January 1901. The lavish event was hosted by Andrew

Carnegie for officials of his companies. The enormous dinner table was the shape of a T-rail end section. Carnegie himself was unable to attend but he sent best wishes to his dinner guests – 'my boys' as he called them – whose immense personal fortunes had been made from the vast transportation network that Carnegie's companies had helped build and maintain. At this time the US steel industry had surpassed that of Great Britain, previously the world's greatest producer. Future global demand for iron and steel seemed limitless.

34. A wealthy merchant giving alms to the poor in Moscow. The last years of tsarist rule were marked by great upheavals and suffering in Russia, but also by curious paradoxes. Although the greed of noble land owners and merchants was largely responsible for the desperate situation of the country's peasants, wealthy Russians would often leave legacies for religious and charitable missions. Merchants in particular believed they were the carriers of ancient Russian traditions which included philanthropic activities and the development of social welfare.

35. *The Three Sisters* (1901), the play in which Anton Chekhov so delicately portrayed the hopes and longings of a trio of young provincial Russian women, was the second of three masterpieces he would write for the Moscow Art Theatre. Although the productions received critical acclaim, the great Russian dramatist and master of the short story was not very pleased with the company's performance of his plays. Chekhov did not become famous outside his native Russia until after the First World War, but thereafter his plays were firmly established in classical repertoires around the world.

36. US President Theodore Roosevelt with the African-American intellectual and leader Booker T. Washington at the Tuskegee Institute in Alabama. Becoming the twenty-sixth US president after the assassination of President William McKinley in 1901, Roosevelt quickly acquired a reputation for single-mindedness and unpredictability. He visited Tuskegee Institute – the foremost centre of black education in the South – and then took the unprecedented step of inviting

Washington, the Institute's founder and the country's most prominent black spokesman, to the White House amid storms of protest from white Americans.

37. Britain's King Edward VII sits for his bust. Queen Victoria did little to prepare her son for his royal duties; in fact she anticipated his accession with thinly-disguised foreboding. As Prince of Wales Edward was well-liked and had travelled widely, but his social activities had involved him in several embarrassing scandals. Not surprisingly perhaps, cabinet proceedings were kept from the future king until he was over fifty years old.

1902

38. The Lucas oil gusher that blew at Beaumont, Texas, in 1901, instantaneously altered the social and economic history of America's south-west. The oil deposits that were eventually discovered under more than two-thirds of the state turned a once poor, conflict-ridden part of the country into an economic powerhouse and major force in national politics. Oil was fuelling massive industrialization around the world, in particular the burgeoning automobile industry. The downside was the concomitant surge of pollution into the global environment.

39. Wilbur Wright flying a Wright No. 1 glider near Kitty Hawk, North Carolina. With only a limited elementary-school education, bicycle-shop owners Wilbur and his brother Orville Wright first caught the world's attention with their experiments in gliding. After observing how buzzards kept their balance in the air the brothers began to construct and test gliders obtaining, in the process, a natural understanding of the effects of air currents on wings. They believed mastery of gliding was essential before powered flight could be achieved.

40. Adapted from a novel by Jules Verne, Georges Méliès' 1902 film *A Trip to the Moon* was nearly one reel in length (fourteen minutes), and became the first film to achieve international distribution, mainly through piracy. More importantly it marked the shift from films as animated photographs to films as stories. Its enormous popular appeal helped establish the fiction film as the cinema's mainstream

product and started the world thinking about the possibility of one day travelling to the moon.

41. Edward Steichen and Alfred Stieglitz, pioneers of American photography and founders of the Photo-Secession Group in New York in 1902, were instrumental in establishing photography as an art form. Together they opened the Little Galleries (better known as 291, the gallery's address on New York's Fifth Avenue) in 1905. Here they held photographic exhibitions in conjunction with shows of famous painters and sculptors including Rodin, whom Steichen befriended in 1900 while studying painting in Paris. For the first time in the US photographs began to be viewed as artistic works alongside more established art forms.

42. The dominant role of Paris over other cities in France at the turn of the century was unique among great cities in the Western world, except perhaps London. Industrial development, population growth and political power in Paris was greater than in any other part of the country. The city's role as the world's cultural capital and a major economic and political centre had been firmly established. But amid the whirl of urban modernization, intrepid photographers could still capture aspects of Paris life which had remained unchanged for centuries.

43. Miners' families listening to speeches during the United Mine Workers of America strike in the anthracite coal regions of Pennsylvania. Coal fuelled the spectacular growth of transport, communications and large-scale industry in nineteenth-century America, but at no small cost to the families in the country's burgeoning coal communities. Coal mining was a gruelling and extremely hazardous occupation, made worse by the perceived indifference to human life among the big financiers who owned the mines. Women were prohibited from working underground in the pits and mine shafts, but the drudgery and toil of life as a miner's wife, together with the constant threat of losing one's husband in a mining disaster, made strikes a family affair.

1903

44. Over the course of 1903 the Wright brothers built a glider that

could be powered by a twelve-horsepower engine. On 7 December 1903, Orville piloted the aeroplane for a flight of 44 metres (144 feet) – the first flight by a powered aircraft. In the coming years the brothers brought their aircraft to Europe, pioneering powered flights in France, Britain and Italy. However, by 1909 European competition had surpassed them in technological sophistication.

45. Edwin Porter's eight-minute film *The Great Train Robbery* (1903) was the movie industry's first spectacular box-office success and is widely recognized for establishing realistic narrative – as opposed to pure fantasy – as the dominant form in motion pictures. The film depicts an armed robbery of a train followed by the pursuit and elimination of the gunmen, all in sequence. It was the first film to achieve temporal continuity of action. Its success led to the construction of the first permanent cinemas in the US.

46. The redoubtable Chinese Dowager Empress Cixi at the summer palace, west of Peking. Cixi's guile and determination enabled her to rise from a maid in the Imperial Court to the wife of Emperor Hsien-Feng (1831–61), and eventually to become the most powerful force in Chinese politics during the last half of the nineteenth century. The only woman to have a significant influence during the Manchu period (1644–1911), Cixi consolidated her power by corrupting eunuch politicians, manipulating the imperial succession and obstructing reform. Cixi was a master of the art of clinging to power. She was far less capable of, or interested in, leading her country into the modern age.

1904

48. Captured men of the Herero tribe, German South West Africa (present-day Namibia). Germany annexed South West Africa during the late 1800s through dubious treaties and unfair arrangements with various Bantu-speaking tribes, including the Herero. Under the leadership of Samuel Maherero, the Herero led a revolt against the Germans in 1904 to reclaim lost territory. More than a hundred newly-arrived white settlers were killed in the uprising, causing the Germans nearly to flee the country

before the colonial forces launched a campaign of extermination to crush the revolt.

49. A Tibetan warlord lies injured beside his sword after British forces invade Tibet. Britain made several unsuccessful attempts to gain a foothold in Tibet during the 1800s in order to secure trade concessions and thwart perceived Russian expansionism in the region. Finally, in 1904, an expedition led by Colonel Francis Younghusband marched into the country and entered the capital, Lhasa. The conflict was a grossly one-sided affair in which hundreds of Tibetans were slaughtered by British machine guns. The Dalai Lama, Tibet's ruler, was forced to sign the Anglo-Tibetan treaty which secured British influence in the region.

50–51. Tsar Nicholas II blessing Russian troops before they depart for the front lines of the Russo-Japanese War (1904–05). Limited in intellectual breadth and grossly incapable of leading the vast Russian Empire, Nicholas II nonetheless possessed an exalted conception of his role as the nation's ruler. The Tsar firmly believed that his authority was derived from God and that the mystic traditions of tsardom were held in awe by the Russian people. He saw the conflict with Japan as an opportunity to fulfil his gradiose dreams of making Russia a great Eurasian power.

52. Japanese soldiers taking a bath on the front lines in Manchuria during the Russo-Japanese War. Rival imperial ambitions in Manchuria and Korea resulted in conflict between Russia and Japan. When Russia reneged on an agreement to withdraw its troops from Manchuria in 1903, the Japanese launched a surprise attack on the Russian fleet at Port Arthur without declaring war (10 February 1904). There was an international tendency to support the Japanese in the conflict. Russia's tsarist leaders had fallen out of favour with the Great Powers and Japan was viewed as the underdog – a small, ancient country still largely unknown to most of the world.

53 top. Russians living in Shanghai fled as Japanese soldiers reached the city during the Russo-Japanese War. After the Japanese laid siege to Port Arthur, Russian forces went on the offensive, with the aid of

reinforcements sent via the Trans-Siberian Railway. The offensive was short-lived. Poor military leadership and widespread corruption and incompetence among Russian officers resulted in the surrender of Port Arthur. Russia also suffered major setbacks in Manchuria and along the Yalu River in Japanese-occupied Korea.

53 bottom. Five dogs waiting to be tested in the laboratory of Russian physiologist Ivan Petrovich Pavlov. In a now classic experiment, Pavlov examined the notion of a conditioned reflex by training hungry dogs to salivate at the sound of a bell, previously associated with the sight of food. His groundbreaking work earned him the Physiology and Medicine Nobel Prize in 1904.

54. Theodore Roosevelt speaking at Grant's Tomb, New York, in 1904, the year he retained the American presidency with an overwhelming election victory. Although Republican, Roosevelt was a key progressive reformer whose mix of nationalism and reformism led to a fiery foreign policy rhetoric and progressive domestic policy. Indignation and moral righteousness were hallmarks of any Roosevelt speech. Most famously, he promised that the US would act as an international policeman, 'walking softly but carrying a big stick'.

55. Paul Cézanne, the father of modern painting, in front of one of his masterpieces, *Les Grandes Baigneuses* (*Great Bathers*) 1900–05. Cézanne's works and ideas were influential in the aesthetic development of many twentieth-century artists and art movements, especially Cubism. However, his paintings were misunderstood and discredited by the public during most of his lifetime. The man chiefly responsible for rehabilitating Cézanne's reputation and ensuring lasting world-wide admiration of his work was the French painter and writer Emile Bernard who took this photograph of his friend in Cézanne's studio at Les Lauves, near Aix-en-Provence, France.

1905

56. In 1900, less than 2 per cent of British children could expect to receive an education after the age of eleven or twelve. Schools in

Britain reflected the harsh realities of nineteenth-century social class structure, with higher education the traditionally exclusive domain of the upper and middle classes. Children of less well-to-do families acquired only the most basic skills. The Balfour Act of 1902 was the first in a series of reforms that sought to redress the balance by transferring control and responsibility for secondary education to the state. Student enrolment surged thereafter and the state took a more active role in young peoples' welfare, including the provision of school meals for poor children.

57. Nomadic people of Hindu origin, Gipsies have been subjected to persecution for centuries, mainly in Europe. Their itinerant existence on the fringe of European societies and their closed way of life led to frequent, and largely involuntary, migrations across the continent. The Balkan Gipsies who made it to North America in the late nineteenth and early twentieth centuries were met with less hostility by a local population not quite sure what to make of these exotic new arrivals.

58. Japan destroyed the Russian navy in the Russo-Japanese War. Although the Russians recovered from initial setbacks to hold off the Japanese armies in Manchuria and along the Yalu River in Korea, Japan's mastery of the seas proved decisive. A formidable Russian fleet took eight months to sail from the Baltic port of Liepája to relieve the besieged Russian forces at Port Arthur. They were annihilated by the Japanese on arrival in the Tsushima Straits on 27 May 1905. Japan's devastating naval victory at Tsushima, together with increasing political unrest in Russia, forced the tsarist leaders to the peace table. Russia abandoned its expansionist policy in the Far East and the world was obliged to come to terms with Japan, the first Asian power to defeat a European power in modern times.

59. Disorganized leadership, gross acts of incompetence and corruption, and loss of prestige following the humiliating defeat in the Russo-Japanese War sparked a number of uprisings in the Russian military, the most spectacular of which was the mutiny of the battleship *Potemkin* on 27 June 1905. Naval mutinies spread to Sebastopol and St

Petersburg, contributing to the popular revolutionary movement sweeping the country in 1905. Matsushenko (arms crossed), leader of the mutiny, reportedly killed ten officers himself on the *Potemkin*, which was regarded as the pride of Russia's Black Sea Fleet. The episode would undoubtedly be less remembered however, were it not for the film director Sergi Eisenstein, who was later commissioned to direct a film celebrating the twentieth anniversary of the mutiny. The film secured his reputation as the pioneering genius of modern cinema and *The Battleship Potemkin* (1925) emerged as one of the most influential and important films ever made.

60–61. Father George Gapon was a Russian orthodox priest who had become an influential trade union leader in St Petersburg prior to the events of 1905. On Sunday, 22 January 1905, Gapon led workers and their families to the Winter Palace in St Petersburg to deliver a petition to Tsar Nicholas II demanding reforms. The Russian troops responded to the petition by opening fire on the demonstrators, killing over a hundred. Subsequently known as Bloody Sunday, this massacre of peaceful demonstrators triggered the 1905 revolution and exploded the popular myth that the Tsar was the loving, benevolent father of the Russian people. Student demonstrations, worker insurrections and mutinies in both the Russian army and navy followed. The revolutionary movement reached its climax in October 1905 with the declaration of a general strike and the formation of a workers' soviet in St Petersburg.

1906

62 left. The corpse of Father George Gapon was found hanging at a dacha south of St Petersburg after his execution by socialist revolutionaries. Gapon had set up the Assembly of Russian Workers, an organization designed to counter the rising influence of Marxism and ensure that workers' demands were controlled within a tightly restricted framework, in co-operation with the St Petersburg police. The bloody end to the demonstration he led to the Tsar's Winter Palace shocked and radicalized Gapon, but too late. He was killed a year later for being an *agent provocateur*.

62 right. The aftermath of the bomb attack outside Russian Prime Minister Peter Stolypin's house near St Petersburg. As governor of Saratov province, Stolypin skilfully quashed peasant uprisings and played a key role in suppressing the revolutionary upheavals of 1905. The following year he was made Prime Minister and quickly moved to re-establish control, executing thousands of insurrectionaries in the process. His planned improvements in education and local and national government, and his far-reaching attempts to improve the lot of the country's peasants through agrarian reforms, were moderately successful. However, his brutally repressive line with the revolutionary movement earned him widespread hatred among the country's democrats and socialists. Stolypin survived this assassination attempt only to be killed five years later when he was shot by revolutionaries while attending a performance at the Kiev Opera.

63. Wilhelm II was just twenty-nine years old when he began his reign as German Kaiser in 1888, the year after his grandmother, Queen Victoria, celebrated her fiftieth anniversary as reigning monarch of the British Empire. Wilhelm was a rather immature man of modest ability, immense insecurity and boundless ambition. He was not satisfied with the accomplishments of the great Prussian leader Bismarck – among them German unity and Germany's industrial primacy on the continent – and was impatient for greater things. His personal vanities encouraged him to seek world leadership for Germany, an attitude that often made foreign contemporaries view him as a warmonger. Wilhelm's fascination with military ceremony verged on the obsessional. As one senior court official noted in 1904, 'at the moment we are witnessing the thirty-seventh alteration of uniforms since the accession to the throne'. His own chief-of-staff grumbled about the uselessness of war games in which the Kaiser always emerged the victor.

64. Citizens of San Francisco viewing the fiery aftermath of the great earthquake of 1906 from a nearby hill. The city experienced several earthquakes and major fires prior to 1906, but none approached the catastrophe of

that year. An earthquake measuring 8.25 on the Richter scale hit San Francisco early on the morning of 18 April. Streets buckled, buildings collapsed and gas and water mains ruptured. About a third of the city was destroyed in the ensuing fires which engulfed it. About 500 people were killed and some 250,000 were left homeless. Under stringent building regulations reconstruction progressed quickly, and within three years a new city had sprung up from the ashes of the old.

65. An elephants' tea party at the Hippodrome theatre in Paris. Trained elephants, the largest surviving land animals, were impressive examples of animal domestication. Their pleasant appearance and awesome size made their trained displays of human-like behaviour a wildly popular attraction in Europe's great cultural centres in the early twentieth century.

66. In 1880 Sarah Bernhardt formed her own travelling theatre company, leading a new wave of European artists who began performing abroad. She became one of the first truly 'international' stars, appearing regularly throughout Europe and North America. She undertook a world tour between 1891 and 1893. A mishap during a performance in 1905 led to the amputation of one of her legs ten years later, but her indomitable spirit would not allow her to abandon the stage. Bernhardt entertained soldiers at the front in the First World War and continued to perform, albeit seated, until 1922, the year before her death.

67 Audiences around the world clamoured to see Sarah Bernhardt play the heroine in Jean Racine's legendary French tragedy *Phèdre* (1677), arguably her most famous role. Considered the greatest *tragedienne* of her day, Bernhardt dazzled theatre goers with the lyrical quality of her speaking voice, dubbed 'the golden voice' by Victor Hugo. During her illustrious career she charmed a series of famous male admirers, Hugo and the future Edward VII among them.

68. Early explorers first speculated about the possibility of building a canal through the Isthmus of Panama in the sixteenth century,

but it was not until 1879 that a French company led by the excavator of the Suez Canal, Ferdinand de Lesseps, made the first attempt. However poor planning, gross mismanagement and lethal tropical diseases forced the French to abandon construction in 1889. By 1906 a second, American-led effort to build a canal was in full swing. This time planners believed they had solved the problem of malaria and yellow fever which had claimed 22,000 lives during the previous attempt. The successful American construction plan (a high level, lake-and-lock design as opposed to a sea-level canal) was virtually identical to one proposed in 1879 but rejected by Lesseps.

69. In many ways, construction of the Panama Canal marked the beginning of what has been called 'the American Century'. The project required audacious, almost reckless self-belief, together with all the ingenuity, strength and resources America could muster. At times more than 40,000 workers were employed on what was then the greatest engineering feat man had attempted. Not surprisingly, Theodore Roosevelt was one of the project's strongest supporters. Once the French company's canal holdings had been acquired by the US, he sent warships to the region to pressure the new republic of Panama to lease the US the territory five miles on either side of the projected canal. The canal opened to traffic on 15 August 1914.

70. An explosion in the Courrières coal mines near Lens in northern France killed 1,230 miners. Reports of the disaster and the courageous rescue efforts of miners such as Ricq Simon, who alone saved twenty-seven of his fellow workers, fuelled enormous popular sympathy throughout France. Despite government calls for a review of safety measures in the country's coal mines in the aftermath of the disaster, the survivors went on strike. The miners did not, ironically, put forward a single demand concerning miner safety but did win significant wage concessions and furthered the cause of pension reform in France.

1907

71. Local Buddhist leader, Khoutoukhta, and his followers standing captivated and utterly

perplexed in Ourga, Mongolia, by the new mode of mechanized travel being developed in the West. Bewildered faces were common among groups who gathered at checkpoints along the 12,000-kilometre (7,500-mile) route of the 1907 Peking-to-Paris rally after rumours of machines that ran by themselves faster than a galloping horse.

72 top. The term 'Entente Cordiale' was first used in the 1840s as a description of the understanding between the liberal powers, France and Britain. It was revived following the Anglo-French agreement in 1904. The agreement ended a long period of tension between the two nations, and settled their outstanding colonial differences especially in Africa. King Edward VII was openly pro-French and gave a stirring speech in Paris (in fluent French) that assuaged anti-British sentiment in the country and undoubtedly contributed to the successful conclusion of the agreement. It was the British King's greatest moment in foreign affairs.

72 bottom. Reports of the Wright brothers' successful powered flight in America spawned many other attempts to duplicate their feat, some less promising than others. Typical of the fantastic experimental designs employed by early aviators, was this unique biplane with three bicycle wheels and a small motor underneath. Death or serious injury to the pilots of such aircraft was not uncommon.

73. The Herero tribe's revolt against German colonial encroachment finally ended in 1907, but not before three-quarters of their population had been exterminated. The extreme savagery of the German tactics which included mass deportations, hangings and shootings, caused thousands of Herero to flee into the Kalahari desert, where many perished under the blazing African sun. Those who remained in South West Africa were incarcerated in concentration camps and forced to work for the German colonial administration.

74 left. A young Mahatma Gandhi with legal clerks in front of his office in Durban, South Africa. Gandhi first went to South Africa in search of clerical work in 1893, and was shocked at the racial

discrimination he witnessed there. Between 1907 and 1914 he became a legal advocate for his fellow Indians living in South Africa. During this time he lead passive resistance campaigns against official discrimination and undertook a series of court challenges which eventually landed him in jail. Gandhi's efforts failed to provide an enduring solution to racial discrimination in South Africa or to the political problems in India, but his experiences there were instrumental in shaping his doctrine of non-violent protest to achieve social and political progress.

74 right. The last Emperor of China, Henry Pu Yi (shown here with his brother, Prince Quen), sitting on the lap of his father Prince Chun, in the Forbidden City, Peking. In November 1908 Pu Yi's great aunt, Dowager Empress Cixi, engineered his accession to the Imperial throne at the tender age of two. Four years later he was forced to abdicate by the revolutionary government which had formed in Nanjing after the Wuchang Uprising. The abdication not only brought to a close 268 years of Manchu rule, but also marked the end of over 2,000 years of continuous imperial tradition in China. The young Pu Yi was permitted to continue living in the Forbidden City under the symbolic title of Manchu Emperor. He became a rallying point for monarchists in the constitutional struggles leading up to the establishment of the People's Republic of China in 1949.

75. French Colonel Hubert Lyautey during the campaign against the Beni-Snassen tribe in Morocco. In spite of his taste for independent action abroad which never failed to infuriate government officials back in Paris, Lyautey was the chief architect of France's colonial ascendancy in north-west Africa. A devoted believer in the civilizing virtues of colonialism, Lyautey conceived of the colonies as realms which needed to be governed for the good of the indigenous population as well as for the benefit of France. He argued that conquest must be combined with respect for local cultures and that France should also take responsibility for the construction of roads, schools and agricultural development in order to ensure the gratitude of her newly acquired colonial subjects.

76. The first photograph of Abdul Hamid II of Turkey which was released to the public shows the Sultan uneasily watching a crowd in 1908. Known as the Great Assassin, the Turkish Sultan was intelligent and resourceful, but also intensely suspicious and cruel. He ruled the Ottoman Empire despotically for over thirty years. During this time, despite his brutal suppression of revolts most notably in the Balkans, he witnessed the dismantling of much of the Ottoman territory in southern Europe and northern Africa. The Young Turks, a liberal group of Turkish exiles pushing for constitutional reform and enlightenment, began as a response to the repeal of the Ottoman constitution by Sultan Abdul Hamid II in 1878. In 1908 disaffection in the army and pressure from the Young Turks forced the Sultan to restore the constitution of 1876 and summon a parliament. He was deposed a year later and forced into exile.

77. An infantry battalion at the dining table in Medellín, Colombia. Tens of thousands of Colombians perished in the civil conflict, known as the War of a Thousand Days, which shook the country in the last decade of the nineteenth century. In 1903 Colombia was faced with the loss of the northern-most part of its territory, the Isthmus of Panama, after Panamanians revolted against the Colombian government in Bogotá. The US, eager to acquire rights to build a canal through the Isthmus, went to the aid of the Panamanians in their struggle for independence. Facing American might, the Colombian military was unable to stop the secession of Panama, which became an independent country in 1904.

78. Anniversary of the Floral Games (*Juegos Florales*), a poetry contest dating from medieval times, at the Palacio de Bellas Artes in Barcelona, Spain. Still a much-honoured institution in Catalonia, the north-eastern region of Spain, the contest included poetry on only three subjects: love, religion and the motherland. Winning entries in each category received the symbolic prize of a flower, hence the contest's name. Catalonia attempted to wrest more power from Madrid during the first two decades of the century through the assertion of its own language,

a growing political awareness and a revived cultural tradition. The Floral Games was a reflection of this.

79 Anarchism, which reached its height in the first decade of the twentieth century, became the favoured form of radicalism in Spain during the 1870s, especially among factory workers in Catalonia. In this region of Spain, opposition to authority inclined towards terrorism and gained the support of a growing number of Catalans. They believed that the anarchist militants were the only effective counter to the Spanish army and the squads of gunmen hired by large employers to quell worker unrest.

80. William Howard Taft, the US Secretary of War with a reputation as a 'safe pair of hands', was nominated for the Republican leadership by President Roosevelt. Taft defeated the Democratic candidate William Jennings Bryan to win the 1908 election, but Roosevelt soon came to regret throwing his support behind the reticent, highly conservative new president. Taft believed that the constitution set strict limitations on the scope of presidential activity, a view greatly at odds with Roosevelt's conception of a progressive, activist role for America's leader. The growing breach between the two men resulted in a split in the Republican Party, with Roosevelt running against his successor in the 1912 election as leader of the Progressive Party.

81. At the age of ten, the young Thomas Edison set up a laboratory in his father's basement and, despite scant formal training and a serious hearing impairment, began experimenting with just about anything he could lay his hands on. By the time he was in his thirties, Edison's astonishing inventive genius was in full bloom and he was arguably the most famous American in the world. During his lifetime he took out more than a thousand patents for inventions which included the first gramophone, the incandescent light bulb, the power plant and even the first talking motion picture. His extraordinary productivity and tireless pursuit of practical inventions made Edison a folk hero among his countrymen and a potent symbol of America's 'can-do' mentality.

82. The spectacular 1908 Franco-British exhibition at White City in London symbolized the new spirit of friendly relations between the two powers. The exhibition covered over 80 hectares (200 acres) and included the 70,000-seat stadium built for the Olympic Games which were held in the city later that year. The overall structure of the event – endless entertainment facilities, dazzling pavilions in different architectural styles and an artificial lake on which boats carried people around the sight – was emulated by many national and international exhibition planners throughout the century.

83. Two years after the earthquake in San Francisco, nature struck again with devastating force in southern Italy. Most of the ancient towns on both sides of the Straits of Messina were severely damaged in an earthquake and resulting tidal wave which struck on 28 December 1908, killing an estimated 200,000 people. The historic city of Messina in Sicily was completely destroyed.

1909

84. The Tsarevitch, Alexis, and his sister Anastasia on the terrace of the old palace at Livadiya, Russia. After four daughters, Tsar Nicholas II was greatly relieved when the desired son, Alexis, was born in 1904. But Alexis' succession to the throne of the Romanov dynasty was cast in doubt when he was discovered to be a haemophiliac. When an exotic, enigmatic figure by the name of Rasputin apparently succeeded in curing the boy's condition, Nicholas II's wife welcomed her son's healer into the royal family's inner circle, and so began one of the strangest and most intriguing chapters in Russian history. Alexis' sister became the centre of an almost equally bizarre episode, when various women around the world claimed to be Anastasia in the decades after her death.

85 top. An armoured car belonging to the Young Turks who sought the removal of the Turkish Sultan and the re-introduction of constitutional rule. In 1909 they succeeded in toppling the Sultan, but serious rifts soon developed in the new government between liberal reformers and nationalists. The latter based their popular appeal more on Islamic nationalism and wanted reform for themselves,

rather than for the various national minorities within the Ottoman Empire's territory.

85 bottom. Triumphant entry of Young Turk soldiers into Constantinople. The Young Turks remained in power until 1918 when they were forced to resign. Although their domestic policy brought constitutional rule to Turkey, their disastrous foreign policy led to the dissolution of the Ottoman Empire.

86. Futurism, an Italian art movement glorifying the dynamism and power of the new technology and the restlessness of all aspects of modern life, had its official beginning in February 1909 with the publication of Filippo Tommaso Marinetti's *Manifeste de Futurisme* in the Paris newspaper *Le Figaro*. Marinetti sought to discard what he held to be the static and now irrelevant art of the past, and celebrate instead the change, vitality and innovation of early twentieth-century culture and society. Umberto Boccioni and other painters published their own manifesto, echoing Marinetti's rejection of inherited traditions. The aggressive and inflammatory rhetoric of the movement, including calls for the destruction of libraries, museums and other government institutions, gave much publicity to its founders, but was not sufficient to sustain popular interest in the movement.

87 top. During *Semana Trágica* (Tragic Week) in Barcelona, Spain, old coffins were pulled into the street and their remains emptied. The troubles started as protest against sending young conscript soldiers to fight in the Spanish colonial war in Morocco, but quickly developed into a ferocious assault on the property of the Catholic Church in Barcelona. Over the centuries the Church had been woven into the fabric of Spanish life, symbolizing all that was traditional and conservative about Spain, and all that prevented the modernization of the country. Thus between 1900 and 1909 the Church became the almost exclusive target of political reformers in Spain. During the *Semana Trágica* thirty-six convents and churches were razed before the government was able to restore order.

87 bottom. Revolutionaries constructing a barricade during the *Semana Trágica*.

88. The Great White Fleet on the final day of its round-the-world cruise, 20 February 1909. President Roosevelt had ordered a tour of America's battleships fourteen months earlier to demonstrate America's naval might and stature as a rising global power. Following the Spanish-American War, the US emerged with new territories in the Caribbean and Pacific and a belief in the importance of sea power as a tool of foreign policy. Roosevelt was particularly concerned about ascendant Japanese power; not surprisingly, the Fleet made a stop in Japan to impress upon its leaders that armed conflict with America would be unwise. After the tour, all US navy vessels were painted grey – a less conspicuous colour at sea than white.

89 top. The idea of taking off and landing vertically and making a transition to horizontal flight had been a dream of inventors for centuries, from the ancient Chinese through to Leonardo da Vinci and the aviation pioneers of the early 1900s. However it proved a far more formidable challenge than conventional flight. Lacking an engine powerful enough to produce the vertical thrust required to raise its own weight, the first helicopters rarely got off the ground. Early designers such as Vuitton never dreamed of the complex in-flight control problems that would frustrate later experimenters still further. The first effective helicopters did not appear until the 1940s.

89 bottom. The fifth Earl of Lonsdale on manoeuvres with Kaiser Wilhelm II in Germany. The celebrated British sportsman and horse-breeder indulged the Kaiser's love of war-games on this occasion, but polite socializing masked growing tensions between their two countries in the first decade of the century. Discord developed during the Boer War in South Africa because of Germany's open support of the Boers against the British. Later in the decade, in an interview with the *Daily Telegraph* in London, the Kaiser emphasized the pervasive anti-English sentiment in German society. Germany was viewed with growing trepidation by the British as a result of its increasing militarism and assertive foreign policy.

90. On 25 July 1909, the French aviator Louis Blériot piloted his monoplane across the English

Channel from Calais to Dover in the first cross-channel flight in a heavier-than-air craft. The Channel Challenge was organized by Lord Northcliffe, publisher of the *Daily Mail*.

91 top. Blériot pictured with his wife after landing on the cliffs of Dover.

91 bottom. Blériot being greeted by cheering crowds at Victoria Station, London.

1910

92 top. Heavy strike activity in traditional industries (particularly garments and textiles) during the pre-war period reflected the change from artisanal to mechanized industrial production. The trend towards the concentration of output and employment in a relatively small number of large factories forced many out of work, while those that remained had to contend with the oppressive conditions and alienation caused by new technology. This photographic account of the French seamstress' strike in 1900 looks deceptively peaceful, due in no small part to photojournalists' tendency at the time to portray women in conventionally pleasant scenes, even when that did not correspond to the full reality.

92 bottom. Pre-war Berlin was filled with cheerful self-confidence. The industrial revolution hit Germany with a vengeance in the latter part of the nineteenth century and nowhere more forcefully than in Berlin. Colossal economic growth in the city was coupled with explosive achievements in literature, science and music. The city became a symbol of urban grandeur.

93. Newsboys standing outside a pool hall in St Louis, Missouri. Brash, precocious newsboys were the perfect symbol for America's flourishing newspaper business in the early 1900s. As circulation battles between papers became commonplace, the US in particular set new standards of sensationalism, and their newspaper sales soared. Newspapers were fast becoming part of mass-market industry, breaking away from many of their former links with the literary world. The clamour of newsboys bellowing the latest shocking headline from America's urban street corners was hard to ignore.

94. Mexico progressed economically under Porfirio Díaz's dictatorship, largely due to favourable terms given to foreign investors, but Mexican industries and workers suffered greatly. Although Díaz expressed an interest in democracy, movements for land reform and civil liberties and those against the Catholic Church met with ruthless government repression. Popular opposition to his repressive policies eventually forced Díaz into negotiations with the imprisoned opposition leader Francisco Madero in 1910. Díaz went into exile in Europe where he died in poverty.

95 left. The sifting process for immigrants arriving at Ellis Island, New York, began with medical checks. Inspectors looked for any physical or mental deformity, but were particularly concerned with contagious or infectious diseases. Here a new arrival is tested for trachoma, an infectious eye disease which can lead to blindness. Overcrowded, poorly sanitized immigrant ships were ideal locations for the spread of this disease, which accounted for more than half of all medical detentions and deportations.

95 right. Arrest of a suffragette in London. Dubbed the 'suffragettes' by the *Daily Mail* – distinguishing them from the suffragists who had been working for the vote for women since 1866 – the British movement was led by Emmeline Pankhurst, who founded the Women's Social and Political Union (WSPU). After forty years of campaigning for the parliamentary vote for women with no results, Pankhurst and her followers argued that the time for militancy had arrived. Their audacious tactics, which included arson attacks, hunger strikes and interrupting speeches by leading politicians, ensured widespread notoriety for the suffragettes.

96 top, 97. Leo Tolstoy was a pre-eminent Russian novelist of his time. His most famous works, *War and Peace* (1863–69) and *Anna Karenina* (1874–76) touch on the ultimate meaning and purpose of human existence. Tolstoy abandoned his career as a writer solely of fiction in mid life, when he became a radical Christian. Born into landed nobility, he was a deeply contradictory man, tormented in his later years by his desire to shed all worldly

possessions and live a life dedicated to the service of others. One of Russia's most famous men, Tolstoy suffered an ignominious death, quietly leaving home one night and dying a few days later in a remote railway station.

96 bottom. Ellis Island, the 277-acre island situated in Upper New York Bay, was the principal immigration centre of the US from 1892 to 1943. During this time an estimated 17 million immigrants passed through, mostly from Italy and Eastern Europe. Views of the nearby Statue of Liberty no doubt added to the powerful emotions of the new arrivals as they disembarked from ships on the island. A series of tests by US immigration authorities awaited all immigrants before they could obtain permission to enter the country.

98. Ellis Island was also known as Heartbreak Island, and for the unlucky ones who faced deportation this name was painfully apposite. By the 1890s the list of undesirables included persons with criminal records for acts involving 'moral turpitude' and those suffering from a 'loathsome or contagious disease'. The largest group of deportees were contract labourers persuaded to emigrate by the offer of jobs, but allegedly brought to America for the purpose of lowering wages and breaking strikes. Labour unions had pressured the US government to ban this importation of immigrant workers on contract and by 1914 about 1,000 new arrivals were sent back to Europe every month under this statute.

99. *The Crowd* by French photographer Robert Demachy who opposed the idea of 'pure' photography. Under the influence of impressionist painters, Demachy firmly believed that photography could not be considered art unless the photographer took an active role in interpreting his subject by manipulating technical aspects of the work. Demachy's reaction against 'pure' photography was widely shared, most notably by the Photo-Secession Group in the US, and by the Linked Ring Brotherhood in Britain.

1911

100. *Avenue des Acacias, Paris* (detail) by Jacques-Henri Lartigue. The French artist Lartigue earned his living selling his canvases and

remained convinced throughout his long life that he would be most remembered for his paintings. However, it is his remarkably evocative photographs – many taken during his adolescence – that first brought Lartigue widespread notoriety after an exhibition of his earliest works at The Museum of Modern Art in New York in 1962. His straightforward, informal approach to photography was applied to innumerable subjects, ranging from his experiences of the First World War to the social outings of France's leisured classes.

101. Mexico's new leader Francisco Madero photographed in May 1911, two weeks before President Porfirio Díaz was forced to resign and flee Mexico. Madero's call for honest elections, a wider franchise and the disqualification of Díaz as a candidate, temporarily unified various democratic and anti-Díaz forces in the country. Sweeping to victory on a tide of popular support, Madero, despite the best of intentions, quickly revealed his lack of political astuteness by his failure to recognize the diverging objectives of many of his supporters. His administration became corrupt and, more importantly, he lost favour with the US, the chief foreign investor in the country.

102. Equipped with motor sledges, dogs and ponies, British explorer Robert Falcon Scott, L.E.G. Oates and ten others embarked on their quest to reach the South Pole from Cape Evans, Antarctica, on 24 October 1911. After overcoming treacherous conditions, Scott's much-diminished party reached its destination on 18 January 1912, only to discover evidence that the Norwegian explorer Roald Amundsen had beat them to the pole. Exhausted and short on supplies, the team did not survive the return journey. When their frozen bodies were discovered several months later, Scott's records and diaries which gave a full account of the ill-fated journey right up until his final hours, were also recovered and published.

103 top. The most formidable aircraft prior to the First World War were airships. These large, self-propelled crafts usually consisted of a rigid, fabric-covered metal frame within which were hydrogen-filled gas bags. Modern militaries were keen to exploit airships because they could carry high-

explosive bombs at a time when aeroplanes were not yet equipped with weapons, and were used only for reconnaissance. But this impressive offensive capacity was offset by structural design flaws, and the highly flammable nature of the hydrogen gas that gave airships their lifting power. Accidents such as the one pictured were common.

103 bottom. The epicurean plenty of the *Fram*, the boat Norwegian explorer Roald Amundsen sailed to Antarctica during his quest to reach the South Pole, was in stark contrast to the hellish conditions that awaited him on land. Reports that American explorer Robert Peary had reached the North Pole in 1909 caused Amundsen to sail southwards towards Antarctica, instead of to the Arctic as he had originally intended. The Norwegian was better prepared for his assault on the South Pole than his fellow Antarctic explorer, Robert Falcon Scott. Amundsen deposited food supplies along the first part of the route to the pole and used sled dogs rather than Siberian ponies, which had to be put down during the Scott expedition. On 14 December 1911, Amundsen's team reached its destination, about a month before Scott.

104. Chinese revolutionaries at Wuchang, China, along the Yangtze River. A series of anti-dynastic uprisings exploded into a full-scale revolution after the Manchu government attempted to push through a railway nationalization scheme in the Yangtze provinces. On 10 October 1911, Manchu troops in Wuchang mutinied and joined with revolutionary forces seeking to oust the imperial dynasty. The revolutionaries' aim was to install a new Republican government headed by their ideological leader, Sun Yat-Sen.

105. The new British monarch George V was an acknowledged expert on shooting and so was understandably elated when a tiger hunt was mounted in his honour during a tour of India 1911–12. Big game hunting by the British monarchy was synonymous with the British Empire and became an integral part of the imperial image, as it had been for the Mogul emperors who ruled India before the British.

106 top. A garden meeting of the Wimbledon branch of the Women's Social and Political Union (WSPU).

The WSPU, formed in 1903 by Emmeline Pankhurst and her daughters Christabel and Sylvia, was the organization that underpinned the British suffragette movement. On the left is Georgina Brackenbury, notable for her efforts to assist those suffragettes temporarily released from prison by the authorities because they had become dangerously weak from hunger strikes. After failed attempts to force-feed suffragette hunger strikers, the government passed special legislation, dubbed the 'Cat-and-Mouse Act', to empower authorities to release hunger strikers temporarily, but then re-arrest them as soon as their health had improved.

106 bottom. Indian suffragettes on the Women's Coronation Procession for King George V, London. Women with origins from across the British Empire marched in the parade and voiced their displeasure at the slow progress made by legislators in London towards female suffrage. Suffrage demonstrations were often marred by abusive taunts from onlookers and even attacks on the women marchers themselves.

107. Harriet Quimby, American aviator and journalist, broke new ground by becoming the first woman to earn her pilot's licence in 1911, eight years after the first flight of the Wright brothers and nine years before women were granted the right to vote in the US. Three years after Blériot's historic channel crossing, Quimby also became the first woman to fly across the English Channel on 12 April 1912.

1912

108. Jim Thorpe throwing the discus at the 1912 Olympics in Stockholm, Sweden. Widely regarded as the finest American athlete of the first half of the twentieth century, Thorpe dominated the 1912 Games, picking up gold medals in both the decathlon and pentathlon competitions. Partly native-American, Thorpe played a host of other sports, including professional baseball, and also excelled as one of the first stars of US professional football. However, a brief spell as a semi-professional baseball player a few years prior to the Olympics came back to haunt Thorpe. In 1913 he was stripped of his medals after the Amateur Athletic Union determined that this career

constituted a breach of Olympic regulations. He was an alcoholic and close to poverty when he died in 1953. Thirty years later the International Olympic Committee restored Thorpe's medals to his family.

109 top. The American social activist Maud Ballington Booth used her prodigious speaking talents to focus public attention on various social problems in America, particularly prison reform and the rehabilitation of ex-convicts. Booth believed passionately that direct communication with people was the most powerful way to improve the lot of society's needy, whether they were prisoners, children or destitute mothers. After helping to establish the Salvation Army in the US, Booth went on to make a significant contribution to US prison reform and the development of the parole system.

109 bottom. Robert Baden-Powell, a British soldier who gained fame during the Boer War as an exceptional strategist, founded the Boy Scouts in 1908. He was inspired to establish the Boy Scouts by the interest young boys had shown in his army training manual *Aids to Scouting*. Baden-Powell's aim was to counteract the moral and physical deterioration which he believed was affecting the new generation, and to train boys to be more efficient and responsible citizens. Within ten years, millions of young boys had joined in Europe and North America. Later he founded the Girl Guides with his sister Agnes.

110. *Dance Study* by Baron de Meyer. Born into a wealthy American family, de Meyer was a man of extravagant tastes, as evidenced in his audacious, sometimes chimerical, photographs. Under the influence of pioneering photographer Alfred Stieglitz, Meyer began developing his own unique style, eventually becoming *Vogue* magazine's favourite photographer. His life-long reluctance to portray 'characters' in his work was reflected dramatically in his *Dance Study*, where his subjects were fitted with masks and then captured in wondrous, provocative poses.

112. Nephew and namesake of the Prussian field marshal famed for victories during the Franco-Prussian war, the younger Helmuth

von Moltke was the man responsible for executing the Schlieffen Plan, Germany's war strategy. Moltke had risen rapidly in the German army, largely as a result of family connections and personal friendship with the Kaiser. He succeeded Alfred von Schlieffen as Chief of General Staff in 1906 and set about modifying his predecessor's military plans to meet modern conditions in the case of eventual war with Europe.

113. The Balkans became the scene of intense nationalist rivalries in the early 1910s. In 1912, Greece, Bulgaria, Serbia and Montenegro formed the Balkan League and, with Russian encouragement, attacked Turkey. Already reeling from defeat in north Africa at the hands of Italy, the Turks were easily defeated, effectively ending centuries of Ottoman rule in Europe. But the League members quarrelled over the division of Macedonia and other spoils of their victory. Bulgaria, which had suffered three-quarters of the casualties in the war and felt cheated by the treaty that ended the conflict, started the second Balkan War by launching a surprise attack on Serbia and Greece on 29 June 1913. Bulgaria found itself invaded by the Romanians and the Turks (with whom Serbia and Greece were still technically at war) and were rapidly defeated. As a result Greece emerged as the most powerful state in the Aegean. Leaving Bulgaria bitterly resentful, Macedonia was divided between Greece and Serbia, and the state of Albania was created. More significantly, the lines were drawn for the future position of the Balkan states in the great conflict to come.

1913

114. British suffragettes being arrested after chaining themselves to the railings of London's Buckingham Palace. The militant tactics of the suffragettes often backfired, sometimes with frightening consequences for the women involved in the protest. Widespread public hostility towards the suffragettes enabled the government to employ the police freely against them. Eventually the suffragettes' methods alienated pro-suffrage members of parliament and antagonized non-militant women; more importantly, working-class men and women did not join the movement *en masse* as predicted.

115. Federal soldiers in Mexico City waiting to leave for La Laguna to fight constitutionalist revolutionaries. The new president Victoriano Huerta proved a drunken and despotic ruler, out of depth in an increasingly bloody conflict where uneasy alliances between rebel groups were apparently formed one day and then broken the next. Venustiano Carranza, the leading constitutionalist in the revolution after Madero's death, led his large rebel army against federal troops, eventually forcing Huerta's resignation in 1914.

116. On the night of 23 February 1913, Francisco Madero and his vice-president were shot dead following a military coup led by his own military chief of staff General Victoriano Huerta, and carried out with the assistance of the US Ambassador to Mexico, Henry L. Wilson. The US had supported Madero during his first months in office, but soon turned against him. Their belief was that he was too conciliatory to certain groups in the Mexican civil war who posed threats to American business interests in Mexico. After his death, Madero became a martyr and an inspiration to democratic forces in the revolution that was now enveloping the whole nation.

117. King Constantine I of Greece in German military dress, discusses strategy with his brother-in-law, Kaiser Wilhelm II. Constantine was educated in Germany, served in the Prussian army and was married to Wilhelm's sister. It was little wonder that he was at odds with his country's pro-Allied government. With the approach of a European war, relations between the Greek monarch and his government deteriorated further as Constantine upheld his belief that the Allies were bent on naval domination of the Mediterranean. In June 1917 he was forced to relinquish his crown, and went into exile where he continued his attempt to disrupt Greece's contribution to the Allied war effort.

118 Around 100,000 garment workers in New York City went on strike in 1913 at the same time that some 150,000 workers walked out in the women's garment industries. Garment workers' grievances stemmed from long hours, low wages and unsanitary conditions of work. The industry was undergoing great change, partly as a result of

its passing from artisan to factory production, but more as a consequence of the great inflow of immigrant labour since the turn of the century. Their cosmopolitan character was noticeable when 50,000 workers marched in a spectacular parade during the second week of the strike.

119. New Polish immigrant workers on strike in Utica, New York. Poles and other newly-arrived ethnic groups in America agitated for job protection and social insurance, but few sought membership in the then burgeoning labour unions. Although the American Federation of Labour was generally keen to organize the unskilled industries in which many of them worked, its leaders were not interested in recruiting non-English-speaking foreigners, and lobbied to restrict the inflow of cheap labour, especially from Eastern Europe. Other Americans worried that these new immigrants were politically radical and would cause problems for industry and management.

120. A Bulgarian soldier giving a drink to a wounded Turk after Ottoman forces invaded Bulgaria in 1913. Photographs of a defeated soldier being helped by the conquering forces were typical of early photojournalism. During the First World War, the power of photographs to generate alternative 'truths' was not lost on governments keen to win the propagandist war at home regardless of the reality on the battlefield. Such images often provided very little information about the event they depicted, but impacted profoundly on the attitudes and beliefs of the society that saw them.

121. Formed in 1899 by the great Italian industrialist Giovanni Agnelli, Fiat entered the fledgling automotive industry in its earliest days and quickly became one of its most successful and most international companies. Its success rested on Agnelli's keen business sense and a small army of highly-skilled employees, trained at the prestigious engineering school in Turin – Fiat's headquarters – and sent to factories in Italy and abroad to assist local workers in the manufacture of Fiat cars. This picture was taken in a factory in Jakarta, Indonesia.

122. Young farm workers from Westerwald, western Germany, going to a dance on the eve of war. The generation of Germans born after Bismarck's unification of Germany experienced peace and prosperity not previously known in the area, and looked confidently to the future. When war erupted, young Germans enthusiastically embraced the opportunity to help their country become a power of world stature. Most believed the war would be over quickly and they would be home in time to celebrate Christmas. Over the next four years, two in every three German soldiers would either be killed, wounded or taken prisoner.

123. The assassination of Archduke Franz Ferdinand, heir to the Austro-Hungarian throne, and his consort Sophie, Duchess von Hohenberg, gave Austria-Hungary the excuse that it had sought for opening hostilities against Serbia, thus precipitating the First World War. Pictured are Gavrilo Princip and accomplices Danilo Ilitch and Nedjelko Cabrinovic, fellow members of the secret Serbian society, the Black Hand, who wanted to destroy Hapsburg rule in the Balkans and unite the southern Slav peoples into a federal nation. At the trial Princip, the man who shot the fatal bullets in Sarajevo on 28 June 1914, was spared the death penalty because of his age: he was nineteen.

124 top. German women present flowers to husbands and sons marching off to war. The Imperial German Army was more efficiently mobilized and better prepared than any land force in the world in 1914, and its equipment was generally superior to that of other European nations. Prior to the war, German military planners were convinced that France could be conquered within six weeks, after which the bulk of the German forces could be transferred to the Eastern Front to tackle the slow-mobilizing Russians. But the Schlieffen Plan collapsed after French resistance at the Marne and the Germans were forced to continue a very different war from that which they had envisaged.

124 bottom. Of those Belgian soldiers lucky enough to survive, few over the next four years would share a moment as light as the one pictured. The country occupied the only wide open space between France and Germany, and Belgian neutrality, guaranteed by all the major European powers since 1831, was a vital component of the European balance of power in 1914. The German ultimatum to Belgium on 2 August 1914, gave Belgian King Albert I and his government the choice of fighting or peacefully accepting effective conquest. Albert opted for the latter. He took personal command of his relatively meagre troops and led them in retreat to the north-west corner of the country. Virtually the whole of Belgium was in German hands within three weeks.

125 top. A regiment of the French army marching in Paris before going to the front in August 1914. The outbreak of war was greeted with relief and jubilation by both ordinary citizens and soldiers across Europe. The diplomatic brinkmanship and growing arms preparations of the early 1910s had fanned flames of xenophobia in countries which were already lurching towards war. The young men who enlisted to fight were generally inflamed with a traditional idealization of war as a noble, character-building experience which was not to be missed. A rather more sober view of war was evident in France and across Europe by the end of the year.

125 bottom. Ingrained hostility to conscription in British society had checked the growth of the nation's army before 1914. Consequently, at the outbreak of war on the continent in August, the number of regular troops of the British army stood at the relatively low numbers of 250,000 men. Britain's war minister Horatio Kitchener, almost alone at the time among European leaders and military men in predicting a prolonged conflict fought by mass armies, immediately began a recruiting drive for new soldiers. By September of 1914, 33,000 men were signing up for duty every day.

126. Families struggling aboard the last ship to leave Antwerp after the forts protecting the city fell to the Germans. The Belgian city was surrounded by inner and outer rings of fortresses which the Allies hoped would pose a serious threat to the flank of the invading German First Army. The British Government, convinced by British Navy Minister Winston Churchill of the importance of securing the channel ports, sent three brigades of Royal navy troops to the Belgian coast. However, the imminent destruction of Antwerp's fortresses forced an immediate evacuation, which was not completed before the city surrendered to the Germans on 9 October 1914. Antwerp was occupied for the next four years but most Allied troops managed to escape down the coast to take part in the subsequent battles in Flanders.

127 top. Soldiers of the tsarist army on their way to the front. In terms of sheer size, the armies of imperial Russia were regarded as a potentially unbeatable force in 1914; their estimated manpower resource included more than 25 million men of combat age. Nonetheless, the quality of leadership in the army (especially the ability to mobilize vast Russian forces along the Eastern Front) and the effectiveness of Russian weaponry were less certain.

127 bottom. Germany had hoped the Belgians would make things easy for them during the invasion of Belgium and allow safe passage through their country, but it was not to be. The Germans countered unexpected Belgian resistance by terrorizing occupied communities. Towns were razed, hostages were taken and mass executions occurred. Graphic reports of atrocities such as the Massacre of Dinant, where 612 town citizens (including women and children) were taken into the town square and shot, shocked neutral public opinion world-wide.

128 top. A German medical orderly tending to a wounded soldier. The wave of patriotism and jubilation that swept across Europe after the outbreak of war did not last the year. Young men, keen not to miss out on what promised to be a great, historic adventure, had rushed to report for duty that summer, but few could have ever imagined the horrors that awaited them on the battlefield. Medical staff dispatched to the front were totally unprepared for the unprecedented numbers of dead and injured, and improvised as best they could.

128 bottom. The first trickle of wounded soldiers arriving at Rheims station in north-eastern France, gave no indication of the scale of what was to come – the nearby countryside witnessed some of the heaviest fighting of the war. The Germans briefly occupied Rheims itself during their offensive of September 1914, and held the surrounding area after evacuating the city. From here they subjected the city to intermittent bombardment over the next four years. By the end of 1914, the French had sustained losses of about 380,000 killed and 600,000 wounded.

129. Russian prisoners in front of Tilsit station, East Prussia, awaiting transportation to a German prisoner-of-war camp after the Battle of Tannenberg. This was the first war in which the numbers of war prisoners reached millions (8.4 million altogether) and were detained for long periods of time. While the Great Powers were obliged to respect prisoners in accordance with the Hague Convention, their treatment in general depended on the standards prevailing in the army of the captor power. The Russian soldiers pictured might have fared well. Other prisoners, particularly those taken by Turkey and Russia itself, were not so lucky.

130. French soldiers being taxied to the front lines of the Battle of the Marne (6–9 September, 1914), the first vital turning point in the war on the Western Front. Three armies of the German invasion's northern wing were sweeping south towards Paris when the French army made a gallant stand at the River Marne, effectively saving France from rapid conquest by the Germans. A German breakthrough along part of the French line seemed imminent until 600 Paris taxis were used to rush 6,000 reserves to the front. They arrived in colourful, old-fashioned infantry uniforms, wearing white gloves. By 1915, safer, pale grey garments had been introduced.

131 top. Wounded Russian soldiers on the Eastern Front. Russia lost some 250,000 men at Tannenberg (of which 92,000 had been taken prisoner) after a spectacular victory by the German Eighth Army over the Russian Second Army in late August 1914. Disorganization and absence of communication between Russian field commanders contributed to the ignominious outcome. The defeat effectively ended the Russian invasion of East Prussia, and undoubtedly crushed any enthusiasm these young men still had left for the war.

131 bottom. British and German soldiers mingling during the Christmas truce. As Christmas approached in 1914, soldiers along both sides of a section of the Western Front in Flanders began detecting a mutual interest in the goings–on in the other side's trench. A strange camaraderie soon developed as opposing soldiers hollered greetings to one another and food was lobbed over the no-man's-land that separated the trenches. The atmosphere of goodwill culminated on Christmas Day when soldiers from both sides clambered warily out of their trenches and shook hands, exchanged cigarettes and souvenirs, and simply behaved like ordinary strangers meeting for the first time. In some places the friendly spirit lasted for a few days before generals ordered the soldiers back into war mode and put a stop to the unplanned truce. It was never to be repeated.

1915–1933
Self-Inflicted Wounds Remain Infected

The war in Europe did not produce swift, decisive victories for either side as so many had predicted in 1914. Instead it produced enormous suffering and death especially in battles such as those at Somme and Verdun. Nothing in human history had prepared any of the participants for a war of such vast dimensions, which displayed such an insatiable appetite for men and machines. After four years of senseless slaughter in which an estimated 10 million men lost their lives on the battlefield, the First World War ended due to exhaustion and despair. Europe's statesmen resolved to ensure that The Great War would indeed be 'the war that will end war'. Unfortunately the crippling reparation payments of the Treaty of Versailles sowed the seeds for the next one. America, virtually untouched by the tragedy and devastation of the war, emerged from the conflict as the wealthiest and most prosperous nation in the world. The post-war years became known as the Roaring Twenties: Americans indulged in their increased prosperity, although the prohibition of alcohol was the politicians' attempt to deny them at least one particular indulgence. In Russia the Bolsheviks under Vladimir Lenin established the world's first communist state – the Soviet Union – but civil war, famine and a long succession struggle prevented them from exporting revolution beyond the country's borders for the time being. The major part played by women in various roles during the Great War finally won them the right to vote in dozens of countries, although their social and economic status still remained vastly inferior to that of men. Film became wildly popular. British-born actor and director Charlie Chaplin made audiences howl with laughter, while the Soviet Union's Sergi Eisenstein created propagandist masterpieces for his country. Ernest Rutherford's pioneering work in radioactivity and nuclear physics changed our views of matter and John Logie Baird gave the first practical demonstration of television, doubtless unaware of how deeply it would change people's lives. Professor Robert H. Goddard was ridiculed by the *New York Times* for his 'impossible' vision of launching a rocket that could travel through outer space. Only posthumously would he be hailed as the father of the Space Age for his experiments in rocketry. The decorative style known as art deco was first shown in 1925 in Paris at the *Exposition Art Decoratifs et Industriels Modernes*, and derived its name from this exhibition. A number of acclaimed Russian dancers introduced classical ballet to the West to great acclaim, helping to establish ballet as a serious art form. The carefree and prosperous Roaring Twenties came to an abrupt end with the crash of the US Stock Market at the end of the decade and the global economic slump which followed. The rapid rise in unemployment and world-wide decline in living standards created millions of dissatisfied and jobless people looking for something – or someone – to pull them out of the mire.

Contemporary Voices

I will not serve that in which I no longer believe
whether it call itself my home, my fatherland or
my church; and I will try to express myself in
some mode of life or art as freely as I can and as
wholly as I can, using for my defence the only arms
I allow myself to use, silence, exile and cunning.

James Joyce, *A Portrait of the Artist as a Young Man*,
1916

No, I read no poetry now; it might soften me.

Field Marshal Paul von Hindenberg, 1916

I knew a simple soldier boy
Who grinned at life in empty joy,
Slept soundly through the lonesome dark,
And whistled early with the lark.

In winter trenches, cowed and glum,
With crumps and lice and lack of rum,
He put a bullet through his brain,
No one spoke of him again.

You smug-faced crowds with kindling eye
Who cheer when soldier lads march by,
Sneak home and pray you'll never know
The Hell where youth and laughter go.

Siegfried Sassoon, *Suicide in the Trenches*, 1917

If you hate a person, you hate something in him that is part of yourself. What isn't part of ourselves doesn't disturb us.

Hermann Hesse, *Demain*, 1919

Civilization and profits go hand in hand.

Calvin Coolidge, speech, 27 November 1920

Think – what I have got for Ireland? Something which she has wanted these past seven-hundred years. Will anyone be satisfied at the bargain? Will anyone? I tell you this – early this morning I signed my death warrant. I thought at the time how odd, how ridiculous – a bullet may just as well have done the job five years ago.

Michael Collins, letter, 6 December 1921

For de little stealin' dey gets you in jail soon or late. For de big stealin' dey makes you Emperor and puts you in de Hall o' Fame when you croaks.

Eugene O'Neill, *The Emperor Jones*, 1921

All the greatest things we know have come to us from neurotics. It is they and they only who have founded religions and created great works of art. Never will the world be conscious of how much it owes to them, nor above all what they have suffered in order to bestow their gifts on it.

Marcel Proust, *Guermantes Way*, 1921

I wanted to avoid violence. Non-violence is the first article of my faith. It is also the the last article of my creed.

Mahatma Gandhi, speech at Shahi Bag, 18 March 1922

Our century has deliberately undertaken a great social and economic experiment, noble in motive and far-reaching in purpose (i.e. 18th Amendment on Prohibition).

Herbert Hoover, letter to Senator W.H. Borah, 23 February 1928

Who is there still remembers
The fame of the giant city of New York
In the decade after the Great War?
…
What people they were! Their boxers the strongest!
Their inventors the most practical! Their trains
the fastest!
And also the most crowded!
And it all looked like lasting a thousand years
For the people of the city of New York put it about
themselves:
That their city was built on the rock and hence
Indestructible.
Truly the whole system of communal life was
beyond compare.
What fame! What a century!

Admittedly that century lasted
A bare eight years.

For one day there ran through the world the
rumour of strange collapses
On a famous continent, and its banknotes, hoarded
only yesterday,
Were rejected in disgust like rotten stinking fish.

Bertolt Brecht, *Late Lamented Fame of the Giant City of New York*, 1930

With Nicole's help Rosemary bought two dresses and two hats and four pairs of shoes with her money. Nicole bought from a great list that ran two pages, and bought the things in the windows besides. Everything she liked that she couldn't possibly use herself, she bought as a present for a friend. She bought coloured beads, folding beach cushions, artificial flowers, honey, a guest bed, bags, scarfs, love birds, miniatures for a doll's house, and three yards of some new cloth the colour of prawns. She bought a dozen bathing suits, a rubber alligator, a travelling chess set of gold and ivory, big linen handkerchieves for ABC, two chamois leather jackets of kingfisher blue and burning bush from Hermes – bought all these things not a bit like a high-class courtesan buying underwear and jewels, which were after all professional equipment and insurance, but with an entirely different point of view. Nicole was the product of much ingenuity and toil. For her sake trains began their run at Chicago and traversed the round belly of the continent to California; factories fumed and link belts grew link by link in factories; men mixed toothpaste in vats and drew mouthwash out of copper hogsheads; girls canned tomatoes quickly in August or worked rudely at the Five-and-Tens on Christmas Eve; half-breed Indians toiled on Brazilian coffee plantations and dreamers were muscled out of patent rights in new tractors – these were some of the people who gave a tithe to Nicole and, as a whole system swayed and thundered onward, it leant a feverish bloom to such processes of hers as wholesale buying, like the flush or a fireman's face holding his post before a spreading blaze.

F. Scott Fitzgerald, *Tender is the Night*, 1934

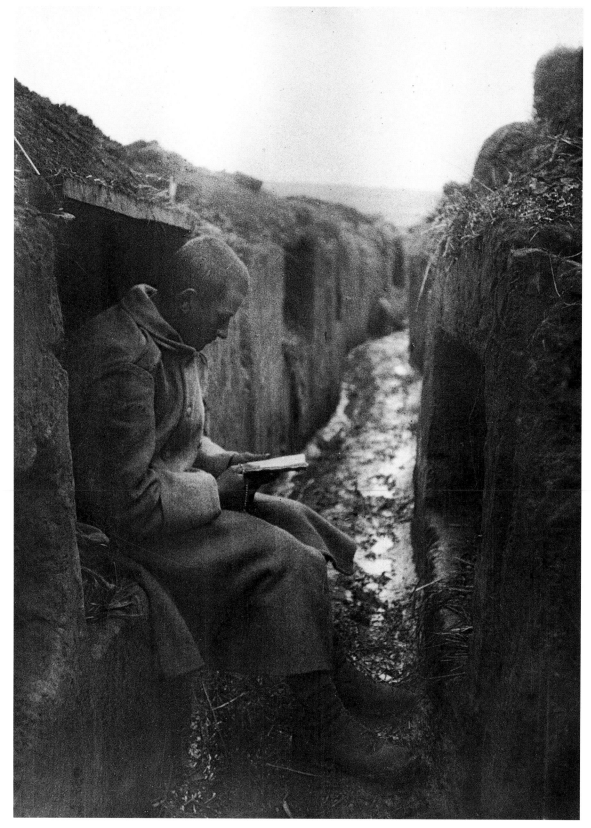

Morning prayer before Gologory, Galicia, by André Kertész, an Austrian soldier destined to become a great photographer.

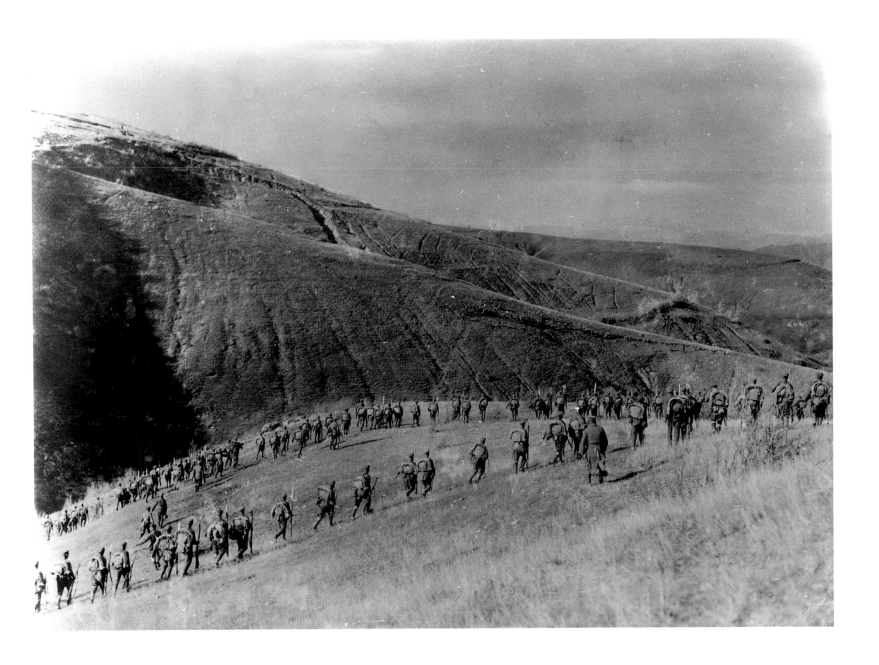

Austrian troops seem unthreatened as they advance over hills near Monastir, Serbia.

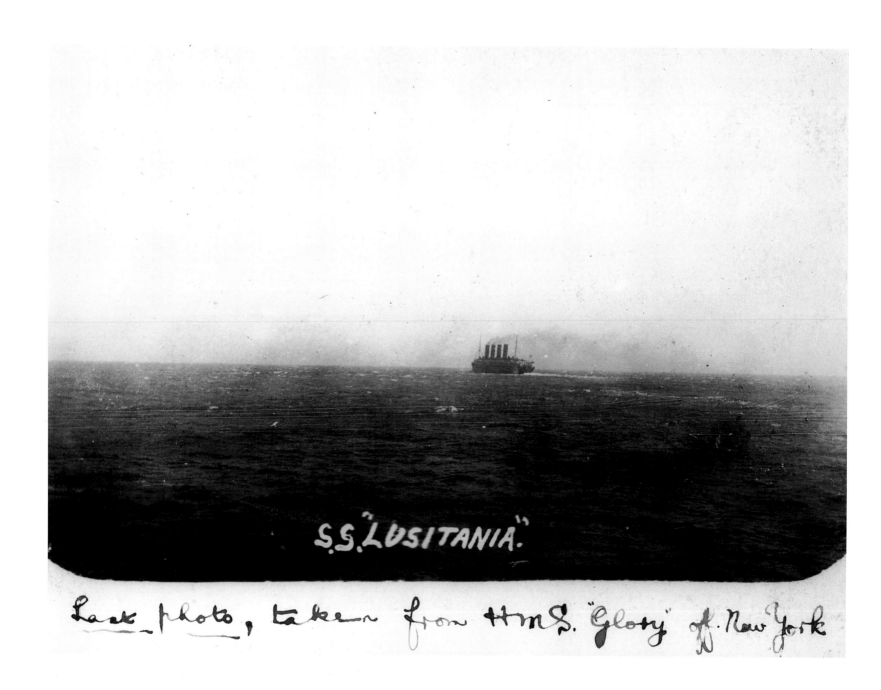

S.S. "LUSITANIA."

Last photo, taken from HMS. "Glory" off New York

The doomed *Lusitania*, her sinking an ill-advised German tactic.

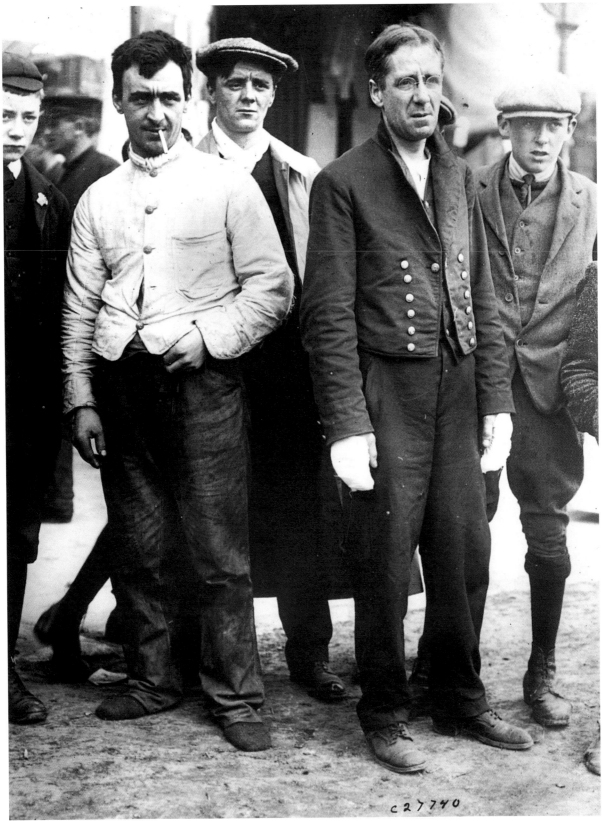

A steward and some crew of the torpedoed Cunarder-built *Lusitania*, lucky to be alive in Queenstown (now Cóbh), Ireland.

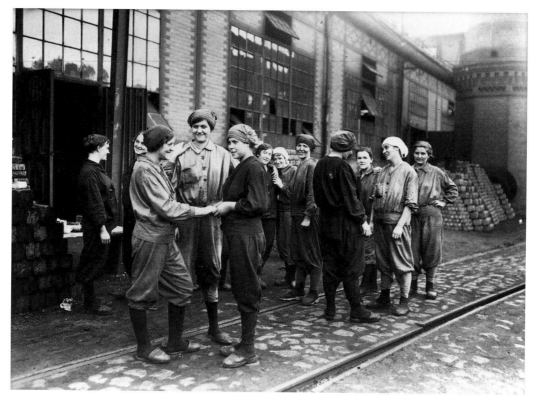

Boyish delight on a prototype tank at Wormwood Scrubs, London.
Photo-call for German munition girls on their midday break.

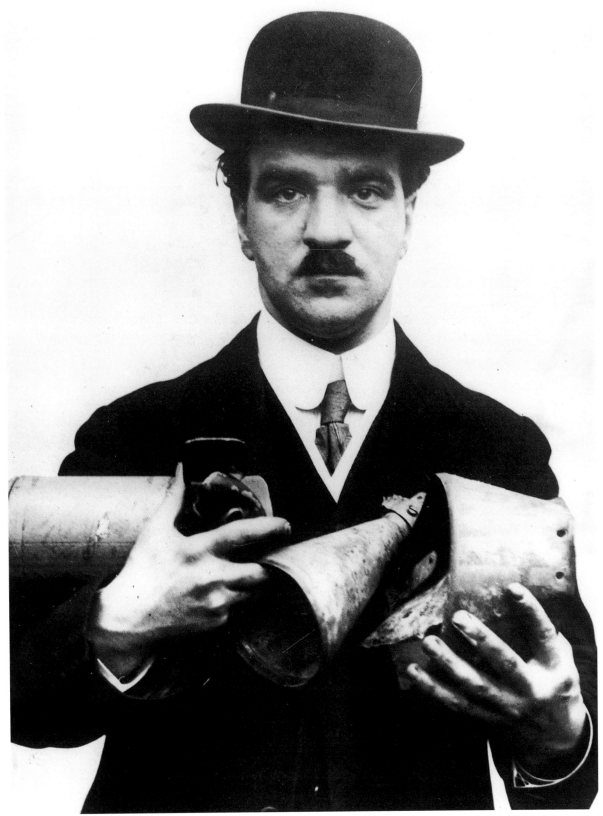

Yarmouth, England – the first bombs ever dropped on civilians, thirty years before Hiroshima. This one was a dud and nobody was killed.

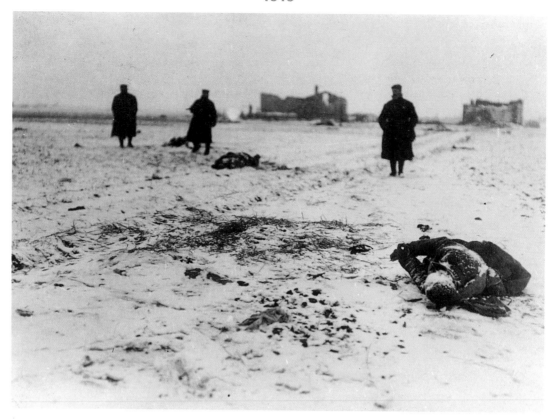

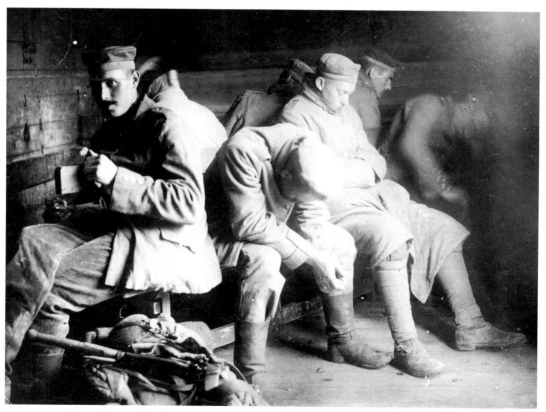

A few of the countless frozen corpses scattered along the several eastern fronts in wintertime.
Germans enduring the endless boredom and discomfort of a railway goods truck.

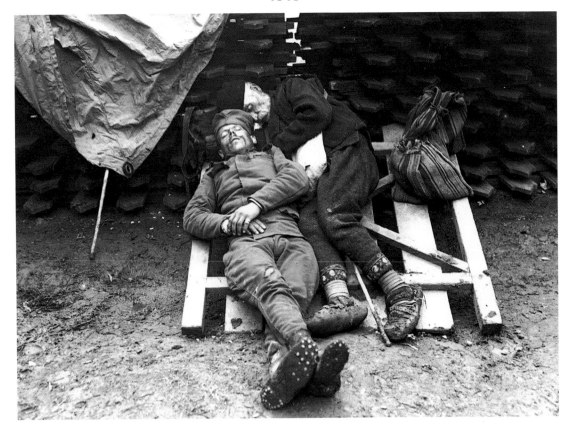

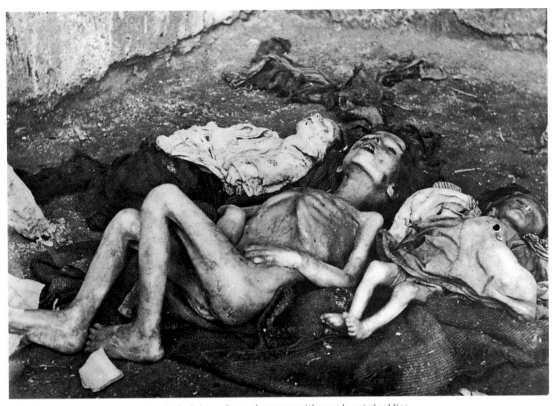

An old Serb irregular seeks repose with an exhausted soldier.
Three of the estimated one million Armenians – men, women and children – starved or killed by the Turks.

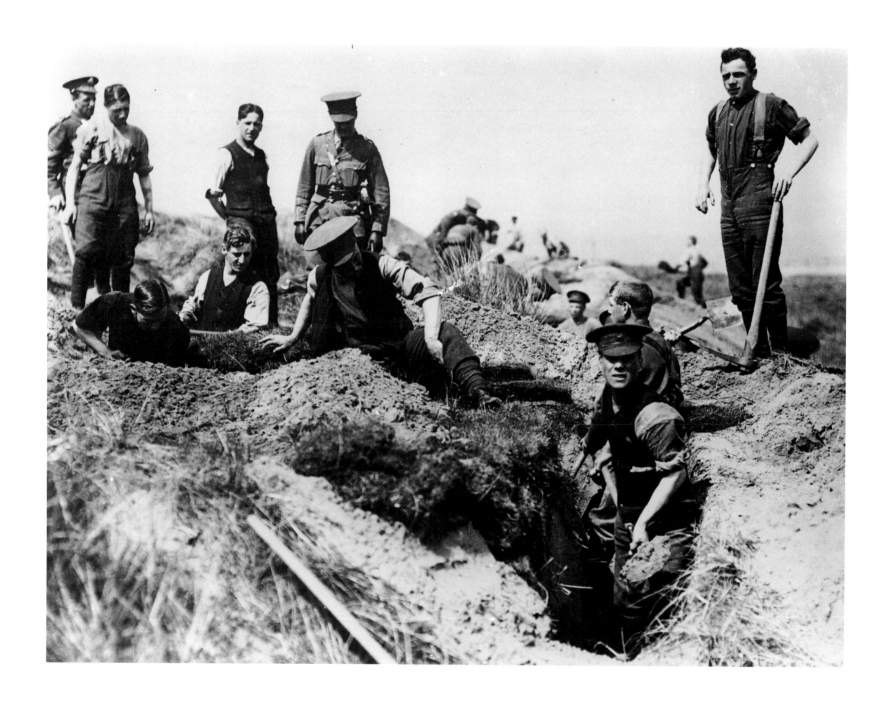

A British regiment digging trenches in Cheshire as an exercise.

An Australian officer in a communication trench in Guedecourt, France.

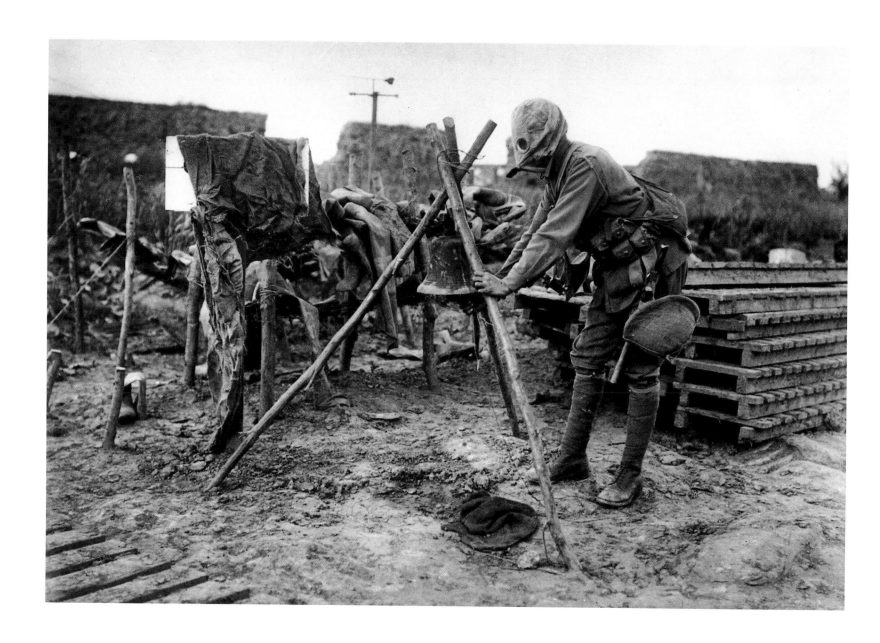

Sounding a gas alarm – grotesque equipment countering a grotesque weapon.

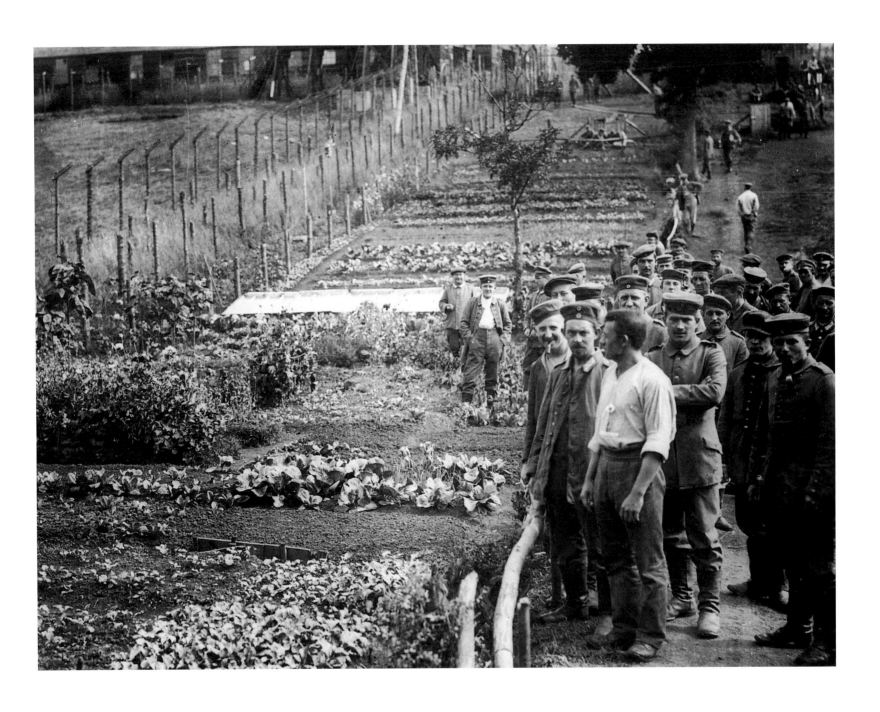

Some prisoners must have felt providentially saved, others dishonoured, to exchange a dangerous mire for a British vegetable patch.

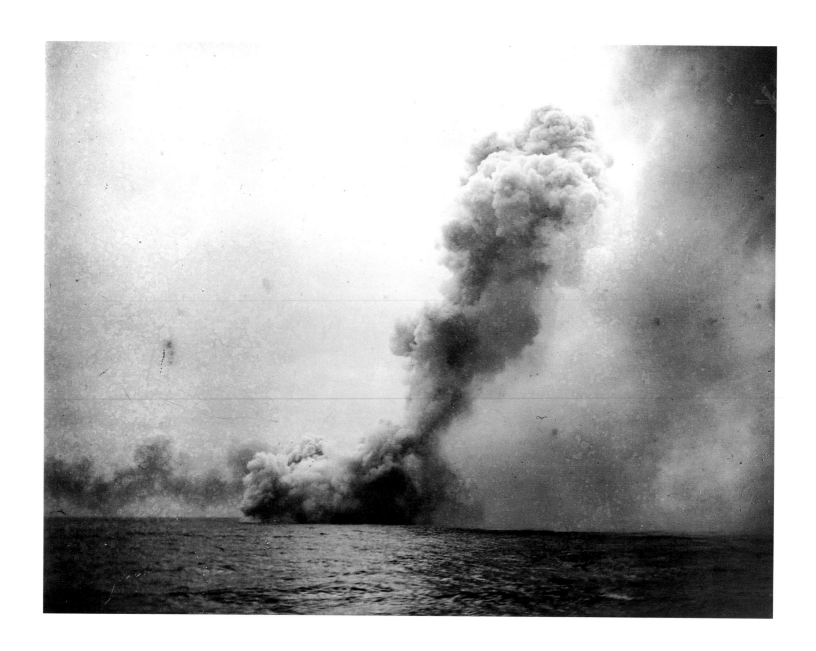

The instantaneous destruction of the battle cruiser *Queen Mary* at Jutland left only nine survivors.

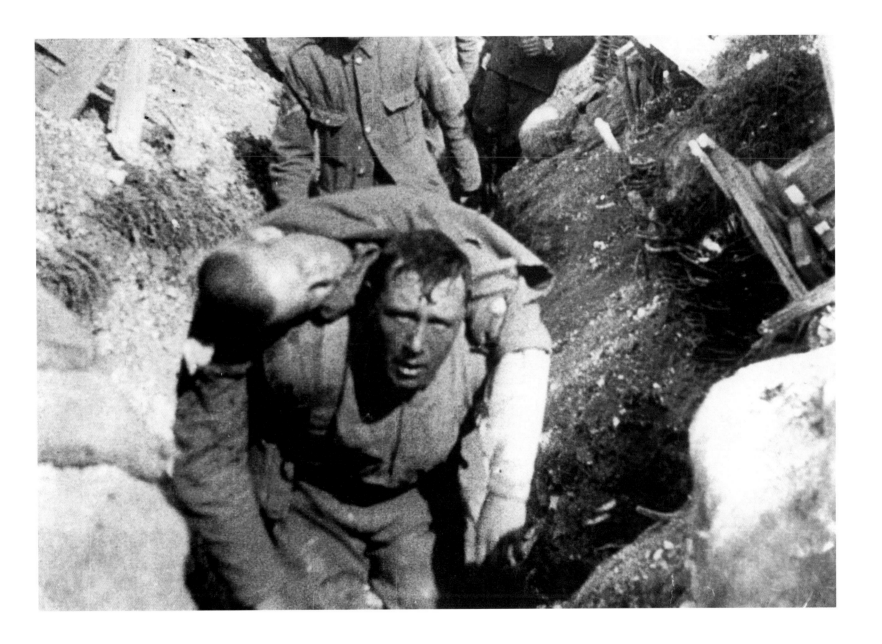

The bloody and futile Battle of the Somme – a British tommy carrying a wounded comrade.

Grandees at Karl I's coronation in Vienna. The last Emperor of Austro-Hungary, he would reign only until its surrender.

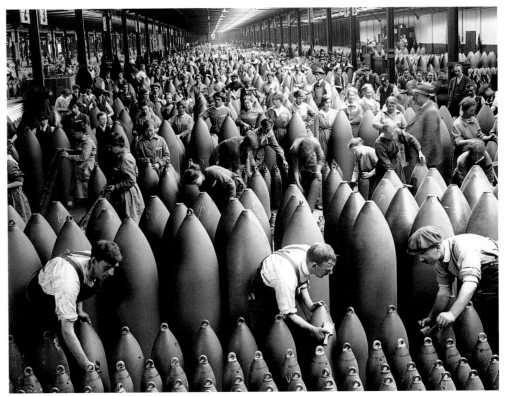

Photographers could always persuade girl war-workers to pose – here at a Nottingham aeroplane factory.
Painting shells in a British factory. Millions were fired, killing more men than any other weapon.

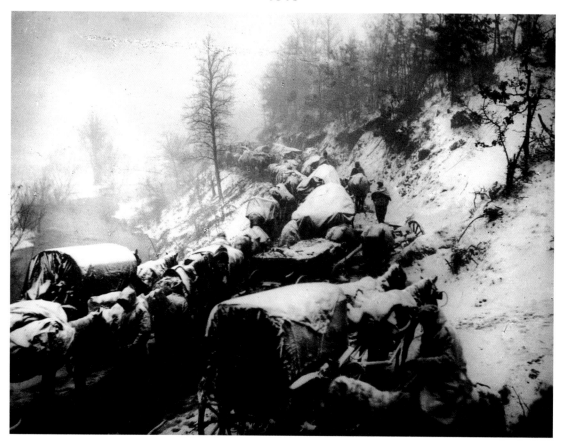

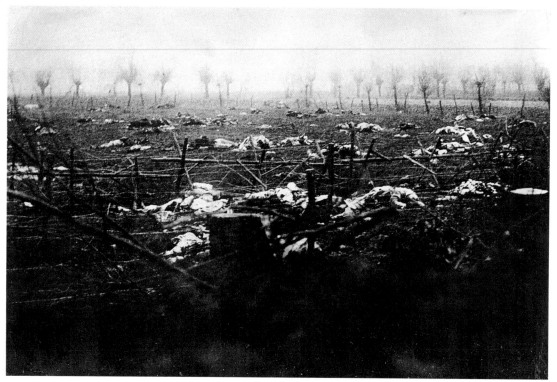

The Serbs suffered greatly, not helped by the bitter winters. Here they are on the retreat.
Uncollected German bodies lie dredged with quicklime after an attack repulsed by the French.

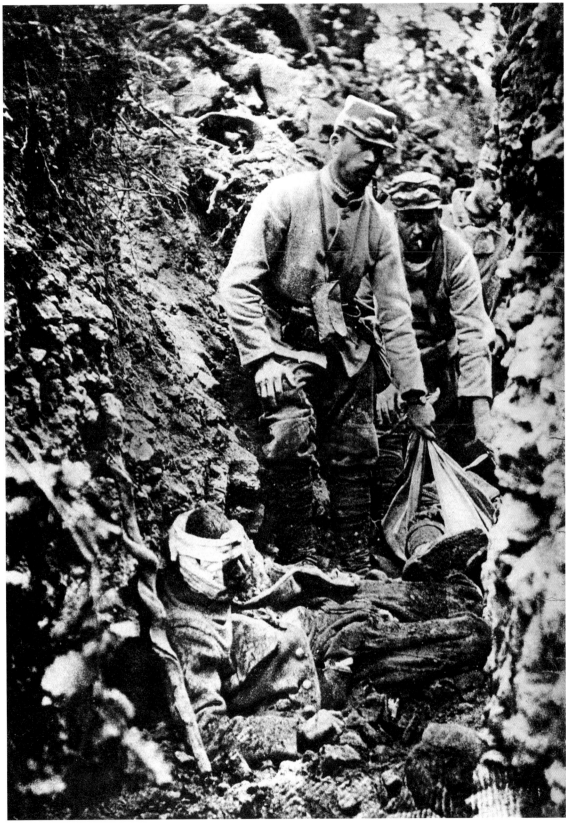

Led by the future-traitor General Pétain, the French at Verdun showed extraordinary courage and endurance.

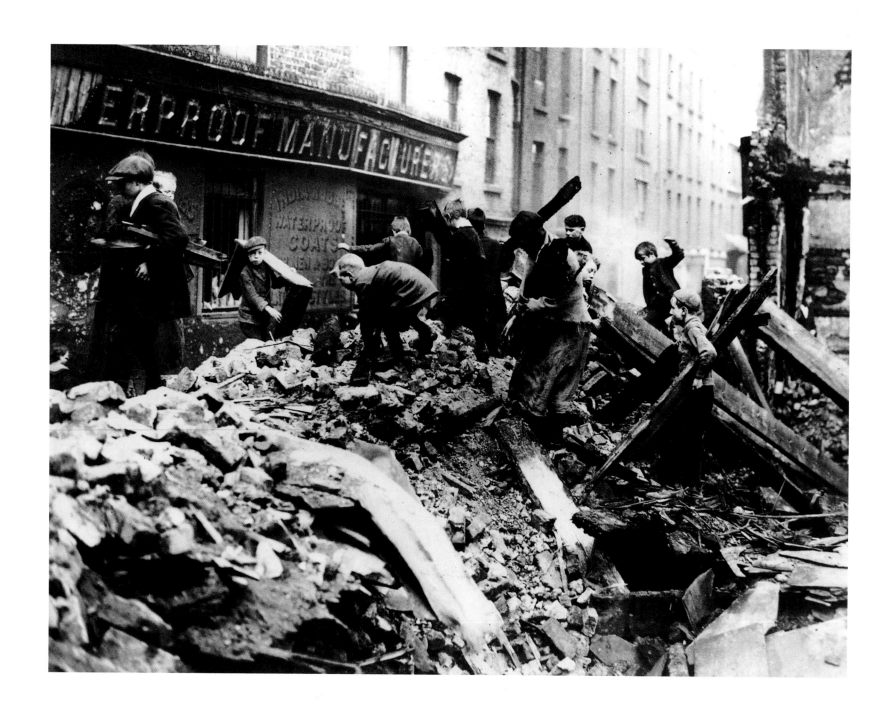

Children pick over ruins in Dublin following the Easter Rising against British rule.

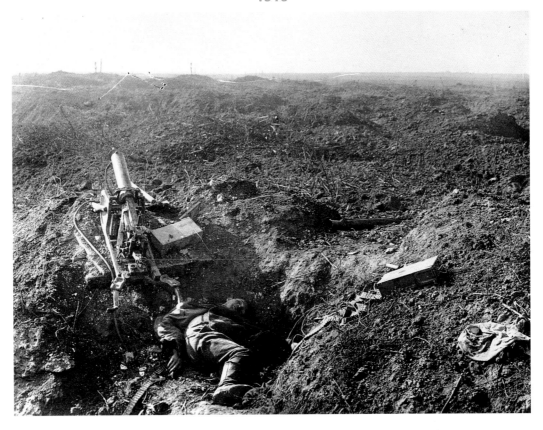

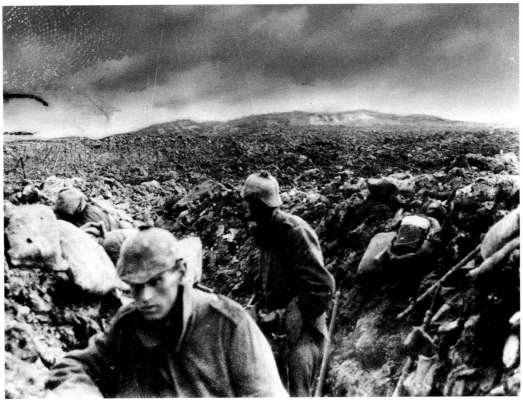

A dead machine gunner, probably German, abandoned on the Ypres salient.
Germans in a trench near Verdun, as their artillery barrage begins.

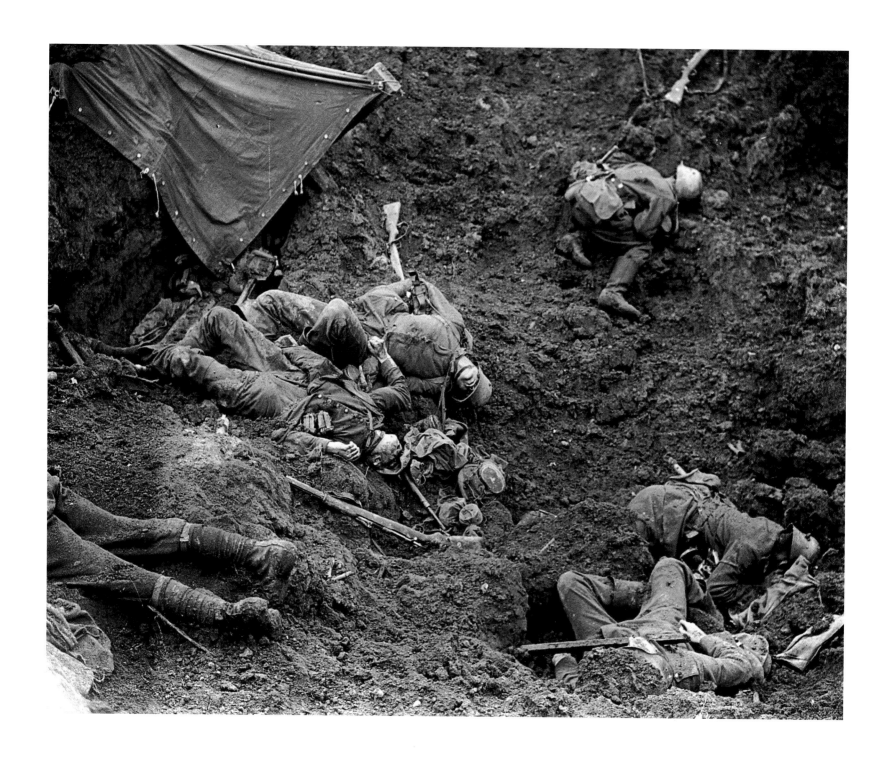

Dead Germans probably early on in the offensive – the only hope of Allied victory lay in mass slaughter.

The great offensive in a nutshell – Passchendaele before and after.

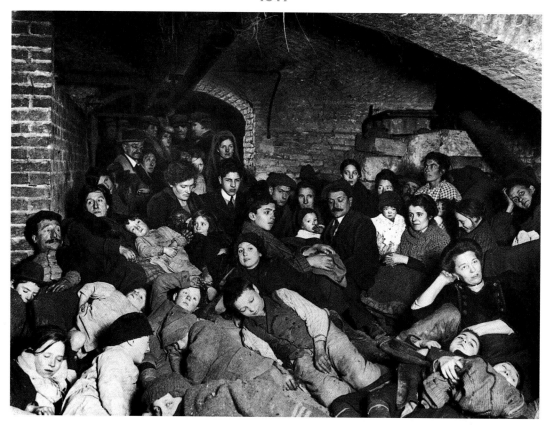

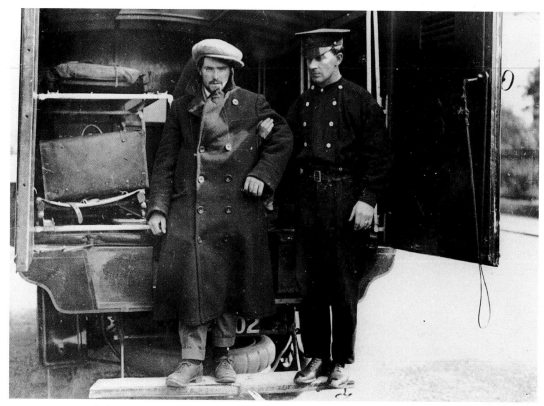

Italians sheltering from an Austrian bombardment in an ancient cellar in Padua.
An Irish hunger striker after the Easter Rising.

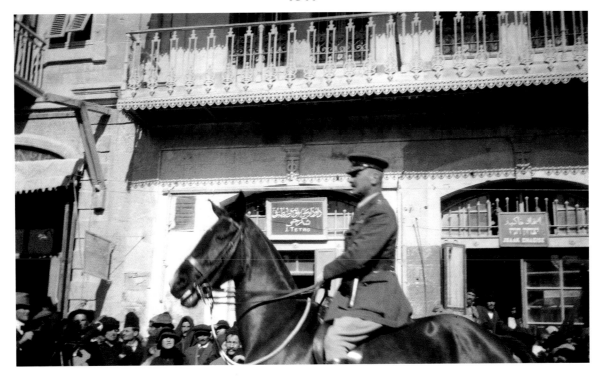

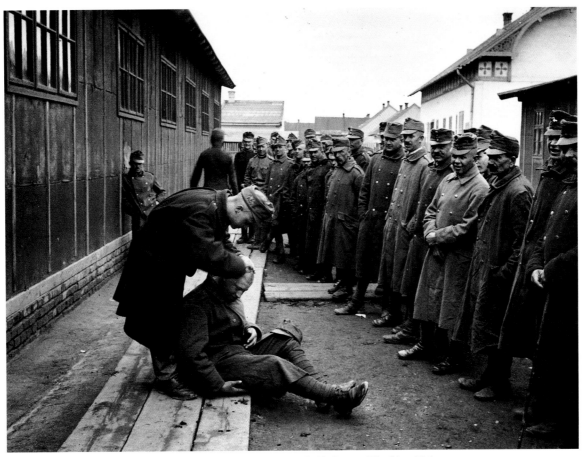

General Allenby enters Jerusalem as the Turks are obliged to withdraw.
A haircut and delousing behind the lines photographed by André Kertész, still at work on the Eastern Front.

Dada ballet within ear-shot of the guns. One of Picasso's costumes for Cocteau and Satie's *Parade* in Paris.

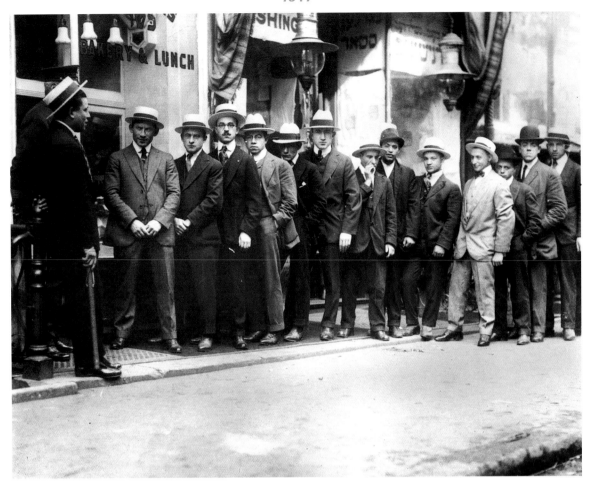

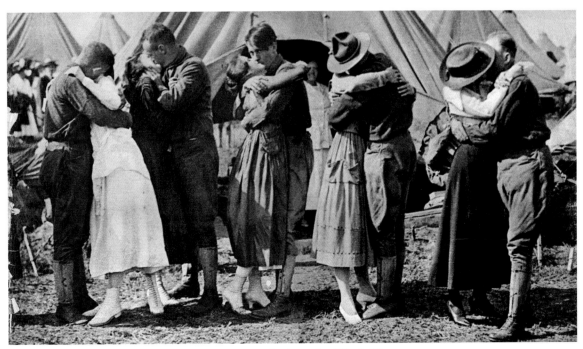

New Yorkers line up for the mud and blood of France.
Kissing goodbye becomes a public display – the Doughboys' farewell, New York.

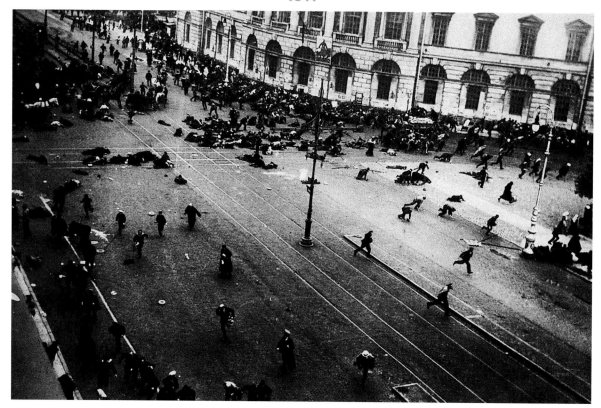

A classic image of panic in the streets – a clash of Bolshevik and government troops ...
... both would have enjoyed the destruction of Imperial eagles.

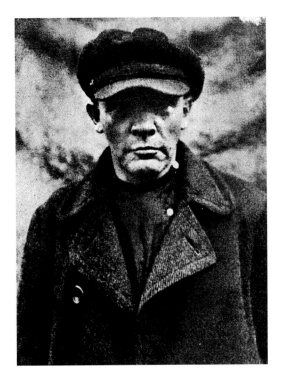
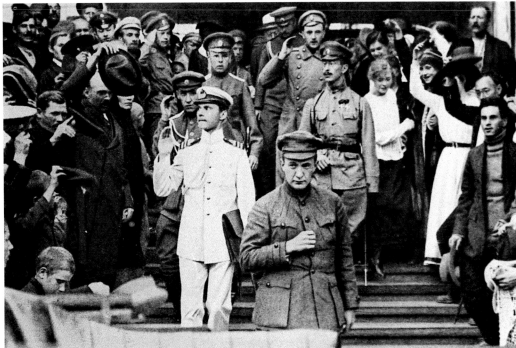

Vladimir Ilyich Lenin awaiting his call to the Finland station in Petrograd for his crucial role in October.
Aleksandr Kerensky, here pictured in Moscow, was doomed by his persistence with the war as well as by Bolshevik single-mindedness.

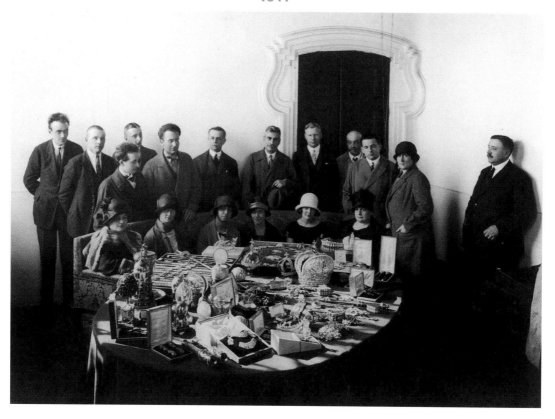

Imperial Russian silver being assessed by an unknown and perhaps rather bourgeois revolutionary committee.
An indication of the severe rubber shortage in Germany.

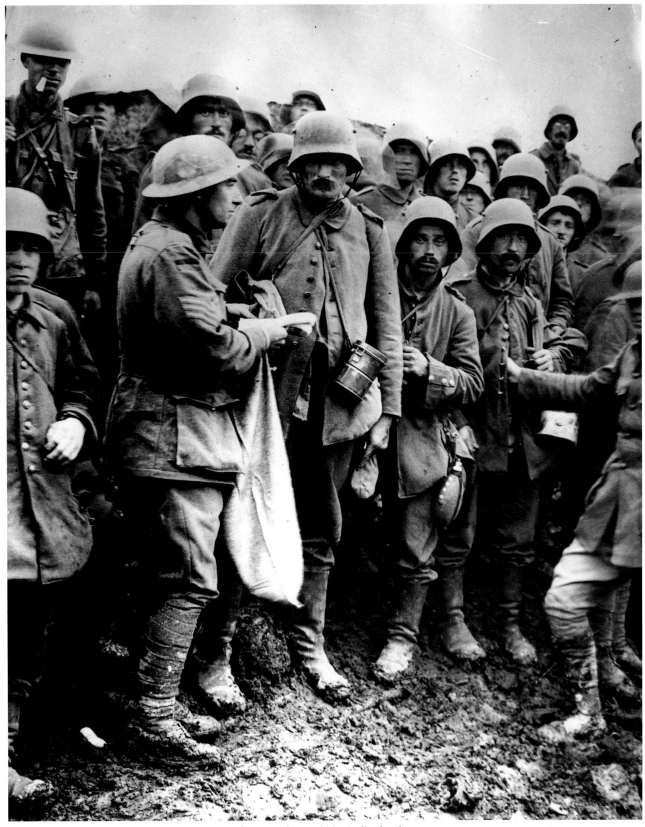

German prisoners in Australian hands.

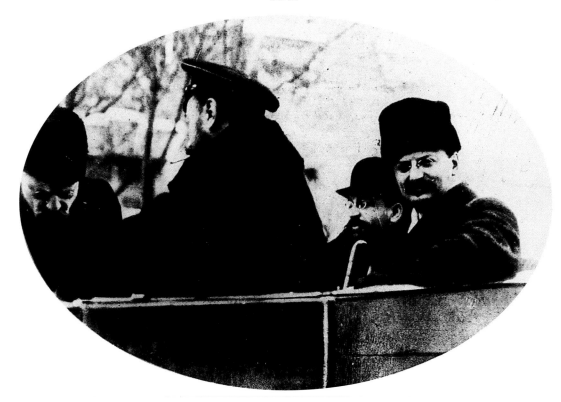

Trotsky at Brest-Litovsk, seeking the best possible terms for the peace his party needed at almost any price.
The Germans left this curious 'barbed-wire' behind on their planned retreat to the Hindenburg Line.

A huge mine crater of unknown location, occupied by scarcely visible British troops in dug-outs.

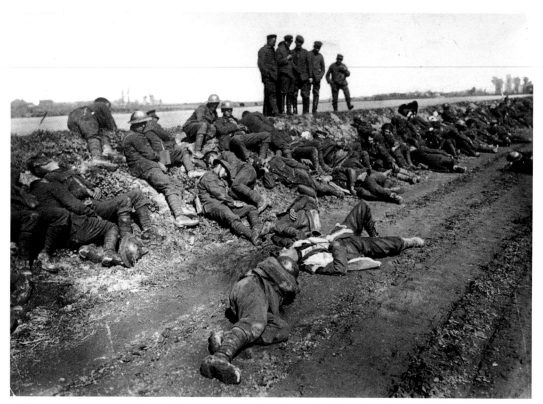

Many Chinese worked for the British as labourers. Here they have left their earthworks to celebrate their New Year.
Captured during General Ludendorff's great March offensive, these British prisoners are utterly spent.

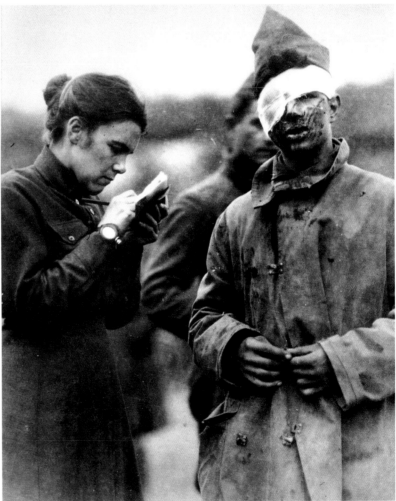

The Tsar and his children held captive at Tobolsk. It is spring and it will be their last.
A Salvation Army woman writing a letter home for a wounded American soldier.

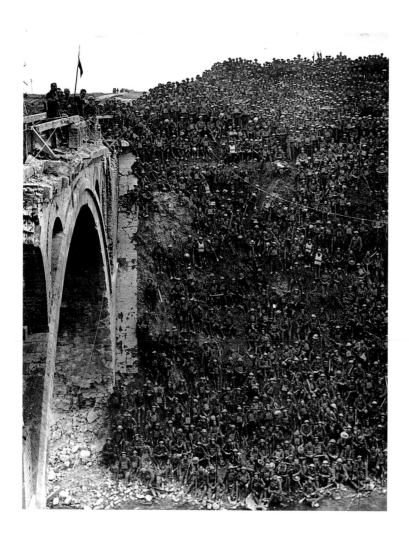

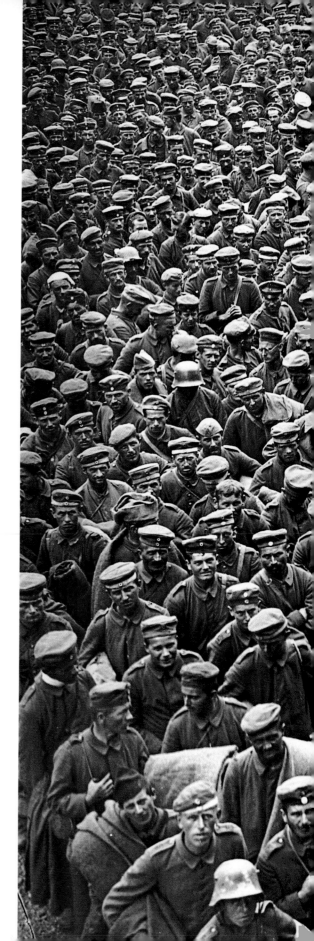

The great German tide has been turned – British officers
congratulating soldiers at the St Quentin canal.
Totally routed in the west, the Germans surrendered in their thousands.

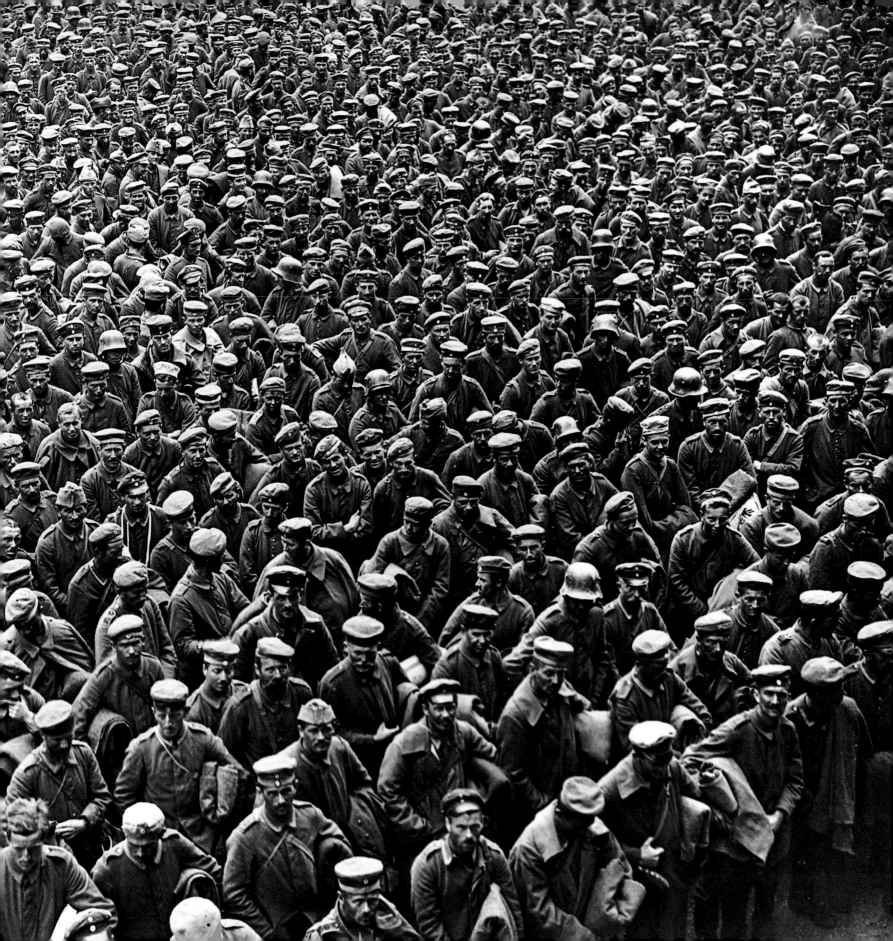

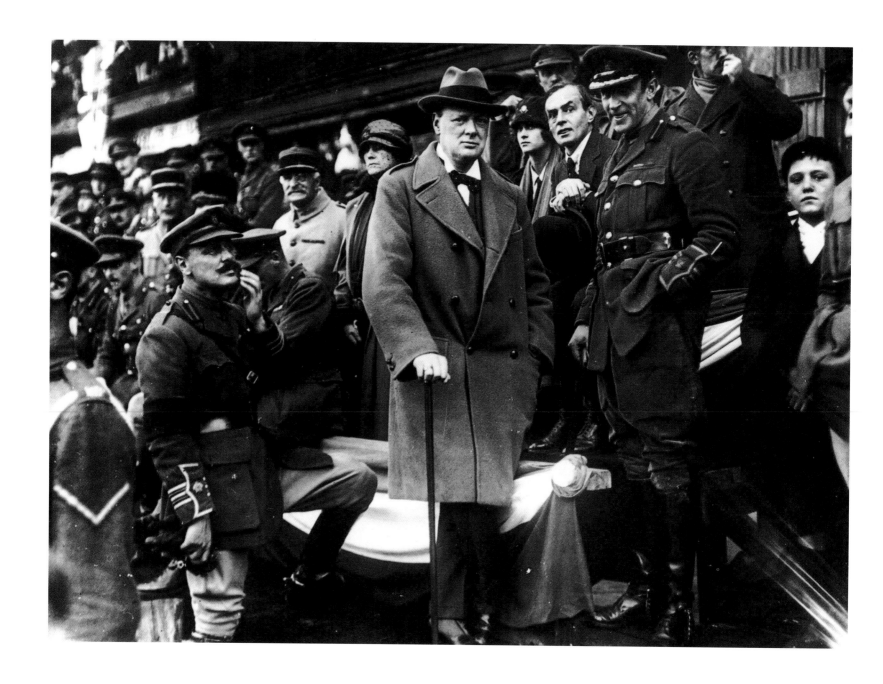

Winston Churchill in France in October, considering perhaps his chequered war and his uncertain destiny.

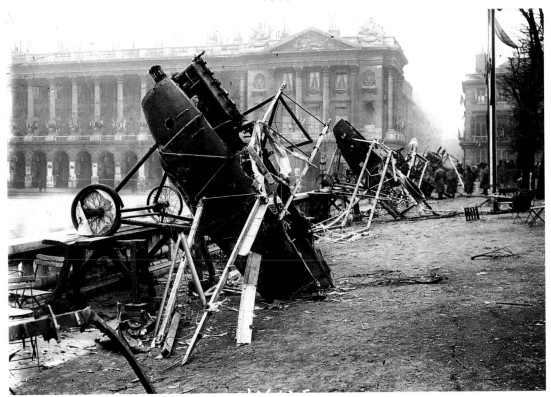

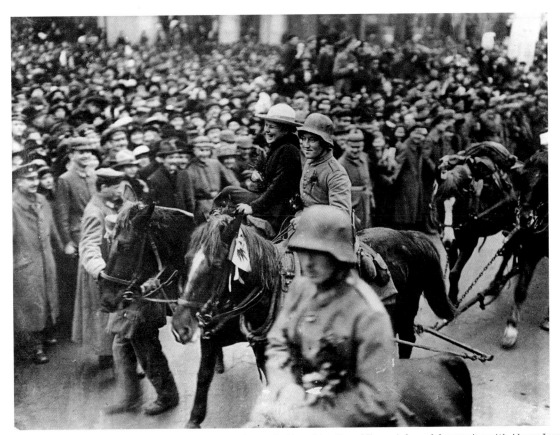

18 November. German planes in the Place de la Concorde, Paris, wrecked in celebration of France's longed-for reunion with Alsace-Lorraine.
German soldiers being welcomed back to Berlin – rare smiles provoked by the woman on horseback.

Lycée students celebrating in Paris after a year of terrible doubts, and then high hopes fulfilled.
Released British prisoners. The 'lions led by donkeys' savour the joy of survival.

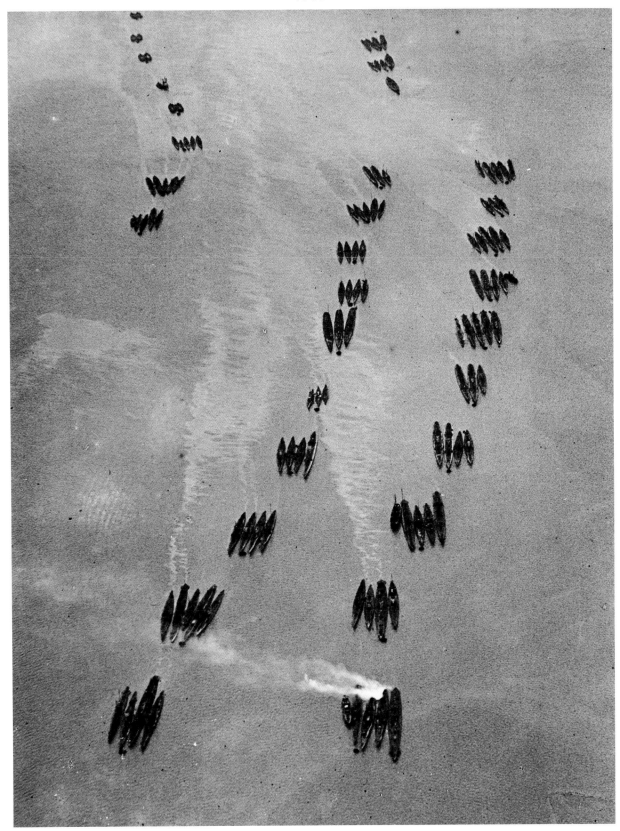

Like harmless-looking but deadly bacilli – some of the 110 German submarines that surrendered at Harwich, England.

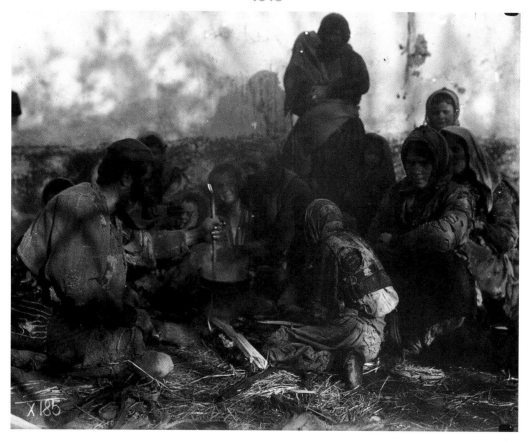

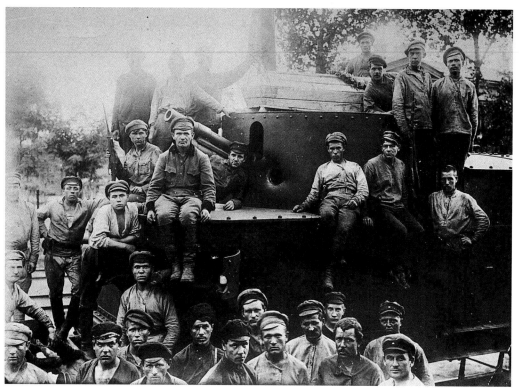

A Serb family returning home offered photographer Lewis Hine a timeless image.
Red Army troops on an armoured train on their way to tackle the White Army.

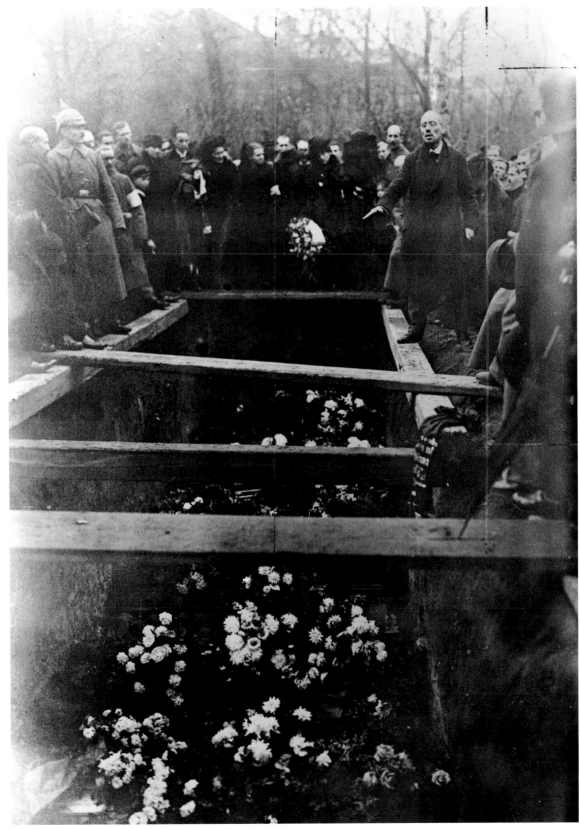

Karl Liebknecht making an oration at the grave of his fallen Spartacist comrades. He was to be murdered a few weeks later.

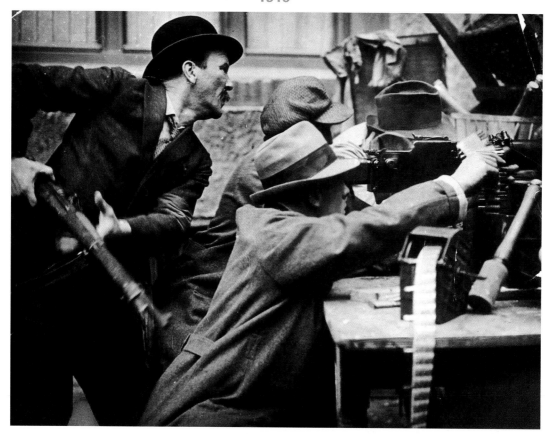

Spartacists fight for socialism in Berlin, here in war-worn bourgeois clothing ...
... and here in working dress, from behind a newsprint barricade.

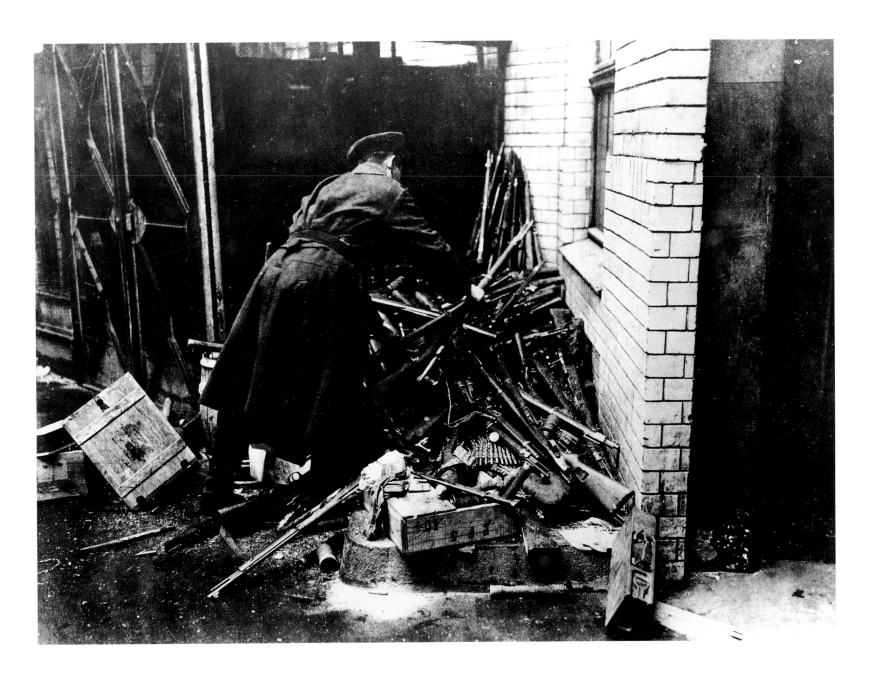

Government supporters making a heap of the defeated Spartacists' weapons.

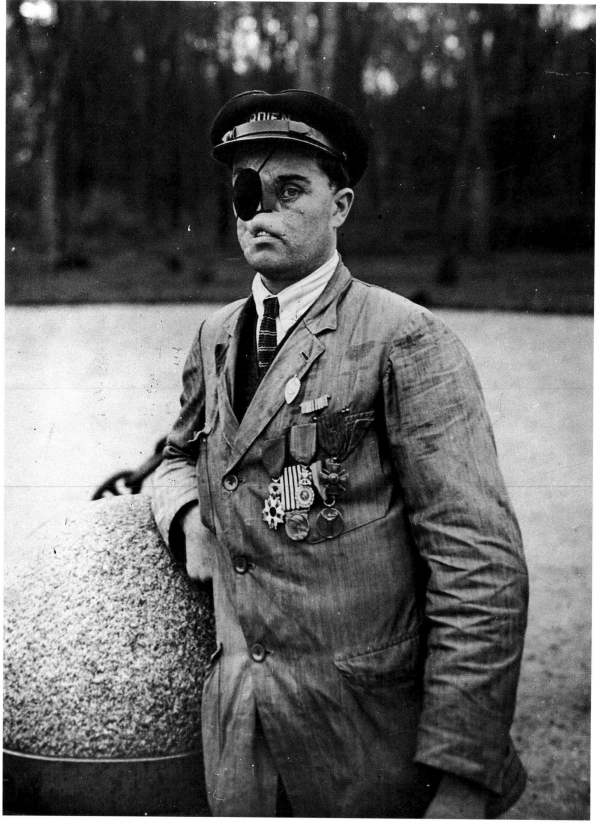

A French veteran exposing his disfigurement as he takes part in victory celebrations.

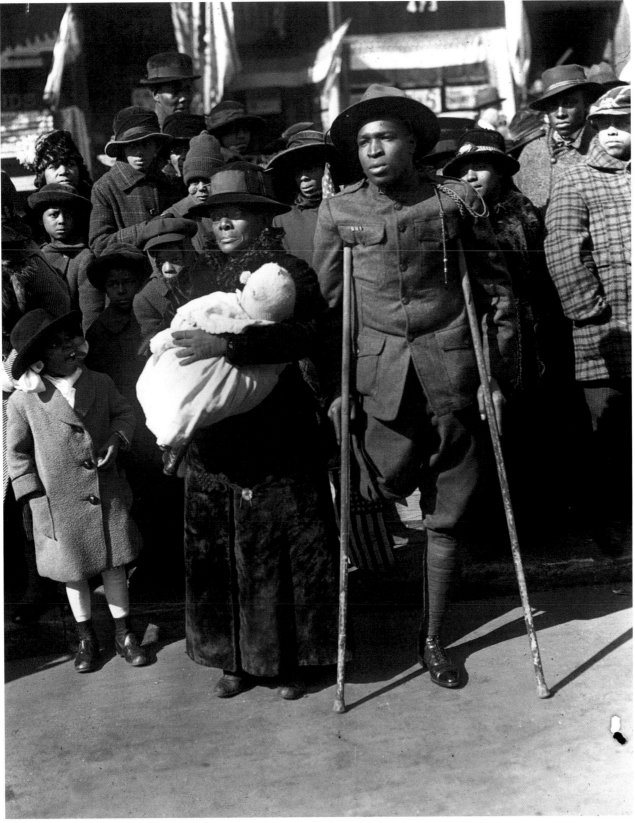

A limbless US soldier, visibly affected by the parade of his regiment in New York City.

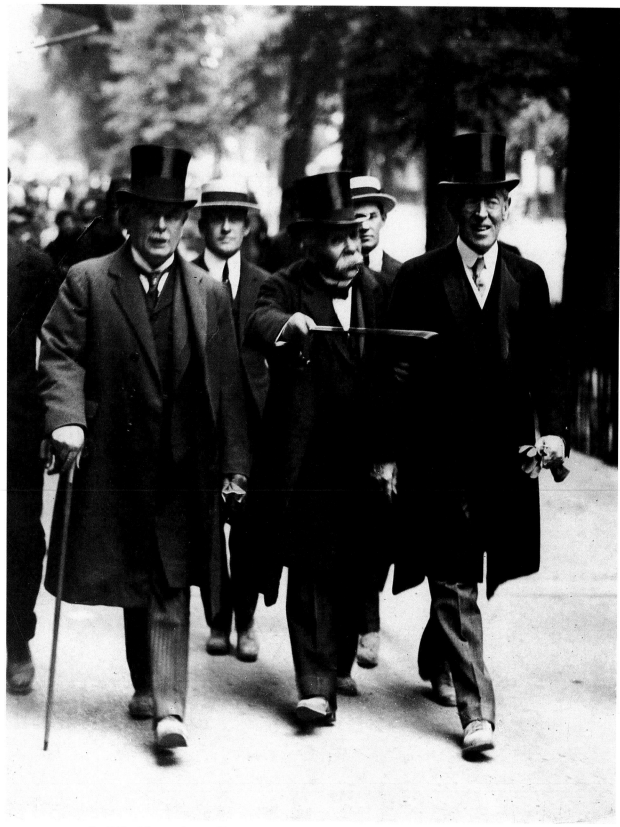

David Lloyd-George, Georges Clemenceau and Woodrow Wilson at Versailles, looking forward to peace.

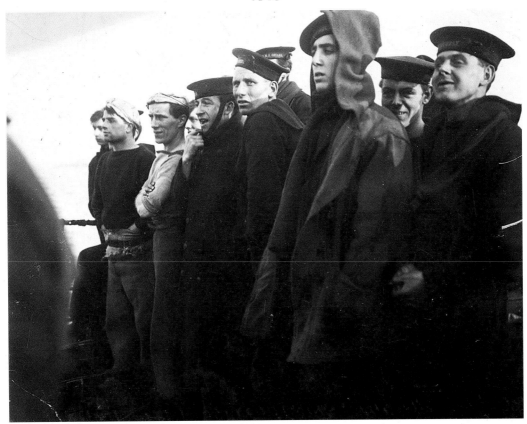

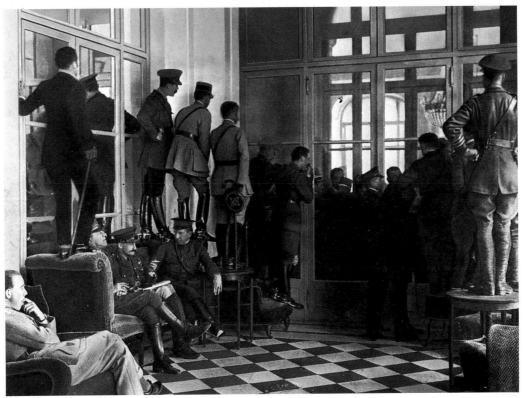

British sailors showing a range of emotions as the huge German fleet surrenders at Scapa Flow, Orkney Islands.
Allied officers hoping to glimpse the fateful signing in the Hall of Mirrors at Versailles.

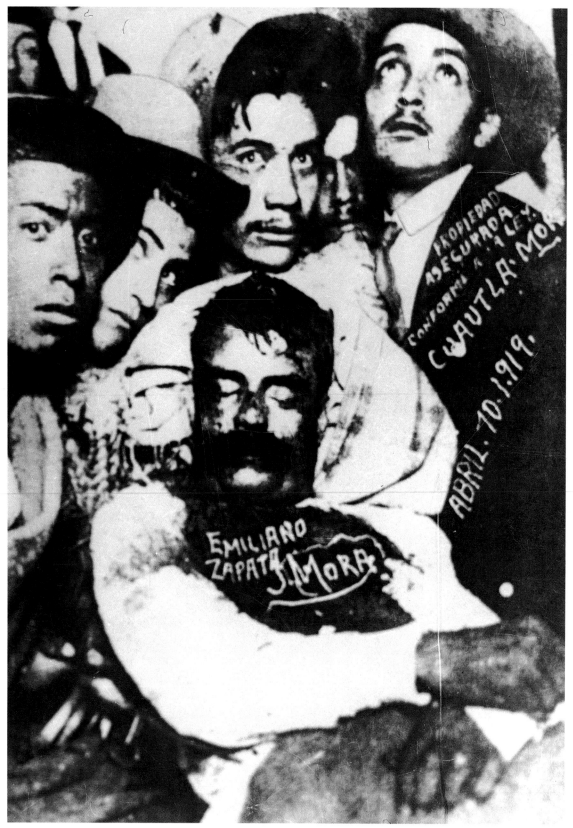

Legendary rebel Emiliano Zapata murdered in Mexico by President Venustiano Carranza's agents.

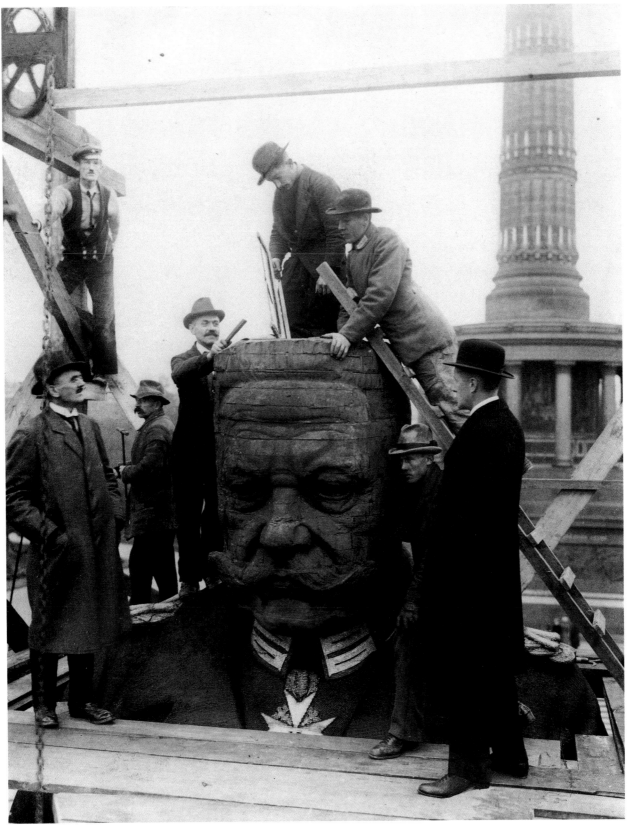

General von Hindenburg's statue being demolished in Berlin, long before he died or lost his influence in Germany.

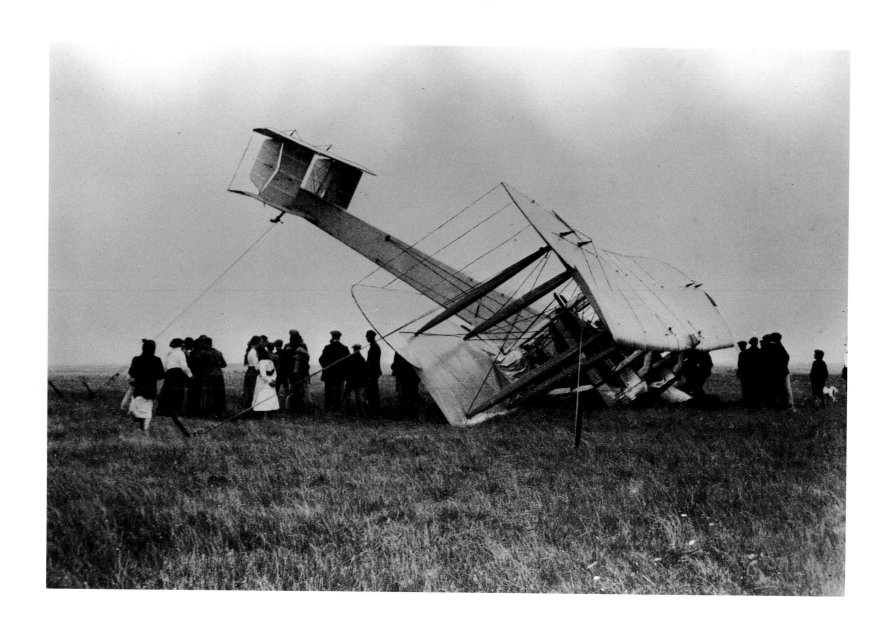

The first aircraft to cross the Atlantic was piloted by Captain John Alcock and Arthur Whitten Brown. It crash-landed in an Irish bog.

Gaby Deslys, a French musical comedy star, photographed by her friend Jacques-Henri Lartigue while making a film at Deauville.

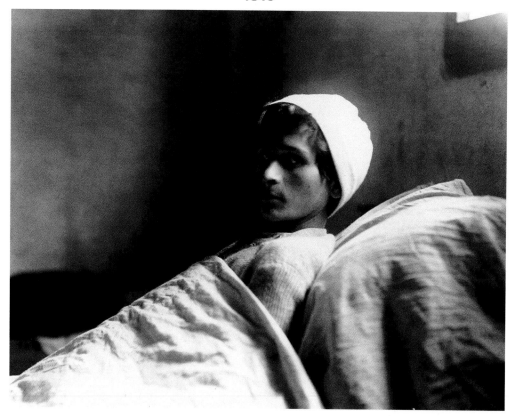

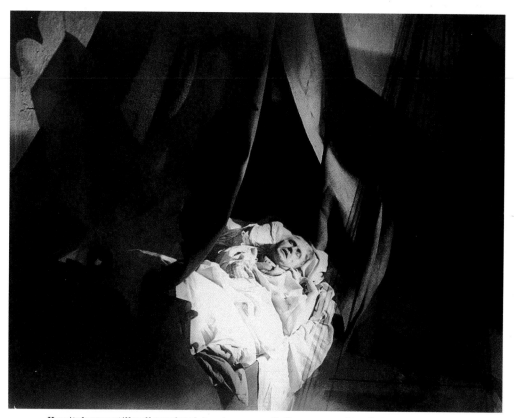

Hospitals were still well populated, here by a young Italian war casualty who had contracted TB.
The German cinema strikes an expressionist note with *The Cabinet of Dr Caligari* – this still photograph by director Robert Wiene.

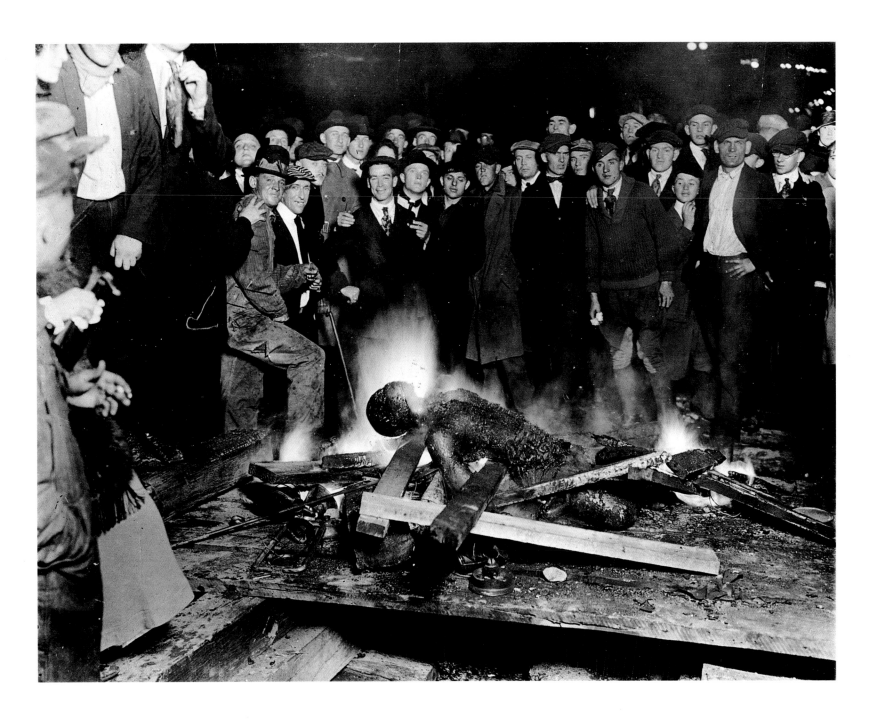

A lynching in Omaha, Nebraska, is perhaps unsurpassed as an image of human vileness.

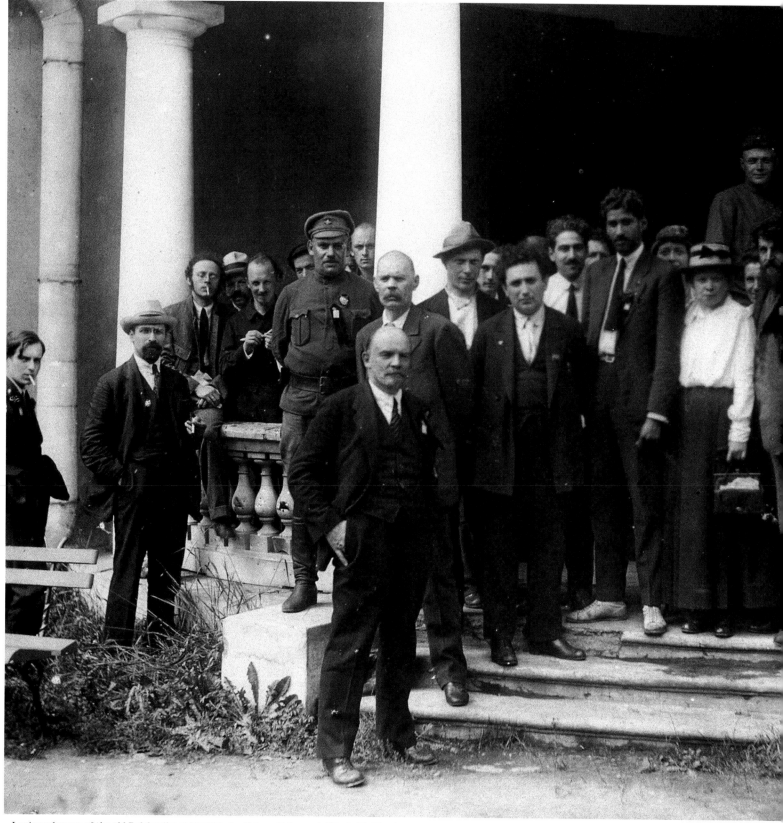

Lenin and many of the old Bolsheviks at the Uritsky Palace, Petrograd. Nikolai Bukharin and Grigori Zinoviev are present, while Maxim Gorky stands behind Lenin (left, in front of steps). Stalin is absent, but later tampered considerably with the dramatis personae.

American rocket pioneer Dr Robert H. Goddard prepares to launch a rocket 50 kilometres (30 miles) into the stratosphere.

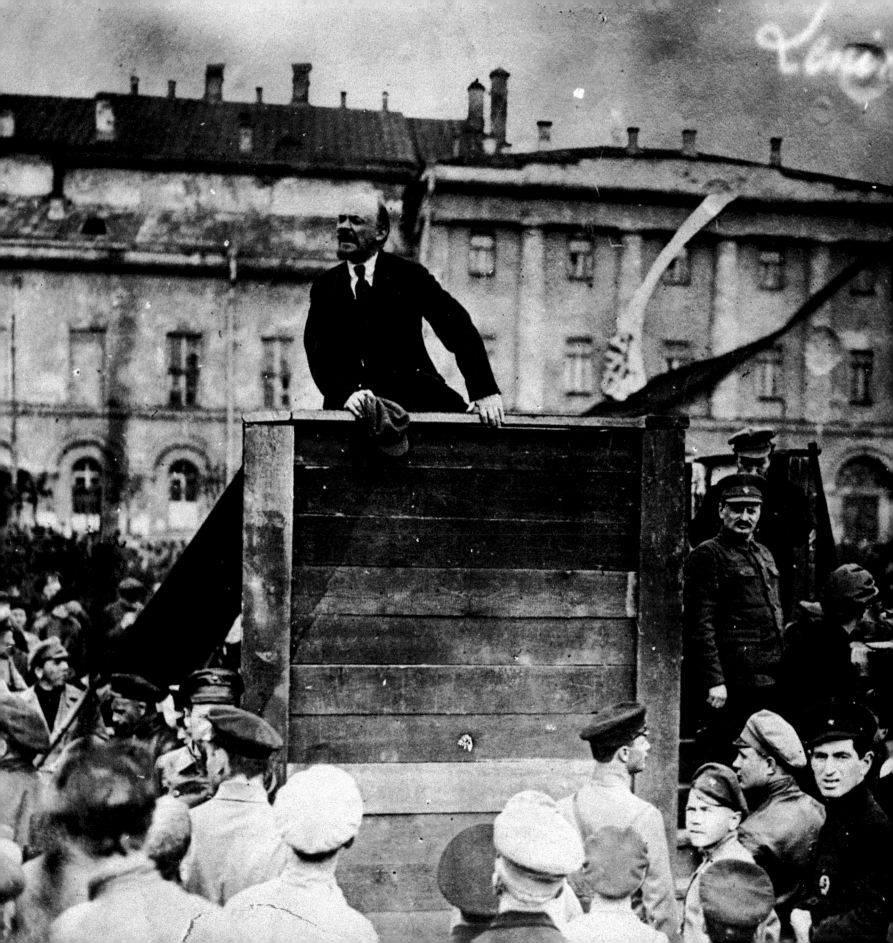

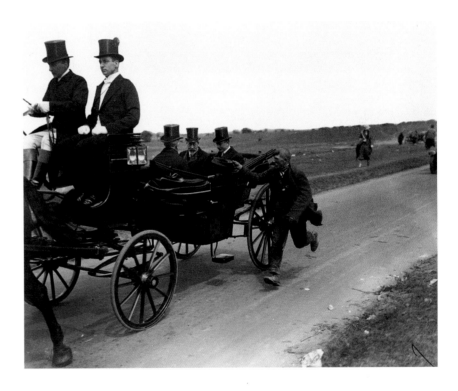

Lenin demanding support in the war against Poland – while Trotsky stands on the steps next to the platform. Stalin would later erase him from the photograph.
A Gipsy is politely ignored while soliciting help from King George V at the Epsom Derby.

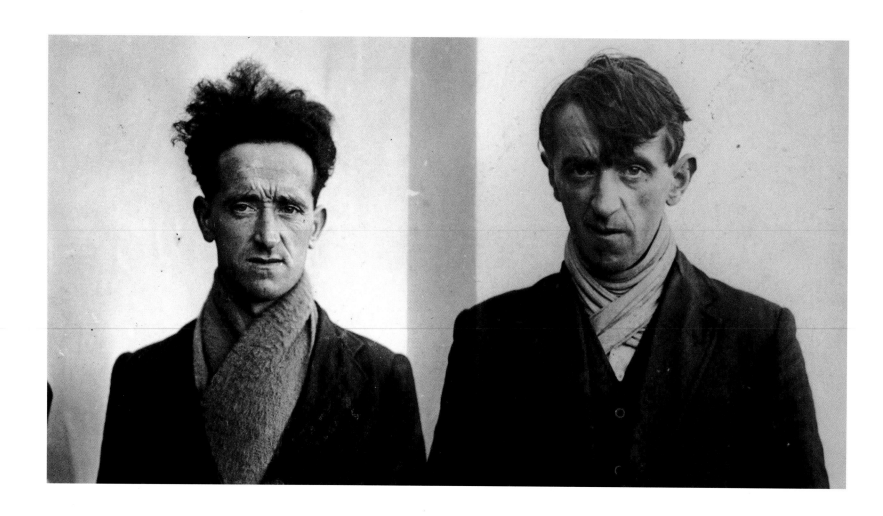

Photographic studies of IRA officers from the British military archives.

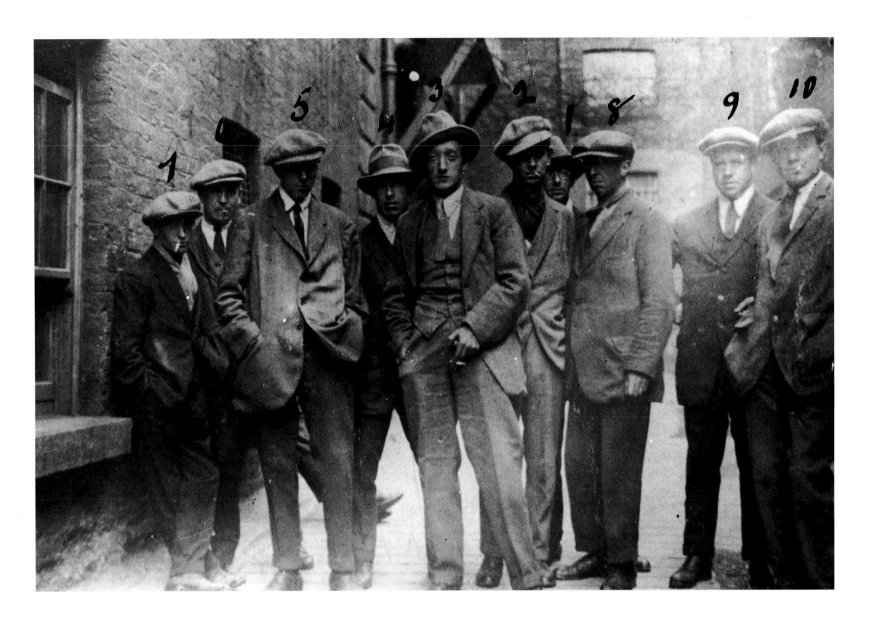

The Cairo Gang – Irish agents who worked for British intelligence, and who were all killed by the IRA.

American women vote for the first time.

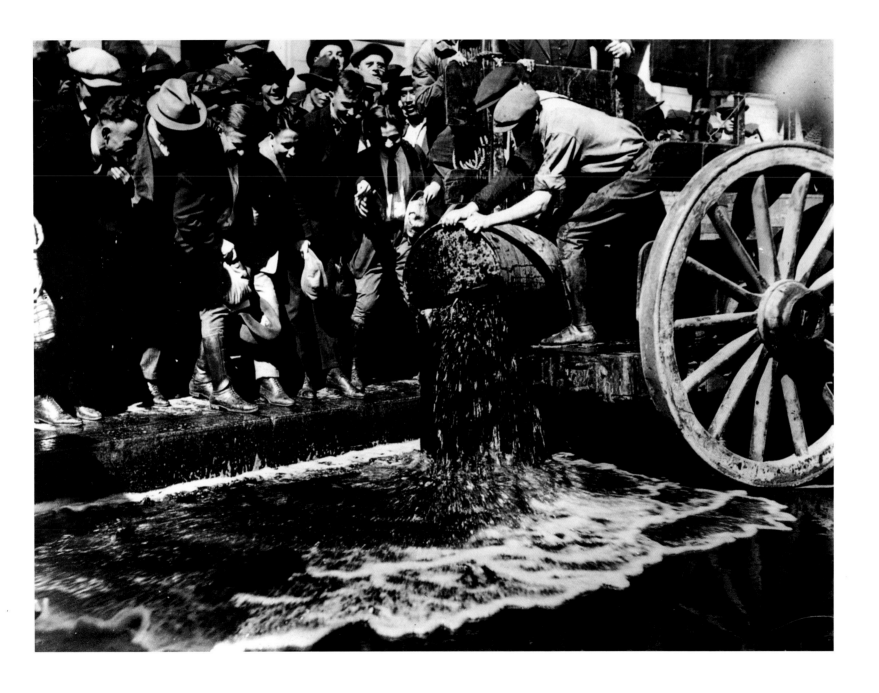

Nine hundred gallons of wine being poured down the drain in Los Angeles. Prohibition, a fit of American puritanism, would cause many problems.

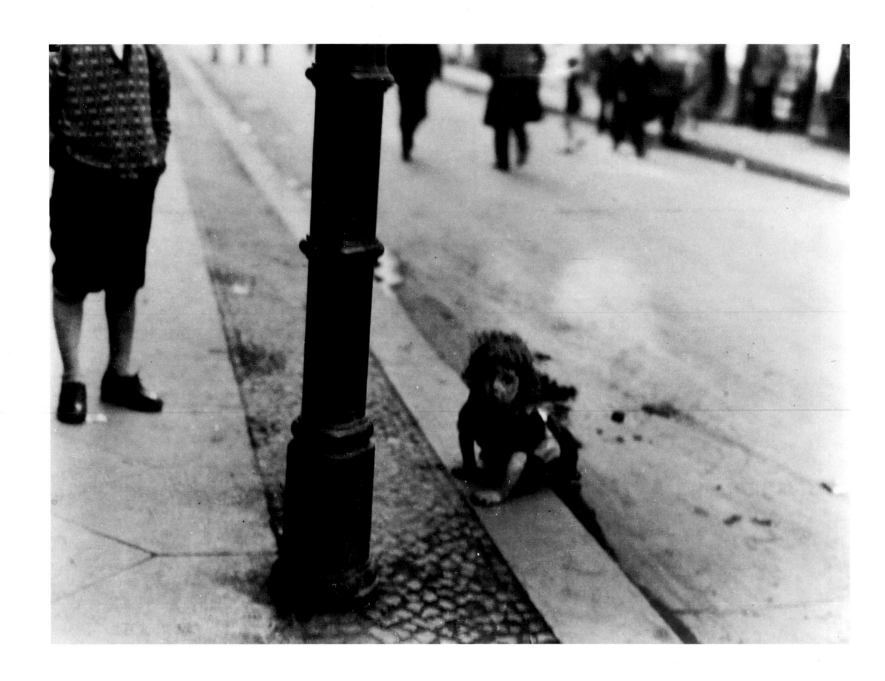

A little girl confused by her abandonment in a Berlin gutter.

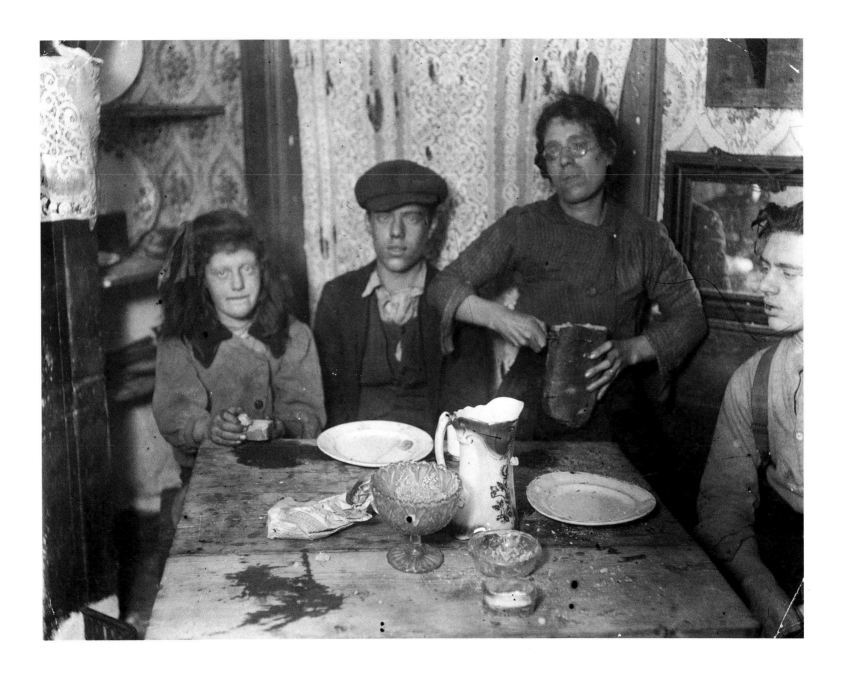

Life in a London slum. At least a million people must have lived in such conditions in post-war Britain.

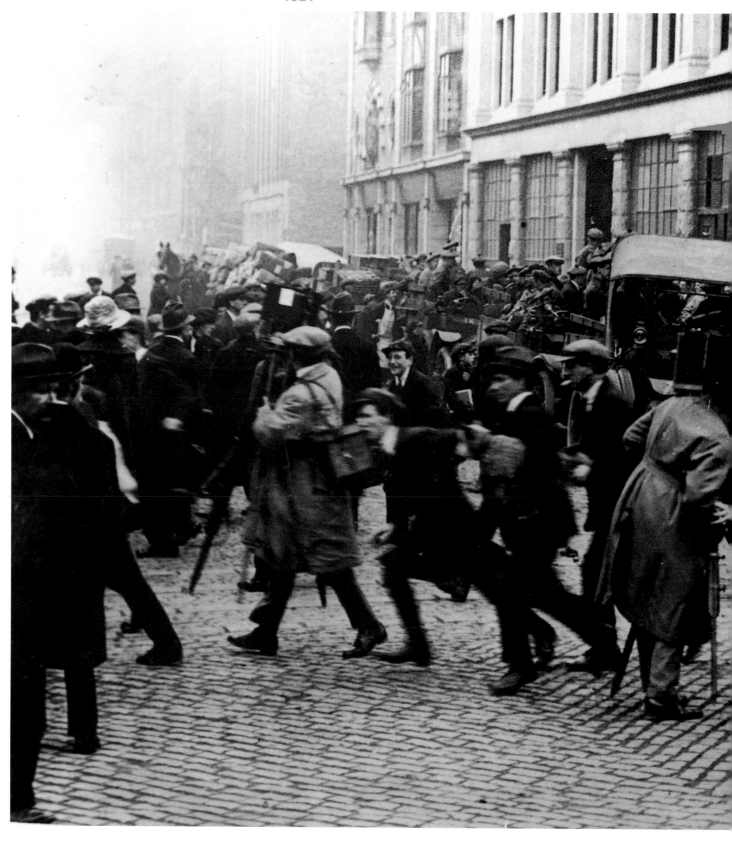

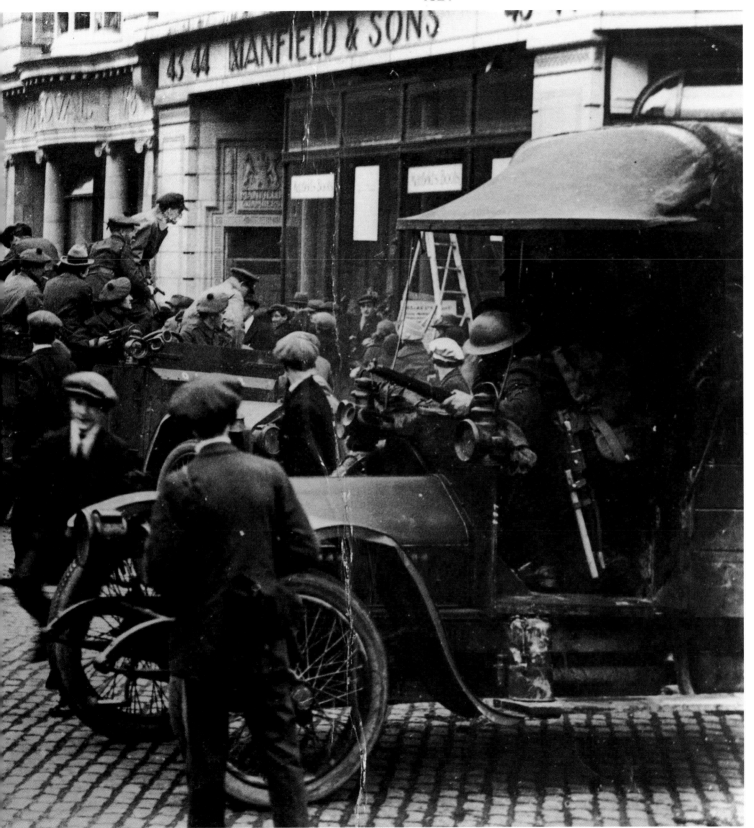

A sizeable mêlée involving the British Army, the Black and Tans, film cameramen and many Dublin citizens.

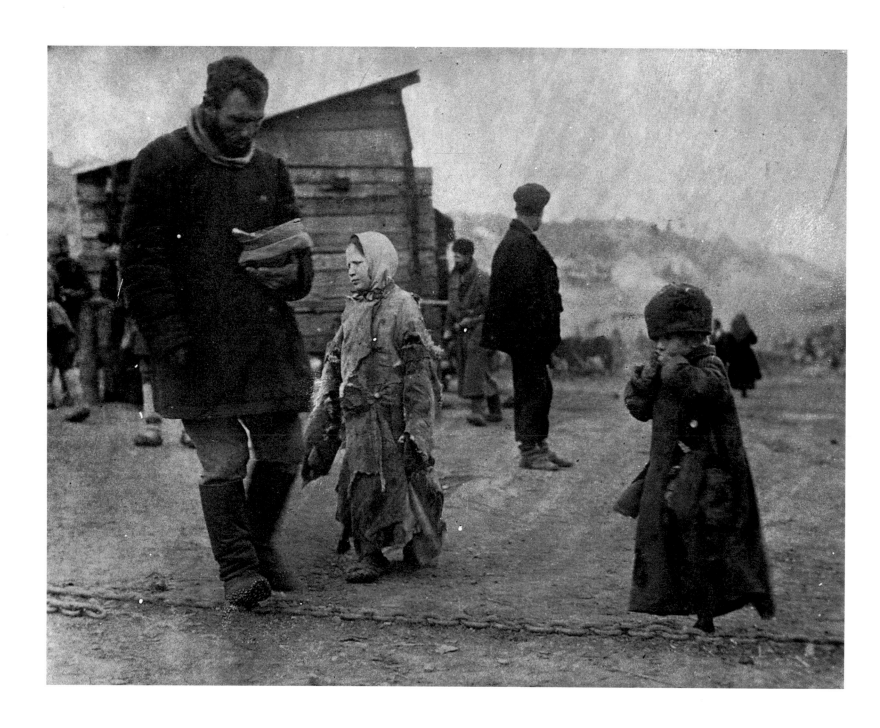

Parts of Russia would starve for well over a decade – these children had little chance of survival in conditions of extreme cold and poverty.

Claude Monet showing his lily pond at Giverny to his friend Georges Clemenceau. The 'Tiger' had always encouraged the painter, even during the war.

Irish delegate Michael Collins leaving 10 Downing Street, close to signing the treaty which would be 'his own death warrant'.

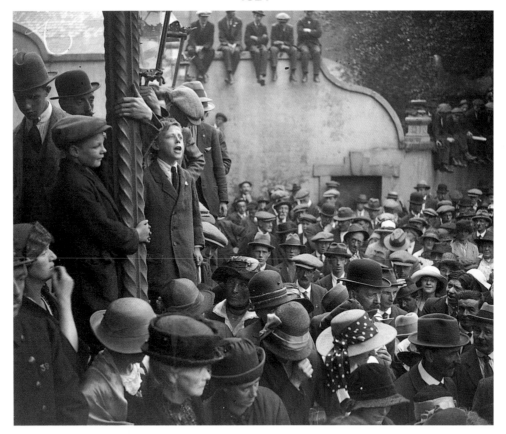

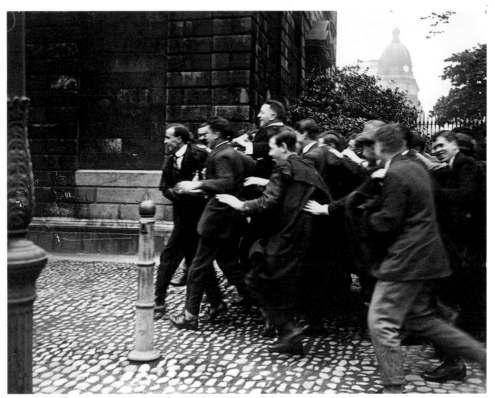

A boy singing a Sinn Fein song at a Dublin rally.
Dublin students stampede for the Southern parliamentary elections.

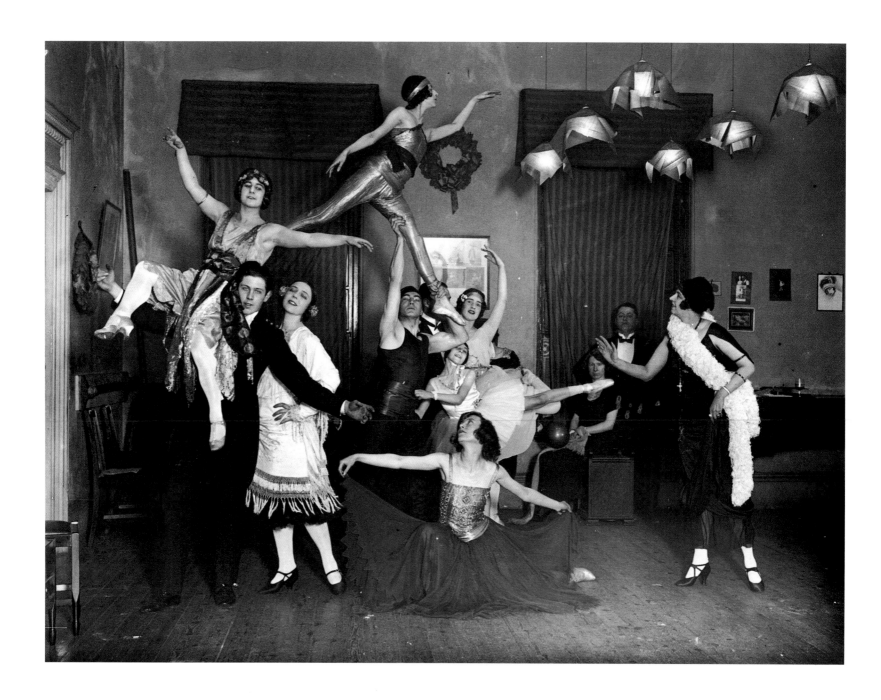

Former Russian dancer Seraphima Astafieva (right) with her bizarre cabaret including Alicia Markova (centre, leg extended), rehearsing for the Ypres charity ball in London.

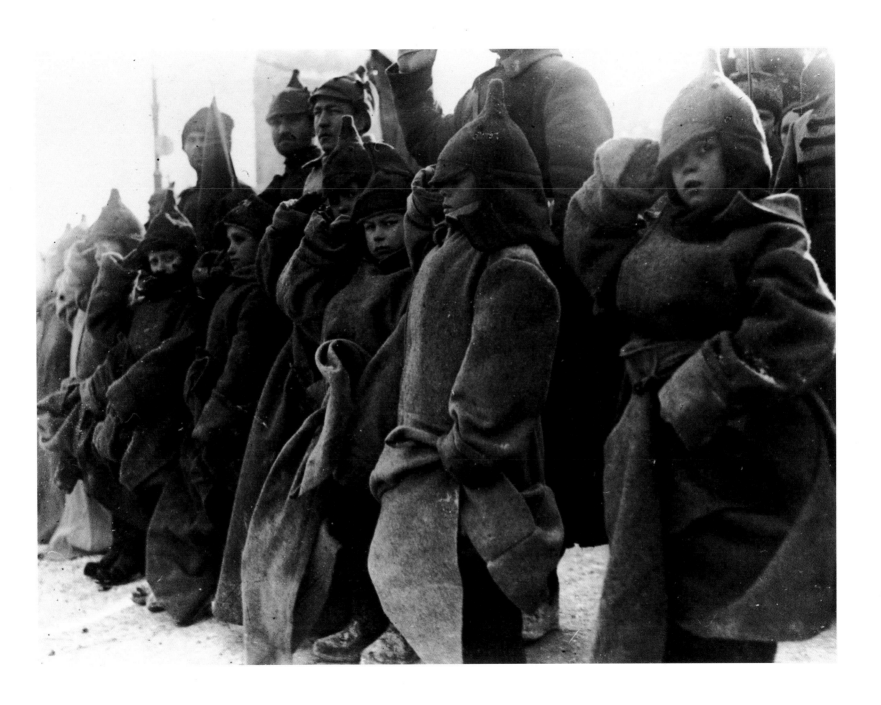

Red Army boy soldiers warm enough perhaps but rather too encumbered to help in the fighting.

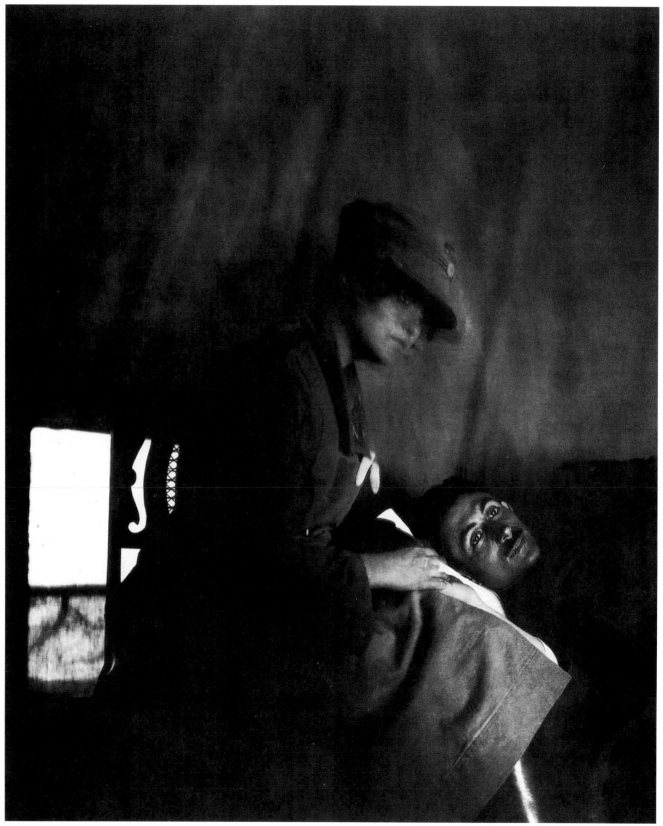

'Artistic' study of a Greek soldier and nurse during the war with Turkey.

Lenin had the first of his strokes in 1922 – here he rests at Nijni Novgorod, now Gorky.

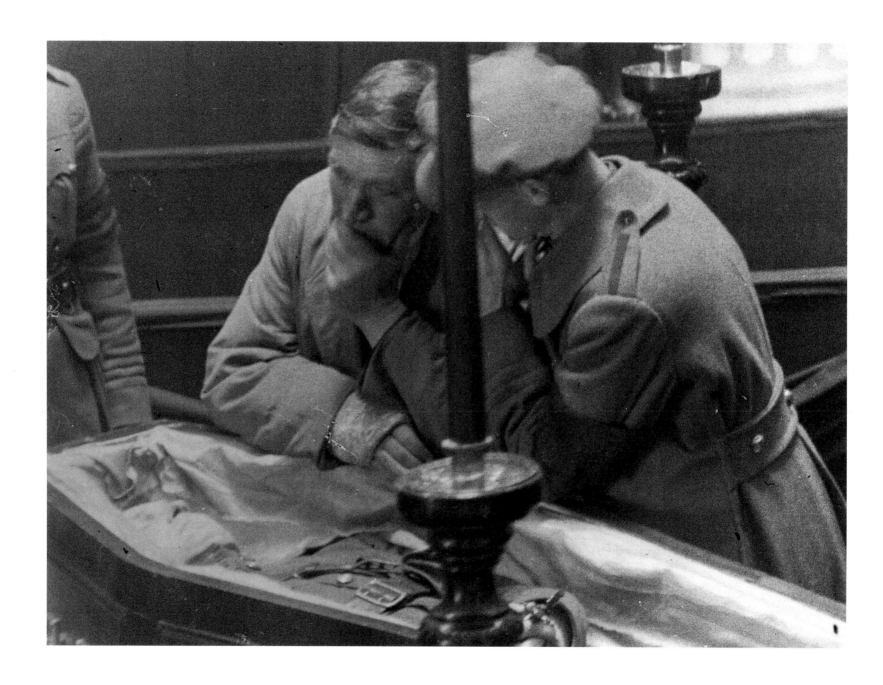

Michael Collins' brother Sean leaning over his coffin – his death cannot have come as a great surprise.

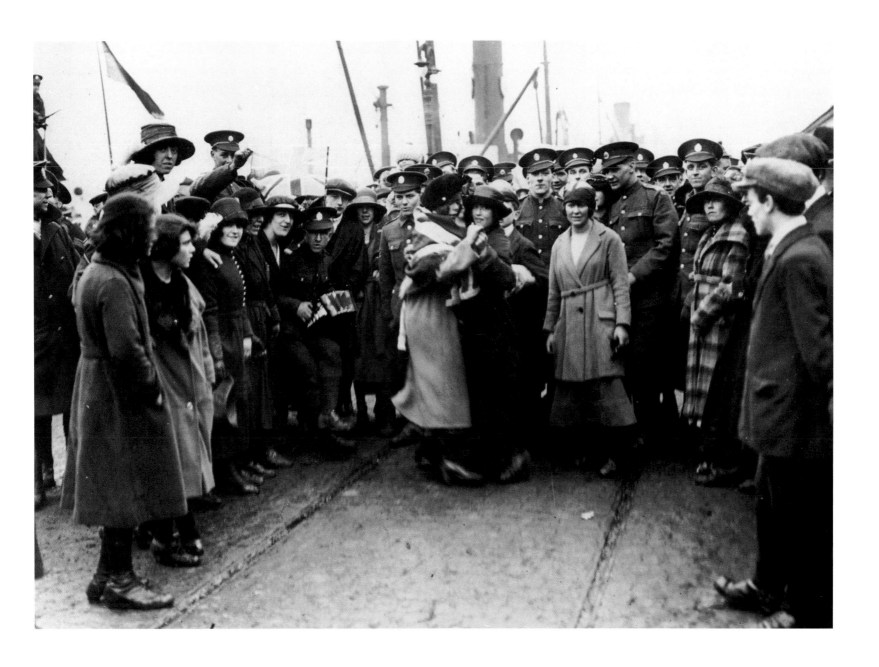

No bitterness here – British troops on their way home from Dublin's North Wall docks having a farewell dance with some Dublin girls.

Alexander Rodchenko in the 'Productivist' suit he designed for Soviet workers and which his painter wife, Varvara Stepanova, made.

All hope abandoned for Lenin – a picture not released until the collapse of the Soviet Union.

The Dolly Sisters – cabaret artists and playgirls – one of whom, Jenny, excelled at spending other people's fortunes and being forgiven.

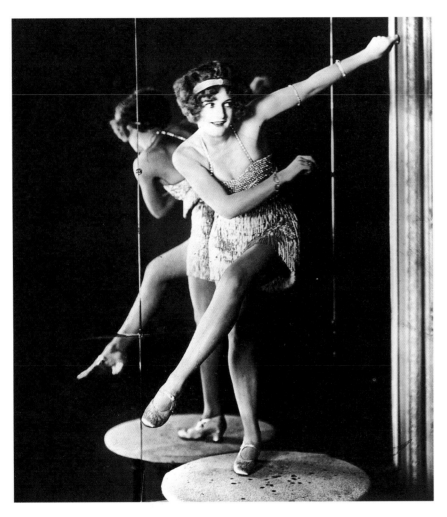 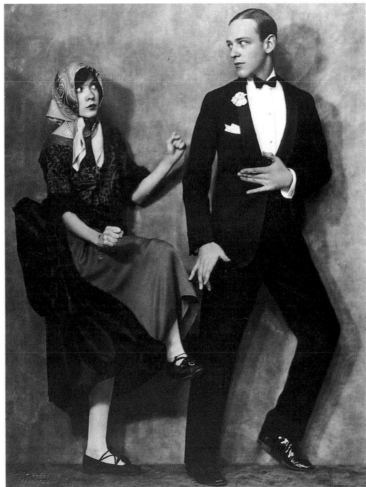

The Charleston, demonstrated on a small table by American dancer Bee Jackson.
Fred Astaire, greatest of all dancers on film, with his sister and early partner, Adele.

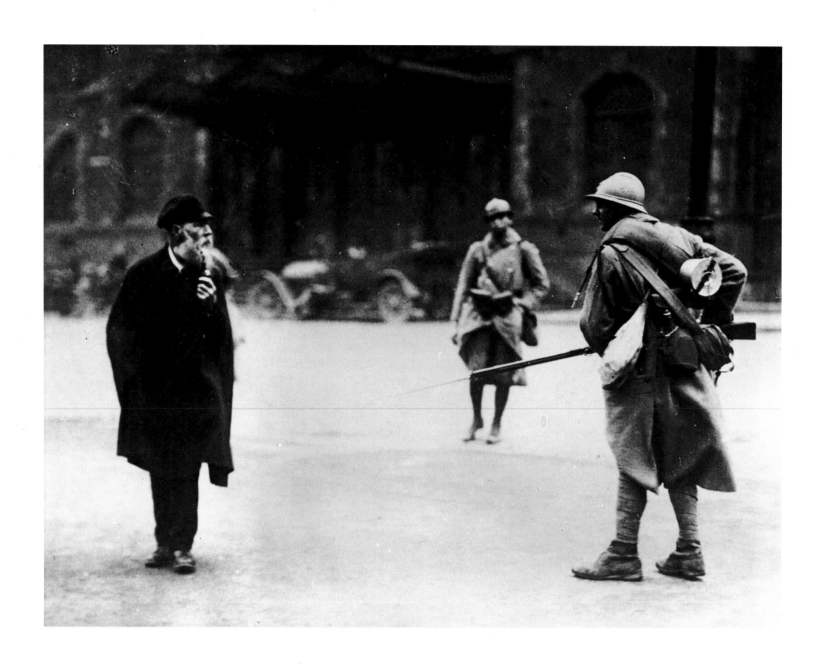

An old German defies a French soldier in Essen, home of Krupp's giant armaments works in the Ruhr.

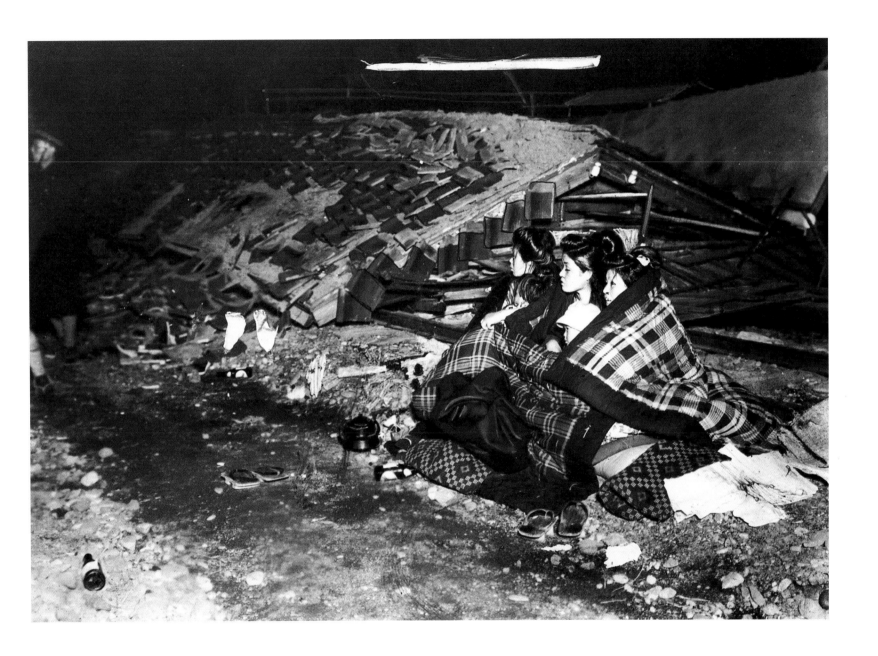

Yokohama girls trying to keep warm after the great earthquake, which razed the city and killed more than 200,000.

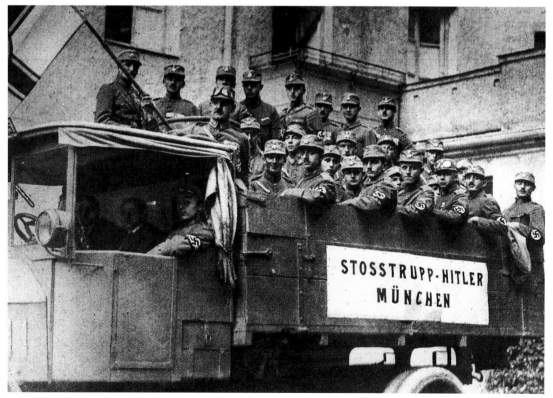

Adolf Hitler with Nazi 'philosopher' Alfred Rosenberg at the time of the Munich *putsch*.
Stosstrupp Hitler – the Hitler patrol – ready to show their strength on the streets of Munich.

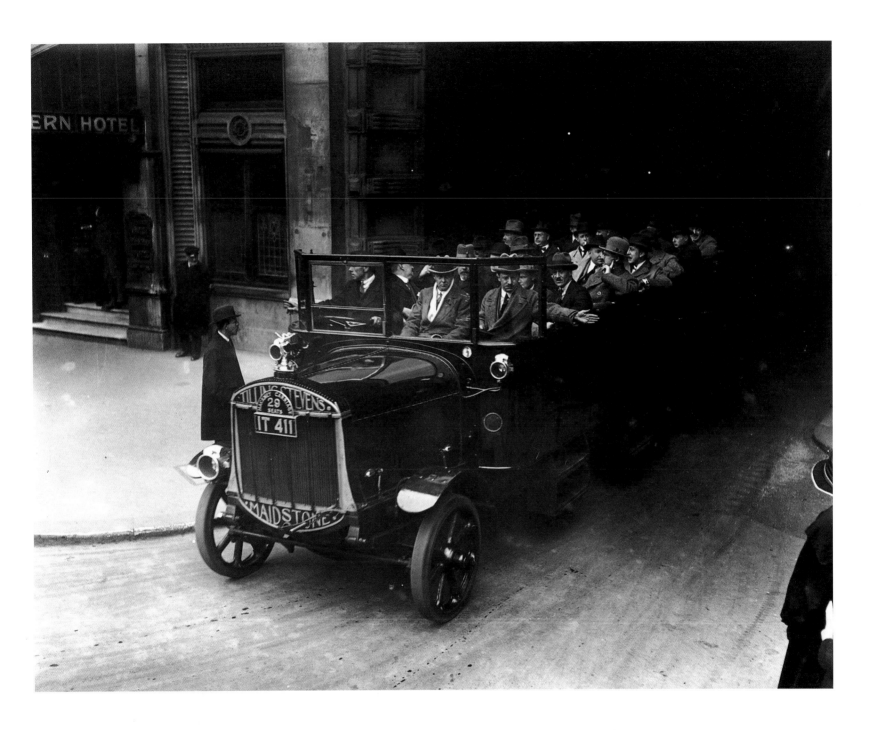

Dutch engineers arriving in Britain via Liverpool Street, London. Such professional gatherings in foreign countries would become a major industry.

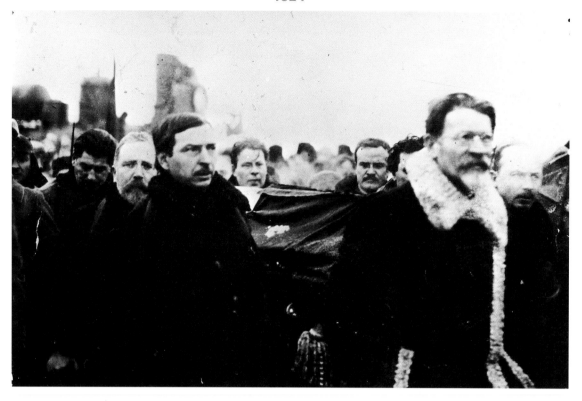

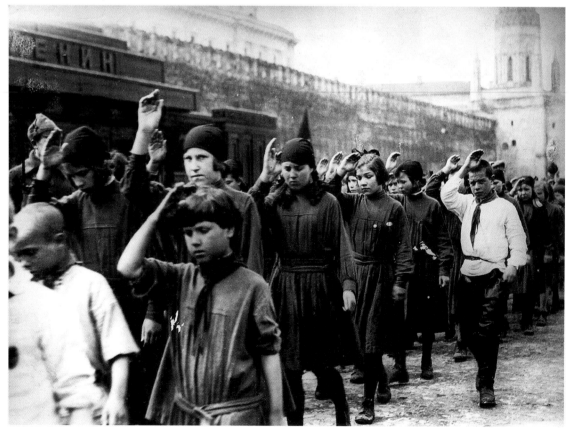

Lenin's body arrives in Moscow – Mikhail Kalinin is leading and clockwise from left are Nikolai Bukharin, Mikhail Tomsky, Stalin, Grigori Zinoviev and Vyacheslav Molotov.
Young Bolsheviks saluting as they file past Lenin's tomb in May. The cult of the immaculate leader had begun.

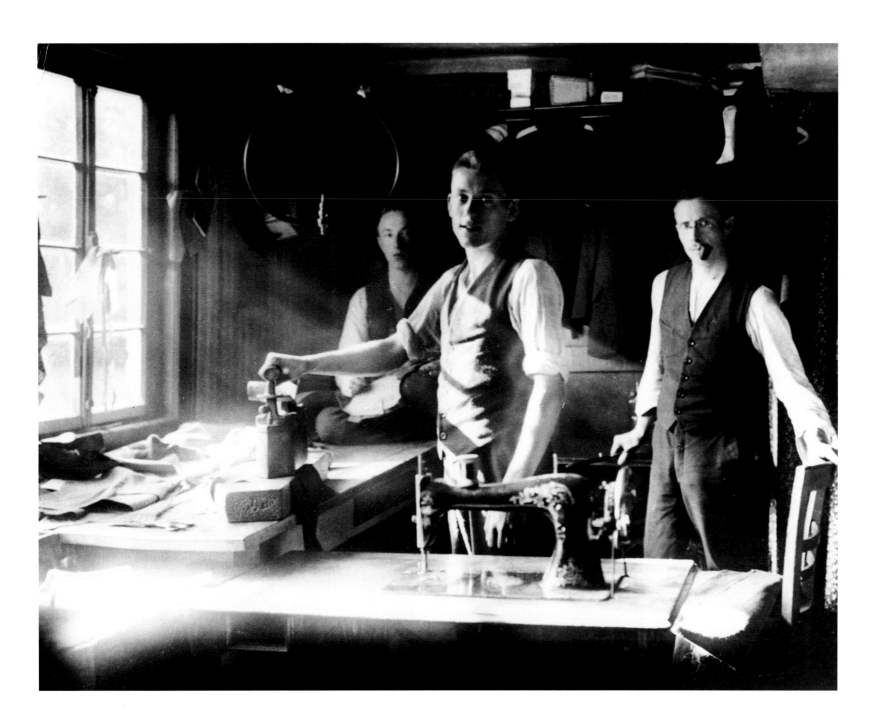

A magical moment of tranquility in a German tailor's shop captured by August Sander.

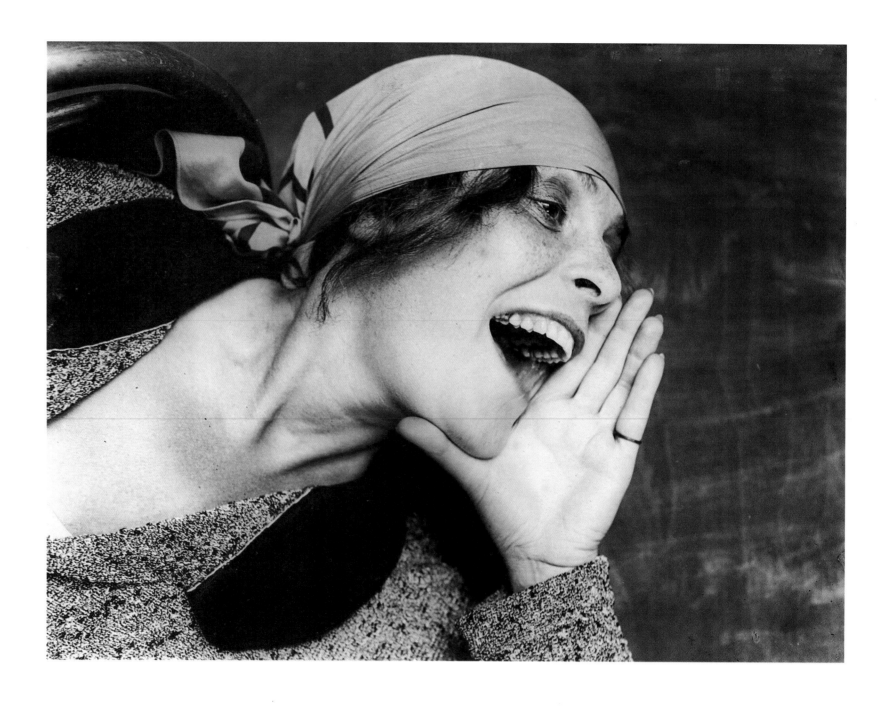

Lily Brik, girlfriend of the poet Vladimir Mayakovsky, photographed by Rodchenko – an image which was used on a poster encouraging women's self-education through reading.

Stalin seems entirely comfortable with his future victims. Top (left to right) Stalin; Aleksei Rykov, shot 1938; Lev Kamenev, shot 1936; and Grigori Zinoviev, shot 1936.
Bottom (left to right) Stalin, Rykov, Zinoviev and Nikolai Bukharin, shot 1938.

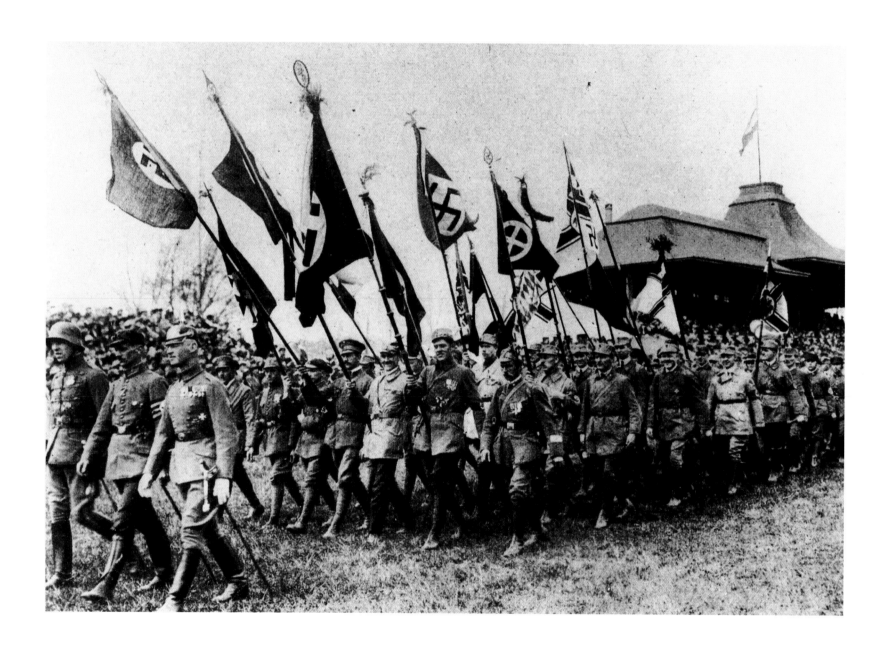

Brown Shirts and others parade with assorted flags before the Nazi art directors had perfected their image.

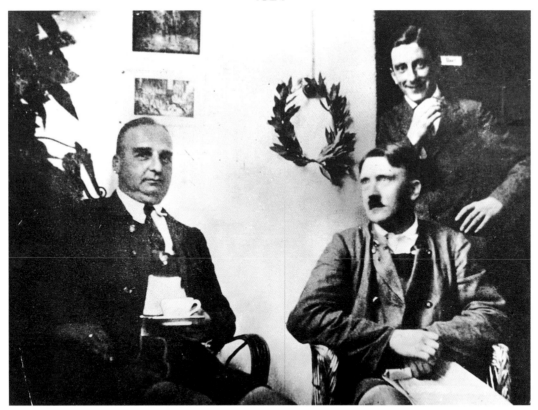

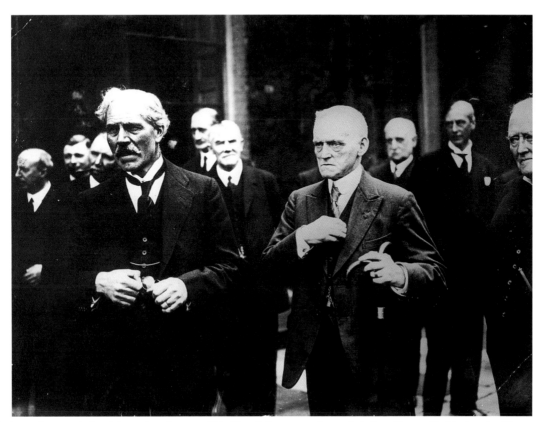

Hitler in confinement in Landsberg where he wrote *Mein Kampf* – he seems to have adopted a rather poetical look and *coiffure*.
Members of Britain's first Labour cabinet – Ramsay MacDonald (left) and Philip Snowden (right) – appear correctly to be anticipating a rough ride.

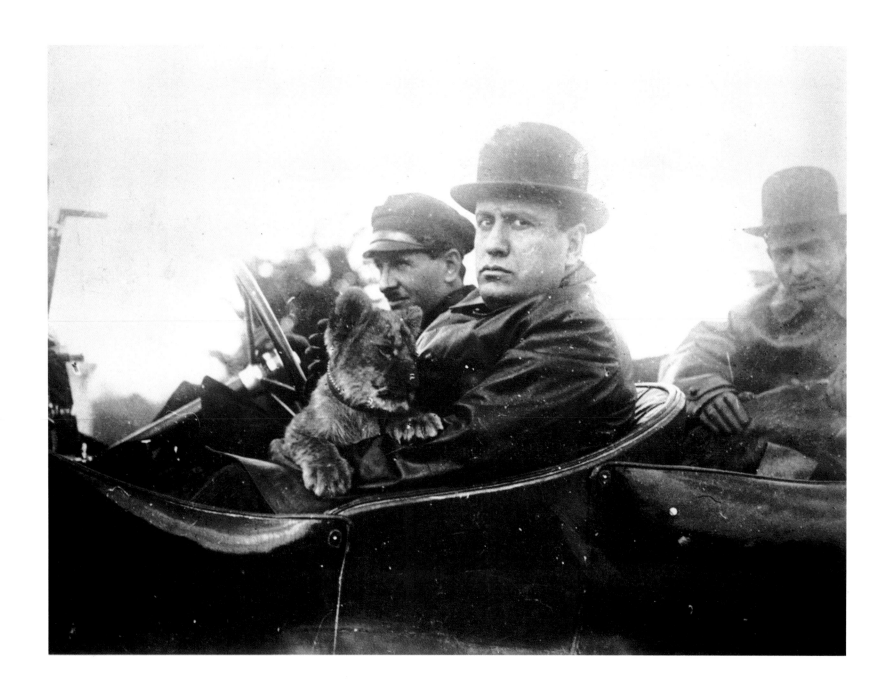

Benito Mussolini, fascist and pioneer of right-wing dictatorship, asserts his kinship with the king of beasts.

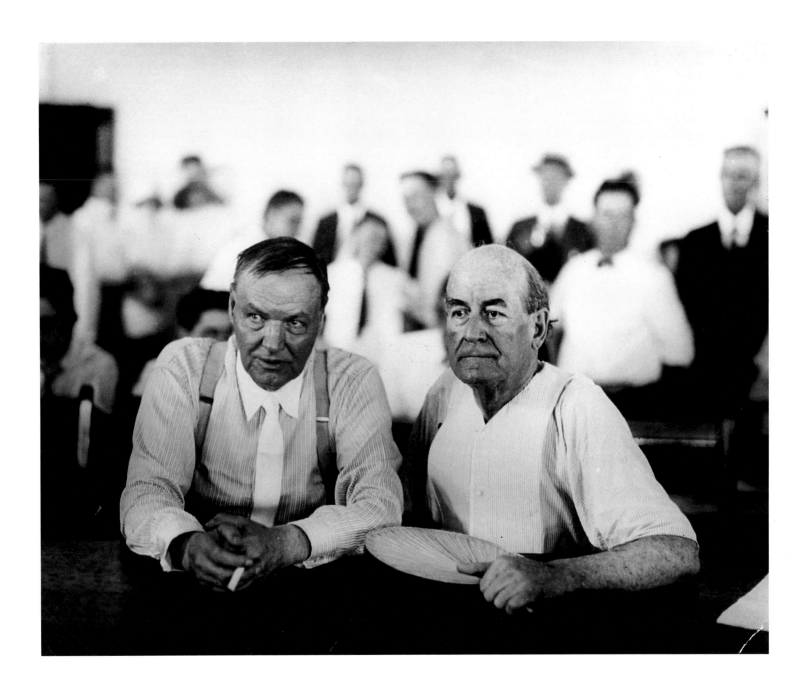

Clarence Darrow (left) and William Jennings Bryan (right) fought a great court room duel over John T. Scopes, who had dared to teach children about Darwin.

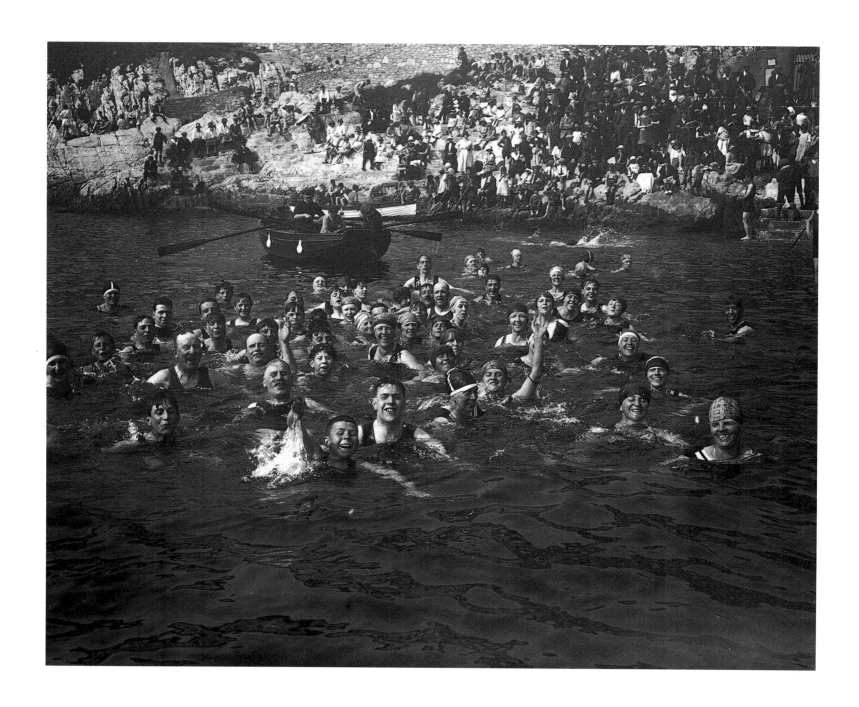

Seaside holidays were more popular than ever in Britain between the wars – these happy bathers are splashing around at Plymouth.

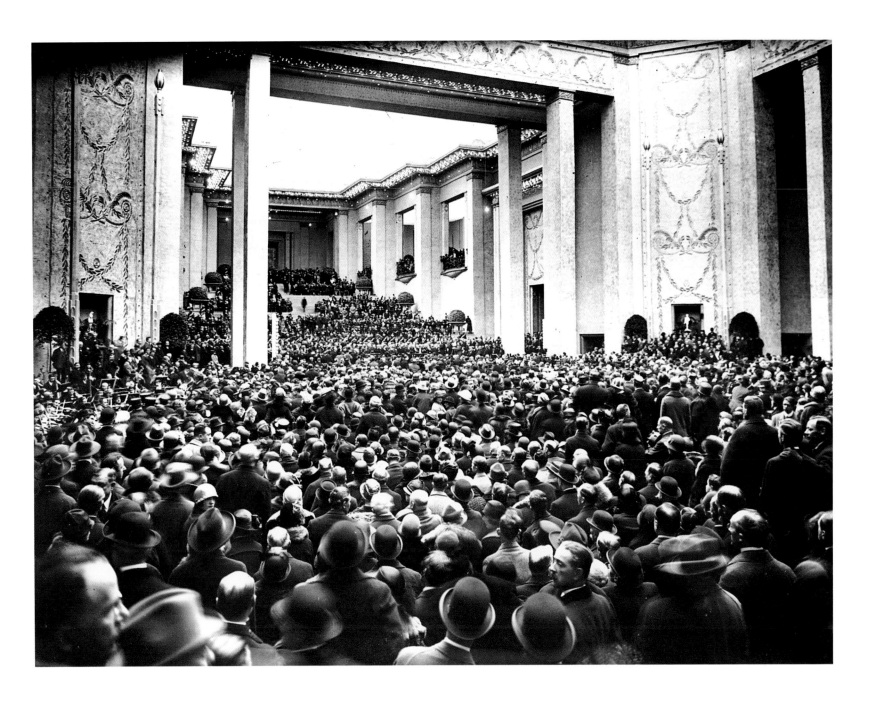

Opening of the *Exposition des Arts Décoratifs* in Paris where the art deco style of design and decoration was established.

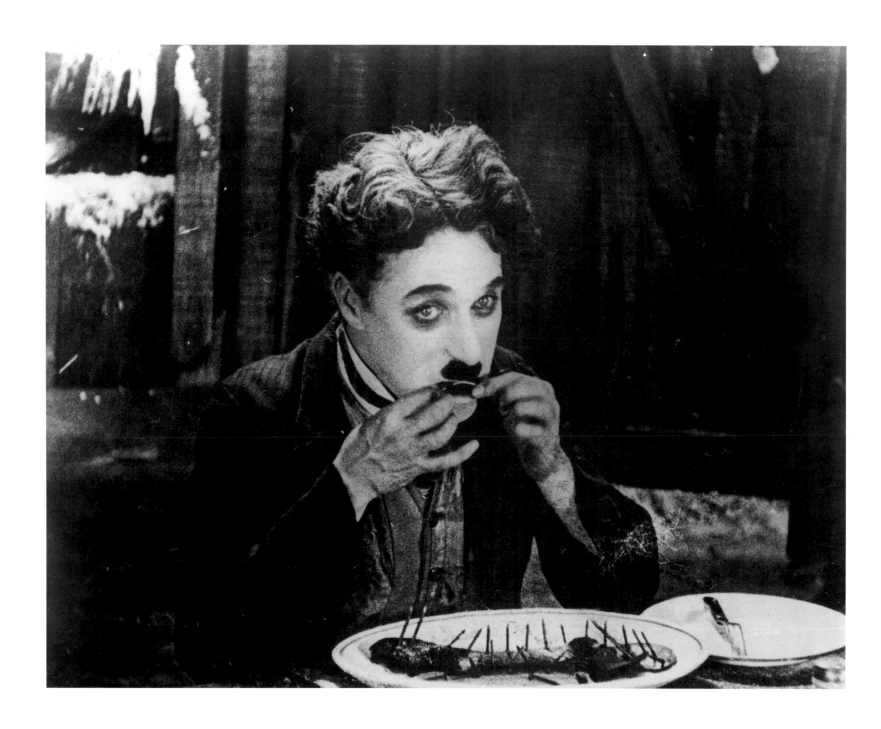

Charlie Chaplin was already the world's supreme film comic – the boot-eating episode in *The Gold Rush* was one of his most celebrated moments.

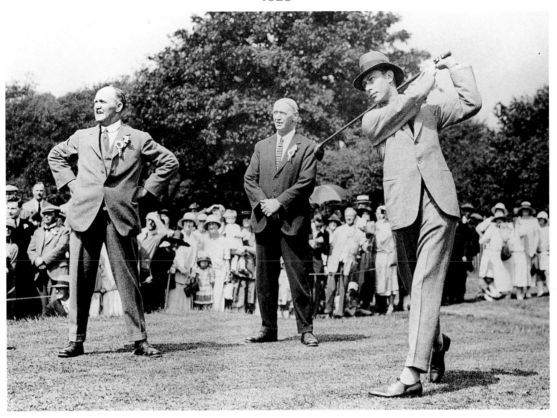

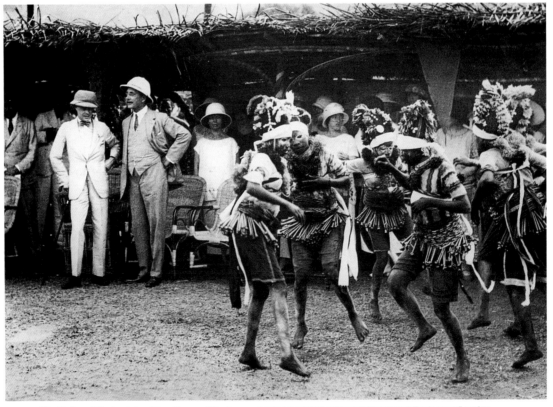

The Duke of York – later King George VI – demonstrates a stylish swing at Richmond Park near London ...
... while his brother the Prince of Wales (left) is entertained by dancing girls in Sierra Leone, a British colony in Africa.

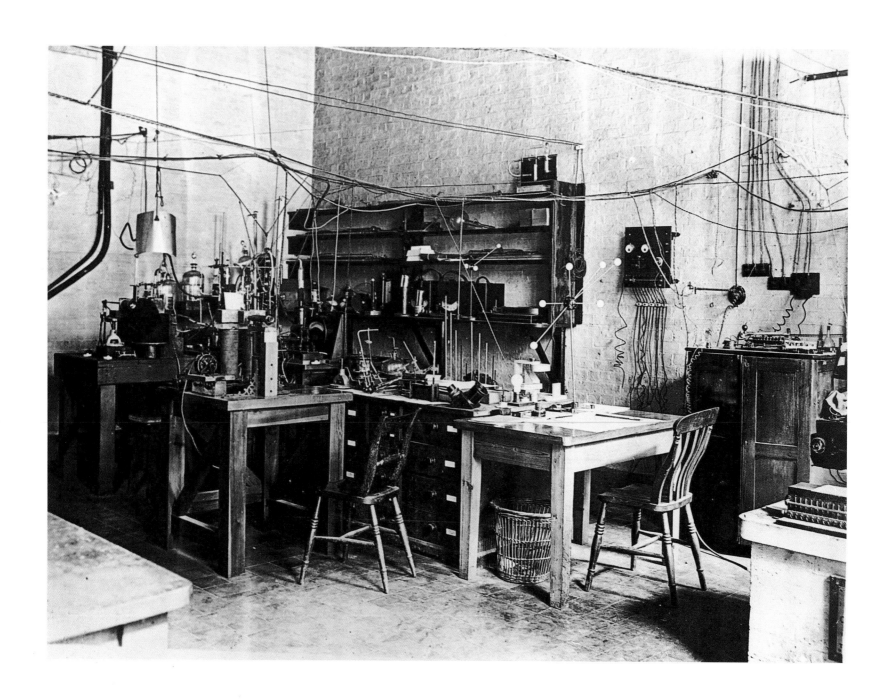

Ernest Rutherford discovered the nature of atomic structure and energy in this room at Cambridge University.

The first image ever transmitted by wireless waves demonstrated by John Logie Baird who determinedly continued his research in spite of a lack of funds. Baird's labours formed a signifcant contribution to what we now know as the television set.

A Russian woman being questioned for being one of the 'new bourgeoisie' in a staged photograph.

Shah Pahlavi of Persia with his ill-fated hubristic son and successor Mohammad Reza.

Fritz Lang's sensational but simplistic film *Metropolis* – this scene is the happy ending in which the downtrodden workers are rescued by their heroine Maria.

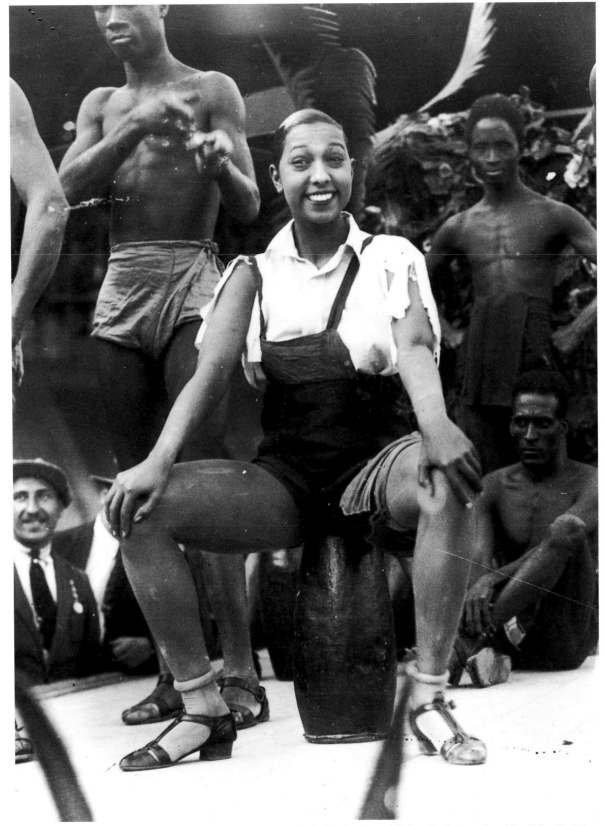

Josephine Baker, a slinkily sensational cabaret artist in Paris, adopts a tomboy outfit for a 'native' number at the *Folies Bergère*.

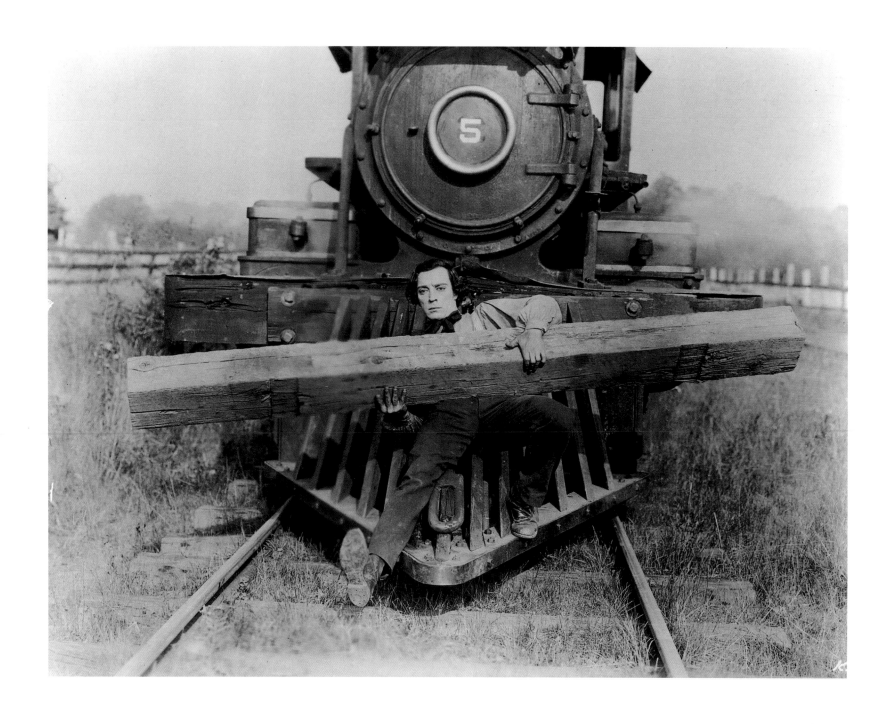

Buster Keaton, the deadpan genius of silent film comedy – impassive as usual in the face of danger in *The General*.

Marathon dancing – a cruelly competitive spectacle which reduced couples to total exhaustion with little reward.

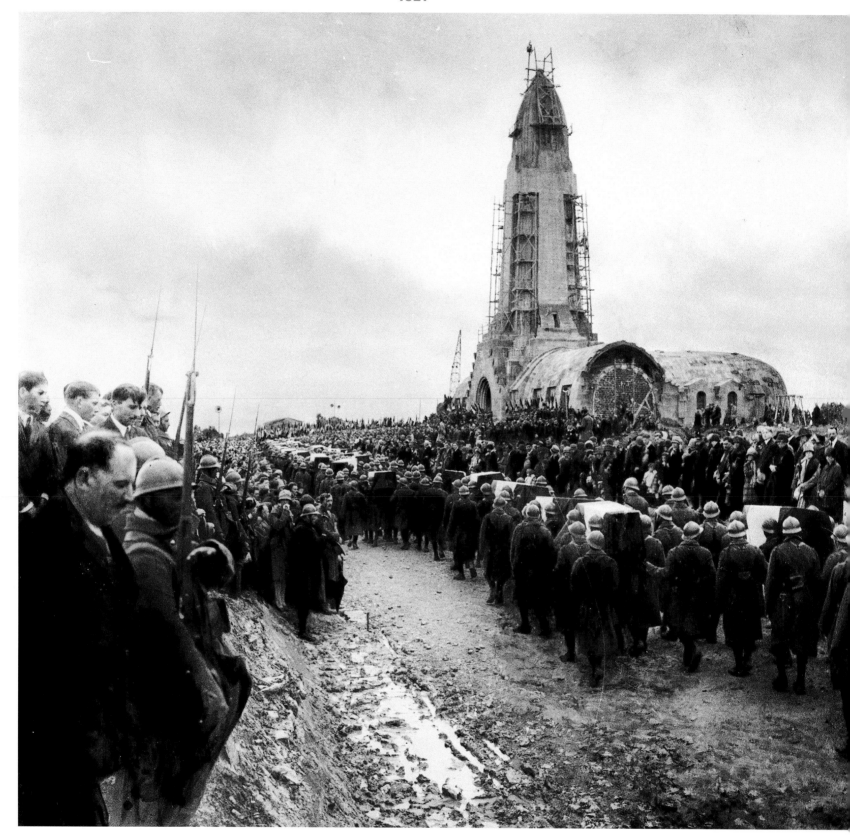

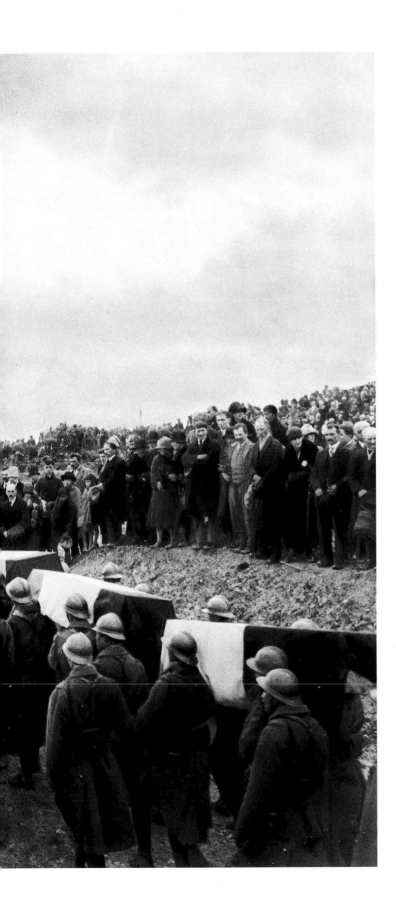

A home for the scattered bones of 130,000 men –
the first inauguration of the ossuary at Douaumont, near Verdun.

Abel Gance's silent masterpiece *Napoléon* – problems with projection and music caused it to lie forgotten for decades.

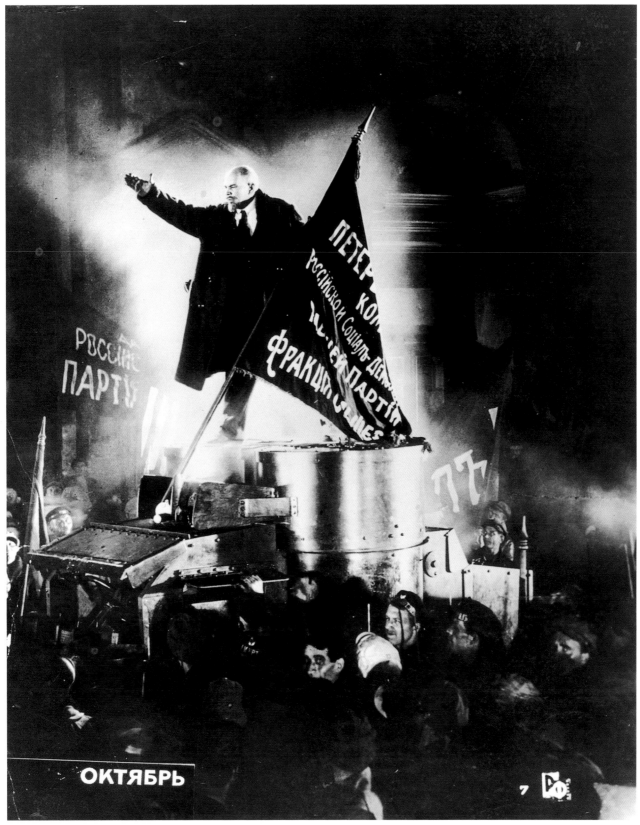

Sergi Eisenstein's film *October* was a romantic evocation of the fall of the Tsar and Lenin's triumph over Kerensky's bourgeois forces.

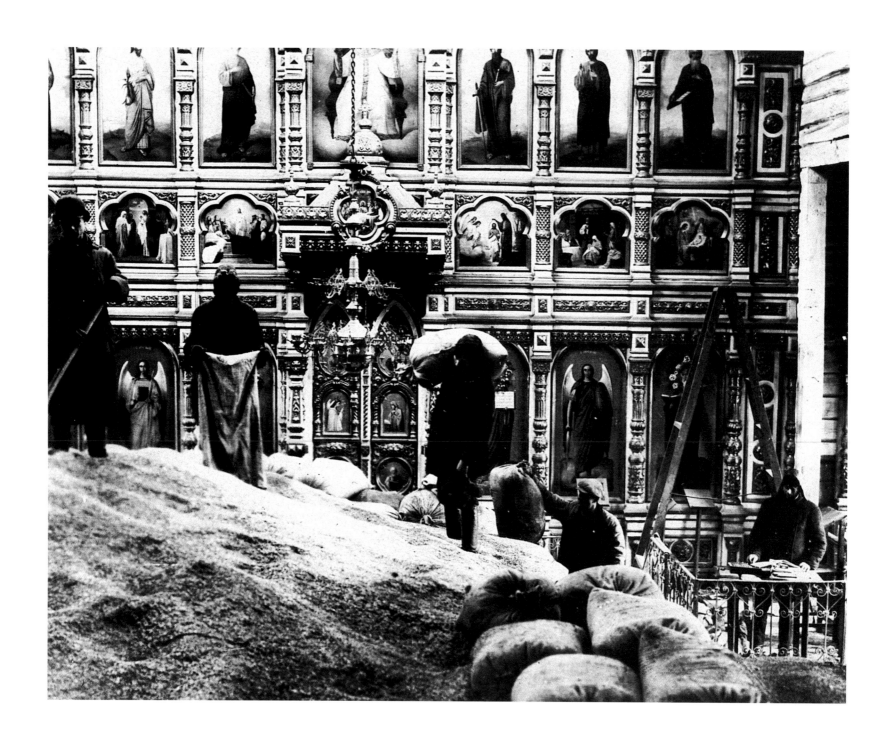

Soviet anti-Christian iconoclasm – a church used as a granary ...

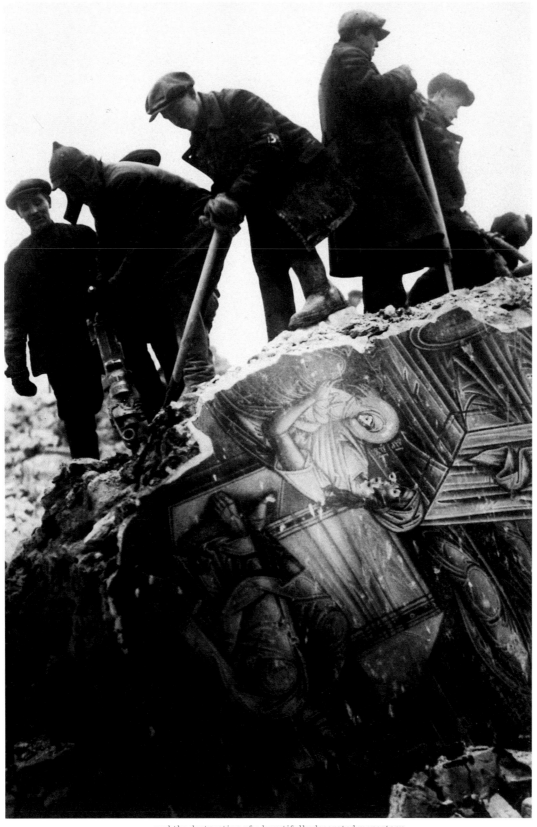

... and the destruction of a beautifully decorated monastery.

Cardinal Pacelli – later Pope Pius XII – leaving President von Hindenburg's eightieth birthday party. Pacelli's relations with Nazi Germany were always suspect.

Nicola Sacco (right) and Bartolomeo Vanzetti (centre) – gentle anarchists wrongly convicted of murder and electrocuted,
but later vindicated by Governor Michael Dukakis of Massachusetts.

This Fiat truck could carry not only tanks, but also human cannon-ball launchers.

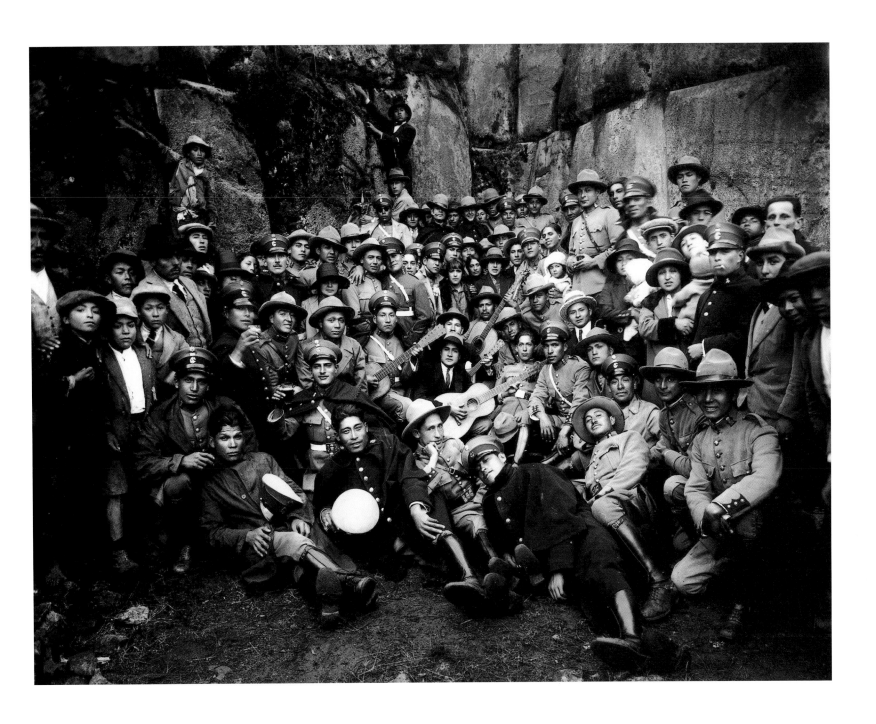

A group of *guardias civiles* at Sacsaywaman, Peru, taken by the great Peruvian-Indian photographer Martín Chambi.

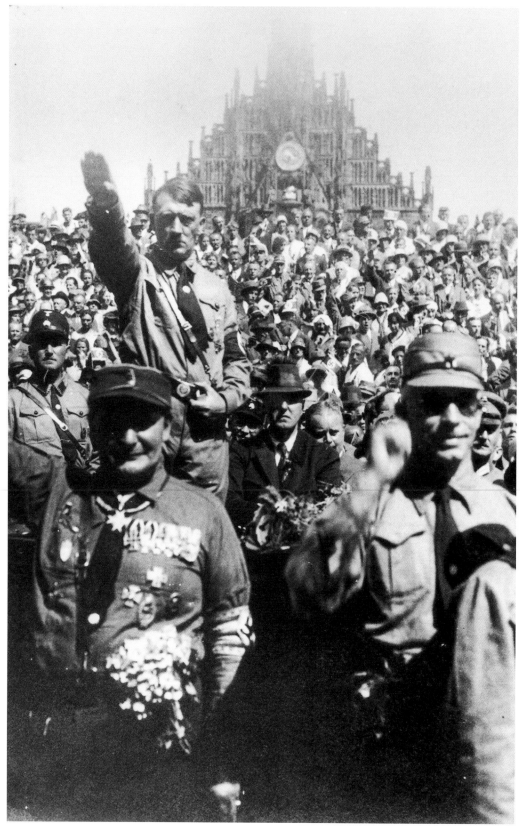

Hitler at a party rally in Nuremberg with Hermann Göring (front left).

Austen Chamberlain (Britain, left), Gustav Stresemann (Germany, centre) and Aristide Briand (France, next to Stresemann) snapped in conference by Erich Salomon.

Die Dreigroschenoper (The Threepenny Opera) by Berthold Brecht and Kurt Weill, based on John Gay's eighteenth-century *Beggar's Opera.*

A still from the film *Un Chien Andalou*, by Luis Buñuel and Salvador Dali – an eternal curiosity.

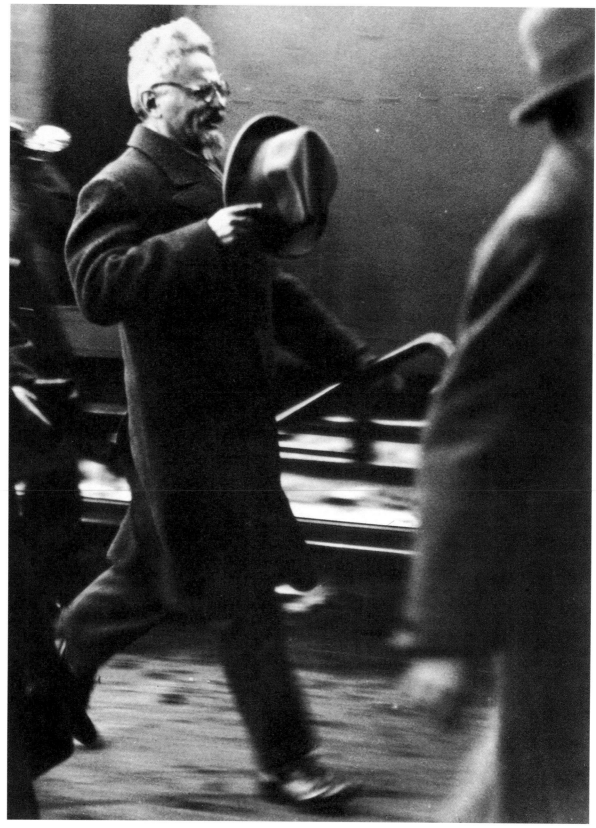

Having been expelled from Soviet Russia by Stalin, Trotsky arrives in Paris.

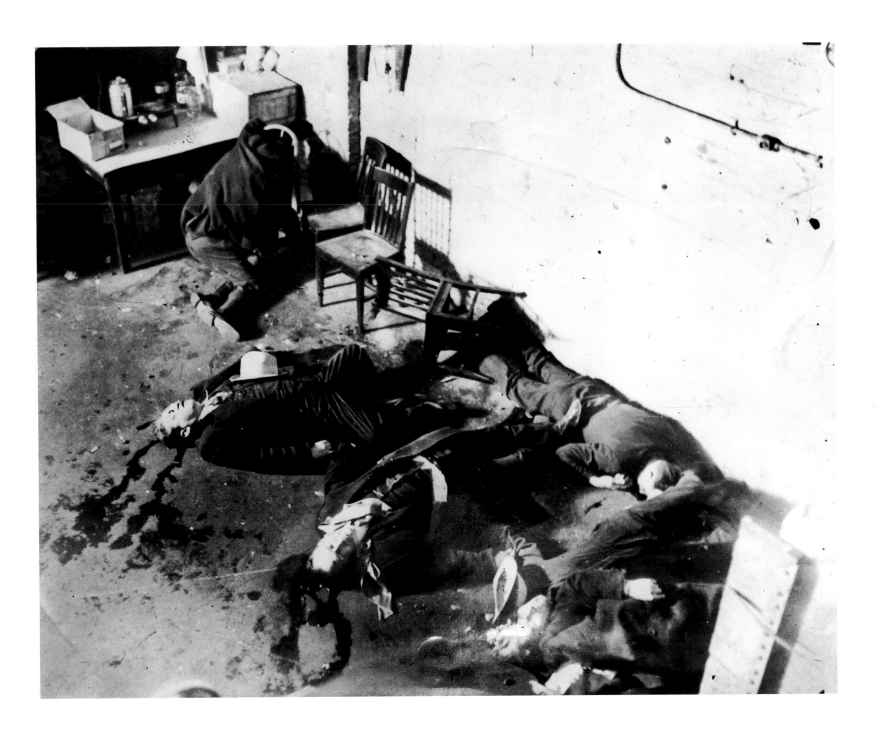

The St Valentine's Day Massacre in Chicago – the bloodiest episode in the Prohibition gang warfare that established the supremacy of Al Capone.

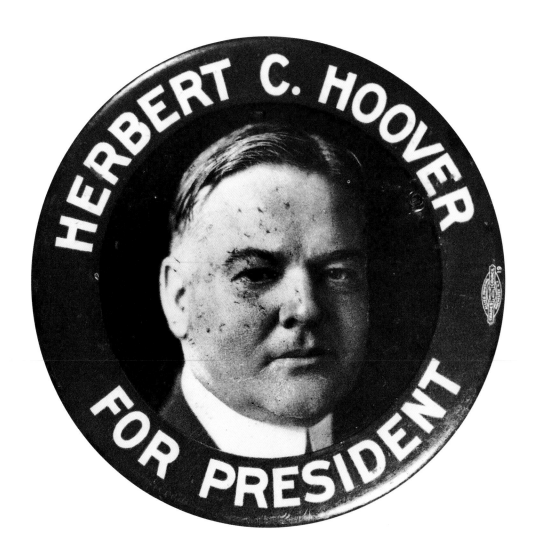

Herbert Hoover, a complacent US Republican president who failed to prevent financial crisis or alleviate the Depression.

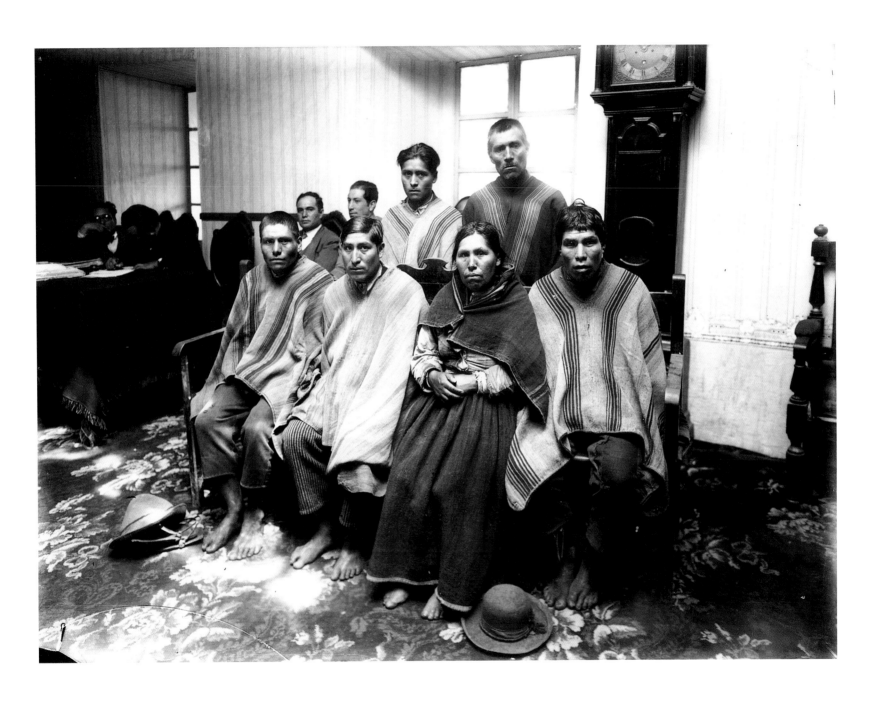

Another Martín Chambi masterpiece shows Peruvian peasants seeking justice in Cuzco, Mexico.

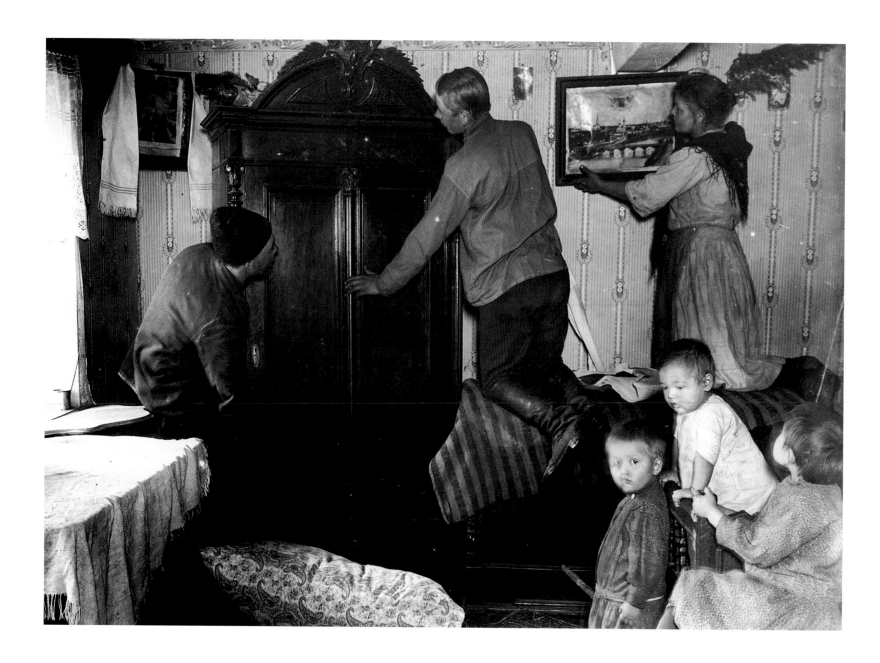

An absurd Soviet picture shows collective-farm peasants rearranging the house of a kulak. The latter were being 'liquidated' by Stalin at the time.

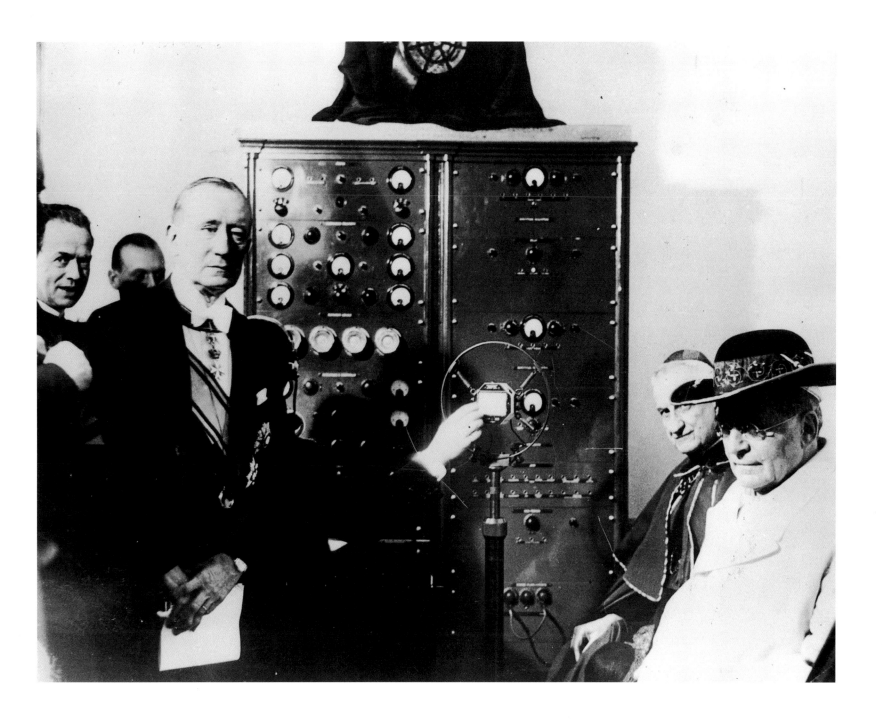

The inauguration of Vatican Radio – a hand testing the microphone before Pope Pius XI hears the inventor Guglieno Marconi speak into it.

German boys make kites of worthless inflation money – inflation was almost certainly the greatest danger to the fragile Weimar democracy.

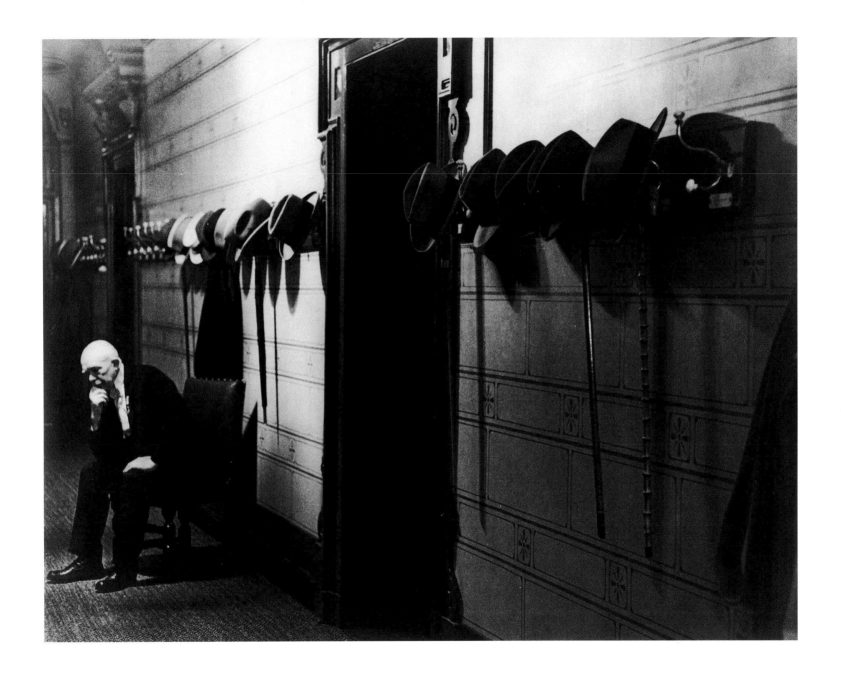

Diplomats' sticks at the Hague Conference proved as ineffective as Chamberlain's umbrella against the dictators.

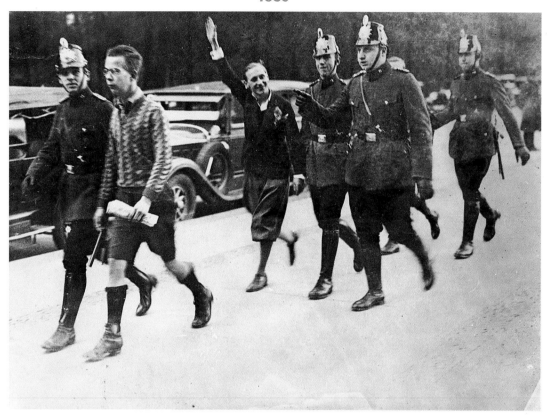

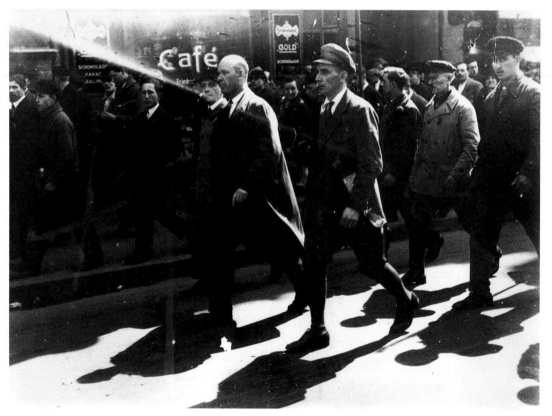

Young Nazis with police making light of their arrest for a minor offence at the opening of the Reichstag.
Ernst Thälmann (left) – of whose KPD (Communist Party) there is little pictorial record – leading a Berlin May Day parade.

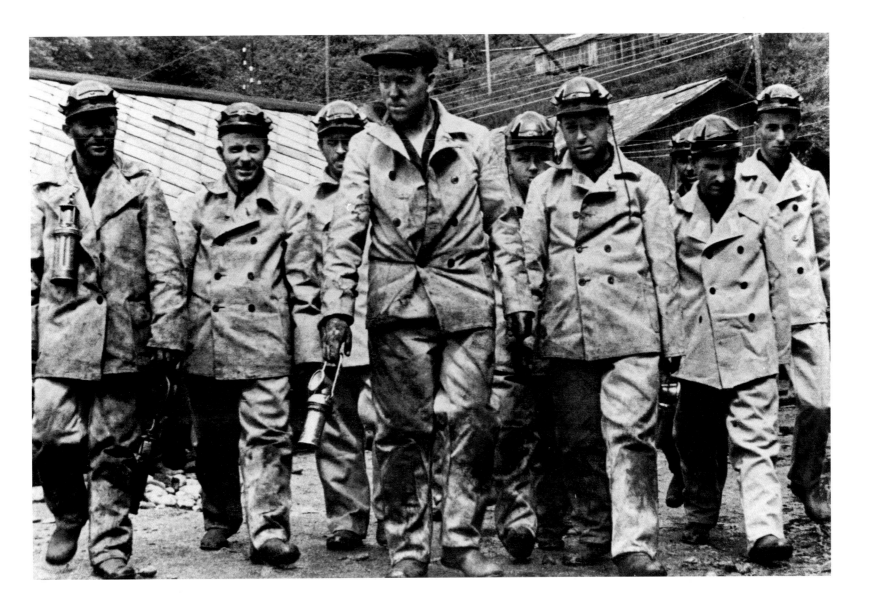

Record-breaking coal-cutter Alexei Stakhanov (leading) was a Soviet superman of labour, whose achievements were used by the state to accelerate industrial production in general.

An almost proud father in Houston, Texas, poses with his baby – and his cigar.

Stan Laurel and Oliver Hardy were inspired film comedians – unlikely friends perpetually at odds.

The little-known history of the American left is one full of violence – here erupting in New York City.
Famine victims in China give way to despair.

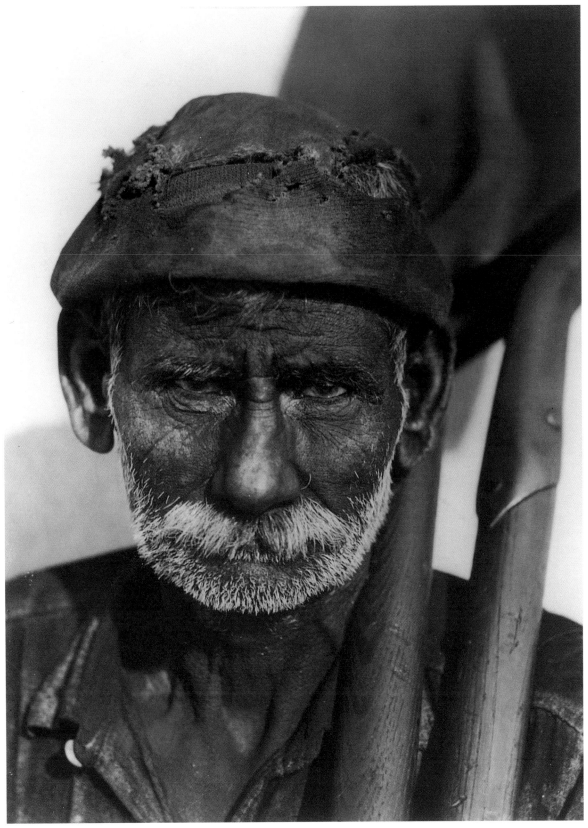

A coal stevedore in Havana, Cuba, photographed by Walker Evans.

Margaret Bourke-White loved photographing heavy industry, and what better than a Soviet five-year plan and a tractor factory.
Bourke-White shoots from the Chrysler building, New York City ...

... and Dr Paul Wolff captured this mechanic servicing an engine of the *Hindenburg* zeppelin in flight.

The Australian Don Bradman, the world-famous cricket batsman, demonstrating his skill at golf.

'Babe' Ruth and his wife. One of the world's greatest baseball players, he scored a record for home runs in a lifetime.

Soviet peasants making haste to join a happy collective farm – one of many such staged images which hid the true reality.

Opening night at the Phoenix Theatre in London. 'Going to the theatre' seemed a necessary social statement and reassurance for some.

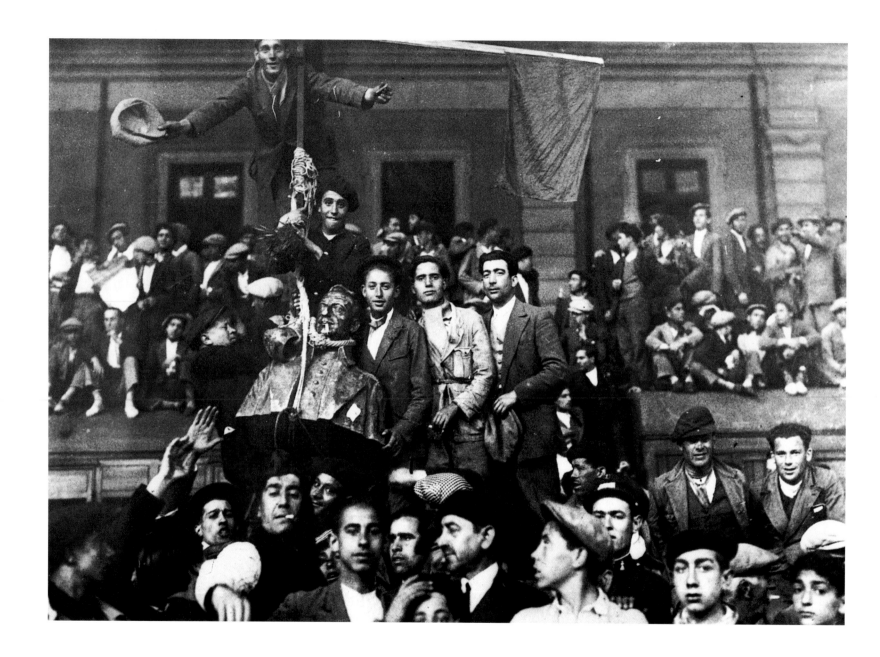

Spanish republicans removing a bust of Spanish dictator Primo de Rivera from its place of honour.

The extraordinary Wallenda high-wire family in action. Over the years accidents on the wire killed many of them, including their founding father.

Brassaï recorded Paris life with an unequalled fluency. Homosexuality was permitted, though public discretion was required by law.

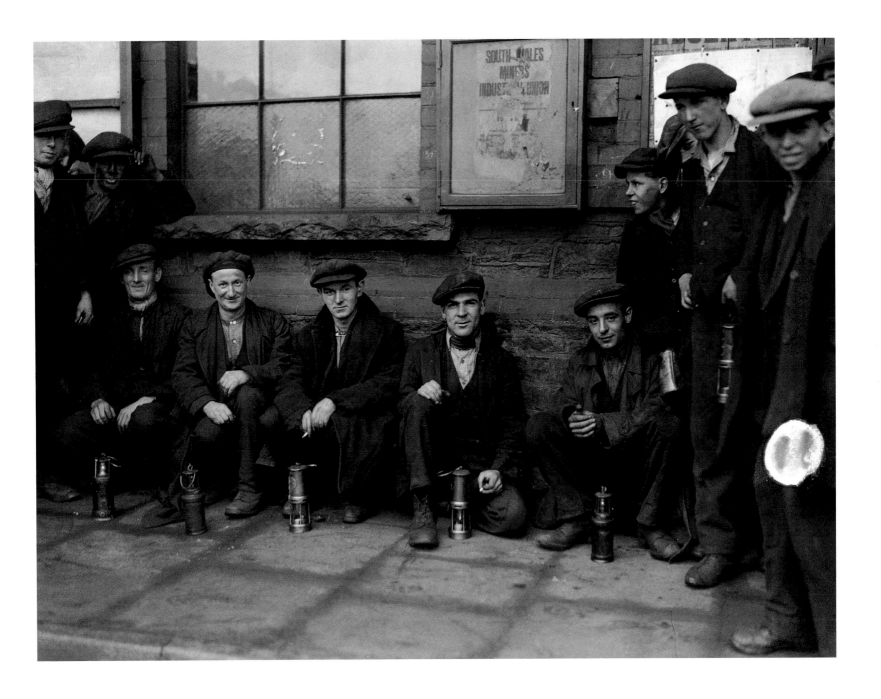

A study of Welsh miners by James Jarché that depicts their dignity in the face of their struggles.

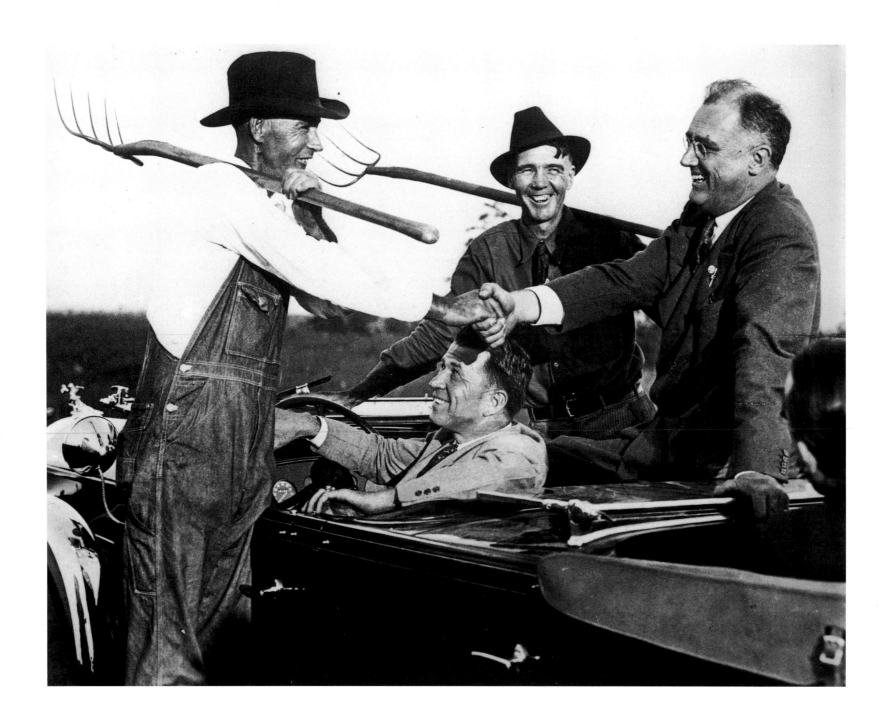

Franklin D. Roosevelt campaigning for the presidency in Georgia – a cheerful collision of infectious smiles.

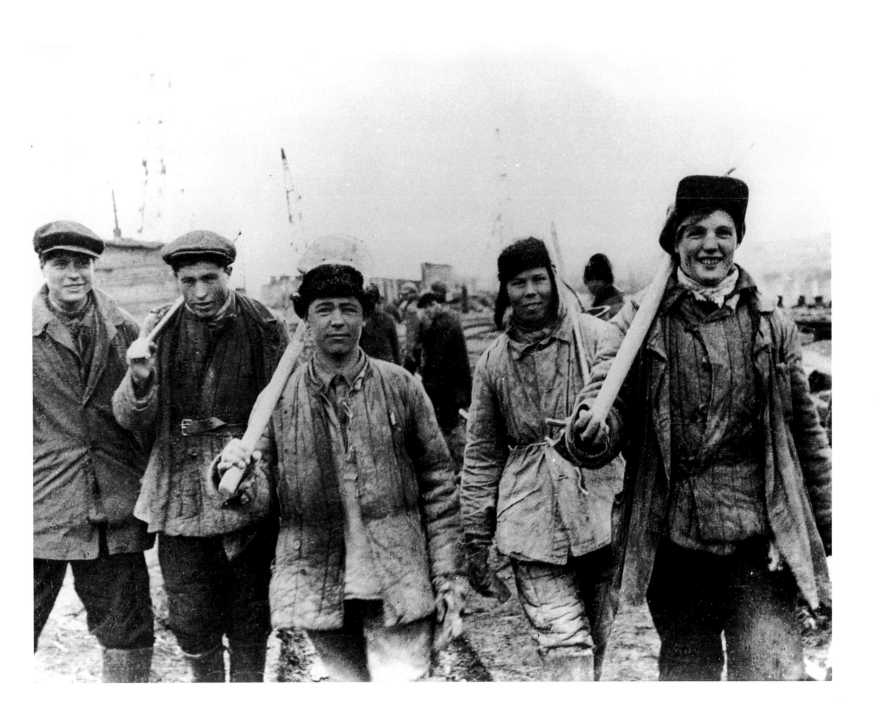

Champion woman concrete-layer Yevgenia Romanenko (right) working with her team on the Dnieper Dam, a great symbol of Soviet industrial capability.

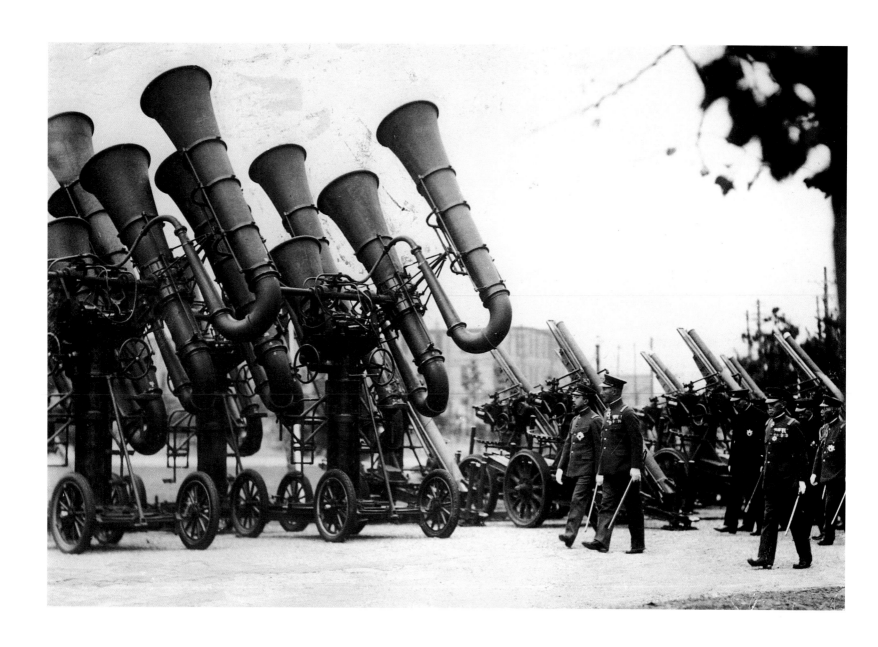

Emperor Hirohito takes a look at giant Japanese ear trumpets made for hearing enemy planes from afar.

Italian traction engines helping to drain the Pontine Marshes near Rome in one of Mussolini's most publicized schemes.

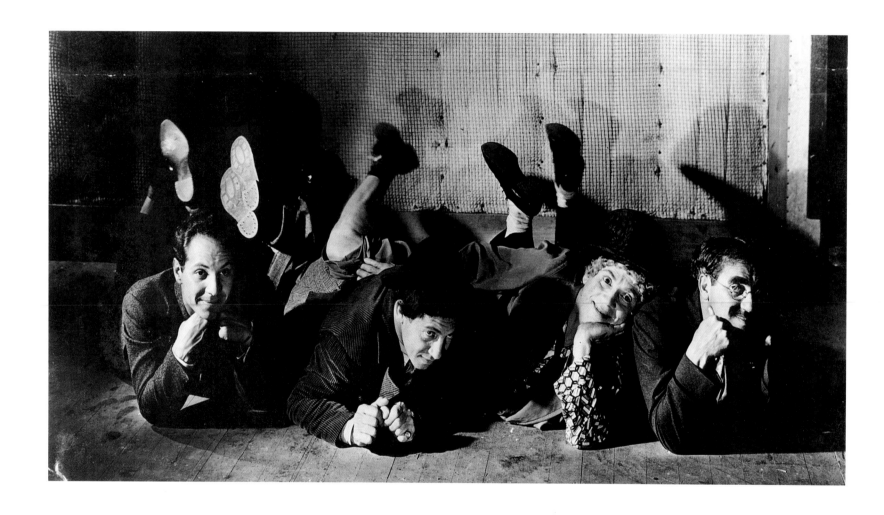

The Marx Brothers – Zeppo, Chico, Harpo, Groucho (left to right) – photographed by Cecil Beaton.

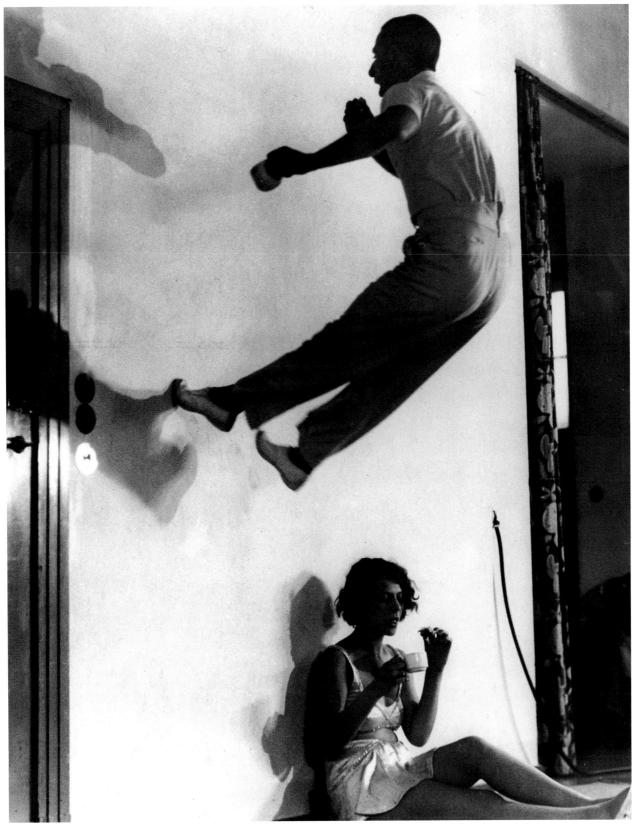

Martin Munkacsi, the photographer who put movement into fashion, called this photograph *Having Fun at Breakfast, Berlin*.

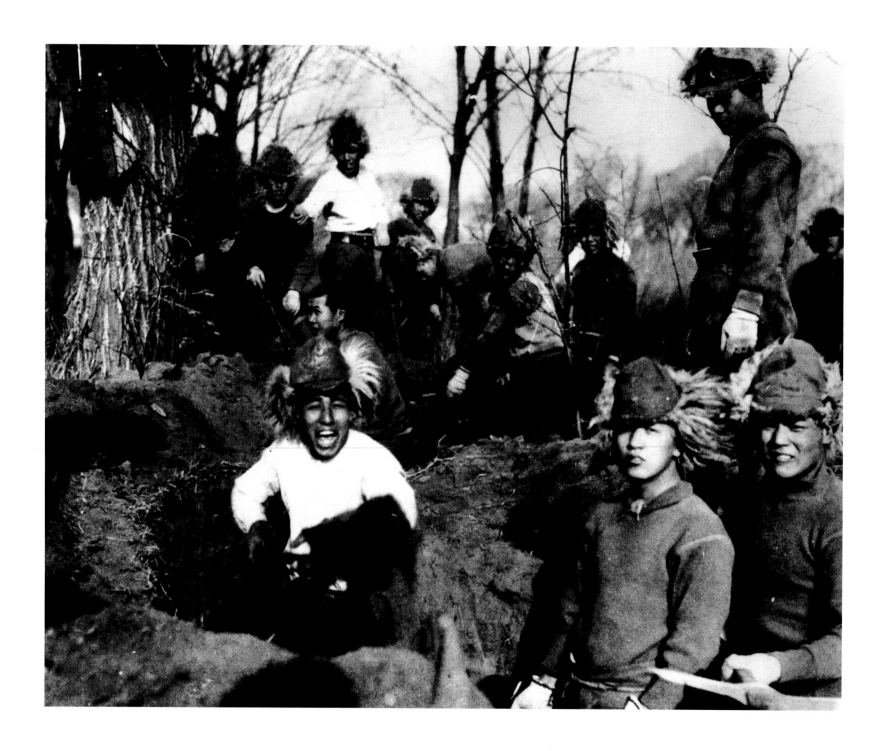

Japanese soldiers digging trenches in Manchuria with a true *banzai* spirit.

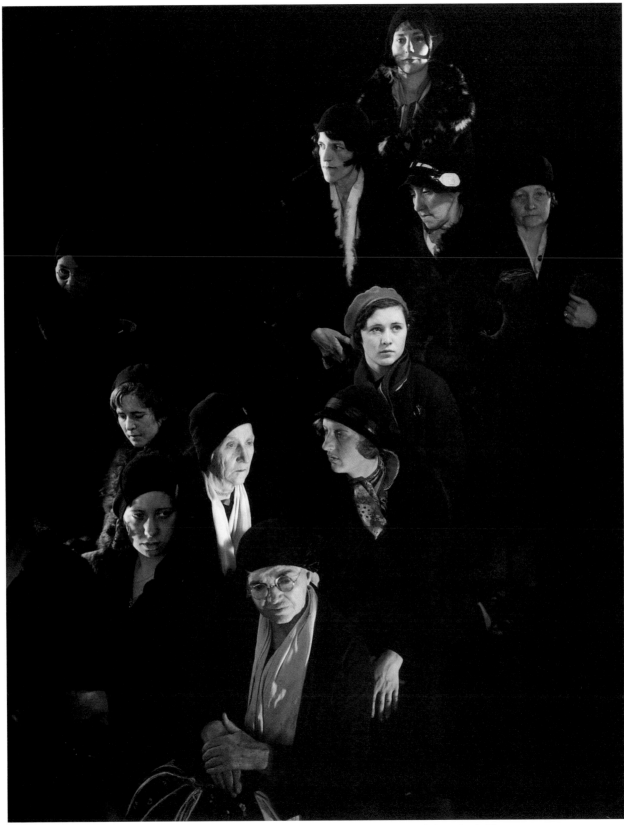

Homeless Women, The Depression. Edward Steichen adapts his *Vanity Fair* style for a charitable purpose.

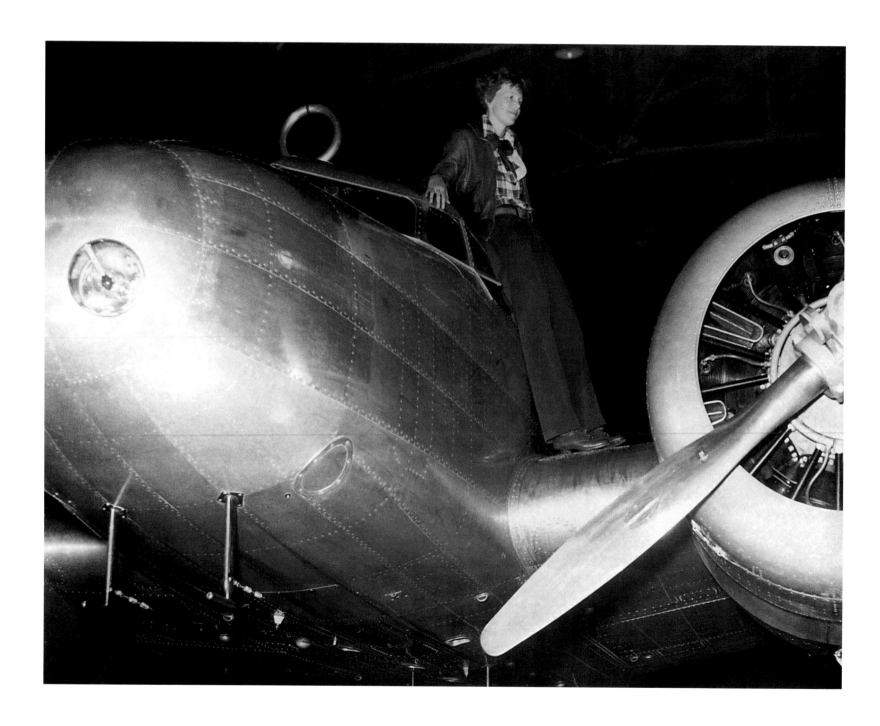

Amelia Earhart, intriguing superstar of women pilots, on becoming the first woman to fly the Atlantic solo.

Dr William Beebe (centre) returning to New York after a dive in his bathysphere, which could achieve the depth of 923 metres (3,027 feet).

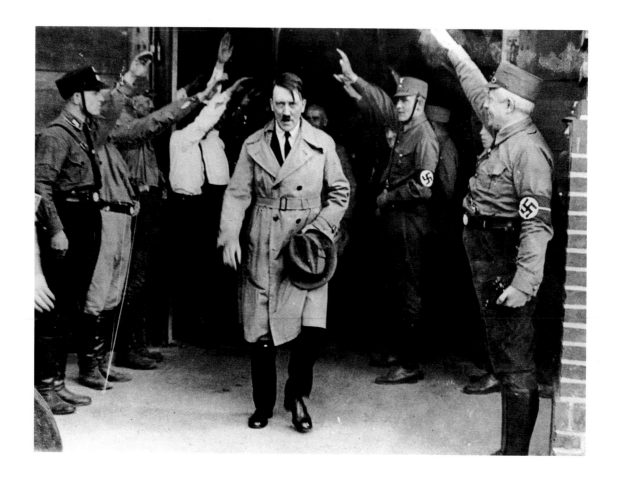

Hitler 'after the speech'. His personal magnetism now seems incredible.

Hitler, with Hermann Göring, shows himself to his supporters on the night he became Chancellor of Germany.

Marinus Van der Lubbe, a mentally retarded young Dutchman, being tried for setting fire to the Reichstag.

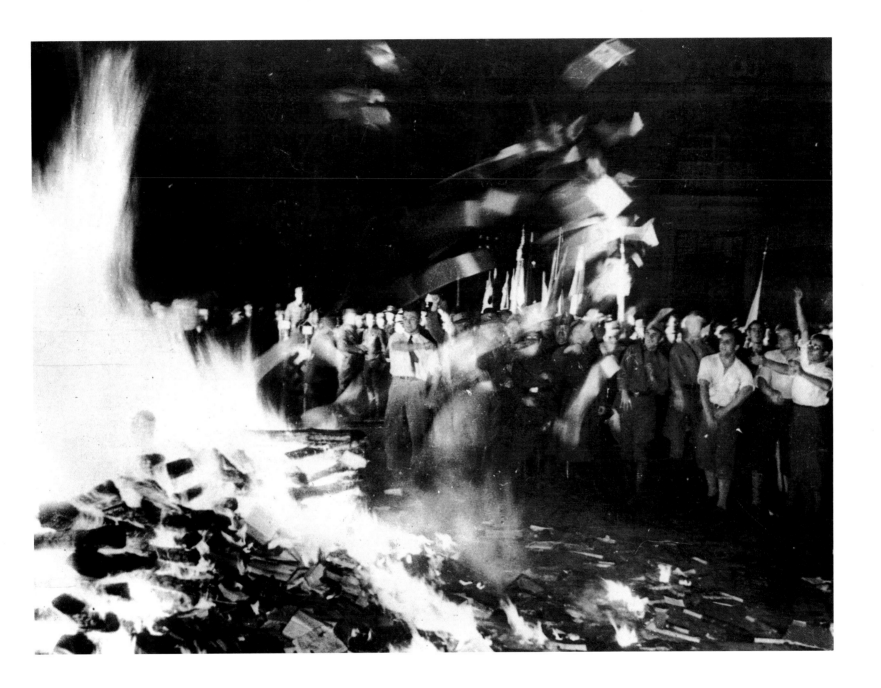

Unfavoured literature makes an inspiring bonfire for Nazis in Berlin.

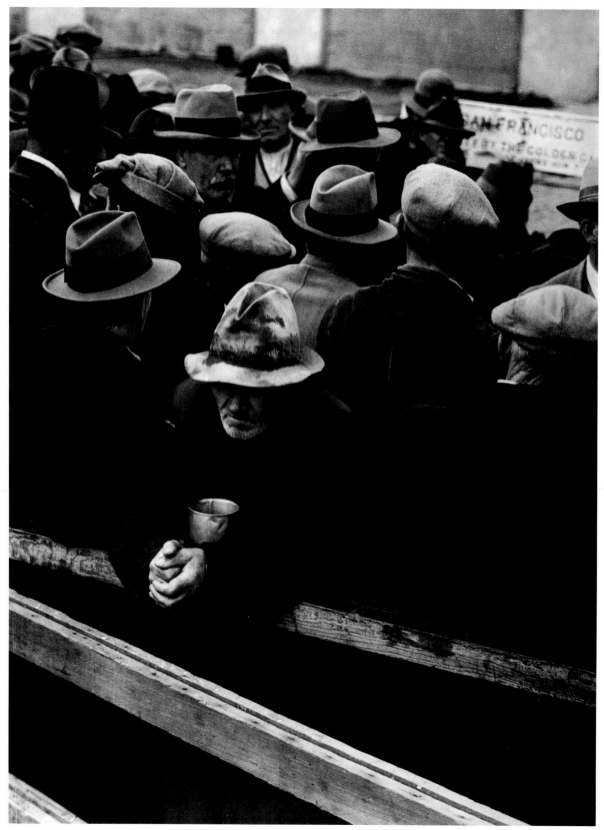

White Angel Breadline, San Francisco by Dorothea Lange, one of the most sensitive photographic chroniclers of the Depression.

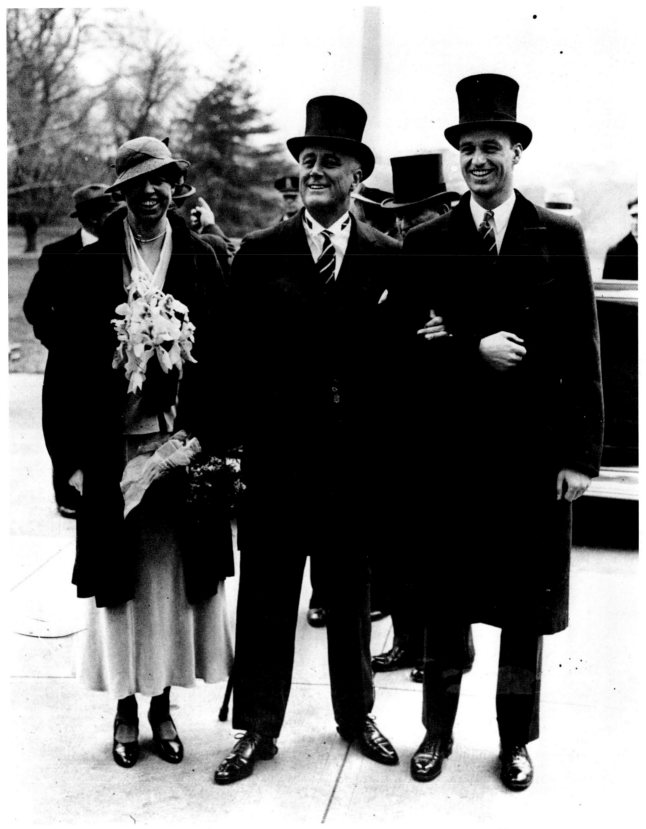

Franklin D. Roosevelt with his wife and son, having just become President of the United States.

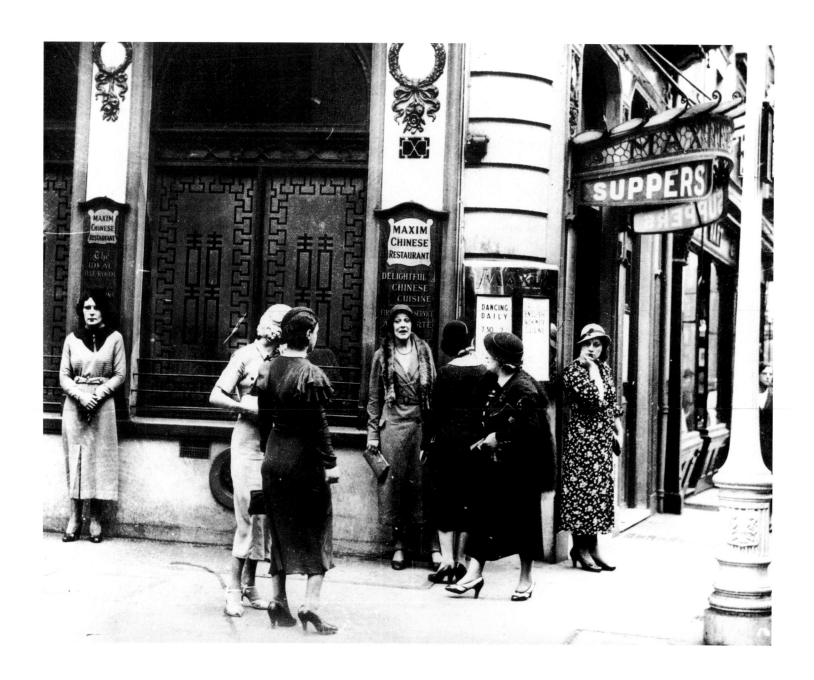

Streetwalkers on Gerrard Street, Soho – a unique document of London low life.

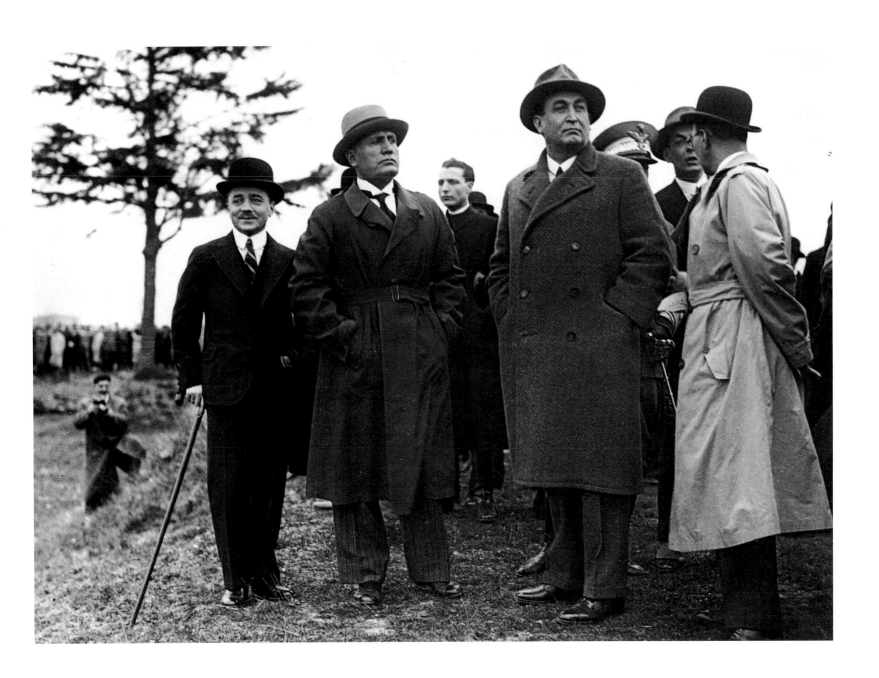

Mussolini (second from left) with Engelbert Dollfuss (far left), the Austrian Chancellor and Julius Gombos (second from right), the Hungarian Prime Minister.

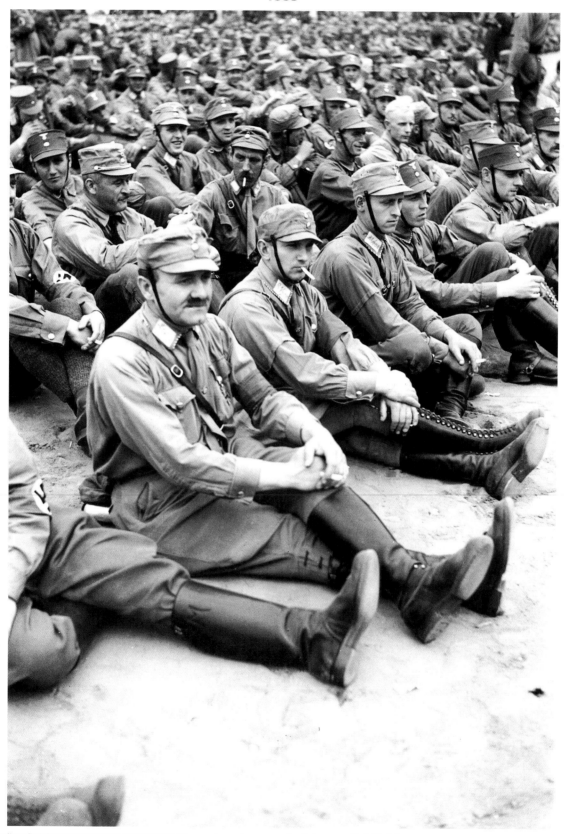

The first Reichsparteitag with the Nazis in power – storm troopers relax between well-drilled demonstrations of devotion to the cause.

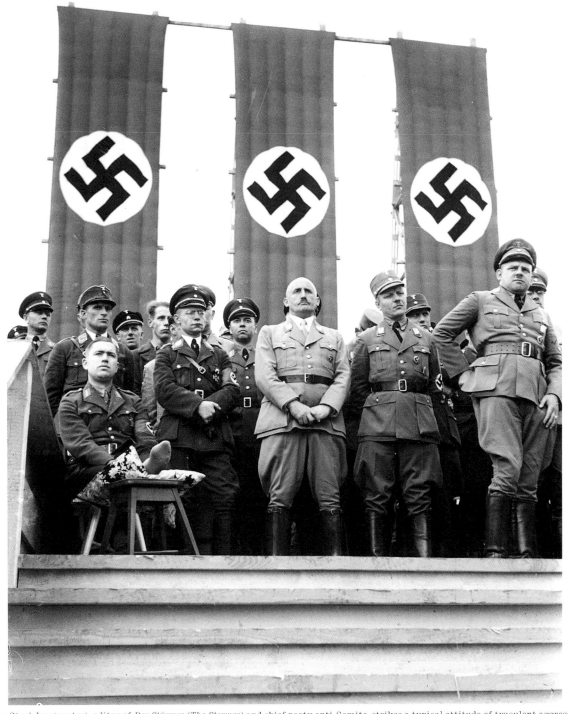

Julius Streicher (centre), editor of *Der Stürmer (The Stormer)* and chief party anti-Semite, strikes a typical attitude of truculent aggression.

1915

146. An Austrian soldier finds a moment of peace in the morning to read prayers. By 1915 the majority of soldiers, and even the most optimistic military planners realized that a long war was now inevitable. Nothing in human history had prepared for a war of such vast dimensions, generating a seemingly insatiable appetite for men and machines. Even the best-kept trenches were frequently cluttered with dead bodies and exhausted, undernourished soldiers.

147. Austro-Hungarian troops near Monastir (present day Bitola) in Serbia. Despite a maximum mobilized strength of over 2 million men, Austro-Hungarian troops had trouble getting the better of the Serb army which was nearly seven times smaller. The Serbs managed to repel three invasions by Austria-Hungary largely due to the skill of Serbia's veteran troops in familiar mountain territory. But the Central Powers were determined to defeat Serbia before Russia could mount a formidable defence of the country which was its Balkan ally. German, Bulgarian and Austro-Hungarian troops had penetrated deep into Serbia by late autumn of 1915.

148. The last photograph taken of the SS *Lusitania* from aboard the HMS *Glory* just outside New York. The British transatlantic liner *Lusitania* was torpedoed by a German submarine on 7 May 1915 on its way to Liverpool. The surprise attack resulted in the loss of 1,198 lives, including 128 Americans. Although German officials claimed that warnings to American citizens not to travel aboard Allied ships during the war had been posted in major US newspapers, the American public was outraged.

149. Surviving crew members of the *Lusitania*, whose valiant rescue work prevented an even greater tragedy. It was fully expected that an American declaration of war on Germany would follow the unprovoked attack on the liner. The public mood in the US was so war-like that William Jennings Bryan, the pacifist Secretary of State, felt compelled to resign. President Woodrow Wilson clung to his policy of neutrality, choosing

instead to send several notes of protest to the German government. Fearing US entry into the war, Germany refrained from further strikes on commercial shipping for two years.

150 top. The emergence at the turn of the century of the car and the agricultural tractor spawned experimentation with both armed and armoured vehicles across Europe. Few designs attracted much attention until the First World War broke out. In September 1915 a series of experiments commissioned by Winston Churchill, First Lord of the Admiralty, led to the construction of the first tank – called *Little Willie* – which was designed to cross wide trenches. The British army ordered a hundred of these tanks in February 1916. By the end of the war Britain had produced over 2,500 and France almost 4,000 tanks. Germany, the only other country to construct tanks during the First World War, built about twenty.

150 bottom . German women enjoying a break from work in a state munition factory. The urgent need for the maximum possible ammunition and weapon production compelled all of the warring governments to adjust radically their domestic economies. In Germany the economy and state machinery were re-organized in the form of war socialism called *Zwangswirtschaft* (state control). Methods of standardization and mass production were introduced, automatic machinery was widely adopted and for the first time German women entered the workplace in great numbers. By 1915, two out of every five workers in a typical armament plant in Germany were women.

151. Zeppelins, German airships, were first used in bombing raids over western Allied countries in 1915. The airship's ability to direct attacks on targets from above the clouds and carry bomb-loads in excess of 1,200 kilograms (2,000 pounds) struck fear into urban populations in France and Britain. In early September 1916 an attack on central London killed thirty-eight people. However, for the most part zeppelins were ineffective weapons (being fragile and slow and therefore easy to

attack) and failed to live up to their lethal reputation.

152 top. By mid 1915 the Russian army had suffered horrendous losses on both the Caucasian and Eastern Fronts, with nearly 3 million casualties. Devastating military defeats, primarily at the hands of the German army, triggered political and economic changes back in Russia. Tsar Nicholas II took direct command of the army in the autumn, temporarily bringing unity and coherence to the central military command, Stavka. Inept generals continued to be promoted however, and fighting between regional commanders over scarce munitions and supplies, together with a crumbling transportation and communications system, exacerbated an already desperate situation for Russian troops on the battlefield.

152 bottom. German soldiers aboard freight trains transporting goods to the Front. Once the state of deadlock on the Western Front became clear to the governments of the warring sides at the beginning of 1915, soldiers were instructed to fortify their positions while their generals considered new strategies of breakthrough. Masses of supplies were shipped to the front lines by rail, by far the most important means of overland transport available to the warring countries. During the Second World War railway lines became the scene of near-continuous fighting as they provided natural lines of retreat or defence during battle offensives.

153 top. Serbia, a largely rural country with few mineral or industrial resources, could hardly hope to win a war with an industrial power such as Germany or Austro-Hungary. After full mobilization the Serb army could only call on 350,000 men, many of whom were over-age and under-equipped. After fighting valiantly on the Balkan Front for nearly one-and-a-half years the Serbs found themselves virtually surrounded by the Central Powers and were forced to make retreat into Albania during blizzard conditions. By early December Serbia was completely overrun and suffered greatly, losing almost 15 per cent of its population during the following three years of German occupation.

153 bottom. On 11 June 1915 the Turkish government began deporting their Armenian population which they believed was creating disturbances in support of the Russians on the Caucasian Front. Local Turkish officials, gendarmes and irregulars attacked the deportees as they travelled. As many as one million Armenians are thought to have been killed, making it one of the worst genocides this century. Subsequent Turkish governments have not accepted the number of dead and have consistently denied Armenian claims that the massacre took place on direct orders from Turkey's political leaders.

1916

154. British soldiers practising trench-building techniques in the British countryside before going off to the Western Front. Trenches built early in the war were often little more than a hastily improvized system of fox-holes dug by soldiers with their hands or a shovel, and were readily abandoned during the course of battle. The French and Germans were the first to recognize that the static intensity of the war on the Western Front necessitated the development of sophisticated trench systems lined with timber or fortified with concrete, protected by sandbags and offering habitable accommodation facilities.

155. An Australian officer wading through a mud-filled trench at Guedecourt, France. The physical condition of trenches varied considerably according to season, geography and construction-type. British trenches were notorious for the poor drainage that turned them into unhealthy mud baths during rainy weather, forcing troops to sleep in caves scraped out of the walls. During the first year of the war, an epidemic of Trench Foot (a fungal infection caused by the unsanitary conditions) claimed 20,000 casualties in the British Army alone. Later, during winter offensives on the Eastern Front, both Russian and Austro-Hungarian troops froze to death *en masse* in their trenches which were poorly equipped for long-term occupation.

156. A gas sentry ringing the alarm near Fleurbaix on the

Western Front. On 22 April 1915 during the second battle of Ypres, the Germans used lethal chlorine gas in battle for the first time. It was carried towards Allied positions by the wind. Use of poisonous gas had been anticipated before to the First World War, but until the static nature of trench warfare forced combatants to explore new attacking methods, it was generally regarded as an uncivilized weapon. Although the use of gas spread total panic in the enemy, it was not the decisive weapon anticipated by its early proponents. Counter measures such as gas masks, protective clothing and early warning systems – introduced within days of the first attack at Ypres – ensured that only 3 per cent of gas casualties were immediately fatal.

157. The steadfastness and fighting spirit of the German army, so pervasive among its young troops at the war's outset, would never be fully recovered after the battles of 1916 in France. Soldiers who survived the prolonged attritional warfare on the Western Front became increasingly disillusioned with a German institutional order that sent men to slaughter without any clear objective other than furthering the imperialist ambitions of the ruling few. For most soldiers anything – including agricultural work in Britain – must have seemed preferable to the blood baths of the Somme and Verdun.

158. The *Queen Mary* blew up and disappeared completely within ninety seconds after taking a hit during the Battle of Jutland. The battle between the British Grand Fleet and the German High Sea Fleet in the North Sea on 31 May 1916 proved to be one of the great anti-climaxes of the war. Although the proportions of the battle were immense (it involved 274 warships and 70,000 seamen), Jutland revealed that great battleships could not secure maritime supremacy for any side in the way naval strategists had envisaged. The battle was a minor tactical success for Germany, but British control of the North Sea remained intact and German naval vessels were kept close inshore for the rest of the war.

159. British soldier carrying a wounded comrade in a real-life

still from *The Battle of the Somme*, a film shot by Lieutenant Geoffrey H. Malins. The film depicted the horror from what was – especially for British soldiers – a devastating battle. Only a few hours after it had begun on 1 July 1916, Britain had suffered 58,000 casualties, one-third of whom died, making it the worst loss of life in a single day in British military history. Contemporary critics of the film alleged that scenes had been faked and questioned whether it was an accurate rendering of the war. While the filmmakers were doubtless guilty of some tinkering with reality in the making of *Somme*, their contribution to the battlefield documentary genre is indisputable.

160. Karl I was recalled from active duty on the Italian Front to become Austrian Emperor on 21 November 1916, and King of Hungary on 30 December. Nephew of the assassinated Archduke Franz Ferdinand, Karl was a humanitarian with strong liberal beliefs. Moderate politicians in both his kingdoms were receptive to his reformist programme, but his desire to halt strategic bombing and restrict the use of gas brought condemnation from his senior commanders. He deplored the Austro-Hungarian Empire's dependence on Germany and was committed to seeking a compromise peace with the Allies. His influence waned as the administration of Austria fell increasingly under German control.

161 top. Young female workers having fun with wood shavings from propellers at an aeroplane factory in Nottingham, Britain. In 1914 the aero-industries of the major Allied countries ranged from modest to non-existent. At the time aeroplanes were fragile, low-powered machines, too feeble to be an effective attacking weapon, but suitable for reconnaissance and observation duties. The fighting in Europe, especially on the Western Front, quickly revealed the military potential of these machines, encouraging governments to invest heavily in developing large-scale production facilities back home. By the end of the war all the countries involved could each field several thousand aircraft.

161 bottom. Britain's system of war management was failing

miserably by the end of 1914. Ammunition production could not keep pace with the great increase in demand, but attempts to renew a depleted workforce with unskilled labour, particularly women, met with stiff opposition from unions. However, the Shells and Fuses Agreement of March 1915 made between employers and organized labour, accepted 'dilution' within the workforce for the duration of the war. Soon after, women in Britain comprised 60 per cent of the workers manufacturing shells. By mid 1916 weapon production had expanded to produce the total output of 1914 within a matter of days.

162 top. Serbian soldiers in retreat on the Albanian frontier. On 23 November 1916 the Serbian Army Chief-of-Staff Radomir Putnik ordered his beleaguered troops into the mountains, away from the advancing armies of the Central Powers. The only viable escape route was a mountain pass through Montenegro and Albania. Ferocious winter weather and a severe shortage of supplies resulted in perhaps as many as 200,000 deaths, including POWs and Serbian refugees who had joined the exodus. Survivors began reaching the Albanian frontier in early December. The retreat ensured further military participation in the war for the Serbian army, which was redeployed for battle in Greece nine months later.

162 bottom. The battles of Verdun and the Somme resulted in roughly a million German casualties in 1916, to say nothing of German losses on the Eastern Front and other areas of the war. In the autumn of 1916 the new German Third Supreme Command team of Erich von Ludendorff and Paul von Hindenburg – both hailed as heroes in Germany after leading the spectacular German victory at Tannenberg – made the decision to abandon offensive operations in France and withdraw their battered troops to their newly-established Hindenburg Line. Retreat to these defensive fortifications behind the northern and central sectors of the Western Front signalled a change in German military strategy, which was no longer predicated on further gains into France. However it did little to lessen the suffering of soldiers on either side.

163. French soldiers in the trenches at Verdun. The chief objective of the great German offensive of 1916 was a ring of fortresses which stood around the French town of Verdun, forming the main obstacle on the route to Paris from the East. At the beginning of their offensive in February, with one million soldiers of Kaiser Wilhelm's Fifth Army facing about 200,000 French defenders, Germans generals mistakenly believed they could 'drain the blood' of French soldiers until surrender was their only option.

164. On 24 April 1916 in the wake of the Easter Rising in Dublin, the Irish nationalist leaders of Sinn Fein and the Irish Republican Brotherhood occupied the main post office in Dublin and proclaimed a provisional independent government. Over the next few days the rebels fought running street battles with British garrison troops and attempted to seize Dublin Castle. On 27 April the British Government imposed martial law over the whole of Ireland. Three hundred people died in the fighting before the rebels, frustrated in their hopes for German assistance, surrendered. The Rising collapsed, but Irish nationalists scored a major propaganda victory in a struggle for independence which was just beginning.

165 top. Invented in 1884, automatic machine guns were capable of firing an unbelievable 600–700 rounds a minute. The most effective defensive infantry weapon of the period and perhaps second only to artillery in killing potential, the machine gun was well suited to cutting down enemy soldiers during the massive frontal assaults which typified the First World War. The widespread use of machine guns (Germany alone produced 100,000 between 1914 and 1918) was one of the primary reasons for the greater number of casualties suffered by attackers compared to defenders driving the war. During the British offensive on the infamous opening day of the Battle of the Somme, German machine guns accounted for 90 per cent of British casualties.

165 bottom. The German front line at Verdun. The loss of the famous French fortress of Douaumont on

25 February, just four days into the German offensive, sparked an explosion of emotions throughout France, making capitulation a moral and political impossibility for the country's leaders. A few days before the battle finally ended, a week before Christmas 1916, Douaumont was eventually recaptured. After ten months of relentless slaughter, the Germans had destroyed several villages and gained only a few kilometres along a 35-kilometre (22–mile) front. Verdun typified the nature of the 'war of deadlock' on the Western Front: despite enormous casualties (the highest of the war) neither side gained much of an advantage.

1917

166. For three years, neither the Germans nor the Allies advanced more than a few miles along a north-south line stretching from Nieuport on the Belgian coast, through Ypres, to Verdun in France and finally ending at the Swiss frontier. The increasingly mechanized nature of the conflict, combined with the static intensity of trench warfare, ensured that the number of dead soldiers far exceeded that of previous wars.

167. In 1917 an unusually rainy summer combined with unrelenting artillery bombardment transformed the low-lying Flanders region of Belgium into a vast mud swamp. It was in these conditions that the Allies attempted to break through the German lines. British and Canadian soldiers were ordered to attack Passchendaele, a ridge that military leaders held to be essential to the success of the campaign. But weary soldiers, facing a German force bolstered with reserves as well as relentless mustard gas attacks, merely floundered in the mud and drowned in shell holes. Finally, after five months of senseless slaughter during which the Allies advanced barely 8 kilometres (5 miles) past the starting point of the offensive, British generals who had ordered the assault but never actually witnessed it, finally halted the campaign.

168 top. Italian families seeking refuge in the dungeons of the famous palace of Countess Papafava, opened to the citizens of Padua following the attack on the city by Austro-Hungarian forces.

By the winter of 1917 Italy's woeful performance during the war had caused widespread humiliation and despair among most Italians. On the Italian front lines mass desertions became commonplace as the army appeared powerless to stop Central Power aggression, which was only resisted by the intervention of French or British forces. The shame of Italy's First World War effort was not easily forgotten in the inter-war years.

168 bottom. An Irish Republican on hunger strike in support of leading nationalist propagandist and Sinn Fein organizer Thomas Ashe. After being charged and jailed for 'inciting the civil population' in August 1917, Ashe organized a hunger strike to protest their lack of political rights among members of Sinn Fein imprisoned at Mountjoy Prison on 20 September. He died five days later while being force fed by the authorities. A subsequent inquest concluded that police treatment of Ashe warranted censure, and calls for Irish independence grew louder.

169 top. The British general Edmund Allenby was appointed Commander on the Palestine Front in June 1917. Eager to rebuild his tarnished reputation after the British set-back at Arras, Allenby boldly led an advance through Palestine to drive out the Turks. After taking Gaza and Jaffa, he captured Jerusalem on 9 December. Although most of his troops in the region were withdrawn to fight in France, Allenby continued to play a vital role in the Middle East throughout 1918. He mounted further successful offensives against the Turks in Syria, and joined operations with the Arab Revolt. He become a celebrated military hero in both Britain and Arabia.

169 bottom. The Hungarian-born André Kertész acquired his first camera in 1913, but any hopes of a career in photography were put on hold when he was drafted into the Austro-Hungarian army the following year. He was wounded in battle and paralyzed for a year, but still managed to produce his first serious works – photographs of soldiers on the Eastern Front. Sadly all his negatives from this period were destroyed in 1918. After the war, Kertész lived in

Paris before settling in New York, producing some of the century's most famous photographs during his long and distinguished career.

170. When French writer, artist and filmmaker Jean Cocteau decided to stage a theatrical event in collaboration with Sergei Diaghilev's Ballet Russe, he sought help from friends and fellow avant-garde artists Pablo Picasso and Erik Satie. Picasso designed the sets and costumes and Satie composed the music. The result was *Parade* (1917), a ballet about a circus side-show, incorporating imagery of the new century such as skyscrapers and aeroplanes. Bewildered audiences were not quite sure what to make of Picasso's shockingly synthetic Cubist costumes. The one pictured represents a burgeoning America.

171 top. Draft registration in New York City. After the US broke diplomatic relations with Germany in early February, popular anti-German feelings intensified, especially following the publication of the Zimmerman Note on 4 March. The intercepted telegram sent from Arthur Zimmerman, the German Foreign Minister, to Johann Bernstorff, the German Ambassador in the US, revealed their government's decision to resume unrestricted submarine warfare. It was also suggested that Mexico would receive German assistance in the re-conquest of Texas, New Mexico and Arizona, if an alliance between the two countries could be secured. On 6 April 1917 the US finally declared war on the German Government (rather than its subjects), and all US male citizens aged between twenty-one and thirty (later expanded to include men aged between eighteen and forty-five) were required to register for the draft within two months.

171 bottom. Immediately following the declaration of war a division of the American Expeditionary Force was sent to Europe, but its role remained largely symbolic until March 1918. Eventually nearly six-and-a-half million Americans were conscripted into the new army. The presence of the Doughboys (the popular nickname of the US conscripts sent overseas) on the Western Front provided an enormous boost to Allied morale, but the long-awaited American

intervention also prompted Germany into launching a massive all-out offensive in the spring.

172 top. Bolsheviks fight the army of the Provisional Government on the streets of Petrograd during the July Days Uprising. In the tumultuous year of 1917, two main groups emerged in the struggle for control of Russia after the abdication of Tsar Nicholas II. The liberal intelligentsia, who sought to transform Russia into a democratic republic and to continue the war effort, were initially the most successful faction and formed the first post-tsarist government. The Bolsheviks challenged this new provisional government's every move. Led by Lenin, the Bolsheviks sought an immediate end to the war with Germany and the establishment of the world's first Communist state.

172 bottom. Eagles being prised from shop fronts during the February Revolution. Russia's woeful performance in the war, combined with civilian shortages and long-standing social tensions, resulted in an outbreak of spontaneous strikes and riots in Petrograd (present-day St Petersburg) on 8 March 1917. Troops ordered to crush the demonstrations sided with the rebels. In response the Duma (Russian parliament) appointed a provisional government under Prince Lvov, which secured the abdication of the Tsar on 15 March. The Julian calendar being thirteen days behind by Western reckoning, this March revolution was named the February Revolution by Westerners.

173 left. Vladimir Ilyich Lenin in disguise. Despite a long exile following the 1905 revolution, Lenin was still Russia's most important revolutionary and ideologue when he returned secretly to Russia with German assistance in April 1917. Profoundly influenced by the teachings of German philosopher Karl Marx, Lenin exhorted his followers to overthrow the new Provisional Government and prepare for the remaking of Russian society on a Marxist (communist) basis. After the first attempt to topple the new government failed in a period of unrest known as the July Days, Lenin temporarily went into hiding.

173 right. Aleksandr Kerensky arriving at a Moscow museum for a state conference. A democratic socialist revolutionary, Kerensky secured rapid promotion in the Provisional Government on account of his prodigious intellect and boundless energy. Only thirty-six years old, he became its leader and immediately confirmed his commitment to the continuance of the war, a move greatly at odds with an overwhelming majority of Russians who sought peace. His attempt to arrest members of the Bolshevik Revolutionary Command (MRC) on 5 November led to his expulsion from office two days later. After a brief attempt to organize resistance to his Bolshevik ousters, Kerensky escaped to France.

174 top. Tsarist treasures seized during the revolution. By early 1917 the patriotic upsurge accompanying Russia's entry to the First World War had given way to deep anxiety and anger in Russian society. Under the Tsar who arrogantly assumed command of all Russian forces in 1916, ill-equipped and ill-fed Russian soldiers suffered defeat after defeat at the hands of the German army. Critics at home in Russia blamed the petty feuds, intrigues and sheer stupidity among the tsarist leadership, but opposition voices were repeatedly ignored. When the Tsar's brother, Grand Duke Michael, declined the crown the day after Nicholas II abdicated, the monarchy in Russia came to an end.

174 bottom. Severe consumer and industrial shortages in wartime Germany were largely a result of the Allied naval blockade and the Hindenburg Programme. Begun in September of 1916, the Third Supreme Command's comprehensive programme of funnelling the country's entire industrial base towards military production – prompted by a massive growth in Allied arms output – necessitated widespread production of substitutes for goods and materials no longer available. Some ersatz products were successful and were produced widely after the war, but many others, such as these impractical iron tyres, failed to catch on.

175. Weary-eyed German prisoners after a successful operation by the British. By 1917 the fighting strength of Britain

was growing, but the war itself had dragged from a situation of desperation to one of deep crisis. With Russia out of the war and France teetering on the edge of collapse, the burden of holding the line until the US could join the fighting fell primarily on British soldiers. Meanwhile, etched on the faces of all combatants were the sacrifices and stresses of a war that was pushing both armies to the limits of human endurance.

176 top. Leon Trotsky and Soviet delegates arriving at Brest-Litovsk in December of 1917 to begin peace talks with Germany. While Russia's new Bolshevik leadership was neither willing nor able to continue fighting Germany on the Eastern Front, the German Third Supreme Command was eager to release troops for service on the Western Front. On 3 March Trotsky, the Bolshevik Foreign Minister, eventually brokered a deal that formally ended hostilities between the two countries, but also deprived Russia of territory holding about 30 per cent of its imperial population. Denounced by the Allies and repeatedly breached by the Soviets, the Treaty of Brest-Litovsk was officially annulled as part of the Armistice agreement.

176 bottom. In early April 1917 the British Third Army under General Edmund Allenby launched an attack on long-established German front-line positions around Arras, France. Anticipating the attack, the Germans had fortified their positions and ensured that reserve troops were in place. As was so often the case, exhausted troops were ordered to attack the German line long after any strategic gain could be achieved. By the time the offensive was halted in late May, 150,000 British soldiers had been lost.

177. Underground explosions occurred almost daily all along the Western Front, especially around heavily contested hills and ridges. Miners dug tunnels under opposition lines, then filled the tunnel with explosives ready to be detonated under enemy positions prior to an assault. Soldiers often occupied and defended the massive craters formed by the explosions, as these soldiers concealed in dug-outs appear to be doing. British General Herbert Plumer remarked before the great attack on

Messines in June 1917, 'we may not make history tomorrow, but we will certainly change the geography'. During the attack a single detonation of mines under German positions killed an estimated 10,000 soldiers.

1918

178 top. Chinese New Year celebrations in a labour camp at Noyelles, France on 11 February 1918. Although China was unable to raise an expeditionary force for overseas military service during the war, about 320,000 Chinese – mostly from coastal regions around Hong Kong and other British enclaves – participated in the Allied war effort as labourers. Chinese recruits began arriving in Europe in 1914, but the numbers increased dramatically after China declared war on Germany in August 1917. By the end of the war roughly 100,000 Chinese were serving British forces, while about the same number of Vietnamese were assisting the French.

178 bottom. British prisoners captured during Germany's March offensive in 1918 taking a short period of rest by the roadside at Pérrone, France. The dramatic early success of the offensive, in which the first positions of the British all along the Front were overrun, provoked an acute sense of national crisis back home in Britain. Conscription was immediately stepped-up and the British public rallied together with a sense of unity and purpose not seen since the early days of the war. But for the troops across the channel, weariness had given way to sheer exhaustion.

179 left. The Tsar and his family photographed on the roof of the house in Tobolsk, western Siberia, where they were held captive between September 1917 and April 1918. Following Nicholas II's abdication, the Provisional Government had intended to send the deposed Romanov family into exile in England, but opposition from the Petrograd soviet and a cold response from Britain's King George V meant an alternative had to be found. During their house arrest the Romanovs were first sent to Tobolsk and then to Yekaterinburg in the Ural Mountains. There, on the night of 16 July 1918, Nicholas and his family were executed after local officials were ordered to prevent

their rescue by approaching anti-Bolshevik White Russian forces.

179 right. The Salvation Army provided succour for the wounded of the First World War, but could only try to bridge the chasm of experience that separated soldiers at the Front from people back at home. Soldiers often discovered that they could not convey the realities of their experience – trench squalor and despair, mechanized slaughter, combat comradeship – to those not involved. For those soldiers most affected by the experience of war, reintegrating into their national communities proved an impossible task.

180. By the autumn of 1918 German troops faced an Allied counter-offensive and were depending heavily on the strength of their Hindenburg Line defensive fortifications to save them from imminent defeat. The St Quentin Canal formed a crucial part of the fortifications, and was filled with traps and barbed wire. Its steep sides varied between 50 and 80 metres (15 and 24 feet) in height, while at its bottom lay several metres of water and mud. On 29 September, the British Fourth Army stormed the strongest section of the line, crossing the canal using a variety of improvised structures. This section of the line was no longer salvageable; without similar fortifications to fall back on, retreat became the only alternative for the German army.

181. By June of 1918 the German spring offensive had exceeded anything achieved by the Allies in the West since the beginning of the war, and its troops were once again on the Marne and threatening Paris. However, their advance took place against a backdrop of economic and political turmoil in Germany which meant that their army was without adequate transport or artillery supplies. The well equipped Allied counter-offensive began at Amiens on 8 August 1918 – a day described by Ludendorff as the 'black day' for the German army in the history of the war. In the three months between the Battle of Amiens and the armistice, the British alone captured 188,700 German prisoners.

182. Winston Churchill in the Grande Place in Lille, France,

watching the Allied 47th Division march past on 22 October 1918. Although he had entered the war a much-admired politician and keen military strategist, the future British Prime Minister's reputation suffered greatly after being blamed for the disastrous Gallipoli campaign in 1915. Forced out of cabinet, Churchill served briefly on the Western Front in France, before returning to England in 1917 at Prime Minister Lloyd-George's behest, to become Minister of Munitions, and eventually War Minister.

183 top. Wrecked German planes at the *Fête d'Alsace-Lorraine* a week after the armistice was signed. The final armistice, marking an Allied cease-fire with Germany, came into effect at 11.00 am on 11 November 1918. Allied losses in devastated territory and economic upheaval brought fervent calls for harsh revenge on Germany. The armistice, ending more than four years of war and unimaginable despair and pain for Europe, sparked a wave of euphoria across the Allied countries and feelings of sheer relief among the German population.

183 bottom. German soldiers returning home to Berlin. The armistice was the formal recognition that, after more than four years of monumental struggle, the Imperial German Army had at last been defeated. However Germany had still not been invaded and when the guns fell silent the German front line still lay on French and Belgian territory. Many argued that Germany had not been beaten in the field. Rather, its fearless soldiers and generals had been sold out by weak-willed leaders who were prepared to accept any conditions in order to achieve peace. In the post-war years this belief developed into a powerful myth and was seized upon by future German leaders and exploited to great effect.

184 top. The US threatened to secure a separate peace with Germany if the Allies did not agree with President Woodrow Wilson's Fourteen Points. This controversial programme for peace was agreed to by the German leader Max von Baden who, on 4 October 1918, made a formal request for a cease-fire on terms specified in the programme.

Wilson finally secured official Allied endorsement of his peace plan after a month of vigorous debate with France and Britain, both of whom were wary of Wilson's liberal internationalist intentions. The armistice with Germany was signed in the railway carriage of the Allied Supreme Commander Marshal Ferdinand Foch in the forest of Compiègne, north-east of Paris, on 11 November.

184 bottom. The first released British POWs to reach Tournay, Belgium, after the armistice on 14 November 1918. Following the armistice, waves of POWs and refugees flooded across the occupied areas of Europe.

185. During the war Germany possessed the largest, most technically advanced and widely used fleet of underwater boats in the world. Britain's pre-war fears of the devastating potential of Germany's submarines on the high seas seemed confirmed by a spate of sinkings of Allied warships during the initial stages of the war. Over time Germany's efficiency in battle proved less decisive, due partly to the anti-submarine manoeuvres adopted by the Royal Navy. However, Germany's deployment of submarines against Allied commercial shipping resulted in heavy losses. This strategy called *Handelskrieg* (literally trade warfare), was officially unrestricted after 1 February 1917, and brought Britain to the verge of a supply crisis in mid 1917. It became necessary for convoys to escort Britain's merchant ships. By the time of the armistice, Germany had lost 5,400 submarine crew and 192 vessels.

186 top. Refugees stopping by the roadside in Serbia, just after the armistice. The disordered waves of refugees fleeing occupied areas of Europe in the aftermath of the First World War were evidence that the end of hostilities did not necessarily mean the end of suffering. Most experienced great hardships during the long, arduous journeys back to their homelands. Until food and welfare stations were set up along main routes to assist the hungry and the ill, the distress among refugees in some regions was acute. That of Serb refugees was increased by the knowledge that almost 15 per cent of their population had been wiped

out during the Central Powers' occupation of their country.

186 bottom. Little more than a month after assuming power, the new Bolshevik regime in Russia faced its first military uprising. For the next three years its troops fought counter-revolutionary forces (known collectively as the White Army) throughout the former empire, and provided support to Bolshevik uprisings in newly-independent states on the Russian border, including Finland, Poland and the Baltic states. In addition to political confusion and regional anarchy a small number of foreign troops including British, French and Japanese were fighting in support of the White Army.

187. The German radical socialist group, the Spartacists, took their name from Spartacus, leader of the slave revolt against Rome in 73 BC, but the goals of the Spartacists were very specific to war-torn Germany. Co-founders Karl Liebknecht and Rosa Luxemburg vehemently opposed German participation in the First World War and advocated a Socialist revolution, similar to that which had occurred in Russia the previous year. In 1919 the Spartacists and other left-wing groups were united under the new German Communist Party (KPD), and its members were told to prepare themselves for the downfall of the unstable post-war government.

1919

188 top. On 6 January 1919, encouraged by developments in Soviet Russia and fearful that the political situation in Germany might stabilize, the Spartacists seized key government and communication centres in Berlin in their attempt to gain power in Germany. For the next seven days Germany's fragile new government fought to avoid the same fate that the Provisional Government in Russia had suffered at the hands of socialists two years earlier.

188 bottom. Forces of the German Republic defending a barricade at the newspaper publishing-factory Ullstein. The lack of mass support for the Sparticist revolt among German workers was evident from the outset and within a week it had been put down by a few

thousand *Freikorps* soldiers (volunteers) returning from the Front. Germany was not yet ripe for revolution as the Sparticists' ringleaders, Luxemburg and Liebknecht, had believed it was. They were both executed during the final stages of the uprising on orders from the *Freikorps*.

189. The Spartacist uprising came to an end when its leaders, Liebknecht and Luxemburg, were executed on 15 January. Over the next three months *Freikorps* units, driven more by a hatred of Communism than loyalty to the new German Republic, carried out a brutal purge of left-wing politicians and organizations. Their unwillingness to oppose a radical nationalist coup attempt the following year – the Kapp *putsch*, which failed – signalled that the prospect of future armed challenges to the Republic by anti-communists was likely, if not inevitable.

190. A horribly wounded French soldier taking part in Armistice Day celebrations. France mobilized fewer troops than Britain during the war, but suffered almost 50 per cent more casualties (roughly 4.2 million, including 1.3 million dead). During the climactic battles of 1918 French forces were so devastated that they could play only a supporting role to their British and American allies. When the end came there was great relief among the French, but hardly a sense of victory. The desire for revenge against Germany was so great that even the punitive measures fixed in the Treaty of Versailles, considered unduly harsh by many contemporary experts, were judged far too lenient by the French public.

191. A wounded American soldier watching the parade of his comrades in New York City. More than 2 million American troops eventually reached Europe, though many were too late to see any action. Nonetheless, the Doughboys played a vital role in the battles for final victory. About 200,000 black soldiers served in American units sent to Europe, but only 42,000 were classified as combat troops. African–Americans were completely segregated and fought in the 93rd division of one hundred eventually formed; they also fought in the 157th division in the more racially tolerant French army.

192. On their way to the Versailles Peace Conference British Prime Minister, David Lloyd-George; French President, Georges Clemenceau; and US President, Woodrow Wilson. The fate of post-war Europe – and much of the international structure – lay in the hands of these three men, but they found themselves poles apart on many of the most contentious issues. Wilson infuriated Clemenceau with his unrelenting idealism and his passionate pleas for reconciliation and a liberal international order based on ethnic self-determination and moral principles. Clemenceau, who survived an assassination attempt during the conference, advocated severe punishment for Germany and total security against future German aggression. Lloyd-George tried to be pragmatic, but ended up siding with his French counterpart on Versailles' most controversial issues: reparations and the war-guilt clause.

193 top. British sailors viewing the surrender of the German High Seas fleet at Scapa Flow in the Orkney Islands. The formidable German fleet still posed a serious threat to Britain at the time of the armistice in November 1918. The previous month German soldiers had refused an order to carry out a suicide mass-attack on the British, triggering a large-scale mutiny and plunging the fleet into chaos. Order was eventually restored and the ships sailed to Scotland, surrendering in the Firth of Forth on 22 November. The majority of old or small vessels was scrapped or adapted for post-war minesweeping; newer ships were transferred to Scapa Flow. On 21 June 1919 Commanding Officer Admiral von Reuter, fearing the British were about to seize the fleet as war bounty, secretly advised the minimal German crew still aboard the ships to scupper the entire fleet. By the end of that day, seventy ships had been sunk.

193 bottom. Allied officers trying to catch sight of the historic signing of the peace treaty formally ending the war with Germany at the Palace of Versailles on 28 June 1919. The victorious Allies tried to accommodate on the one hand the French and British demand for harsh measures to be imposed on Germany, and on the other US determination to see the

establishment of a new ethically-rooted international order, and reconciliation between Germany and the rest of Europe. The final terms of the treaty, especially Article 231 which assigned all blame for the war to Germany (the war-guilt clause), were strongly criticized in Germany and to a lesser extent in the US, as being unjust. Although Germany signed the treaty under protest and the US Congress refused to ratify it, many in France and Britain argued that the terms were too lenient.

194. Emiliano Zapata's body being shown to the camera by his comrades after his assassination. Zapata was a leader of Mexico's Indian peasants, champion of agrarian reform and the most idealistic of all leaders of the Mexican Revolution. He set up the Rural Loan Bank and an impartial commission for land distribution under his troops' control in southern Mexico. Together with Pancho Villa he organized attacks against Venustiano Carranza's government which opposed agrarian reform. On 10 April 1919 Zapata was lured by Carranza's agents to a hacienda in Morelos where he was executed.

195. A statue of General Paul von Hindenburg being destroyed in Berlin. Friedrich Ebert, leader of the new German Republic proclaimed on 9 November 1918, was determined to turn Germany into a loosely defined social republic. Threats to his government (by Spartacists in particular) were mounting all over the country. His programme of post-war reconstruction involved dismantling the last vestiges of the old German nation whose military mindset and virtues were embodied by Hindenburg.

196. The Vickers-Vimy biplane flown by John Alcock and Arthur Whitten Brown landed in a marshy bog on the west coast of Ireland after their historic transatlantic flight. With Alcock in the pilot's seat and Brown as navigator, the pair set out on the 3,040 kilometre (2,000 mile) journey from Newfoundland, Canada, on 14 June 1919. Sixteen-and-a-half hours later they safely landed near Clifden, County Galway in Ireland, having completed the world's first non-stop transatlantic flight. They shared a £10,000 prize offered by the London *Daily Mail* and both

men also received knighthoods for their achievement. Alcock died in an aeroplane accident in France soon afterwards.

197. The free spirit and elegance of Jacques-Henri Lartigue's early work is exhibited in this photograph of Gaby Deslys and Harry Pilcer being filmed at Deauville on the north coast of France just after the war. At the age of seven, Lartigue was troubled by his inability to capture motion with his cumbersome first camera given to him by his parents. A year later he was given the more practical hand-held Brownie No. 2 camera, and set about capturing scenes from the lives of the leisured classes as well as anything else he found interesting.

198 top. The American photographer Lewis Hine travelled to Europe at the end of the war to record the relief activities of the International Red Cross. His photographs of wounded soldiers (here an Italian soldier in hospital) and refugees emphasized the underlying humanity of all victims of battle, whether enemy or friend. But his was only a partial record. Many of the wounded of the First World War were so horribly damaged by the blasts of war that they were kept from public view forever.

198 bottom. A still from the making of the great German Expressionist film, *The Cabinet of Dr Caligari* (1920). Director Robert Wiene employed three prominent Expressionist artists, Herman Warm, Walter Röhrig and Walter Reimann, to construct sets of exaggerated dimensions and bizarre spatial designs that would convey the warped mind of the film's narrator – a madman confined to an asylum. The film centres on a series of brutal killings in a sleepy town in northern Germany committed by a sleepwalker apparently under the influence of a disturbed man who believes he is the reincarnation of an eighteenth-century homicidal hypnotist Dr Caligari. Wiene's use of decor and lighting to convey troubled psychological states was shockingly original and had a wide impact on German cinema.

199. An African–American man being cremated by a lynch mob, after hundreds of whites had

stormed the courthouse where he was being held in Omaha, Nebraska, and took justice into their own hands. The man, who had been accused of assaulting a white girl, was mutilated and then shot several times before being burned. In post civil-war America, lynching became the preferred method of summary execution, particularly of blacks accused of crimes against whites. Of the 4,720 recorded cases of lynching in the US between 1882 and 1951, three-quarters of the victims were black.

1920

200. Famed Bolshevik writer Maxim Gorky with, among others, Lenin, Grigori Zinoviev and Nikolai Bukharin at the Uritsky Palace, Petrograd. Regarded by many as the father of Soviet literature, Gorky first gained international recognition with the appearance of his play *The Lower Depths* (1902). At this time he was also politically active and became associated with Lenin and other Bolsheviks. Forced to flee Russia after his involvement in the 1905 revolution, Gorky returned eight years later and published a series of scathingly anti-Bolshevik articles in his newspaper *Novaya Zhizn* (*New Life*). Like Zinoviev he was opposed to the violent seizure of power being advocated by Lenin. Gorky fell out with Lenin, and eventually also with Zinoviev, and was once more forced to flee Russia in 1921. He settled in Italy where, for a time, he was the world's most famous communist writer living, ironically, under the world's only fascist regime.

201. The launching frame used by the father of modern rocketry, Professor Robert H. Goddard, in experiments to send an early rocket 50 kilometres (30 miles) into the air at 1,126 kilometres (700 miles) per hour. Goddard began his work on rocketry in 1912 and seven years later published *A Method of Reaching Extreme Altitudes*. On 16 March 1926 he launched the first liquid-fuel rocket. It was only after his death that he was given due recognition for his pioneering work, which led directly to the founding of the National Aeronautics and Space Administration (NASA) and the US space exploration programme.

202. A conflict over disputed territory between Bolshevik Russia and Poland had been

brewing since the end of the First World War. During the last stages of a civil war that had engulfed Russia following the October Revolution, the Bolshevik Red Army launched an offensive into Poland. The offensive was pushed back on the approach to Warsaw and the Red Army decisively defeated in a battle on the Vistula River. The Polish victory, named the Miracle of Vistula, crushed the Bolshevik's last chance of a widespread revolution in central and Eastern Europe and was the last aggressive military action it would take outside its own frontiers until the outbreak of the Second World War.

203. Britain's King George V with Prince Henry at the Epsom Derby. During his reign George V made great strides in bringing the British monarchy closer to the people. His regular appearances at numerous sporting events and public occasions made the monarchy genuinely popular. In an era of great social change at home and abroad, George V's quiet dignity and conciliatory manner contributed greatly to the relative political stability post-war Britain enjoyed during this period.

204. Officers of the Irish Republican Army (IRA), which was formed by Michael Collins in January 1919 to fight against British rule in Ireland until a unified republic was established. The organization's rapidly growing strength in the south was bringing the country to the brink of civil war. The British government responded by passing the Government of Ireland Act (1920). Under this legislation, Ireland was divided into two self-governing areas, one comprising the six counties of the north-east and the other the twenty-six counties in the south.

205. During the Irish War of Independence, the Cairo Gang provided intelligence to British authorities on members of the IRA and other nationalist forces. On 21 November 1920 a rebel faction called The Squad (formed by Michael Collins) assassinated eleven members of the Cairo Gang. The killings provoked immediate reprisals from the British.

206. The various capacities in which women contributed to the war effort during the First World War broke down the remaining opposition to the enfranchisement of women in the US and many European countries. In the US an amendment granting women the right to vote on equal terms with men was passed by Congress in time for the national elections of 1920, ending a struggle which had begun a century earlier. Its most notable early results were improved child welfare legislation and more rights for women.

207. On 29 January 1919, the US ratification of the 18th Amendment which prohibited the manufacture, sale or carriage of alcoholic drinks marked the culmination of a long campaign by US temperance societies. Members had long argued that alcohol represented a demoralizing force in American society, affecting family life, worker productivity and levels of poverty. But Prohibition was not the great panacea its supporters had envisaged: illicit production and distribution (bootlegging) of alcohol exploded in the 1920s. Despite the apparent success of the particular anti-drinks operation pictured, Prohibition was evaded on a vast scale, often with a wink and a nod from corrupt elements within federal and state law-enforcement units.

208. In its early years the new German Republic was beset with political turmoil and enormous financial hardship. The nation had amassed a huge debt in financing its war, as had all the European participants. But unlike the victorious Allies, Germany was burdened with a colossal reparations bill. Repayment proved impossible and inflation soared in the early 1920s as continuing food shortages caused widespread poverty and social unrest.

209. A slum in Shadwell, East London. Economically, Britain had been severely hurt by the war. The country fell from its position as world financial leader and chief creditor nation to that of a debtor nation. Towards the end of the conflict, the British government's average daily expenditure was about 164 million pounds in contemporary values. In all, one-quarter of the nation's wealth had been used up in the war effort. Years of wartime neglect by Britain's political leaders exacerbated already serious problems, such as unemployment, poor housing and the revival of industry. By 1920, ordinary Britons were wondering why a nation which had funded a vast war machine for four years could not provide its own citizens with the basic necessities of life.

1921

210–11. Trouble starting for British soldiers and the Black and Tans in Dublin. Widespread ambush attacks by the IRA on British installations in Ireland led to ruthless reprisals carried out primarily by the Black and Tans. This auxiliary police force was recruited in Britain from the scores of ex-servicemen returning from the Western Front. It was ill-disciplined and often engaged in drunken brutality against the local community in Ireland, usually in response to successful IRA operations.

212. Famine victims in a camp in the Volga town of Samara, Russia. Lenin's attempt to accomplish economic revolution while waging civil war had disastrous consequences for ordinary Russians, especially those living in the countryside. His severe economic policy of 'war communism' led to the mass expropriation of private business and industry. It also meant forced requisitioning from the peasantry of grain and other food products in order to feed the cities and the Red Army. Most industries stopped for lack of materials, fuel and labour, while the policy of requisitioning led to mass starvation and eventually to widespread peasant revolts.

213. Claude Monet and his step granddaughter Lily Butler, with Georges Clemenceau at Giverny, France. The French president strongly believed in his nation's culture heritage and befriended many of France's best-known artists of the time. He was an enthusiastic supporter of Impressionism, particularly the movement's founder and leader, Monet, and personally arranged an exhibition of his paintings in the Tuileries Gardens in Paris after the First World War. Monet's late home in Giverny on the Epte River east of Paris, where Clemenceau sometimes visited, became a French national monument after the painter's death in 1926.

214. Irish representative Michael Collins leaving Downing Street after talks with British leaders. A truce on 11 July 1921 ended the war between the IRA and the British administration. Deadlock ensued. The British Prime Minister Lloyd-George wanted Dominion Home Rule for Ireland while the nationalists, led by Collins and Arthur Griffiths, sought an Independent Irish Republic. On 6 December 1921, after much hesitation and scepticism, the Irish leaders negotiated and eventually concluded a treaty with the British Government. Ireland would become a free state with full dominion status, while the six counties of Ulster would remain part of Great Britain. The agreement did not prevent the country from plunging into civil war, as Republicans who felt themselves cheated, promptly rose against the treaty.

215 top. Sinn Fein (Gaelic for 'we ourselves') emerged from obscurity in 1916 to become the main rallying point for the republican movement in Ireland. The organization professed an anti-capitalist, republican ideology and advocated forms of passive resistance such as hunger strikes to fight British rule. Rejecting partition, Sinn Fein leaders set up a provisional government to replace the British administration on the island. During the civil war that engulfed Ireland in 1921, Sinn Fein took a back seat in the military campaign, eventually becoming the political wing of the military IRA.

215 bottom. The Irish elections of May 1921 were predictably divisive. Ulster Unionists won forty out of fifty-two seats in the North, and the Republicans all but four in the South. The new legislatures in Dublin and Belfast reflected a deeply divided people: an overwhelmingly Catholic, republican South, and a predominantly Protestant, unionist North. George V opened the new legislature in Northern Ireland appealing for an end to fratricidal violence, but symbolic gestures could not stem the tide of war. English public opinion had had enough of the prolongation of the First World War, and pressured the British Government to take dramatic steps to bring peace to Ireland.

1922

216. Russian ballerina and ballet teacher Seraphima Astafieva with her pupils. Astafieva began her ballet career in 1909 with Sergei Diaghilev's Ballet Russe. She opened her own ballet school in London in 1914, eventually counting Margot Fonteyn and Anton Dolin among her students. Diaghilev, Astafieva and other Russians brought classical ballet to the Western world where it was greatly admired early in the twentieth century, thus establishing it as a serious international art form.

217. After the disintegration of the Russian Imperial Army in 1917 Trotsky, the People's Commissar for War, recruited massive numbers of workers and peasants for Soviet Russia's new military force – the Red Army. During the civil war political advisers (commissars) were attached to all units in order to assess the loyalty of officers and to carry out political propaganda designed to persuade its mainly peasant soldiers of the virtues of communism. Coercion, moral suasion and material incentives were employed regularly by commissars, especially on the younger generation, who were regarded as untainted by Russia's tsarist past and there-fore more reliable.

218. Following the First World War, Greece invaded Asia Minor (Asian Turkey), attempting to reassert control over lands that had been under Greece at the time of the Byzantine Empire. Turkish nationalists under Kemal Atatürk resisted Greece's eastward expansion, and in June 1920 heavy fighting broke out. In August 1922 the Greeks suffered a major defeat when the Turks occupied Smyrna (present-day Izmir), home to roughly half-a-million Greeks, many of whose ancestors had lived in the region for many centuries. The Greeks were expelled, those who tried to stay were killed, and the city itself was set ablaze. The Treaty of Lausanne ended hostilities between the two countries and restored Smyrna to Turkey. It also provided for the mass transfer of populations, with over a million Greeks forced to leave Turkey and 350,000 Turks expelled from their homes in Greece.

219. Famine and widespread unrest in Russia forced Lenin to pull back from the application of pure communist principles. Instead he introduced limited capitalism in his New Economic Policy (NEP) in order to reinvigorate the economy. But as the health of the Russian economy began to improve, Lenin's own health took a turn for the worse. His physical condition had been deteriorating ever since an assassination attempt in 1918 left him wounded, and a series of strokes beginning in 1922 triggered an irreversible decline. Competition among his potential successors began in earnest.

220. Michael Collins, Irish revolutionary leader and politician, became the key figure during the struggle for independence in Ireland, infiltrating various sections of the British administration in the country. Collins met with British leaders against his deepest beliefs, and signed the Anglo-Irish Treaty which recognized the partition of Ireland. When civil war broke out between pro-treaty and anti-treaty republicans, Collins struggled to find a basis for peace with his former comrades in the fight for an independent Ireland. On 22 August Collins was killed in an IRA ambush while visiting troops in the west of Cork.

221. Three centuries of direct British rule in the south of Ireland came to an end with the Anglo-Irish Treaty, but many issues remained unresolved. The British Government showed an old colonial arrogance in its dealings with the new state. The precise definition of the Free State's constitutional connection with Britain, including control of foreign affairs and the potential for border changes with Northern Ireland, was not adequately addressed.

1923

222. Alexander Rodchenko worked for the People's Commissariat of Enlightenment after the Bolshevik Revolution. An accomplished painter, photographer and designer, Rodchenko joined his wife, a textile designer named Varvara Stepanova, in the Russian avant–garde movement. Both were prominent members of the Constructivist movement of the 1920s. This group of artists attempted to dispense with the individualistic bourgeois impetus of art and focus instead on a technical or scientific approach resulting in the incorporation of industrial materials such as glass and aluminium to their work. Rodchenko taught in Moscow until 1926 and also design 'Socialist' costumes, propaganda posters and book covers among other utilitarian and political objects.

223. In 1923 Lenin suffered another stroke, as a result of which he lost the power of speech and was partially paralyzed. Nonetheless he was able to muster enough strength to dictate his political testament, assessing the suitability of his potential successors as party leader. He was particularly critical of the party's general secretary Joseph Stalin, whom he had approved for the post in 1922. Lenin expressed particular concern that Stalin's volatile personality could jeopardize the future of the party if he were to emerge as leader.

224. The Dolly Sisters, Rosie and Jenny, were popular cabaret artists and socialites of extravagant, free-spending 1920s Britain. Wealthy American businessman Harry Gordon Selfridge fell under their spell when he saw the sisters perform in London. He is estimated to have spent roughly 2 million pounds on numerous gifts between 1924 and 1931 on Jenny alone, and both sisters were given virtually free reign over the giant Selfridges store which he established on Oxford Street in central London.

225 left. Originally a black folk dance, the Charleston did not reach mainstream audiences in the US until its appearance in the 1923 musical *Runnin' Wild*. Within months, Americans were trying it in their own homes or flocking to social and entertainment clubs to see the vibrant, fast-paced dance performed. The Charleston did not remain popular for long, but the dance itself will forever evoke the Jazz Age in which it was born.

225 right Fred Astaire and his elder sister Adele began their entertainment career as a touring vaudeville act. Both were immensely capable dancers, singers and actors, with seemingly boundless energy. They rose to stardom together on Broadway, starring in shows written especially for them such as George Gershwin's *Lady Be Good* (1924). Adele married in 1932 and her fame faded thereafter. Fred went on to Hollywood and became one of the most beloved American entertainers this century. He starred alongside many of the industry's leading ladies, and revolutionized film musicals with a succession of hits which invariably featured him tapping out an innovative new dance routine he had created.

226. French soldiers occupying the Ruhr Valley, Germany. After repeated German defaults on reparations payments, the French Government decided to send its troops into the densely populated industrial region of the Ruhr Valley to force German compliance or, if necessary, to collect payments by direct seizure. The occupation was met by passive resistance from ordinary Germans. It was condemned by the British and American governments who favoured a reduction of Germany's financial burden in order to get the country back on its feet. The French action proved of little worth and considerable expense but rather than lose face the French stayed until 1925 when the US brokered a revised reparations scheme for Germany called the Dawes Plan.

227. On 1 September 1923 a massive earthquake struck Tokyo and nearby Yokohama, the country's largest cities, killing 200,000 people. Damage caused by the earthquake and the ensuing fires was enormous. Japan's Emperor Hirohito accepted aid sent from abroad, particularly from the US, which caused a brief warming of relations between the two countries.

228 top. After active service in the First World War, Austrian-born Adolf Hitler committed himself to rebuilding a powerful, nationalistic Germany. Like many of his countrymen, Hitler clung zealously to the belief that Germany's military had been betrayed by its politicians and that the defeat of 1918 needed to be reversed. In 1923 Hitler was thirty-four years old, head of a little-known extreme right-wing party called the National Socialist German Workers' Party (its members were first called Nazis in a derisive abbreviation of the German party name). Germany was suffering in the aftermath of France's occupation of the Ruhr, and the nation's economy was reeling from hyperinflation. Hitler felt the time was right to lead his followers in a coup attempt known as the Munich *putsch*.

228 bottom. Hitler's *Stosstrupp* (meaning Patrol) during the abortive Munich *putsch*. In 1922, in response to the growth of the *Sturmabteilung* (SA, the storm troopers), Hitler established his own personal guard whose members would later form the nucleus for the *Schutzstaffel* (SS, the defence unit) of the Nazi party. In November 1923 storm troopers provided the muscle behind Hitler's attempt to seize the regional government of Bavaria as a prelude to a march on Berlin and the establishment of a Nazi government. The *putsch* was badly planned and easily crushed when police opened fire on the Nazi column as it marched through the streets of Munich. Sixteen of Hitler's supporters were killed.

229. Developments in transportation and communications fostered the growth of a number of transnational communities of specialists in different fields of science and technology during the inter-war years. In turn, the flow of expertise and technology across national boundaries increased. The term 'globalization' would not become part of the international vernacular until the 1990s, but its chief elements – the convergence and interdependence of national economies, and the global scope and availability of markets, goods, services and knowledge – were present from the early twentieth century.

1924

230 top. Lenin's body being carried from the Paveletsky Station to the Dom Soyousov (Labour Temple) in Moscow. The death of the Soviet leader and communism's most implacable champion on 21 January 1924, marked the beginning of a volatile period at the top of the Soviet hierarchy which lasted until the end of the decade. Lenin had hoped this could be avoided. He intended his political testament, which was highly critical of Stalin, to be read at the first party congress after his death. However, Stalin suppressed Lenin's testament and prevented its publication during his lifetime, ensuring his own emergence as a frontrunner in the succession struggle.

230 bottom. Careful planning ensured that Lenin's embalmed body was placed in a specially designed mausoleum in Moscow's Red Square. It became a place of pilgrimage at the heart of the Soviet Union. Stalin was keenly aware of the benefits he would accrue by promoting an extravagant cult around the deceased communist leader. As Lenin became deified in the eyes of ordinary Russians, Stalin shrewdly promoted himself as the natural successor to this legacy at every opportunity.

231. August Sander dedicated himself to compiling a comprehensive photographic account of men from all strata of German society. The first part of his work, entitled *Faces of our Times*, was published in 1929 and beautifully conveyed the social realism for which he would become famous. His subjects, whether peasants, workers, students or artists, were portrayed too realistically for the Nazis. After 1934 Hitler's Ministry of Culture advised Sander to refrain from taking overly-honest photographs.

232. Lily Brik, girlfriend of Russian poet, painter and Bolshevik propagandist, Vladimir Mayakovsky, posing for a portrait used in one of the artist's famous revolutionary posters made in collaboration with Rodchenko. Founder of the Russian Futurists, Mayakovsky had joined the Bolsheviks at the age of fifteen and was an enthusiastic supporter of the revolution. He expressed his support through his art, perhaps most notably in the millions of political posters he helped produce during the early years of the Soviet system. His powerful image succeeded in transmitting the Bolsheviks' message to a still largely illiterate Russian population. Mayakovsky's commitment to the revolution waned under the stifling bureaucracy of the Stalinist years. His unexpected suicide dealt a severe blow to the

reputation of officially approved art in the Soviet Union.

233. From the time Stalin was appointed General Secretary in 1922, he secretly began to build up his power base to ensure his control of the succession struggle following Lenin's death. Stalin stealthily outmanoeuvred his more brilliant comrades who regarded the peasant-looking Georgian as boorish and non-intellectual. Although they were all brothers in revolution, once Lenin was gone senior members of government were either co-opted by Stalin or eliminated, as was the fate of those photographed here: Aleksei Rykov, Lev Kamenev, Grigori Zinoviev and Nikolai Bukharin.

234. Protection groups – formed largely from Germany's war veterans' groups – were organized under the name of *Sturmabteilung* (SA, storm troopers) to safeguard early Nazi rallies and meetings. In many ways the SA was the embodiment of the party's extreme right-wing ideology. It stressed a militant spirit in individual and civic life, the racial and cultural superiority of Germanic peoples, anti-Semitism and a determination to reverse the iniquitous Treaty of Versailles. As Hitler was officially prohibited from making public speeches, first in Bavaria, then in many other German states until 1928 as a result of his role in the *putsch*, the SA played a key role in keeping the party together during its years of relative obscurity in the 1920s.

235 top. Hitler in detention with fellow putschist Herman Kriebel (left) and his personal chauffeur Emil Maurice. When a Munich court submitted its verdict on 1 April 1925, participants in the Munich *putsch* received lenient sentences, or as in the case of the great German General Erich von Ludendorff, none at all. The ruling judges empathized with Hitler's fierce anti-communism and even conceded that he and his followers had 'honourable motives'. Hitler was sentenced to the legal minimum of five years imprisonment but was released after having spent only nine months in prison at the Landsberg am Lech fortress. During his sentence he dictated his autobiography and political testament, *Mein Kampf*, to his fellow inmate and putschist

Rudolf Hess.

235 bottom. Ramsay MacDonald leaving a Privy Council meeting after introducing members of Britain's first Labour Cabinet to King George V. With him are J.H. Thomas, Arthur Henderson and J.R. Clynes. In January 1924 MacDonald agreed to head a Labour minority government and to act as his own foreign secretary. As the leader of the first Labour government, MacDonald became a popular hero among socialists, and contributed more than any other individual to building the Labour Party in Britain. His nine-month reign as Prime Minister would not be his last and proved, among other things, that Britain would not fall apart under a Labour government.

1925

236. Benito Mussolini with his pet lion cub. The first of the twentieth-century's fascist dictators, Mussolini was appointed Prime Minister of Italy in October 1922 by King Victor Emmanuel III in order to forestall an anticipated communist take-over of the country. As *Il Duce* (The Leader), Mussolini emphasized pride in the nation, radical destruction of the old order, hostility towards Marxism, primacy of military virtues and obedience to a leader. The Italian people were tired of the chaos and uncertainty which marked the post-war years and welcomed his flamboyant style and passionate rhetoric. They were ready to submit to his dictatorship provided he stabilized the economy and restored some of the dignity Italy had lost during the First World War.

237. In 1925 a biology teacher in the state of Tennessee went on trial for violating a new state law. This forbade any teaching in publicly-funded schools which denied the story of the divine creation of man as found in the Bible. John T. Scopes, who had been teaching Darwinian biological theories to his students, was represented at the trial by the distinguished attorney Clarence Darrow, while the state of Tennessee was represented by a former Secretary of State, William Jennings Bryan. Scopes was convicted (although as a result of a legal technicality served no time in prison), but the world-wide publicity generated by the trial

discouraged similar legislature elsewhere in the country.

238. Prior to the mid 1920s, women went to great lengths to avoid any darkening of their skin from exposure to the sun – it was usually only peasants who had sunburned complexions. Once the French designer Coco Chanel popularized the 'tan' in the 1920s, sun worship became a favourite summer pastime and Western women flocked to beaches and seaside resorts, wearing bathing suits that revealed more of the female form than any costume since ancient times.

239. The architectural and decorative arts style we now know as art deco was first shown at the *Exposition Internationale des Arts Décoratifs et Industriels Modernes* in Paris in 1925, and derived its name from the exhibition itself. During the late 1920s and early 1930s the sleek, anti-traditional art deco movement came to symbolize wealth and sophistication in the US and western Europe. After briefly falling out of fashion during the Second World War, art deco design was pursued with renewed interest and vigour in the late 1960s.

240. Charlie Chaplin's on-screen persona of the endearing, zany man with bowler cap, out-turned feet, moustache and walking cane was so popular in the 1920s that eventually no studio in the world could afford his acting talents. In order to retain artistic and financial control over his work, the London-born star of numerous silent motion picture classics formed his own film production company directing and starring in many comic epics including *The Gold Rush* (1925). After the introduction of sound in the late 1920s, Chaplin appeared in fewer films, but remarkably his fame never waned. His early works remain acknowledged masterpieces of the silent film era.

241 top. Britain's future King George VI grew up in the shadow of his elder brother, the Prince of Wales, who was next in line to succeed their father, King George V. From a very early age the young George was an intensely shy boy and developed a stammer. In the First World War he served in the Royal Navy, manning a turret of the battleship *Collingwood* during the Battle of Jutland. In 1923 he

married Lady Elizabeth Bowes-Lyon (the future Queen Mother), and together they began a very happy family life, unaware of the enormous responsibilities that lay ahead of them.

241 bottom. The Prince of Wales being entertained by girls performing a dance at a marriage preparation in Freetown, Sierra Leone, during his tour of the British colonies in Africa. The limited perception of Africans as a cheerful, child-like race of people largely incapable of administering their own affairs, was still very much in evidence throughout Western society during the inter-war period. White rule in English-speaking Africa reflected the popular view in Britain that, beneath a veneer of civility, Africans were inclined towards primeval savagery and conflict unless properly managed. Britain maintained a system of indirect rule of its African colonies, strengthening traditional governance supporting tribal chiefs. They created tribal governments where none had existed, all the while ensuring that the chiefs remained firmly under the paternal control of British colonial authorities.

1926

242. The apparatus used by Ernest Rutherford in his atom-splitting experiments, set up on a small table in the centre of his Cambridge University research room. The New Zealand-born scientist built up the Cavendish Laboratory in Cambridge, England, one of the great research schools in the history of science. Rutherford was renowned for devising relatively simple and decisive experiments and his work in radioactivity and nuclear physics. He was the first to name the nucleus. His discovery of the alpha, beta and gamma rays and his recognition of the ionizing nature of the atom changed our views of matter. He was awarded the Nobel Prize for Physics in 1908. In 1920 he predicted the existence of the neutron, later discovered by his colleague James Chadwick.

243. The first image ever successfully televised (top) and John Logie Baird working on his transmitting station (bottom). Scottish inventor John Logie Baird was able to demonstrate a

shadowy television image in the Selfridges store in London in March 1926, which was was followed by a public demonstration to members of the Royal Institution. Although the cathode-ray tube was invented as early as 1897, no practical television system was developed until Baird's experiments in London between 1925 and 1929. In spite of poor health and a lack of financial support, Baird experimented with a crude home-made transmitting apparatus built mostly from scrap materials, and succeeded in building a television apparatus.

244. A Soviet financial inspector questioning a woman at her home. The New Economic Policy (NEP) was a temporary tactical retreat from the enforced socialism initiated by Lenin in 1921. It produced some troubling developments for the communists. Although the NEP principally benefited the peasants and improved the efficiency of food distribution, the freedom it granted internal trade permitted limited private commerce, and a small middle class began to emerge. The era of giant state planning, begun in 1926 with the first of Stalin's Five-Year Plans, ensured that the 'new bourgeoisie' were crushed before they could exert any political power.

245. Reza Pahlavi, an officer in the Persian army, led a successful coup in 1921. He served as premier until 1925 when he deposed the last ruler of the Kajar dynasty in Persia and declared himself Shah. He sought to modernize the country (officially called Iran after 1935), improving roads and railways, communications and schools, emancipating women and introducing European style dress and customs. When British and Russian troops occupied the country during the Second World War, pro-German Pahlavi was forced to abdicate in favour of his son, Mohammad, on 16 September 1941.

246. A still from the making of Fritz Lang's Expressionist masterpiece *Metropolis* (1927). The Austrian-born filmmaker's stunningly futuristic film was a bleak vision of a future totalitarian world in which the majority of the population was reduced to slavery. It was regarded as one of the greatest science

fiction films ever made. Lang later employed the provocative, stylized images that characterized *Metropolis* in a series of films that explored fate and the individual's struggle with his/her destiny.

247. In 1925 Josephine Baker left her native America and went to France, where her exceptional dancing and singing abilities landed her a place in *La Revue Nègre* at the Théâtre des Champs-Elysées. Baker's performances were acclaimed by French audiences, and she soon came to symbolize the glamour and vitality of African-American culture which was highly popular in Paris in the 1920s, although still largely marginalized in the US. After becoming a French citizen in 1937, Baker went on to work for the Red Cross and the Resistance during the Second World War, and even returned to America periodically to join her people in the US civil rights campaign.

248. Star and director of several classics from the silent-film era, Buster Keaton's popularity was second only to Chaplin. Like his fellow comedian, he formed his own company, producing nineteen short films and ten features, including his much beloved masterpiece, *The General* (1926). Keaton's trademark stoicism and deadpan expression were popular in films which centred on man's attempts to deal with machines or the forces of nature. Unlike Chaplin, Keaton's fame dwindled with the advent of sound, but was re-established in the 1960s after the re-release of many of his films.

249. Marathon dancing was one of the more peculiar pastimes to take hold in America in the 1920s. Aspiring couples took to the dance floor hoping to outlast all others in a contest to see which couple could stay on their feet the longest. What the winners lacked in artistry they made up for in extraordinary perseverance.

1927

250–51. Coffins of the fallen victims of the Battle of Verdun being carried to the ossuary at Douaumont during its unofficial inauguration on 18 September 1927. The remains of 130,000 unknown French and German soldiers who perished at Verdun

were placed in the Douaumont ossuary, but disagreement over how the remains should be dealt with meant it was not officially inaugurated until 1995 at a ceremony attended by the then German Chancellor Helmut Kohl and French President François Mitterrand. Great memorials to the battles of the First World War were constructed throughout the French and Belgian countryside in the 1920s to honour the war dead and to remind future generations of this terrible, senseless slaughter.

252. A still from Abel Gance's film *Napoléon vu par Abel Gance* (1927). A French filmmaker best known for making extravagant historical spectacles, Gance became identified with the Impressionist School, a group of filmmakers working to gain recognition for motion pictures as an art form. *Napoléon* was a mammoth four-year undertaking in which Gance explored experimental techniques, including the use of three separate cameras to film huge battle sequences. When the film appeared in cinemas, three projectors showed separate views of certain scenes. This technique anticipated the wide-screen cinemas of the future.

253. A still from the making of Sergi Eisenstein's film *October* (1928). The great Russian director was commissioned by the Soviet Central Committee to make a film celebrating the tenth anniversary of the Bolshevik Revolution. The end product was nearly four hours in length, but a third had to be cut on orders from Stalin that all references to his political rival Trotsky should be omitted. Although vast resources of the Soviet army and navy had been placed at the director's disposal, the film received heavy criticism from the country's leaders for its alleged 'elitist' style. Stalin despised Eisenstein for being an intellectual and a Jew, but could not purge the filmmaker because of his world-wide fame. However, he managed to prevent Eisenstein from working for the next ten years.

254. A Russian Orthodox church being used as a grain store. When the Russian civil war ended in 1922 the Bolsheviks launched an intensive anti-religious propaganda campaign, subjecting the Russian Orthodox Church to

every kind of indignity and constraint. The Bolsheviks sought to undermine the Church economically and, more importantly, supplant its clergy as mentors of the Russian people. Trotsky, chief architect of the anti-religious strategy, ordered the expropriation of Church property under the guise of famine relief. The new regime made economic progress, and soon churches were adapted for other uses. Later churches were even transformed into recreation facilities such as swimming pools. In spite of this, tens of millions of Russians adhered heroically to their faith, maintaining religious rituals as best they could.

255. The destruction of the Simonov monastery. One of the Bolsheviks' first decrees after seizing power in Russia separated Church and State and ordered the church to provide schooling. All religious bodies were affected, but the most pronounced impact was on the well-established Russian Orthodox Church. From the 1920s onwards the country saw a drastic reduction in the number of churches, the imprisonment of countless clergy and the widespread destruction of its monasteries.

256. Papal diplomat Eugenio Pacelli (later Pope Pius XII) leaving the Presidential Palace in Berlin amid celebrations marking the eightieth birthday of German President Paul von Hindenburg. As distinguished nuncio to the Weimar Republic in the 1920s, much of Pacelli's Vatican career was involved with German affairs. During his twelve years in Germany he developed a strong affection for the country and its people. Pacelli's close ties with the Nazis became a source of controversy over the next two decades.

257. Italian-born anarchists Nicola Sacco and Bartolomeo Vanzetti arriving at the court-house in East Dedham, Massachusetts, on 11 April 1927. The two men were accused of murdering a paymaster and his guard at a shoe factory. Although the evidence against them was insubstantial, they were convicted and sentenced to death in 1921. The case became a *cause célèbre*; a protesting public in the US and abroad argued that the men had

been tried for their support of socialism, their radical political activities and for their ethnicity, rather than for their alleged crime. A special state commission set up to study the case sustained the verdict and the men were executed in the electric chair later that year.

258. Fiat ran its vast auto-plants in Turin at full capacity during the First World War to provide the Italian military forces with armaments. In 1921 Fiat's factories were seized by its workers bent on a communist-style take-over. The company's founder, Giovanni Agnelli, resigned his leadership immediately, but returned to head the company a short time later. This was at the request of thousands of workers who pleaded with their genial boss not to go. Agnelli became one of Mussolini's most vocal and prominent supporters, and was predictably at the forefront of the mobilization of the Italian war industry leading up to the Second World War.

1928

259. Civilian guards in Sacsaywaman, Peru. Martín Chambi was the first native Latin-American photographer to record the peoples and landscapes of Peru. Born into an Indian peasant family, Chambi became interested in photography while living and working in a small mining community. Early in his career he demonstrated a mastery of light and an instinctual ability to produce 'candid' portraiture. In 1920 he opened his own studio in Arequipa and thereafter produced a rich and important body of work. As an indigenous photographer, Chambi was uniquely capable of documenting Indian life in Peru.

260. The failure of the Munich *putsch* convinced Hitler to seek power through legal means. The Nazis' steadily mounting electoral strength was impressive for a party whose leader had been officially banned from making speeches in public since 1923. However, in 1929 the Nazis were still a relatively small, fringe party with membership of about 180,000. It would take the world economic slump and the accompanying depression in Germany for the Nazi party to

gain nation-wide popularity.

261. Nobel Peace Prize winners Austen Chamberlain (1925), Aristide Briand (1926), and Gustav Stresemann (1926) conversing at a conference in 1928. Each politician worked tirelessly in pursuit of peace and co-operation in Europe during the post-First World War period. In his efforts to win the confidence of his country's former enemies in the West, Stresemann, Germany's Foreign Minister, met regularly with Chamberlain, Britain's Foreign Secretary, and Briand, French Prime Minister. In 1928 the latter took the initiative in proposing a pact (later named the Kellogg-Briand Pact) to renounce war as an instrument of national policy. At the time it was regarded as a significant step towards post-war reconciliation and the peaceful settlement of future international conflicts. Sadly events in the 1930s revealed the pact to be completely ineffective.

262. The first performance of *Die Dreigroschenoper* (*The Threepenny Opera*) at the Schiffbauerdamm theatre in Berlin on 31 August 1928. Kurt Weill, an outstanding German musician of the period, collaborated with poet and playwright Berthold Brecht in the making of the successful ballad opera which was an adaptation of John Gay's *Beggar's Opera* with its improvised Victorian London setting. *Die Dreigroschenoper* reflected Brecht's interest in developing theatrical experiences that engaged both the intellect and social conscience of his audiences, even as they entertained and charmed. Brecht, a Marxist, fled Germany in 1933 after the rise of Hitler.

263. A still from the making of Spanish film-director Luis Buñuel's *Un Chien Andalou* (*An Andalusian Dog*, 1929). Made with Surrealist painter Salvador Dali, *Un Chien Andalou* caused a sensation with its macabre fantasy style. One of the world's great satirists, Buñuel was deeply influenced by the Surrealist movement which flourished after the First World War. The movement rejected the rationalism that permeated all aspects of European culture and politics, and sought to fuse the seemingly incommensurable forces of dreams and reality, and of unconscious and conscious

experience. Throughout Buñuel's long career in films he continually turned to Surrealism as a means to expose social injustice and religious dogmatism in Western society.

1929

264. Trotsky's preoccupation with military and foreign affairs during Lenin's illness between 1922 to 1924 enabled his archenemy, Stalin, to acquire control of the party's administration and gradually to undermine his authority. Trotsky was expelled from the party in 1927 and forced to leave the country two years later. After a brief period in Turkey, he moved to France where he wrote his epic *History of the Russian Revolution* (1932).

265. On 14 February 1929 notorious Chicago crime-boss Al Capone ordered his men to enter a garage run by members of a rival gang and execute them in cold blood. The unarmed gangsters had been engaged in Chicago's lucrative bootlegging trade. Their shocking deaths dramatized the violent rivalries for control of the illegal traffic of liquor during the Prohibition era in the US, especially in the city of Chicago.

266. A campaign button for Republican-party candidate Herbert Hoover. During the 1928 presidential election in the US Hoover, former Commerce Secretary, promised Americans that an era of even greater prosperity than the Roaring Twenties was on the horizon. He defeated the Democrat candidate Al Smith, but seven months after taking office a financial depression of crushing dimensions, alleged to be due in part to unrestrained speculation during his years as Commerce Secretary, overtook his presidency. Hoover reacted slowly and was reluctant to extend Federal responsibilities to remedy a crisis that he erroneously claimed would work itself out. When the economic depression spread to Europe, he continued to demand punctual payment of war debts until mid 1931, thus enraging European leaders.

267. *Indian peasants in the judicial office*, *Cuzco*, by Martín Chambi (1929). Most legal discrimination against Indians was nominally abolished in the nineteenth century, but the actual conditions of Latin America's indigenous peoples remained the same, or worse in the early twentieth century. In Peru, as in most of Latin America, there was a total failure to improve the lot of the Indian population, whose communal lands were seized indiscriminately throughout the country. Even liberal legislation tended to have the effect of eliminating all communal property and the legal existence of Indian communities. The early twentieth century saw a partial change in intellectual attitudes and political conditions, resulting in initiatives aimed at improving the conditions of these groups. However, prejudice against the Indians as biologically inferior to the Europeans ran deep.

268. A Russian peasant-labourer's family moving into the former home of a kulak (wealthy peasant) after Stalin initiated his policy of Collectivization. In 1929 he sought to bring the country's means of agricultural production under central ownership and control and to crush the power of kulaks, whom he regarded as the last real popular threat to his totalitarian state. Brutally coercive measures were employed to expropriate peasants' land to form agricultural collectives (Kolkhoz), or in some cases state-owned farms (Sovkhoz), run by state employees.

269. Italian physicist and inventor Gugliemo Marconi, at the inauguration of Vatican radio, standing in front of the transmitting set. Marconi sent his first wireless radio transmission from Pontecchio, Italy, in 1895. His subsequent experiments in wireless telegraphy revolutionized communications and played a prominent role in the commercial development of broadcasting. He later worked on the evolution of short-wave wireless communication, which now constitutes the basis of nearly all modern long-distance radio. In 1932 Marconi installed a radio telephone system between the Vatican City and the papal palace at Castel Gandolfo using a very short wavelength.

270. German boys with a kite made of bank notes from the hyperinflation of the early 1920s. German banknotes were in fact worth less than the paper they were printed on at the height of the country's economic crisis in 1923. The German mark was valued at 4.2 billion to the dollar at its lowest level. Weimar's leaders pulled the country out of the mire with a little help from its more magnanimous former enemies, and by the end of the decade it seemed that democracy had indeed gained a strong foothold in Germany and the political and economic situation had stabilized. Paul von Hindenburg, the nation's father figure, was installed as president, and Germany's reintegration into the international community was completed by the Allies' decision to dispense with the question of reparations and the Kellogg-Briand Pact, which had outlawed all German recourse to aggressive war (negotiated at the Hague Conference).

271. A cloakroom attendant waiting with coats and sticks during a night meeting at the Hague Conference. Delegates at the conference approved the Young Plan which substantially reduced the sum of German war reparations, eased the repayment schedule and provided Germany with a loan of 300 million dollars. The question of reparations was the central political issue for Weimar Germany, not only because of the vast sums involved, but because repayment was legitimized by – and inextricably linked to – the hugely controversial war-guilt clause of the Versailles Treaty. Decisions made at the Hague Conference were annulled by the onset of the Depression and the rise of Hitler.

1930

272 top. Teenage Nazis causing trouble at the opening of the Reichstag (German parliament). The rapid rise in unemployment in Germany in 1929 and 1930 due to the world economic slump resulted in millions of jobless and dissatisfied Germans whom the Nazi party could exploit to its electoral advantage. Together with the Nazis' superior propaganda techniques and backing from leading German industrialists fearful of communism, the party vastly increased its membership and voting power. In the Reichstag elections of 14 September 1930 the Nazis won 6.4 million votes.

272 bottom. Chairman and co-founder of the German Communist Party (KPD), Ernst Thälmann gradually built up the party's strength in Germany until 1932, when it received roughly 5 million votes in the national elections. He was arrested a year later, following a fire at the Reichstag. The Nazis imprisoned him in solitary confinement for the next eleven years, effectively wiping out Communist opposition in the country. He was offered release in 1939 after the conclusion of the Nazi-Soviet Pact but declined because he would have had to sign a promise to refrain from political activity. In 1943 he was executed inside Buchenwald concentration camp.

273. Legendary Soviet miner Alexei Stakhanov with Georgian miners in the Soviet Union. In August 1935 Stakhanov was reported to have mined 102 tonnes of coal in five hours and forty-five minutes – roughly fourteen times the average rate. This was apparently due to his use of innovative working methods as well as sheer determination. Throughout the Soviet Union Stakhanovite movements formed to accelerate production capacity; films and books glorified his exploits. However, in October 1988 the Soviet press revealed that it had all been an elaborate propaganda exercise. Stakhanov had been provided with first-class equipment and favourable conditions; in addition work done by his fellow miners in the pits was simply added to his daily production results.

274. A successful American businessman with his baby. Throughout the 1920s the bubble of prosperity in the US continued to swell and the idea that everyone investing in the stock market could 'get rich quick' seemed, for a time, more than just wishful thinking. When the bubble burst on 29 October 1929, 30 billion dollars was wiped off the market. Soon the vast majority of Americans could no longer afford most of the indulgences of the previous decade.

275. Laurel and Hardy in *Brats* (1930). The comic acting partnership of Stan Laurel and Oliver Hardy began in 1926 and the duo went on to become the first great Hollywood motion-picture team. Their disaster-prone antics thrilled silent movie audiences around the world. But unlike many of their contemporaries, Laurel and Hardy lost none of their popular appeal when the film industry converted to sound. Laurel and Hardy's hilarious films transform the mundane tasks of life into unpredictable and chaotic incidents.

276 top. Police breaking up a communist demonstration in New York City. Founded in 1919, the Communist Party in the US was driven underground almost immediately because of the post-war anti-Bolshevik hysteria sweeping the country. Newspapers and government officials attributed a series of strikes and indiscriminate bombings in the wake of the First World War to communist agitators, though little evidence existed to support their claims. Americans were generally distrustful of organized labour and proved decidedly unreceptive to the communist message. In the 1932 election, the Communist Party candidate for president, William Foster, won a paltry 102,000 votes nation-wide.

276 bottom. Spring famine scenes in China. Drought and overpopulation in northern China caused one of the great famines of the century. Roughly 3 million people died from severe food shortages on the northern Chinese flood plain after months of dry weather destroyed already meagre subsistence agriculture in the region. Famine would continue to plague parts of China periodically throughout the century.

277. *Cuban Portrait* by Walker Evans. In the 1930s Cuba was nominally independent, but the country was ruled as a virtual economic colony of the US. Having supported Cuba's fight for independence from imperial Spain, the US secured preferred trading rights with Cuba (set out in the Platt Amendment 1901) and also permission for military intervention as it saw fit. Income from sugar production was augmented by a fledgling tourism, and gambling and prostitution business as developed by Americans eager to escape the restraints of the Prohibition era. A few Cubans prospered but the vast majority languished in poverty.

278. Margaret Bourke-White began her colourful professional career as an industrial and

architectural photographer. One of her projects took her travelling through the Soviet Union recording the early stages of the country's massive industrialization programme. A tractor factory she visited in Stalingrad was part of Stalin's collectivization policy. In 1929 Henry Luce, publisher of a new magazine called *Fortune*, hired Bourke-White and soon after she was documenting the skyward growth of America's major cities.

279. Zeppelins had been pioneered at the turn of the century to give the German military a key advantage over the Allies in the First World War, but technical problems greatly reduced their effectiveness. After the war they were built primarily for commercial use, and a transatlantic passenger service was launched in 1928. The service came to an abrupt end on 6 May 1937 when the *Hindenburg*, the most modern of these German airships, burst into flames while approaching the mooring mast at Lakehurst, New Jersey. Remaining zeppelins were broken up for scrap metal a short time afterwards.

280. Don Bradman, Australian national cricket team captain from 1936 to 1948 and one of the world's greatest batsmen broke numerous records and became Australia's first cricketer to be knighted. His extraordinary batting ability – developed in his youth by hitting a softball against a metal water tank – filled opposing bowlers with panic throughout his illustrious twenty-year career.

281. If any American sporting hero of the early twentieth century deserved the description 'larger than life' it was Major League baseball's George Herman Ruth, better known as 'Babe' Ruth. His superb pitching and prodigious batting feats, including 714 career home runs – a record that stood for thirty years – coupled with his reputation for flamboyance and excess off the field, made Ruth an irresistible popular icon of the Roaring Twenties in America. By 1930 he was receiving an annual salary of 80,000 dollars, an all-time high for a team sportsman, playing for the New York Yankees.

1931

282. In 1929 Stalin moved to bring the means of agricultural production in the country under central ownership and control, and to crush the power of wealthy peasants (kulaks). His policy called for peasants' land to be expropriated by the state to form agricultural collectives (Kolkhoz), or in some cases state-owned farms (Sovkhoz) run by state employees. The scale of the undertaking was gigantic, as was the human cost. Stalin, recognizing that famine conditions usually forced peasants into collectives, embarked on a deliberate policy of starving non-complying peasants in the Ukraine and north Caucasus. Estimates of the number of peasants who died vary widely but it is certain that several million perished. In addition, up to 10 million peasants were sent to labour camps where many died.

283. The Depression first hit Britain within months of the 1929 stock market crash, but never developed into a nation- and industry-wide condition as it did in the US. It was only certain parts of Britain, particularly the coalfields of the Midlands and Wales and the ports and shipyards of the North, that were struck by high unemployment. In these regions, despair and discontent among the local population was high. London however, was relatively unaffected and for those in work, wages remained stable and life continued much as it had done in the previous decade.

284. A statue of Primo de Rivera being dismantled as Spain's first Republican government takes power. The prestige of Spain's King Alfonso declined rapidly in the early 1920s, largely because of the defeat of the Spanish army in Morocco. In 1923 he attempted to consolidate his power by convincing an army general, Primo de Rivera, to become prime minister of a new fascist-style dictatorship in the country. Student and worker discontent grew as martial law was imposed and strict censorship was enforced. In 1930 ill health forced Rivera to resign, and a year later municipal elections in which Republicans scored over-whelming victories led to the King's departure (14 April 1931). A new Spanish Republic was born, but

insuperable problems ensured its days were numbered.

285. The 'Great Wallendas' perform their high-wire act in London. Famed for their three-person pyramid on the high wire, the Wallendas were one of the most popular circus acrobatic troupes of the century. In 1928 they joined the Ringling Brothers and Barnum and Bailey Combined Circus, with whom they developed a remarkable seven-man pyramid. The stunts sometimes failed however, often with disastrous consequences. Four members died in separate accidents before the troupe's German-born founder Karl Wallenda was killed attempting to cross between two hotels on a high wire suspended 37 metres (123 feet) above the ground in San Juan, Puerto Rico, in 1978.

286. Paris nightlife seen through the eyes of Brassaï. In 1924 the Hungarian-born photographer Gyula Halász, better known by his pseudonym Brassaï (derived from his home-town in Hungary), settled in Paris where he became friends with famous writers and painters, among them Henry Miller, Pablo Picasso and Salvador Dali. He developed a taste for the city's abundant nightlife which in the artistic heyday of the 1920s was open to strange and fanciful behaviour. His rich, provocative and often ambiguous photographs from the period were published in book form in the early 1930s, bringing international fame to the man Henry Miller had dubbed the 'eye of Paris'.

287. The economic depression devastated many of Europe's industrial regions, particularly areas dependent on exports. Wales had been the world's leading exporter of coal for decades but the collapse of the export market brought massive unemployment and a wave of emigration to mining areas in England and abroad. The exodus of nearly half a million people from Wales during the 1930s coincided with a sharp decline in the use of the Welsh language, which all but disappeared after having been the main language spoken in the industrial south of Wales.

1932

288. Franklin Delano Roosevelt on the Democratic campaign trail

with two Georgian farmers. FDR, as he was popularly known, was an admirer of the former progressive Republican president Theodore Roosevelt who was a distant cousin. During the campaign of 1932 Franklin D. Roosevelt displayed a smiling confidence, fostering a new sense of hope among Americans with his skilful, optimistic style. He promised immediate action on the one subject that was on the minds of all Americans – the Depression. His vast programme for recovery and reform became known as the 'New Deal'.

289. Many new heroes of the Soviet Union were created over the five years that it took to build the Dnieper hydro-power plant, the largest hydroelectric station in the world. The *Komsomol* (Young Communists) concrete layers' team was led by Yevgenia Romanenko. She became the first woman to be accorded the Order of Lenin in 1932, the highest possible civilian award. It was given to Romanenko for setting the world record in concrete laying. Although the propaganda value of these new heroes and heroines of the Soviet state was great, leaders in the Kremlin did not seem to appreciate the contradiction that elevating the status of a few, and providing them with honours and social benefits denied to ordinary Soviet citizens in the face of the egalitarianism they so adamantly espoused.

290. Emperor Hirohito inspecting anti-aircraft defences at Okada. Hirohito's reign began in 1926 at a time when militarism in Japan was beginning to supplant the parliamentary liberalism that had started to flourish in the 1920s. Army leaders and extreme nationalists had used the Emperor's legendary divinity as a source of autocratic authority to minimize the effectiveness of the parliamentary liberalism engaged in during the reign of his predecessor, Emperor Taishō. After 1930 the Imperial Japanese forces played an increasingly central role in the country's life. The Japanese grew wary of any co-operation with Britain or the US in the international arena, preferring instead to go it alone.

291. The filming of a documentary on the drainage of the Pontine Marshes, Italy. Massive public works projects –

such as the construction of roads, upgrading the railways and urban renewal – were central to Mussolini's commitment to a revolutionary transformation of the country. His ambitious programme of land reclamation and improvement (*bonifica integrale*) was one of the fascist regime's most successful undertakings. The famous draining of the Pontine Marshes region near Rome (begun in 1928), where the regime built new towns like Latina and Sabaudia in the early 1930s, brought Mussolini the popular support he had long desired.

292. The Marx Brothers began their show-business careers in vaudeville, but soon brought their legendary blend of visual and verbal humour to motion pictures. In films such as *Animal Crackers* and *Monkey Business* (both 1932) the brothers sent up social conventions and ordered society in seamless comic interplay which left audiences creased with laughter. The brothers disbanded their act in 1949. Only wise-cracking Groucho went on to further fame, becoming a writer and television quiz show host.

293. *Having Fun at Breakfast, Berlin*, by Martin Munkacsi (c.1932). Born in Hungary, Munkacsi was the first photographer to borrow techniques from photojournalism and apply them to fashion photography. His subjects often seemed poised to leap out of the photograph, such was his ability to infuse his work with energy and action. In 1934 he fled his home in Nazi Germany and emigrated to the US, where he continued his pioneering work in fashion photography with *Harper's Bazaar*.

294. Japanese troops at Shanhaikwan, the gateway to Manchuria from China proper. In February 1932 the Japanese established an independent puppet state in Manchuria, having occupied the whole province the previous year. In order to legitimize this new state known as Manchukuo the Japanese Army brought Henry Pu Yi, who had been the last Emperor of China, out of seclusion and installed him as Regent, and subsequently Emperor. Japan's actions were strongly opposed by the US and condemned by the League of Nations. The following year Japan withdrew from the League.

295. *Homeless Women*, *The Depression*, by Edward Steichen (1932). In America the Great Depression lasted longer and affected more lives than in any other country. Mass unemployment and a 50 per cent decline in industrial production over three years meant a dramatic fall in the standard of living for most Americans. Worse still, the Depression had a profound psychological impact on a population which had felt itself wholly immune to the crises of other nations. Americans were virtually untouched by the tragedy and devastation of the First World War, and the 1920s had seen more and more Americans acquire wealth beyond anything imagined possible in the nineteenth century. Bread lines and large numbers of homeless on city streets came as quite a shock.

296. Amelia Earhart became the first woman to fly solo across the Atlantic on 21 May 1932. Three years later she completed a longer and more treacherous journey flying solo from Hawaii to California, and become the first person to fly such a distance successfully. Earhart used her widespread fame to promote the cause of women in commercial aviation and in society in general. In 1937 she attempted to fly around the world, but after completing two-thirds of the distance her aircraft vanished over the Pacific Ocean somewhere in the vicinity of New Guinea. The facts surrounding her disappearance remain a mystery.

297. Dr William Beebe and members of his party photographed with his bathysphere. An American naturalist and explorer, Beebe combined his biological research with a rare literary skill, writing many widely-read books. Beebe led numerous scientific expeditions, exploring new depths of the ocean. He descended to a record depth of 923 metres (3,027 feet) in Bermuda waters with co-inventor of the bathysphere Otis Barton in 1934.

1933

298. President Hindenburg reluctantly appointed Hitler to the post of Chancellor of Germany in 1933. The Republic had become ungovernable and Hindenburg had chosen two ineffective chancellors in quick succession. The Nazi party emerged from the 1932 election with 230 members, the largest voting block in the Reichstag. Although Hindenburg was wary of the Nazi leader's personality and aims, he admired Hitler's nationalistic language and believed his military orientation was similar to his own. On the advice of politicians he trusted, notably the non-Nazi Deputy Chancellor Franz von Papen, he concluded that Hitler would be best controlled if he was close to him, inside the cabinet where other ministers could curb his excesses.

299. Adolf Hitler and Hermann Göring looking out on to the Wilhelmstrasse, Berlin. Nearly killed standing alongside Hitler during the Munich *putsch* in 1923, Göring skilfully secured himself second place in the Nazi hierarchy by the time the party had achieved power. Although his personal vanity and ostentation infuriated many leading Nazis, he became Prime Minister in 1933, and was the man chiefly responsible for building up the German *Luftwaffe* (air force) and the Gestapo. In time Göring's total lack of scruples ensured that the most pernicious aspects of the Third Reich invariably bore his imprint.

300. Reichstag fire suspect Marinus Van der Lubbe being questioned. The burning of the German parliament in Berlin on 27 February 1933 provided Hitler with the opportunity to establish a one-party system, maintaining that the fire was the first move in a communist conspiracy. Van der Lubbe, a Dutch worker of low intelligence, was tried and later executed, but it soon became clear that the Nazis might have been responsible for instigating the crime themselves. What is certain is that after the trial Hitler used the Communist 'threat' as an excuse for rushing through the Enabling Acts (23 March 1933) which allowed him to dispense with constitutional restraints and confer totalitarian powers on himself as the new chancellor.

301. On the evening of 10 May 1933, 40,000 people gathered on the Opernplatz in Berlin to hear Nazi Public Enlightenment and Propaganda Minister Joseph Goebbels exhort students and Nazis to 'cleanse German literature'. The works of philosophers, scientists, humanist poets and contemporary authors, many of them Jewish, were burned. It was the culmination of a series of actions taken by Nazis against art deemed to possess a 'non-German spirit'. No opposition was raised against the book burnings in Germany, and abroad it was given only passing attention. Few people noted the premonitory warning of the nineteenth-century poet Heinrich Heine, whose own works were set alight, 'Where books are burned, in the end people will be burned.'

302. *White Angel Breadline, San Francisco, CA*, by Dorothea Lange (1933). The Depression of the 1930s was more far-reaching than any other economic recession before or since. A world-wide agricultural recession was aggravated by a general financial collapse, especially in the US. The stock market crash of 1929 triggered an unprecedented decline in international trade and prosperity. In most countries the consequence of the recession was mass unemployment and a rise in the number of poor. Nothing required more urgent attention than the hungry families who soon overwhelmed the miserably under-financed bodies that attempted to provide direct relief.

303. President Franklin D. Roosevelt with his wife Eleanor and their son Edward. The niece of Theodore Roosevelt, Eleanor quickly redefined the role of the First Lady in American society. Among other things she assembled the first press conference for a President's wife, wrote a syndicated newspaper column called 'My Day' and travelled and lectured widely to further the numerous charitable and humanitarian causes she supported. Roosevelt was stricken with polio in the mid 1920s forcing Eleanor to undertake extensive political activity, serving as his 'eyes and ears' throughout the country during his long periods of convalescence.

304. Prostitutes plied their trade openly in the streets after brothels had been closed down in Britain in the late nineteenth century. The police grudgingly tolerated their presence but attempted, as in most large Western cities, to regulate the crimes associated with prostitution. The prosperity of individual prostitutes varied considerably in the 1930s, but no doubt reached its peak with the massive influx of Allied soldiers stationed in Britain during the Second World War.

305. Mussolini with Hungarian Prime Minister Julius Gombos and Austrian Chancellor Engelbert Dollfuss. Gombos and Dollfuss were great admirers of *Il Duce* and both established authoritarian regimes based on Italian-fascist principles. The Hungarian leader also befriended Hitler and was the first foreign head of state to visit Germany under the Third Reich. Dollfuss, nicknamed 'Millimeternich' because of his diminutive stature, did not share Gombos' affection for Hitler. Both he and Mussolini were firmly opposed to the Nazis' thinly-veiled plan to annex Austria. In July 1934 Austrian Nazis attempted a coup during which Dollfuss was shot and then bled to death while rebels occupied the Federal Chancellery in Vienna. Hitler was eager for the Nazi coup to succeed but withdrew support after Mussolini sent army units to the Austrian frontier. Austria did not retain its independence for long.

306. The Bavarian city of Nuremberg, an early Nazi stronghold, hosted the annual Reich party Congress from 1927. The Nazis used the Nuremberg rallies as a showcase for Germany's formidable achievements in technology, armaments, sports and other fields, and to demonstrate the population's near-religious adulation of the Führer. Members of the SA, SS, Hitler Youth and other ancillary Nazi organizations numbering hundreds of thousands would march through the city and gather in vast formations on the congress grounds to listen to the proclamation of party slogans and watch sporting demonstrations and the consecration of banners. The euphoric response to Hitler's closing speech at the 1933 rally – titled 'Victory of Faith' in celebration of the Nazi's rise to power – ensured that foreign dignitaries in attendance had no doubt about the popularity of Germany's new leader.

307. Julius Streicher attending a Nazi rally in Nuremberg. After taking part in the failed 1923 *putsch*, Streicher founded the anti-Semitic newspaper *Der Stürmer* (*The Stormer*) and became one of the leading figures in the fledgling Nazi Party. Although he was not highly regarded within the party, his virulent anti-Semitism kept him in Hitler's favour. The Führer used Streicher's outspokenness to prepare the ground for the acceptance of his racist policies by ordinary Germans. In 1933 Streicher became director of the ominously named Central Committee for Deflecting Jewish Atrocity and Boycott-Mongering. On 1 April the committee organized a boycott against Jewish businesses, department stores, lawyers and physicians. It was the Nazi government's first official action against Jews.

1934–45
Rise and Fall of the Unspeakable

The 1930s witnessed the rise of some of the most pernicious leaders and political movements of the twentieth century. In Japan militarization and nationalism fuelled a ferocious appetite for new territory in the Far East which resulted in mass atrocities committed by Japanese occupation forces against conquered peoples, especially the Chinese. In the Soviet Union, Stalin's modernization programme transformed an underdeveloped, war-ravaged economy into an industrial giant by the end of the 1930s, but in the process millions of ordinary Russians died. In Europe several countries turned to fascism as a way out of the economic and social ills caused by the First World War and the Great Depression. Nowhere was fascism more pronounced or sinister than in Nazi Germany under Adolf Hitler. After becoming Chancellor in 1933 he began to prepare for the conquest of Europe and – in accordance with his hatred for non-Aryan races and his fanatical anti-Semitism – the extermination of its entire Jewish population. Three years later at the 1936 Olympic Games in Berlin, a black track-and-field athlete from America became the undisputed star by winning four Gold Medals. This made a mockery of Hitler's intention to use the sporting spectacle as a showpiece for the inferiority of non-Aryans. In dramatic juxtaposition to the brutal German leader, Mahatma Gandhi led a number of non-violent campaigns in his native India which won him respect and admiration around the world. His commitment to non-violent protest to achieve social and political ends was put to the test countless times, but he never wavered. The rise of totalitarianism and radical nationalism, particularly in Europe, created a sense of foreboding. H.G. Wells wrote ominously of *The Shape of Things To Come* and Picasso expressed revulsion at the horrors of war – as well as compassion for its victims – in his painting *Guernica*. Albert Einstein, the twentieth century's most famous scientist, abandoned his home and research in Germany convinced that the Nazis were preparing to conquer Europe, and settled in the US. His worst fears were realized when two decades of foreign policy aimed at preventing another major conflict finally collapsed with Hitler's invasion of Poland in 1939. Within a year Holland, Belgium and France had been overrun by the German military's devastatingly effective new warfare techniques, and nearly all of western Europe had fallen under the control of fascist leaders. Japan's surprise attack on a US naval base in Hawaii in late 1941 brought America into the Second World War. By the time America and the Allies began the liberation of northern Europe in June 1944, much of Hitler's army was retreating in the wake of a westerly advance by Soviet troops. Stalin's army had courageously rebuffed a massive German invasion which had resulted in unprecedented numbers of military and civilian casualties in the Soviet Union. At the end of the war in 1945, 50 million soldiers and civilians had lost their lives in a conflict that dwarfed even the First World War in its level of death and destruction.

Contemporary Voices

All good books are alike in that they are truer than if they had really happened and after you are finished reading one you will feel that all that happened to you and afterwards it all belongs to you: the good and the bad, the ecstasy, the remorse and sorrow, the people and the places and how the weather was.

Ernest Hemingway, 'Old Newsman Writes', *Esquire*, December 1934

Hitherto, Hitler's triumphant career has been borne onwards, not only by a passionate love of Germany, but by currents of hatred so intense as to sear the souls of those who swim upon them ... Does he, in the full sunlight of worldly triumph, at the head of the great nation he has raised from the dust, still feel racked by the hatreds and antagonisms of his desperate struggle; or will they be discarded like the armour and cruel weapons of strife under the mellowing influences of success? Although no subsequent political action can condone wrong deeds, history is replete with examples of men who have risen to power by employing stern, grim and even frightful methods, but who nevertheless, when their life is revealed as a whole, have been regarded as great figures, whose lives have enriched the story of mankind. ... So may it be with Hitler.

Winston Churchill, *Strand Magazine*, November 1935

Politics and the fate of mankind are formed by men without ideals and without greatness. Those who have greatness within them do not go in for politics.

Albert Camus, *Notebooks*, 1935–42

I have seen war. I have seen war on land and sea.
I have seen blood running from the wounded.
I have seen men coughing out their gassed lungs.
I have seen the dead in the mud. I have seen cities
destroyed. I have seen 200 limping, exhausted men
come out of line – the survivors of a regiment of
1,000 that went forward forty-eight hours before. I
have seen children starving. I have seen the agony
of mothers and wives. I hate war.

Franklin D. Roosevelt, speech at Chautauqua, New
York, 14 August 1936

How deeply this corruption of taste had eaten into
the German mind was shown in the material
submitted for hanging by artists in the House of
German Art. There were pictures with green skies
and purple seas. There were paintings which could
be explained only by abnormal eyesight or wilful
fraud on the part of the painter. If they really
paint in this manner because they see things that
way, then these unhappy persons should be dealt
with in the department of the Ministry of the
Interior where sterilization of the insane is dealt
with, to prevent them from passing on their
unfortunate inheritance. If they really do not see
things like that and still persist in painting in this
manner, then these artists should be dealt with by
the criminal courts.

I was always determined if fate ever gave us
power, not to discuss these matters, but to make
decisions. Understanding of such great affairs is
not given to every one.

Adolf Hitler, speech at Munich, 18 July 1937

My good friends, this is the second time in our
history that there has come back from Germany to
Downing Street peace with honour. I believe it is
peace for our time. We thank you from the bottom
of our hearts. And now I recommend you go home
and sleep quitely in your beds.

Neville Chamberlain, speech from the window of 10
Downing Street, 30 September 1938

Every communist must grasp the truth, 'Political power grows out of the barrel of a gun'.

Mao Zedung, speech, 6 November 1938

I sit in one of the dives
On Fifty-Second Street
Uncertain and afraid
As the clever hopes expire
Of a low dishonest decade
Waves of anger and fear
Circulate over the bright
And darkened lands of the earth,
Obsessing our private lives;
The unmentionable odour of death
Offends the September night.

W. H. Auden, *September 1, 1939*, 1939

Faster than a speeding bullet! More powerful than a locomotive! Able to leap tall buildings at a single bound! Look! Up in the sky! It's a bird! It's a plane! It's Superman! Yes, it's a Superman! Strange visitor from another planet, who came to Earth with powers and abilities far beyond those of mortal men. Superman! Who can change the course of mighty rivers, bend steel with his bare hands, and who – disguised as Clark Kent, mild-mannered reporter for a great metropolitan newspaper – fights a never ending battle for truth, justice and the American way!

Preamble to *Superman*, US radio show, 1940 onwards

One of the main differences between representational and abstract painting is that the former can transport you to Greece by a representation of blue skies and seas, olive trees and marble columns, but in order that you may take part in this you will have to concentrate on the painting, whereas the abstract version by its free use of form and colour will be able to give you the actual quality of Greece itself, and this will become a part of the light and space and life in the room – there is no need to concentrate, *it becomes a part of living*.

Ben Nicholson, *Horizon*, October 1941

But I saw the little Ant-men as they ran
Carrying the world's weight of the world's filth
And in the filth in the heart of Man –
Compressed till those lusts and greeds had a
greater heat than that of the sun

And the ray from that heat came soundless, shook
the sky
As if in search of food, and squeezed the stems
Of all that grows on the earth till they were dry
– And drank the marrow of the bone:
The eyes that saw, the lips that kissed, are gone
Or black as thunder lie and grin at the murdered
Sun

The living blind and seeing Dead together lie
As if in love ... There was no more hating then,
And no more love. Gone is the heart
of Man

Edith Sitwell, *Dirge for the New Sunrise (Fifteen minutes past Eight o'clock of Monday the 6th of August 1945)*, 1945

I am become death, the destroyer of worlds.

J. Robert Oppenheimer, on the explosion of the first atomic bomb in New Mexico, 16 July 1945

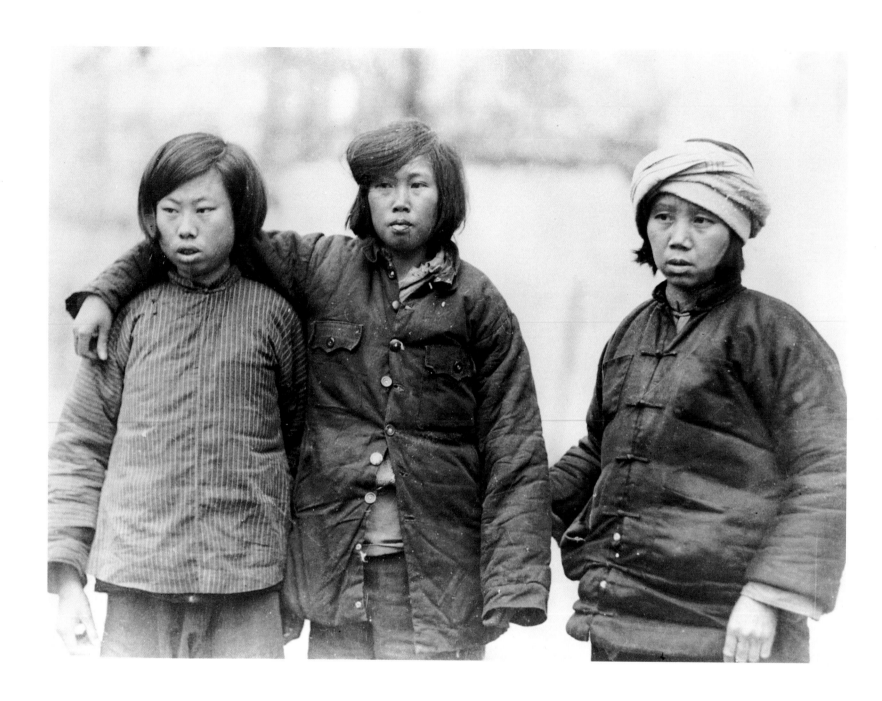

Young communist women – members of Mao's Communist Party in China – left behind by the Long Marchers and arrested by the Kuomintang.

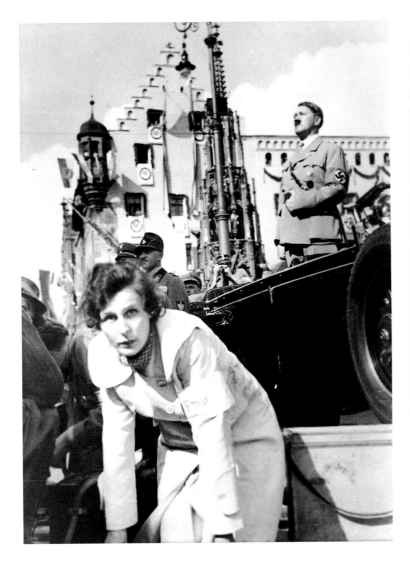

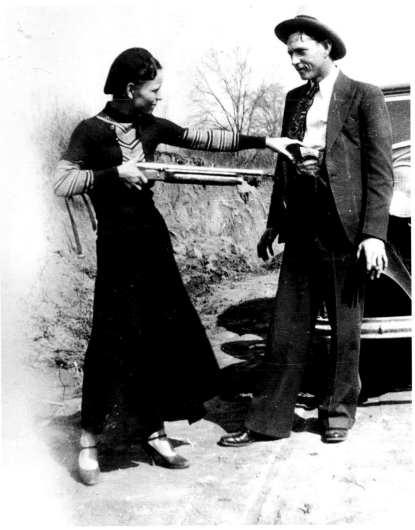

Leni Riefenstahl making *Triumph of the Will* – her monumental film in praise of Hitler.
Bonnie Parker and Clyde Barrow – the legendary American robbers and killers whose story was made into a powerful film in the 1960s.

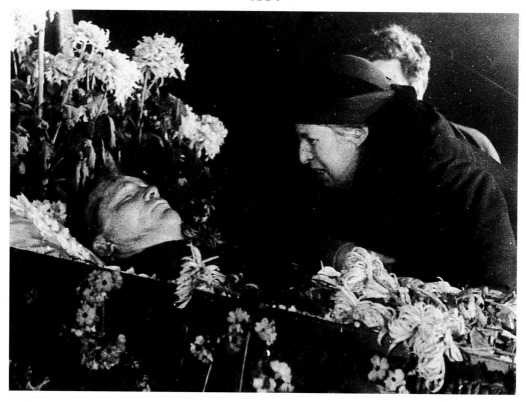

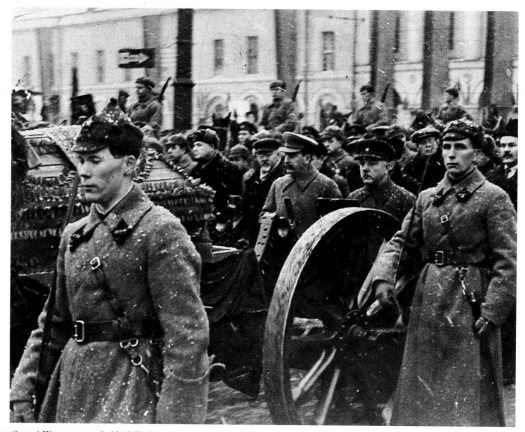

The popular Sergei Kirov was probably killed by a rival in love, but Stalin took advantage of the murder to mount a huge purge in Leningrad.
Stalin (centre) was present at Kirov's funeral.

Hitler's faithful genius of propaganda Joseph Goebbels could have had many reasons for elation on his way to the Reichstag.

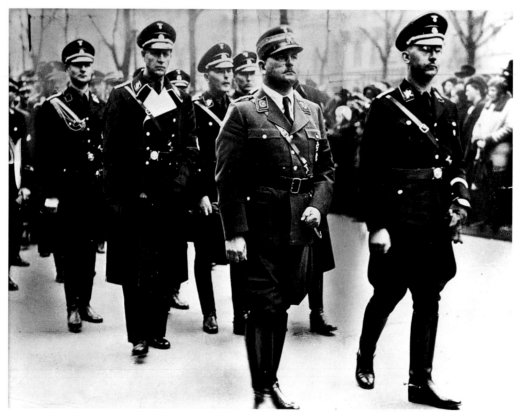

Ernst Röhm, leader of the Brown Shirt thugs, posing for a magazine feature designed to show his gentler aspect as a loving son and brother.
Heinrich Himmler (right), SS and Gestapo chief and perhaps most chilling of all the Nazis, parades with Röhm (left). Hitler and Himmler had Röhm killed before the end of the year.

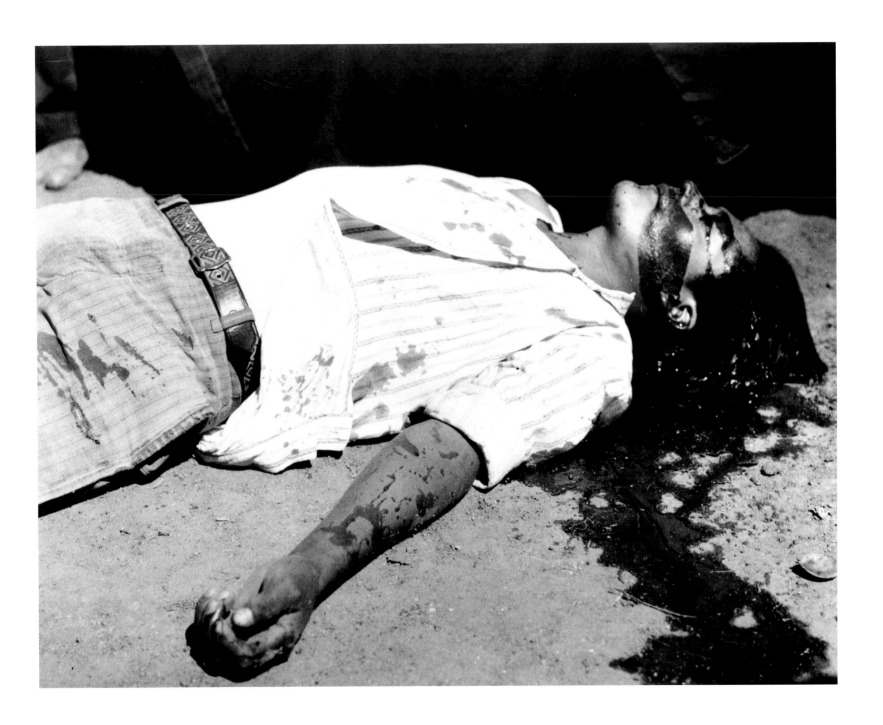

A stark photograph of a murdered striker by the Mexican master Manuel Alvarez Bravo.

Thomas 'Fats' Waller – the great and humorous exponent of the 'stride' style of piano – a virtuoso of great delicacy who died young.

Albert Einstein delivering a progress report on his view of the universe which involved his new mass-energy theorem to the New York press.

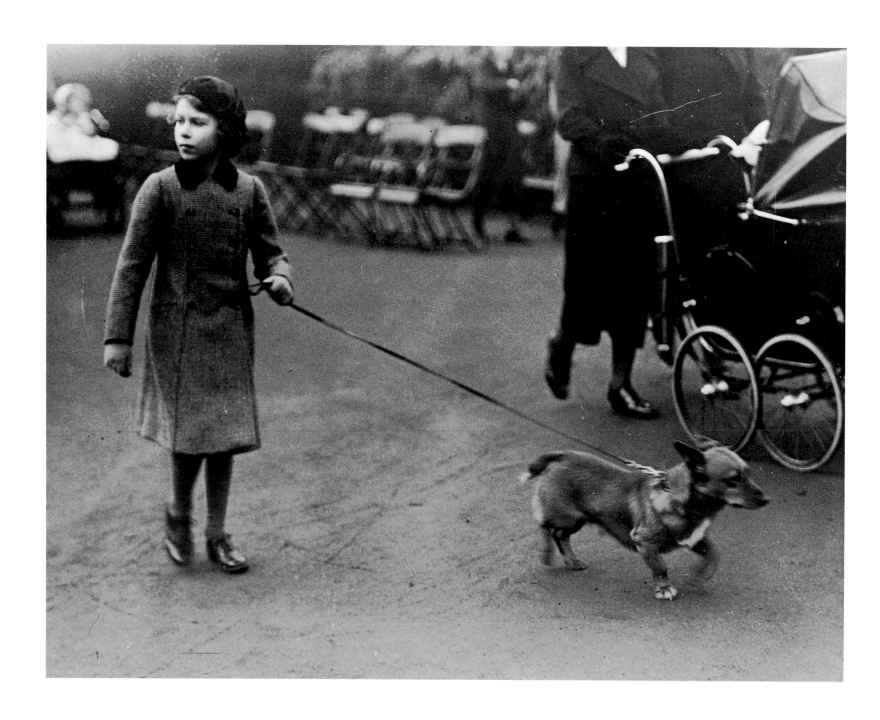

Princess Elizabeth taking a corgi, always her favourite breed of dog, for a walk in London's Hyde Park.

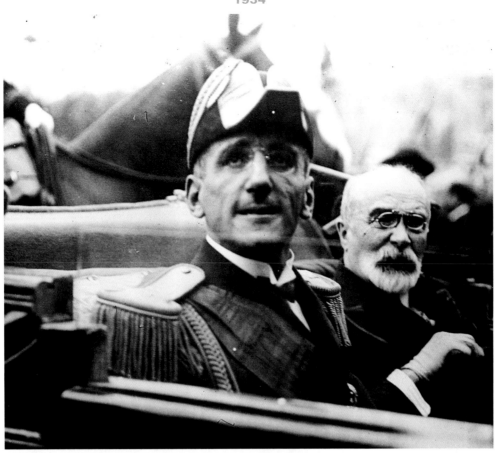

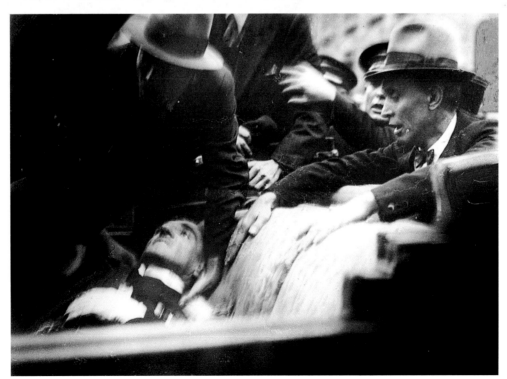

Before and after the assassination of King Alexander I of Yugoslavia and the French Foreign Minister Jean Louis Barthou in Marseilles – the photographs were taken seconds apart.

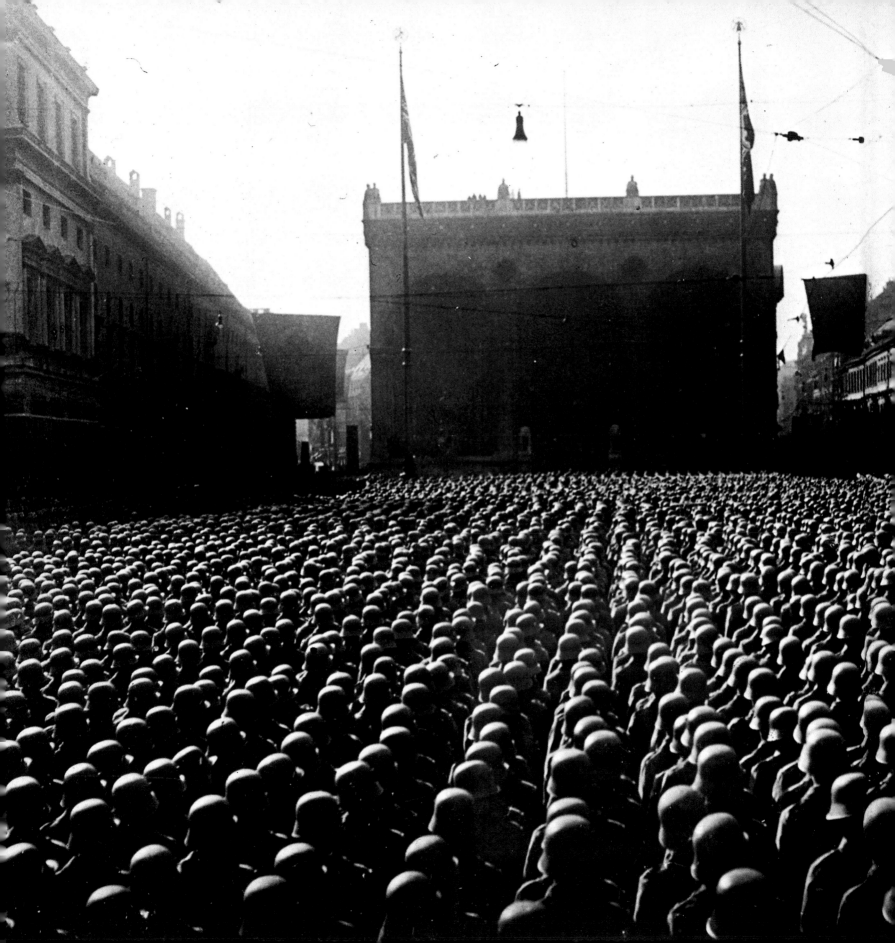

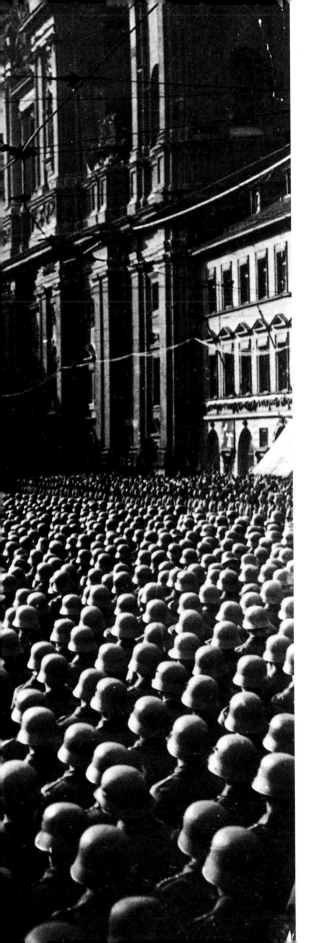

The German army in Munich's Heldenplatz swearing its fateful oath of personal allegiance to Hitler.

Hitler Youth listening to their Führer's weekly message on a 'people's radio' – as chilling in its way as a Nuremberg rally.

The *Normandie* – France's answer to Britain's *Queen Mary* – a little faster and perhaps a little smarter.

Stalin looking with favour on a young party activist – being singled out was not a guarantee of survival.

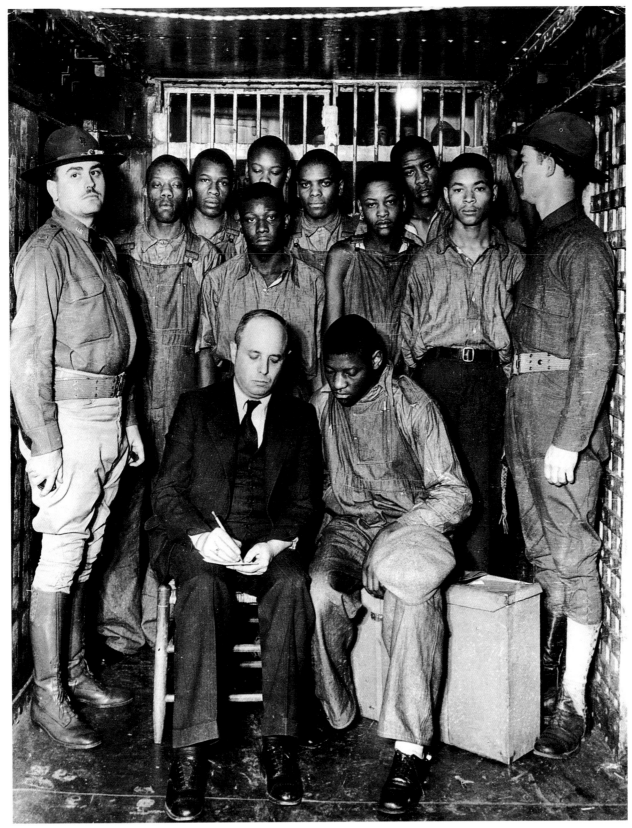

The 'Scottsboro Boys' during their struggle for vindication – their plight focused attention on general injustice towards African-Americans.

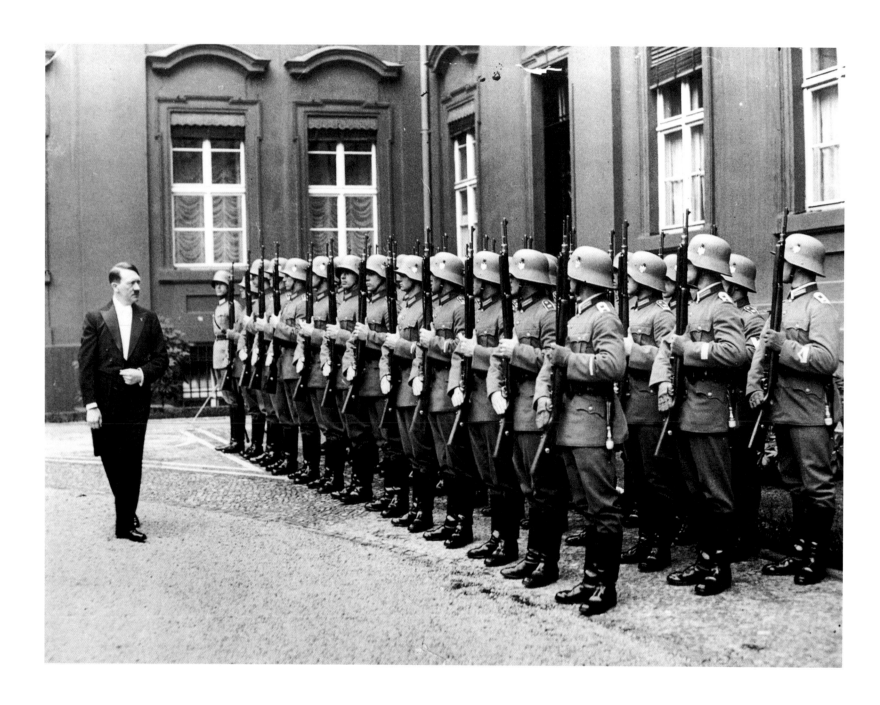

Hitler, having just received the new Polish ambassador in Berlin, inspects the guard of honour.

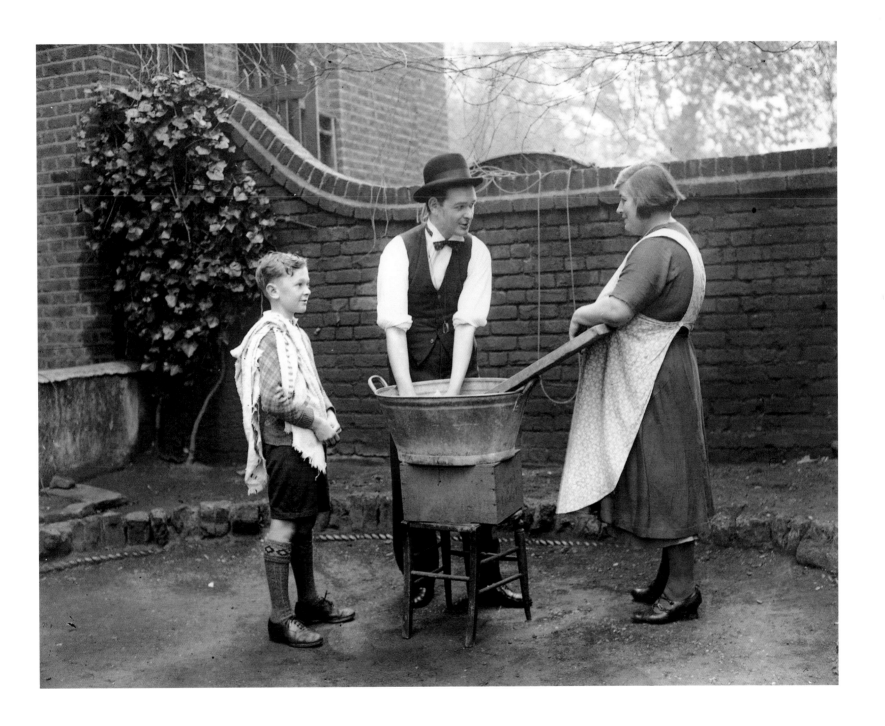

A Liberal candidate for Parliament shows British democracy at work.

Dorothea Lange's photograph of a Midwest family's sole means of housing and transportation in their search for work, taken for Farm Security Administration.

H.G. Wells, prophet of the tank and the atom bomb, predicted space travel in the film of his novel *The Shape of Things to Come*.

The march of British unemployed from Jarrow to London (457 kilometres, 284 miles) captured the entire nation's imagination. A British miner who had just spent two weeks on strike underground.

Edward VIII has just abdicated – he had been King for only ten months and was never crowned.

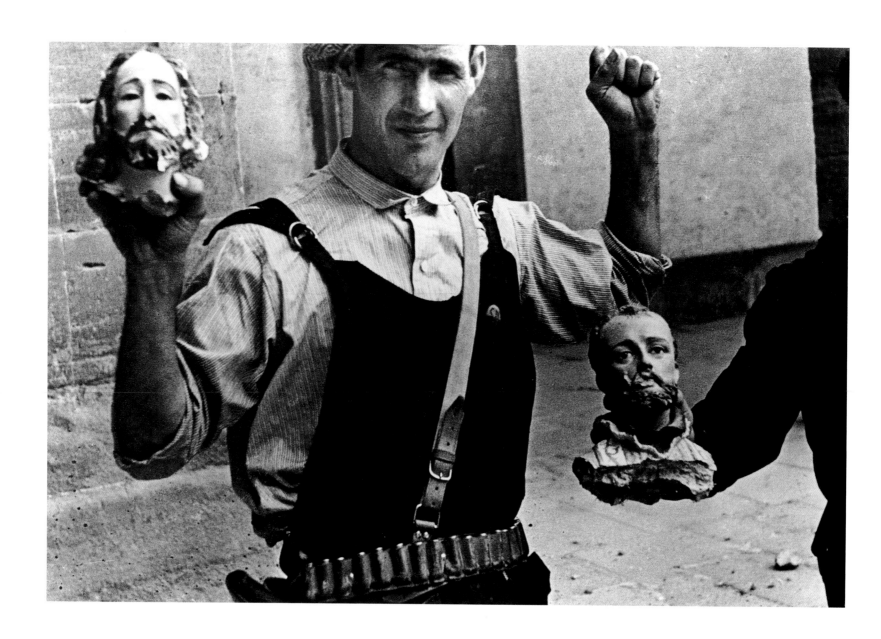

A young Republican iconoclast in Barcelona. The Spanish left were for the most part aggressively anticlerical.

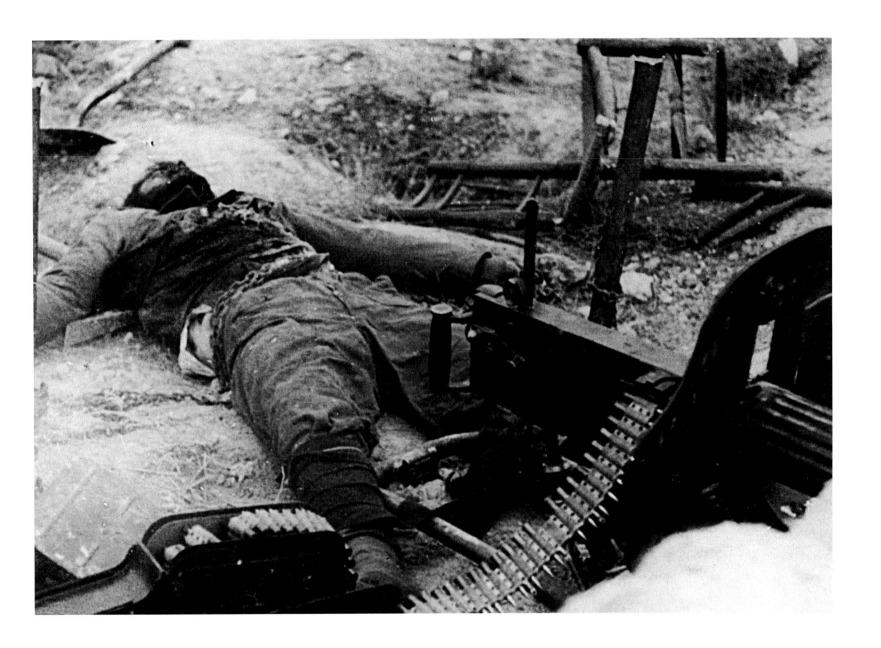

A machine gunner – probably Republican – killed by Franco's insurgents.

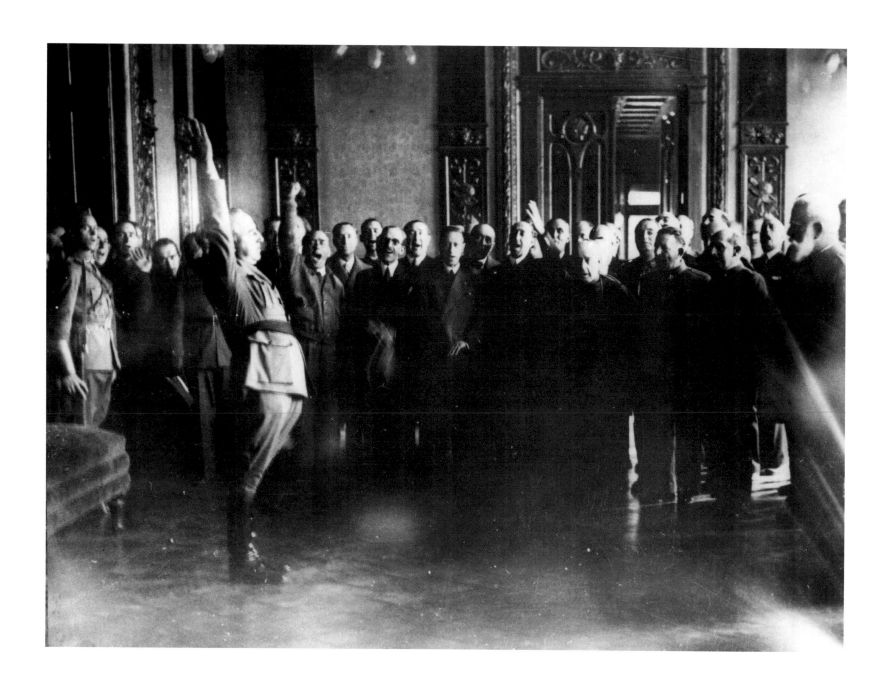

Franco takes his oath as Head of State of the insurgent Nationalist government.

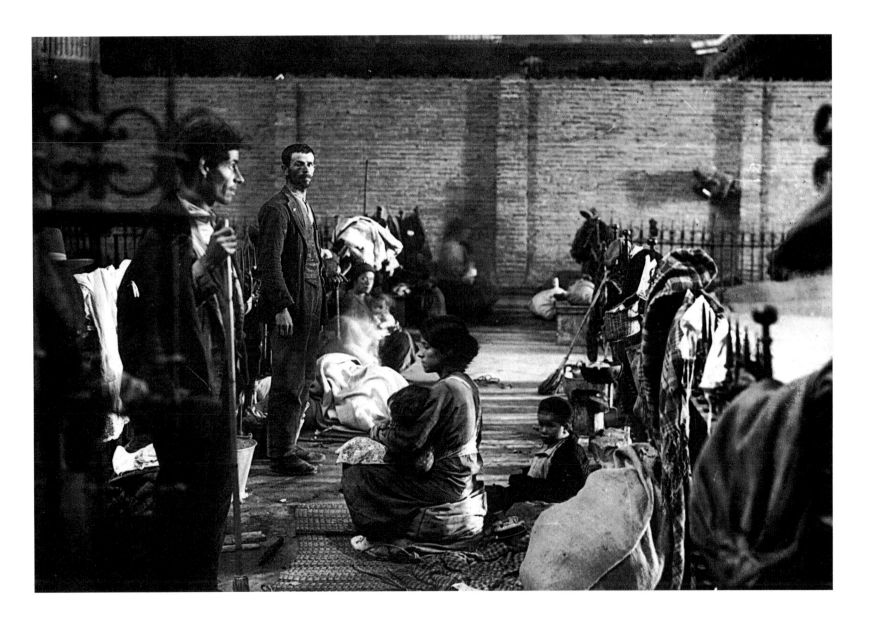

Spanish peasant refugees from the battlegrounds seeking shelter next to Málaga Cathedral.

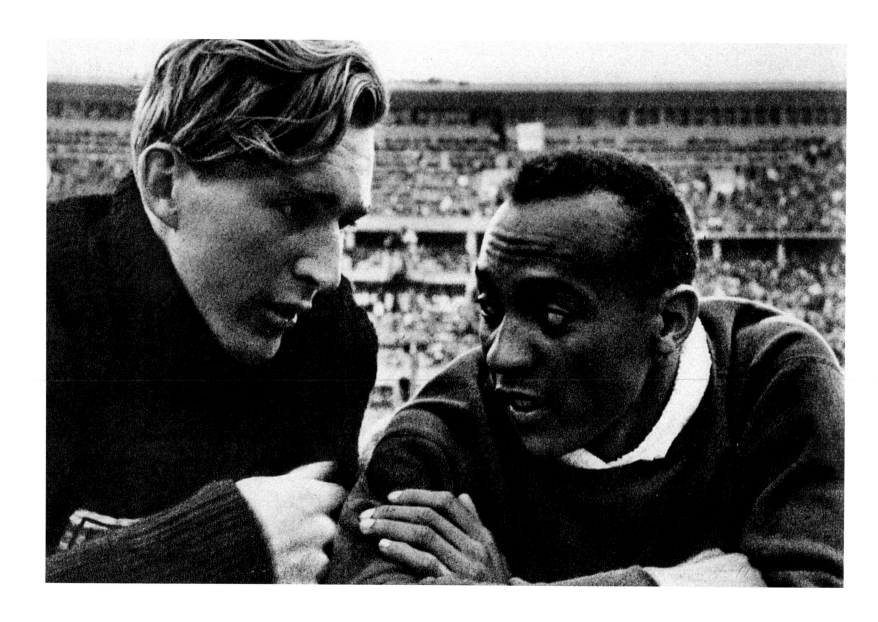

The Berlin Olympics. German Lutz Long (left) who won silver in the long jump and American Jesse Owens who won gold, presumably not discussing politics.

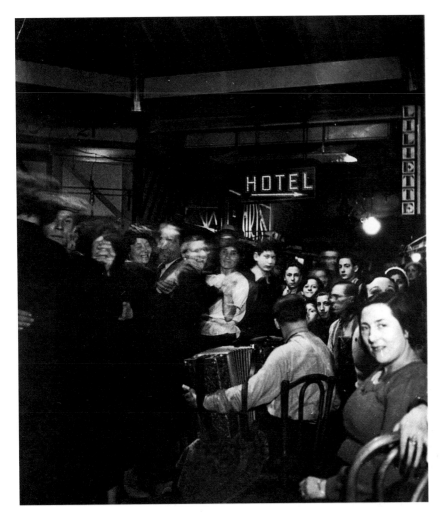

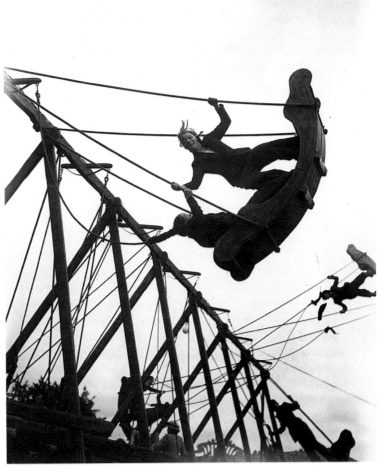

Paris strikers dancing in a shop they have taken over.
The swingboats on Hampstead Heath in London. Sometimes they swung dangerously over the top.

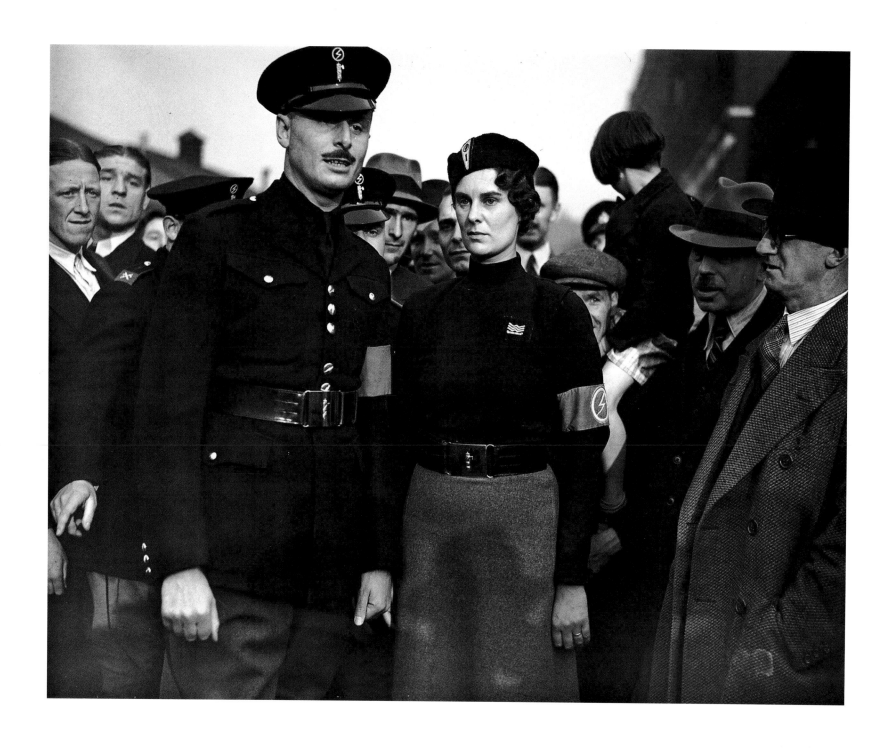

Britain's 'gentleman' fascist leader Sir Oswald Mosley being appraised uncertainly by local residents in London's East End.

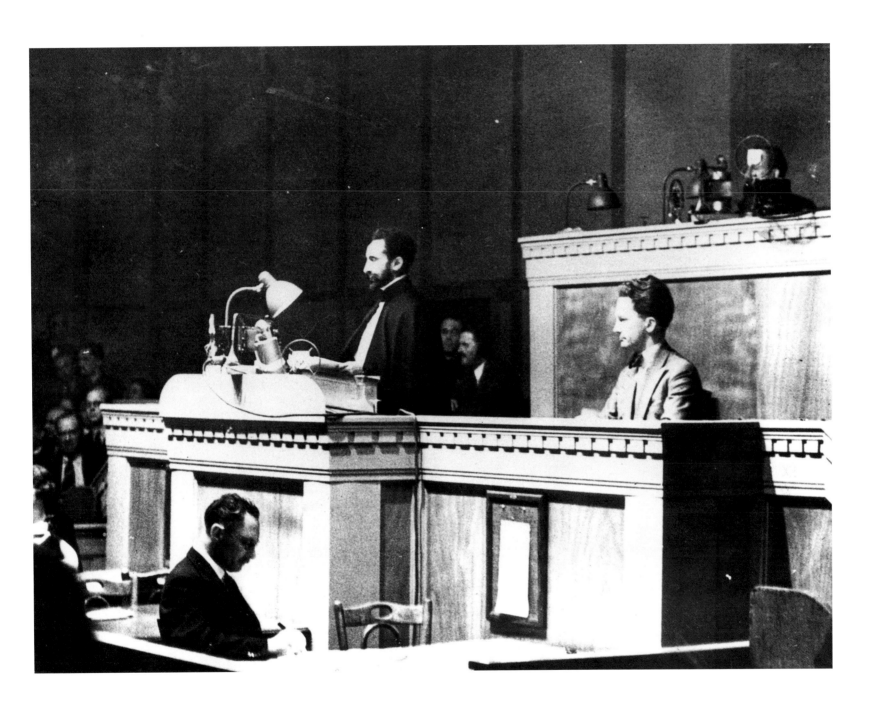

Haile Selassie, Emperor of Abyssinia, appealing at the League of Nations for help against Mussolini's invasion of his country.

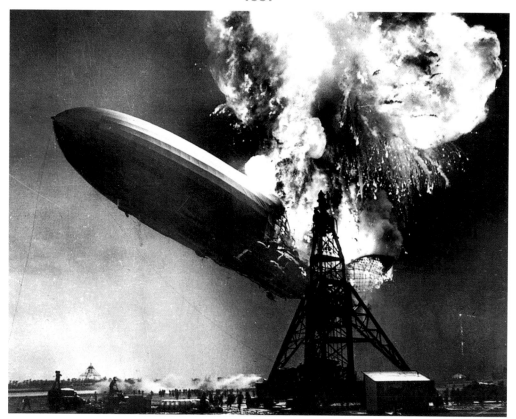

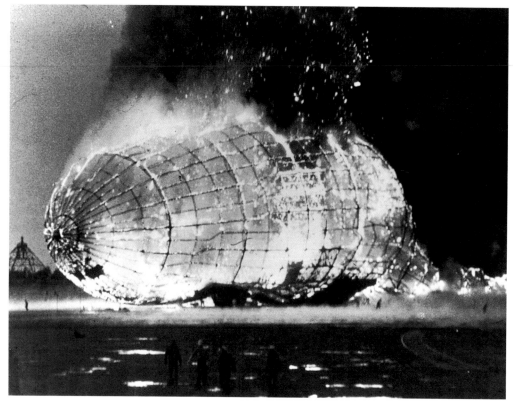

Images of destruction still somehow unparallelled – the *Hindenburg* explodes and burns at Lakehurst, New Jersey.

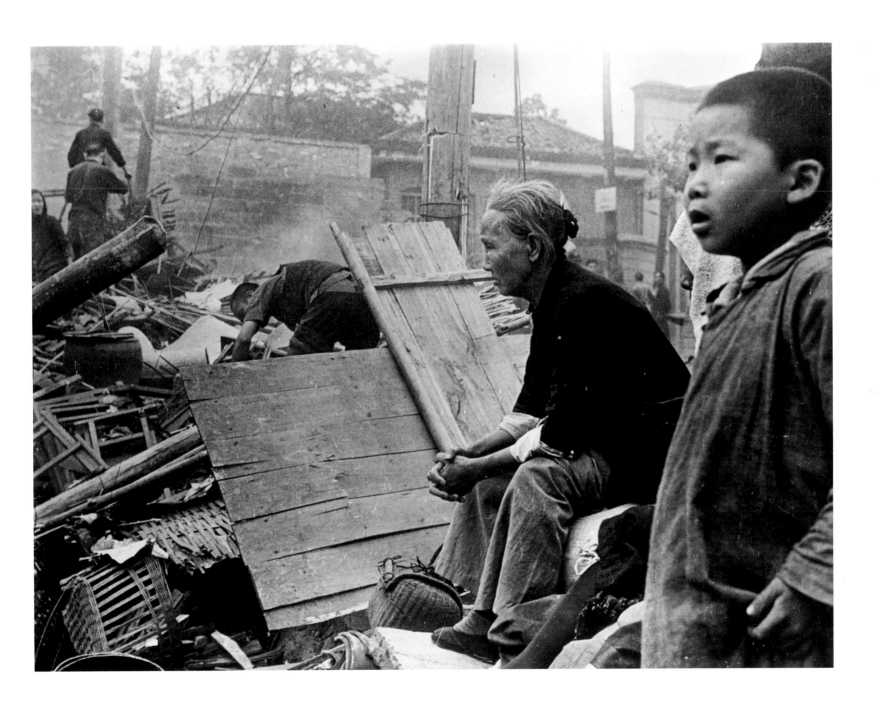

A woman and boy in Chungking in China seem baffled by Japan's destruction of their home.

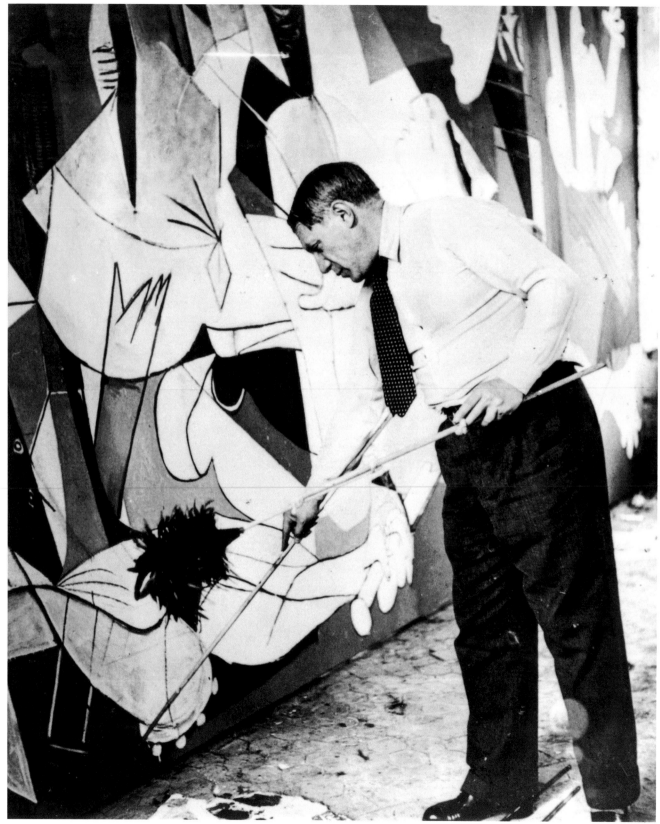

Picasso, photographed by his companion Dora Maar, completing *Guernica* – his great political statement in paint.

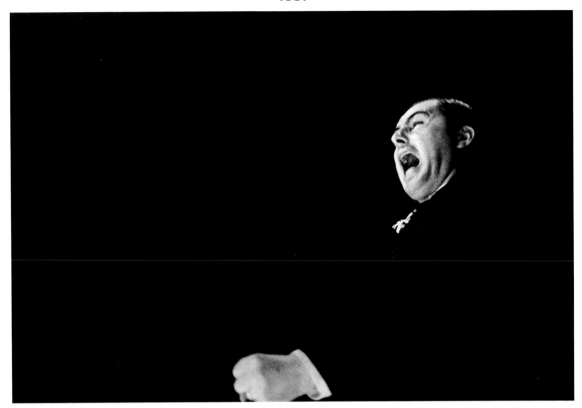

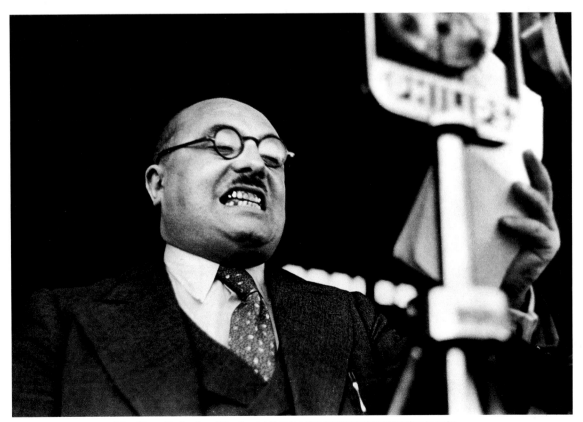

Léon Degrelle, leader of the fascist Belgian Rex Party seeking election in vain ...
... while French communist Jacques Duclos addresses a French rally in much the same manner.

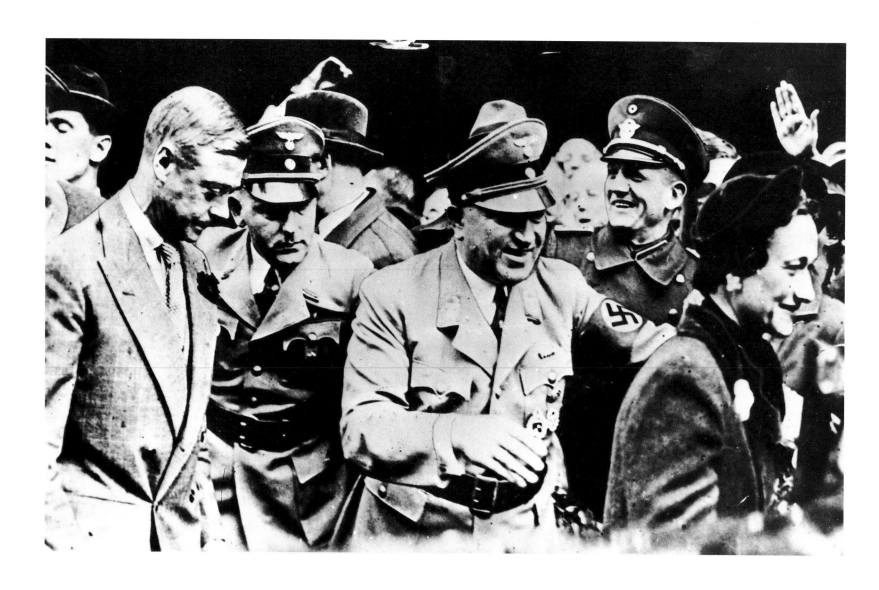

The Duke and Duchess of Windsor welcomed by Nazi dignitaries in Berlin. A polite chat with Hitler was part of their programme ...

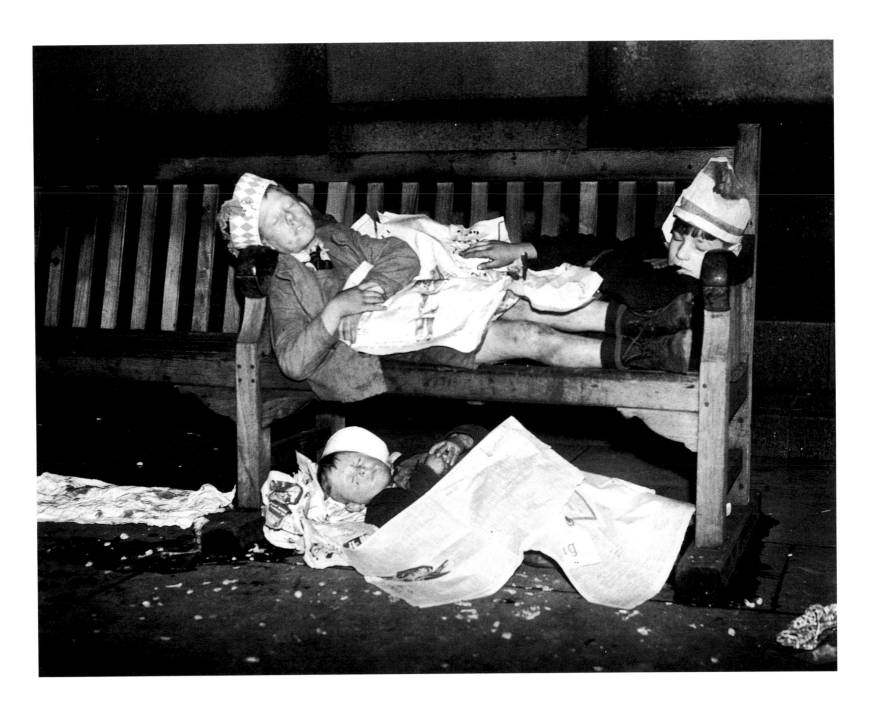

... meanwhile loyal British boys slept out all night to see George VI and Queen Elizabeth go by on their Coronation Day.

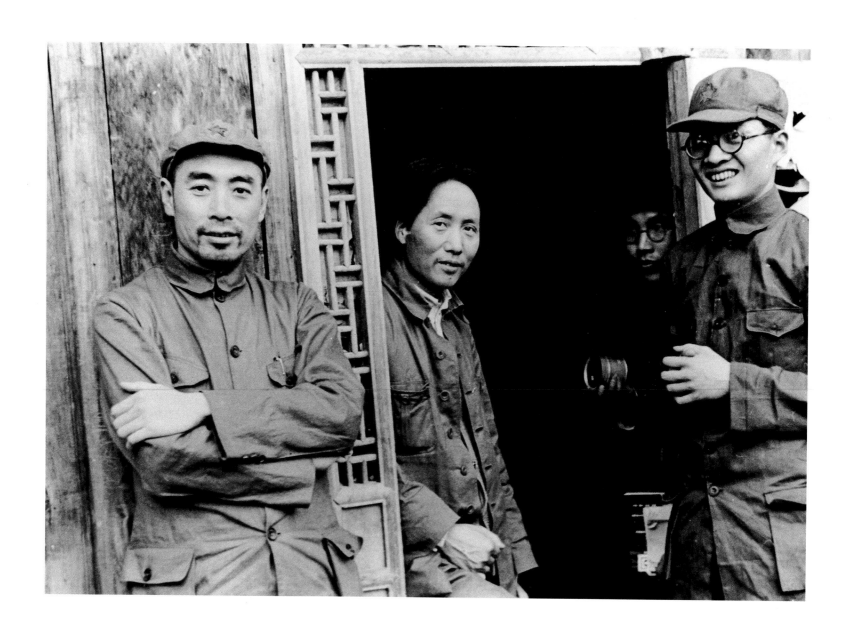

China's future leader Mao Zedong (centre) with Zhou Enlai (left) and Bo Gu (right) – confident on beginning their long climb to power.

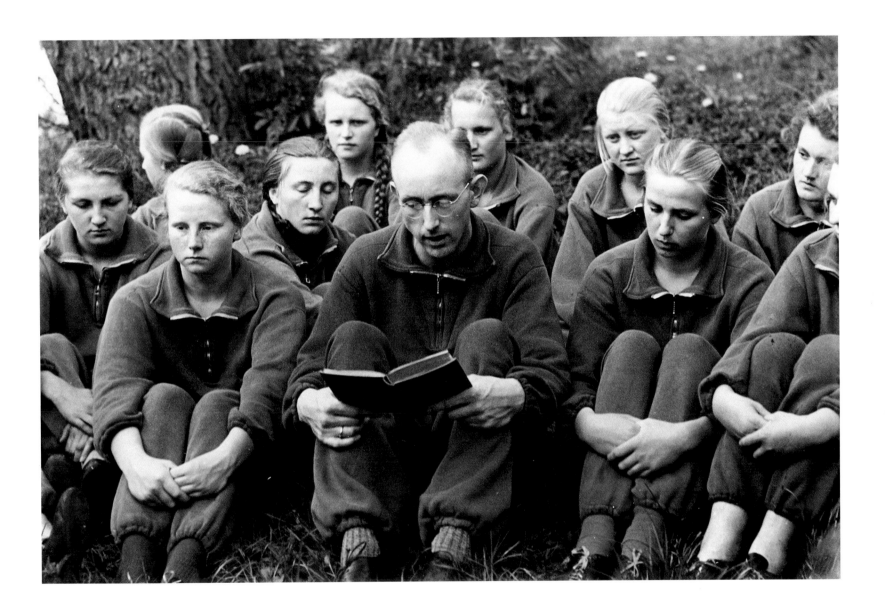

German agricultural students being taught about their native soil.

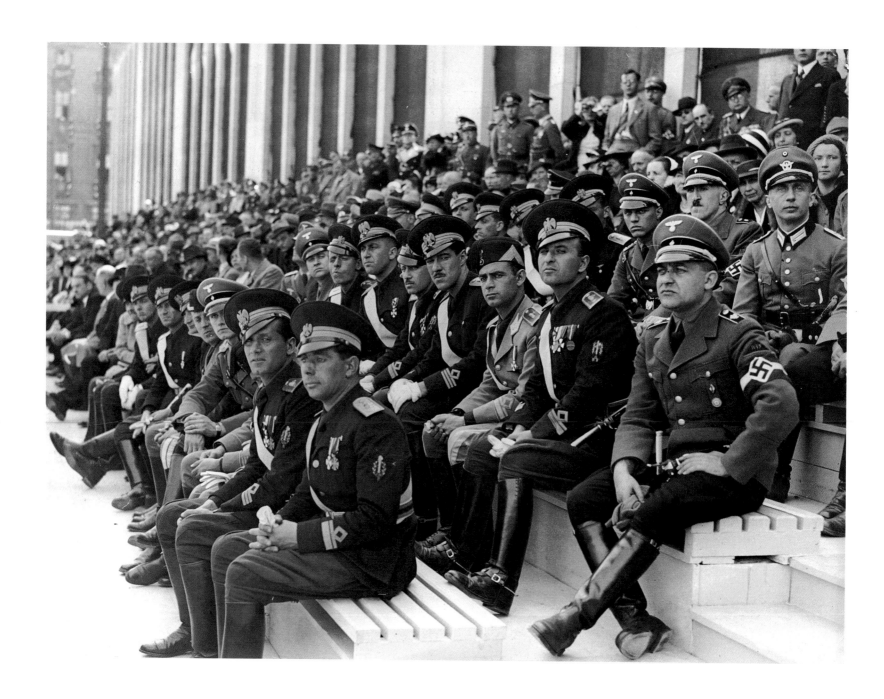

In Berlin's Lustgarten, German and Italian youth leaders glory in the shared ideals of the Rome-Berlin Axis.

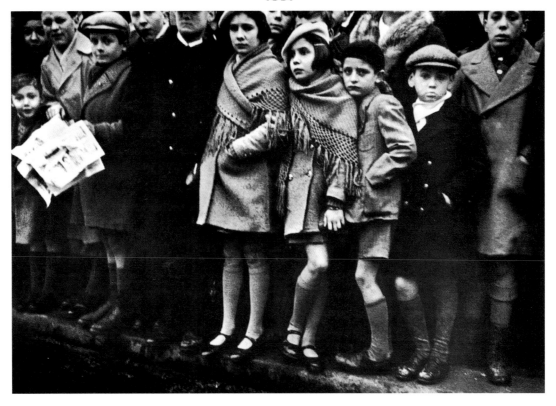

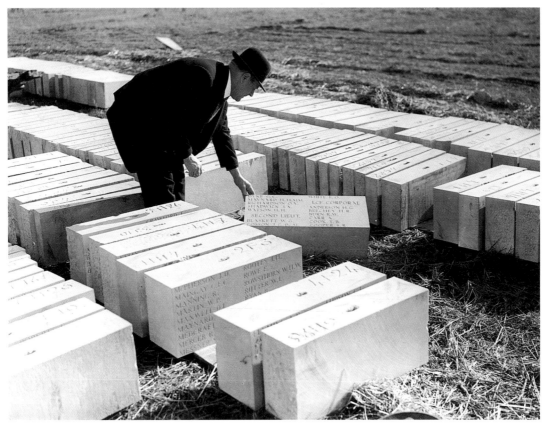

Robert Capa noticed anxious children at the Paris Armistice Day parade – a hard time to grow up in France.
First World War memorials still being erected – this one for Australians at Amiens in France had the names of 10,860 unrecovered bodies.

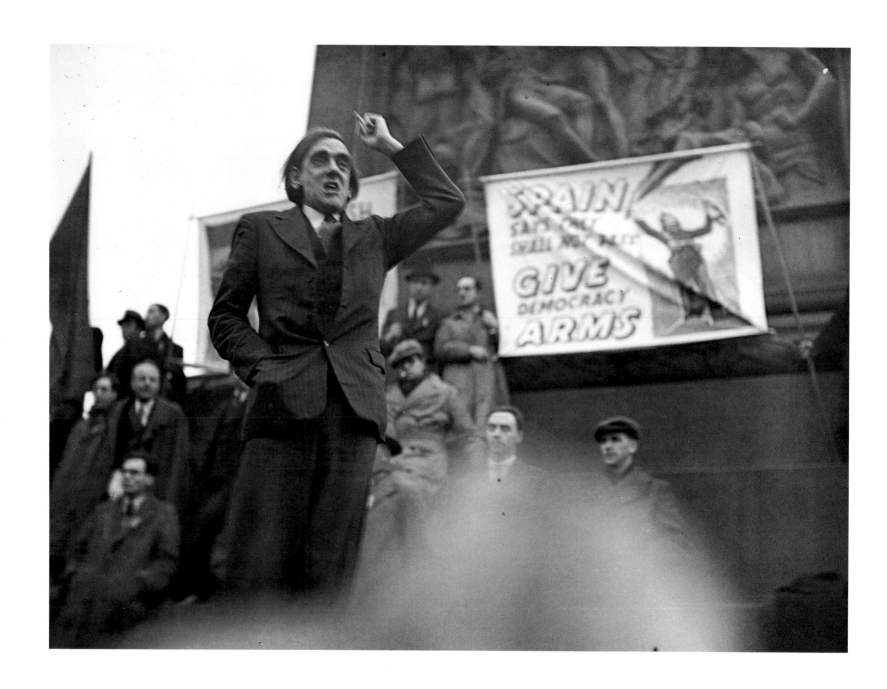

James Maxton, an extreme left-wing Scottish Labour MP, appeals for aid for the Spanish Republicans.

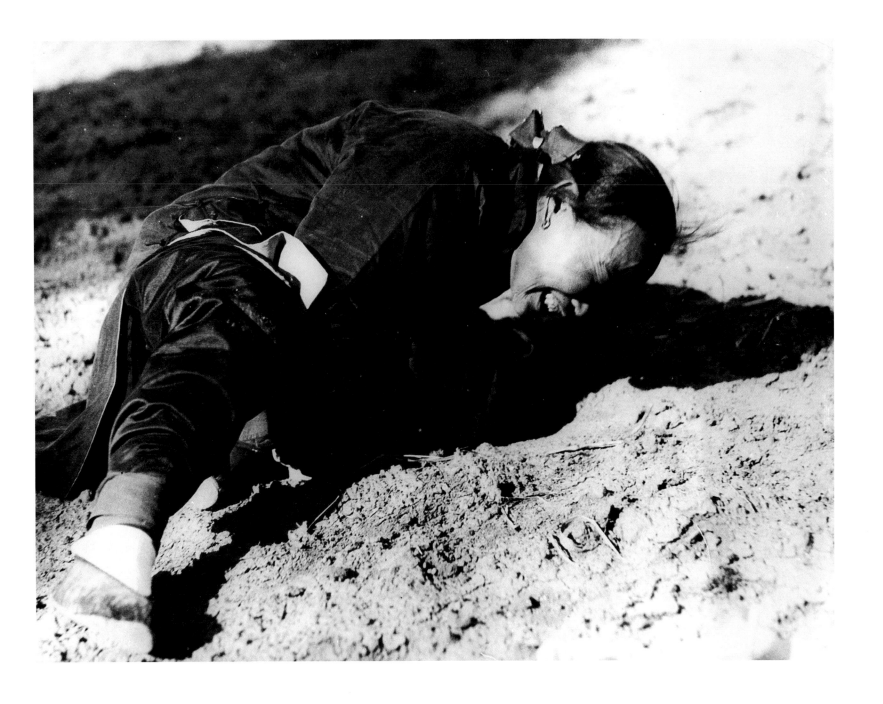

A Chinese woman weeping on her husband's grave – one of many killed by the Japanese.

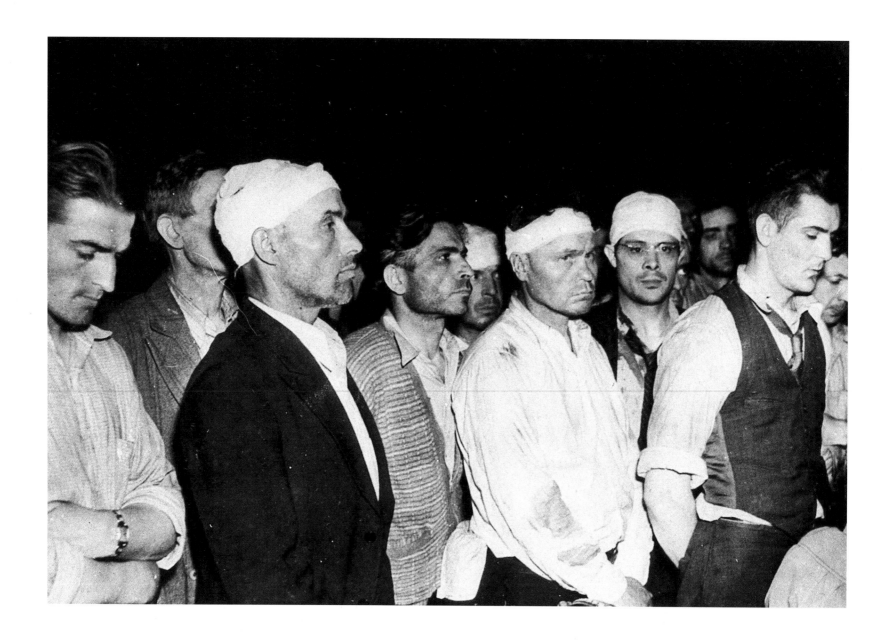

The strike riots at Republic Steel in Chicago were unusually violent – six were killed and nearly a hundred injured.

Czech Prime Minister Eduard Beneš at the funeral of Tomás Masaryk, the founder of Czechoslovakia. Their beloved country would not last the century.

Austrians greeting a Nazi train as it arrives in Vienna. Only Jews, liberals and communists failed to welcome the Nazis.

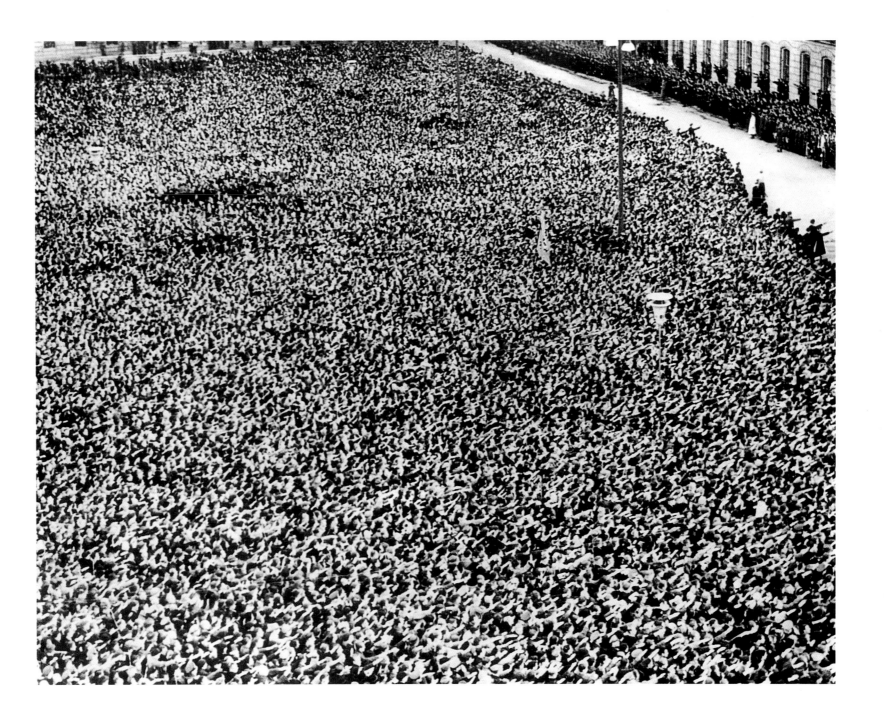

Berlin greets Hitler on his return from Austria. One-and-a-half million people were said to have lined his route from the airport.

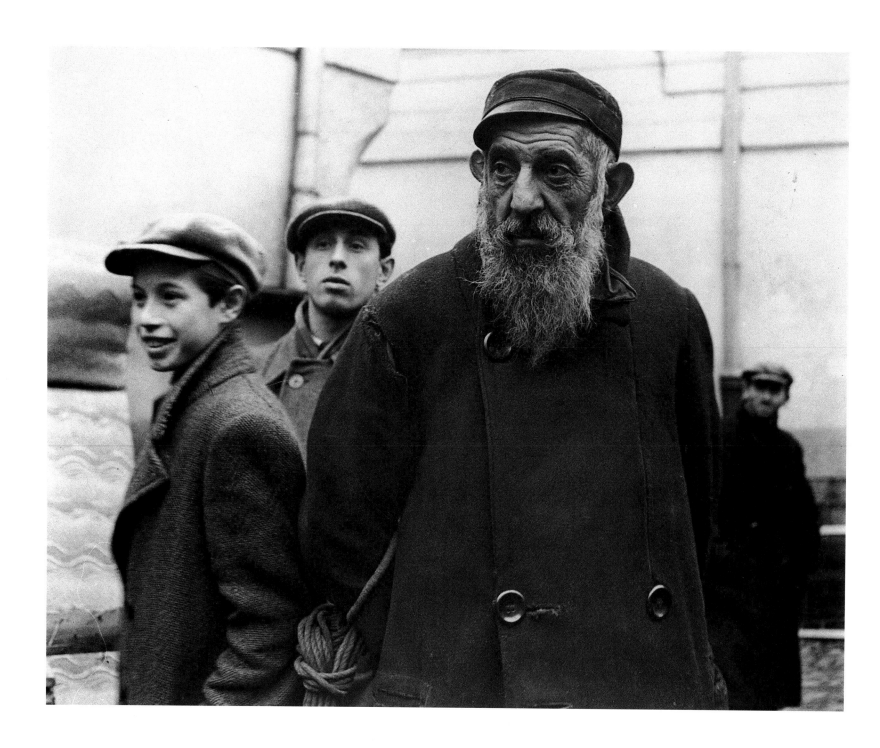

A Street Porter, Warsaw. Later events would make Roman Vishniac's photographic document of Warsaw Jewry even more poignant.

Kristallnacht, the night of broken Jewish windows and burnt synagogues. A shopkeeper seems incredulous at the Nazis' fulfillment of Hitler's avowed intentions.

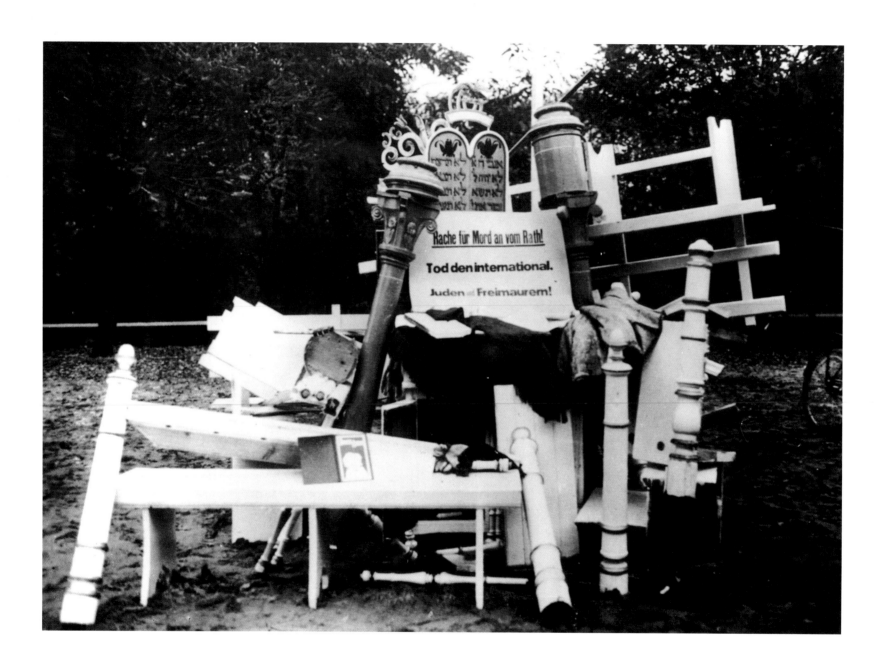

The furnishings from a German synagogue are declared a bonfire of revenge for the murder of a Nazi by a Jew.

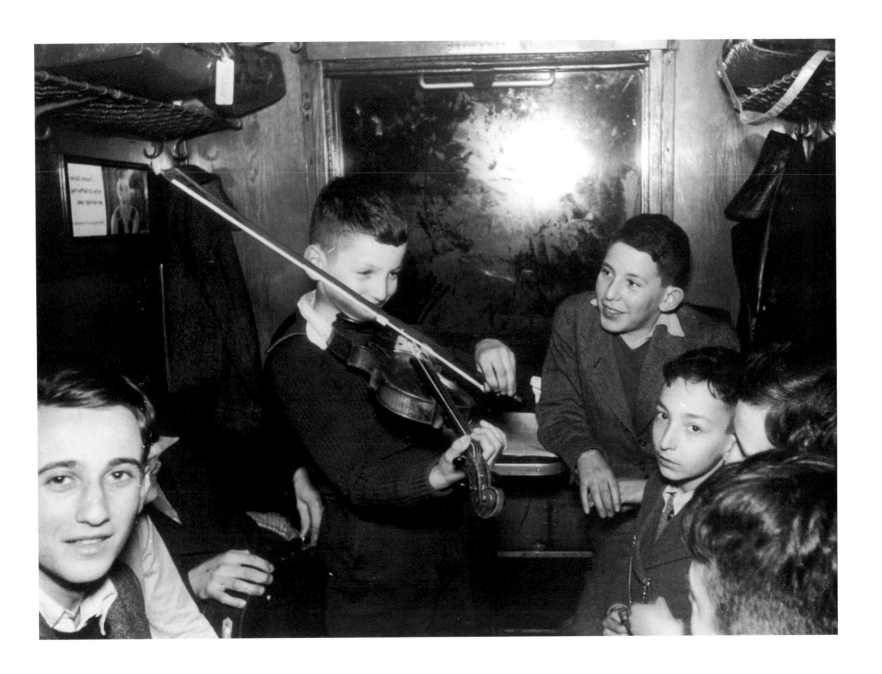

Jewish refugee children celebrate their freedom on a European train. It was not just musical talent which was lost to the 'decadent democracies' through Nazi racial policies.

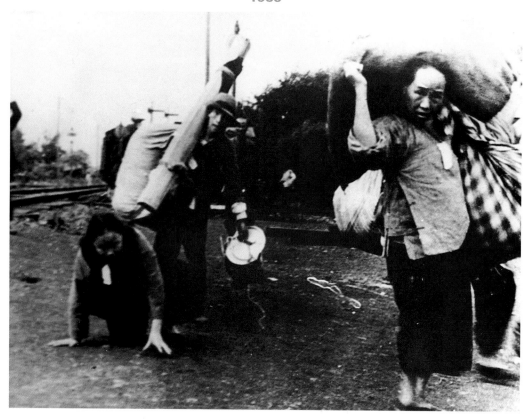

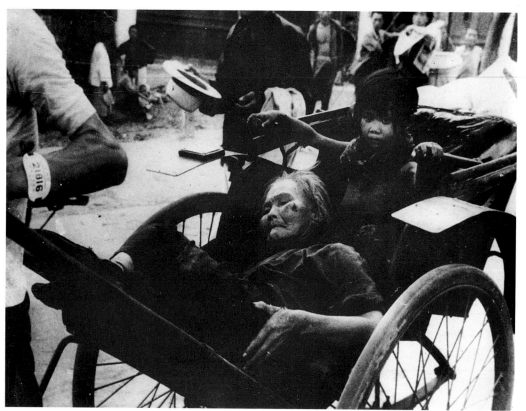

Citizens of Shanghai fleeing the city as Japanese excesses become more and more extreme.
A wounded woman from Shanghai being pulled to relative safety in a rickshaw.

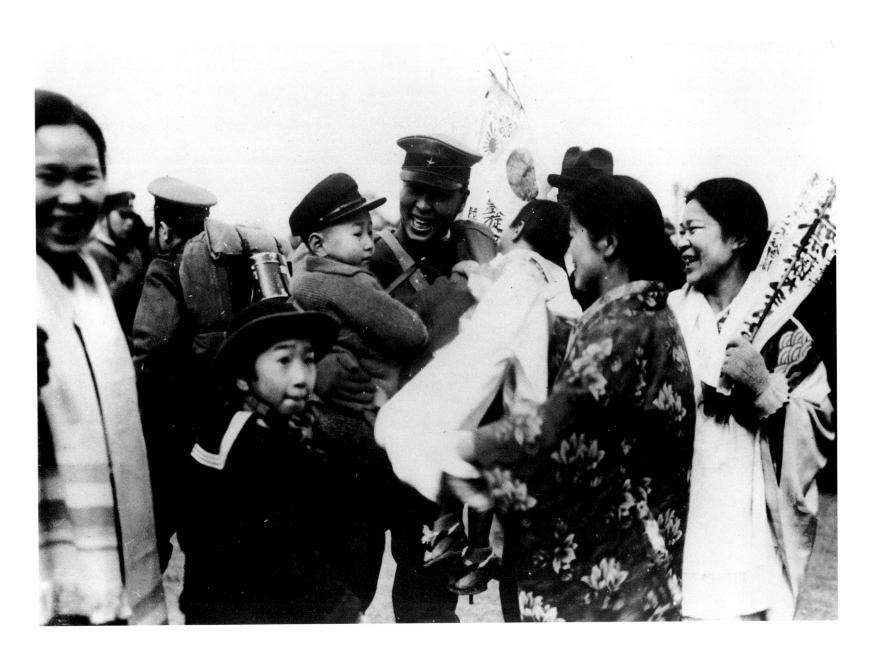

A Japanese soldier home from China receives a hero's welcome in Tokyo.

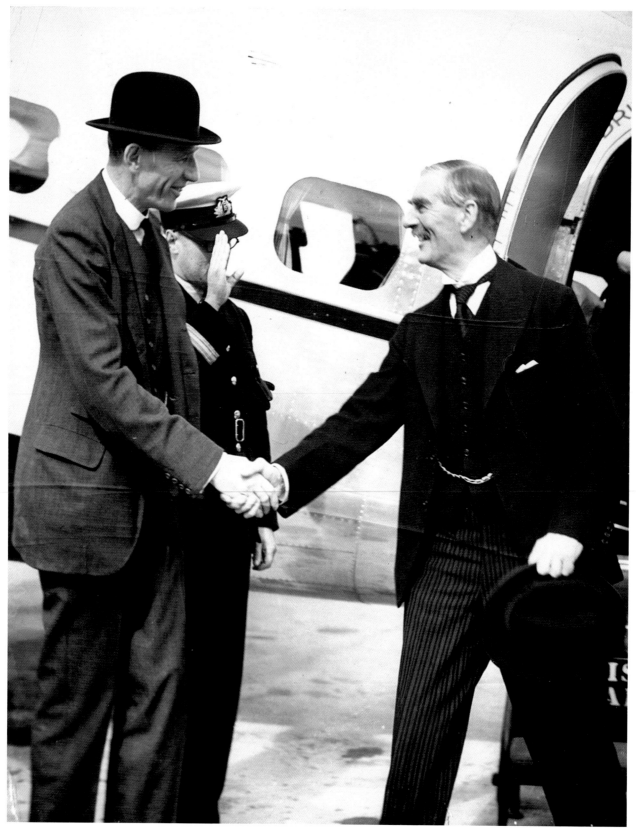

Lord Halifax (left) and Neville Chamberlain seem confident that their deal with Hitler had gained them more than a breathing space.

A strange combination of folk costume and Nazi triumphalism – Romanian women expressing their support for Hitler.

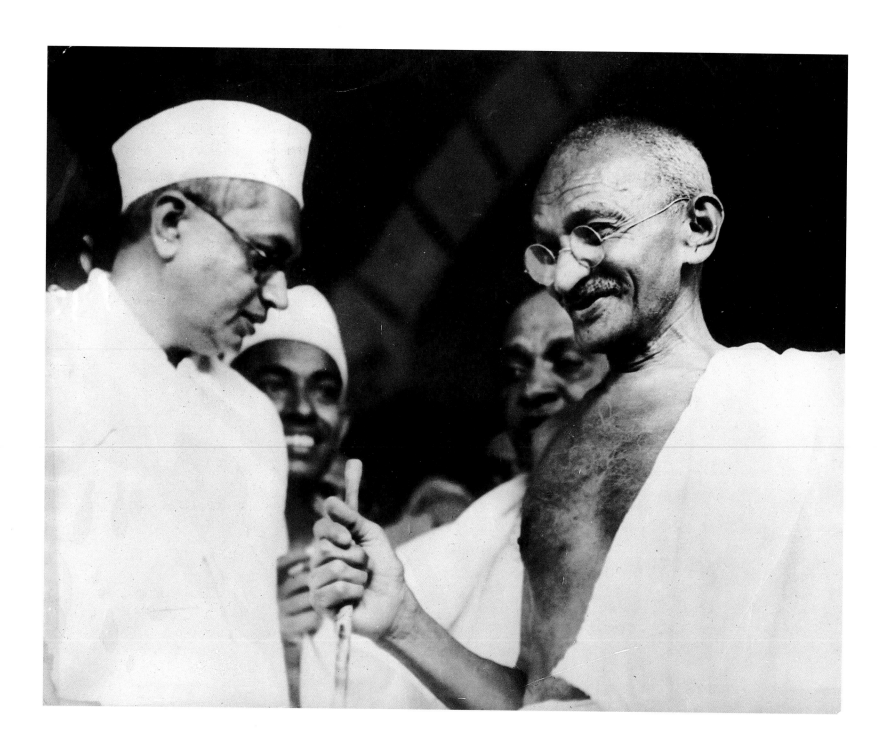

Mahatma Gandhi leaving a Hindu-Muslim Unity meeting, having just predicted his own imminent death.

The Eighteenth Congress of the Communist Party in Moscow applauds news of increased defence spending.

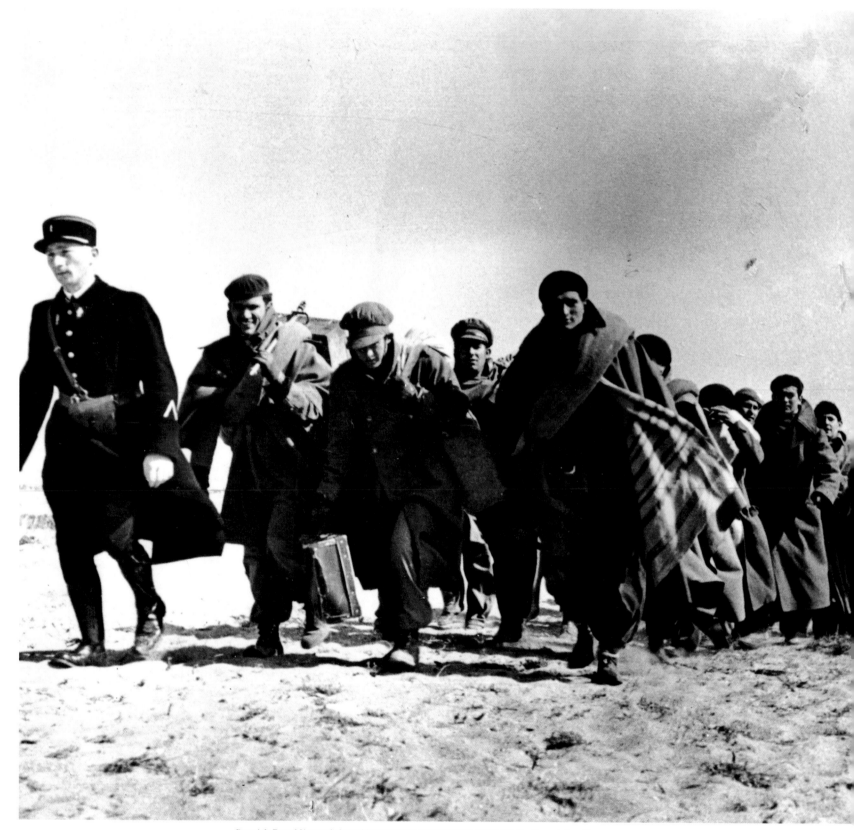

Spanish Republicans defeated by Franco's Nationalists make for the French frontier.

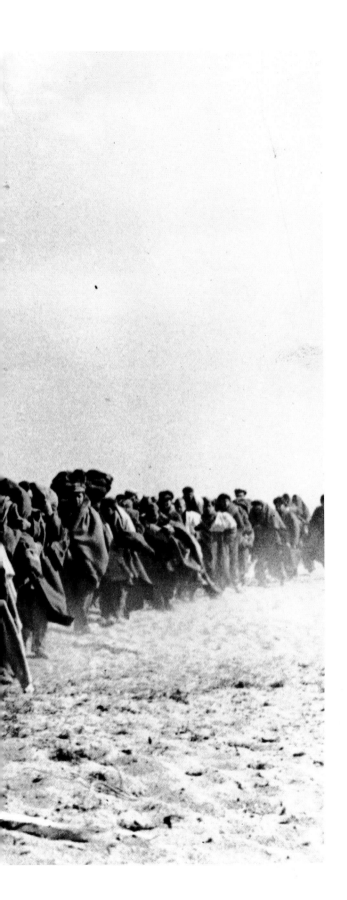

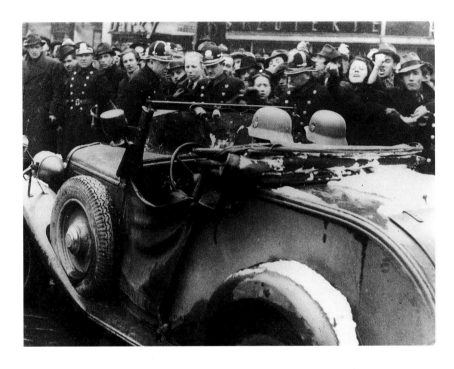

In March 1939 the Germans entered Prague unopposed.
The Czechs had been helplessly expecting it, but more than one man is shaking his fist.

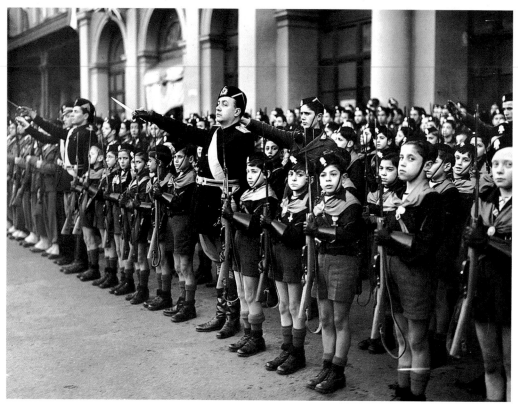

Young SS officers well prepared to keep order in the 'Thousand Year Reich' ...
... while young Italian Blackshirts untidily prepare to welcome Mr Chamberlain.

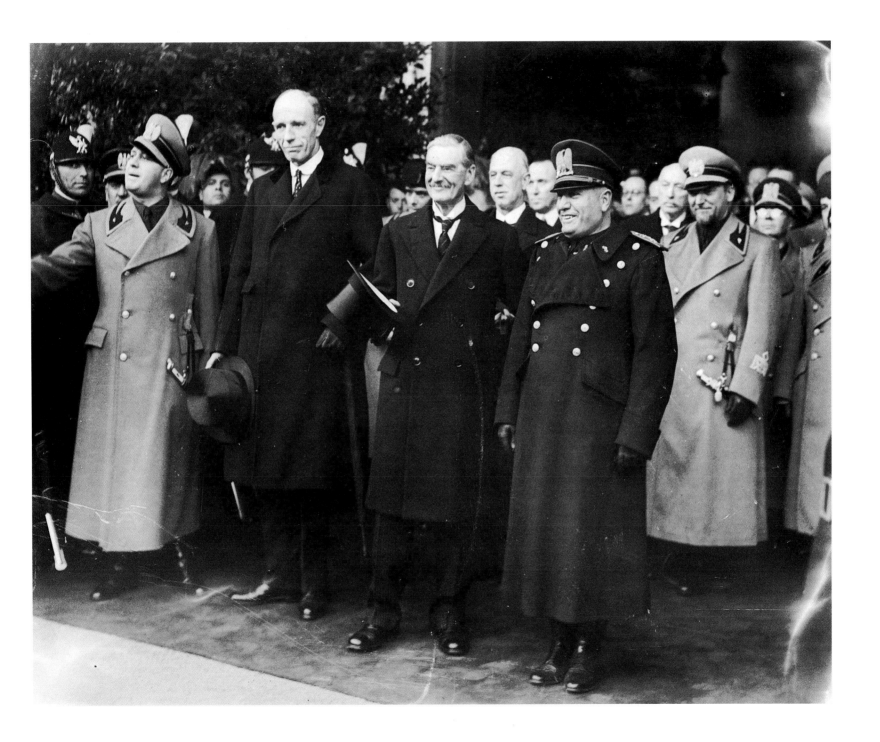

Lord Halifax and Neville Chamberlain (with top hats) seem genuinely pleased with the jovial company of Mussolini and Counts Ciano and Grandi (far left and right).

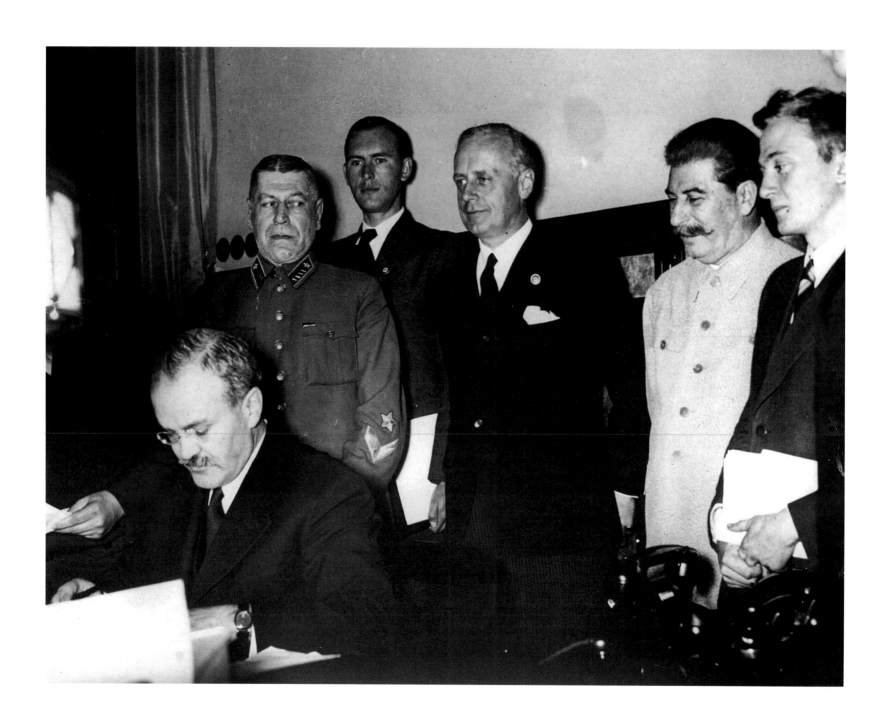

Stalin (second from right), Vyacheslav Molotov (seated) and Joachim von Ribbentrop (centre) at the signing of the non-aggression pact with Hitler.

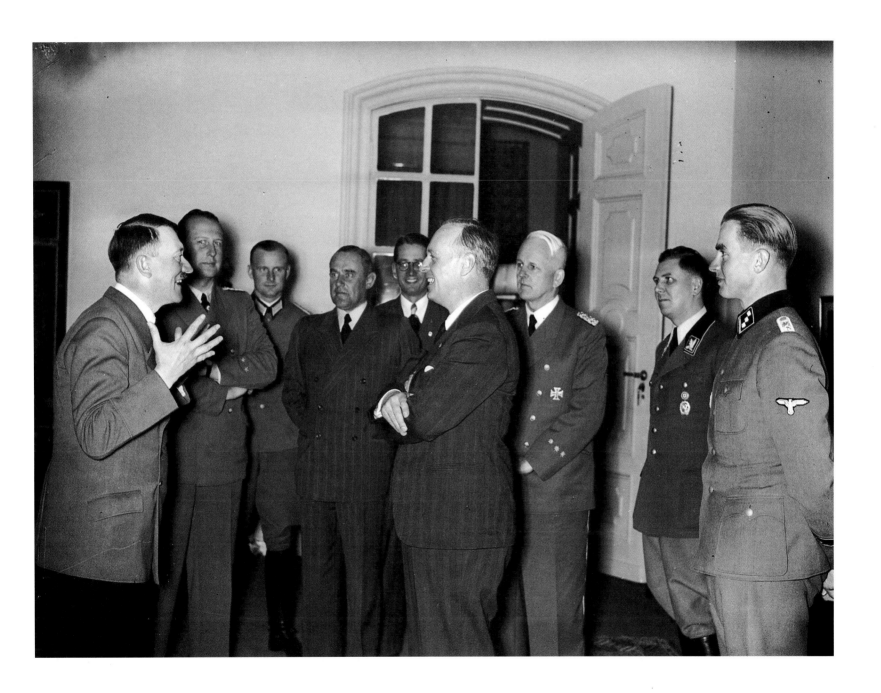

Hitler (left) and Ribbentrop (centre) delighted with their treaty with Stalin which would soon bring Germany half of Poland and then a Soviet Union unprepared for attack.

Ninotchka – a brilliant film comedy detested by those on the left. Greta Garbo's icy Russian envoy has finally been thawed by the debonair American Melvyn Douglas.

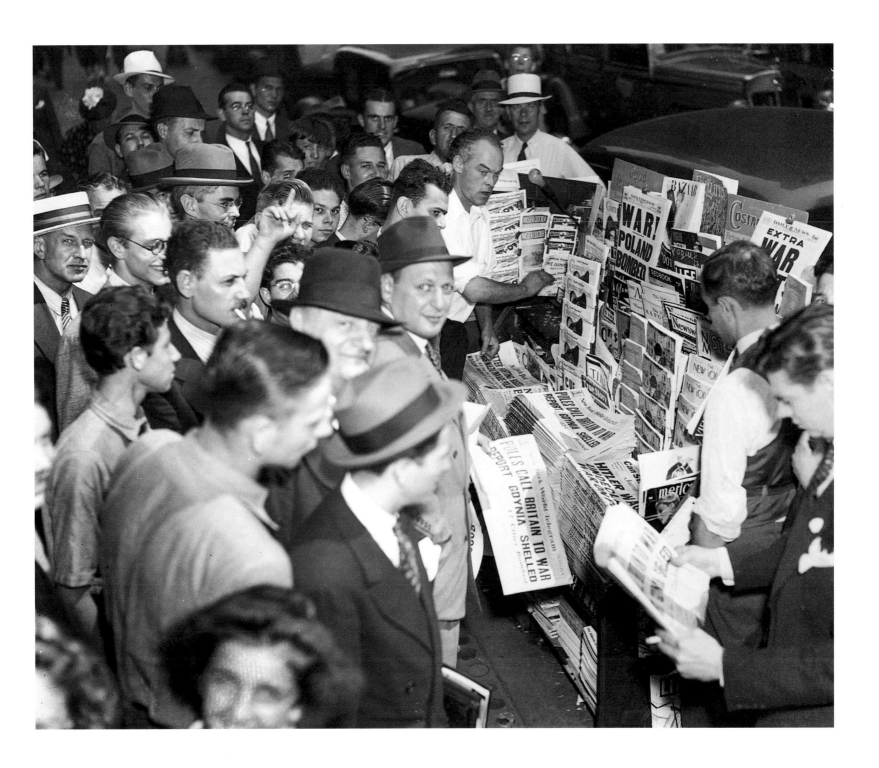

On the other side of the Atlantic Americans still felt far from the new war, although they wouldn't be for long.

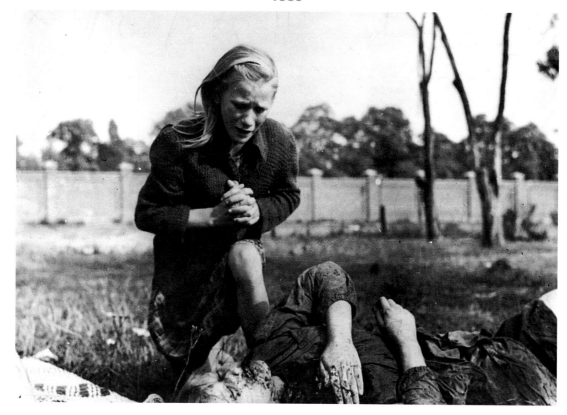

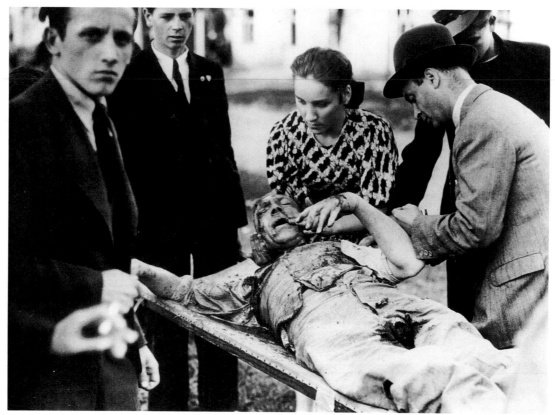

A girl kneels helplessly by a victim of a German air raid on Warsaw.
Another Polish air-raid victim.

French women reading of the war outside a newsagent – the First World War would have still been clear in their memory.

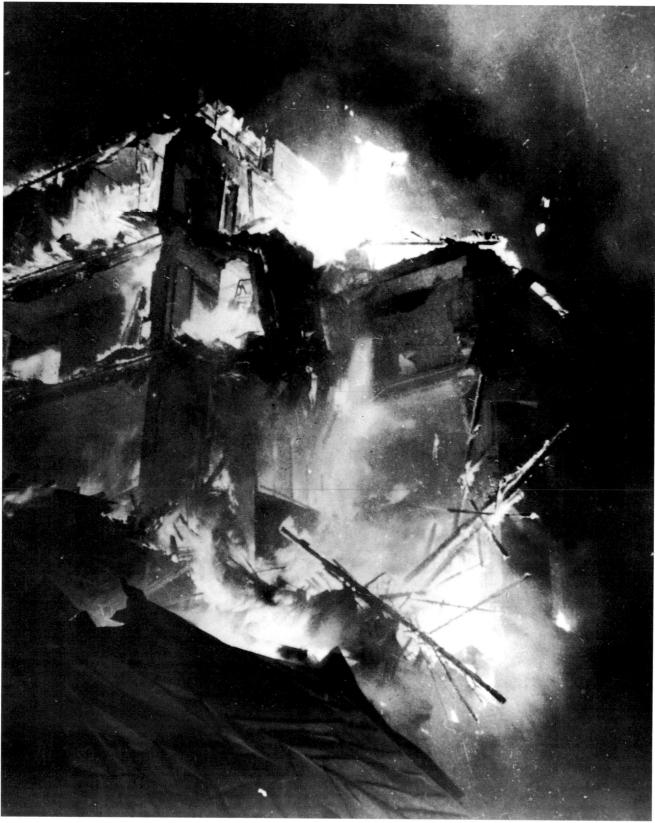

Helsinki set alight by Russian planes in an opportunistic attack on their small neighbour.

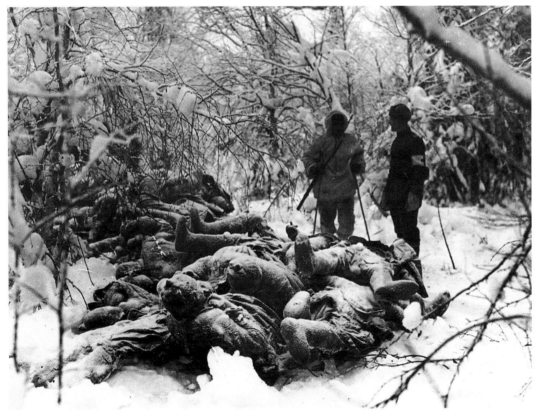

Russians held prisoner by the Finns were amazed by their good treatment and food.
The Finns at first resisted the Russians but were soon forced to bow to Russia's greater numbers.

German *Luftwaffe* men on a transport plane bound for Norway.

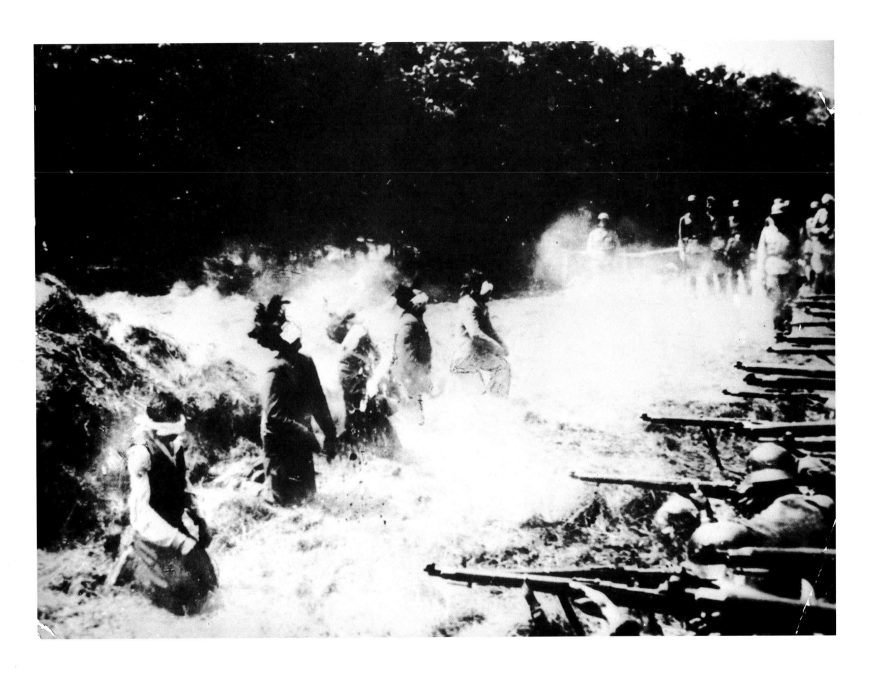

Polish resistance or other 'undesirables' being shot – soon a common occurrence in Eastern Europe.

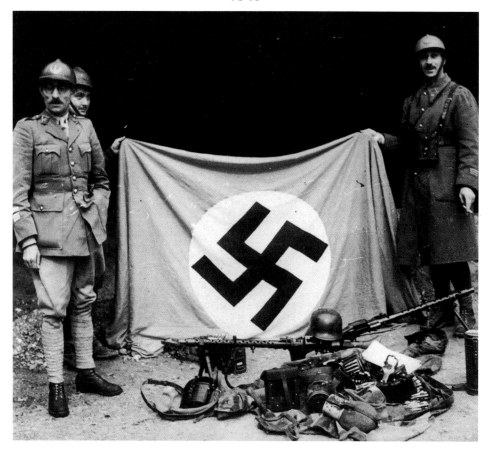

French patrols with unimpressive booty from the Germans – their apparent complacency was misjudged.
A Belgian family heading for France on a bright new tandem. They would have needed to get further than France to escape the war.

Messerschmitt Bf 109s dogfighting over Rotterdam with Dutch Fokker G1s which have distinctive gated tails.

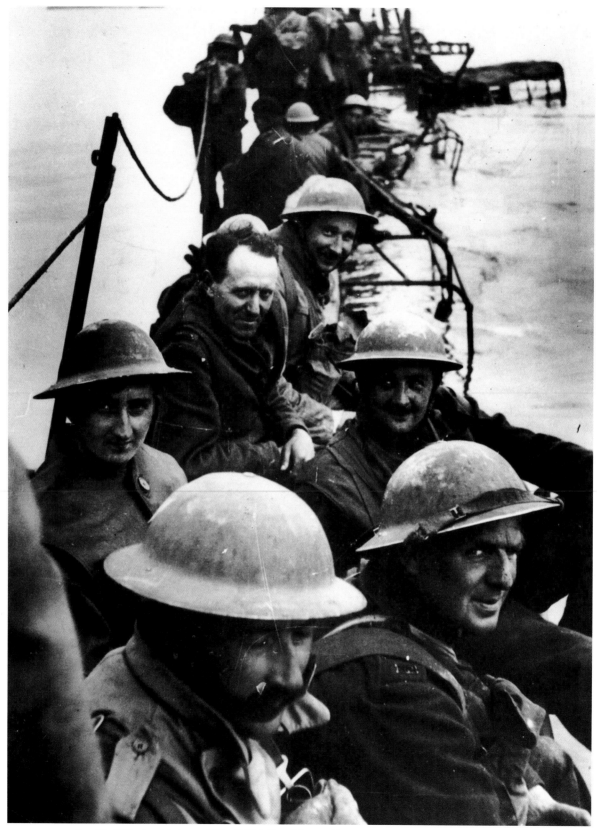

Saved by Hitler's misjudgment? The British Expeditionary Force at Dunkirk lives to fight another day.

Devotion to their game earns these British golfers an armed guard against German paratroopers.
A man at a London train station is overwhelmed by the sight of captured German airmen.

Italians in Milan urging the annexation of Tunisia and Corsica – which Italy never implemented.

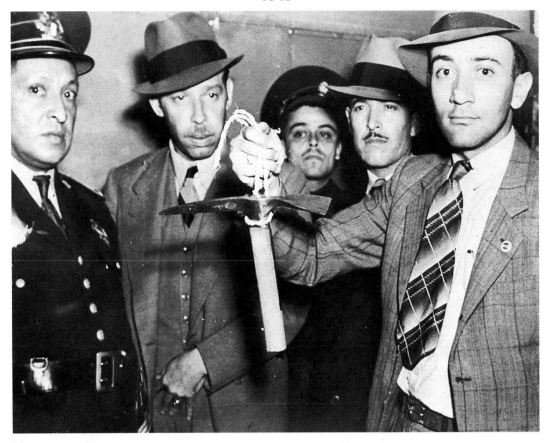

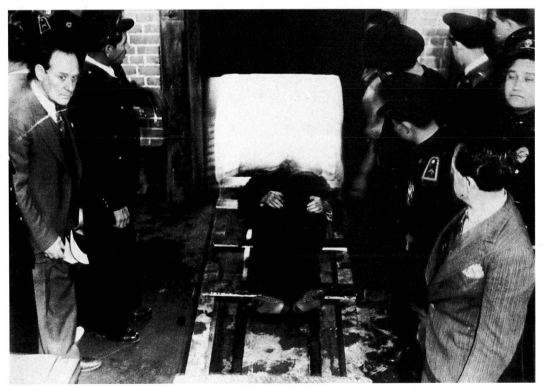

Mexican police with the ice axe used by Stalin's agent to kill Trotsky.
Trotsky's body being cremated. Followers of the Fourth International would however continue their fruitless struggle.

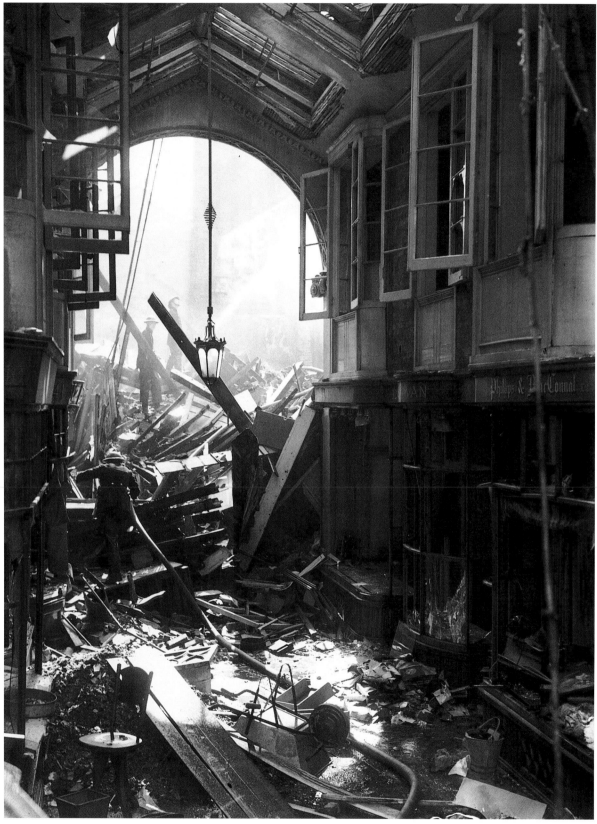

The Blitz caused considerable damage and loss of life in London – even closing down the Burlington Arcade.

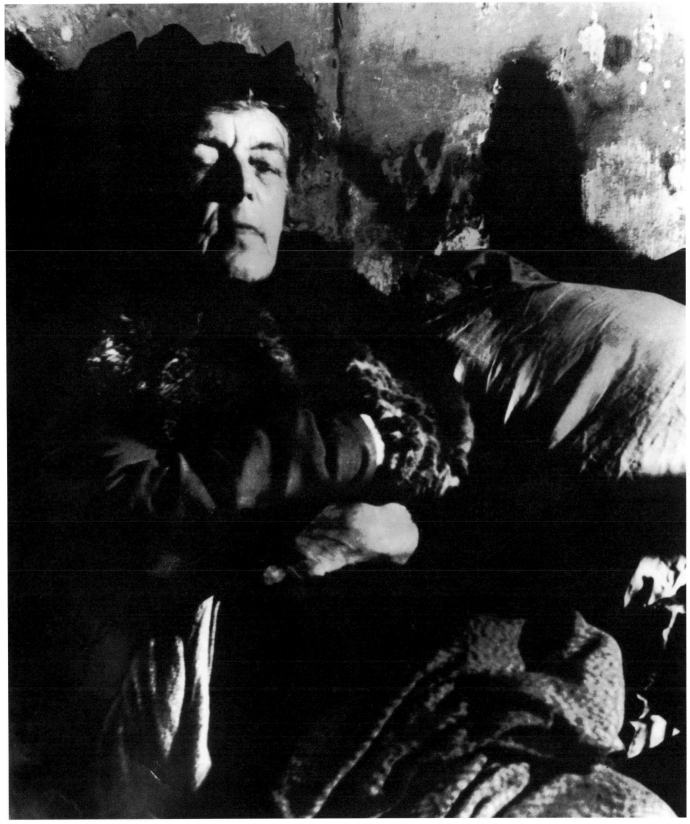

Bill Brandt took this photograph in the crypt of Christ Church in Spitalfields, London, of
an East End resident who had sought shelter from the Blitz.

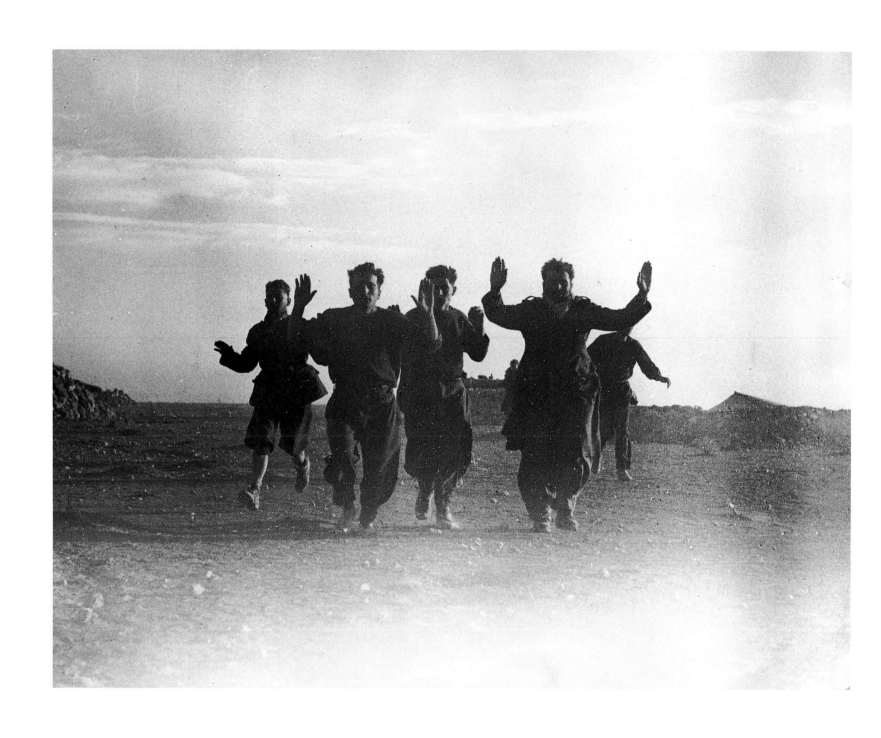

Italians surrendering to the British in Libya. They offered little serious resistance.

Orson Welles undaunted by the initial failure of *Citizen Kane*, which was soon rated among the greatest of all films.

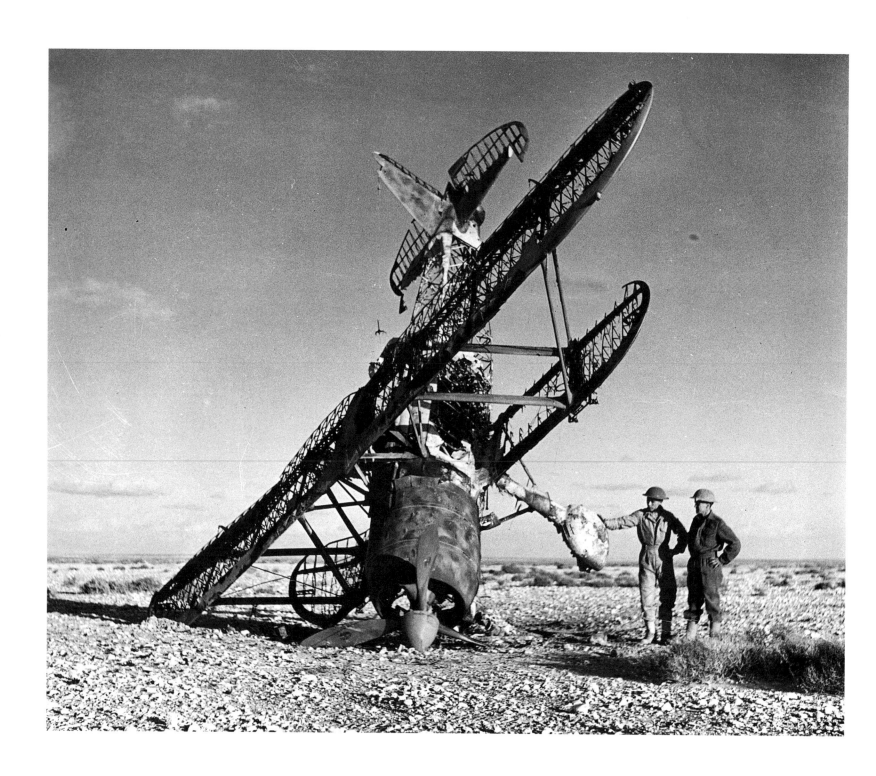

An Italian biplane brought down in the Western Desert in Libya. Italy's air force was by no means negligible.

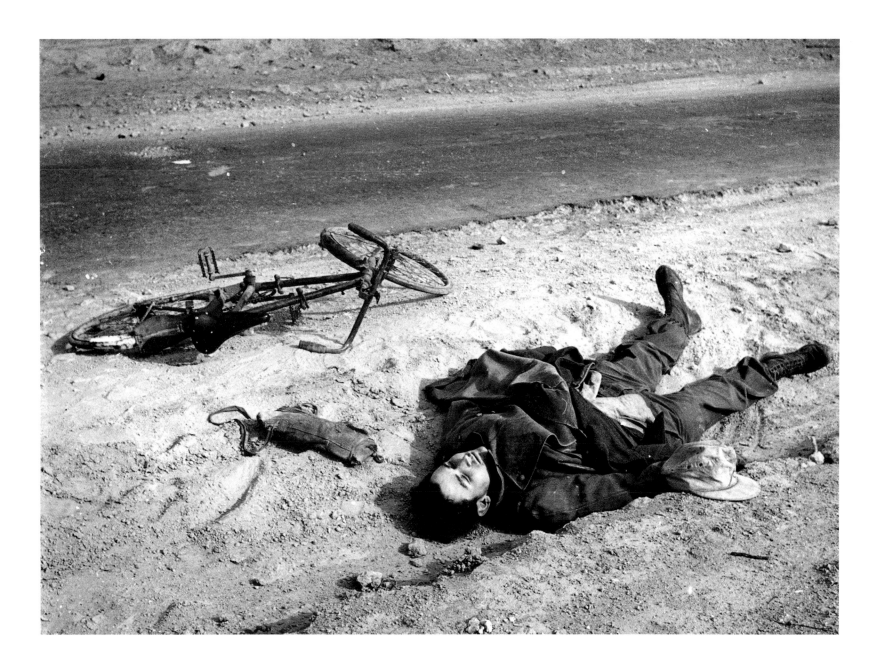

George Rodger's charitable eye was caught by this young German's untimely end in the Western Desert.

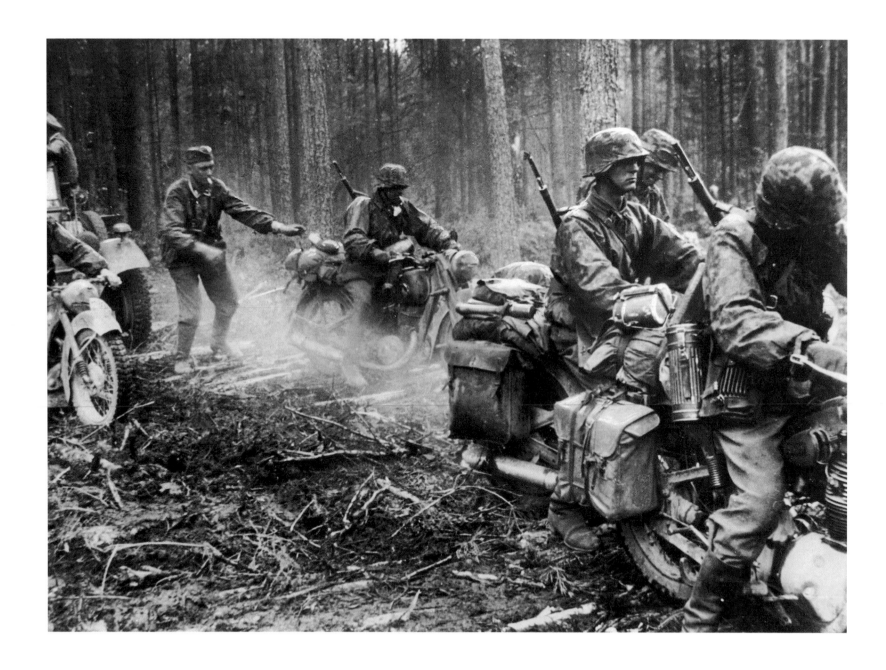

The German army advancing confindently into Russia, just as Napoleon's soldiers had once done.

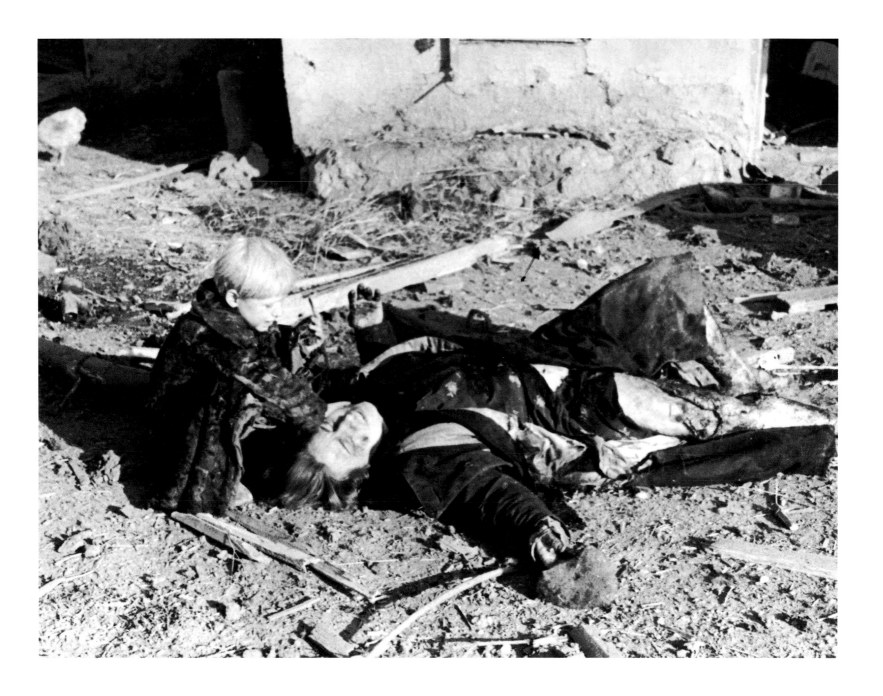

A Russian mother and her son at the southern sector of the Front.

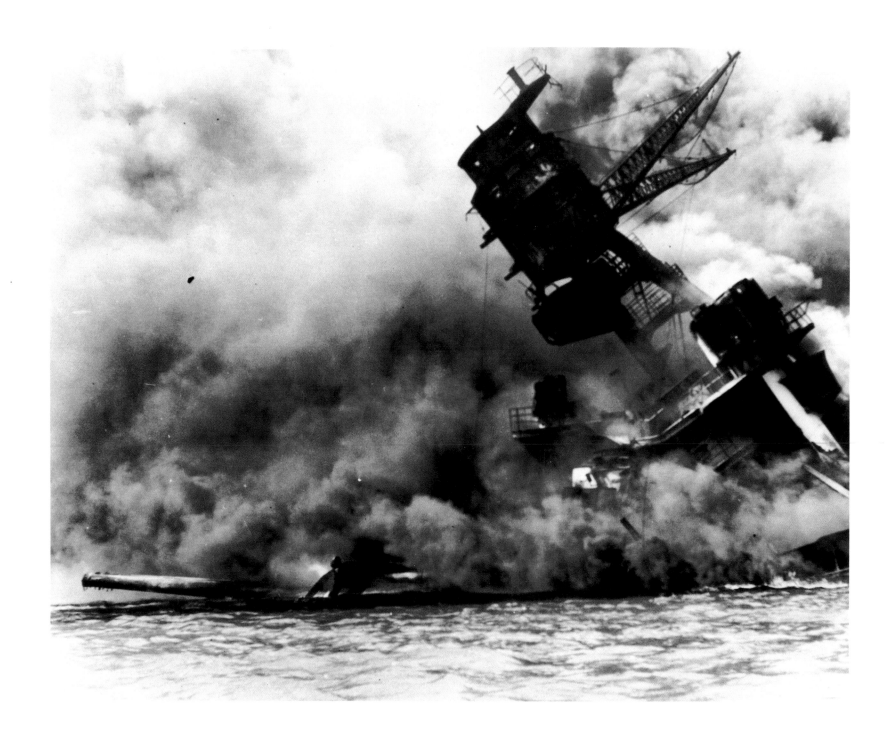

The 'Day of Infamy' – the USS *Arizona* after the Japanese rained bombs on Pearl Harbor.

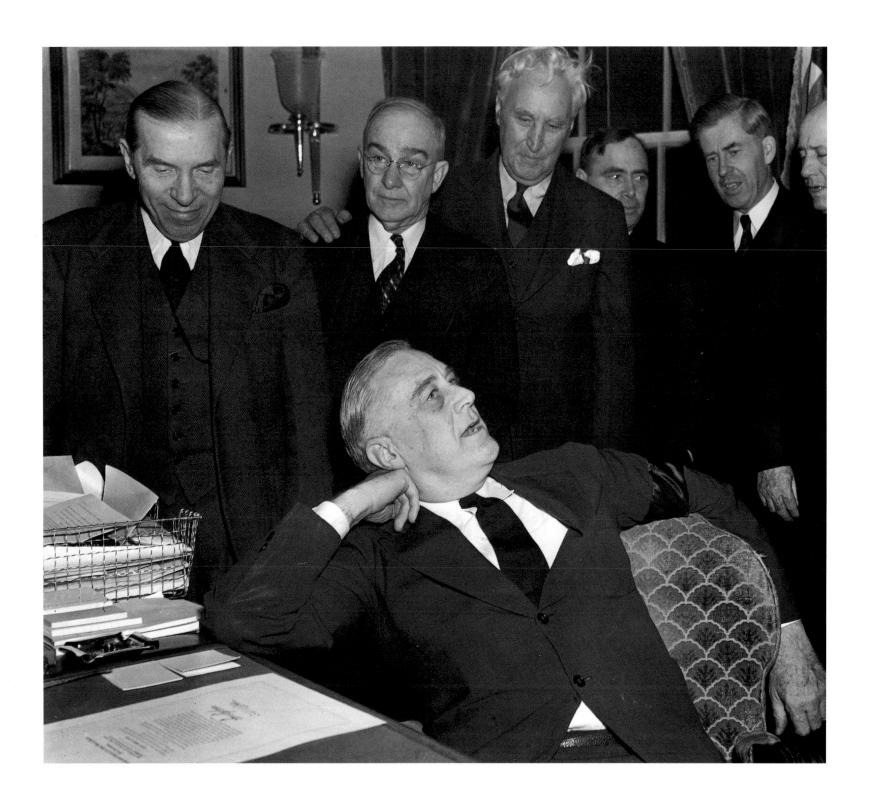

Another first for the camera – a declaration of war. Franklin Roosevelt has just changed the course of history with his signature.

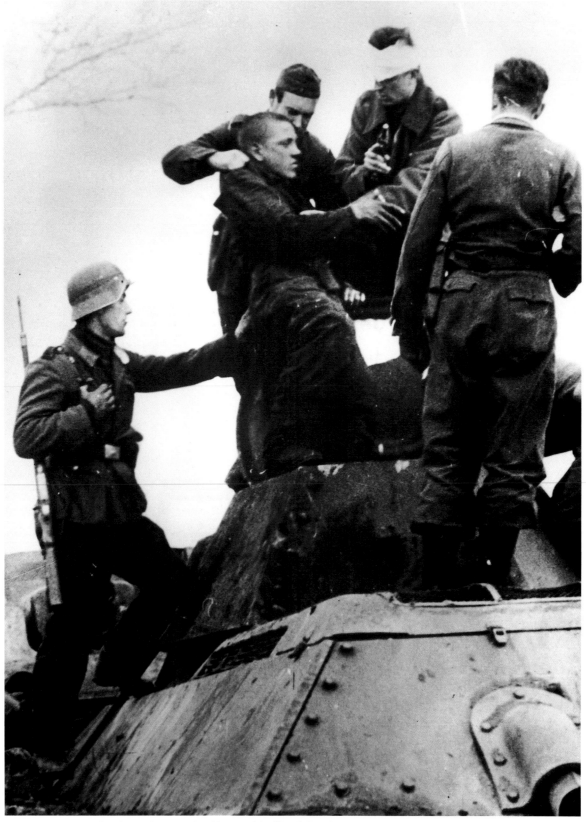

A Russian tank captured and its crew humiliated. But there would be tens of thousands more.

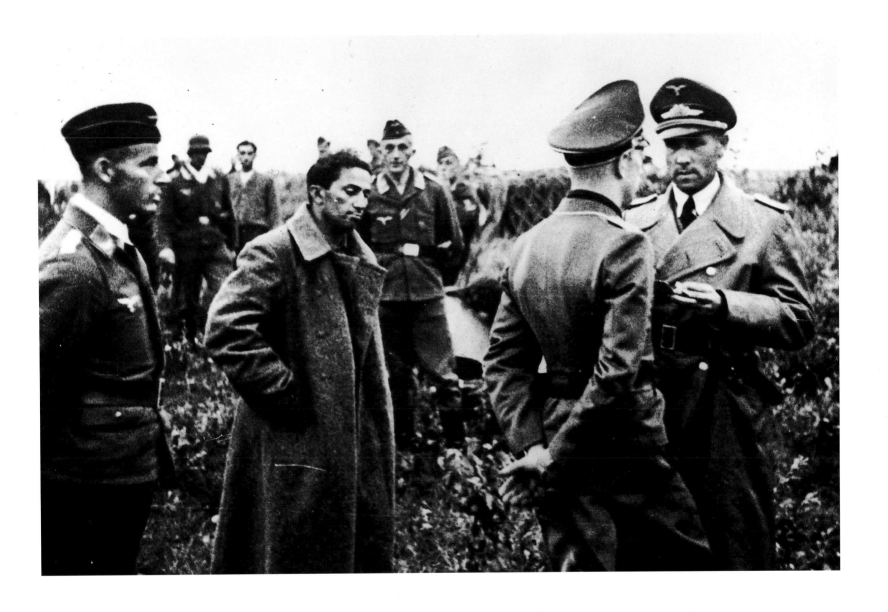

Stalin's eldest son Yakov in German hands. His father refused to ransom him.

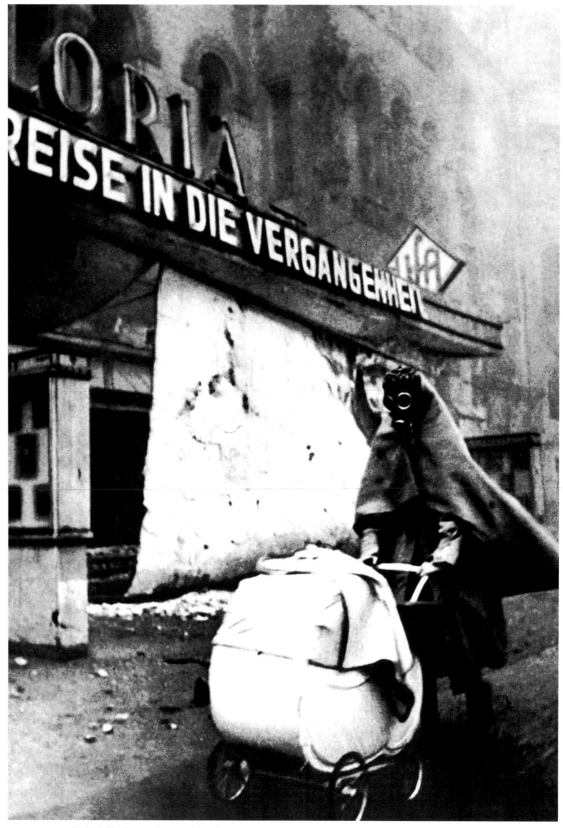

Berlin's Kurfürstendamm after a heavy British raid – this was only the beginning of the bombing.

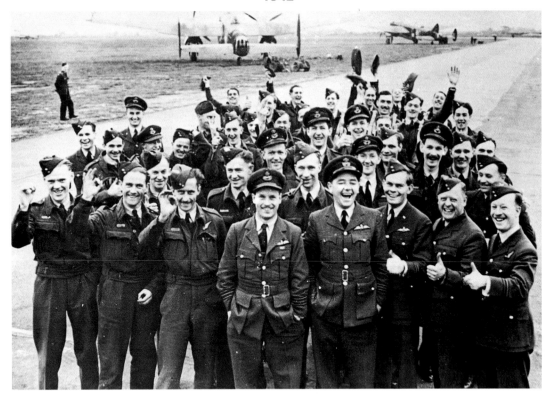

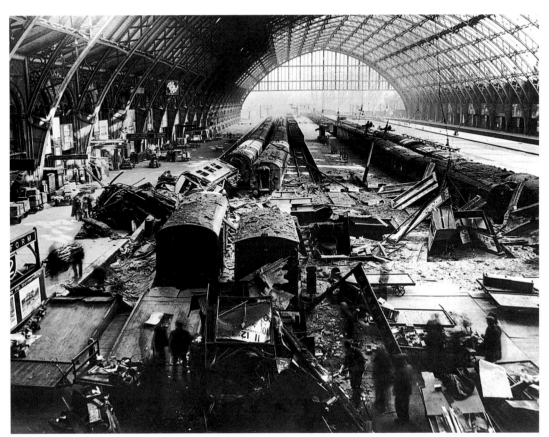

British bomber crews after a one-thousand-bomber raid on Cologne, no doubt celebrating their survival as much as their success.
London's St Pancras station after an air raid. Damage to London was severe – but Germany 'reaped the whirlwind'.

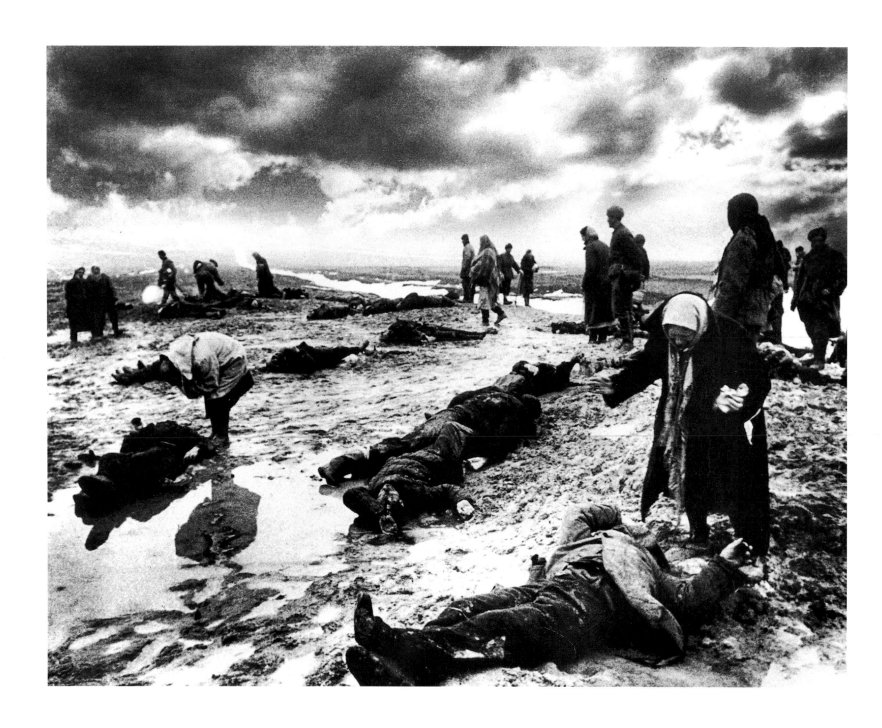

Perhaps Dmitri Baltermans' greatest image – people searching for relatives and friends murdered by the Germans on the Kerch Peninsula in the Crimea.

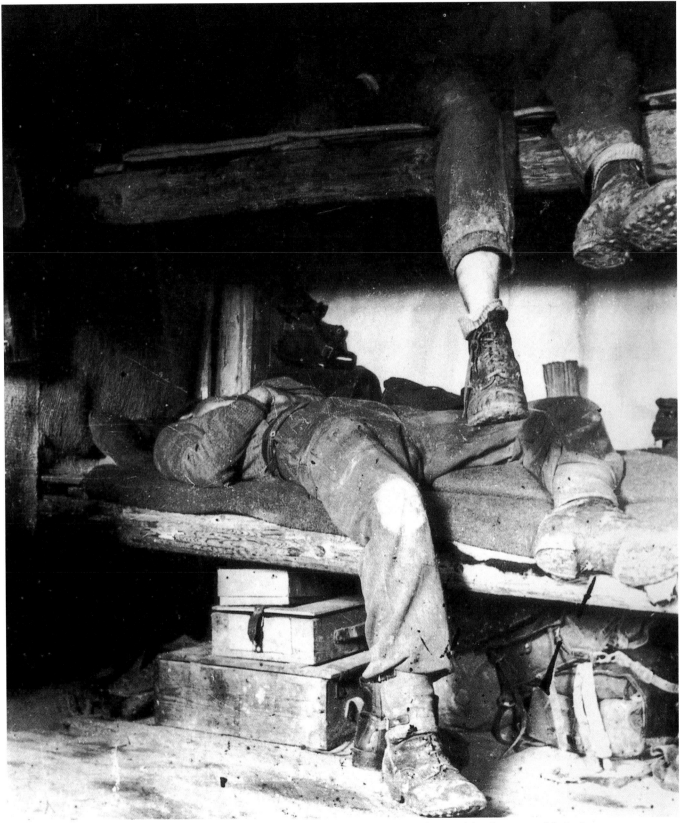

Exhausted German soldiers somewhere on the Russian Front. Hard defence is more tiring than successful attack.

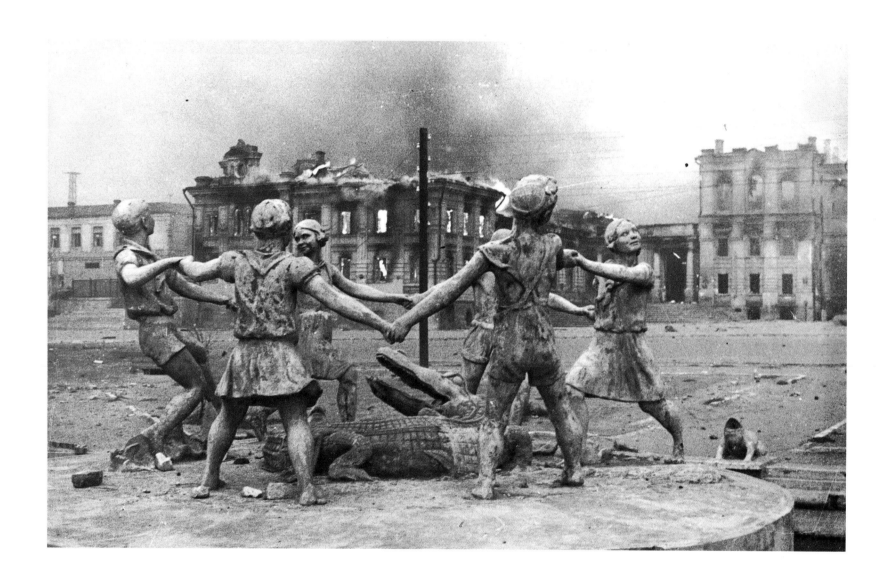

A sculpture for children in Stalingrad. It survived one of the fiercest battles in history.

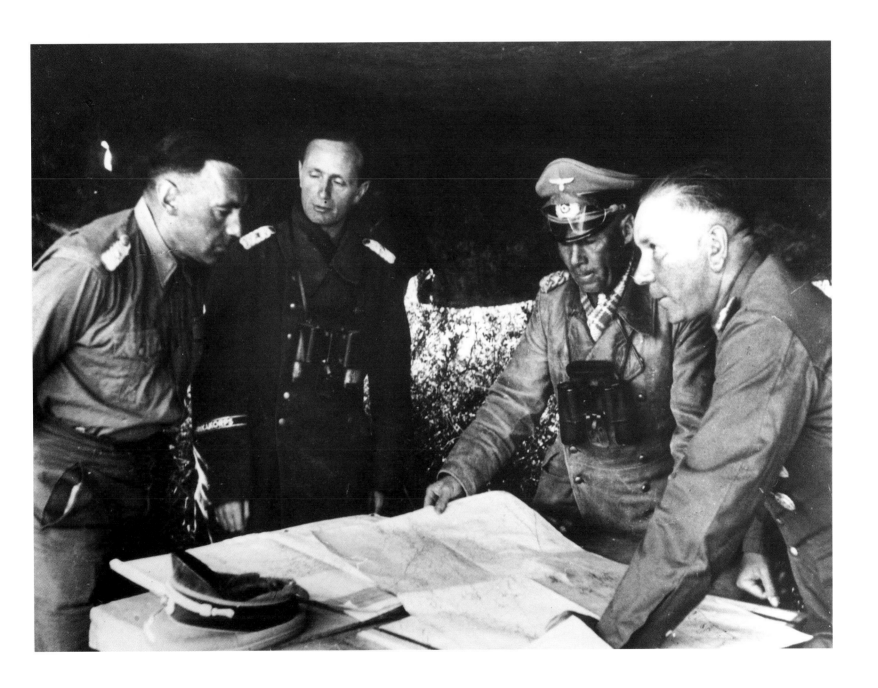

Field Marshal Rommel (holding map) – 'Desert Fox' and hero to his enemies, plots his escape from Africa in vain.

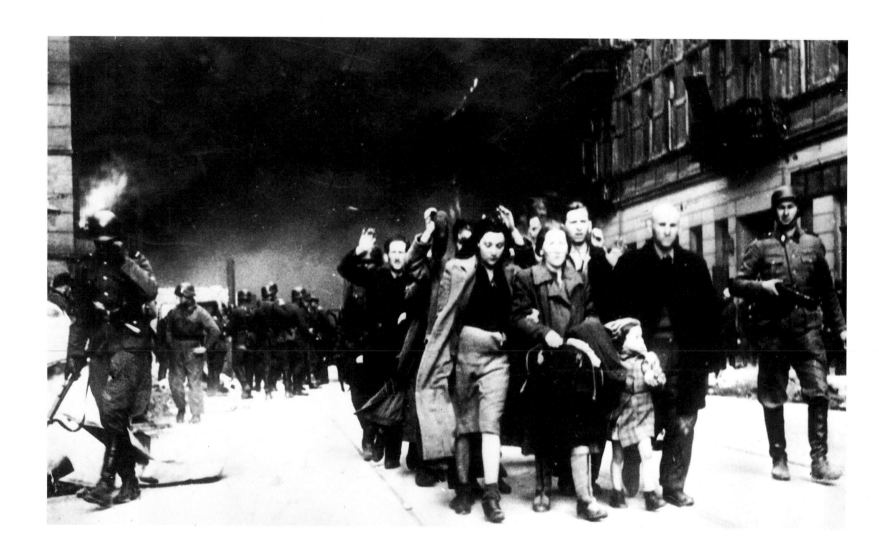

Clearing ou the Warsaw ghetto – an image of ruthlessness and resignation that has moved millions.

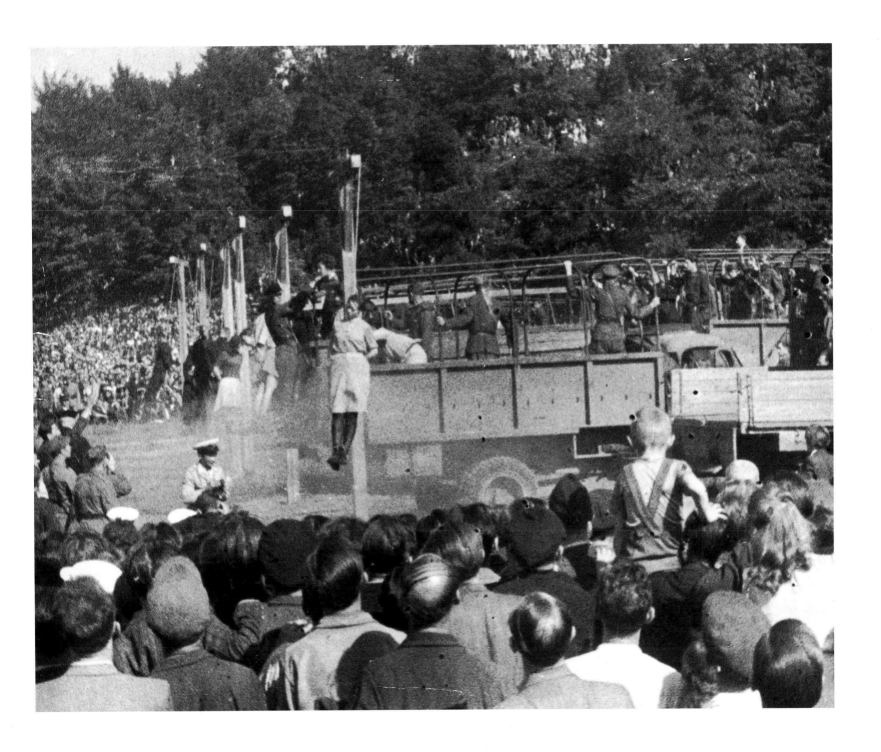

Perhaps the worst photograph of all. Somewhere (possibly the Ukraine or the Baltic States) conquered peoples join the Nazis at a mass execution.

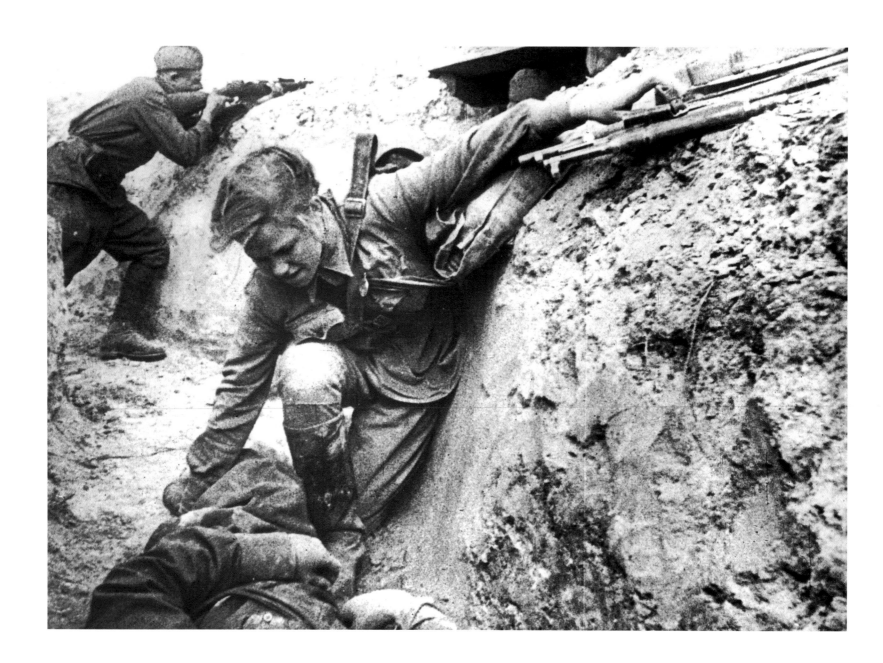

A Russian nurse comes to the aid of a fallen soldier – the participation of Russian women at the front was of incalculable value to their army.

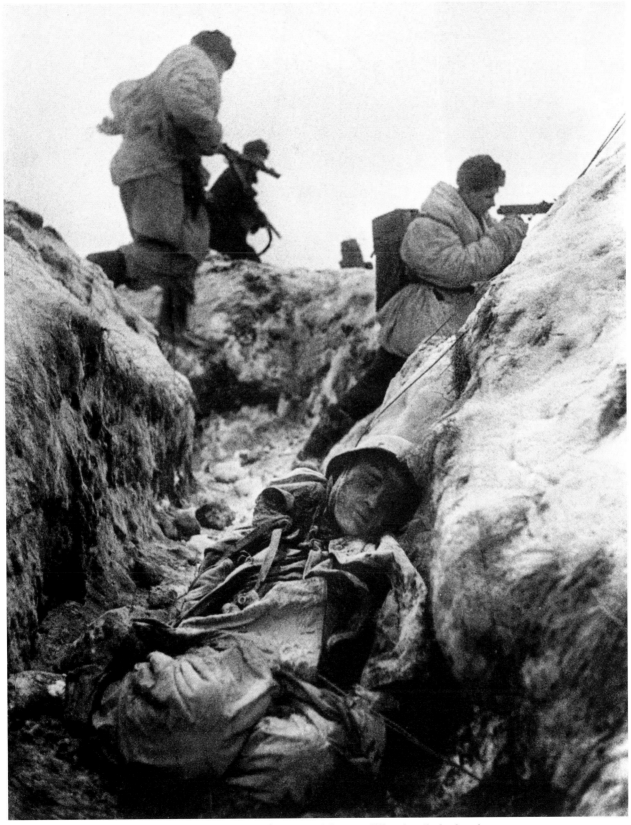

Trenches were not yet obsolete in spite of the many different methods of warfare.

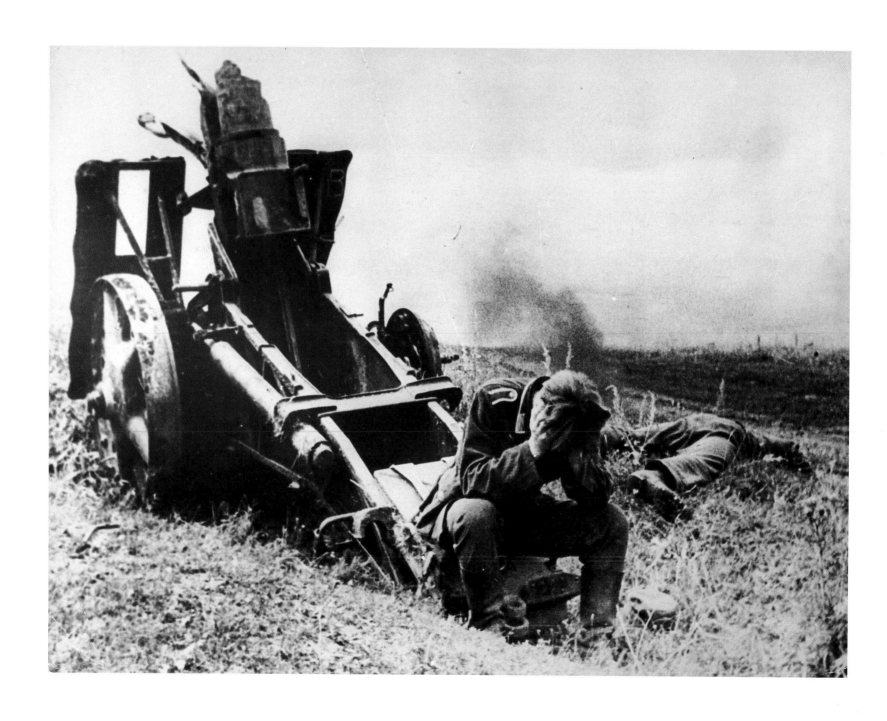

A photograph used for Russian victory propaganda purposes – in the battle at Kursk a young German officer gives up hope.

An image of German low spirits and impotence in the face of determined Russian resistance.

At a New York fancy-dress ball 'Weegee the Famous' snapped an avuncular Stalin – a costume no doubt admired by all.

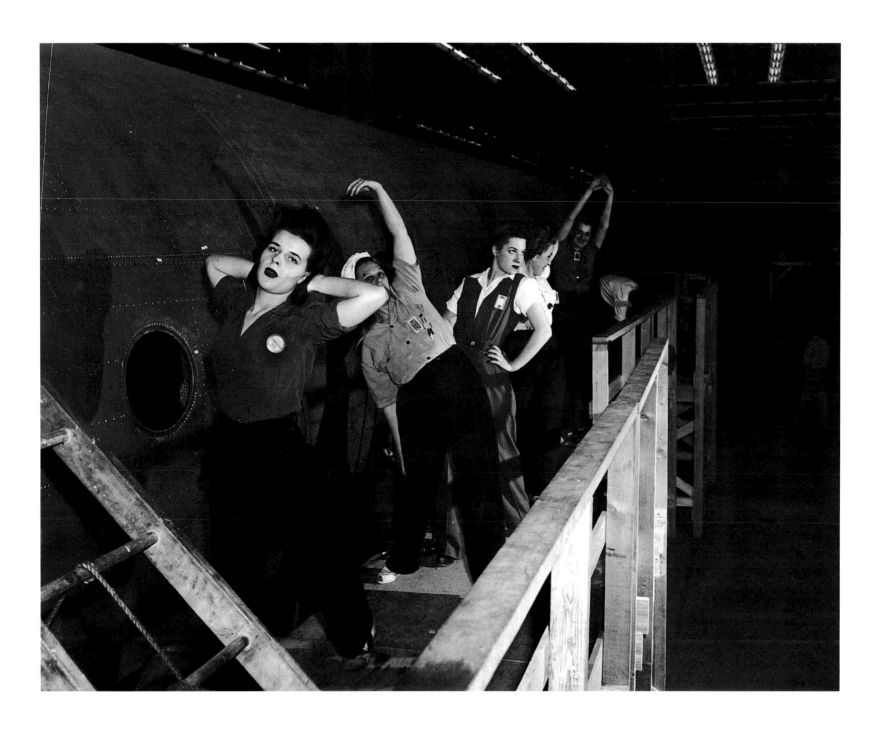

Exercises for women in a US aircraft plant were found to improve both health and productivity.

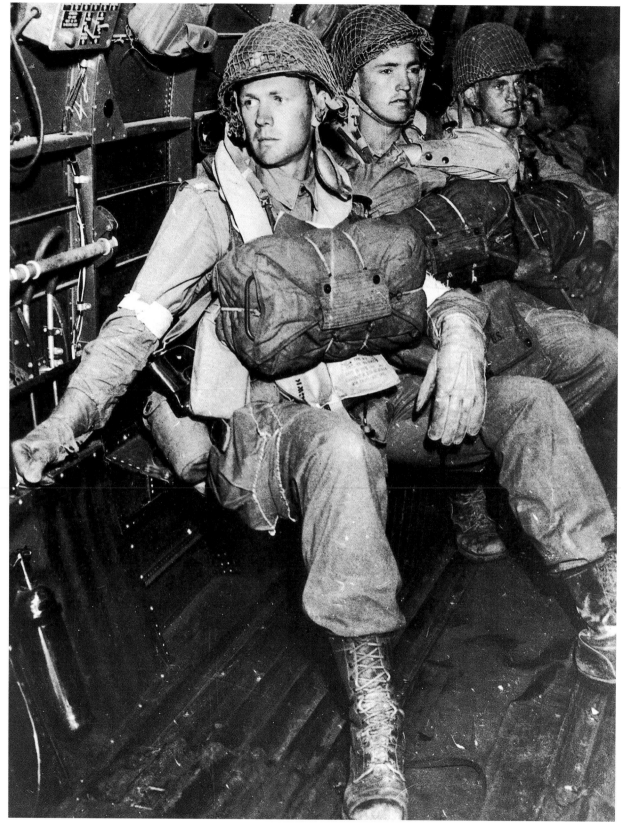

Anxiety before battle – US paratroopers bound for Sicily.

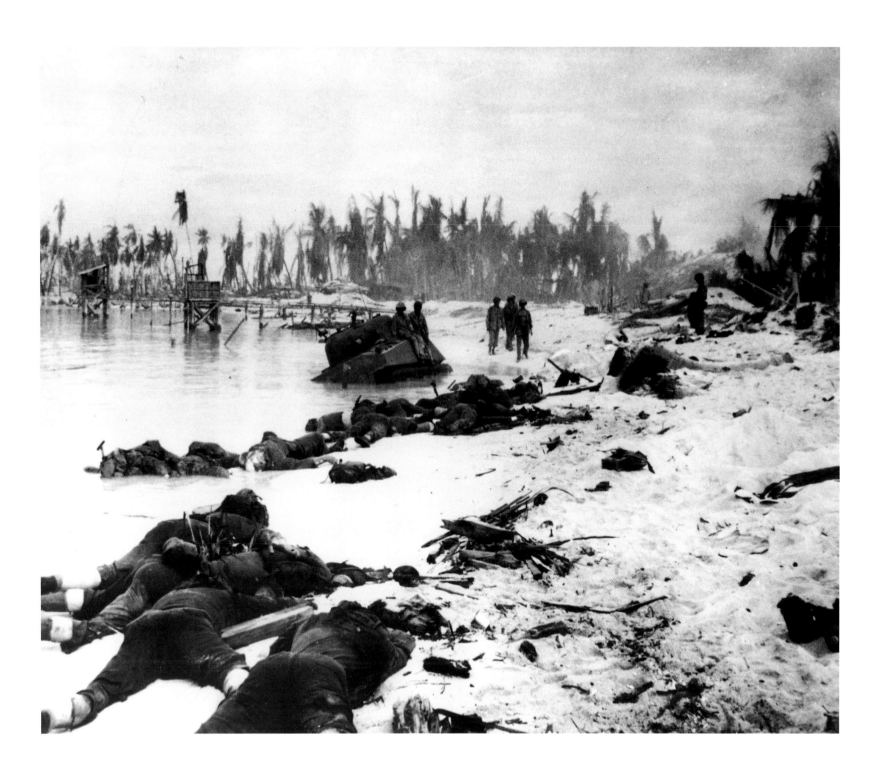

This beach at Tarawa in the Pacific Islands shows the huge numbers of US troops lost in pursuit of their victory in the Pacific war.

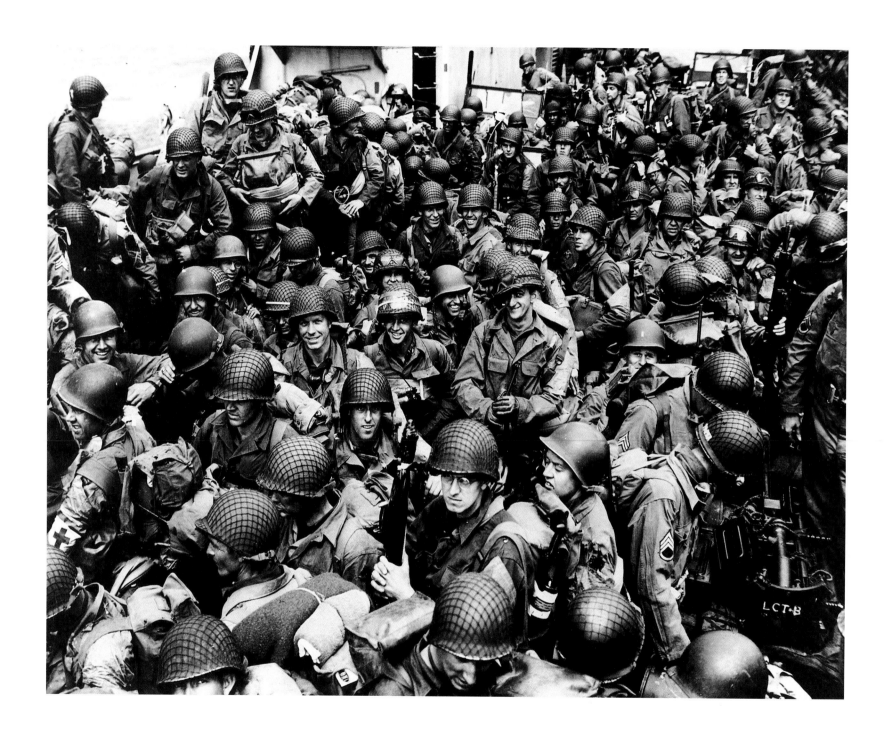

US troops show studied nonchalance for the camera before heading for the Normandy beaches.

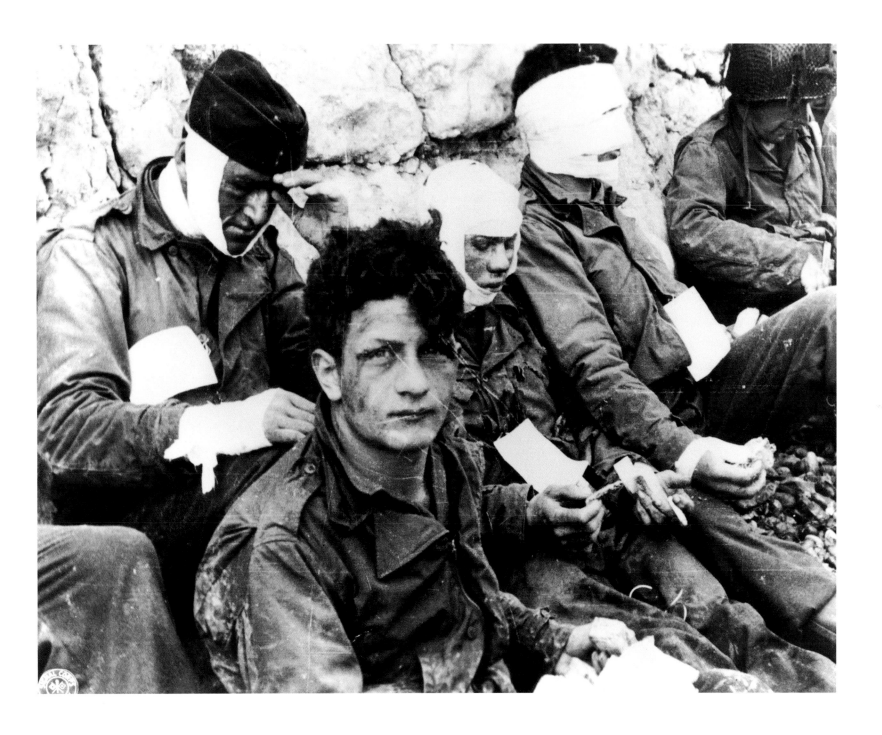

Here they have landed and many have been killed and wounded.

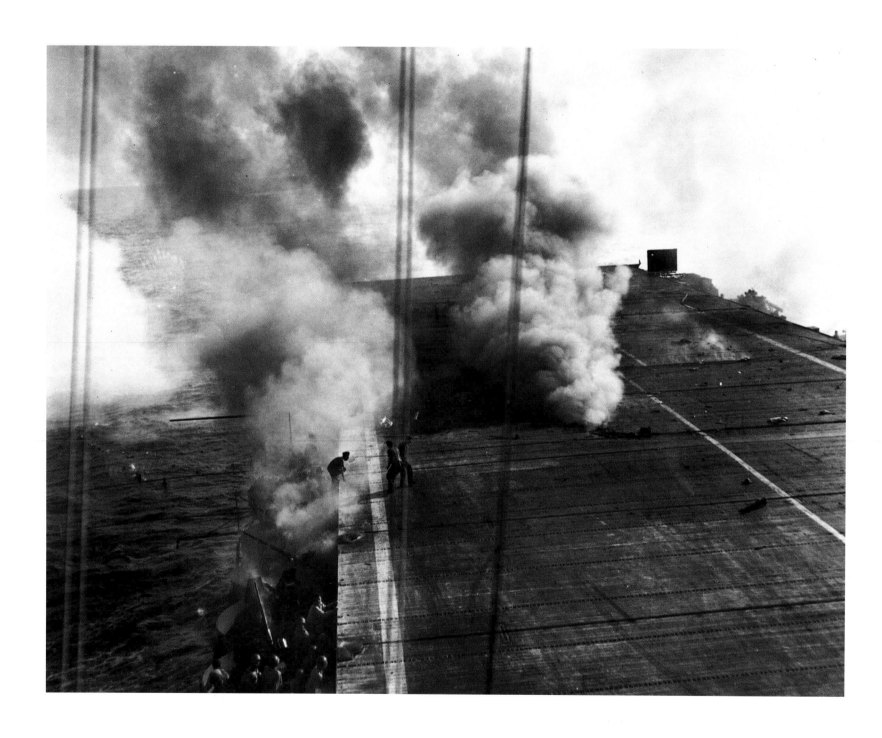

A kamikaze attack during the Battle of Leyte Gulf in the Philippines – the biggest naval battle in history – leaves the carrier USS *Suwannee* burning.

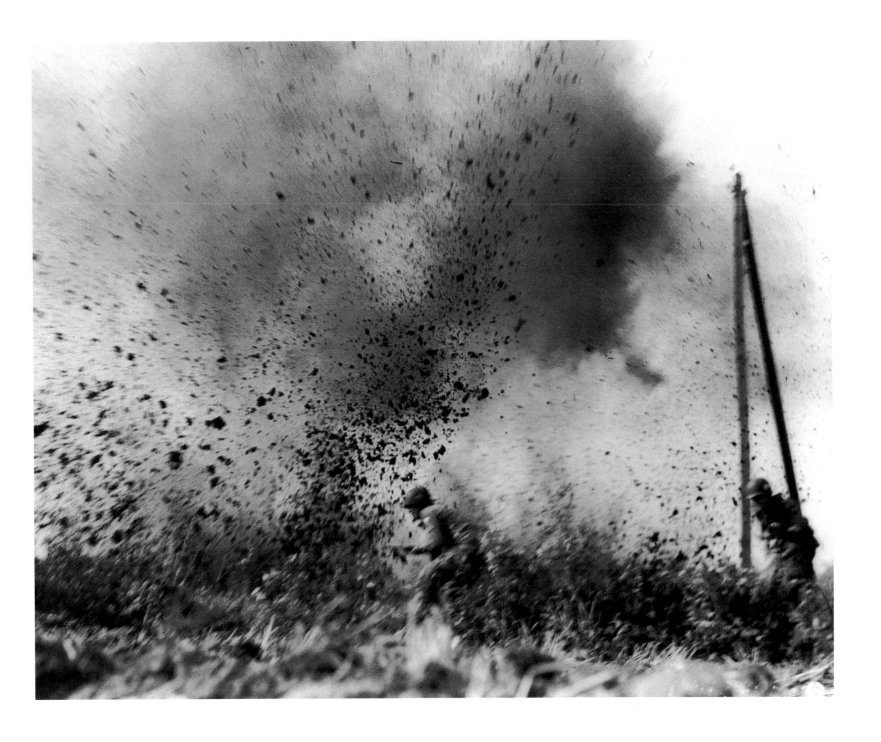

US infantry advancing through shellfire at Nijmegen in the Netherlands.

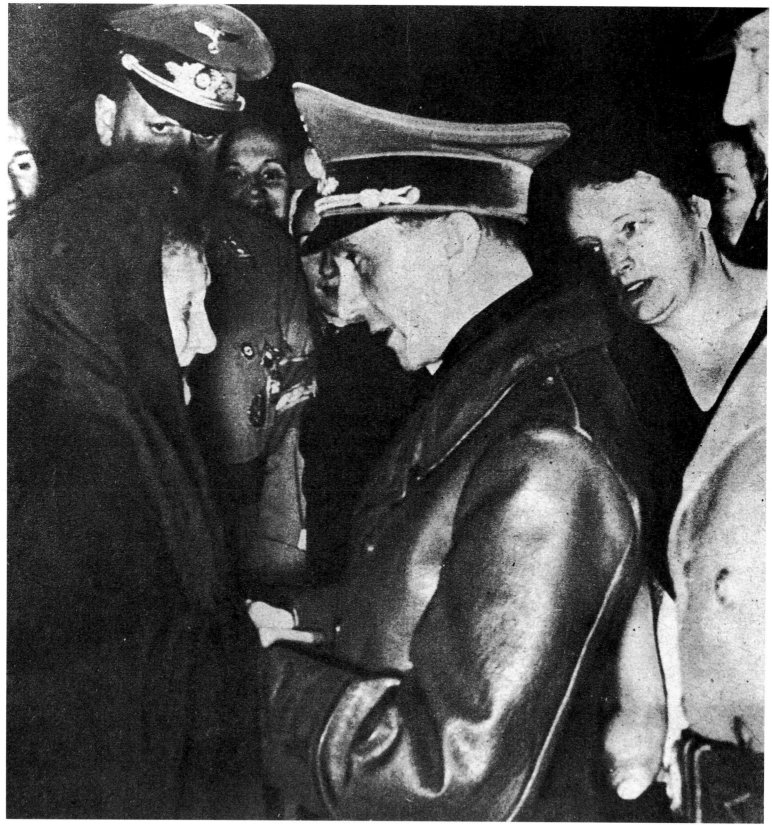

Goebbels comforting a victim of a Berlin air raid. He seems to play his part well.

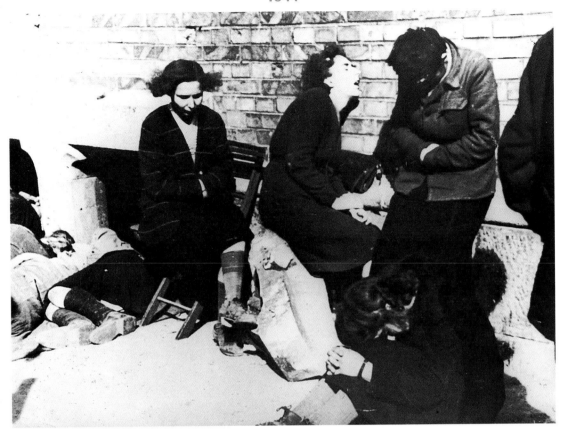

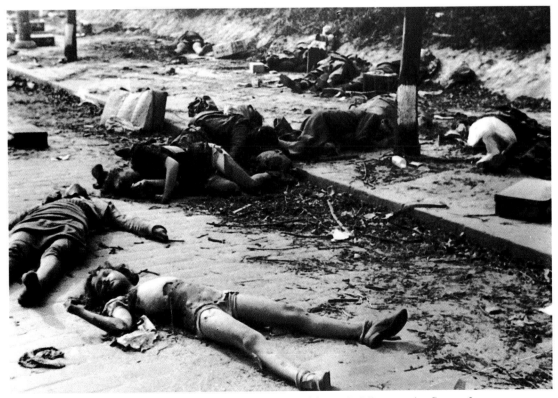

Citizens of Warsaw in despair at the failure of their uprising against the occupying German forces.
The indiscriminate bombing of German civilians still troubles many British and American consciences.

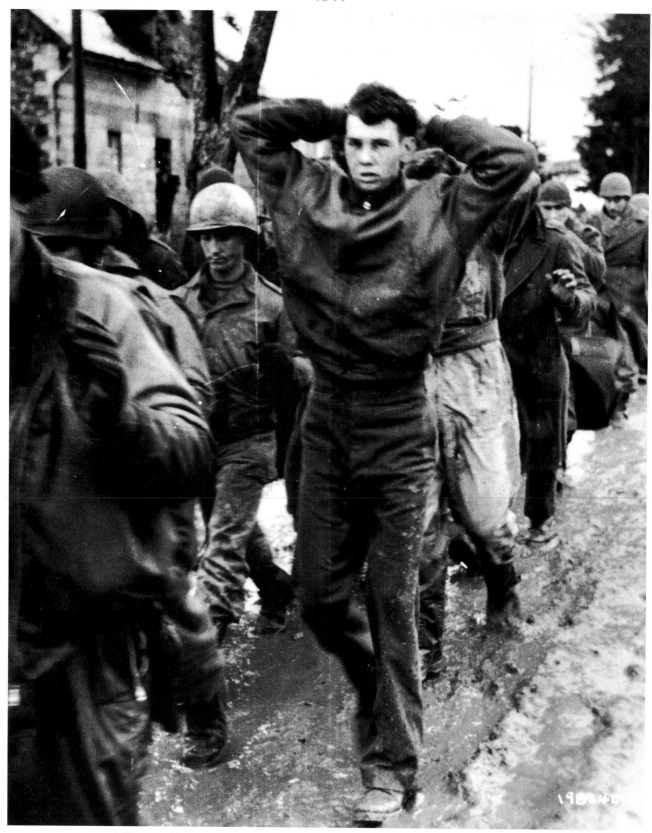

A GI captured by Germans in a counter-attack who seems more apprehensive than his companions.

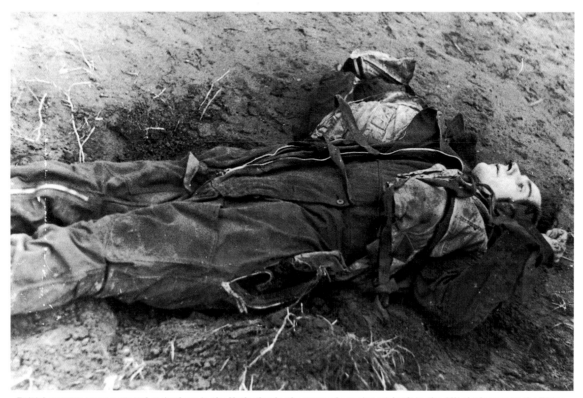

British paratroopers captured at Arnhem in the Netherlands, the scene of a major set-back to the Allied advance on the Rhine.
A British airman brought down over Berlin – one of thousands.

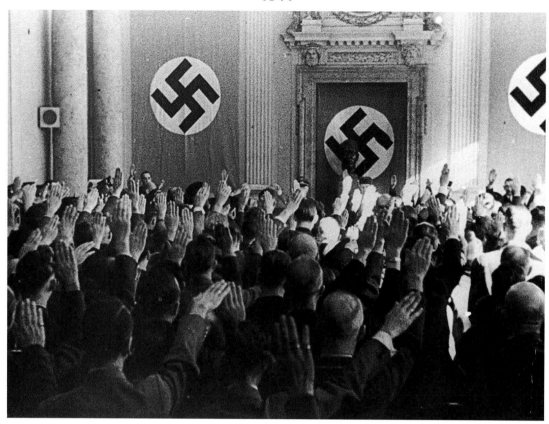

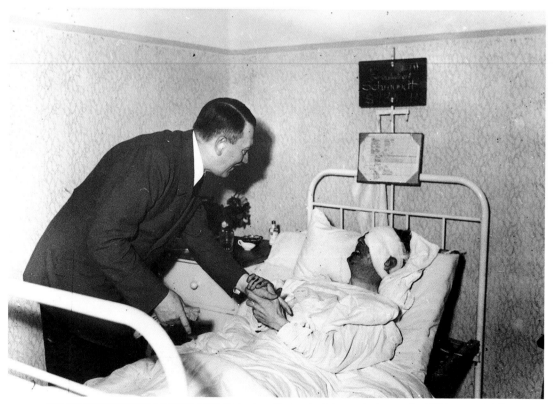

*Heil Hitler*s in Dr Roland Freisler's court room where the bomb-plot conspirators against Hitler were tried.
Hitler's narrow escape from death seemed to offer him a gleam of hope. Here he commiserates with an officer wounded by the bomb attack on his headquarters.

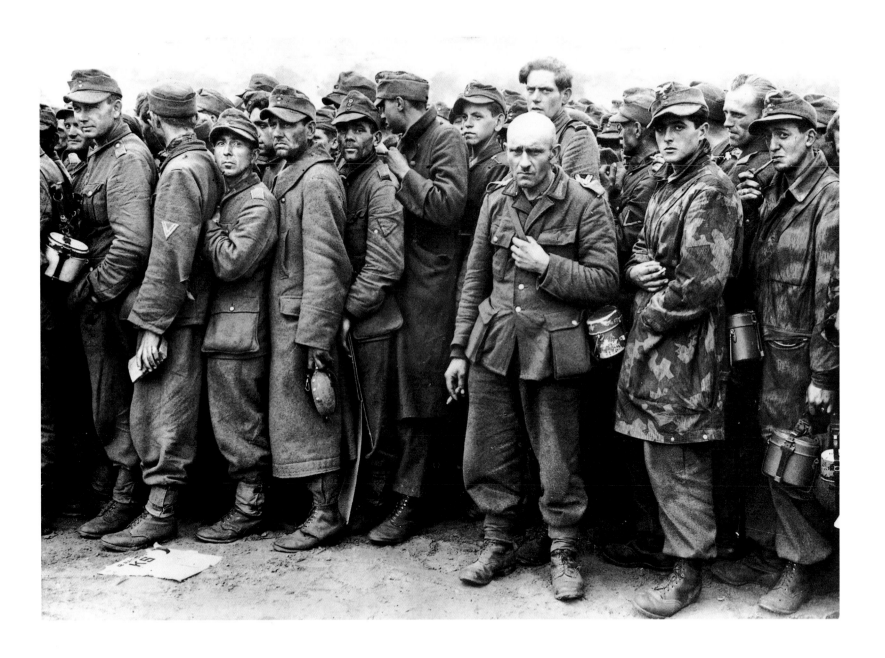

German prisoners at Nijmegen in the Netherlands show mixed feelings in the face of their defeat.

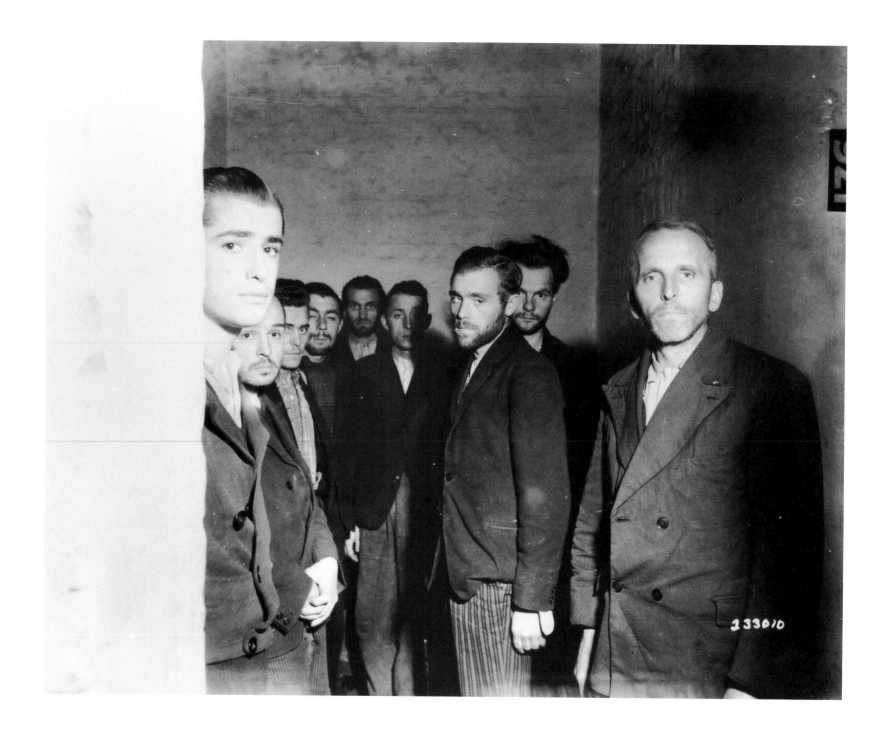

Captured Gestapo agents in Belgium – their reign of terror and butality was at an end.

One of the victims of extreme Japanese cruelty found in a prison camp at Davao in the Philippines.
Bereft of all else, a Catholic woman from Leyte Island clings firmly to the symbol of her faith.

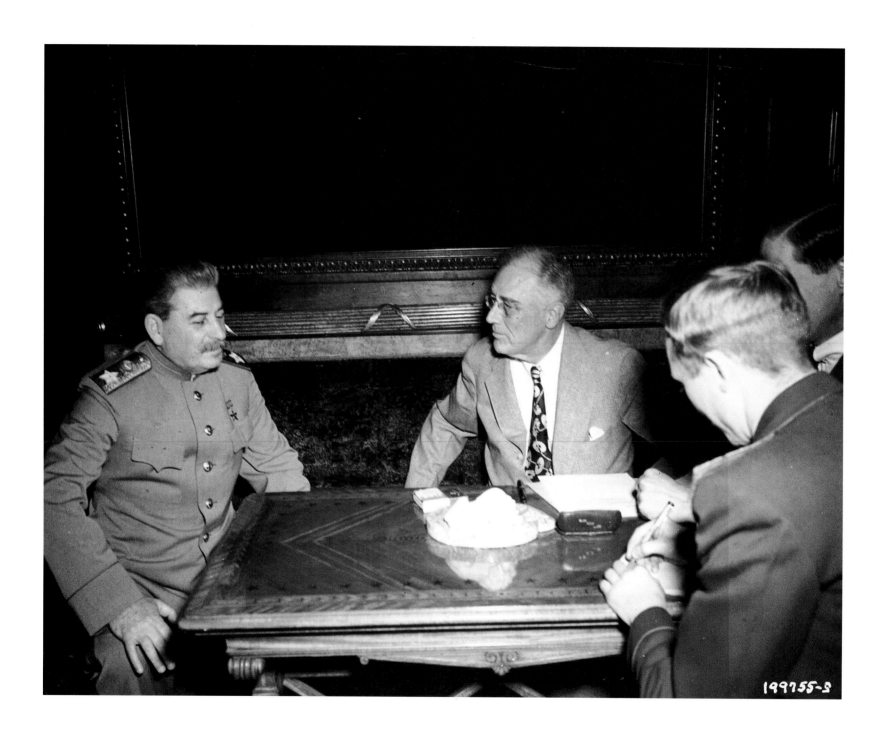

Roosevelt (centre) defers to Stalin (left) at their conference with Churchill at Yalta in the Crimea. Roosevelt would later be much criticized for his trust in the Russian dictator.

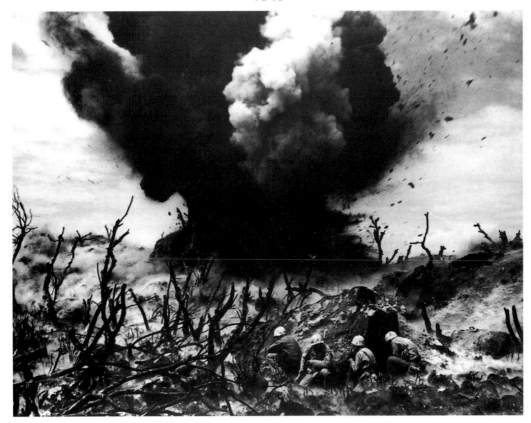

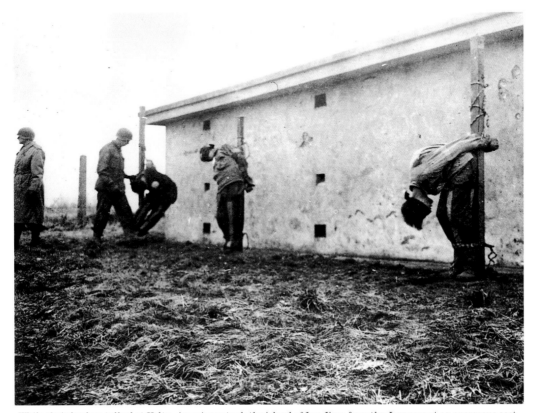

While their leaders talked at Yalta, Americans took the island of Iwo Jima from the Japanese at an enormous cost.
During the German counter-offensive in the Ardennes several French were shot by US troops for espionage against the Allies.

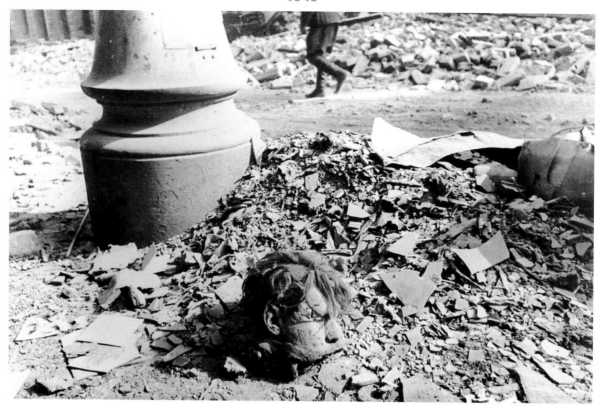

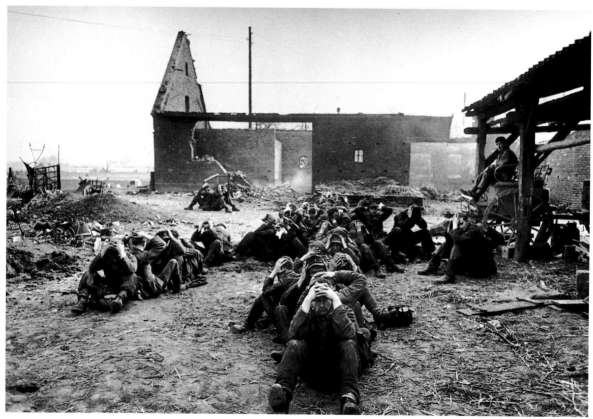

Near Berlin and surrounded by Russians, an SS man evaded capture by pulling the pin from a grenade in his belt, causing several more to explode at the same time.
A powerful image by Robert Capa. These Germans captured in Germany by Americans seem completely broken.

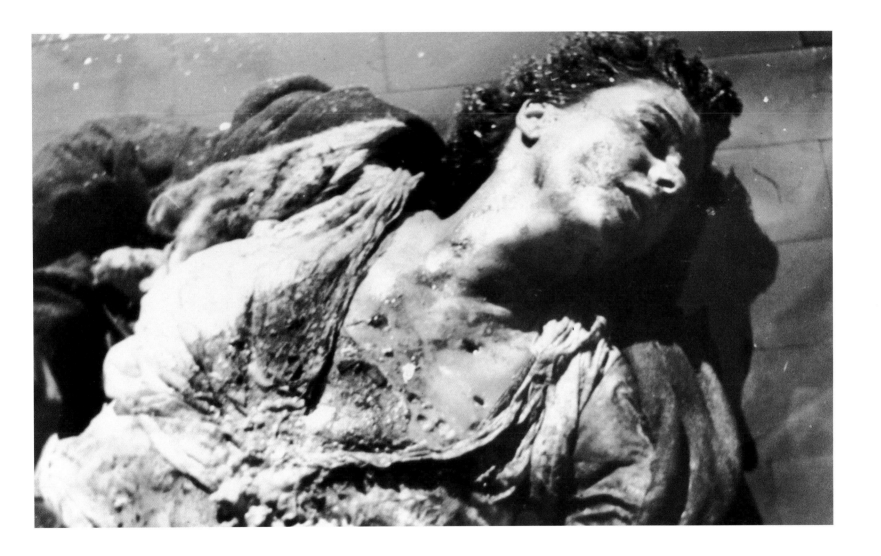

Clara Petacci and her lover Mussolini were shot by partisans and strung up by their ankles. Here is her body a little later.

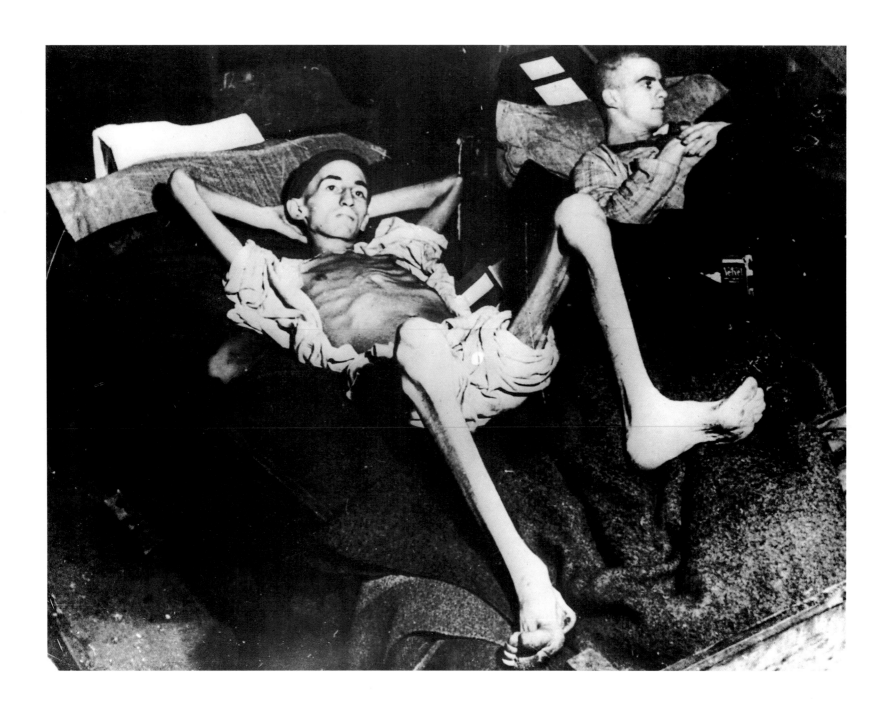

An emaciated victim of the death camps. He had certainly nearly died but now seems to be awaiting his return to life.

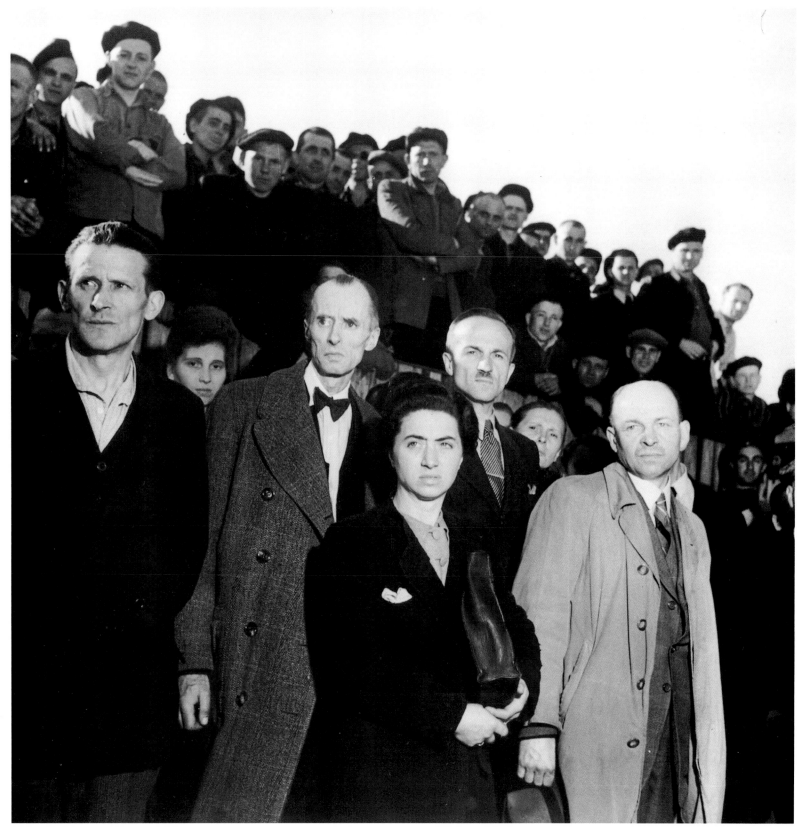

Margaret Bourke-White took this striking image of citizens of Weimar who had been asked to look at evidence of atrocities at the Buchenwald concentration camp.

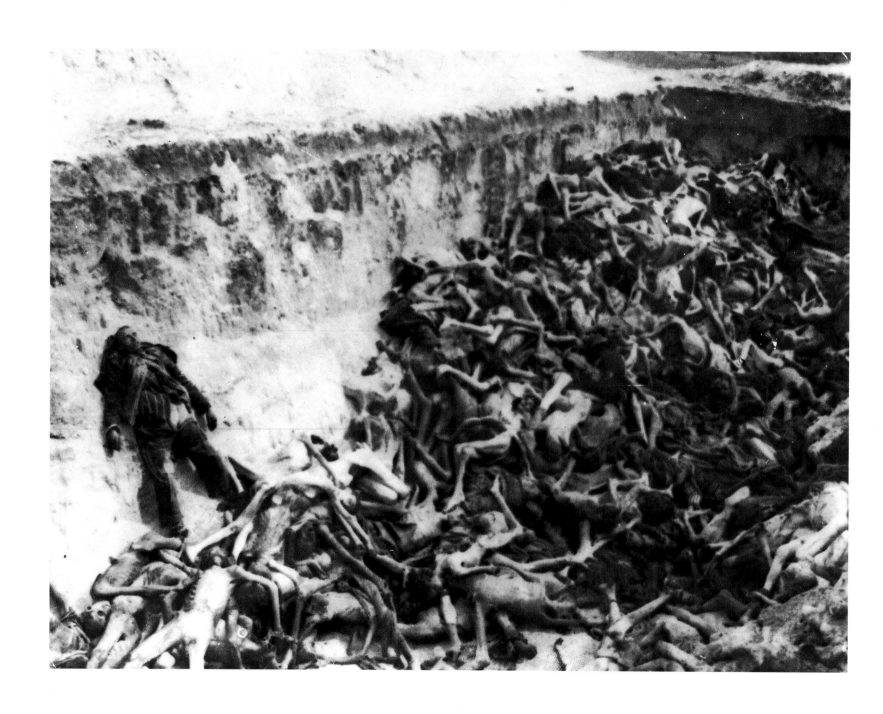

Mass murder becomes something of an abstraction in a blurred photograph from Belsen.

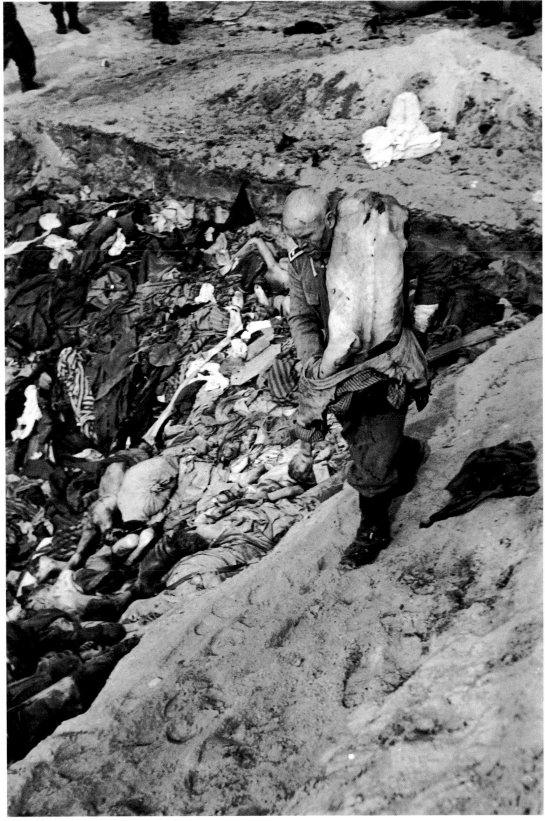

One of the guards at Belsen who were ordered to tidy the horror away.

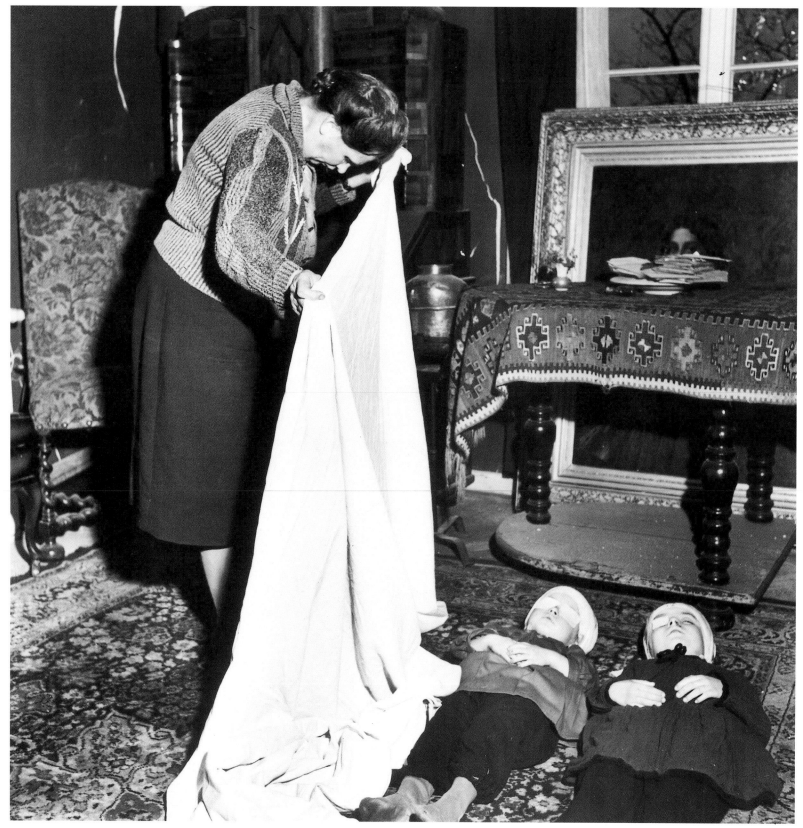

Margaret Bourke-White photographed this mother who had murdered her children and who afterwards killed herself. Her Nazi husband was already dead.

The last Imperial awards – Field Marshal Lord Alanbrooke presenting an OBE to Major Allah Mohammed who had fought bravely against the Japanese in Burma.

Soviet tank men at the Victory Parade in Moscow seem very worthy representatives of their comrades in arms.

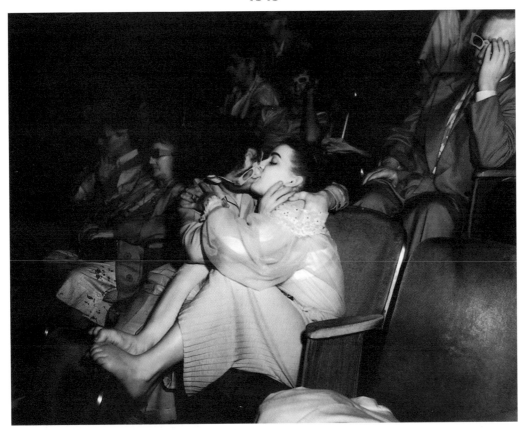

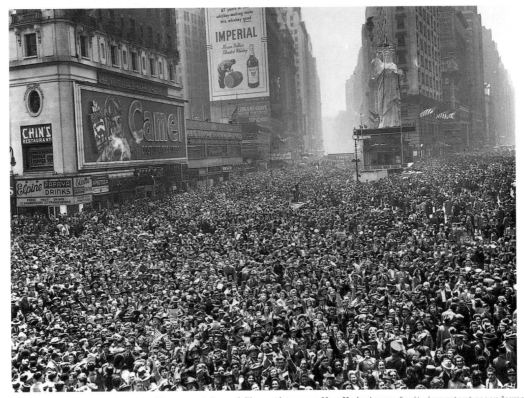

Lovers at the Palace Theatre – captured by Weegee on infra-red film as they use a New York cinema for its important secondary purpose.
Times Square in New York at noon on 7 May. Huge crowds prepare to celebrate the announcement of Germany's imminent surrender.

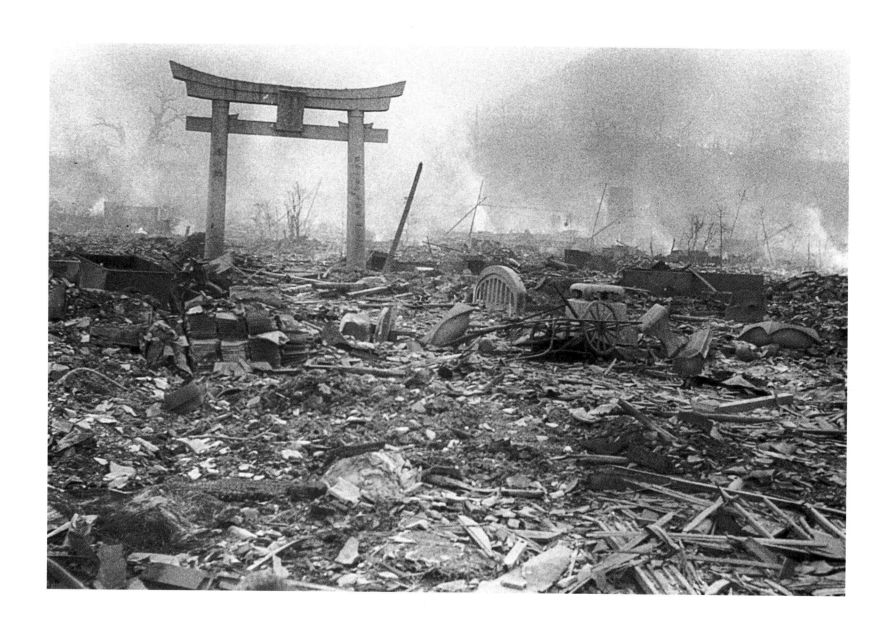

Devastation after the second and more controversial atom bomb – dropped this time on Nagasaki where it killed tens of thousands.

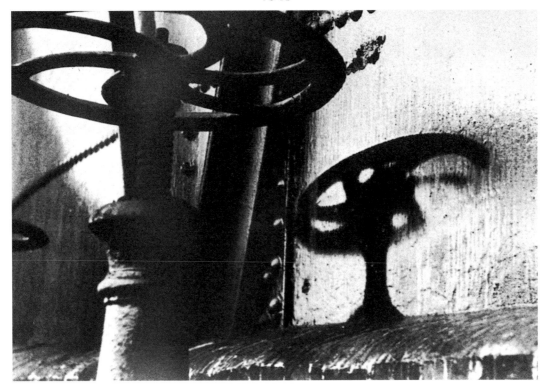

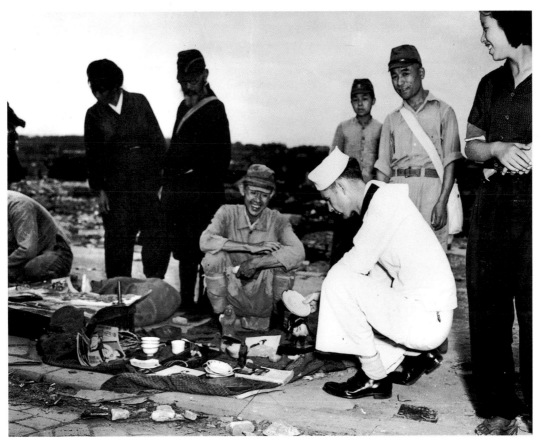

The heat radiating from the bomb's flash imprinted the shadow of a gasometer handle on metal 2 kilometres (1 mile) from the explosion.
In Yokohama friendly trading between recent deadly enemies started up again without delay.

1934

326. Mao Zedong, the Chinese communist leader, set up a Communist Peoples' Republic in Jiangsi in south-east China between 1931 and 1934. The Communists had been encircled by nationalist (Kuomintang) armies and their stronghold had been sealed off with a network of barbed wire and concrete blockhouses. Mao evacuated the region and led his followers on the Long March to establish a Communist regime in Shansi province, north-west China. Covering 65–115 kilometres (40–70 miles) a day the marchers reached Shansi on 20 October 1935, a year after setting out. Only 30,000 of the original 100,000 who set out survived the epic 12,870 kilometre (8,000 mile) march. This show of human endurance became a source of inspiration and a myth for future communist leaders. The picture shows three female communist 'marchers' who were left behind and arrested by Kuomintang forces.

327 left. Leni Riefenstahl during the making of the Nazi propaganda film *Triumph of the Will*. Riefenstahl's first feature film *The Blue Light* (1932) brought her to Hitler's attention and soon afterwards he commissioned her to direct a film about the 1934 Nazi Party rally in Nuremberg. The result was an extraordinary document of the Führer cult and the power and pageantry of the Nazi movement. Hitler made a spectacular appearance in the film, arriving at the rally by aeroplane as if descending from the heavens, and later reviewing endless marching columns of adoring troops. For decades *Triumph of the Will* and Riefenstahl's 1936 documentary of the Olympic Games in Berlin were widely regarded as seminal works in twentieth-century cinema because of the revolutionary techniques she employed in making the films. The Nazi-era films of Hitler's favourite director were not shown in Germany until retrospectives of Riefenstahl's work opened in Cologne and Potsdam in 1998.

327 right. Bonnie Parker and Clyde Barrow, better known as Bonnie and Clyde, gained fame in the US after carrying out a series of small-time robberies. Their sensational encounters with local police and their promotion by the nation's newspapers created national interest in their flamboyant behaviour. They were finally gunned down during a police ambush on 23 May 1934 after being betrayed by friends.

328 top. A mourner weeps beside the coffin of Sergei Kirov, assassinated on 1 December 1934 in the Soviet Union. Kirov's official image as Leningrad party boss was that of a staunch Stalinist, but by the early 1930s his influence in the Communist Party rivalled that of its leader and he increasingly opposed government policies. He condemned the extreme measures taken by Stalin in dealing with the countryside in particular, and advocated the dismantling of the collective farm system.

328 bottom. The suspicious circumstances of Kirov's death are still a matter of dispute but it was officially blamed on fascists and their allies in the Communist Party. Documents released from Russian archives in the late 1990s suggest that Kirov was probably murdered as a result of a lover's quarrel. Stalin claimed that Kirov's murder was part of a widespread conspiracy against the Soviet leadership and used it to justify an extensive purge of his opponents.

329. Joseph Goebbels, Nazi Propaganda Minister, originally intended to be a priest. Later he believed his future lay in the literary field and attained a doctorate in literature, specializing in romantic drama. His formidable intellect and cynical understanding of mass psychology made him an invaluable ally to Hitler. Goebbels was instrumental in building up the Nazi following and presenting a favourable image of its leader to the people. He had less success with his own image however. His club foot kept him out of the German army and this exclusion left him resentful.

330 top. Ernst Röhm, Chief of the Nazi *Sturmabteilung* (SA), at home in Munich where he lived with his elderly mother and sister. After participating in the failed Munich *putsch*, Röhm left political life. He was recalled to lead the SA by his friend Hitler after the Nazis' spectacular electoral success of 1930. Between 1930 and 1933 Röhm's storm troopers played an indispensable role in the Nazis' rise to power. Consisting largely of thugs, the SA relentlessly harassed and intimidated members of opposition parties, particularly the communists. Röhm, who seemed incapable of controlling his own loutish behaviour and was well-known to have a fondness for homosexual orgies, fell out of favour with other prominent Nazis, particularly Hermann Göring, head of the *Luftwaffe*, and Heinrich Himmler, leader of the SA's rival army, the *Schutzstaffeln* (SS).

330 bottom. After 1933 Röhm became increasingly independent of the Nazi party and pushed, against Hitler's wishes, to make the SA – now numbering 4.5 million men – Germany's national army. In 1934 Hitler finally acceded to Himmler's wishes and purged his old friend. Röhm was arrested on 30 January 1934, and executed in a large-scale assassination operation with other potential rivals within the Nazi party. Hitler later announced that the executions were justified by an alleged conspiracy against the government and Röhm was posthumously labelled a traitor. Less than two weeks later Hitler dramatically named the operation 'Night of the Long Knives'.

331. For nearly eighty years photographer Manuel Alvarez Bravo has photographed the culture and people of his native Mexico. Since the beginning of his career in the 1920s Bravo has boldly confronted the death and anguish of his people rather than hiding the violence which has marred most of post-revolutionary Mexican history. During the 1930s Bravo was deeply influenced by contemporary modernist trends and produced a number of alluring and seemingly otherworldy images in which his dead subjects were infused with surreal qualities.

332. One of the century's great jazz pianists, Thomas Wright or 'Fats' Waller, received his coaching from James P. Johnson, founder of the 'stride' school of jazz piano. Waller began his recording career in 1922 and by the end of the decade was an established songwriter with numerous jazz standards to his credit, such as *Ain't Misbehavin'* (1929). From 1934 onwards he made hundreds of recordings with his own small band in which superb music was interspersed with slapstick humour. Although his performance style won him wide commercial fame – a rarity for jazz musicians of the period – Waller's comedic antics often deprived him of the critical acclaim he richly deserved.

333. German-born Albert Einstein achieved world fame in the early twentieth century for his theories of relativity. He was director of the Kaiser Wilhelm Physical Institute in Berlin from 1914 to 1933 and received the Nobel Prize in 1921 for his work in physics. He left Germany after Hitler's rise to power, convinced that the Nazis were preparing for war. Einstein went to the US, eventually accepting a Chair at the Institute for Advanced Study at Princeton, where he continued his invaluable contributions to our understanding of the universe.

334. The future Queen Elizabeth II of Britain was born in 1926 to the Duchess and Duke of York (future King George VI). A cheerful and obedient child, Elizabeth was raised in a tightly-knit and affectionate family. She was educated at home, where a host of teachers and governesses taught her constitutional history and languages, and escorted her to art galleries and museums. Her strong sense of royal duty was evident at a very young age, even before events in 1937 placed such enormous demands upon it.

335. King Alexander I of Yugoslavia with the French Foreign Minister Jean Louis Barthou, before and after being fatally shot in Marseilles on 9 October 1934. After succeeding his father as King of the newly unified kingdom of Serbs, Croats and Slovenes in 1921, Alexander struggled to create a united Yugoslav state out of politically- and ethnically-divided communities. In the process he created a police state which rested on Serbian predominance while bitter disputes, especially between Serbs and Croats, raged on. He was assassinated at the beginning of a state visit to France by Macedonian and Croat Uŝtaŝe terrorists on orders from Ante Pavelic, future head of the fascist Independent State of Croatia. Barthou, who was caught in the line of fire, was a greatly admired diplomat and fiercely anti-Nazi. At the time of the assassination he was attempting to build alliances against Hitler.

1935

336–37. The re-arming of Germany, begun in secret in 1933, was made

public in March 1935. The German army, navy and air force were officially instituted as the *Wehrmacht* (German armed forces) on 16 March 1935 under the supreme command of Adolf Hitler, Führer and Reich Chancellor. Universal general conscription was reintroduced to provide manpower for the significant increases in troop strength planned by Hitler. The previous year a compulsory 'Oath of Allegiance' to Hitler had been introduced in place of the Weimar Republic's constitutional oath.

338. The Nazi organization for young Germans within the Third Reich was known as 'Hitler Youth'. The movement began in 1926 as the youth wing of the SA. After Hitler came to power the organization developed into a massive state agency that all young male, Aryan Germans were expected to join. Apart from Roman Catholic organizations, all other youth associations were banned. Boys under the age of eighteen were educated in Nazi principles and expected to lead a Spartan life of national conformity and loyalty to the Führer. A parallel organization for young females – the League of German Maidens – trained girls for domestic duties and motherhood. By 1939 around 9 million young Germans were enlisted in the Hitler Youth.

339. During the prosperous decade of the 1920s tourist travel expanded rapidly and fuelled a new wave of ship building. In 1930 the French launched the *Normandie*, a pinacle of achievement in the passenger-liner business. When it was built it was the fastest liner and was also by wide consensus the most beautiful large ship ever built. As the first liner to be built according to the 1929 Convention for Safety of Life at Sea, the *Normandie* could safely maintain high speeds in rough waters. Its interior was an art deco masterpiece, popularizing a modern design style that was emulated throughout the world.

340. By 1935 Stalin's achievements were impressive by any standards. The Soviet Union had been transformed into a major industrial power and was equipped for defence in any military conflict that might arise. Mass unemployment had been eliminated and millions of illiterate or poorly educated peasants had been trained in

industrial skills. But the cost to Russia was immense. Eleven years after the death of Lenin, Stalin had finally succeeded in transforming the Soviet Union's Communist Party into a body completely obedient to him alone. His personality cult had reached extraordinary proportions in spite of his utter disregard for morality and truth. With the loss of personal freedom under his regime, the arts were driven underground. Millions died of starvation, execution or in the labour camps.

341. In March 1931 eight African-Americans charged with the rape of two white women in Alabama were convicted and sentenced to death, in spite of a lack of evidence linking them to the crimes. The plight of the 'Scottsboro Boys' created nationwide attention and was championed by northern liberals and radical groups, notably the American Communist Party. The case remained in the courts for six years, but their lawyers failed to secure a reversal of the verdicts. However, persistent pressure from citizens' groups across the country eventually forced the state to free and parole all but one.

342. Hitler inspecting his guard of honour, having just received the new Polish ambassador. Hitler had secured Polish agreement to a German-Polish non-aggression pact a year earlier on 26 January 1934, which promised peaceful settlement of all differences between the two neighbouring countries. The pact, which was valid for a minimum of ten years, contravened stated Nazi policy at the time, particularly with respect to Poland's western border. The Nazis argued that Germany was entitled to alter the border through the unilateral use of force.

343. A Liberal candidate for the British parliament on the campaign trail in London. One of the defining features of the 1930s in Europe was the growth of totalitarianism and the resulting erosion of democracy. The trend was most evident in Italy and Germany, but fledgling authoritarian parties built followings across the continent, even in Europe's strongest democracies. Britain was not immune from the forces fuelling the rise of these movements – economic depression, unemployment, nationalism and social crises. In 1932 the British

Union of Fascists was founded, led by the charismatic Oswald Mosley. For the most part, however, the British public's faith in democracy did not wane.

1936

344. During the height of the Great Depression in the US, dust storms swept across several midwestern states adding to the misery of the millions of unemployed families travelling the country looking for work. Severe drought combined with years of over-cultivation and shoddy land management had loosened the topsoil of the land in the region. Consequently heavy spring winds in the early 1930s carried off the layer of topsoil creating tremendous black blizzards of windblown dirt which blocked out the sun. Occasionally the storms swept right across the country, causing havoc among the bands of migrant-worker families living in makeshift accommodation.

345. A still from *The State of Things to Come*, the American film directed by William Cameron Menzies based on H.G. Wells' classic tale of space travel in a bleak future. Wells' novel about war and human progress centred on the fear of a tragic wrong turn taken in the development of the human race – his thinly-veiled plea to confront fascism before it was too late. As a pioneering science-fiction writer, Wells' imaginative energies were directed increasingly towards the social problems of his time. Eventually Wells abandoned fiction altogether to write political commentary and analysis.

346 top. The inter-war period was a lean time for the global shipbuilding industry as the demand for capital goods dropped sharply after the First World War. The Depression also brought world trade to new lows. By the early 1930s dozens of shipbuilding firms had been closed in Britain and launchings from the once-mighty British shipyards in the north-east were at barely 7 per cent of their 1914 level. The unemployed did sometimes take action, most famously in the Jarrow Crusade in which 200 jobless shipyard workers mounted a hunger march from the town of Jarrow in north-eastern England to London. The government paid little attention, but the hunger marches raised much public concern for the plight

of the unemployed throughout British industry in the 1930s.

346 bottom. By 1914 the coal industry – Britain's oldest continuously recorded industry, dating from the thirteenth century – was Britain's primary male employer, providing jobs for over a million miners. During the inter-war years the industry was beset by declining productivity, decreasing demand and massive worker unrest from which it never recovered. After a brief resurgence during the Second World War, the industry was nationalized in 1947 and underwent a comprehensive modernization at great public cost.

347. The Duke of Windsor hiding his face on leaving Windsor Castle after his abdication speech to the nation. On 16 November 1936 Edward VIII, later Duke of Windsor, informed Prime Minister Stanley Baldwin that he wished to marry Mrs Wallis Simpson, an American citizen and recent divorcee. Baldwin believed marriage to a divorcee was inconsistent with the King's official position as Supreme Governor of the Church of England. When the British newspapers broke their self-imposed censorship on 3 December, there was widespread popular support for the King, but little in the House of Commons except, notably, from Winston Churchill. Faced with the option of either giving up the woman he loved or the throne, Edward chose to abdicate.

348. A Popular Front (Republican) soldier with objects from a ransacked church in Barcelona, following the outbreak of the Spanish Civil War. In July 1936 an attempted army coup led by General Francisco Franco tried to topple Spain's left-wing anticlerical Popular Front government. Republicans did not lay down their arms as Franco had mistakenly predicted, and civil war broke out across the country. Disorganization and political in-fighting within and between Republican forces who were drawn from members of all of Spain's left-wing political parties – Republicans, Socialists, Communists, Anarchists and Catalan and Basque Nationalists – frequently resulted in heavy losses against unified Nationalist forces under Franco.

349. During the Spanish Civil War Spain became an ideological

battleground for all of Europe. Despite international declarations against foreign involvement, the fascist governments of Italy and Germany aided Franco's troops with soldiers, tanks, aircraft and artillery, while Russia and France provided military assistance, albeit less substantial, to the Republican side. International Brigades of volunteers from around the world were formed by volunteers from many countries to fight for the Republicans.

350. Franco being sworn in as Head of State of the insurgent Nationalist government in Spain on 1 October 1936. In 1926 at the age of thirty-four Franco became the youngest General in Europe. Ten years later, as Governor of the Canary Islands, his leadership skills and proven ability to gain military assistance from Germany and Italy made him a natural choice as leader of the army coup against Spain's Popular Front government. Within a year of the coup he had organized the Falange (Spanish Fascist Party) and made it the rebel regime's official political movement.

351. By the end of 1936 surprise tactics and superior military strength enabled Franco to gain control of half of Spain, including the length of the Portugese frontier. Basque and Catalan regions rallied to the government forces in the east and the north of the country. Waves of refugees, primarily from Republican zones overrun by Franco's troops, flooded into Spain's major cities. Madrid and Barcelona experienced the greatest influx and the resulting severe strain on food supplies and local services.

352. American journalists covering the 1936 Summer Olympics in Berlin reported widely on the friendship which developed between Jesse Owens, who won four Track and Field gold medals, and his German competitor in the long jump event, Carl Lutz Long. Although German athletes performed extremely well, Owens was the undisputed star of the Berlin Games, frustrating Hitler's intention to use the sporting spectacle as a showpiece for the superiority of Aryan races. However, in other ways the Olympics were a great success for the Führer. The Games' planners had shrewdly concealed the most pernicious aspects of the Third

Reich from the world's media, enabling the Nazis to score a tremendous propaganda victory. Hitler appeared almost daily at the packed Olympic stadium, proving to be an extremely popular statesman. Long was killed in action during the Second World War.

353 left. In 1936 Léon Blum's Socialist Popular Front government was elected in France. He embarked on an ambitious programme of social reform but his efforts were predictably hindered not only by the right, but also by the left, who organized a series of strikes designed to push the reform process along. In June 1936 a factory strike escalated into a country-wide general strike. Strikers held sit-ins at their places of work and even forced the closure of some of France's much-loved cafés. Unfortunately the strikes weakend the economy and strengthened the right's resistance.

353 right. Picturesque Hampstead Heath in London provided a welcome respite from the crowds and chaos of one of Europe's most congested cities in the 1930s. With London's population approaching 9 million on the eve of the Second World War, municipal authorities struggled to cope with housing shortages and heavy street congestion. After the war the city's population went into decline as vast numbers of Londoners migrated to more distant suburban areas.

354. Oswald Mosley, leader of the British Union of Fascists, visiting the East End of London with his Black Shirts. Mosley served with distinction in the First World War and went on to become a Member of Parliament, changing his party allegiance in the House of Commons several times between 1918 and 1931. Disillusioned with conventional party politics, Mosley formed a new fascist organization in 1932 modelled on similar groups in Italy, but it rapidly turned anti-Semitic and Hitlerite. Wearing Nazi-style uniforms and insignia, his followers staged hostile demonstrations in the Jewish areas of East London. Mosley's party had a membership of 30,000 in 1934, but this declined after the British government's Public Order Act of 1936 banned political uniforms and private armies. Mosley himself was imprisoned shortly after the Second World War began and

without his leadership the Union disbanded.

355. Exiled Ethiopian Emperor Haile Selassie delivering his famous address to the League of Nations in Geneva on 30 June 1936, urging League members to save his country from invading Italian forces. Mussolini's desire to strengthen his domestic position through the establishment of an Italian East African Empire, and his awareness of Italy's defeat there in 1896, led to the Abyssinian crisis. Rejecting all attempts by the League of Nations to mediate, Mussolini invaded Ethiopia on 2 October 1935. Six months later the ill-equipped Ethiopian army succumbed to Italian tanks, aircraft and poison gas. Italy's aggression caused international outrage. The League was unable to agree to anything more than limited sanctions against Italy, demonstrating the ineffectiveness both of the League and of the concept of appeasement.

1937

356. Germany's zeppelin passenger service launched in 1928 came to an abrupt end on 6 May 1937. On that day, the *Hindenburg*, the pride of German airships, making its twentieth transatlantic voyage, was torn in half by an explosion while approaching the mooring mast at Lakehurst, New Jersey. The detonation was most probably caused by the high-volatility paint used to coat the airship, akin to covering it with rocket fuel, which ignited the hydrogen inside. Of the thirty-five people killed in the disaster, twenty-seven died after jumping from the burning zeppelin as it floated to the ground 61 metres (200 feet) below. The sixty-two passengers who stayed on board avoided the toxic fumes and all survived. Remaining zeppelins were broken up for scrap metal a short time later.

357. A street scene in Chungking, China, after Japanese bombers had passed over. Having occupied Manchuria since 1931, the Japanese overran most of northern China in the autumn of 1937, capturing Shanghai and penetrating deep into the Yangtze River region. In the Kuomintang capital Nanjing, as many as 300,000 civilians were killed between December 1937 and January 1938 when the Japanese took over the city on the heels of the Kuomintang's evacuation.

Chiang Kai-shek's government set up a new capital in Chungking, but it too suffered terribly throughout the war, mostly as a result of heavy bombardments from the Japanese air force.

358. The grotesque facial and bodily distortions on the immense canvas of *Guernica* were an expression of Picasso's revulsion at the bombing of the Basque town of that name during the Spanish Civil War. The painting was a cry against war in general and a call for compassion and hope for its victims. During the war the Basque region remained loyal to the Republican government but suffered immensely for it at the hands of the air unit of the German Condor Legion which fought alongside Franco's forces. With the support of the Republican Government Picasso exhibited *Guernica* at the Paris World Fair in 1937.

359 top. Belgian Rexist leader Léon Degrelle expounding his quasi-fascist message, which centred on the family, work and country, to his largely uninterested countrymen. An energetic demagogue, Degrelle and his Rexists (Christ-the-King movement) won just over 10 per cent of the seats in the 1936 Belgian election following his virulent verbal attacks on Jews, communists and the parliamentary system. As in Switzerland and the Netherlands, the Belgian parliamentary system was too strong to allow the success of a fascist party and the terrorist violence so characteristic of Italy and Germany remained virtually unknown. In 1937 Degrelle lost his own seat in a by-election.

359 bottom. After the First World War, having survived the horror of Verdun and later a German POW camp, Jacques Duclos resumed his career as a pastry chef. In the 1920s he became active in left-wing groups and eventually joined the new French Communist Party (PCF) which had strong affiliations in the Soviet Union. He developed a reputation as a superb negotiator, but also as a troublemaker. He was jailed repeatedly in 1927 for inciting French servicemen to disobedience. When the PCF was banned just before the outbreak of the Second World War he became the party's leader after his predecessor, Maurice Thorez, was ordered to Moscow by Soviet authorities.

360. The Duke and Duchess of Windsor with Nazi politicians during a visit to Germany. After his abdication Edward went into voluntary exile in France. The following year, as the Duke of Windsor, the title created by his successor and brother George VI, he married Mrs Simpson. In some circles it was feared that the Duke would be regarded as a king-in-exile and a threat to the new British king. The couple's much publicized visit to Hitler in October 1937 raised suspicions that this was indeed the case, but his trip was more naïve than sinister. Although evidence suggests that key Nazi leaders, notably Foreign Minister Joachim von Ribbentrop, did consider the Duke as a possible king for a future German-occupied Britain, there is no evidence that the Duke of Windsor agreed to this plan.

361. Boys asleep on a bench waiting to view the coronation parade of George VI on 12 May 1937. When Britain's King George V died on 20 January 1936 he was succeeded by Edward VIII who had abdicated by the end of the year leaving the Duke of York, Albert Frederick Arthur George, next in line to throne. He had dreaded the prospect of becoming King and admitted he was ill-prepared for the role. After a tumultuous year for the Royal family, he was crowned George VI in an attempt to restore a sense of continuity and stability to the British monarchy.

362. Chinese Communist Party leaders Zhou Enlai, Mao Zedong and Bo Gu in Yenan. In late 1936 Chinese communists moved their headquarters from the northern town of Baoan to Yenan in Shansi province, which acted as the capital of Communist-controlled areas of China until 1947. During this period the communists brought vast numbers of peasants to their cause against the Japanese, owing to their skills in organization and guerrilla warfare in the countryside. By 1940 the party membership had grown to 800,000 from just 20,000 in 1936. Mao Zedong, the party's leader, also launched a series of campaigns to promote his own interpretation of Marxism and instituted a purge of potential opponents within the party personnel.

363. In the mid 1930s the Reich Labour Service, originally devised as a means of combatting

unemployment, was remoulded by the Nazis into yet another state instrument to train and educate young people in the spirit of the party and above all prepare them for war. Young women were often trained in agriculture and after 1939 a 'duty year' of general labour service was obligatory for women. The 'Work Maidens', as they were called, were also sent to the settlement areas to help overburdened German mothers.

364. By the late 1930s the fascists' significant domestic achievements in Italy did much to strengthen ties with their ideological cousins, the Nazis in Germany. The party brought long overdue modernization to Italy, developed a vigorous foreign policy and restored a sense of national pride among ordinary Italians still smarting from their nation's humiliating performance in the First World War. The effectiveness of Italian fascism was limited, however, by its growing dependence on Nazi Germany and the unwavering power of the Roman Catholic Church with which Mussolini dared not interfere too much. Dazzled by the Nazis' success, Mussolini began to turn more towards Hitler. During his visit to Berlin in 1936 he proposed a Rome-Berlin Axis, and in November 1937 Hitler persuaded him to sign the Anti-Comintern Pact which further strengthened the bond between the two leaders.

365 top. The terrible ordeal of the First World War weighed heavily on the French people. In addition they had experienced a pervasive mood of crisis caused by endemic political instability in France during the inter-war period. The country was sharply divided between left and right, each side more interested in battling with the other than with the enemies on France's borders. Weak party structures, political irresponsibility and extremism on both sides led to numerous factions and a dizzying number of short-lived governments. Between 1918 and 1940 France had forty-four governments, headed by twenty different prime ministers.

365 bottom. An Australian war memorial designed by renowned British architect Sir Edwin Lutyens under construction near Amiens in northern France. From a total population of under 5 million, about 322,000 Australian men volunteered for overseas

service in the First World War, primarily in the Middle East and France. More than 280,000 became casualties of the war (including more than 60,000 dead) making it the highest rate of attrition suffered by any national army. Nonetheless, the Australian public were nearly unanimous in support of their leaders' decision in September 1939 to go to war against Germany again.

366. James Maxton converted to Marxist socialism after witnessing great poverty in Glasgow in Scotland, where for a time he was a pacifist school teacher. He joined the Independent Labour Party in 1904 and thereafter acquired a reputation as a fiery and uncompromising champion of the socialist cause. At the height of the war in 1916 he was briefly imprisoned for inciting a strike among munition workers. Fellow parliamentarians were aghast at Maxton's actions and vehemently disagreed with him time and again during his long career in politics. But no one disputed his integrity and compassion, nor his unfailing wit and charm which made him one of the most popular MPs in Britain's House of Commons during the inter-war period.

367. In the early 1930s two parallel conflicts in China both promised to ignite into full-scale war at any time. The Japanese forces occupying Manchuria made periodic incursions into Chinese territory, whilst the communists and Kuomintang battled intermittently for control of the rest of China from their power bases in Jiangsi and Nanking. In July 1937 the waiting ended. Japan used a brief clash between its troops and Chinese forces at the Marco Polo Bridge near Peking as a pretext for launching an all-out invasion of the country. At the height of the invasion Japan controlled two-thirds of China.

368. Strikers ready to appear in court following the end of a sit-down strike in Chicago. In the first half of 1937, 500 people were injured and twenty-four killed in strike actions in the US. Worst hit was America's massive steel industry where 85,000 workers in five states walked out in 1937, paralyzing twenty major plants. Staging a sit-down strike – the passive seizure of a plant by striking employees – was the preferred method of work stoppage among labour activists

until the US Supreme Court put a stop to it in 1939. The major independent steel companies were forced to recognize the giant employees' union, United Steelworkers of America (USWA), as a bargaining agent. Over the next two decades the USWA achieved significant benefits for its workers and by the mid 1950s its membership had swelled to more than a million.

369. Czechoslovakia's President Eduard Beneš at the funeral of his predecessor and founder of the country, Tomáš Masaryk. Beneš travelled abroad with Masaryk during the First World War to promote Czech independence. Czechoslovakia was granted independence in 1918 and Masaryk became the country's first President with Beneš as Foreign Minister. After struggling for more than a decade and half to resolve recurring conflicts between the country's Czech and Slovak populations, Masaryk retired in favour of Beneš in 1935. Beneš resigned a year after Masaryk's death in 1937, and following the agreement of independence. He set up a Czechoslovak government-in-exile first in France, and later in Britain.

1938

370. The deliberate destabilization of the Austrian government by the Nazis in 1938 led Austrian Chancellor Kurt von Schuschnigg to call for a plebiscite on the question of Austrian independence in an attempt to forestall Hitler's annexation of his country. In response the Germans submitted an ultimatum demanding his resignation. Schuschnigg resigned on 11 March 1938 and was replaced by Arthur Seyss-Inquart, a Nazi nominee who invited the Germans to occupy Austria. German troops crossed the Austrian frontier on 12 March and on 10 April a Nazi-controlled plebiscite returned a vote of 99.7 per cent in favour of the Anschluss – the union of Austria with Germany.

371. Enormous crowds lined Berlin's streets to greet Hitler on his return from Austria. In many ways the Anschluss became a formality after Hitler was made chancellor of both countries, even though the Treaty of Versailles clearly forbade such a union. After 1933 Hitler made little secret of his intentions to cast aside the

restrictions imposed on Germany by the victorious Allies and 'protect' the 10 million Germans living on the frontiers of the Reich. Popular support for the union was high in both countries. Results from the Nazi-controlled plebiscite in Austria (renamed Ostmark after the annexation by Germany) in April 1938 did in fact closely reflect Austrian sentiments. It is doubtful however, that Austrians would have expected the scale of brutal and unrestricted repression suffered by Jews, Social Democrats and other anti-Nazi groups at the hands of the SS during Hitler's control of Austria.

372. *A Street Porter, Warsaw* by Roman Vishniac. The work of photographer Roman Vishniac stands as a powerful reminder of the richness and vitality of Jewish culture in Eastern Europe prior to the Second World War and the Holocaust. Vishniac, a Russian doctor who lived in Germany during the inter-war years, recognized the vulnerable position of European Jews and set out to create a photographic record of Jewish life in Eastern Europe before it was extinguished. He took more than 16,000 photos with a hidden camera during his travels in the region between 1933 and 1939, of which around 2,000 survive.

373. A Jewish shopkeeper clearing away the damage of his vandalized store after the *Kristallnacht* (Night of Broken Glass), the night of 9 November 1938 during which Jewish property was attacked. The destruction wrecked by Nazi activists and SA marchers on *Kristallnacht* was triggered by a virulently anti-Semitic speech given by Nazi Propaganda Minister Joseph Goebbels. He used the murder of a member of the German Embassy in Paris by a Jew as a pretext to incite a spontaneous uprising in which over 7,000 Jewish shops and almost every synagogue in Germany were destroyed. Hitler had long sought an opportunity for the intensification of anti-Jewish measures but in many ways this attack backfired. Few ordinary Germans joined in and most were angered by the lawlessness of the violence although there was little actual protest from the public.

374. A sign calling for the death of International Jewry and freemasons to atone for the murder of Ernst von Rath, on top of the contents of a synagogue about to be

burned. On 7 November 1938 Herschel Grynszpan, a Polish Jew distressed over the treatment of fellow Polish Jews living in Germany, attempted to assassinate the German ambassador to France in Paris. Instead he shot the Embassy secretary, Rath, who died two days later. The *Kristallnacht* pogrom against Jews took hold. Rath was posthumously declared a great martyr by the Nazis who conveniently ignored an earlier report by the Gestapo which declared him 'politically unreliable'. In 1940 Grynszpan was deported from France to a Nazi concentration camp. Amazingly he survived the war, as the Nazis were planning a show trial against him once the war was over in order to demonstrate the evil of world Jewry.

375. Only 180,000 of more than 500,000 Jews living in Germany in early 1933 had emigrated by the end of 1938. It was a small number considering the growing social discrimination and persecution they faced, and the active encouragement by the Nazis to emigrate. Throughout the 1930s the Nazis had attempted to undermine the political and economic foundations of the Jewish community in Germany, but many Jews still hoped for a normalization of conditions. Others wished to leave but were unable to do so due to inadequate means and the unwillingness of many countries to accept destitute Jews.

376 top. The Japanese attack on Shanghai was the catalyst that united, albeit temporarily, the warring armies of the Kuomintang and the communists. Zhou Enlai, Mao's second-in-command and a leading communist ideologue, had argued for a combined effort against Japanese incursions since 1931. After both parties agreed to join forces he became military adviser to Kuomintang leader Chiang Kai-shek, whom he had helped free from a rebel Kuomintang kidnapper a year earlier. China was briefly united, and about 14 million Chinese soldiers, both nationalist and communist, were deployed against the Japanese invaders.

376 bottom. Chinese victims of war. The extreme brutality of the Japanese occupation was made worse for Chinese civilians by the fact that their communist and Kuomintang protectors could not

maintain a truce. The mutual acknowledgement of a common foe failed to prevent either side from mounting guerrilla attacks against the other when their leaders saw an opportunity to gain an advantage. Under Chiang Kai-shek the more established Kuomintang army received economic and military aid from the US during the war, but as the conflict with Japan wore on this was countered by increasingly effective resistance by Mao's communist troops.

377. A Japanese 'hero' of the war in China being greeted on his return to Tokyo. The ferocity and viciousness of the Japanese campaign in China surprised even their most hostile international enemies. Red Cross officials stationed in Nanjing during the invasion reported almost unimaginable acts of barbarism by Japanese forces against the city's inhabitants, ranging from mass decapitations to live burials. This was only the beginning of a series of genocidal campaigns by Japanese forces in China which eventually left several million civilians dead as a result of massacre, military attack, forced starvation and germ warfare.

378. After the Anschluss, Hitler moved to incorporate Czech lands into German territory. British Prime Minister Neville Chamberlain flew to Hitler's residence in order to avert a military conflict. At their final meeting in Munich, an agreement was signed allowing Hitler to annex the Sudetanland – home to 3.25 million Germans – but not the entire Czech lands. War had been avoided, leading Chamberlain to make his famous proclamation 'peace in our time' upon his return to Britain. The Agreement reflected the general desire for appeasement with Germany in Britain and at the time was widely hailed as a triumph. But the British Foreign Secretary Lord Halifax displayed mixed feelings during the Munich crisis, and early the following year he argued for Britain to make tougher policies and for faster rearmament.

379. In the 1930s Romania became increasingly tied to expansionist Nazi Germany even while the country's leaders were officially still committed to maintaining the status quo in Central Europe and the Balkans. A new Romanian extreme right-wing party the Iron

Guard, gained widespread popular support during the period. This was true particularly among ethnic Germans in Romania, less because of its affinity with Hitler or his racist policies than with the party's fiercely anti-Soviet stance. After the Soviet Union seized the Romanian lands of Bessarabia and Bukovina, a formal alliance with the Nazis became inevitable. In September a pro-German dictatorship was established and a few months later Romania was forced to agree to participate in Hitler's invasion of the Soviet Union.

380. Gandhi returned to India from South Africa in 1915 and his subsequent involvement in political life in India won him a degree of respect and admiration around the world matched by few leaders this century. His commitment to non-violent protest to achieve social and political ends was put to the test countless times, yet he never wavered. His peaceful campaigns variously sought to work against poverty, to improve the status of Hindu Untouchables, to gain religious tolerance and unity and to achieve independence from Britain. In spite of enormous international fame he refused earthly possessions, opting to wear only the loincloth and shawl of the lowliest Indian and subsisting on a meagre diet of vegetables, fruit and goat's milk. He risked death by giving up food altogether for several days during many protests.

381. Stalinist paranoia was at its peak in the Soviet Union between 1934 and 1939 and nowhere were its consequences felt so acutely than in the Communist Party. Following the murder of Sergei Kirov in 1934, Stalin systematically sought out his opponents in the party and accused them of various crimes (usually imaginary). They were then executed. At the height of Stalin's terror, 9 million 'enemies' of his regime were in prison or forced labour camps. As a result of the purges, less than 2 per cent of the delegates attending the 1939 Communist Party Congress had been present at the previous Congress four years earlier.

1939

382. Madrid fell to Franco's Nationalist troops on 28 March 1939 and all fighting in the Spanish Civil War ceased three days later. After three years of bloody conflict which

had claimed between 500,000 and a million lives and involved many of Europe's major powers, Franco's regime was recognized as the legitimate government of Spain. France, having provided exile for defeated Republican soldiers, now saw herself surrounded by fascist powers to the east and the south.

383. The Germans entered Prague in March 1939. By cleverly exploiting the Sudeten Germans' grievances over high unemployment and repression by the Czechoslovak government, the Nazis engineered a diplomatic crisis and then demanded a resolution to a dilemma they themselves had purposely aggravated in their favour. The result was the Munich Agreement, signed in September 1938. It did not, as the Allies had hoped, bring peace. Instead it was part of Hitler's grand design for the conquering of Europe. In early March 1939 the Czechoslovak president Emil Hacha went to Berlin to plead with Hitler not to interfere any further. He was told that a Nazi invasion of his country was already under way. He reluctantly signed the surrender document and subsequently urged his countrymen to collaborate with Germany.

384 top. Originally Hitler's personal guard, the SS became the embodiment of Nazi master-race ideology under its leader Heinrich Himmler. Entry into the elite force was based primarily on physical condition and racial purity. Requirements even stipulated that marriages of SS men had to be approved by the Nazis' Race and Resettlement Office. For Hitler, the chief significance of the SS lay in the force's unconditional loyalty to him, something that was not assured from the SA. After 1936 the SS became responsible for uncovering opposition within the German population and later provided concentration camp guards and police squads in occupied territories. The organization remained above the law and was responsible for some of the worst Nazi atrocities.

384 bottom. Members of a Young Fascist organization greeting British Prime Minister Neville Chamberlain in Rome. During the late 1930s Italy lurched towards war and a military alliance with Nazi Germany. But Mussolini's zest for

conquest was not shared by the Italian public who were lukewarm about the prospect of even a short war and had serious misgivings about *Il Duce*'s choice of ally. Undoubtedly Mussolini would have been less enthusiastic had he realized how ill-prepared the Italian army was for a major conflict.

385. British Prime Minister Neville Chamberlain and Foreign Secretary Lord Halifax receiving a warm welcome from Mussolini and Counts Ciano and Grandi on their visit to Rome for talks on 10 January 1939. Having witnessed Mussolini's efforts to moderate Hitler's demands at the Munich talks the previous year, Chamberlain believed he could prevent a formal alliance between the two fascist powers, Italy and Germany. As a last desperate inducement to Mussolini, the British recognized Italian supremacy in Ethiopia and agreed to keep out of the Spanish Civil War in which Italy was deeply involved. In spite of Chamberlain's efforts, on 22 May 1939 a formal alliance called the Pact of Steel was agreed between Italy and Germany.

386. Soviet Foreign Minister Vyacheslav Molotov checking over the plan for the demarcation of Poland while German Foreign Minister Joachim von Ribbentrop observes from behind with Stalin. Throughout the summer of 1939 Ribbentrop repeatedly expressed Germany's urgent desire to Molotov to establish a non-aggression pact with the Soviet Union which would guarantee that the Soviet Union would not interfere during the Nazi invasion of Poland. Negotiations were stalled until a personal telegram from Hitler to Stalin on 20 August secured a meeting between the Germans and the Soviets in Moscow on 24 August. Within twenty-four hours the coveted agreement was signed.

387. The Nazi-Soviet pact was supposed to be valid for ten years but Hitler no doubt saw it as both a temporary arrangement with Stalin and an emergency response to the necessity of beginning the European war with a 'reversed front'. The agreement, having been made with a communist power, marked a temporary deviation from the ideological underpinnings of Nazism in favour of strategic military calculation.

Hitler's main purpose was to ensure military neutralization of the Soviet Union during an attack on Poland. Stalin on the other hand was motivated primarily by a desire to escape involvement in a major war and also to add Eastern Europe to his sphere of influence. This was in fact gained through secret clauses in the pact on the partition of Poland which were unknown to the public.

388. A still from the film *Ninotchka* starring the incomparable Greta Garbo. A prodigious talent and legendary beauty, the Swedish-born actress became the most glamorous star of 1930s cinema. Garbo stars as a Russian agent in this romantic comedy, caricaturing her own aloof image. She famously displayed a surprising gift for comedy in a role which turned out to be one of her last. Two years later, at the age of thirty-six, Garbo withdrew completely from the world of entertainment after scathing reviews of her most recent work. She lived in New York for the next fifty years as one of the world's most famous recluses.

389. Americans in New York reacting to news that war had broken out again in Europe. Inter-war isolationist attitudes in the US presumed that German power and expansionism presented no danger to the security of America, with its formidable air and naval defences. After the First World War most Americans concluded that participating in international relations had been a mistake and that it was better to seek peace through isolation. Although most Americans were sympathetic to the British, they were over-whelmingly opposed to sending troops into the conflict and hoped their govern-ment would officially remain neutral.

390 top. German troops crossed the Polish frontier on 1 September 1939. When demands for Germany's immediate withdrawal from Poland were ignored by Hitler, Britain and France declared war on 3 September. Less than a week earlier – and one day after the Nazis signed the non-aggression pact with the Soviet Union – Chamberlain had signed the Anglo-Polish Alliance. The Alliance, guaranteeing British military assistance to Poland in the event of an attack by another European state, was agreed at a point when war was clearly imminent, and was

a signal that Britain was unwilling to appease Hitler any further. Two decades of foreign policy in Europe aimed at preventing another major war had failed. The Second World War had begun.

390 bottom. German military dominance over the ill-equipped Polish army was obvious from the outset of the invasion. Aerial attack from the *Luftwaffe* wrecked the Polish rail system and destroyed most of the country's vital infrastructure. On the ground Polish forces were being devastated by ferocious German attacks based on modern *blitzkrieg* (lightning war) tactics which involved fast moving armoured forces combined with warplanes. The Polish defence had been reduced to random efforts by isolated bands of troops when they were attacked on several fronts. Soviet forces entered Poland from the east on 17 September. The Warsaw garrison held out until 28 September before succumbing to German terror-bombing and artillery barrages which reduced parts of the city to rubble with no regard for the civilian population. A week later the first campaign of the Second World War had come to an end and Poland was divided between Germany and the Soviet Union.

391. In 1938 French Premier Edouard Daladier had taken the British Prime Minister Chamberlain's lead in promoting the appeasement of Hitler. They had both supported the Munich Agreement, although they believed that while war might be averted, the deal would spell disaster for France. The French public had greeted news of the agreement with jubilation. A fragile political situation and crisis-weary population in France was not auspicious for mounting a formidable defence of the nation if Germany decided to cross the French border. In 1939 France nevertheless glumly followed Britain's lead as the crisis over Poland deepened. This eventually resulted in the Allies' declaration of war on Germany in early September.

392. In the 1930s fragile Finnish governments pushed through anti-communist legislation, weakening relations with the Soviet Union, its neighbour to the east and already at odds with the Finns over disputed territory in the Karelian Isthmus. When Finland rejected

Soviet demands for border changes in the region Stalin promptly rescinded the non-aggression pact he had signed with Finland in 1932. He sent Red Army units into Finland on 30 November. Stalin hoped to duplicate what Hitler had done in Poland a few months earlier.

393 top. For fifteen weeks a fierce 'Winter War' raged between attacking Soviet forces and the hugely outnumbered Finnish troops. Despite the Soviets' overwhelming advantage in manpower and equipment, Finland inflicted heavy defeats on the Red Army during the initial stages of the war. The Finns checked the Soviet advance at the so-called Mannerheim Line (named after Marshal Carl Mannerheim, leader of the Finnish army) with a system of defences stretching across 105 kilometres (65 miles) of the country's south-eastern border. Finnish successes in repelling Soviet attacks came as a great surprise to observers and a costly embarrassment to Stalin, whose faith in the fighting power of his massive Red Army was cast into grave doubt. By the end of the war the Soviet Union had lost eight times as many soldiers as Finland.

393 bottom. Six weeks after the initial Soviet invasion Stalin's Red Army launched a second major assault across the frozen Gulf of Finland which broke the Finnish line, finally turning the war irreversibly in Stalin's favour. The Finnish government, unable to wait any longer for the assistance of a promised Anglo-French expeditionary force (cancelled due to Germany's occupation of Norway) and denied aid from the rest of Europe, signed a peace treaty with the Soviets on 13 March 1940. Although Finland was forced to surrender roughly 41,000 square kilometres (16,000 square miles) of territory to the Soviet Union, it had given the reputation of the vaunted Red Army a battering which boded well for Hitler. In the hopes of recovering lost lands, the Finns allied with Germany in Hitler's invasion of the Soviet Union a year later.

1940

394. Hitler decided to launch a naval and air invasion of neutral Norway on 9 April 1940. Hitler was convinced of the need to occupy Norway, whose coastline was strategically important. The Nazi invasion took the form of the world's first offensive airborne operation. The *Luftwaffe*'s transport fleet carried *Wehrmacht* troops directly to Norwegian targets inland, while a series of amphibious landings took place along the coast. Resistance to the German invaders was strong, particularly at Narvik in the north where an Anglo-French force held out for eight weeks before the crisis in France necessitated the evacuation of the expeditionary troops. Their departure sealed the Norwegians' fate, and an armistice was signed on 9 June 1940 between Norway and Germany.

395. The Nazis' plans for the territories occupied by the German army were designed to achieve two primary objectives: economic exploitation of the conquered territories and the persecution and later extermination of their Jewish populations. The *Einsatzgruppen* (SS attack or task groups) were essentially given free reign to carry out this persecution. The Nazis appointed Hans Frank as Governor-General in occupied Poland in 1940. During the next four years he oversaw the systematic repression and murder of Polish nationalists, intellectuals and professionals and, in accordance with Hitler's wishes, attempted to exterminate the country's entire Jewish population. Poland suffered a higher percentage of deaths, including 3 million Jews, than any other country during the war.

396 top. In 1940 French military leaders had optimistically claimed to have Europe's most powerful army, capable of deploying roughly 5 million trained men. They also placed great faith in the country's supposedly impregnable defensive fortifications, the Maginot Line. This stretched along the French-German border running from Luxembourg in the north to Switzerland in the south and was built during the 1930s under the supervision of French War Minister, André Maginot. They were wrong on both counts. The French army was defeated by the German onslaught launched on 10 May against Belgium, the Netherlands and France not unlike the way in which the much weaker Poland had fallen. The Maginot Line proved to be easily avoided as advancing German troops simply bypassed the defences during their march into France. On 22 June 1940 France signed an armistice with Germany in defiance of its treaty commitments to its ally, Britain.

396 bottom. At the time of the German invasion on 10 May, Belgium had mobilized 900,000 military personnel, but the country had no tanks and few aircraft. Over the next eighteen days Belgian troops were overwhelmed, not by superior numbers, but as a result of Germany's devastatingly effective new strategy of tank warfare. The tactic consisted of rapid penetration by mobile armoured units attacking forward of the opponent's armies in order to achieve tactical gains by surprise. On 28 May, without warning his allies, Belgium's King Leopold surrendered his army. British and French troops which had left their fortified positions in an effort to rescue Belgian forces, scrambled to escape the German advance.

397. The Netherlands's vaunted Fokker G1 fighter planes were no match for German Messerschmitt Bf 109s during the air battle that took place over the Netherlands in May 1940. All but one of the twenty-three Fokker G1s deployed against the attacking German air force were destroyed. Despite clear signs of an imminent attack, the neutral Netherlands were caught unprepared for the German invasion and Dutch defences collapsed after just five days. During the short battle, Rotterdam was subjected to ruthless aerial bombardment aimed at terrorizing the civilian population into a surrender. Both German and Allied air forces would frequently use this controversial tactic during the course of the war.

398. As German tank forces pushed rapidly through Belgium in May 1940, 335,000 British and French soldiers found themselves encircled near the coastal city of Dunkirk. Hitler, believing victory was assured, ordered a two-day halt to the German advance to wait for reinforcements. This enabled hundreds of hurriedly-gathered British boats and warships to take the besieged Allied troops from the beaches. Between 26 May and 4 June they were transported back to England under heavy air and artillery bombardment. Although disaster was averted, the evacuation dented British pride and resulted in a substantial loss of equipment which had been left behind in the rush to escape the German advance.

399 top. After the fall of the Netherlands, Belgium and France in the late spring of 1940, the British waited anxiously to see if Hitler would mount an invasion of Britain. On 16 July 1940, frustrated by Britain's stubborn refusal to accept her hopeless military predicament, the German leader issued a directive to his generals to begin planning an invasion. Code named Sealion, the operation was not to begin until Germany established supremacy over the skies of Britain, something Hermann Göring, the *Luftwaffe* Commander, insisted was possible.

399 bottom. Göring believed Germany's night strikes on Britain's cities would catch the British unawares, but he hadn't counted on British radar systems. The *Luftwaffe* lost the crucial element of surprise as the British early warning radar system, then the most advanced of its kind in the world, enabled the Royal Air Force (RAF) to quickly determine when and where German attacks would occur and then direct their fighter planes accordingly. By the end of the Battle of Britain, the RAF were bringing down *Luftwaffe* planes faster than German industry could manufacture them. Although Britain lost about 900 fighters during the battle, they shot down roughly 1,700 German aircraft and Hitler's invasion plans for Britain were indefinitely postponed.

400. Italian students demonstrating in favour of the annexation of French territories. Mussolini decided that Germany's surprisingly rapid advance through north-west Europe meant that Italy would risk not getting a share in the spoils of a German victory if she stayed out of the war. Italy finally entered the war on 10 June 1940, as the French army collapsed under the devastating assault of the German army. Hitler allowed Italy to occupy two small pieces of territory in southern France when the country fell, but this was hardly enough to satisfy Mussolini's boundless ambition. Mussolini took it upon himself to launch a disastrous invasion of Greece in October, which ended when his troops were pushed back into Albania at the end of the year. Italian forces proved similarly ill-prepared for battle and suffered heavy losses in North and East Africa.

401. Had Trotsky been prepared to use his control of the Red Army to achieve power, as Lenin's likely successor he would undoubtedly have got the better of his rival, Stalin. Instead he was expelled from the Soviet Union in 1929. For the next decade Trotsky lived as an exile in various countries. His anti-Stalinist harangues landed him a death sentence *in absentia* from a Soviet court in 1937. The long arm of Stalinist terror finally reached Trotsky in the summer of 1940. A Spanish-born assassin in the pay of the Soviet Secret Police attacked the great Russian revolutionary with a pickaxe on 20 August in Coyoacán in Mexico. Trotsky died of his wounds the following day and was cremated.

402. The 'Blitz' was a British colloquialism for the German air attacks on major industrial centres in the country, which usually took place at night during 1940 and 1941. At its height in the late summer of 1940 the *Luftwaffe* was launching daily bombing raids on Britain's cities involving up to 1,500 aircraft. London was particularly hard hit – during one nine-week stretch it was bombed every night but one.

403. *Air Raid Shelter, London* by Bill Brandt. The total number of British casualties during the Blitz was less than feared, although 40,000 were killed and 86,000 injured. Damage to buildings was more extensive than predicted. Fear and panic among civilians was high at the outset of the bombings, particularly in crowded urban areas. After one of the first raids on East London the government had brought in the army to ensure that panic-stricken residents who threatened to flee the city stayed in their homes. British leaders were acutely aware of the damage widespread evacuation might cause to morale, which is doubtless why this particular event in East London was concealed from the British public at the time. The raids did not succeed in terrorizing the British as anticipated by the Germans. As the bombings continued, fear was soon replaced by a stubborn resolve to survive.

1941

404. Any pretensions to military expertise among Italy's leaders were crushed after the country's

humiliating defeats at the hands of the Greek army in the Balkans and throughout north and east Africa at the hands of the British. Italy lost all of Italian East Africa (Ethiopia, Eritrea and Somalia) to the British in early 1941, and was ejected from Egypt and eastern Libya. Mussolini's mad rush to establish Italian hegemony in the Mediterranean greatly expanded the war and proved a costly mistake for him as well as a great liability for Hitler. Germany was forced to join the North African campaign and the costly occupation of the Balkans to prevent the defeat of the beleaguered Italian forces.

405. Orson Welles wrote, directed, produced and acted in *Citizen Kane*, a landmark film about a newspaper publisher corrupted by power, politics and love. Welles' unique narrative techniques and extraordinary fusion of photography, lighting and music to create different moods, made *Citizen Kane* essential viewing for generations of film students. It remains one of the most critically acclaimed films of the century. Ironically *Citizen Kane* flopped at the box-office when it was first released in 1941. William Randolph Hearst, the newspaper magnate whom Welles undoubtedly used as a model for the film's main character, successfully quashed *Citizen Kane* by intimidating movie distributors, issuing threats of blackmail and running a smear campaign in his newspapers. It was nearly a quarter of a century before Welles' masterpiece received worldwide recognition and praise.

406. In the mid 1930s Italy's *Regia Aeronautica* was one of Europe's most formidable air forces. It was used successfully during the Spanish Civil War in support of the fascists. By the time Italy entered the war against the Allies in June 1940 the *Regia Aeronautica* possessed nearly 2,500 war planes, including hundreds of obsolete Fiat CR 42 Falcos, the last biplane manufactured by any of the participants in the Second World War. Italian Falcos saw extensive action against the RAF's Middle East Command, consisting of fewer, but similarly obsolete biplane fighters. Despite the Italians' numerical superiority, the RAF gained the upper hand throughout North Africa, due partly to Italy's inability to supply sufficient fuel and equipment to its air force in the field. In subsequent

air battles during the war the *Regia Aeronautica* ceased to be a major force.

407. A German soldier killed in the Western Desert during the North African campaign, photographed by George Rodger. Early in 1941 Hitler sent the German *Afrika Korps* to North Africa under the young general Erwin Rommel in an attempt to alleviate the desperate position of the Italian forces in the region. When he arrived in Libya Rommel decided to launch an offensive against the depleted British forces. German losses were high but Rommel's rapid and brilliant early successes against Britain's Eighth Army forced the British into a hasty retreat to Egypt.

408. Hitler's massive invasion of the Soviet Union launched on 22 June 1941 and code named Operation Barbarossa, was the largest military campaign in history. Over 3 million German soldiers (three-quarters of the total German army) attacked nearly 5 million Red Army soldiers stationed in the European part of the Soviet Union west of the Urals. The invasion was a deliberate rupture of the Nazi-Soviet non-agression pact which Hilter had signed less than two years earlier. His desire to annex Soviet territory for its resources and raw materials, and for the vast living space (*Lebensraum*) it could provide for Aryans had been known since he wrote about it in *Mein Kampf* nearly two decades earlier, but the timing of the attack was a complete tactical surprise.

409. Russian victims of a German air raid. At the outset of the invasion Germany's overwhelming military and industrial might which drew on the resources of more than a dozen European countries, seemed formidable enough to conquer even the Soviet colossus. In the first ten days of fighting, strikes on Soviet air bases by the *Luftwaffe* resulted in the loss of nearly 3,000 Soviet aircraft. Within six months the German army had occupied the Ukraine and Crimea, and had advanced to the outskirts of Leningrad and Moscow. Over half of the original Soviet fighting force were wounded or had been taken prisoner.

410. An early morning attack on 7 December 1941 by 370 Japanese aircraft on Pearl Harbor – a giant

US naval base in Hawaii – left five battleships in ruins, another three badly damaged and dozens of other ships, aeroplanes and military facilities destroyed. Leaving 2,403 military personnel dead and enraging the American public, the attack made US entry into the Second World War almost a certainty.

411. US President Franklin D. Roosevelt, looking relaxed following his speech to the Joint Session of Congress and his signing of the declaration of war with Japan on 8 December 1941. American leaders had met with their Japanese counterparts on a regular basis during 1941 despite grave misgivings over Japan's aggression in the Far East. The suddenness and ferocity of the Japanese Pearl Harbor attack unified the American public and swept away the last vestiges of support for American neutrality in the war. Roosevelt, who had believed war to be imminent many months prior to Pearl Harbor, now had the fervent popular backing he needed. Five days later Germany and Italy declared war on America.

1942

412. A Russian soldier being pulled from his tank by German troops. Soldiers captured by the German army during their eastward advance through the Soviet Union were humiliated, brutalized or simply executed. However, by mid 1942 Soviet army losses and the huge territorial gains made by advancing German troops did not spell imminent defeat for the Soviet Union as Germany's deep penetration into Soviet territory had stretched German supply lines to the limit. Soviet man-power was proving virtually inexhaustible, and a massive transfer of the country's industrial forces to the east, beyond the reach of the Germans, was being organized. Soviet allies, the US and Britain, sent vast amounts of aid. The Germans were grossly ill-prepared to withstand another Soviet winter.

413. Yakov Stalin was a first lieutenant with the Soviet 14th Armoured Division when his unit was surrounded by German troops near Vitebsk on 4 July 1941 and he was taken prisoner. Upon discovering he was the oldest son of the Soviet leader, Germany dropped thousands of leaflets over Soviet

lines claiming that Stalin's son had defected, and included a short personal message from Yakov to his father informing him that he was being well-treated. After the Battle of Stalingrad in early 1943 Hitler sent a message to Stalin via the Swedish Red Cross proposing the release of captured German Field Marshal Friedrich von Paulus in exchange for Stalin's son. The Soviet leader allegedly responded by saying that a 'Marshal will not be exchanged for a lieutenant'. Yakov, who was regarded as a decent and capable officer by his contemporaries, had been rebuked by his father throughout his life which had contributed to severe bouts of depression. Although his status ensured he was well-treated in captivity (Germany sought to maintain the option of exchanging prominent prisoners until the very end), Yakov's depression deepened and on 14 April 1943 he entered the neutral zone of the camp in whch he was imprisoned, doubtless aware that by doing so he would be fired on by German officers. In the moments before he was gunned down prison guards reportedly heard him screaming 'shoot me'.

414. A Berliner after a British bombing attack. In early 1942 the British War Cabinet decided to intensify Allied air strikes which were designed to crush the morale of the German population, particularly that of industrial workers. Air Marshal Arthur 'Bomber' Harris took over Bomber Command. He devised British night-time carpet-bombing raids on German cities. From August 1942 the US Air Force made precision attacks by day. Although area bombing proved ineffective in crushing the resolve of Britain during the Blitz, Harris was convinced that massive aerial bombardment of urban areas and civilian populations in Germany would result in a swift Allied victory, precluding the necessity for a mass Allied land invasion of Europe.

415 top. British airmen after the RAF raid on Cologne. Code named Operation Millennium, the bombing of Cologne was the first test of the effectiveness of Bomber Harris' so-called 'thousand bomber' raids. On 30 May 1942 every RAF plane available to Harris, which numbered 1,050 aircraft, bombarded Cologne in a ferocious attack that lasted less than two hours. Civilian casualties were high and about a

third of the city was left severely damaged.

415 bottom. Bomb damage to London's St Pancras station. British Prime Minister Winston Churchill was unequivocal in claiming that neither London nor any other British city would capitulate in the face of Nazi aggression. He declared that he 'would rather see London laid in ruins and ashes' than fall to the Germans as Paris had done. Although damage to buildings was greater than authorities had predicted (with roughly 2 million homes destroyed), the Blitz did not seriously harm British industrial production, port facilities or internal communications. The damage wrought by Allied raids on Germany was far greater and more costly for German civilians.

416. Survivors of Nazi atrocities searching for relatives in Crimea. When Germany invaded the Soviet Union in 1941 the SS were instructed to eliminate all Jews and Soviet political commissars in conquered Soviet territory. In practice this meant Jews and all those deemed uncooperative with German occupation forces were rounded up, transported to an isolated area and shot. After 1942 'gas vans' were used to murder women and children, apparently in response to SS leader Heinrich Himmler's aversion to seeing women executed by a firing squad. German atrocities were particularly severe in Crimea and Ukraine, strategically important because of their proximity to the Black Sea and the abundant oil reserves of the Caucasus.

417. Although Soviet troops suffered terrible losses during the first few months of Germany's invasion of the Soviet Union (over 2 million soldiers were forced to surrender), the Red Army displayed a remarkable ability to consolidate its beleaguered defences and halt the German advance. By late 1942 over-extended German forces found themselves cut off from supply and communication lines, resulting in the death of vast numbers of soldiers who perished in the bitterly cold Soviet winter. Soviet production of munitions and tanks had increased dramatically and soldiers who were injured or killed during the initial stages of the invasion were replaced with fresh troops. The tide of the war

on the Eastern Front seemed to be turning in the Soviet Union's favour.

418. On 19 August 1942 the German Sixth Army under Field Marshall Friedrich von Paulus advanced on Stalingrad. The city was a key communications and munitions production centre on the Volga river. Perhaps even more importantly, by virtue of its name it was also of great symbolic importance to both Hitler and Stalin. German artillery bombardment reduced much of the city to rubble and Paulus' troops seemed poised to take the city before savage street fighting and bitter weather conditions stalled the German advance at the end of the year. At this point the besiegers became besieged as Soviet troops launched a counter-offensive against German troops trapped in the Stalingrad pocket.

419. Field Marshal Erwin Rommel discussing strategy with his aides. Rommel's brilliant and inventive tactics against Britain's Eighth Army in North Africa in mid 1942 compelled Churchill to admit he was a 'great general'. After forcing the British into a hasty retreat to Egypt, Rommel was about 50 kilometres (31 miles) from Alexandria at El Alamein when the British launched their own offensive on 23 October under General Montgomery. Rommel was driven back into Libya, and advocated a strategic withdrawal from North Africa, but his advice was ignored by Hitler. This undermined Rommel's faith in his leader. Germany never regained the initiative in North Africa and Rommel was sent back to Europe to command an army in France. While recovering in hospital from wounds suffered during an RAF attack he was visited by Gestapo agents who accused him of involvement in an assassination attempt on Hitler. Rommel was given the option of standing trial or taking a fatal dose of poison and chose the latter on 14 October 1944.

1943

420. Warsaw was the centre of Jewish life and culture in pre-Second World War Poland. The city's Jewish community was also the largest in Europe, representing about 30 per cent of Warsaw's total population. A year after the German occupation, all Jews were ordered into Warsaw's walled

Jewish quarter, the entrances to which were then sealed off from the rest of the city. In the summer of 1942 a purge of the ghetto rounded up 300,000 Jews for transportation to the extermination camp at Treblinka. Word of the mass execution leaked back to the survivors in the ghetto. A group known as ZOB (Zydowska Organizacja Bojowa, or Jewish Fighting Organization) was created and led an uprising when SS troops attempted a final round-up of the remaining Jews for deportation on 19 April 1943. For nearly a month the Jews fought heroically against the heavily-armed Nazis with a small supply of arms which had been smuggled inside the ghetto. The Germans eventually reduced the area to rubble and crushed the resistance. Of the more than 56,000 Jews captured about 7,000 were shot. The remainder were deported to the camps.

421. Jews and partisans being hanged, possibly in part of German-occupied Soviet Union. Able-bodied men and women of Jewish faith living in German-occupied lands were executed for alleged offences such as arson, support of partisans and the highly ambiguous 'actions hostile to the Reich'. At the Wannsee Conference in January 1942, SS leaders, in accordance with Hitler's wishes, approved the *Endlösung* (Final Solution) which planned for the extermination of all European Jews. After this the Nazis dispensed with the pretence of meting out 'justice' and Jews were murdered simply for being Jewish.

422. A still from *One Day of War – Russia 1943*, a Time documentary film. In the midst of fierce fighting a Russian nurse is shown sliding down an embankment to give assistance to a fallen Red Army soldier. The battles of the Second World War stimulated great interest in the still nascent documentary film industry in Europe and America. The Nazis were particularly adept at using their nationalized film industry to produce documentary-style pictures for propaganda. British and American filmmakers followed suit, albeit with more emphasis on works that educated and entertained the public.

423. Kursk, an important rail junction in the eastern Ukraine, had been liberated from the Germans by the Red Army on 8

February 1943 following the Soviet victory at Stalingrad. Four months later Hitler ordered a German offensive (Operation Citadel) to retake the Soviet salient, a move cleverly anticipated by the Soviet Commander-in-Chief Marshal Zhukov. The climax of Operation Citadel was the Battle of Kursk which involved more than 2 million soldiers, roughly 6,000 tanks and 4,000 aircraft, making it the biggest armoured battle of the Second World War. The battlefield was known as the 'gully of death' because of the exceptionally heavy losses of soldiers and tanks in the mud-churned battlefield. The Soviets' eventual victory in the battle ensured that the German army was never again able to mount an offensive on the Eastern Front. Hitler called for an end to Operation Citadel in mid July after hearing of the Allied invasion of Sicily and continuing reports of Soviet attacks elsewhere.

424. By January 1943 bitter cold and frost had severely weakened German troops desperately attempting to hold onto Stalingrad amidst incessant Red Army bombardments and brutal hand-to-hand combat. The capture of the city had come at enormous cost to Field Marshal von Paulus' armies. With all supply lines into Stalingrad cut, he sought permission from Hitler to surrender his forces. Hitler refused and demanded that Paulus fight to the last man.

425. Russians capture a German tank crew. With Stalingrad in smouldering ruins and thousands of unburied dead littering the streets, Paulus finally surrendered, against Hitler's explicit orders, on 31 January 1943. The defeat and capture of his huge army (94,000 German soldiers were taken prisoner) was the turning point of the war on the Eastern Front. Hitler had attached tremendous importance to the capture of the city and concentrated much of the German army's strength on the futile struggle. Germany's will to continue fighting in the Soviet Union waned thereafter and the Allies had the first clear indication that Hitler's troops were not invincible.

426. A Stalin costume at a fancy dress ball at the Waldorf Astoria Hotel, New York City, photographed by Weegee. The wartime conferences at Tehran in 1943 and

at Yalta and Potsdam in 1945 made Stalin very popular in the West. Stalin successfully propagated an image of himself – both at home and abroad – as a national hero and liberator, while cleverly outwitting his wartime Allies by securing agreements that would leave him in control of Eastern Europe after the war. The press often referred to Stalin as 'our Uncle Joe', which Western interpreters had to explain to him was a friendly nickname. Roosevelt developed a particular fondness for the Soviet leader who he believed would be instrumental in the defeat of Nazi Germany. At the time it was not realized that 'Uncle Joe' was in fact responsible for a greater number of deaths than Hitler.

427. America's entry into the Second World War heralded a fundamental change in the political, social and economic landscape of the country. The war sparked a spectacular boom in the nation's economy. Unemployment vanished, wages increased and war rationing was minimal. Women in the US (as in many other warring nations) found themselves in jobs vacated by men sent off to the war or in new jobs created by the war economy. Their experiences in the workplace caused many women to reconsider their ideas and expectations of their role in society which had changed little since 1900 despite enfranchisement in most western countries during the inter-war years. After the war, despite the vital contribution women had made on the home front, resistance to their remaining in the labour market was high. This failed to dissuade women from pursuing further social and economic advancement, particularly in industrialized nations.

428. US paratroopers bound for Sicily. The Allies landed in Sicily on 10 July 1943, followed two months later by a landing on the Italian mainland. Mussolini was ousted and, despite the presence of sizable German forces in the country, the new Italian government negotiated a secret armistice with the Allies in return for its co-operation with the war against Hitler. Nonetheless, the Allies met stiff German resistance all along their advance northward on the Italian peninsula. Only at the end of May 1944 did they manage to break through to the outskirts of Rome which fell on 4 June. The 'Eternal City',

Mussolini's former capital, was now in Allied hands, but Germany still had a firm hold on the northern half of Italy.

429. Dead US soldiers on the beach at Tarawa in the Pacific Islands. The most westerly of the Gilbert Islands in the Pacific, Tarawa had been occupied by the Japanese during their initial advance into the Pacific Island territories in 1941. Under the command of Admiral Chester Nimitz this territory became a prime objective of the US campaign in the central Pacific. On 20 November 1943, 5,000 soldiers of the US Second Marine Division attempted to land on Tarawa. The coral reef surrounding the island precluded the use of landing craft, forcing the Americans to wade ashore under heavy Japanese artillery fire. Hundreds of soldiers were killed before they reached the beach. The island was secured by the marines on 23 November 1943 after three days of vicious fighting against determined Japanese defenders which resulted in 3,000 American dead or wounded.

1944

430. D-Day (Decision Day). On the morning of 6 June 1944 assault troops of the combined Allied armies landed on the beaches of Normandy to begin the invasion of France and the liberation of Europe. Code named Overlord, the invasion of north-west Europe had been discussed by the Allies for nearly two years before British Prime Minister Winston Churchill, the last dissenting voice among Allied leaders, finally approved the plan at the end of 1943. Planning and preparation for the invasion took place in Britain under the command of US General Dwight Eisenhower, Supreme Allied Commander.

431. On D-Day British, American and Canadian divisions came ashore on five beaches between the rivers Orne and Vire in Normandy on the north coast of France. While four of the beaches were taken rapidly, the American troops landing at the beach code named Omaha encountered heavy German resistance and suffered terrible losses in a matter of hours. Nonetheless, by nightfall roughly 150,000 Allied soldiers were ashore and extensive beachheads had been secured in all five landing zones. By 18 June the Allies had landed 619,000

soldiers and 95,000 military vehicles in France.

432. Crewmen move from the galleries of the USS *Suwanee* to repair damage to the flight deck from Japanese kamikaze attacks during the Battle of Leyte Gulf in the Philippines. US forces under General Douglas MacArthur landed on the island of Leyte on 20 October 1944, in an attempt to recover the Philippines from Japanese occupation. In a series of scattered engagements over the next few days Japanese naval forces converged repeatedly on American ships, and suffered enormous losses of men and equipment as a result. Forty Japanese ships were sunk, another forty-six badly damaged and over 400 planes were destroyed. American losses were comparatively light in what was the greatest naval confrontation of the war. The US victory cleared the way for the American occupation of the Philippines.

433. The combined US and British Operation Market Garden was the largest airborne offensive in history, designed to outflank German forces along the Rhine and advance into northern Germany. The Americans secured their targets at Nijmegen and Eindhoven, but German resistance at Arnhem proved too formidable for the beleaguered British paratroopers to overcome. The failure of Operation Market Garden dashed Allied hopes for victory over the Nazis before the end of the year and enabled Hitler, encouraged by his troops' successful defence, to mount a counter-offensive.

434. Joseph Goebbels, the German Propaganda Minister, was a boundless source of energy, support and inspiration for the beleaguered civilians of Germany's heavily bombed cities. The crushing Allied air attacks of 1943 and 1945 were driving the German population to the limits of physical and psychological endurance. Goebbels' singular efforts often appeared to be all that kept them from going over the edge. His ministry produced an endless stream of speeches and articles designed to bolster war morale and ensure that ordinary Germans did not lose faith in the Nazi leadership. Even in the bombed-out carnage of Berlin, Goebbels insisted on going out among the victims long after his Führer had stopped interacting with civilians.

435 top. On 1 August 1944, when the Red Army seemed to have gained the upper-hand over the Germans at the Vistula river, Polish civilians joined the underground Polish Home Army in an uprising launched against German forces in Warsaw. However, Soviet troops grouped on the outskirts of Warsaw did not, as the Home Army expected, come to the insurgents' aid, nor did Stalin allow the Poles to receive Allied aid from bases in Soviet territory. Thus, despite having successfully retaken a large portion of the city in the first few days, the Polish forces were soon decimated by heavily-armed SS troops bent on savage destruction. When the Red Army finally entered Warsaw in January 1945 the city lay in ruins and over a million of its pre-war inhabitants were dead.

435 bottom. The Allied air offensive against Germany intensified dramatically after the summer of 1943 during which nearly 7,000 tons of bombs were dropped on Hamburg over one week in late July, causing terrible devastation and leaving over 30,000 dead. From October 1944 British Air Marshal 'Bomber' Harris was directing over 40 per cent of RAF attacks against Germany onto its cities. The US and British raids on Berlin and Dresden in early 1945, which killed as many as 100,000 German civilians, were the most severe. The morality of such actions has been questioned repeatedly since the end of the war, but at the time the defeat of Nazism transcended all other moral imperatives in the minds of Allied leaders.

436. American POWs captured during the Battle of the Bulge. In late December 1944 Hitler attempted to thwart the Allied advance into Germany with an offensive in the Ardennes region of northern Luxembourg and Belgium. The German attack completely surprised the Allies, and created a dangerous weakness in American defences, temporarily placing the entire Allied advance into Germany in doubt. Within days, however, speedy troop reinforcements and heroic actions from scattered American units halted the German attack. The Allied counter-attack which began in early January 1945 had cleared the region by the middle of the month. German forces, collapsing due to inexperienced leadership on the ground and meagre air support

and equipment, had mounted their last offensive of the war.

437 top. On 17 September 1944 a British airborne division (including a brigade of Polish parachutists) was dropped near Arnhem in the southern Netherlands, as part of Operation Market Garden. The British had been instructed to seize the Rhine bridges in preparation for the Allied Second Army's rapid advance into the Ruhr region of Germany. The paratroopers hit their landing targets but had insufficient time to secure their positions before a German force in transit cut them off from Allied support. For eight days the isolated troops made a gallant stand before the survivors (2,000 of an original force of 9,000) were ordered to withdraw across the Rhine.

437 bottom. By 1944 fuel shortages and severe damage to Germany's war economy had virtually grounded the *Luftwaffe*, enabling Allied bombers to conduct raids over German cities with relative impunity. But the success of British and American air attacks came at a very high price. The combined total of personnel losses for the RAF and USAF during the war exceeded 10,000 men.

438 top. Dr Roland Freisler's People's Court where suspects were tried for the assassination attempt on Hitler. The insurrection, by a handful of German officers who sought to gain control of Berlin, had been motivated as much by disillusionment with Hitler's management of the war as by moral outrage at the excesses of Nazism. The conspirators provided some historical legitimacy to the existence of the 'other' (anti-Hitler) Germany under the Third Reich.

438 bottom. Hitler visits victims of bomb attack on his headquarters. On 20 July 1944 as Hitler and his top military advisors gathered at his headquarters in East Prussia for an afternoon strategy session, a bomb planted by Colonel Count Claus Schenk von Stauffenberg, a Nazi officer, ripped through the meeting room. Several Nazis were killed, but Hitler survived the assassination attempt and ordered a ruthless man-hunt for the conspirators. Over the next few days Berlin was engulfed in retribution killings and in the following months hundreds more suspects were tried before the

People's Court. Suspects were humiliated, tortured into naming others and finally executed by firing squad, decapitation or strangulation.

439. German prisoners captured by American troops in the Netherlands during Operation Market Garden. After five years of war German troops faced an insurmountable man-power crisis and a severe shortage of supplies and equipment. The German war economy had all but collapsed and by late 1944 the army's leadership had been decimated by Hitler's purge of senior officers following the failed assassination attempt. Operations had been placed in the hands of inexperienced SS men. Remarkably, most ordinary German soldiers continued to fight with great efficiency and resilience, and even more remarkably, continued to believe in their leader.

440. German Gestapo agents arrested after the fall of Liège are herded together in the city's citadel in October 1944. When Belgium was liberated after more than four years of Nazi occupation, members of the dreaded Gestapo stationed there during the war were forced to account for their actions. The Gestapo were used extensively by the Nazis to control and suppress populations under their rule, both inside Germany and later in the occupied territories. Its members implemented their own brand of punishments to those deemed 'hostile' to the Reich, ranging from physical abuse to deportation to the death camps and summary execution. As Germany began to falter in the war, the terror unleashed by the Gestapo intensified. By the end of the war, the Gestapo in Belgium had organized the deportation of about 25,000 Belgian Jews, nearly all of whom died in the camps.

441 left. General MacArthur kept his famous promise and returned to the Philippines in October 1944. However, American troops who had been trapped in the Philippines during the Japanese sweep through the country in early 1942 would have stood little chance of survival. POWs who managed to endure the oppressive heat, tropical sickness and grossly insufficient food rations provided in the prisons still had to contend with horrific acts of brutality from Japanese guards. Only Nazi Germany could claim a similar level of barbarism towards

prisoners during the Second World War.

441 right. A refugee from the fighting on Leyte Island in the Philippines reaches US lines. Although a small number of Filipinos were pro-Japanese and collaborated with Japan in setting up a puppet government ironically called the Independent Philippine Republic, the majority of the islands' inhabitants had waited anxiously for over two years to see their country liberated by the Americans. Leyte was liberated by the end of the year, at a cost of 3,500 Americans and more than 50,000 Japanese lives.

1945

442. Stalin with an ailing Roosevelt at Yalta in the Crimea in February 1945. With their armies already pushing through Germany, the two leaders met with Churchill to discuss the final Allied initiatives in the war. Agreement on the four occupation zones of a defeated Germany was finally reached and France was accepted as a fourth Allied power. In addition Stalin promised to enter the fight against Japan in the Pacific three months after the German surrender. An atmosphere of goodwill pervaded the conference proceedings. Secret intelligence reports of Stalin's brutal domestic repression coming to light in Britain and the US were largely ignored by Allied leaders until after the war.

443 top. The tiny volcanic island of Iwo Jima 1,207 kilometres (750 miles) south of Tokyo was a major base for the Japanese during the Second World War and a crucial territory in the stepping-stone operation leading to the end of the war in the Pacific. In bitter fighting between 19 February and 17 March 1945 the US marines met determined Japanese resistance. Heavy casualties were suffered on both sides. The final moments of their assault on Mt. Suribachi on 23 February were captured in one of the most famous photographs of the century. By 17 March the Americans had secured the island, and quickly transformed it into an important base for bombing raids on mainland Japan.

443 bottom. Henri Pétain, leader of the pro-German Vichy regime in France, first used the word 'collaboration' to denote a positive

working relationship with the occupying Germans. However, in France and other German-occupied territories, the term quickly became synonymous with aiding and abetting the Nazis in the persecution of fellow citizens. When Germany was defeated, many 'collaborators' were severely punished. French caught spying for the German army were shot by Allied troops. Many French civilians attacked and even sometimes executed people perceived as collaborators.

444 top. The suicide of one of Hitler's SS soldiers, interviewed before his death and recorded by photographer Yergery Khaldei. The advancing Soviet army began bombing the centre of Berlin on 20 April. When troops of the First White Russian Front commanded by Marshal Zhukov entered the city five days later, frenzied street fighting broke out between Soviet soldiers and nearly half a million desperate German troops still holding out inside Berlin. Finding himself cut off from his troops and facing the humiliation of defeat, this SS solider perfered to die by his own hands.

444 bottom. German soldiers captured by American troops during the Allied advance eastward towards Berlin. The Americans and British met little opposition driving eastward from the Rhine and stopped at the Elbe River, 100 kilometres (60 miles) from Berlin on 11 April. By 25 April the Soviet armies of Georgi Zhukov and Ivan Konev, advancing from the East, had completely encircled Berlin and linked-up with the Allies at the Elbe. Hitler had chosen to stay in the threatened capital, hoping for some miracle that could save the devastated Third Reich. Realizing defeat was inevitable, exhausted German troops and civilians were anxious to see the British and American armies sweep eastward and occupy the country as rapidly as possible. The prospect of a Soviet occupation was no more attractive than continued Nazi rule. Hitler, sensing defeat, committed suicide in his bunker under the Reich Chancellery on 30 April. Berlin surrendered two days later.

445. During the final stages of the war Mussolini had become all but irrelevant, living in isolation in Gargnano on Lake Garda. Hitler had installed the fascist leader as head of a Nazi puppet regime, the Salo Republic, nominally in charge of German-occupied northern Italy. In April 1945 with Allied forces advancing on his headquarters and Hitler obviously about to be defeated, Mussolini attempted to cross the border into Switzerland with his mistress, Clara Petacci. They were captured on the shores of Lake Como in northern Italy by Italian partisans on 27 April. The following day the couple were shot and their bodies taken to the Piazzale Loreto in Milan where they were hung up for public degradation.

446. Emaciated inmates at a German concentration camp await transport to hospitals after being freed by Allied troops. When the German war effort began to crumble in early 1945, vast numbers of desperately weak prisoners were evacuated from concentration camps by the SS and forced to march away from advancing Allied armies. Thousand died. Relief to prisoners left behind finally came in April when Allied soldiers arrived at the camps.

447. American troops who liberated the Buchenwald concentration camp in April 1945 forced the citizens of nearby Weimar to witness the terrible suffering which had been inflicted on the camp's inmates by the Nazis. Historians remain divided over the issue of collective German guilt in Nazi war crimes, particularly those against European Jews. After the war, most Germans claimed not to have known about the gas chambers and the death camps. Whatever the case, post-war German governments have ensured that their people will never be able to forget them.

448–49. The Nazis carried out Hitler's Final Solution with terrifying efficiency. An estimated 6 million Jews died in Nazi concentration camps. In addition a further one million people, including Gypsies, political prisoners, Soviet POWs, homosexuals and other 'undesirables' also perished in the camps. The scale of the atrocities was so great that most German attempts to conceal the horrors in the months prior to Allied victory proved hopeless. On 15 April the first Allied forces, in the form of a British tank unit, entered the concentration camp at Belsen in north-west Germany. They counted about 35,000 corpses within the camp, of which about 10,000 were simply piled in heaps in uncovered pits. Roughly 30,000 inmates were still alive at the time of liberation, but most were so weak that they could not even stand to greet the Allied troops entering the camp. British soldiers watched helplessly as hundreds of inmates died each day before Allied medical services, which arrived a week later, began treating prisoners suffering from starvation and disease.

450. In the days leading up to the Allied victory and in its immediate aftermath, many Nazis took their own lives rather than accept the consequences of Germany's defeat. In occupied territories, reprisals from victims of Nazi terror often resulted in swift and brutal deaths for German soldiers. In Germany the chances of evading capture by Allied troops or of surviving the war crimes trials were slim. In parts of Germany occupied by the Soviet Union, rape and looting by Soviet troops was rife, particularly in Berlin. Many Nazis preferred to follow the example of Hitler, Goebbels (who killed his six children before commiting suicide with his wife) and other senior party officials rather than taking responsibility for confronting Germany's war crimes.

451. As Commander of the Second Corps, Lord Alanbrooke was instrumental in the evacuation of the British expeditionary forces from the beaches of Dunkirk in 1940. The following year he became Chief of the Imperial General Staff and Prime Minister Churchill's principal strategic advisor for the duration of the war. Here he is at the end of the war, decorating one of the more than 2 million men who served in Indian divisions during British campaigns in Africa, Italy and Burma.

452. Soviet tank men during the Victory Parade in Moscow on 24 June 1945. During the parade Hitler's personal standard, along with hundreds of Nazi banners, were trailed in the mud and cast on the ground in front of a crowd of 100,000 who had gathered to join Stalin, the Soviet government and the Diplomatic Corps in celebration of the victory over the Nazis. In a short congratulatory address, Marshal Zhukov declared triumphantly, 'the Germans have shared the fate of all the other invaders who have ever encroached on our land: they drew the sword against us, and perished by the sword'.

453 top. *Lovers at the Palace Theatre* by Weegee. Born in Austria as Arthur Fellig, Weegee established his reputation as a photographer with his close-up shots of dead gangsters in New York, where he moved with his family in 1910. His territory expanded from the streets to Greenwich Village where he chronicled the activities of New York's social elite. His photographs were often taken at such close range that he seemed to be intruding into his subject matter, blurring the line between the artist and his environment. In keeping with his flamboyant style, Weegee began stamping the back of his photographs with 'Credit Photo by Weegee the Famous'. In 1945 Weegee published a popular book based on his observations of New York which inspired the popular Hollywood film-noir *The Naked City* (1945).

453 bottom. At midnight on 8 May 1945 the war in Europe was officially over. General Eisenhower, Commander of Allied Forces in Europe, had accepted the German surrender the previous day. Millions of soldiers had lost their lives in the fight against Nazism. Many of Europe's great cities lay in ruins. VE (Victory in Europe) celebrations broke out across all the Allied countries, although in America popular euphoria seemed a little premature in light of the ongoing struggle against the Japanese in the Pacific.

454. On 17 July 1945 the US secretly conducted a successful test of an experimental atomic weapon in the desert in New Mexico. Nine days later US President Truman demanded Japan's unconditional surrender under the threat of 'prompt and utter destruction'. His warning fell on deaf ears. On 6 August an American aircraft dropped an atomic bomb – nicknamed Little Boy – over the Japanese city of Hiroshima. It exploded 610 metres (2,000 feet) above the ground. The blast flattened 122 square kilometres (47 square miles) of the city and killed tens of thousands of people instantly. Three days later a second atomic bomb – Fat Boy – was dropped on Nagasaki while Japan's leaders debated a response to the levelling of Hiroshima. The combined death toll from the two attacks is difficult to determine given the long-term effects of radiation on the survivors, many of whom died from radiation sickness in the days, months and even years after the bombings. The Japanese estimates of the number of dead range between 200 and 250 thousand.

455 top. Japan surrendered within a week of the attack on Nagasaki and on 2 September. Japanese General Yoshijiro Umezu signed the surrender document aboard the USS *Missouri* in Tokyo Bay. The Second World War was over at last, but celebrations around the world were coloured by the immense emotional and psychological impact of the atomic devastation of Hiroshima and Nagasaki. The dropping of the atomic bombs rendered obsolete ideals which had governed relations between states and the conduct of war for centuries. The new technology represented a thousand-fold increase in the lethal power of a single weapon and provided those who possessed it with the capacity to destroy people, cities, industries and the earth itself, on a totally unprecedented scale.

455 bottom. The occupation of Japan began on 28 August when the first American soldier, Colonel Charles Tenich, landed at Atsugi Airfield near Yokohama. Within weeks contingents of American, British, Australian and New Zealand forces under the command of US General Douglas MacArthur arrived to assist in the demilitarization and recon-struction of the country. The terms of surrender allowed Hirohito to remain Emperor, but he was no longer permitted to uphold the Shinto idea of imperial divinity. The occupation forces guided his devastated state towards democracy and modernity. In time, Japan's post-war recovery and rate of productivity outstriped all its wartime adversaries. The period of occupation officially lasted until 28 April 1952 when a peace treaty which had been signed in San Francisco the previous year came into effect. The treaty meant that Japan forever renounced the use or threat of war as a means of settling international disputes.

1946–1965
Atomic Truce Walks a Tightrope

The atomic bombs dropped on Hiroshima and Nagasaki by America in August 1945 represented a thousand-fold increase in the power of a single weapon and signalled the birth of a lethal new force in international relations. Countries that possessed such weapons would have the capacity to destroy people, wealth and the Earth itself. This change in the nature of warfare led to the outbreak of the cold war between the communist Soviet Union and right-wing America when the Soviet Union acquired its first nuclear weapon in the late 1940s. An Iron Curtain fell across Eastern Europe, separating Soviet-controlled communist regimes from democratic countries in the west. Conflicts and crises in Berlin, Korea and Cuba pitched not just nations, but whole systems of thought against one another, and threatened to bring about unprecedented human and physical devastation. The two superpowers America and the Soviet Union competed for the allegiance of newly-independent African countries which had finally broken the chains of European colonialism. South Africa's leaders implemented the system of apartheid in order to maintain the privileged status of their country's white minority. A rogue white-settler government in the British colony of Rhodesia refused to share power with the country's black majority and unilaterally declared independence. In the Middle East, Israel was founded despite overwhelming hostility towards the new state from the region's predominantly Muslim population. India lost its national father figure and one of the twentieth century's great moral thinkers, Mahatma Gandhi, at the hands of a Hindu assassin. A lone gunman in the US ended the life of the most popular American leader in modern times, John F. Kennedy. Elvis and the Beatles sold millions of records, much to the horror of some parents who worried about what effect the new rock and roll music and culture would have on their children. *The Second Sex* by French writer Simone de Beauvoir became an international bestseller and provoked a vigorous debate on the status of women, many of whom were openly challenging traditional ideas of women's roles in society. Belgian-born actress Audrey Hepburn captivated cinema audiences in *Roman Holiday*, her US film debut, and helped to define an entirely new conception of feminine beauty. In Argentina Eva Perón, a stage and radio actress of modest acclaim, married a president and became a saint to her country's poor. In the art world, Abstract Expressionism raised eyebrows and bemused many critics, but one of the movement's number, Jackson Pollock, became one of the most influential painters of the century. Unidentified Flying Objects, more commonly known as UFOs, became a major subject of interest for governments and scientific organizations as well as ordinary people. In 1953 a former beekeeper from New Zealand, Edmund Hillary, and a Nepalese Sherpa, Tenzing Norgay, became the first men to set foot on the summit of Mount Everest. Their conquest of the Earth's highest peak dazzled the world, as did the achievement of a Soviet cosmonaut, Yuri Gargarin, who completed the first manned space flight seven years later.

Contemporary Voices

The unleashed power of the atom has changed everything save our modes of thinking and we thus drift towards unparalleled catastrophe.

Albert Einstein, telegram 24 May 1946

The atom bomb is a paper tiger which the United States reactionaries use to scare people. It looks terrible, but in fact it isn't.

Mao Zedong, interview, 1946

Friends and comrades, the light has gone out of our lives and there is darkness everywhere. I do not know what to tell you and how to say it. Our beloved leader, Bapu as we called him, the father of the nation, is no more.

Jawajarlal Nehru, broadcast, 30 January 1948, after Gandhi's assasination

If her functioning as a female is not enough to define woman, if we decline also to explain her through 'the eternal feminine', and if nevertheless we admit, provisionally, that women do exist, then we must face the question: what is a woman?

Simone de Beauvoir, *The Second Sex*, 1949

The cradle rocks above an abyss, and common sense tells us that our existence is but a brief crack of light between two eternities of darkness.

Vladimir Nabokov, *Speak, Memory*, 1951

History is a combination of reality and lies. The reality of History becomes a lie. The unreality of the fable becomes truth.

Jean Cocteau, *Diary of an Unknown Man*, 1953

In the nineteenth century the problem was that *God is dead*; in the twentieth century the problem is that *man is dead*. In the nineteenth century inhumanity meant cruelty; in the twentieth century it means schizoid self-alientation. The danger of the past was that men became slaves. The danger of the future is that men may become robots.

Erich Fromm, *The Sane Society*, 1955

I saw the best minds of my generation destroyed by madness, starving hysterical naked,
dragging themselves through the negro streets at dawn looking for an angry fix,
angelhead hipsters burning for the ancient heavenly connection to the starry dynamo in the machinery of the night,
who poverty and tatters and hollow-eyes and high sat up smoking in
the supernatural darkness of cold-water flats floating across the tops of cities contemplating jazz.

Allen Ginsberg, *Howl*, 1956

Let the word go forth from this time and place, to friend and foe alike, that the torch has been passed to a new generation of Americans – born in this century, tempered by war, disciplined by a hard and bitter peace, proud of our ancient heritage – and unwilling to witness or permit the slow undoing of those human rights to which this nation has always been committed, and to which we are committed today at home and around the world.

Let every nation know, whether it wishes us well or ill, that we shall pay any price, bear any burden, meet any hardship, support any friend, oppose any foe to assure the survival and the success of liberty.

John F. Kennedy, speech accepting the Democratic nomination in Los Angeles, 15 July 1960

Now, I say to you today my friends, even though we face the difficulties of today and tomorrow, I still have a dream. It is a dream deeply rooted in the American dream. I have a dream that one day this nation will rise up and live out the true meaning of its creed: 'We hold these truths to be self-evident, that all men are created equal'.

I have a dream that one day on the red hills of Georgia the sons of former slaves and the sons of former slave owners will be able to sit down together at the table of brotherhood. I have a dream that one day even the state of Mississippi, a state sweltering with the heat of oppression, will be transformed into an oasis of freedom and justice.

I have a dream that my four little children will one day live in a nation where they will not be judged by the colour of their skin but by the content of their character.

I have a dream today.

I have a dream that one day the state of Alabama, whose governor's lips are presently dripping with the words of interposition and nullification, will be transformed into a situation where little black boys and black girls will join hands with little white boys and girls and walk together as sisters and brothers.

I have a dream today.

[...] And if America is to become a great nation this must become true. So let freedom ring from the prodigious hilltops of New Hampshire.

Let freedom ring from the mighty mountains of New York. Let freedom ring from the heightening Alleghenies of Pennsylvania!

Let freedom ring from the snowcapped Rockies of Colorado!

Let freedom ring from the curvaceous peaks of California!

But not only that; let freedom ring from Stone Mountain of Georgia!

Let freedom ring from every hill and molehill of Mississippi. From every mountainside, let freedom ring.

When we let freedom ring, when we let it ring from every village and every hamlet, from every state and every city, we will be able to speed up that day when all of God's children, black men and white men, Jews and Gentiles, Protestants and Catholics, will be able to join hands and sing in the words of that old Negro spiritual, 'Free at last! Free at last! Thank God almighty, we are free at last!'

Martin Luther King, speech at the Civil Rights March in Washington, 28 August 1963

What a mess the Kennedy murder is! Very much like a gangster film so far. It hasn't been possible to buy an American newspaper since the news broke ... it's certainly a scandal, the way the thing was handled in Dallas, and enough to make one suspect the police were in on the arrangements of the higher-ups, and wanted to help by allowing the assassin to be removed, to ensure silence. The Moroccans were very emotional about it, and actually wept when they talked about it. The entire country was shut down on Monday ... no schools, banks, movies, bars, shops or music on the radio. If their own king had died they couldn't have observed a more complete day of mourning.

Paul Bowles, letter from Tangiers, 28 November 1963

Come mothers and fathers,
Throughout the land
And don't criticize
What you can't understand
Your sons and your daughters
Are beyond your command
Your old road is
Rapidly agein'
Please get out of the new one
If you can't lend your hand
For the times they are a' changin'

Bob Dylan, 'The Times They Are A-Changing', song 1964

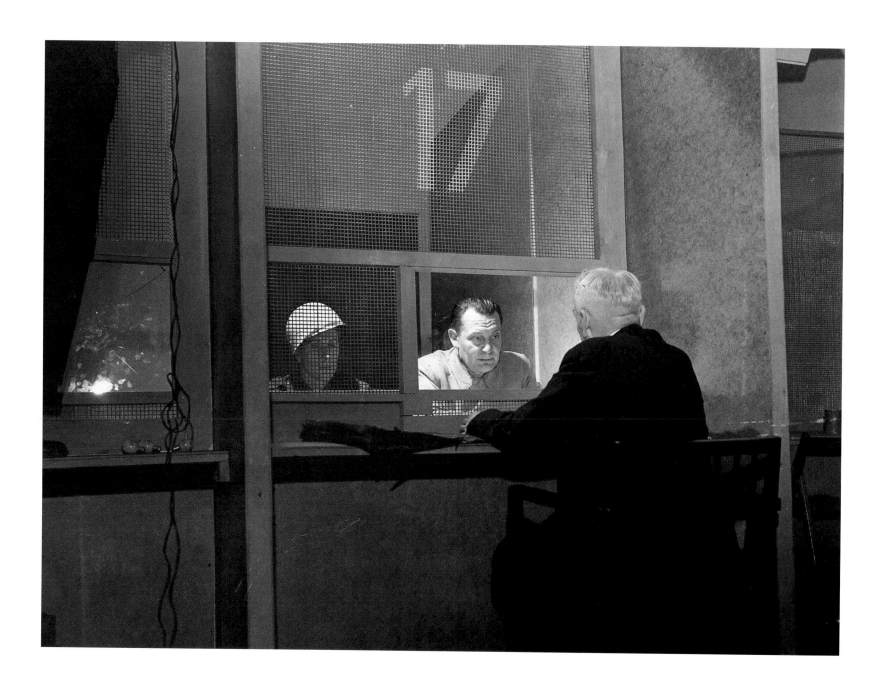

Hermann Göring in Nuremberg prison – on trial for war crimes which could result in the death penalty – having his regular evening talk with his lawyer.

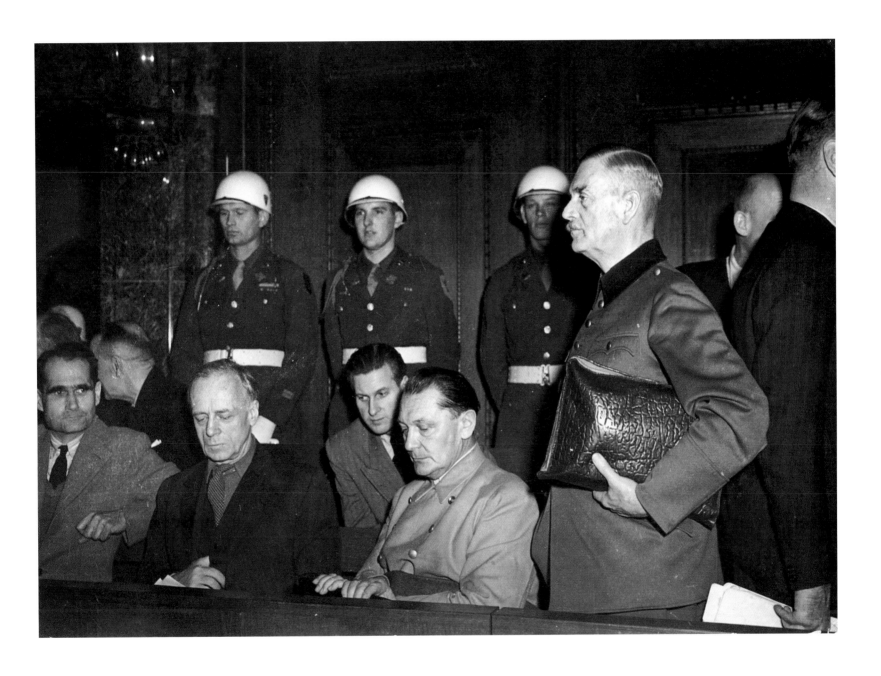

A picture of the weary war criminals – Hess who survived, and Ribbentrop, Keitel and Göring, all of whom received the death penalty (seated left to right).

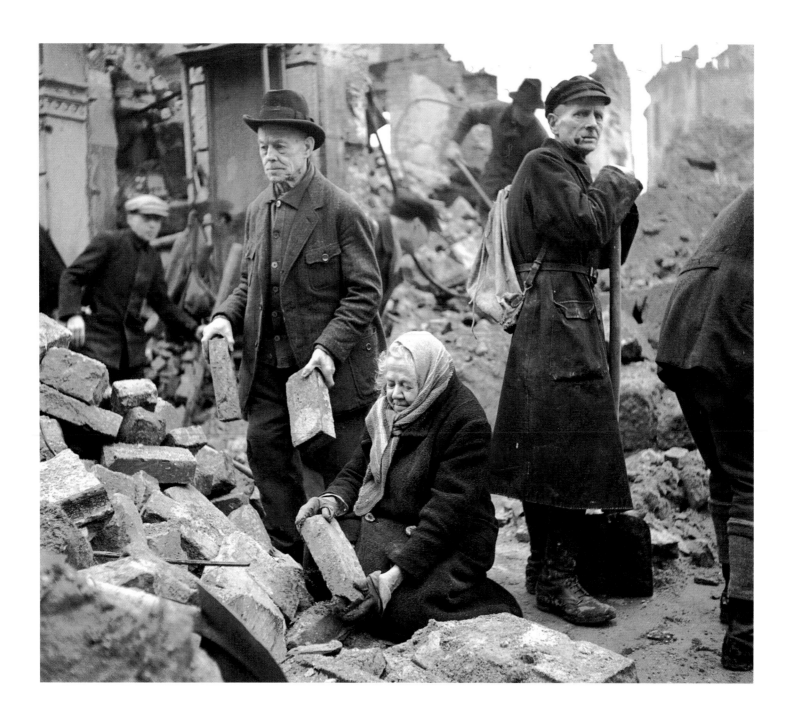

Over a year after the devastating air raid massacre of Dresden, an old couple help to clear the rubble.

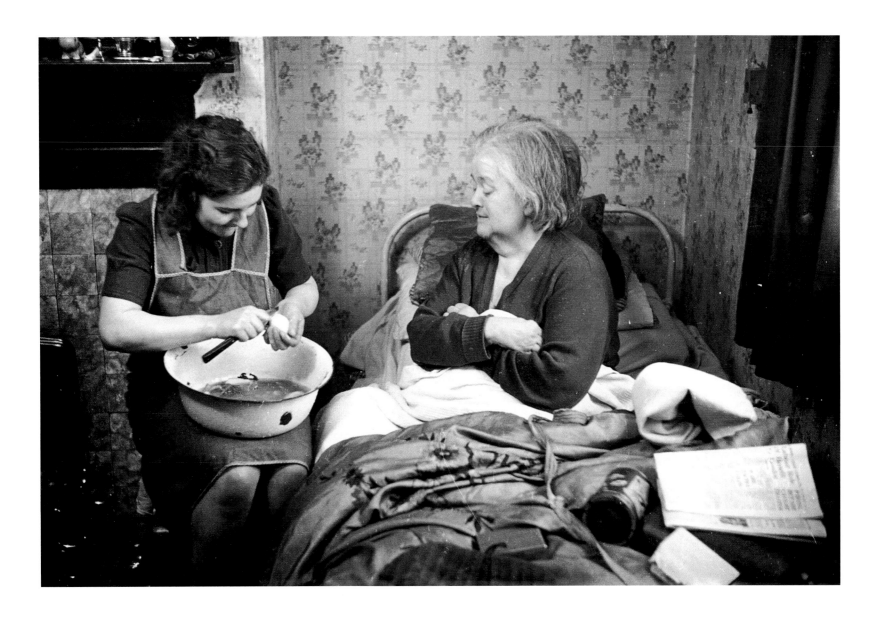

An early beneficiary of the Welfare State in Britain – a London amputee watches her home help with approval.

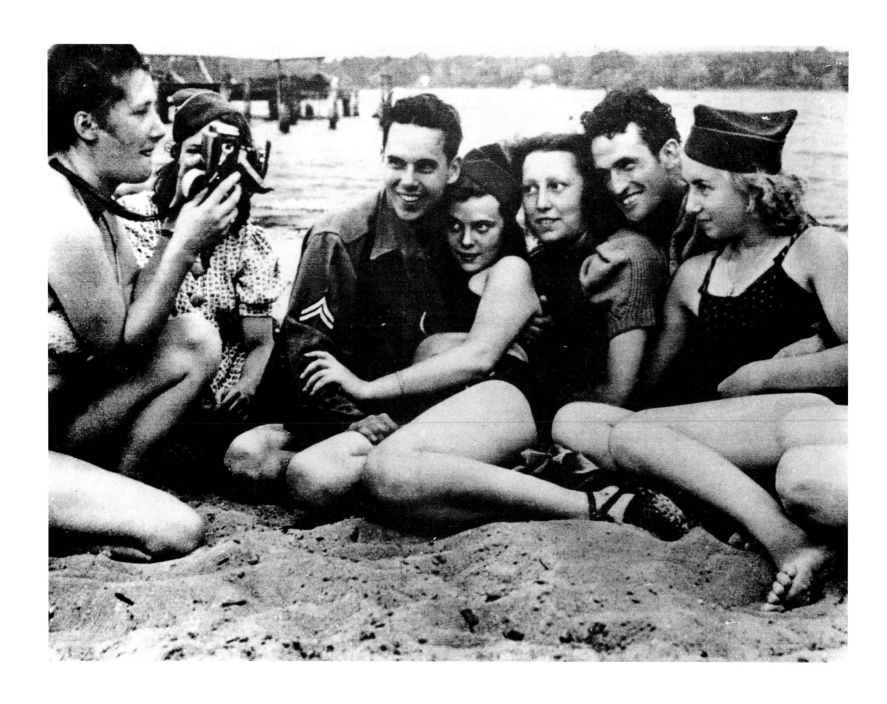

Spoils of victory – GIs on a sunny German beach.

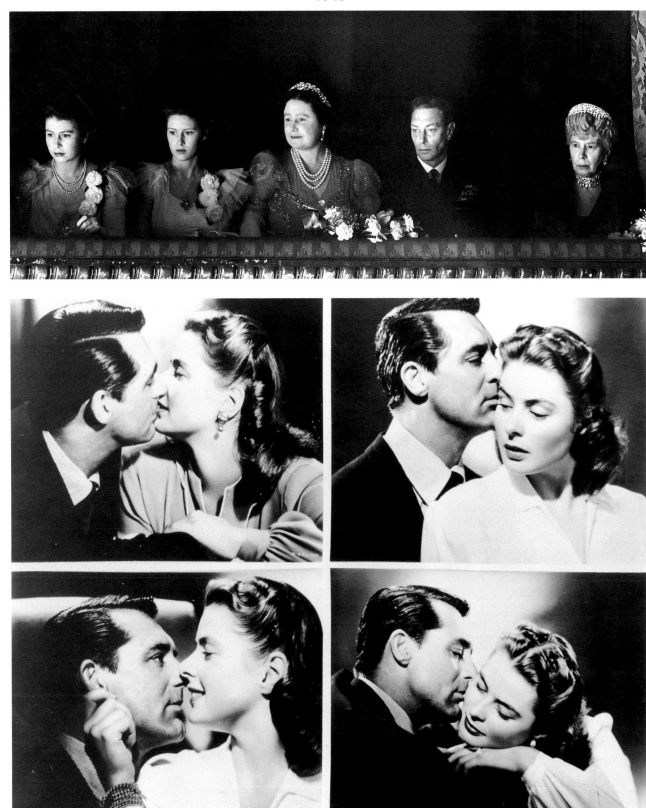

British Royals in their Covent Garden Opera box – Princesses Elizabeth and Margaret, Queen Elizabeth, King George VI and Queen Mary, the Queen Mother (left to right).
Cary Grant demonstrating his unique amatory style to Ingrid Bergman in *Notorious*.

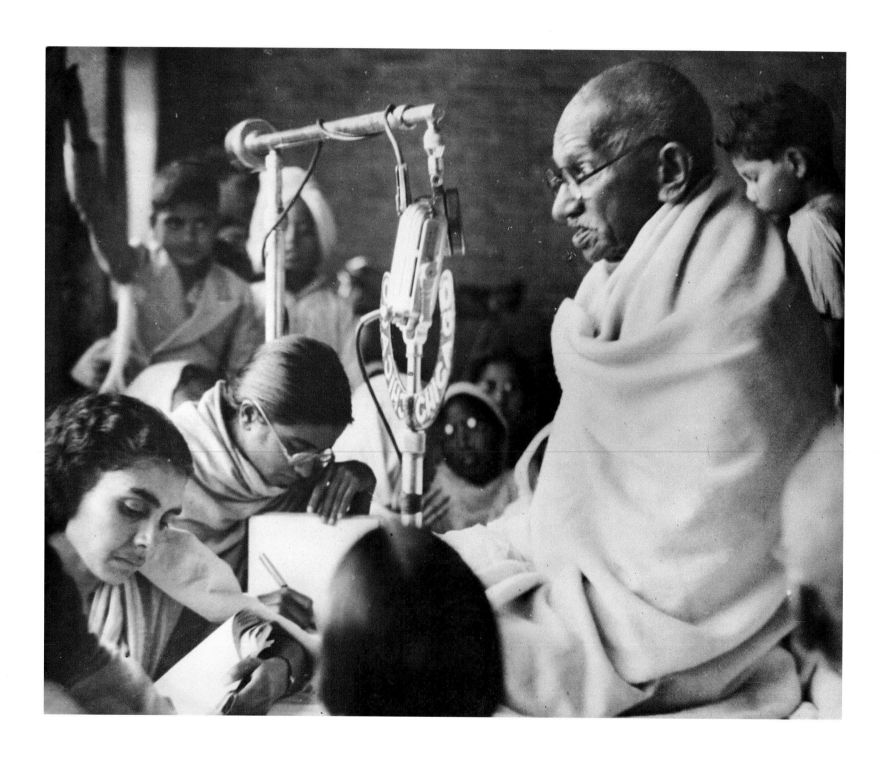

Mahatma Gandhi fasting for a peaceful transition to independence – he received the pledges of non-violence he asked for from both Hindus and Muslims ...

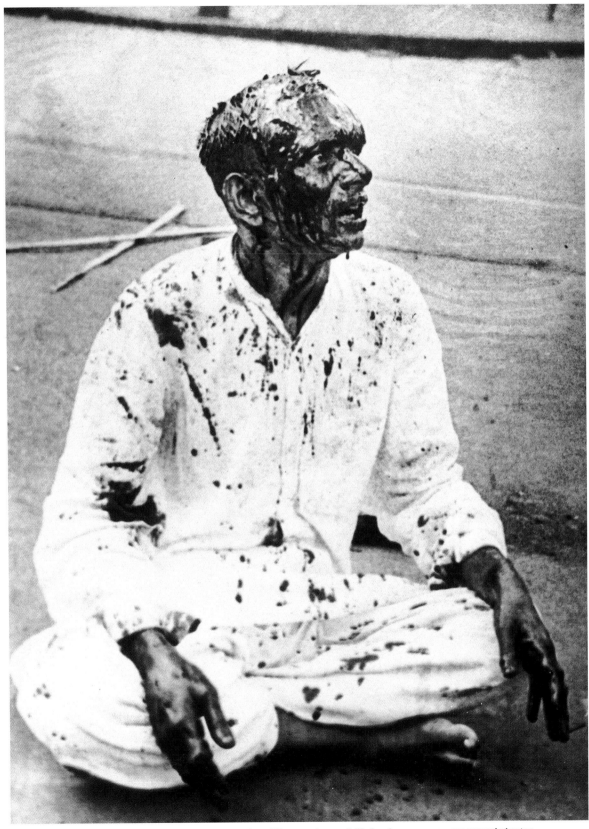

... but to no avail as more than a quarter of a million people were killed and many more were severely beaten.

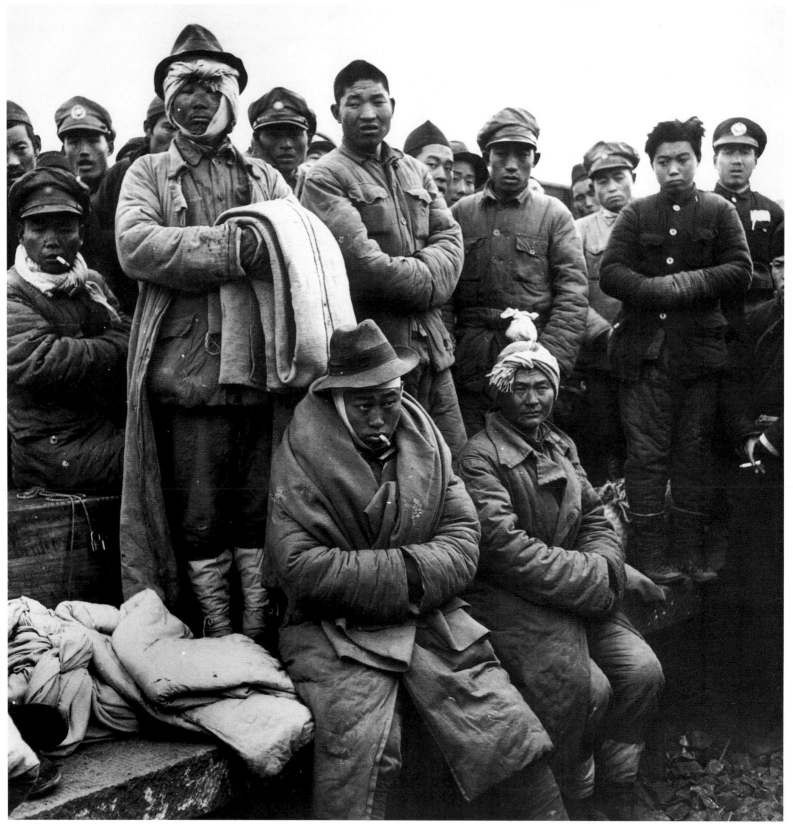

Disconsolate and defeated by the communists, Kuomintang troops wait to be evacuated by train.

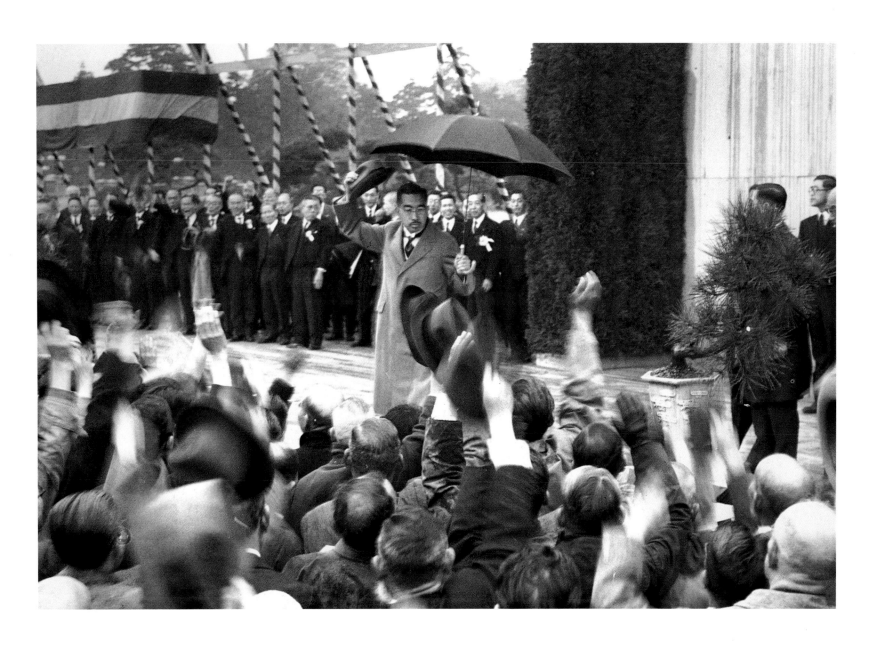

Hirohito – Emperor, marine biologist, but a god no longer – gratefully adopts the image of a European constitutional monarch.

Eva, wife of Juan Perón and national heroine of Argentina, visits Paris in style.

Eva Perón seems preoccupied at an official ceremony with Franco in Spain.

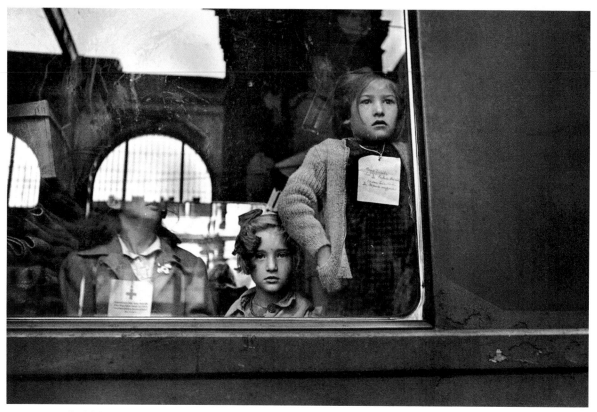

Jewish immigrants from Europe bound for Palestine on board the *Exodus* were turned back by the British.
Anxious children – Werner Bischof sensitively recorded the predicament of displaced children in Hungary.

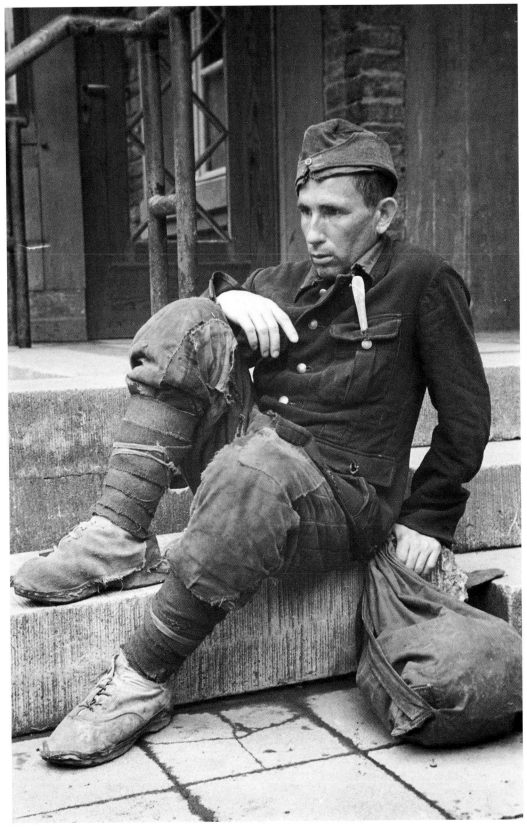

A German prisoner of war from the eastern zone. He is apathetic and hopeless, but his country is on the brink of revival.

Humphrey Bogart, Evelyn Keyes and Lauren Bacall in Washington to protest against the communist witch-hunt in Hollywood.

Movie Moguls Jack Warner (left) and Louis B. Mayer (right) with their attorney at the Un-American Activities hearing.

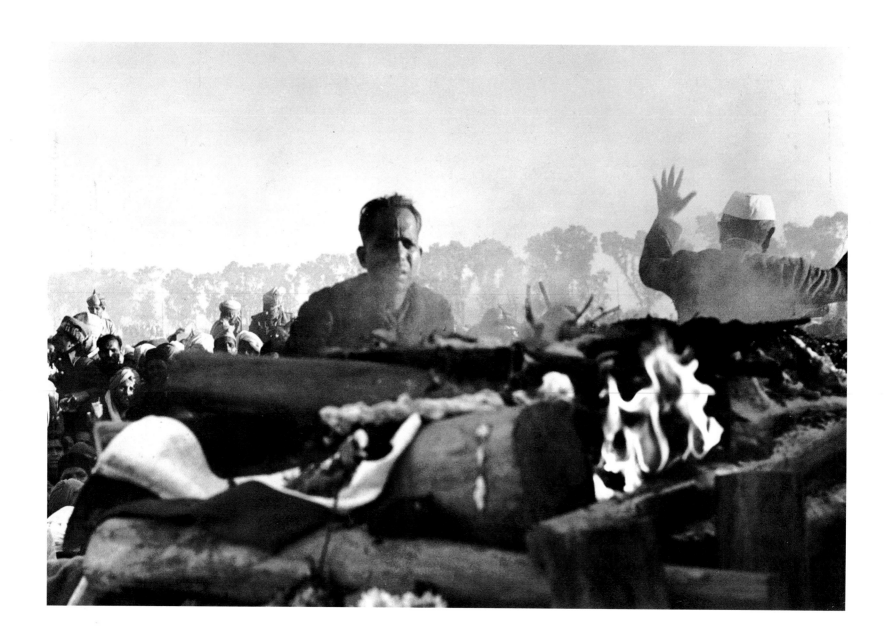

Mahatma Gandhi's secretary watches the kindling of his funeral pyre while his doctor tries to pacify the crowd.

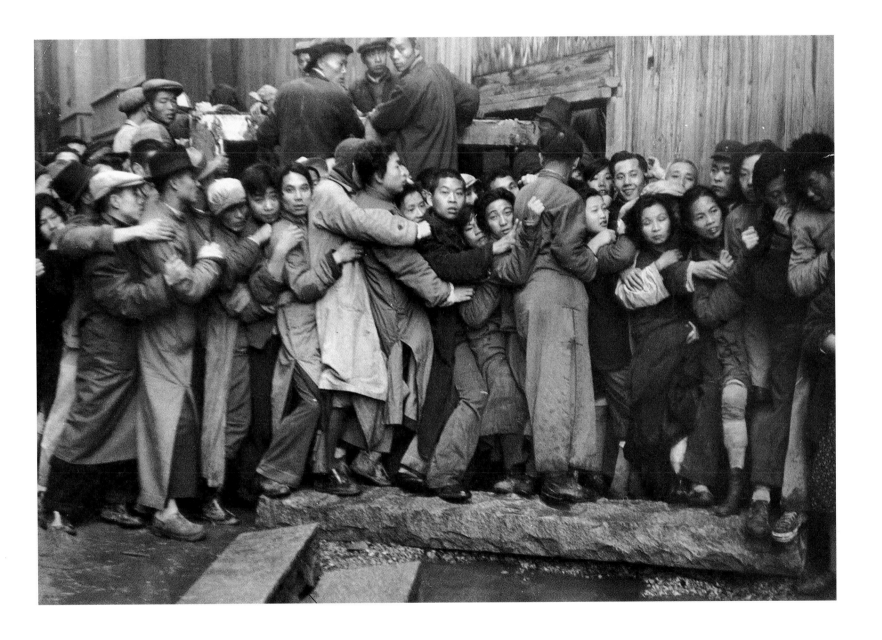

An apocalyptic photograph by Henri Cartier-Bresson of people desperate to change their paper money into gold in Shanghai.

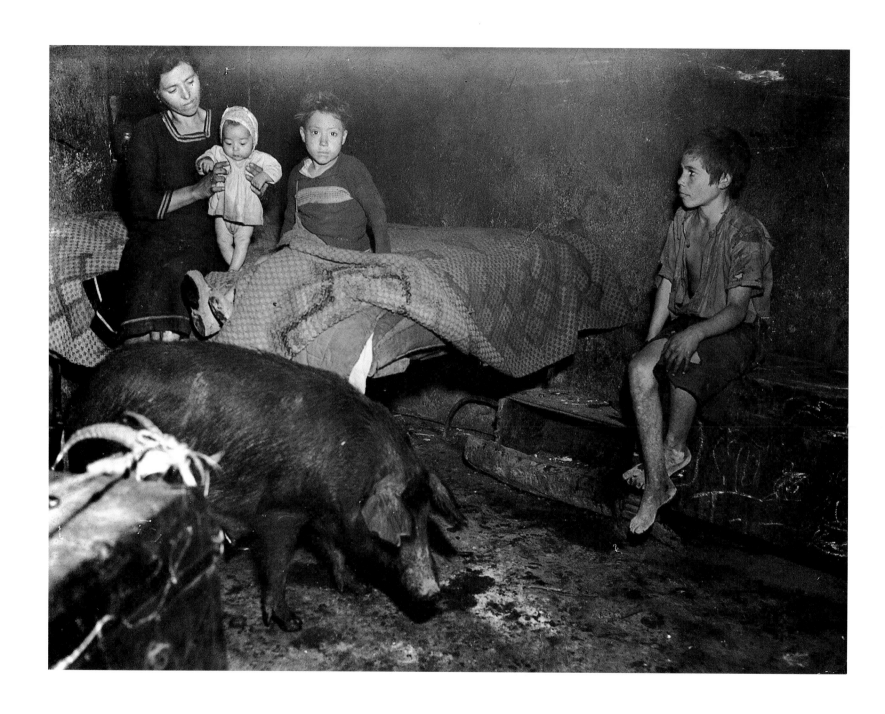

Captioned 'Africa in Calabria' – a picture showing how the poorest were living in southern Italy.

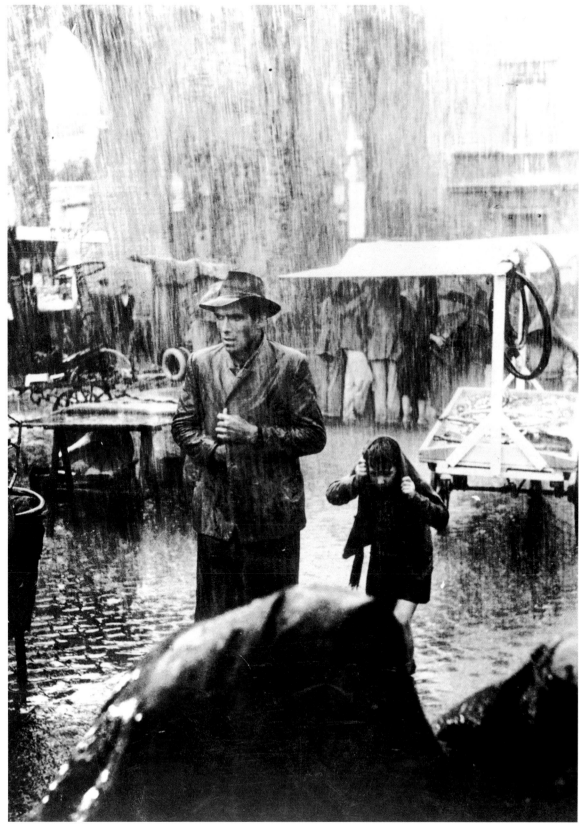

An image from Vittorio De Sica's *The Bicycle Thief*, one of the finest films from the new Italian school of neo-realism.

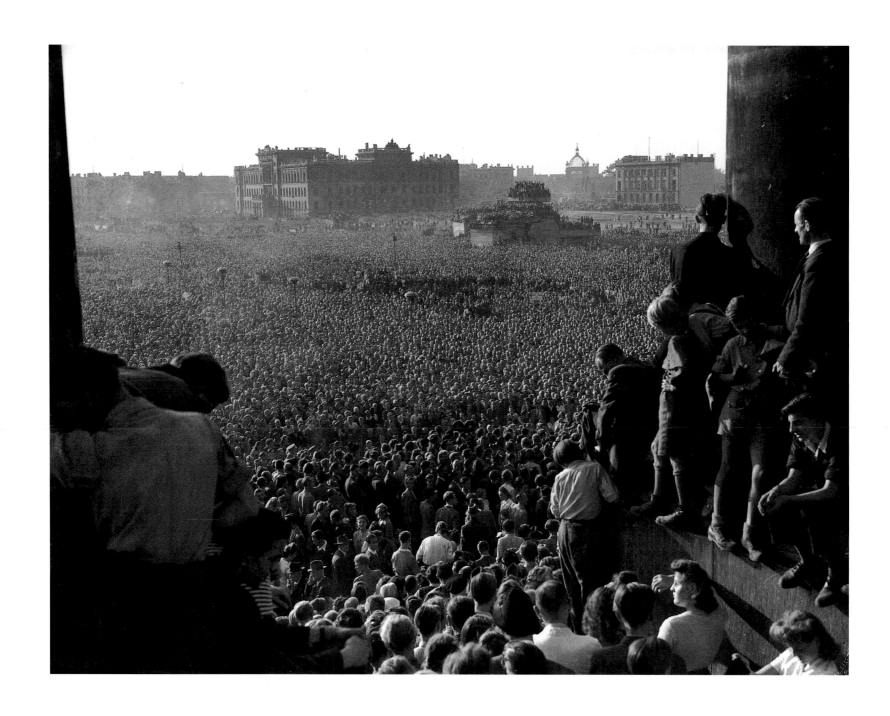

East Berliners demonstrating against communism near the Reichstag. Everything, including liberty, was in short supply.

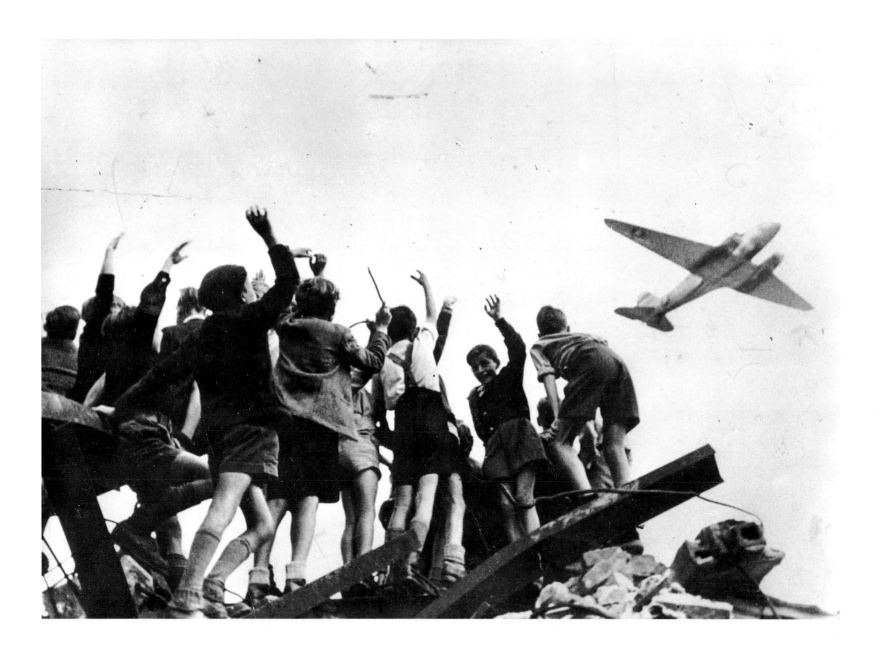

Children greeting the first cargo planes of the Berlin airlift, a peaceful victory for the West over Stalin's dangerous cold war tactics.

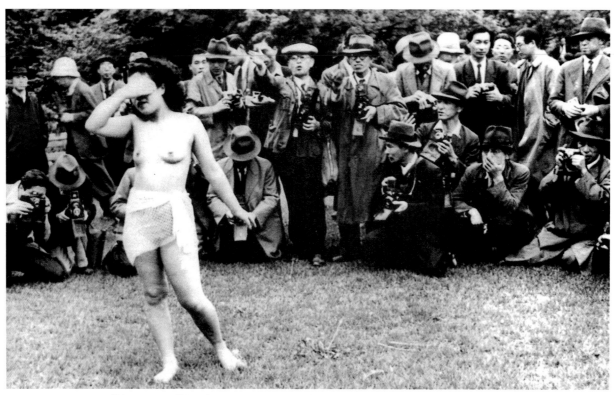

Chinese men talking about news or prices at the market, photographed by Cartier-Bresson.
'A semi-nude photo' – an unusual topic for Japanese photographers.

Albert Camus, French novelist (right), with the Swiss-French composer Arthur Honegger (seated) and French actress Maria Casares at a rehearsal of his play *L'Etat de siège*.

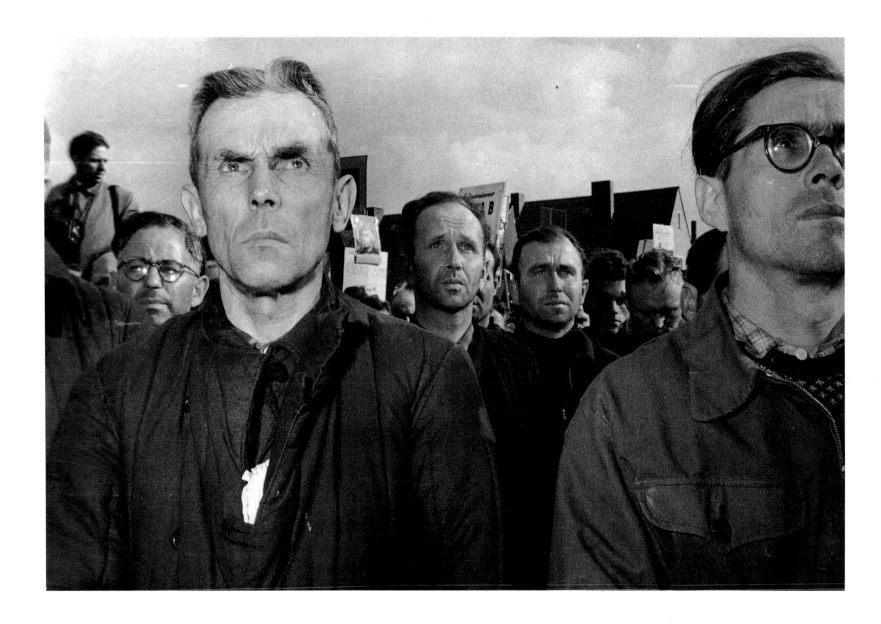

Back home from the East – a group of West German prisoners released from the communist bloc.

The Hungarian communist leader Mátyás Rákosi congratulates Árpád Szákásits, leader of the new Hungarian Workers' Party. Rákosi has just swallowed Szákásits' party whole.

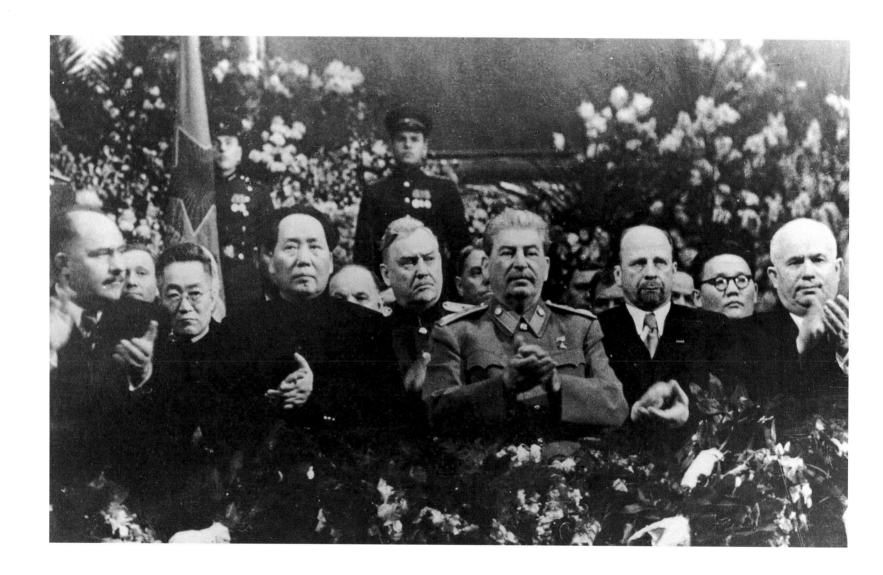

Mao (third left) meets Stalin (third right) in Moscow. Marshal Bulganin is inbetween them with Walter Ulbricht and Nikita Khrushchev on the right.

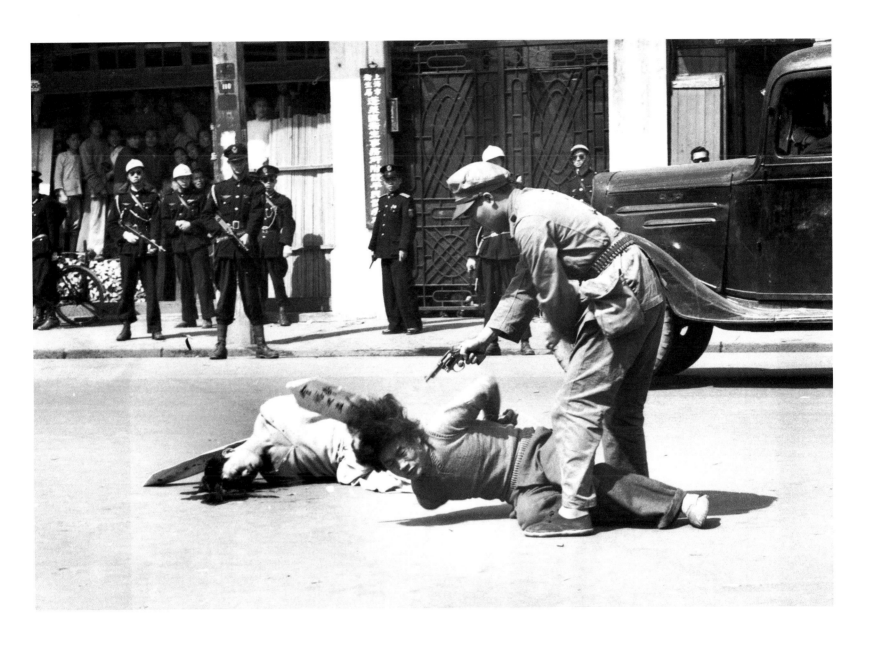

The pointless slaughter of communists in Shanghai by desperate Kuomintang forces. The communists would control the city within days.

Achmad Sukarno's young partisans who liberated the huge territory of the Dutch East Indies, now Indonesia.

Sukarno, who had fought the Dutch colonists for four years, is finally President of Indonesia.

1949

High ranking Russian party officials celebrating May
Day. Georgi Malenkov in silhouette, Andrei Zhdanov,
Alexei Kuznetsov, Lavrenti Beria, Vyacheslav Molotov
and A.S. Shcherbakov (left to right) favour an American
gangster style.

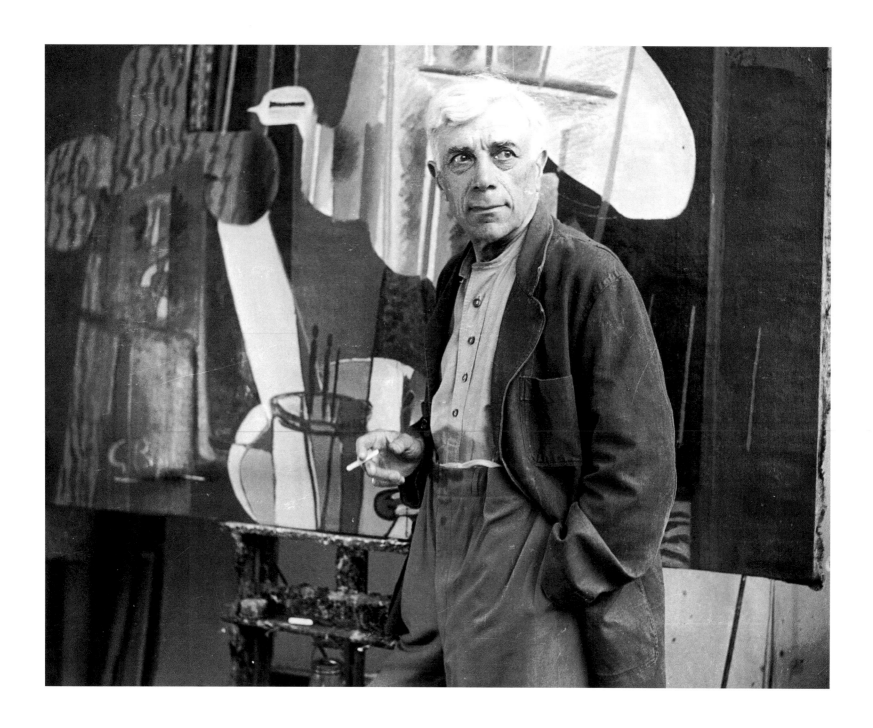

Georges Braque in his studio with the bird motif which he used in his increasingly poetic visions in the late 1940s.

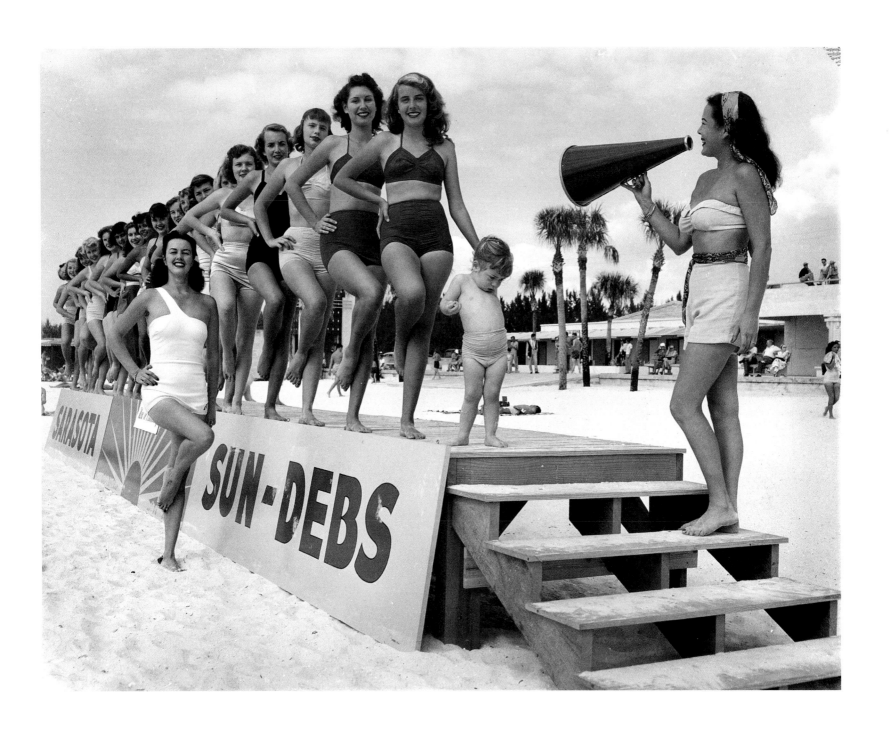

'Sarasota Sun-Debs' showing their *joie de vivre* and a contemporary notion of ideal young womanhood. A recruit who will mature in the early 1960s seems a little doubtful.

Marcel Cerdan (right), a great French boxer, with the brilliant young French violinist Ginette Neveu and her brother Jean, enjoying a publicity photo-call just before all were killed in an air crash near the Azores.

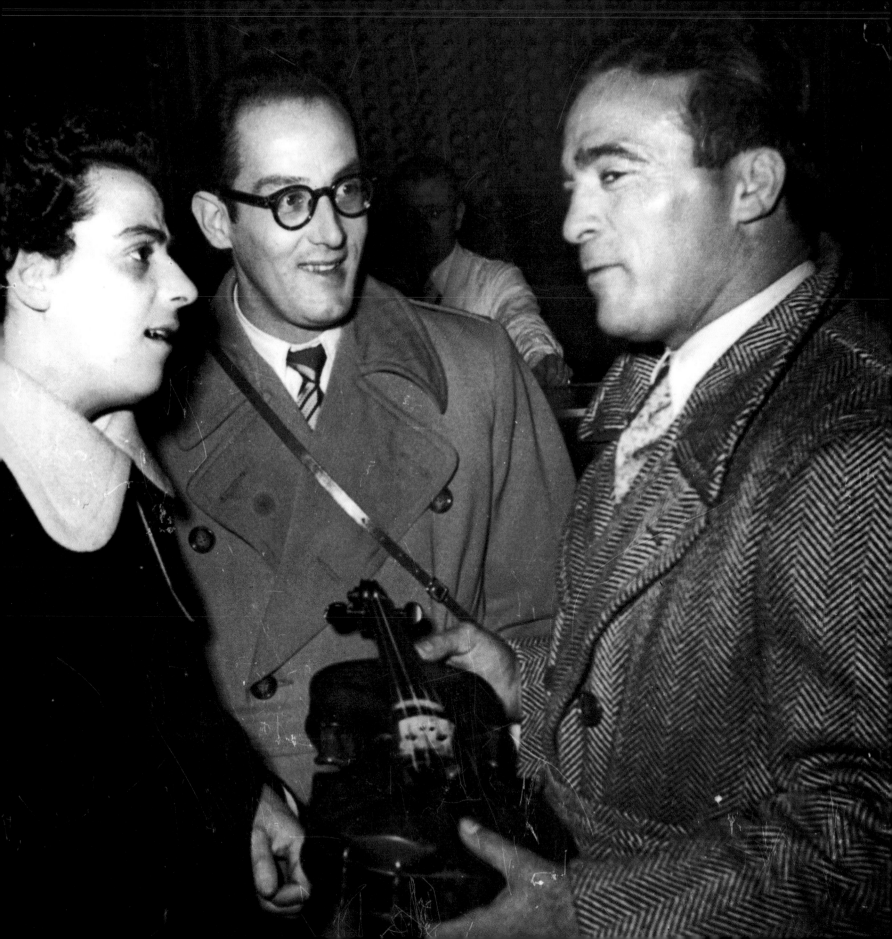

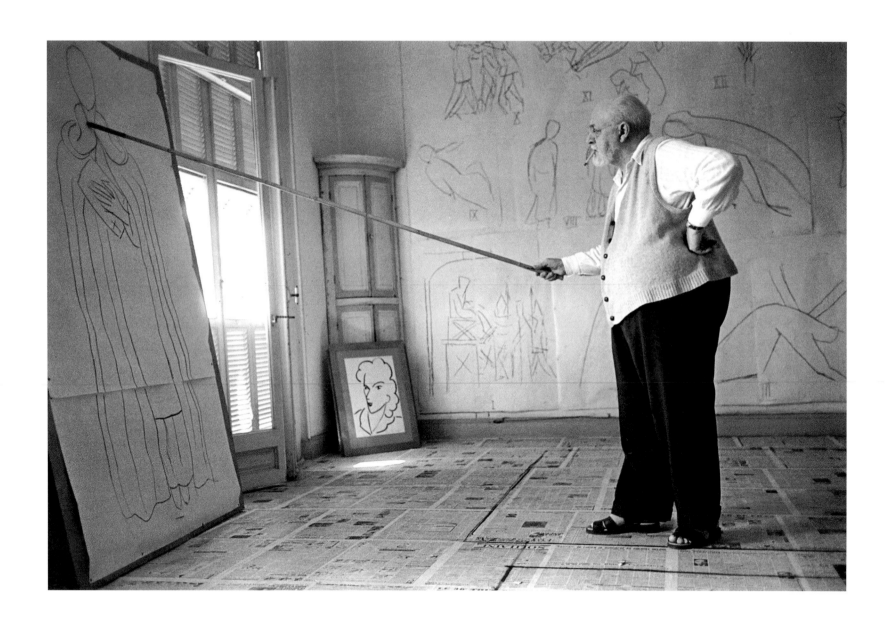

Henri Matisse drawing St Dominic for his Chapel of the Rosary at St Paul de Vence. He carried on working until his death in 1954.

Oppressed by post-war bleakness, Londoners seek solace in the words of Billy Graham, a pre-eminent American evangelist.

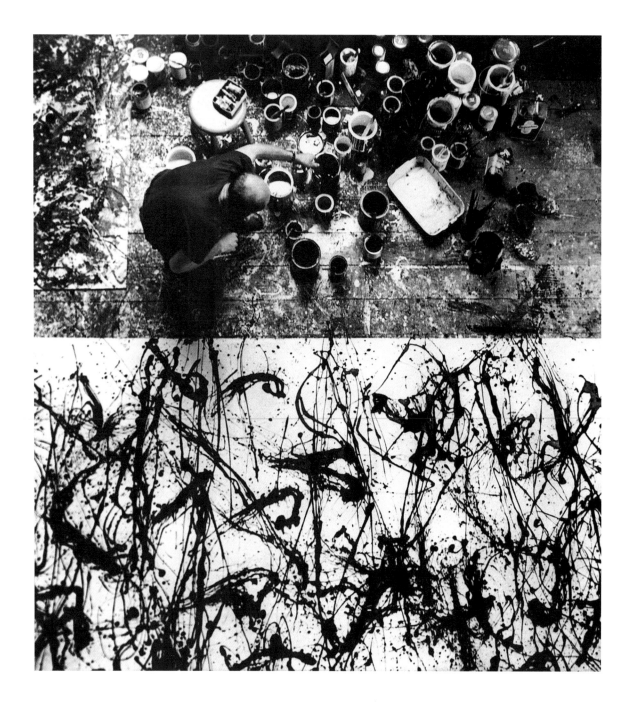

Jackson Pollock – one of the twentieth century's most influential painters – seen at work from above.

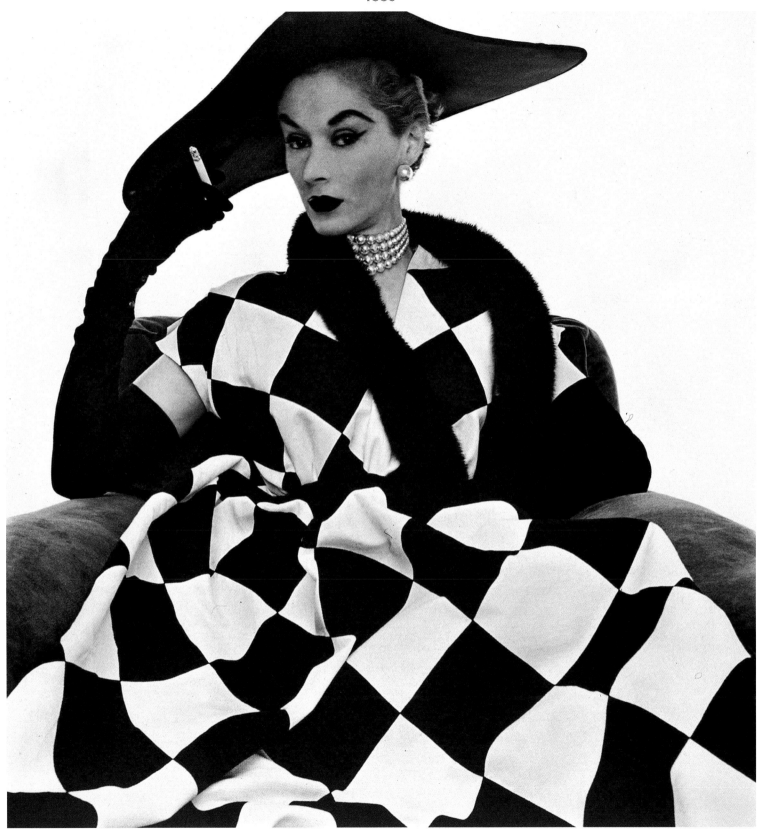

Irving Penn's wife and model, Lisa Fonssagrives, poses for him in Jerry Parnis' harlequin dress – a cool new American elegance.

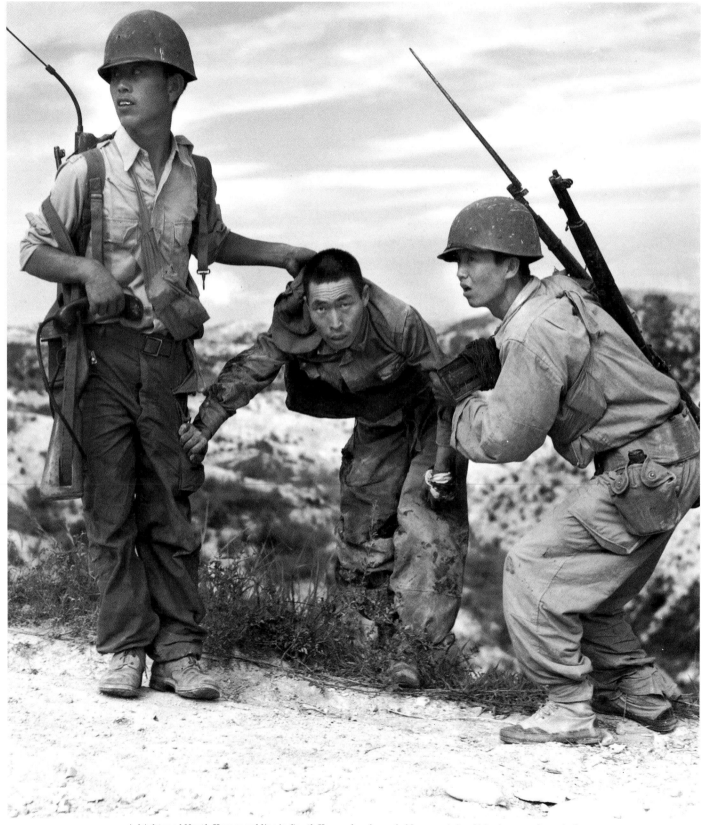

A frightened North Korean soldier in South Korean hands, probably uncertain of his chances of survival.

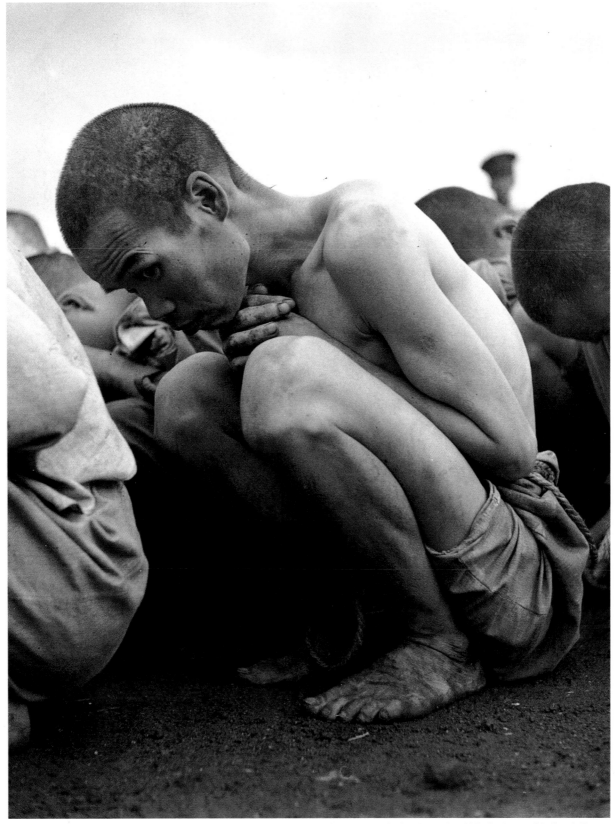

Bert Hardy the photographer, and James Cameron the journalist, exposed the wholesale slaughter of 'political prisoners' in South Korea.

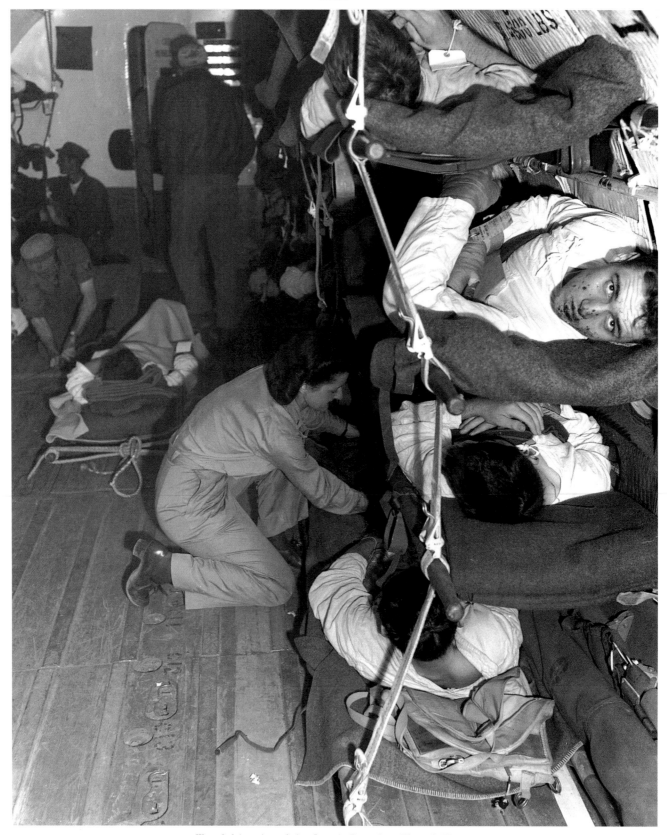

Wounded Americans being flown to Japan from Kimpo in Korea.

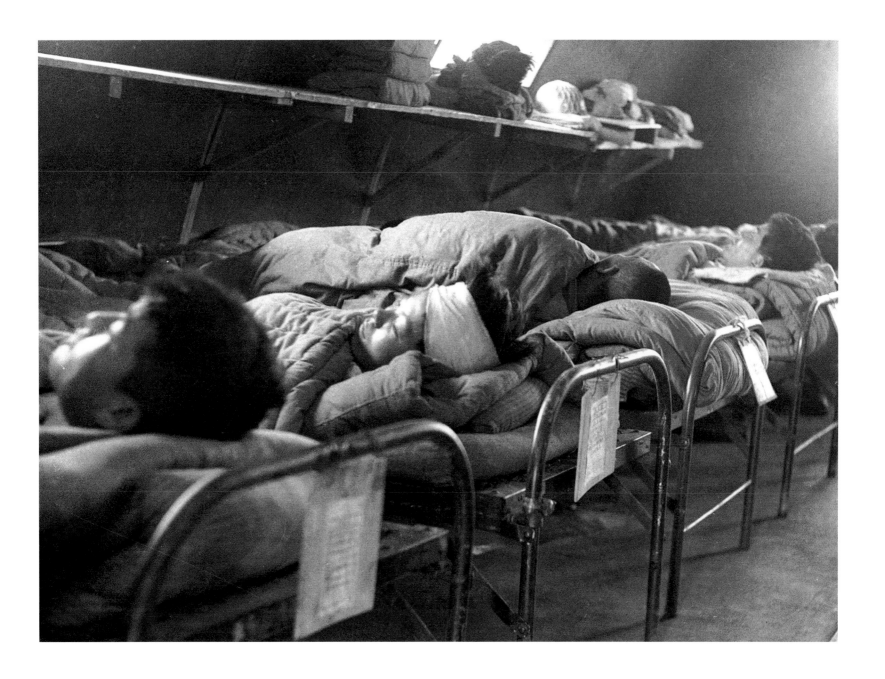

South Korean wounded being treated in their own country.

Chaim Weizmann, President of Israel (second from right), casting his vote in the municipal elections.

German boys playing it cool on a street corner.

Palmiro Togliatti – later the Italian founder of Euro-communism – enjoying good relations with the Church after a car accident in the Valle D'Aosta.

The volatile Betty Hutton playing Annie Oakley, legendary markswoman of *Annie Get Your Gun*.

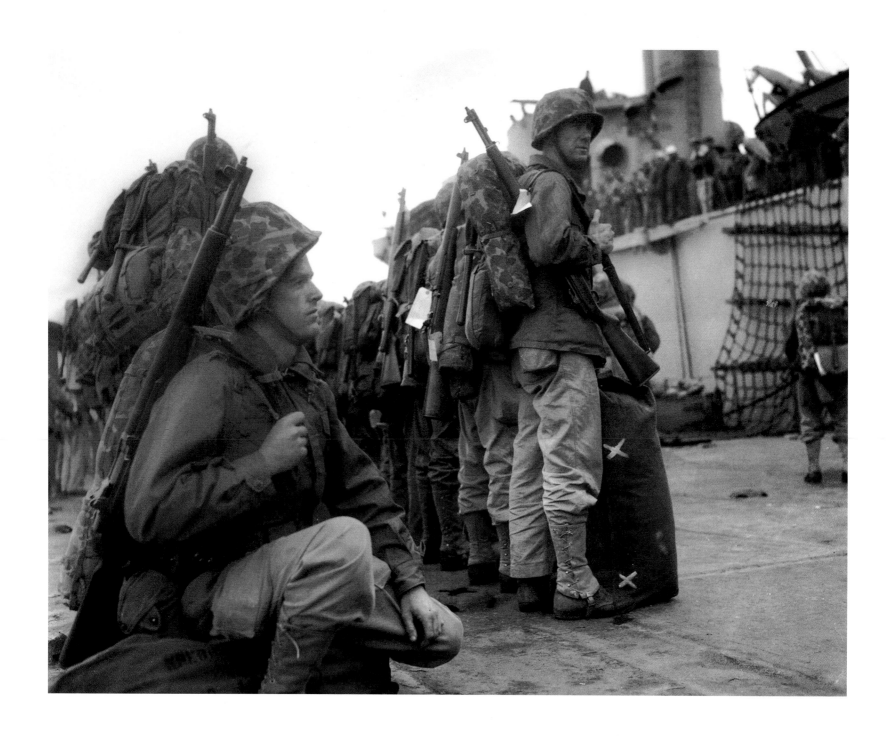

US marines waiting to embark for Korea. The image could move us to wish them – and their enemies – well.

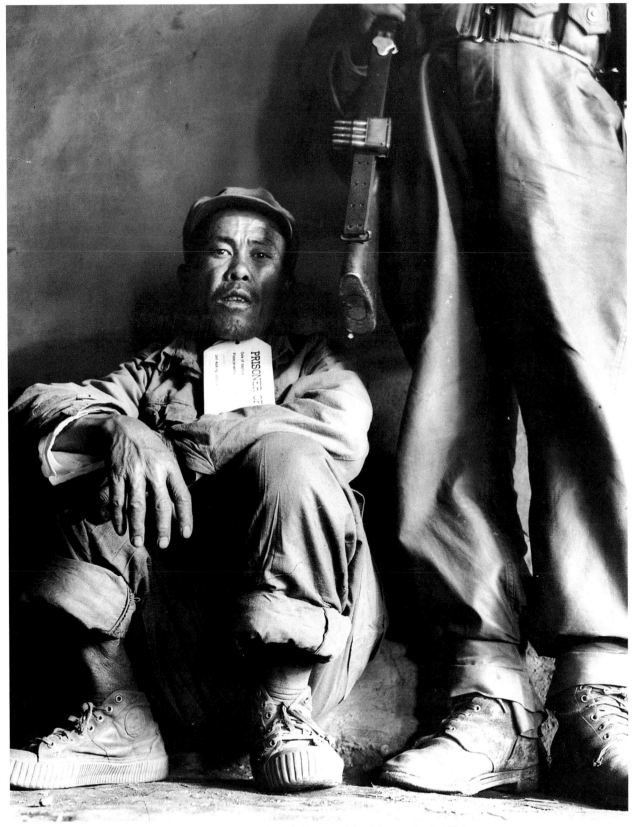

A 'Red' Chinese prisoner of war in Korea awaiting interrogation by UN forces.

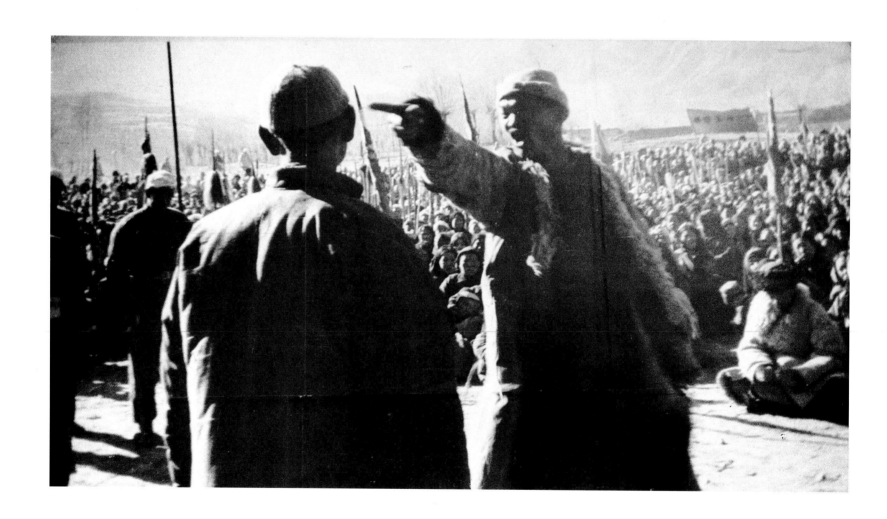

A Chinese peasant denouncing a former landowner in front of a People's Tribunal. The landowner is likely to have been executed.

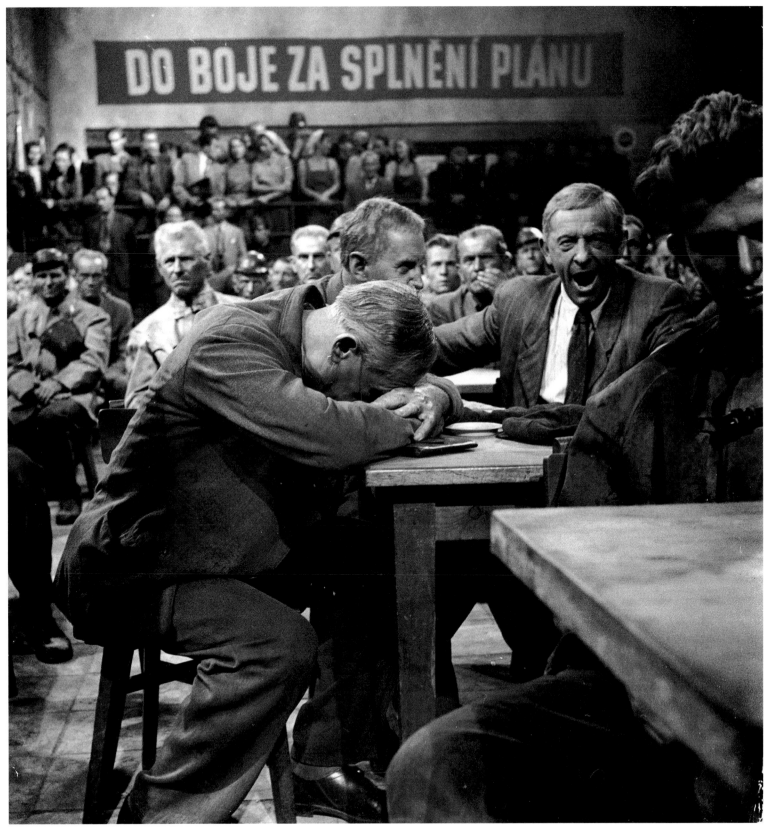

'Let us fight for the fulfilment of the plan' says the Czech slogan on the wall. There seems, however, to be a lack of zeal.

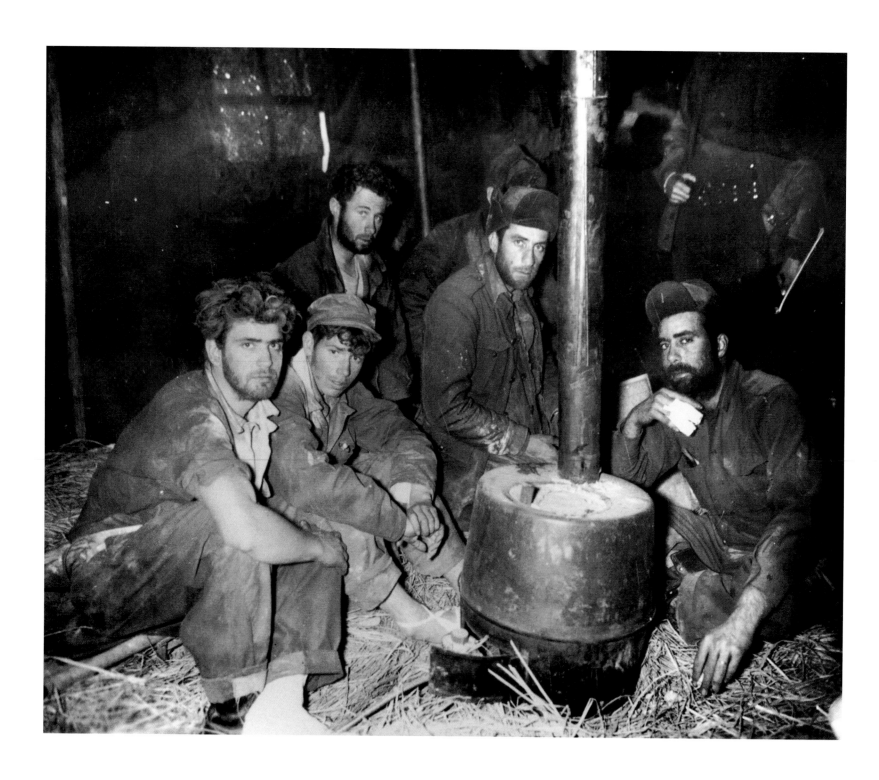

Americans and Australians released by the Chinese at a medical clearing station behind American lines in Korea.

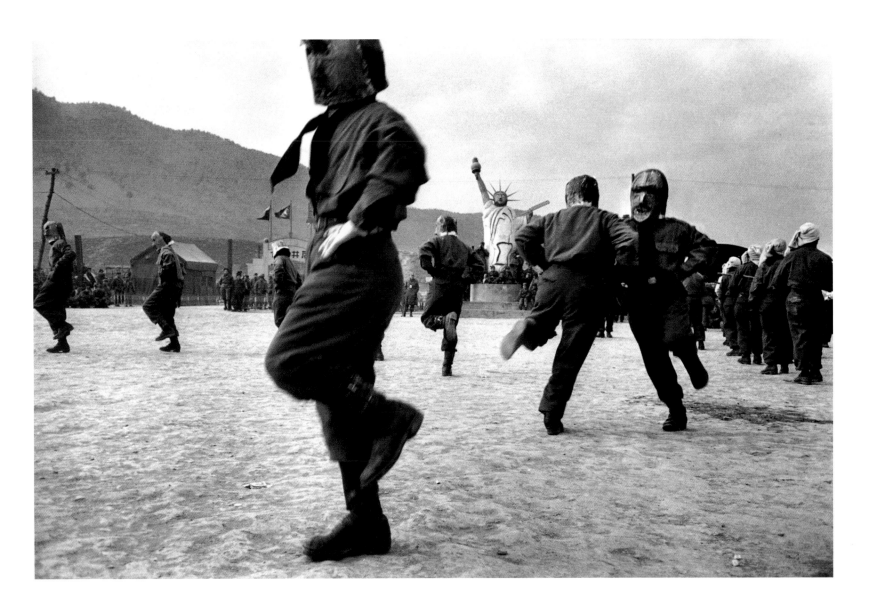

North Korean prisoners perform a 'square dance' in front of a model of a the Statue of Liberty at Koje-do internment camp in South Korea.

Captured communist guerrillas being fed in South Korea.

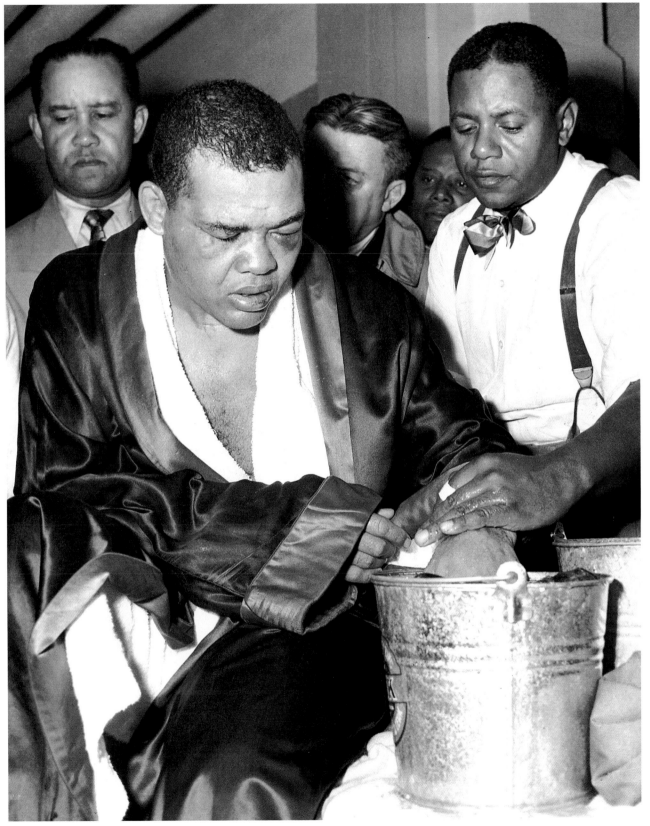

Joe Louis, probably greater than any heavyweight champion before him, is finally beaten by a human tank, Rocky Marciano.

Iranian Premier Mohammed Mossadegh (right) jokes with a US lawyer (centre) and the former US ambassador to Iran,
Wallace Murphy (left), about the oil crisis he provoked with Britain.

The Shah of Iran's wedding to Soraya who, like his first wife Princess Fuzieh, was divorced for failing to produce an heir.

An American Ku-Klux-Klan member described by the photographer Eugene Smith as
'Female Spokeswoman for White Superiority'.

Klement Gottwald (right), President of Czechoslovakia, with his Vice-President Rudolf Slanský. Gottwald was forced to have Slanský executed in a Stalinist purge.

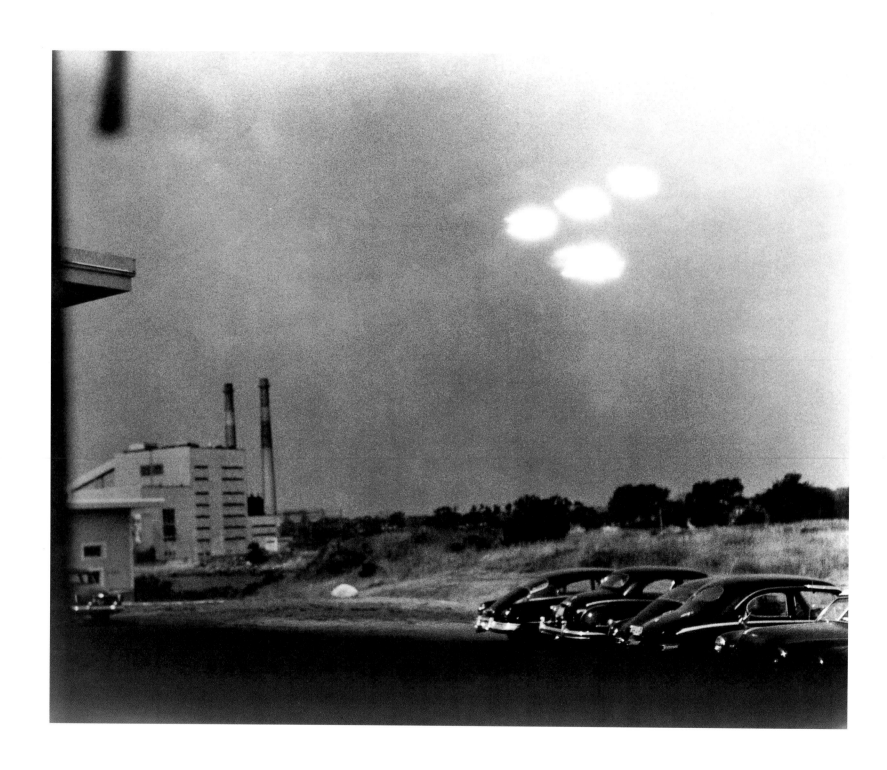

Almost unbelievable – one of the first alleged photographs of UFOs started arguments which still continue today.

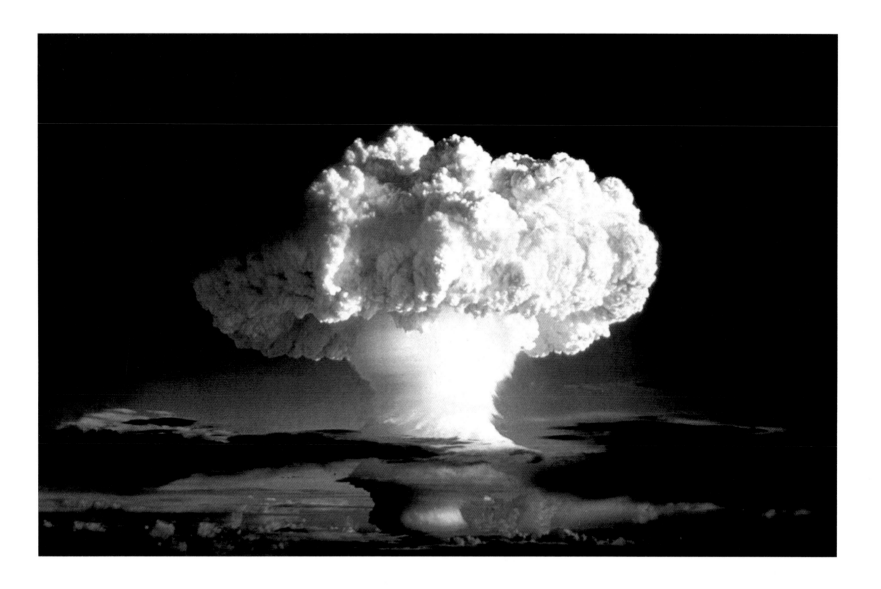

An intolerable power is achieved – the first hydrogen bomb being tested at Eniwetok Atoll in the Pacific. It would have obliterated over one hundred Hiroshimas.

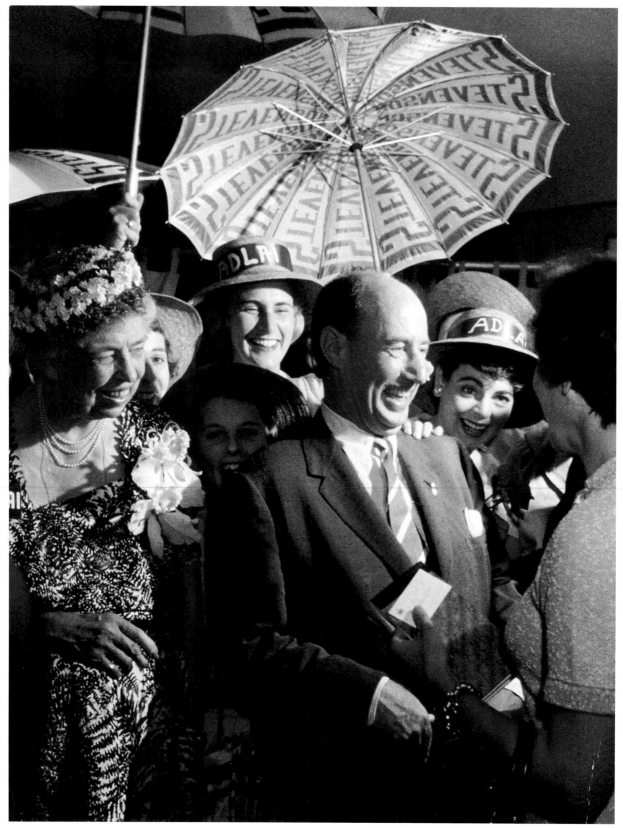

The intelligent and witty Adlai Stevenson seeking the American presidency. 'Ike' Eisenhower's prestige was too much for him even with Eleanor Roosevelt's support.

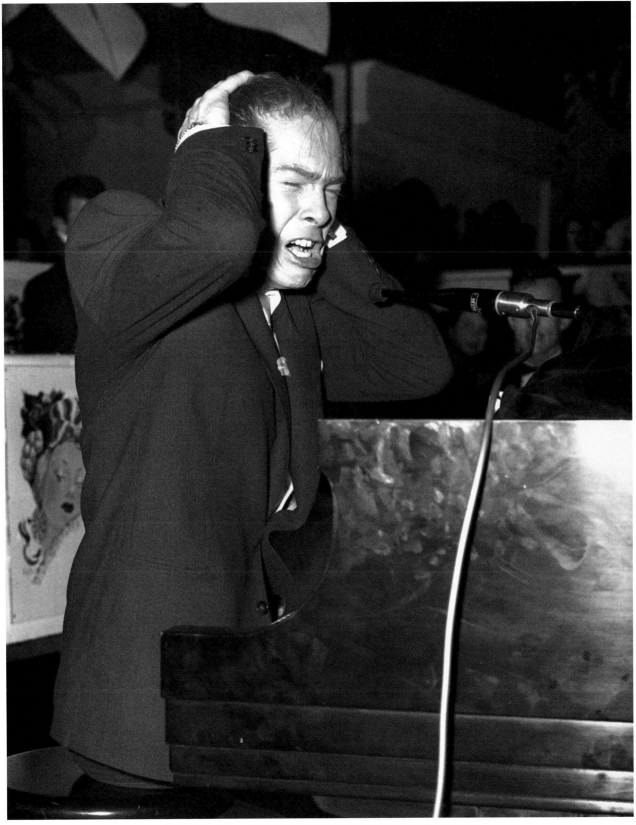

Johnnie Ray, the emotional crooner. His popularity was brief but intense.

The great 'Little Mo' Connolly absorbed in her Wightman Cup programme at Wimbledon. A riding accident cut short her meteoric career.

Bert Hardy shot a story for *Picture Post* about artists' parties in London's Chelsea. It was never printed probably for the most likely reason.

South Koreans proudly display the head of a guerrilla from the North – Margaret Bourke-White recorded it with a steady hand.

Dwight and Mamie Eisenhower (right), with Richard and Patricia Nixon, exultant at becoming candidates in the US presidential election.

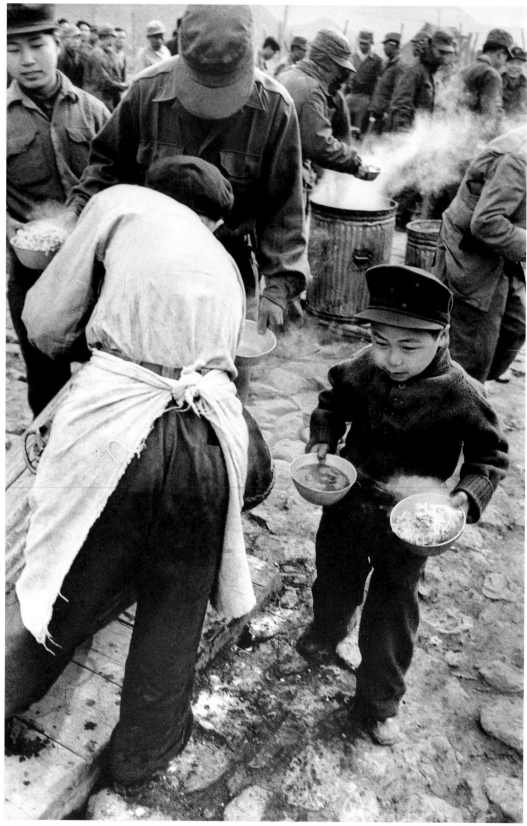

Werner Bischof shows his sensitive eye for children at a POW camp in South Korea.

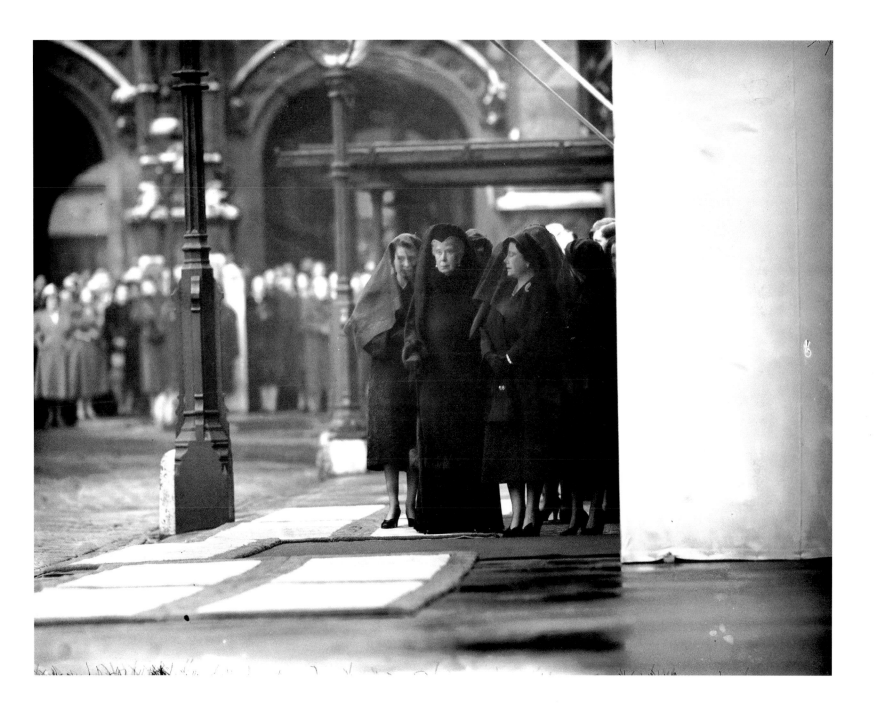

Three British Queens – Elizabeth, Mary and Elizabeth – at the funeral of their father, son and husband, King George VI.

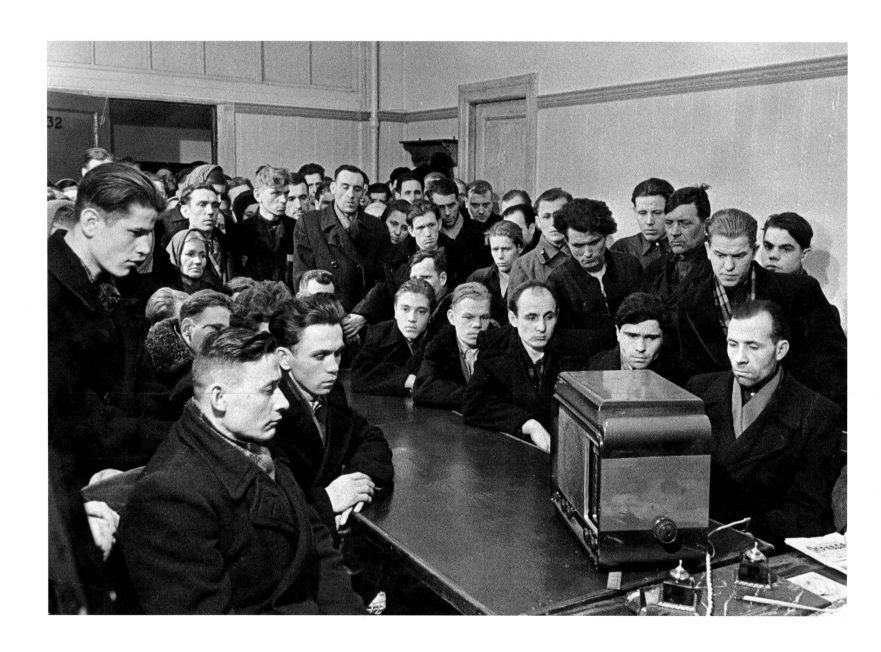

Conformity in mourning – Russian factory workers listen to the news of Stalin's death.

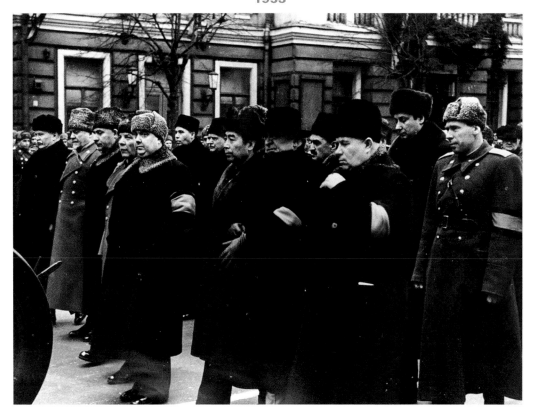

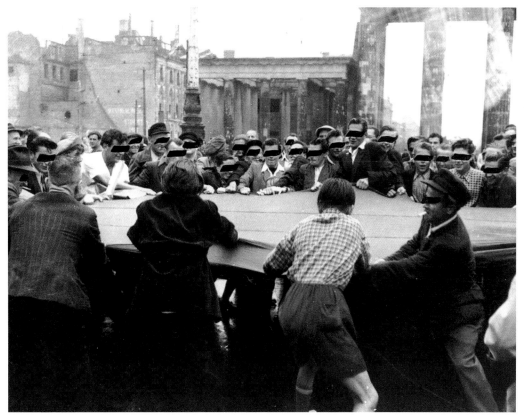

All of Stalin's possible successors were at the funeral. Georgi Malenkov (centre of line) was to rule briefly followed by Nikita Khrushchev (closest to camera). During the Berlin Uprising which followed Stalin's death, workers pulled down flags and enjoyed a brief orgy of disrespect for those in power.

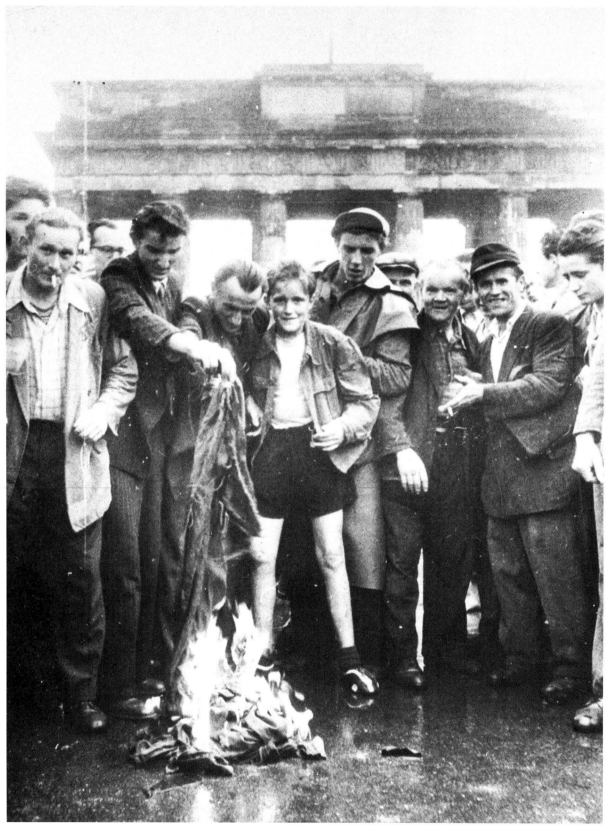

Another group of East Berlin iconoclasts burning a flag – before Soviet troops moved in and crushed the rebellion.

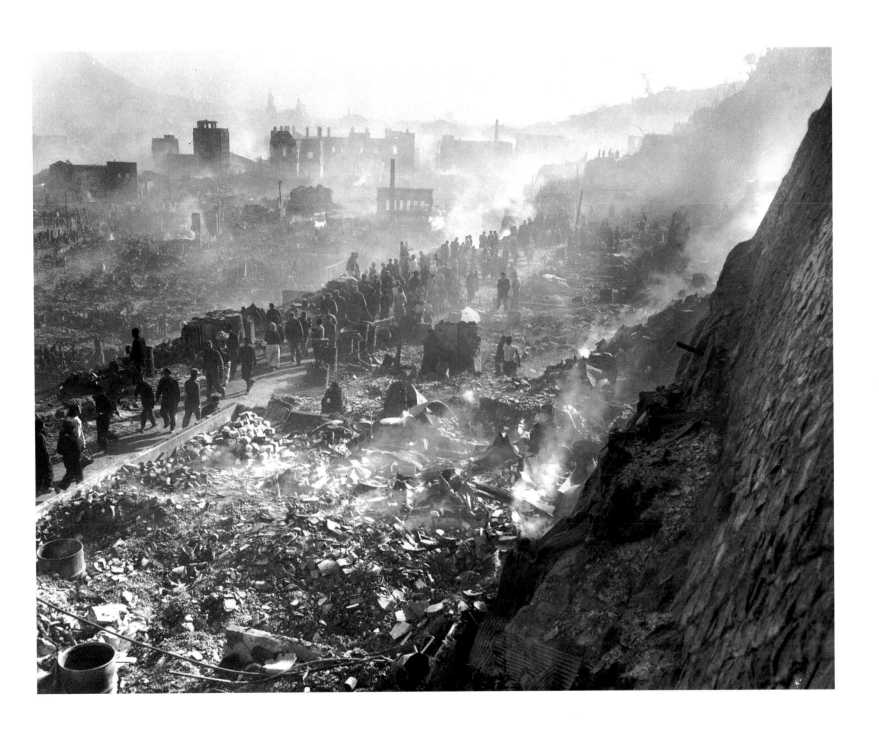

Fire devastated Pusan before the Korean truce was signed, adding to the enormous material and human costs of the conflict.

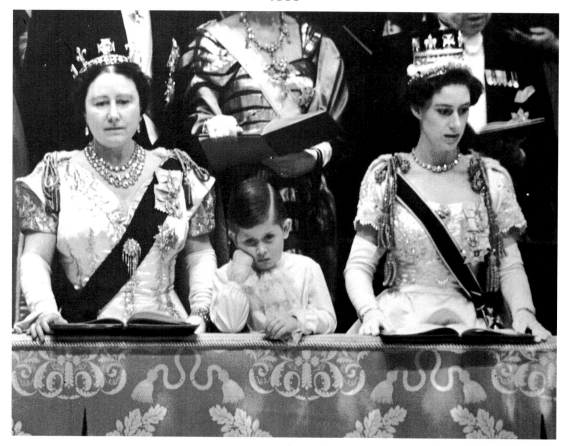

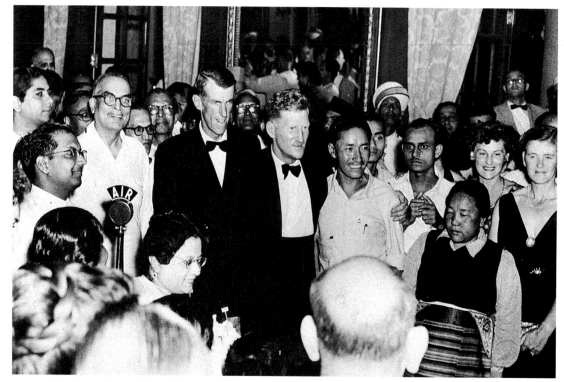

The Queen Mother, Prince Charles and Princess Margaret all looking pensive at Elizabeth II's Coronation.
The conquest of Mount Everest by Edmund Hillary and Tenzing Norgay, here celebrating in Calcutta, was seen as a coronation gift for the new Queen.

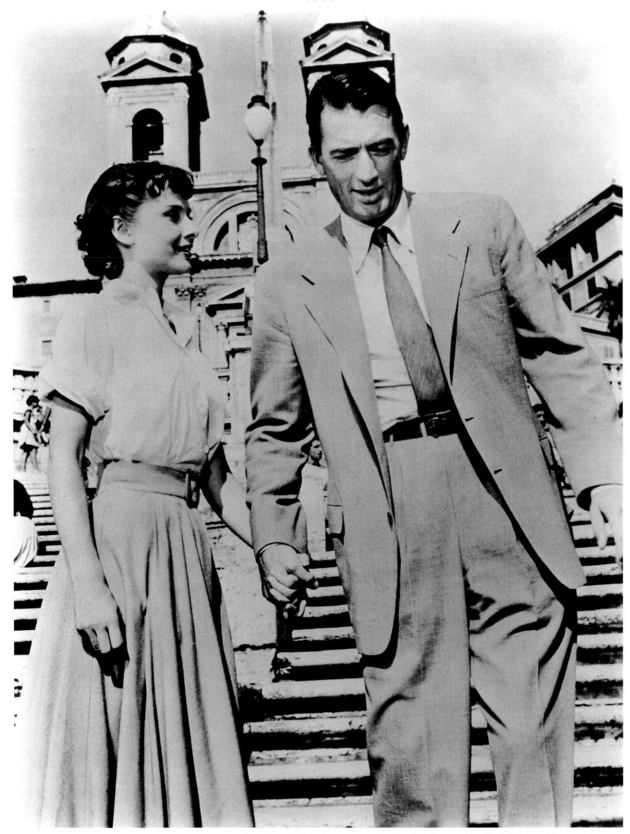

Gregory Peck and Audrey Hepburn in *Roman Holiday* – in Britain some saw Hepburn's role as an idealized Princess Margaret.

Monsieur Hulot's Holiday – one of the most acclaimed French films since the war – Jacques Tati as Hulot is playing ferocious and ridiculous tennis.

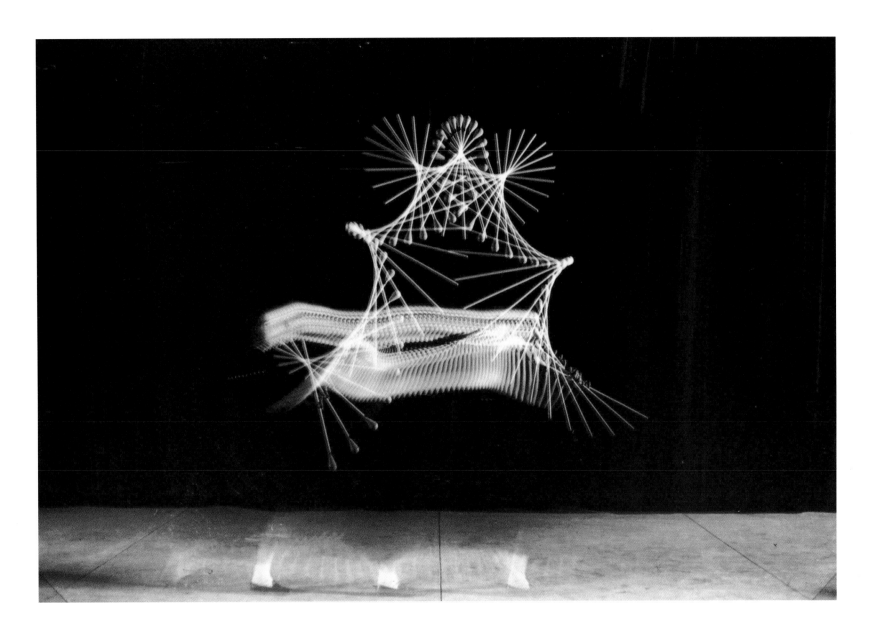

One of Harold Edgerton's most intriguing multiple stroboscopic flash images – a drum majorette twirling her baton.

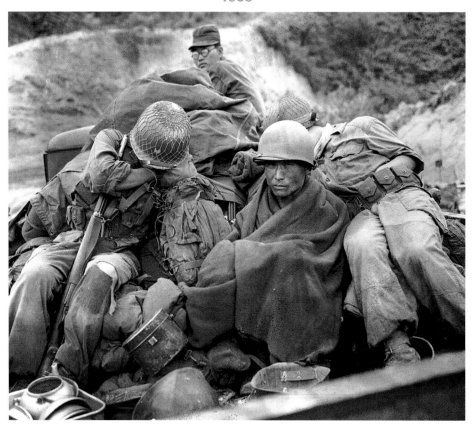

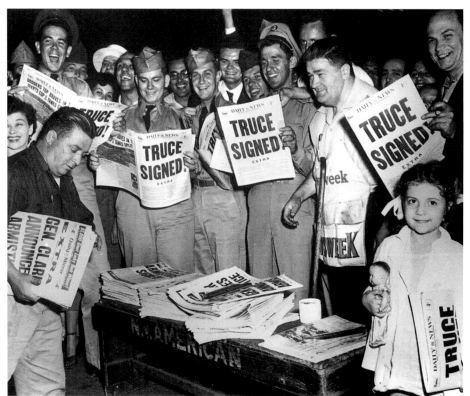

Exhausted troops after fierce communist attacks just days before the Korean truce.
GIs in New York happy at the news of the truce.

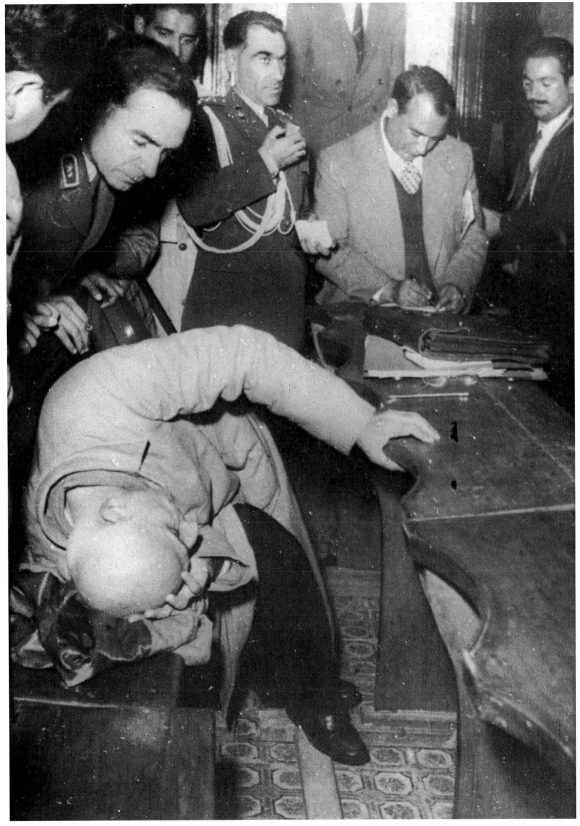

Supplanted by the new Prime Minister General Fazlollah Zahedi who had been appointed by the Shah,
Mossadegh was tried and imprisoned for treason.

One of the very last British colonial grandees, Sir Evelyn Baring, inspecting his native troops in Nairobi.

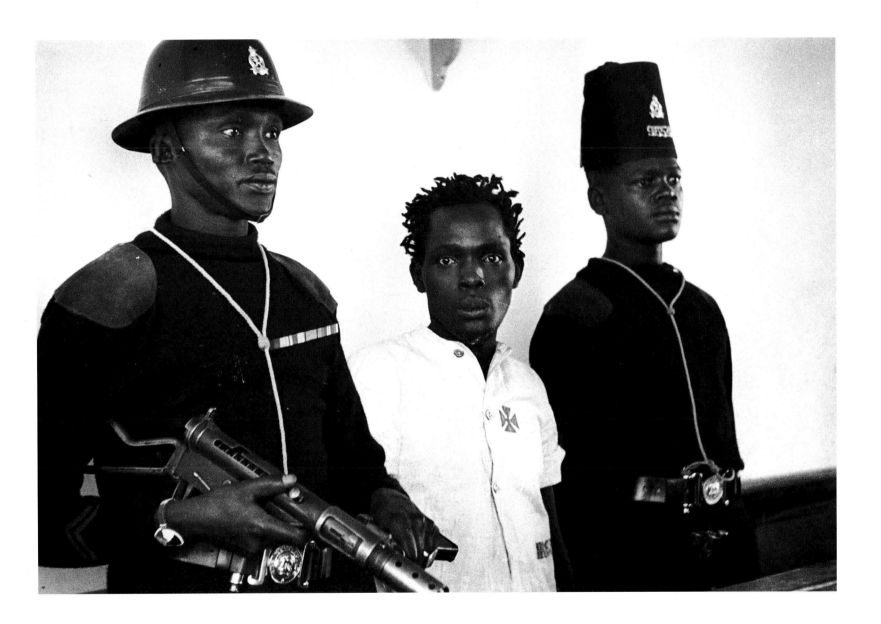

An important Mau Mau leader 'General China', on trial in Kenya. The rebels against British rule would get their way quite soon.

Gregory Peck – probably seriously miscast as Captain Ahab in John Huston's film *Moby Dick*, putting on a fine show of unrepentant hubris.

Seven Samurai, one of Akira Kurosawa's most important films. He did much to establish Japanese cinema's international reputation.

French troops under attack by Van Dong's army at Dien Bien Phu.

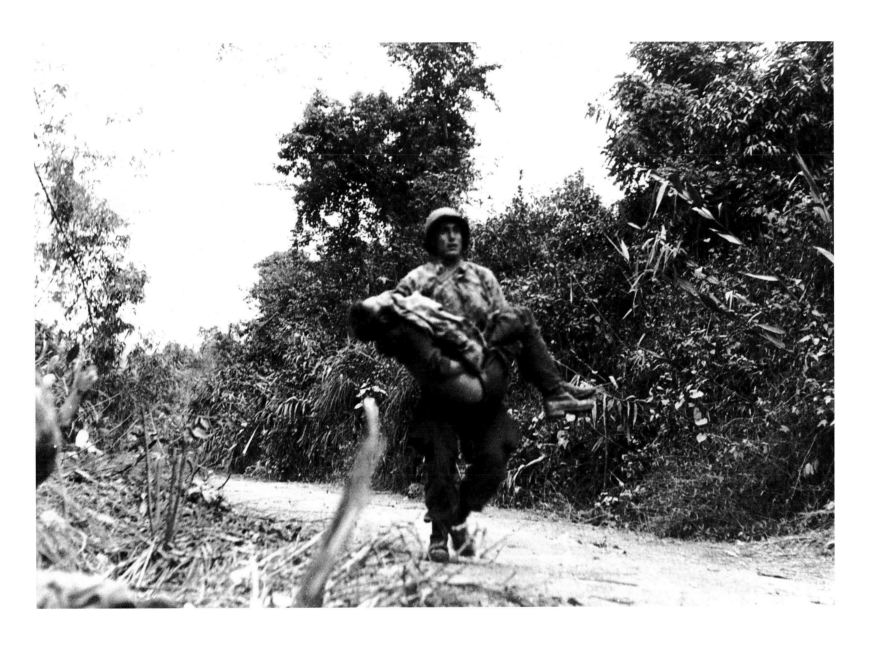

Dien Bien Phu was a disaster for French troops – over three-quarters of their men died before they were forced to surrender.

A homage to Winston Churchill at the Conservative Party Conference over which he was presiding for the last time.

Representatives of four major powers in Paris betray their origins – Pierre Mendès-France, Konrad Adenauer, Anthony Eden and John Foster Dulles (left to right).

General Neguib (centre) who had seized power in Egypt, with Lieutenant Colonel Gamal Abdel Nasser (right), who then took it from him.

Neguib (still President) being met by a workers' delegation in his home.

The unquestionably beautiful Grace Kelly at the Cannes Film Festival with Elsa Maxwell, the ubiquitous gossip columnist.

Elsa Maxwell (seated left) at a party with Liberace and Zsa Zsa Gabor – two performers entirely dependent on publicity.

A couple in a dance-hall in Newcastle in Britain – sixties cool is still some way off.

Kim Philby, the Soviet master spy, addressing the British press and shamelessly denying that he is any such thing.

A homeless man in Leeds in Britain receiving charity from the Church. The expressions of both parties speak volumes.

A scene in New York photographed by William Klein who made a book of his documentation of the city's life.

A still from *The Seventh Seal* – the film that made Ingmar Bergman's name.

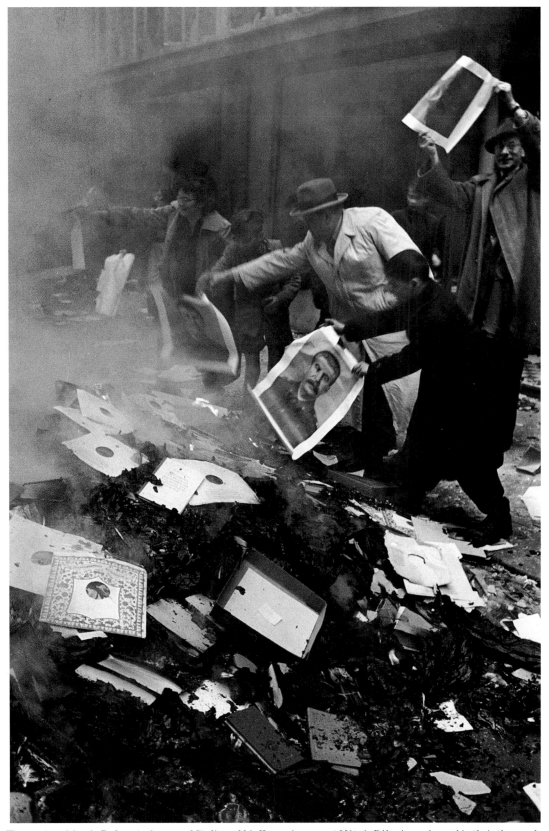

The great uprising in Budapest – images of Stalin and his Hungarian puppet Mátyás Rákosi were burned in their thousands.

A Teddy boy and his future wife photographed by Roger Mayne in a London street. The *soigné* couple were later married.

A Greek policeman under attack in Athens in protest against the execution of two Cypriot terrorists.

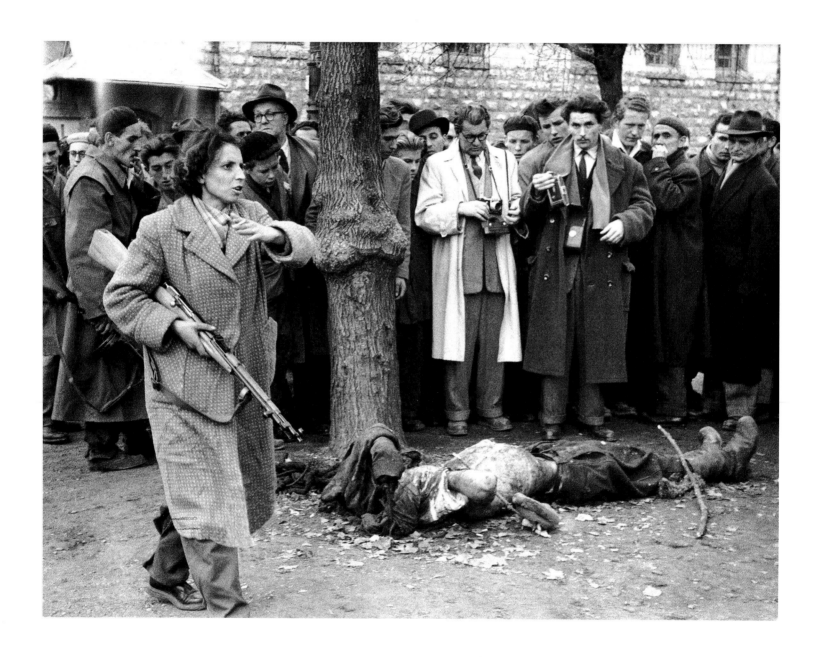

An armed woman rebel commands respect in a Budapest street. The streets were littered with corpses, mainly the bodies of government soldiers and police.

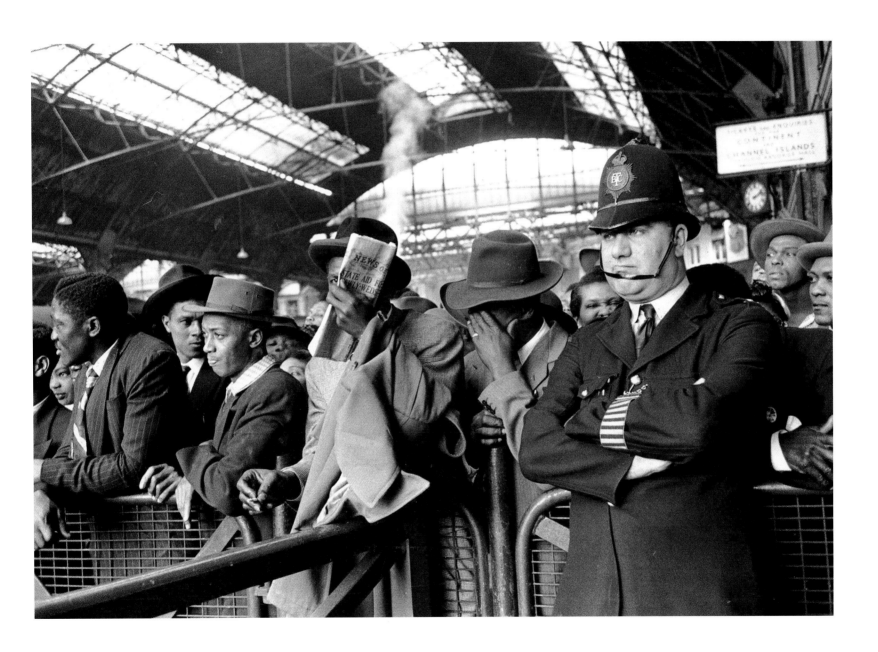

Black immigrants arriving in London. There was widespread anxiety about their numbers, but real hostility from only a tiny minority.

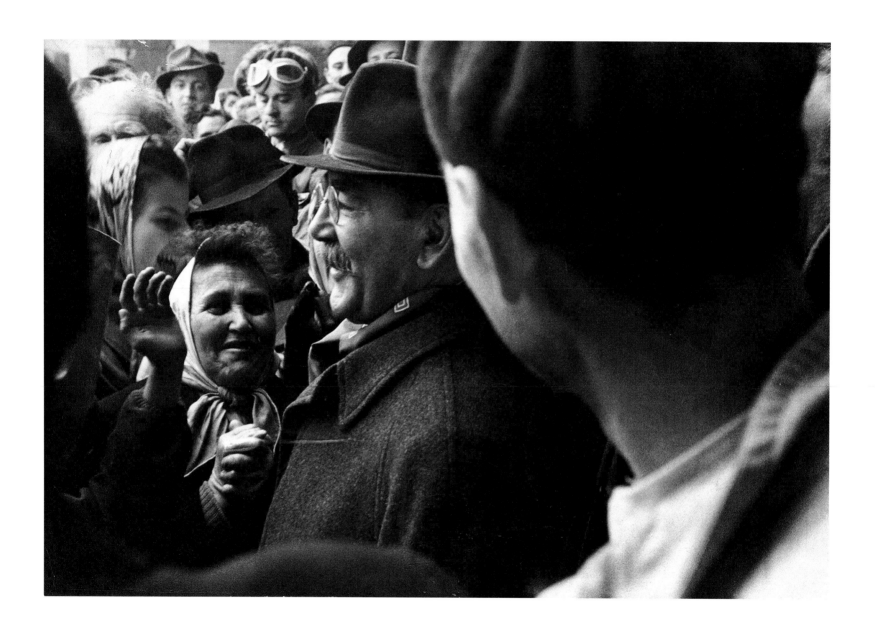

Imre Nagy, who became Hungary's premier during the uprising, was imprisoned and shot by the hardline communists on their return to power.

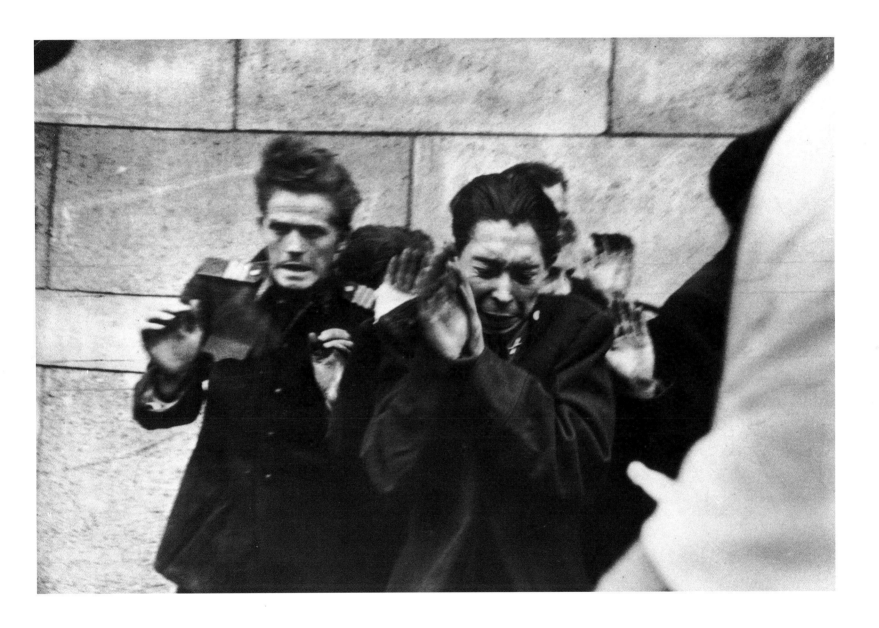

Bullets hitting Budapest secret police – only one of whom survived. The secret police were passionately hated by a large majority.

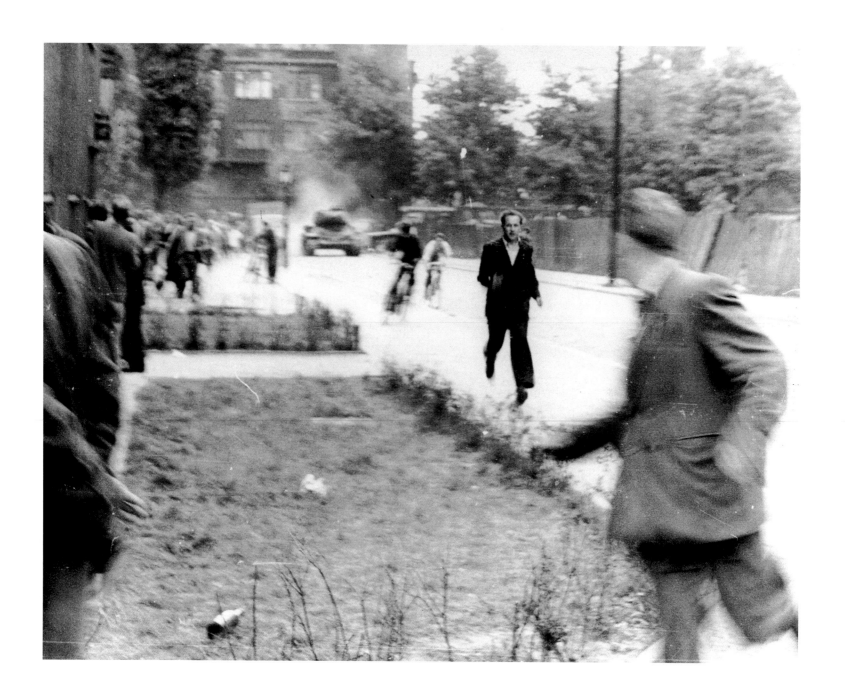

Strikers in Poznań in Poland, fleeing a Soviet tank. Seventy strikers were killed.

President Abdel Nasser, now in complete control of Egypt, having just announced the nationalization of the Suez Canal.

Adlai Stevenson tried out his good nature and wit again – and again he failed.

Nixon with Patricia and the re-elected Esienhower with Mamie. 'Ike' never trusted Nixon, but put on as much of a show of approval as necessary.

A rare picture of George Grivas, leader of the EOKA terrorists in Cyprus.

Zhou Enlai and Chinese Vice-Premier Ho Lung visiting Indian Prime Minister Jawaharlal Nehru for the Chinese New Year – which was toasted in orange juice.

Maria Callas being embraced by Ghiringhelli, the director of La Scala, Milan – she had just performed in Verdi's *Masked Ball*.

The young defence lawyer Nelson Mandela – his confinement and the role he was to play in his country's future still lay before him.

Elvis Presley being weighed during his medical for the army. Much of the teenage world must have held its breath.

A white man cuffing a young beggar round the head in Johannesburg.
Pickpocketing in Johannesburg – a white man so incensed at being touched by a 'black' that he does not notice the hand in his back pocket.

Jack Kerouac leaving the Artists' Club in New York after a New Year's Eve party.

Sugar Ray Robinson (right) on his way to regaining his world middleweight title from Carmen Basilio in a rematch of their bout the previous year.

Coleman Hawkins playing, perspiring and caught on film by Ed van der Elsken.

Martin Luther King being arrested in Montgomery, Alabama, by police unaware of his identity.

Nikita Khrushchev (right) and Richard Nixon (left) shake hands during the 'kitchen debate' tour, Nixon's 'sincerity' provoking a mocking grimace from Mr K …

On a tour of farms and cities in the US, Nikita Khrushchev was presented with a turkey by President Eisenhower – which seems to amuse everyone.

Fidel Castro warmly embracing a young girl after having driven Fulgencio Batista and his cohorts out of Cuba.

The most sincere form of flattery? Fidel Castro with children wearing look-alike beards.

Having secured the independence of Cyprus, Archbishop Makarios returned from exile to be elected the country's first President.

Elizabeth Taylor in a screen adaptation of Tennessee Williams' play *Suddenly Last Summer*.

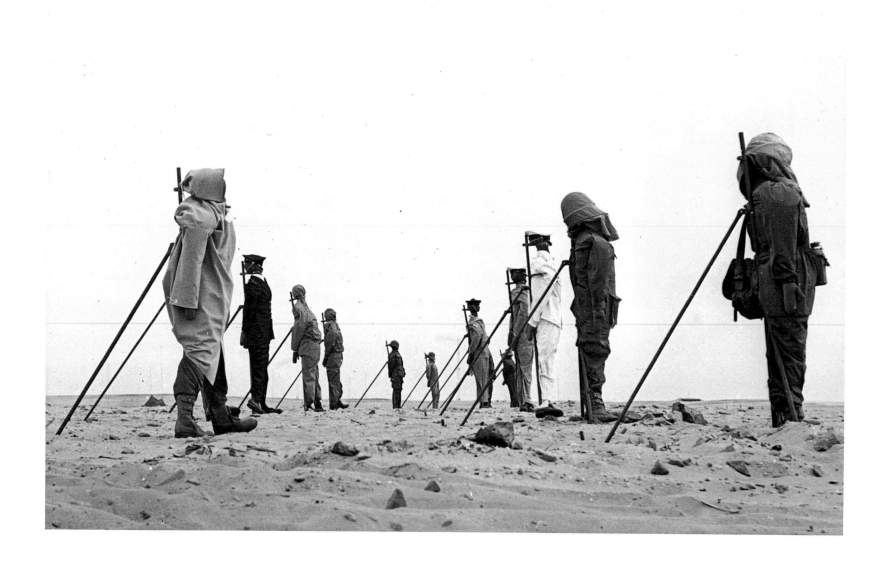

Dummies dressed up for the third French atomic bomb test – a variety of materials being tested for their resistance to the flash.

Socialist Chairman Inejiro Asanuma being stabbed by a seventeen-year-old right-wing fanatic during a political rally.

Sergeant Presley signs his autograph for a delighted fan.

Fidel Castro (out of sight) speaking to his enraptured followers in Havana – there would be countless hours of more speeches to come.

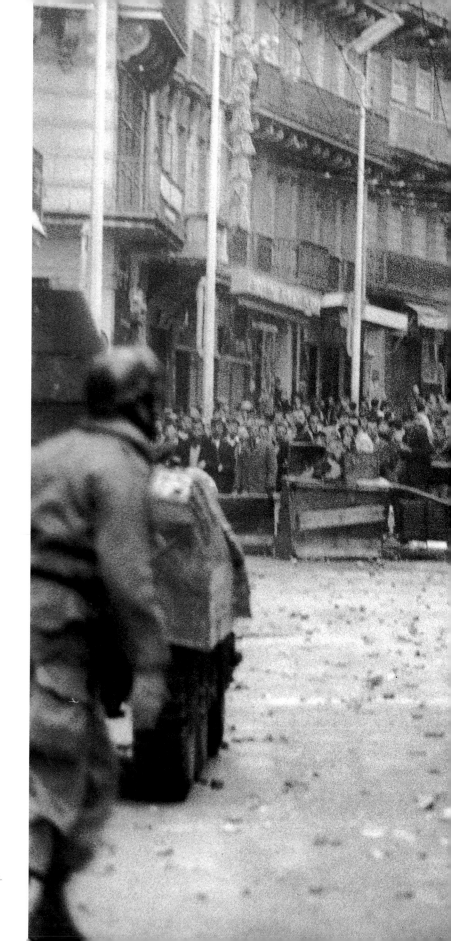

The demolition of Stalin's enormous statue in
Prague, as the Eastern bloc begins its de-Stalinization.
The French army in tense confrontation with demonstrators for Algerian independence.

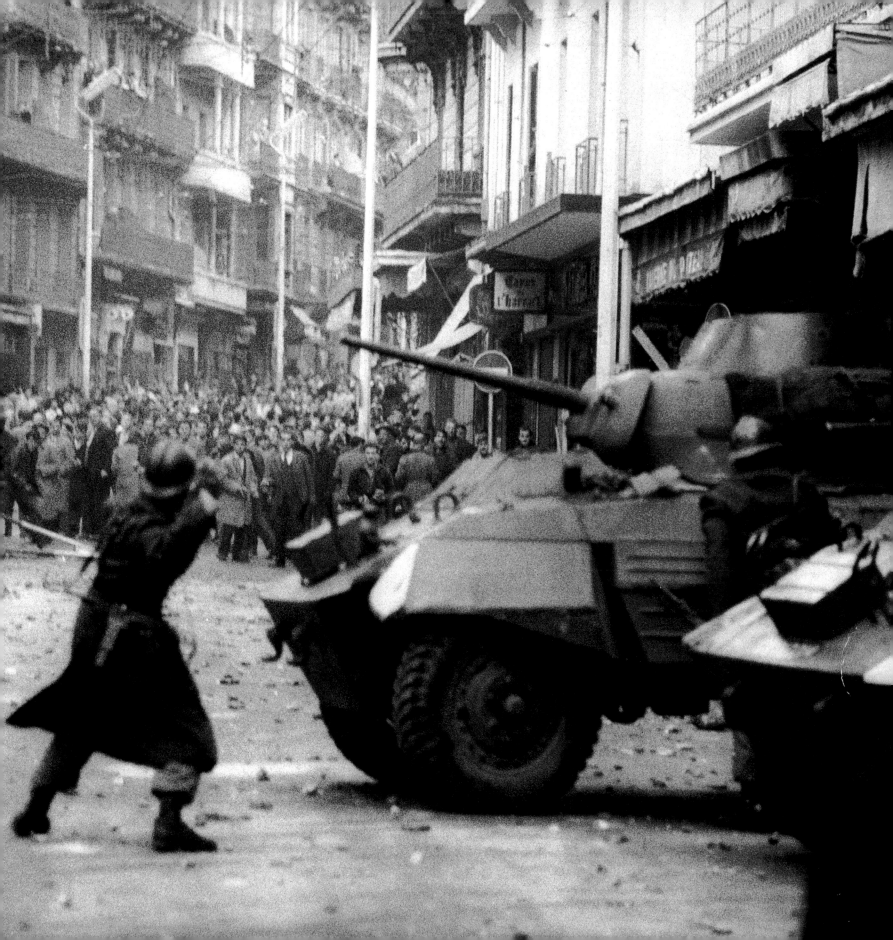

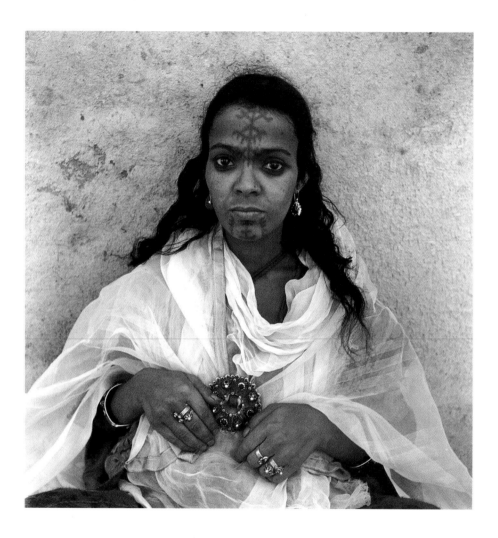

Photographer Marc Garanger's job in the French army was to photograph
Algerian Muslims for French records – women had to be unveiled against their will.
Native Algerians waiting for President Charles de Gaulle in the hope that he will bring them independence.

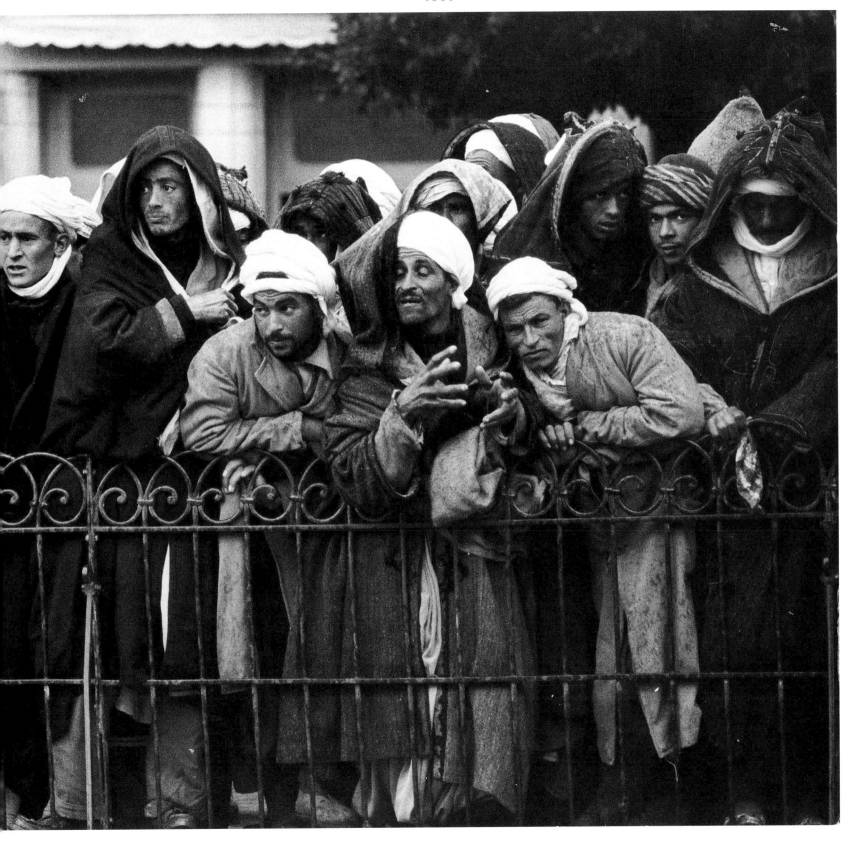

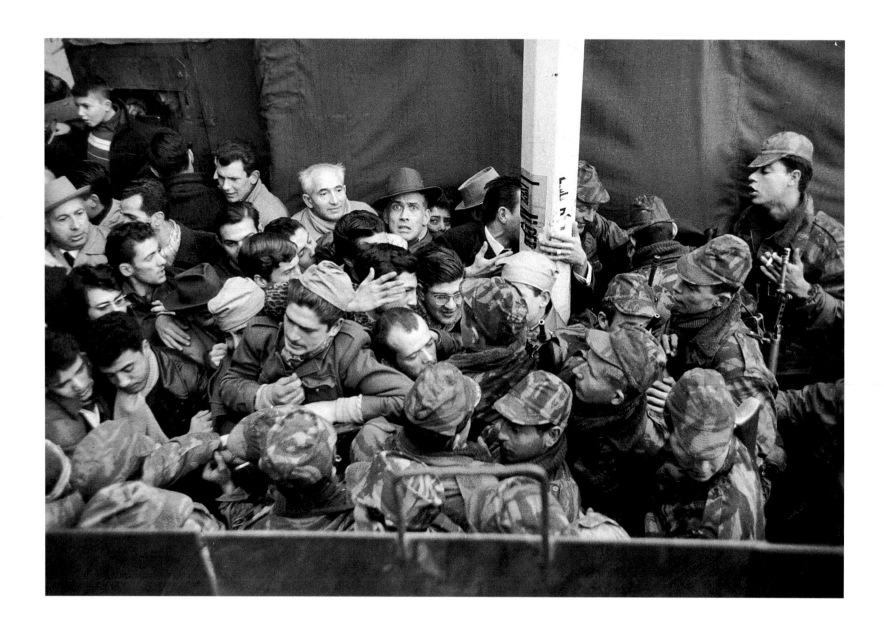

French troops and Algerian natives in the crush caused by the visit of '*Le Grand Charles*'.

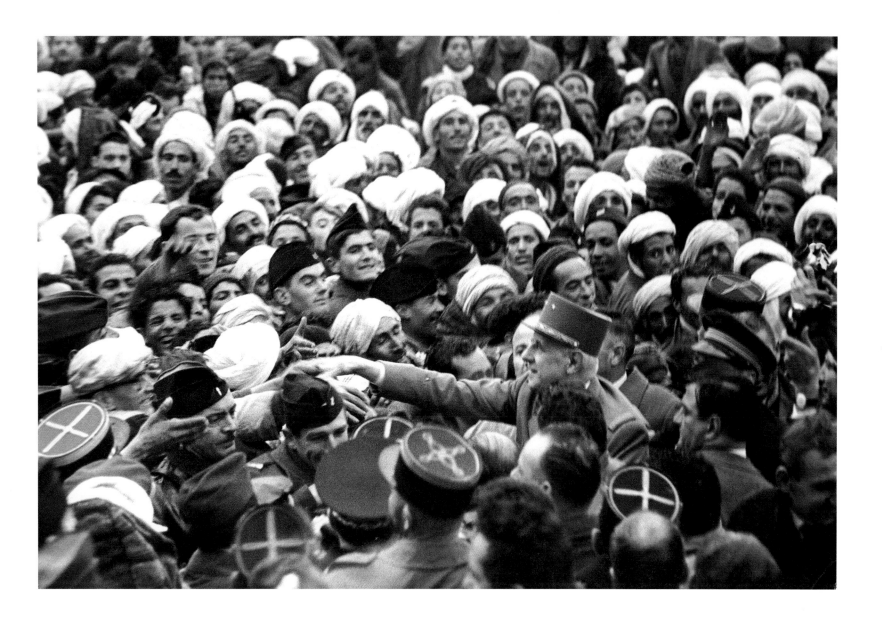

President de Gaulle mingles with ordinary Algerians in Algiers.

French starlets of 1960 include Cathérine Deneuve aged seventeen, second from the left in the back row.

Princess Margaret trying out her fiancé Antony Armstrong-Jones' camera. The results were not published.

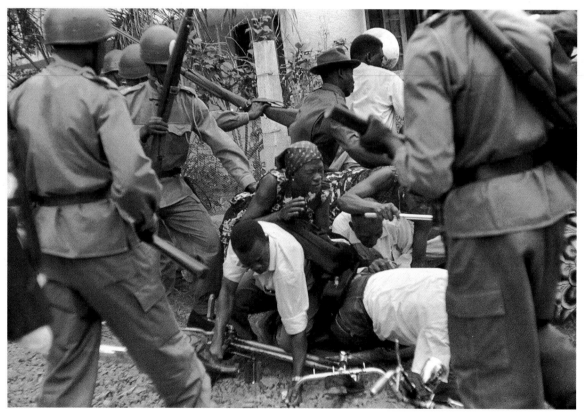

A Nigerian member of 'the House of Chiefs' arriving at the opening of the parliamentary Upper House for west Nigeria in Ibadan.
Rioting in Léopoldville in the Congo Republic photographed by Ian Berry with his customary coolness and empathy.

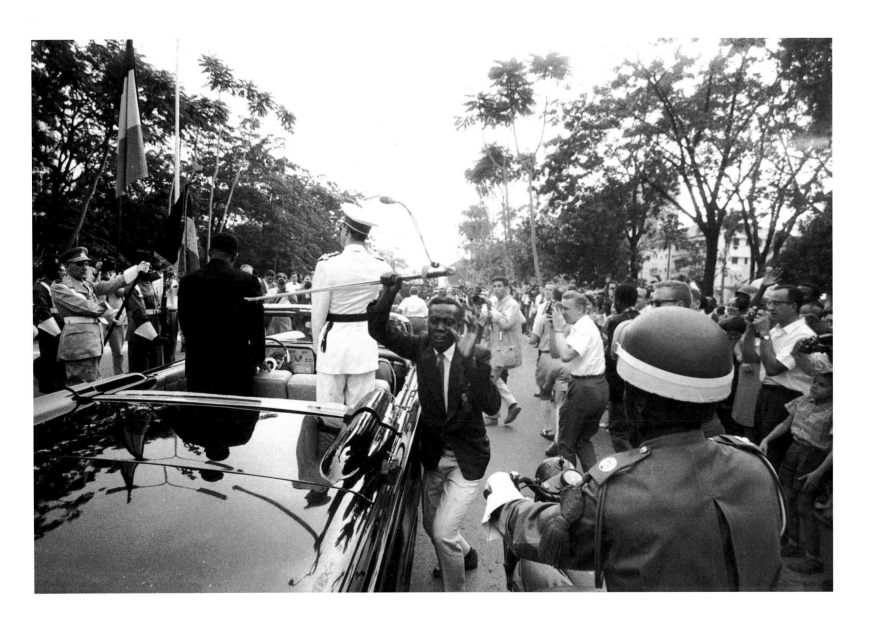

King Baudouin of Belgium losing his sword the day before giving up his colony, the Belgian Congo.

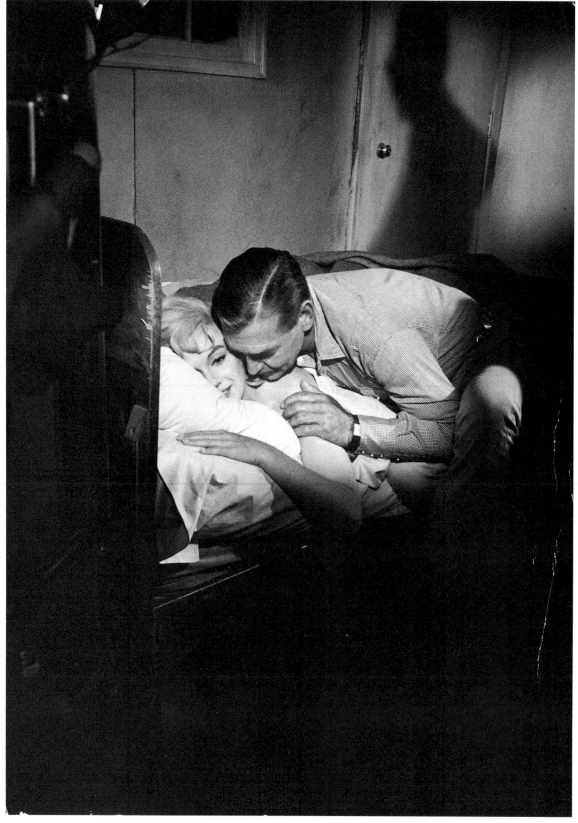

Clark Gable with Marylin Monroe photographed by Eve Arnold on the set of *The Misfits*.

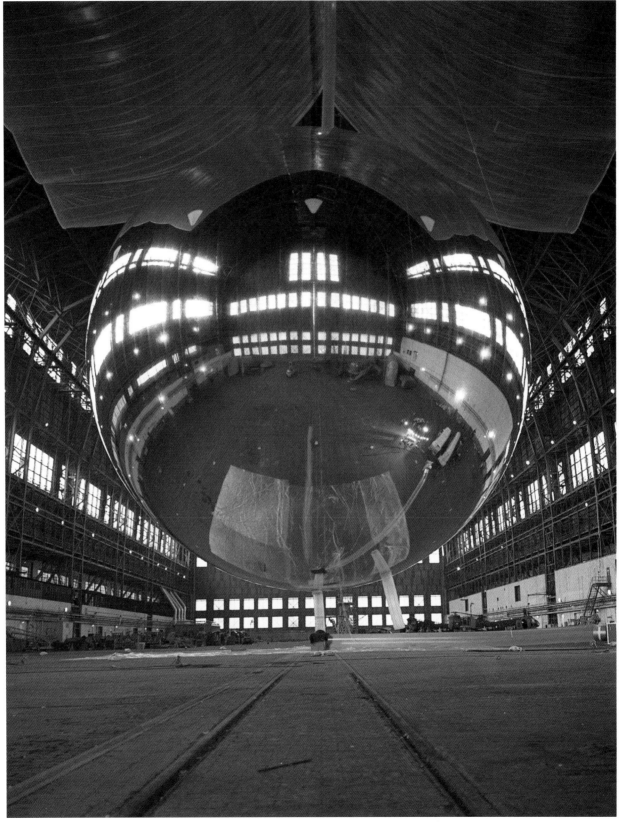

Russia may be about to put the first man into orbit, but the US has gone for size with its vast communications satellite balloon *Echo*.

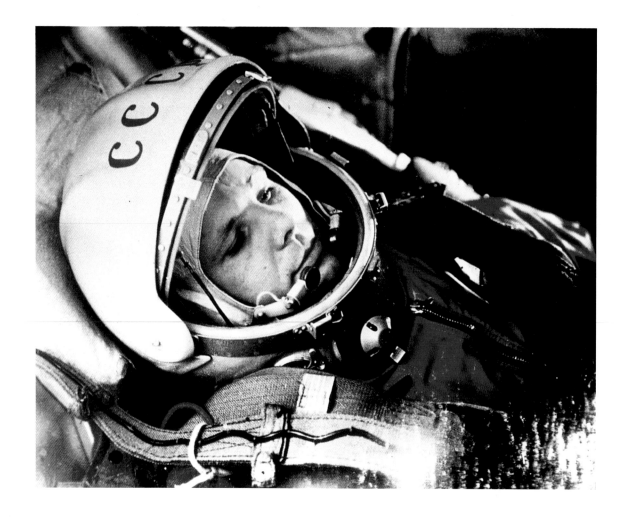

Yuri Gagarin tucked-up in his space capsule before blast-off. He became a national hero after completing the first manned space flight in history.

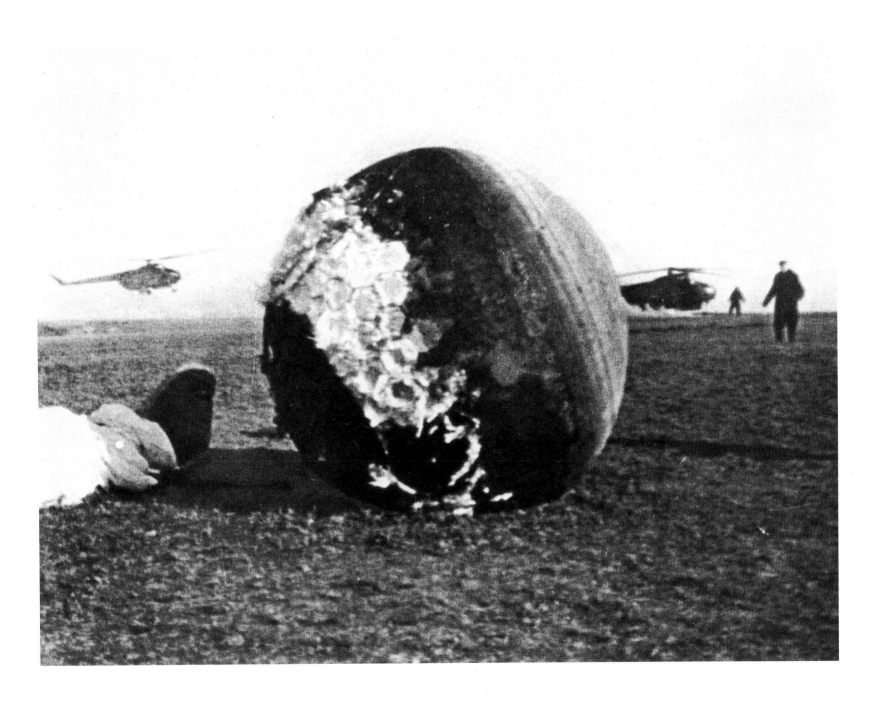

Gagarin back on Earth after one orbit, his capsule charred by re-entry friction.

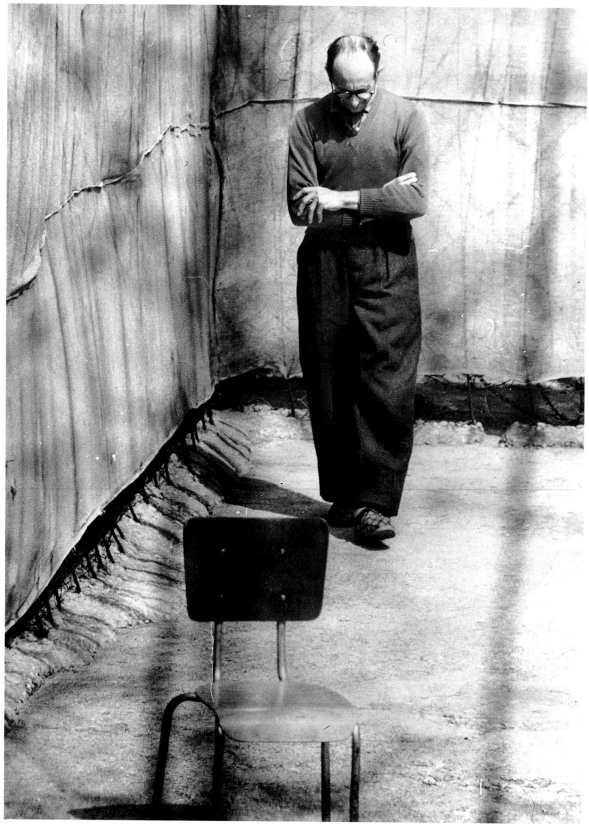

Adolf Eichmann in captivity near Nazareth, Israel, charged with a commanding role in the Holocaust.

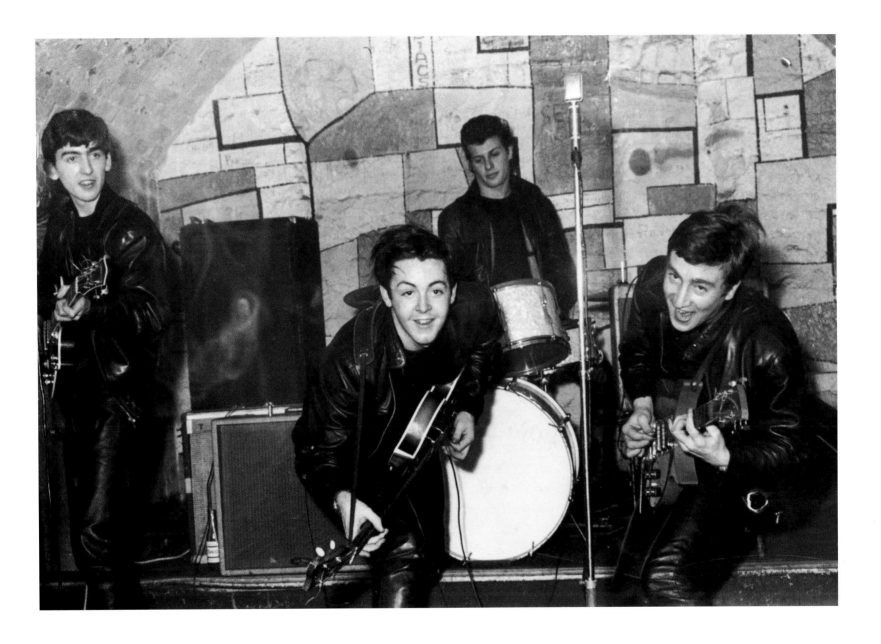

Soon to be the most famous British musicians in history – George Harrison, Paul McCartney and John Lennon (left to right), with
Pete Best on drums – beginning the ascent of the Beatles in the Cavern Club in Liverpool.

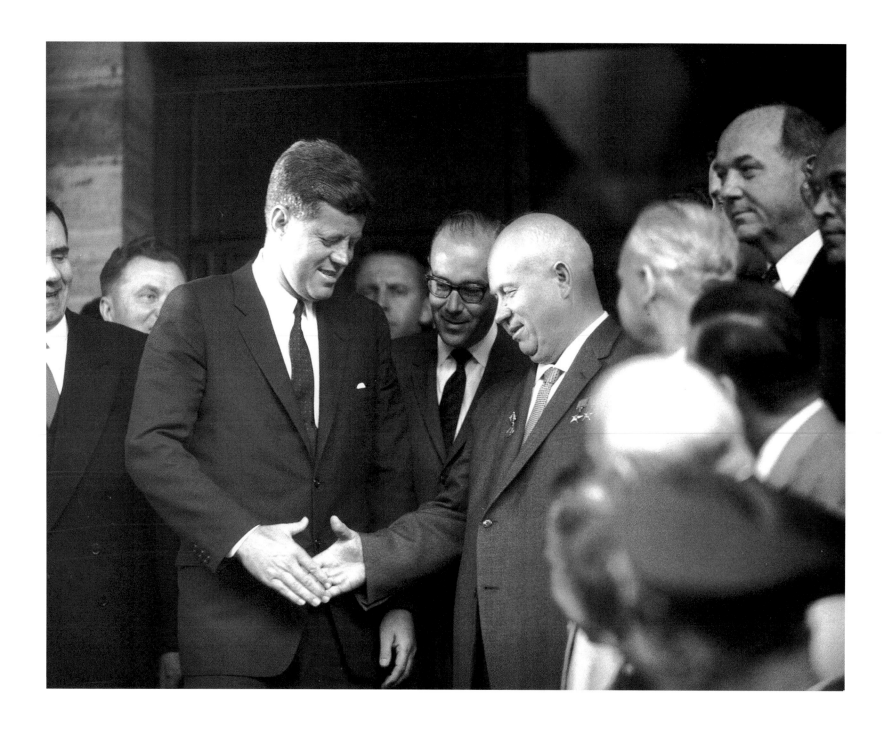

John F. Kennedy and Nikita Khrushchev mock their mutual suspicions at their first meeting in Vienna.

A small part of the Berlin Wall. All windows bordering the western sector were bricked up.

Kwame Nkrumah, first Prime Minister of Ghana, waiting to receive Queen Elizabeth II as head of the commonwealth he has just joined.

The sons of Congolese Prime Minister Patrice Lumumba are shown the debris from a riot protesting against their father's death.

A Japanese action painter photographed by William Klein.

Jeanne Moreau and Oskar Werner in François Truffaut's most famous film *Jules et Jim.*

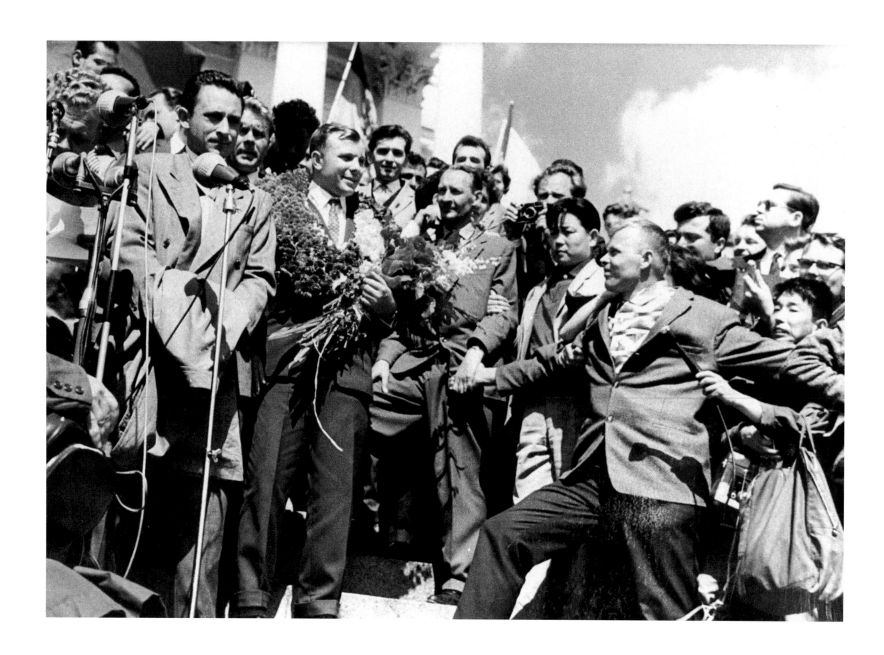

Gagarin, the man of whom nearly everyone was a little proud, being greeted at a youth festival in Helsinki, Finland.

John Glenn about to make the first American manned orbit of Earth – incredibly he would orbit it again thirty-six years later.

A ship that might have sunk the world – a Russian missile carrier heads for home after delivering atomic warheads to Cuba.

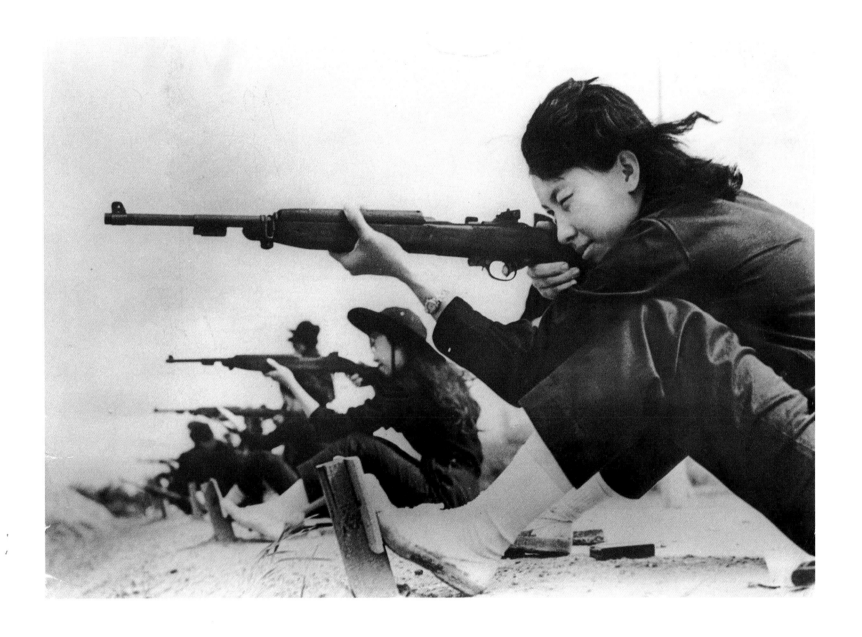

South Vietnamese girls learning to shoot – but they needed to prepare for a different sort of war.

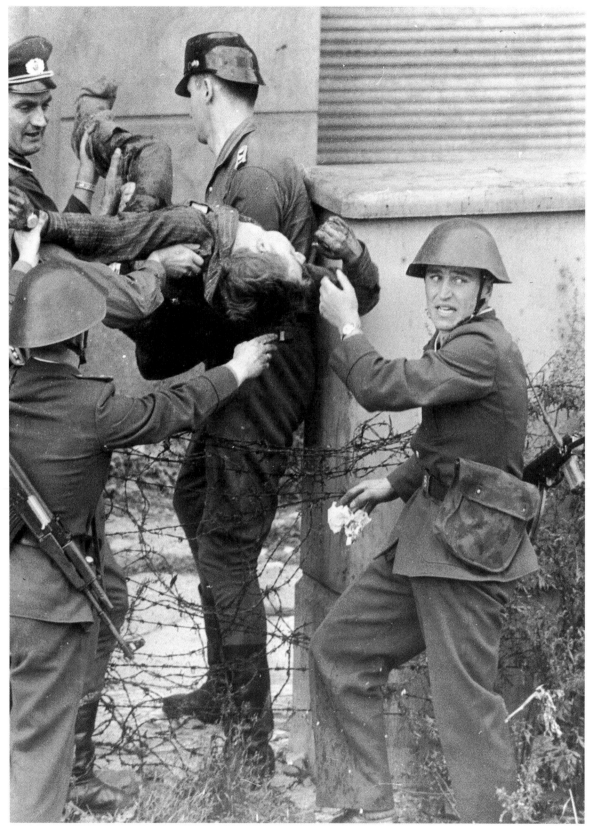

Shot while attempting to escape – East Berlin police retrieving the body of one of their victims.

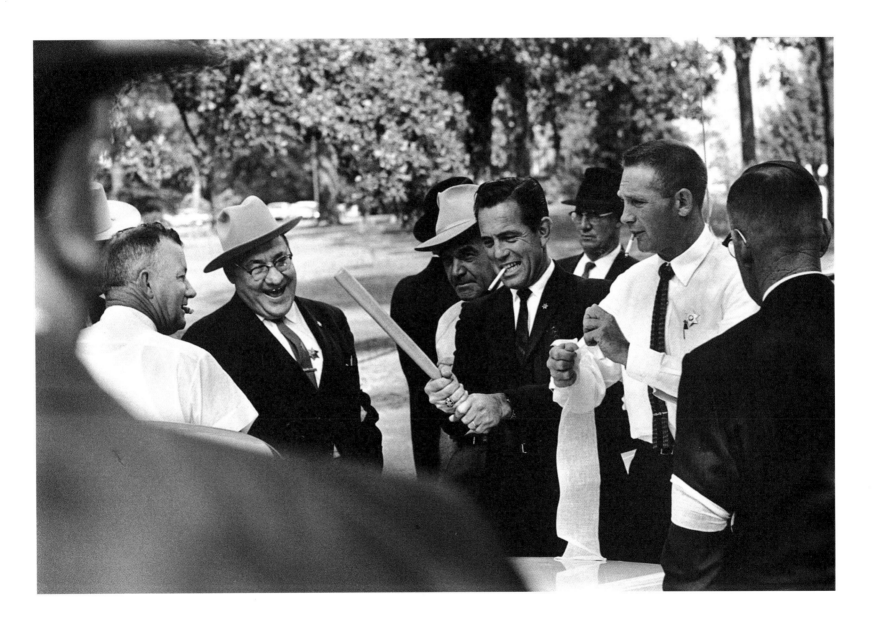

Mississippi police unrepentent at having refused to protect the first African-American student enrolled at their university.

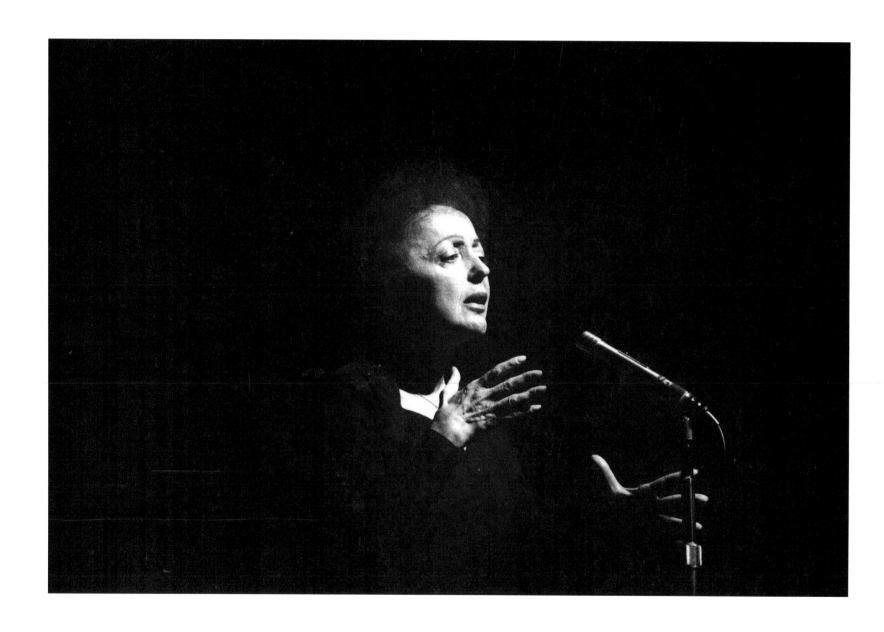

Edith Piaf, the 'little sparrow' and famous Paris *chanteuse*, casting her spell.

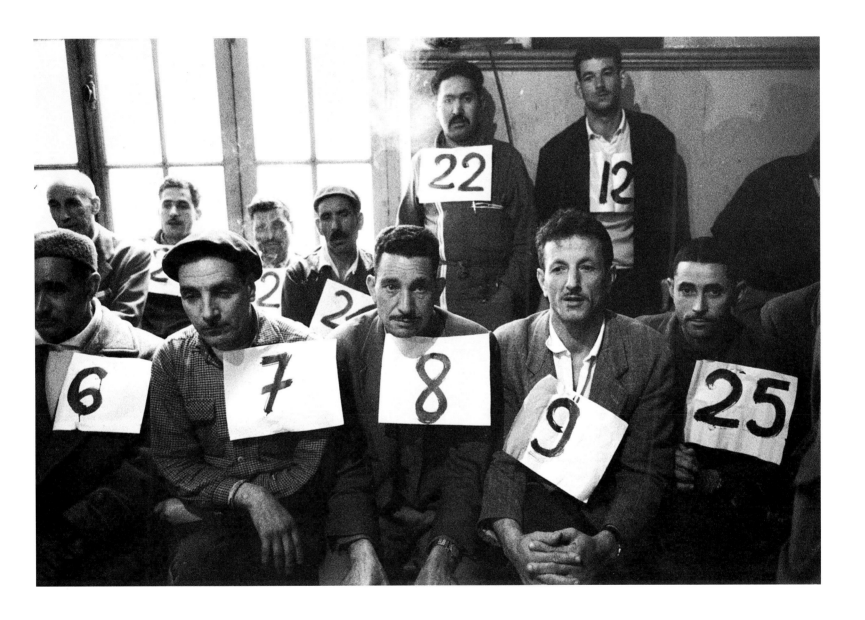

In newly-independent Algeria electoral candidates wear numbers to enable the illiterate to vote for them.

A Liverpool docker at a protest meeting against employers using only casual labour.
Colin Jones' portrait of a man whose self-possession and general demeanour anyone might envy.

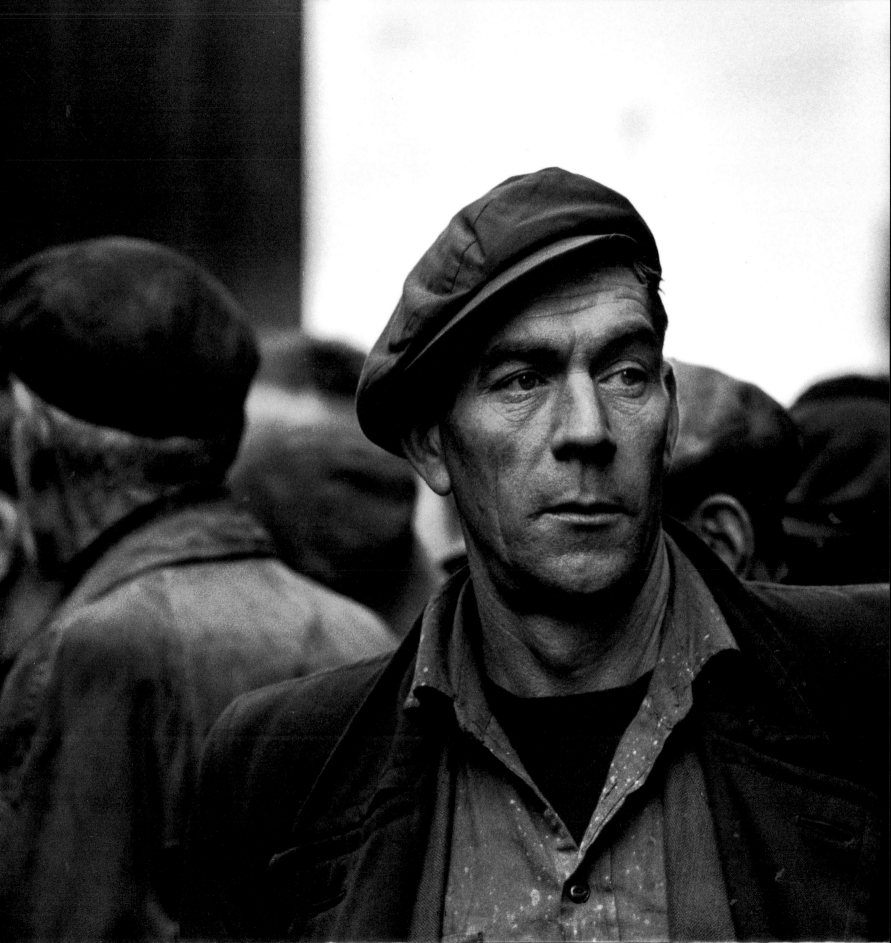

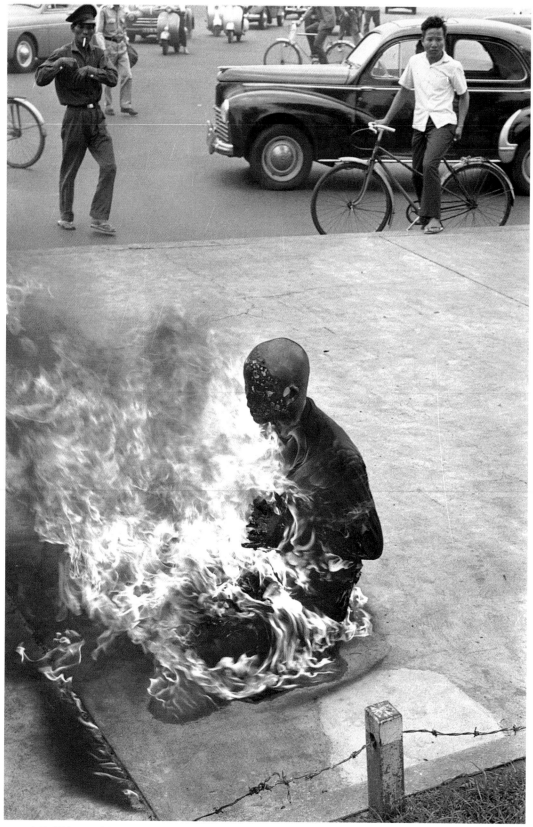

A Buddhist monk burns himself to death in protest against the Saigon government's anti-Buddhist policies.

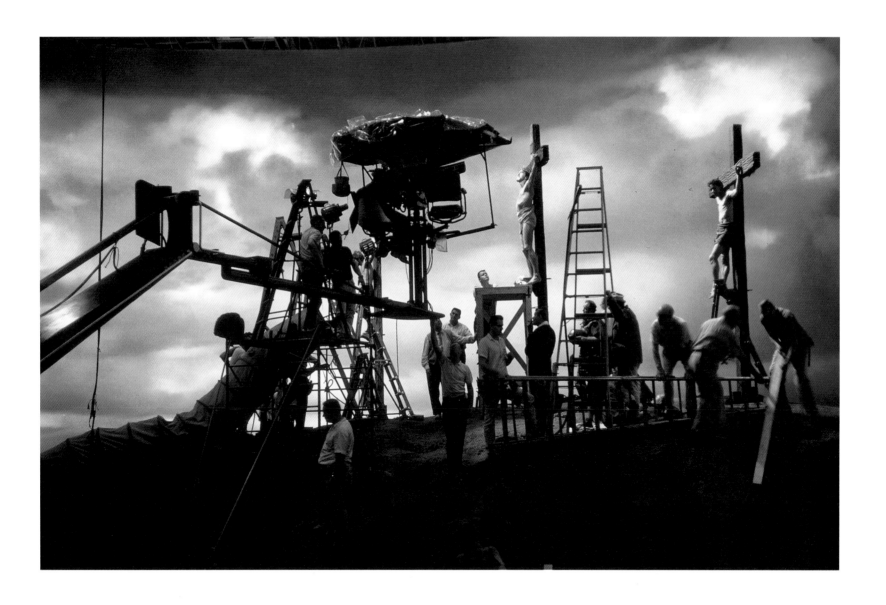

The salvation of mankind through the Crucifixion required considerable technological and financial resources from Hollywood to become *The Greatest Story Ever Told*.

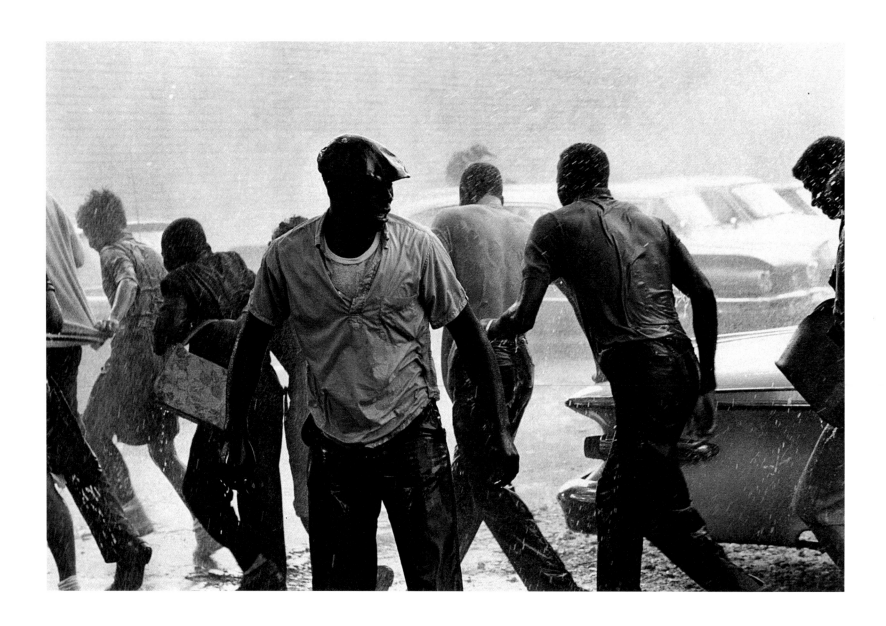

A civil rights demonstrator turns to face the police fire hoses in Birmingham, Alabama.

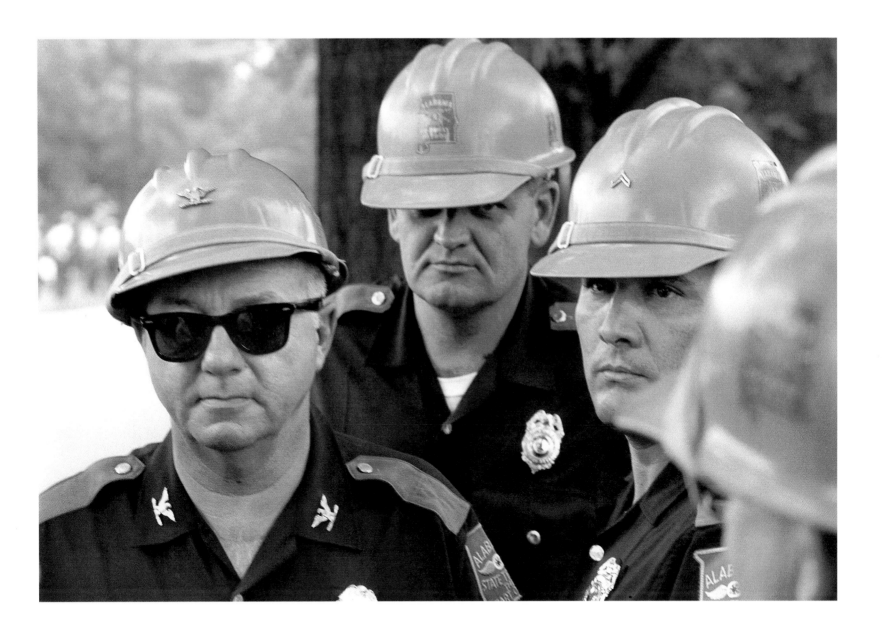

Mistrustful Alabama patrolmen watching African-Americans intent on racial integration.

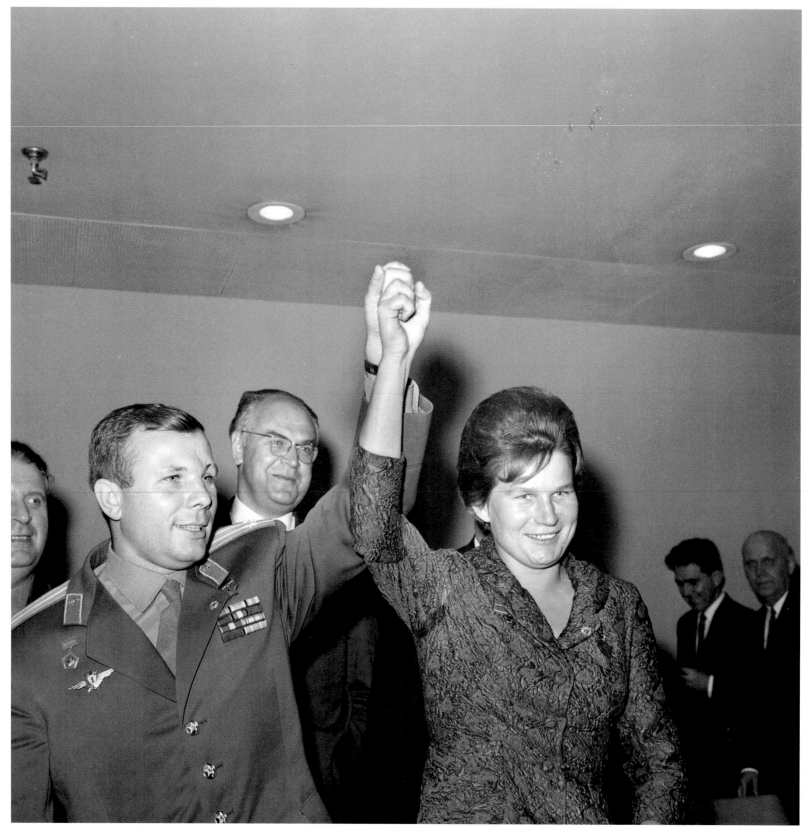

Yuri Gagarin and Valentina Tereshkova, the first woman in space, acknowledging an ovation at the UN General Assembly.

Retired man and his wife at home in a nudist camp one morning, New Jersey, 1963. Photograph by Diane Arbus.

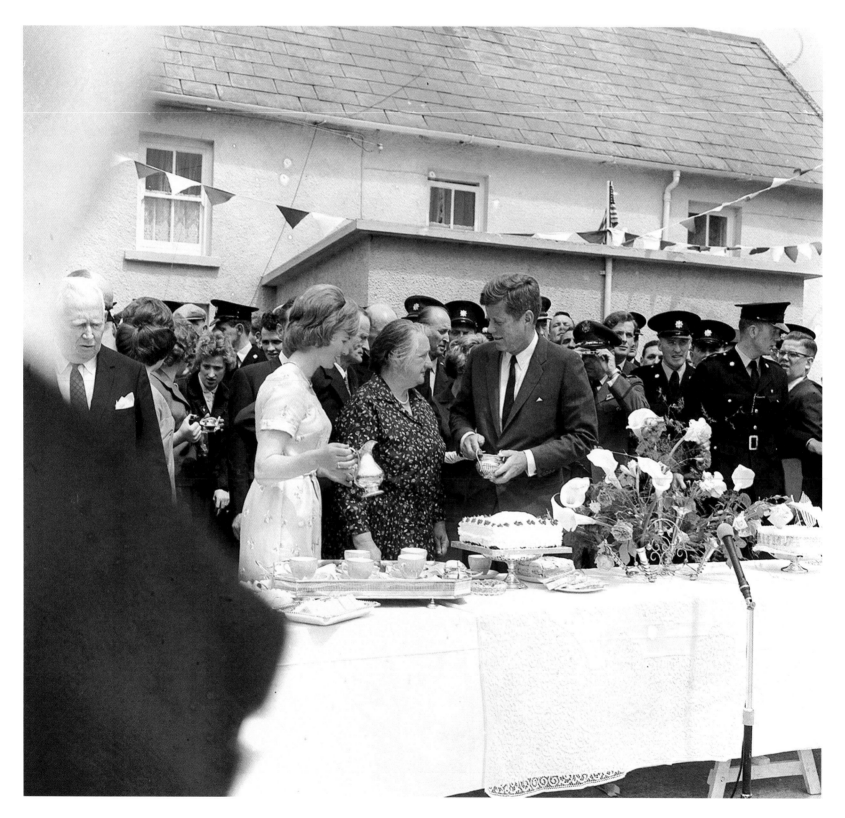

A street party for President Kennedy in his ancestral village of Dunganstown in County Wexford, on his visit to Ireland.

Lee Harvey Oswald's second bullet has just struck the President and Jacqueline can only hold on to him.

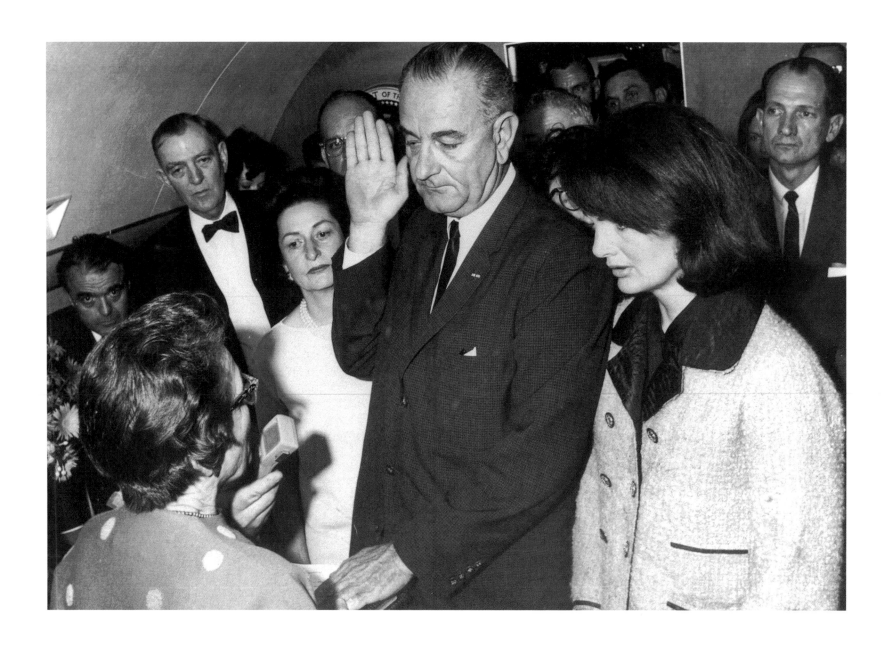

Lyndon Johnson with his wife Lady Bird and Jackie Kennedy, being sworn in as President of the United States aboard *Air Force One*.

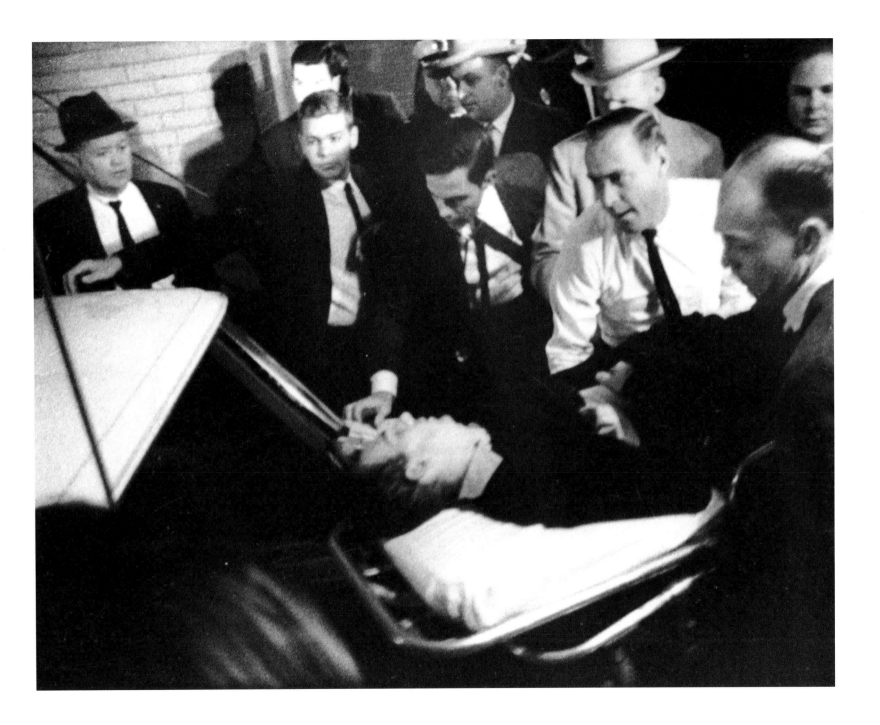

The assassin Oswald – himself just shot by a man called Jack Ruby – being taken to hospital where he soon died.

Winston Churchill leaving for his last appearance at the House of Commons. Tears were surely shed, including a few by the great man himself.

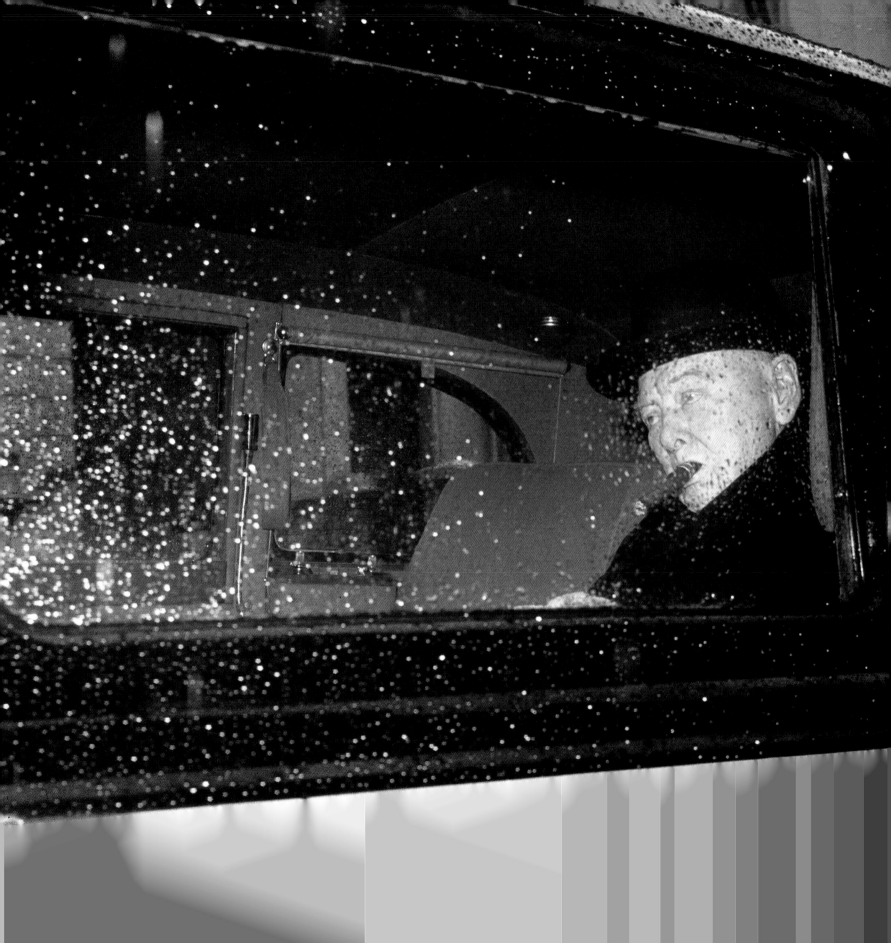

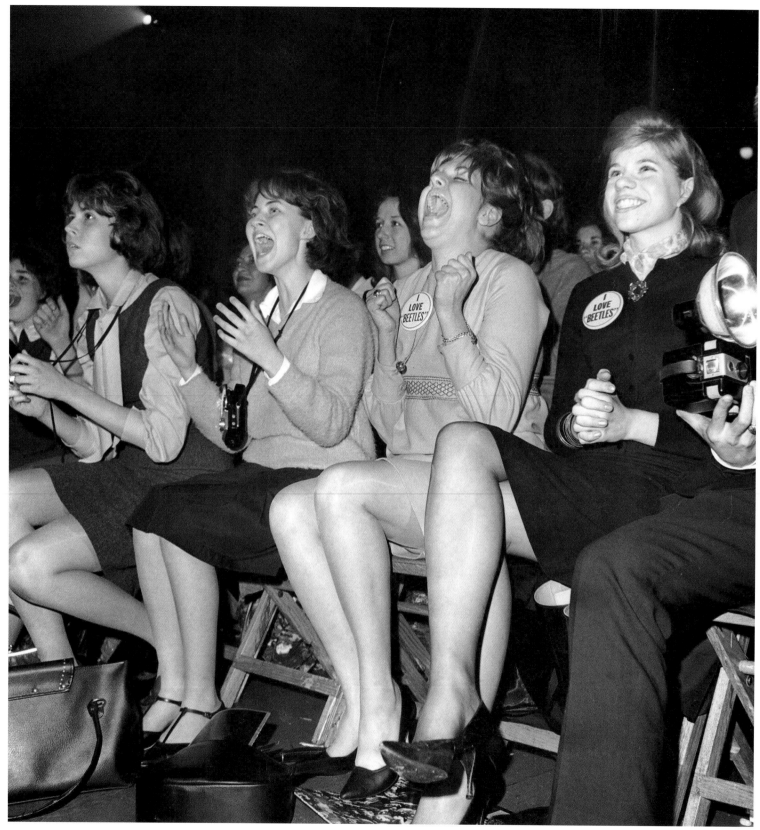

A new kind of epidemic – Beatlemania hits America.

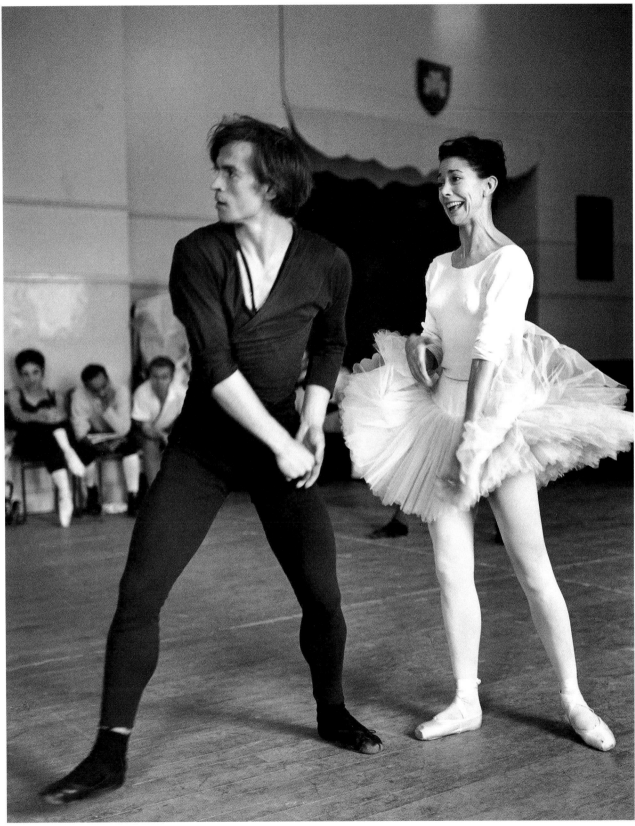

Fonteyn – most beautiful of ballerinas – and Nureyev – supreme dancer and muscular Narcissus – photographed in rehearsal by Jane Bown.

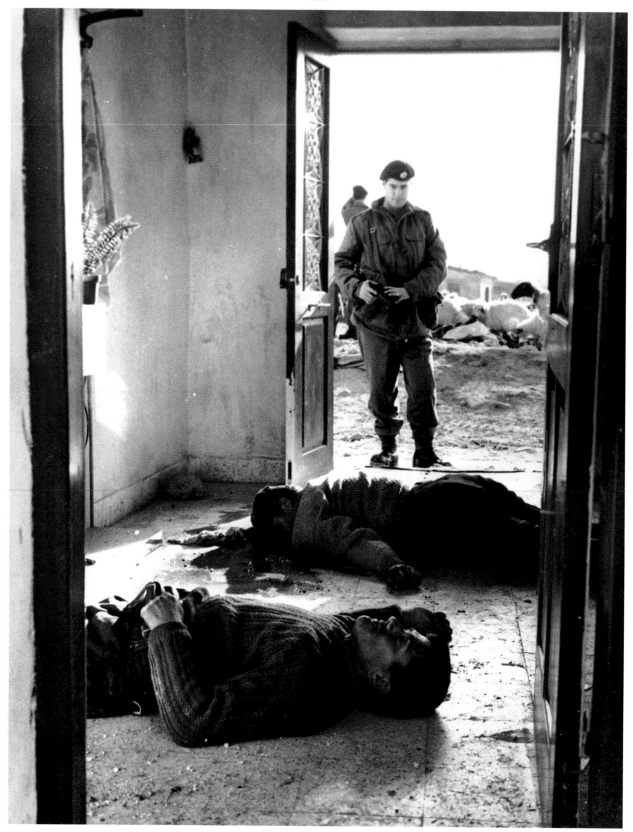

An unnamed press photographer found a British soldier looking at two Turks killed by Greeks in Cyprus ...

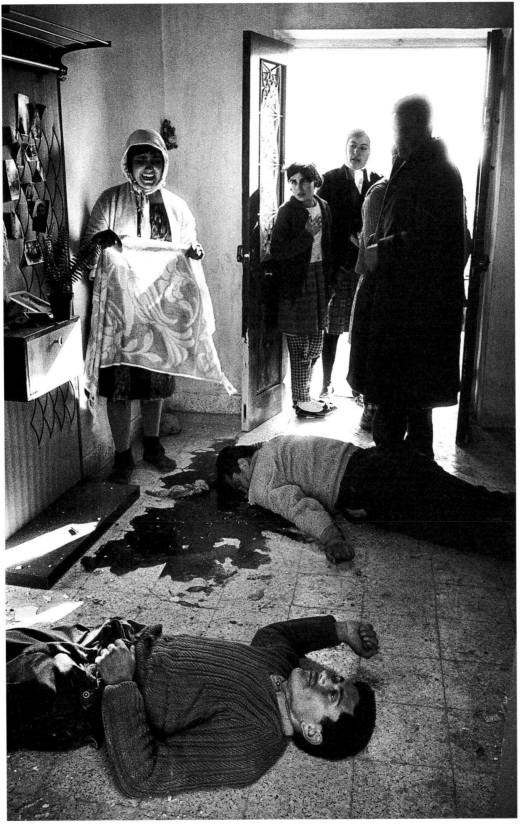

... minutes before Don McCullin recorded the family's response.

Genuine jollity at the Commonwealth Conference in London – Robert Menzies of Australia, Sirimavo Bandaranaike of Ceylon and Kwame Nkrumah of Ghana.

Harold Wilson becomes Britain's first Labour Prime Minister in a long time – he faced a tough challenge.

A fierce supporter of Barry Goldwater's presidential campaign.

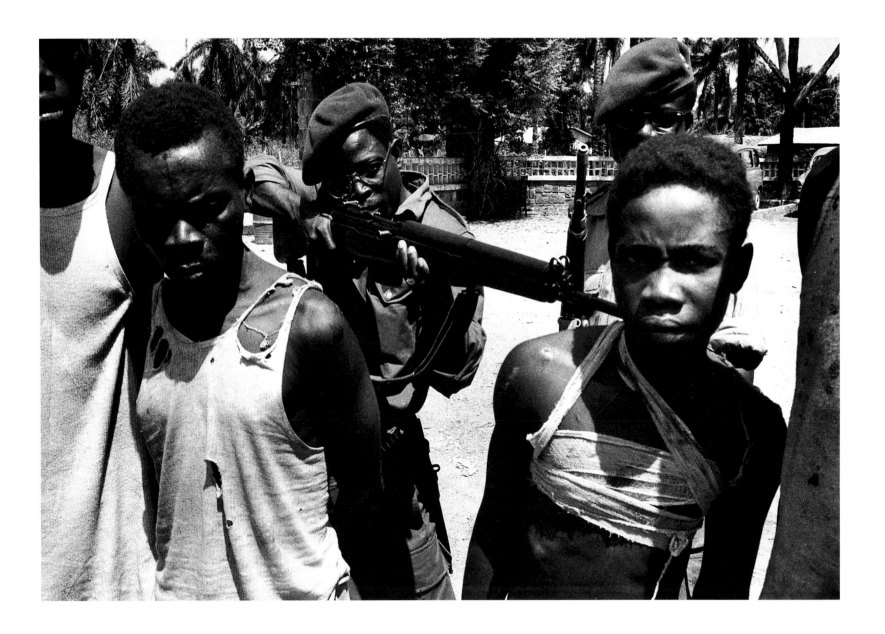

Lumumbist freedom fighters about to be executed by Congolese soldiers.

Despite legislation that classified blacks as second or third-class citizens, many white South Africans were brought up by their black nursemaids.

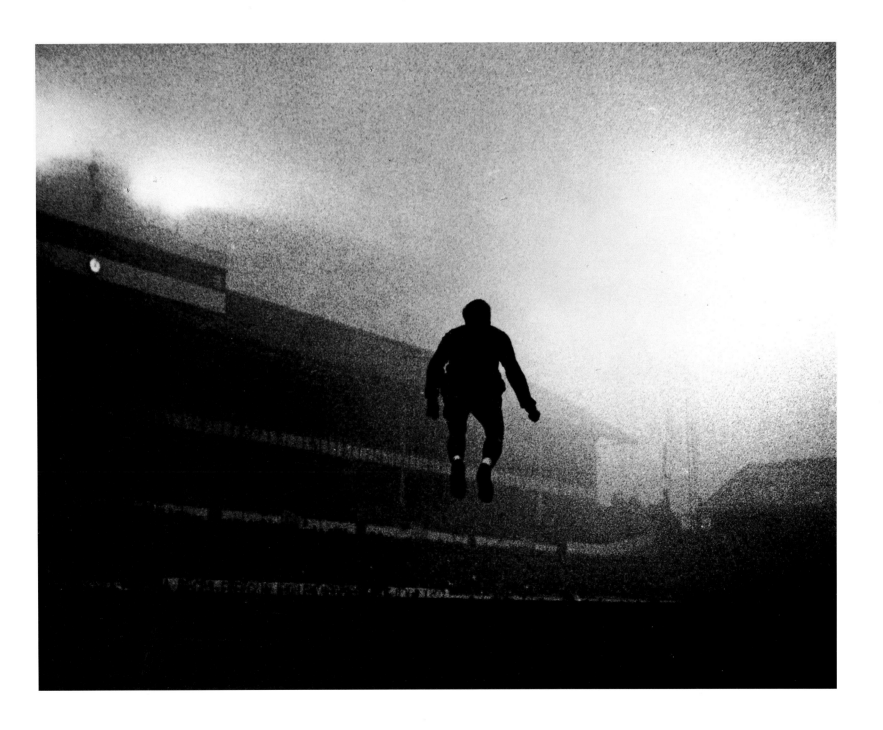

Sports photographer Gerry Cranham captures a great leap by the Tottenham goalkeeper – jumping to see his team attacking.

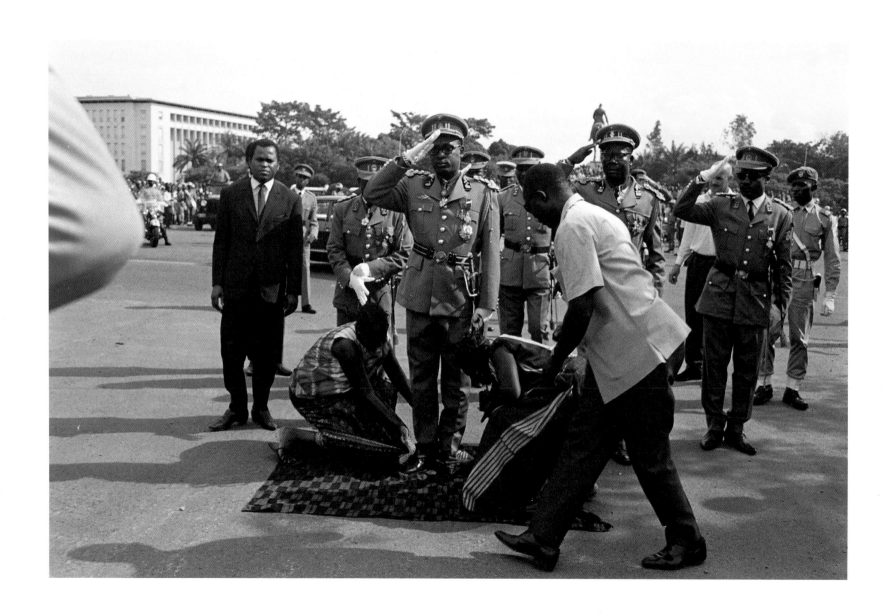

President Sese Seko Mobutu – one of the greediest new African dictators – having his shoes polished on assuming power in Congo.

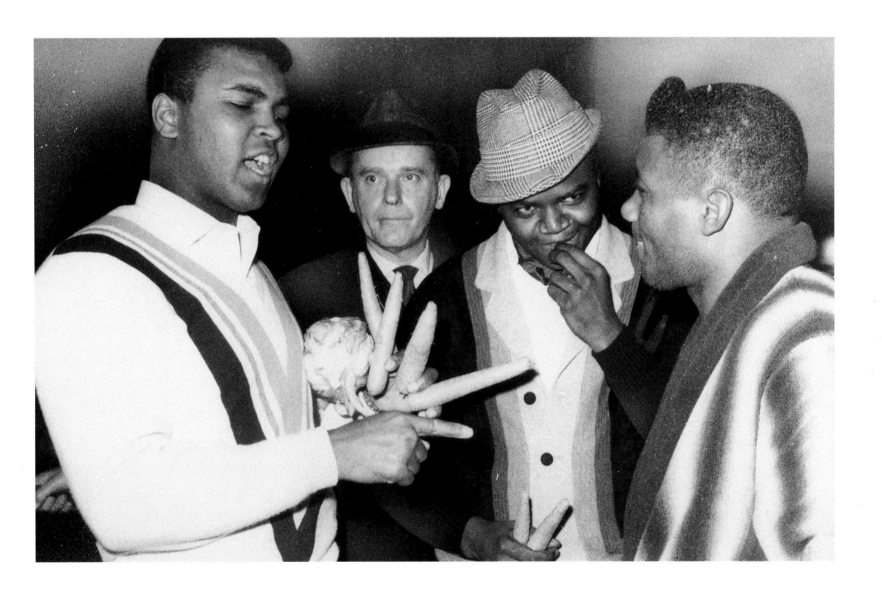

Muhammed Ali offering a good-humoured Floyd Patterson – whom he nicknamed 'the rabbit' – some nourishment before sending him back to the warren.

A South Vietnamese officer interrogating a Vietcong suspect
caught in the Mekong delta.

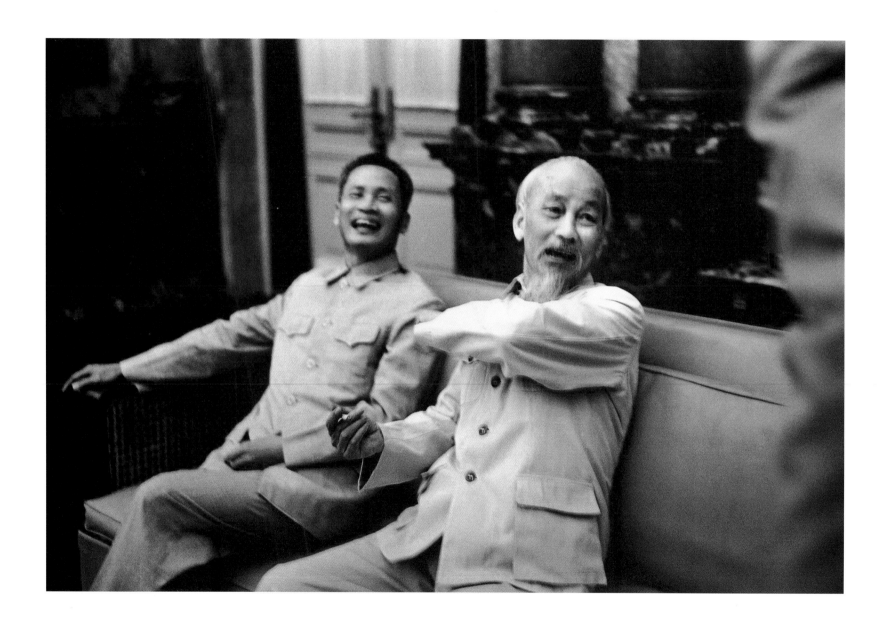

Ho Chi Minh (right) and Pham Van Dong, the political and military geniuses of North Vietnam,
being interviewed by journalist James Cameron and photographed by Romano Cagnoni.

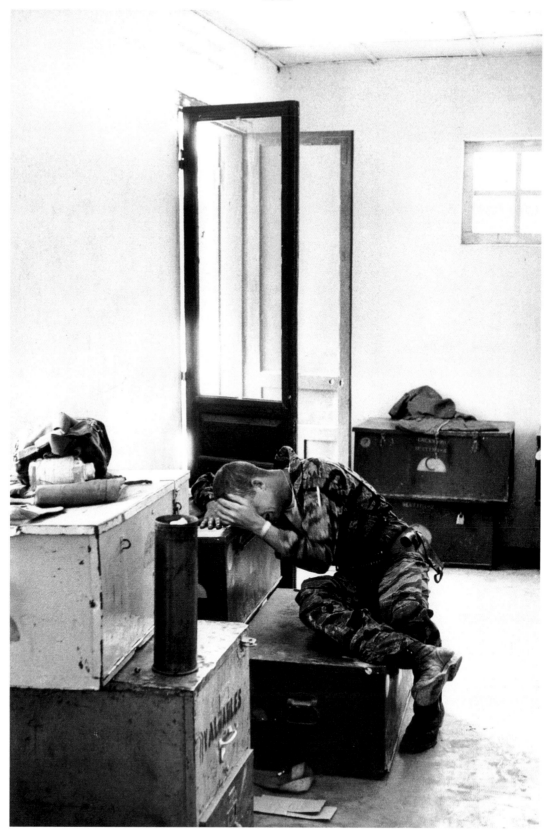

American crew chief James Farley breaks down after failing to rescue one of his pilots who was shot down during a sortie.

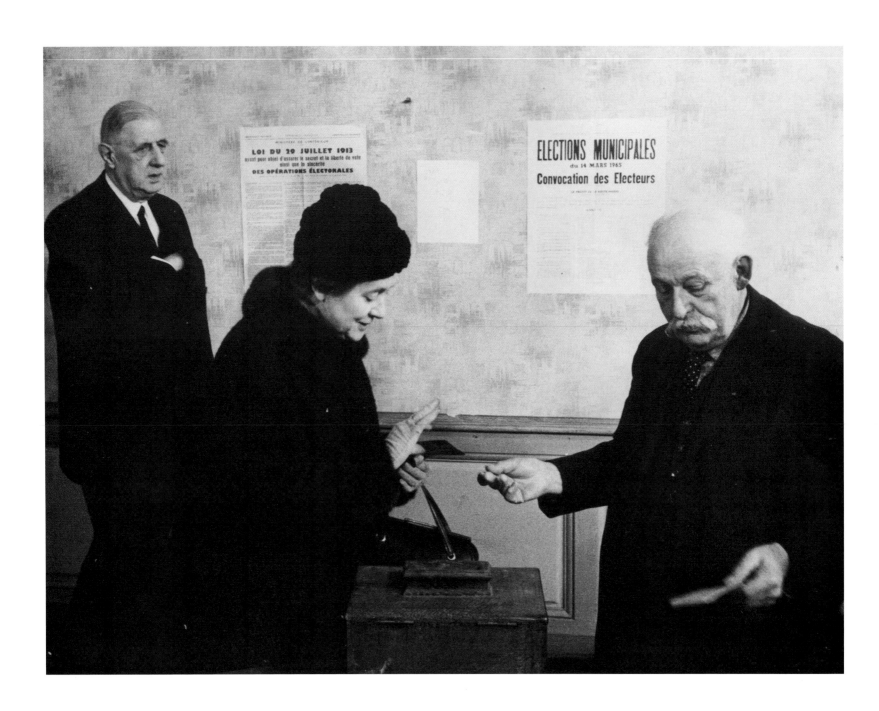

General and Madame de Gaulle casting their votes in local elections at Colombey-les-deux-Eglises.

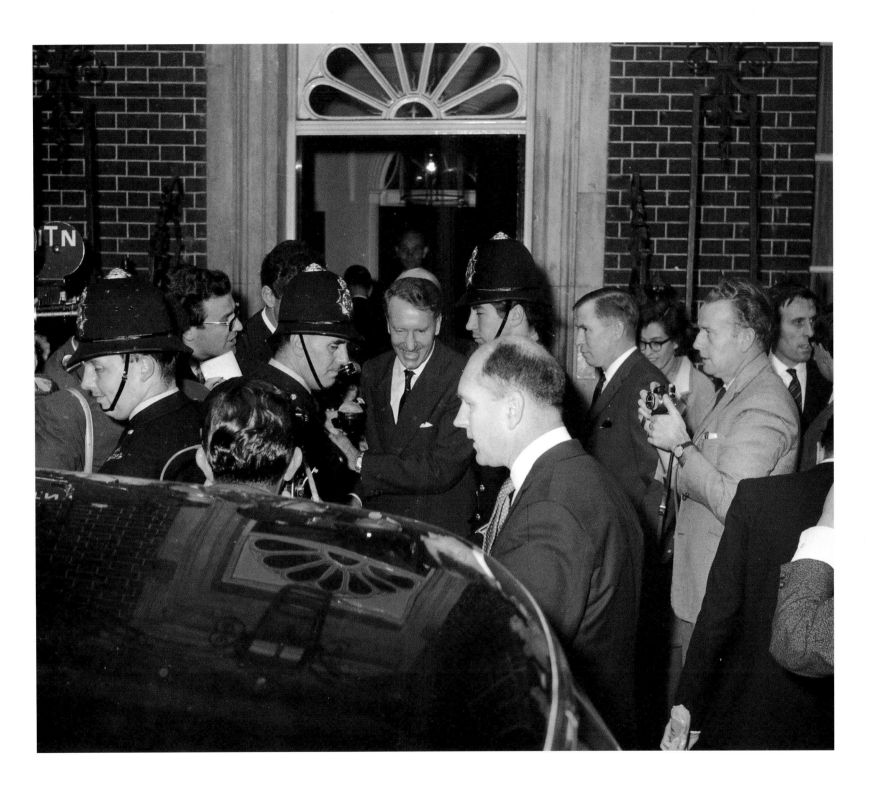

Ian Smith, Prime Minister of breakaway Rhodesia, leaves 10 Downing Street after talks with Harold Wilson.

1946

472–73. On 20 November 1945 legal proceedings began against some of the leading figures of the Nazi regime. The military tribunal was composed of judges from the Allied countries and was located symbolically in the Bavarian city of Nuremberg where the Nazis had held their annual mass rallies in the 1930s. The first and most famous trials were those of Rudolf Hess and Hermann Göring who both faced the death penalty for Crimes Against Humanity. Once thought to be Hitler's natural successor, Göring's influence had waned during the war because of perceived incompetence in his management of the air war, his well-known drug addiction and his insatiable vanity. Göring confidently assumed the role of chief spokesman for the defendants at the Nuremberg Trials. He was impressive in his own defence against indisputable evidence implicating him in many of the worst Nazi atrocities. Göring was sentenced to death, but less than three hours before his execution he committed suicide with a fatal dose of poison. How he smuggled the poison into his cell remains a mystery. In all, 177 people were tried at Nuremberg, twenty-four of whom were sentenced to death, although only half the death penalties were carried out. The tribunal produced extensive documentation which revealed the full extent of the horrors of the Nazi regime for the first time.

474. The devastation of Dresden was a symbol of Germany's defeat. Once a majestic German city, Dresden had been considered immune from Allied air strikes because of its unique architectural beauty. Germany was almost destroyed by the time it finally conceded defeat in 1945. Its economic and transportation infrastructures had been wiped out and over 50 per cent of housing had been demolished in urban centres. After the war governmental responsibilities passed to the occupying Allied powers.

475. In December 1942 Sir William Beveridge, Master of University College, Oxford, published a landmark report on the need for a comprehensive system of state-sponsored social insurance in Britain. This was necessary to check the persistent problems of squalor, disease and unemployment which had worsened in Britain during the 1930s. His proposals were of great interest to the Labour Party, especially to its leader, Clement Attlee. During the general election in July 1945, Attlee exploited Prime Minister Churchill's wartime estrangement from domestic affairs to persuade the electorate that the Labour Party was fully committed to wholesale reform and was the best party to tackle the challenges of post-war Britain. Following his landslide victory, Attlee used the Beveridge Report as a blueprint for a series of legislations passed between 1945 and 1948, which included the National Health Service and National Insurance Act. These formed the basis of the modern British welfare state.

476. When Germany surrendered, the Allied powers took control of the country. It was divided into four occupied zones: Britain governed in the north, the Soviet Union in the east, America in the south and France in the west. The process of de-Nazification and immediate post-war reconstruction proceeded relatively smoothly under the British, American and French administrations, with peaceful and often friendly relations developing between occupation forces and ordinary Germans. In the area of Soviet control however, administrators introduced widespread censorship and suppressed all forms of dissent. Industries were nationalized without compensating former owners and free, multiparty elections were abolished.

477 top. Britain's King and Queen had continued to reside in bomb-damaged Buckingham Palace during the war, in breach of the King's own wartime regulation of evacuation. This was intended to demonstrate the nation's resolve in the face of *Luftwaffe* air raids. Princess Elizabeth served in the Auxiliary Transport Service, and further reinforced a sense of shared purpose – and danger – among the British and their Royal family. In 1946 the King and his family visited the Royal Opera House in London; this was the year the Royal Ballet and Royal Opera were established as the theatre's permanent resident companies.

477 bottom. The 1946 romantic spy thriller *Notorious* starring Cary Grant and Ingrid Bergman was directed by Alfred Hitchcock, a master of suspense films. In keeping with his penchant for casting Hollywood's biggest stars, the English-born director chose the dashing and sophisticated Grant to play an American agent who falls for the charms of an international jet-set playgirl and daughter of a Nazi war criminal, played by the beautiful Swedish actress, Ingrid Bergman. The chemistry between the two stars, combined with Hitchcock's innovative and stylistic camera work, made *Notorious* one of the most popular films of the 1940s.

478. In August 1942 Mahatma Gandhi and several of his Hindu Indian National Congress (INC) colleagues were imprisoned by the British authorities for encouraging 'Open Rebellion', i.e. civil disobedience campaigns among Indians designed to obstruct the war effort. Upon his release in 1944, Gandhi continued the struggle against British rule and became a leading figure in independence negotiations with the British Cabinet Mission. His attention was increasingly focused on the increase in communal violence between Hindus and Muslims. This was caused in part by Muslim separatists who benefited greatly when many of India's Hindu leaders were imprisoned. Gandhi fasted in protest against this violence. Here a desperately weak Gandhi is shown attending a prayer meeting after which one hundred Indian religious leaders gave him a peace pledge in order to encourage him to end his fast.

479. A Hindu man who had been severely beaten with lathies during the Hindu-Muslim riots in Bombay in September 1946. In 1946 the British Cabinet Mission to India offered the country full independence, but India's leaders could not agree on a plan acceptable to the two main parties, the Hindu Congress and the Muslim League. The leader of the Congress Party, Jawaharlal Nehru, demanded sovereignty for the Hindu popular majority, while Mohammed Ali Jinnah of the Muslim League insisted on separate Muslim homelands. Jinnah called on all Muslims to launch a 'Direct Action Day' on 16 August. Massive communal rioting swept across the subcontinent, especially in those areas where Muslims and Hindus lived together. It was the beginning of the bloodiest year in India for nearly a century.

1947

480. The civil war in China temporarily abated during the Second World War but erupted again in early 1946 following the final collapse of the United Front (the precarious coalition between the nationalist Kuomintang and the communists in the fight against Japanese invaders). The American mediation effort also broke down that year. A year later in 1947, the communists' organization and popular base enabled Mao's forces to gain the upper hand over Chiang Kai-shek's nationalist troops. By the summer the Kuomintang had lost half of their territory in Manchuria and indecisive leadership led to mass desertions across the country.

481. Emperor Hirohito's support for Japan's ruthless wartime imperialism in the Far East and his country's alliance with Nazi Germany led to the request in 1945 by several countries – notably China, New Zealand and Australia – that he be tried as a war criminal. General MacArthur refused, believing Hirohito's cooperation with occupation forces and the nation's new constitution (drafted by occupying US authorities), would give legitimacy to the new democratic structures being formed in Japan. During the transition from occupation to self-government Hirohito, who was allowed to remain as Emperor but without divine status, made significant efforts to bring the monarchy closer to the Japanese people. He made numerous public appearances and gave extensive interviews. Eventually he visited a number of Japan's wartime enemies, including Britain and the US.

482. Born into a poor family in Buenos Aires, Eva Perón had won modest acclaim as a stage and radio actress before she married the future Argentine President Juan Perón in 1945. She displayed a surprising gift for politics and during her husband's first term as president (1946–51) she became an unofficial political figure and national leader. She was adored by

the country's working classes. The establishment derided her flamboyant behaviour and bombastic pleas to improve conditions for the poor in Argentina, but Evita, as she was affectionately known, played an indispensable role in gaining popular support for her husband's policies.

483. Eva Perón at an official ceremony during a visit to Spain in 1947, the year General Franco was declared head of state for life. Perónism, as Juan Perón's policies were collectively known, was an ill-defined ideology designed to bring industrialization and greater economic and social benefits to Argentina's working classes, blending populism, authoritarianism, nationalism and international non-alignment. Its success depended heavily, both at home and abroad, on the magnetic appeal of Eva Perón. This allowed her to exercise a quasi-official legislative power. She became Argentina's *de facto* Minister of Labour and Health, and was largely responsible for the introduction of women's suffrage. Eva Perón died of cancer in 1952. There were loud calls in Argentina for her canonization. Her remains have been the subject of intense disagreement among political figures intent on eradicating the legacy of Perónism's greatest symbol.

484 top. Hagana, a Jewish defence organization fighting for an independent Jewish state in Palestine, purchased the *Exodus* to transport Jewish immigrants from Europe to Palestine after the Second World War. The ship, carrying 4,544 Jewish refugees all hoping to build a new life in Palestine, was boarded by British authorities when it reached Palestine, which at that time was under British mandate. Three passengers were killed in skirmishes before the refugees , were transferred to British ships returning to Europe. British soldiers boarded the ships at Hamburg and forcibly disembarked the immigrants in Germany. The incident did much to move world opinion against Britain's policy in the Near East, and in favour of establishing an independent Jewish homeland as advocated by American-Jewish

activists. The State of Israel was proclaimed on 14 May 1948. The following day Britain announced the official end of its mandate in the territory.

484 bottom. In 1945 Werner Bischof, a Swiss-born photographer, began to make his personal record of the devastation left by the Second World War. He travelled with the Red Cross, photographing the organization's efforts to resettle refugees and care for the sick in those areas hit hardest by the war. During this period Bischof became fascinated with children, the most innocent victims of war, whom he saw capable of demonstrating astonishing resourcefulness and resilience under even the bleakest of circumstances.

485. After the war British and American forces captured roughly 4 million German POWs. Some were released as early as three weeks after the German surrender and, by the end of 1948, all German POWs in Western hands had been freed apart from those sentenced for war crimes. The treatment of German POWs varied widely depending on which Allied power had taken them captive. During the immediate aftermath of the war, brutal revenge attacks on German soldiers were common as the extent of Nazi crimes became apparent. But in general the Western powers adhered to the Geneva conventions on the humane treatment of prisoners. German POWs in Soviet custody were not so lucky. The mortality rate was several times that of Germans captured by the Allies – about 95 per cent of German soldiers captured by the Soviets during 1941–42 did not survive the war. By 1945 the death rate was still around 25 per cent. Stalin was slow in releasing German POWs who provided cheap labour for Russia's post-war reconstruction.

486. Producer Joe Sistrom with film stars Humphrey Bogart, Evelyn Keyes and Lauren Bacall, members of the Committee for the First Amendment (CFA), in Washington to protest against attacks on Hollywood by the House Un-American Activities Committee (HUAC). With the onset of the cold war, a 'Red Scare' spread throughout American society. HUAC was founded in 1947 and given the right to investigate and purge America of all

suspected communist influences. The high profile enjoyed by the film industry made it a prime target for such investigations.

487. HUAC's investigation of the film industry (along with other industries and government agencies) was prone to excess and distortion from the outset. Its agenda was to establish that certain Hollywood actors and filmmakers inserted subversive communist propaganda into their films, and more generally that the Screen Writers Guild was rife with Soviet sympathizers. Despite meagre evidence, dozens of promising Hollywood talents were 'blacklisted' and their careers destroyed.

1948

488. Mahatma Gandhi spent the final months of his life attempting to cool the passions inflamed after independence and partition of the subcontinent. Deeply disturbed by the division of India and the Hindu-Muslim violence that accompanied it, Gandhi used his much publicized fasts to disgrace the main instigators of the violence and prevent wider bloodshed. On 11 January 1948 Gandhi began a fast in protest of the treatment of Muslims in Delhi. Less than three weeks later he was assassinated by a Hindu fanatic outraged by his show of benevolence towards the country's Muslims.

489. Citizens of Shanghai lining up to change their old currency into the new gold yuan. Desperate to control inflation caused by spiralling military expenditures, the Kuomintang leadership introduced a new currency to replace the old notes at the rate of 3 million to one. People were also required to sell their gold, silver and foreign currency at a fixed rate. However the government continued to spend vast sums of money on their faltering troops and inflation continued. Morale crumbled in Kuomintang-held cities as prices skyrocketed once again. Popular support for the communists grew by the day.

490. The post-war Italian Republic, like many new governments in Europe after 1945, faced the daunting challenge of rebuilding a devastated country and restoring basic services to its citizens. Rehabilitation and

recovery in Italy were complicated by historical north-south and urban-rural divides as well as by the social and political legacies of fascism. By the late 1940s Italy's level of pre-war production had been restored, but mass unemployment remained high, particularly in the poor rural regions of southern Italy. Prime Minister Alcide de Gasperi initiated a series of economic reforms intended to develop the south, including a land redistribution scheme in the province of Calabria. This did little to narrow a widening gap between the north and south which led to another surge in Italian emigration.

491. Vittorio De Sica's *The Bicycle Thief* tells the story of an impoverished post-war Italian family whose happiness and well-being is threatened when the bicycle upon which their livelihood depends is stolen. The search for the bicycle takes on an epic quality, and is portrayed with great compassion and sensitivity. The film is a masterpiece of the neo-realist movement that emerged in European cinema following the Second World War, and which focused on ordinary people and their struggle with the day-to-day reality of living in a country devastated by war and in the throes of political and social upheaval.

492. Two very different political and economic systems developed in occupied Germany following the war. In the western zones economic recovery was rapid and strong democratic institutions emerged. In the east however, post-war development and reconstruction were slow, and the Soviets were quick to stamp out nascent democratic movements. When the three Western allies introduced a new currency in the parts of Germany under their control in 1946 – including West Berlin – relations between the Western allies and the Soviet Union greatly deteriorated. The Soviet Union argued that the currency was a contravention of agreements made at the Yalta conference in 1945. Stalin ordered a blockade of the city in June 1948 in an attempt to assert Soviet control over all of Berlin.

493. When Soviet authorities closed all roads, canals and railway lines leading into the

western part of Berlin, American and British air forces began airlifting supplies into the city. During the airlift, which lasted from 24 June 1948 to 12 May 1949, roughly twenty flights an hour carried a total of nearly 2 million tons of coal, food and other necessities to western Berlin, enabling its inhabitants to hold out against the Soviets' eleven-month blockade. Relations between the Soviet Union and the Western allies remained extremely tense throughout the blockade, which marked the first direct confrontation of the cold war. Although Britain and the US had demonstrated their resolve in guaranteeing West Berlin's security, most predicted that Soviet authorities would test this commitment again and look for other means to assert control over the city in the future.

494 top. The galloping inflation caused by the Kuomintang's policy of printing extra money to pay for the war effort against the communists caused severe hardships for ordinary Chinese. It was made worse by the looting and terror carried out against local populations by poorly-paid Kuomintang troops. Although US aid to the Kuomintang continued to flow into the country, the money invariably found its way into the pockets of corrupt and inefficient Kuomintang officials. This only increased popular disillusionment with Chiang Kai-shek's government. Subjected to relentless and effective communist propaganda, the masses had turned decisively in favour of Mao's armies by the end of 1948.

494 bottom. Changes to the economic, social and political status of Japanese women began during the Allied occupation Japan (1945–52). Reforms and constitutional guarantees established during this period gave women a full legal basis for equality for the first time in the country's history. Before Japan's post-war constitution of 1947 the country's civil code had reinforced the traditional power of the male head of the family. When the constitution was rewritten by the occupying authorities, it provided for equality between the sexes and the protection of women against discrimination. Women were given joint inheritance rights, the right to vote and the right to sit in the Diet (Japan's parliament).

Nonetheless the unofficial practices and policies of employment as well as popular attitudes towards women's roles in society continued to prevent Japanese women from achieving 'real' equality despite their new-found legal guarantees.

495. Algerian-born Albert Camus wrote his first novel *L'Etranger* (*The Outsider*) in 1942. It immediately established him as one of France's leading writers and political thinkers. He co-edited the left-wing newspaper *Combat* with existentialist writer Jean-Paul Sartre until 1948. Together they became two of post-war Europe's most influential moralists and political theorists. Camus' many plays, novels and political writings, which centred on problems of evil and the alienation of man from both himself and society, were a reflection of the intense isolation and disillusionment experienced by post-war intellectuals. In 1957 at the remarkably young age of forty-four, Camus won the Nobel Prize for Literature. He died three years later in a car accident.

496. Homecoming POWs arriving in Germany in the late 1940s bore the scars of appalling living conditions, poor medical care and hard labour suffered in the Soviet Union. In the mid 1950s extensive negotiations between Soviet officials and Konrad Adenauer, the West German Chancellor, secured the release of 10,000 German soldiers still in Soviet hands. However, the fate of the tens of thousands of German POWs still being held in the Soviet Union remained a mystery until 1999 when Russian officials handed over secret KGB files to the German Red Cross. Of the 3.6 million German soldiers captured by the Soviets during the war, more than a third died in custody.

497. Between 1945 and 1948 Soviet authorities transformed Hungary into a Stalinist state under their appointed leader Mátyás Rákosi, an Hungarian communist exile who had lived in Moscow during the war. He crushed all non-communist opposition and forced the Communist Party and the Social Democrats, led by Arpád Szákásits, to merge to form the Hungarian Worker's Party on 12 June 1948. The ground was prepared for the declaration of a Communist People's Republic the following year. Soviet control of the party became complete after Rákosi ordered a series of purges to eliminate recalcitrant members during 1948 and 1949. Hungary fell firmly behind what Winston Churchill described as an Iron Curtain separating Soviet-controlled Eastern Europe from the West.

1949

498. Mao was quick to recognize that the communist triumph in China might be short-lived if his inexperienced government did not acquire some advice and assistance in overseeing the transition to socialism and industrialization in China's huge urban areas. During the Chinese leader's stay in Moscow from December 1949 to February 1950, Stalin proved a reluctant and often difficult comrade. After exhaustive negotiations, Mao obtained 300 million dollars in assistance from the Soviet Union (considerably less than he had hoped for) and the two countries signed a Friendship and Mutual Assistance Treaty. Despite a problematic beginning, communism seemed very much on the ascendant in Asia.

499. Policemen executing communist agents as Kuomintang troops look on. Before Shanghai fell to Mao's troops on 25 May, the city's streets were the scene of frenzied killings by the nationalists. By autumn of 1949 Kuomintang fighting in the civil war was reduced to scattered pockets of resistance. Most of Chiang Kai-shek's troops had fled to the island of Formosa (present day Taiwan), taking much of the country's gold reserves and military air and naval craft with them. This cleared the way for Mao to proclaim the birth of the People's Republic of China on 1 October 1949.

500. The Dutch East Indies (now Indonesia) were the cornerstone of the Netherlands' vast colonial empire, which was the third largest in the world at the beginning of the century. In January 1942 Japanese forces invaded the archipelago and within two months the last Dutch East Indies troops had capitulated. Indonesian nationalists, whom the Dutch had suppressed and imprisoned, co-operated willingly with Japanese occupation forces. In return, Japan encouraged the growth of Indonesian nationalism provided it was anti-Western in nature. After the Second World War, Indonesia's nationalist leader Achmed Sukarno declared independence, but this was not recognized by the Dutch who returned to the archipelago and recaptured considerable parts of their former colony after two brutal 'police actions' in 1947. Vastly outnumbered and overstretched Dutch colonial forces could no longer prevent damaging guerrilla attacks. Nor could the Dutch authorities exercise effective control over the various peoples living in the vast territory. The Netherlands finally bowed to growing international pressure to withdraw from Indonesia and on 27 December 1949 the country was declared independent.

501. Achmed Sukarno founded the Indonesian Nationalist Party in 1927. Like many of his colleagues in the party, he was imprisoned by Dutch colonial authorities and later exiled to the island of Sumatra. Sukarno returned to Jakarta (later the capital of Indonesia) following the Japanese invasion and gave his support to Japanese occupation forces who in return recognized him as the leader of the nationalist community. After the war he was the natural choice to unite and lead Indonesia's heterogenous resistance forces against the Dutch, who finally recognized him as the country's first president in 1950.

502. During the war Stalin had made a number of domestic concessions and relaxed some of the more pernicious aspects of his regime in order to win popular support during the fight against Germany. Widespread hopes that this trend might continue after the war were crushed as the primacy of communist values was harshly reasserted. Under Stalin's direction the Communist Party's chief ideological henchman Andrei Zhdanov purged the Soviet artistic and intellectual world of anti-Stalinist influences, while other party members intensified the repression of Jews and non-Russians living in the Soviet Union. Stalin secured his grip on Eastern Europe, imposing similarly ruthless regimes throughout the region.

504. During the 1920s and 1930s Sicilian-born Charles Luciano became New York's mafia crime boss, controlling a vast underground network of narcotics peddling, prostitution and extortion. Nicknamed 'Lucky' because of his success at evading arrest and prosecution, Luciano finally fell into police hands in 1936 and spent the next ten years in prison, from where he still managed to control his family's lucrative criminal operations. After his release in 1946, US authorities designated him an 'undesirable alien' and he was deported back to Italy. Luciano's influence on organized crime in America was such that he continued to direct illegal activities in the US – in particular drug trafficking and the smuggling of illegal aliens into the country – from his home in Naples.

505. In 1949 *The Second Sex*, a seminal text by French writer Simone de Beauvoir, became a worldwide best-seller and provoked a vigorous debate on the status of women in society. Developments in Western countries were compelling growing numbers of women to challenge openly traditional social structures. This included women's wartime participation in the workplace, the advent of new technology in household appliances which lessened the traditional burdens on women's time, and the development of new contraceptives, in particular the pill which became available in Europe and America in 1952. Feminists such as de Beauvoir also contributed to breaking down prevailing female stereotypes.

506. The young French violinist Ginette Neveu and the French boxing champion Marcel Cerdan were among the forty-eight passengers and crew who died aboard a flight from Paris to New York which crashed in the Azores on 28 October 1949. Cerdan was set to join his lover Edith Piaf in New York. Devastated by his death, Piaf sought refuge in drugs and alcohol.

1950

508. One of the most influential French painters of the twentieth century, Henri Matisse first gained notoriety as founder of the Fauvist movement, a style of painting which used idosyncratic colours intended to invoke feeling rather than describe nature. Although his style changed frequently over the years, his work continued to reflect his unique mastery over the relationship between form and colour. During the last years of his life Matisse was a solitary man, living alone in a large studio at the old Hôtel Regina in Nice in the south of France. Although he was suffering from cancer, his intensity and creative energy remained undiminished. In his eighties he took to working on his mural-sized pieces from a distance, often in bed, with the aid of a crayon attached to a long pole. Remarkably, it was in these advanced years that Matisse produced some of his most celebrated works.

509. In 1940 at the age of twenty-two William Franklin (Billy) Graham was ordained a minister of the Southern Baptist Church in the US. He began preaching on street corners, in small churches and at rescue missions in the southern states where his sincerity, eloquence and vitality made a deep impression. His reputation as an evangelist grew rapidly at the end of the Second World War, when he made appearances at George W. Wilson's 'Youth for Christ' rallies in America, Canada and Europe. By 1950 he was the chief spokesman of Christian fundamentalism and was responsible for converting millions to Christianity worldwide.

510. In the late 1940s and early 1950s the American painter Jackson Pollock was the leading proponent of action painting. Pollock was the first to use drip-painting techniques to create abstract works, often on large, mural-sized canvases. At the time, critics labelled him 'Jack the Dripper', unaware of the huge influence he was to have on the art world. He died in a car accident in 1956, never having made any substantial profits from his work.

511. *Harlequin Dress* by Irving Penn. Irving Penn began designing photographic covers for *Vogue* magazine when he was twenty-six. Over the next two decades his incisive portraits of famous celebrities wearing the latest fashion trends helped to make him one of the most influential style gurus of the 1950s. He married one of his favourite

subjects, the ballet dancer turned model, Lisa Fonssagrives. Although Penn's greatest impact was on style and glamour in Europe and America, he also proved adept at capturing life in the world's most traditional societies. His stunning portraits of Indians in Peru are among the most memorable.

512. After the Second World War Korea was jointly occupied by the US and the Soviet Union with the territory north of the 38th parallel under Soviet control and the southern half of the country under American administration. Preparations for independence faltered when occupying leaders on both sides claimed sovereignty over the whole country, and the situation on the peninsula deteriorated rapidly. The leader of the northern territory Kim II Sung, finally received permission from Stalin to invade the southern half of the country in Spring 1950. The first direct military conflict of the cold war was underway.

513. The Scottish journalist James Cameron and *Picture Post* photographer Bert Hardy were among the first Westerners to bring to the world's attention the desperate plight of POWs in the Korean War. During the first six months of the fighting, large numbers of prisoners from both sides died due to inadequate food, water and housing in the POW camps, or by summary execution.

514–15. After North Korean soldiers crossed the 38th parallel into the South on 25 June 1950, the United Nations Security Council met in an emergency session and passed a resolution requesting UN members to provide assistance to halt the invasion. The resolution was boycotted by the Russian member. As part of a joint force drawn from fifteen nations – the United Nations Command or UNC – American President Harry Truman ordered US troops to the Korean peninsula to aid the beleaguered South Korean army who by the end of August had lost their capital, Seoul, and all of South Korea except the vital port of Pusan. On 15 September 1950 UNC forces, composed primarily of US marines and under the overall command of General Douglas MacArthur, made a daring amphibious landing at Inchon,

320 kilometres (200 miles) north of North Korean lines. North Korean troops were caught between MacArthur's forces who were advancing from the north, and the UNC-reinforced South Korean troops' counter-offensive from the south. About 125,000 North Korean troops were taken prisoner. Both sides suffered high casualties as the remaining North Korean troops scrambled to escape encirclement. MacArthur carried the war northwards across the 38th parallel towards the North Korean-Chinese border.

516. Chaim Weizmann, President of Israel, arriving to cast his ballot in the municipal elections in Tel Aviv in 1950. As leader of the World Zionist Organization before the war, Weizmann had lobbied tirelessly for the establishment of a Jewish homeland in Palestine. After the Second World War he gained the sympathy and crucial support of America and the United Nations. The new state of Israel was internationally recognized. Weizmann, who was a Russian-born chemist, became Israel's first Head of State in 1948. Despite frail health and failing eyesight he performed his presidential duties with great dignity and was a source of inspiration and pride for Israelis throughout the tumultuous post-independence period.

517. The Federal Republic of Germany was founded on 23 May 1949 in the western zones of Allied-occupied post-war Germany. In response, authorities in the Soviet-controlled eastern zone proclaimed the German Democratic Republic on 7 October 1949. The official division of Germany was an inevitable consequence of the divergent social and economic policies pursued by its occupying powers. Although the governments of the two new states each claimed to be an interim creation awaiting a united Germany – and each recognized only one German nationality – soon two markedly different societies developed. Leaders in West Germany regarded the East German government as illegitimate and reliant on Soviet force, while West Germans came to regard their national kin in the East as poor relations.

518. Palmiro Togliatti, one of the founders of the Italian Communist

Party (PCI), fled fascist Italy in 1926. He agitated for Mussolini's downfall from abroad and fought against Franco's forces in the Spanish Civil War before returning from exile in 1944. He presided over the rise of the PCI and played a crucial part in the coalition government which ruled Italy during the fragile post-war period. By 1947 the PCI was the largest communist organization in Europe, although unlike Stalin's puppet regimes in Eastern Europe, the party did not fall foul of Western powers. Togliatti's anti-Soviet stance, moderate policies and commitment to working within a democratic framework, convinced Britain and America that the PCI would not jeopardize the stability of post-fascist Italy. Togliatti also advocated a new Euro-communism on the continent, independent of Soviet influence and opposed to the spread of communism through force.

519. Energetic blonde bombshell Betty Hutton played the role of the famous American sharpshooter and Wild West performer Annie Oakley in George Sidney's 1950 film *Annie Get Your Gun*. The film was an adaptation of Irving Berlin's immensely popular 1946 musical about the exploits of an illiterate hillbilly woman who joined Buffalo Bill's Wild West Show.

1951

520. On 25 November 1950 the Korean War took on an entirely different dimension when, against all predictions made by UNC Commander General MacArthur, China entered the war. Around 300,000 Chinese soldiers crossed the Yalu River, which divided North Korea from Chinese Manchuria, and poured into the country to assist embattled North Korean troops and push back UN forces. The Chinese forces were called 'Chinese Volunteers' by Chinese leaders to give the appearance, however implausible, that China had not ordered its troops to intervene. China hoped this would enable them to escape criticism for their actions in Asia and make it difficult for the US to justify expanding the war into China which General MacArthur was keen to do. The massive Chinese offensive drove UNC troops back beyond the 38th parallel, and then ground to a

halt. The war settled into a bloody stalemate.

521. By the spring of 1951 talks to end the war had begun. The key issue upon which negotiators could not reach agreement was the status of POWs. The UNC forces at that time held 171,000 prisoners, 50,000 of which were unwilling to return to their communist countries. However the communists, not wanting to lose face, were determined to see all the prisoners returned. The negotiations reached a deadlock because of this and did not resume until March 1953.

522. In June 1950 the first government of the new People's Republic of China passed the Agrarian Reform Law, launching the largest land redistribution scheme in history. Mao sought to eliminate the landed class and use the programme as a means to exert control over the vast, newly occupied rural areas. By satisfying the long-repressed demands of poor peasants who made up the majority of the rural population, Mao could secure their support for his new government. Land was confiscated from landlords and wealthy peasants, and was redistributed on an equal basis to 300 million poor peasants and hired hands. Although in principle the movement was to be organized from grass roots instead of reform being imposed by governmental authority, the coercive power of the state was evident during each stage of the programme. Once-poor peasants were mobilized to denounce formerly wealthy compatriots through the establishment of peasant associations, and 'accusation' – or 'speak bitterness' – meetings became commonplace. As many as 5 million Chinese landlords and wealthy peasants are thought to have been killed by execution or mob violence during the period.

523. Czechoslovakia's pre-war traditions of liberalism and tolerance evaporated in the aftermath of the Second World War as the country came firmly under the control of Moscow. The country's leader Klement Gottwald, proved incapable of standing up to Stalin and agreed to wide-scale purges of party members. Similar hopes for a bright post-war future had given way to cynicism and despair by

the early 1950s across most of Eastern Europe.

524. American and Australian prisoners released by the Chinese in a one-off exchange. General MacArthur was shocked by the fighting strength of Chinese troops in Korea and argued that the best way to defeat them and halt the spread of communism in the Far East was to bomb bases in Chinese Manchuria. He was even prepared to use atomic weapons if necessary. US President Harry Truman did not want to risk full-scale war with China and so tried to moderate these views. When MacArthur made his views public on 11 April 1951, Truman relieved him of his duties. He was replaced as Commander-in-Chief of UN forces by Mathew Ridgway. Thereafter, the American aim to unify Korea was abandoned and both sides seemed content to hold their positions along the 38th parallel.

525. The prison population at Koje-do internment camp included North Korean communists, North Korean anti-communists who had deserted and did not wish to return to their country, Chinese communists and even Chinese anti-communists who were former Kuomintang soldiers. Each group was housed in a different compound but this did not prevent unrest and violent night-time skirmishes between former comrades. This was partly because UNC guards rarely entered the enclosures. In the anti-communist compounds, the guards permitted the POWs to hold demonstrations, celebrate holidays and even display signs and placards reading 'Kick out the communists!'. In stark contrast, similar political activity in the communist enclosures was crushed by violence and shootings.

526. Captured soldiers from both sides of the Korean War were subjected to exhaustive questioning at interrogation centres at Koje-do internment camp. UNC officials would determine whether or not soldiers wished to avoid repatriation and then assign them to a designated area of the camp. Meanwhile in North Korea UNC soldiers taken prisoner faced intensive ideological persuasion and political indoctrination by Chinese interrogators, who took control of prison camps from

North Korean officials in May 1951. The Chinese attitude towards POWs was based on the so-called Lenient Policy, which guaranteed good treatment for captured UNC soldiers if they submitted to certain political 'truths'. The location of prisons along the Yalu River was extremely effective in preventing UNC troops from escaping. Between 1951 and 1953 none managed to do so, although many attempts were made.

527. Joe Louis won the world heavyweight boxing championship in 1937 and held it for a record twelve years, defending the title twenty-five times. A fighter of extraordinary swiftness and grace, the 'Brown Bomber' retired in 1949. He returned to the ring in a failed comeback bid two years later. In his last fight he was knocked out in eight rounds by the future champion Rocky Marciano, who went on to become the only undefeated heavyweight champion of the century.

528. Mohammed Mossadegh joined the Iranian government in 1942 and rose rapidly. In April 1951 he was appointed Prime Minister. Mossadegh was a fervent nationalist, and led the move to nationalize Iran's Western-controlled oil industry. He also proposed a series of measures designed to curtail foreign influence in all areas of Iranian society. His policies were extremely popular among the general population and restored much of the pride that had been lost over more than a century of imperial – primarily British and Russian – dominance in the country. Britain and America hoped the Shah would restrain the Prime Minister's nationalist policies, which jeopardized their interests in the country, or simply dismiss him from office. But Mossadegh's immense popularity at the time placed him beyond the Shah's control.

529. After succeeding his father as Iran's reigning monarch in 1941, Mohammed Reza Shah Pahlavi continued the modernization drive and secular reforms initiated by his father. The Shah was careful not to alienate Western governments, but was perhaps too conciliatory. He relied heavily on Western aid to quell internal popular opposition to his regime, which increased the already strong anti-British and US

sentiment in the country. In August 1953 he attempted to dismiss his popular nationalist prime minister, Mohammed Mossadegh. The Shah was forced into exile with his family when Mossadegh's supporters took to the streets in protest. Within a few days the US intelligence agency, the CIA, helped the Iranian army to stage a coup to restore the Shah to power and place Mossadegh under arrest.

530. The nativist secret society begun in America's southern stage of Georgia in 1915 adopted the name Ku Klux Klan during the 1920s. It dedicated itself to a programme of hostility towards minority and non-conformist groups, especially black Americans. Fuelled partly by a distorted patriotism, partly by a romantic nostalgia for the old South, but mostly by ignorant xenophobia, the Ku Klux Klan boasted a membership of around 4 million at its height in the 1920s. White-robed Klansmen carrying a burning cross participated in marches and parades all over the country. Membership dropped dramatically during the Depression and the organization was temporarily disbanded in 1944, but in the 1950s and 1960s it experienced a resurgence in some southern states in response to the civil rights movement.

531. Rudolf Slanský joined the Czechoslovak Communist Party shortly after it was founded, and over time became one of its most ruthless ideologues. He played a key role in the communist take-over in Czechoslovakia in 1948, implementing Stalinist measures and becoming Vice-Premier of the new government. However, Slanský was of Jewish descent and was unable to escape Stalin's attempted purge of supposed Jewish and Titoist influences in the Czech Communist Party. Stalin pressured the party leader Klement Gottwald to agree to a series of show trials, as a result of which Slanský was arrested together with thirteen other communist officials, most of whom were Jewish, and charged with spying for the West. Slanský was hanged with ten of the accused on 2 December 1952 in what was Stalin's greatest purge of communists outside the Soviet Union.

532. In the late 1940s Unidentified Flying Objects (UFOs) became a major subject of interest for governments and scientific organizations as well as members of the public. Previously only the subject of science-fiction books and films, a series of sightings of 'alien spacecrafts' was reported and publicized widely in the US and Europe, no doubt stimulating further sightings. In 1952 a number of reports in the north-eastern US coincided with unexplained radar detections in the region. This led the US government to establish the first scientific panel specifically for investigating UFOs. Despite finding that most, if not all, suspected UFO sightings could be attributed to meteorological phenomena, searchlights or various types of aircraft and balloons, popular interest in the existence of UFOs has remained strong.

533. When the Soviet Union successfully tested an atomic bomb in 1949, the US responded to their loss of the global nuclear monopoly by developing the hydrogen bomb. On 1 November 1952 the US exploded the first such bomb at Eniwetok Atoll in the Marshall Islands in the Pacific. Based on destruction through nuclear fusion, the bomb blast achieved a yield of 10.4 million tons of TNT and produced a crater over 1,830 metres (6,000 feet) wide and 49 metres (160 feet) deep. With the development of ballistic missiles and the Soviet Union's own hydrogen bomb in 1953, the destruction of the whole human race in a nuclear exchange became a practical possibility.

534. The grandson of a former vice-president (Adlai E. Stevenson 1893–97), Adlai Stevenson started out as a delegate to the founding conferences of the United Nations and became a widely respected state governor. In 1952 the Democratic National Convention in Chicago drafted him to run for president against the Republican candidate, Dwight D. Eisenhower. Stevenson was a liberal reformer and internationalist with a formidable intellect and an impressive record in both domestic and international politics, but the popularity of America's greatest wartime hero till proved irresistible. Eisenhower

won the election with more popular votes than any previous candidate.

535. In the days before rock and roll, Johnnie Ray's tunes filled the airwaves in Britain and the US. In 1951 Ray scored his biggest hit with 'Cry'. In nearly every performance thereafter, Ray managed to cry, and even the word 'cry' seemed to find its way into every one of his songs. Although his musical career was overshadowed by the arrival of Elvis and the rock and roll scene, Ray's on-stage histrionics were matched by few, if any, of his successors.

536. American tennis sensation Maureen Catherine Connolly, nicknamed 'Little Mo', dominated women's tennis in the early 1950s. She won both the US and Wimbledon singles titles in three consecutive years, and became the first woman to win the Grand Slam (the sport's four major tournaments: Wimbledon and the US, French and Australian Opens) in 1953. Her career was cut tragically short when she severely injured her right leg in a riding accident in July 1954.

537. A couple at an artist's party in Chelsea, London, caught on film by Bert Hardy. The London-born photographer covered several major world conflicts for the *Picture Post* between 1940 and 1952. His deeply moving photographs of ordinary people caught in the madness of war helped to establish the British magazine's reputation for high quality photojournalism with a strong social conscience. Hardy also produced a series of intimate photographs for *Picture Post* centring on his native London and the young fashionable set who frequented the city's growing number of private drinking and dancing clubs.

538. No-one captured the fierce and often savage fighting of the Korean War with the same immediacy as the legendary American photojournalist Margaret Bourke-White. As an official UN correspondent during the conflict she could penetrate Communist-held territory to record the horrors of war as she had done in the Second World War and during the fighting in India and Pakistan. In an era before television, Bourke-White

became famous for her innovative photo-essays that brought images and events of war to the rest of the world's attention.

539. Dwight D. Eisenhower was courted by both the Republicans and Democrats to be their party's nominee in the 1948 US presidential election when he returned from the Second World War. The victorious Allied commander refused both offers, opting to accept the presidency of Columbia University. In 1951 he assumed the role of Supreme Commander of NATO in Europe. The following year Eisenhower gave in to persistent pressure from his Republican supporters and put his name forward as the party's candidate for president in the 1952 election. He won the Republican nomination and went on to become President with more popular votes than any previous candidate in American history. Eisenhower's victory was based almost entirely on his role in the Second World War and a popular belief that his military expertise would enable him to end the war in Korea. His running-mate Richard Nixon was one of HUAC's (House Un-American Activities Committee) most determined prosecutors in the late 1940s. This choice reflected Eisenhower's desire to avoid any charges that he was 'soft on communism'.

540. After the Second World War George Braque, an influential and radically innovative French painter who, along with Pablo Picasso founded Cubism around 1907, resumed his life-long practice of painting a series of works on a single subject. As before the war, Braque was drawn to sombre themes: 'The Studio' series which he began in late 1945 featured a mysterious bird, an over-sized, lumbering creature that served as a symbol of aspiration. Throughout his life he produced many acclaimed paintings, graphics and sculptures, characterized by brilliant colour and textured surfaces. They were imbued with a contemplative quality. In 1961, two years before his death, Braque became the first living artist to have his work exhibited in France's most prestigious museum, the Louvre.

541. At the funeral of the British King George VI, three generations of the Royal Family were present

great boost to national morale and earned him widespread admiration, as did his efforts to overcome a chronic speech defect. After the King's sudden death from lung cancer on 6 February 1952, his eldest daughter Elizabeth ascended the throne.

1953

542. Factory workers listening to the radio announcement of Stalin's death. Towards the end of his reign Stalin had become increasingly paranoid and anti-Semitic. In 1952 he accused a number of Jews of an alleged Zionist conspiracy and had them executed. Another purge, known as the Doctor's Plot, was planned but Stalin's mysterious death (official records say he died of a brain haemorrhage) prevented this. For the remainder of the Soviet era no single person was able to acquire the dictatorial power that Stalin had wielded during the last twenty years of his reign.

543 top. Stalin's death triggered a fierce struggle for power among party members that was carried out behind the cloak of collective leadership. Among potential successors, the first to attempt to seize power was Lavrenti Beria, the notorious Soviet Secret Police Chief and a main architect of Stalin's purges. His effort was foiled by fearful military and party leaders, and he was later executed. Nikita Krushchev, the most junior member of the ruling group, shrewdly outmanoeuvred his rivals. Georgi Malenkov who served briefly as First Secretary of the party and then as Prime Minister in March 1953, served to strengthen Krushchev's position.

543 bottom. In 1952 East Germany (the German Democratic Republic or GDR) closed its borders with West Germany (the Federal Republic of Germany or FRG). However thousands continued to enter the West via Berlin where people could still move freely across the four separate occupation zones of the city. Inhabitants of the eastern section of the city were eager to leave behind its severe economic hardships, repressive government and relentless communist indoctrination for the promise of a better life in the West.

544. Popular disenchantment with East Germany's slow post-war economic recovery and the dictatorial regime of the Socialist Unity Party (SED), sparked a popular uprising in East Berlin, the first such protest among the new Soviet bloc countries. On 17 June 1953, 300,000 workers took to the streets demanding a change in government. The rebellion quickly spread to other parts of East Germany and was crushed only when Soviet troops and tanks intervened. East German leaders claimed that America and West Germany had encouraged the uprising.

545. Devastation caused by the Korean War resulted in the loss of more than two-fifths of the country's industrial facilities and a third of its homes. The United Nations Korean Reconstruction Agency (UNKRA) was established under a UN resolution on 1 December 1950, and organized a massive relief effort in the south to alleviate disease, food shortages, and lack of shelter. A large injection of economic aid, principally from the US, enabled South Korea to rebuild its war-damaged infrastructure quickly and to establish a foundation for the country's spectacular economic growth and prosperity in the 1960s under UNKRA guidance. In the north, the Soviet Union and China provided similar levels of aid for post-war reconstruction. In sharp contrast to US policy in the south, communist assistance helped to ensure that North Korea became one of the most highly centralized and successful economies in the world.

546 top. The Royal Family at the coronation of Queen Elizabeth II. The lavish and colourful coronation of 1953, the first to be seen on television, became a symbol of national revival in austere post-war Britain. The new Queen's strong sense of duty and independence of mind were evident in her insistence that the ceremony be televised, against the wishes of the Prime Minister Winston Churchill. Despite the Queen's reserve and apparent lack of warmth noted by commentators, the public hoped that her coronation would mark the beginning of a new 'golden' Elizabethan age.

546 bottom. Edmund Hillary was a former beekeeper from New Zealand and an experienced Himalayan mountaineer. He was selected to make the ascent of Mount Everest, the world's highest peak, together with Nepalese sherpa Tenzing Norgay by the expedition leader, John Hunt. On 29 May 1953 the two men became the first people to set foot on Everest's summit at 8,848 metres (29,028 feet) above sea level. News of their extraordinary achievement reached London during the Queen's coronation.

547. William Wyler's bitter-sweet film *Roman Holiday* is best remembered for the enchanting debut of its female star, Audrey Hepburn. Her portrayal of the sheltered European princess who falls in love with an American journalist, played by Gregory Peck, captivated contemporary audiences. Her delicate features and lithe frame defined an entirely new conception of feminine beauty and became an ideal aspired to by a new generation of young women.

548. Jacques Tati's absurdist comedy *Les Vacances de Monsieur Hulot* (*Mister Hulot's Holiday*) introduced film audiences to Tati's best-loved character Hulot, a pipe-smoking, lugubrious fool who is continually at odds with modern technology. In the 1950s Tati wrote, produced, directed and acted in a number of popular French comedies reminiscent of American slapstick films of the 1920s. He developed his unique style and innovative physical humour when he performed as a music hall entertainer and pantomime artist during his early days in show business.

549. In 1948 Harold Edgerton became full professor of electrical engineering at the Massachusetts Institute of Technology (MIT). There he developed a xenon gas tube which was capable of producing high-intensity flashes of light for a millionth of second. This was called a stroboscope. The flash from a stroboscope could be synchronized with the movement of an object to make it appear stationary, thereby allowing the motion and speed of the object to be determined. With this groundbreaking work Edgerton made an invaluable contribution to various areas of industry and science, ranging from high-speed photography to eye surgery. His instrument remains the basic flash device used in still photography.

1954

552. Evelyn Baring had been a colonial administrator in India and southern Africa before becoming Governor and Commander-in-Chief of Kenya in 1952. In that year, British rule in

550. The death of Stalin and the election of a new American administration under Dwight D. Eisenhower led to the temporary relaxation of tension between the superpowers. America was determined to exploit this opportunity and end the impasse in the Korean War which, after two years of static warfare, was increasingly viewed by both sides as pointless slaughter. An estimated 3 to 4 million soldiers and civilians had been killed. The repatriation of prisoners remained a sticking point in the negotiations until the very end, but finally an armistice was signed at Panmunjom on 27 July 1953. Negotiators for the UNC were able to secure most of their demands at the armistice talks, but they could not bring lasting peace to the peninsula. A number of conferences were dedicated to unifying Korea peacefully but in spite of this the 38th parallel separating the north from the south became one of the most militarized borders in the world and one of the major potential flashpoints of the cold war.

551. Mossadegh's programme of nationalization gained widespread popular support between 1951 and 1953 but his promises of social revolution in Iran never materialized. He had made many enemies in the army, judiciary and parliament. Moreover, the boycott by the West and the withdrawal of their oil experts from Iran crippled the oil industry and deprived the government of much needed revenue. By 1953 Mossadegh's histrionics, which included fits of weeping in public, had become more frequent and many Iranian politicians were questioning his once-renowned political common sense and shrewdness. After defying the Shah's order for him to step down from his post as Prime Minister in August, he was arrested on a charge of unconstitutional behaviour and imprisoned for three years in solitary confinement. He was later released and spent the rest of his life under house arrest.

Kenya came under threat from a militant guerrilla movement called Mau Mau which was composed primarily of members from the Kikuyu tribe of east Africa. The movement was founded to counter the widespread discrimination by whites which had reduced black Africans to second-class citizens in their own country. In October 1952 Mau Mau attacks against settlers and their black African labourers escalated sharply, causing the British to declare a state of emergency in the colony.

553. In an attempt to quell the Mau Mau uprising in Kenya, Governor Baring established special detention centres on the Kikuyu reservation where colonial authorities used suspect methods (effectively torture) to identify the main instigators of the uprising. The rebellion had been crushed by 1956, but Britain's reputation as a colonial power in Africa had suffered irreparable damage. Less than a hundred Europeans died during the uprising in which more than 10,000 Mau Mau were killed by British troops and other Africans. Political protest at home shocked British leaders into recasting their country's role in Kenya.

554. Gregory Peck during the making of John Huston's *Moby Dick* (1956). Herman Melville's nineteenth-century tale of Captain Ahab's relentless pursuit of a great white whale was adapted for the screen by John Huston in 1956. Huston's fanatacism about overcoming the numerous obstacles encountered in the making of the film led to comparisons between him and Melville's Ahab. In a case of art imitating life, the film was a dramatic reflection of Huston's lifelong interest in people beset by delusions of grandeur, forever occupied in essentially futile pursuits.

555. In 1951 Akira Kurosawa's widely-acclaimed film *Rashamon* drew Japanese cinema's first international audience. Three years later Kurosawa established his position at the forefront of international cinema with his 1954 film *Seven Samurai*. The three-hour epic centred on a sixteenth-century Japanese village which hires seven samurai to defend itself against bandits. It was a forerunner to the American

drew Japanese cinema's first international audience. Three years later Kurosawa established his position at the forefront of international cinema with his 1954 film *Seven Samurai*. The three-hour epic centred on a sixteenth-century Japanese village which hires seven samurai to defend itself against bandits. It was a forerunner to the American western *The Magnificent Seven*. Kurosawa's masterful storytelling and the film's stunning cinematography contributed to making it one of the director's most admired works.

556. Following the Japanese occupation of Vietnam during the Second World War and their subsequent withdrawal in 1949, France returned to its former colony of French Indochina to set up a puppet state. Attacks against French rule by a growing nationalist movement led by Ho Chi Minh's communist Vietminh, escalated into a full-scale conflict in the early 1950s. The war soon proved beyond the capacity of French soldiers and equipment. This prompted America – convinced that a Vietminh success there, together with other events in South East Asia, could foment communist revolution throughout the region – to pour financial and military resources into the French effort. By 1954 the US government bore 78 per cent of France's total costs for fighting the war. Ho Chi Minh's forces gained control of most of the countryside and were making inroads on Vietnam's French-held cities despite US action. An international conference on the region was held in Geneva in the spring of 1954 to try to resolve the conflict.

557. In 1953 the French Expeditionary Corps had occupied Dien Bien Phu, a valley 483 kilometres (300 miles) north-west of Hanoi, and had constructed a group of fortresses there to prevent Vietminh troops from crossing the nearby border with Laos. On 13 March 1954 the Vietminh attacked the garrison, determined on a decisive victory against France's embattled colonial troops. French authorities hoped to use Dien Bien Phu as an opportunity to demonstrate their unshakable colonial control of the country. For fifty-seven days, the numerically superior Vietminh troops laid siege to the garrison.

Losses were heavy on both sides, but the French inability to reinforce their troops from the air meant that they were forced to surrender. From the original total of 16,500 French soldiers, only about 3,000 survived the battle of Dien Bien Phu, famously described as 'hell in a very small place'. The humiliating surrender on 7 May 1954 ended France's colonial presence in the country and led to the downfall of French Prime Minister Joseph Laniel's government in June. The French defeat greatly enhanced the Vietminh's standing at the subsequent Geneva Conference, which gave Ho Chi Minh's troops control over the northern half of Vietnam.

558. In 1949, while he was leader of Britain's opposition Conservative Party, Winston Churchill suffered a stroke, although at the time the news was kept from the general public. In October 1951 he became Prime Minister with a slim majority of fifteen seats. Domestically, his second term as leader was marked by few significant policy changes. He accepted most of the reforms in employment, health and welfare enacted by the previous Labour government, and was generally too removed from the day-to-day running of the country to offer much creative leadership. Churchill was treated with the highest respect and admiration at summit meetings abroad, but his greatest contributions to international relations were already behind him. In 1953 he became the first world leader to be awarded the Nobel Prize for Literature 'for his mastery of historical and biographical description as well as for brilliant oratory in defending exalted human values'. That same year he suffered a second heart attack which forced him reluctantly to step down as Prime Minister in 1955 to make way for Anthony Eden.

559. In October 1954 the foreign ministers of France, Britain and America met in Paris with West German Chancellor Konrad Adenauer for a historic conference on the future of the Federal Republic of Germany. After the Republic was formed in 1949, Adenauer exploited British, French and American fears of communist encroachment into western Europe to gain

concessions from the western occupying powers. In return for these concessions he agreed to re-arm West Germany within the framework of a western European defence system. At the Paris conference in October 1954 the Occupation Statute over West Germany was ended and its government was granted full sovereignty and membership in the North Atlantic Treaty Organization (NATO).

560–61. On 23 July 1952 the weak and corrupt government of King Farouk of Egypt was overthrown by a group of young military men calling themselves the Free Officers. A new Egyptian republic was proclaimed on 18 June 1953 led by General Mohammed Neguib. It was clear from the outset of Neguib's presidency that, although he gained international fame for his part in Farouk's downfall, he lacked the political skills of his rival Free Officer, Abdel Nasser, who was his deputy and Minister of the Interior. President Neguib's plans to establish a multi-party democracy gained widespread popular support, but Nasser quickly began to usurp his rule. On 17 November 1954 Neguib was forced to resign and was placed under house arrest for a brief period. He retired from public life the same year. Abdel Nasser went on to become one of the most revered leaders in the Arab world.

1955

562. Grace Kelly was born into a wealthy Irish-American family in Philadelphia. By her early twenties she had established herself as a major Hollywood star, acting opposite some of the most famous leading men of the time. Her elegant beauty and cool demeanour made her a favourite of many prominent directors, particularly Alfred Hitchcock who cast her in three films, including *To Catch a Thief* (1955). It was while promoting this film at the Cannes film festival that Kelly met Prince Rainier of Monaco, whom she married the following year. At the age of twenty-seven Grace Kelly abandoned her film career to become Princess Grace of Monaco.

563. Popular US pianist Liberace and Hungarian actress Zsa Zsa Gabor typified the publicity-mad artists and well-to-do elevated to celebrity status by Elsa Maxwell

from the 1930s to the 1950s. As a legendary *Vogue* columnist and party organizer *par excellence*, Maxwell combined entertaining fashion writing with a flair for showbiz promotion. She was a regular guest at fancy dress galas in the chic resorts of the French Riviera in the 1950s.

564. A couple dancing to New Orleans-style jazz at Club Martinique on Tyneside in Britain. The growth of radio and television was significant to the popularization of different forms of music and dancing in the 1950s. 'Black' music became diffused among wide audiences in America and Europe for the first time. Jazz, in many ways the most enigmatic of musical forms, was the most popular of the black music, especially Dixieland jazz which originated in New Orleans in the 1920s.

565. British double-agent Kim Philby fending off accusations of spying for the Soviets at a London press conference. One of a group of Cambridge University students recruited as Soviet agents and known as the Cambridge Spy Ring, Philby was later appointed a British Liaison Officer in the CIA and FBI. He was the 'third man' warning diplomats Guy Burgess and Donald Maclean when they were about to be named as Soviet spies. They were also members of the Spy Ring. Philby worked as a journalist between 1956 and 1963 during which time he committed various acts of espionage and betrayed several British agents. Faced with discovery, he defected to the Soviet Union where he was granted citizenship and lived in comfort as a major-general in the KGB.

566. St George's Crypt hostel for the homeless in Leeds in Britain. The 1950s and early 60s were years of apparent prosperity in Britain as the economic well-being of the average person rose substantially. However the country as a whole lost its place as world financial leader as its share of world trade fell by about one per cent a year. Moreover Britain did not share in the astonishing post-war growth in production and trade taking place on the continent such as the economic miracle in West Germany. Germany had not won the war, but to most British citizens it seemed that the fruits of victory had gone to the vanquished.

567. Photographer William Klein spent six years experimenting in painting, graphic design and abstract photography in Paris before he returned to his native New York to compile a unique and extraordinary document of life in America's biggest city. Klein transformed the daily mayhem on New York's streets into elaborate photographic compositions which portrayed the city as a theatre of the absurd with its maddening crowds, senseless violence, decaying buildings and seemingly endless chaos. The result was the ironically titled *Life is Good and Good for you in New York: Trance Witness Revels*, published in France in 1956 and instantly recognized as one of the finest photographic books of the decade. Klein's potent mix of social criticism, black humour and graphic style won him many admirers. The same technique was used with powerful effect in studies of other major cities later in his career.

1956

568. The international sucess of Bergman's film *The Seventh Seal* placed him firmly among the great directors of the century. Shot in only thirty-five days, this potent morality tale set in seventeenth-century Sweden depicted the cruelty of medieval life but also the joys of ordinary people. Like so many of his films, *The Seventh Seal* reflected the Swedish director's lifelong pre-occupation with death, loneliness, guilt and emotional repression.

569. Hungarians burning portraits of their reviled former leader, Mátyás Rákosi. Nicknamed 'Little Stalin', Rákosi successfully transformed Hungary into a brutally repressive Soviet satellite, organizing his own purges and show trials, and crushing all forms of dissent. The regime fell out of favour with the Soviet Union after Stalin's death and Rákosi was forced to resign. Although he had returned to power briefly in 1955, memories of his terror were so strong that he was forced to return to exile in the Soviet Union. His resignation only heightened popular demands for democratization, which exploded into a massive uprising against communist rule in October 1956.

570. Teds (an abbreviation of the nickname Teddy boys due to their appropriation of Edwardian style)

began appearing in Britain in 1954. Wearing draped coats, drainpipe trousers and their hair slicked back with copious amounts of Brylcream, the Teds were the British embodiment of the general spirit of teenage rebellion arising in many Western countries in the 1950s. They embraced a fast-paced and irreverent lifestyle which was associated with the new phenomenon of rock and roll. The Teds are reputed to have behaved aggressively, committed minor crimes and had a number of celebrated run-ins with the police. They were soon to be replaced by other youth cultures such as mods, rockers and skinheads.

571. Greece emerged from the aftermath of German occupation and its subsequent civil war in a state of financial devastation. With aid from the American Marshall Plan, Greek leaders tried to direct the country towards social and economic development. Reform and modernization were jeopardized by a renewed crisis in Cyprus. Groups within the army began a terrorist campaign for *Enosis* (the union of Cyprus with Greece). Public opinion in Greece was decidedly in favour of the Cypriot community.

572. Demonstrations by students and workers against communist rule in Hungary forced Soviet troops to pull out of the country in late October 1956. This created an atmosphere of renewed hope and patriotism in a nation beset by years of violent Stalinist repression. But the mood was short-lived. Soviet troops soon returned and surrounded Budapest, entering the city early on 4 November. Hungarian insurgents resisted, but within a fortnight 150,000 Warsaw Pact troops (a Soviet-led alliance of communist states in Eastern Europe) had crushed the revolution.

573. A policeman overseeing the arrival of West Indian immigrants in Britain. Post-war labour shortages at all levels prompted the British government to recruit large numbers of workers from the Commonwealth and former empires. As the new immigrants tended to congregate in the poorer areas of Britain's cities, their arrival was only noticed by the local inhabitants, who felt their presence acutely. Racial tensions sometimes boiled over into

violence in areas of dense immigration where competition for housing and jobs was great. In 1963 access to Britain was restricted by the Immigration Act.

574. After being appointed Hungarian Prime Minister in 1953, Imre Nagy passed various popular measures such as relaxing press censorship and slowing the rate of agricultural collectivization. Nonetheless, he still considered himself a communist, and addressed adoring crowds of revolutionary demonstrators on the streets of Budapest as 'comrades'. When rebels toppled the hardline communist regime which had briefly replaced his government in October 1956, Nagy immediately dissolved the one-party system, announced a withdrawal from the Warsaw Pact and asked the UN to recognize Hungarian neutrality. In anticipation of the reaction the Soviet Union, Nagy pleaded for Western assistance to keep the Soviets at bay, but the world's attention was gripped by the Suez crisis and his pleas were ignored. When Soviet troops invaded, Nagy was arrested by KGB troops and only returned to Hungarian authorities two years later. He was sentenced to death and executed in secret in 1958. Hungarians lived under a repressive communist regime for the next thirty years. During this period 200,000 refugees, comprising a substantial number of the country's educated class, escaped to the West.

575. The Hungarian uprising began on 23 October 1956 when Hungary's Internal Security Police (AVH) opened fire on a peaceful crowd of university students in Budapest demonstrating for democracy and the return of the liberal-minded Imre Nagy as Communist Party leader. In the chaotic aftermath of the shootings, factory workers supplied the crowd with weapons and panicking guards surrendered their arms. Revenge killings followed and within days a general uprising against the repressive communist regime spread across the country.

576. In 1948 Poland was established as a communist state under the leadership of Boleslaw Bierut, a harsh Stalinist. Dissatisfaction with high living costs and blatant Soviet

exploitation grew steadily, and in 1956 industrial workers in Poznań went on a general strike. On 28 June a procession of 50,000 workers demanding basic freedoms and the departure of the Soviets was brutally dispersed on orders from Stalin's appointed Russian Minister of Defence and Commander-in-Chief for Poland, Konstantin Rokossovsky. To forestall a major rebellion in the wake of the strikes in which about seventy demonstrators had been killed, Wladyslaw Gomulka, a more moderate communist leader who sought to develop a uniquely Polish form of socialism, was installed as the country's leader.

577. President Gamal Abdel Nasser in Alexandria in Egypt after announcing the nationalization of the Suez Canal. Nasser sparked the Suez crisis when he took control of the vital waterway on 26 July 1956. His decision was widely popular in Egypt, but Britain and France who were major shareholders in the canal were incensed. Alarmed at what they viewed as Nasser's fervent Arab nationalism, they moved to overthrow him. In late October 1956 Britain and France joined the Israelis in a combined invasion of the Sinai Peninsula. Pressure from America and world opinion soon forced a cease-fire and withdrawal of the invading troops. Instead of ousting Nasser, the invasion only boosted his status in the Arab world. Britain and France were forced to accept a much-diminished role in the region.

578. In 1956 Adlai Stevenson stood as the Democratic Party candidate for president for a second time. He stood as little chance of defeating the popular President Dwight D. Eisenhower as he had four years earlier. Nonetheless, Stevenson's campaign sparked great excitement across the country, less on his account than because of the man who nearly became his running-mate, John F. Kennedy. The handsome and urbane young senator from Massachusetts made an enormous impression on audiences with his speeches in support of Stevenson on the campaign trail. After the election, Kennedy's stature in the Democratic Party grew rapidly.

579. President Eisenhower easily won re-election in 1956, and

became the first president to be constitutionally limited to two terms under the 22nd Amendment. The 'unofficial' struggle to succeed him as Republican leader began immediately after the election. His running mate and Vice-President, Richard Nixon, seemed the natural choice for the party. Nixon was young, experienced and possessed strong anti-communist credentials. He conducted his vice-presidential duties in a stately manner and was well received during foreign trips. Eisenhower's support for Nixon was lukewarm at best; when asked at a press conference for an example of Nixon's contribution to his presidency, Eisenhower replied 'If you give me a week I might think of one'.

1957

580. Lieutenant Colonel George Grivas with fellow Cypriot terrorists. In 1955 Grivas, a Cypriot who had served as an officer in the Greek army, began a concerted campaign for *Enosis*. His National Organization of Cypriot Struggle (EOKA) launched an underground campaign against British rule in Cyprus, bombing public buildings and assassinating both Greek Cypriot and British opponents of *Enosis*. As leader of EOKA he began to call himself 'Digenis Akritas' after a legendary Greek hero. Acclaimed as a national hero by Greeks and Greek Cypriots alike, he fought for *Enosis* until his death.

581. The Chinese leaders' goodwill tour of India: behind the festive masks are Indian Prime Minister Jawaharlal Nehru, Chinese Premier Zhou Enlai and his Vice-Premier Ho Lung. At the time of independence, India had virtually no political, economic or social relations with China and little understanding of its giant communist neighbour. Nehru sought China's agreement on a plan to exclude the whole of Asia from the cold war, and to establish an alternative to China's alliance with the Soviet Union. Nehru also took the initiative of introducing China's new leaders, in particular Premier Zhou Enlai, to the non-communist Third World at every opportunity. But five years later mutual goodwill expired as India suffered an embarrassing defeat by China during a short war along their Himalayan border.

582. Born in the US of Greek parents, Maria Callas first gained notoriety at La Scala Opera House in Milan where she showed a mastery of the intricate *bel canto* style of pre-Verdian opera. She gained international acclaim singing all the most exacting soprano roles at opera houses across Europe and America. The intensity of her performances captivated opera-goers although critics sometimes faulted her technique. As a singer Callas loved the spotlight, but it was her volatile temperament and turbulent private life that increasingly came to dominate the headlines.

583. Nelson Mandela practised as a lawyer in Johannesburg until 1952 when he became completely taken up with the fight against apartheid and the campaign for democratic, multi-racial elections in South Africa. Under laws initiated by the National Party in 1948 apartheid saw the political, social and territorial separation of the races designed to retain the white minority's privileged status in the country. In response, the African National Congress (ANC) led by Mandela and Oliver Tambo began sponsoring peaceful strikes, boycotts and marches in protest against the regime. ANC members became frequent victims of police arrests and harassment, before the organization was banned in 1960. Mandela went underground to prepare for a guerrilla war against the repressive white leadership but he was captured and sentenced to life imprisonment in 1964 for political offences that included sabotage and treason.

1958

584. In 1953 a music company executive by the name of Sam Phillips, searching for a white singer who could sound black, heard a private recording of a young singer from Tupelo, Mississippi. Phillips promptly signed the singer, Elvis Presley, to his first music contract and for the rest of the 1950s no-one in popular music could match, or even approach, his success and popularity. Elvis' synthesis of country and western music with black rhythm and blues (the basic formula behind rock and roll) produced a string of records selling in the millions. His overtly sexual gyrations on stage, totally unprecedented at this time, drove

government of Daniel Malan, South African society was rife with fear, mistrust and resentment. Only whites enjoyed full political rights, while Indian, black and mixed-race South Africans were increasingly denied the most basic civil liberties. The economic gap between the wealthy minority, nearly all of whom were white, and the poor 'black' masses under their control, was enormous and continued to widen. Increased racially directed repression was the only means the white government had to keep the potentially explosive situation under control. The white government was faced with two alternatives to preserve the state – repression or liberalization.

585 right. Under the leadership of the ANC, blacks in South Africa took increasingly bold steps to counter the discriminatory policies of the white government in the late 1950s, mostly through non-violent protest. The custodians of apartheid adamantly refused to consider reforms and opted instead to intensify the repression which culminated in the Sharpeville massacre of 1960 in which sixty-nine peaceful demonstrators were killed by the police. The massacre came to symbolize the abuses of the repressive white rule and resulted eventually in the militarization of nascent anti-apartheid groups who in the 1950s still believed change in South Africa could be brought about through peaceful means.

586. In 1943 Jack Kerouac was discharged from the US Navy, which had labelled him a 'indifferent character', and roamed the US and Mexico, working in a number of jobs and writing stories about his various adventures. During this period Kerouac fell in with a number of poets, musicians and eccentrics including Allen Ginsberg, Gary Snyder and William Burroughs, all members of the so-called Beat Generation (Kerouac himself coined the term, although he later repudiated it). In 1957 he published his second and by far his most famous novel *On the Road*. The story follows two penniless friends and their affair with drugs, mysticism and jazz in an aimless journey across America. Written in three weeks, *On the Road* developed a spontaneous, fast-paced and seemingly anarchic

writing style that shocked the established literary world, and proved hugely popular with a younger generation of readers.

587. Sugar Ray Robinson's boxing career, which spanned three decades and included a professional record of 175 wins and nineteen losses, inspired world-wide awe and has been considered by many authorities to be the greatest all-round boxing career in history. He retired a universally loved and admired sporting figure and bore remarkably few visible signs of his many years spent in the ring. Much later revelations about his private life suggested there was also a dark side to Robinson. As he grew older he slid into dementia.

588. Coleman Hawkins began studying the piano, cello and the saxophone before he was ten years old. As part of the Fletcher Henderson orchestra he became a master of improvizations on the tenor saxophone, which he helped to establish as the pre-eminent solo instrument of jazz. His most famous work, a version of *Body and Soul*, was released in 1939.

589. After Martin Luther King was awarded his PhD by Boston University in 1955, he went to Montgomery, Alabama, to work like his father as a Baptist pastor in a local church. That same year, an African-American seamstress named Rosa Parks was arrested for refusing to relinquish her seat on a bus to a white passenger. This brave act, regarded as the beginning of the modern civil rights movement in the US, prompted King to organize a city-wide boycott of the bus company and mount a legal challenge in a Federal court to the constitution-ality of the segregation laws still common in parts of the southern US. Despite threats to his family and attacks on his home, King persisted with the boycott for several months until the city's buses were forced to desegregate. King's courageous leadership and eloquent speeches brought him national prominence and fuelled new calls among African-Americans for equality in the south. The experience crystallized King's divergent influences into a coherent philosophy for social change which had similarities with Gandhi's doctrine of non-violent civil disobedience. Over the next decade King's philosophy

would be put to the test many times.

1959

590. A thaw in East-West relations enabled US Vice-President Richard Nixon to visit the Soviet Union in 1959 to open a Trade Fair exhibition in Moscow and stage talks with Soviet leaders in advance of Premier Nikita Krushchev's visit to the US the following month. The exhibition, which depicted the life of ordinary Americans, was the site of the impromptu 'kitchen debate' between the two leaders, in which Richard Nixon was called on to defend the American lifestyle.

591. Soviet Premier Krushchev being presented with a turkey by US President Eisenhower. Krushchev's visit to America, where he toured farms and urban centres with the vivacity of a local politician on the campaign trail, was an unqualified success. The two leaders met for talks at the presidential retreat of Camp David in Maryland and agreed on the need for peaceful coexistence. The warm and friendly spirit of the tour brought US-Soviet relations to a new high.

592. As a lawyer in Havana in the early 1950s, Fidel Castro began fighting on behalf of Cuba's poor and against the repressive policies of President Fulgencio Batista. In 1953 he became an active revolutionary and three years later made an unsuccessful attempt to seize power. He fled into the Sierra Maestra Mountains where he organized an insurgent force to wage guerrilla attacks against Batista's US-backed regime. Castro's unrivalled leadership skills and immense popular appeal, combined with Cuba's degeneration into a police state, brought many recruits to his cause. His guerrilla campaign finally forced Batista to flee the country on 31 December 1958 and nine days later Castro triumphantly entered Havana.

593. Fidel Castro became Prime Minister of Cuba in February 1959 and quickly set about implementing a Marxist-Leninist programme adapted to local conditions. Major reforms in the agriculture industry and education were followed by a comprehensive effort to destroy the US dominance of Cuba's economy. Cuban-American

relations deteriorated rapidly while Castro investigated the possibility of developing a close relationship with the Soviet Union.

594. Born Mihail Christodoulon Mouskos, Archbishop Makarios assumed his new name (meaning 'blessed') in 1950 when he became head of the self-governing Orthodox Church of Cyprus and took on the traditional duties of ethnarch, the national and spiritual leader of his people. He became a powerful figure in the campaign for *Enosis* and in 1956 was deported to the Seychelles by British colonial authorities who mistakenly believed him to be directing EOKA terrorists. In April 1957 he was permitted to return to Athens and later campaigned vigorously at the United Nations on behalf of Greek Cypriots. After talks in London and Zurich in February 1959, a compromise solution was reached. Cyprus was to become an independent republic within the British Commonwealth the following year. Makarios was elected as the first president in December 1959 and took office on 16 August 1960.

595. Elizabeth Taylor in Joseph Mankiewicz's screen adaptation of Tennesse Williams' 1958 play *Suddenly Last Summer*. Glamourous Hollywood stars Taylor and Montgomery Clift were thrust into a story of pederasty, lobotomy and cannibalism in the film version of Williams' suspense drama about truth and propriety in the 1930s American South. Taylor received one of her many Academy-award nominations for her mesmerizing portrayal of a young woman who witnesses the shocking death of her cousin. She is later confronted by the victim's family, who brutally attempt to suppress the lurid details being revealed. The film shocked conservative sensibilities among American audiences with its frank treatment of subjects rarely mentioned in the 1950s.

1960

596. On 13 February 1960 France detonated its first atomic bomb from a 101-metre (330-ft) high tower in the Sahara desert. Like Britain, who had tested their first atomic weapon in 1952, France viewed possession of nuclear weapons as essential for Great Power status. As British Prime

Minister Harold MacMillan remarked, such weapons would allow Britain to continue to 'eat at the top table' and participate in US nuclear decision-making. In contrast to Britain, France invested in nuclear weapons in order to ensure independence from the US.

597. Japanese Socialist Chairman Inejiro Asanuma was in the middle of a speech at a political rally on 12 October 1960 when a right-wing extremist raced to the stage and stabbed him to death. Seen live on television by thousands of horrified viewers, the assassination ended Asanuma's career as a tireless campaigner for socialism in Japan and the country's most outspoken critic of US policy in East Asia. The previous year Asanuma had aroused controversy when he denounced American imperialism as the common enemy of both Japan and China during a visit to Peking.

598. On 24 March 1958 Elvis was inducted into the US Army at his local draft board office in Memphis and within six months was assigned to the 4th Armoured Division in Wiesbaden, West Germany, as a jeep driver. His recording career was temporarily put on hold, although his music continued to sell in record numbers. On 3 March 1960 Elvis was promoted to the rank of sergeant and two days later was honourably discharged from the army. He resumed his music profession and a burgeoning career in film, but at only twenty-five his greatest achievements were already behind him.

599. A year after the revolution in Cuba, Castro's popular appeal seemed boundless. His nationalization of US businesses and the expropriation of Cuba's large foreign-owned plantations had restored feelings of pride and national independence lost during the long period of corruption among officals and US economic exploitation under Batista. However, supporters of the former dictator who fled to America during the revolution convinced the US government that popular support for Castro was not as strong as reports indicated and that large numbers of Cubans would rise against Castro if a counter-revolutionary force was landed on the island.

600. During the historic Twentieth Congress of the Communist Party in Moscow in 1956, Nikita Krushchev revealed the true extent of state terror during the Stalinist period for the first time. Under Krushchev a policy of de-Stalinization was implemented. Many of Stalin's policies were reversed and the most pernicious aspects of the Soviet system lessened. This had a major impact beyond the Soviet Union's borders. Political unrest became more widespread in Eastern Europe, as did official attempts to rid its cities of the countless monuments and tributes erected in Stalin's honour. Otakar Svek, the Czechoslovakian architect of the monument pictured, had entered a contest to design a monument to Stalin against his will. Concocting what he hoped to be an unfeasible entry, he was shocked when his design was chosen and so horrified at the prospect of glorifying Stalin that he committed suicide rather than live to see the monument built.

601. In 1954 a Muslim independence movement led by the French National Liberation Front (FLN) began an uprising against French rule in Algeria. By the late 1950s General Raoul Salan, the Commander-in-Chief of the French army in Algeria, was directing a vicious war against the FLN. In France all attempts to resolve the Algerian troubles were failing. Charles de Gaulle accepted office as the first President of the Fifth Republic in 1958, determined to end the fighting in the colony even if that meant granting independence to Algeria.

602. In 1960 identification cards were issued to Algerian villagers by the colonial administration to enable French authorities to monitor the population more closely. Village women were forced to take off their veils and reveal their faces for these portraits, something strict Muslims would normally only do in private. Actions such as this served to highlight the conflict that existed between native Algeria Muslim nationalists and the *pieds noirs*, Christian colonists of French descent in Algeria. Back in France the war was fuelling an enormous domestic crisis and increasingly challenging the French self-image of a liberal and tolerant society.

603. On 9 December 1960, following an announcement by the French government that a referendum to decide the future of Algeria would be held in a month's time, President de Gaulle began a tour of the colony. The President had tried to placate local anti-French sentiments by granting full rights of French citizenship to Algerian Muslims and providing better schools and social services. However de Gaulle received an unenthusiastic welcome from the local European population and serious rioting broke out in various towns. After European-Muslim clashes in which French troops opened fire on Algerian-native demonstrators, killing over a hundred, he cut short his visit and returned to France.

604. A French army of half a million soldiers was sent to suppress the uprising in Algeria, but within France itself there was disagreement over how the war was to be conducted. Algerian colonists became radicalized and the French military's hard-line policies became more extreme. On his return to power in 1958, de Gaulle struggled to restore order and curtail the military's increasingly brutal attempts to pacify the country.

605. Charles de Gaulle's illustrious background suggested that he might be the person capable of bringing the seemingly intractable Algerian conflict to an end. He had been a French army officer in the First World War, and later wrote the highly influential text, *The Army of the Future* (1940). While in exile during the Second World War he had become the leader and soul of the French Resistance. Following the war he served briefly as President of France and was elected Provisional Head of State. He then left politics until 1958 when he returned as president after a right-wing revolt of French extremists in Algeria led to the fall of the Fourth Republic. His steadfast determination, single-mindedness and unfailing belief in his own destiny as the saviour of France had served de Gaulle well in the past. He saw no reason why the conflict in Algeria could not be settled in accordance with French interests.

606. Born into a theatrical family in Paris, Cathérine Deneuve made her debut in *Les Collégiennes* (1956) and found herself occasionally cast as the sister of her real life sibling, actress Françoise Dorléac. Although virtually unknown at the beginning of the sixties, by the end of the decade Deneuve was one of the most famous women in France, and one of the most glamorous actresses in the world. Her unmatched elegance and composure concealed a fiery passion evident even when she was young which helped make Deneuve a favourite of the world's greatest film directors.

607. Princess Margaret taking a snap at the Badminton Horse Trials watched by her fiancé, the professional photographer Antony Armstrong-Jones. In 1960 Margaret, the younger daughter of King George VI and only sister of Queen Elizabeth, married Armstrong-Jones, who was made the first Earl of Snowdon the following year. Armstrong-Jones was particularly adept at capturing unusual aspects of famous people in his informal portraits. He worked as a photographer for *Vogue* magazine and artistic adviser for a variety of other publications.

608 top. Nigeria achieved independence on 1 October 1960 after nearly eighty years of British colonial rule and became a federal state with a constitution based primarily on Britain's political system. Nigeria was one of the most populated countries in Africa and the country's immense ethnic and religious diversity made the federation fragile and uneasy from the outset. Of 430 different ethnic tribes, four major groups (the Hausa, Fula, Yoruba and Ibo) vied for power and influence. Feuding between these groups soon paralysed the government and led to the growth of regionally based political movements.

608 bottom. In the months before the Congo achieved independence, Belgian colonial authority there collapsed as troops of armed police attacked Belgian senior officers. A number of European properties were raided. As police forces became increasingly ineffective, rivalries between many of the different tribes erupted and strikes broke out across the country. Thousands of Belgians were forced to flee the country as their leaders in Brussels prepared to relinquish control of the vast central African nation.

609. Young King Baudouin of Belgium was unaware that his sword was being stolen as he maintained his salute on a drive through Léopoldville with the Congo's new president, Joseph Kasavubu, during the country's Independence Day celebrations on 30 June 1960. The Independence Day festivities were hardly over when trouble began again. Tribal violence flared, Belgian expatriots were attacked and there was widespread looting. The new Prime Minister Patrice Lumumba appealed to the US for assistance and as a result the Security Council approved the establishment of a peacekeeping force which was sent to the country a few days later.

610. *The Misfits* was written especially for Marilyn Monroe by her third husband, the playwright Arthur Miller. It was the last film both she and her co-star Clark Gable made. Gable died of heart troubles in 1960. Monroe's last few years were difficult and tumultuous. She was anxious to receive praise for her acting ability, but her private life continued to dominate her press coverage. Monroe was divorced from Miller less than a year after *The Misfits'* release. She died from an overdose of sleeping pills on 5 August 1962.

611. *Echo 1* was a balloon satellite, the first passive communications satellite to be put into orbit. Launched on 12 August 1960, *Echo 1* consisted of an aluminium-coated plastic balloon that inflated to a diameter of 30 metres (100 feet) once in space. By reflecting radio signals from one ground station to another, the satellite made two-way voice transmissions possible. *Echo 2* was launched in 1964 and was most notable for being the first joint US-Soviet space venture.

1961

612. Yuri Gagarin joined the Soviet air force in 1955 and five years later was selected for training as a cosmonaut in the country's fledgling space programme. On 21 April 1961 at 9.07 am Moscow time, the *Vostok* spaceship satellite was launched. It reached an altitude of 300 kilometres (187 miles), orbited the Earth once, in one hour and twenty-nine minutes, and landed in the Soviet Union at 10.55 am. Gagarin had just completed the first manned space flight in history.

613. Gagarin's sensational space flight thrust him into the world's spotlight and gave Premier Nikita Krushchev good reason to boast about Soviet scientific research and technology. The son of a collective farmer, Gagarin was made a Hero of the Soviet Union and travelled internationally as an ambassador of Soviet science.

614. Adolf Eichmann during the daily hour he was allowed outside at Teggart Fortress, near Nazareth in Israel, prior to his transfer to Jerusalem where he would stand trial for his role in the Holocaust. The former Nazi SS leader was captured by US forces in 1945, but escaped and made his way to Argentina. Israel's security service, Mossad, eventually discovered Eichmann's whereabouts and smuggled him to Israel in 1960. At his trial, prosecutors produced documents signed by Eichmann which revealed him to be one of the chief initiators of the Nazi's extermination policy. He was sentenced to death for 's against humanity' and hanged. David Ben Gurion, then Prime Minister of Israel, described the trial as an invaluable history lesson for the country's youth.

615. Paul McCartney and John Lennon were the founding members of a then-little-known British musical foursome called the Beatles, here seen live on stage at the Cavern Club in their native Liverpool in December 1961. With George Harrison and later Ringo Starr, who replaced Peter Best (here pictued on drums), the 'Fab Four' rose to become the most commercially successful rock-pop band of the 1960s.

616. US President John F. Kennedy greeting Soviet Premier Nikita Krushchev at the US Embassy in Vienna in June 1961. The atmosphere of goodwill which had developed between the two superpowers during Eisenhower's second term as president had evaporated with the two leaders' disagreement over Germany, the status of Berlin in particular and the stalled disarmament talks.

When the two leaders met, the dynamism of the new American president failed to impress the Soviet leader. Despite Kennedy's staunchly anti-communist pronouncements, Krushchev came away from their talks in Vienna suspecting his counterpart in Washington was something of a political lightweight.

617. Between 1949 and 1961 an estimated 2.5 million East Germans fled into West Germany, mostly through Berlin, despite vigorous attempts by East German authorities to stop them. Among those who left East Germany were many young skilled professionals and intellectuals, whose departure led to a decline in the country's economic vitality. In order to halt the exodus, East Germany erected a wall through the middle of Berlin on the night of 12 August 1961. The original wall was made of barbed wire and breeze blocks, but a complex system of walls up to 4.5-metres (15-feet) high, electrified fences and watch-towers stretching 45 kilometres (28 miles) through the city was subsequently constructed.

618. In 1949 Kwame Nkrumah founded the Convention People's party which sought independence for the British colony of the Gold Coast, which he renamed Ghana. When he became president in 1960 the country became an independent republic within the Commonwealth. Nkrumah subsequently attempted to mould himself as an African Gandhi, peacefully uniting the continent's disparate peoples and fostering post-colonial economic prosperity. Despite his good intentions, Nkrumah became increasingly dictatorial and corrupt and as a result the Ghanaian economy grew weak and chaotic. In 1966 Nkrumah was overthrown in an army coup while on an official visit to China.

619. The children of Patrice Lumumba the murdered Congolese Prime Minister, looking at the damage inside the Belgian Embassy after students rioted on 15 January. A leading proponent of Pan-Africanism, Lumumba argued passionately for a unified Congo and against the breakaway of Katanga province whose leaders were supported by white mercenaries in the pay of a

Belgian mining company with major interests in the province. Lumumba was ousted in a coup and handed over to the rebellious troops of the secessionist province of Katanga by the army leader Colonel Sese Seko Mobutu, and was subsequently murdered. His death sparked renewed fighting and chaos across a country already on the brink of collapse. The following year the first UN peacekeeping force was sent to the Congo to restore order.

620. William Klein's exhilarating photographic record of the dynamic changes taking place in Japanese society in the early 1960s included shots of action painters frenetically creating their works. This impulsive, energetic style of painting which had been termed 'action painting' by the American art critic Harold Rosenberg, was part of the Abstract Expressionist movement most often associated with the American painter Jackson Pollock. Similar developments in Japan were part of the Gutai movement.

621. François Truffaut's lyrical new wave film *Jules et Jim* centres on two male writers whose lives are changed forever when they meet a woman who appears to be the personification of a stone goddess with which both men have become enchanted. The exuberant and independent Catherine, played by Jeanne Moreau, is beautifully captured by Truffaut particularly in circling, swirling shots that reflect the two men's disorientation by her beauty and elusiveness. A tragi-comic tale of obsessive love and friendship in Paris of the 1910s and at the outbreak of the Second World War, *Jules et Jim* is widely regarded as the finest of Truffaut's films.

1962

622. The Finnish people shared the worldwide fascination with Yuri Gagarin after his historic space flight, but were uncertain about hosting the cosmonaut at the communist-sponsored World Youth and Student Festival in Helsinki in the summer of 1962. Liberal youth organizations argued that it would jeopardize Finland's policy of neutrality in international affairs. Antagonistic demonstrations, a rare occurrence in Finland, broke out among crowds of youths at the festival. President Urho

Kekkonen, eager to maintain good relations with his country's eastern neighbour, issued a formal apology to the Soviets soon after.

623. US astronaut John Glenn became the first American to orbit the Earth on 20 February 1962. Glenn made three orbits aboard *Friendship 7* before the capsule landed safely in the Atlantic later that day. Thirty-six years on, the astronaut-turned-politician would achieve an equally impressive feat when he returned to space aboard the shuttle *Discovery* and became the oldest person in space.

624. On 16 October 1962 aerial photographs over Cuba convinced US President Kennedy that ballistic missiles with atomic warheads, which if launched could easily reach any US city, were being installed on the island by the Soviet Union. Less than a week later, Kennedy ordered the US Navy to blockade Cuba and, under threat of an imminent aggressive action, made a formal demand to Soviet Premier Krushchev to remove the missiles. Krushchev replied that he would comply only if America withdrew all NATO missiles stationed in Turkey. Kennedy flatly refused and the superpowers seemed poised on the brink of nuclear war. On 28 October Krushchev agreed to withdraw the missiles under UN supervision, provided the US lifted the blockade and agreed not to invade Cuba again. Within a week the missiles had been dismantled and were being shipped home. Kennedy's firmness in the crisis won him great respect at home and abroad.

625. By 1962 several thousand US military advisers were stationed in South Vietnam and were training soldiers loyal to the country's anti-communist president Ngo Dinh Diem. The US sought to build up South Vietnam's defences against communist encroachment from the North, but it seemed increasingly unlikely that South Vietnamese troops would be able to accomplish the task on their own. Communist guerrillas (Vietcong) were beginning to gain control of rural areas in the south and in the process winning growing numbers of villagers over to their cause.

626. The construction of the Berlin Wall was immediately

condemned by the non-communist world and quickly came to symbolize a physical and ideological faultline between the East and West during the cold war. In total about 5,000 East Germans managed to cross the wall to freedom in safety, but about the same number were caught in the attempt. Over a hundred people were killed attempting to escape.

627. Despite the US Supreme Court's Brown v. Board of Education case that overturned the 'separate but equal' legislation and mandated racial integration in schools in 1954, the issue of racism remained hotly contested in the US, particularly in the south. In the autumn of 1962, a twenty-nine-year-old airforce veteran James Meredith attempted to become the first African-American student to enrol at the University of Mississippi. Protests and riots broke out in the university town, but local police took little action. Two people died in the riots. The state governor tried physically to prevent Meredith from entering a campus building. President John F. Kennedy intervened on behalf of Meredith and called in the National Guard to protect him. Meredith remained at the university in spite of relentless abuse and intimidation, and became one of the most significant and inspirational figures in the civil rights struggle.

628. A prominent cabaret owner noticed the powerful voice and expressive style of twenty-year-old Edith Piaf, then Edith Gassion, who was singing in the cafés and streets of Paris. He named her *la môme piaf* (the little sparrow) because of her diminutive frame and gave her a job. From that time Edith Piaf's singing won her adulation and international acclaim. Her musical genius never waned and she recorded some of her best work, including her signature song, 'Non, je ne regrette rien' as late as 1960. She died of cancer in the south of France in 1963. Piaf's association with Paris was so deep-rooted in the French national psyche that her body was secretly transported back to Paris, where it was said she had died.

629. A flour-mill election in a suburb of Algiers, Algeria. De Gaulle's protracted peace negotiations with the FLN led to a

cease-fire in March ending seven-and-a-half years of bloody conflict. A plebiscite was held on 1 July in which the Algerian electorate voted overwhelmingly in favour of independence. The war had uprooted nearly 2 million Algerians from their homes and left the country's economy and infrastructure in tatters. By the time the French president declared the country officially independent two days later, acute polarization between the *pieds noirs* and the native Algerian community had triggered a massive exodus of Europeans from the country. The first elections for Algeria's new parliament took place on 20 September.

1963

630. Once one of Europe's thriving seaports and the leading handler of shipping traffic in Britain, Liverpool declined significantly both as an export and a passenger port after the Second World War. Several factors, including the diminishing importance of Britain's industrial centres, developments in air travel, and the drop in the transatlantic shipping trade with America caused employment at Britain's docks to fall steadily before virtually collapsing in the 1960s. Few places were hit as hard as Liverpool. Dockers tried to hang on to the jobs still available while employers attempted to cut costs by using cheaper casual labour. During this decade industrial unrest was common.

632. The ritual suicide of a young Buddhist monk on a street in Saigon in protest at the policies of South Vietnam's US-backed president, Ngo Dinh Diem. The anti-communist Roman Catholic regime of Diem maintained order in South Vietnam through brutally repressive tactics. Buddhists were particularly affected; their pagodas were raided and desecrated and Buddhist monks were caught up in mass arrests. World opinion condemned religious persecution in the country, and by the autumn US support for the regime had waned considerably. US officials, sensing that Diem's harsh repression was driving the South Vietnamese into the arms of the communists, gave tacit approval to a military *coup d'état*. Diem was overthrown on 1 November and later executed.

monks were caught up in mass arrests. World opinion condemned religious persecution in the country, and by the autumn US support for the regime had waned considerably. US officials, sensing that Diem's harsh repression was driving the South Vietnamese into the arms of the communists, gave tacit approval to a military *coup d'état*. Diem was overthrown on 1 November and later executed.

633. Prior to its release in 1965 *The Greatest Story Ever Told* – a story recounting the life of Jesus from his birth to his resurrection – was hyped in Hollywood as the film of the decade. It cost more than 20 million dollars to produce and included a cast of some of the biggest stars in cinema. The film's financial backers believed George Stevens' film would sweep that year's Academy Awards and be an unqualified success at the box-office. But they were wrong. Critics were scornful and audiences found it difficult to take the film seriously with so many unlikely cameos, including the legendary Hollywood cowboy John Wayne as a Roman centurion. Until the release of *Heaven's Gate* in 1980, *The Greatest Story Ever Told* held the record for suffering the greatest financial loss of any film in cinema history.

634–35. In the early 1960s law enforcement officials in parts of the southern US ignored or even encouraged violent acts against African-Americans working for political, social and economic advancement. They unwittingly created propaganda for the civil rights movement when television images of courageous civil rights demonstrators confronting unprovoked police repression were broadcast. Figures such as Eugene 'Bull' Conor, the brutish Public Safety Commissioner of Birmingham, Alabama, became potent symbols of racist southern states such as Alabama and Mississippi. His attitudes embarrassed many southerners. The US Civil Rights Act was passed in 1964.

636. Valentina Tereshkova was a parachutist at her local aviation club before Soviet authorities selected her for training as a cosmonaut in 1962. On 16 June 1963 she made her one and only space flight aboard *Vostok 6*, becoming the first woman in space and a world celebrity. Tereshkova was

made a Hero of the Soviet Union and like her fellow cosmonaut Gagarin visited many countries after her historic space flight, extolling the virtues of Soviet progress in science and technology. She later entered politics and played a leading role in the Soviet Committee for Women.

637. *Retired man and his wife at home in a nudist camp one morning, New Jersey, 1963*. Arbus is perhaps best remembered for her unique ability to establish intimacy with the extraordinary – and often bizarre – subjects of her photographs. Arbus rebelled against her wealthy, conservative upbringing and her work in conventional fashion photography, and instead devoted much of her later work to recording people on the fringe of society, such as nudists, transvestites and circus performers.

638. During President Kennedy's celebrated tour of Europe in the summer of 1963 he visited his ancestral home of New Ross in County Wexford, Ireland, where his great-grandfather Patrick Kennedy had been born. The President praised Ireland's role in international affairs before an enraptured audience. His popularity across Europe proved to be as great as it was back home. Spectacular foreign policy successes such as the Cuban Missile Crisis and the signing of a Nuclear Test-Ban Treaty, combined with his innate ability to inspire and lend hope to different peoples around the world, meant that Kennedy had few peers on the global stage.

639. The First Lady Jacqueline Kennedy holding John F. Kennedy after the fatal shots. On 22 November 1963 President Kennedy was assassinated by rifle fire while being driven in an open limousine through Dallas, Texas. He was hit twice, once at the base of the neck and once in the head, and was pronounced dead on arrival at a local Dallas hospital. Texas Governor John Connally, who also rode in the presidential motorcade, was hit and seriously wounded, but later recovered.

640. Vice-President Lyndon Baines Johnson, who had ridden in Kennedy's motorcade earlier in the day, being sworn in as America's 36th President aboard

the presidential plane at Love Field, Dallas. To his left, a dazed Jackie Kennedy, still wearing the blood-stained outfit from that morning, looks on. After the short ceremony the entire presidential party flew to Washington where Johnson announced his firm commitment to carrying out the legislative programme of his deceased predecessor. Although no fan of the youthful Kennedy, Johnson shrewdly refrained from tinkering with his policies: shocked, grief-stricken Americans needed time to come to terms with the sudden death of the most popular American leader of modern times.

641. A Marxist and a former US marine, Lee Harvey Oswald became disillusioned with capitalist American society and moved to the Soviet Union in 1959. He returned to the US in 1962 and began a campaign against America's anti-Castro policy. In the autumn of 1963 he got a job at the Texas School Book Depository in Dallas, and it was from the sixth floor of this building that he was alleged to have shot and killed President Kennedy as he passed by in a motorcade in the early afternoon of 22 November. Two days later, while under police custody in a Dallas County jail Oswald was himself shot dead by a local nightclub owner, Jack Ruby. Conspiracy theorists have claimed ever since that Oswald was working as part of a wider plot to assassinate the president.

1964

643. Winston Churchill leaving his London home to make his final appearance in the House of Commons on 27 July 1964. Britain's incomparable wartime leader had served as Prime Minister again between 1951 and 1955 and remained a Member of Parliament until he died in 1965. Although he had presided over the decline of Britain as a world power, Churchill's charisma, vitality and brilliant leadership in the face of extreme adversity made him one of the greatest public figures of the twentieth century.

644. Teenage girls driven into a frenzy at a Beatles concert in Washington, DC. After the release of several chart-topping songs in Britain, the 'Fab Four' went on tour in America in early 1964 and Beatlemania, as it became known,

swept the country. An appearance on the US television programme *The Ed Sullivan Show* established the Beatles as the most popular rock and roll group in the world. US critics, who had claimed that the Beatles' American tour would demonstrate the band's limited appeal outside their native Britain, were amazed by their popularity.

645. In 1961 the Soviet ballet dancer Rudolf Nureyev defected while on a European tour with the Kirov Ballet in Paris. The following year the flamboyant and charismatic young dancer made his debut with the Royal Ballet in London opposite Margot Fonteyn who was twenty years his senior. Nureyev breathed new life into the career of the legendary English ballerina and their acclaimed partnership in ballets such as *Swan Lake* and *Giselle* in the 1960s significantly increased Western ballet audiences, and established Nureyev as the most important male ballet dancer of the decade.

646–47. A British soldier looking at the bodies of two Turkish Cypriots in the village of Ayios Sozemenos near Nicosia in Cyprus. Friction between the island's Greek and Turkish communities had been growing since the country achieved independence from Britain in 1960 when violence erupted in the capital, Nicosia, and brought Cyprus to the verge of civil war. Turkey sent its air force to the island to assist Cyprus' beleaguered Turkish minority in 1964 and a full-scale invasion seemed imminent. After intense fighting in the north-west part of the island, contingents of troops from both Greece and Turkey were brought secretly to the island to assist and train the forces raised by the two communities. Britain obtained permission from the Greek, Cypriot and Turkish governments to form a joint peacekeeping force to restore order to the island. The city of Nicosia was subsequently divided by a cease-fire line, which was policed initially by British troops. When fighting erupted again in the spring of 1964, a UN force made up primarily of Canadian, Swedish, Irish and British troops, was sent out in April. By the following month the UN head-quarters in Nicosia had around 7,000 peacekeepers under its command.

648. Sir Robert Menzies Prime Minister of Australia, Mrs Sirimavo Bandaranaike Prime Minister of Ceylon and President Kwame Nkrumah of Ghana, sharing a joke before the opening of the Commonwealth Prime Ministers' Conference in London on 13 July 1964. Britain's dwindling influence in world affairs during the post-war era was partly compensated by its continuing leadership of the Commonweath, which in 1964 still accounted for a quarter of the world's land area and contained about a half of the global population. The 1964 conference emphasized the importance of the multi-ethnic Commonwealth's role in improving global race relations.

649. Britain's new Prime Minister Harold Wilson being greeted by jubilant crowds following the Labour Party's victory in the general elections of October 1964. Labour narrowly defeated a worn-out Conservative Party on a platform designed to exploit what Wilson called 'the white heat of the technological revolution'. Having been out of power for thirteen years, Labour was confronted with enormous economic difficulties and its leader would need more than a clever slogan to cure the country's social and fiscal problems.

650. During the 1964 election in which he ran for president, Barry Goldwater became, in many ways, a martyr for the radical right-wing in American politics. He was the most prominent representative of a new republicanism advocating smaller government, lower taxes and brinkmanship with the Soviet Union with which ordinary Americans were clearly still uncomfortable. Goldwater suffered a crushing defeat at the hands of his presidential rival, President Lyndon Johnson, but the conservative values he championed during the campaign would have a profound impact on the American political landscape in the coming years.

651. In 1963 a UN force of nearly 20,000 troops restored some semblance of order to the Congo when they finally overthrew the secessionist regime in the province of Katanga and forced its leader, Moise Tshombe, to flee the country. However, after a brief lull in the fighting and the withdrawal

of UN troops, tribal rivalries erupted once again, aggravated by unemployment and other economic problems. Tshombe returned from exile to become Prime Minister of the Congo Republic in July 1964, triggering yet further disturbances in rebellious parts of the country. Order was not restored until November 1965 when the Congolese army leader Sese Seko Mobutu, backed by the US and Belgium and employing white mercenaries, crushed all resistance and took over the government himself.

652. A farmer's son and his nursemaid in South Africa. After the banning of the ANC and the imprisonment or exile of its leaders in the early 1960s, organized resistance to apartheid in South Africa all but disappeared and the country settled into a decade of apparent stability and unparalleled prosperity. Massive foreign investment and a vast pool of cheap labour enabled the white minority to achieve one of the highest standards of living in the world. The country's growing wealth did not, however, improve living standards for the black majority who were legally barred from many professions and forced to live in black-only zones set up by the apartheid regime in depressed areas on the outskirts of urban centres. Domestic work with a white family was one of the more lucrative careers available to blacks.

653. Played on nearly every continent and in nearly every country, football became the world's most popular sport at the beginning of this century. The fact that the game can be played virtually anywhere, with only the most basic equipment, ensured that poor and rich countries alike could produce great players. Professional football leagues were formed in most countries and over time intense rivalries developed between opposing teams. At an international level opposing countries fielded national sides to participate in international competitions, the most prestigious being the World Cup held every four years. Unfortunately since the 1960s, and most notably in England, the enthusiasm of supporters has often boiled over into anti-social behaviour and occasional violence.

1965

654. When it appeared that Prime Minister Moise Tshombe had rigged the Congo's national elections, Colonel Mobutu staged a *coup d'état* on 25 November 1965 and declared himself Head of State. As the new president he imposed discipline ruthlessly, but gradually brought competent and effective officials into his administration, thereby restoring stability to the strife-riven Congo (renamed Zaïre in 1971). He satisfied the demands of his people for Africanization while securing a number of profitable trading agreements with foreign companies exporting the country's vast copper deposits. Over time, more and more profits from these trading exchanges would go directly into Mobutu's numerous personal bank accounts.

655. In 1960 Cassius Clay won the Olympic amateur light-heavyweight title for the US at the Rome Olympics. Four years later, he won the professional world heavyweight title by defeating the reigning champion, Sonny Liston. That year, Clay joined the 'Black Muslim' sect (Nation of Islam) and changed his name to Muhammed Ali. He knocked out the former heavy-weight champion Floyd Patterson in 1965 and quickly established himself as one of the most dazzling fighters ever to enter the ring – and one of the most intelligent and charismatic boxers outside the ring. In 1967 Ali was stripped of his world title after he refused, on religious grounds, to be inducted into the US armed forces.

656–57. Founded in 1960, the Vietcong was the military arm of the communist National Liberation Front (NLF) which operated in South Vietnam. Its early activities were largely restricted to terrorist and guerrilla attacks against the US-backed government in the south. These were planned from its headquarters across the border in Laos. The fighting strength of the Vietcong insurgency grew from about 30,000 in 1963 to 150,000 in 1965. Aided by a regular infil-tration of weapons and advisers from the north (arriving via the Ho Chi Minh Trail), the Vietcong had control of nearly every village in the south and scored increasing victories over government forces.

658. North Vietnam's President Ho Chi Minh with his Prime Minister Pham Van Dong at the Presidential Palace in Hanoi. Born Nguyen Tat Thanh, the President adopted the name Ho Chi Minh (meaning he who enlightens) early on in his struggle against the foreign domination of Vietnam. After leading the Vietnamese resistance against the Japanese occupation during the Second World War, Ho Chi Minh became President of the new Democratic Republic of Vietnam which he proclaimed independent in 1945. His ability to inspire and generate popular support was crucial to the successful expulsion of the French from Vietnam in 1954 and the establishment of a socialist state in the territory north of the 17th parallel which was granted to his government by the Geneva Agreements. By 1965 'Uncle Ho', as he was known among his followers, was directing most of his efforts towards undermining the US-backed South Vietnam govern-ment in every possible way.

659. A US crew chief feeling the frustration of a defeat in which he lost several men. With the increasing Americanization of the war and the landing of the first US ground troops in March 1965, the Vietcong became engaged in more conventional confrontations with both the South Vietnamese army and newly-arrived US troops. By July the US had 75,000 troops deployed in the south. Although well trained and well equipped, most American soldiers were unaccustomed to the difficult jungle terrain and intense heat and were ill prepared for the problems of low morale and poor military leadership among their South Vietnamese allies.

660. Despite his autocratic presidential style and the growing popularity of the left among the French electorate, de Gaulle just managed to win re-election in 1965 after a second vote. The new anti-Gaullist alliance, the Federation of the Left led by François Mitterrand, proved a serious rival to de Gaulle's party when it won 45 per cent of the vote in the second round. Mitterrand, a fellow Resistance fighter and member of de Gaulle's first post-war government, proved that socialism in France was alive and growing.

661. Rhodesian Front leader Ian Smith leaving British Prime Minister Harold Wilson's residence at 10 Downing Street in London on 11 October. When the Central African Federation (present day Malawi, Zambia and Zimbabwe) broke apart in 1963, white settlers in what was then called Southern Rhodesia (Zimbabwe) quickly asserted their desire for independence through the racist right-wing Rhodesian Front (RF) led by Ian Smith. However the British government refused to grant independence to its former colony unless the black majority were given fair representation in the new government. In November 1965 Smith ignored British warnings and made a Unilateral Declaration of Independence (UDI). Britain responded by declaring the RF a rebel organization and, with UN support, imposed economic sanctions. The measures were initially ineffective, however, because they were ignored by Rhodesia's main trading partner, South Africa.

1966–1985
Vietnam to the Moon to Soviet Collapse

In the 1960s American society was being torn apart by student protests, the counter-culture movement and racial unrest, all related in different ways to the escalating US involvement in the war in Vietnam. The historic moon landing briefly turned the nation's attention away from its troubles, but for the most part the conflict remained a thorn in America's side until its final, ignominious departure from Vietnam in 1975 just before the country was reunified under communist rule. The war in Vietnam – which had been a French colony – also exacerbated student frustrations in France, leading to riots in 1968 which threatened the survival of the Fifth Republic. In Northern Ireland sectarian violence erupted between its Protestant and Catholic populations. Religious strife between Hindus, Muslims and Sikhs in India showed no signs of abating. Israel withstood an onslaught by its Arab neighbours and captured the Western Wall in Jerusalem, a site sacred to Jews around the world. Prospects for lasting peace in the region seemed remote. Central America became a focal point of the cold war as left-wing groups attempted to topple American-backed right-wing regimes. Ronald Reagan, the staunchly anti-Soviet US President elected in 1980, announced his intention to crush any communist encroachment in Central America, long considered 'America's backyard'. Chairman Mao died in China in 1976 and the Cultural Revolution ended after nearly ten years

of state-sponsored repression and terror which had ravaged Chinese society. African countries were decimated by drought. Widespread famine in the Sahel and East Africa caused hundreds of thousands of deaths before international relief efforts could alleviate the suffering. Zaïre was the unlikely host for the world heavyweight boxing championship and Muhammed Ali emerged as the winner. Ali's international fame was briefly rivalled by that of Nadia Comaneci, when the young Romanian gymnast scored the first perfect score in an Olympic competition. The film *Jaws* catapulted an unknown director by the name of Steven Spielberg into the limelight and the film's star – a great white shark – entered international popular culture. Fame was also achieved by the punk movement, particularly the Sex Pistols, a band whose violent lyrics and tempestuous behaviour created sensation and controversy wherever they performed. The space shuttle, the first reusable rocket-launched vehicle built to take a human being into orbit around the Earth, lifted off on its maiden voyage, signalling the dawn of a new age in space exploration. The Soviet Union's artists, scientists and writers were often reluctant to stay in their country. In 1974 Nobel Prize-winning writer Alexander Solzhenitsyn was expelled because of his fierce criticism of the Soviet system. In the same year the leading classical dancer Mikhail Baryshnikov defected after becoming exasperated with official

restrictions placed on him as an artist by the government authorities. In 1985 a little-known agriculture minister Mikhail Gorbachev became the General Secretary of the Communist Party and within months initiated sweeping reforms designed to save the Soviet Union's crumbling political and economic system. This was the beginning of the collapse of the Soviet Union.

Contemporary Voices

I say violence is necessary. It is as American as cherry pie.

Rap Brown, speech, 27 July 1967

You only have power over people as long as you don't take everything away from them. But when you've robbed a man of everything he's no longer in your power – he's free again.

Alexander Solzhenitsyn, *The First Circle*, 1968

If an elderly but distinguished scientist says that something is possible, he is almost certainly right, but if he says that it is impossible he is very probably wrong.

Arthur C. Clarke, *New Yorker*, 9 August 1969

It's natural the Boys should whoop it up for
so huge a phallic triumph, an adventure
it would not have occurred to women
to think worthwhile, made possible only
because we like huddling in gangs and knowing
the exact time: yes, our sex may in fairness
hurrah the deed, although the motives
that primed it were somewhat less than *menschlich*.

W. H. Auden, *Moon Landing (August 1969)*, 1969

Learning from the existing landscape is a way of
being revolutionary for an architect. Not the
obvious way, which is to tear down Paris and begin
again, as Le Corbusier suggested in the 1920s, but
another, more tolerant way; that is, to question
how we look at things.

Robert Venturi, Denise Scott Brown, Steven Izenour,
Learning From Las Vegas, 1972

Fame requires every kind of excess. I mean true
fame, a devouring neon, not the sombre renown of
waning statesmen or chinless kings. I mean long
journeys across grey space. I mean danger, the
edge of every void, the circumstance of one man
imparting an erotic terror to the dreams of the
republic. Understand the man who must inhabit
these extreme regions, monstrous and vulval,
damp with memories of violation. Even if half-
made he is absorbed into the public's total
madness; even if fully rational, a bureaucrat in
hell, a secret genius of survival, he is sure to be
destroyed by the public's contempt for survivors.
Fame, this special kind, feeds itself on outrage, on
what the counsellors of lesser men would consider
bad publicity – hysteria in limousines, knife fights
in the audience, bizarre litigation, treachery,
pandemonium and drugs. Perhaps the only natural
law attaching to true fame is that the famous man
is compelled, eventually, to commit suicide.
(Is it clear I was a hero of rock 'n' roll?)

Don Delillo, *Great Jones Street*, 1973

A photograph is not only an image (as a painting is an image), an interpretation of the real; it is also a trace, something directly stencilled off the real, like a footprint or a death mask.

Susan Sontag, *New York Review of Books*, 23 June 1977

[M]y prediction from the sixties finally came true: 'In the future everyone will be famous for fifteen minutes.' I'm bored with that line. I never use it any more. My new line is, 'In fifteen minutes everybody will be famous.'

Andy Warhol, *Andy Warhol's Exposures*, 1979

The basic idea of *The Female Eunuch* has never been very well understood, perhaps because I was unable to explain it properly. Nevertheless the concept of the castration of women is the key to the book and, I still believe, the key to the situation. Women's sexuality has been repressed because it served no social or domestic function. Whole women would have been restless, aggressive, unpredictable, curious, lustful, imaginative and in league with their naughtiest chidren against men and their machines. They might have been artists, inventors, explorers, revolutionaries, but they would not have been housewives, and housewives were what was wanted. Because they did not want them to be miserable, women connived in the deadening of their daughters.

None of the women were completely successfully castrated; their wild selves would peep through their eyes sometimes and create havoc, but, by the same token, they could not recover their completeness either, for the wild woman was etiolated and demented by her suppression.

But her time is coming, and it will not be granted to her. She will seize it.

Germaine Greer, *The Female Eunuch*, April 1980

More than any other time in history, mankind faces a crossroads. One path leads to despair and utter hoplessness. The other, to total extinction. Let us pray we have the wisdom to choose correctly.

Woody Allen, 'My Speech to the Graduates', *Side Effects*, 1980

After all, what's a cult? It just means not enough people to make a minority.

Robert Altman, *The Guardian*, 11 April 1981

Cricket civilizes people and creates good gentlemen. I want everyone to play cricket in Zimbabwe; I want ours to be a nation of gentlemen.

Robert Mugabe, *The Sunday Times*, 26 February 1984

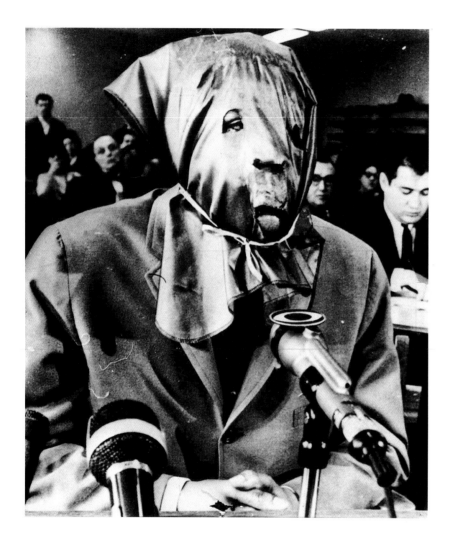

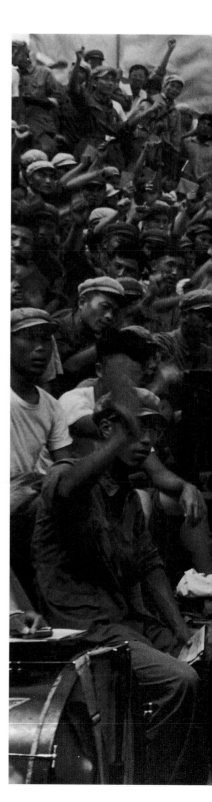

Concealed by a hood, a witness testifies to the wide use
of drugs on college campuses in Philadelphia.
A First Party secretary being humiliated during the Cultural Revolution –
often good public servants were destroyed in the process.

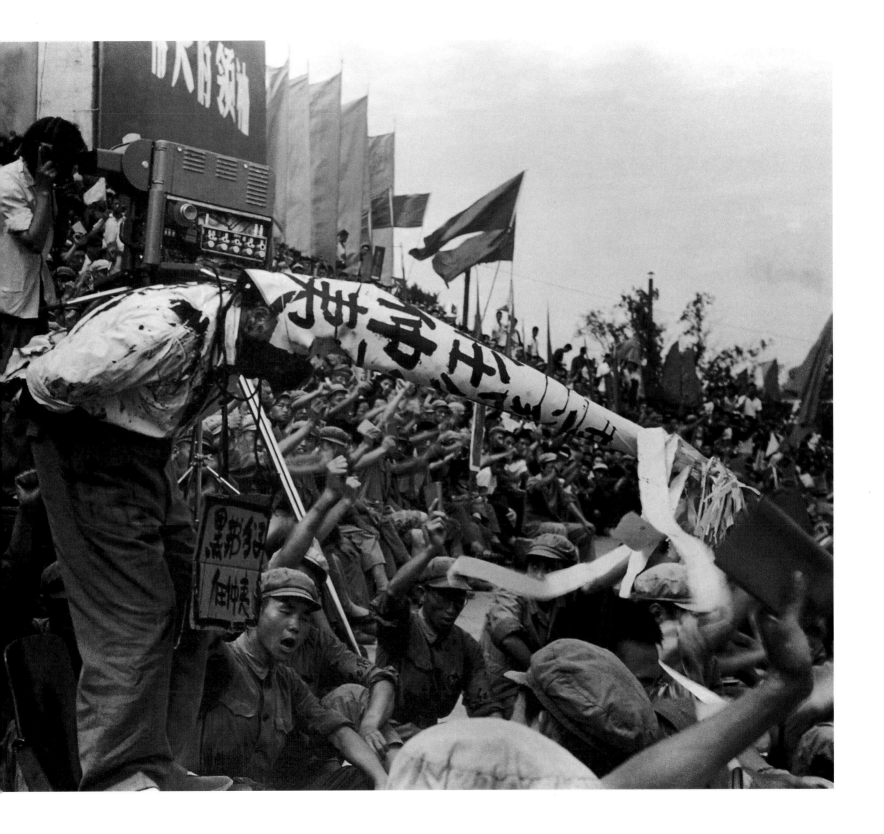

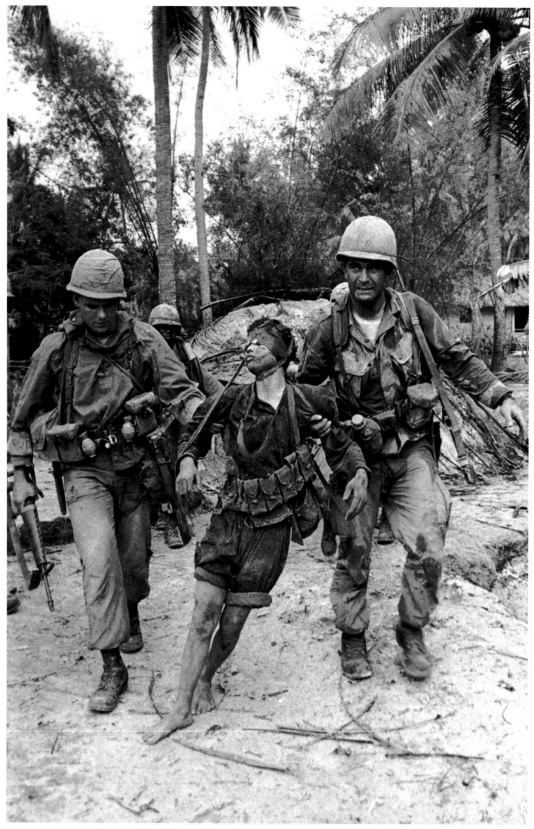

A Vietcong sniper being dragged from his bunker by US cavalry.

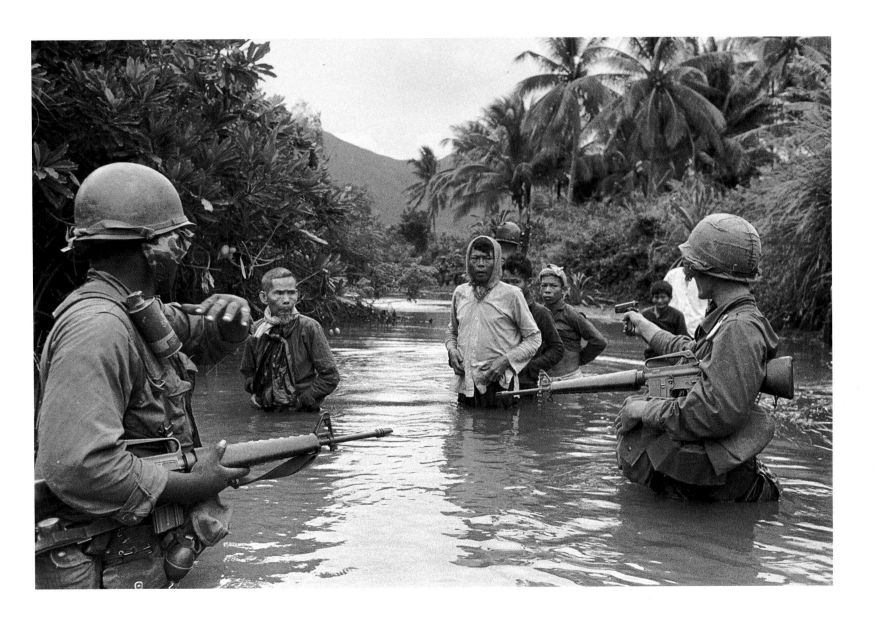

US troops moving Vietcong suspects across a river.

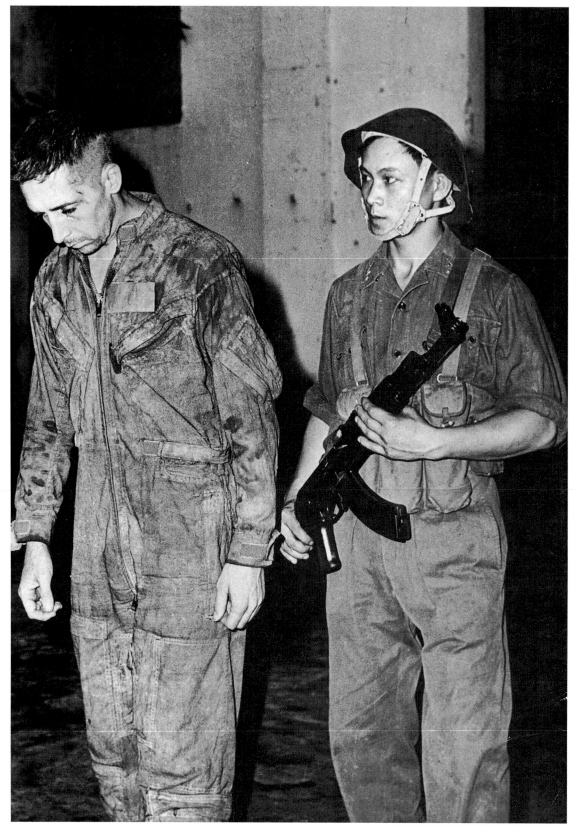

A US lieutenant commander in the hands of the North Vietnamese who claimed – impossibly – that his was the 2,000th US plane brought down over North Vietnam.

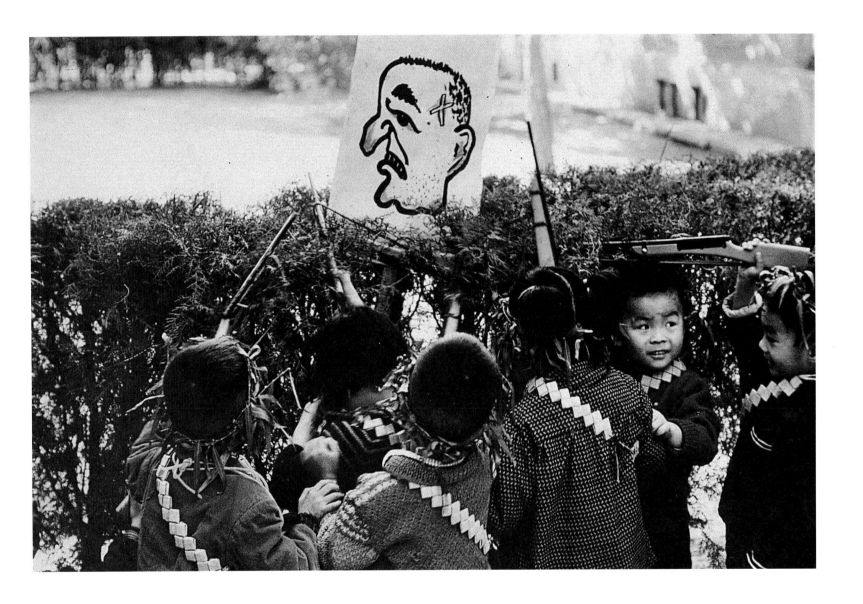

Chinese children playing at soldiers, mocking an image of US President Lyndon Johnson.

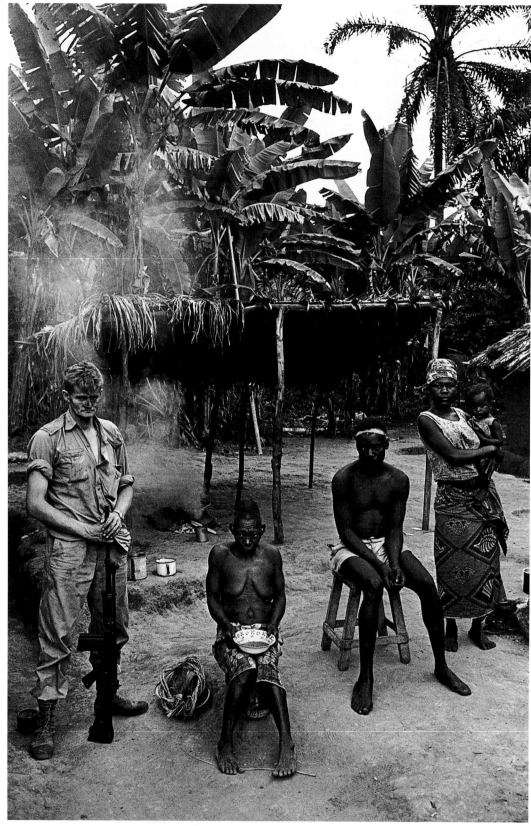

Don McCullin captioned this picture 'A Rhodesian mercenary humbles a Congelese family'.

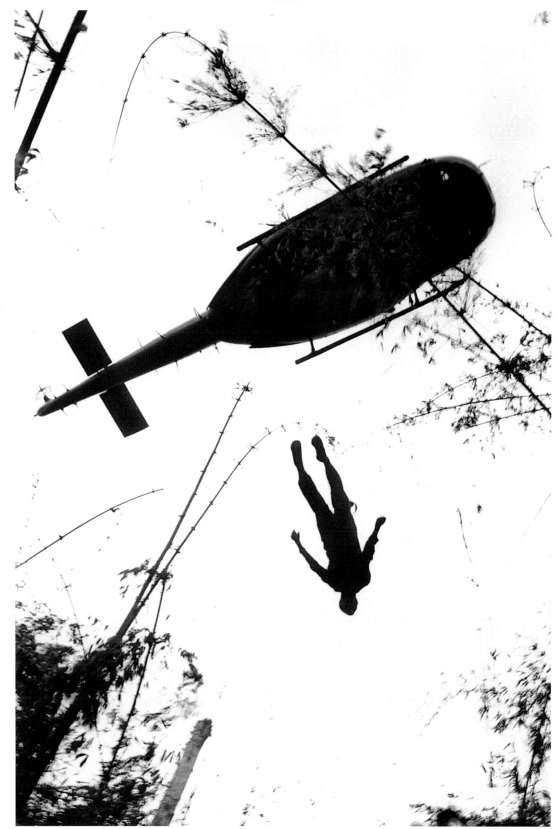

The body of an American paratrooper being raised to an evacuation helicopter after he was killed near the Cambodian border.

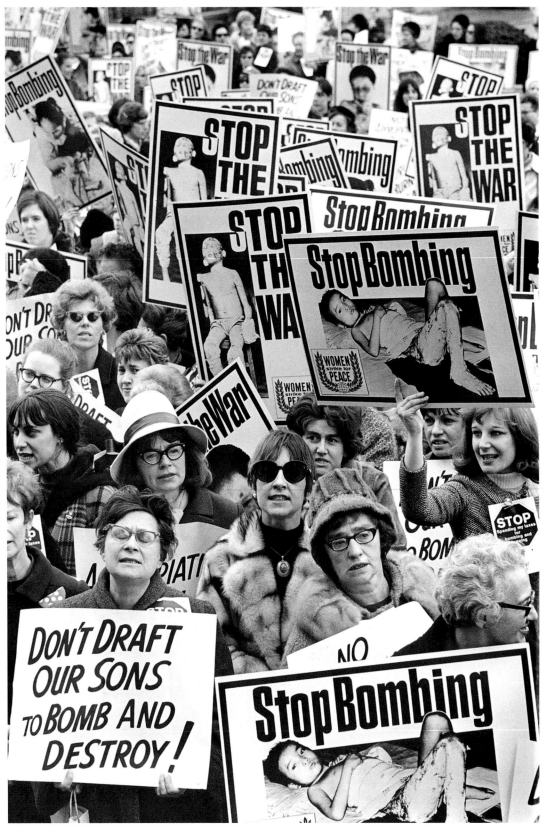

The 'Women's Strike for Peace' storming the Pentagon in Washington where they obliged Defence Secretary Robert McNamara to see their delegation.

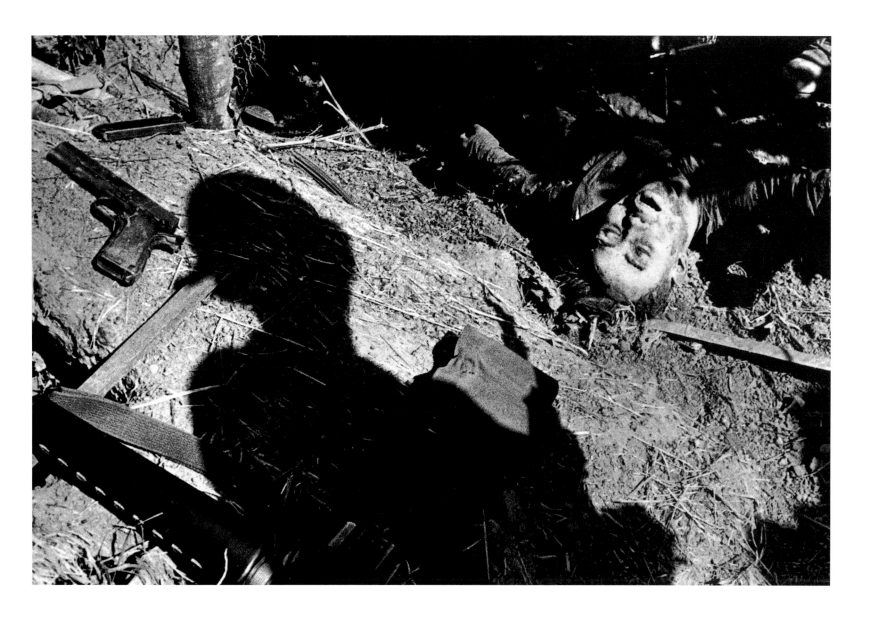

Philip Jones-Griffiths' somewhat eerie composition could suggest futility and injustice with its American shadow and Vietcong corpse.

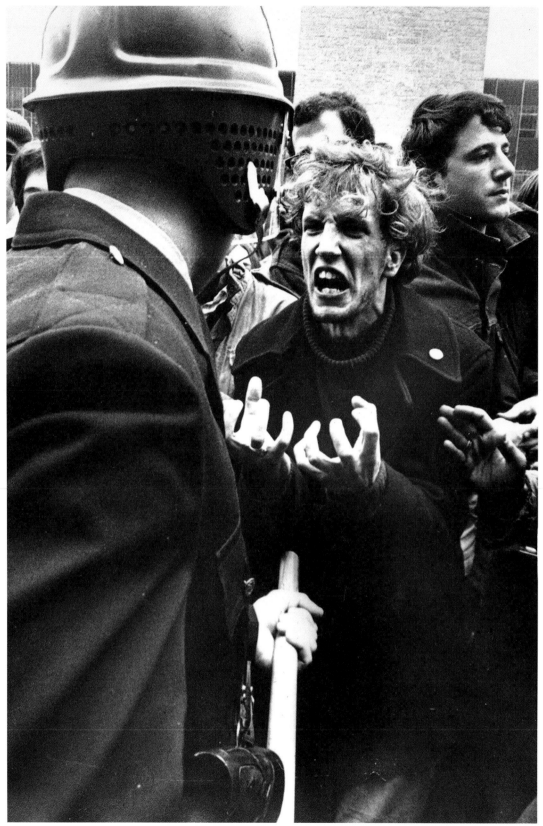

The sharp contrast of one unruffled anti-war demonstrator and the passion of another makes a curious picture.

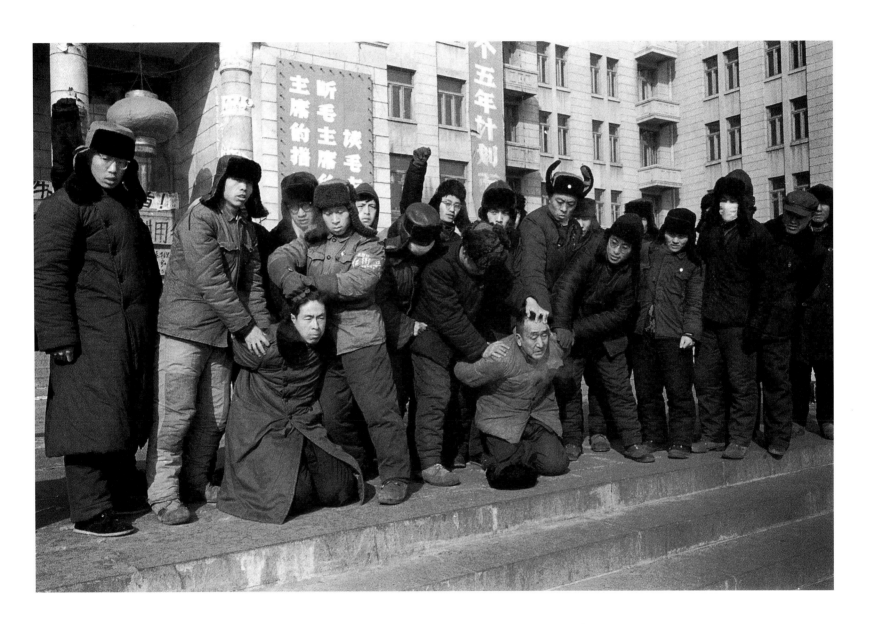

Red Guards purging their own ranks of erroneous political thinking.

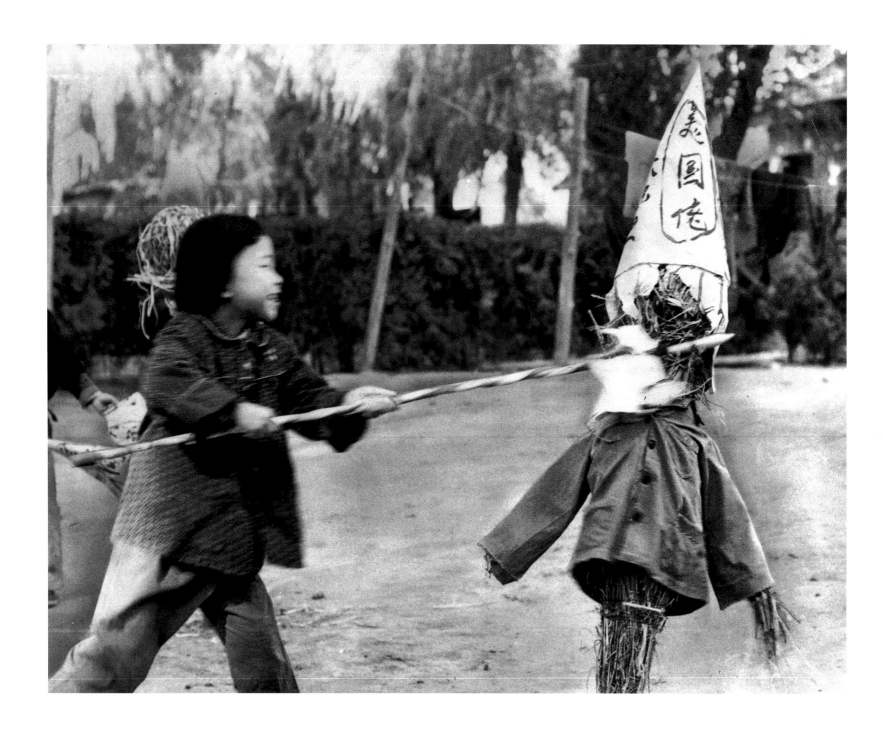

A Chinese schoolgirl having fun with an effigy representing the evils of America.

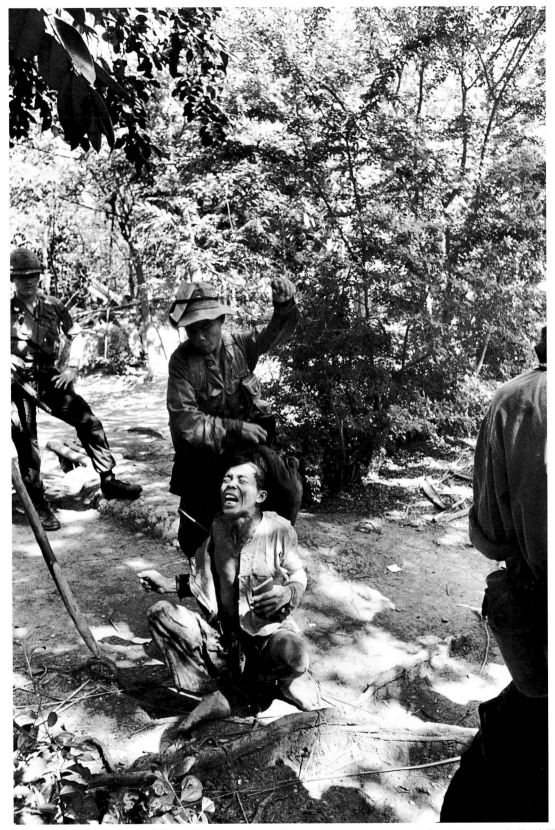

A harsh interrogation of a Vietcong suspect by South Vietnamese troops. The guerrillas' defeat was essential to victory over the North Vietnamese.

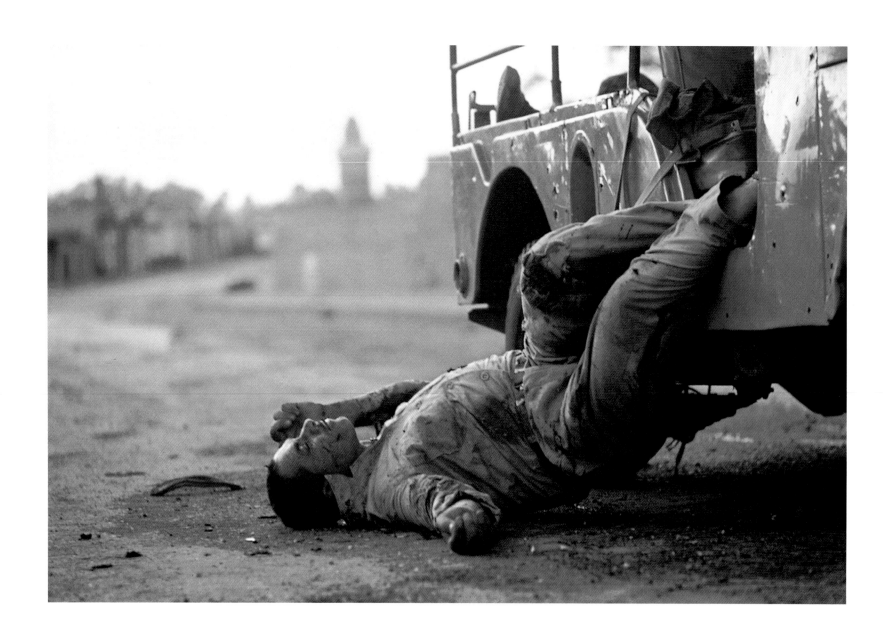

One of the many victims of Israel's pre-emptive attack on the Egyptians on the Sinai peninsula ...

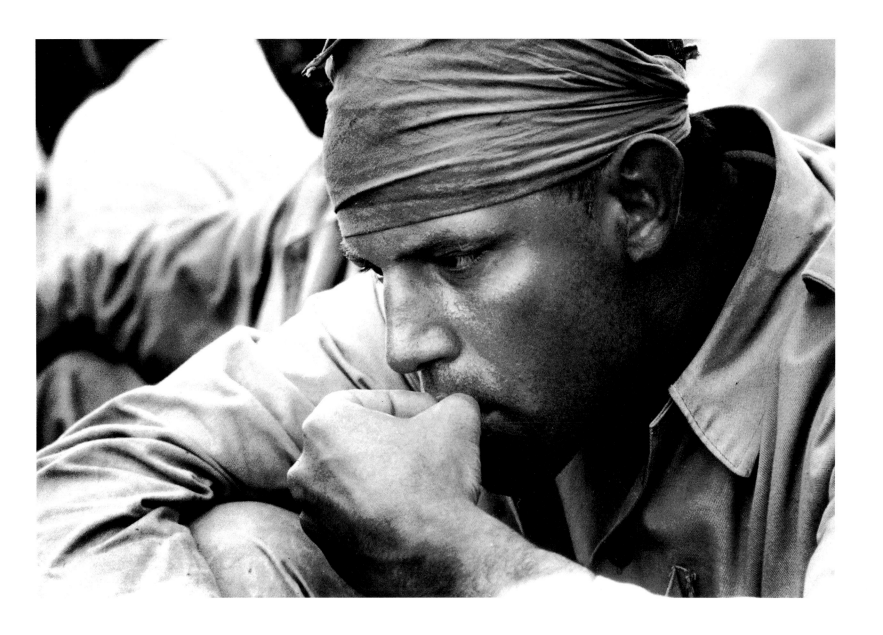

... and a lucky survivor looking pensive after the shock of defeat and capture.

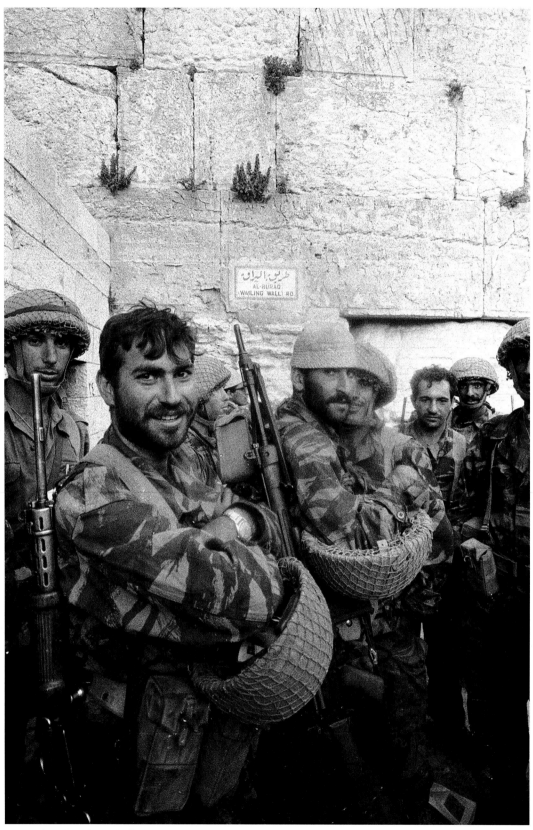

Triumphant Israelis at the Wailing Wall in Old Jerusalem – a great symbolic gain in their victory over the Arab states.

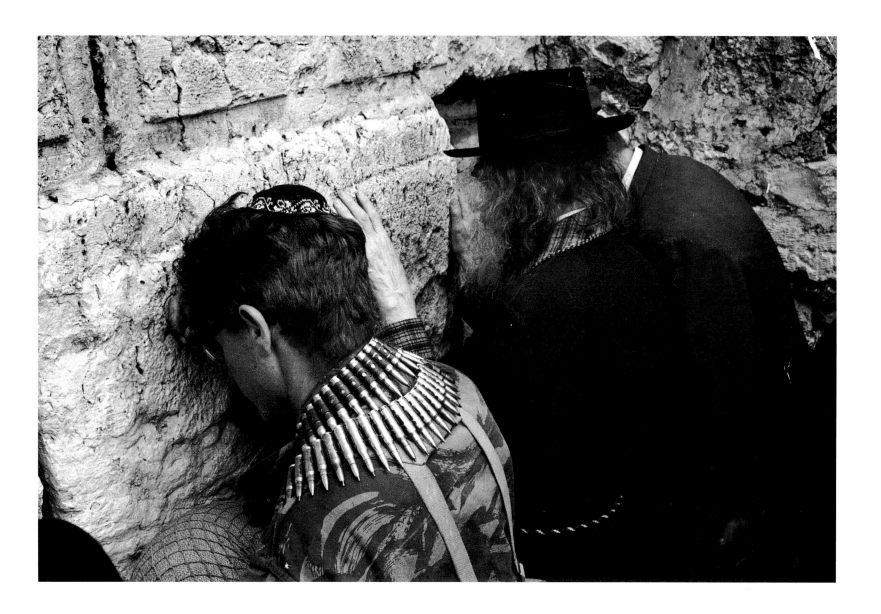

Gratitude, both military and spiritual, being expressed at the Wall.

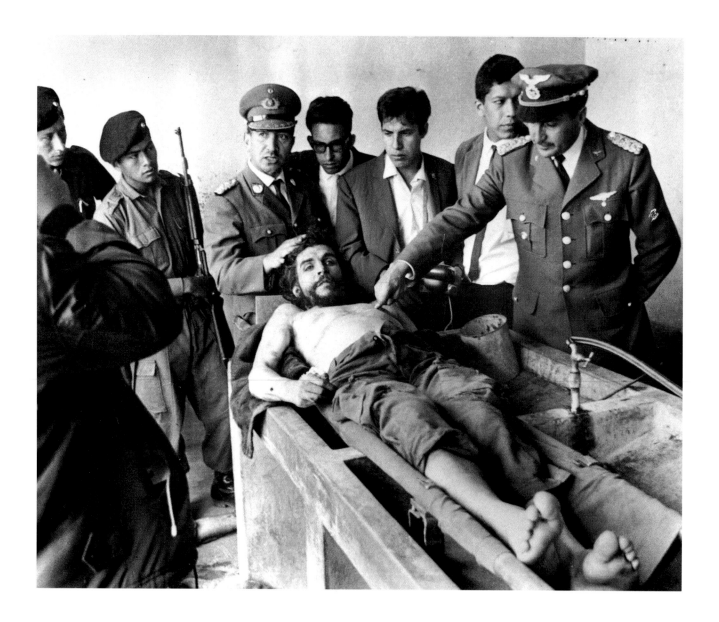

Che Guevara – soon the hero of a generation – suffers posthumous humiliation in an image distributed by his Bolivian killers.

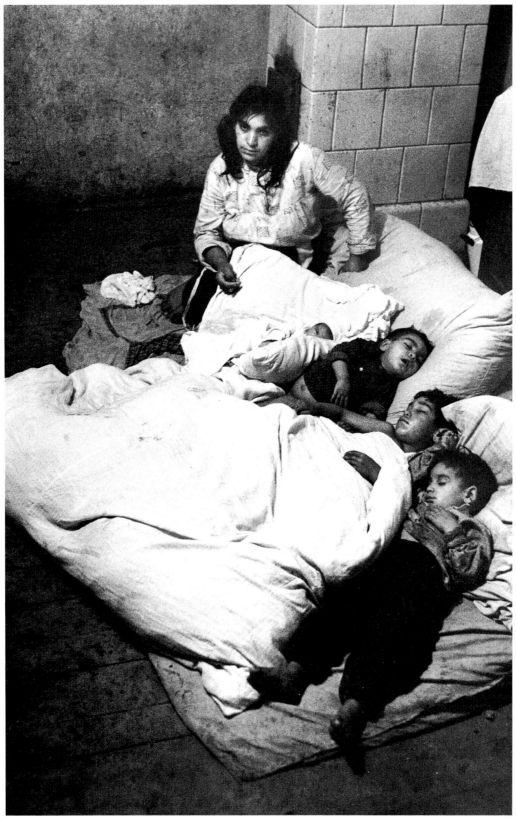

Gipsies photographed by Josef Koudelka in his native Czechoslovakia.

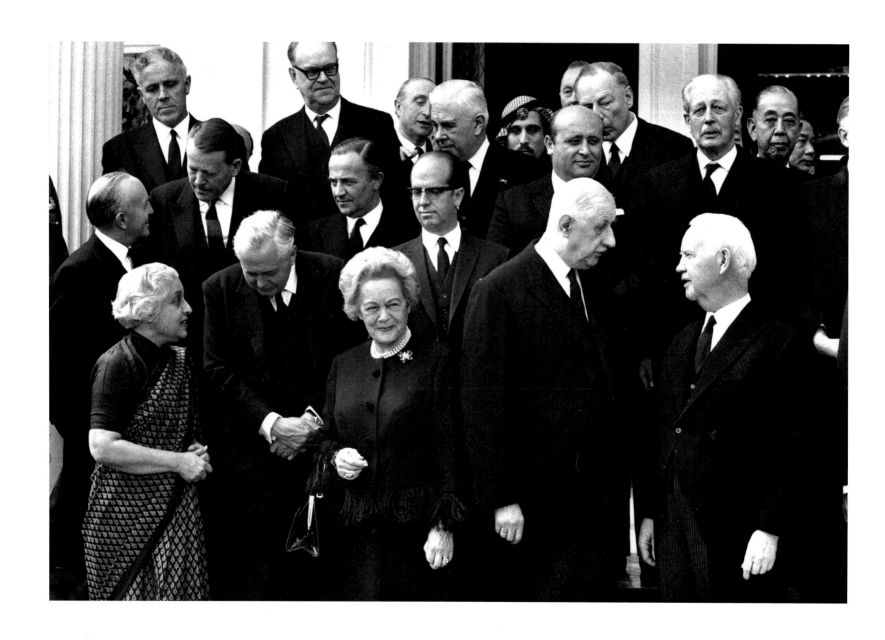

Mourners at Konrad Adenauer's funeral – the West German Chancellor who restored his country's fortunes and earned the respect of all western European statesmen.

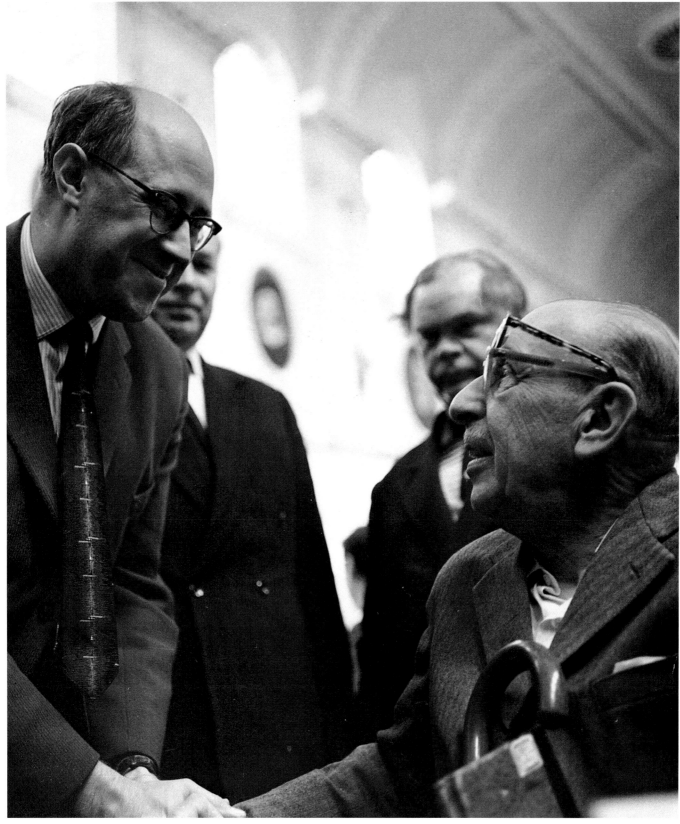

The great composer Igor Stravinsky (right) welcoming the great cellist Mstislav Rostropovich on a visit to America.

Cathérine Deneuve in *Belle de Jour* – Luis Buñuel's film about a respectable woman who sought diversion as a prostitute.

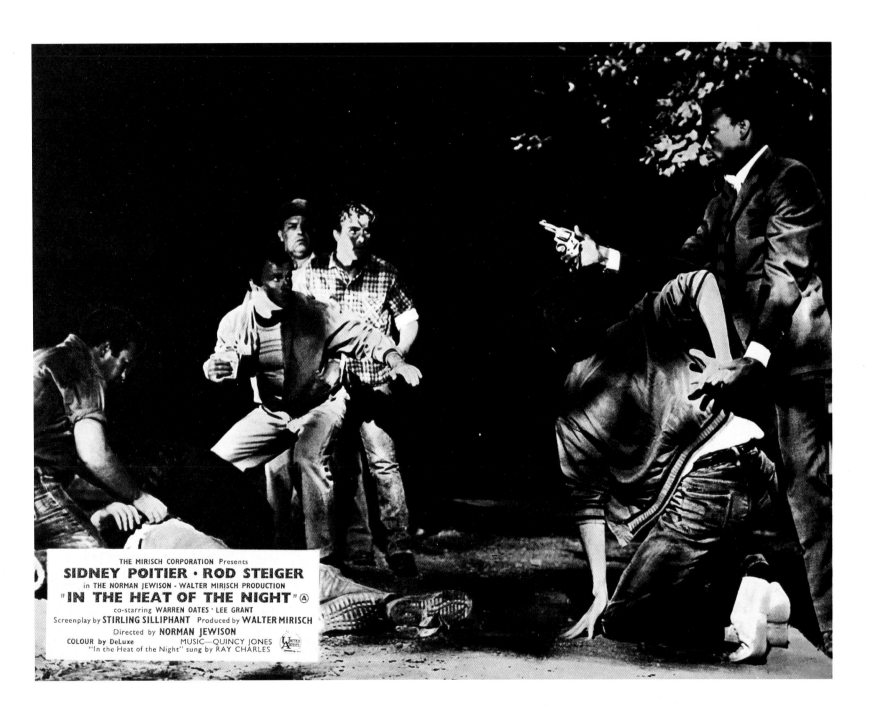

THE MIRISCH CORPORATION Presents
SIDNEY POITIER · ROD STEIGER
in THE NORMAN JEWISON - WALTER MIRISCH PRODUCTION Ⓐ
"IN THE HEAT OF THE NIGHT"
co-starring WARREN OATES · LEE GRANT
Screenplay by **STIRLING SILLIPHANT** Produced by **WALTER MIRISCH**
Directed by **NORMAN JEWISON**
COLOUR by DeLuxe MUSIC—QUINCY JONES
"In the Heat of the Night" sung by RAY CHARLES

In the Heat of the Night – one of the first films which explored race-relations in the American police – starring Sidney Poitier and Rod Steiger.

Lesley Hornby, the model who came to be known as Twiggy and became an icon of swinging sixties London.

Robert F. Kennedy showing his delight at winning the California primary in the presidential elections. He was fatally wounded by an assassin only moments later.

A French *garde républicain* in violent pursuit of a student in Paris.
The riots of May 1968 are well under way.
Daniel Cohn-Bendit gently mocking authority in front of the
Sorbonne in Paris.

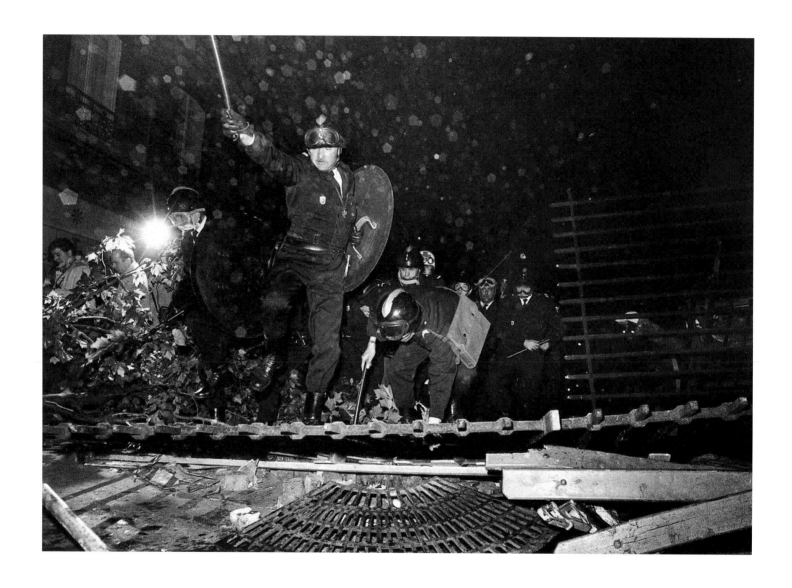

Gardes républicains on the rampage against the students and strikers whom de Gaulle regarded with contempt.

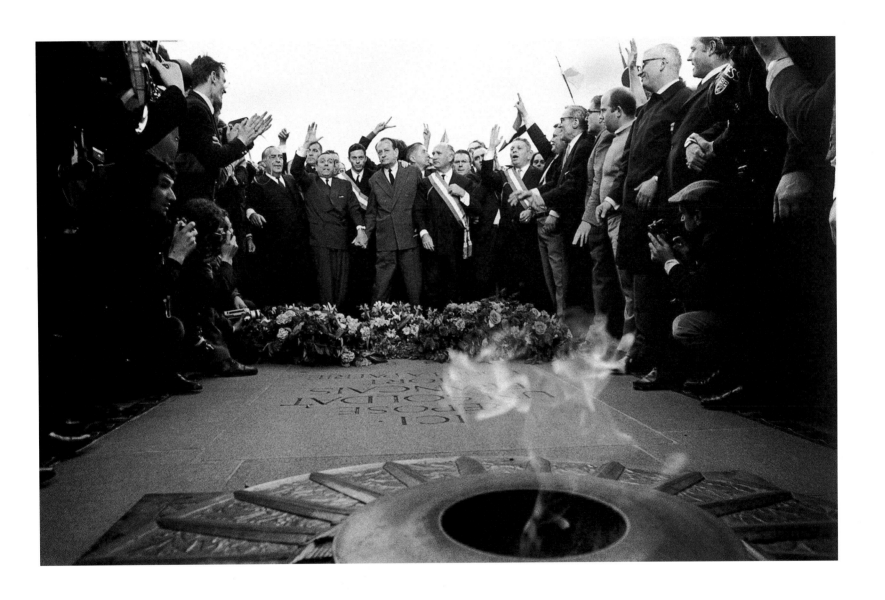

Gaullists led by André Malraux demonstrate against the rioters at the Arc de Triomphe.

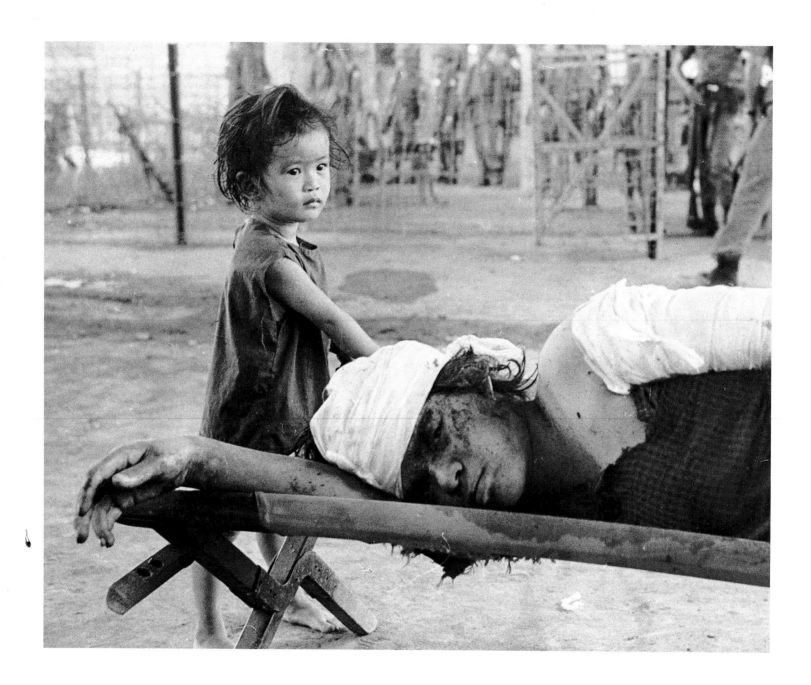

A little girl with her badly wounded mother in Saigon.

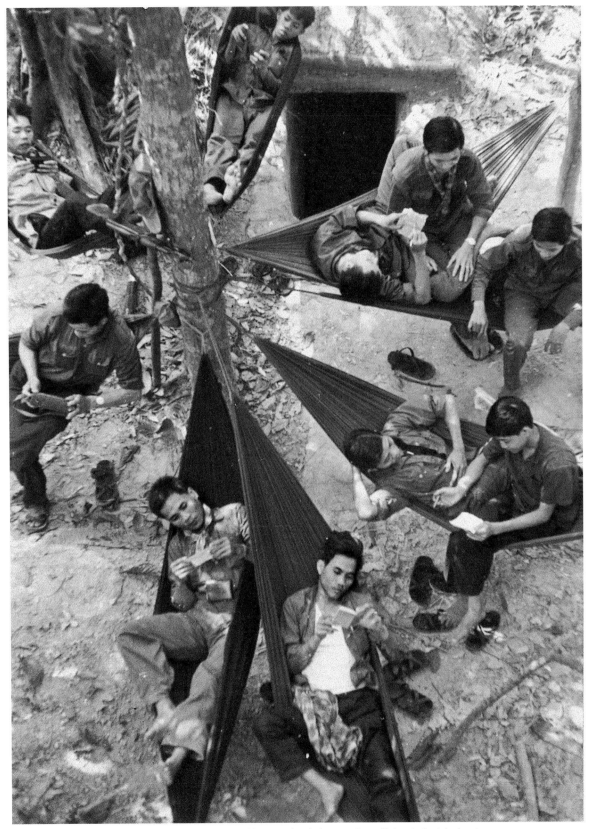

A propaganda shot of young Vietcong soldiers resting in hammocks as if at a students' adventure camp.

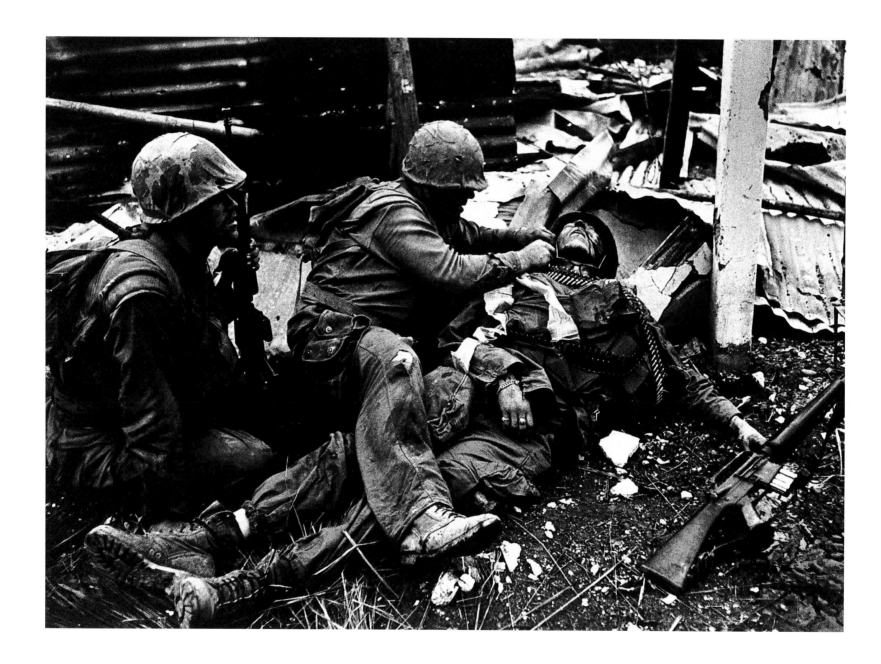

Either dead or seriously wounded, another American pays the price for his government's misguided policy.

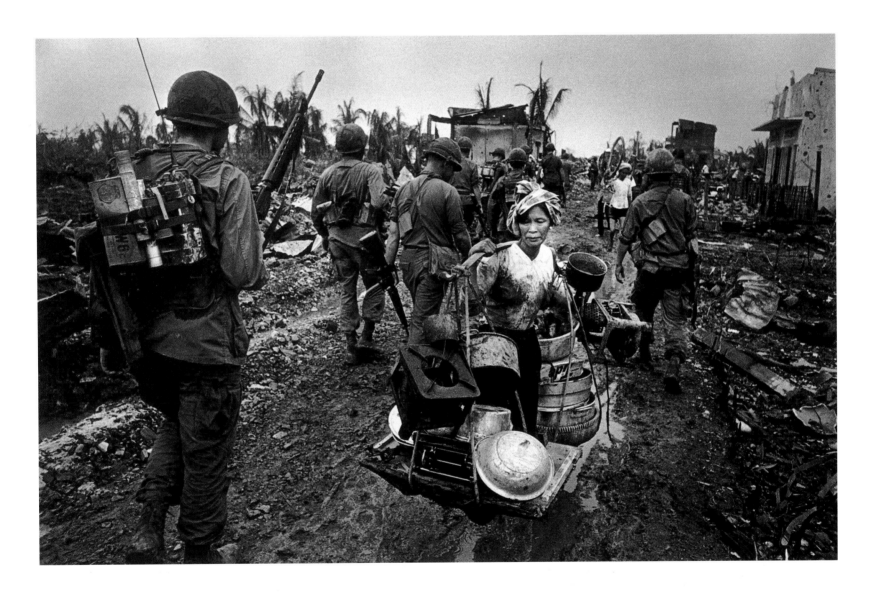

Philip Jones-Griffiths' camera catches a woman fleeing Saigon during the Tet offensive.

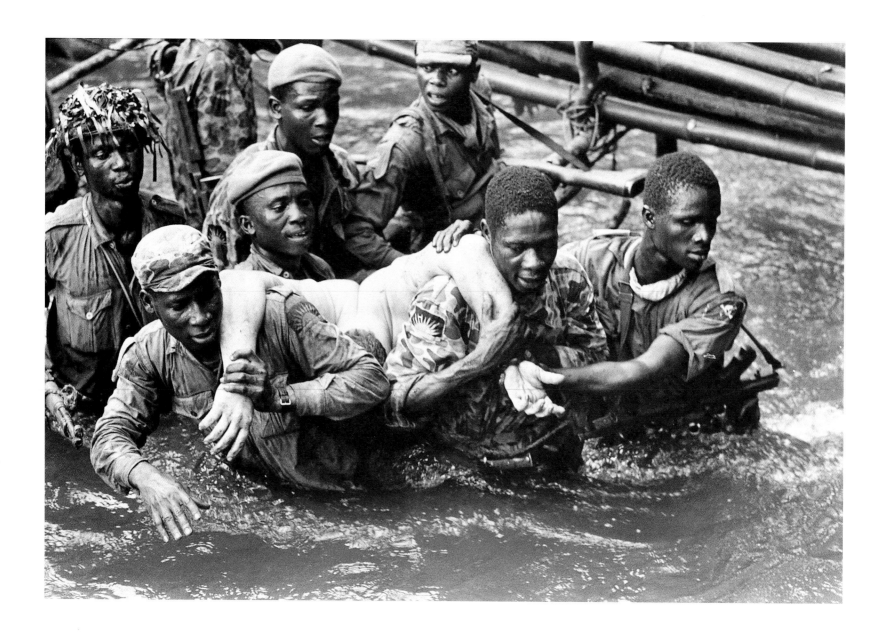

In Biafra in Nigeria a wounded Belgian mercenary is carried to safety by General Ojukwu's freedom fighters.

The smile on the face of the tiger – Leonid Brezhnev (right) with Alexei Kosygin (centre), winning over Alexander Dubček, the Czech leader, at their talks in Bratislava, before sending the tanks into Prague.

1968

Utterly confounded at his reception in Prague.
A Soviet soldier learning about paint as a weapon of war – one of Josef
Koudelka's images of the invasion.

A Russian trying to counter the passionate protests of Prague citizens – the photographer Josef Koudelka again …

... he also photographed two Czechs who had climbed onto a Russian tank to make their point to one of the crew.

Black Panthers at a rally in Oakland in California calling for the release of their leader Huey Newton from jail.

When Huey Newton was found not guilty of shooting a police officer, opponents 'shot up' an image of Newton at the Black Panther HQ.

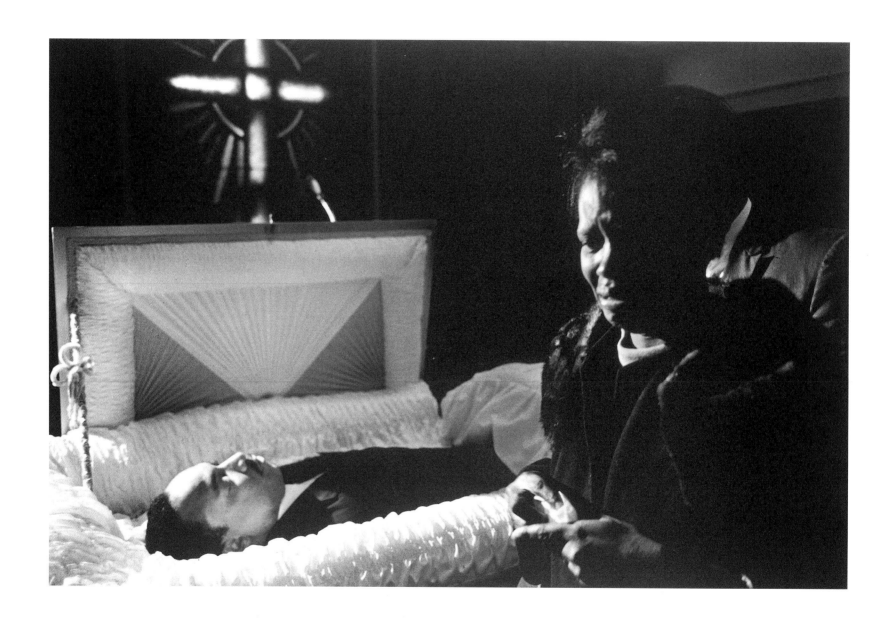

Martin Luther King's body 'lying in state' after his assassination, photographed by Burk Uzzle.

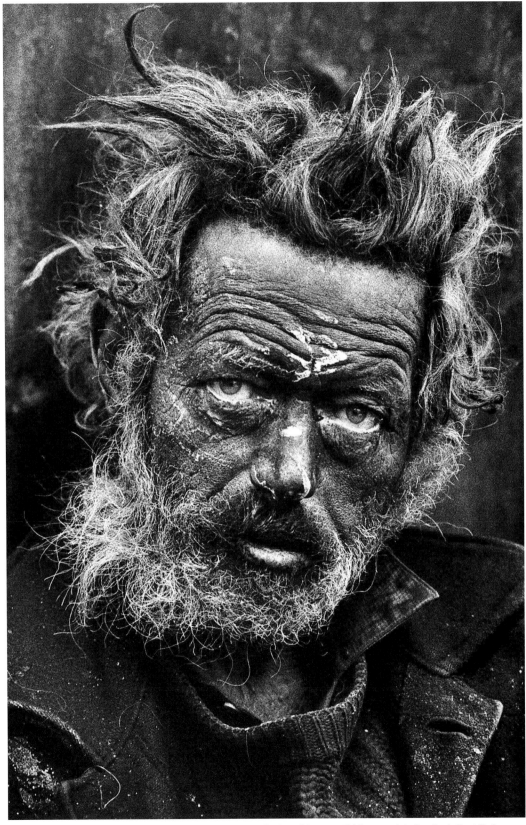

A portrait by Don McCullin that seems fully engaged by its subject – an Irish vagrant in London's East End.

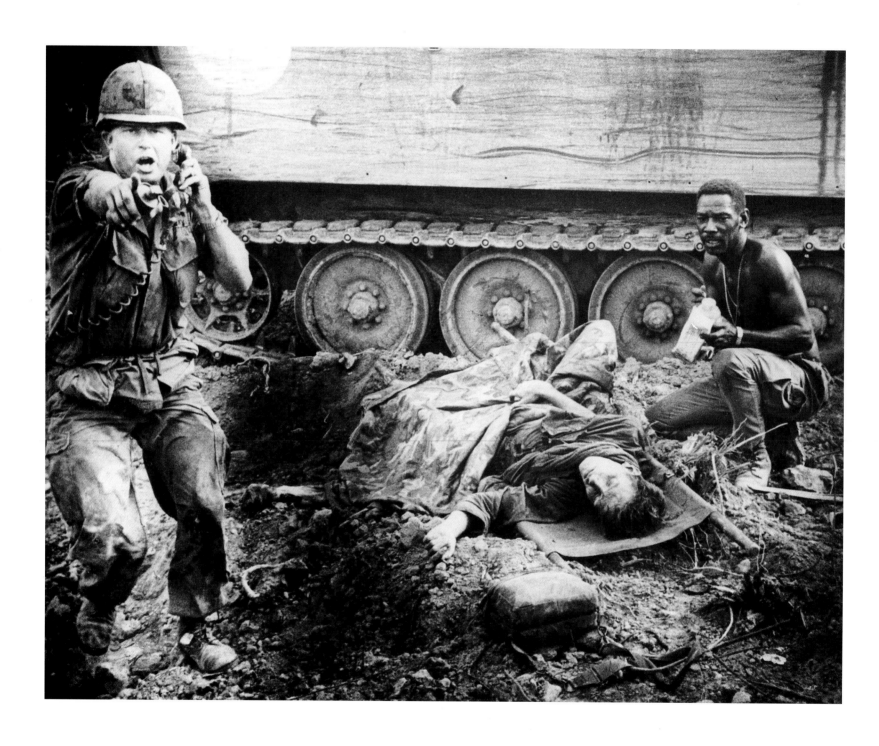

Americans ambushed by the Vietcong. Oliver Noonan, who photographed this wounded soldier, paramedic and officer, was later killed in action.

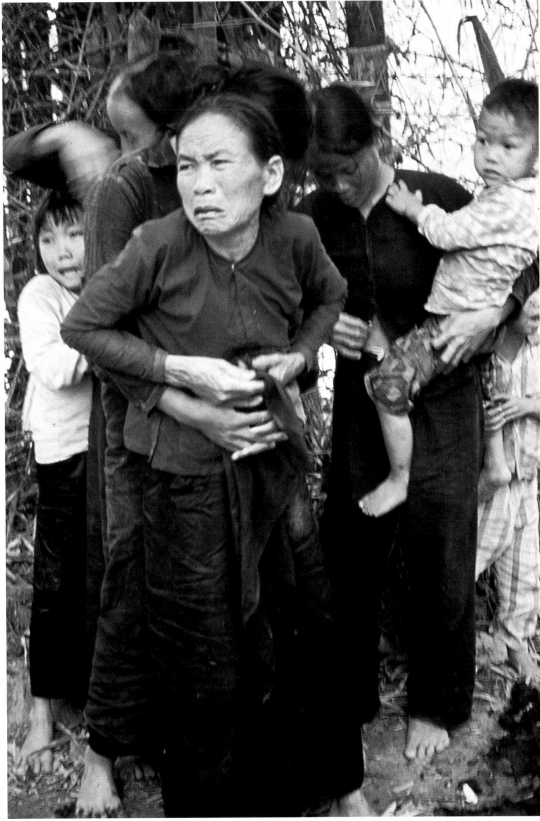

The discovery of this and other pictures of a ruthless massacre by US soldiers at My Lai shamed America into new reflection on the Vietnam War.

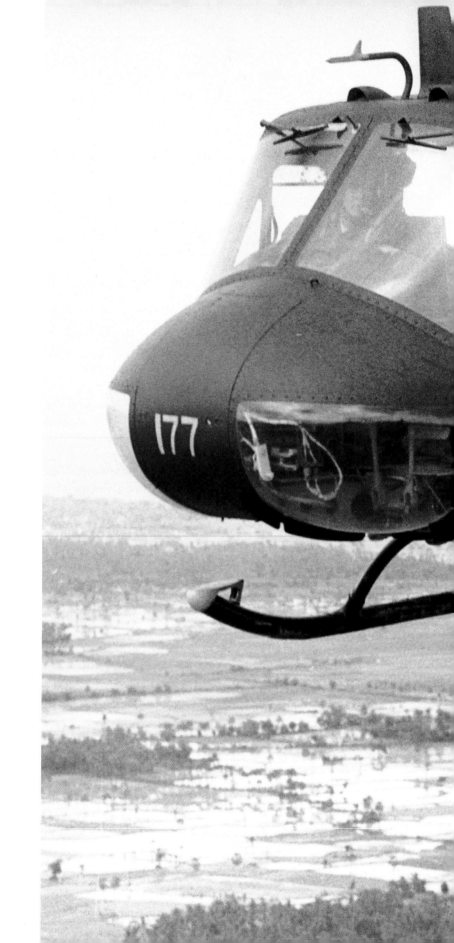

Insouciant Cambodian boys off to fight the communists
– this was the first war in which helicopters played a major role.

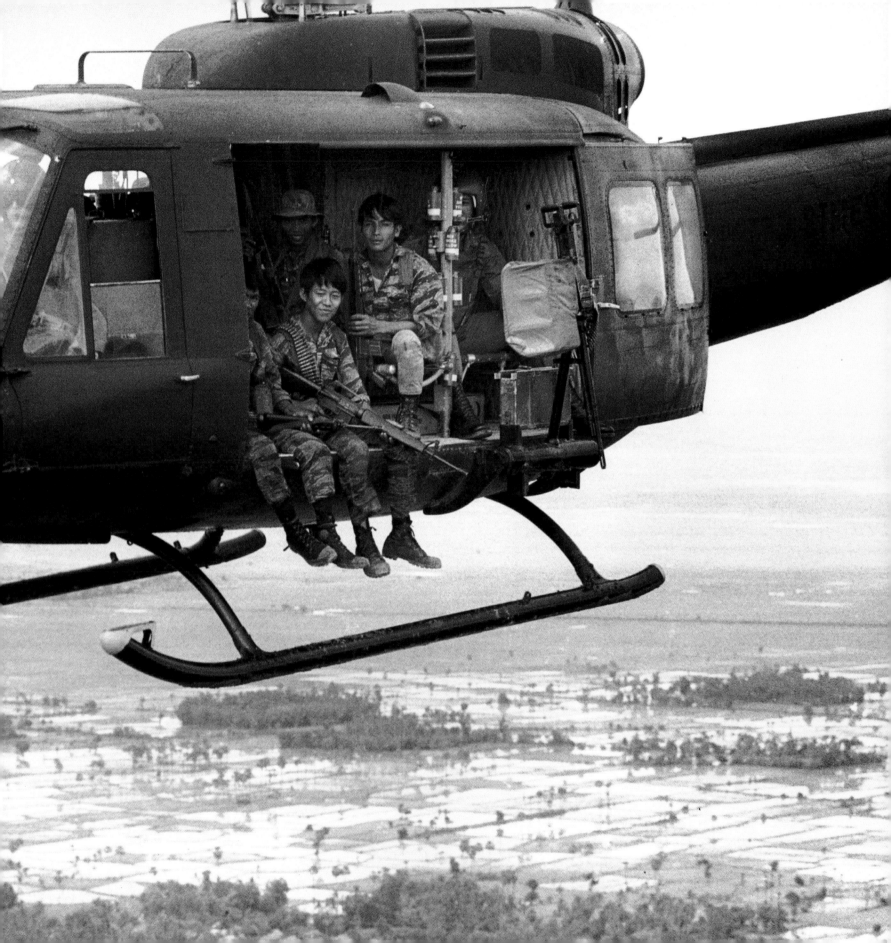

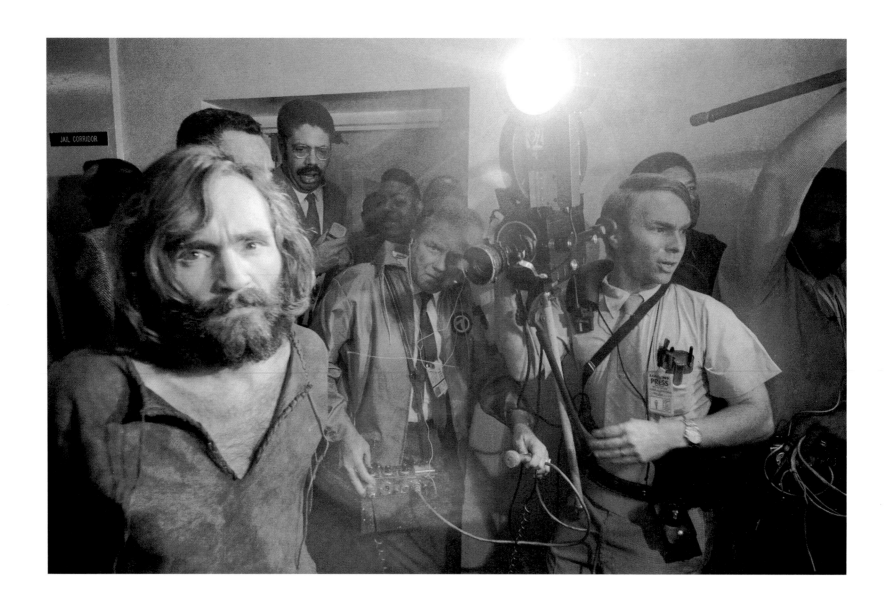

Charles Manson, soon to be convicted – along with members of his 'family' – of the murders of Sharon Tate, her unborn baby and four other people in California.

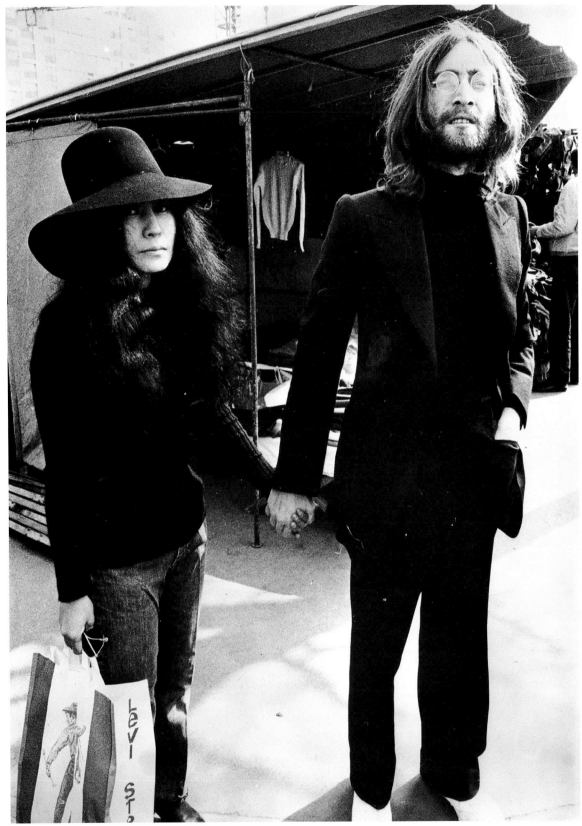

John Lennon soon after marrying Yoko Ono – a happy marriage which was also a public performance.

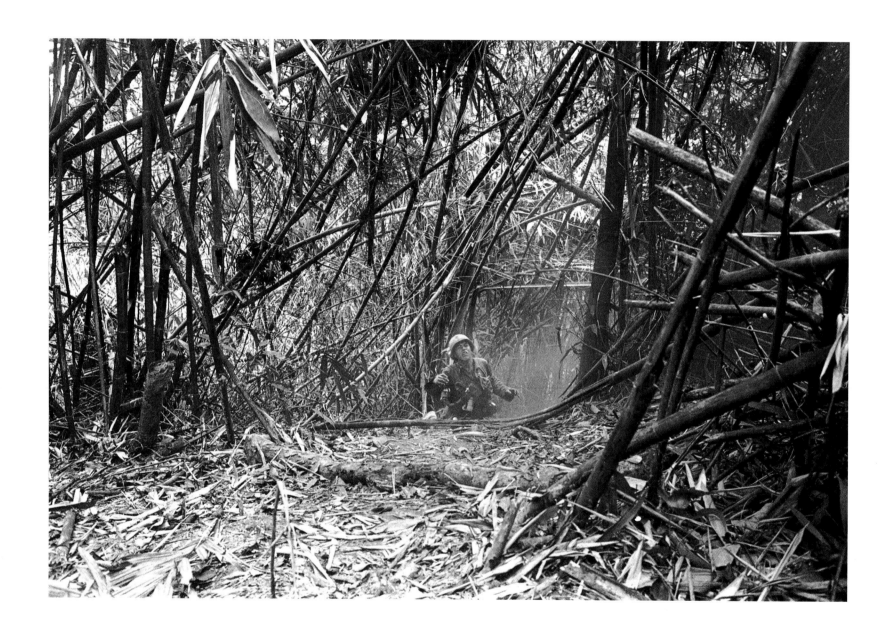

A US soldier hit by rocket shrapnel near A Shau Valley, in one of the fiercest battles of the Vietnam War.

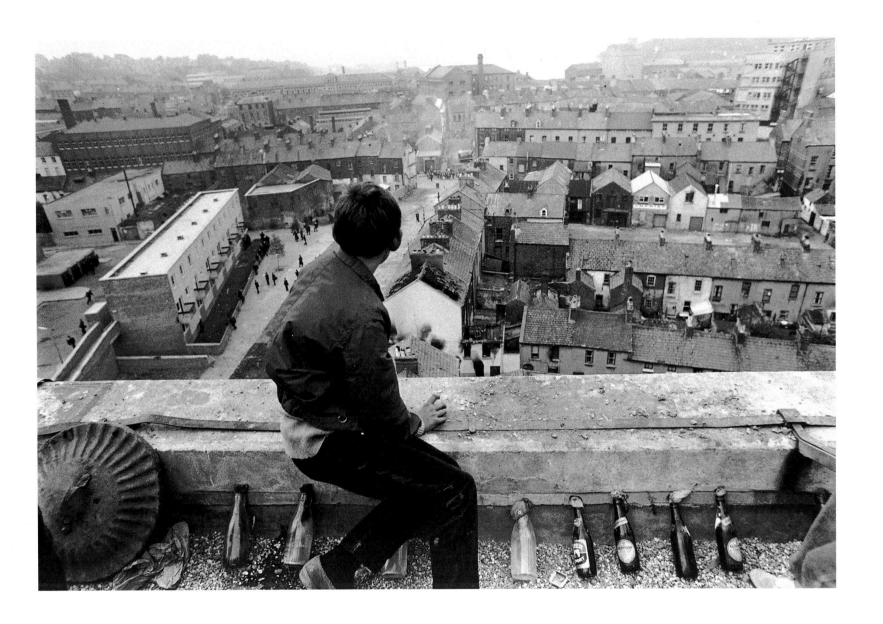

Violence in Londonderry in Northern Ireland – a boy perches with his arsenal of petrol bombs ready to hurl them from a rooftop. He was photographed by Gilles Carron.

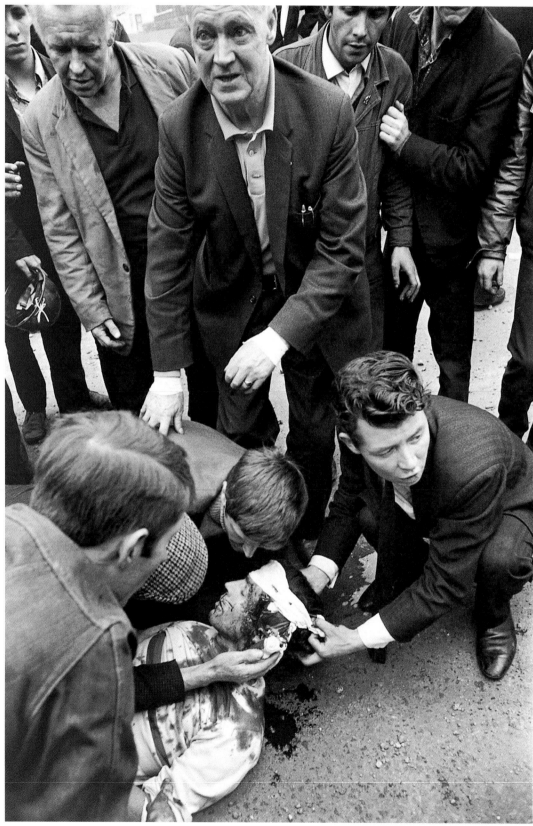

A Catholic seriously injured in the Londonderry riots.

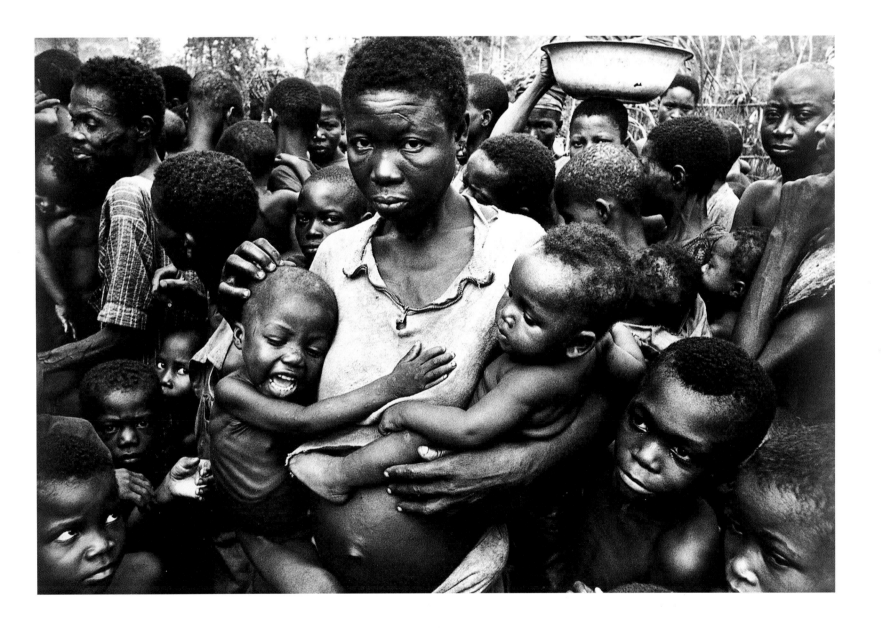

A food distribution centre in Biafra, whose only seaport had been captured by Nigeria.

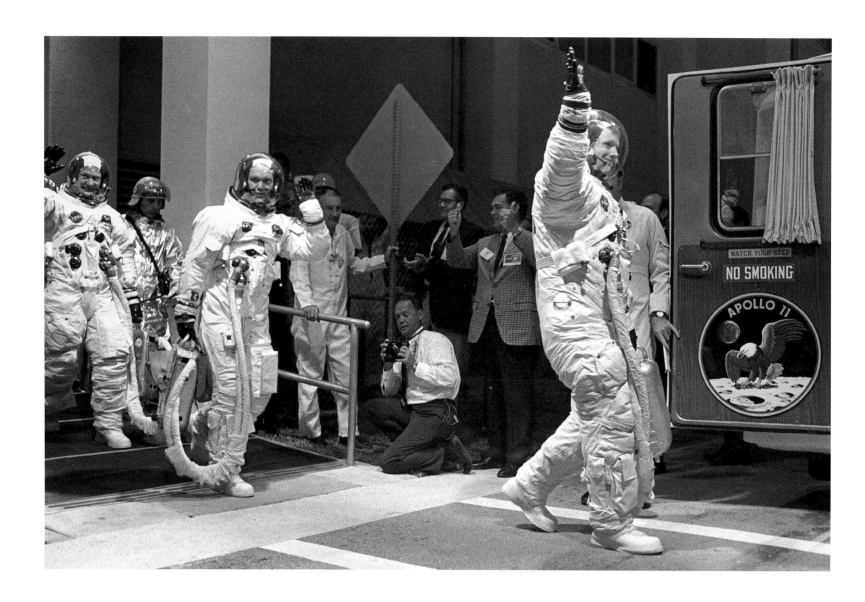

Not a care in the world except getting to the moon – Ed Aldrin, Mike Collins and Neil Armstrong boarding transport to the *Apollo 11* launch pad.

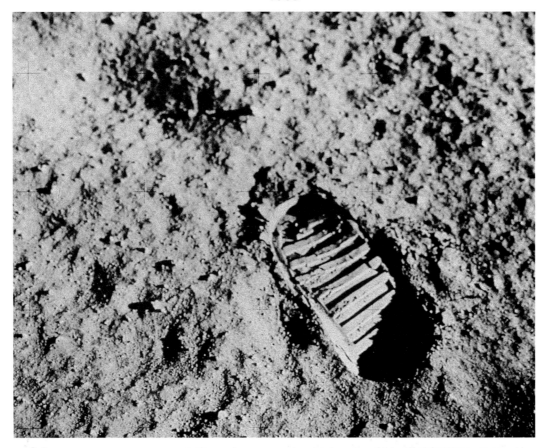

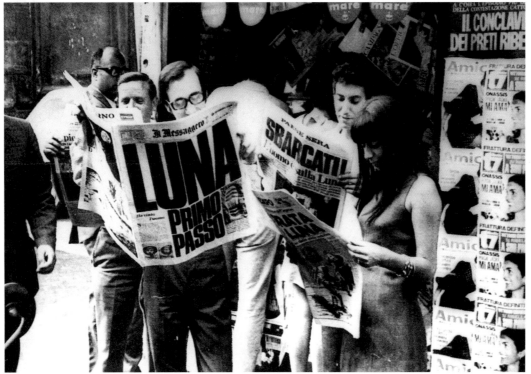

One of Neil Armstrong's boot prints on the moon dust photographed by 'Buzz' Aldrin.
Rome newspapers announcing the first landing of men on the moon.

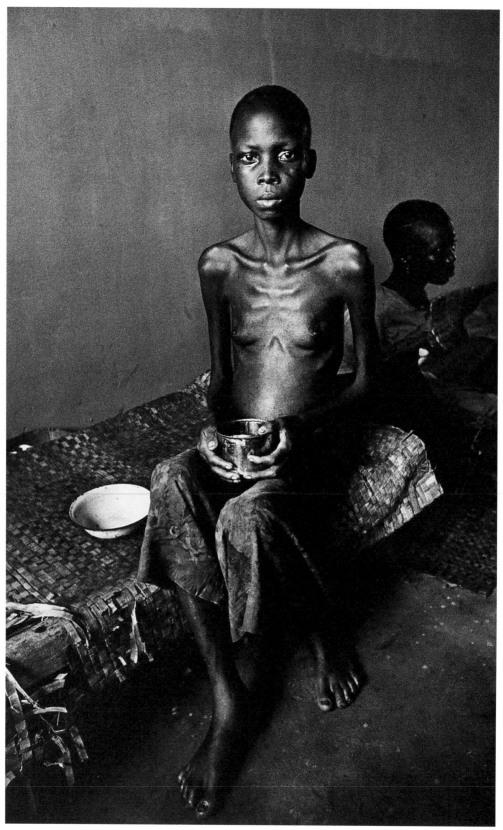

A starving Biafran girl whose enduring beauty was photographed by Don McCullin.

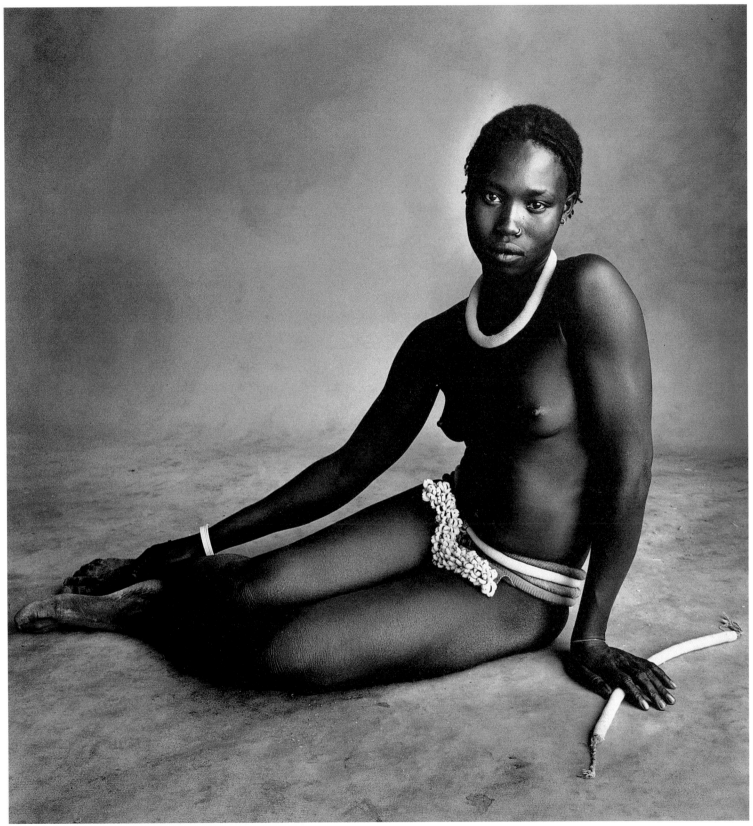

Nubile Young Beauty of Diamaré, Cameroon, taken by Irving Penn in a portable canvas studio.

Ostpolitik (eastern policy) being kindled with a light – Willy Brandt, Chancellor of West Germany (far right) meeting East Germany's Foreign Minister Otto Winzer (centre) in Kassel, West Germany.

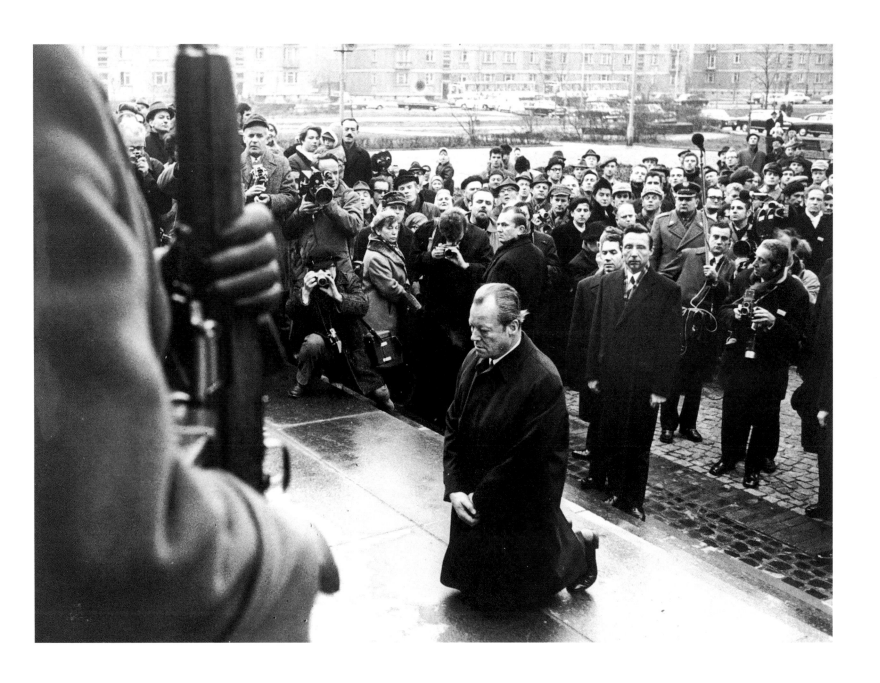

Willy Brandt, in Warsaw to sign a border treaty with Poland, kneels before a memorial to those who died in the tragic 1943 ghetto uprising.

Jean-Paul Sartre (far right) with Simone de Beauvoir (centre) at the Paris office of *La Cause du Peuple* which Sartre edited and which was briefly banned by the government.

Salvador Allende at a press conference during election year in Chile. His dream of a new kind of socialism for South America was to evaporate in 1973.

A student demonstrator wounded by police fire at Kent State University in Ohio. Four were killed and nine wounded.

Three hijacked aeroplanes in Jordan – one Swiss (burning), one American and one British – after Arab guerrillas detonated the bombs on board.

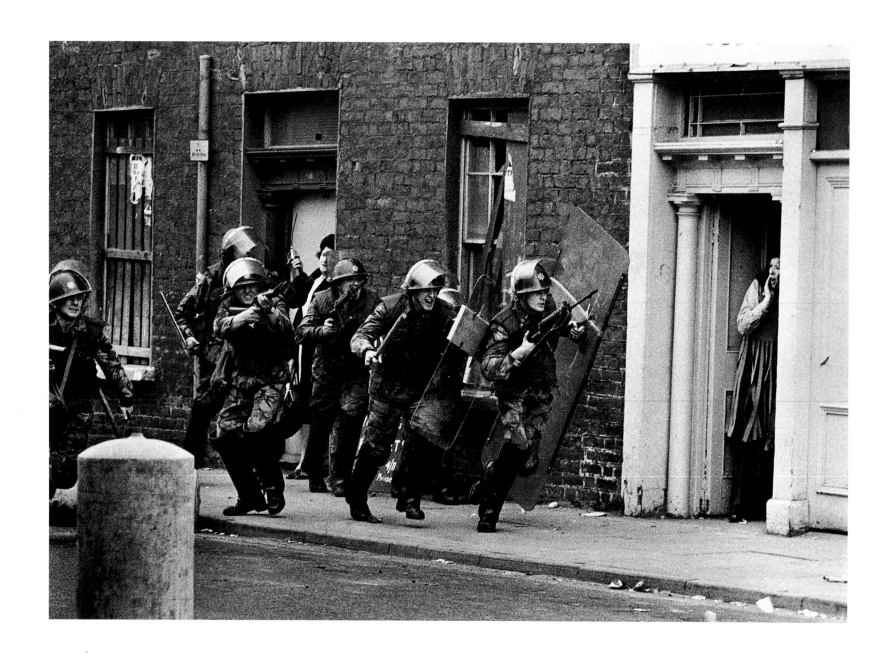

The police react speedily to stone throwers in Londonderry – and the photographer is just as quick on the shutter.

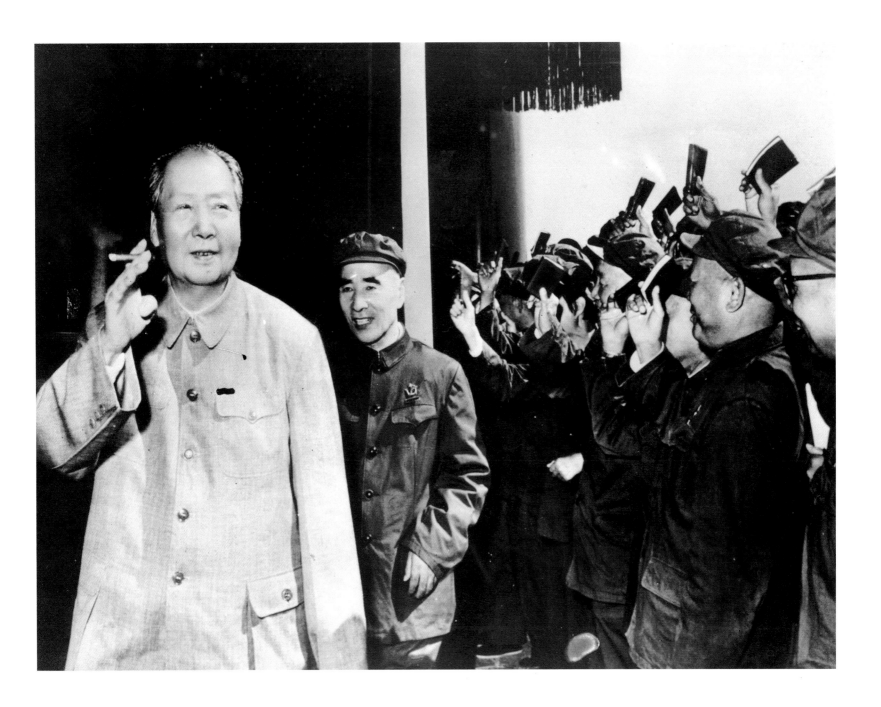

A complacent Chairman Mao (left) with his deputy Lin Piao, acknowledges the waving of 'little red books' on the twenty-first anniversary of the People's Republic.

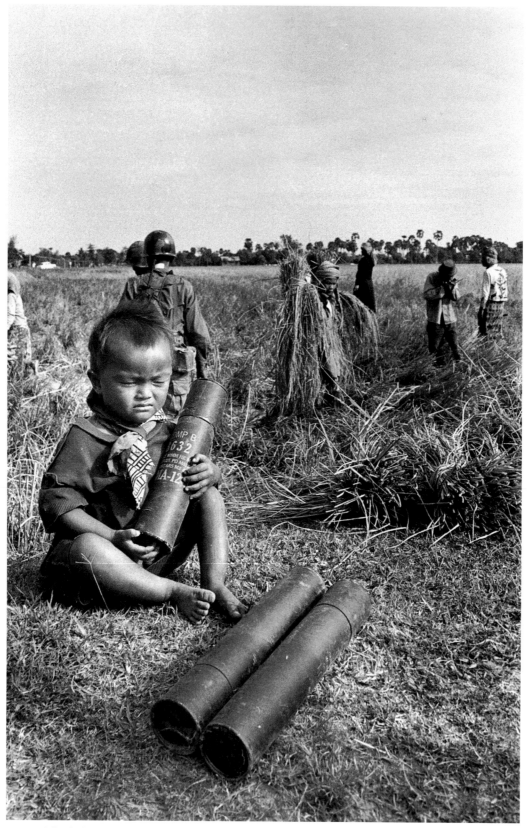

A Cambodian child moodily playing with mortar tube casings as precious rice is harvested behind him.

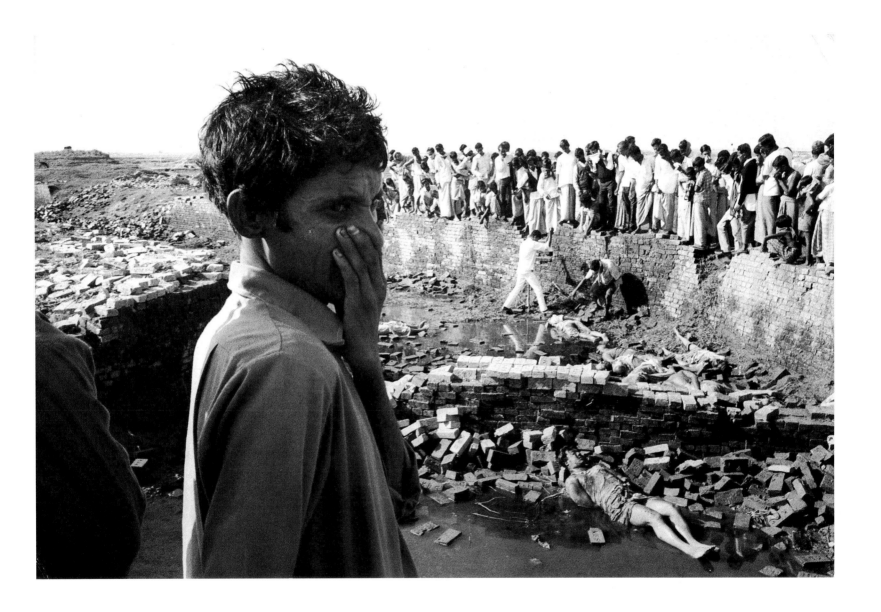

Following the West Pakistani surrender in the conflict with India and East Pakistan, the bodies of murdered Indians are being searched for and identified.

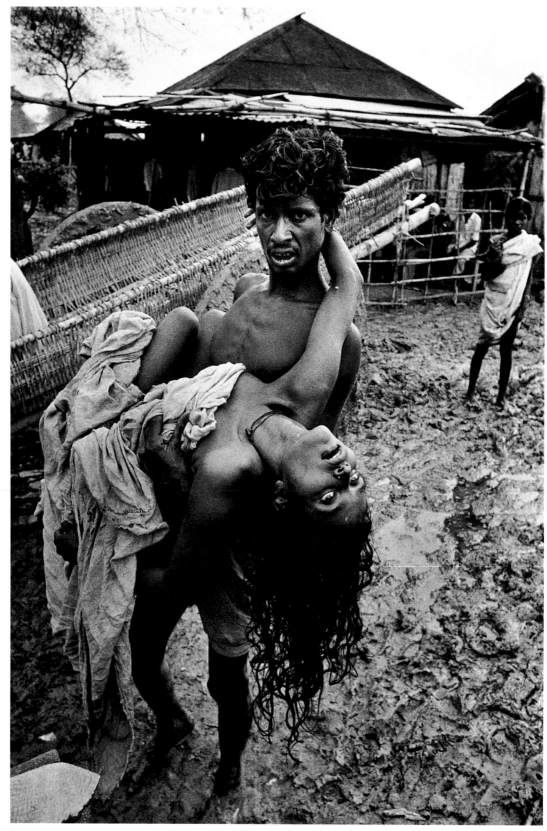

A cholera epidemic added to the general misery in Bangladesh. A husband carries his wife to seek medical aid.

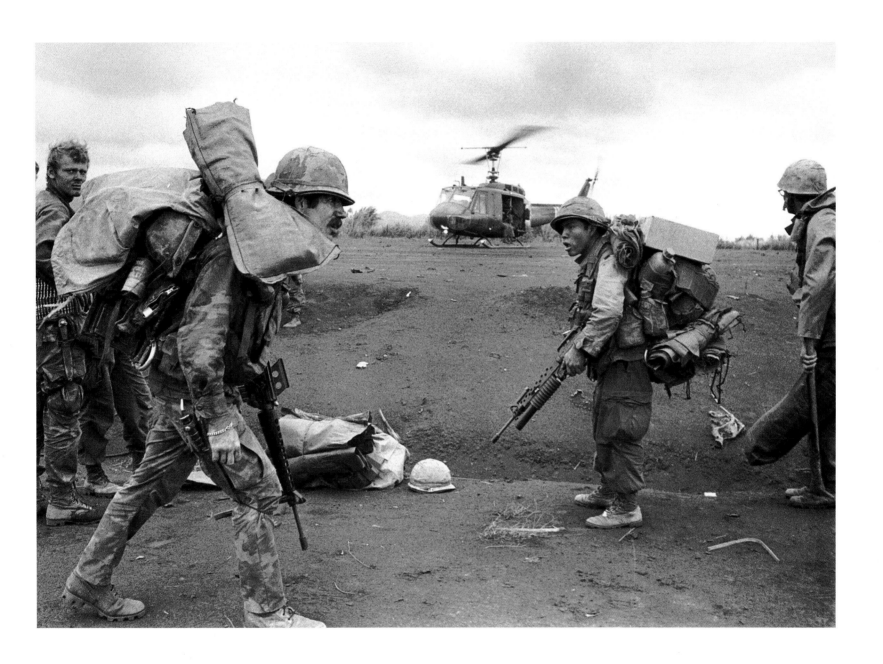

South Vietnamese and US troops waiting for the weather to clear before they make an undeclared attack on communists in Laos.

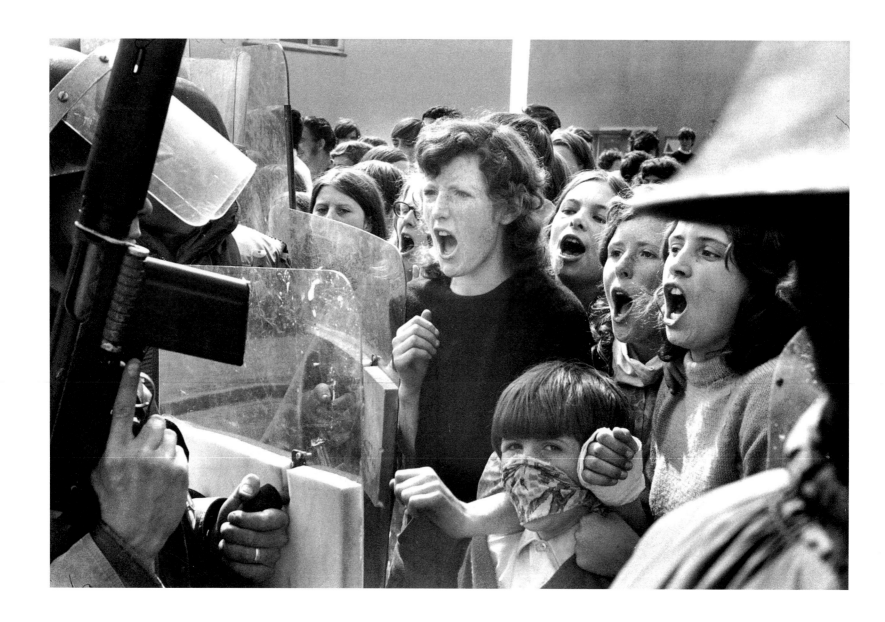

A crowd of Catholic women in Londonderry loudly protesting against the new internment laws.

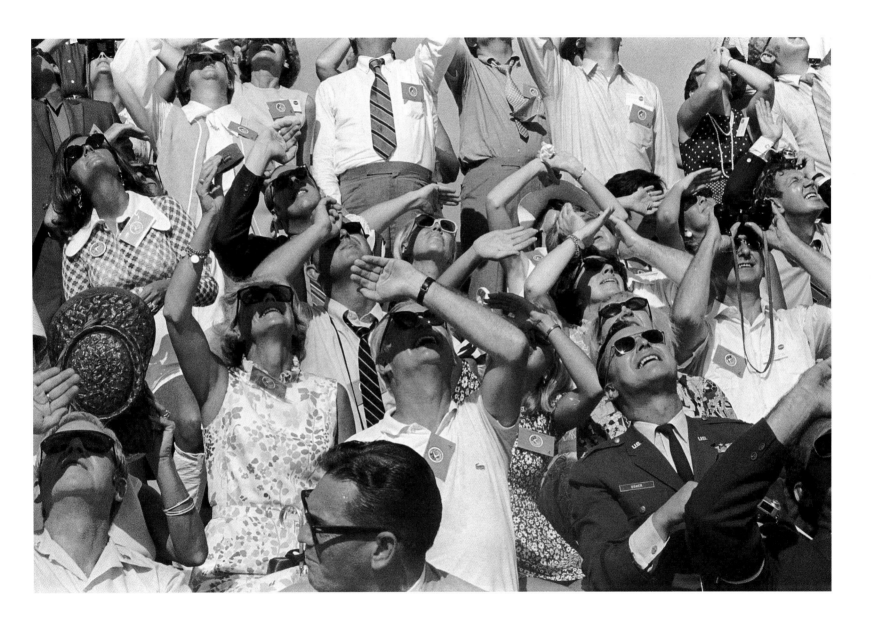

A relief from earthly troubles – a crowd at Cape Kennedy watching *Apollo 15*'s ascent.

The Bundestag opposition in their seats – Kurt Kiesinger, Ludwig Erhard, Joseph Rösig, Rainer Barzel and Werner Marx (left to right).

The Bundestag public in action – uproar in their gallery during a parliamentary debate on *Ostpolitik* (eastern policy).

A Palestinian terrorist on a balcony of the Israeli living quarters at the Munich Olympic Games – eleven athletes were killed.

A concealed camera produced this grainy picture of Bobby Fischer on his way to winning the world chess championship at Reykjavik in Iceland.

Barney McGuigan receiving the last rites – he was one of thirteen killed by British paratroopers in Londonderry on 'Bloody Sunday'.

Blood from another victim of the tragic British blunder in Londonderry.

An image of anguish in Belfast. Such scenes – many much worse – would be common over twenty-five years of IRA and Orange terror.

Bernadette Devlin, the independent MP for mid Ulster, leaving Newry Court with a suspended sentence for her involvement in a protest march about Bloody Sunday.

Apollo 17 – Eugene Cernan, Ronald Evans and Harrison Schmitt enjoying the wide-open lunar spaces in a moon buggy.

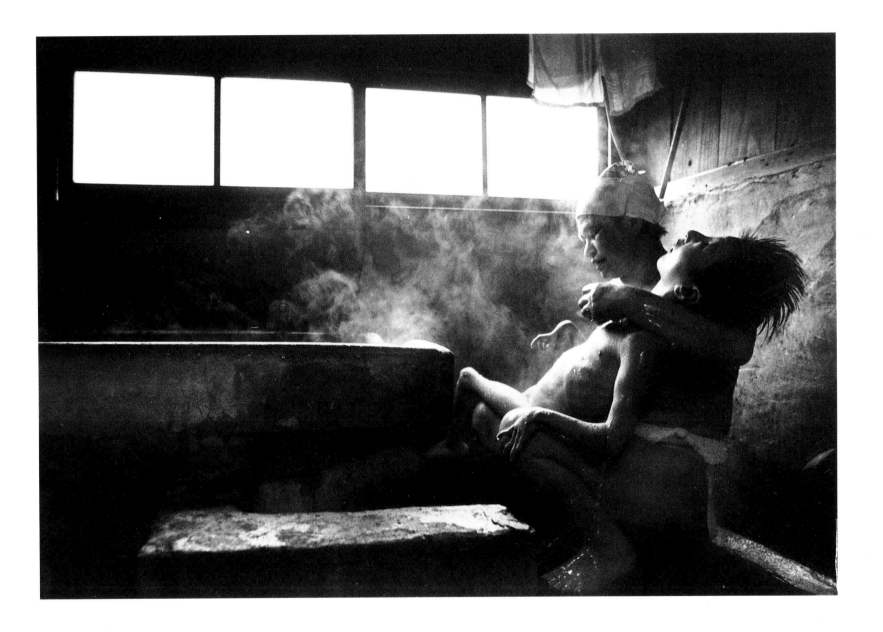

From Eugene Smith's harrowing picture story – a victim of mercury poisoning at Minimata in Japan being bathed by her mother.

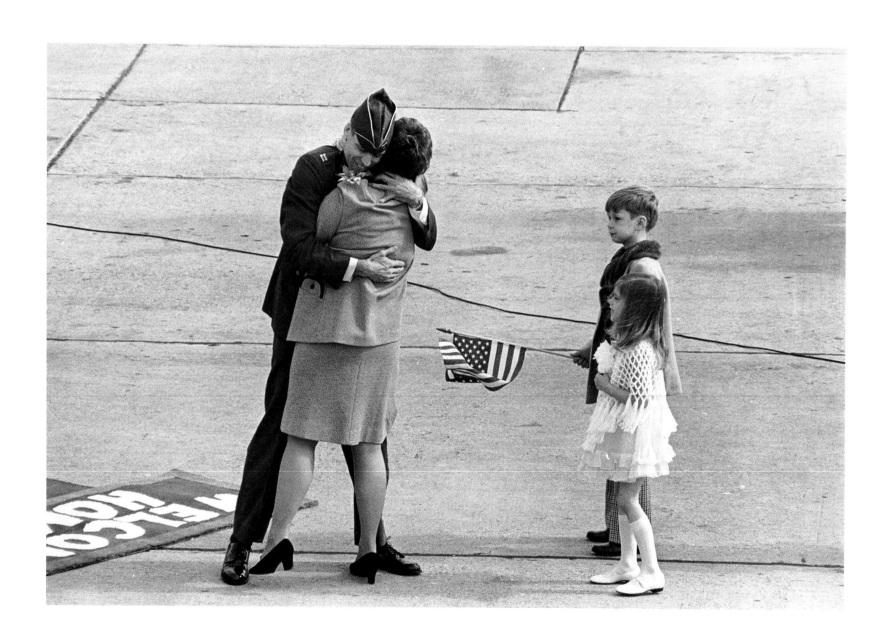

After six years as a prisoner in North Vietnam, a USAF Captain embraces his wife while their children look on.

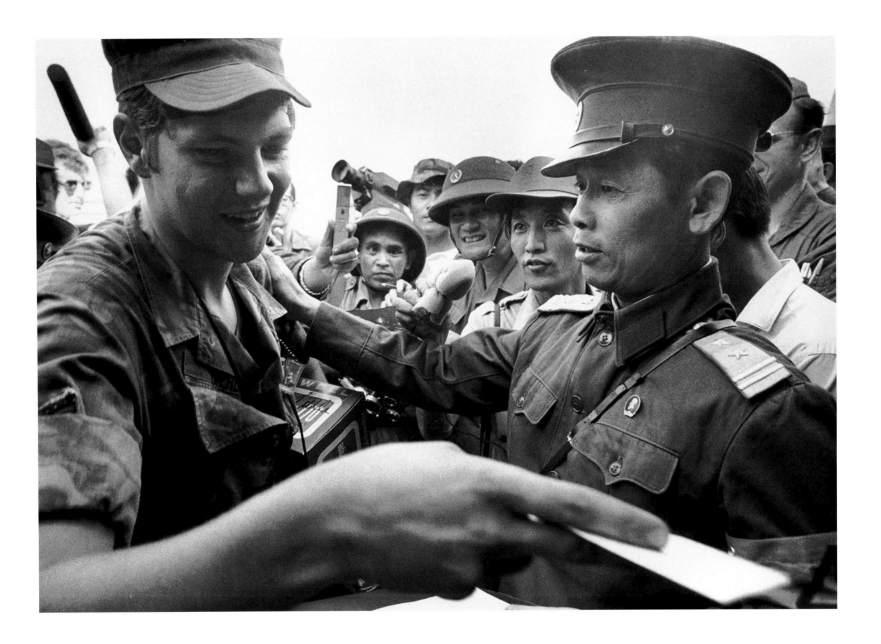

One of the last US servicemen in Vietnam feels the conciliatory hand of a recent deadly enemy on his shoulder.

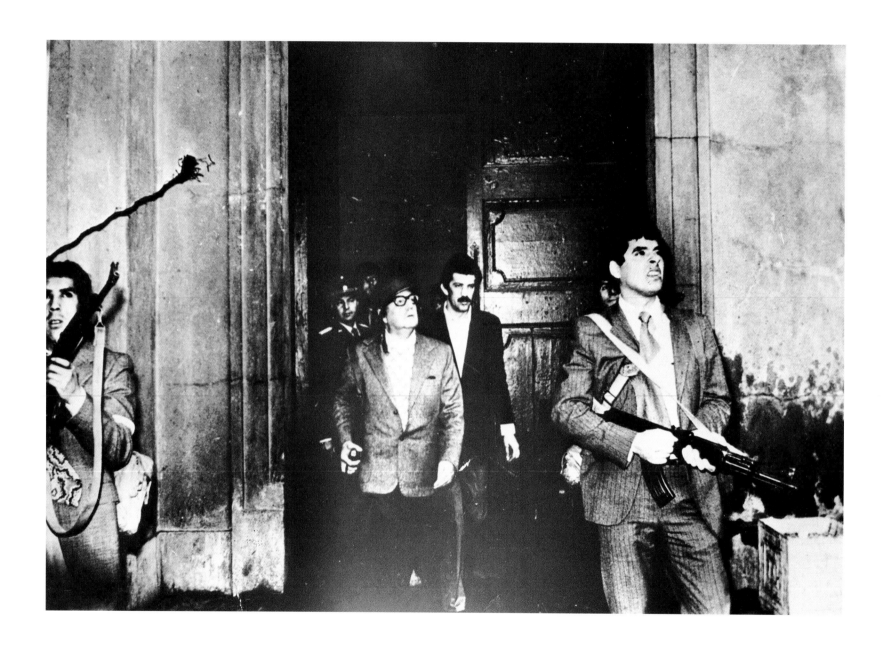

Salvador Allende (centre, looking up) perhaps assessing the strength of General Pinochet's coup which would kill him before the day was out.

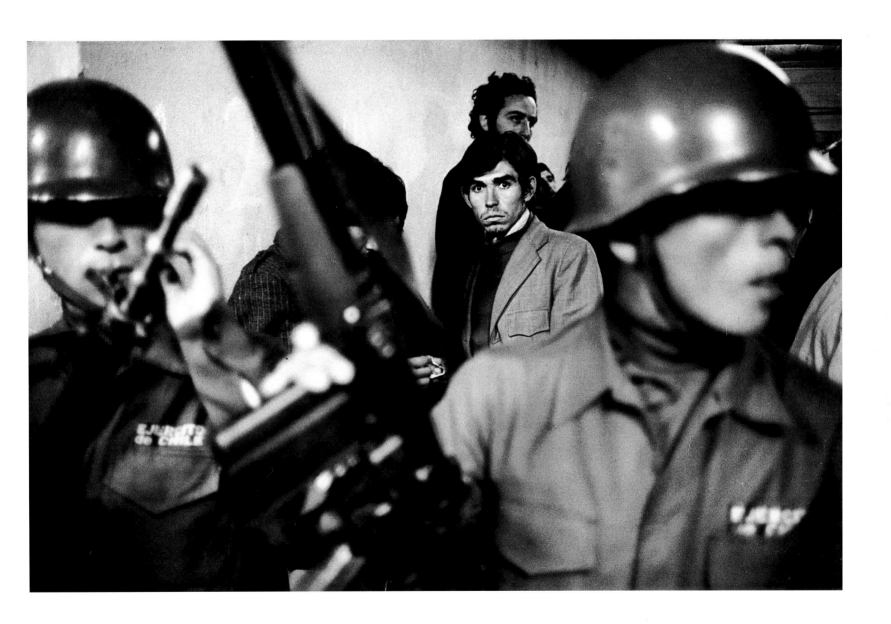

A suspected leftist is stopped to be searched by the military in Santiago on the day of the coup.

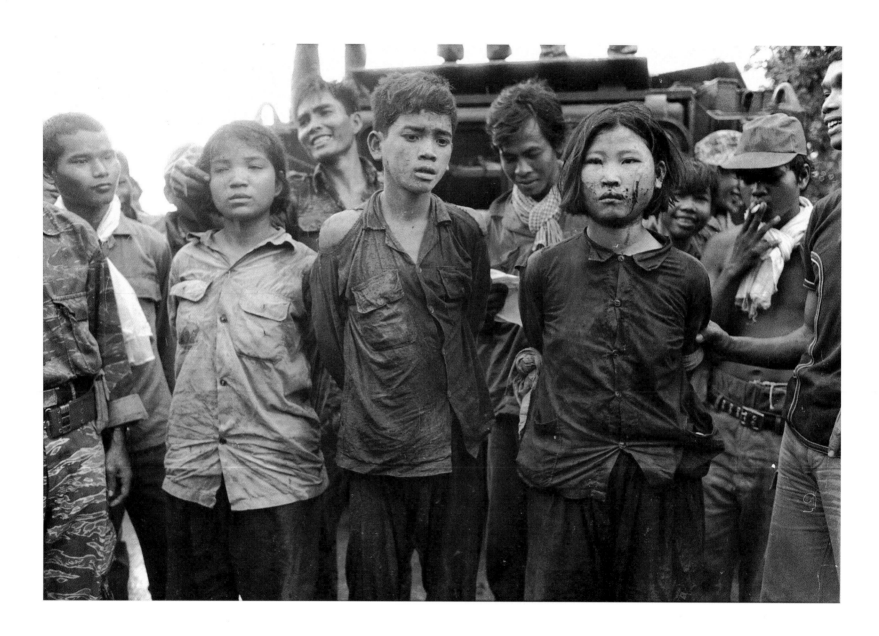

Khmer Rouge prisoners in Cambodia being taunted – some were raped and many were killed.

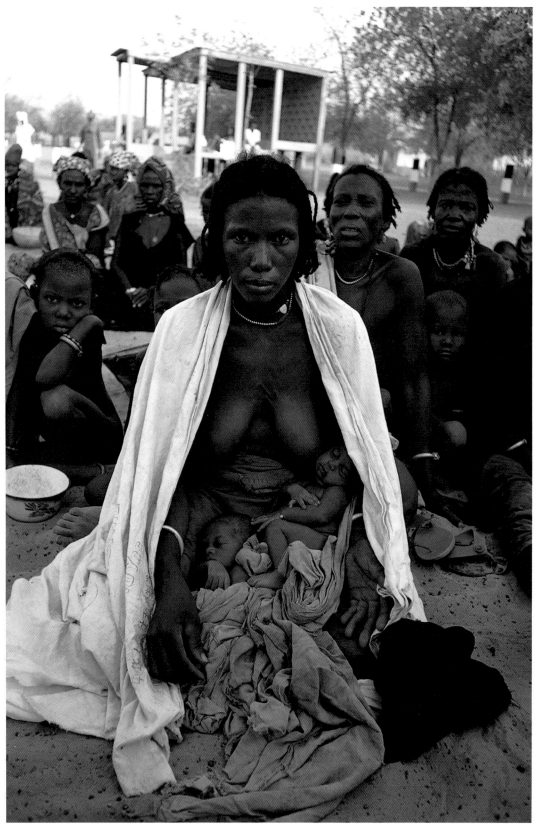

A mother patiently waiting with other victims for help after a severe drought in Chad.

Alexander Solzhenitsyn, the Russian writer most valiant for truth and therefore expelled, just after his defection to West Germany ...

... while Mikhail Baryshnikov is longing to dance in Toronto, where he defected from the Kirov Ballet.

President Nixon (seated, right) seems preoccupied while visiting President Sadat of Egypt (seated, front left) – possibly with Watergate, which was about to ruin him.

Nixon's successor Gerald Ford (far right) joins the big boys – Brezhnev (second from left), Henry Kissinger (third from left) and Gromyko (second from right).

British political leaders Ted Heath (Conservative, left), Jeremy Thorpe (Liberal, centre) and Harold Wilson (Labour Prime Minister, right) sharing a joke.

John Mitchell (second from right), formerly Nixon's Attorney General and a suspect in the Watergate conspiracy, celebrating being found not guilty in the first of two trials, photographed by Harry Benson.

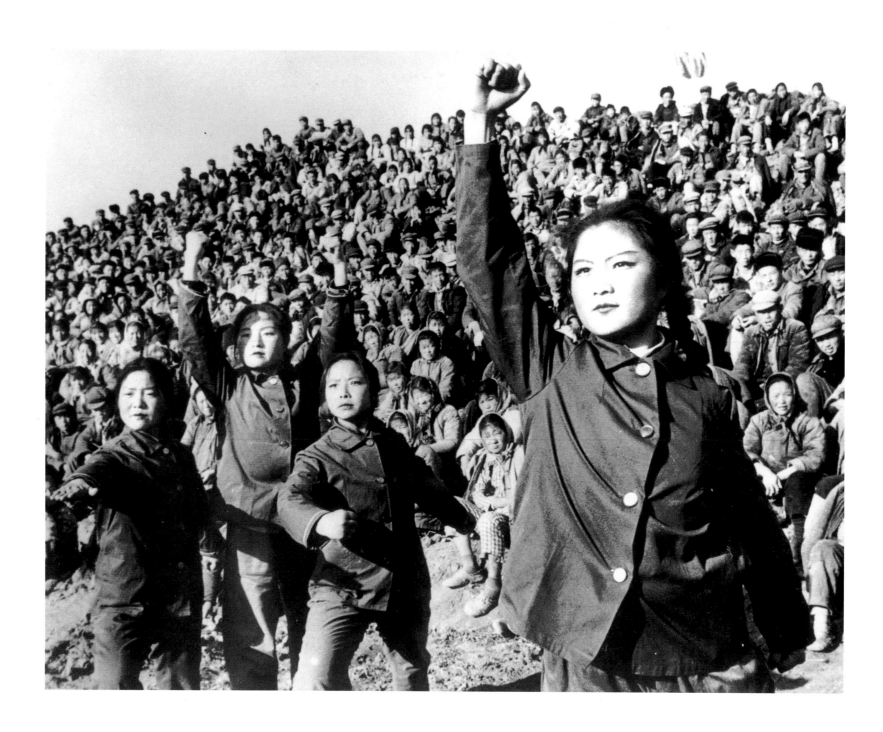

Chinese girls dramatizing their support for Mao and their rejection of the teachings of Confucius.

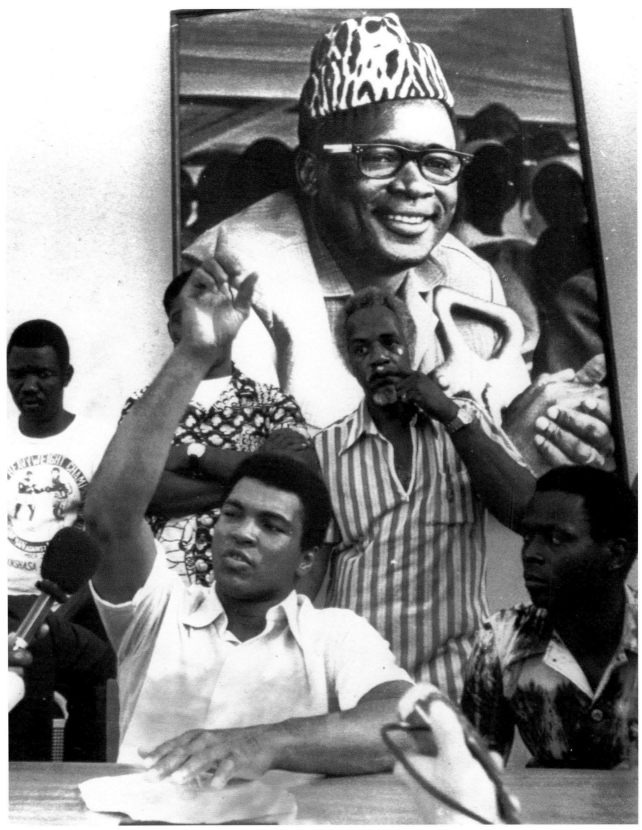

Muhammed Ali, fresh from his epic victory over George Foreman, generously sharing the publicity with President Mobutu of Zaïre.

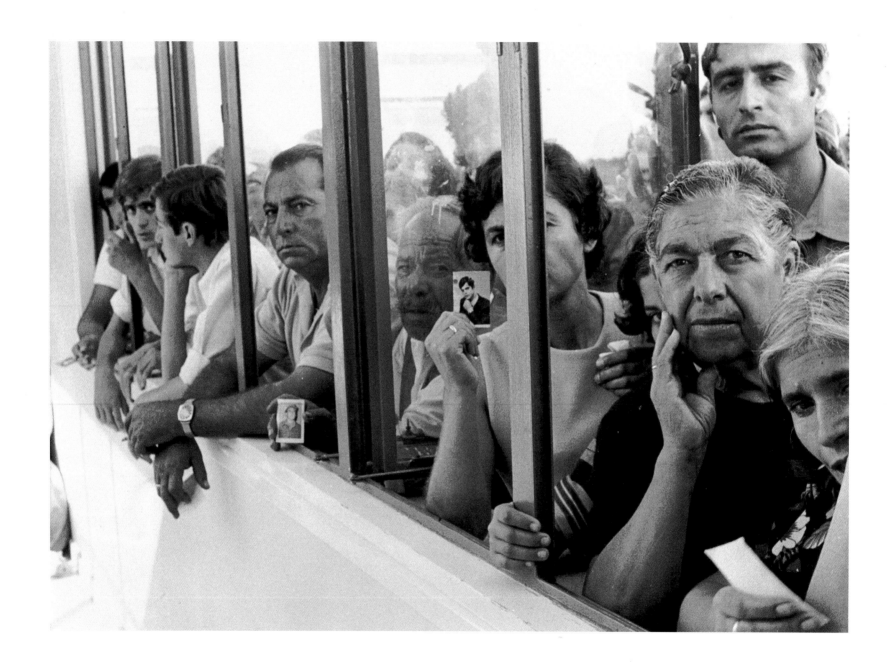

Hopeful Greek Cypriots showing pictures of their lost relations to prisoners released by the Turks.

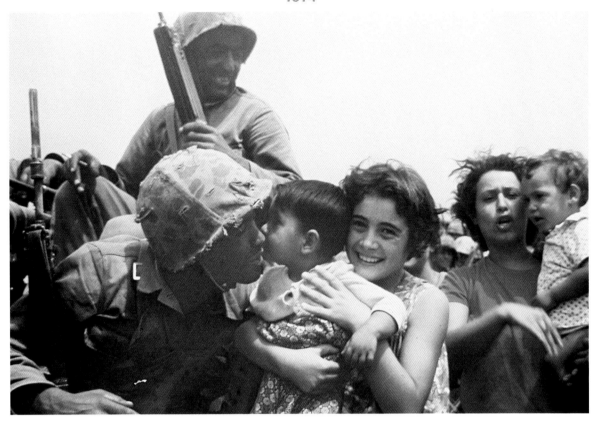

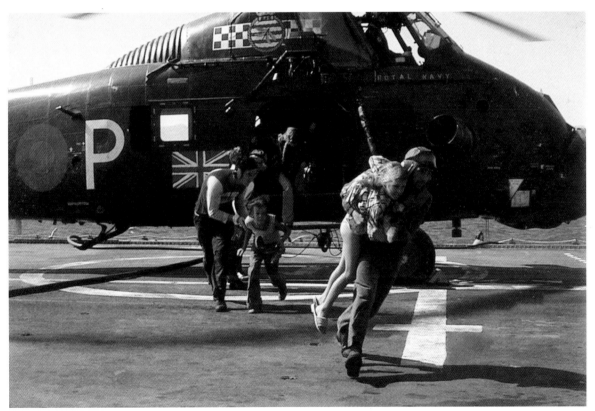

Turks invading Cyprus being welcomed by their ethnic kin.
British troops evacuating Greek children from Turkish Cypriot areas.

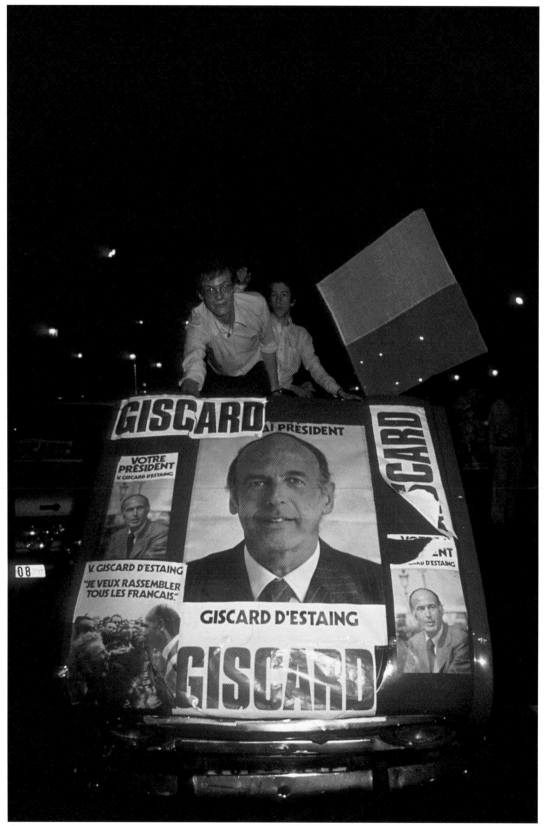

Valéry Giscard d'Estaing's charm narrowly beat François Mitterrand's magnetism – d'Estaing became President of France.

On Juan Péron's death in Argentina, the body of his first wife Eva was brought from Milan to rest beside him.

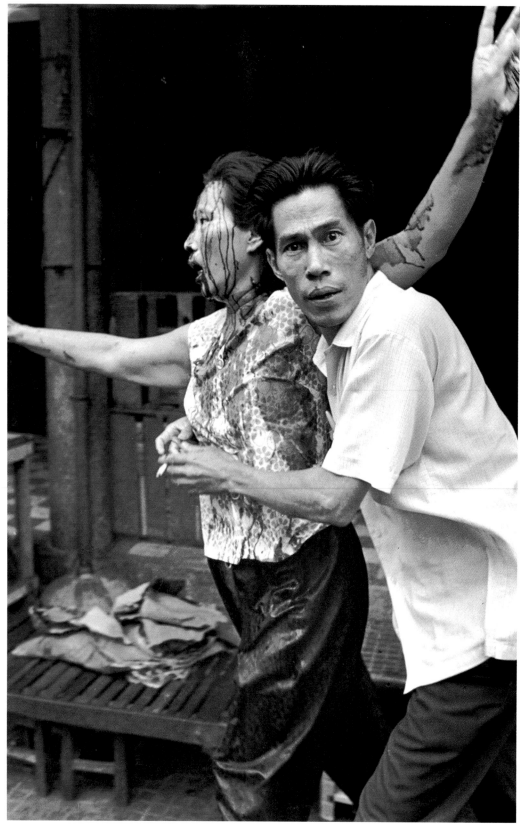

A man attempting to help a woman wounded in a Khmer Rouge rocket attack on Phnom Penh in Cambodia.

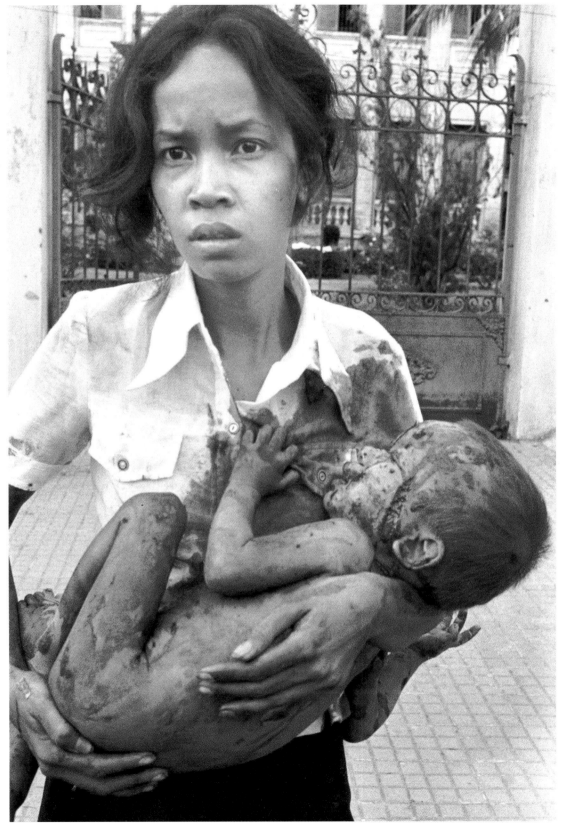

A woman holding a blood-spattered child during the same attack.

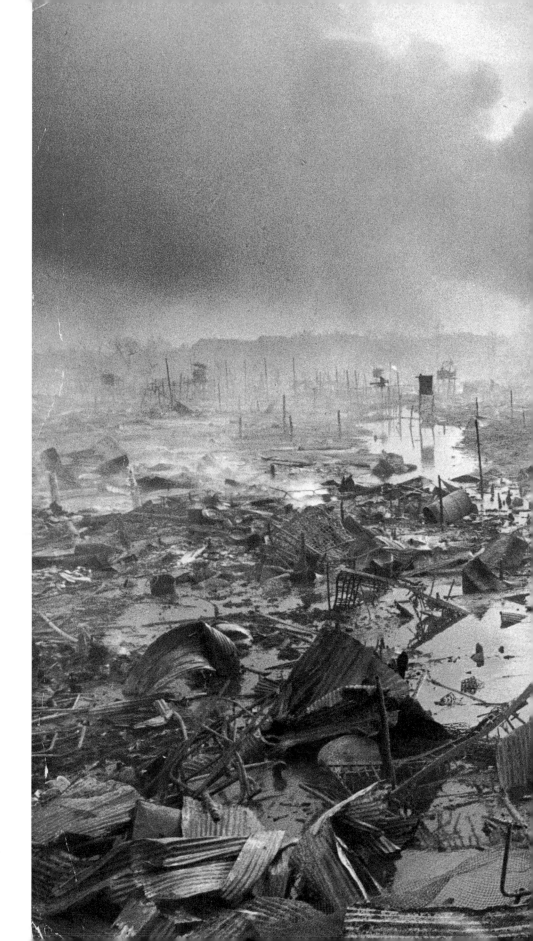

The awesome beauty of a shattered city – the fall of Phnom Penh
to the Khmer Rouge.

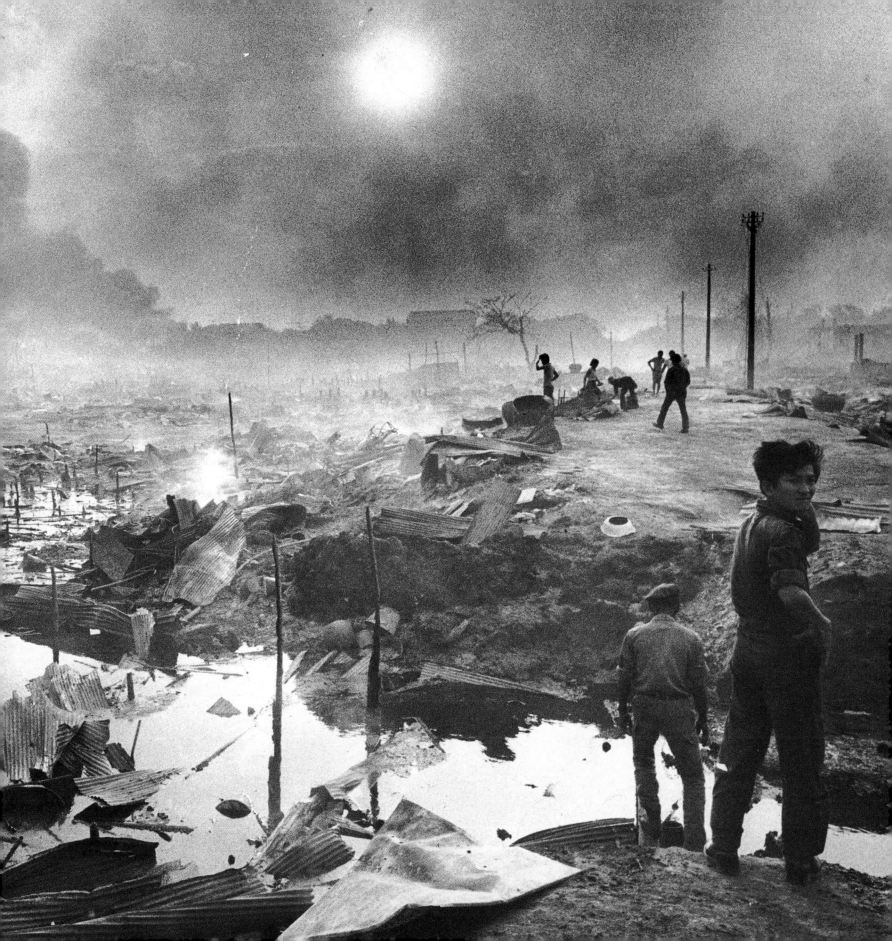

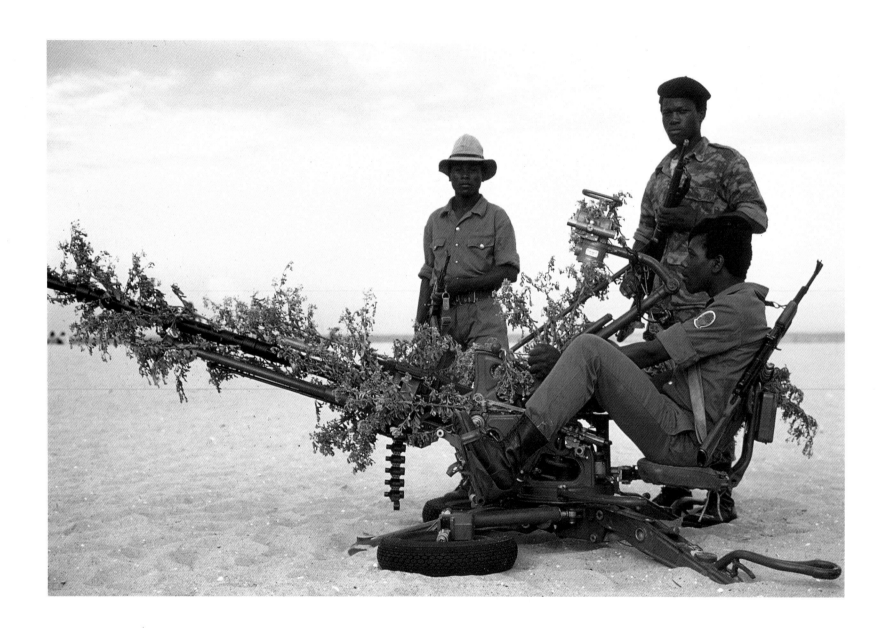

Cuban-backed MPLA government troops in Angola posing with their Soviet 14.5 mm heavy machine gun and on guard against attacks from the anti-Marxist guerrillas, UNITA.

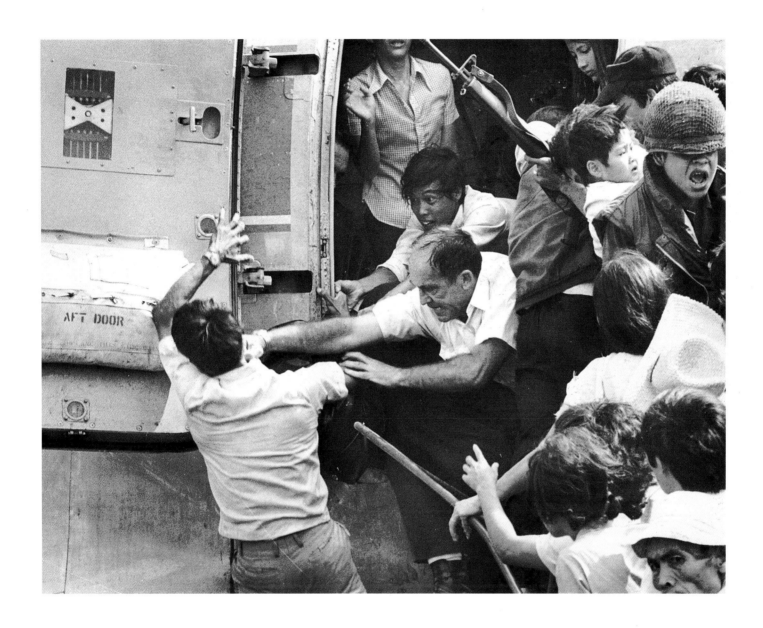

Americans looking desperate as they await evacuation by helicopter from the US Embassy compound in Saigon.

Jaws – a film that profitably frightened much of the Western world.

The first international handshake in space – between the Russian Valeri Kubasov in *Soyuz* and the American Thomas Stafford in *Apollo*.

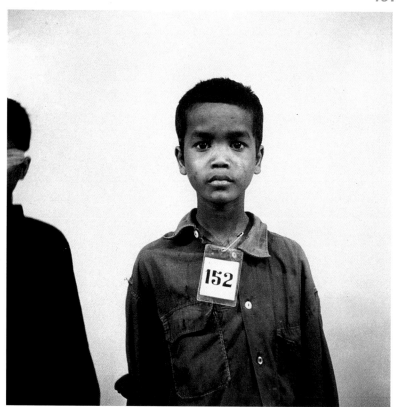
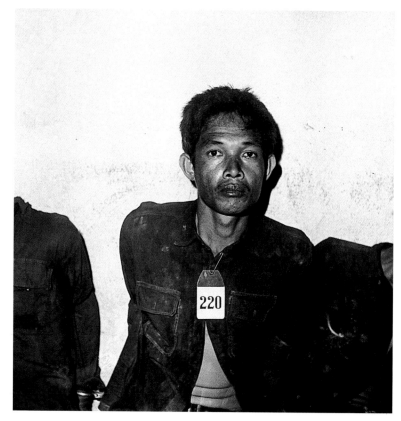
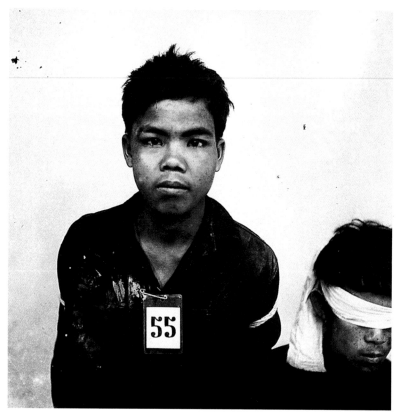
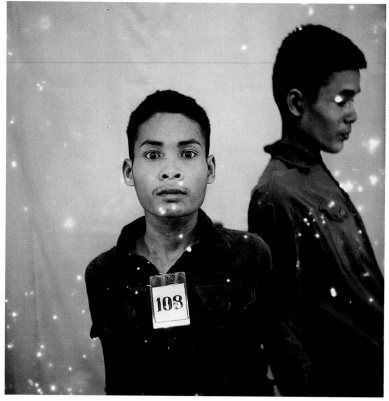

Some of roughly 2 million victims of Pol Pot's Khmer Rouge – one of the worst atrocities in human history.

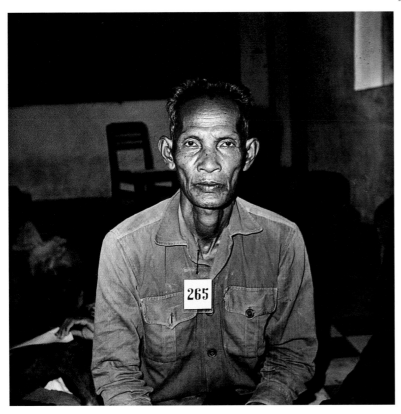

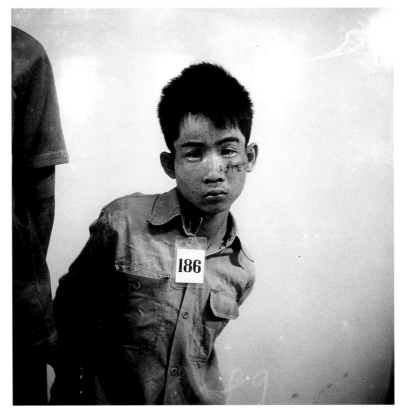

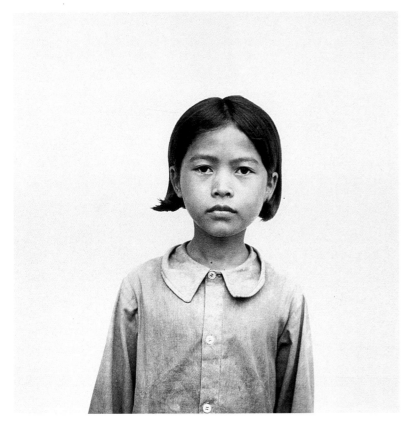

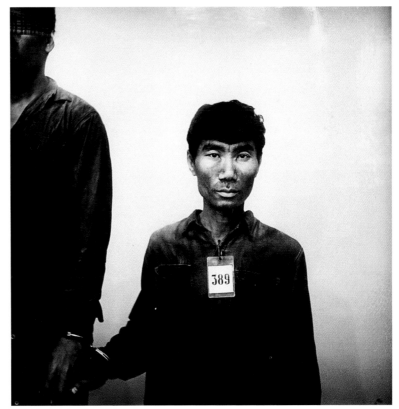

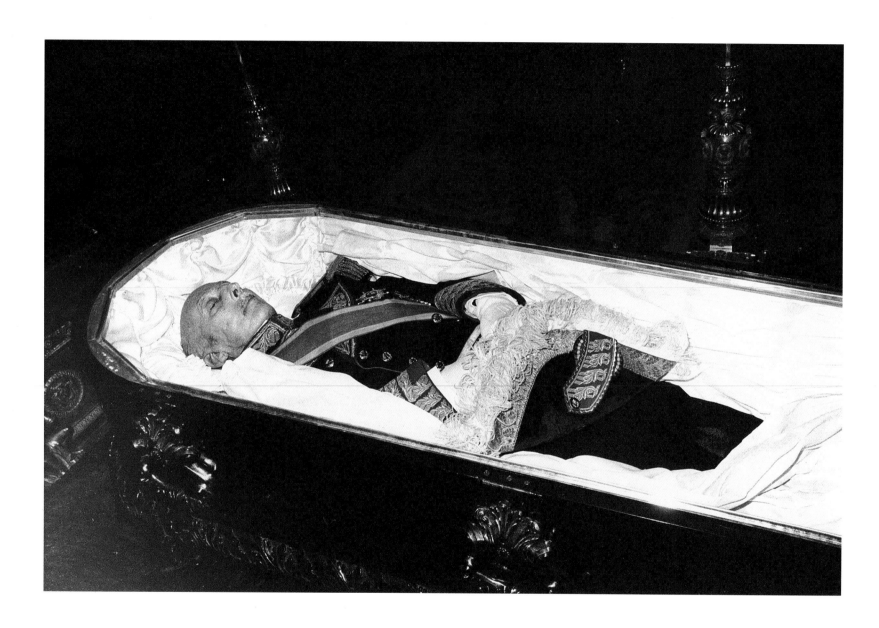

Franco, the enigmatic dictator of Spain, lying in state. He had fortunately named the liberal King Juan Carlos I as his successor.

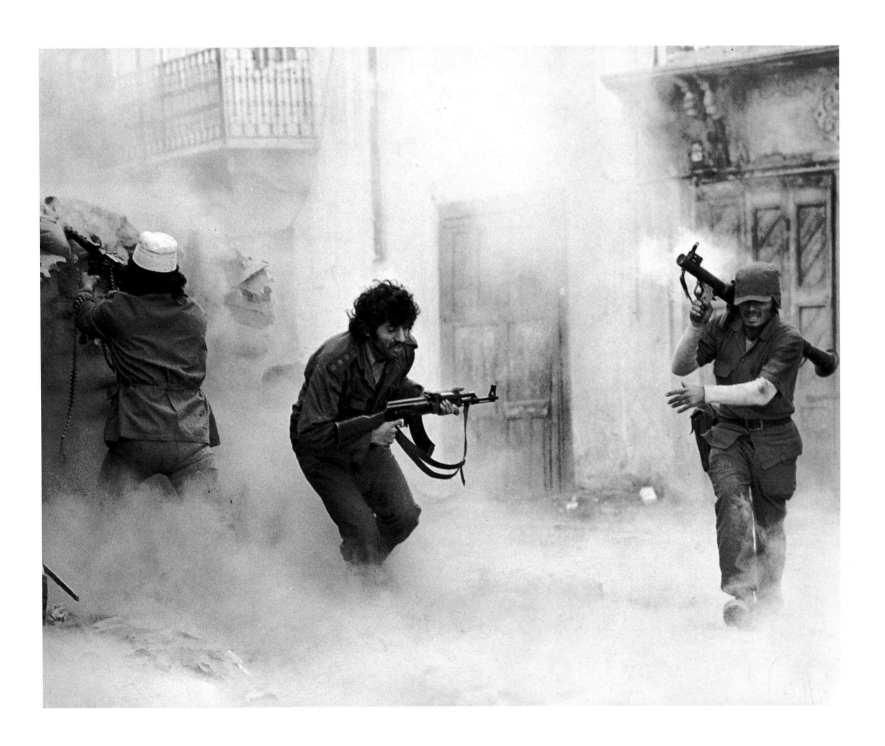

A dramatic shoot-out in Beirut – just one of many in the war between Lebanese Christians and Muslims.

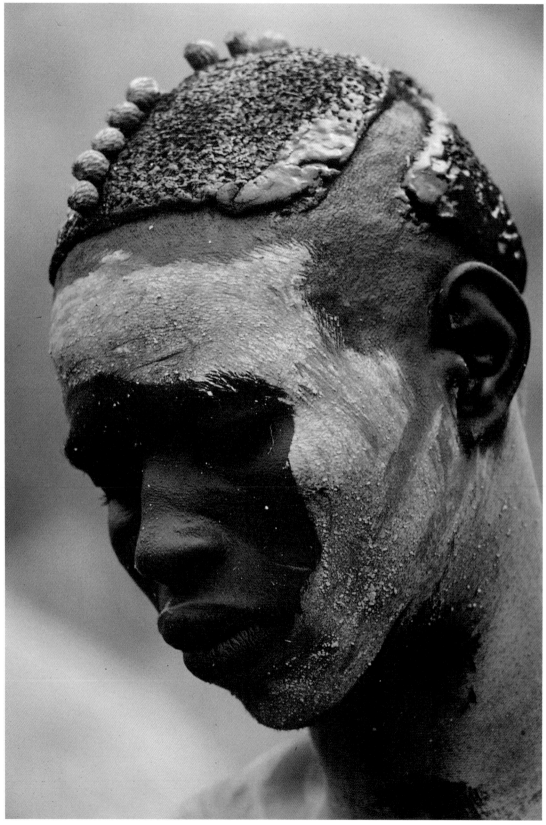

Leni Riefenstahl took many remarkable pictures of the Nuba tribes in Sudan ...

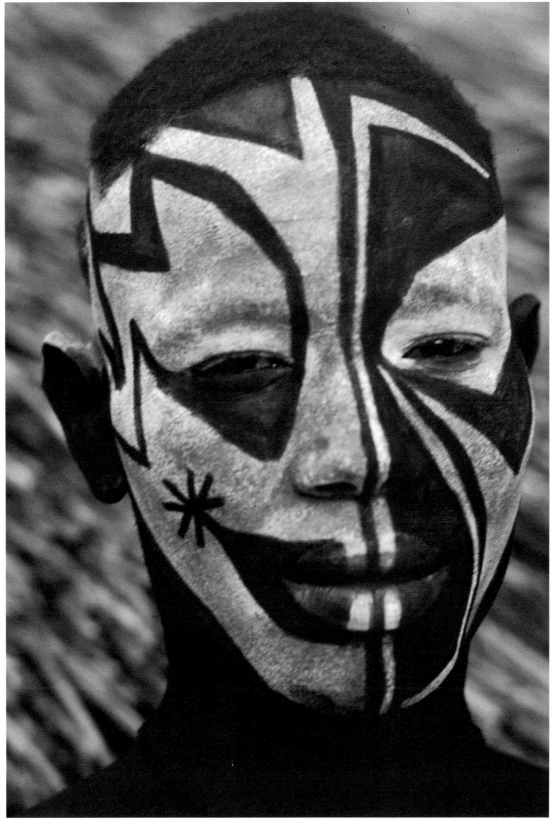

... the face painting of the men reveals some of the inspiration behind Picasso and Miró.

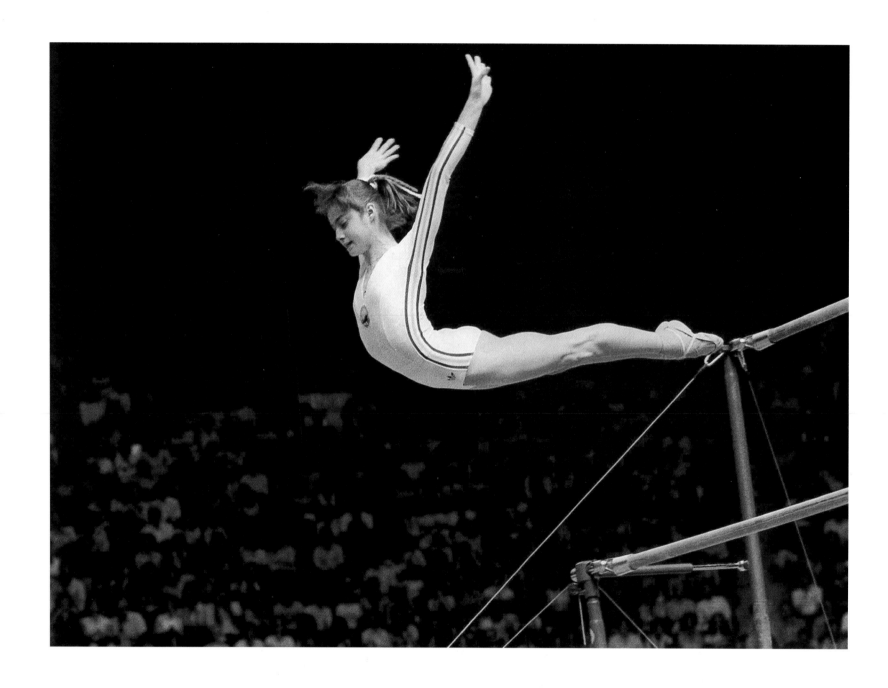

Nadia Comaneci of Romania giving a flawless gymnastic performance at the Montreal Summer Olympics.

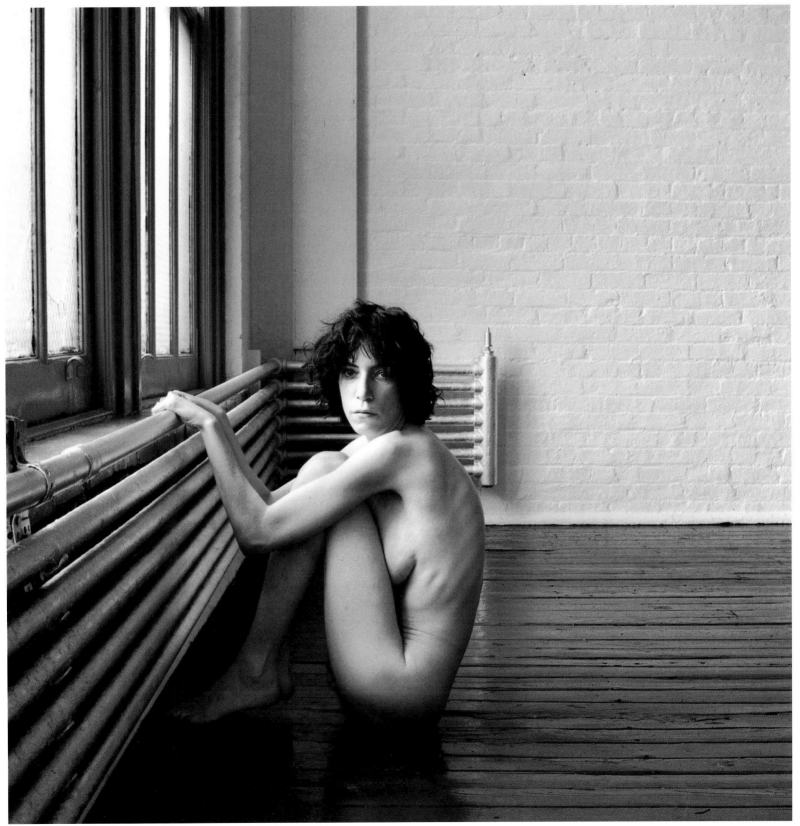

Patti Smith, photographed by her friend Robert Mapplethorpe.

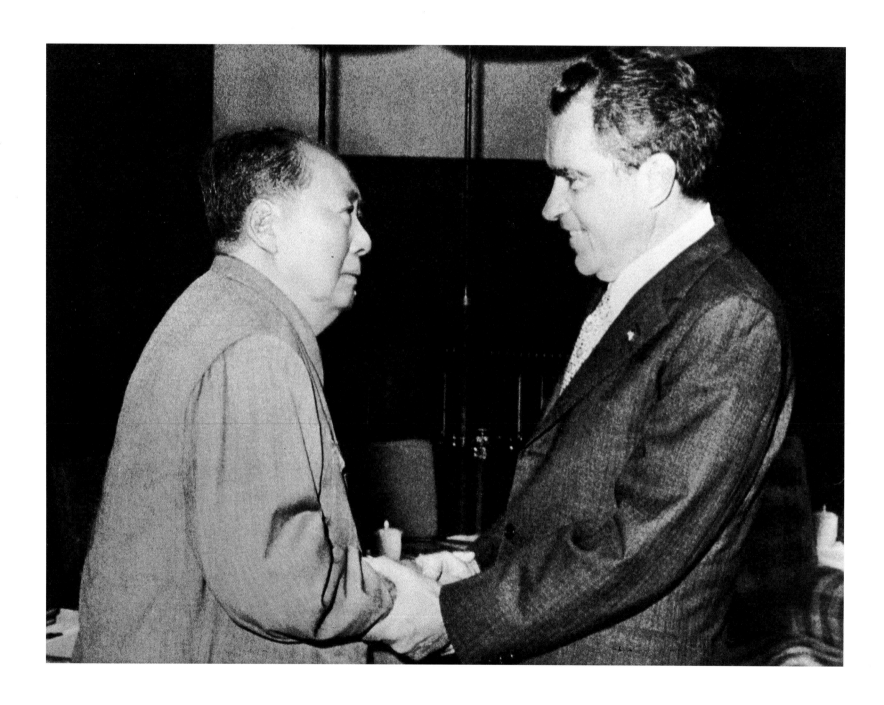

Nixon perhaps reliving his diplomatic triumphs in Sino-US relations – Watergate does not seem to have affected Mao's goodwill ...

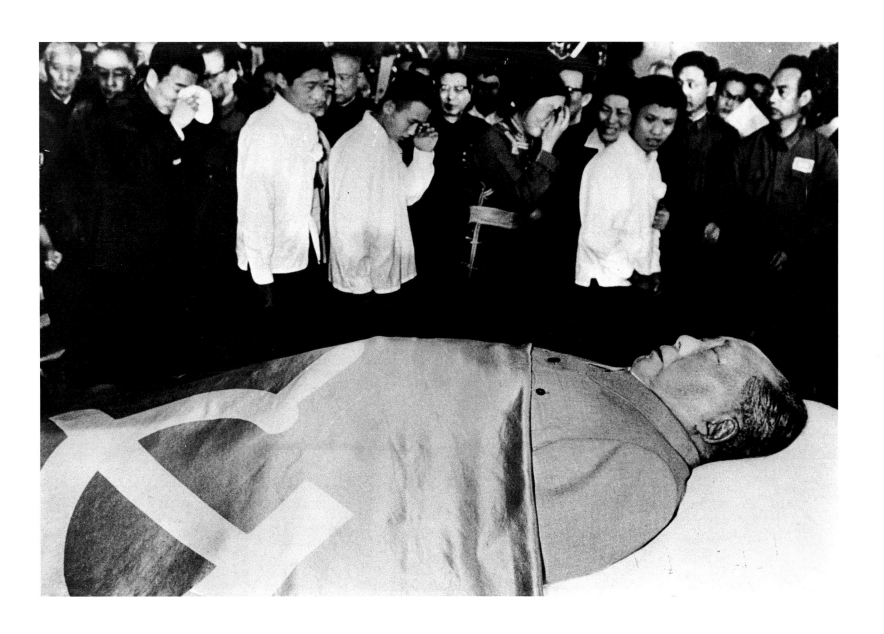

... but the Chairman died soon afterwards and here his wife, Chiang Ching stands in the background (centre in glasses) looking at his embalmed body.

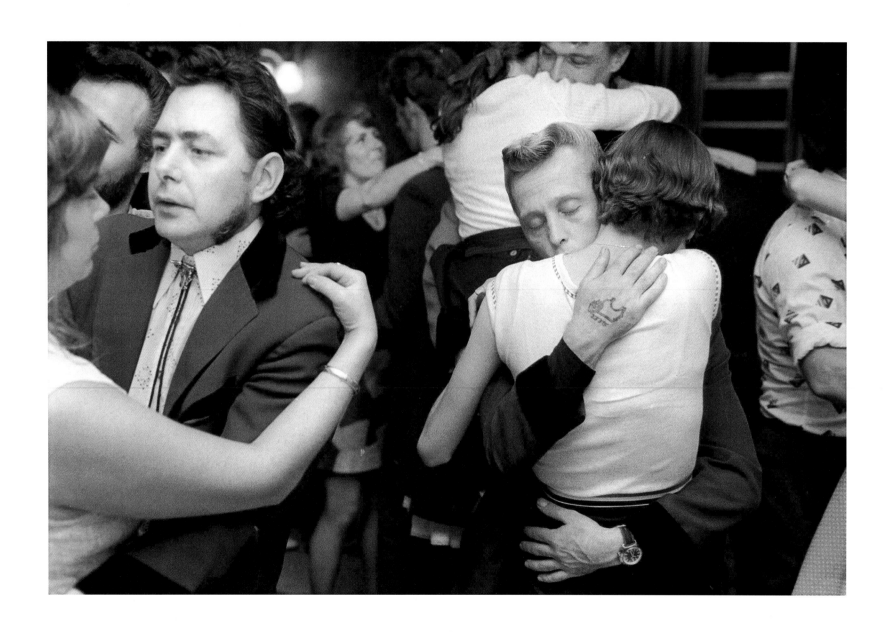

The 'Ted' revival in England – and Chris Steele-Perkins captured its combination of Edwardian and Wild West style.

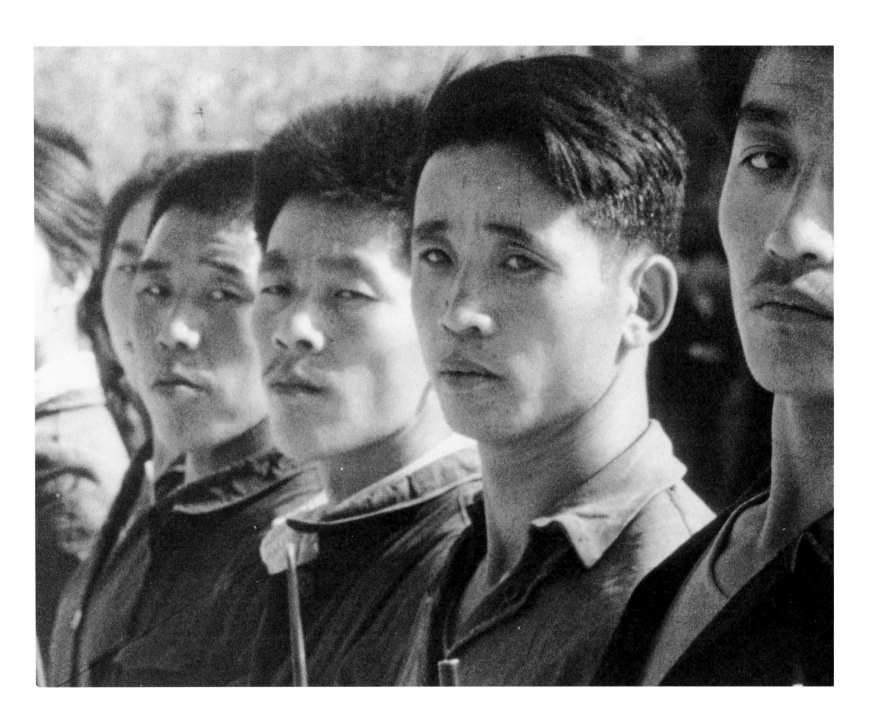

Chinese communist students on parade long after the Red Guards had been disbanded.

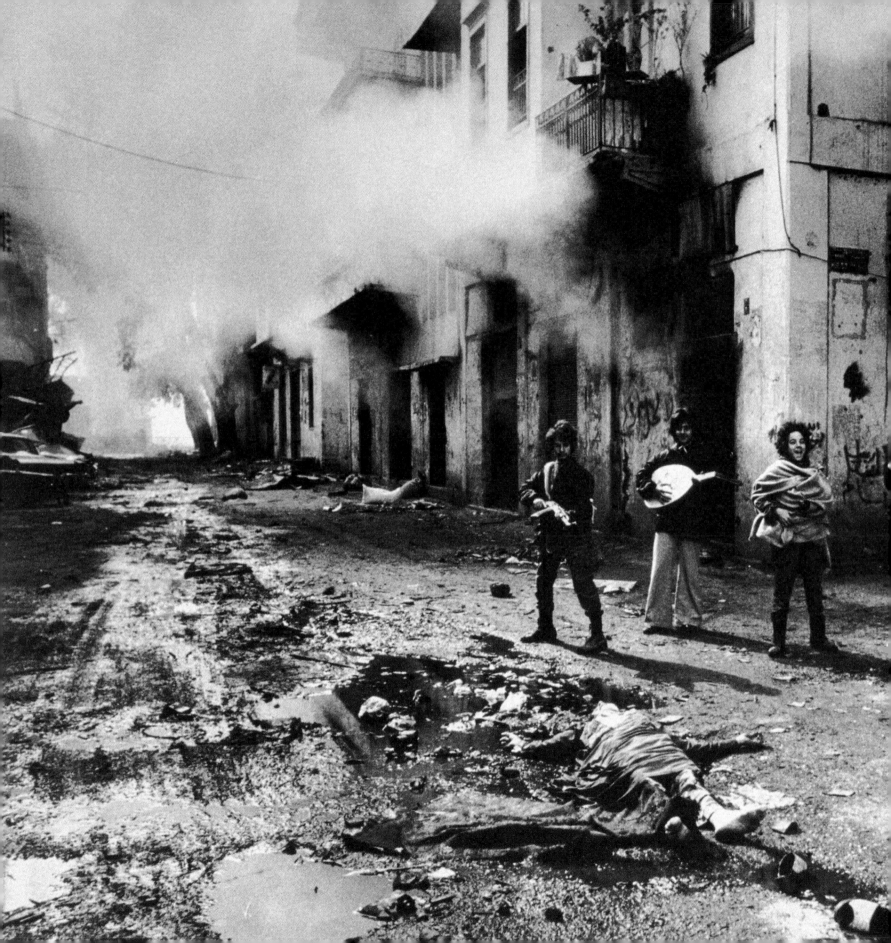

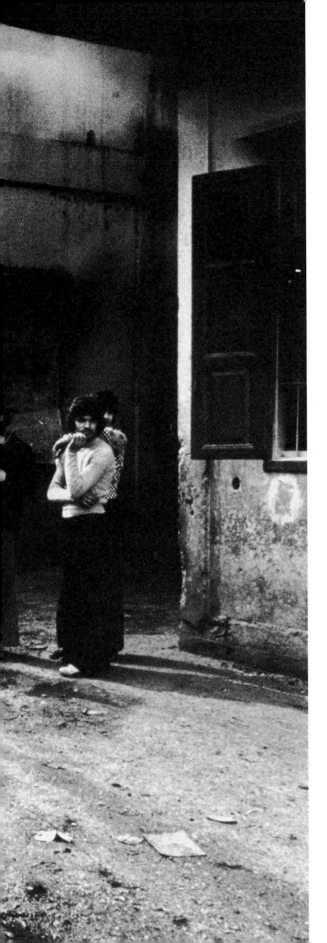

Falange gunmen serenading the corpse of a young Palestinian girl in Beirut.

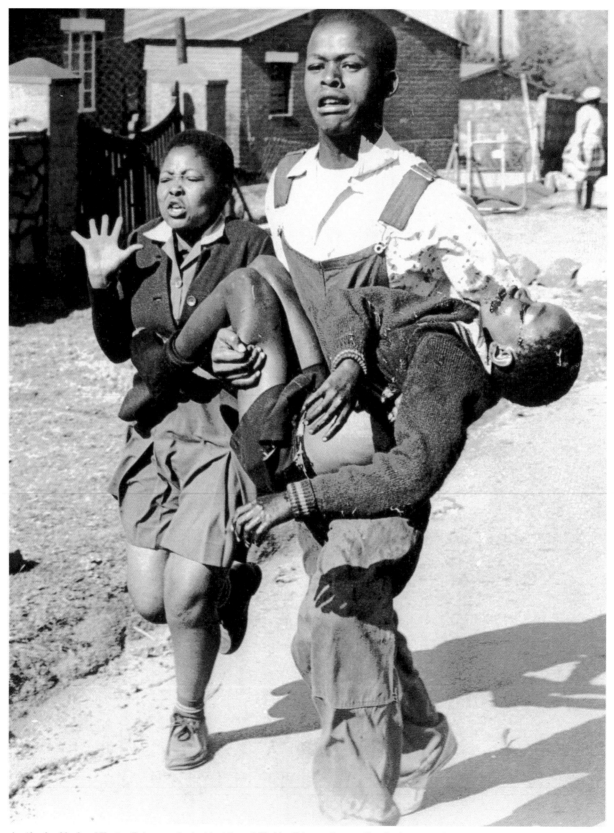

A fellow student carries the dead body of Hector Petersen who had just been killed by Johannesburg police during an anti-apartheid demonstration. Hector's sister runs alongside.

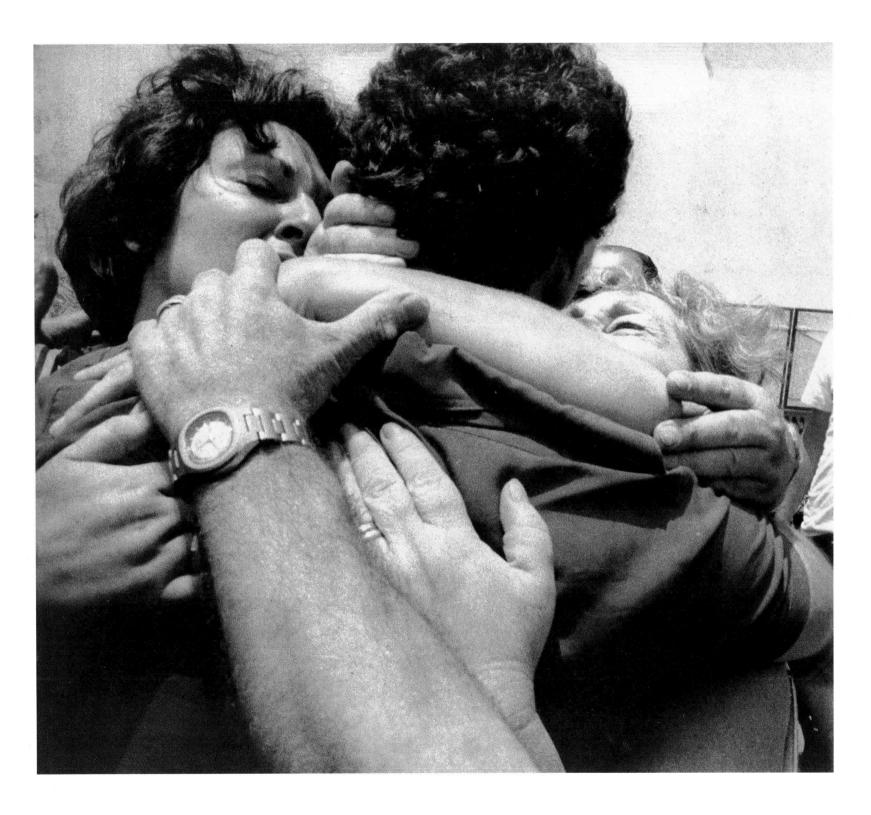

A hostage from the hijacked Tel Aviv-to-Paris flight, being greeted after his rescue along with over a hundred others by an Israeli raid on Entebbe Airport in Uganda.

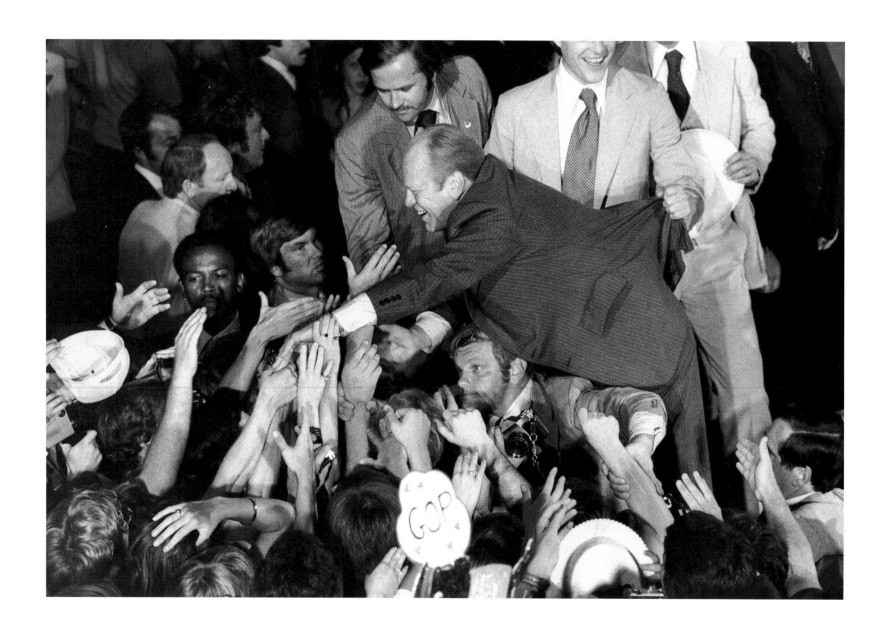

Gerald Ford seems able to command all kinds of support at the Republican Convention.

Barry Humphries half way to becoming Dame Edna Everage – Australian scourge of the English-speaking world.

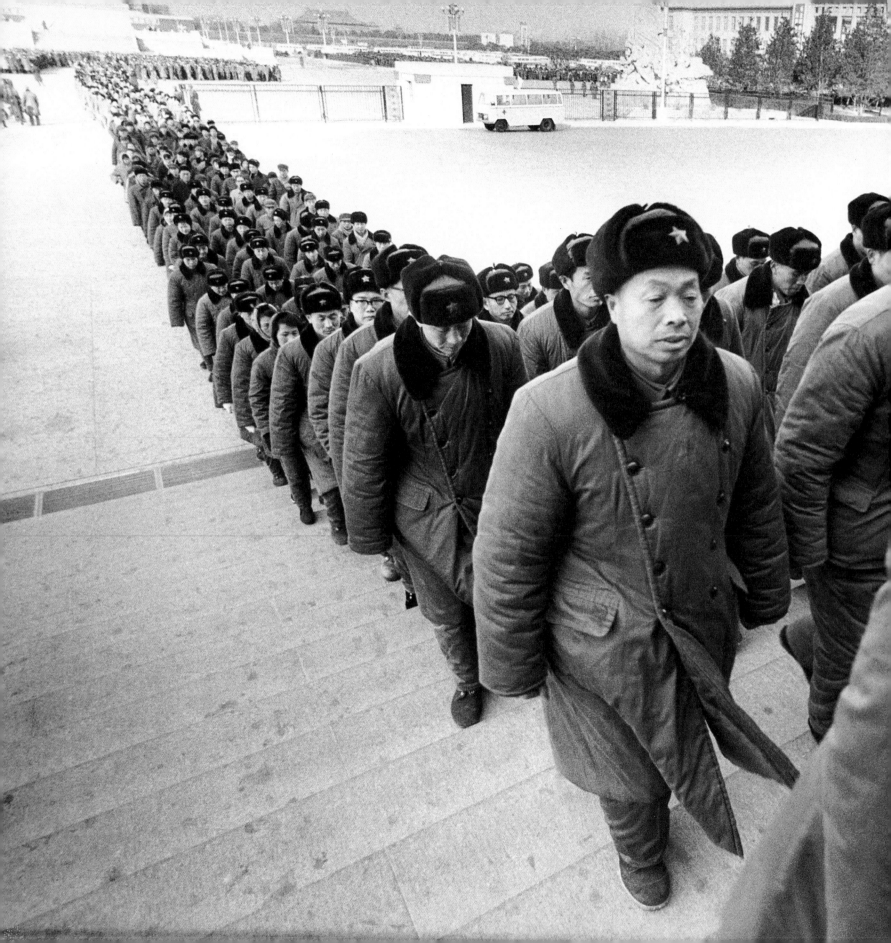

Chinese soldiers line up to pay their respects to the embalmed Mao Zedong.
His grand mausoleum was completed less than a year after his death.

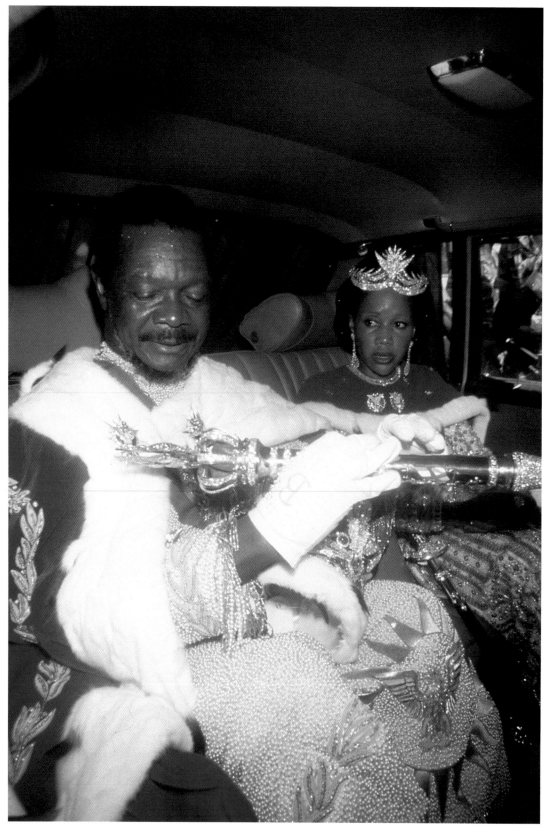

The new Emperor Bokassa of the Central African Republic with his Empress. His coronation cost a fifth of his country's annual budget.

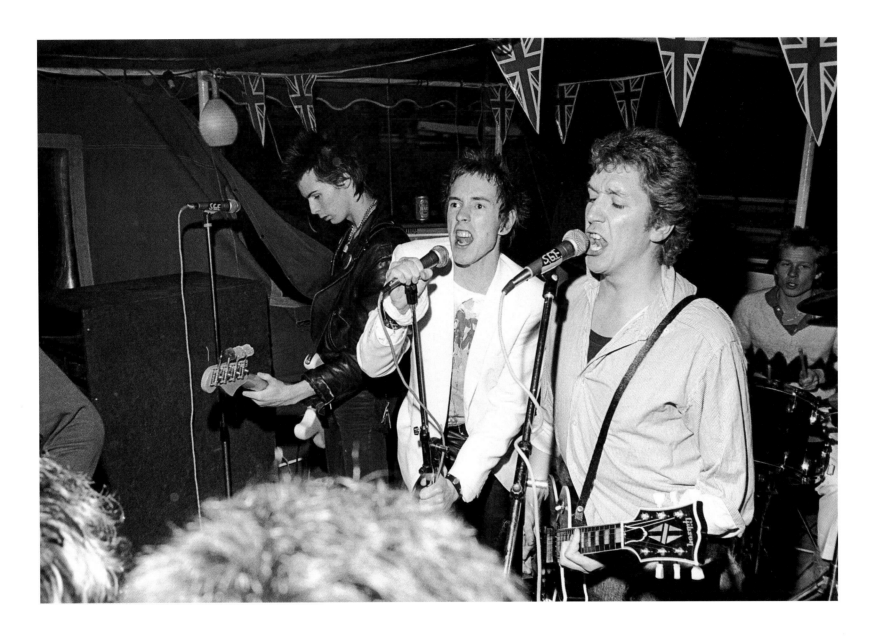

The Sex Pistols in concert – Sid Vicious (left) became the most notorious member of the band.

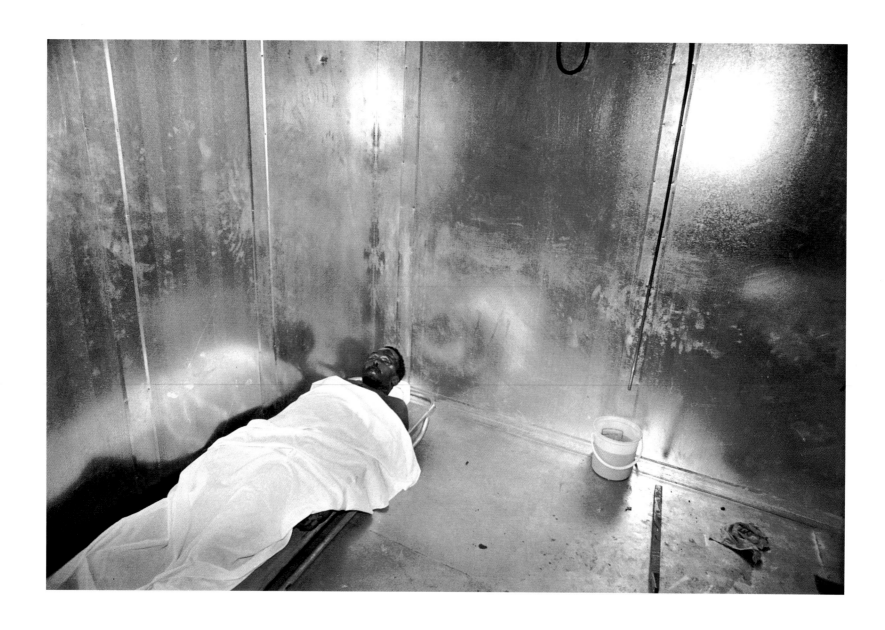

Steve Biko – the body of the black leader after his murder by South African police.

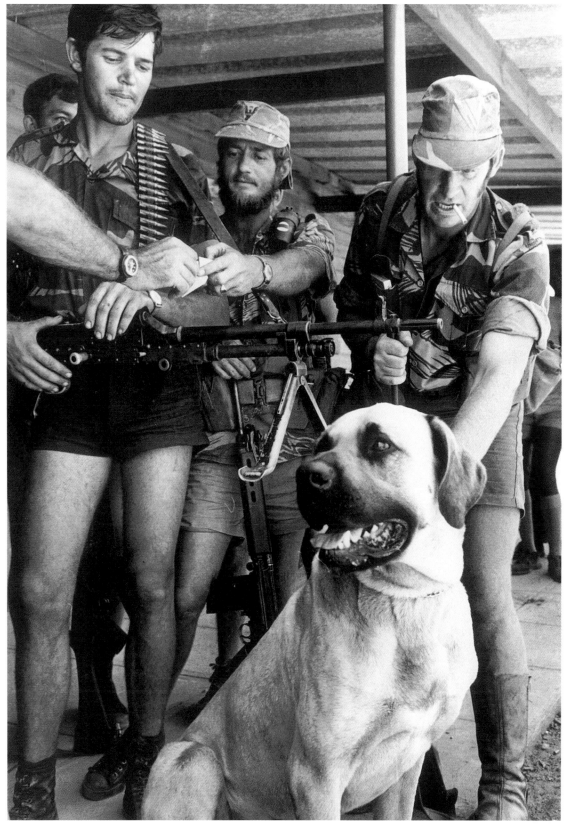

White Rhodesian commandos during their fight against black nationalists near the Mozambique border. They were hugely outnumbered in the future Zimbabwe.

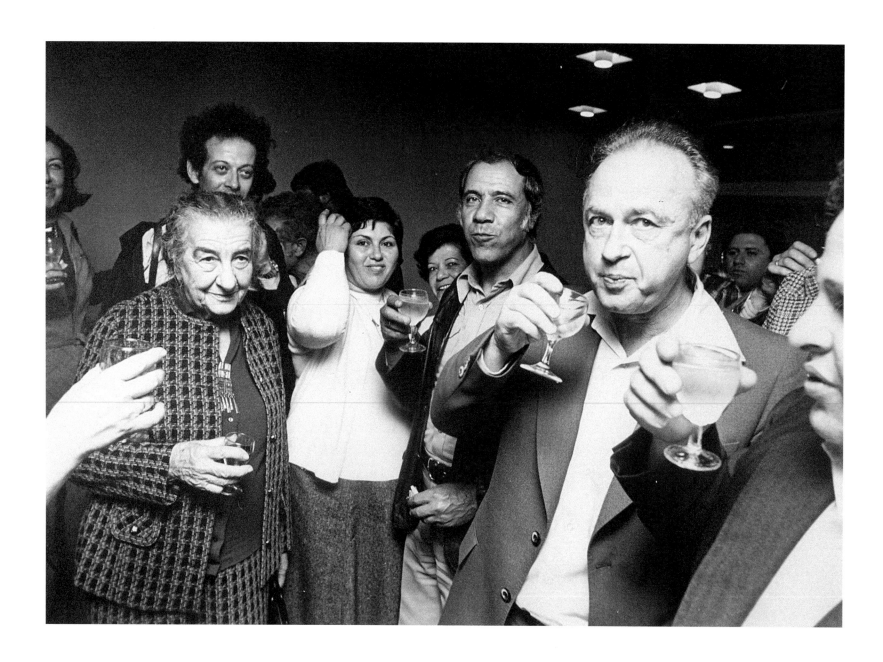

Israel's Prime Minister from 1969 to 1974, Golda Meir (left) with her successor Yitzhak Rabin (second right).

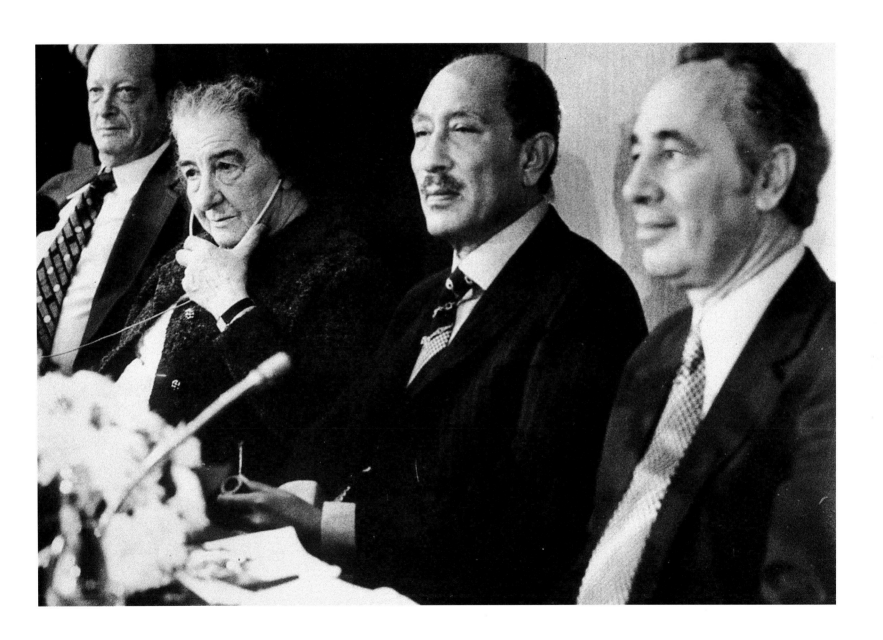

With Israeli labour politician Shimon Peres (right), Meir entertains President Sadat of Egypt (centre) on his historic visit to Jerusalem.

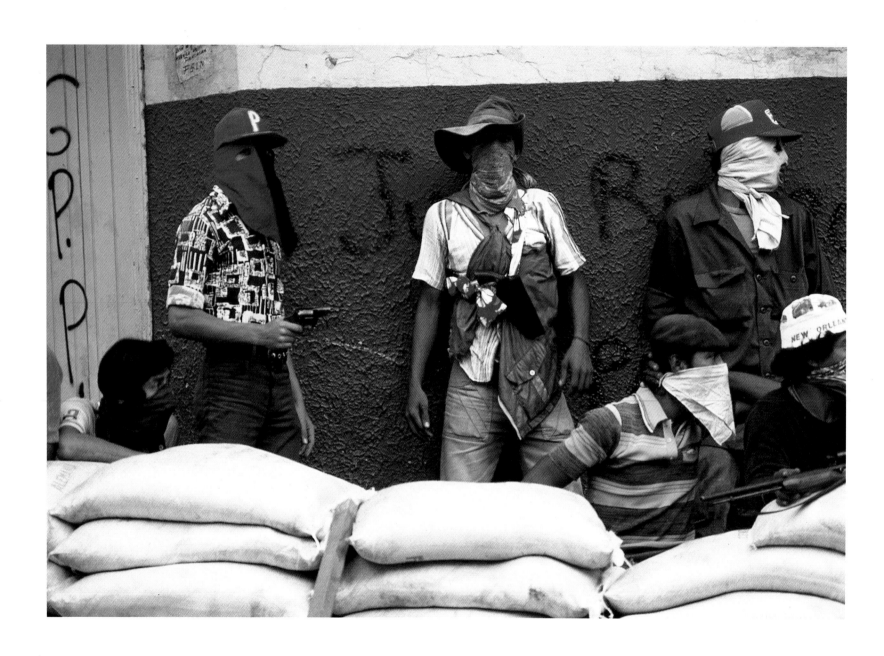

Nicaraguan youths pose like cowboys for photojournalist Susan Meiselas.

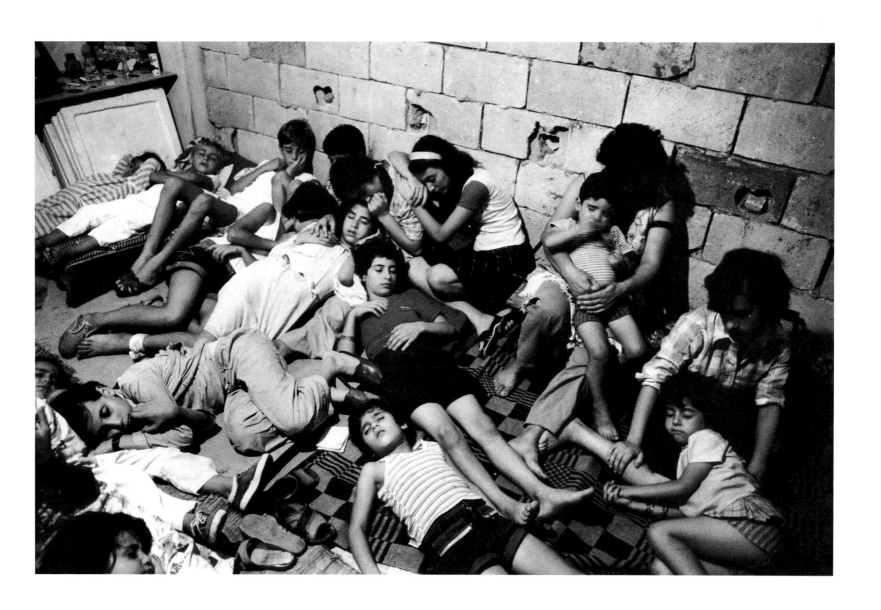

War-weary women and children in an underground shelter in the Christian sector of Beirut.

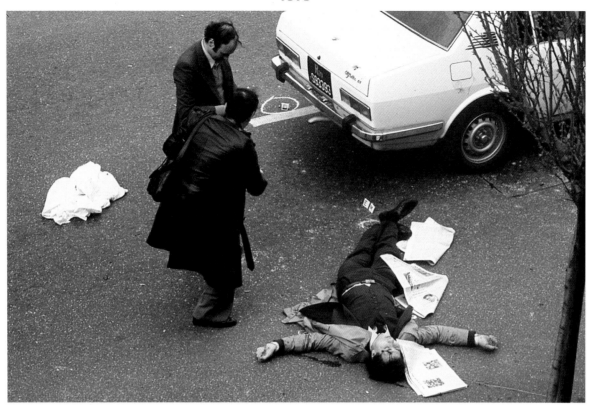

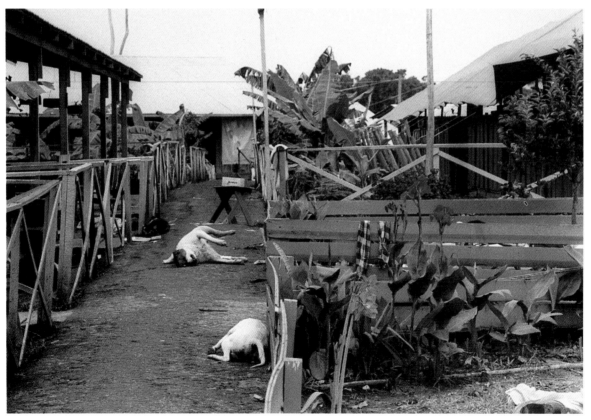

A bodyguard of the fomer Italian Prime Minister – Aldo Moro – killed during Moro's kidnapping. Moro was murdered in his turn two months later.
Dogs as well as over 900 followers of Jim Jones died by mass suicide in the People's Temple commune in Jonestown in Guyana.

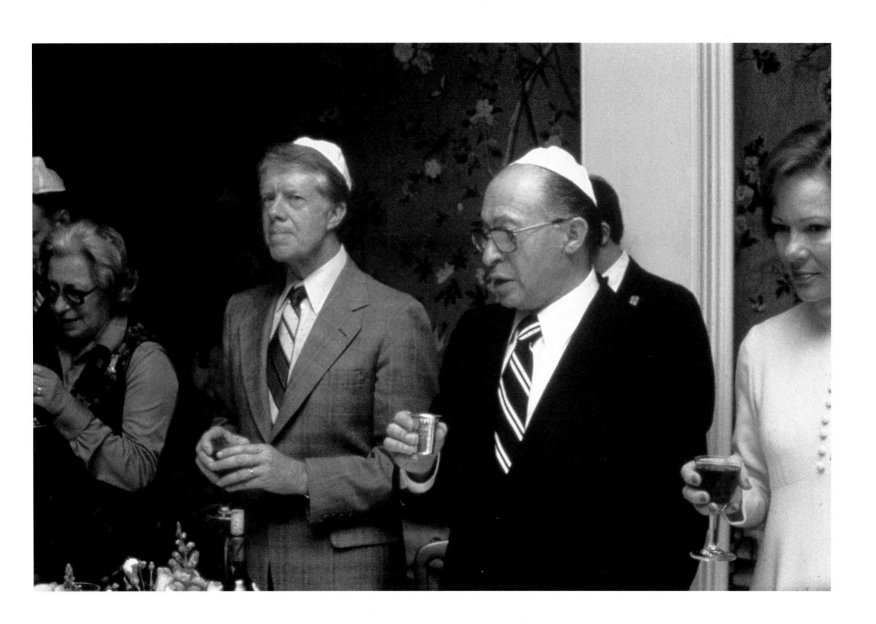

US President Jimmy Carter (left) and Israeli statesman Menachem Begin (right) praying at Camp David before they arranged an Israeli-Egyptian Peace treaty with President Sadat.

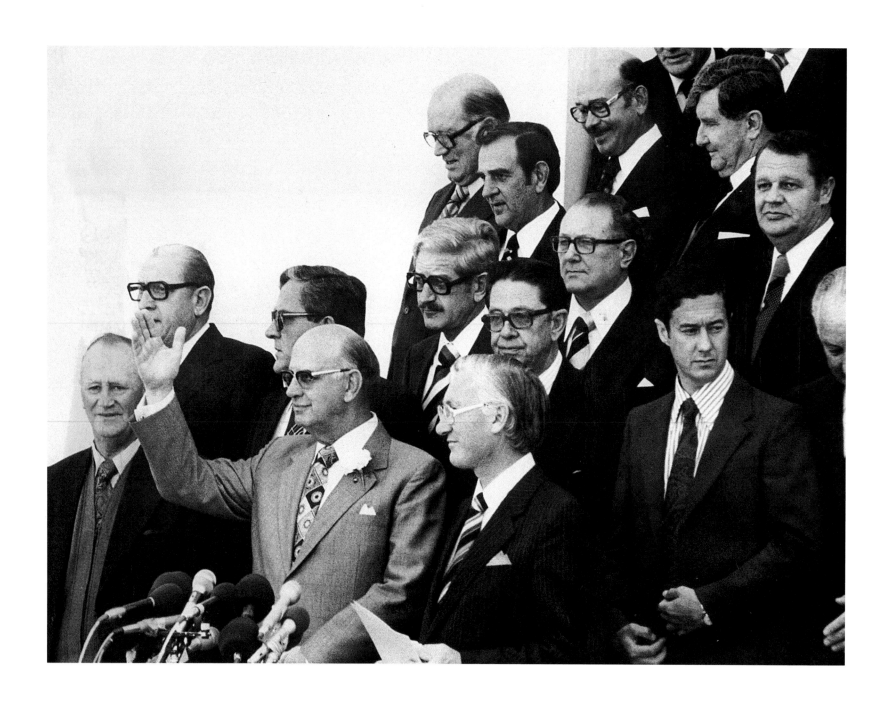

Die-hard South African Prime Minister P.W. Botha waving to his supporters on his election to office.

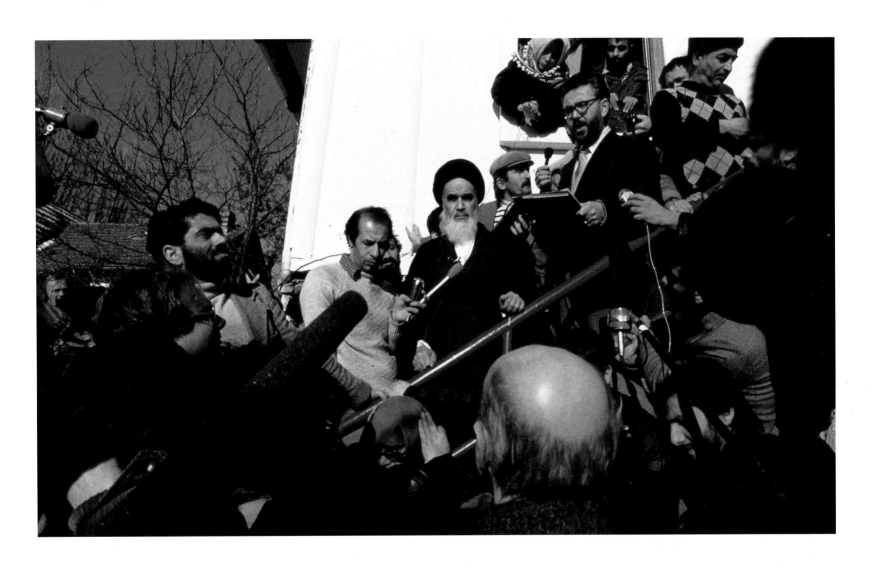

The expelled Ayatollah Khomeini used France as his springboard to the seizure of power in Iran.

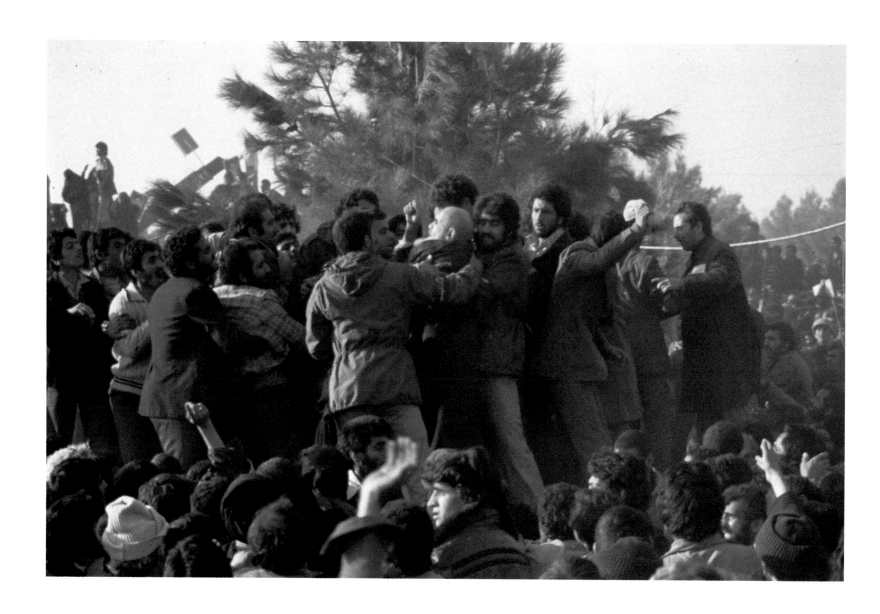

Khomeini's safety seems endangered by his supporters, so physical is their welcome on his return to Tehran.

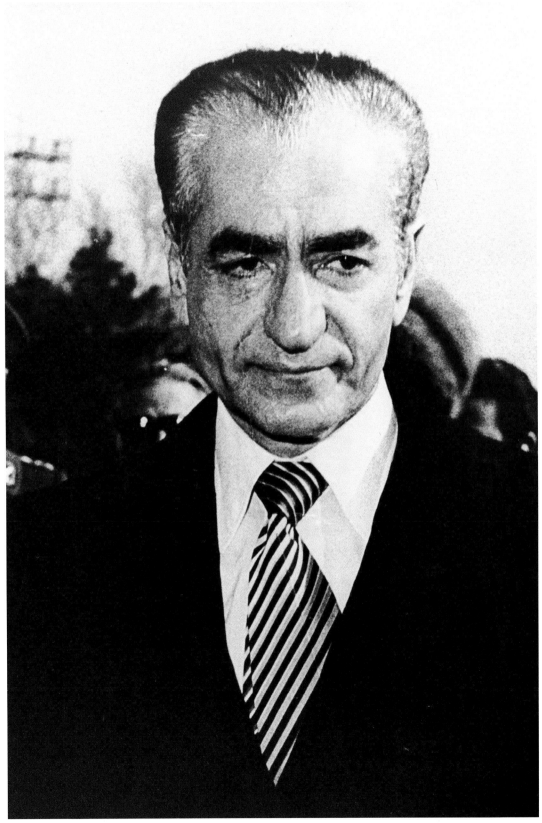

The end of a dynasty – the Shah leaves Tehran for Morocco on the verge of tears.

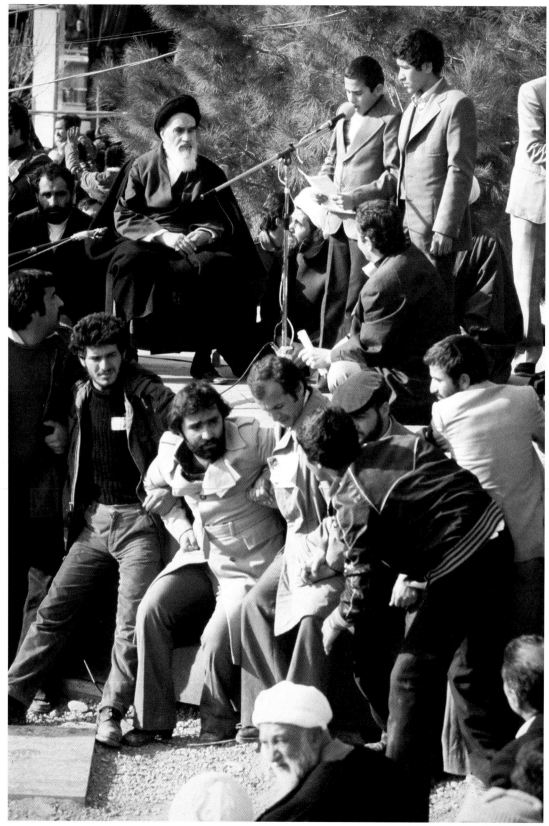

The Ayatollah on his return from exile listening to addresses of welcome and devotion from his young cadets.

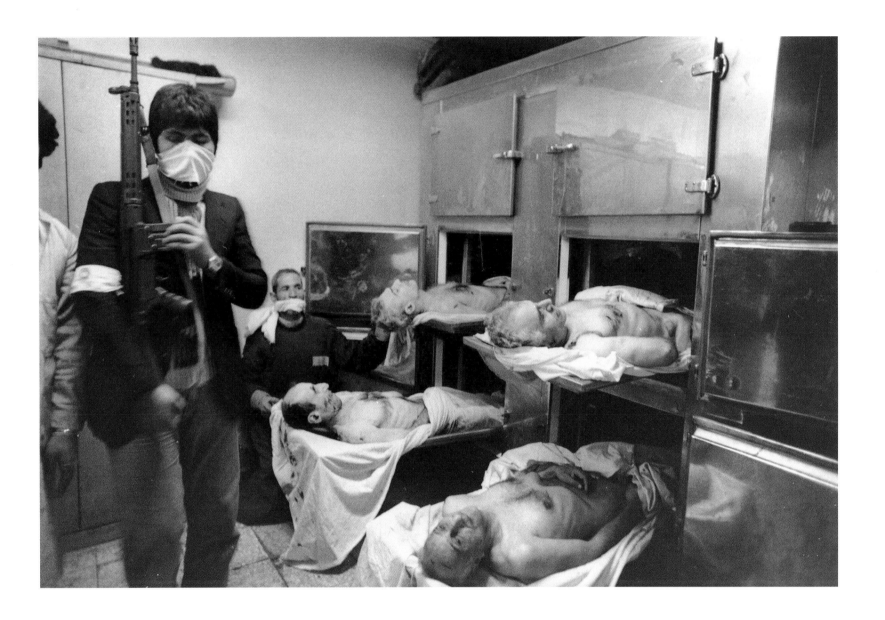

The corpses of the first four generals executed by the Islamic court in Tehran are made available for photographs.

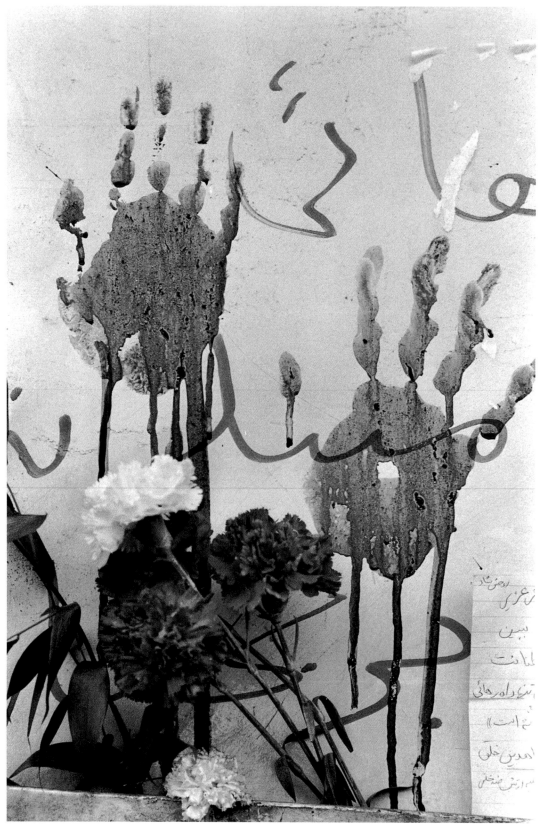

The bloody nature of the new Iranian regime was evident everywhere.

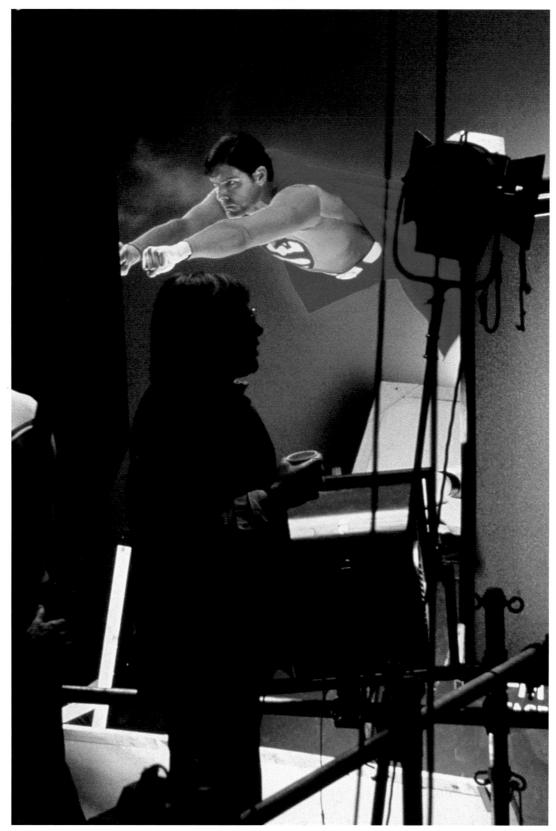

The filming of *Superman*, starring Christopher Reeve, who saves the world from destruction time and again.

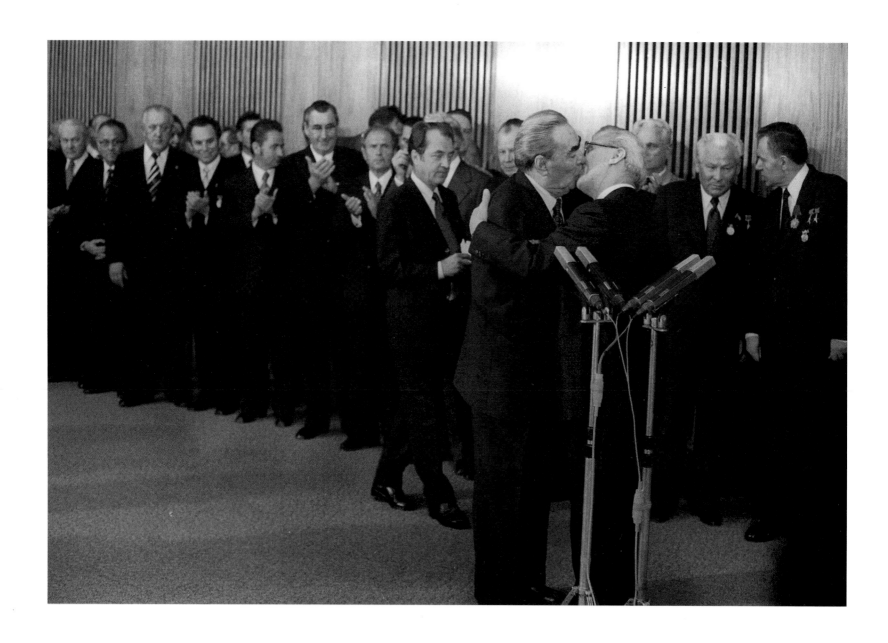

A monstrous embrace applauded – Erich Honecker and Leonid Brezhnev in East Berlin celebrating the thirtieth anniversary of East Germany.

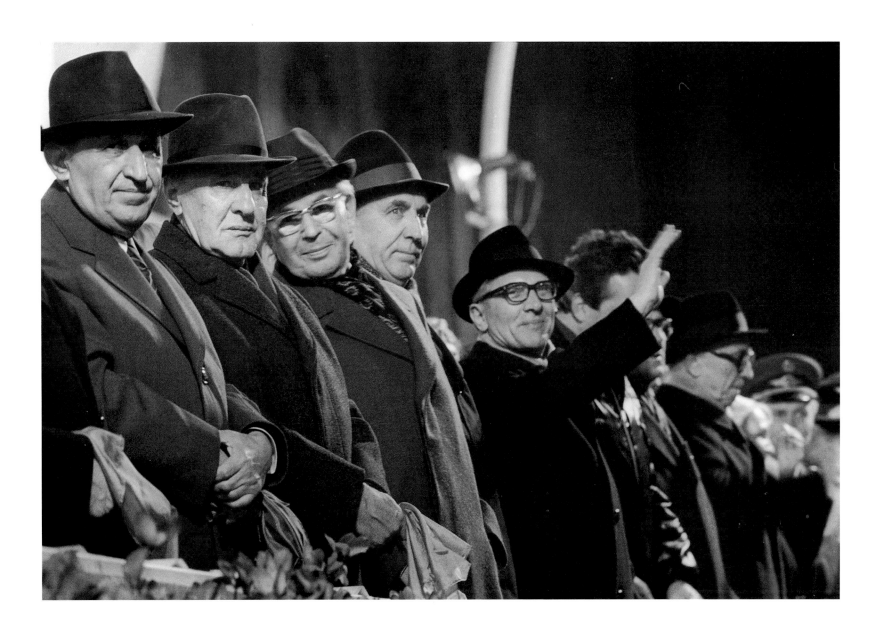

The Kremlin's East European 'running dogs' celebrate the same anniversary of East Germany – Schirokoff, Kadar, Kusak, Gierek, Honecker (left to right).

A moment of pure joy from Margaret Thatcher – shared by her husband and son – on hearing that she is Britain's first woman prime minister.

Rolling Stone Mick Jagger and Texan model Jerry Hall in Paris. They lived together for nearly twenty years.

Pope John Paul II in New York – by far the most travelled Pope in history.

Junk imagery from the Pope's travels are found in unexpected places.

Monty Python's *Life of Brian*, one of the most profane films ever made in Britain ...

... while in the Lebanon nothing untoward is seen in an image of Christ on a devout Christian's machine-gun magazine.

Polish strikers enjoying every moment of their freedom to down tools.

A Nicaraguan mural celebrating the Sandinista struggle and emphasizing the role of Agosto Sandino and Carica Fonceca Amador.

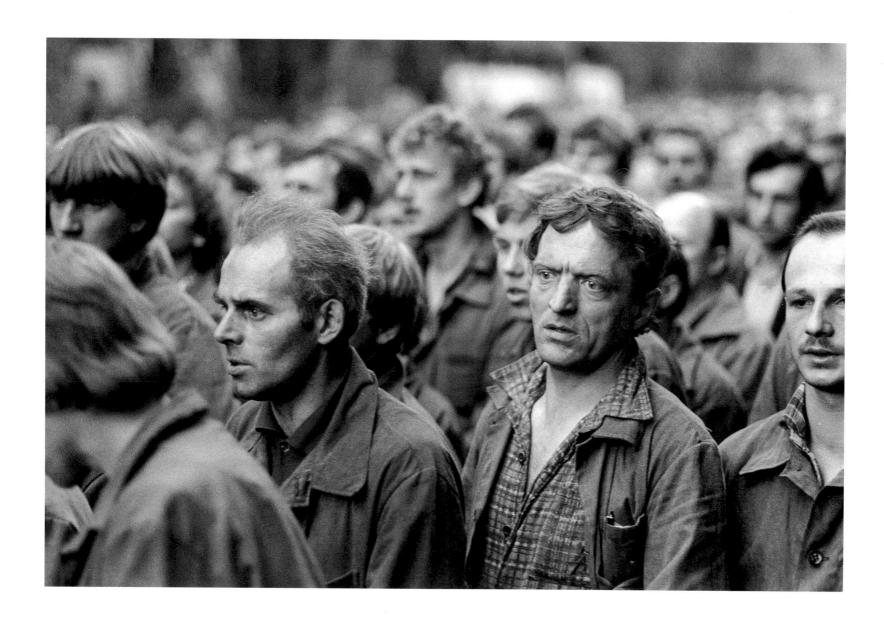

Strikers' new-found freedom in Poland – they now faced a different set of problems.

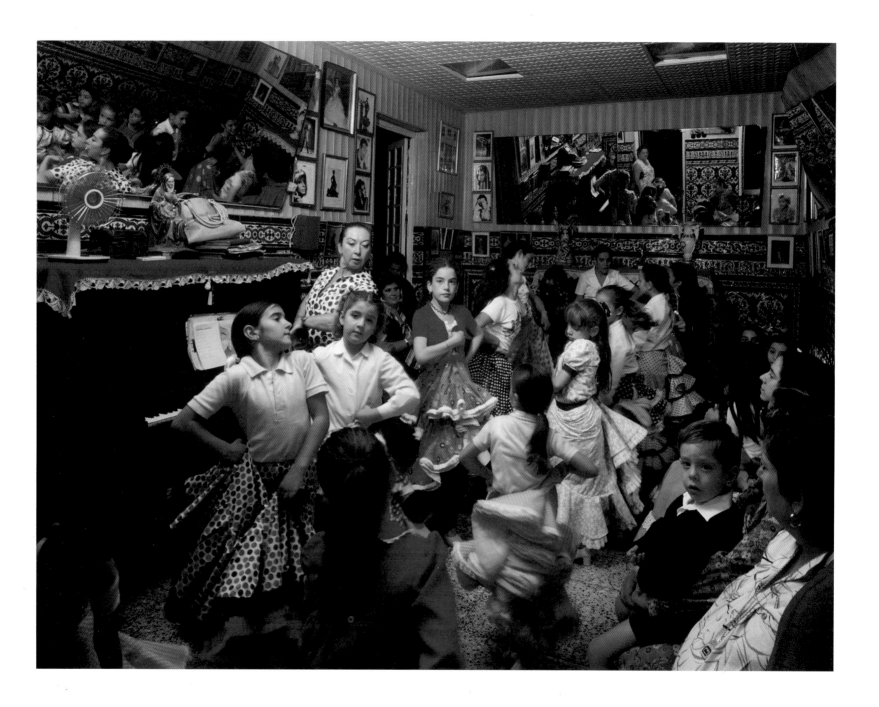

A Flamenco class for children in Seville discovered by photographer Ken Griffiths.

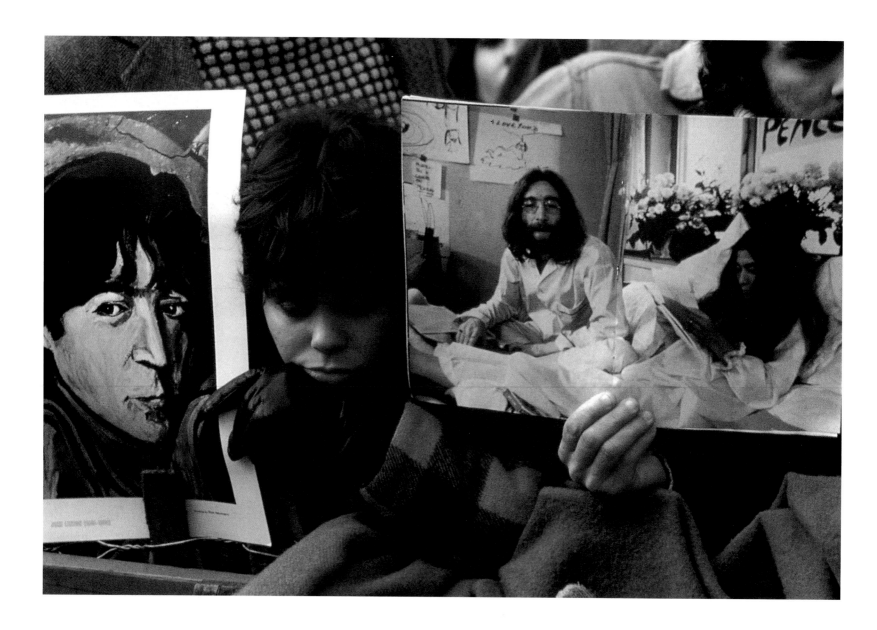

The murder of John Lennon provoked shock and grief among his fans.

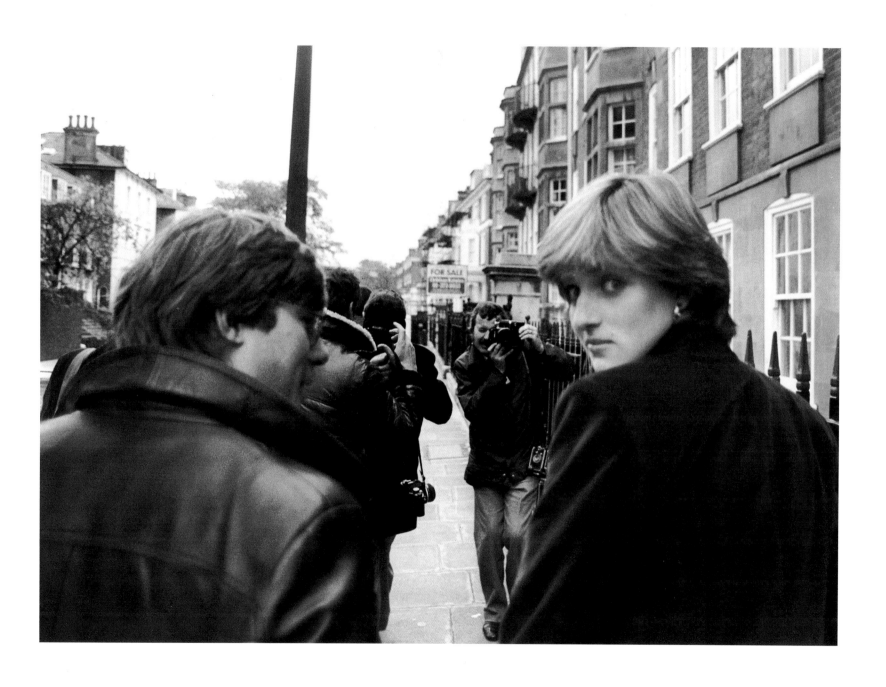

Lady Diana Spencer embarking on two close and difficult relationships – with Prince Charles and the tabloid press.

President Reagan a split second after he was shot in Washington, DC.

Queen Elizabeth has just been fired at with blanks during the trooping of the colour in London.

The Pope seriously wounded by an assassin's bullet in the Vatican – he was lucky to survive.

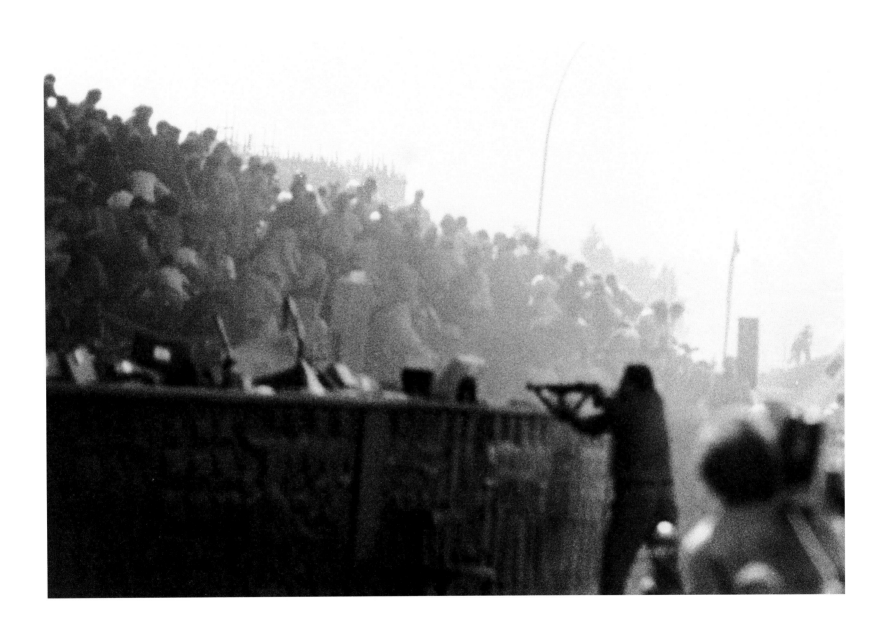

President Sadat being shot down with five others on his saluting stand in Cairo in a raid planned by six of his army officers.

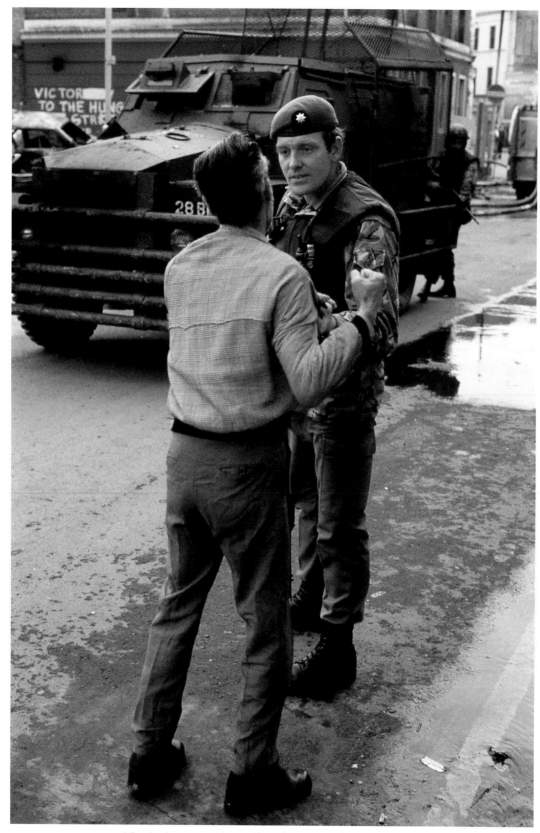

A Londonderry man puts on a show of anger towards a British soldier.

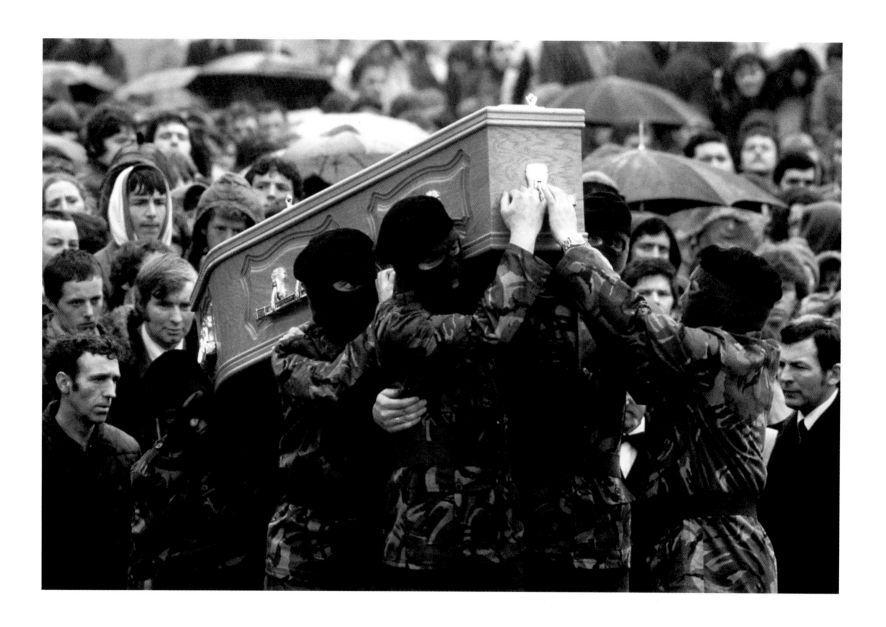

Here James Nachtwey captured a martyr's funeral – hunger striker Bobby Sands is carried to his grave by IRA 'officers'.

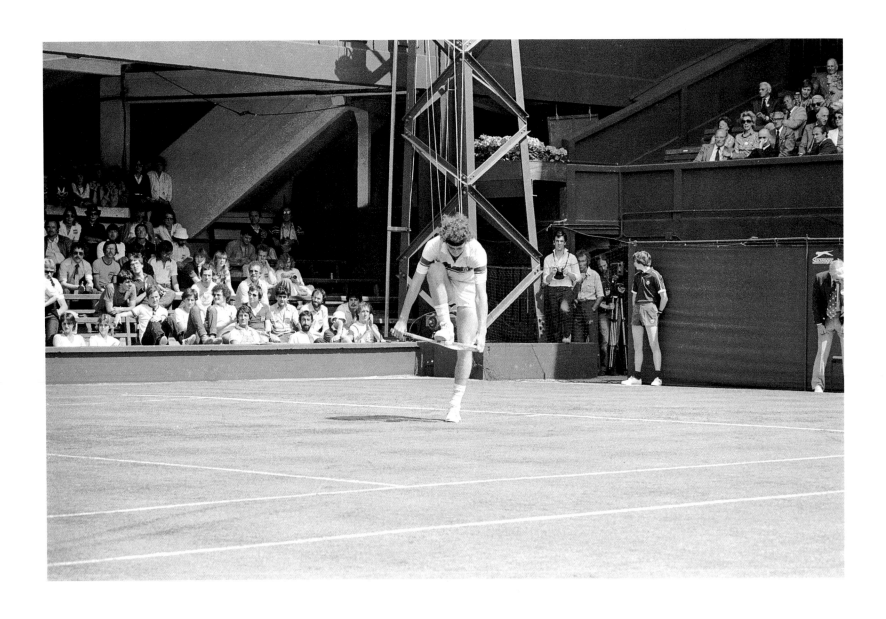

A tough contender and complainer – and this particular year a winner – John McEnroe unsuccessfully trying some racket-busting at Wimbledon.

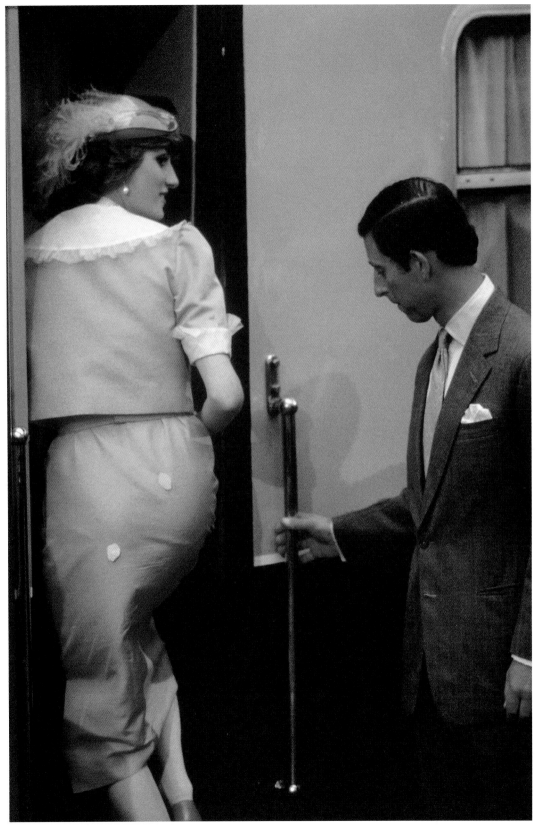

Prince Charles and Princess Diana's flawed fairytale romance included this decorous departure for their Mediterranean honeymoon cruise.

Chiang Ching, once Mao Zedong's wife and subsequently a 'Gang of Four' leader, about to receive the death sentence for plotting against Deng Xiaoping's government.

French fashion designer Pierre Cardin staged a ground-breaking show on the Great Wall of China to the bemusement of many local people.

Petrol bombs thrown by Catholics in Belfast destroy a British armoured car.

The first launch of the space shuttle *Columbia* – an important step in the development of space travel.

Chinese art students are encouraged, for inscrutable reasons, to make faithful drawings of a cast of the head of Michelangelo's *David*.

President Mitterrand – his image one of superior wisdom and grandeur – who became the fourth president of the Fifth French Republic in May 1981.

A transvestite prostitute in Rio de Janeiro photographed by Peter Lavery …

... who also found this couple dancing the tango for small change in a side street.

The newspaper office of Solidarity, Poland's trade union movement, making ironic use of Lenin's image.

A Solidarity meeting and poetry reading celebrating the Polish Gdansk agreements. The caricatures mock former leaders Boleslaw Bierut, Józef Cyrankiewicz, Wladyslaw Gomulka, Piotr Jaroszewicz and Edward Gierek.

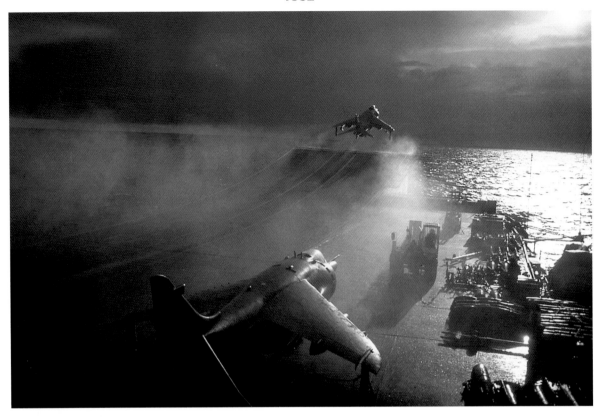

A Sea Harrier of the British Falklands task force taking off from the flight deck of a carrier in the south Atlantic.
Argentinian prisoners of the British army in the Falklands War – Argentina had not expected its invasion to be so severely punished.

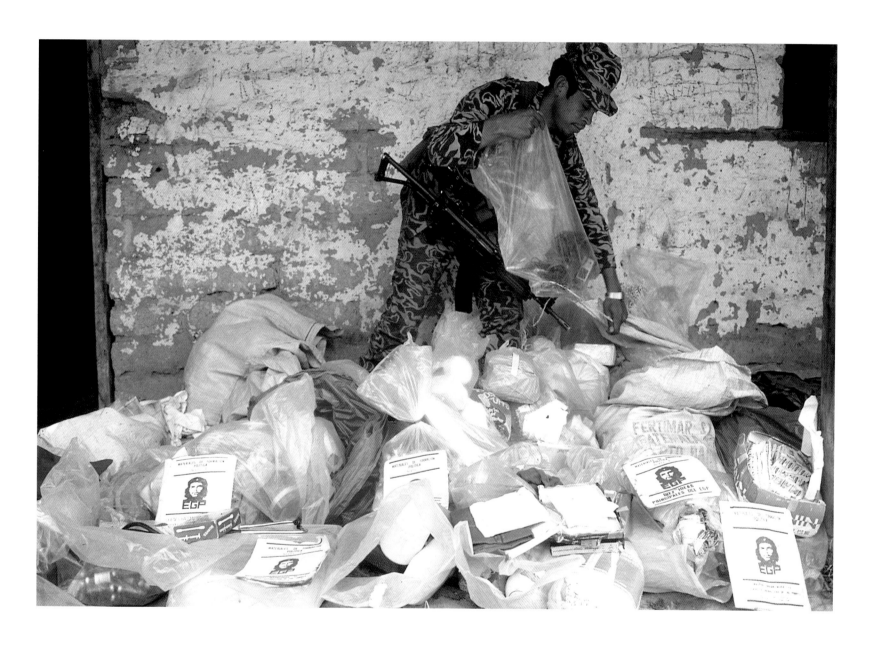

The Guatemalan government's brutal US-backed suppression of the opposition involved a constant search for weapons and supplies hidden by the left.

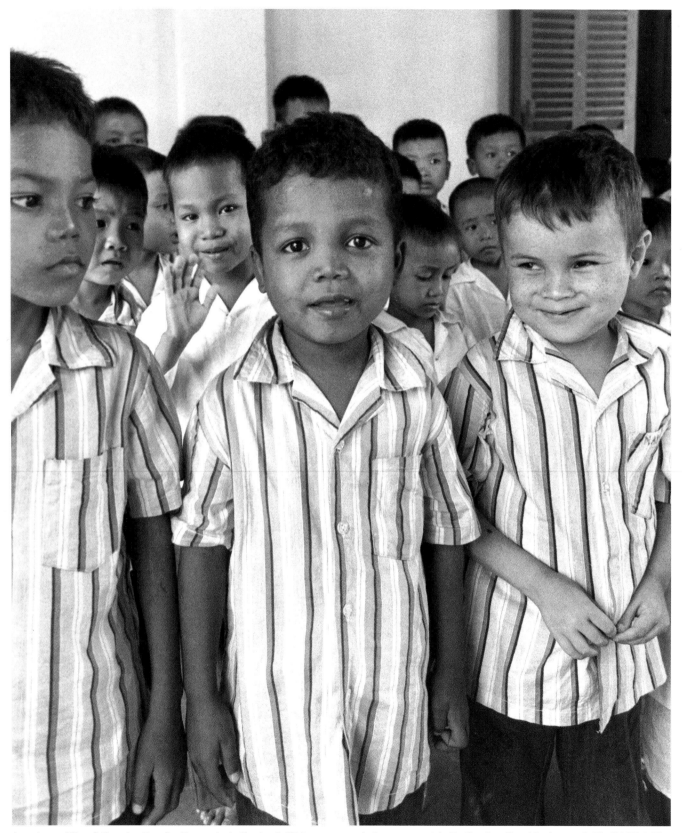

American soldiers fathered quite a few 'Amerasian' offspring in Vietnam, many of whom were sent to the Bamboo Shoot Orphanage in Ho Chi Minh City.

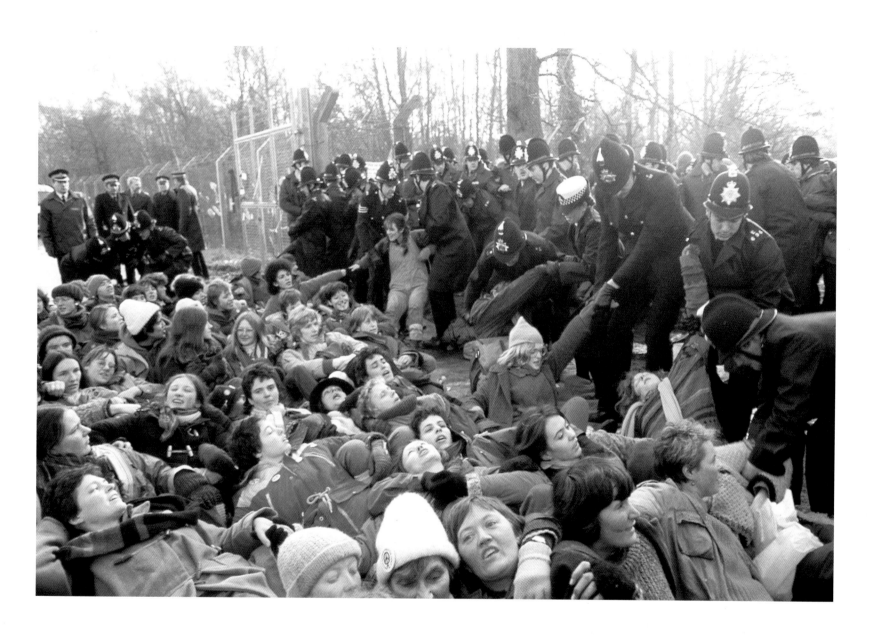

The US cruise missile base at Greenham Common in England was besieged by women protesters for ten years.

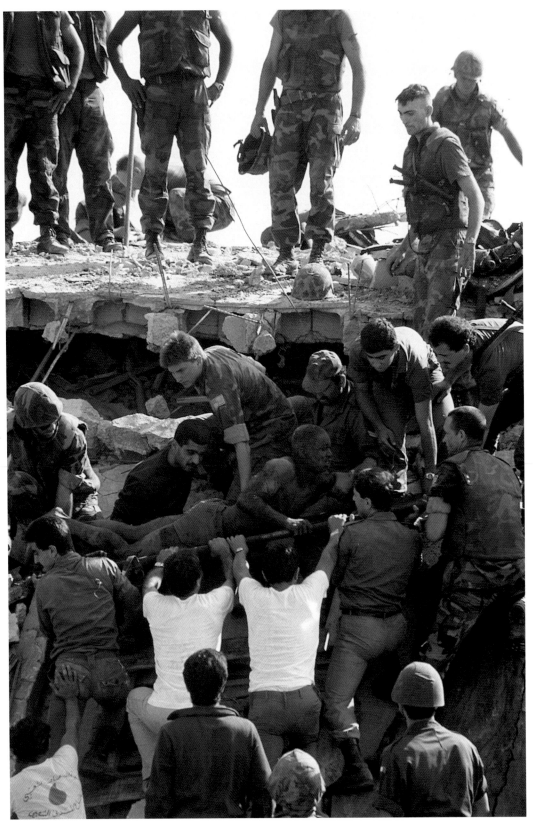

Yet another suicide bombing in Beirut killed 241 US marines.

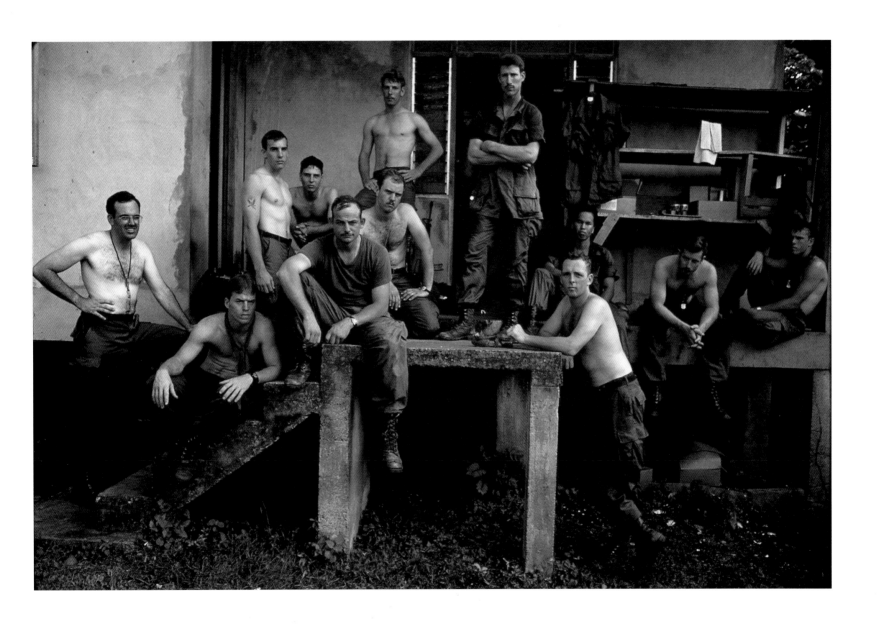

US troops have plenty of time to pose for a studied group photograph during their intervention in a Grenada coup.

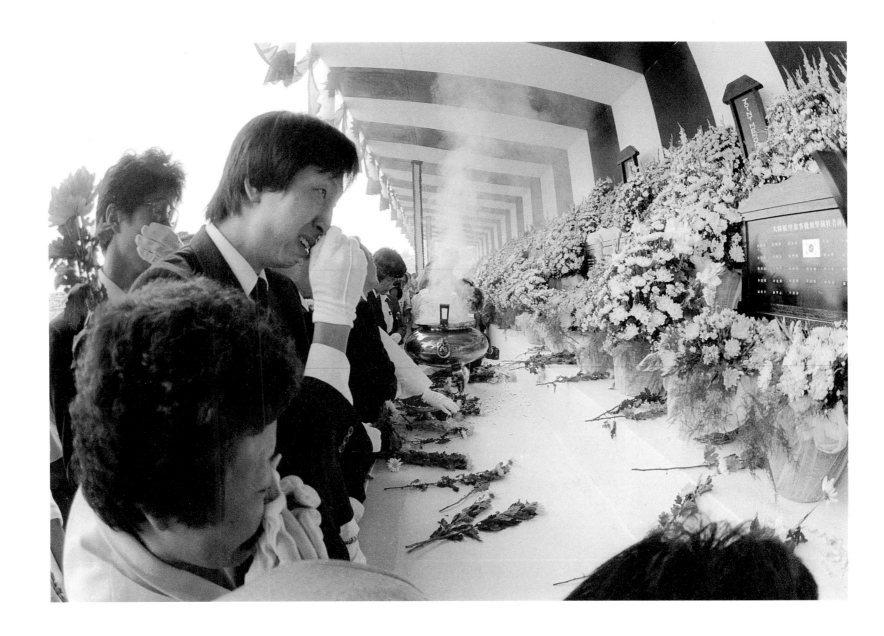

A memorial service for those killed by the Soviet destruction of a South Korean airliner.

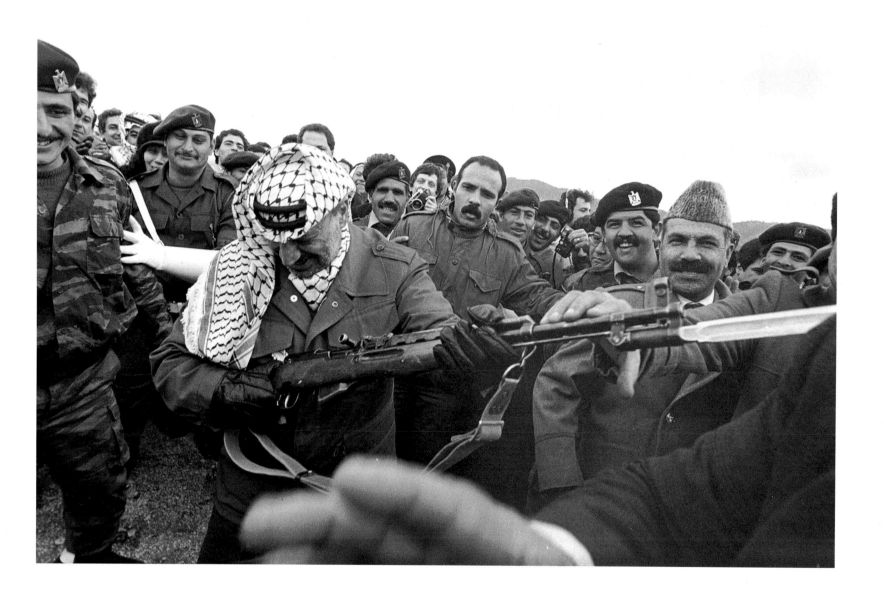

Yasser Arafat showing off his familiarity with the latest weaponry at a Palestinian training camp in Algeria.

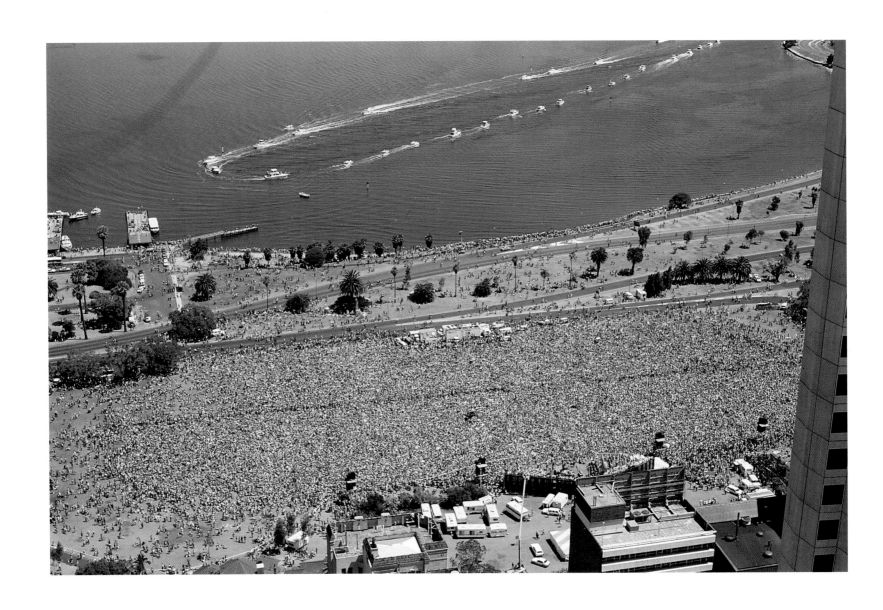

Australia triumphs in the America's Cup race off Newport, Rhode Island – the first time any challenger had taken it from the US.

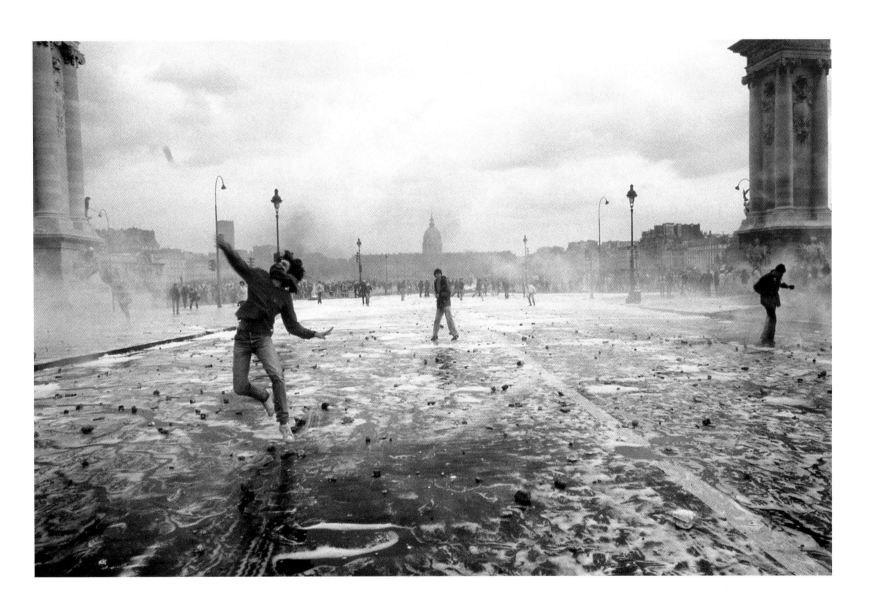

Parisian students keeping up their reputation for protest.

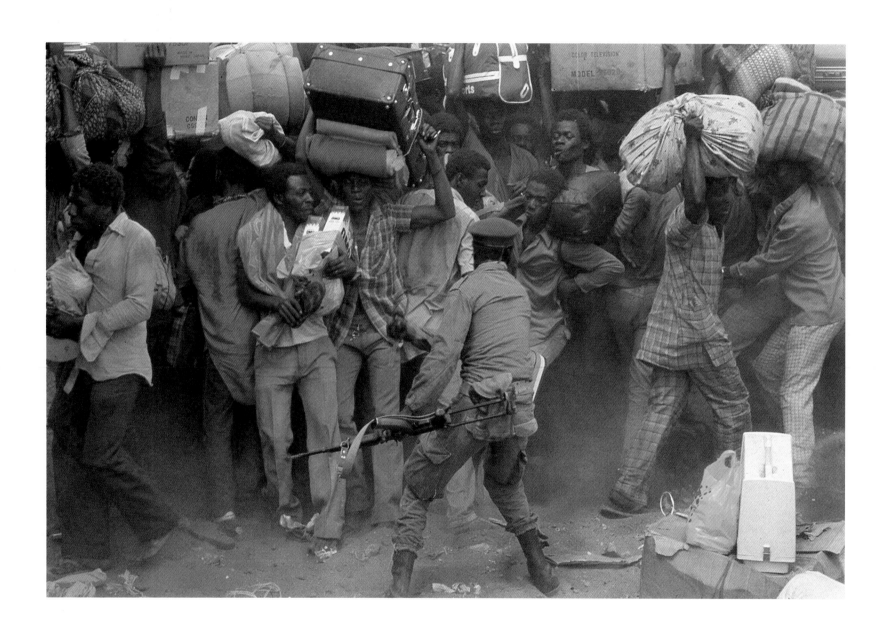

Thousands of Ghanaian immigrants were expelled by the Nigerian government for the sake of the Nigerian unemployed.

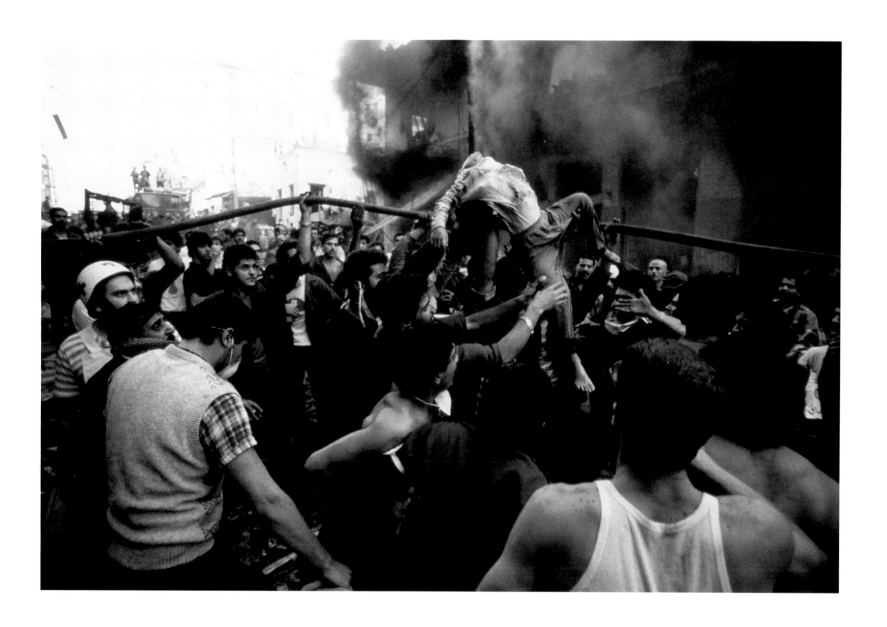

A Muslim child, one of fourteen victims of a Beirut car bomb, is carried aloft as the assembled crowd shouts 'Allah is great'.

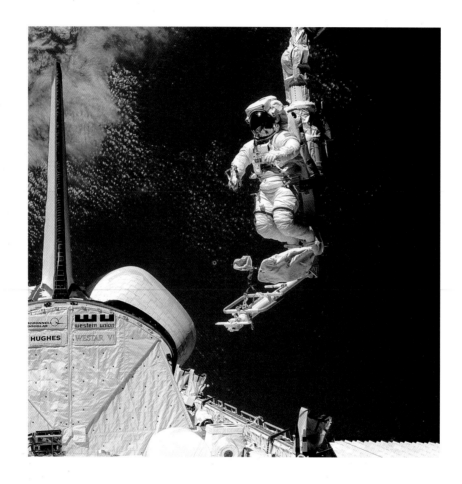

US astronaut Bruce McCandless intrepidly demonstrating the first space suit to give complete freedom of movement outside a spacecraft.
McCandless, now gloriously unattached, enjoys his exhilarating but limited freedom.

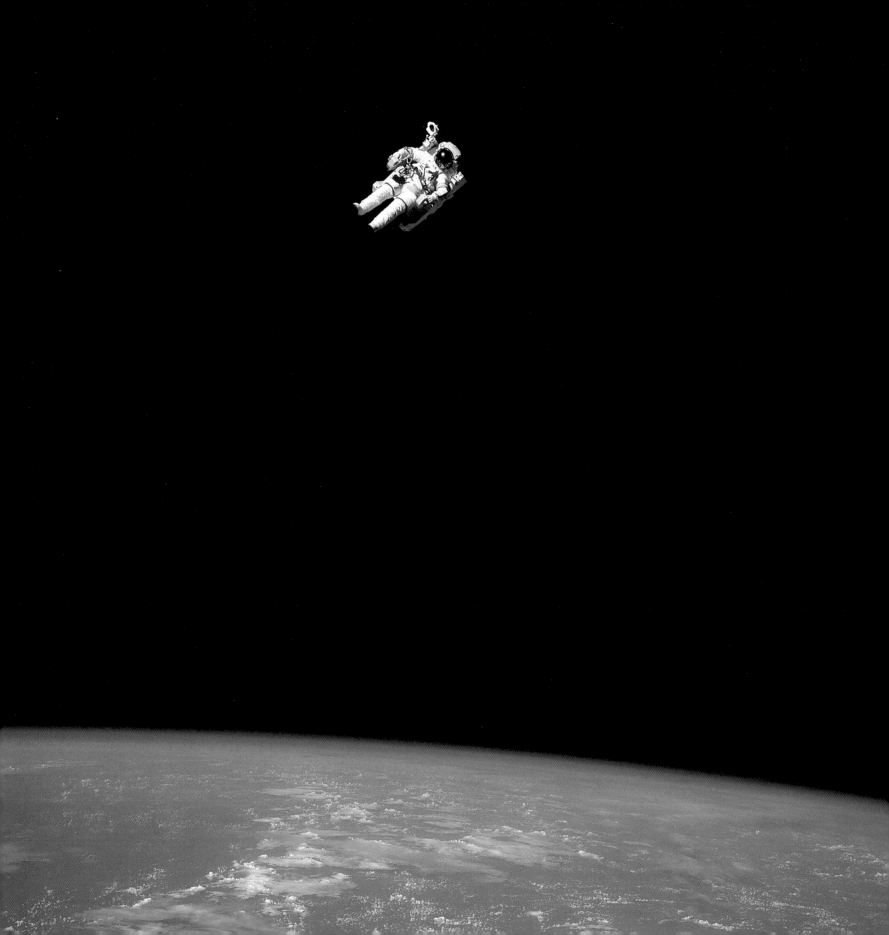

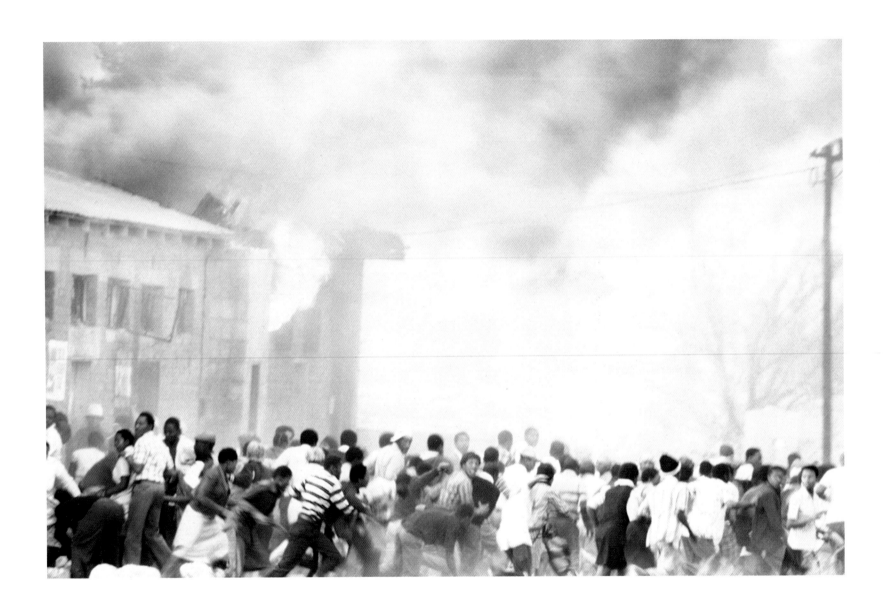

Black dissatisfaction and international condemnation of apartheid increased to the point where racial segregation could no longer be sustained.

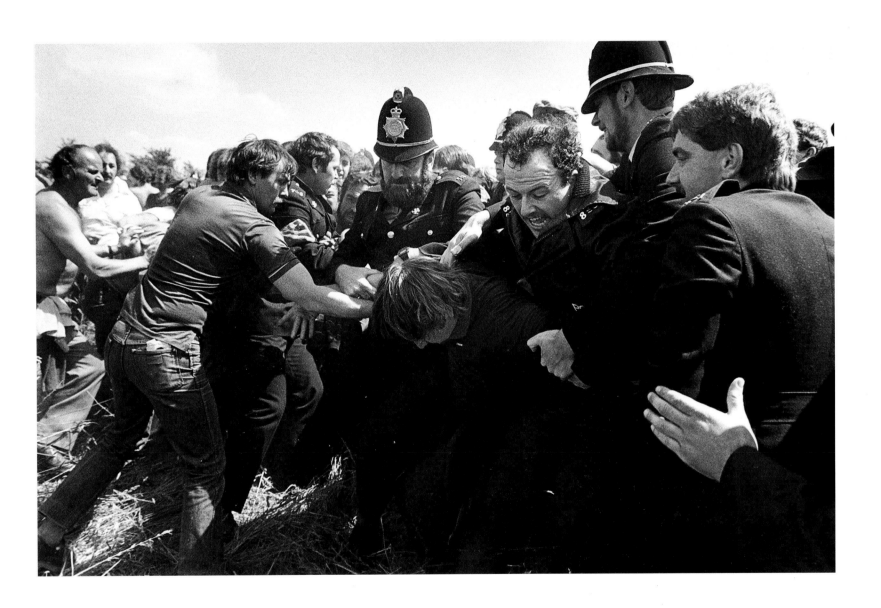

One of the many bitter clashes between coal miners and police during the most critical strike in Britain since 1926.

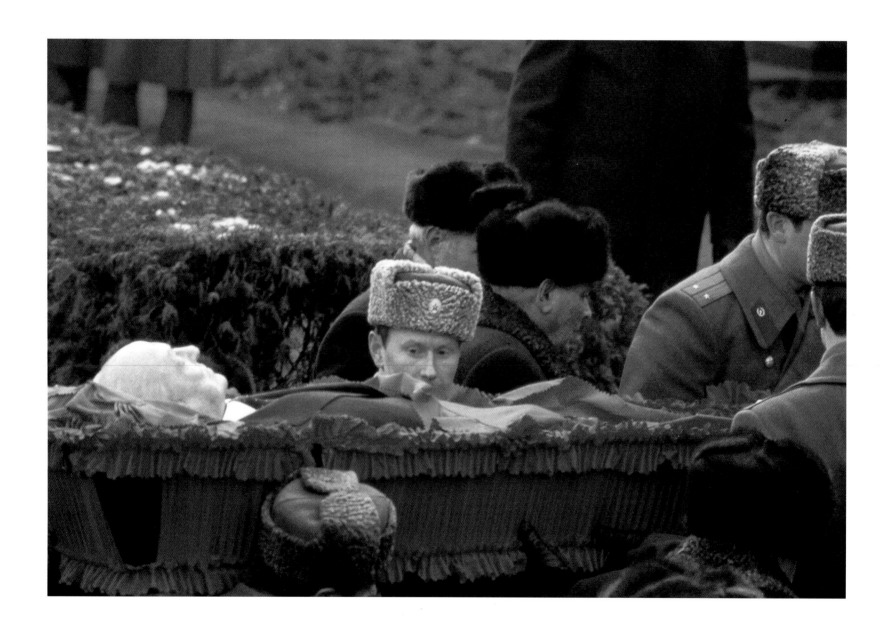

Yuri Andropov, the former KGB chief who became the Soviet leader, held office for only fifteen months before being succeeded briefly by Konstantin Chermenko.

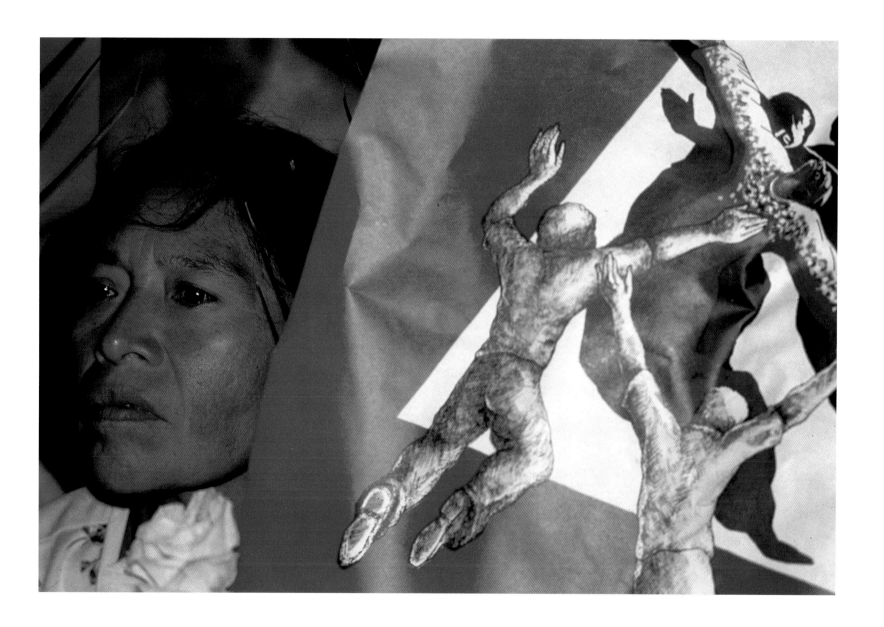

A mourner at a memorial service for Archbishop Oscar Romero of El Salvador who was assassinated while celebrating mass in 1980.

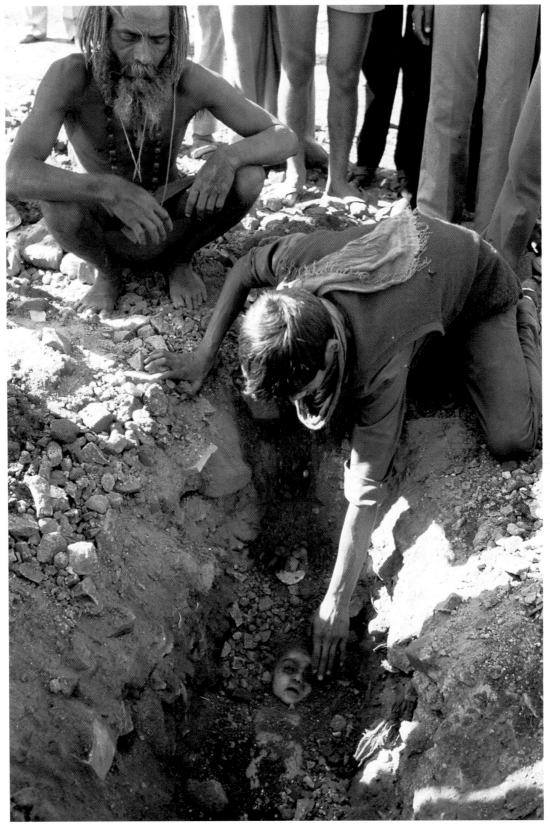

The world's worst ever industrial disaster – gas leak at Union Carbide's pesticide plant in Bhopal in India killed several thousand.

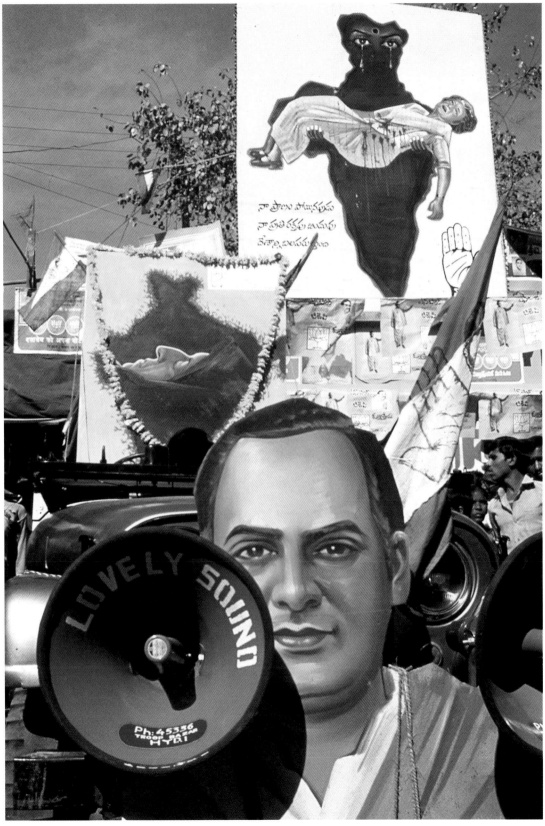

Emotive images help Rajiv Gandhi's campaign to succeed his assassinated mother as prime minister of India.

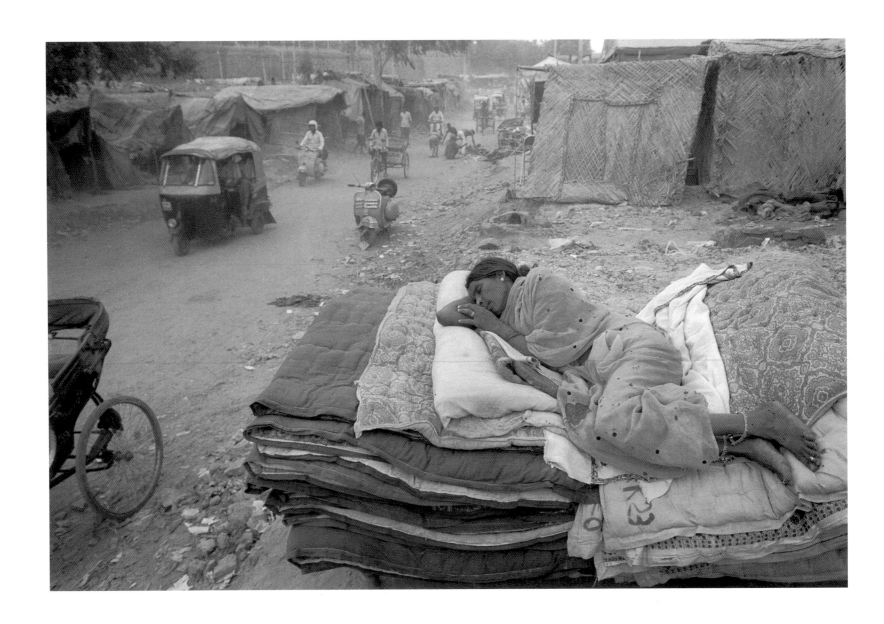

A Sikh woman collapses after fleeing Hindus seeking their revenge for Indira Gandhi's murder.

American Mary Decker shows her rage and chagrin on being tripped by Zola Budd in the 3,000-metres final at the Los Angeles Olympics.

The IRA's most penetrating outrage in Britain – very nearly a major success for terror at the Brighton Conservative Conference.

Margaret Thatcher's bathroom at the Grand Hotel in Brighton shows how close both she and her government came to grief.

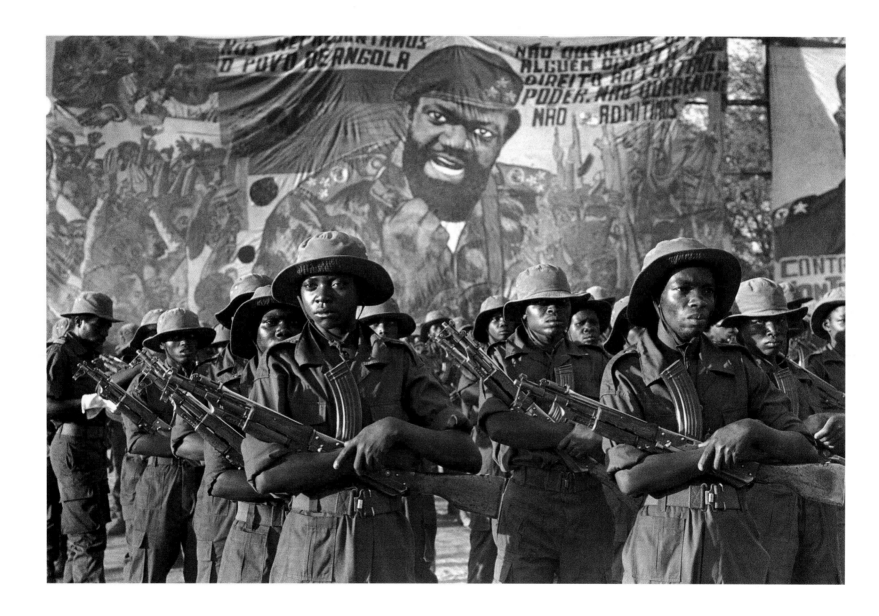

Troops parade under a portrait of Jonas Savimbi, UNITA's guerrilla leader, on the tenth anniversary of Angola's independence from Portuguese rule.

Apartheid still firmly in place – women walking through the 'whites only' section of a railway station in Cape Town to the 'non-whites' section.

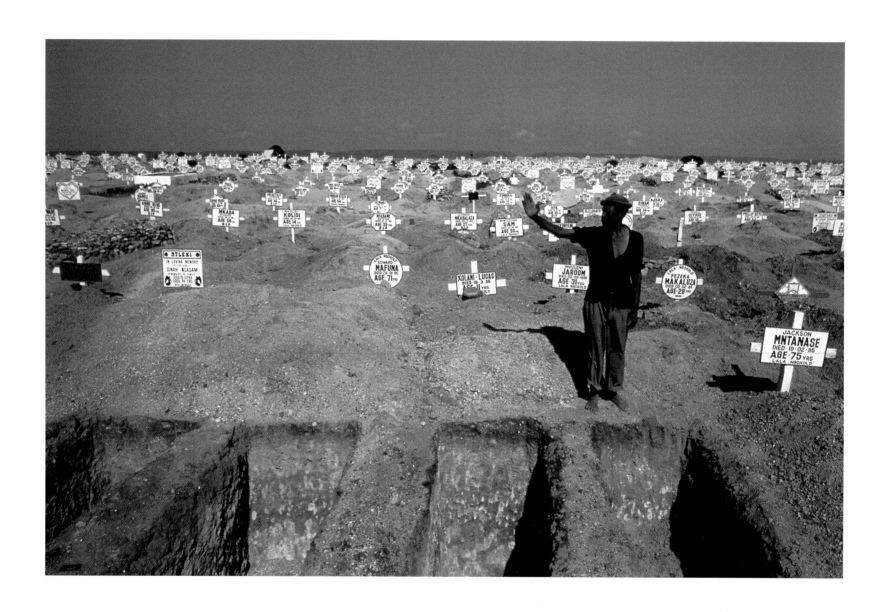

Graves for some of the nineteen blacks killed by unprovoked police gunfire at Port Elizabeth in South Africa on 21 March, the anniversary of the Sharpeville Massacre.

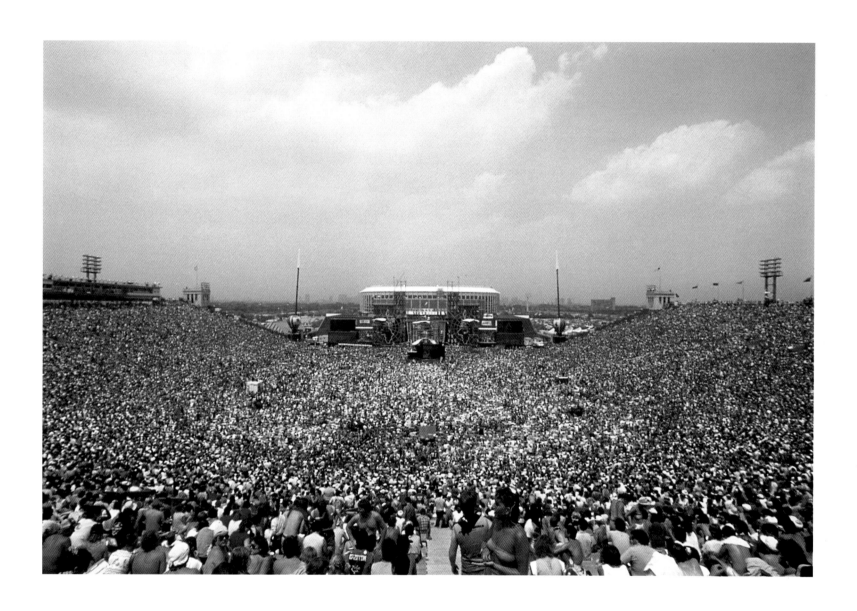

One of Bob Geldof's 'Live Aid' concerts for the starving in Ethiopia at the Kennedy Stadium in Philadelphia.

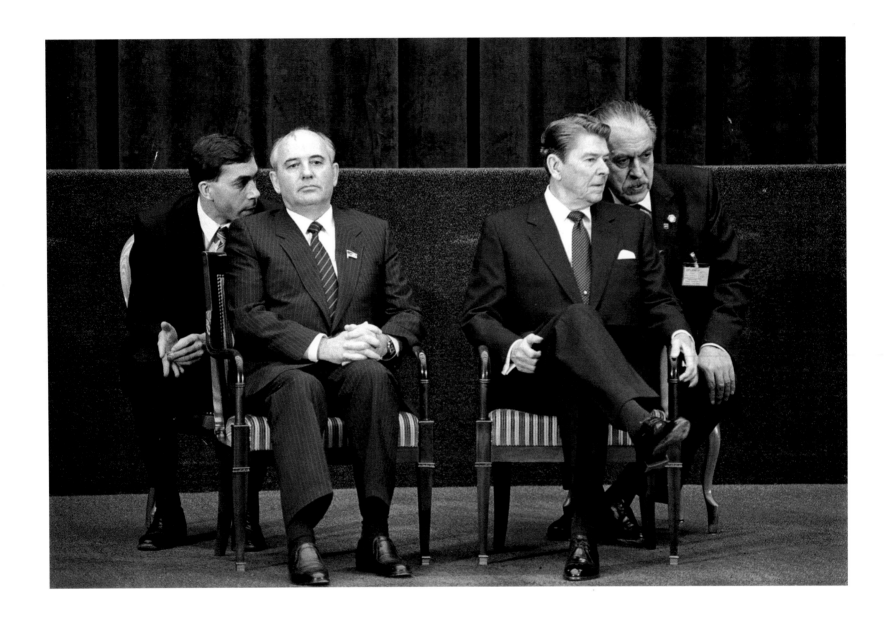

Reagan and Gorbachev talking to their interpreters rather than each other at the Geneva Disarmament Summit Meeting.

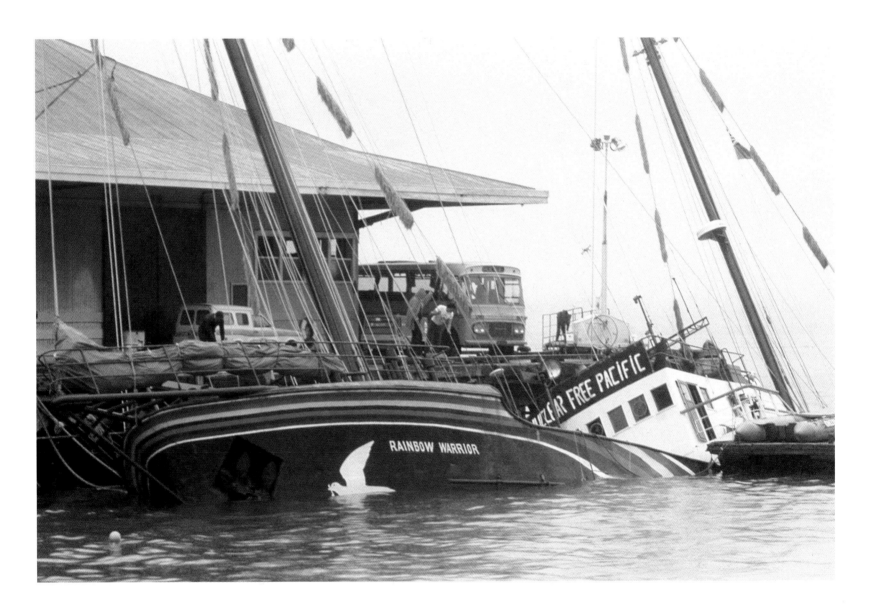

The Greenpeace ship *Rainbow Warrior*, out to sabotage a French nuclear test, was sunk by French agents and salvaged by New Zealand.

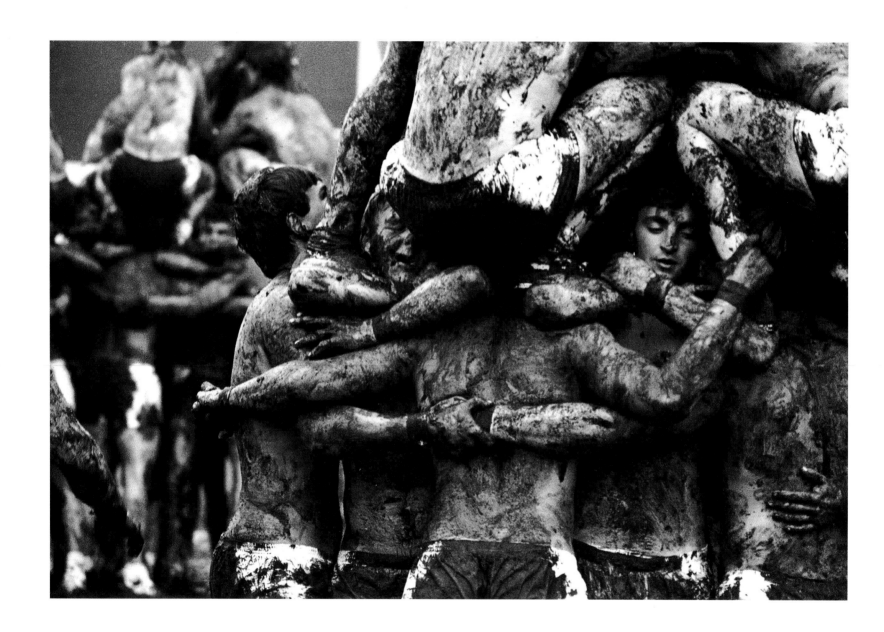

Czechs piling themselves up during the *Spartakiáda*, a gymnastic festival in Prague.

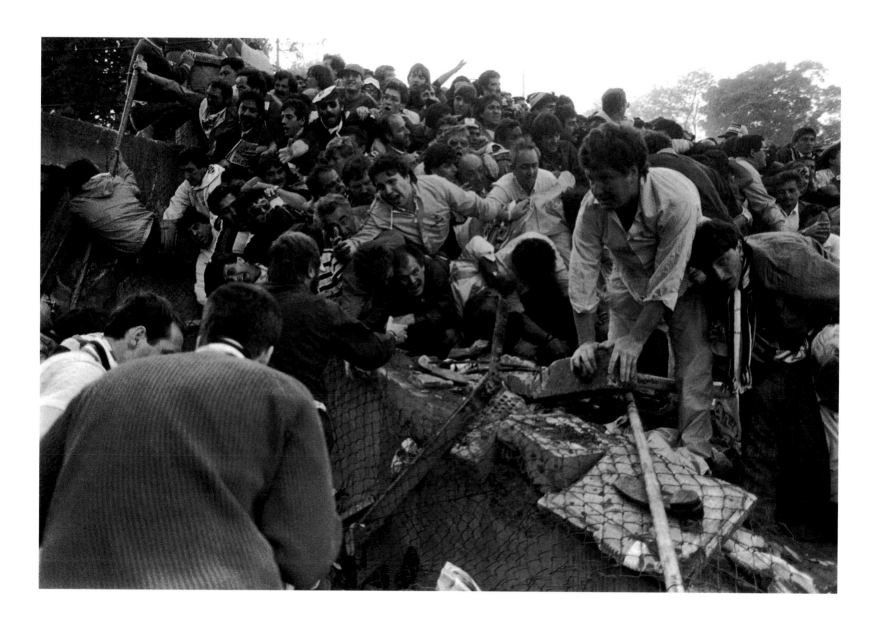

A riot caused by Liverpool football fans at the Heysel stadium in Brussels – thirty-nine people were killed.

1966

682. A young drug user concealing his identity during his testimony at the opening of the Pennsylvania Legislature's investigation of the use of narcotics on American college campuses. Young Americans, especially university students, were at the centre of enormous change in morals and behaviour in American society in the 1960s. The decade saw a rebellion against what young people felt to be the repressed, conformist attitudes of their parents' generation. This took many forms, the most controversial of which was perhaps the widespread use of narcotics. Marijuana and LSD were among the most widely used.

683. China's Cultural Revolution – the Great Proletarian Cultural Revolution – officially began with a government announcement on 8 August 1966. Ordinary citizens were encouraged to denounce friends or neighbours who were not 'genuine' communists. Mao sought to purge the priviliged classes he saw developing in Chinese society, particularly within the party itself, and replace them with a new generation which was totally committed to Marxist, and by implication Maoist, principles. The words of Chairman Mao, summarized in the 'little red book', became official law from this time. All established patterns of conduct came under scrutiny and no group was exempt from public criticism and ridicule. Encouraged by Mao, Zhou Enlai and other senior communists to attack traditional values which were collectively known as the four olds: old ideas, customs, habits and culture, the Red Guards began to drag teachers, members of the party and state bureaucrats from their workplaces and subject them to various indignities – for example wearing dunce caps – at mass public trials. This photograph was taken by Li Zhensheng, staff photographer of a communist newspaper at the time of the Cultural Revolution. He had kept his work hidden until recently when he recovered and restored the old negatives and made them available as an archive.

684. The number of American soldiers in South Vietnam grew steadily after 1965. They fought alongside 600,000 regular South Vietnamese troops which included regional and self-defence forces as well as smaller contingents sent from South Korea, Thailand, Australia and New Zealand. While US combat units fought the Vietcong and North Vietnamese troops, the South Vietnamese army concentrated on paci-fication, i.e., gaining the allegiance of the South Vietnamese populace.

685. US President Lyndon Johnson vigorously defended the growing American presence in South East Asia on the grounds that if Vietnam fell to communism, other countries in the region might also turn that way. The so-called 'domino theory' was generally accepted by most Americans at the time. More importantly, Johnson's policies were supported by a highly-respected team of advisers which he had inherited from President Kennedy, including Secretary of State Dean Rusk and Secretary of Defense Robert McNamara.

686. During the initial stages of the war the US government had hoped that air power alone might succeed in containing the insurgency in South Vietnam. Operation Rolling Thunder, the code name for US bombing attacks on strategic targets within North Vietnam, was launched in March 1965 with this in mind. The appalling level of damage inflicted on the country's population and infrastructure was designed to persuade the North Vietnamese to end their support of the Vietcong through a show of superior American military strength. Initially confined to targets south of the 20th parallel (Vietnam was divided along the 17th parallel), the attacks were expanded to the whole of North Vietnam in 1966 after Ho Chi Minh's government gave no indication that the strike had caused any change in policy, save perhaps a strengthening of commitment to topple the government in the South. The North Vietnamese treated US pilots shot down over North Vietnam with extreme cruelty. Torture was routinely employed by interrogators to gain military information and to elicit confessions from captured US servicemen for propaganda purposes.

687. In a kindergarten in China children mock-shoot a caricature of the American President Lyndon Johnson. By 1966 US air attacks and the escalating numbers of American ground troops in Vietnam was raising the spectre of possible Chinese intervention in the war. Animosity towards the US, particularly towards the president, was intensifying among China's communist leaders because of what they perceived to be America's attempt to deny the Vietnamese people the right to determine their own political future. Johnson on the other hand seemed to dismiss the threat of Chinese intervention, asking rhetorically, 'Why would the Chinese want to take on the US? It would be like an eleven-year-old coloured girl from Tennessee going up against (ex-Boxing Champion) Jack Dempsey.'

688. White mercenaries fighting in the Congolese army played an indispensable role in crushing the Lumumbist insurrection in the early 1960s and bringing General Mobutu to power in 1965. But soon the Congo's new leader began to view the mercenaries as unreliable and a threat to state security, and moved to eliminate 'European' units in the army. In 1967 Jean Schramme, a Belgian settler, led a mutiny in response to this, involving approximately a hundred white mercenaries and roughly 1,000 Katanganese soldiers. It lasted until the 32,000 strong national army forced the mutineers to flee across the border into Rwanda, where Schramme and his mercenaries surrendered to local authorities.

689. By the end of 1966 more than 6,000 Americans had been killed in action in Vietnam and nearly 400,000 US military personnel were actually in the country fighting the war. President Johnson's advisers had produced many reports and a dizzying array of charts and graphs which very clearly con-cluded that communist troops would crumble under the weight of superior American firepower. However the situation on the ground suggested that America was becoming severely entrenched in an increasingly costly land war very far from home.

1967

690. By early 1967 only a small majority of Americans still supported US involvement in Vietnam, which was arousing greater resentment across the country than any other military undertaking in America's history. The growing anti-war movement came from all segments of American society – liberals and conservatives, religious groups and communists, pacifists and anarchists, utopians and intellectuals. The older generation were generally less hostile to the war, but they also began to develop serious doubts about Johnson's policy in Vietnam when US casualties increased significantly and their children were drafted.

691. In 1967 the scale of American bombing in North Vietnam and expanded combat operations in the south temporarily checked the strength of the communist insurgency in South Vietnam. On 30 October 1967 the Second Republic of Vietnam was pro-claimed in Saigon in the south under President Nguyen Van Thieu. This brought a measure of stability to the government of South Vietnam after a tumultuous five-year period. Emboldened by developments in the region, the Johnson administration con-fidently predicted an imminent victory in South Vietnam.

692. There were several reasons behind the growth of student anti-war protest in 1967, including the US Universal Military Training Act which meant that young males who had just completed university could be drafted and sent to Vietnam. Student organizers of the anti-war demon-strations borrowed heavily from prominent civil rights campaigners in their direct action techniques. When protests failed to alter the administration's policies in Vietnam, a rift developed between those advocating vigilant non-violent civil disobedience and those calling for violent confrontation and the use of force.

693. In 1966 Red Guard reviews of more than a million youths were held in Peking, providing dramatic evidence of the strength of the Red Guards and the powerful ability of senior communist leaders to mobilize vast numbers for their ideological ends. By 1967 however, outrages committed by increasingly militant Red Guard members threatened to undermine China's economic development and the

authority of its leaders. The military was ordered in and by 1969 the rampant lawlessness of the Red Guards was put to an end.

694. Propagandists of the Cultural Revolution attacked many different people and nations deemed hostile to the correct (i.e. Maoist) way of life. Few targets attracted as much scorn and derision as America, particularly its foreign policy. China regarded the US policy of containment, which sought to halt communist expansion wherever it threatened US interests, as blatant interference in the affairs of sovereign states. China repeatedly demanded the immediate withdrawal of American troops from South East Asia. The economic, social and cultural power of the US during the post-war era has triggered similar outbursts of anti-Americanism in many parts of the world.

695. As responsibility for large-scale military operations against Vietcong and North Vietnamese troops was transferred to US forces, South Vietnamese units redoubled their pacification efforts. The programme involved identifying and eliminating the leaders of the Vietcong and initiating civic action and economic development schemes. It was believed that the most effective way to undermine popular support for communism in rural areas was by 'winning the hearts and minds of the people'. In practice, however, 'pacification' was often used as a euphemism for repression and torture.

696. War between Israel and its Arab neighbours broke out once again in June 1967. Israel was provoked by the Egyptian army's movement across the Sinai peninsula towards the border with Israel and by President Abdel Nasser's decision to blockade the Gulf of Aqaba. Israel launched a pre-emptive strike against Egyptian air forces and bases on 5 June 1967. Israel also bombed Egypt's allies Iraq, Jordan and Syria. Over the next few days Israeli forces pushed the Egyptian troops back to the Suez Canal, captured East Jerusalem, all of the West Bank and the strategic Syrian Golan Heights. Israel's victory in what became known as the Six Day War was gained without US assistance and was a huge military achievement.

697. Israel's attacks caught the entire Arab world off guard. Without warning Israeli fighter planes launched raids on the Sinai peninsula, decimating the Egyptian air force while its jets were still on the ground. The rest of the Egyptian military, which was considered to be the Arab world's most effective force, were no match for Israeli troops who drove them back to the Suez Canal within a few days. Egypt's humiliating defeat caused President Abdel Nasser to resign on 9 June, but he reversed his decision a day later after massive demonstrations of popular support.

698. The Western Wall (or Wailing Wall) in the Old City of Jerusalem was a place of prayer and pilgrimage sacred to both the Jewish and Arab people, and had long been the subject of intense dispute between Jews and Arabs. When Israeli forces drove Jordanian troops out of Jerusalem during the Six Day War, Israel gained control of the Wall causing elation and euphoria among Jews around the world. In a matter of weeks, Jews outside Israel responded to this victory with more than 560 million dollars in voluntary contributions to help Israel arm itself.

699. Israel's victory removed the immediate threat of an Arab onslaught on its borders and was a great source of pride for its citizens. The brief conflict had serious implications for Arab-Jewish relations in the Middle East. The West Bank and Gaza, part of the territory seized during the war, was home to roughly 600,000 Palestinians. Their struggle for self-determination and independence united the Arab world against the Jewish state.

700. Having been a member of Guatemala's left-wing government which was over-thrown in 1954 with backing from the CIA, 'Che' Guevara became a physician in Argentina for a short time, before returning to politics as a left-wing revolutionary. He joined Castro in exile in Mexico and together they plotted to overthrow the Batista regime in Cuba. After their success in Cuba, Guevara tried to export his revolutionary ideology which rejected both capitalism and orthodox communism across Latin America and Africa. In 1967 he travelled to Bolivia hoping to

rouse the country's impoverished tin miners to insurrection, but his revolutionary zeal failed to attract much interest. In October 1967 he was captured by Bolivian government forces and executed. Unfailingly committed to his political beliefs, Guevara became a symbolic martyr for a generation of student radicals and a powerful icon for left-wing governments around the world.

701. For nearly ten years the celebrated photojournalist Josef Koudelka travelled along routes taken by Gipsies through Romania and his native Czechoslovakia to various countries in Western Europe. Koudelka's interest in Gipsies stemmed from a fascination with their physical appearance, clothing and lifestyle. Eventually he became completely absorbed by these unique people and devoted himself to compiling the most comprehensive photographic record of the nomadic Gipsies ever produced. Koudelka's intimate chronicle of Gipsy life appeared in a series of widely acclaimed books in the 1970s, at a time when assaults and crimes against the Gipsies of Eastern Europe were soaring, in part because of crimes committed by the Gipsies themselves. Their culture and way of life has come under threat recently for a variety of reasons, including acute unemployment which in parts of Eastern Europe has risen to over 95 per cent among Gipsy populations.

702. West German Chancellor Konrad Adenauer realized his dream of building a stable, prosperous and democratic country integrated with the West long before his retirement in 1963. During Adenauer's time in office West Germany made a spectacular economic recovery from the devastation of the Second World War and regained its international respectability. This was symbolized by its membership of NATO and the EEC (European Economic Community). Adenauer's other achievements included the Restitution Agreement, a programme of compensation payments to Jewish victims of the Holocaust which initiated the difficult process of reconciliation between Germany and Jewish people around the world. Adenauer also succeeded in winning the friendship and trust of France, thereby laying the

foundation for a special new relationship between the two countries.

703. Famed cellist Mstislav Rostropovitch with the influential and versatile composer Igor Stravinsky during one of the cellist's extensive world tours. Both musicians were born in Russia but spent much of their extraordinary careers in America, and worked to promote Soviet-American cultural exchanges during a period of tense relations between the superpowers. Both settled in America, Stravinsky in 1945 and Rostropovich in 1974. Although Rostropovich received countless honours in the USSR for his remarkable cello playing, including the Lenin prize in 1964, he also received censure from Soviet authorities for his outspoken support of the country's dissidents.

704. Luis Buñuel's *Belle de Jour* is best remembered for Cathérine Deneuve's performance as a bourgeois housewife who, no longer able to feel any passion for her husband, decides to live out her fantasies as a prostitute. Buñuel constantly juggles reality with dream-like scenes, blurring the line between reality and fantasy. The film was withdrawn from circulation by its producers at the end of the 1970s, but was re-released with much publicity in 1995.

705. The Academy Award for best picture of 1967 went to Norman Jewison's thriller *In the Heat of the Night*. The story centres on the relationship between a shrewd southern sheriff (Rod Steiger) and a black detective (Sidney Poitier) who reluctantly join forces to investigate the murder of a wealthy industrialist in Mississippi. The film explored the issue of race relations in America with candour and sensitivity at a time when blacks were rioting in some of the country's major cities to end the racism they experienced particularly at the hands of local police forces.

706. Lesley Hornby, better known as Twiggy and Mary Quant's muse, began modelling in her native London in 1966. Her short hair, youthful gaucheness and wire-thin frame provided a popular new look. She quickly shot to fame, appearing in countless newspapers and on the covers of most major

fashion magazines across Europe and America. Twiggy became the symbol of London in the swinging sixties.

1968

707. Robert F. Kennedy entered politics as a campaign manager for his older brother, John, who appointed him Attorney General after becoming President in 1960. He distinguished himself as a compassionate liberal in matters of social welfare and racial discrimination. After John F. Kennedy's assassination, Robert Kennedy became a Senator and a firm opponent of President Lyndon Johnson's policies in Vietnam. In 1968 he condemned America's participation in the war, and in the same year declared his candidacy for president. His victory in the California primary on 5 June 1968 placed Kennedy in a position to win the Democratic Party's nomination, but he was shot only minutes after learning the results at the Ambassador Hotel in Los Angeles. He died the following day. His assassin, Sirhan Sirhan, was a Jordanian immigrant who believed Kennedy supported the Zionist cause against the Arabs.

708. Political stagnation in France together with public discontent over the government's high expenditure on defence (particularly nuclear weapons) to the detriment of social services and education, as well as agitation over French participation in the war in Vietnam, led to the formation of a revolutionary student group in the spring of 1968. Called the March 22nd Movement after the date of its foundation, its members put forward demands for higher spending on education and modernization of the educational curricula. Demonstrations began in the industrial Paris suburb of Nanterre on 2 May and on Paris' Left Bank the following day. After brutal police attacks on demonstrators the protests turned to riots, and classes were suspended at the Sorbonne and other French universities. The student riots sparked an outbreak of broader political protest across the country. Workers joined the protestors, professionals rose against their antiquated organizations and artists complained about state interference in the arts.

709. One of the key figures in the March 22nd Movement was a young German national studying sociology at Nanterre University, named Daniel Cohn-Bendit. In early 1968 he rose to prominence in the student movement through his vituperative attacks on Gaullism. He became known as Danny the Red because of his left-wing views. During *les événements de '68*, as the period of protest became known, he exhorted his fellow students to join forces with workers, calling for a general strike of all left-wing groups on 13 May. After leaving France for a speaking engagement abroad on 22 May, he was barred from re-entry. He returned secretly in late May but was never again to assume a substantial role in the protests.

710. After violent riots in Paris on 10 and 11 May, 10 million workers began the most sustained general strike in France's history, threatening the survival of the Fifth Republic. Although it was not made public at the time, President de Gaulle fled into exile in Baden-Baden in West Germany on 29 May, but was persuaded to return to France and face the crisis by a senior adviser. The day after his return day he broadcast a defiant message to the nation which brought massive demonstrations of support – less for him, perhaps, than out of a desire to see stability return to the country.

711. French writer and Minister of Cultural Affairs André Malraux, former French Prime Minister Michel Debré and his deputy Robert Poujade demonstrating in support of de Gaulle. The President's speech on 30 May announced new elections for the National Assembly. In addition, workers were to be given a significant pay rise and educational reforms were to be initiated. Public opinion in France had turned against the strikes and the political unrest which was paralyzing the economy. The revolt collapsed as workers withdrew their support. In the June elections the Gaullists successfully exploited popular fears of further unrest and the prospect of a communist revolution to win a resounding victory.

712. North Vietnamese and Vietcong troops launched the Tet offensive against US and South Vietnamese forces on 30 January 1968. This was timed to coincide with the first day of *Tet Nguyen Dan*, the lunar new year festival. In the weeks prior to the offensive, diversionary raids enabled 100,000 communist troops and vast amounts of supplies to be moved undetected into the cities. Over a hundred villages and several cities in the south were attacked and the US embassy in Saigon was besieged.

713. The Tet offensive was a mortal blow for the independence of the Vietcong. Since 1966, when heavily reinforced US troops and firepower in the South inflicted heavy losses on Vietcong troops, their ability to mount operations without major North Vietnamese assistance was severely weakened. During the Tet offensive South Vietnamese civilians did not rally to the Vietcong as the guerrillas had predicted and this, combined with devastating troop losses, left the Vietcong unable to recover. By the end of 1968 the task of fighting the Americans had largely been taken over by North Vietnamese cadres.

714. Within a month of the communist offensive being launched, US troops had regained control in the south, except in Hué where the fighting continued for several weeks. Roughly 1,100 American and 2,300 South Vietnamese soldiers were killed during the Tet offensive, while as many as 40,000 Vietcong and North Vietnamese troops lost their lives. Nonetheless, the offensive was a political disaster for America and arguably the turning point of the war. It exposed the communists' fierce determination to succeed in spite of the presence of massively-armed US forces which now numbered more than half a million soldiers. The predictions of US leaders since 1965 of an eventual communist capitulation were shown to be misguided.

715. The extent and ferocity of the Tet offensive shocked the American public, particularly the sight of dead Vietcong soldiers lying so close to the door of the US Embassy in Saigon. Prominent critics alleged that the conflict in Vietnam could not be won. The anti-war movement gained momentum and vast numbers of Americans began to rally behind the political campaigns of anti-war candidates. President Johnson decided not to seek re-election and declared he would devote his remaining time in office to finding an 'honourable' way out of the war.

716. Irreconcilable ethnic tensions in Nigeria resulted in the breakaway of the predominantly Ibo-populated eastern region of the country on 30 May 1967. This new state, the Republic of Biafra, led by the former military governor of the area Colonel Odumegwu Ojukwu, struggled to gain legitimacy. Eventually official recognition from only four other African nations was secured. Nigerian federal troops supported by the British invaded Biafra in July, beginning a devastating civil war that continued for the next twenty months.

717. Warsaw Pact leaders gathered for talks in Bratislava in Czechoslovakia on 3 August 1968. Czechoslovakia's leader Alexander Dubček had been appointed First Secretary of the Czechoslovakia Communist Party in January 1968 after two decades of repression and economic mismanagement in the country. Dubček hoped to use the talks to reassure his Soviet caretakers that Czechoslovakian communism would not be jeopardized by his programme of far-reaching economic and political reforms. These included the abolition of censorship, increased freedom of speech and the purge of Stalinist government members. Unfortunately for Dubček the Soviet leaders were not convinced. Three weeks later Soviet troops invaded the country and in 1969 he was forced from power. For the next two decades the former statesman worked as a clerk in a lumber yard in Slovakia.

718–19. Dreams of greater freedom and liberalization were realized briefly under Dubček's rule in a period known as the Prague Spring. But leaders in Moscow, fearing Czechoslovakian reform would fuel similar movements elsewhere in the Soviet bloc, invaded on the night of 20 August 1968. About 250,000 Warsaw Pact troops – mostly Soviet – invaded Czechoslovakia, occupying Prague and other cities.

720. Dubček and government officials were captured at the time of the invasion but in the absence of any suitable leaders the Soviet authorities chose to leave them nominally in charge. The Czechoslovak army was instructed to offer no resistance, but there were widespread protests and spontaneous acts of civil disobedience during which communications were disrupted and supply lines damaged.

721. In the aftermath of the invasion, Dubček tried to keep alive the population's hopes that 'socialism with a human face' could be maintained in Czechoslovakia – albeit with tighter controls – even while Soviet troops remained in the country. The people were not persuaded. Dubček was eventually ousted by Soviet hardliners in April 1969 after a spate of anti-Soviet rioting. A new Soviet puppet regime under Gustav Husak was quickly installed and most of the reforms of the Prague Spring were reversed or abandoned.

722. Black Power candidates fighting elections in Alabama in 1966 used the black panther as their symbol, and the revolutionary black group founded by Huey Newton and Bobby Seale appropriated the symbol as their name in the same year. The Black Panthers were an aggressively radical organization, acting out of frustration at the lack of progress towards equal rights for blacks in American society despite the civil rights campaign. Conflicts between the Panthers and the police in the late 1960s and early 1970s led to gun battles in California, New York and Chicago, one of which resulted in Newton's imprisonment for killing a policeman.

723. The Black Panther movement developed into a Marxist-oriented group calling for radical measures such as the arming of all imprisoned blacks, the exemption of blacks from the draft and financial compensation for centuries of white exploitation and slavery. Panthers faced regular police harassment and even violent attacks. This prompted Congressional investigations into law-enforcement methods to deal with the organization. However the increasingly violent and incendiary language of the Panthers caused many liberal whites to turn against the civil rights movement in what became the 'white backlash' of the late 1960s. By the mid 1970s support for the movement even among blacks had all but disappeared.

724. In early April 1968 American civil rights leader Martin Luther King travelled to Memphis, Tennessee, to support a strike by the city's sanitation workers. On 4 April he was shot and killed outside his motel room by a local white petty criminal, James Earl Ray. The event came at a time when King was attempting to bring unity to the fragmented civil rights campaign in America and link the movement to the anti-war struggle. His death sparked riots in black areas of major cities across America. When Ray was captured by authorities in London he confessed to the murder and was sentenced to ninety-nine years in prison. He recanted his confession, however, and maintained his innocence until he died in 1998.

725. Throughout his illustrious career in photojournalism, Don McCullin has earned a reputation for confronting head-on situations which other photographers often shied away from. From the horrors of war in Nigeria and Vietnam to the devastation of floods and famine in India and Africa, McCullin's images stand among the finest evocations of human pain and suffering ever produced. He began taking photographs in the depressed and crime-ridden area of east London in which he was born. His images of vagrants and homeless people 'living rough' on streets near his own home launched a career which has taken him to many diverse corners of the world.

1969

726. In 1969 America moved to disengage itself from the war in Vietnam, which the new president Richard Nixon acknowledged could not be won by 'attempting to impose a purely military solution on the battlefield'. In August 1969 his National Security adviser Henry Kissinger began secret peace negotiations in Paris with representatives from North Vietnam. In Vietnam itself Nixon initiated 'Vietnamization' – the gradual handing over of all military responsibilities to South Vietnam. This resulted in the withdrawal of American troops,

putting an end to the previous four years' escalation in the American involvement in the area. The US administration hoped 'Vietnamization' would enable America to secure 'peace with honour' but in practice it meant the resumption of large-scale bombing, the increased use of pernicious chemicals such as napalm gas and Agent Orange and expansion of the war into Cambodia.

727. After months of investigation, American journalist Seymour Hersh published a story in November 1969 about a civilian massacre carried out by US forces in the village of My Lai in South Vietnam. A platoon of twenty-five soldiers led by Lieutenant William Calley Jr. entered My Lai on 16 March 1968 and herded an estimated 150 unarmed civilians into a ditch and gunned them down. Over the next few hours, Calley's men raped and murdered other villagers. US helicopter pilots on the scene reported large numbers of civilian deaths but the slaughter was covered up by senior officers and kept from the public until Hersh broke the story. Calley was court-martialled and received a life sentence, but was released on parole in 1974. Charges against all other US military personnel were eventually dismissed due to lack of evidence. The episode created widespread controversy in America and caused speculation about other possible atrocities committed by US troops in Vietnam.

728–29. The war across the border in Vietnam generated many problems for 'neutral' Cambodia. The country's President Norodom Sihanouk realized that the Vietminh and the Vietcong were using Cambodia as a supply route from the north to the south, but feared that an attempt to drive them out would trigger a North Vietnamese invasion. Sihanouk secretly permitted America to begin bombing enemy targets inside its border in 1969. Meanwhile the radical communist Khmer Rouge, encouraged by North Vietnam, began to wage civil war against the Cambodian government. The fiercely anti-communist Marshal Lon Nol deposed Sihanouk in a US-backed coup, but he quickly found his position untenable.

730. Charles Manson committed a series of crimes as a teenager,

including armed robbery and rape. After serving seven years in prison, he was released in 1967 and set up a hippy commune, first in San Francisco and later at a ranch outside Los Angeles. Called 'The Family', Manson's followers engaged in various criminal activities and eventually drew up a list of individuals targeted for death. The campaign was to begin on a chosen day code named Helter Skelter. During a two-day period in August 1969 members of 'The Family' carried out several murders at Manson's behest, most notable among them the brutal killing of Sharon Tate, actress and wife of Polish director Roman Polanski. In 1979 Manson was found guilty of instigating the killing and sentenced to life imprisonment.

731. John Lennon married Yoko Ono, a respected Japanese painter and avant-garde film-maker, in 1969. His marriage seemed to crystallize Lennon's social conscience and the couple quickly made headlines with a number of highly-publicized political statements and protests. The most famous of these was their honeymoon *Bed In for Peace*, where they sat together naked in bed with peace slogans on the walls. This 'performance' was broadcast live all around the world. The couple also collaborated on a number of protest songs, such as 'Give Peace a Chance' (1969). Lennon's band, the Beatles, disbanded in 1970 much to the dismay of millions of fans around the world, many of whom blamed Ono for the break-up.

732. Between 10 and 20 May 1969 the South Vietnamese and US 101st airborne armies fought against communist troops in Operation Apache Snow. The battle took place in A Shau Valley, one of the chief entry points into South Vietnam from the Ho Chi Minh trail, and centred on the capture of a strategic hill, known by the Americans as Hamburger Hill. Despite heavy artillery, napalm and B52 attacks, North Vietnamese units tenaciously maintained their positions on the hill, forcing the US and South Vietnamese infantry to mount a dangerous assault. After ten days of fierce, often hand-to-hand fighting, communist forces retreated into nearby sanctuaries in Laos. Many critics questioned

whether Apache Snow was consistent with 'Vietnamization'. Others viewed the battle as typical of the war effort – the isolated hill was of no strategic importance to US forces, nor was it part of any larger strategy for defeating the communists.

733. In the late 1960s friction developed between Northern Ireland's Catholic and Protestant communities over discrimination against the Catholic minority in electoral laws, policing practices and housing and social conditions. Catholics launched a civil rights movement and began demonstrating peacefully in the province's major cities. In October 1968 Londonderry police attacked unarmed civil rights campaigners with water cannons and batons. The following year, controversy surrounding moderate reforms instituted by the Ulster government sparked further clashes between Catholics and Protestant extremists. The clashes exploded into full-scale riots in Londonderry. The British government sent troops into Northern Ireland to relieve the beleaguered Londonderry police and protect Catholics from Protestant attacks.

734. Polarization of Protestants and Catholics in Northern Ireland intensified sharply after the summer riots of 1969, in which eight people were killed, and 514 civilians and 226 police injured over a five-day period in August. The British army failed to restore order in Ulster and their continuing presence in the province, which had initially been welcomed by the Catholic community, soon came to be resented by the Catholics, who mostly favoured unification with the Irish Republic in the south. By the end of the year the situation had deteriorated considerably.

735. International sympathy for the plight of the Ibo people in the breakaway Republic of Biafra increased after Nigerian federal troops captured the new state's only seaport, Port Harcourt, and cut off all food and energy resources to the area. Foreign governments, religious organizations and private donors arranged shipments of food and medicine to the country, but as supplies could only arrive by air, the amount of aid proved insufficient to prevent mass starvation and disease.

736. America was eager to demonstrate its technological superiority and recapture some lost prestige after the Soviet Union's launch of the world's first orbital satellite, *Sputnik*, in 1957, and Yuri Gagarin's historic spaceflight. The *raison d'être* of the *Apollo* space programme, underway since July 1960, was explained in a speech by President John F. Kennedy in 1961 urging America to land a man on the moon by the end of the decade. On 16 July 1969 Neil Armstrong, Edwin 'Buzz' Aldrin and Michael Collins blasted off from Cape Canaveral in Florida aboard the *Apollo 11*. Four days later the lunar landing module, the *Eagle*, touched down on the moon's surface near the Sea of Tranquillity.

737 top. At 10.56 pm Eastern Daylight Time on 20 July 1969, Neil Armstrong stepped down from the *Eagle* onto the moon's surface, uttering the famous words 'that's one small step for man, one giant leap for mankind'. Aldrin became the second man to set foot on the moon shortly afterwards and for two hours the astronauts made scientific measurements, collected samples from the moon's surface and took photographs. Collins remained in the command module.

737 bottom. On 24 July 1969 the three astronauts aboard *Apollo 11* splashed down safely in the Pacific Ocean. After eighteen days in quarantine to ensure that they had not been contaminated by lunar microbes, Armstrong, Aldrin and Collins embarked on a tour of twenty countries during which they were praised for their contribution to an exciting new era in space exploration.

738. The Organization of African Unity (OAU), numerous national governments and even the Pope tried to reconcile the combatants during the Biafran War, but finally Nigeria, determined not to lose its oil-rich eastern region, defeated the ill-supplied forces of the breakaway republic which was forced to surrender on 15 January 1970 after Colonel Ojukwu fled to the Ivory Coast. Roughly a million Ibo people died during the war from starvation and disease.

739. *Nubile Young Beauty of the Diamaré, Cameroon* by Irving Penn. Penn was unique among

photographers who worked in less developed countries in that he remained faithful to photography in the studio regardless of the circumstances. He believed it was essential to maintain control of background and specific lighting conditions in order to capture the essence of his subject. He used the same principles to create sharply rendered portraits of world-renowned politicians and celebrities as he did for works of indigenous peoples in Africa, South America, and Asia. Penn's famous 'eye' for fashion and its various expressions was applied with equal sensitivity whether he was photographing models in Paris and New York or tribesmen in an African village.

1970

740. Chancellor Willy Brandt's main objective upon coming to power in West Germany in 1969 was to achieve reconciliation and cooperation with his country's neighbours to the east. As mayor of West Berlin between 1957 and 1966, Brandt gained worldwide fame for his toughness during the crisis over the Berlin Wall, and his shrewd handling of regular threats and blandishments from both East Germany and the Soviet Union. Through his *Ostpolitik* (eastern policy), Chancellor Brandt was determined to end the hostility which had marked West Germany's relations with eastern-bloc countries since the Second World War.

741. Willy Brandt kneeling before the Monument to the Heroes of the Ghetto in Warsaw in December 1970. The West German Chancellor went to Poland to sign a treaty of non-aggression with the Poles. During the trip he visited the memorial which commemorates the 1943 Jewish uprising in the Warsaw ghetto under wartime Nazi occupation. Brandt laid a wreath on the monument and then dropped to his knees for a short time. On his return to Germany Brandt made a speech in which he eloquently explained that his gesture was a request for a 'pardon in the name of our people for a million-fold crime which was committed in the misused name of the Germans'.

742. Jean-Paul Sartre and Simone de Beauvoir in October 1970. Life-long companions and the most prominent members of the

illustrious left-wing, Left Bank intellectual life of Paris, Sartre and de Beauvoir were deeply influential in French socio-political thinking from the 1930s to the 1970s. In 1929 de Beauvoir, a renowned socialist and feminist writer, began what she called her 'free life by association' with Sartre. In 1946 they founded and edited the avant-garde monthly *Les Temps Modernes*. Sartre is perhaps best known for his contribution to the existentialist movement. De Beauvoir's international reputation was established by the publication of *The Second Sex* (1949), her controversial study of women and their role in society.

743. After several unsuccessful campaigns to be elected president of Chile, Salvador Allende finally led his Socialist Party to victory in 1970. He became the first Marxist to attain the presidency of a Latin American country through democratic means. He carried out a number of sweeping reforms including price freezes, pay rises and land reforms, despite having only a modest mandate – little more than a third of the Chilean electorate had voted for him. His nationalization of the country's copper mines and other mostly externally-owned businesses placed him at odds with many foreign governments, particularly the US. As a result foreign investment soon dried up. By 1973 wealthy Chileans and most of the country's middle class were pushing for Allende's downfall.

744. In early May 1970 anti-war protests at Kent State University and other universities across America became increasingly radical following President Nixon's announcement on 30 April that the war in Vietnam had expanded into Cambodia. On 4 May 1970 national guardsmen, who had been ordered onto campus the previous day after students had set fire to the University's ROTC building, opened fire on unarmed demonstrating students. Four students were killed and fourteen wounded. The shootings sparked mass unrest at college campuses and a massive march on Washington, DC, on 9 May 1970. The guardsmen were brought to trial but were not found guilty.

745. On 6 September 1970 one Swiss and two American aeroplanes were hijacked by

terrorists of the Popular Front for the Liberation of Palestine (PFLP) and the passengers taken hostage. Two of the aeroplanes were flown to Dawson Field airstrip in the desert near Amman in Jordan, while the third was flown to Cairo where it was evacuated and then blown-up. Three days later a British aeroplane was hijacked by members of the same organization and flown to join the others in Jordan. On 11 September all three aircrafts were blown up thirty minutes after the last hostages had evacuated the planes. Three hundred passengers were taken hostage. They were later freed after the terrorists' demands to release Arab guerrillas held in custody in Britain, Switzerland and West Germany were satisfied. International condemnation of the PFLP's actions was virtually unanimous even in quarters customarily supportive of the Palestinian cause. The hijackings also marked a new departure in Arab terrorism. Western nationals were now prime targets for the first time.

746. The landing of British troops in Northern Ireland was the catalyst for a number of ominous developments in the province, not the least of which was the split in the Irish Republican Army (IRA). The paramilitary organization, largely inactive since 1940, exploited the rise in popular discontent among Catholics and announced a resumption of activities in August 1969. Delegates to an IRA convention decided, in view of reforms in the province, to recognize the London, Belfast and Dublin parliaments. Hardliners in the IRA repudiated the move, believing it undermined the basic military role of the organization and ran contrary to nationalist aspirations. A breakaway faction formed the Provisional IRA. After 1970 the 'Provisionals' began to portray themselves as the unofficial protectors of the Catholic community against the repressive British army which was seen to be a tool of the Protestant government in Northern Ireland.

747. One of Mao's earliest supporters, Lin Piao had commanded an army during the Long March and in the 1940s had led impressive victories over the Japanese and the Kuomintang. As Defence Minister in Mao's

government, Lin Piao ordered the military to assist the Red Guards at the outset of the Cultural Revolution and then later to disarm them. The Ninth Party Congress of 1969 officially designated him as Mao's successor, and Lin himself had it written into the Chinese Communist Party (CCP) constitution. The following year Lin grew impatient and formulated a plan to seize power and assassinate Mao. According to the CCP official account, when this attempt failed he fled to the Soviet Union, but the aeroplane he was flying in with his family crashed over Mongolia on 13 September 1971, killing everyone on board.

1971

748. US troops pulled out of Cambodia on 29 June 1970, less than three months after it had launched its much criticized invasion of the country. Nixon still ordered massive and largely indiscriminate bombing raids over much of the country during the early 1970s, which alienated the rural population and fuelled popular support for the communist Khmer Rouge. The Khmer Rouge leader, Pol Pot, achieved steady gains in the countryside, while in the capital Phnom Penh the chronic ineptitude and corruption of the new US-backed regime of Lon Nol was increasingly resented by the city's inhabitants.

749. Violence between the Muslim and Hindu communities in independent India led to 'partition' – the creation of East and West Pakistan which contained the two main concentrations of the Muslim population. East and West Pakistan were separated by over 1,600 kilometres (1,000 miles) of Indian territory. In May 1971 troops from West Pakistan put down a large scale independence movement in East Pakistan which was attempting to gain autonomy for its distand namesake. Millions of East Pakistani refugees fled across the border into India as a renewed guerrilla campaign for independence began in earnest. On 4 December 160,000 Indian troops invaded East Pakistan, a day after the West Pakistani Air Force had launched a surprise attack on Indian airfields. The Indian goal was to assist the independence struggle as well as to stem the tide

of refugees flooding into India. West Pakistan surrendered twelve days later and became the new state of Bangladesh.

750. The flight of about 10 million Bangladeshis into India following West Pakistan's crackdown on Eastern Pakistan's struggle for secession made a major humanitarian disaster imminent. Famine and widespread disease was averted through massive food aid from India and the UN. Musicians from around the world contributed their skills, organizing the Bangladesh benefit concert which raised millions of dollars for the relief effort.

751. By the end of 1970 the number of US military personnel fighting in the Vietnam War had been reduced to 335,000, but President Nixon's objective of 'peace with honour' seemed more incongruous with the real events in Vietnam every day. The disastrous invasion of Cambodia re-energized the anti-war movement. Morale among US troops on the battlefield was plummeting. In early 1971 Nixon, Kissinger and a few select military planners decided to mount a major South Vietnamese-led invasion of Laos in yet another attempt to cut off the Ho Chi Minh trail. Code named Operation Lam Son, the invasion was launched in February 1971, with disastrous results for the attacking forces. Massive US bombing strikes on Laos obliterated much of the country's infrastructure, but could not prevent communist forces from inflicting enormous losses on South Vietnamese troops, who suffered 50 per cent casualties. The invasion failed to halt the North Vietnamese Army's (NVA) build-up as its planners had hoped, and demonstrated the weakness of Nixon's Vietnamization policy.

752. Bombing and shootings carried out by the IRA in 1971 led Northern Ireland's Prime Minister Brian Faulkner to ask the British government at Westminister for the power to detain suspected IRA members without trial. Despite claims from the nationalist community that such a move would spark outright rebellion, internment without trial was introduced in early August. A major upsurge in sectarian violence followed. Thousands of mostly Catholic homes were burned to the ground,

barricades were erected in Catholic working-class areas of several cities in the north and the British army came under fire in a gun battle with the IRA in Belfast. Internment intensified nationalist animosity towards the British and provided the IRA with more propaganda to justify their armed struggle.

753. *Apollo 15* was the fourth mission in NASA's *Apollo* Manned Space Programme to land people on the moon. The crew of David R. Scott, Commander; Alfred J. Worden, Command Module Pilot; and James B. Irwin, Lunar Module (LM) Pilot, was launched on schedule from the Kennedy Space Centre in Florida on 26 July 1971. The landing site for the twelve-day scientific mission was the Hadley Rille-Apennine mountain region on the lunar surface. The lunar module carrying Scott and Irwin and the Lunar Roving Vehicle (LRV) landed on the moon on 31 July 1971. The first deployment of the LRV proved a success as the astronauts carried out a series of experiments and sample collections during three excursions within a 5-kilometre (3-mile) radius of the landing site. The command module and the lunar module rejoined on 2 August 1971 and performed photographic experiments in orbit around the moon for two days. *Apollo 15* then headed back to earth, splashing down in the Pacific Ocean north of Honolulu on 7 August 1971.

1972

754. Former West German Chancellors Kurt Georg Kiesinger and Ludwig Erhard together with other German politicians attending a debate in the Bundestag over *Ostpolitik*. As a precondition to reconciliation with East Germany, Chancellor Willy Brandt secured agreements with the Soviet Union and Poland, resulting in recognition of the post-Second World War annexation of German territory by the Soviet Union and Poland. This reaffirmed the inviolability of Poland's western border and led to the signing of the Basic Treaty (treaty of friendship) in 1972. Though controversial, Brandt's diplomatic efforts contributed greatly to his resounding victory in the 1972 election, reflecting both popular support for *Ostpolitik* and the country's willingness to accept the consequences of defeat in 1945.

755. On 21 December 1972 both East and West Germany accepted each other's existence with the signing of the Basic Treaty. Border agreements over traffic and communications between East and West Berlin were secured. The debate over *Ostpolitik* fuelled enormous acrimony and made Chancellor Willy Brandt many political enemies at home, particularly among those who viewed the treaty as official legitimation of the communist regime in East Germany. West Germany maintained its hope for the self-determination of a unified German people. East Germany erased any mention of re-unification of the two 'Germanies' from its constitution two years later.

756. The extremist Palestinian group Black September committed a series of public crimes in the 1970s, the worst being an attack on Israeli athletes at the 1972 summer Olympic Games in Munich in Germany. On 5 September the Black September terrorists armed with Kalashnikov rifles and hand grenades stormed the quarters of the Israeli team in the Olympic Village, killing two team members and taking nine others hostage. The terrorists demanded the release of Arab prisoners and their own safe escort back to an Arab country. All the hostages and five of their captors were killed when the German police attempted a rescue operation. The surviving terrorists were flown to Libya where they were released in a deal brokered after the subsequent hijacking of a German aircraft.

757. At the age of fifteen Bobby Fischer became the youngest person ever to attain the rank of Chess Grandmaster. He dominated both the junior and senior chess circuits in his native America during the 1960s. His youth and brilliance fascinated the American public, bringing widespread attention to chess in the US for the first time. In 1972 he beat the reigning Soviet and world champion Boris Spassky in an acrimonious duel in which Fischer characteristically demanded a number of conditions from the match organizers, such as dimmed lights and no photographs except those taken from hidden cameras. The victory made Fischer World Chess Champion – the first American

officially to hold the title – but his numerous phobias and volatile temperament placed him at odds with the International Chess Federation. He was stripped of his title in 1975 and for many years remained in virtual seclusion before reappearing in 1992 to beat Spassky again in an exhibition match in Yugoslavia. The event violated US sanctions against the country at the time and a warrant was issued for Fischer's arrest. Unable to return to America, he settled somewhere in Eastern Europe.

758. On Sunday 30 January 1972, soldiers from the British army's First Parachute Regiment opened fire on unarmed Catholic demonstrators in Londonderry in Northern Ireland, killing thirteen people. The 'illegal' demonstration, mounted in protest over the government's policy of internment, was the largest ever organized by the Catholic Civil Rights Association and numbered 30,000 marchers. Within hours, British authorities claimed that the paratroopers had shot dead thirteen 'gunmen' and bombers, although no weapons had been found on any of the killed or wounded demonstrators.

759. Headed by Lord Chief Justice Widgery, the British government inquiry established in the aftermath of the killings in Londonderry reached an inconclusive verdict. The final report claimed that the soldiers were fired upon first, but some actions by the paratroopers were deemed reckless. No evidence was found to prove that any of the casualties had been armed. The inquiry's findings were dismissed by nationalists as a British cover-up. The Republic of Ireland's Ambassador in London was re-called to Dublin in protest. Two days later the British embassy in Dublin was burned down after it was attacked by thousands of protestors. Nearly three decades on, the controversy over Bloody Sunday still affects Irish-British relations.

760. In the aftermath of Bloody Sunday the ranks of the Irish Republican Army swelled with new recruits. Large numbers of nationalists now viewed the IRA as a necessary evil to protect themselves against British troops and Protestant (Loyalist) paramilitaries. Others believed

that the time was right for the IRA to go on the offensive and force the British troops to with-draw from Northern Ireland as a prelude to unification with the South. By the end of the year, sectarian violence had claimed nearly 500 lives including over 300 civilians, making it the worst year in the history of 'the troubles'.

761. Elected in Northern Ireland to the British parliament, at twenty-one Bernadette Devlin was the youngest Member of Parliament to be elected to the House of Commons since William Pitt the Younger. Devlin quickly established a reputation as a combative and outspoken politician. After Bloody Sunday at which Devlin had been present, she accused the Home Secretary Reginald Maudling of lying about the shootings. She then ran across the floor of the House, pulled his hair and slapped his face. In 1973 she and her husband Michael McAliskey were wounded in an assassination attempt.

762. On 7 December 1972 the sixth and final *Apollo* lunar mission blasted off with Commander Eugene A. Cernan, Ronald Evans and geologist-astronaut Harrison H. Schmitt on board. Cernan and Schmitt landed the lunar module in a mountain-ringed valley on the moon's surface named Taurus-Littrow. They set up a science station and then assembled their Lunar Roving Vehicle for three days of 'camping' in Taurus-Littrow, making a seven hour excursion each day. The lightweight four-wheel 'buggy' was the first manned surface transportation system designed to operate on the moon and had been used in two previous *Apollo* missions, greatly extending the lunar area that could be explored by humans. By 1972 the rising cost of the *Apollo* programme and declining public interest in lunar exploration prompted NASA to end manned spaceflights to the moon.

763. During the early 1950s pollution from the effluent waters of a chemical plant in the city of Minimata in Japan caused an outbreak of mercury poisoning among the town's fishermen and their families, which had perhaps begun as early as the 1930s. The disease leads to a progressive weakening of the muscles, loss of vision, eventual paralysis and

in some cases coma and death. It was first discovered when fish and shellfish taken from Minimata Bay – a staple part of the local diet – were found to contain high levels of dangerous methyl mercurials commonly used in the manufacture of chemicals, paints and various household items. By 1971, 121 cases of 'Minimata' disease had been confirmed. Of these 121 victims, forty-seven died. By 1993 the number of reported cases exceeded 3,000 and the Chisso Corporation, which owned the factory responsible for the contamination of the bay, was still involved in court battles over compensation payments to the victims.

1973

764. An emotional homecoming for United States Air Force Captain Michael S. Kerr after six years in a North Vietnamese POW camp. Kerr was shot down over North Vietnam on 16 January 1967 while on a reconnaissance mission. The issue of US POWs was one of the most difficult and controversial of the Vietnam War, not the least because POWs on both sides were subjected to torture and malnutrition. North Vietnam returned 566 US military personnel under the Paris Peace Accords between February and April 1973.

765. After more than four years of negotiations begun following the Tet offensive in 1968 and interrupted regularly by US bombing campaigns, the Paris Peace Accord was signed in January 1973. The terms of the Accord meant a cease-fire in Vietnam and an end to direct US involvement in the war. Democratic elections were planned in the south. The agreement was concluded by Henry Kissinger and Le Duc Tho, both of whom received Nobel Peace Prizes for their efforts. The remaining US forces in Vietnam were withdrawn by 29 March 1973. The cease-fire never took hold and fighting flared up between North and South Vietnamese forces over the next two years. America had already suffered 55,000 dead and 300,000 wounded but its final humiliation in the country was not to come for another two years.

766. On 11 September 1973 Chile's new Commander-in-Chief of the army Augusto Pinochet staged

a military coup and installed a right-wing military junta. Moderate political forces supported the coup because popular sentiments had turned against the ousted President Salvador Allende. Many believed Pinochet's rule would be merely a transitional phase until a speedy return to democracy could be secured. In fact Pinochet established an extremely repressive regime, suppressing the slightest hint of opposition from left-wing and even centrist elements in Chilean society. Between 1973 and 1976 about 100,000 people were imprisoned for political reasons, many of whom were tortured and thousands of whom disappeared.

767. Popular dissatisfaction with Allende's reform programme, particularly among Chile's business elite, and the deteriorating economic situation in the country sparked protests and demonstrations in 1973 main in the capital, Santiago. Right-wing elements in the army backed by the US administration exploited the unrest and overthrew Allende's government in September of the same year. Allende died during the coup inside the burning presidential palace. Official reports stated that he committed suicide, but many of his supporters still claim that he was assassinated by invading soldiers.

768. Between 1970 and 1975 popular support in Cambodia for the communist Khmer Rouge increased steadily, due in no small part to the extraordinary ineptitude and corruption of the US-backed regime of Lon Nol. Despite having suffered a stroke in 1971 which rendered him incapable of effective leadership, Nol had declared himself president in 1972. By 1973 the Khmer Rouge had established control of the countryside, with only minimal assistance from North Vietnam, and had forced the Cambodian army into a few, largely besieged, cities. The communist guerrillas had looked poised to capture the capital and key urban centre of the country, Phnom Penh, in 1970, but massive US air strikes had shattered Khmer Rouge strength. The civil war settled into a stalemate until the Khmer Rouge attempted another major assault on the city in 1973.

769. Famine victims in Chad. The drought that had ravaged the Sahel region of Africa for over six years finally came to the attention of the world's developed countries in 1974. The horrible suffering of the region's inhabitants was compounded by enforced migration and government corruption at local and national levels. International aid eventually arrived, but the effort was hampered by problems of supply, transport and fair distribution.

1974

770. Nobel Prize winner Alexander Solzhenitsyn in West Germany in February 1974. In the West the Russian writer was renowned for his renunciation of the hypocrisy of social systems in novels such as *One Day in the Life of Ivan Denisovitch* (1962) and *The Gulag Archipelago* (1973–75). After suggesting that the path to socialism was paved with corruption, Solzhenitsyn spent several long periods in prison and in exile in Siberia before being expelled from the Soviet Union. During Solzhenitsyn's first few weeks in exile throngs of cameramen and reporters followed his every move. For a fiercely private individual accustomed to Soviet-style controls, coming to the West was a painful and disorienting experience.

771. Mikhail Baryshnikov talks with his manager Dina Makarova on 10 July 1974 in Toronto in Canada, during his first public appearance after his defection. Regarded as the pre-eminent male classical dancer of the 1970s and 1980s, Baryshnikov defected while dancing with a touring unit of the Bolshoi Ballet in Canada. Although extremely popular in his native Soviet Union, Baryshnikov became exasperated with the official restrictions placed upon him as an artist by the Soviet authorities. He was granted asylum by the Canadian government and began a series of highly acclaimed dance tours in North America.

772. President Richard Nixon during talks with Egyptian President Anwar Sadat. The US President received a great popular welcome in the Middle East during his visit to the region in June 1974. The tour symbolized a change in America's Middle East policy and an improvement in US-Arab relations. The jubilant crowds which greeted Nixon abroad were a far cry from the escalating calls for his resignation back home over his role in the Watergate scandal.

773. Leonid Brezhnev, Henry Kissinger, Anatoly Dobrynin, Andrei Gromyko and Gerald Ford. American and Soviet leaders signed an agreement on guidelines for Strategic Arms Limitation Talks (SALT II) at the port city of Vladivostok in the eastern Soviet Union in December 1974. The two sides reached a tentative agreement to limit numbers of offensive strategic nuclear weapons on both sides, thereby establishing the principle of equivalency and reaffirming the bilateral commitment to a *détente* secured by Brezhnev and Nixon between 1972 and 1974. The meeting was also an opportunity for Soviet officials to size-up Nixon's successor, Gerald Ford.

774. British Prime Minister Edward Heath was forced to call a general election against a grim backdrop of strikes in the coal, power and transport industries in Britain in the winter of 1973. His Conservative Party gained more votes than Labour but fewer seats, and Labour leader Harold Wilson formed a minority government until the subsequent elections in October 1974. Wilson was immediately confronted with a balance-of-payments problem several times worse than when he had first taken office as Prime Minister in 1964. Heath, who had led Britain into the European Economic Community (EEC) and championed most of the initiatives aimed at deepening European integration, was ousted as Conservative Party leader in 1975 by a candidate with a rather different vision of Britain in Europe and the wider world, Margaret Thatcher.

775. Nixon's former law partner and campaign manager during the 1968 presidential election, John Mitchell became Attorney General after the Republican victory. He abused his office frequently, ordering wire taps without court authorization and using dubious means to prosecute anti-war protestors. He was appointed Nixon's campaign manager again in 1972 but resigned at the outset of the Watergate scandal in which five employees of a Republican Party organization were arrested after breaking into the headquarters of the Democratic National Party Committee in Washington, DC. The break-in was followed by a series of illegal actions and cover-ups by senior White House aides and the president himself was eventually forced to resign on 9 August 1974. Mitchell was found guilty of perjury and obstruction of justice in the second of two trials, and spent more than a year-and-a-half in prison. Similar sentences were served by other prominent officials in the Nixon administration also convicted of offences related to the scandal.

776. Children dramatizing slogans of the ideological campaign which demanded a complete break with traditional Chinese custom which had been based on the teachings of Confucius for over 2,000 years. The ideological campaign formed the final stage of the Cultural Revolution in China. This particular campaign was mounted in 1974 by radicals in order to revive waning popular interest in the Cultural Revolution. The late Defence Minister, Lin Piao, was attacked for defending the old order against the new. Months of poster campaigns and mass criticism led to disruptions at schools and businesses, but support for the movement faded after Mao called for calm and unity. In reality Mao's revolution brought young Chinese few, if any, benefits in spite of their excited rhetorical allegiance to him. Maoist doctrine and the Maoist cult which dominated the educational curriculum in the late 1960s and early 1970s meant they devoted much of their time simply to chanting Mao's slogans and reciting his proverbs. The damage done to an entire generation of Chinese students by the excesses of the Cultural Revolution was incalculable.

777. Muhammad Ali talking to reporters the morning after his triumph over George Foreman in the pre-dawn World Heavyweight title fight in Kinshasa in Zaïre on 30 October 1974. At the age of thirty-two, Ali staked his claim to join the all-time greats in boxing history by beating the odds and knocking out his formidable opponent in eight rounds. President Sese Seko Mobutu (in the picture above Ali) received tremendous publicity from the so-called 'Rumble in the Jungle' even though he kept out of public view during the many celebrations leading up to the fight. Increasingly ruthless and corrupt, Mobutu was ever mindful of possible assassination threats from his numerous political enemies.

778. By 1970 the Turkish minority on the island of Cyprus had ceased to recognize the legitimacy of the government in the capital, Nicosia, electing an unofficial administration of their own in northern Cyprus. On 15 July 1974 President Makarios, leader of the Greek Nicosia government, was forced into exile after officers in the Cypriot National Guard seeking union with Greece had launched a *coup d'état*. Cyprus was thrown into chaos. With the rights and safety of the scattered Turkish communities threatened, Turkey seized the opportunity to invade the northern part of the island on 20 July 1974. Subsequently over 200,000 Greek Cypriots were expelled from their homes and forced to flee south.

779 top. Greek Cypriots forcibly expelled from Turkish-occupied areas were quickly replaced by members of the invading armies and settlers from mainland Turkey. Three weeks after the invasion nearly half of the island was under Turkish control. When international pressure brought about a halt to fighting in late August, Cyprus had been effectively partitioned. A Turkish Federated State was established in the north on 13 February 1975, and eventually an independent Turkish Republic of Northern Cyprus was declared in 1983. Only one state in the international community officially recognized it, however, and that was Turkey.

779 bottom. After a series of short battles between Turks and Greek Cypriots following the coup, UN troops which had been in Cyprus since 1964 intervened and brokered an 'end to hostilities', although this was not an official cease-fire. The Blue Line, a buffer zone separating the Greek and Turkish areas of Cyprus, was established and patrolled by UN peacekeeping forces. Attempts at reconciliation between the two communities were led by Makarios, who had returned from exile in December 1974. This reduced tensions slightly, but since his death in 1977 Turkish-Greek relations on the island have seen no significant improvements.

780. A Valéry Giscard d'Estaing poster during the 1974 election for president. After the sudden death of President Georges Pompidou on 12 April 1974, France was thrust headlong into an exciting election battle between the former Minister of Economy and Finance, Giscard d'Estaing, and the United Left Candidate, François Mitterrand. Both candidates made exhaustive tours of the country promising change and reform. Giscard d'Estaing narrowly defeated Mitterrand.

781. Deposed by the army in 1955, Argentine President Juan Perón fled to Spain and remained in exile for almost two decades. In spite of his absence, the various economic and social policies known collectively as Perónism remained in place in Argentina. Coaxed into returning from exile by a Perónista revival, Perón won re-election in 1973 with 62 per cent of the popular vote. But his political resurrection was short-lived. He died nine months later and was replaced as President by his third wife and Vice-President, Isabelita Perón. He was buried next to his first wife Eva, whose remains were finally returned to Argentina after having been hidden in Italy by the Argentine military for nearly two decades.

1975

782. On 1 January 1975 the Khmer Rouge launched its Mekong River offensive to topple self-proclaimed president Lon Nol's regime in Phnom Penh. The city was shelled relentlessly and before long it was encircled by Khmer Rouge troops. Pro-government refugees poured into the city. Only when all supply routes into the capital had been cut off did the United States mount an emergency airlift of food and supplies, reminiscent of the 1948 Berlin airlift. The airlifts were too late as Lon Nol was already planning to flee the country.

783. On 1 April 1975 Lon Nol and his entourage flew into exile, eventually arriving in America. Twelve days later, America decided that a Khmer Rouge victory was inevitable and evacuated US Embassy staff in Phnom Penh as well as a number

of non-Americans and their dependents. A similar although much larger evacuation operation was mounted by US forces across the border in Saigon at the end of the month. Phnom Penh fell to Khmer Rouge troops under the leadership of Pol Pot on 17 April. The population was generally elated at the communist triumph and were eager for their country to return to peace after five years of bloody civil war.

784–85. In the weeks that followed the communist victory, Khmer Rouge troops began forcibly depopulating Cambodia's cities. Inhabitants were ordered to abandon their homes and take up life in rural agricultural communes. Anyone who resisted was killed, as were any Cambodians with ties to the former government. In less than a week Phnom Penh and other cities and towns were empty. Although thousands died during the forced marches to the countryside, the worst horrors were still to come.

786. After the collapse of the Portuguese military regime in Lisbon in 1974, Angola was granted independence on 10 November 1975. A struggle for power followed among various guerrilla movements which had successfully attracted foreign sponsors and were already firmly established in the early 1970s. At the behest of the US administration, South Africa invaded the country to aid the anti-communist group, the National Union for the Complete Independence of Angola (UNITA) led by Jonas Savimbi, in their attempt to seize power. In February 1976 the Soviet and Cuban-backed Popular Front for the Liberation of Angola (MPLA) gained the upper hand and proclaimed a Socialist People's Republic. Cuban troops poured into the country to defend the new government and eject the South Africans, while Savimbi's force established a guerrilla base in the southern part of the country and reorganised itself with foreign backing.

787. With American assistance, more than 100,000 South Vietnamese refugees fled the country in the final chaotic days before the fall of Saigon's US-backed regime on 30 April 1975. President Duong Van Minh's army, though numerically superior to the North Vietnamese army and

well-supplied with US arms, had collapsed in the absence of direct American military involvement. After its surrender to the North Vietnamese, Saigon was renamed Ho Chi Minh City. The communist victory ended almost thirty years of continuous warfare in the country in which millions of Vietnamese, from both north and south, had been killed. The reunification of Vietnam under communist rule marked the final failure of America's grossly misguided policy in the region. The world's most powerful nation had been defeated by a small, underdeveloped communist country. At home, the war had divided American society and its legacy continues to exert a profound impact on the country's national psyche and its foreign policy.

788. A film still from *Jaws*, the popular adventure thriller about the pursuit of a giant man-eating shark that is terrorizing the inhabitants of a small town on America's north-east coast. Director Steven Spielberg tapped into a common fear and played on it brilliantly. The film catapulted Spielberg, who was still unknown at the time, into the limelight and the film's star – the great white shark – entered international popular culture. The widespread success of *Jaws* generated enormous financial profits for the filmmakers and the blockbuster, a new phenomenon in the film industry, was born.

789. An agreement between the US and the Soviet Union in 1972 had provided for the docking of the Soviet *Soyuz* and a US *Apollo*-type spacecraft while in Earth orbit in 1975. The *Apollo-Soyuz* Test Project was the first inter-nationally manned spaceflight and was designed to test the compatibility of rendezvous and docking systems for both spacecraft. The mission was also intended to open the way for international space rescue as well as future joint ventures in space. The *Soyuz* was launched roughly seven hours prior to the the *Apollo*. Fifty-two hours later on 17 July 1975 the *Apollo* manoeuvred to meet with and then link to the *Soyuz*. The Soviet and American crews shook hands and toasted the occasion. They conducted a variety of experiments over a two-day period before the crafts separated. Both returned safely to Earth.

790–91. Within six months of the evacuation of its cities Cambodia, renamed Kampuchea in a return to its ancient name, had experienced the most rapid and radical social transformation in its history. Money, markets and private property were abolished. Travel was prohibited. Schools, shops and offices were closed. Everyone was forced to wear peasants' clothes. The new order under the leadership of Pol Pot declared Year Zero and used almost unimaginable brutality to create the first truly 'communist' society. Estimates of the number of Cambodians killed over the next four years at the hands of the Khmer Rouge range between 1 and 2 million people.

792. One of the great paradoxes of the Spanish dictator General Franco is that he oversaw the modernization of his country in the 1950s and 1960s and prepared it for the transition to democracy in the 1970s. Yet throughout his thirty-six year reign he had maintained Spain as a traditional society in which the Catholic Church played an important role. His strident anti-communism enabled a *rapprochement* with the West, particularly after the regime began to abandon fascism in the post-war years. In 1969 Franco announced that the Spanish monarchy was to be restored after his death and he appointed Juan Carlos I, grandson of the country's last ruling King as his successor. He died of a heart attack in Madrid on 20 November 1975.

793. Long-simmering tensions between Christian and Muslim communities in Lebanon were exacerbated in the early 1970s by an influx of Palestinian guerrillas evicted from Jordan. Outbreaks of sectarian violence followed, including periodic Israeli raids on Lebanese villages suspected of harbouring newly arrived Palestine Liberation Organisation (PLO) guerrillas. A massacre of Palestinians by Falange gunmen (Christian Maronite paramilitaries) on 13 April 1975 plunged the country into full-scale civil war. Initially Christian groups were supported by Israel while Muslim militias were backed by Syria. Soon other players entered the conflict, making it increasingly violent and complex.

794. After the fall of the Third Reich, filmmaker Leni

Riefenstahl, who had once made films for Hitler, was imprisoned, placed in an insane asylum and finally put under house arrest before being freed in 1949 and cleared of all charges of political complicity with the Nazis. Although she vigorously refuted all accusations that her work glorified Nazism, Riefenstahl was blacklisted in her native Germany. After a failed attempt to revive her filmmaking in the mid 1950s Riefenstahl discovered photography in the early 1960s and moved to Africa. She lived for a time with a tribe in the Nuba mountains of Sudan, recording extraordinary images of a people virtually untouched by the advance of industrial civilization. The Nuba culture was entirely peaceful, the only form of combat being wrestling matches between friendly tribes. Riefenstahl found her happiest and most rewarding artistic achievements in photography, although even her celebrated photographs of the Nuba did not escape the legacy of her Nazi-era film career. Exhibitions of her photographs were sometimes marred by protestors carrying signs reading 'Nazi Exhibition' and even her images of naked Nuba tribesmen were deemed by some critics to possess 'fascist tendencies'. In the 1990s, Riefenstahl, well into her nineties and still as irrepressible and formidable as ever, focused most of her energies on scuba diving and underwater photography.

795. Leni Riefenstahl's work in Sudan appeared in two widely acclaimed photographic books in the 1970s, *The Last of the Nuba* and *The People of Kau*. Sadly, the popularity of these books contributed to an influx of foreigners into the Nuba mountains in the 1980s, resulting in a gradual weakening and commercialization of their culture. Money was introduced, some traditions were transformed into tourist spectacles and the tribespeople were forced to wear clothes after government authorities deemed the 'primitiveness' of Nuba traditions incompatible with the image of the 'modern Sudan' they aimed to establish. By the end of the 1990s international human-rights groups reported acts of genocide being carried out against the Nuba by local and national militia. This could not be

confirmed as the government of war-torn Sudan declared the Nuba mountain region closed to foreigners.

1976

796. At the 1976 Summer Olympic Games in Montreal in Canada, Nadia Comaneci became the first gymnast to obtain a perfect score of 10 in an Olympic competition. The fourteen-year-old Romanian achieved this historic award for her performance on the first day of the gymnastic events. The scoreboard inside the stadium displayed '1.0', the only way the electronic apparatus could register the unprecedented perfect score. Comaneci went on to win six more perfect scores during the Montreal Games and five Olympic medals in total, including three gold. Her lithe frame and bright smile instantly became one of the most recognized images in the world.

797. In 1970 Robert Mapplethorpe left his painting studies at the Pratt Institute in New York and took up photography. The same year he moved into the city's infamous Chelsea Hotel – haunt of avant-garde artists and musicians – with his friend Patti Smith, rock music singer, poet and sometimes sketch artist, whose drawings were exhibited alongside Mapplethorpe's early work. His classical 'still-life' photographs began appearing in galleries in the late 1970s, but it was his homoerotic images that were to make Mapplethorpe a household name. Shocking, audacious and – some said – flagrantly obscene, his homoerotic photographs were designed to appeal simultaneously to the intellect and to the senses. After he died in 1989, his first posthumous exhibition, 'The Perfect Moment', caused such an uproar that it was closed by police and the museum exhibiting his photographs was indicted on charges of child pornography. The juxtaposition of images of extreme sado-masochism with naked pre-pubescent children were largely responsible for the furore. Subsequently Mapplethorpe's work became a focus for artists discussing issues of censorship and government funding of the arts, particularly in America and Britain.

798. Former US President Richard Nixon was invited to visit China

by the Chinese government in February 1976. The visit was timed to coincide with the anniversary of Nixon's historic first visit in 1972. It was also designed to demonstrate the communist leadership's determination to maintain good relations with America despite a continuing row between the two countries over the status of Taiwan. In the aftermath of the Watergate scandal and Nixon's forced resignation of his presidency the trip signalled the beginning of his attempt to restore his reputation as a statesman abroad.

799. For much of the last five years of his life Mao was merely a figurehead in China's government. Government policy was managed largely by Zhou Enlai, particularly China's relations with the West. Mao died on 9 September 1976, nine months after the death of Zhou. Although he was removed from the day-to-day running of the country, his personal triumph during the Cultural Revolution made Mao a revered national father figure. Following his death his fourth wife Chiang Ching attempted to eliminate potential rivals for the party leadership and seize power herself. Formerly an actress, Chiang had gradually built up her influence in the party since the 1940s, and by the 1970s she was playing a leading role in most areas of China's cultural life. She was also a driving force behind many of her husband's domestic initiatives. In October 1976 her activities were denounced and she was placed under arrest as leader of the 'Gang of Four' who had challenged Deng Xiaoping's leadership.

800. The spirit of the original Teddy-boy subversive teenage subculture in Britain in the 1950s, was revived two decades later in reaction to the latest teen revolt, the Punk movement. Former Teds, still wearing their Edwardian-inspired clothes, resented the publicity received by the anarchic and wildly irreverent Punks. The Punks' crude rebellious behaviour and grungy appearance induced a nostalgia for a comparatively innocent age when the Teds reigned supreme.

801. When senior Communist Party leaders ordered the Chinese army to crush the Red Guards in the summer of 1976, many of the

chief instigators of the Red Guard terror were arrested. Others escaped to Hong Kong. Large numbers were also sent to the countryside for 're-education' from the peasants. The Red Guard continued to exist as a student organization for a few more years but failed to maintain its political appeal or revolutionary zeal among Chinese youths.

802–03. In June 1976 Lebanon plunged deeper into chaotic civil war. Syrian troops invaded Lebanon partly to support Palestinian guerrillas who sought to use the country as a base for launching attacks on adjacent Israel. Over the next few months Christian Falangists, whose political power in Lebanon was resented by its local Muslims, engaged in fierce fighting with both Syrians and Palestinians. This period of the war was characterized by kidnappings, assassinations and shifting alliances between various factions embroiled in the conflict.

804. Riots broke out in black townships in South Africa on 16 June 1976 after police opened fire on black students in Soweto, near Johannesburg. They were demonstrating against the apartheid government's proposal to make Afrikaans, the language of the ruling white Afrikaners, the compulsory language of instruction in all schools instead of English. Tensions in the black townships were aggravated by impoverished living conditions, and remained high throughout the country in spite of the government's announcement the following month that it was dropping the proposed legislation. Riots were eventually brought under control by police repression, but not before an estimated 600 young blacks had been killed in the disturbances. The Soweto Uprising, which came to epitomize the black struggle against apartheid in the late 1970s and 1980s, has been commemorated annually since 1994 and 16 June has been declared a national holiday in South Africa.

805. On 27 June 1976 an Air France plane travelling from Tel Aviv to Paris was hijacked by Popular Front for the Liberation of Palestine (PFLP) guerrillas and forced to land at Entebbe airport in Uganda. The hijackers demanded the release of fifty Arab

terrorists held in Israel in return for the safe release of the plane's (mostly Jewish) passengers. Six days later a commando unit was flown 3,620 kilometres (2,250 miles) from Israel to make a surprise assault on the airport. During the thirty-minute battle all but three of the hostages were rescued and later flown back to Israel. One Israeli commando and seven hijackers were killed, as were twenty Ugandan soldiers who had been ordered by Ugandan dictator Idi Amin to assist the terrorists.

806. Gerald Ford was sworn in as President immediately after Richard Nixon's resignation in August 1974, becoming the first American to hold non-elected office as both president and vice-president – he had replaced Vice-President Spiro Agnew in 1973 after he had resigned when alleged financial improprieties came to light. Among his first acts as president was the highly controversial pardon of his predecessor for any crimes he might have committed during Watergate. During his short tenure Ford could not escape association with the 'corrupt' Nixon years and was constantly overshadowed by his globe-trotting Secretary of State, Henry Kissinger. Ford also had the distinct misfortune of being portrayed as a bumbling klutz by the American media. After a well-publicized slip on a rain-slicked ramp in Austria, Ford's susceptibility to accidents, whether real or not, often attracted more popular attention than his policy initiatives.

807. Barry Humphries began writing and performing songs and sketches in university revues in his native Australia before joining the newly formed Melbourne Theatre Company in the early 1950s. He created his most famous character, Dame Edna Everage in 1956. Humphries went on to popularize many other characters and appeared in numerous successful plays in London. He gained widespread notoriety in 1969 when he first brought Dame Everage to the West End for his one-man act *Just a Show* which polarized British critics at the time. The acid-tongued Melbourne 'housewife' proved irresistible to audiences and figured prominently in many of Humphrey's subsequent theatrical offerings.

808–09. Chinese soldiers file past Mao's mausoleum in Tiananmen Square in Beijing on the first anniversary of his death on 9 September 1976. The most important figure in twentieth-century Chinese history, Mao died just as his devastating Cultural Revolution had come to an end and when his regime had become riven by internal feuds. Deng Xiaoping emerged from the succession struggle as leader, and took steps to ensure that popular adulation of Mao was tempered by a sober assessment of his reign. Mao was to be remembered both for his outstanding qualities as leader of the revolutionary movement which so changed China, as well as for the disastrous and costly policies he had pursued once in power.

810. Jean Bedel Bokassa just after his coronation as Emperor of the Central African Republic. Bokassa made himself life-President of the former French colony in 1966 after overthrowing his cousin, David Dacko, in a coup. Bokassa established a ruthless dictatorship, notable for its gratuitous violence and his brazen plundering of the nation's wealth. In 1976 he proclaimed himself Emperor, and in a lavish ceremony the following year he crowned himself Emperor Bokassa I of the Central African Empire. French support for his rule was finally withdrawn in 1979 when he was personally involved in the appalling murder of a hundred schoolchildren. He was ousted from power and sentenced to death, but the sentence was never carried out.

811. The Sex Pistols created sensation and outrage whenever they performed in their native Britain or abroad, in the mid 1970s. Their adolescent nihilism and rage produced some of the Punk Rock movement's most inflammatory and popular music. Songs such as 'Anarchy in the UK' and 'God Save the Queen' from their album, *Never Mind the Bollocks*, were adopted by angered, alienated youths in Britain and elsewhere. By 1978 the band's violent lyrics and tempestuous behaviour led to widespread bans on their performances in Europe and America. The same year, the band's bass player John Simon Ritchie (better known as Sid

Vicious) was arrested for stabbing his girlfriend, Nancy Spungen, to death. He died the following year of a drug overdose before he could be brought to trial for her murder.

812. The body of Steve Biko in a prison in King Williamstown in South Africa. Biko was a young medical student in Durban when he became involved in the Black Consciousness Movement which fought apartheid in South Africa. Biko's idea that blacks could not acquire freedom until they had become self-reliant and conscious of their own identity was well received among the educated classes and mixed races, but did not attract much support in the black townships. Nonetheless, his brilliant and charismatic speeches won him widespread influence, much to the displeasure of the South African government who eventually imposed a banning order which severely restricted his movement and freedom of speech and association. On 19 August 1977 he was arrested for travelling outside his restricted area, and later died from a brain haemorrhage and other injuries sustained while in police custody. The official report of his death at the time claimed that he had behaved violently and hit his head while struggling with police. In 1997 five former members of the South African security forces admitted to having been involved in his murder.

813. One of the last bastions of white rule in Africa, the Rhodesian government first came under threat from black resistance forces in 1972. Four years later, a fragile coalition called the Popular Front led by Robert Mugabe and Joshua Nkomo was created among rival insurgent armies. In 1978 they rejected Rhodesian Prime Minister Ian Smith's proposals of a power-sharing agreement with the country's white minority. Despite Anglo-American and UN mediation efforts, clashes continued between the Rhodesian army and Popular Front insurgents acting from alleged guerrilla bases in Mozambique until December 1979. A negotiated settlement resulted in the independent Republic of Zimbabwe being declared in 1980 with Robert Mugabe as the new country's first President.

814. Born in the Ukraine and a signatory of Israel's independence declaration, Golda Meir was elected Prime Minister of the Jewish state in 1969. She immediately began to press for a diplomatic peace settlement in the Middle East. Her forceful campaign for peace in the region was halted by the outbreak of the Yom Kippur War in 1973, which was the result of a surprise attack on Israel by a combined Egyptian-Syrian force. Yitzhak Rabin, former Israeli ambassador to the US and leader of the Israeli military's spectacular defeat of its Arab neighbours in the subsequent Six Day War, succeeded Meir as Labour Party leader and Prime Minister following her resignation in 1974. He promptly set himself the task of ridding his party of the corruption scandals which had plagued it during Meir's tenure. His efforts were largely unsuccessful and, on the eve of the 1977 general election, Rabin himself was touched by scandal when it was revealed that his wife held an illegal foreign bank account. The Labour Party, which had ruled Israel since the country's establishment, was ousted from power the next day by the Likud Bloc led by Menachem Begin.

815. Faced with a deepening economic crisis caused by high military expenditure, Egyptian President Anwar Sadat sought to hasten a peace agreement with Israel by offering to travel to Jerusalem and speak to the Israeli parliament, the Knesset. The change in Egyptian policy towards the Jewish state came on the heels of the failed Egyptian-Syrian surprise attack on Israel in 1973 known as the Yom Kippur War. Sadat realized that Egypt would not regain the Israeli-occupied Sinai peninsula by force. Israeli Prime Minister Menachem Begin accepted Sadat's proposal and in late November 1977 the Egyptian leader visited Israel despite strong condemnation from other Arab leaders. His bold peace initiative marked the first tacit recognition of Israel's right to exist by an Arab head of state, and laid the groundwork for further Israeli-Egyptian talks on a permanent peace settlement.

1978

816. In the 1970s the Somoza family dictatorship in Nicaragua came under attacks from guerrillas of the Sandinista National Liberation Front (FSLN). The organization was founded in 1962 and took its name from Augusto Sandino, hero of the resistance to the US military occupation of Nicaragua, which had lasted from 1927 until 1933. The Sandinistas' socialist programme and commitment to overthrowing the corrupt Somoza dynasty, which had ruled Nicaragua since the US departure in 1933, attracted wide support among the country's trade unions, middle classes and students. FSLN guerrilla raids from sanctuaries inside Costa Rica and Honduras were countered by bloody reprisals from President Anastasio Somoza's National Guard. The US, long supporters of the anti-communist Somozas, withdrew their assistance to the regime during the Carter administration in the late 1970s when atrocities committed by the National Guard against the Sandinistas came to light.

817. The cease-fire in Lebanon which began in October 1976 held until early 1978, when the eastern Christian sector of Beirut was bombarded and surrounded by Syrian forces. In the south, Israel invaded Syria in order to establish a security zone for defence against cross-border attacks by Palestinians who were making raids into northern Israel.

818 top. On the morning of 16 March 1978 Italian terrorists ambushed a car carrying Aldo Moro, the former Italian Premier and one of the country's most influential political leaders. His driver and four bodyguards were killed and he was taken hostage. His captors were members of the Red Brigades who believed that kidnapping Moro would undermine capitalist democracy in Italy and clear the way for a Marxist-Leninist revolution. The terrorists demanded the release of imprisoned Red Brigade terrorists in return for Moro. The Italian government organized the largest manhunt ever mounted in peace-time Italy. Despite these efforts and an impassioned plea for his release from the Pope, Moro was found dead in the back of a stolen car in central Rome on 9 May. His murder shocked Italy.

818 bottom. In November 1978 a tiny South American country became the scene of one of the most horrifying and macabre events in modern times. The Reverend Jim Jones had taken his San Francisco-based People's Temple organization to Guyana and established a commune in Jonestown, near the border with Venezuela. The same year a delegation from the United States, who had travelled to the commune to investigate complaints of abuse made by former members, were killed by Temple members soon after their arrival. The following day Guyanese troops reached the commune to investigate the killings, only to find that the entire population of the commune – 913 people – was dead. The few survivors who had escaped into the jungle reported how an increasingly paranoid Jones told his followers to commit suicide by cyanide poisoning. Some had been shot or forcibly ejected, but the vast majority appeared simply to have obeyed Jones' orders.

819. Israeli Prime Minister Menachem Begin and Egyptian President Anwar Sadat accepted an invitation from US President Jimmy Carter to meet at the Camp David retreat in Maryland in September to discuss a peace settlement for the Middle East. The resulting Camp David Accords provided a framework for lasting peace between the two countries. Most importantly, Egypt officially recognized Israel's sovereignty which other Arab states violently opposed. The historic Accords were recorded in a formal treaty signed on 26 March 1979.

820. New South African Prime Minister Pieter Willem (P.W.) Botha waves to supporters in Pretoria following his election victory in October 1978. The former Defence Minister was a fervent supporter of apartheid even before it became the official national policy in South Africa, but he was also keenly aware of the serious problems arising from the country's growing economic, political and cultural isolation. The brutal repression of the Soweto Uprising in 1976 further worsened the country's already poor reputation in the international community. Botha believed the only way to save the apartheid system was to moderate or at least mask its more pernicious elements.

821. Ruhallah Musavi Khomeini studied the philosophy of the strict Imam Shia Sect of Muslims in Iran for two decades. He was eventually recognized by his followers as Ayatollah – a leader on whom the 'sign of God' had been bestowed. He was fiercely critical of the Shah's westernizing policies, particularly the emancipation of Iranian woman. Khomeini was arrested in the holy city of Qum in 1963 and exiled the following year for his political activities. During his long period in exile, first in Turkey, then in Iraq and finally near Paris in France, he maintained a vigorous opposition to the Shah's 'alien' Western regime and campaigned for the establishment of an Islamic theocracy in Iran. He became the chief symbol of the growing anti-Shah movement in the country. Widespread unrest in 1978 sparked calls for his return.

1979

822. Iran slid into chaos in late 1978 when popular strikes and protests against the Shah exploded into full-scale revolution. By December Ayatollah Khomeini was calling for the Iranian army to desert and join the protestors demanding his return from exile. On 1 February 1979, two weeks after the Shah had fled the country, 3 million people lined the streets of Tehran to welcome Khomeini as he returned to Iran as leader after fifteen years in exile.

823. From the mid 1970s the Shah had attempted brutally to suppress a growing popular movement calling for the reassertion of Islamic values in Iranian society. Thousands of political opponents to his regime were tortured and maltreated. The Shah was forced to leave the country to go 'on holiday' on the 16 January 1979. He settled in Morocco and later in Mexico. Two months after he had left he was formally deposed as Iranian leader and sentenced to death *in absentia*. In October US authorities allowed him to be admitted to a hospital in New York for cancer treatment. Iranian students responded by storming the American Embassy in Tehran and taking fifty-two Americans hostage in an attempt to induce the US to deport the Shah back to Iran. President Carter flatly refused. The Shah left the hospital in New York and was eventually granted asylum in Egypt where he died on 27 July 1980.

824. After Khomeini's return to Iran in February 1979, attempts were made to form a new government based on his strict Islamic code of obedience to the teachings of the Koran. His religious pre-eminence and political astuteness were evident during the difficult transition period of the following year when he acted as *de facto* ruler of the country. With the election of Abolhassan Bani-Sadr as the first President of Iran on 1 February 1980, Khomeini reverted to the status of moral supervisor and supreme leader (*Velayat Faqih*). This gave him a position of unassailable authority in the country which he maintained until his death in 1989.

825. Before the Shah fled into exile in January 1979 he implored the army to remain loyal to Shahpur Bakhtiar, his appointee as Prime Minister. After mass civilian and guerrilla attacks eventually overran the major army bases in the Tehran area in mid February, Ayatollah Khomeini ordered all senior military personnel to appear before newly-erected Islamic courts. Over the next eight months more than 600 political and military officials of the former regime were executed.

826. The new Shiite-dominated Revolutionary Council under Ayatollah Khomeini faced a daunting task in trying to bring stability to a country convulsed by revolution. Several members of the Council were murdered in the general mayhem following the Shah's departure. Khomeini's new constitution was rejected by factions opposed to his monopoly on power in the government, resulting in pitched battles in Tehran and other cities. Extremists and students went on the rampage, brutally enforcing the new Islamic code and engaging in virulently anti-Western behaviour. This culminated in the takeover of the US embassy. A measure of stability was finally restored in late 1981, by which time Iran was involved in a bitter war with its neighbour, Iraq.

827. Christopher Reeve as Superman. Director Richard Donner undertook an exhaustive search of the acting world for the right person to play the 'man of steel' in his hugely expensive adaptation of the famous American comic strip. Reeve so perfectly captured the muscular

power, charm, humour, aloofness and boundless humanity of Superman that it became virtually impossible to envisage anyone else in the role.

828. Leonid Brezhnev kisses East German Prime Minister Erich Honecker after the Soviet leader's arrival in East Berlin to celebrate the thirtieth anniversary of East Germany as a Soviet bloc nation. During Honecker's reign, East Germany developed the most successful economy in the communist sector, in part because of the generous hard-currency payments from West Germany, agreed under *Ostpolitik* in return for humanitarian improvements in the East. Honecker favoured the East-West *détente*, but never strayed too far from the lead he was given by the Kremlin.

829. Soviet leader Leonid Brezhnev was at the height of his power in the mid 1970s and the Soviet Union had never been stronger internationally. Marxist-Leninist regimes were gaining popularity in Africa, Asia and Latin America. The US-Soviet *détente* enabled the Soviet Union to achieve relative military parity with America and also to extend its global reach in cultural and scientific fields. In contrast the US seemed temporarily in retreat, plagued by scandal and political uncertainty. The Warsaw Pact, signed in 1955 as a treaty of 'friendship, co-operation and mutual assistance' between the USSR and East European states, became less an alliance than a vehicle for the extension of Soviet power and communism in Europe. Functioning as both the primary military rival to NATO and the chief means by which Moscow could control political developments in the region (i.e. through the deployment of Soviet troops in each of the member states), the Warsaw Pact saw virtually no dissent from its constituent members in the 1970s. The first cracks in the alliance began to develop in 1980.

830. The first woman party leader in British history, Margaret Thatcher was less popular than the Labour Prime Minister James Callaghan in most opinion polls a year before the next British general election. Thatcher's message that Britain needed a dramatic policy overhaul to encourage vigorous free enterprise

liberated from government and trade union interference was only beginning to resonate with the British public. Internationally however, Thatcher's staunchly anti-socialist credentials had already been well established. In the Soviet Union the Conservative Party leader had been referred to as the 'Iron Lady' since 1976. By early 1979 popular opinion had swung in her favour, and on 4 May she defeated Callaghan in the general election, becoming Britain's first woman prime minister. During the campaign Thatcher shrewdly maintained a balanced, even measured approach to the major issues affecting Britain. Recognizing that the electorate was already in the mood for a change, for the most part she avoided saying anything which a large number of voters might consider too extreme.

831. The Rolling Stones' energetic lead singer Mick Jagger had reinvented himself from a reticent middle-class student at the London School of Economics to a swaggering, irreverent rock hero adored by millions. Second only to the Beatles in popularity among rock and roll audiences in the 1960s, the Rolling Stones were part of the successful 'British invasion' of the American music scene. Its band members were among the leading anti-establishment figures in 1960s Britain. Unlike the Beatles, the Rolling Stones continued touring the world and producing bestselling albums well into the 1970s, 1980s and 1990s, displaying remarkable stamina for a band notoriously fond of the 'fast life'. To what extent Jagger's long relationship with the American fashion model, Jerry Hall, curbed his excesses has been the subject of tabloid speculation for nearly two decades.

832. The first non-Italian pontiff since 1552, Polish-born Karol Wojtyla became Pope John Paul II on 22 October 1978. Known for his tremendous energy and keen intellect during his two decades as a cardinal, John Paul II quickly distinguished himself as an outspoken and uncompromising conservative on theological and moral issues such as marriage, divorce, homosexuality, contraception, abortion, celibacy of the clergy and the ordination of women. He championed economic justice but was critical of liberation theology. He vigorously defended

the role of the Church in communist countries, and Catholics in the Soviet bloc looked hopefully to the Pope as someone capable of undermining the power of communist regimes without encouraging violent confrontation.

833. Above all, John Paul II became known as the 'travelling Pope'. In mid 1979 the Polish government allowed him to return to his native country. Later the same year he became the first Pope to visit Ireland, where he condemned sectarian violence. He also travelled to America. Over the next ten years of his pontificate he would visit seventy-five countries.

834. A film still from Monty Python's *Life of Brian*. Large audiences flocked to see the latest movie from the British comedy troupe, not least because of the controversy surrounding the film. Some conservative critics and religious organizations charged the filmmakers with blasphemy. The film's hero is an exact contemporary of Jesus and follows a parallel life, albeit with considerable comic modifications. Pickets and calls for bans across Britain and America did little to discourage movie-goers.

835. The parade marking the independence of 'Free Lebanon'. On 22 April 1979 Major Saad Haddad, commander of one of many rival Christian militias, proclaimed an Independent and Free State in an 800 square kilometre (3 square acre) chunk of territory in south Lebanon. Israel supported the declaration, but President Elias Sarkis' Lebanese government dismissed Haddad's action as an illegal secession and issued a warrant for his arrest. Heavy fighting broke out when the government unsuccessfully attempted to reassert sovereignty over the partitioned area.

1980

836. In the absence of lasting improvements in Polish standards of living increases in the price of foodstuffs became a regular spark for popular discontent among workers in Poland in the 1970s. One such unannounced rise in food prices on 1 August 1980 triggered massive unrest at the Lenin shipyards in Gdansk. Strikes led by the charismatic Lech Walesa

broke out, and quickly spread across the country. Economic grievances soon transformed into political opposition (e.g. demands for independent trade unions) and by mid September various strike committees had mobilised 300,000 workers into action. On 17 September committee leaders met to form the *Solidarnosc* (Solidarity) trade union movement. Reeling from the sheer scale of the protest, the communist regime of Edward Gierek reluctantly accepted the new organization on 10 November.

837. The Nicaraguan regime of Anastasio Somoza collapsed after Sandinista rebels overcame fierce bombardment from government troops in Managua, the capital, and forced the dictator to flee the country in July 1979. Somoza was assassinated in Paraguay the following year. The revolution cost 50,000 lives and left the impoverished country in political disarray. The new ruling junta led by Daniel Ortega carried out land reforms and embarked on an ambitious programme to improve health and literacy. Initially assistance came from many quarters, including both America and Cuba. After the election of Ronald Reagan in 1981, US aid to the Sandinistas was terminated. Reagan feared the emergence of a Cuban-style communist regime in Nicaragua. He decided that US money was better spent on right-wing counter-revolutionary forces organizing guerrilla attacks against the Sandinistas from bases in neighbouring countries.

838. Once Solidarity was legalized, up to 80 per cent of the total Polish workforce registered with the trade union. The government made concessions providing for a reduction of the working week, a promise of greater food supplies as well as increased freedom of expression in the media, including the broadcast of Catholic masses on Sundays. Solidarity was increasingly seen as a direct political challenge to Gierek's communist regime. Foreign observers feared armed intervention by the Soviet Union to halt the reforms.

839. Flamenco, the traditional music and dance of the Andalusian region of southern Spain, underwent a renaissance in the 1950s. The great performer

Antonio Mairena was its key exponent. Flamenco exists in three forms, *Cante*, the song; *Baile*, the dance; and *Guitarra*, the guitar. It fuses passionate singing, syncopated rhythms and rapid footwork in an artform that has become a great symbol of Spanish culture. Its roots are diverse and can be found in Gipsy, Andalusian, Arabic and even Spanish-Jewish folk songs. In the past few decades mass media has brought the great intensity of its music and energetic dance to worldwide audiences.

840. On 9 December 1980 John Lennon, the Beatles' intellectual leader and one of the most celebrated activists in the anti-war movement, was shot dead in front of his New York apartment. His murderer, Mark David Chapman, was a rock music enthusiast with a history of mental instability. Shock and grief at his senseless death extended far beyond the music world. On the Sunday following his murder, mourners around the world paid a ten minute silent tribute to him at 2:00 pm New York time, at the request of his widow Yoko Ono.

841. In 1980, Lady Diana Frances Spencer became the subject of intense media scrutiny following reports that she was dating Prince Charles, heir to the British throne. Third daughter of the eighth Earl Spencer of Althorp, Lady Diana was working as a kindergarten teacher in London when the highly-publicized relationship began. Her father had been an equery to George VI and subsequently to Prince Charles' mother, Queen Elizabeth II, between 1952 and 1954. In early March 1981 the Queen announced that the couple were to be married that summer.

1981

842. Ronald Reagan appeared in more than twenty Hollywood films before he entered politics in 1967 and became Governor of California. Campaigning as a staunchly right-wing, anti-communist candidate in the 1980 presidential election, he easily defeated his rival, Jimmy Carter. He became the oldest American to enter office as president for the first time on 20 January 1981. Less than ten weeks later he was wounded in an assassination

attempt outside a Washington hotel by a twenty-five-year-old drifter, John Hinckley, who was apparently acting out of a desire to impress his favourite Hollywood actress, Jodi Foster. Hinckley was later found not guilty by reason of insanity, prompting nationwide protests against the use of the insanity defence. Reagan made a remarkably quick recovery which bolstered his popularity considerably.

843. Approaching the thirtieth anniversary of her coronation, Queen Elizabeth II had lost none of the serenity and distance with which she had first performed her royal duties in the early 1950s. She had modernized the British monarch, through the introduction of lunch parties for distinguished guests and Royal walkabouts – steps designed to bring the Royal Family closer to ordinary British people. She made it her special mission to strengthen the loose consti-tutional ties within Britain's former overseas empire while simultaneously working to recast the British Commonwealth as a 'voluntary association of equal partners'. She travelled more widely than any previous British monarch, visiting virtually all the different people and cultures which make up the Commonwealth.

844. On 13 May 1981 Pope John Paul II was wounded in an assassination attempt in St. Peter's Square in the Vatican. The Turkish gunman, Mehmet Ali Agca, initially stated that he was a member of the Popular Front for the Liberation of Palestine (PFLP), but his claim was quickly refuted. Agca subsequently claimed he was acting in co-operation with Bulgaria's secret police at the instigation of the Soviet KGB, although neither country's alleged involvement in the plot has ever been proved. The Pope spent several months recovering before resuming his general audiences in St Peter's Square in early October 1981. The Pope later visited Agca in an Italian prison and publicly forgave him.

845. Most Egyptians welcomed President Sadat's courageous peace initiatives with Israel in the late 1970s and the new course he was forging in foreign policy. But by making peace with Israel he incurred the wrath of his Arab

neighbours and Islamic extremists within Egypt. On 6 October 1981 Sadat was assassinated at a military parade in Cairo. A group of extremists jumped out of an army truck passing in front of the reviewing stand where he stood and opened fire with submachine guns. His successor, Hosni Mubarak, remained committed to completing the peace agreements signed by Sadat but he also made efforts at reconciliation with more moderate Arab leaders.

846. The conflict in Northern Ireland showed no signs of abating at the start of the 1980s, although popular support for terrorists on both sides waned as a result of the rising number of civilian casualties of sectarian violence. The IRA continued a bloody campaign to oust the British from Northern Ireland through attacks on both the security forces and economic targets in Ulster, the Republic of Ireland and England. The growth in loyalist paramilitary strength produced a regular stream of sectarian bombings and assassinations committed by both sides. In early 1981 'the troubles' intensified dramatically after a little known IRA prisoner, Bobby Sands, began a hunger strike.

847. Bobby Sands became the international symbol of Irish republican resistance to British rule in Northern Ireland after he began his hunger strike in the Maze Prison on 1 March 1981. Sentenced to fourteen years for possessing firearms and ammunitions with intent, Sands embarked on a fast in order to gain political-prisoner status from the British government. Other IRA prisoners in the Maze Prison soon joined the hunger strike. Sands' name was put forward as a candidate in a local by-election for the British parliament. Although he won, he was never able to take his seat at Westminister. Sands died on 6 May 1981 in the medical wing of the Maze Prison after refusing food for sixty-six days. He was the first of ten hunger strikers to die that year. Nearly 100,000 people attended his funeral in Belfast the following day.

848. John McEnroe turned professional at the age of nineteen after winning the US collegiate tennis championship in 1978. He reached the Wimbledon final in 1980, losing a five-set marathon to

Björn Borg in what many tennis experts regard as the finest tournament final in the game's history. McEnroe's heroic performance earned him a standing ovation from the Wimbledon crowd. He defeated Borg in the 1981 final but his notoriously poor behaviour on court during the tournament which included 'racket abuse', temper tantrums, berating umpires and line officials and frequent foul language, did not endear McEnroe to the fans or the Wimbledon officials. During his remaining years on the men's professional tennis circuit, fines and suspensions for his poor behaviour marred an otherwise successful career.

849. On 29 July 1981 Prince Charles and Lady Diana Spencer were married at St Paul's Cathedral in London. The day was made a national holiday in Britain. The lavish event, attended by heads of state and dignitaries from around the world, was hailed as a fairytale wedding. After the ceremony the couple spent three nights in Hampshire before flying to Gibralta where they boarded the Royal Yacht Britannia for a fortnight's Mediterranean cruise. The marriage of Charles and Diana attracted enormous public interest and almost unprecedented press coverage of a royal couple in Britain and around the world. The press coverage continued throughout their relationship.

850. A leading member of the so-called 'Gang of Four', Chiang Ching was sentenced to death for acts of sedition and conspiracy committed in the aftermath of the death of her husband, Mao. This was later commuted to life in prison. Chiang and the other three members of the 'Gang' (Chang Cunchiao, Wang Hung-wen and Yao Wen-juan) were all prominent communists whose power was jealously resented by other senior party members. Chiang succeeded briefly in isolating her chief enemy in the succession struggle, Deng Xiaoping, but he re-emerged as party leader in 1978. In 1991 Chiang committed suicide by hanging herself. Chinese reports indicated that she had been released from prison and had been undergoing medical treatment since 1984.

851. French designer Pierre Cardin began his career in fashion

as a tailor during the Second World War in Vichy. After the war, he worked as a design assistant on Christian Dior's 'New Look' which débuted in 1947. In 1953 Cardin opened his own fashion house in Paris. He steadily gained a reputation for elegantly cut clothes for women and as a pioneer in the development of high fashion for businessmen. In 1978 he became the first Western designer to show in China and thereafter continued to make groundbreaking forays into the Chinese market and later the Soviet Union. Cardin also distinguished himself as a shrewd businessman and an innovator. He eventually acquired 840 licenses around the world, lending his name to everything from bidets to caviar. His fashion business is only part of his vast global empire.

852. The death of Bobby Sands was a defining moment in the history of 'the troubles' and set off a wave of anger and revulsion among Catholics on both sides of the Irish border and in the rest of the world. The hunger strikers had aroused worldwide sympathy for Irish nationalists. For the first time members of the IRA were seen to be willing to endure suffering and even death for their cause rather than simply inflicting suffering on others. British Prime Minister Margaret Thatcher saw things differently. She refused to bow to the hunger strikers' demands because she maintained that IRA prisoners were terrorists, responsible for heinous crimes and thus should be treated no differently to other criminals. Immediately after Sands' funeral she remarked in the House of Commons, 'He [Sands] chose to take his own life. It was a choice that his organization did not allow to many of its victims.' There was a sharp rise in support for the IRA and its political wing, Sinn Fein, in the aftermath of the hunger strikes.

853. US space shuttle *Columbia* lifted off on its maiden voyage from the Kennedy Space Center in Florida on 12 April 1981. Piloted by veteran astronaut John Young, *Columbia* was the first reusable rocket-launched vehicle built to send humans into orbit and return them to Earth in a manner similar to that of an ordinary jet plane. One of the driving forces behind the space shuttle programme was NASA's desire to reduce the high costs of space flights. The first

mission, designed to test the flight worthiness and reliability of the shuttle, was a great success and a much-needed boost for NASA.

854. Once Deng Xiaoping was firmly established as China's leader in late 1978, he introduced a number of reforms designed to liberalize academic debate in the country and open up the Chinese economy. A year earlier Deng had made an important speech to the party leadership urging them to embrace modern cultural ideas and technological change. As a result limited private enterprise was permitted. In education and the arts he assigned top priority to upgrading the country's schools and training centres to world-class standards. Foreign scholars were employed in Chinese universities and students were sent abroad. In urban centres, artists and intellectuals, targets of particularly harsh treatment during the Cultural Revolution, began to assert themselves and increasingly came into conflict with orthodox officials. In general, the range of cultural fare available to ordinary Chinese was broadened, though political freedom remained severely restricted.

855. François Mitterrand took office as the fourth President of the Fifth Republic in May 1981. He won the presidency on his third attempt in a close race against his rival, Valéry Giscard d'Estaing. Mitterrand received 51.7 per cent of the popular vote in the decisive second round of the election, becoming France's first freely-elected socialist president. He introduced a series of innovative and radical socialist reforms that were in keeping with a widespread desire for change in France at the time, but which quickly made him extremely unpopular as the country plunged into severe economic crisis.

1982

856–57. Brazil felt the debt crisis which shook Latin America in the 1980s particularly acutely, amassing the highest foreign debt in the Third World. The country faced massive problems of poverty, illiteracy and crime. After nearly two decades of corrupt and inefficient military rule, almost 25 per cent of Brazil's population of 150 million did not have an income sufficient to meet the basic needs

of food, housing, clothing and health care. Consequently, increasing numbers of young people in Brazil took to the streets searching for work. Many children and adolescents had no other home than the streets, and tried to survive by begging, stealing or prostitution.

858. Food shortages led to renewed popular unrest in Poland in autumn 1981. Possibly in order to forestall a Soviet military intervention, General Wojciech Jaruselski staged a military coup (the first military coup in any people's republic) on 13 December 1981. He declared martial law the following day. Trade union activities were banned and Solidarity leaders, including Lech Walesa, were imprisoned. Many of the reforms of the previous fifteen months were reversed.

859. By the end of 1982 strict repression in Poland had abated, but Jaruselski, who had governed through a Military Council of National Salvation during the martial law period, remained prepared to re-impose curfew restrictions at the first signs of renewed political demonstrations. A planned visit by Pope John Paul II was postponed that year for fear his presence might incite widespread rebellion against the new regime. Lech Walesa was released along with other Solidarity leaders on 12 November 1982. Solidarity itself remained banned even after martial law was lifted in July 1983. It survived as a clandestine organization until it was legalized in 1989.

860 top. The dispute between Britain and Argentina over the Falkland Islands had triggered periodic outbreaks of anti-British demonstrations in Argentina and a few incidents around the Islands' waters throughout the century. Called the 'Malvinas' in Spanish, the cluster of islands lies 579 kilometres (360 miles) off the Argentinian coast in the south Atlantic. In the early 1980s growing impatience with Britain's continued presence on the islands and unrest in the Argentinian capital, Buenos Aries, incited the military regime of General Leopoldo Galtieri to seek a prestigious victory that might deflect attention away from the regime's abysmal economic and human rights record. On 2 April 1982 an Argentinian invasion force

seized the islands. Within days Britain had assembled thirty warships with supporting aircraft and auxilliary vessels, and 6,000 troops were ferried about 13,000 kilometres (8,000 miles) to retake the colony by force.

860 bottom. British troops arrived on South Georgia (a dependency of the Falklands) on 25 April and easily recaptured the island. A month later the main British invasion began, and by mid June Argentinian forces had surrendered. Nearly a thousand British and Argentinian soldiers and civilians perished in the brief conflict. The most controversial act of the war was the British sinking of the cruiser *Belgrano* with the loss of 368 Argentinian seamen on board, as it was sailing away from the islands on 2 May. The British victory was a great triumph for Prime Minister Margaret Thatcher who had rejected US pleas for a negotiated settlement to the crisis. It was arguably the turning point of the political fortunes of her Conservative government. In Argentina the defeat led directly to the fall of President Galtieri's regime.

861. In 1954 an army of Guatemalan exiles backed by the American CIA overthrew President Jacobo Arbenz's left-wing government in Guatemala. Soon after this the security forces of the new right-wing military junta began a 'dirty war' which lasted nearly four decades and claimed roughly 200,000 lives. Trained and equipped by the CIA and the US Army, Guatemalan security forces terrorized countless peasant communities suspected of supporting left-wing guerrillas seeking to overthrow the new regime. Massacres, kidnappings, torture and other horrors were commonplace. Some guerrillas were dumped, dead or alive, out of aircraft flying over the sea. The vast majority of victims were Mayan Indians who made up nearly 45 per cent of the country's total population. Entire Mayan villages suspected of harbouring left-wing guerrillas were routinely razed by the security forces in a campaign that verged on genocide. When the war ended with help from the UN in 1996, a report on the situation was prepared by the Historical Clarification Commission, a body which had developed out of the

UN's role in the region. The report claimed that government forces were responsible for over 90 per cent of atrocities committed during the conflict.

862. From October 1982 the government of Vietnam began permitting 'Amerasians' to leave the country for resettlement in the US. The children were the offspring of Vietnamese women and US servicemen who had been stationed in the country between 1962 and 1975. During the late 1970s and early 1980s journalists visiting Ho Chi Minh City reported on the wretched plight of Amerasian children who were ostracized in Vietnamese society and were found begging in the streets. The US and Vietnamese governments, neither very keen to recognize the children as their own, argued bitterly over which country was ultimately responsible for the children, until the US Congress passed what became known as the 'Amerasian Homecoming Act'. The legislation acknowledged the children as American offspring and provided assistance for their resettlement in America.

863. Between 28 August and 5 September a group of women marched over 160 kilometres (100 miles) from Cardiff in Wales to Greenham Common in Berkshire in England. They were protesting against the decision by NATO to site cruise missiles at RAF Greenham Common which had become a base for the United States Air Force (USAF). Upon arrival the women established a Peace Camp outside the main gate of the base and before long other satellite camps were set up around the 14-kilometre (9-mile) perimeter fence of the base. Over the next ten years Greenham Common became the site of a continuous women's peace protest which came to represent a fundamental challenge to the basic assumptions of NATO military planning. During this time huge numbers of non-violent actions, legal challenges, arrests and imprisonments took place. The last American cruise missiles were removed in March 1991.

1983

864. A terrorist truck bomb killed 241 US marines at their barracks in Beirut in Lebanon while a simultaneous attack at the French barracks killed fifty-four French

soldiers. American forces were in Lebanon as part of a multi-national peacekeeping force attempting to bring peace and stability to the war-torn country. In the early 1980s the American presence in Lebanon increasingly came under attack from Islamic groups who claimed, with ample justification, that the US had abandoned its role as impartial mediator in the conflict and was attempting to back up Lebanon's Christian-led government. The US was even providing direct combat assistance to the Lebanese army. The bomb attack on the marine barracks renewed pressure at home on President Reagan to withdraw American troops. He viewed the conflict through the prism of East-West relations and thus blamed the Soviets for fomenting hostilities in the country through their support of Syria. Reagan eventually agreed to withdraw troops and by 30 March 1984 all US military personnel had been evacuated from the country.

865. On 21 October 1983 the organization of the Eastern Caribbean States appealed to the US to assist the people of Grenada after that country's leader, Prime Minister Maurice Bishop, was killed during a left-wing military coup. US President Ronald Reagan, convinced that Cuba and the USSR were seeking to use the island as a base for the export of revolution to the Caribbean basin, was happy to oblige. He argued that the coup threatened the safety of the 1,000 Americans, mostly medical students, on the island. An invasion force of 6,000 US marines supported by fifteen warships and token contingents from six other Caribbean countries landed on the island four days later. Resistance from Grenadian troops and Cuban 'construction workers' on the island was easily overcome and within seventy-two hours the US forces had restored order.

866. All 269 people on board Korean Air Lines (KAL) Flight 007 flying from Anchorage in Alaska to Seoul in South Korea were killed when a Soviet jet fighter fired on the plane after it had strayed into Soviet airspace over the Sea of Japan on 1 September 1983. The destruction of the civilian aeroplane brought furious condemnation from governments around the world, despite claims

by Soviet authorities that KAL 007 had been spying on Soviet military installations on Sakhalin Island. Tension between the two superpowers intensified dramatically in the aftermath of the attack. But the Reagan administration, sensing that the Soviets were determined not to concede any fault in the incident, refrained from taking any major retaliatory steps in order to avert a serious rift with the Kremlin at a delicate time in the cold war.

867. Yasser Arafat began gun-running for Palestinian guerrillas in Jerusalem as a teenager during the first Arab-Israeli war. After building a reputation as a shrewd and resourceful guerrilla leader in various Palestinian resistance groups, he was accepted as Chairman of the Palestinian Liberation Organization (PLO) in 1969. Numerous splits and challenges to his rule in the PLO occurred over the next decade as he struggled to hold the more militant terrorists within the PLO in check. The organization was evicted from Jordan and then Lebanon before finally establishing its headquarters in Tunisia in 1983. An untalented public speaker who was frequently perceived as shifty and duplicitous, Arafat was constantly underestimated by his political opponents. He skillfully enhanced his personal standing through a number of high-profile international meetings for which he always wore the symbolic *kaffiyeh* on his head. Arafat secured recognition for the PLO as the sole representative of the Palestinian people in the Arab world, and in 1974 the UN bestowed official recognition on the organization. By the early 1980s Arafat began to view diplomatic means as a more viable route than terrorism for achieving Palestinian statehood.

868. The oldest and most prestigious trophy in international yacht sailing, the America's Cup, became Australia's cup in 1983. American yachts had successfully defended the cup twenty-four times without a defeat since the first race in 1870, until the 12-metre (40-foot) Australian yacht, *Australia II*, representing the Royal Perth Yacht Club, beat the US defending champion, *Liberty* in the seven-race series. The Australians' historic victory was attributed to

a controversial new design feature on their yacht – *Australia II* had a revolutionary wing on the foot of the keel and less body in its stern, enabling more manoeuvrability and increased speed in light winds. The cup returned to American tenure in 1987 when Dennis Connor skippered *Stars and Stripes* to victory for the San Diego Yacht Club of California.

869. French students demonstrating in Paris. Few events in the history of the French Fifth Republic left as powerful a legacy as the student revolts of 1968, but for the students themselves *les événments de '68'* as they were known, were not the beginning of the new era in French education they had hoped for. Universities in France continued to be overburdened. Enrolment increased but the promised expansion and upgrading of facilities was not carried out. In addition the government's objective of smaller classes proved difficult to realize in practice. Although strike action by students in the late 1960s had shown that the authority of the French establishment could be challenged, by 1983 students were less inclined to 'take to the streets'. This was due to the changed political situation in France, namely the election of a socialist president François Mitterrand in 1981, and the presence of a socialist government between 1981 and 1986. These factors inhibited trade unions as well as students who, except for some isolated protests, generally refrained from militancy for fear of playing into the hands of right-wing political parties less sympathetic to their demands.

870. In January 1983 Nigeria ordered 2 million illegal immigrants to leave the country within a month. The expulsion of the 'aliens' (nearly a million from Ghana, half a million from Niger and smaller numbers from other neighbouring countries) was rooted in a number of factors. Xenophobia, growing hostility towards immigrants suspected of taking jobs from Nigerians during a period of economic uncertainty, and reports that immigrants were involved in criminal activities, all played a role in the government's decision. The plight of 'aliens' fleeing the country, many of whom suffered severe hardships and attacks from marauders as they

attempted to get back to their native lands, attracted widespread attention and dented Nigeria's image internationally. Domestically, however, support for the government's actions was strong. Despite local opposition to immigrants, they were already starting to return by April.

871. By the early 1980s the bloody conflict in Lebanon had reduced much of the country's capital, Beirut, to rubble. As the centre of Lebanon's warring religious communities, Beirut – once considered the 'Paris of the Middle East' – was constantly under attack from aircraft, artillery and bombings. The previously wealthy city lost its position as the region's chief economic and banking centre, and was divided into Muslim and Christian-dominated areas by the 'green line', a dangerous no-man's land that cut through the middle of Beirut.

1984

872. *Challenger* blasted off on NASA's tenth space shuttle mission on 3 February 1984. The primary objectives were to launch two communication satellites into orbit and to evaluate the reliability and effectiveness of the two Manned Manoeuvring Units (MMU) on board. The new technology was reminiscent of images from science-fiction cartoons: the units were shaped like chairs with extended arms containing hand controls and powered by twenty-four dry nitrogen thrusters enabling maximum speed in space of 18 metres (60 feet) a second.

873. On 7 February 1984 Captain Bruce McCandless and Colonel Robert Stewart conducted the first untethered space walks for a total of five hours at distances of up to 90 metres (295 feet) from *Challenger*. Images of the astronauts 'floating' out into space made for spectacular and slightly unreal viewing. NASA was thrilled with the success of the first experiments with MMUs, which were designed for the retrieval and repair of satellites already in orbit, as well as the construction and maintenance of space stations planned for the future. Unfortunately problems were encountered with the devices during the follow-up mission in April.

874. President P.W. Botha's attempt to ease some of the more extreme aspects of apartheid while maintaining the core tenets of the racist system backfired in the mid 1980s. His new constitution which came into effect in September 1984 gave limited recognition to Indians and coloureds but South Africa's black majority remained excluded and virtually powerless. Protests in the form of school boycotts and stay-away campaigns by black workers spread across the country's segregated townships. The new constitution also sparked a revival of black militancy, leading to riots in the townships and brutal repression by South African security forces. Hundreds of protestors were arrested and an estimated one hundred people died. By the end of the year Botha's reforms seemed nothing more than a further entrenchment of apartheid and South Africa's white leaders faced the prospect of a full-scale black rebellion.

875. In response to the long-term decline of the British mining industry, due primarily to the availability of cheaper coal imported from overseas and the growing importance of alternative fuels, on 6 March 1984 Britain's National Coal Board announced plans to close twenty uneconomic pits and thereby make redundant 20,000 of the mining industry's 180,000 workers. Arthur Scargill, head of the National Union of Mineworkers (NUM), claimed there was no such thing as an uneconomic pit and the union launched a strike. Set against a background of persistent rising unemployment, the bitter and often violent dispute became fiercely political, demonstrating the change in the balance of power which had moved away from the trade unions following Thatcher's election victory in 1979. Her toughness and resolve was evident throughout the crisis, and nearly a year after the strike began Scargill's miners were forced to concede defeat.

876. As Soviet ambassador to Budapest in the mid 1950s, Yuri Andropov played a key role in crushing the 1956 Hungarian uprising. He was head of the KGB from 1967 to 1982 and was chosen as Leonid Brezhnev's successor as General Secretary of the Communist Party in 1973. After Brezhnev's death in 1982, Andropov

became leader of the Soviet Union and quickly proved more committed to reform than his previous career in the party might have suggested. He groomed and promoted a number of potential successors and initiated steps designed to make the Soviet economy more efficient and increase worker discipline. Andropov died on 9 February 1984 fifteen months after taking office. His short term as Soviet leader prevented him from leaving any significant legacy, save perhaps his promotion of reform-minded communists, most notably Mikhail Gorbachev.

877. A memorial service for Archbishop Oscar Romero. When Oscar Romero was appointed Archbishop of San Salvador in 1977 his colleagues in the Roman Catholic church generally regarded him as a cautious and conservative priest, unlikely to interfere much in an ongoing conflict between El Salvador's right-wing military regime and the leftist rebels. However, three weeks after his ordination a close friend and popular left-wing priest was murdered. This event seemed to radicalize Romero and he soon became an outspoke critic of the government's human rights abuses. During his Sunday sermons broadcast on national radio he denounced the kidnappings and murders. He also gave publicity to independent investigations which implicated government forces in such crimes. He spoke out strongly on economic issues and championed the cause of the country's poor. By 1980 Romero had become famous internationally and was nominated for the Nobel Peace Prize. Although he received numerous death threats, Romero openly backed popular left-wing groups and called on the US administration to cease shipments of arms to El Salvador's military junta. Romero was shot by a member of a government death squad while performing mass in the early evening of 24 March 1980. His death instantly transformed Romero into one of the twentieth-century's great martyrs for truth, justice, dignity and human rights around the world.

878. In the early hours of 3 December 1984 roughly 45 tons of the dangerous gas methyl isocyanate escaped from an insecticide plant in Bhopal in

India and drifted over the densely populated neighbourhoods surrounding the factory. An estimated 2,500 people were killed, although Indian sources place the figure much higher and subsequent deaths due to illnesses related to the leak have probably increased the mortality rate by several thousand. Many residents died in their sleep. The very old and the very young were particularly susceptible to the poisonous effects of the gas, and thus represented a disproportionate number of the victims. Nearly 50,000 residents suffering from various illnesses due to exposure to the toxic substance poured into local medical facilities ill-prepared to handle what turned out to be the worst industrial accident in history. Later investigations concluded that sub-standard operating and safety procedures were used at the plant. Executives of Union Carbide, the American-owned company responsible for the disaster, faced criminal charges in India and multi-million dollar suits from the families of the dead and those still suffering ill-effects from the toxic gas leak.

879. Indira Gandhi began her political career as an aide to her father, Jawaharlal Nehru, India's first prime minister. In 1966 the ruling Congress Party selected Gandhi as Prime Minister. Initially she achieved popularity with her ardent nationalism and commitment to eradicating poverty in India, but mounting criticism of her management of the economy edged her towards authoritarianism. She lost power briefly in 1977 before regaining office in 1980. During her last four years in office, Gandhi was widely regarded by the international community to be the leader of the developing Third World. However she was unable to suppress sectarian violence within her own country. In June 1984 she ordered the Indian army into the Golden Temple at Amritsar to remove the Sikhs occupying the holy shrine by force, resulting in the deaths of about 300 Sikhs. On the morning of 31 October 1984 she was assassinated in the garden of her home in New Deli by two Sikh members of her bodyguard in a mission of revenge for the killing of Sikhs at Amritsar.

880. Following the announcement of Gandhi's assassination, anti-

Sikh riots exploded across the country, particularly in the capital, New Delhi. Hindus attacked Sikhs in the streets and hundreds of houses, shops and vehicles were burned. On the evening of 31 October Gandhi's son, Rajiv, was sworn in as Prime Minister. He appealed for calm and ordered stern punishments for rioters. The situation was brought under control within three days but not before an estimated 3,000 Sikhs had been massacred.

881. The eagerly awaited duel between Mary Decker and Zola Budd in the women's 3,000 metre race at the 1984 Summer Olympics in Los Angeles promised to be the highlight of their running careers. Instead the race turned into a nightmare for both of them. The youthful Budd had created sensational headlines in the months prior to the Games both for her extraordinary bare-footed running feats in which she set a world-best time in the 5,000 metres, and for her controversial acquisition of British citizenship. The native South African was the subject of intense anti-apartheid protests following the British government's expeditious moves to grant Budd – who, as a South African, was banned from international competition – citizenship just in time for her to compete for Britain at the 1984 Olympics. Budd's hero, Decker, was acclaimed as the 'golden girl' of US athletics, holding the world record for middle and long-distance running. During the 3,000 metre final at Los Angeles the two athletes were running close together near the leaders when they bumped slightly. Decker fell to the ground in agony. Budd, visibly distraught, continued while the enormous crowd at the Olympic stadium booed unrelentingly until she finished the race, a disappointing seventh. Budd was immediately disqualified but the decision was reversed after officials determined it was just an accident.

882. The devastating IRA bomb attack on the Grand Hotel in Brighton in England left five people dead including Sir Anthony Berry, a member of parliament, and several others seriously maimed or injured, including Norman Tebbit, Secretary of State for Trade and Industry. Immediately after the blast an official IRA statement was issued with the ominous warning: 'Today, we were unlucky, but remember, we only have to be lucky once – you will have to be lucky always.'

883. At around 3:00 am on 12 October 1984 a 9 kilogramme (20 pound) bomb planted by the IRA sliced four floors out of the middle of the Grand Hotel in Brighton where Margaret Thatcher and members of her cabinet were staying for the annual Tory Party conference. Thatcher narrowly escaped with her life, having been in the bathroom of her Napoleon Suite just two minutes before it was torn apart by the blast. She and her husband were escorted out of Brighton by the police immediately, before she was able to discover the fate of other Conservative Party members staying at the hotel.

1985

884. After the collapse of the Portugese military regime in Lisbon in 1974 Angola was granted independence on 10 November 1975. A struggle for power ensued among three established guerrilla movements which had successfully attracted foreign sponsors and were firmly entrenched by the 1970s. In February 1976 the Soviet and Cuban-backed Popular Front for the Liberation of Angola (MPLA) gained the upper hand and proclaimed a Socialist People's Republic. Cuban presence in the country rose steadily while South African intervention to support the US-backed National Union for the Complete Independence of Angola (UNITA), led by Jonas Savimbi, attempted to oust the MPLA from power. By 1985 right–wing elements in the US government, alarmed at the estimated 40,000 Cuban troops and massive Soviet tank and weapon supplies in Angola, began to regard Savimbi's UNITA forces as 'freedom fighters' and shipped arms through Zaïre in order to get around a Congressional ban on arms shipments to Angola. Savimbi's strength grew. Although he represented democratic and capitalist forces, his association with the US and South Africa made him unpopular in other African countries.

885. Black townships in South Africa descended into bloody chaos between July 1985 and March 1986 as apartheid laws were brutally enforced under special 'state of emergency' powers passed by President Botha in thirty-six districts of the country. Civil unrest and police repression claimed hundreds of lives and nearly 8,000 opponents of the white regime were detained. In August 1985 the South African leader publicly reaffirmed his government's commitment to apartheid, incurring the wrath of all non-whites in the country and virtually the whole international community. The isolation of his regime became acute. Over a hundred companies left South Africa and most Organization of Economic Cooperation and Development (OECD) countries imposed sanctions. The UN declared apartheid a crime against humanity. Israel (one of the few remaining allies of the apartheid regime) voted not to extend existing defence contracts with South Africa.

886. On 21 March 1985 police opened fire on a procession of black mourners near Port Elizabeth in South Africa. They were on their way between townships after the funerals of several people killed in a recent clash with security forces. The police commander later claimed that the incident, which occurred on the twenty-fifth anniversary of the Sharpeville Massacre, was provoked by attempts by the mourners to rampage through a nearby white suburb. A subsequent investigation dismissed this allegation and reported that the crowd had been fired on while they were running away from the police, just as they had been in Sharpeville in 1960. Roughly three-quarters of the more than forty people killed or wounded in the shootings had been shot in the back.

887. After seeing horrific television images of starving children in Ethiopia pop star Bob Geldof, lead singer of the Boomtown Rats, began urging celebrities and colleagues in the music industry to record a song to raise money for famine relief in Africa. His efforts resulted in the phenomenally successful single *Do they Know It's Christmas*, which spawned similar fund-raising records by artists in the US and around the world. The records were followed on 13 July 1985 with 'Live Aid', a concert staged simultaneously at Wembley Stadium in London and Kennedy Stadium in Philadelphia which featured many of the biggest names in popular music. The concert attracted an enormous worldwide television audience and did more to raise global awareness of the problem of famine in central Africa than any other single event.

888. On 11 March 1985 Mikhail Gorbachev became General Secretary of the Communist Party. Little was known about the former agriculture minister outside the Soviet Union when he met Ronald Reagan in Geneva nine months later for the first meeting between leaders of the world's two superpowers in six years. Reagan's anti-communism was, by 1985, almost legendary and there were few signs leading up to the Geneva Summit to suggest that the new leader of the 'evil empire' (in Reagan's famous words) would change his views. The initial meeting between the two men was a very brief personal encounter, but after meeting they decided, unexpectedly, to hold further discussions with one another behind closed doors.

889. On 10 July 1985 the Greenpeace ship *Rainbow Warrior* was sunk by two bomb explosions while docked in Auckland Harbour in New Zealand. The blasts also killed a Greenpeace photographer, Fernando Pereira. The environmental organization was planning to sail the vessel to Mururoa Atoll in the South Pacific to protest against French atmospheric nuclear tests being carried out in the area. A subsequent investigation into the explosions revealed that the bombs had been planted by French intelligence agents, who later went on trial in an Auckland court and pleaded guilty to charges of manslaughter and willful damage. The incident proved deeply embarrassing for France and caused a major international scandal. As a result the head of France's intelligence service was dismissed and on 19 September 1985 the country's Defence Minister, Charles Hernu, resigned.

890. The traditional Czech group-gymnastic society, the Sokol, had been dissolved by the country's communist leaders in 1948, but its spirit lived on in revived Sokol-style festivals under the new name *Spartakiáda*. This name conferred by the communists had been used for the Czech trade union movement's gymnastic event in 1921. The name was derived, fittingly, from the Spartacists who had made a failed attempt to seize power in Germany in 1919. The name also referred to the Roman slave-rebel, Spartacus. Although group gymnastics disappeared in most countries, in Czechoslovakia it continued to attract thousands of young participants. Local festivals were held to determine the best teams for the nationwide *Spartakiáda* event, where as many as 10,000 people performed in unison.

891. An hour before the start of football's European Cup Final in Brussels on 29 May 1985 between Liverpool (Britain) and Juventus (Italy), violence erupted among rival fans inside the Heysel Stadium. Liverpool supporters charged into a section of the stand occupied by Juventus fans. Several Italians were trampled to death as part of the stand collapsed under the weight of the surging English 'hooligans'. In total thirty-nine people were killed, the vast majority Juventus fans, and hundreds were injured. Fearing further riots if the match was cancelled, officials ordered the teams onto the playing field and the match went ahead. Juventus won, one goal to nil. The appalling incident highlighted the growth of hooliganism in football and reinforced a widely-held image of English fans as the worst offenders. FIFA, football's governing body, banned English clubs from European competitions for the rest of the 1980s.

1986–1999
Chaos and Hope on a Burdened Planet

The fall of the Berlin Wall in 1989 ushered in a new era in international politics. The Soviet Union's empire in Eastern Europe disintergrated peacefully and the cold war came to an end. Germany was re-unified within two years of the fall of the Wall. The Soviet Union itself collapsed when Mikhail Gorbachev's reforms exposed the dire condition of the country's infrastructure. US President George Bush was compelled to herald the dawn of a 'New World Order' but his slogan failed to stick, and for good reason. China opened up its doors to business, but the Tiananmen Square massacre in 1989 demonstrated that the leaders of the world's largest country remained steadfastly opposed to political reform. Rwanda descended into tribal genocide on a scale not seen since the Second World War. In the Blakans, nationalism and ethnic rivalries have once again erupted into war. Europe's major powers watch from the sidelines. Yugoslavia's leader Slobodan Milosevic acts with impunity in the region as he brutalizes neighbouring populations and attempts to crush opposition to Serbian rule by Croats, Bosnian Muslims and ethnic Albanians. Although the threat of war – especially nuclear war – has significantly diminished in many parts of the world, it has been replaced by an increasing awareness of the dangers posed by industrial pollution and environmental destruction which threatens everyone, regardless of national borders. The explosion at the nuclear power-plant in Chernobyl in 1986 which sent radioactive clouds across Europe and killed hundreds of people, has caused some countries to abandon their nuclear energy programmes. It has raised global awareness of the devastating long-term effects of industrial disasters on the natural world. In sport France hosted football's World Cup and its national side won the tournament, sparking the largest spontaneous celebrations the country had seen since its liberation from German occupation in 1944. A significant milestone in aviation was achieved in the century's final year as two balloonists made the first non-stop balloon flight around the world in their Breitling Orbiter 3. The leader of the African National Congress Nelson Mandela was released after more than a quarter of a century in prison. In 1994 he became South Africa's first black president and won universal praise and admiration for his commitment to peace and reconciliation with his former oppressors, rather than seeking revenge. The untimely death of Princess Diana shocked much of the world and caused an outpouring of public grief in Britain which was exceptional in its intensity and magnitude. Extraordinary developments in technology – notably telecommunications, computers and information technology – have fundamentally changed the way governments, corporations and private individuals do business. The power of media barons such as Rupert Murdoch and technology leaders such as Bill Gates seem virtually limitless. National governments are increasingly falling prey to forces beyond their control, particularly fluctuations in world financial markets. In 1999 people can look back in awe on a century which has witnessed remarkable technological and scientific achievements. Conflict in many parts of the world serve to remind us that the twentieth century has been one of the bloodiest centuries in human history.

Contemporary Voices

The guilt of Stalin and his immediate entourage before the Communist Party and the people for the mass repressions and crimes they committed is enormous and unforgivable.

Mikhail Gorbachev, speech on the seventieth anniversary of Russian revolution, 2 November 1987

Fidel Castro is right. You do not quieten your enemy by talking with him like a priest, but by burning him.

Nicolae Ceausescu, speech, 17 December 1989

My arrival at the castle was full of surprises. I was studying the topography of the hall where my [presidential] office was located, when I realized that there had to be two more rooms. I didn't know what was in them. I started to break in, and as it turned out, the two rooms contained the supersecret teleprinter of the Warsaw Pact [the Soviet-led military alliance]. It was an immense machine that occupied both rooms and was enclosed in cages. I asked to be let inside to use the machine. Some secret-service colonels unlocked everything and set the gigantic machine in motion. I sent a message to [Mikhail] Gobachev thanking him for congratulating me on my election as president. After some time, I received a message from [KGB chief Vladimir] Kryuchkov saying he was impressed by how quickly I had discovered their machine.

Vaclav Havel, account of the Velvet Revolution, 29 December 1989

Under the thick leaves of the forest, there's a life
more intricate than ours, with our vows of love,
that seethes under the spider's veil on the wet leaf.

There's a race of beetles whose nature is to bleed
the very source that nourishes them, till the host
is a rattling carapace; slowly they proceed

to a fecund partner, mounting the dry one's ghost.
No, there is no such insect, but there are creatures
with two legs only, but with pincers in their eyes,

and arms that clinch and stroke us; they hang like leeches
on the greenest vines of paradise.
And often, in the female, what may seem wilful

will seem like happiness, that spasmic ecstasy
which ejects the fatal acid, from which men fall
like a desiccated leaf; and this natural history

is not confined to the female of the species,
it all depends on who gains puchase, since the male,
like the dung-beetle storing up its dry faeces,

can leave its exhausted mate hysterical, pale.
This is succession, it hides underneath a log,
it crawls on a shaken flower, and then both mates

embrace, and forgive; then the usual epilogue
occurs, where one lies weeping, which the other
hates.
All I had gotten I deserved, I now saw this,

and though I had self-contempt for my own deep
pain,
I lay drained in bed, like the same dry carapace
I had made of others, till my own turn came.

Derek Walcott, *Omeros*, 1990

You can make a throne of bayonets, but you can't
sit on it for long.

Boris Yeltsin, speech, August 1991

So read my lips. Mo-ney. Pow-er. Fame.
And had I been asked, in my time,
in my puce and prosperous prime,
if I recalled the crumbling slum
of my Daddy's home,
if I was a shit, a sham,
if I'd done immeasurable harm,
I could have replied with a dream:
the water that night was calm
and with my enormous mouth, in bubbles and
blood and phlegm,
I gargled my name.

Carol Ann Duffy, *Fraud*, 1993

Power, in Case's world, meant corporate power. The zaibatsus, the multinationals that shaped the course of human history, had transcended old barriers. Viewed as organisms, they had attained a kind of immortality. You couldn't kill a zaibatsu by assassinating a dozen key executives; there were others waiting to step up the ladder, assume the vacated position, access the vast banks of corporate memory. But Tessier-Ashpool wasn't like that, and he sensed the difference in the death of its founder. T-A was an atavism, a clan. He remembered the litter of the old man's chamber, the soiled humanity of it, the ragged spines of the old audio disks in their paper sleeves. One foot bare, the other in a velvet slipper.

[...] Case had always taken it for granted that the real bosses, the kingpins in a given industry, would be both more and less than *people*. He'd seen it in the men who'd crippled him in Memphis, he'd seen Wage affect the semblance of it in Night City, and it had allowed him to accept Armitage's flatness and lack of feeling. He'd always imagined it as a gradual and willing accommodation of the machine, the system, the parent organism. It was the root of street cool, too, the knowing posture that implied connection, invisible lines up to hidden levels of influence.

William Gibson, *Neuromancer*, 1993

It's better to burn out than fade away.

Kurt Cobain, suicide note, 8 April 1994

There was a surreal sense of madness. A convoy of gendarmes and soldiers also arrived. They, too, had machetes, but also automatic rifles and grenades. Hacking, clubbing and shooting, they slaughtered every Tutsi they saw. The killing lasted into the night. The object was to destroy everyone. I hid under a pile of bodies and, after dark, fled into the mountains. I was born in an extended family of 1,000 members. Of them, only I and two children remain.

José Rumbambana, account of Rwanda, 16 April 1994

My husband was very apprehensive about the rally. He [wondered] whether the crowd would be big enough. [But later] we saw this huge, joyful crowd. It was like a carnival. He didn't look worried, but [worry] never left my mind. At one point a reporter asked me if my husband was wearing a bulletproof vest. I looked at her and said, 'What are you talking about? He never wears a bulletproof vest.' As we were going down the stairs [at the end of the rally], I said to the man in charge of security, 'Thank God, everything went well', meaning that the crowd was safe. And he said to me, 'So far.' Two minutes later there were the bullets.

Leah Rabin, account of Rabin's assassination, 4 November 1995

I am troubled, however, by the possibility that in the very long run computers and software could achieve true intelligence. Predicting a time frame is impossible because progress in artificial intelligence research is so incredibly slow. But once machines can really learn, they will be able to take over most things humans do today. This will raise issues of who is in control and what the whole purpose of our species is.

Bill Gates, *The Road Ahead*, 1996

Millenial questions record our foibles, rather than nature's dicatates, because they all lie at the arbitrary end of this spectrum. At the opposite and factual end, nature gives us three primary cycles – days as earthly rotations, lunations (we define our months slightly differently, and for interesting reasons) as revolutions of the moon around the earth, and years as revolutions of the earth around the sun. (God, who on this issue, is either ineffable, mathematically incompetent, or just plain comical – also arranged these primary cycles in such a way that not one of them works as a simple multiple of any other – the source of many millennial issues.)

Stephen Jay Gould, *Questioning the Millenium*, 1998

An image of Ferdinand and Imelda Marcos crudely but deservedly defaced during the Filipino presidential elections they had rigged.

The worst ever nuclear disaster – the Chernobyl explosion and meltdown eventually killed thousands of Ukranians as a result of exposure to radiation.

Freddie Mercury, the brilliant pop star who died of AIDS, confidently strutting his stuff for his fans.

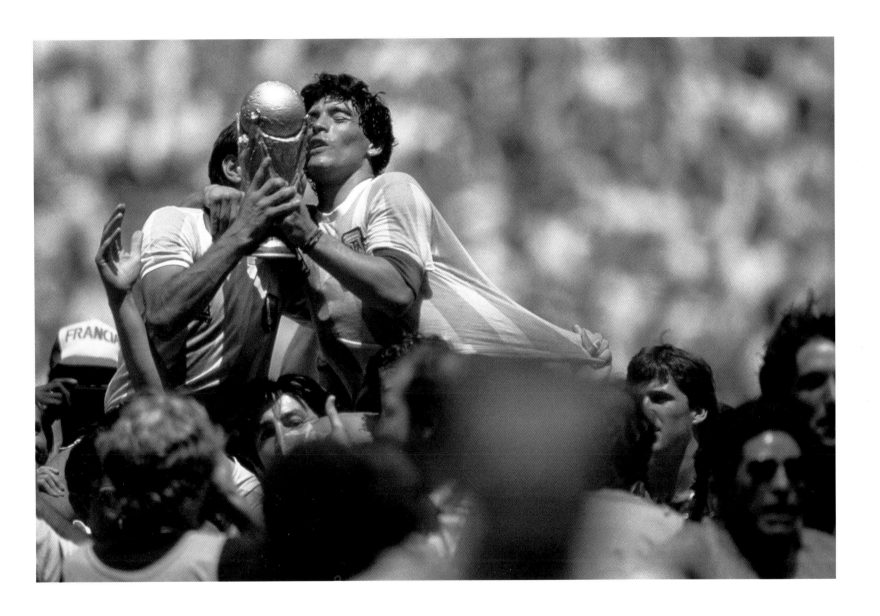

Diego Maradona, the footballer who attributed his disputed goal to 'the hand of God' embracing the 'heaven-sent' World Cup.

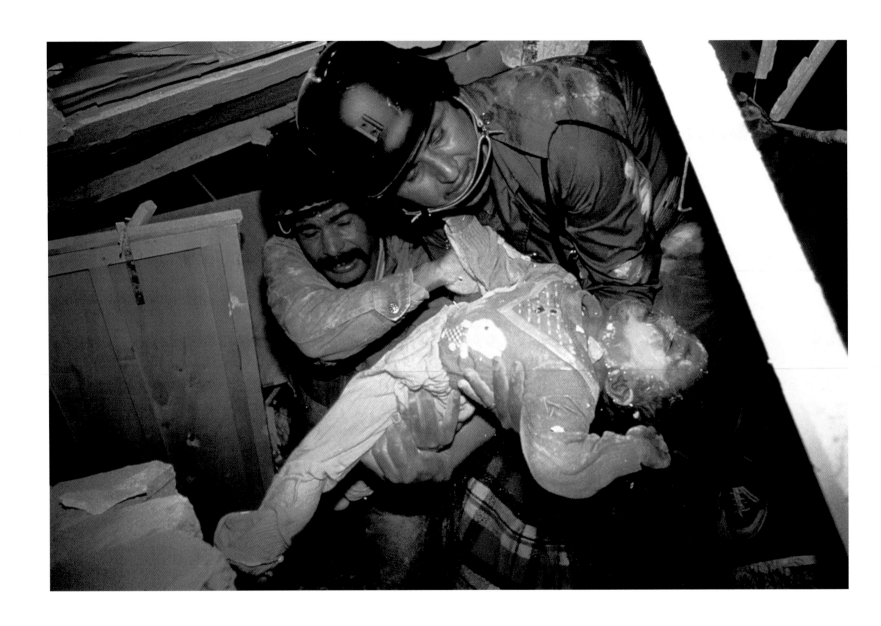

President Reagan's bombings on Libya to avenge acts of terrorism against Americans attributed to Colonel Gaddafi, killed over a hundred people including this little girl.

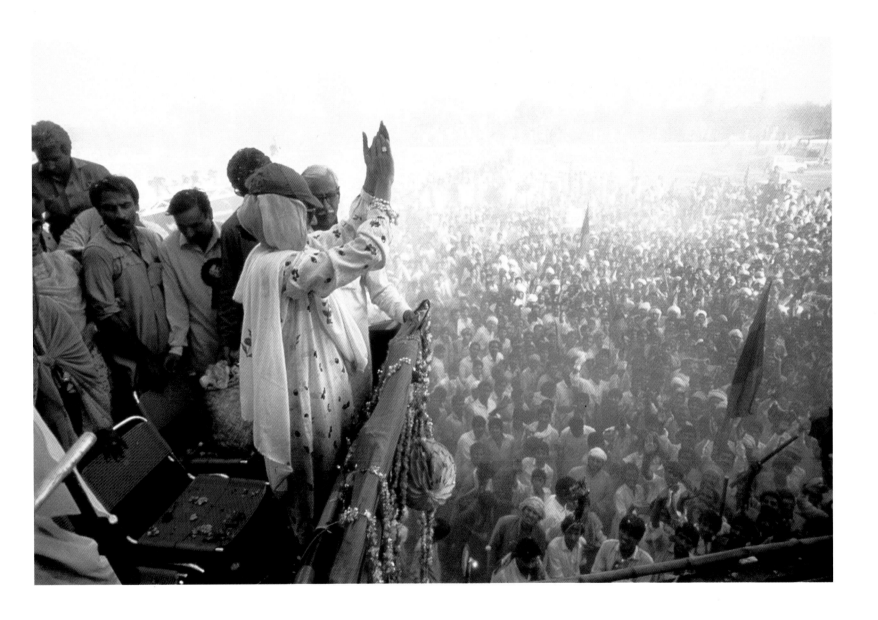

Benazir Bhutto returns to Pakistan after two years in exile to a rapturous welcome from a million.

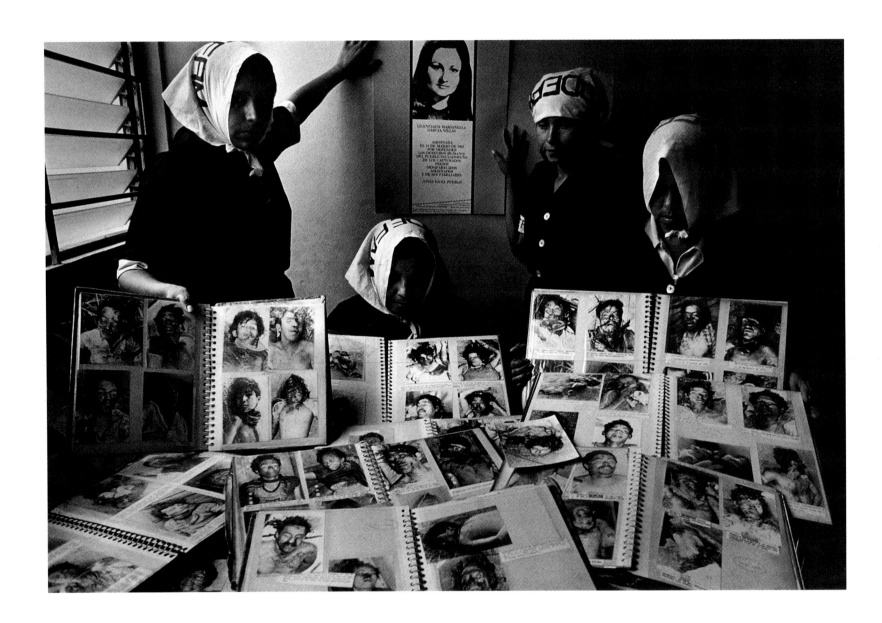

Women of El Salvador showing photographs of men who had 'disappeared' – probably murdered by the government.

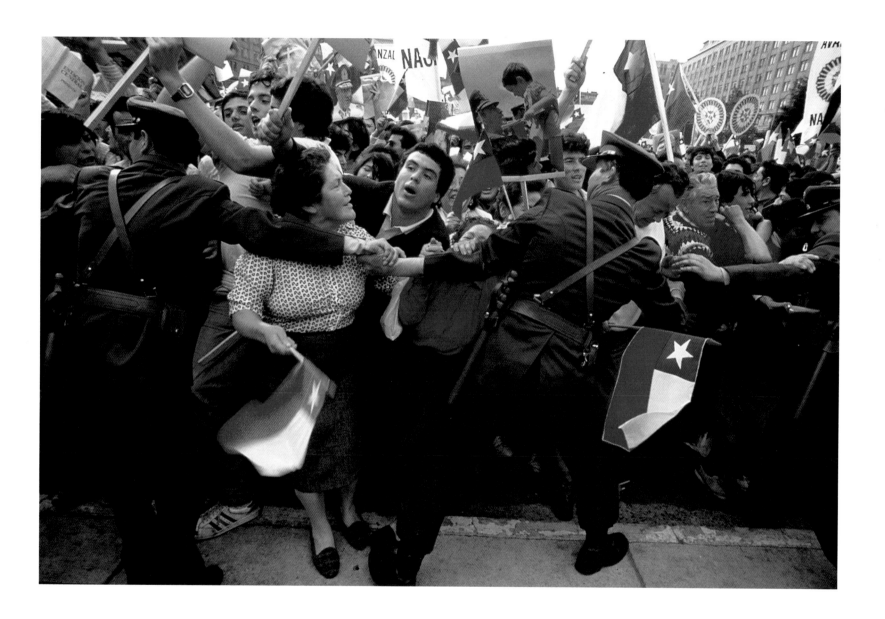

Supporters of General Pinochet demonstrating in Santiago.

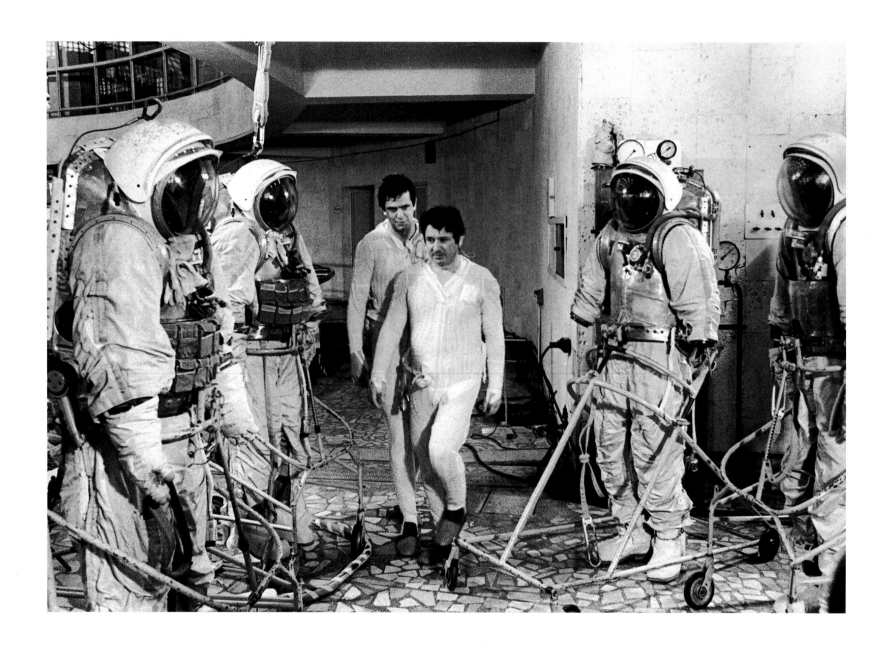

Russian cosmonauts choose from an off-the-trolley space wardrobe.

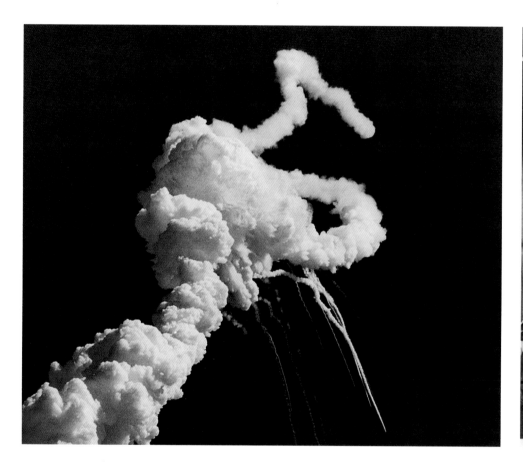

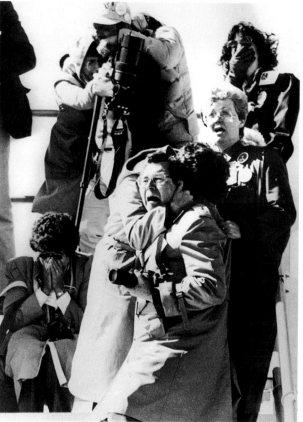

An American space tragedy in which the first ever civilian crew member, Christa McAuliffe, was killed. Six astronauts died with her.
Sheer horror and grief are instantly expressed by spectators who had hoped only for exhilaration from the launch.

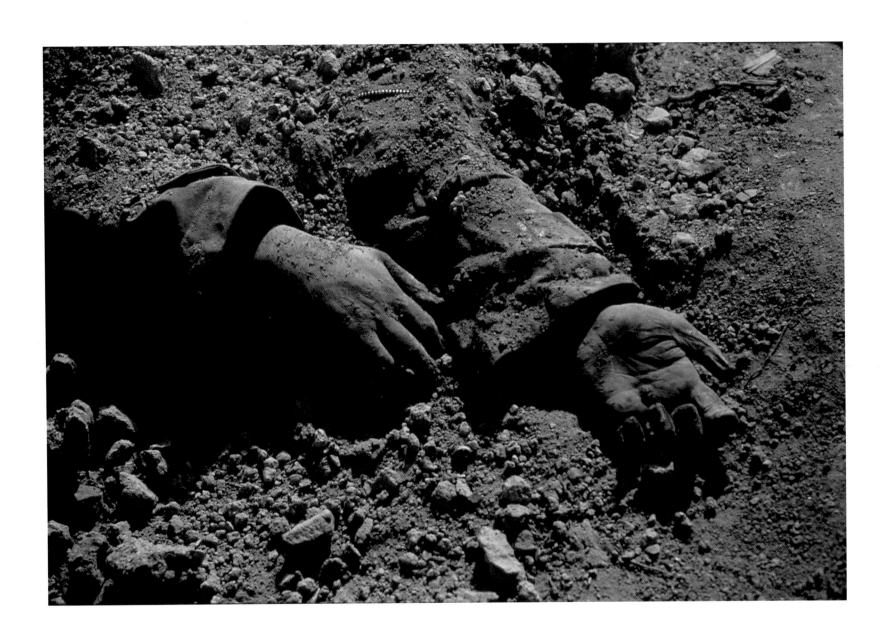

An Iranian shattered by Iraqi artillery fire.

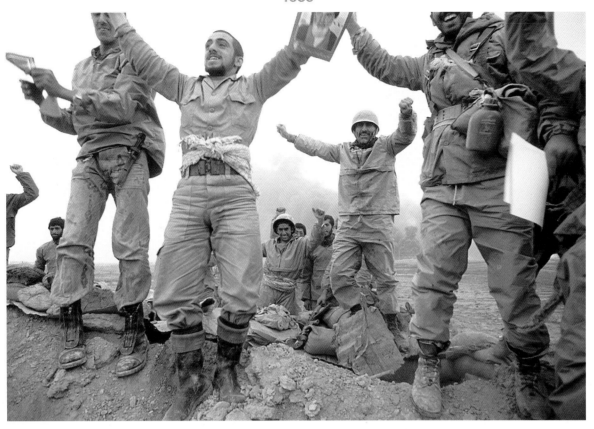

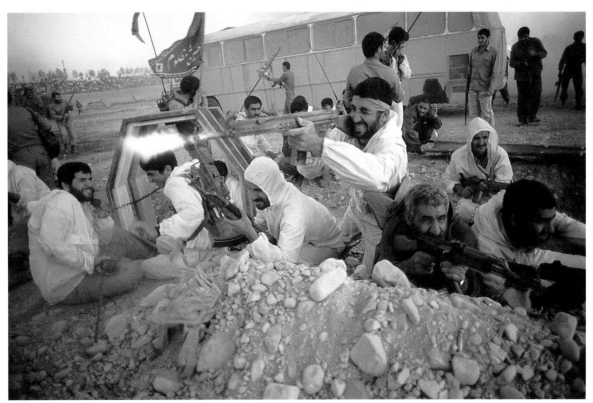

Iranians waving images of the Ayatollah in affirmation of their implacable hostility towards Iraq.
Iranian troops firing wildly to mark the sixth anniversary of their war with Iraq.

Traditional folk-weaving masks the brutal reality of a powerful Russian weapon – a Kalashnikov used by Afghans against its country of origin.

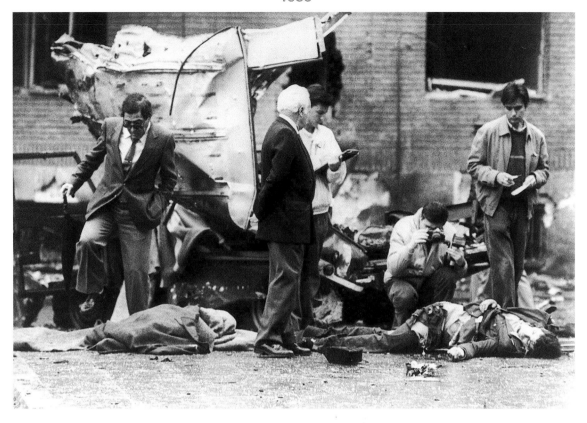

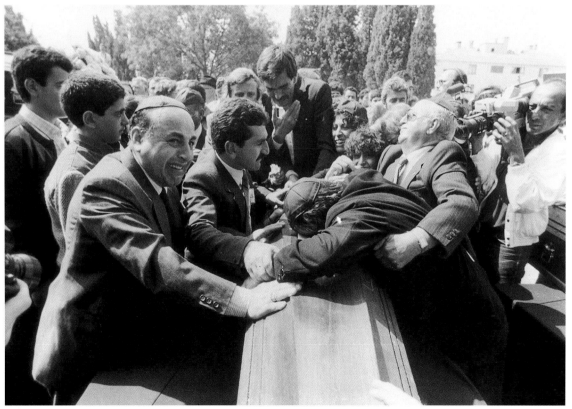

The Spanish Basque ETA were responsible for this bomb carnage in Madrid which killed five civil guards and wounded eight others.
The funeral of twenty-one Jews killed in an Istanbul synagogue.

Oliver North, briefly a hero for right-wing America, swearing his oath at the Iran-Contra hearing.

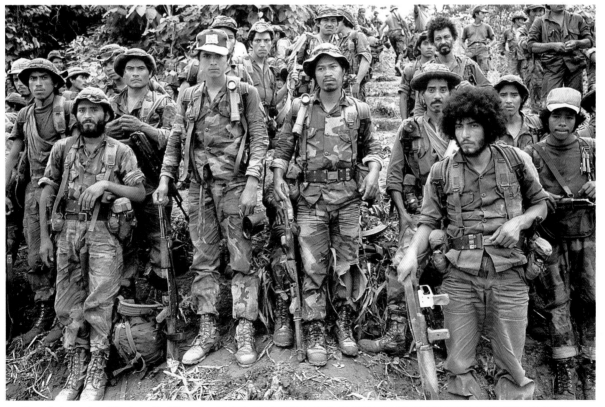

Two photographs of Contras, the Nicaraguan rebels who fought against the left-wing Sandinista government of Daniel Ortega.
The rebels were secretly supplied with arms and money by America.

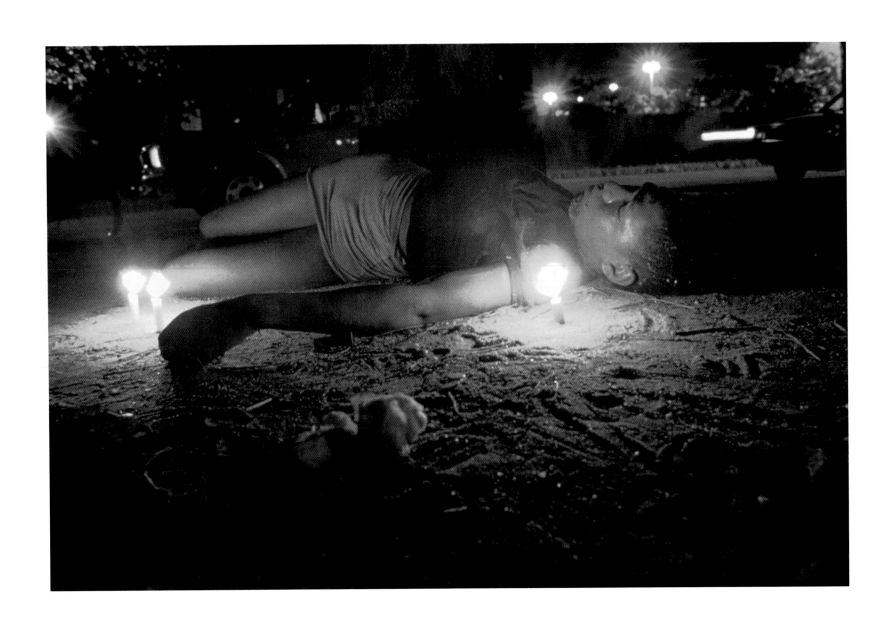

The appalling plight of street children in South American cities – here a murdered seventeen-year-old Brazilian transvestite.

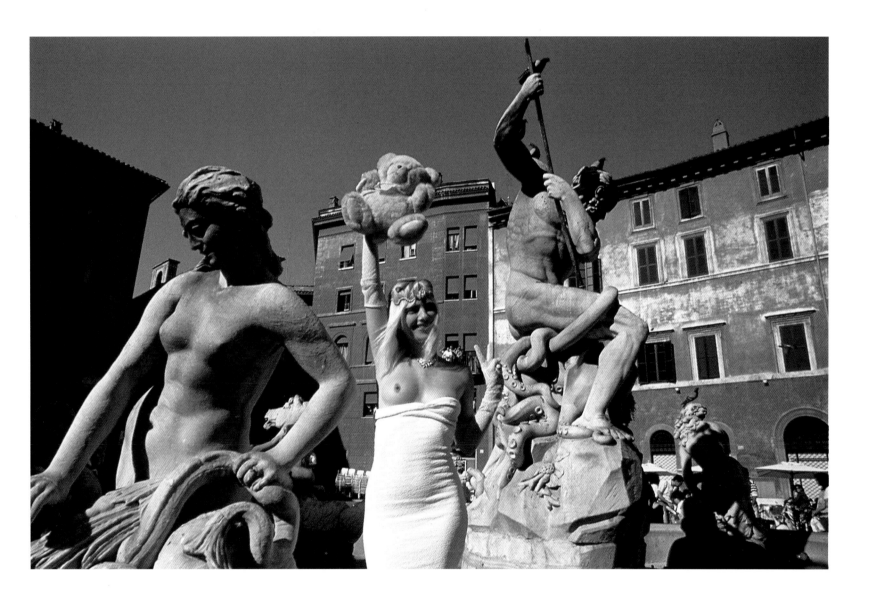

Cicciolina, the porn-star who became an Italian deputy, displaying herself as a living sculpture.

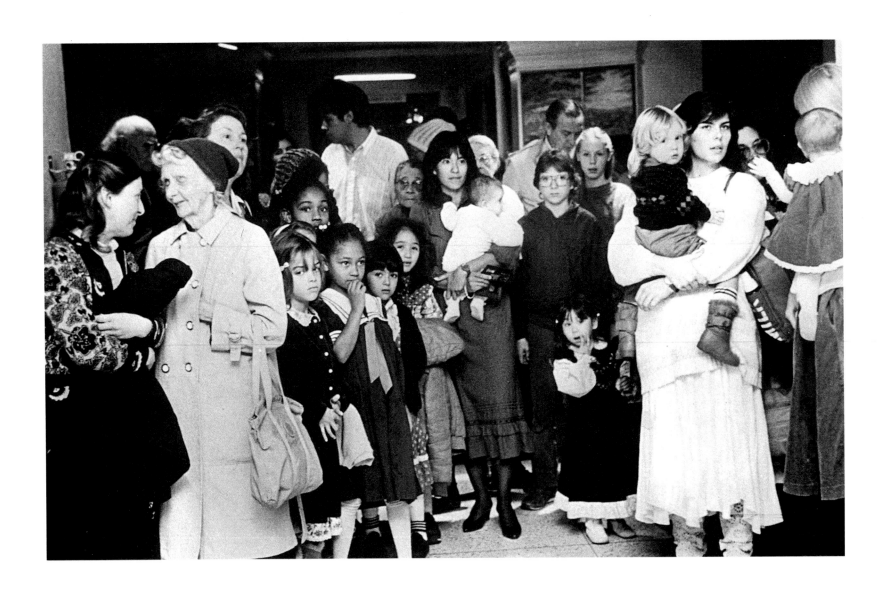

Followers of David Koresh, the charismatic leader of the Branch Davidians, an American cult. Koresh led more than eighty followers to their deaths in 1993.

Klaus Barbie, who as head of the French Gestapo sent thousands of Frenchmen to their deaths, is at last put on trial in Lyons.

A supporter kissing a benign image of General Pinochet just before the referendum which obliged him to step down.

Relatives of 'disappeared' Chileans opposing Pinochet's tenure of power.
Anti-Pinochet demonstrators assaulted by water laced with pepper which causes painful inflammation.

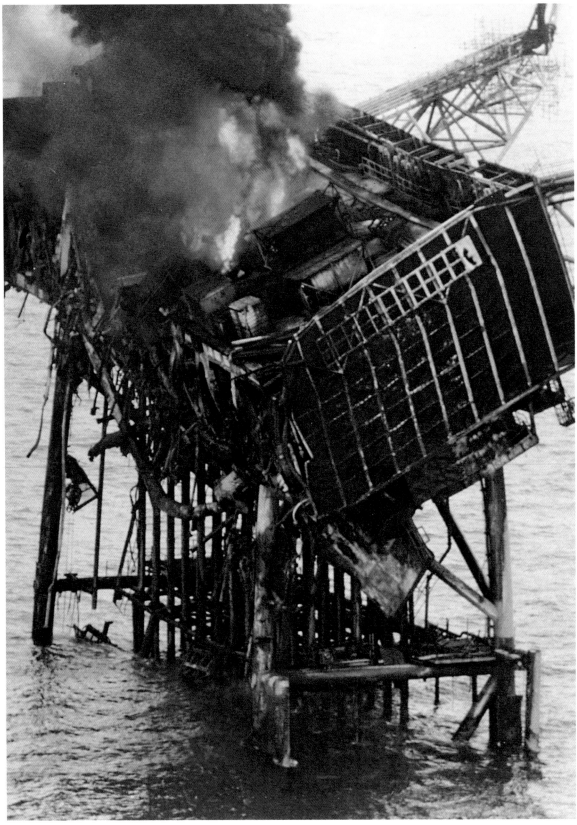

An explosion on the Piper Alpha North Sea platform killed 167 people – this is sometimes the price of oil.

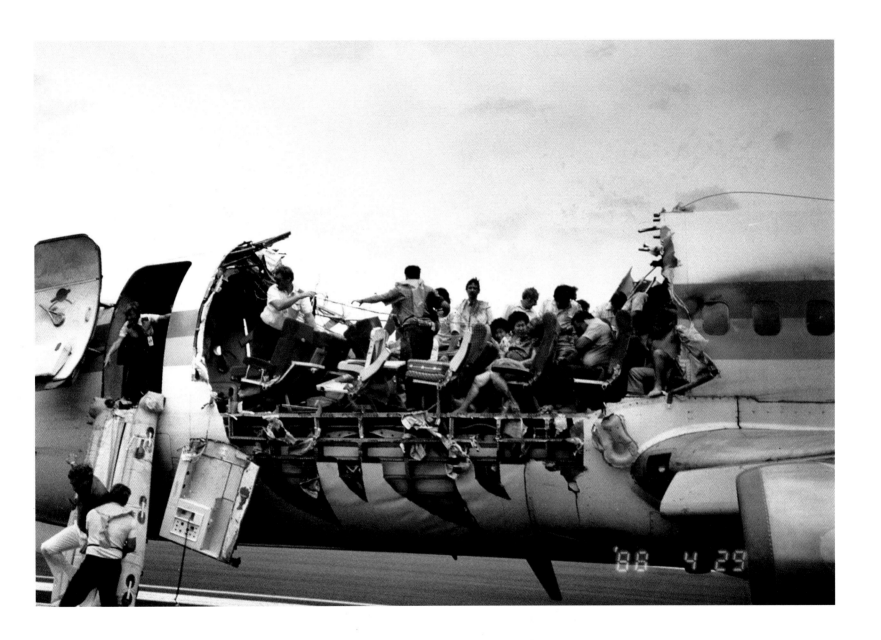

Only one person was killed when the fuselage of this aeroplane partially disintegrated at 7,300 metres (2,400 feet). The aeroplane managed to land on the Hawaiian island of Maui.

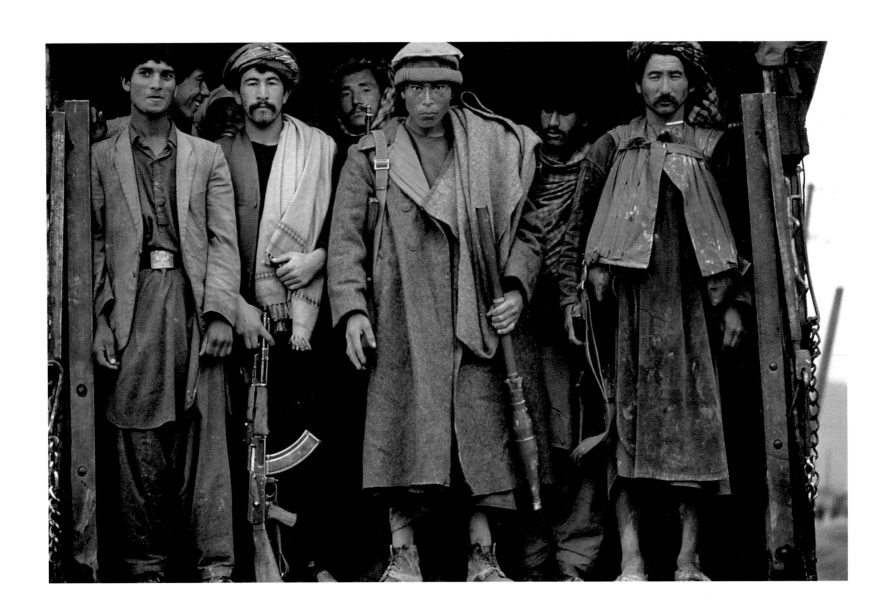

Men of Kabul at the time of the Russian withdrawal from Afghanistan.

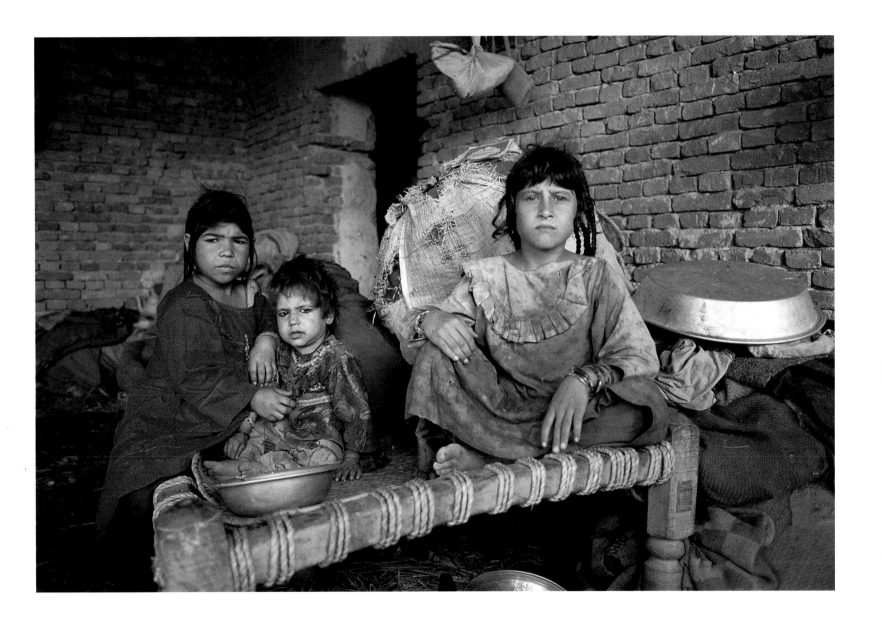

Kabul children displaced by the war.

From Eric Valli's brilliant picture story on honey hunting in Nepal – Mani Lal Gurung climbing a woven bamboo ladder to reach a hive ...

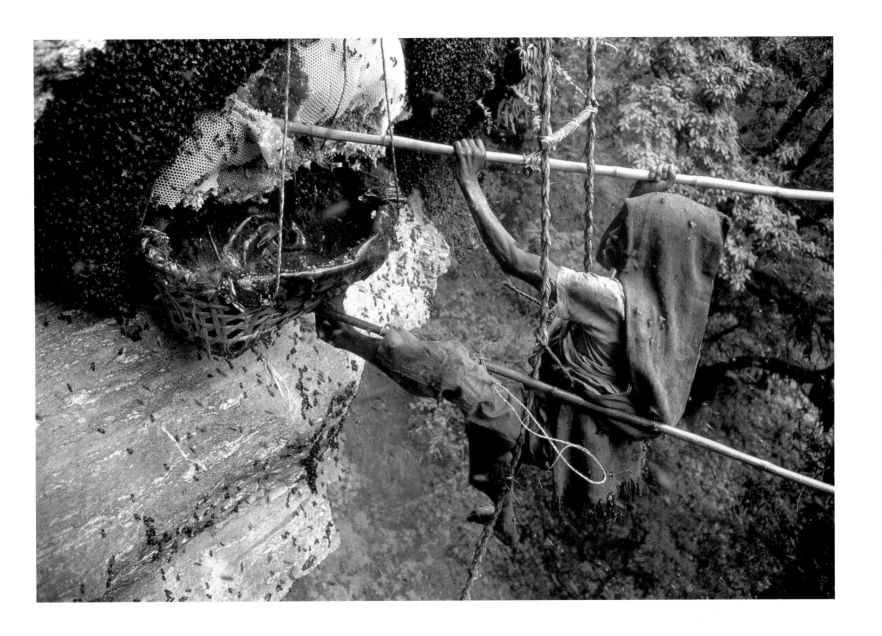

... and removing the honey 30 metres (100 feet) above the ground, despite fierce opposition from the bees.

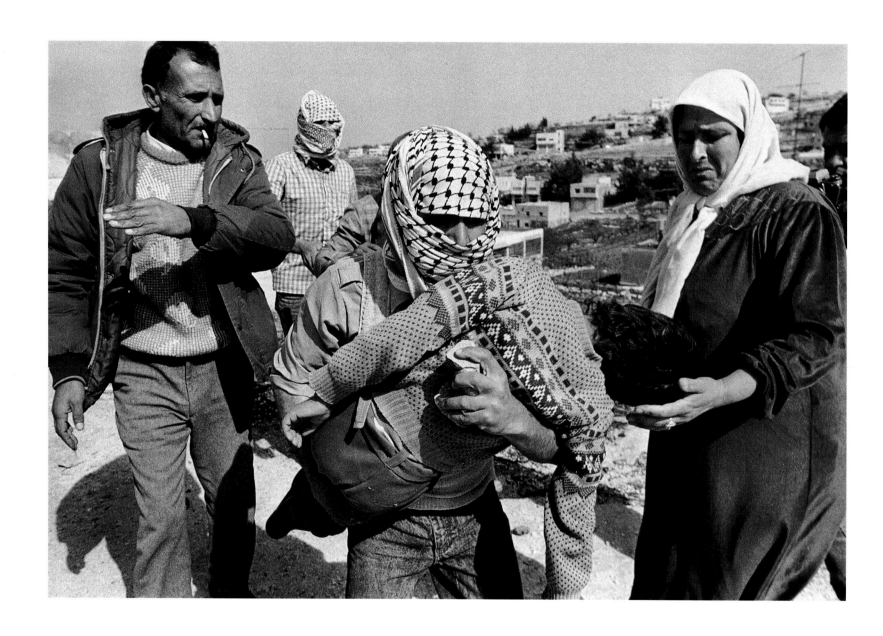

A Palestinian boy hit by a rubber bullet on the West Bank. Rubber bullets hurt, and can also injure and even kill.

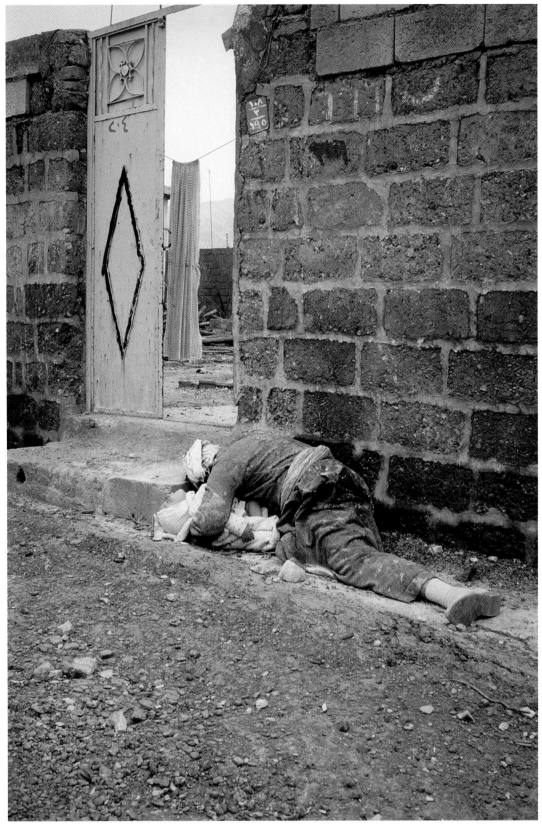

Saddam Hussein's murderous treatment of Iraq's Kurdish minority with chemical weapons demonstrated his determination to achieve his goals at any price.

Chinese students in Peking shortly before the Tiananmen Square massacre with slogans favouring democracy and free speech.

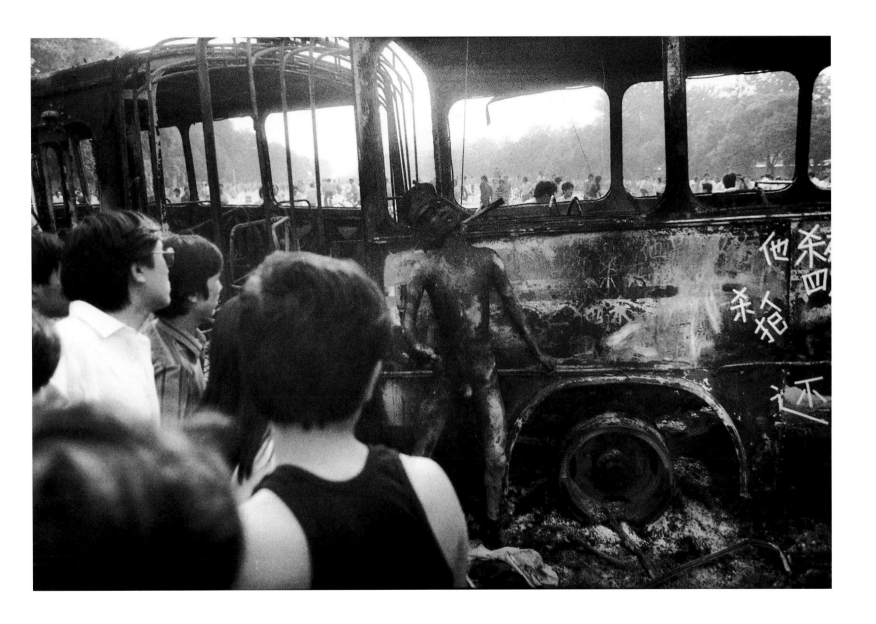

A Chinese soldier burnt to death during the Tiananmen Square democracy protests.

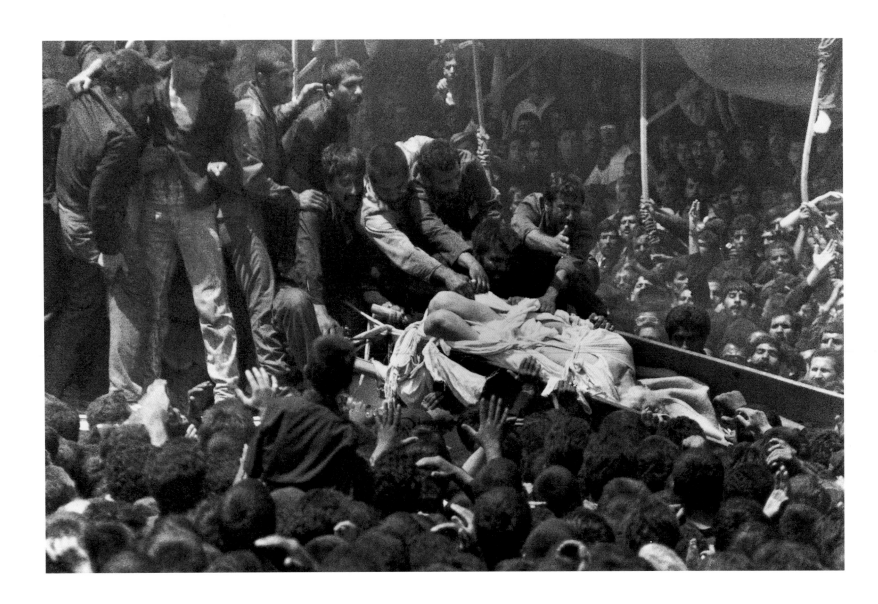

Mourners at Ayatollah Khomeini's funeral made his remains seem more desecrated than revered.

Nicolae and Elena Ceausescu of Romania seconds from execution – possibly the least mourned public figures of the decade.

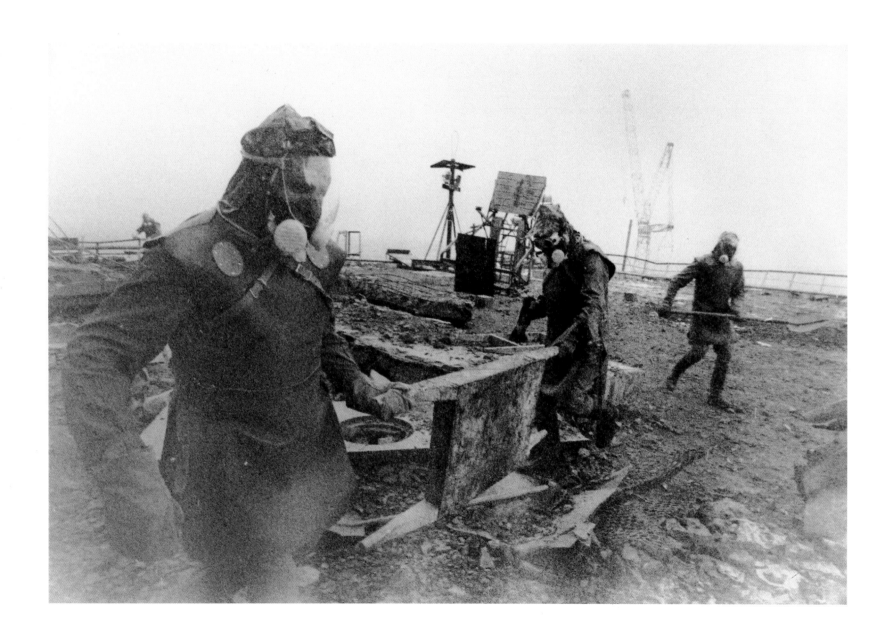

A Soviet team cleaning the roof of a Chernobyl reactor was only allowed to work for forty seconds at a time because of the risks of radiation.

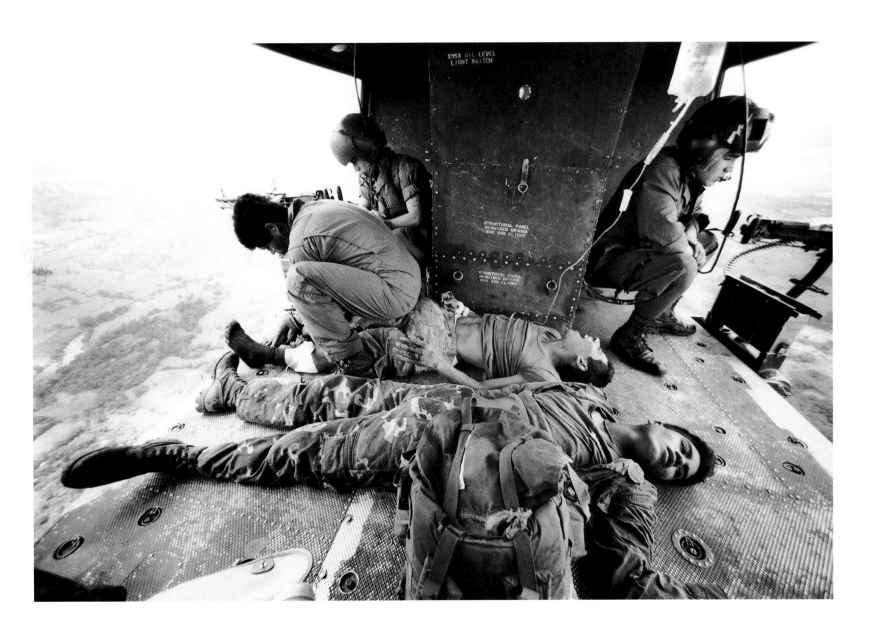

Wounded government soldiers in El Salvador being flown to hospital.

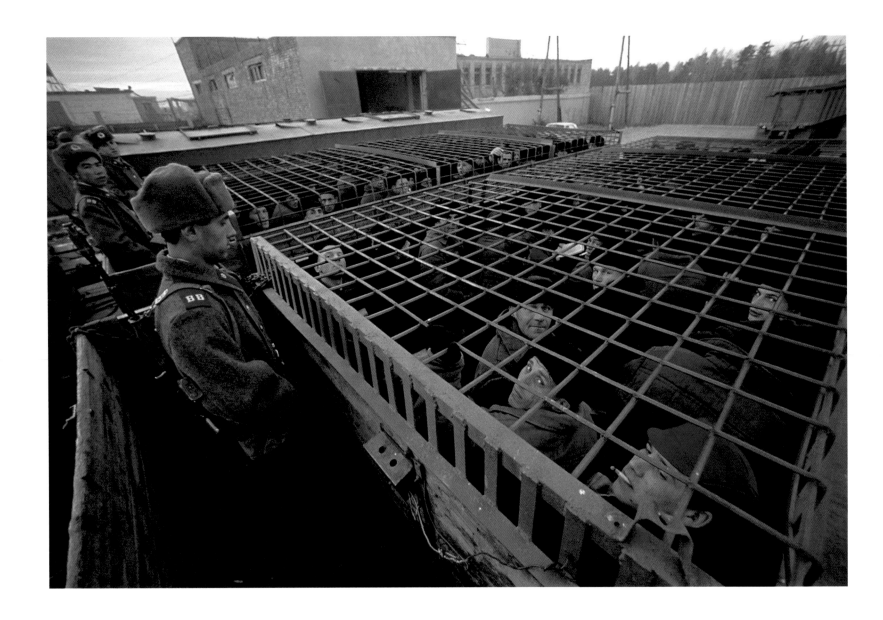

Siberian labour camps never close down – these men have been caged and are being taken to work.

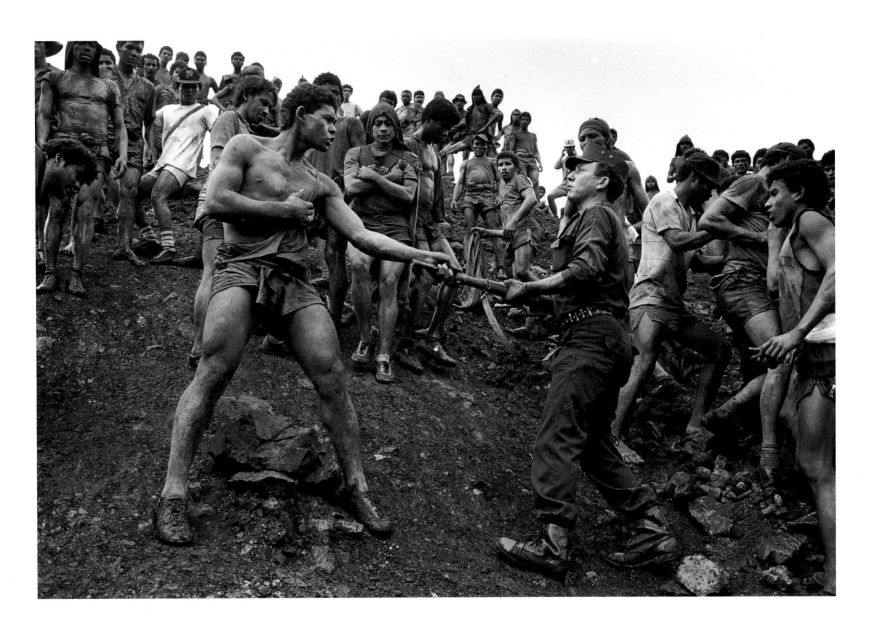

A tense moment between a security guard and a well-built miner photographed by Sebastiao Salgado in the Brazilian gold fields.

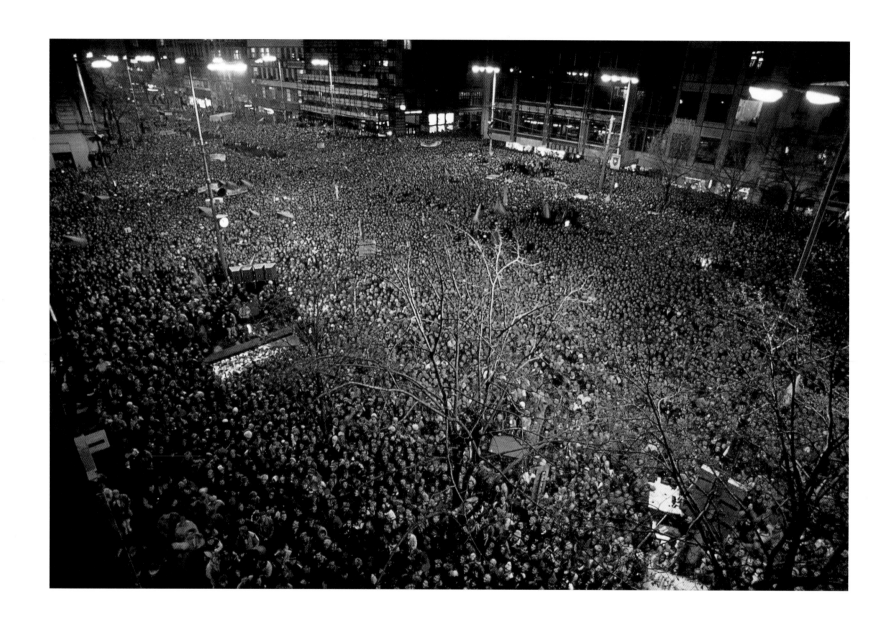

Enormous crowds in Prague listening to Alexander Dubček and Vaclav Havel announce the resignation of the Communist government.

Dubček and Havel joyfully embracing each other at the announcement of Czechoslovakia's new freedom.

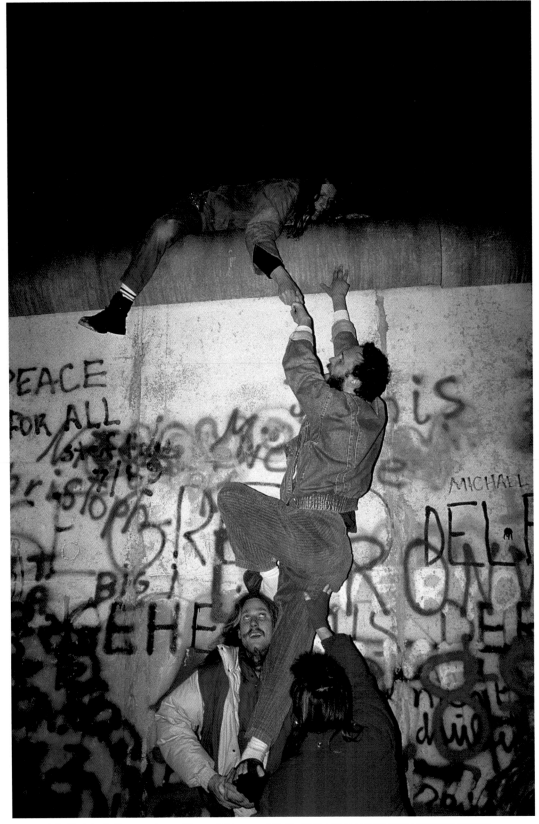

The first tentative crossings of the graffiti-covered Berlin Wall, prime symbol of the cold war division ...

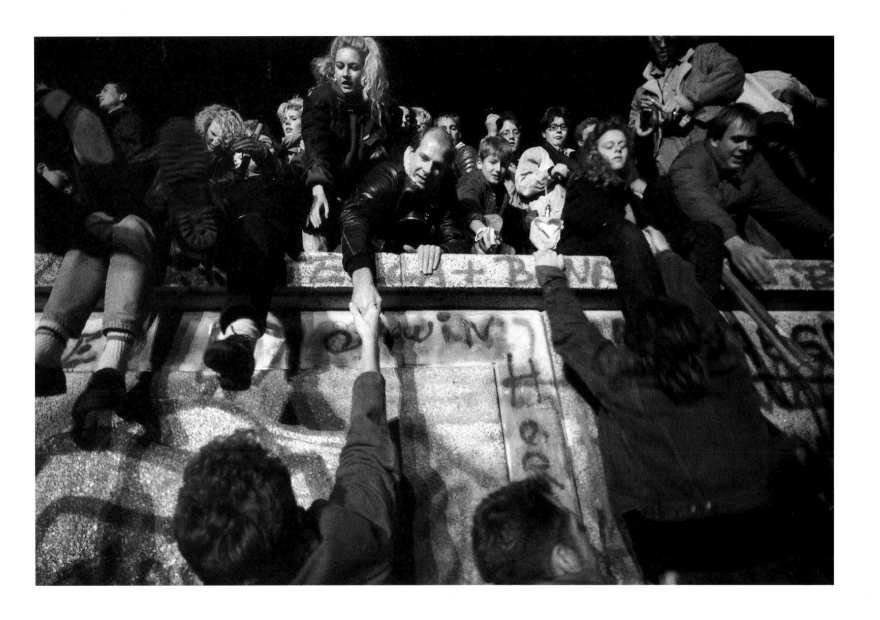

... soon to become a flood as Berliners cross the wall both ways in their thousands.

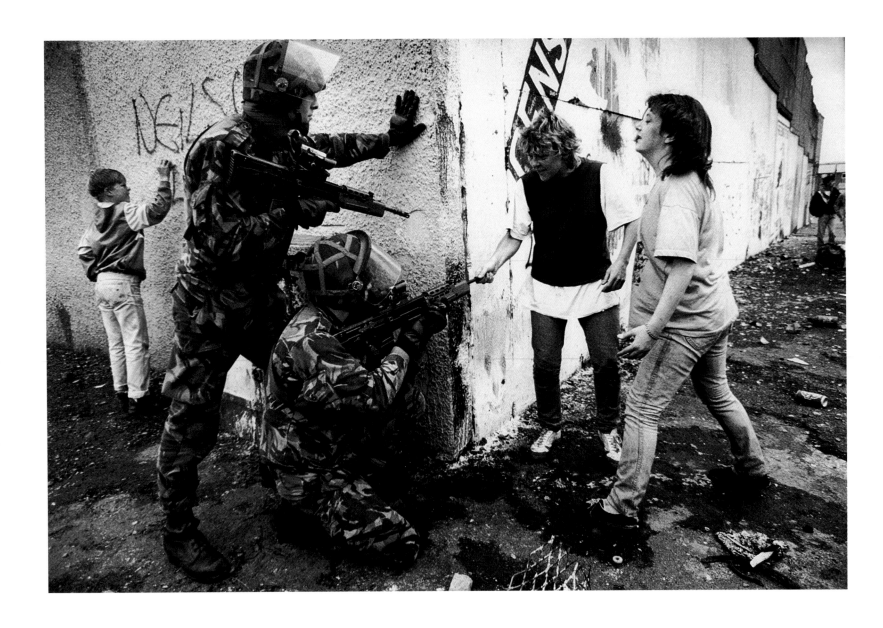

No respect for the British – Catholics displaying their loyalties in Ballymurphy, west Belfast.

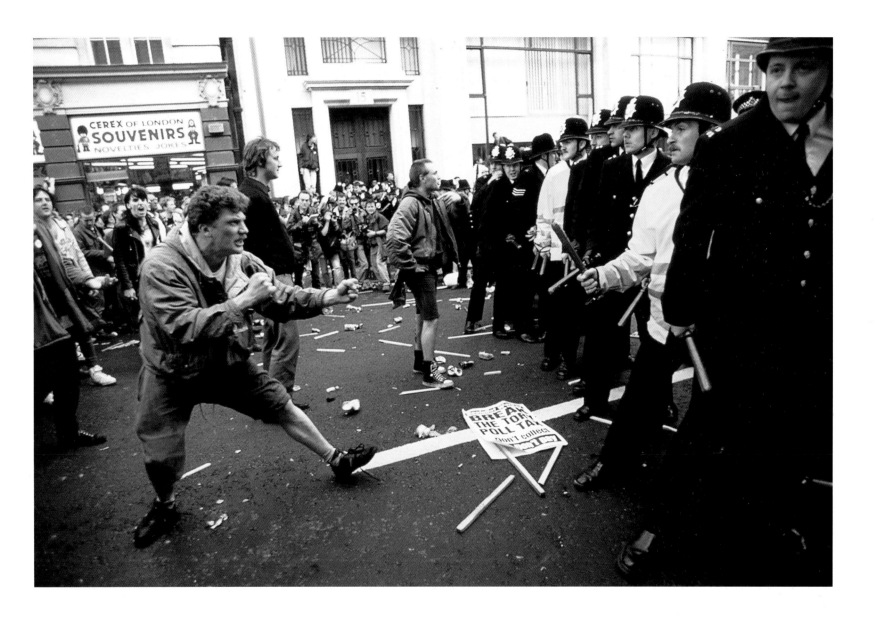

Ugly confrontations with police marked the most dangerous riots in London this century.

A Liberian in Paynesville during the civil war putting on the style.

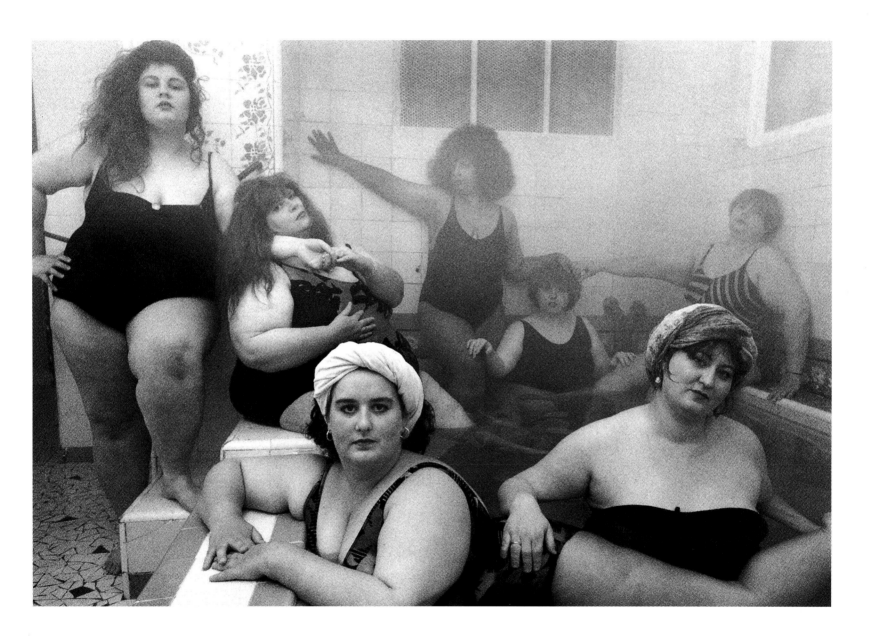

The Allegro Fortissimo club for prosperous fat Parisians – William Klein's picture pleased the club members.

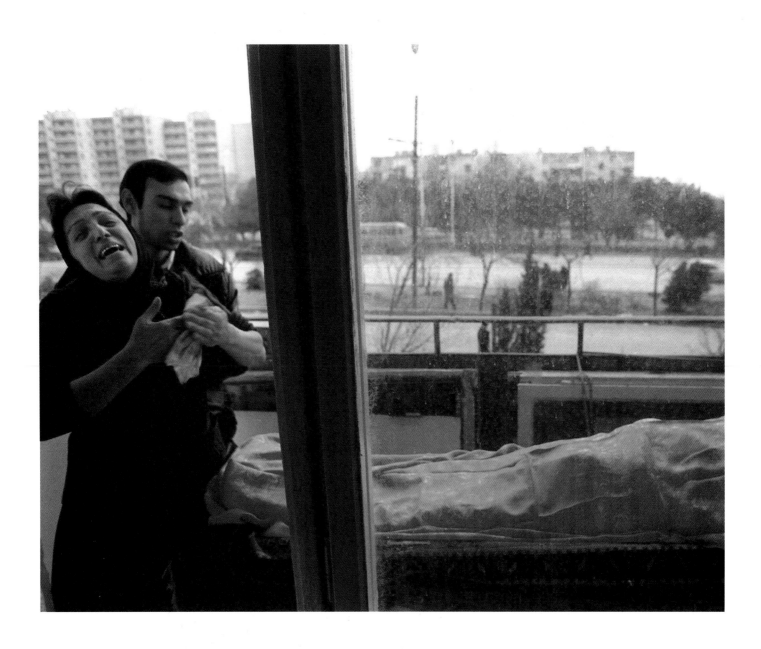

The covered corpse of a victim of the Soviet invasion following the anti-Armenian pogrom in Baku in Azerbaijan.

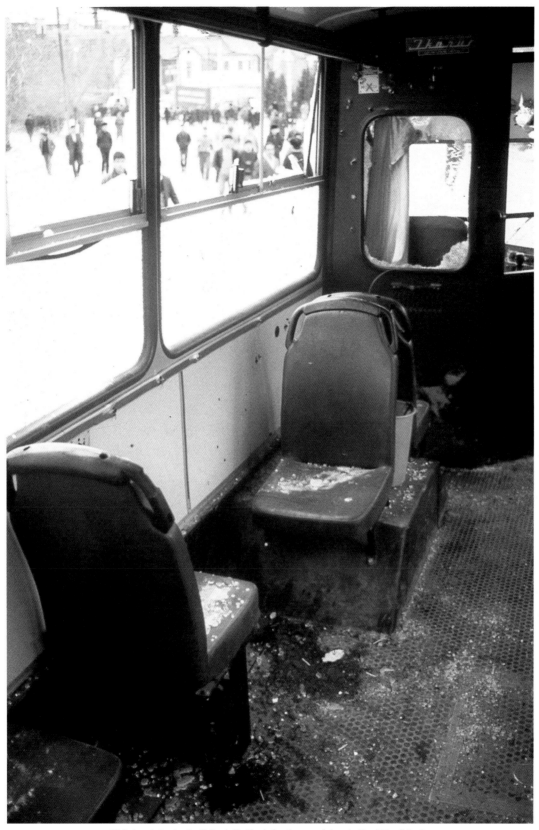

This bus interior in Baku tells the tale of general Azerbaijani bloodshed.

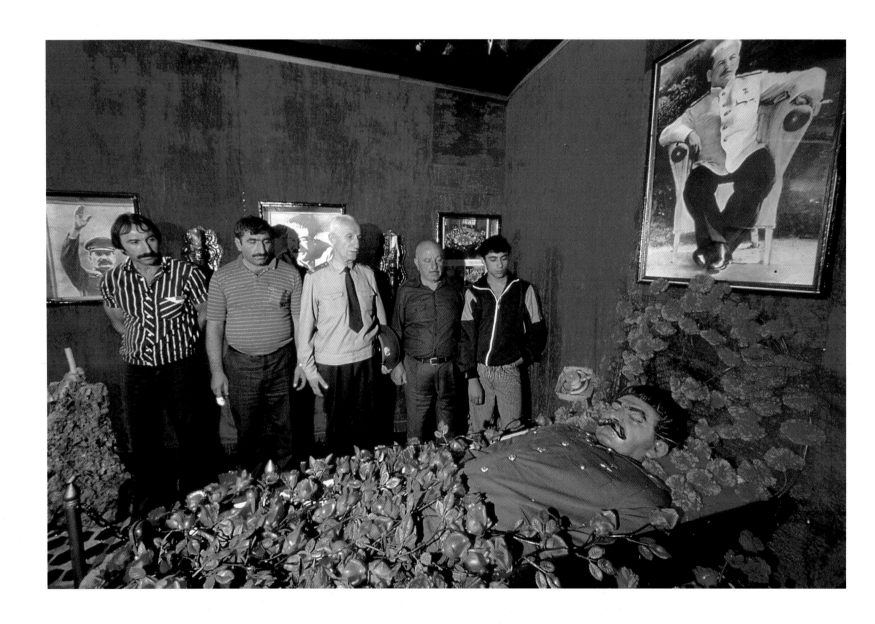

A museum devoted to Stalin in his native Georgia still pulls in the crowds.

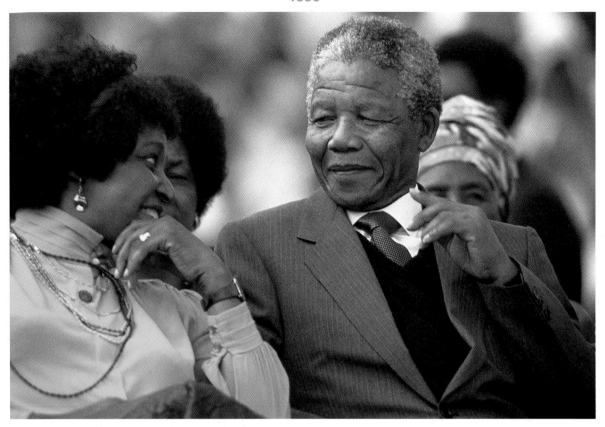

Two days after his release, Nelson Mandela with his errant wife Winnie in Soweto's Soccer City.
The great leader with his courageous white liberator F.W. de Klerk.

West German flags being waved in East Berlin.

The Brandenburg Gate in Berlin at midnight on 3 October – crowds watch the fireworks celebrating German reunification.

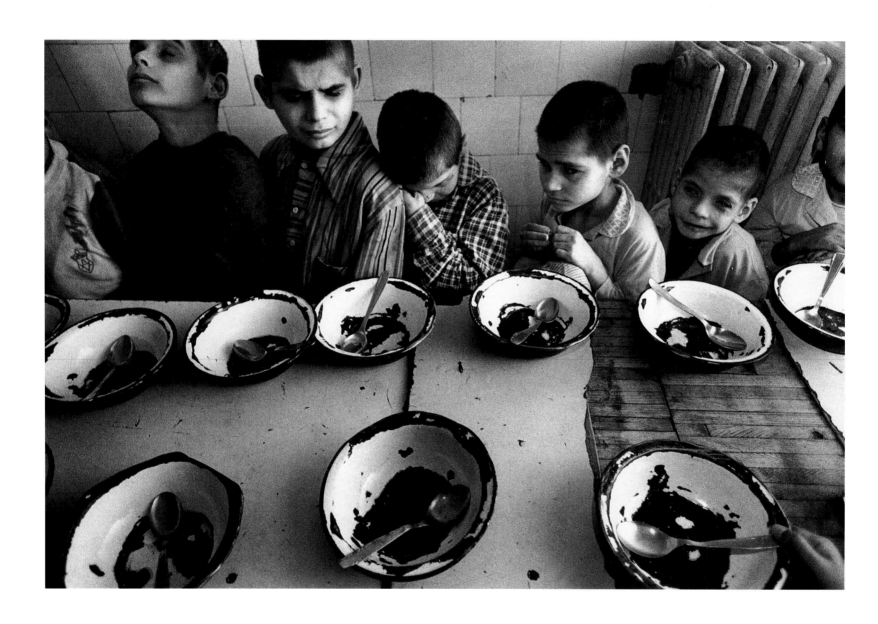

Starving Romanian orphans with empty and chipped plates. Nicolae Ceausescu had been more concerned with his own sumptuous lifestyle.

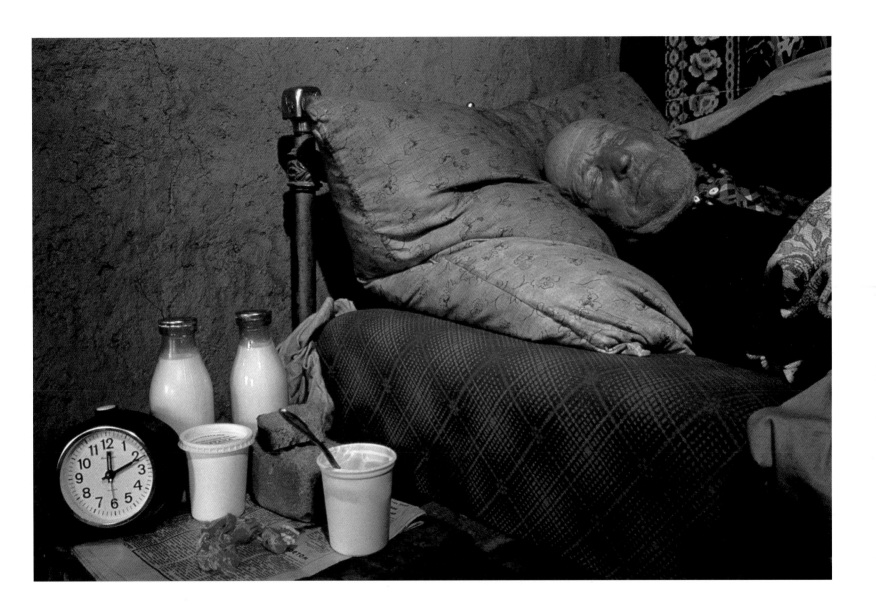

An old man who once lived near Chernobyl returned home to die in spite of the danger.

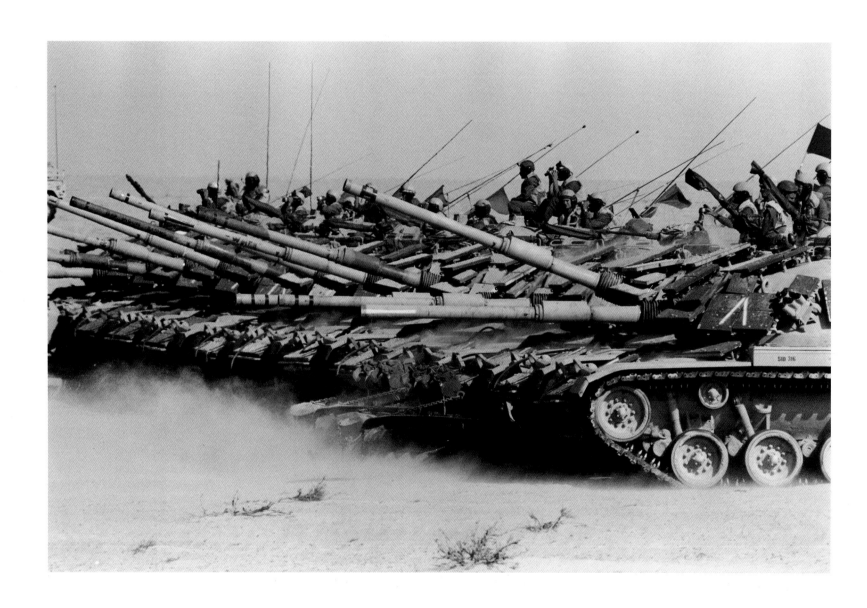

US tanks exercising in the Saudi desert before attacking the Iraqis in Kuwait.

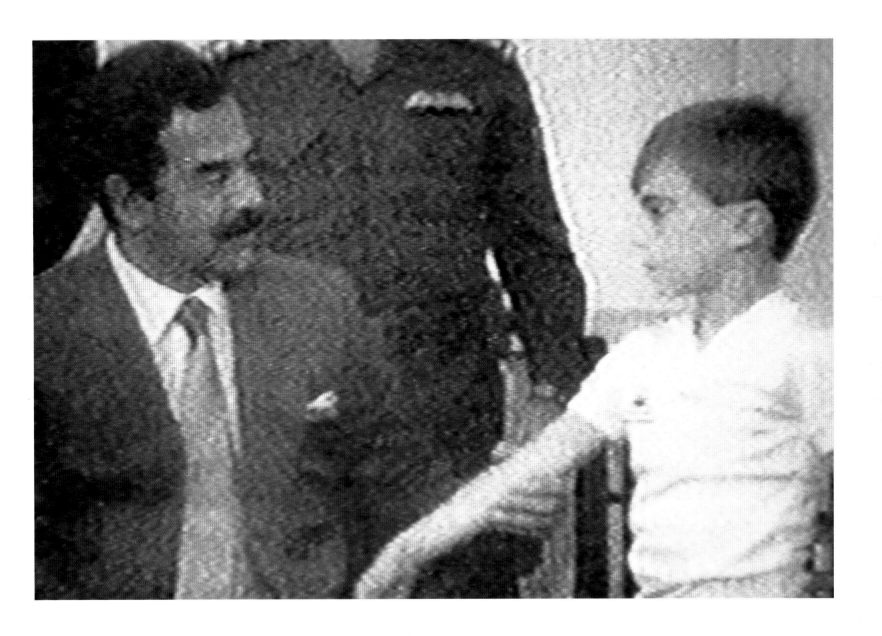

Saddam Hussein 'interviewing' an understandably nervous British boy on Iraqi television before the Allied attack.

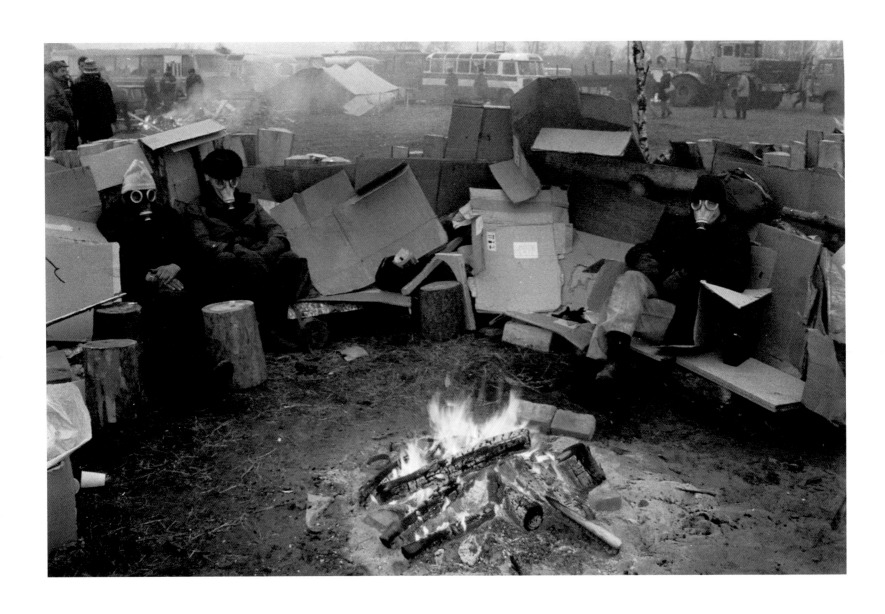

Latvians in Riga with their gas-mask protection against Russian tear-gas attacks.

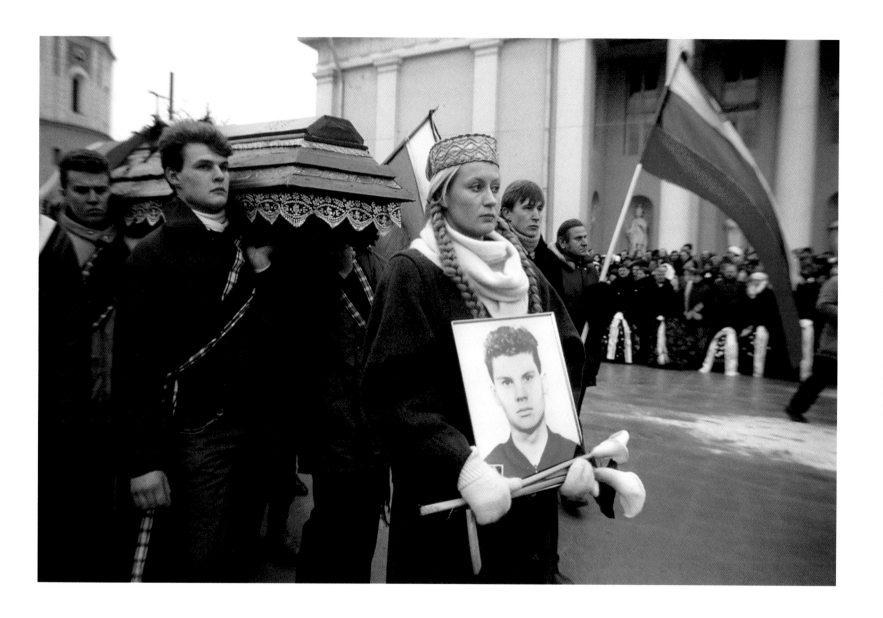

A funeral for a victim of Soviet attempts to check Lithuanian nationalism in Vilnius.

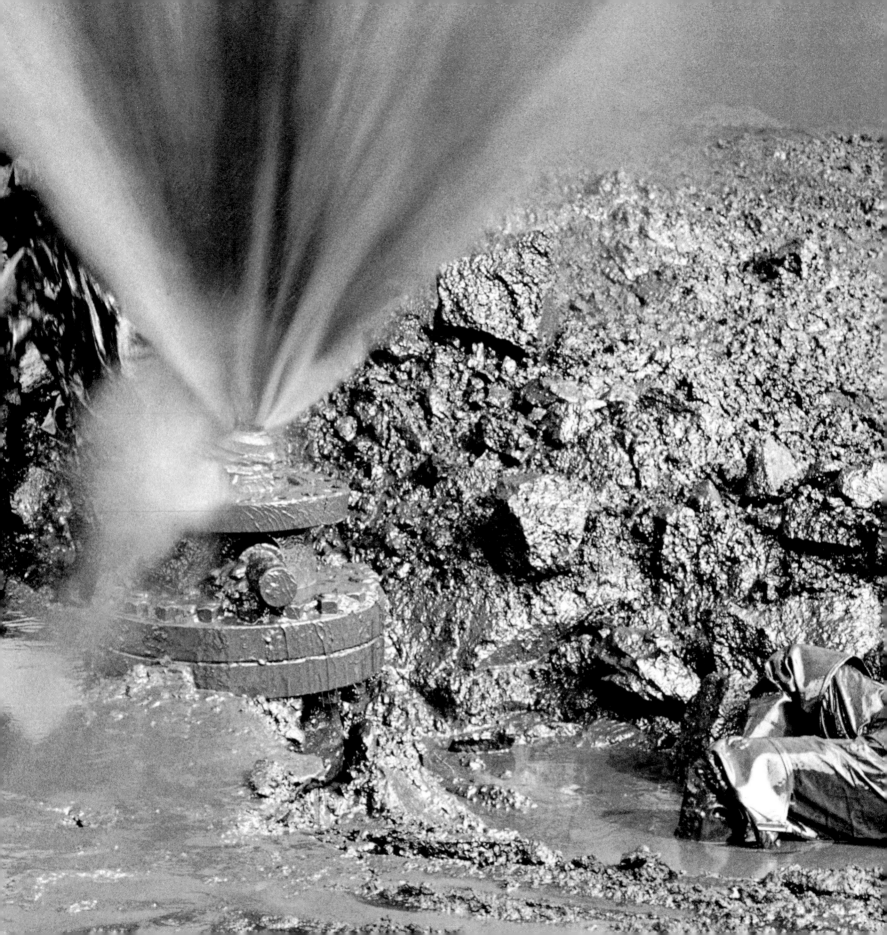

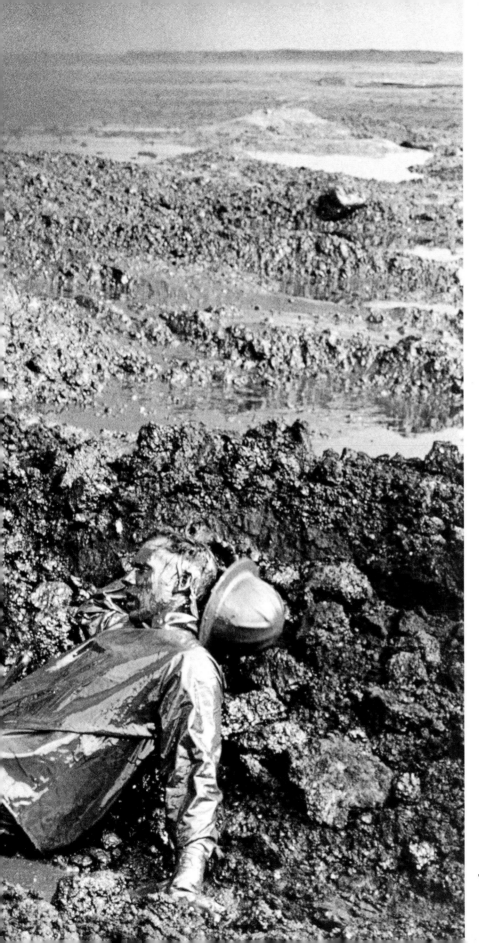

The retreating Iraqis created havoc in their wake by setting fire to nearly every Kuwaiti oil well. This technician is completely soaked in crude oil.

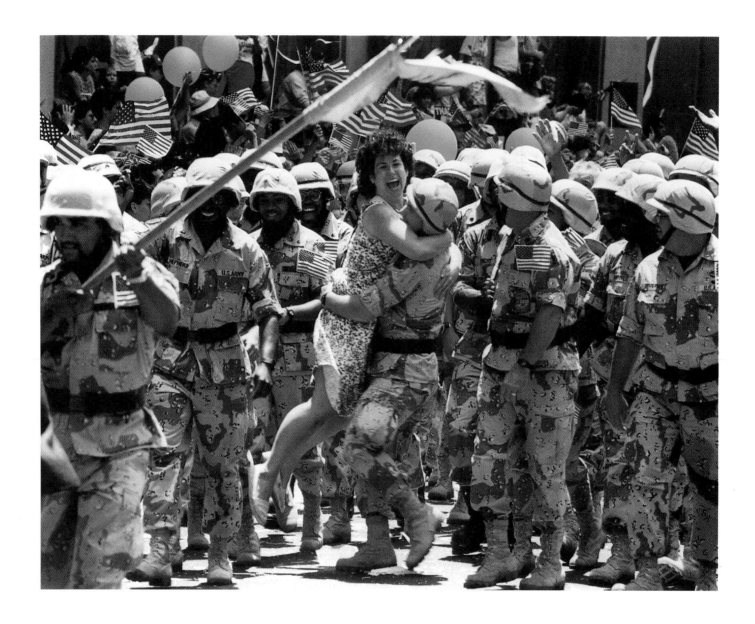

The Welcome Home parade for Gulf War soldiers in New York – a woman predictably breaks through the barricade.

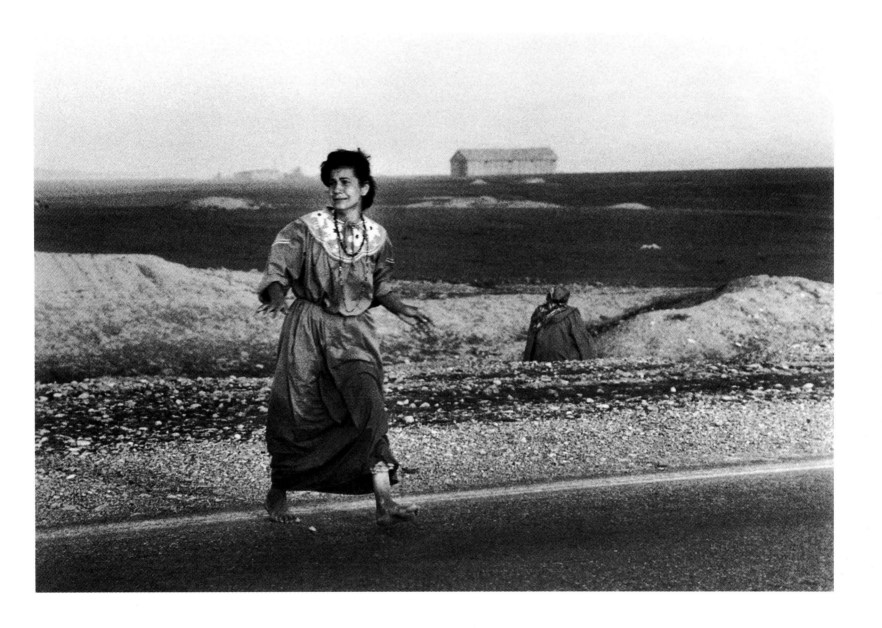

A Kurdish woman threatened by an Iraqi helicopter.

The annual fishing orgy in the Rima river in north-west Nigeria – the climax of the
week-long Argungu festival of sport and music. After the festival the river is not fished
for a year to let the fish multiply in time for the next piscatorial pandemonium.

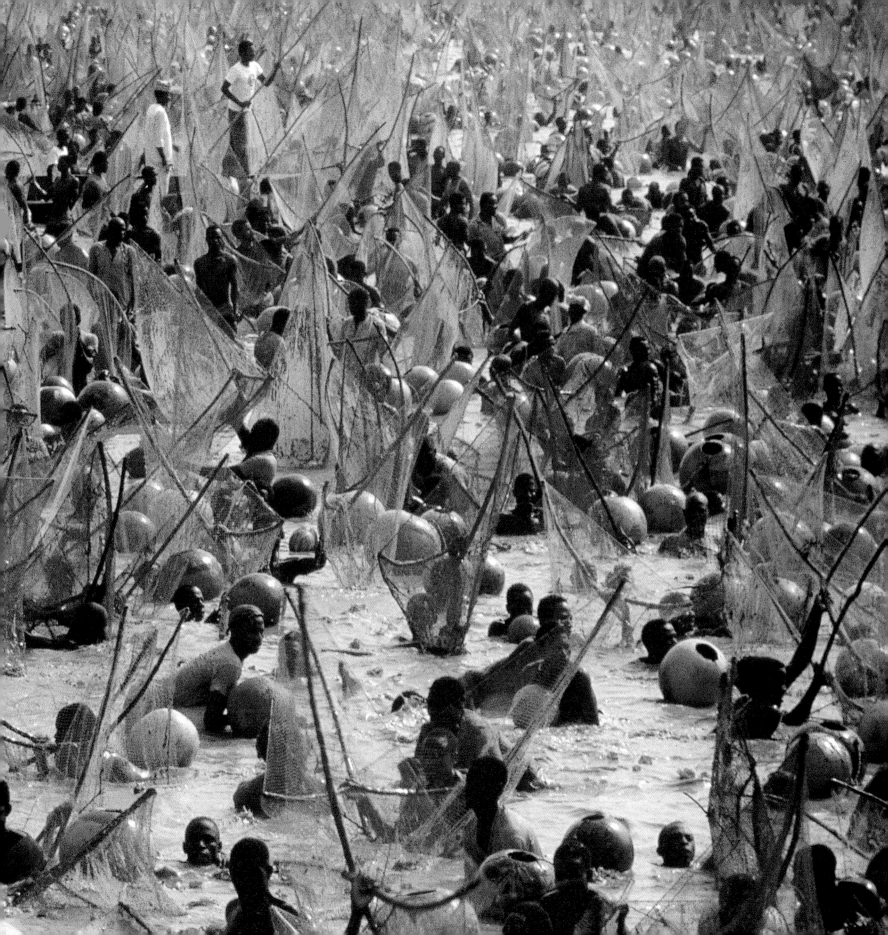

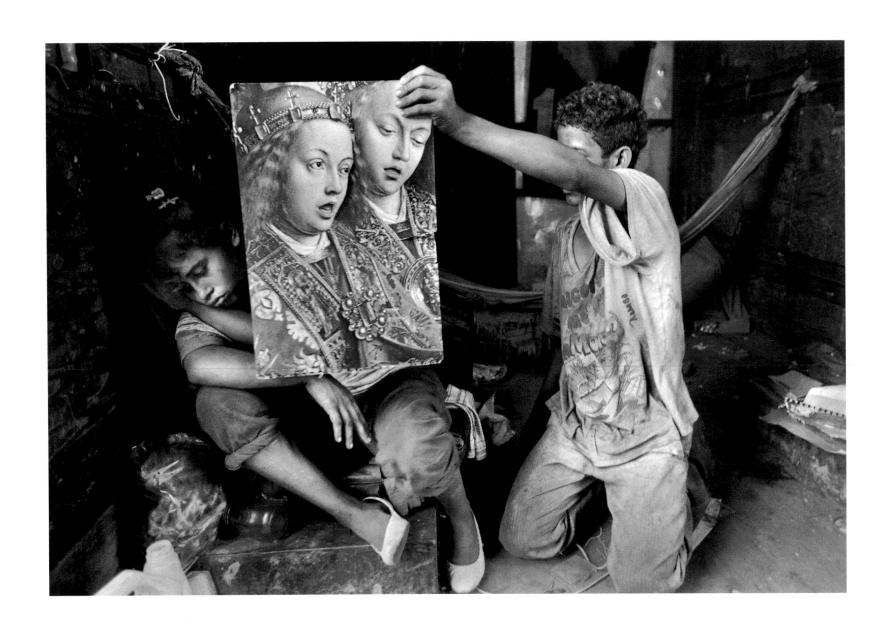

Glue-sniffing teenagers in an impoverished shanty town in San Salvador. The enlarged detail from the great Ghent altarpiece is unaccountable.

Prince Sihanouk bows ironically perhaps as well as humbly to Buddhist monks on his return to Cambodia.

A vast crowd gathered in Leningrad, soon to revert to its fomer name, St Petersburg, to protest against the anti-Gorbachev coup.

Jay Maisel pointed his camera downwards as the New York Marathon crossed the Verrazzano Narrows Bridge as the race began.

The funeral of three young men killed resisting the coup in Moscow.

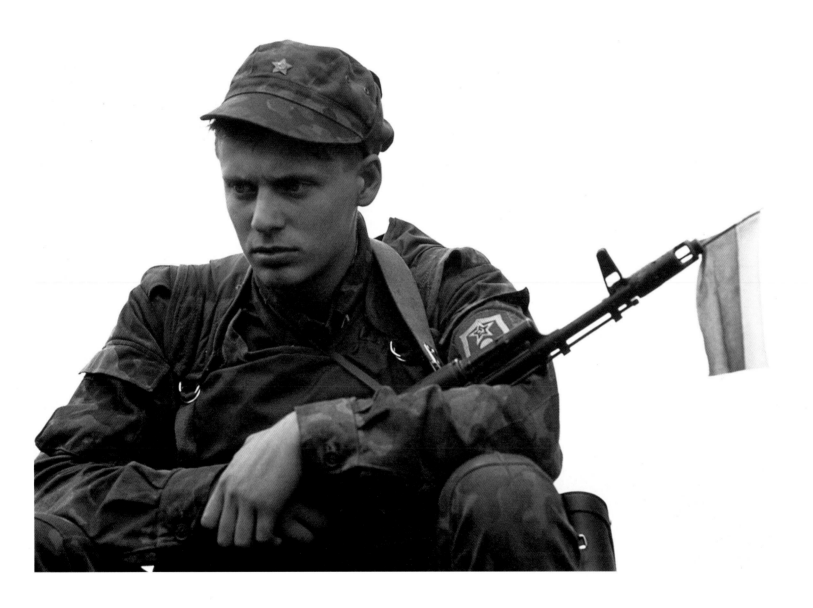

A pensive pro-Yeltsin soldier waiting while the hardliners are defeated in Moscow.

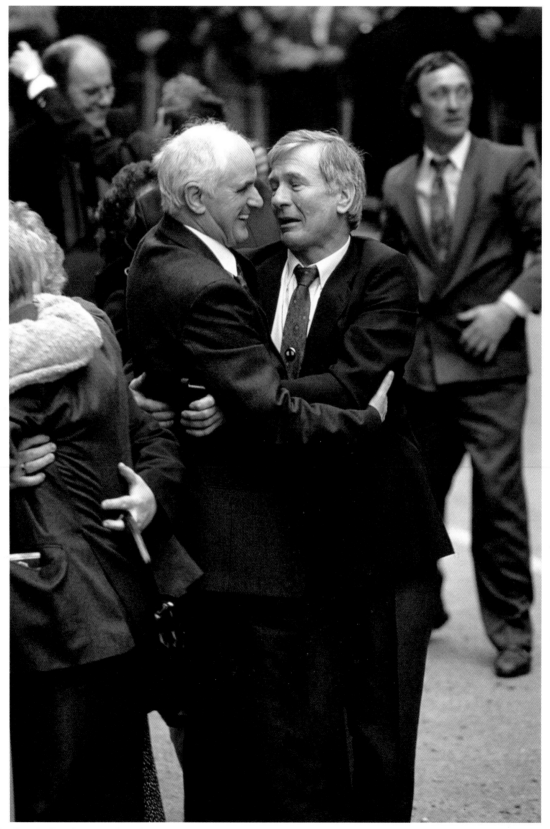

The 'Birmingham Six' are freed after the convictions which had kept them behind bars for almost seventeen years were overturned.

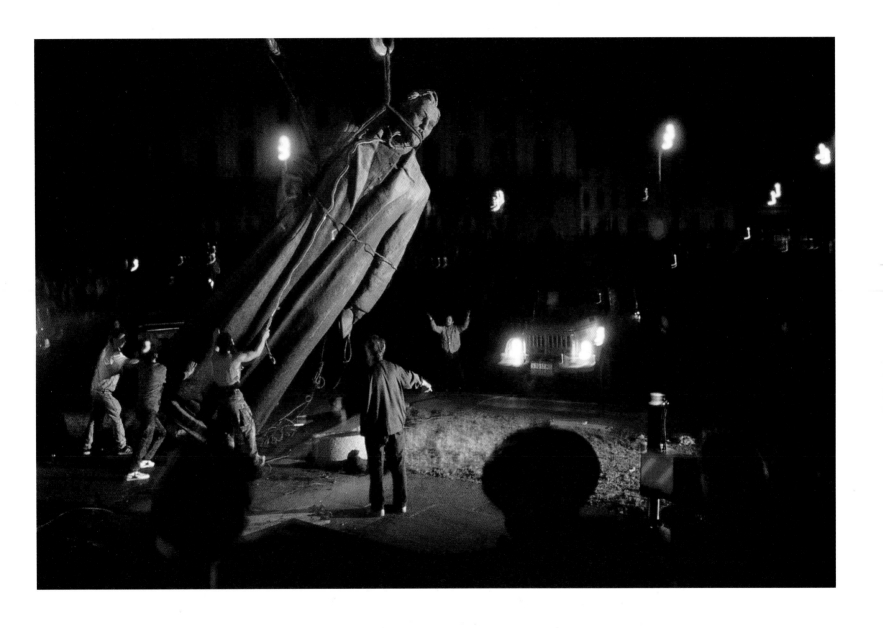

A symbol almost as potent as Lenin or Stalin is degraded. Felix Dzerzhinsky, grandfather of the KGB, bites the dust in Moscow.

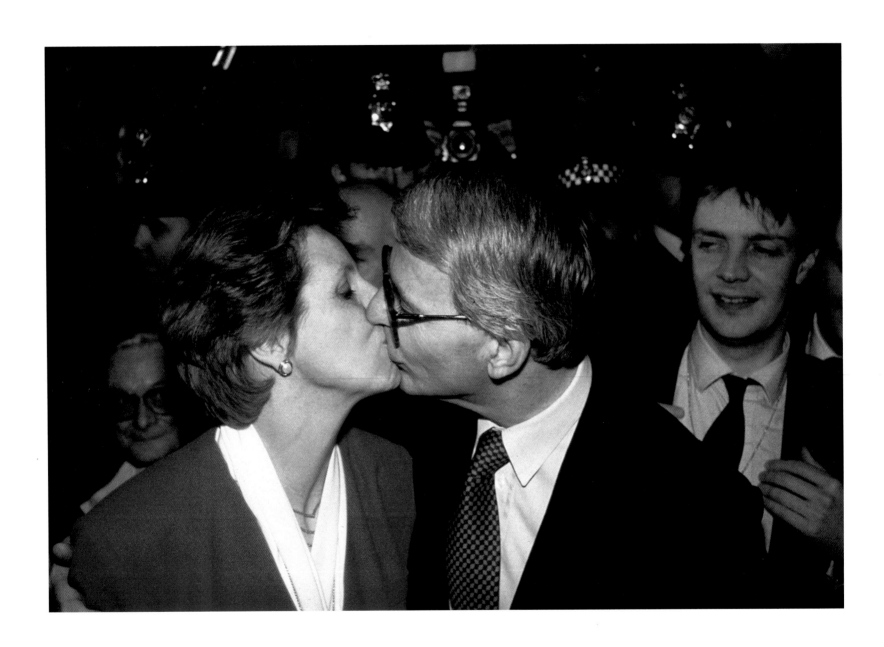

John Major celebrates his surprise British election victory by kissing his wife.

President-elect Bill Clinton on the saxophone with members of the Sugar Bear Marching Band of Macon, Georgia.

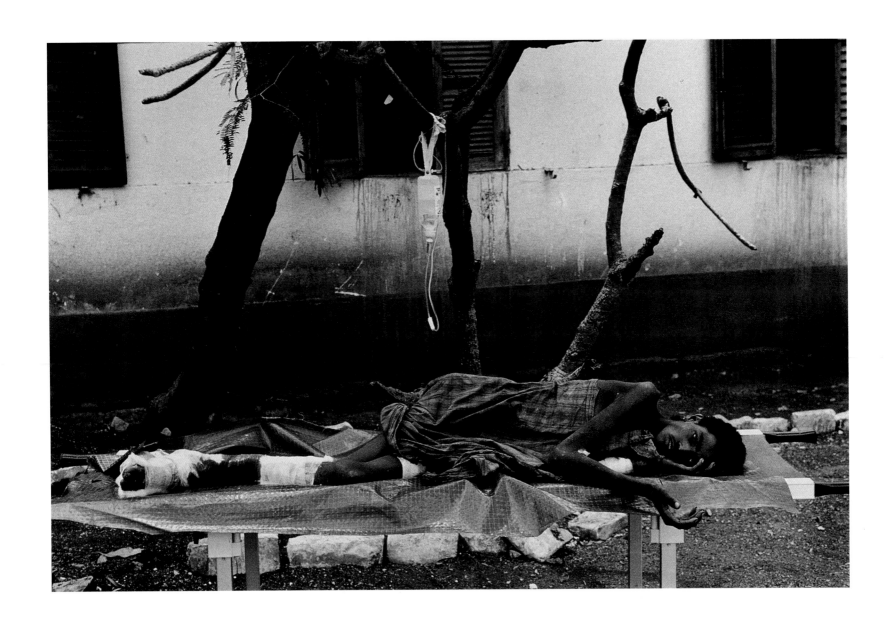

Over a million Somalis were threatened with death by starvation as the UN infrastructure in the country dissolved.

William Klein's open-flash technique – a long exposure interrupted by a flash – produces a backstage image at Spanish designer Paco Rabanne's show in Paris.

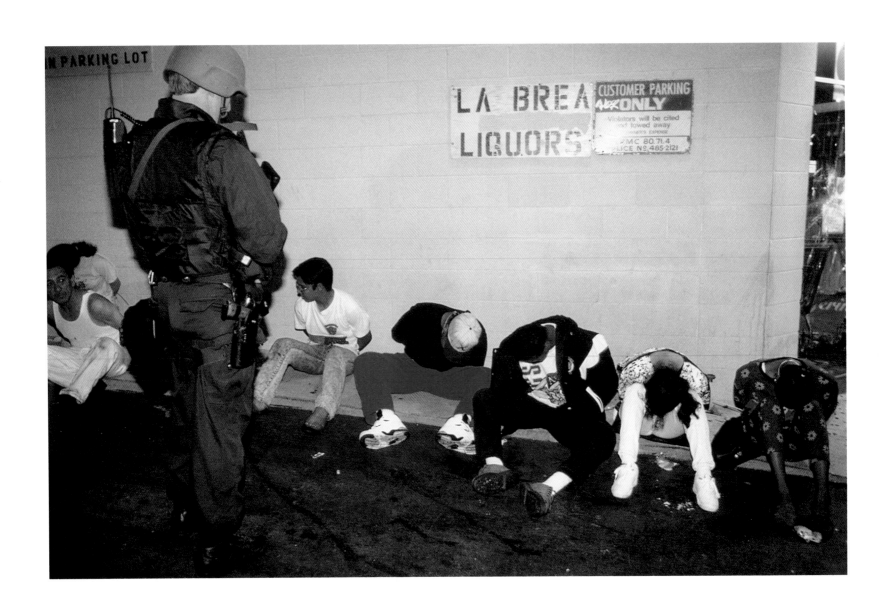

Looters arrested in Los Angeles during riots protesting the acquittal of police officers clearly guilty of assaulting an African-American.

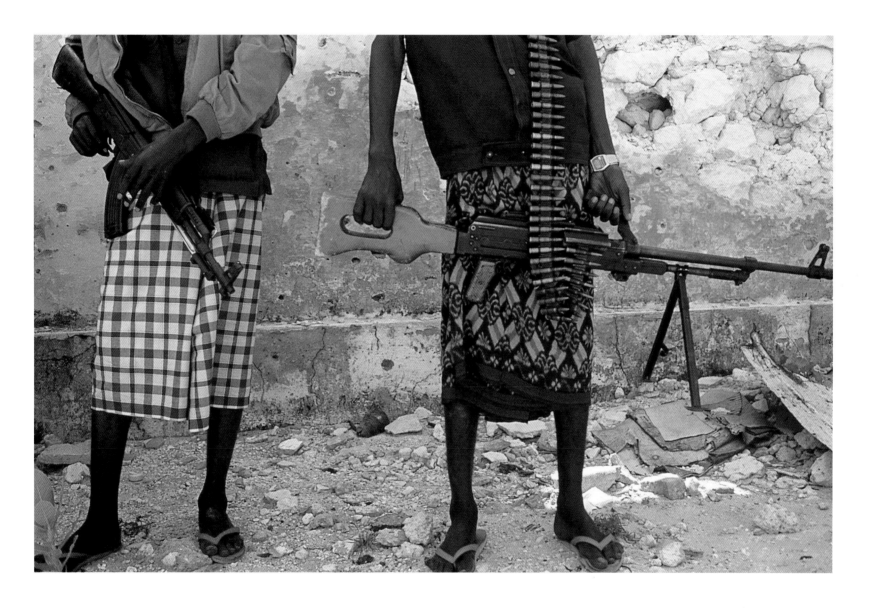

Gunmen in Mogadishu guarding threatened food supplies almost certainly stolen from official distributors of famine relief.

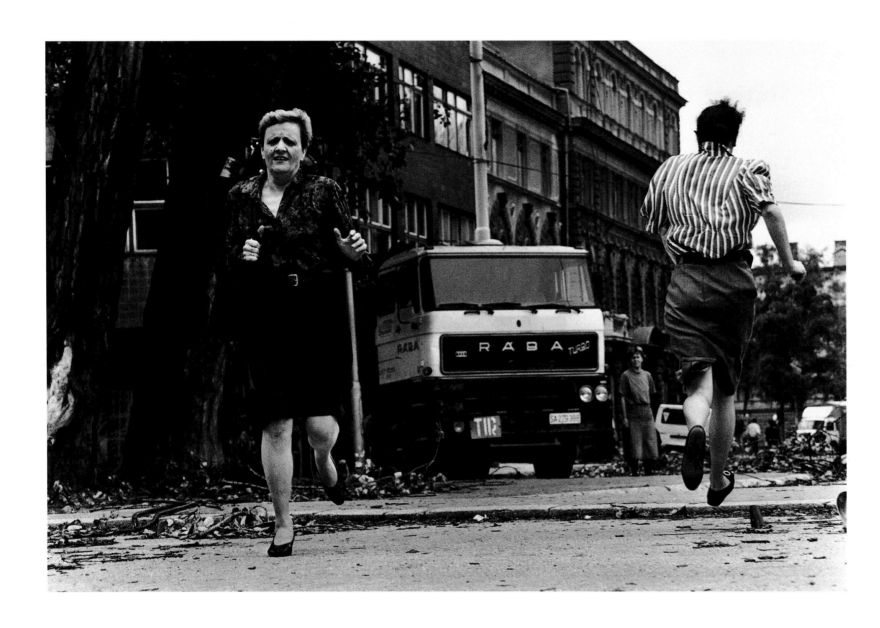

Running for their lives in Sniper Alley – hundreds were killed by Serb bullets on the 3-kilometre (2-mile) stretch of road.

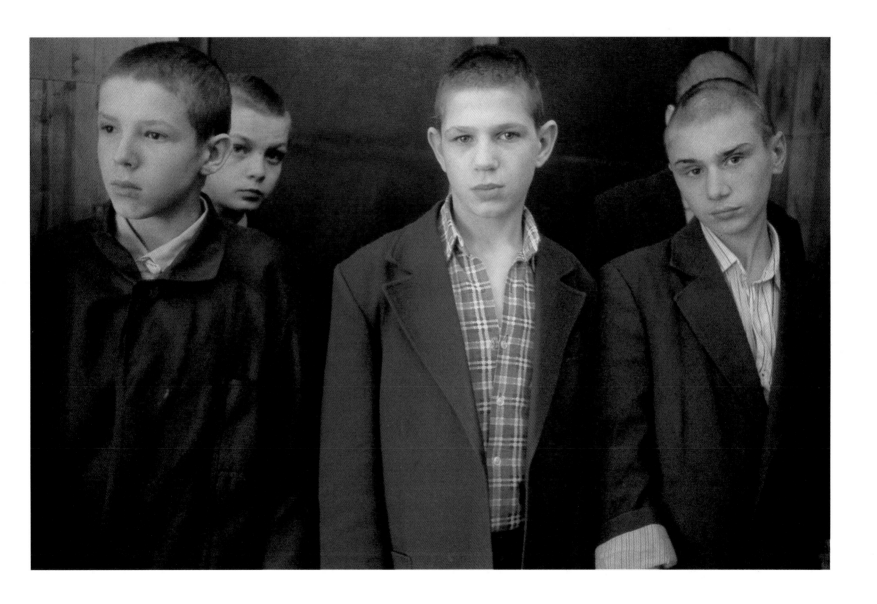

Apparent innocents – delinquent youths found on the Moscow streets and put to work in a detention centre.

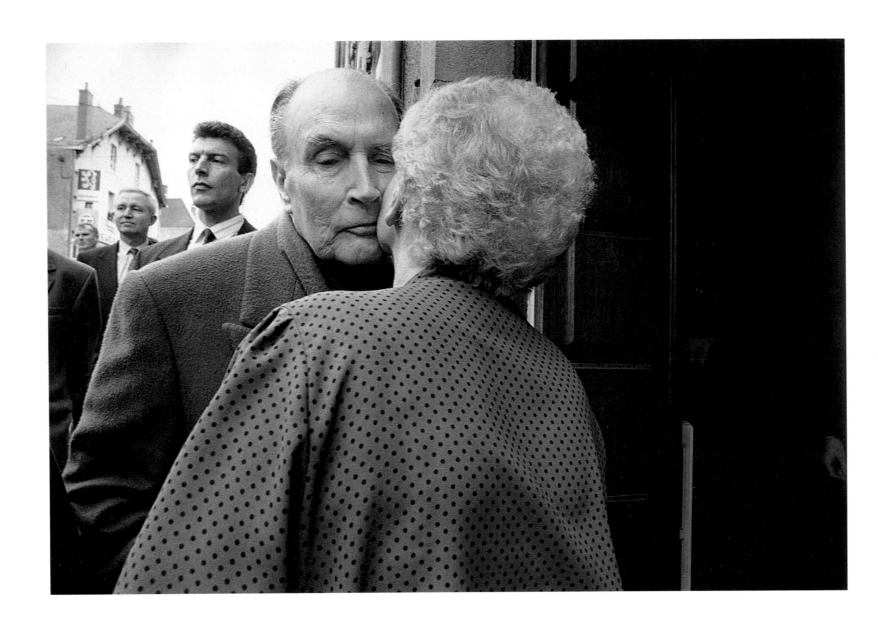

François Mitterrand looking frail as he greets a member of his electorate.

Slobodan Milosevic, to many the Serbian ogre, aroused the bitter emnity of other Yugoslavian ethnic peoples.

Peaceful road-building families belie the violent Hindu-Muslim riots taking place in central Bombay.

A Hindu prayer meeting at a roadside shrine seems similarly removed from possible violence.

Christo posing with an image of his proposed 'wrapped Reichstag' project which he realized in 1995.

The great Hubble telescope – a giant step for astronomy – undergoing successful repair in space.

Demonstrations in Moscow against Boris Yeltsin's dissolution of the new Russian parliament.
Palestinian peace demonstrators on the walls of old Jerusalem.

A solitary corpse in Sarajevo – there would be many more in the conflicts between Muslims and Serbs.

A hotel in San Francisco became an organized refuge for AIDS sufferers – here Roger and Steve ...

... and James, who was first diagnosed HIV positive in 1985, and cared for until his death.

Neo-Nazis firebombed a house occupied by Turkish immigrants at Solingen in Germany. Flags and bouquets were left in mourning.

A prison in Baku, Azerbaijan.

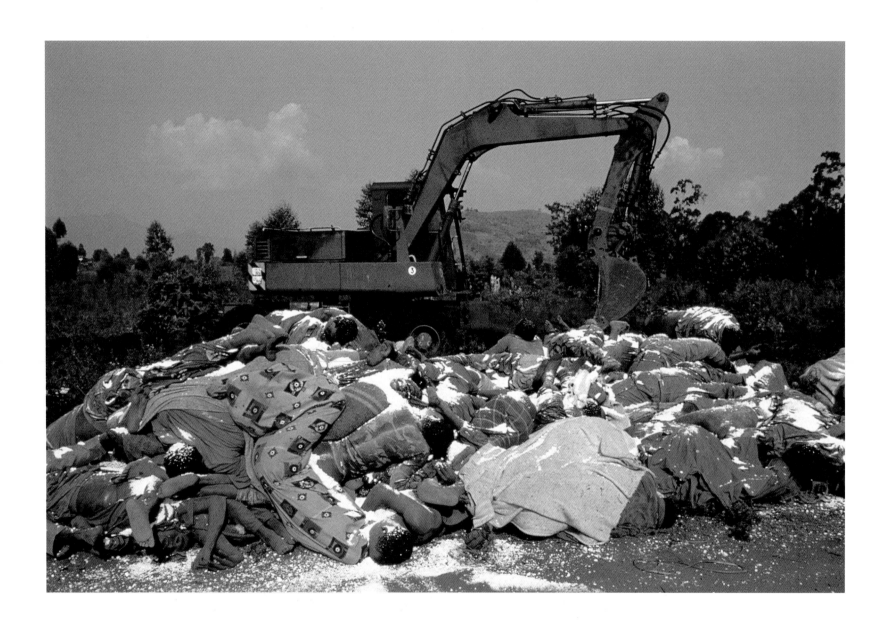

The Hutus began a sickening slaughter of the traditionally dominant Tutsis, here bulldozed and covered in quicklime.

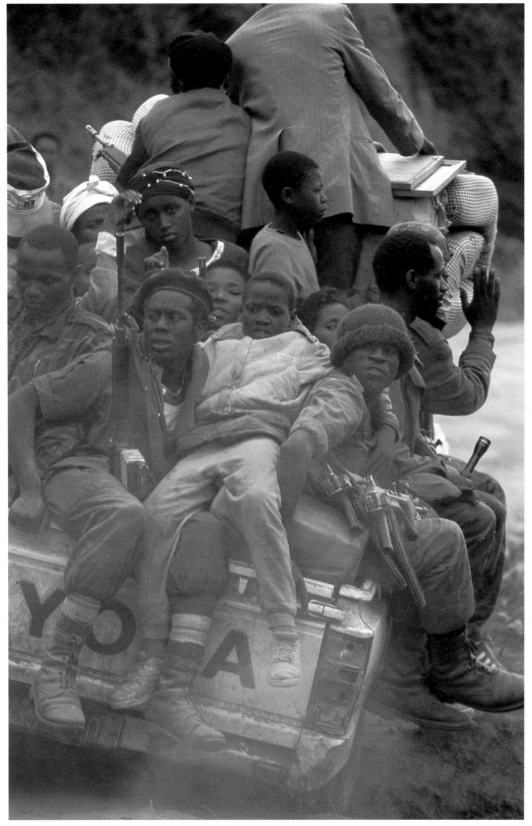

Routed by the Rwandan Patriotic Force, government forces and Hutu civilians find themselves on the road to Ruhengeri in northern Rwanda.

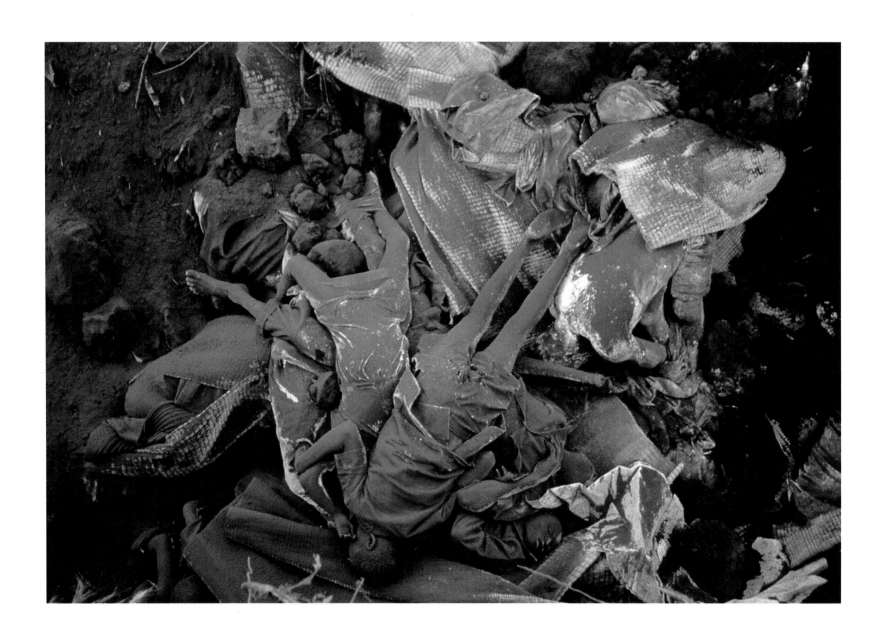

Zaïre was invaded by refugees from Rwanda, not only starving but stricken with cholera and, as here, buried in mass graves.

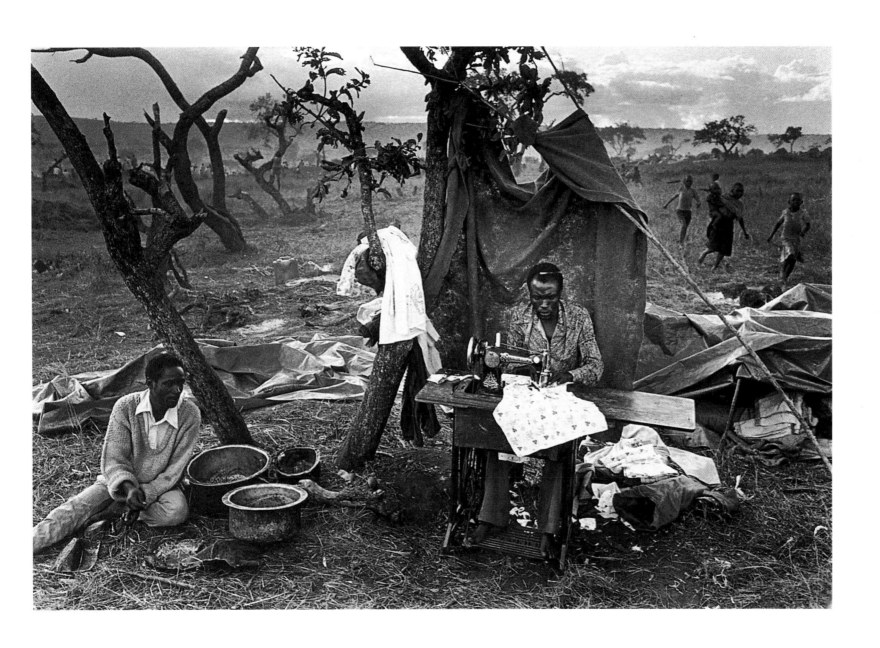

A less distressing view of refugees in Zaïre where a sewing machine is in use.

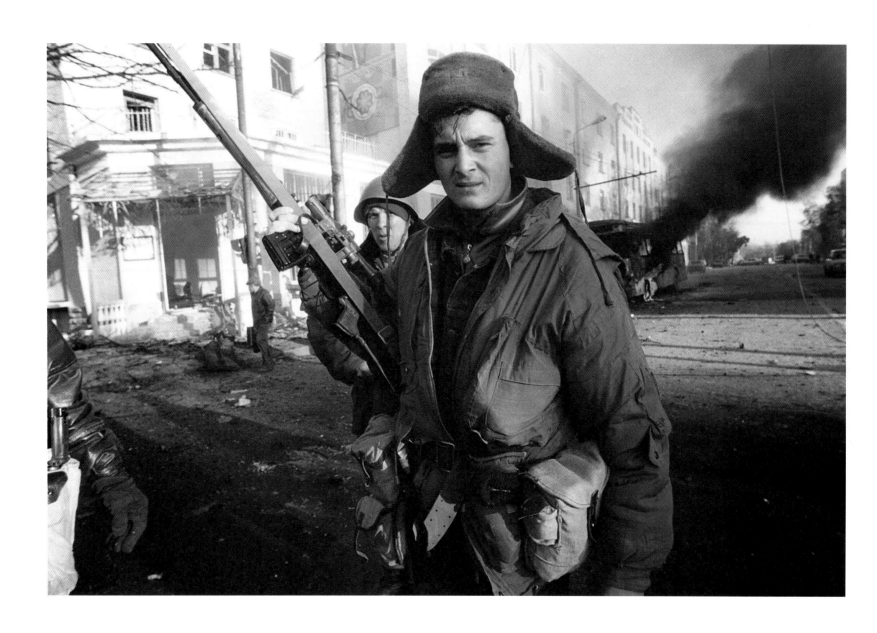

A Russian soldier defiant in Grozny, Chechnya's capital.

Snow and blood on their boots – the Russians were clumsy with a determined enemy.

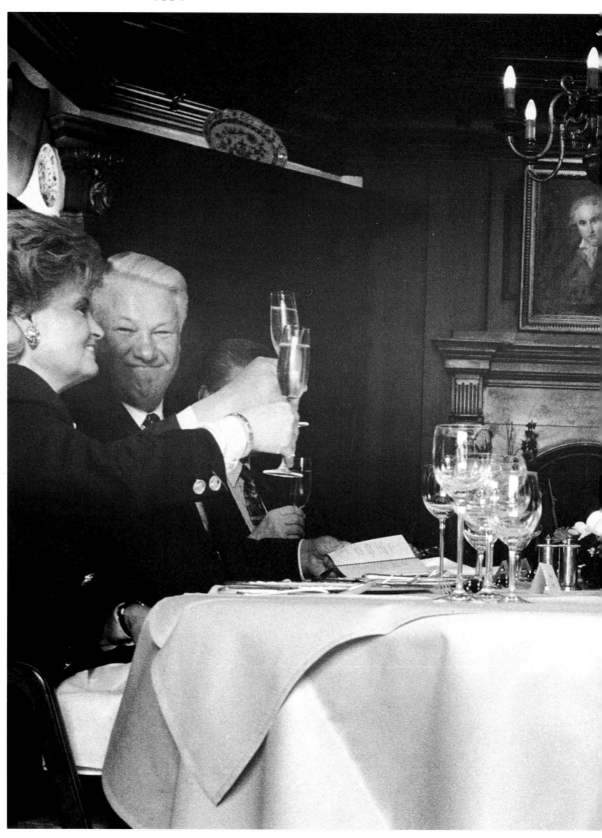

Boris and Naina Yeltsin with Helmut and Hannelore Kohl
relaxing at a diplomatic banquet in Bonn.

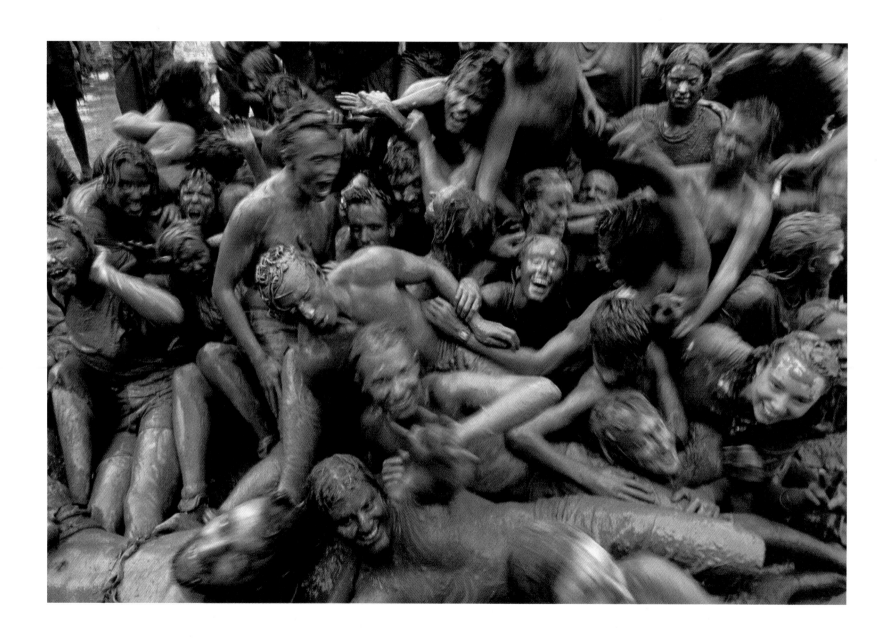

Woodstock, New York State's fading rock festival, being revived for a moment in the mud and rain.

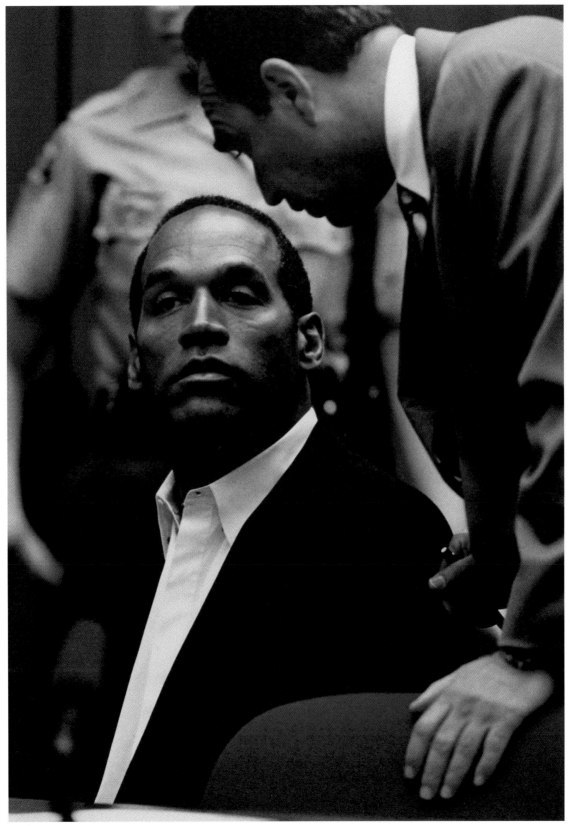

Famed American footballer O.J. Simpson with one of his many lawyers at the arraignment where he pleaded not guilty to the murders of his ex-wife and her friend.

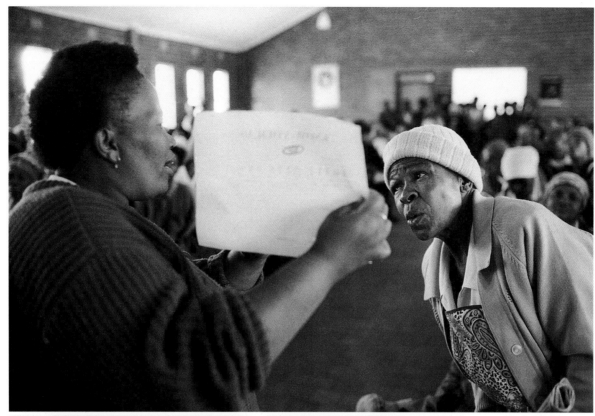

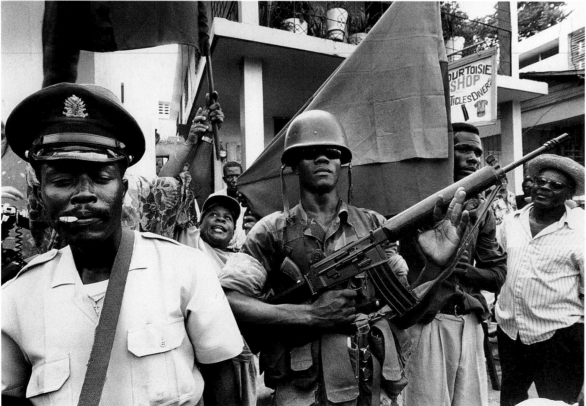

An illiterate woman from South Africa's Orange Free State being shown how to vote.
A policeman and soldier at a FRAPPE rally in Port-au-Prince, Haiti.

A rally of Zapatistas in southern Mexico, whose bid for cultural independence and economic reform was brutally crushed.

Two Chechen women frozen in fear as the Russians shell their homes.
A Chechen woman just killed by a Russian bomb near Grozny.

Shaken young couples comfort each other after the shock of the bombing in Oklahoma which killed 168 people.

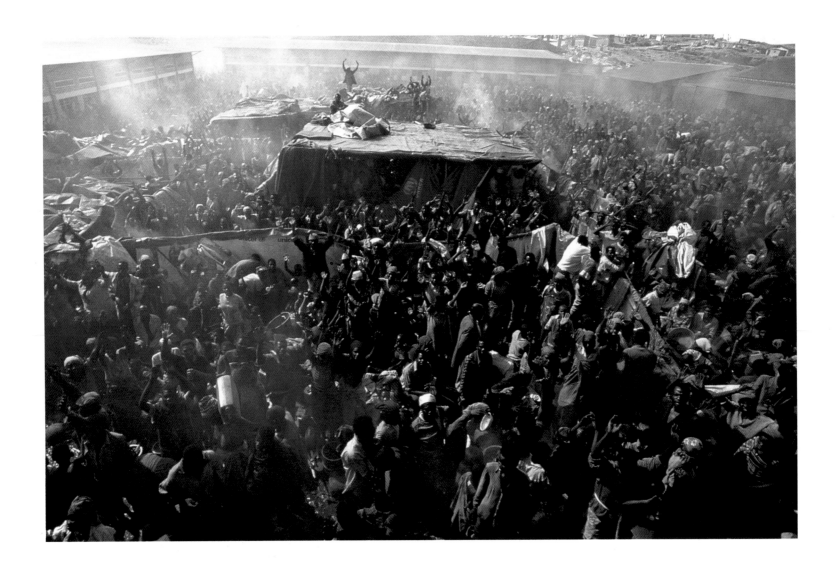

There was a mass slaughter of Hutus by Tutsis at the cruelly overcrowded Kibeho camp in Rwanda where conditions were already unspeakable.

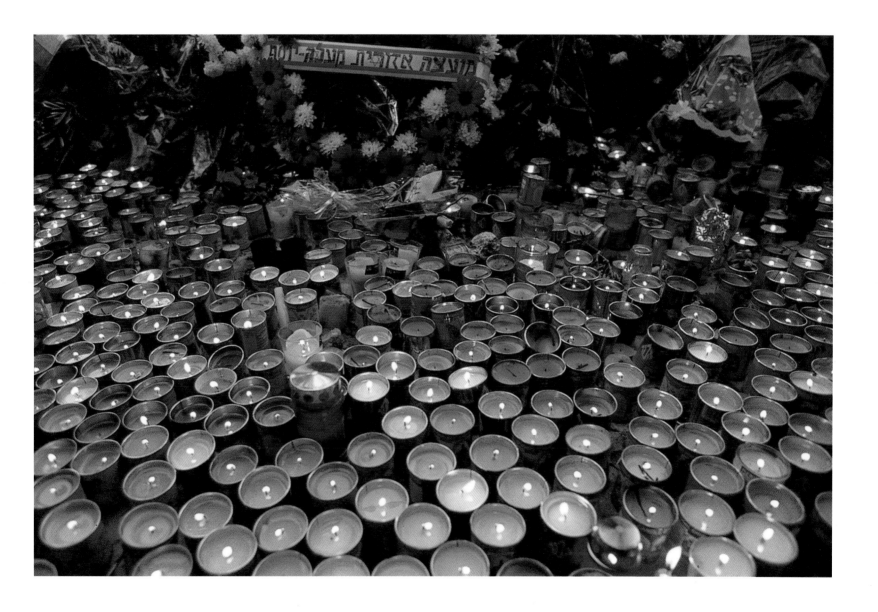

Candles lit in homage to the assassinated Israeli leader Yitzhak Rabin.

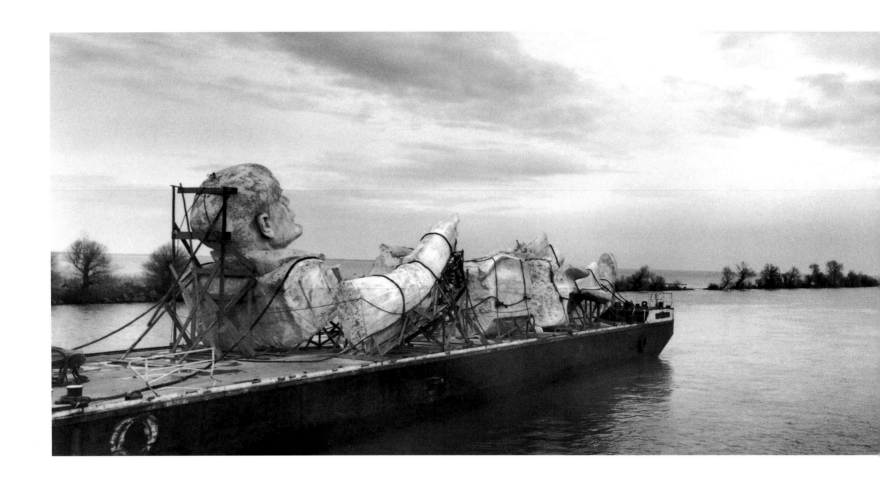

A photograph taken by Josef Koudelka during the making of the film *Ulysses' Gaze* showing a barge taking a statue of Lenin down the Danube.

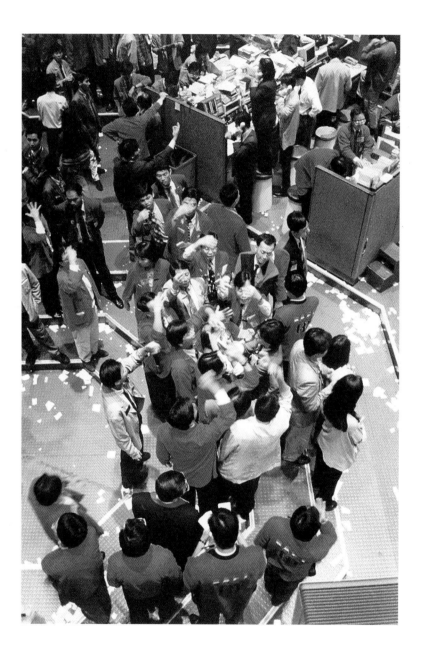

Fierce trading at the Singapore Stock Exchange. The merchant bank Barings was about to collapse.

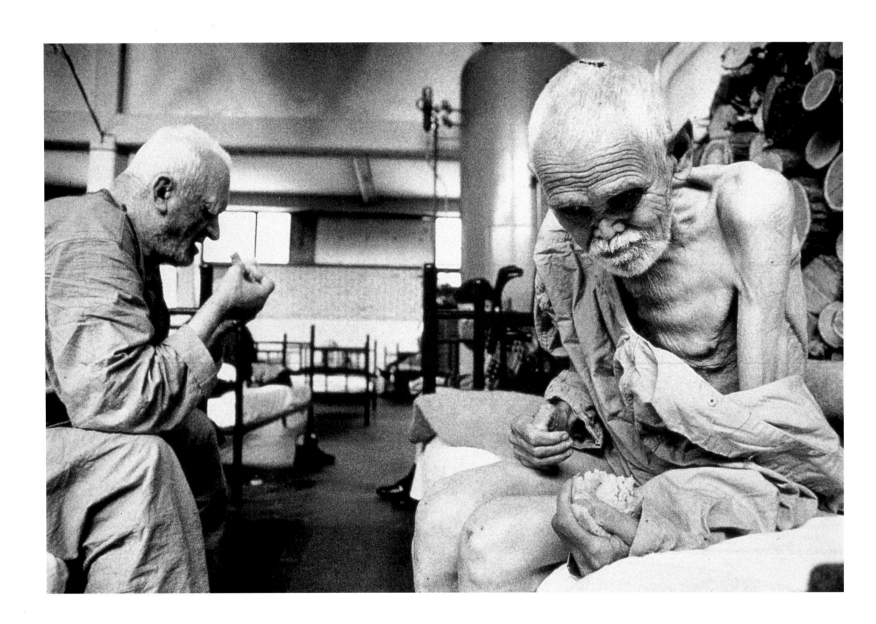

Physically and mentally ill old people in a boiler house in the Muslim 'safe-zone' of Srebrenica in Bosnia.

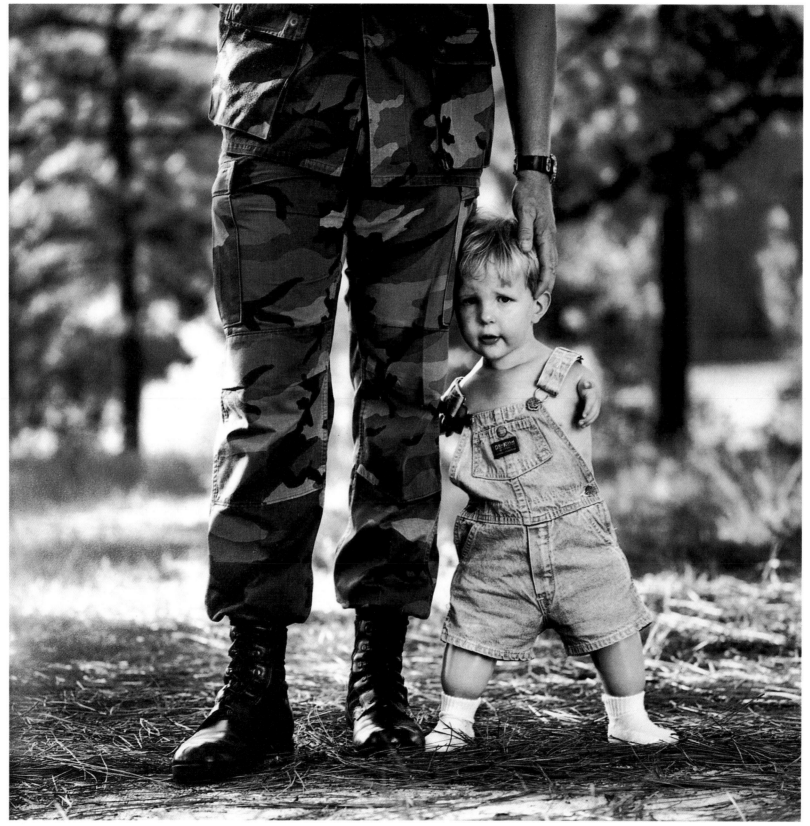

A child born without arms – a deformity claimed to be due to 'Gulf War Syndrome' although medical experts are divided over this.

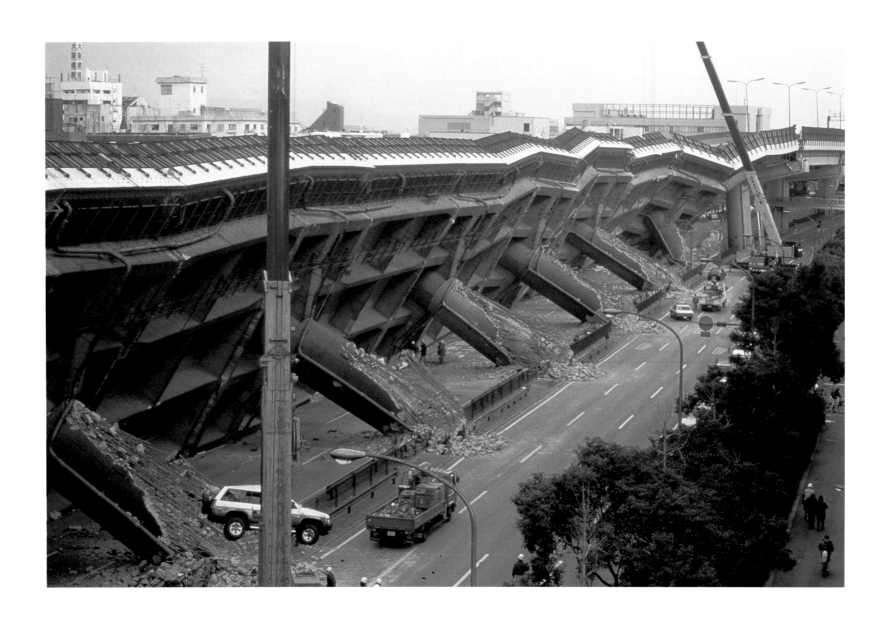

Only a very small shrug of the earth's crust created havoc in Kobe in Japan ...

... while these 'columns' of interstellar gas discovered by the Hubble telescope could envelope our whole universe about fifty times.

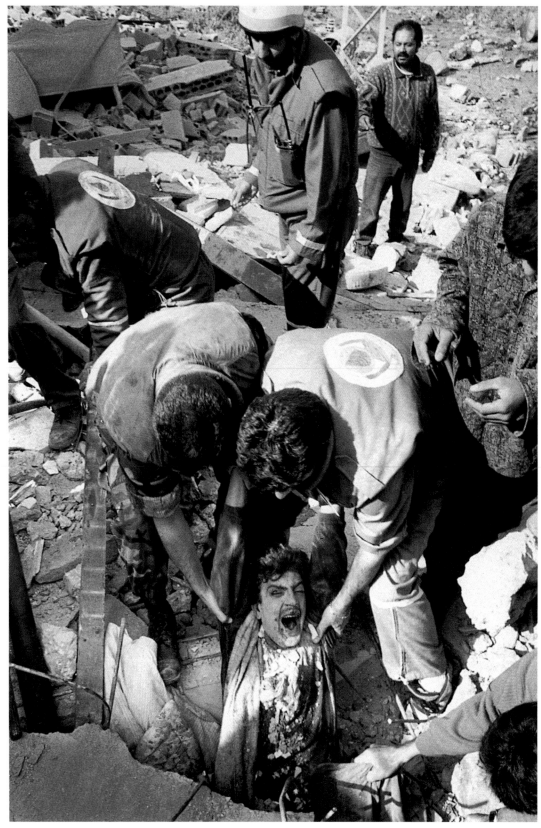

A tragically misdirected shell wrecked the UN shelter in Lebanon from which this survivor is being rescued – 150 people were killed.

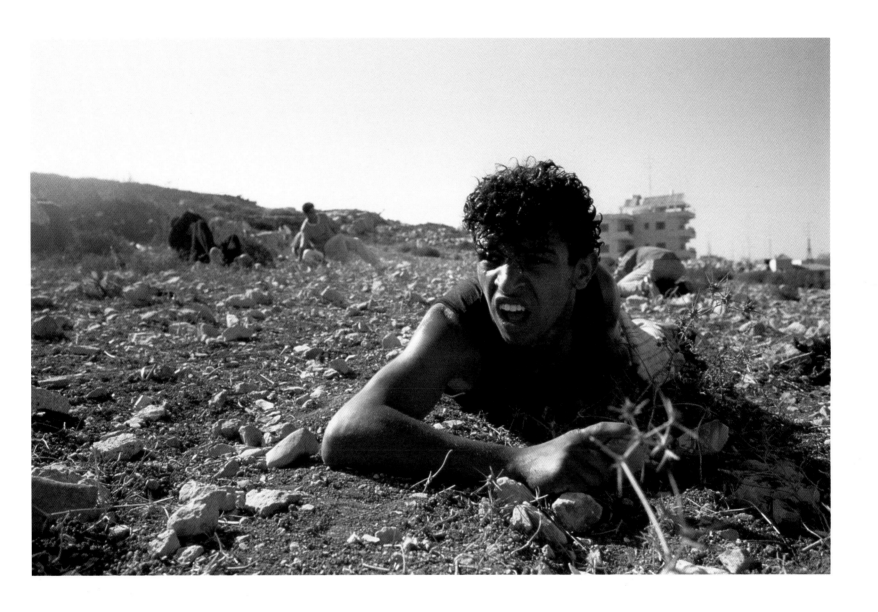

An angry young Palestinian who told Luc Delahaye, the photographer, of his thirst for revenge for a comrade's death.

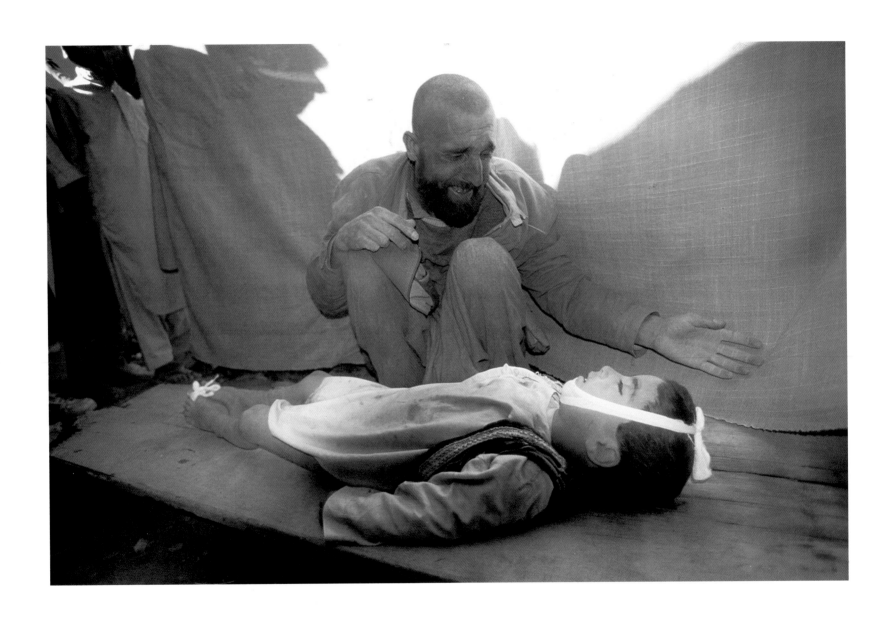

Killed by a mine – a six-year-old boy is mourned by his uncle in Kabul, Afghanistan.

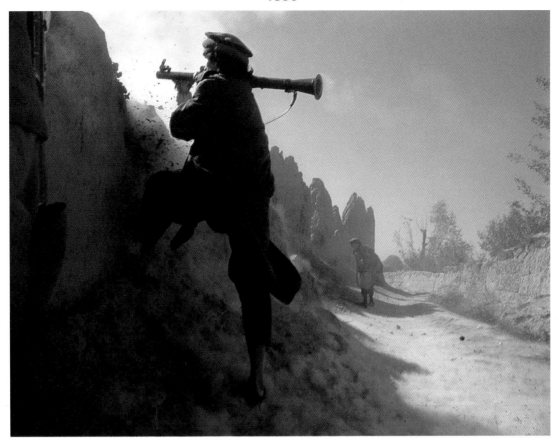

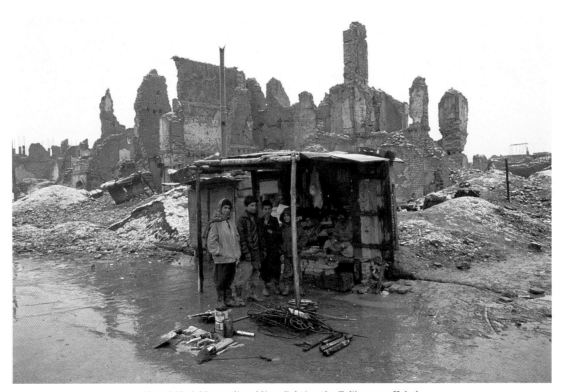

Ahmed Shah Massoud's soldiers fighting the *Taliban* near Kabul.
Kabul under siege by the *Taliban*. Very little of the city remains.

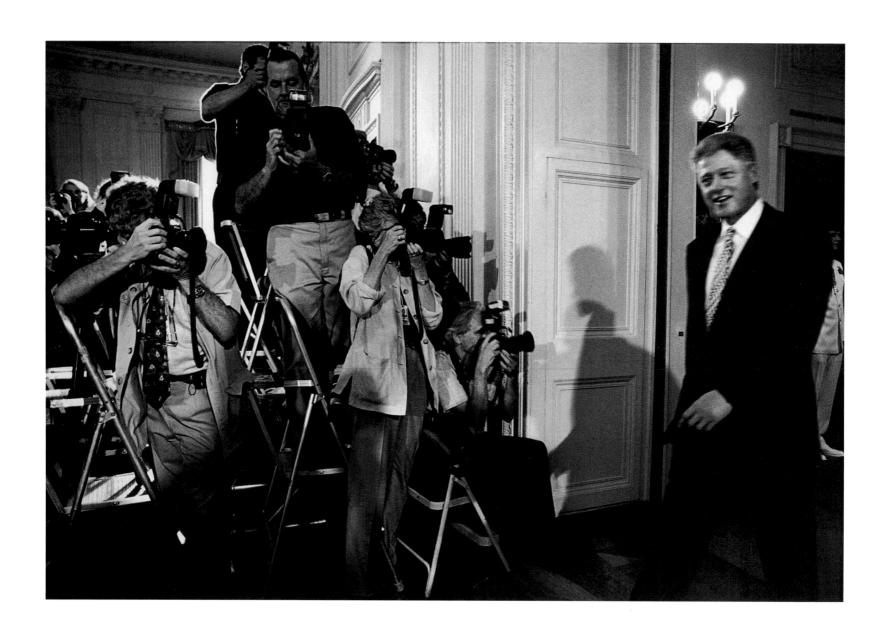

Bill Clinton attending a press conference at the White House.

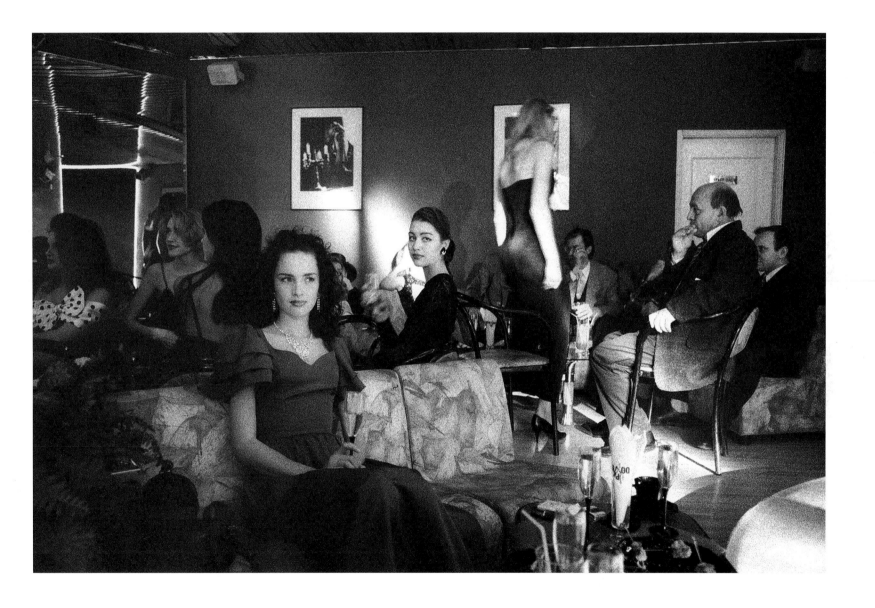

A 'Mafia' club in Moscow, where aspiring Miss Moscows are being inspected by members of the quasi-criminal class.

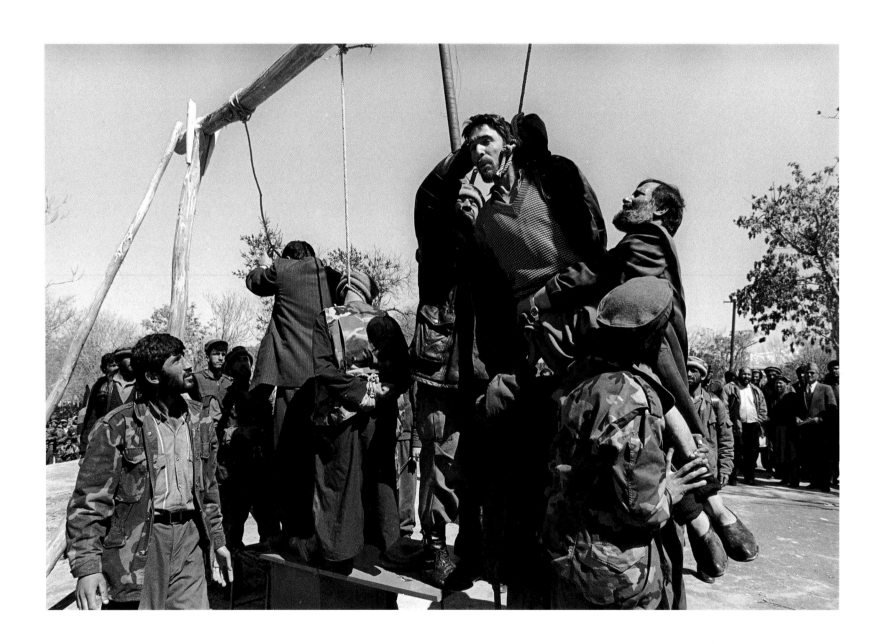

The hanging of the murderers of a shepherd in the ruined city of Kabul.

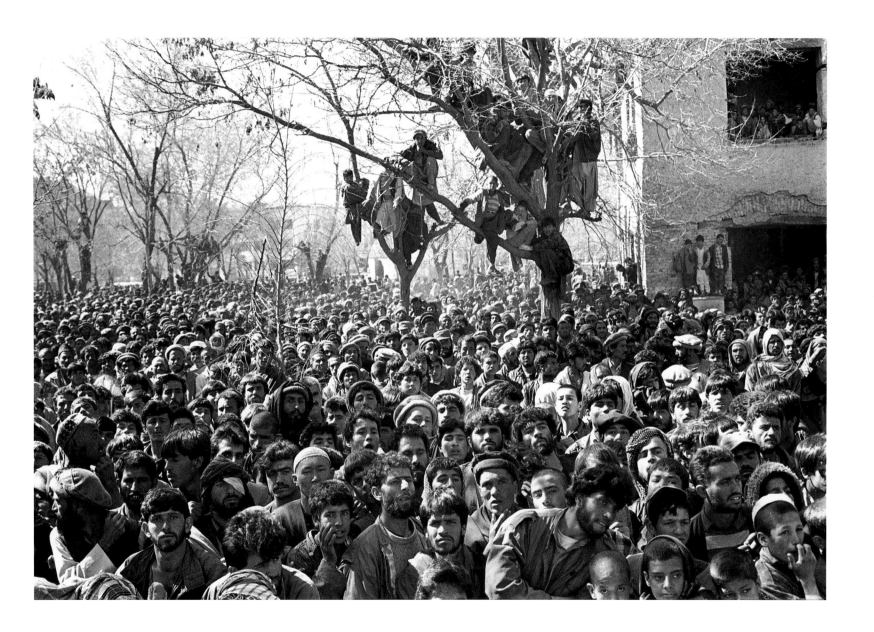

The public spectacle was aimed at discouraging crimes which had dramatically increased during the long period of national upheaval.

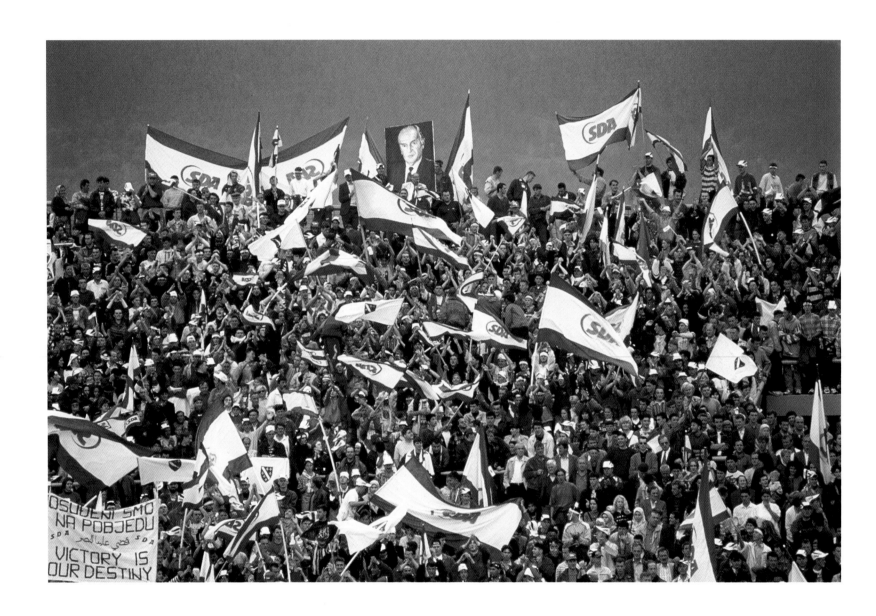

An election in Bosnia - the Muslim SDA party defiantly waving their flags by day ...

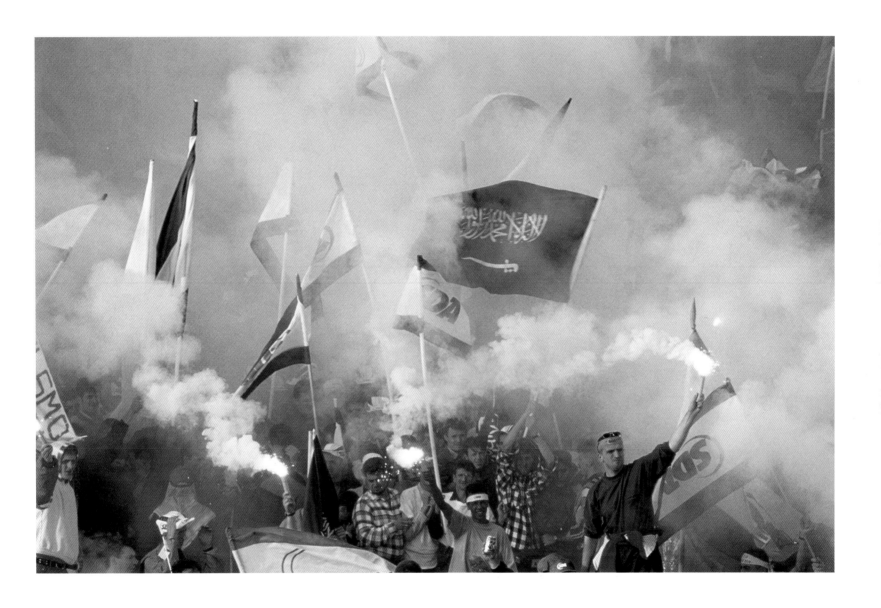

... and reminding the world of their roots in the old Ottoman Empire by night.

Cross-dressing at the New York gay parade Dragapalooza.

Protesters dramatically occupying trees to impede to their removal by motorway builders in Berkshire in Britain.

The burning of a Londonderry bus – by now routine television fodder in Britain.

Richard Billingham, an artist from the British West Midlands, made a tragicomic record of his home life – this is an unusually decorous episode.

Tony and Cherie Blair happy and victorious on the steps of No. 10 Downing Street. 'New Labour' had just gained power with a huge majority.

Deng Xiaoping – the great political and physical survivor – died aged ninety-two, having exerted enormous influence on the development of China.
A new generation of neo-Nazis in Germany.

Dr Ian Wilmot looks lovingly at the cloned ewe he helped to create.

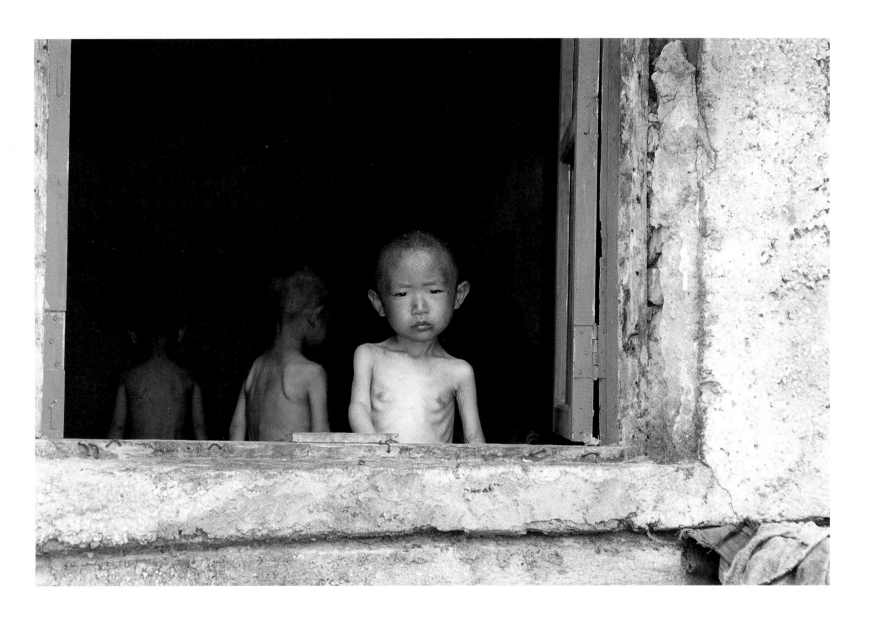

Starving boys in Sanch'on, North Korea. They look too old and tired to play.

One spirited couple found a way to keep the flag flying as Hong Kong was handed back to China at last.

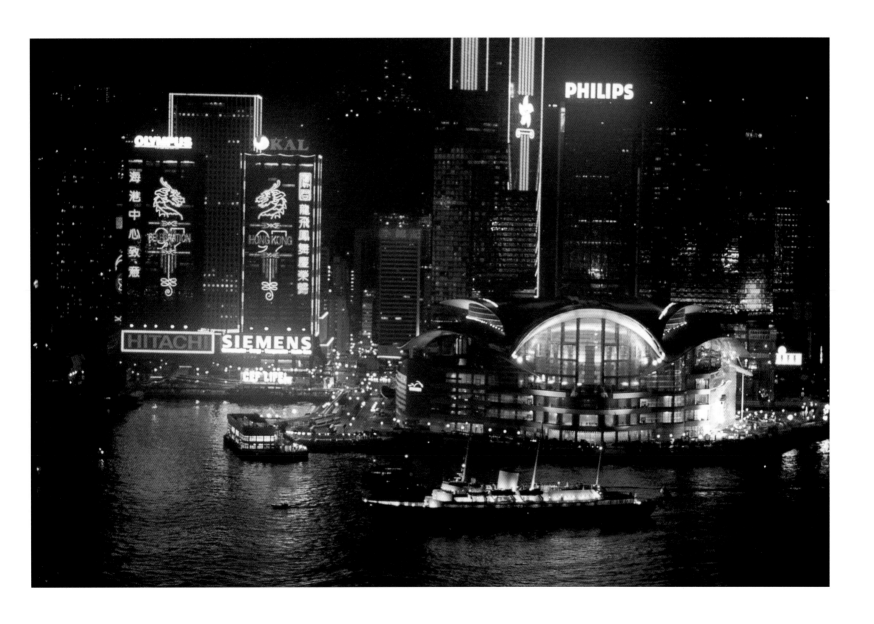

The Royal Yacht *Britannia*, her days numbered, seems dwarfed by Hong Kong's now communist skyscrapers.

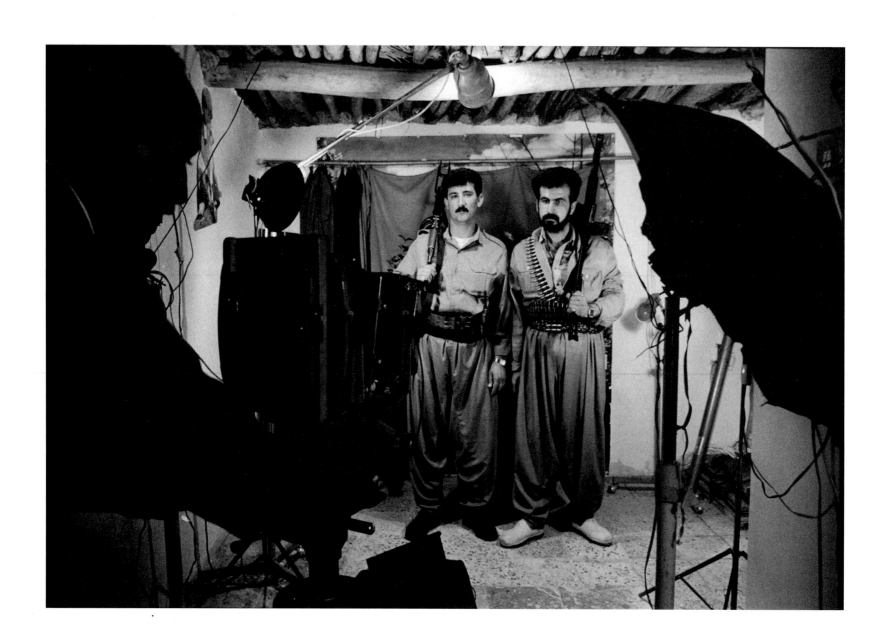

Iraqi Kurdish freedom fighters in traditional costume posing proudly in their village which was largely destroyed during the Gulf War.

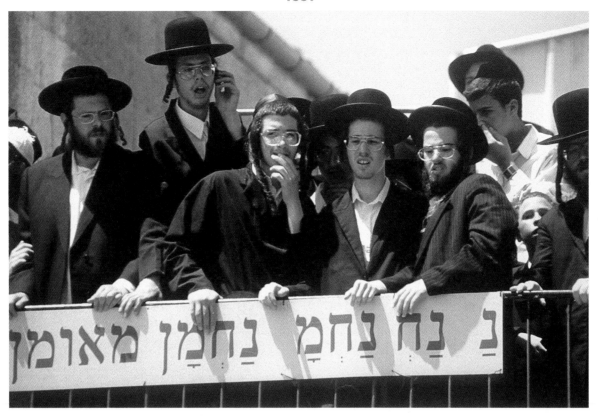

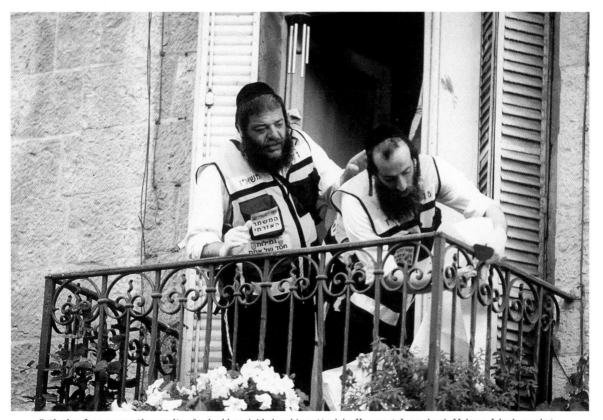

Orthodox Jews survey the results of a double-suicide bombing attack by Hamas at Jerusalem's Mehane Jehuda market.
Jews looking at the carnage caused by a triple-suicide bombing in Jerusalem – again claimed by Hamas.

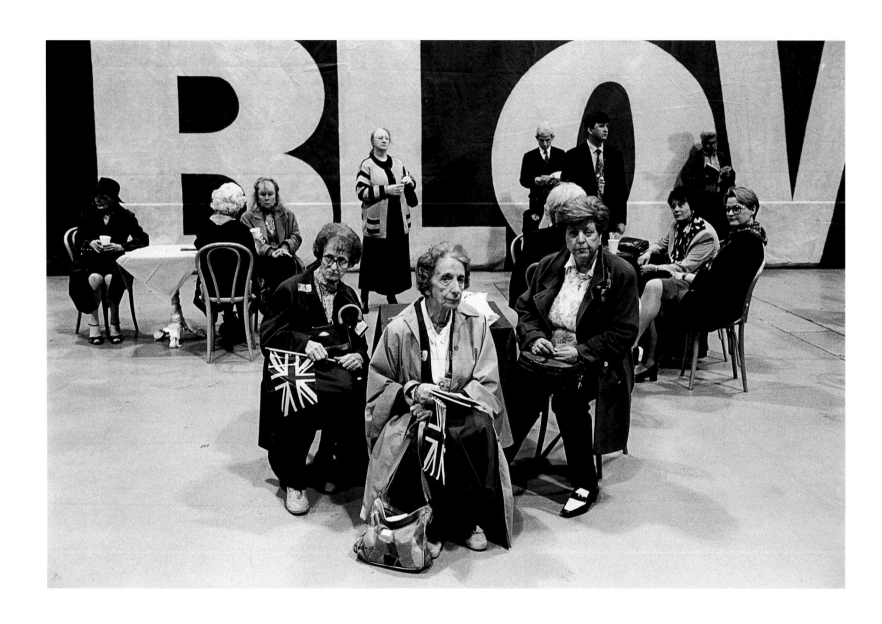

The end of Tory rule in Britain – time to restructure the shipwrecked party.

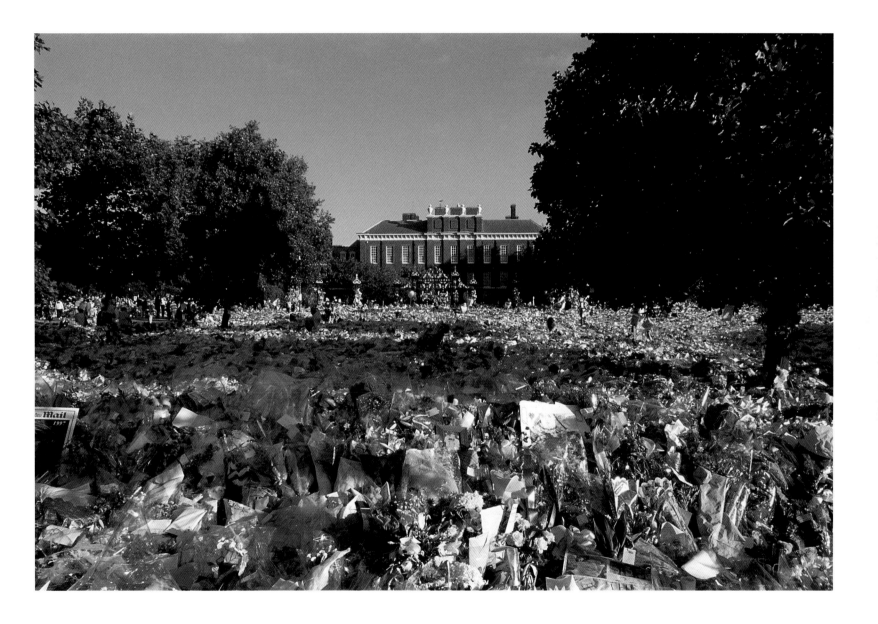

Floral tributes following Princess Diana's death in a car accident constituted the greatest ever display of public emotion in British history.

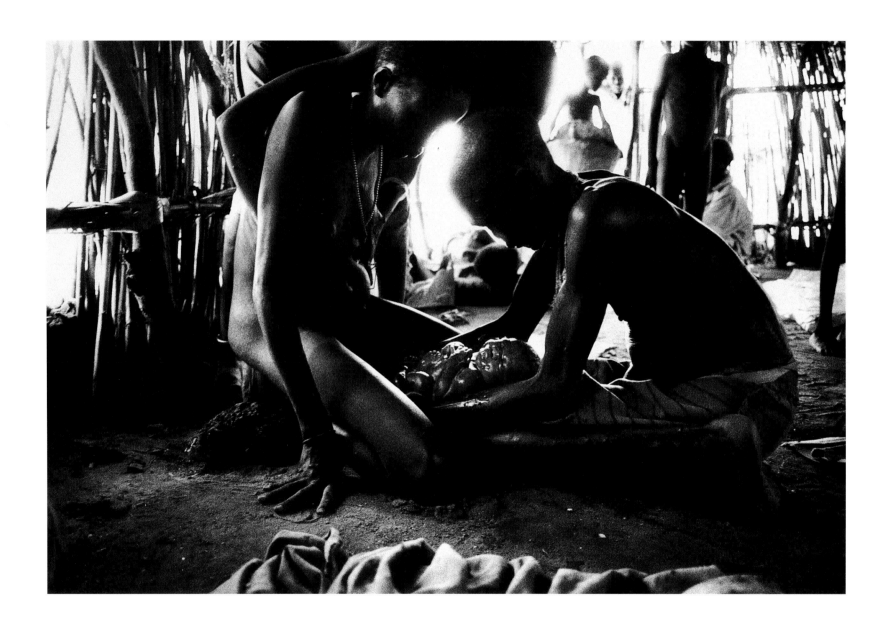

An undernourished Sudanese woman delivering a child, bringing one more mouth to feed into the famine-stricken country.

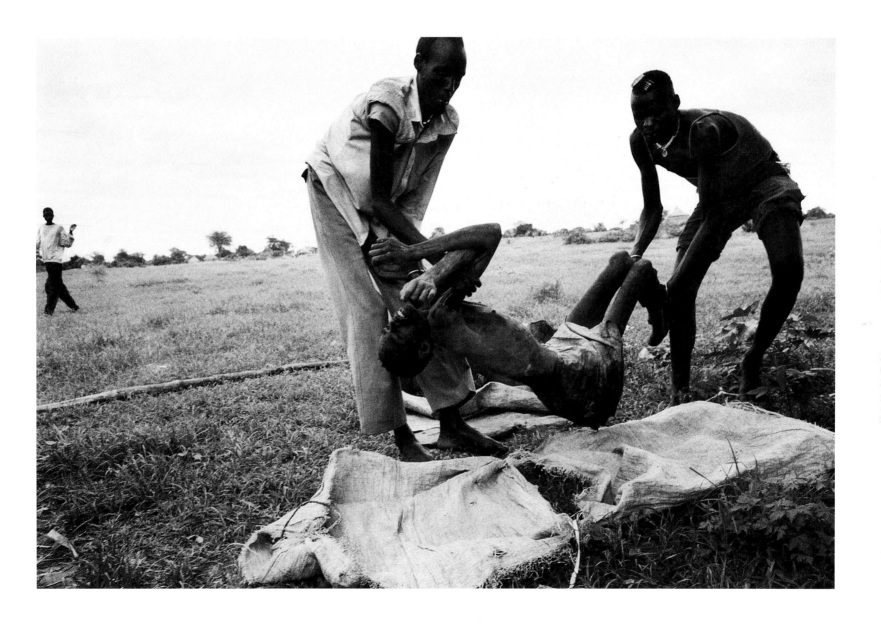

The burial of a young man in Sudan – he is likely to have died from famine-related disease.

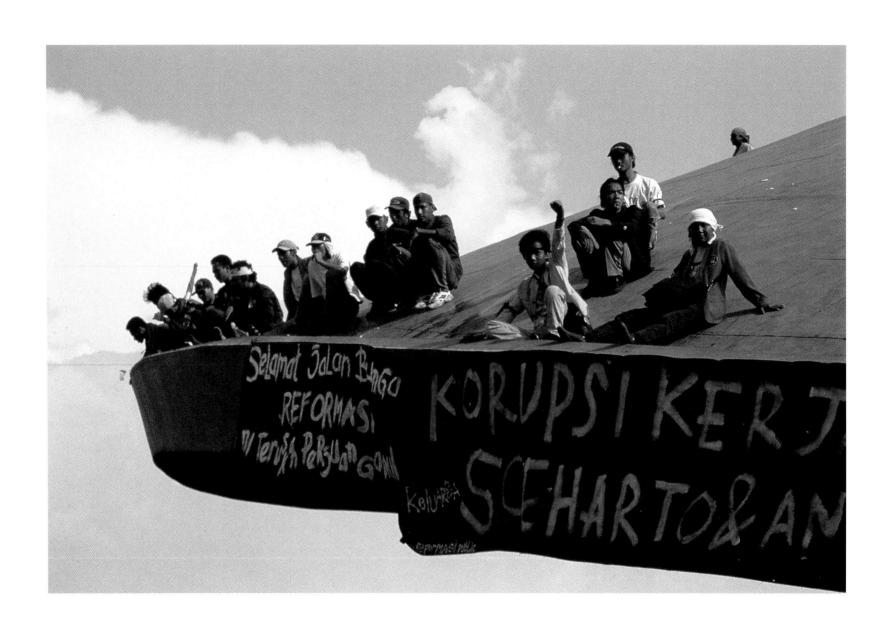

Indonesian students on the occupied parliament building in Jakarta demanding an end to General Suharto's regime.

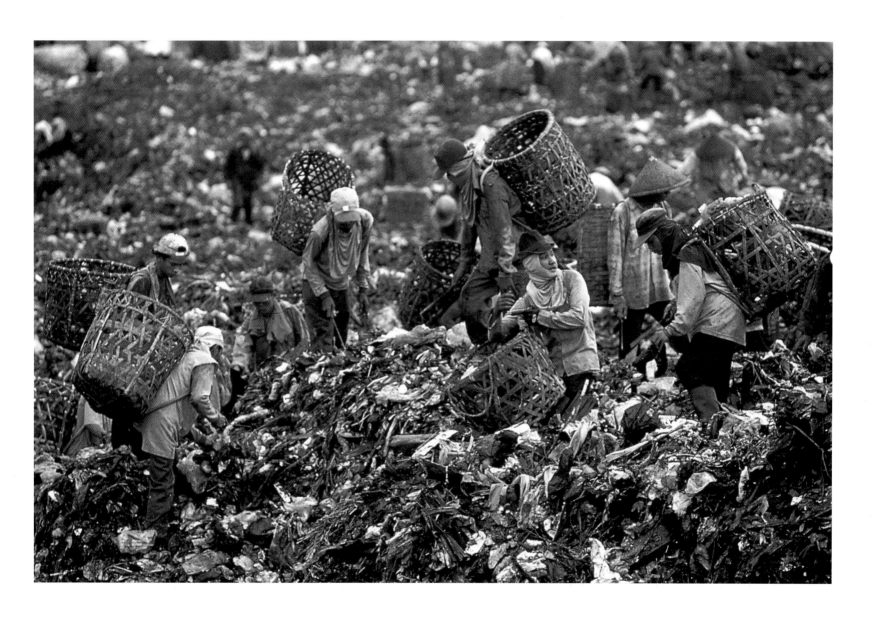

The poverty and squalor in Jakarta's slums completely ignored by a government which had been ruling for over thirty years.

Euphoria at Yugoslavia's victory over Russia in the World Basketball Championships.

A Los Angeles family visits a gun store to buy an assault rifle based on the latest army weaponry.
These Memphis housewives are armed to the teeth, legally, and take courses in self-defence which recommend total ruthlessness.

Independent Counsel Kenneth Starr addressing the press about President Clinton's alleged improprieties.

Before the World Cup final 300 fashion models paraded forty years of French designer Yves St Laurent's fashions.
France win the World Cup at last – the competition was instituted by Frenchman Jules Rimet in 1928.

The daughter of an Afghan woman forbidden to work by the *Taliban* government begging for her whole family.

Mourners of the Omagh bombing that killed twenty-eight – an unsuccessful attempt by the 'Real IRA' to sabotage the peace process in Northern Ireland.

The bones of the Romanovs – murdered by the Bolsheviks in 1918 – on display in Yekaterinburg before respectful reburial in St Petersburg.

Hurricane Mitch failed to fell this tree, but killed over 11,000 people in Honduras.

The controversial Millennium Dome at Greenwich in London during the early stages of its construction. The construction workers seem 'spidermen' indeed.

Aboard USS *Enterprise* during Operation Desert Fox – ghostly figures ready to punish Saddam and the Iraqis once more.

King Hussein of Jordan and his son and heir Prince Abdullah embrace just weeks before the King's death.

King Hussein's subjects show their grief at their ruler's death with a traditional display of emotion.
Princes Hamza (third from left), Hashem (unseen), Faisal (with back turned) and Ali (second from left) unite in their filial respect for the dead King.

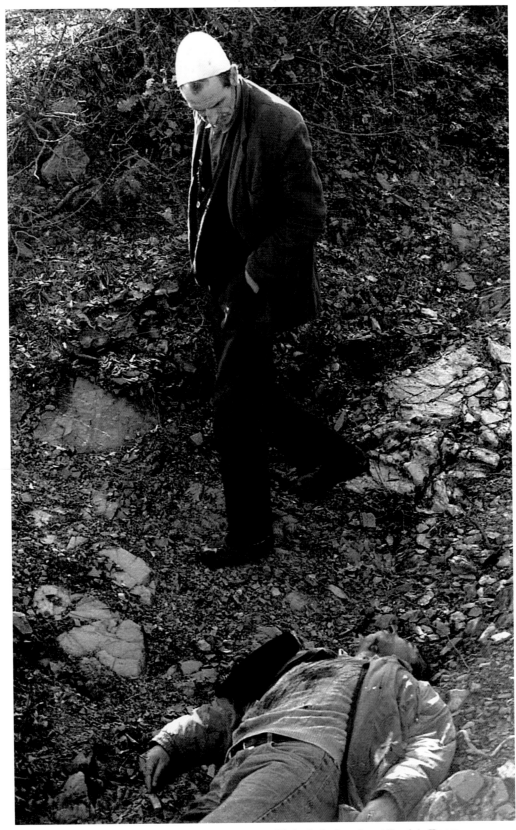

A fellow Muslim looks resignedly at a victim of Serb ethnic cleansing at Racek in Kosovo.

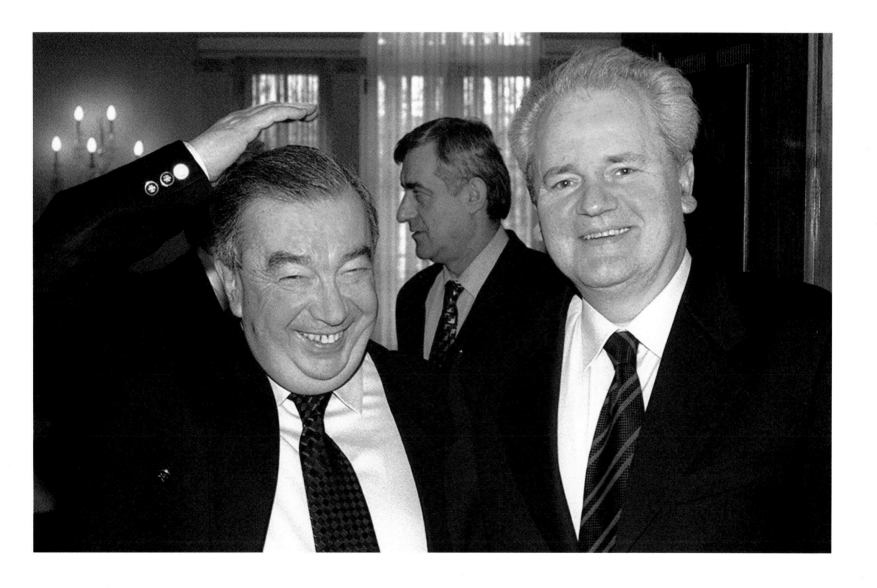

Yevgeni Primakov the Russian Prime Minister (left), and Slobodan Milosevic the Serbian leader, seem in happy accord about the actions that have provoked an international crisis.

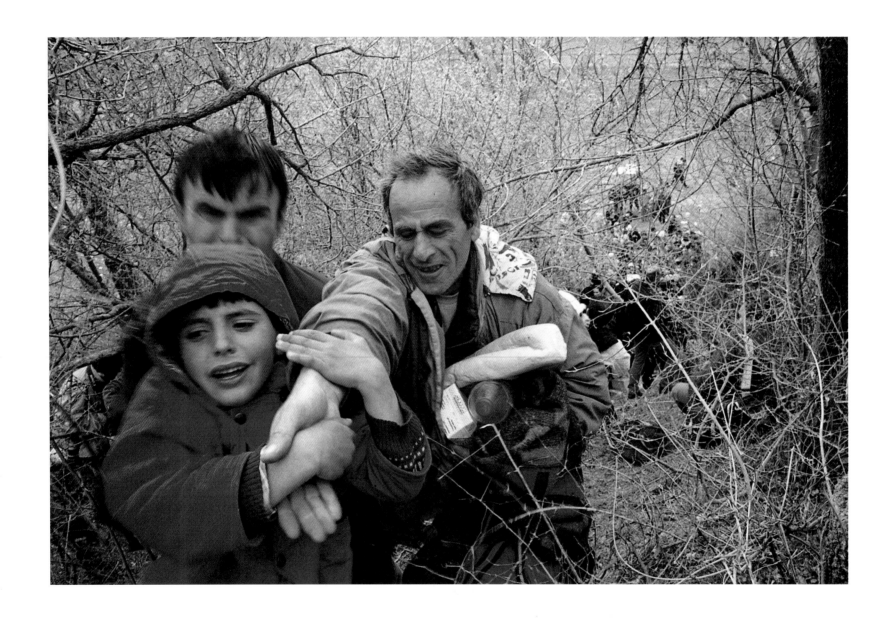

Crossing into Macedonia – Kosovans of all ages and in all conditions flee from the Serbs.

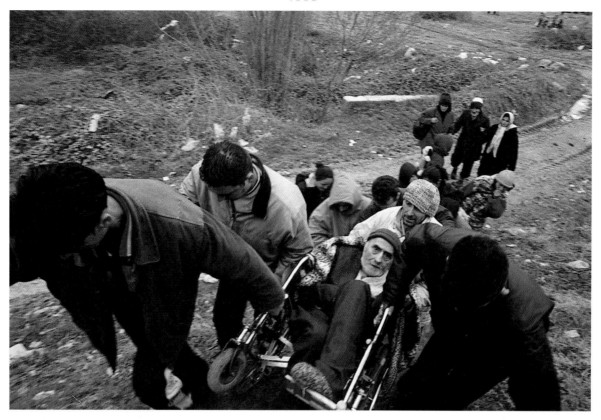

Some of the million-plus ethnic Albanians dispossessed by the Yugoslav government and seeking any haven on offer.
Fighting back tears for his lost family – nothing can compensate this man for his misfortune.

A Serbian soldier helping to 'mop up' an ethnic Albanian village in Kosovo. Scores of villages were burned to the ground.

A French customs X-ray at Calais reveals ten Kosovan refugees in a juggernaut attempting to get through the Channel Tunnel undetected.

Serbs with a swastika-daubed Union Jack on a bridge at Novi Sad, protesting against the NATO bombing.

Refugees being taken out of Kosovo. Wherever wars start, children must look on with dismay and wonder at the world's instability.

Will this baby ever live in Kosovo? Its mother might never want it to – many Kosovan refugees may not want to return to the wreckage.

The most unpredictable horror involving deliberate human action – pupils at Denver Columbine High School expressing their anguish.

Beethoven's opera *Fidelio* which was performed at the Berlin Staatsoper in early 1999. Its simple story of love and courage conquering hatred and brute force is one of the glories of Western art. Here Leonora, disguised as a boy, has just persuaded the jailer Rocco to let the prisoners out of their cells for some sunlight and fresh air.

1986

914. Dictator Ferdinand Marcos ruled the Philippines for more than two decades, siphoning vast amounts of the country's wealth directly into inter-national bank accounts. Marcos apportioned the remaining wealth through an extensive system of patronage designed to reward his supporters within the army and the business community. The rest of the Filipino population lived in poverty and were subject to harsh restrictions and government repression. In 1983 a popular anti-Marcos politician Benigno 'Ninoy' Aquino was assassinated, allegedly on Marcos' direct orders, upon his return to the Philippines after a period of exile. Aquino's wife, Corazon, assumed the role of unofficial opposition leader following her husband's death. On 2 February 1986 she claimed victory in a snap election – which Marcos had called – when it became clear that the Marcos regime had resorted to widespread vote-rigging. Marcos attempted to cling to power but a massive non-violent civil disobedience campaign, the so-called 'People's Power' movement led by Aquino, eventually forced him to flee the country. He left on 26 February with his wife Imelda, and hundreds of millions of dollars. Aquino was declared President the following day. Marcos died in exile in 1989. In 1999, after prolonged legal actions in US courts, the Marcos family agreed to pay damages to the victims of human rights abuses under his regime. The ruling marked the first time any national leader has been forced to pay compensation for the violent excesses of their rule.

915. On 26 April 1986 an explosion ripped through Reactor 4 at the Chernobyl nuclear power plant near Kiev in the Ukraine. Exposure to massive amounts of radiation immediately killed thirty-two plant workers and firefighters. Soviet authorities at first denied the extent of the accident at Chernobyl and even allowed May Day parades to be held in Kiev within days of the accident while fires in Reactor 4 were still bur-ning. Only when Western scientists had produced indisputable evidence of widespread radioactive contamination was the disaster finally admitted by the Soviet government. An evacuation of around 130,000 people living in a radius of 30 kilometres (18 miles) took place. Reactor 4 was buried in concrete. The rest of the nuclear station continued to function and is not scheduled for shut-down until the year 2000. By the time the last fires were extinguished several weeks after the first explosion, radioactive clouds had spread through Scandinavia and western Europe, contaminating agricultural produce in many areas. Chernobyl is the worst nuclear accident in history and created major environmental and health problems which are still being felt today.

916. As leader of the British group Queen, Freddie Mercury became one of the most popular figures in rock music in the 1970s and 1980s. During 1986 Queen sold a staggering 1,774,991 albums in Britain alone. Over the years Mercury had developed an increasingly camp and flamboyant public persona – for example, dressing in ermine robes and a crown – both on stage and in the new medium of 'pop videos', of which he was one of the key innovators. Mercury remained intensely protective of his private life. He disappeared from public view in early 1991 amidst widespread rumours that he was suffering from AIDS. On 23 November Mercury finally admitted he had contracted the disease. He died within forty-eight hours of the announcement.

917. Diego Maradona was championed as the greatest football player of his generation prior to the 1986 World Cup in Mexico. His extraordinary power and balance, combined with an uncanny skill developed during his youth in one of the poorest areas of Buenos Aries, made this Argentine one of the highest paid and most popular athletes in the world. Maradona's performance in the Mexico tournament did not disappoint – he scored five goals and captained Argentina to their second World Cup triumph in eight years, although not without controversy. During the quarter-final match against England Maradona used his hand to direct the ball past the English goalkeeper into the net. The infraction was not seen by the match referee and the goal was allowed to stand. Maradona later attributed the goal to the 'hand of God'. Four minutes later Maradona scored a second goal, widely regarded as the finest in World Cup history. For the rest of his career, Maradona's brilliant football playing was similarly marred by controversy of one form or another.

918. On 15 April 1986, after a period of mounting tension between the US and Libya during which US President Ronald Reagan repeatedly accused Libyan leader Muammar Gaddafi of encouraging and organizing international terrorism, US planes bombed Libya's capital, Tripoli, and its second city, Benghazi. At least a hundred people, including Gaddafi's adopted baby daughter, were killed in the raids. US authorities claimed that the planes had hit only terrorist-related targets, but the attacks were loudly condemned in much of the rest of the world. France had refused a request by US officials for permission to fly the planes over French airspace, but British Prime Minister Margaret Thatcher had allowed US planes to use bases in Britain to launch the attack. In an apparent revenge attack for the bombings, one American and two British hostages in Lebanon were killed by terrorists two days after the strike.

919. On 10 April 1986 nearly a million Pakistanis turned out to welcome home the exiled leader of the Pakistan People's Party (PPP), Benazir Bhutto. Daughter of former Pakistani Prime Minister Zulfiqar Ali Bhutto, Benazir had suffered long periods of house arrest and eventually exile in London following the overthrow of her father in 1977 by General Zia al-Haq and his execution two years later. Charismatic and well-educated, Bhutto assumed a high profile in the burgeoning Movement for the Restoration of Democracy, a broad alliance among anti-Zia forces in Pakistan. Bhutto took office as the Islamic world's first woman prime minister in December 1988 after elections held in the wake of Zia's death in a plane crash. Despite her talent for wooing crowds, Bhutto – only thirty-five-years-old at the time of her election – proved a poor administrator. She was ousted within two years after her government fell victim to scandal and corruption.

920. El Salvador began to slide into conflict and violence in the late 1970s when it became clear that only through the defeat of the country's right-wing military junta could an end be put to their rule of large-scale repression and terror. After the assassination of Archbishop Romero in 1980, left-wing opposition parties united under the *Frente Farabundo Marti de Liberation* (FMLN) to wage a guerrilla campaign to oust the military regime. Government forces and paramilitary groups, trained and armed by the US, responded by kidnapping, murdering and torturing tens of thousands of El Salvadorians suspected of backing the FMLN.

921. In the 1970s Chile's military regime pursued a liberal economic programme which helped stabilize the economy, increase foreign investment and reduce foreign debt. In spite of this the country suffered persistent poverty. The regime brutally repressed left-wing elements and opposition groups did not pose much of a threat to Augusto Pinochet, the military leader. By the 1980s however, opposition groups had developed a stronger base. They covered a wide spectrum of political interests, but grouped together to organize protests and strikes in response to the regime's continuing repression and a downturn in the economy. This opposition to Pinochet was emboldened by rising inter-national pressure for him to abandon his draconian policies and liberalize the government. Protest and violence against the regime climaxed in a failed assassination attempt on Pinochet in September 1986. This was followed by an intense period of government terror and abductions which forced some prominent opposition leaders into hiding.

922. On 19 February 1986 the Soviet Union launched its newest space station, *Mir* (meaning peace). This took them one step further towards the construction of a permanently operated manned orbital complex. Vladamir Solovyoz and Leonid Kizim were the only crew to board the station during its inaugural year in orbit. Within two months of taking off aboard *Soyuz T–15* on 13 March, the cosmonauts had flown the Soviet spacecraft from *Mir* to the existing *Salyut* space station. They boarded *Salyut*

for two months of tests and observations in the first station-to-station transfer ever accomplished. They returned to earth on 16 July after 125 days in orbit.

923 left. NASA hoped that their twenty-fifth space shuttle mission launched on 28 January 1986 would generate renewed interest in space exploration and rekindle popular support for the shuttle programme. With this in mind Sharon Christa McAuliffe, a high school teacher from New England, was selected in a nationwide competition to be the first private citizen to board the shuttle. After her mission aboard *Challenger* McAuliffe was scheduled to visit schools across the United States to highlight the role of teachers in society and get young Americans interested in pursuing careers in high technology and space industries. She never made the tour. *Challenger* exploded at an altitude of 14,240 metres (47,000 feet), seventy-three seconds after liftoff. McAuliffe and all six astronauts on board were killed.

923 right. Debris from *Challenger* rained into the Atlantic ocean for more than an hour after the explosion. Rescuers found no sign of the crew. A huge investigation was mounted by NASA and an independent commission was appointed by President Reagan in the aftermath of the disaster. Findings revealed that the immediate cause of the accident was flawed booster rocket seams. The investigations also uncovered gross negligence on the part of the planners who were streamlining shuttle operations in the hope of achieving their declared goal of flying twenty-four shuttle missions a year. Shuttle flights were suspended for several months while NASA re-evaluated the goals of the programme and implemented new safety measures.

924. Hoping to exploit the chaos and instability of a country still in the throes of the Islamic revolution, Iraq invaded Iran on 12 September 1986. Saddam Hussein, Iraq's leader, hoped to retake the Shatt-al-Arab waterway at the confluence of the Euphrates and Tigris rivers. Long a source of dispute between the two countries, the waterway formed Iraq's only access to the Persian Gulf. Iraq had ceded 500 kilometres (300 miles) of land along the waterway

to its eastern neighbour in the Algiers Agreement of 1975 in return for Iran's termination of support for Kurdish rebels in northern Iraq. Hussein was also concerned that Iran's new Shiite-led regime might incite rebellion among his country's Shiite majority.

925 top. Iran's leaders, who bore tremendous animosity towards Saddam Hussein, rejected the Iraqi leader's cease-fire overtures in late 1982 after he had withdrawn his army from all captured Iranian territory. Hussein continued to make half-hearted attempts to secure a peace agreement, but Ayatollah Khomeini's regime remained intransigent and the war settled into a bloody stalemate along a line just inside Iraq's border. Iran repeatedly launched futile infantry assaults, often with untrained conscripts, against heavily fortified Iraqi positions. Each side bombed the other's oil installations relentlessly, severely reducing their respective oil-producing capacities. The massive diversion of funds to the military and damage to the oil industry brought both country's ambitious economic development programmes to a standstill.

925 bottom. One of the longest, costliest and bloodiest wars of the latter half of the twentieth century, the Iran-Iraq War (known widely as the Gulf War prior to the 1991 war between Iraq and Kuwait which was given the same name) finally ended on 20 August 1988 when a UN-mediated cease-fire came into effect. The war resulted in half a million deaths and more than a million wounded. Neither side gained any territory, although in some ways the war enabled leaders in both countries to entrench their dictatorial regimes more firmly.

926. In December 1979 the Soviet army invaded Afghanistan to shore-up the country's unpopular communist regime led by Barbrak Kemal. The Soviet Union's southern neighbour had been a sphere of Russian interest since the nineteenth century. The Soviet invasion gave the various anti-communist and opposition factions, collectively known as the *Mujahideen* (from the Persian word meaning 'warriors') a common enemy. Aided by the country's rugged terrain as well as vast amounts of arms and supplies

from Pakistan, Arab states and above all the US, the opposition forces managed to sustain a successful guerrilla campaign against government troops and their Soviet allies. By 1986 morale among troops fighting the rebels was plummeting, particularly in the Afghan army where new conscripts were deserting at the earliest opportunity.

927 top. After a brief lull in terrorist activities, ETA renewed its violent campaign for Basque independence from Spain in the spring of 1986. On 25 April a car bomb exploded in Madrid, killing five civil guards and wounding eight others. In response to this attack, and in order to prevent further bombings and assassinations, the French government announced that it would offer assistance to the Spanish government against the terrorists who were also claiming part of Basque territory in south-western France. When French Prime Minister Jacques Chirac arrived to meet government officials in Madrid, Basque demonstrators mounted a protested by burning French vehicles and blocking roads. By the end of the 1980s ETA had claimed responsibility for more than 600 deaths in fifteen years of terrorism.

927 bottom. On 6 September 1986, twenty-one Jewish worshippers were killed when two Arab terrorists armed with automatic weapons and hand grenades attacked the Neve Shalom synagogue in Istanbul in Turkey. Four separate Arab organizations initially claimed responsibility for the massacre. The Palestinian Abu Nidal terrorist group was later confirmed as the sole instigator. The deaths shocked the Muslim country's tiny Jewish community and sparked fears of a surge in anti-Semitic attacks in secular Turkey.

1987

928. In December 1986 a Special Prosecutor was appointed by President Reagan to investigate claims that proceeds from secret arms sales to Iran had been diverted into the administration's clandestine effort to assist the Contras in their war against the Sandinistas in Nicaragua. The arms sold to Iran were shipped to Lebanese terrorists who, in return,

released Western hostages held in Beirut. Selling arms to Iran and making deals with terrorists were both illegal and against declared administration policy. The funding of the Contras was also prohibited by the US Congress' Boland Amendment. Reagan denied all knowledge of the diversion of profits to the Nicaraguan rebels although he did accept responsibility for the affair, dubbed the Iran-Contra scandal, which severely compromised the rest of his term in office. During televised hearings on the scandal between May and August 1987, a virtually unknown marine colonel Oliver North became a media sensation after testimony revealed his central role in the CIA-organized scheme. He was reviled by those Americans who saw him as a dangerous renegade, flouting America's democratic traditions with impunity in the name of the administration's right-wing agenda. Others saw North as a patriotic folk hero, dutifully accepting the role of scapegoat in the scandal. He was later found guilty of misleading Congress but his conviction was overturned on appeal.

929 top. The Contra insurgency in Nicaragua in the 1980s destroyed the Sandinistas' reform pro-gramme for the impoverished Central American country. The rebels, drawn principally from former Nicaraguan dictator Anastasio Somoza's National Guard, mounted guerrilla attacks on Sandinista targets from bases in Honduras and Costa Rica. The Nicaraguan economy was ruined due to the resulting damage to factories and infrastructure, as well as the government's unsus-tainably high level of military spending. The Sandinistas were forced to rely heavily on Soviet and Cuban support. The CIA supplied and trained the Contras (short for *contrarevolucionarios*), and were also involved in the rebels' mining of Nicaraguan ports in 1984 for which the US was widely condemned at the UN and the World Court in the Hague. The US administration's support for the Contras was consistent with the Reagan doctrine of assisting anti-communist insurgencies worldwide and reflected the president's misguided belief that the Sandinistas were bent on fomenting instability and exporting communism in a region which US officials have long

considered America's 'backyard'.

929 bottom. By the mid 1980s the various Contra groups, championed as 'freedom fighters' by right-wing organizations and politicians in the US, were a force of about 15,000 soldiers. Widely-reported human rights violations by the Contras ensured that popular support for the rebels was never particularly strong in America. In the wake of the Iran-Contra scandal, remaining support all but collapsed. A Central American peace initiative led by Costa Rican President Oscar Arias secured a cease-fire in 1987. Preparations commenced for democratic elections scheduled for 1990.

930. Children living on the street in Latin American cities were perhaps the most tragic victims of the region's economic troubles in the 1980s. Large numbers of young people were drawn into an urban underworld of crime, drug abuse, prostitution and gang warfare. By the end of the decade the threat of disease, particularly AIDS, added to their misery. Shocking incidents of police brutality against prostitutes and children became commonplace in large cities. The middle and upper classes often turned a blind eye – or even encouraged – these acts of violence, claiming that young people living on the streets were a threat to businesses and responsible for rising crime in cities. International Non-Governmental Organizations (INGO) saw things differently, and the plight of street children became a *cause célèbre* among countless groups in western Europe and North America. By the 1990s most major cities in Latin America had extensive programmes designed to provide various forms of assistance to street children and eventually reintegrate them into mainstream society.

931. In 1987 Hungarian-born porn star Ilona Staller, better known as 'Cicciolina', confirmed Italy's reputation for strange and colourful politics. She stood as a candidate for the Radical Party in the constituency of Latium and was elected Deputy to the Italian parliament with more than 20,000 votes. In parliament Cicciolina predictably advanced various causes related to greater sexual freedom and less censorship in Italian society, but also concerned

herself with more prosaic issues such as nuclear energy, the environment and the death penalty.

932. After a failed attempt at rock music stardom in Los Angeles, twenty-two-year-old Vernon Wayne Howell went to Waco, Texas, in 1981 and joined the Branch Davidians, a religious sect that had broken away from the Seventh Day Adventist church. His charisma and extensive knowledge of the Bible helped him develop a loyal following among the cult's largely vulnerable and insecure members. In late 1987 he and seven of his followers went on charge for the attempted murder of a rival leader in the Branch Davidians, but insufficient evidence led to their acquittal. By 1990 Howell had become the undisputed leader of the Branch Davidians and a self-proclaimed messiah. He changed his name to David Koresh, because he believed that he was now the head of the Old Testament House of David. Koresh is a Hebrew transliteration of Cyrus, the name of the Persian king who permitted the Jews held captive in Babylon to return to Israel. His apocalyptic pronouncements and rumours that he was stockpiling weapons in the early 1990s eventually led to a siege of the Branch Davidian compound in April 1993 by federal authorities. Eighty cult members as well as Koresh died when Bureau of Alcohol, Tobacco and Firearms (ATF) troops stormed the compound.

933. Klaus Barbie, head of the Gestapo in Lyons, France, during the Second World War Nazi occupation, was convicted for crimes against humanity by a French court in 1987. After the war Barbie had worked for the US Army Counter-Intelligence Corps who later arranged his escape to Bolivia, for which US officials later formally apologized to France. He lived there under the name of Klaus Altmann. Barbie was eventually deported to French Guyana where he was arrested by authorities in 1983 and taken to Lyons to stand trial. Responsible for the torture and deportation to death camps of thousands of Jews and French partisans between 1942 and 1944, Barbie – known as the Butcher of Lyons – remained unrepentant and proud of his Nazi past throughout the trial. He died in prison in 1991.

1988

934. In 1988 Chilean dictator Augusto Pinochet called a snap referendum on his leadership. Although a plebiscite was part of the 1980 constitution, Pinochet was widely expected to ignore this and not hold elections. But he gambled that the disparate and proliferating opposition groups of the centre and left would fail to unify their supporters against his regime, allowing him to win, and gain some semblance of popular legitimacy for his by then largely discredited regime. As polls began to show Pinochet trailing behind the opposition he exchanged his military attire for civilian clothes and appeared to adopt a more conciliatory tone. He even permitted political exiles to return to the country. Nonetheless Pinochet appeared out of touch with the electorate and his campaign offered Chileans nothing new. His only promise was that he would not let the country descend into the chaos that had prevailed during the Allende years (1970–73), and this proved not to be enough.

935 top. The most difficult task for Chilean opposition groups during the referendum campaign was overcoming voter apathy. This was partly the result of a prevailing belief among the masses that Pinochet would never allow a free and fair election to take place. As the campaign progressed, an opposition coalition of thirteen centre-left parties succeeded in rallying various political factions against Pinochet, whilst extremists on both sides engaged in acts of terrorism and violent protests. Despite police intimidation and minor voting irregularities, international observers believed the referendum was being conducted fairly.

935 bottom. Pinochet's gamble backfired. On 5 October 1988, 55 per cent of the electorate voted against him. He accepted the verdict but made it clear that he intended to remain firmly in charge until his mandate expired in 1990, and that thereafter he would remain in the pivotal position of commander-in-chief of the army. From this position Pinochet would be able to shield himself and members of his security forces from any potential prosecutions stemming from human rights violations

committed during his reign. In spite of this Latin American leaders hailed Pinochet's defeat and the return of civilian government as a triumph for democracy in the region.

936. On 6 July 1988 a gas explosion and subsequent fire completely destroyed Occidental Petroleum's Piper Alpha oil rig in the North Sea, killing 167 people on board the platform. Following the accident which was the world's worst offshore oil disaster, the British government launched an inquiry under Lord Cullen. The immediate cause of the accident was a massive leakage of gas condensate which had ignited, causing an explosion leading to large fires and further explosions on the rig. The report, released in 1990, also found gross mismanagement and slack procedure on the platform. Piper Alpha workers had feared they would put their jobs at risk if they raised safety issues with senior management. The oil industry spent more than a billion dollars on introducing new safety measures on all offshore platforms after the disaster.

937. On 28 April 1988 an Aloha Airlines Boeing 737–200 cruising at 7,000 metres (24,000 feet) over the island of Maui in the Pacific Ocean suddenly lost an entire fuselage section in the upper cabin area. Remarkably, the pilot was able to execute a successful emergency landing in spite of the damage suffered to his plane. A flight attendant was the only fatality, swept out of the aircraft during the explosive decompression. Sixty-nine of the ninety-five passengers sustained mainly minor injuries from falling debris and wind burn. Subsequent investigations determined that metal fatigue in the ageing Boeing 737 had caused the fuselage to rupture and break off. Within months of the accident there were a number of regulatory changes in the aircraft industry, involving inspection requirements for older aircraft.

938. Mounting domestic and international criticism of Soviet occupation of Afghanistan and the rising economic cost of a seemingly unwinnable war, which had caused the deaths of 15,000 Soviet soldiers, caused Mikhail Gorbachev to order a withdrawal of Soviet troops from the country

in 1987. Peace accords were signed in April 1988 and the last Soviet soldiers left the country in early 1989. The end of the Soviet involvement in Afghanistan lent further credibility to Gorbachev's sweeping domestic and foreign policy reforms, and marked the beginning of the Soviet Union's general withdrawal from global competition with the US.

939. Out of a population of 13 million in 1979, an estimated one million soldiers and civilians are believed to have been killed during the war in Afghanistan. Almost 5 million people were uprooted by the fighting, creating a refugee crisis both within the country itself and in its neighbours Pakistan and Iran which each received more than a million fleeing Afghans. Peace in Afghanistan was short-lived as the rebels' victory exposed deep divisions within the *Mujahideen*. Civil war quickly started again and the country plunged into violent anarchy.

940–41. The ancient techniques used by hunters in the Himalayas to extract the honey from the hives of the largest bee in the world, the Apis Laboriosa, have been described in cave drawings dating back 12,000 years. Honey-hunters ascend to heights of 30 metres (100 feet) or more on bamboo ladders to extract the honey from the single huge comb that the Apis Laboriosa construct under overhanging cliff ledges. The way in which these bees construct their combs means that large quantities of honey are within relatively easy access to raiding human predators. The fabled Himalayan hunting methods are not likely to change much as commercial cultivation of the wild combs in boxed hives has proved impossible.

942. In December 1987 a Palestinian uprising against continued Israeli rule in the Gaza Strip and West Bank began after four Palestinian workers from Gaza were run over and killed by an Israeli truck. Rumours circulated that it was not an accident and during the funerals violent demonstrations broke out. The so-called *Intifadeh* (shaking off) erupted sporadically over the next six years as young Palestinians in the occupied territories hurled molotov cocktails and stones at Israeli

security forces, who responded with rubber bullets and occasionally live ammunition. The uprising cost the lives of 160 Israelis and nearly 2,000 Palestinians before the Israeli inability to end the violence persuaded Jewish leaders to seek a negotiated settlement with the chief representative of the Palestinians, the PLO.

943. During the Iran-Iraq War Iraqi Kurds attempted to exploit the weakened condition of government forces and, with assistance from Iran, secure territory in the northern part of the country. Saddam Hussein, the Iraqi p president, prevented the Kurds' success largely through the extensive use of germ warfare. In one instance following the Iranian and Kurdish capture of Halabja, Hussein ordered Iraqi planes to drop chemical weapons on the town and nearby villages. Western journalists, who entered the area from Iran soon after the gas attacks, reported that about 5,000 Kurds, mostly civilians, had been killed. Condemnation of Hussein's appalling actions by Western governments was immediate, although after the war with Iran ended in August 1988 the continuing mistreatment of the Iraqi Kurdish population failed to attract much attention.

1989

944. The death in April 1989 of Hu Yuobang, a key liberal reformer in Deng Xiaoping's government who had been dismissed in 1987 for his failure to contain protests by Chinese students, sparked demands for democratic reform and brought tens of thousands of young demonstrators into Tiananmen Square in Beijing. Against a climate of liberalizing reform in other communist countries such as Poland and the Soviet Union, Chinese teachers, human rights activists and others joined the peaceful protest at Tiananmen, the largest square in the world. By early June, six weeks later, the number of protestors had swelled to over a million. Meanwhile the government had ordered 300,000 troops stationed outside of Beijing to advance into the city.

945. On 3 June China's communist leaders ordered the army to end the occupation of Tiananmen Square. Tanks rolled into the

centre of Beijing and thousands of soldiers began clearing the square, opening fire on the peaceful demonstrators. Altogether an estimated 3,000 protestors were killed, many simply mown down indiscriminately or crushed by the advancing tanks. Over the next few weeks, security forces detained thousands who had led or participated in the demonstration. Maoist-style repression and control mechanisms were reintroduced in the universities, the very institutions in which the movement to democratize Chinese socialism had begun. The massacre severely damaged China's international reputation, and continues to be a source of protests around the world during visits by Chinese leaders.

946. Ayatollah Khomeini died on 3 June 1989. He was buried on the outskirts of Tehran three days later amidst scenes of hysterical mourning by crowds estimated at more than 2 million people. At one point during the pandemonium, Khomeini's body fell out of the coffin as mourners fought to touch his shroud. He had occupied a unique position of political and spiritual authority in Iran for ten years. He alienated European and American governments during his reign by making many virulent public attacks on Western impiety and consumerism. Most famously, he had issued a *fatwa* (edict of faith) in February 1989 which called on Muslims to kill the Indian-born British author, Salman Rushdie, for what he viewed as blasphemy against Islam in Rushdie's novel *The Satanic Verses*. Khomeini's death triggered a power struggle in the country between moderates and radicals, and constitutional changes were introduced to elevate the power of the president.

947. Romania became increasingly independent of the Soviet Union under Nicolae Ceausescu's leadership (1967–89) especially in its foreign policy, although internally it retained all the hallmarks of a brutally repressive communist state. Ceausescu's personal excesses became legendary in the international community. He promoted his friends and family, lived extravagantly and ordered the construction of grandiose buildings such as the monolithic Presidential Palace to glorify his regime. Throughout 1989 he adamantly refused to bow to persistent international criticism and domestic pressure to introduce reforms as other leaders across Eastern Europe had already done. He was seized by revolutionaries along with his wife Elena, his Deputy Prime Minister and Minister of Culture, on 22 December after several days of clashes between rebels and government forces. The couple were given a summary trial, during which Ceausescu was wildly defiant and refused to acknowledge the authority of his accusers. He was executed with his wife on Christmas Day. After the execution their corpses were shown on television.

948. The accident at the Chernobyl nuclear power station was a watershed in the history of the Soviet Union. Human error, compounded by a faulty technical design, had led to the explosion. Provisions to prevent contamination were virtually nonexistent. Hundreds of thousands of people living close to Chernobyl were exposed to dangerous levels of radiation as a direct result of Soviet bureaucratic incompetence in the aftermath of the accident. The catastrophe epitomized the decay and deterioration of the communist system and convinced Gorbachev of the need for farreaching reforms. By 1989 Soviet and international experts were still in disagreement over what to do with the several tons of radioactive dust which had accumulated inside the 'sarcophagus', the concrete tomb encasing the damaged reactor. Some nuclear experts believed the pressed slab of uranium and concrete could lead to a chain reaction, causing a far more powerful explosion than the original one.

949. In San Salvador, the capital of El Salvador, the continuing civil war in 1989 claimed 600 civilian deaths in the month of November alone. That month six Jesuit priests were tortured and murdered in a single pre-dawn raid by death squads working in collusion with government forces. Incidents such as these all but destroyed popular support for the El Salvadoran government in the US, whose government had spent roughly a million dollars a day training and arming the regime's troops for most of the 1980s. America's defence of the entire Central American region from the so-called 'domino effect' of communist expansion meant that they had strengthened the brutal right-wing military leaders whose violent anti-communist campaigns had resulted in the deaths of tens of thousands of innocent non-combatants and uprooted millions.

950. Between October 1989 and February 1990 German photojournalist Hans-Jürgen Burkard was given permission by Soviet authorities to travel across Siberia, allowing him unprecedented access to this remote region. Burkard recorded harrowing images of Stalinist-style labour camps still in operation. This particular camp east of Lake Baikal was still 're-educating' its prisoners and attempting to instill in them an increased 'communist consciousness'. To what extent they were made aware of the great changes sweeping across Russia under Gorbachev is not known.

951. The discovery of large gold deposits in the Serra Pelada region of northern Brazil sparked a 'gold rush' in the 1980s. Attracted by dreams of riches and freedom, 200,000 *garimpeiros* (prospectors) flooded into the area from all over the country. The new arrivals, many of whom had fled wretched living conditions in other parts of Brazil, were forced to live in grisly camp settlements where crime, prostitution and disease were rife. Mutual animosity between the miners and the poorly paid military police who controlled the gold mines, frequently boiled over into violence. For some the hardships were worth it. During the 1980s, 13 tonnes of gold were excavated by *garimpeiros* at Serra Pelada in one year alone.

952. Czechoslovakia's growing opposition groups organized themselves into the Civic Forum Movement for Democracy after a student demonstration was dispersed violently by police in early November 1989. Vaclav Havel, a prominent Czech playwright and founding member of the anti-communist dissident movement Charter 77, emerged as the unofficial leader of the movement. His calls for a return to the liberal, democratic traditions of inter-war Czechslovakia had resulted in his imprisonment a number of times, the last of which was in early 1989. The mass protests of November sparked renewed hope that change might finally be at hand.

On 24 November, after more than 300,000 Czechoslovak citizens had gathered in the centre of Prague for the eighth consecutive day, Milos Jakes and other senior communist leaders resigned. The former Czechoslovak President Alexander Dubček returned to Prague after years of political exile to join Havel in front of jubilant crowds to announce the collapse of the old regime.

953. In what became known as the Velvet Revolution, Czechoslovakia's communist leaders were swept from power in the space of a few weeks and replaced with leaders committed to reclaiming the country's traditions of prosperity and tolerance. Alexander Dubček, leader of the Prague Spring in 1968, was elected Chairman of the parliament. Vaclav Havel became President, albeit reluctantly as he regarded himself as foremost a dramatist rather than a politician. He quickly found that satisfying the political aspirations of the country's Slovak minority was more difficult than disolving the country's communist legacy. At midnight on 31 December 1992 the country peacefully split into two new independent states – the Czech and Slovak Republics in what became known as the Velvet Divorce.

954. By the spring of 1989 East Germans were fleeing to the West by the thousands through other East European countries which had already begun to relax border restrictions. East Germany's hardline communist leader Erich Honecker had ruled the country with an iron fist for nearly two decades and had stubbornly resisted Soviet leader Mikhail Gorbachev's calls for reform throughout the year. He was finally forced from power in October. On 9 November the new government removed virtually all restrictions on travel to the West and openings were made in the Berlin Wall. The following day hundreds of thousands of East Germans swarmed over the wall to celebrate their new freedom and be reunited with family members. Over the next few days the wall was the scene of a gigantic spontaneous celebration and nearly 3 million people crossed the now obsolete border. A small number opted to settle in the West.

955. The fall of the Berlin Wall, which had been an important emblem of the cold war, became the most potent symbol of the beginning of a new era in East-West relations. Excited journalists relayed images across the world of Berliners from both sides of the once-divided city rejoicing together and using hammers, pick-axes and whatever other tools they could find to chip away at the wall which had kept them apart for nearly thirty years. With the sudden disappearance of a functioning barrier between East and West Germany, demonstrations in Leipzeig and other cities were soon calling for German reunification.

956. Terrorist actions and tit-for-tat killings by both the IRA and Protestant paramilitaries continued as before through most of 1989 both in Northern Ireland and on the British mainland. On 15 December 1993 British Prime Minister John Major and the leader of the Republic of Ireland Albert Reynolds reached an agreement that many hoped might finally bring an end to the troubles. The British government announced that it held 'no inherent strategic, political or economic self-interest in Northern Ireland' for the first time. The so-called Downing Street Declaration also established a framework for negotiations on the future of Ulster based on consent in which all sides involved in the conflict, including former terrorists, could participate on condition that they laid down their arms. The declaration led to a cease-fire the following year.

1990

957. Central London descended into the worst rioting the city has seen this century as thousands of anti-poll tax demonstrators clashed with police on 31 March 1990. What began as a peaceful protest organized by the All Britain Anti-Tax Federation, degenerated into violent unrest resulting in the arrest of almost 350 peopleand injuries to hundreds of police officers and demonstrators. Margaret Thatcher remained obdurate, claiming she had no intention of

repealing or amending the tax as was being demanded. By the end of the year Thatcher had been forced to resign. This unpopular tax which had led to her downfall was abolished by her successor, John Major.

958. Widespread dissatisfaction with the corrupt regime of President Samuel Doe among Liberia's various ethnic groups generated a number of opposition movements, the most prominent being the Libyan-supported National Patriotic Front of Liberia led by Charles Taylor. This group began a guerrilla campaign on 24 December 1989. By mid 1990 the conflict had created large numbers of refugees within Liberia and an estimated 500,000 in neighbouring countries. Doe's crackdown on the rebels led to numerous atrocities, including the massacre of 600 refugees by government troops on 30 July in St Peter's Church in the capital, Monrovia. A West African peacekeeping force – the Economic Community of West African States (ECOWAS) – intervened in an attempt to secure a cease-fire and halt the flow of refugees. Fighting intensified and Doe himself was killed and mutilated in the autumn. This led to vicious battles between rebel groups vying for power. By 1996 more than two-thirds of the entire population had been displaced by the war.

959. Founded in Paris in 1989, the Allegro Fortissimo was established to bolster the self-image of overweight people and provide an outlet for their various grievances against a society increasingly scornful of their appearance. Instead of hiding behind closed doors, members of Allegro Fortissimo wanted to celebrate their 'largeness' and mock media-generated concepts of (largely feminine) beauty which they believed were unnatural and unrealistic for most people to achieve. The group's membership rose to 200 in 1990. Their activities included weekly discussion meetings and yoga and swimming lessons. The group even had a ready-to-wear range of clothing designed especially for them.

960–61. Encouraged by Gorbachev's sweeping reforms in the late 1980s, the Armenian population of Nagorno-Karabakh, a semi-autonomous region within

Azerbaijan then part of the Soviet Union, began lobbying for the region's transfer from Azeri to Armenian jurisdiction. Friction had existed between the Christian Armenian and Muslim Azeri communities in the area since the transcaucasian republic had split in 1936 with Armenia, Azerbaijan and Georgia becoming separate republics within the Soviet Union. Serious ethnic violence erupted in 1988 and again in mid January 1990, when bands of Muslims rampaged through the capital Baku, killing twenty Armenians. Gorbachev placed Nagorno-Karabakh under a state of emergency and sent 11,000 Soviet troops into the region in late January to quell the unrest which at times threatened to explode into civil war. The invasion resulted in more than a hundred deaths, mostly in Baku, and generated intense anti-Russian feelings in Azerbaijan. Hostilities erupted again in Nagorno-Karabakh as soon as the troops pulled out. Leaders in the Kremlin seemed increasingly incapable of controlling developments in many of its ethnically diverse republics.

962. In a village near Tiblisi in Georgia, the birthplace of Joseph Stalin, a local family built a private mausoleum to the former Soviet dictator. Up to forty busloads of visitors arrived each day in 1990 to pay homage to a man responsible for the death of several million of his fellow countrymen. For the most part visitors were older Soviet citizens from rural areas, where Stalin was still synonymous with old-style security and Soviet status in the world. Most of them had experienced few, if any, benefits as a result of Gorbachev's reforms and longed for the certainties of a somewhat mythologized past. In the 1990s this group constituted the vast majority of electoral support for the Communist Party, whose candidates still made a point of laying wreaths at the tombs of both Stalin and Lenin. In 1995 the Communists won the largest block in the Russian Duma, or Lower House of parliament, with over 20 per cent of the vote.

963 top. During his long imprisonment Nelson Mandela became the most powerful symbol of black resistance to apartheid in South Africa. Given a life sentence in 1964 for sabotage, Mandela

never ceased to demand his unconditional release from prison and flatly refused the white regime's offers of freedom on condition he renounced all forms of violence. Apartheid leaders were only moderately successful in their portrayal of Mandela as nothing more than a terrorist, a depiction embraced by various prominent right-wing leaders outside the country, notably Margaret Thatcher. A massive international campaign for his release developed during the 1980s with his wife, Winnie, becoming its most prominent spokesperson. By 1989 the new South African government led by F.W. de Klerk realized that the country would remain isolated in the international community until far-reaching reforms were carried out and that no solutions would be possible with the symbolic leader of South Africa's black majority still in prison. On 11 February 1990 Mandela was released from Victor Verster prison after more than a quarter of a century in confinement.

963 bottom. Within months of his release from prison Nelson Mandela was elected President of the ANC. After a second meeting with the country's President F. W. de Klerk, Mandela renounced violence thereby opening the way for joint discussions on a timetable for democratic elections and interim governmental structures which involved power-sharing between the ruling National Party and various black leaders. The process of dismantling apartheid began in early February with de Klerk's announcement to parliament calling for a 'new South Africa based on racial equality'. The ban on the ANC was repealed. In 1993 de Klerk and Mandela shared the Nobel Prize for Peace.

964. Following the collapse of the Berlin Wall, West German Chancellor Helmut Kohl moved swiftly towards reunification of East and West Germany. It was important to act before a massive exodus occurred from the rapidly disintegrating eastern region of the country. Although many Germans had abandoned any hope of reunification long before 1989, Kohl immediately recognized the unique opportunity presented by the fall of communism in Eastern Europe and quickly secured crucial co-operation for his plan from the

Soviet Union. At midnight on 3 October the German Democratic Republic (East Germany) ceased to exist. Its territory and 16 million inhabitants were officially incorporated into West Germany, thus reuniting a nation that had been divided since the end of the Second World War. An estimated one million Germans attended a jubilant celebration at the Brandenburg Gate in Berlin which was to be the country's new capital.

965. Two months after reunification Chancellor Kohl led his Christian Democratic Party to victory in the first democratic elections for a united Germany in nearly sixty years. The country's President Richard von Weizsacker, mindful of the apprehension felt by many Europeans towards reunification in light of Germany's Nazi past, declared, 'We want to serve peace in the world and a united Europe'. Despite the euphoria surrounding the momentous events in Germany between 1989 and 1990, most Germans were well aware of the immense effort required by the new government to restore vitality to the depressed eastern part of the country. Unification in the social, economic and cultural spheres became the dominant issue in German politics and society in the 1990s.

966. In 1990 journalists visiting Romania exposed the excruciating conditions in the state-run orphanages which housed thousands of children abandoned during the last years of Nicolae Ceausescu's regime. They also discovered an unusually high number of children testing positive for the AIDS virus, giving rise to speculation that the orphans acquired the disease from infusions of infected blood or dirty needles which were being reused in hospitals. Their desperate plight moved hundreds of Westerners to adopt Romania's 'forgotten children' in the early 1990s. Although conditions have improved, more than 100,000 Romanian children remain institutionalized and the country is home to more than half the children with AIDS in Europe.

967. Four years after the Chernobyl disaster it was still virtually impossible to determine the human cost of the accident. At least 600,000 people living in the Ukraine had suffered various illnesses as a result of radiation

exposure and the number of deaths was in the hundreds, possibly thousands. Experts fully expected the number to rise considerably in the coming years. The catastrophe caused some countries to abandon their nuclear energy programmes, and construction of new plants in the Soviet Union was stopped. Public opinion around the world generally swung against further development of nuclear power plants.

968. Iraq had laid claim to Kuwaiti territory ever since Kuwait had become independent in 1961. Home to the third largest oil reserves in the world and located in a prime position on the Persian Gulf, Kuwait represented an ideal target for Iraqi leader Saddam Hussein's imperialist ambitions. On 2 August he ordered 100,000 Iraqi troops to invade the country and after six days of fighting Kuwait was formally annexed. The US government, stunned by Hussein's actions, announced the despatch of US forces to the Gulf to protect Saudi Arabia's borders from a possible invasion by Iraqi troops. In the following months the Gulf witnessed a massive build up of military force as the number of US troops in Saudi Arabia rose to 500,000. US troops were supported by an international coalition of more than 150,000 troops from Saudi Arabia, Britain and several other countries.

969. Saddam Hussein responded to the US-led build-up of troops in the Gulf by ordering Iraqi security forces to locate all Westerners inside Iraq and conquered Kuwaiti territory for use as 'human shields' at possible target sites for air attacks by coalition forces. Concern for the safety of foreign nationals in both countries, some of whom were paraded in front of television cameras by Hussein for propaganda purposes, intensified throughout the autumn as a massive US-led attack seemed increasingly likely. After negotiations between Hussein and various foreign dignitaries, the Iraqi leader freed all the hostages claiming that his actions were motivated by humanitarian considerations.

1991

970. The parliaments of the Baltic republics of Lithuania, Latvia and Estonia declared independence

from Moscow in 1990. Soviet President Mikhail Gorbachev issued repeated warnings that these states would suffer severe consequences if they did not cease these 'unconstitutional acts'. In January 1991 he ordered a crackdown on the rebel forces. In the Latvian capital Riga, units of AMON or Black Berets, a notoriously brutal paramilitary force developed by the Soviet Interior Ministry, seized the main press building. Two local policemen and a cameraman were killed. More violence was threatened unless independence demonstrations were halted.

971. Soviet troops and tanks entered Vilnius, Lithuania's capital, in mid January to help the pro-Moscow Salvation Committee seize control of the city. More than fifteen people were killed and 200 wounded in the takeover, which centred on the city's main TV station. A curfew was imposed by the Soviet forces and strict press censorship was enforced. However, the democratically-elected independent parliament remained behind barricades for some time, protected by buses and other vehicles as well as several poorly armed militia. On 16 January hundreds of thousands of Lithuanians attended the funerals of those who had been killed. Further evidence of the erosion of Soviet authority was revealed four days later when 100,000 former Soviet sympathizers marched to the Kremlin to denounce the killings in Vilnius. Gorbachev expressed deep regret at the bloodshed, blaming local Soviet commanders for over-reacting. His failure to condemn formally the actions of the commanders was strongly criticized within Russia and around the world. Over the next few months Gorbachev struggled to hold the Union together as efforts by the republics to gain more autonomy from Moscow intensified.

972–73. Following Hussein's failure to respond to a UN ultimatum to withdraw his troops from Kuwait, Operation Desert Storm commenced on 15 January under the overall command of Norman Schwarzkopf. The coalition effort to liberate Kuwait began with a massive bombing campaign against strategic targets in Iraq and the bombing of Iraqi troops. The ground offensive

in Kuwait was launched on 24 February after nearly six weeks of relentless air attacks. Within a hundred hours President Bush announced that the war was over and that Iraqi troops had been expelled from the country. Potentially irreparable damage had already been inflicted on Kuwaiti territory and the sabotage of oil wells had caused an environmental catastrophe. Iraqi troops sabotaged 732 Kuwaiti oil wells, setting 650 alight. Fires of enormous proportions raged in the Kuwaiti desert. An elite corps of firefighters, mostly from the American state of Texas and from western Canada, arrived to begin the dangerous task of extinguishing the fires. The firefighters worked mostly during the day as the brightness of the blaze was often too overpowering for human eyes at night. It took several months of tireless work to extinguish the fires. In addition to the intense heat and smoke, they had to contend with other hazards such as toxic gases from non-burning wells and the corrosive effects of crude oil on the skin. On 5 November, after an eight-month battle, the last well-fire.was extinguished. This was much earlier than had originally been forecast.

974. Within months of the US-led victory in the Persian Gulf, nearly all US soldiers had returned home. Official US estimates of casualties from the war included 343 coalition-force deaths, roughly 110,000 Iraqi soldiers and 10,000 Iraqi civilians. Much of the American public was buoyed by the success of US forces in the Gulf and ceremonies honouring the troops were held across the country. President Bush's approval ratings soared to a higher level than had been achieved by any previous president. Many commentators noted the sharp contrast between the rapturous welcome given to returning soldiers from the Gulf and the reception afforded to US troops returning from Vietnam in the 1960s and early 1970s. The victory in the Gulf went some way towards expunging the ghosts of America's disastrous experience in Vietnam. It did not however, produce a 'New World Order' as Bush had promised at the end of the war. Within a few years Bush and most other leaders of the UN coalition countries were no longer in power. Saddam Hussein

remained firmly in control of Iraq.

975. In the aftermath of Iraq's defeat, revolts against Saddam Hussein's regime broke out among Shiite Muslims in southern Iraq and among Kurds seeking an independent homeland in the north of the country. During the war the US administration had sought to oust Hussein, but after the coalition victory President Bush declared that the US would not interfere in Iraq's internal affairs and would therefore not assist the rebels. Iraqi troops loyal to the government brutally attacked the Kurds and Shiites, and the rebels were crushed by early April. In northern Iraq more than a million Kurdish refugees, fearing an Iraqi slaughter, fled towards Turkey and Iran. Huddled in mountain camps along the Turkish-Iraq border, up to a thousand died of disease and exposure every day. The US, widely criticized for abandoning the Kurds after first encouraging them to revolt, launched a massive relief operation. They began to drop food and other supplies with French and British assistance and placed 7,000 military personnel on the ground to aid the relief effort and protect the refugees from possible Iraqi attacks. A 'safe zone' was established above the 36th parallel in northern Iraq in which Hussein agreed not to undertake any military actions.

976–77. At the sound of a gunshot several thousand men on the banks of the Rima river in northwestern Nigeria swarm into its muddy waters to begin a unique annual fishing ritual. The ensuing mayhem, resulting from a frantic contest to ensnare the biggest fish – Nile perch which weigh up to 95 kilogrammes (210 pounds) are sometimes caught – is the climax of an ancient music and sports festival *Argungu* which was revived in the 1930s and has since become one of Nigeria's most popular spectacles.

978. El Salvador's civil war ended in January 1992, by which time at least 70,000 people, mostly civilians, had lost their lives and the country's economy and infrastructure had been devastated. The first post-civil war government faced enormous challenges despite its optimistic announcement that the nation had entered a new era of peace, prosperity and social justice. El Salvador leaders needed to address

the terrible suffering the war inflicted on a generation of young people in the country. By the end of the war thousands had been forced into prostitution or onto the streets of El Salvador's cities.

979. Prince Norodom Sihanouk was deposed as Cambodia's leader in 1970 during the US-backed coup that brought Lon Nol to power. Sihanouk returned to the country after the Khmer Rouge takeover in 1975 but was forced back into exile following the Vietnamese invasion four years later. Although outside the country, Sihanouk gradually managed to unite opposition parties and secure recognition from the UN as the official 'democratic government-in-exile'. Following the Vietnamese withdrawal at the end of the 1980s Sihanouk worked closely with the UN to secure a cease-fire among the forces vying for power in order to stage a comeback. He returned to Cambodia in 1991 where he became interim president. He was confirmed in that position, albeit with largely ceremonial powers, in 1993. Sihanouk and the rest of his new government faced enormous challenges. Massive international assistance was needed to repair the damage wrought by two decades of devastating conflict. The legacy of the genocidal Khmer Rouge regime was still evident throughout Cambodia, and residual Khmer Rouge guerrillas (including the dreaded Pol Pot) remained ensconced in camps deep in the jungle.

980. In the latter half of the 1980s Mikhail Gorbachev gained attention across the world for his reforms, unprecedented for a communist leader, of *glasnost* (openness) and *perestroika* (restructuring). Inside the Soviet Union however, he became immensely unpopular as his liberalizing policies increasingly exposed fundamental flaws in the Soviet system. Later reforms only seemed to exacerbate the problems and the economy, untenably positioned somewhere between capitalism and communism, virtually collapsed. At the same time the country's diverse national communities were demanding increasing autonomy and Gorbachev appeared unwilling to use the force required to bring their recalcitrant leaders into line. In mid August 1991 Vice-President Gennady Yanaev, Minister of Defence Dimitry

Yazov and other senior communist officials seeking to exploit the widespread resentment in the army and state bureaucracy of Gorbachev's reforms attempted a coup. Gorbachev was placed under house arrest by KGB agents whilst on vacation at his holiday cottage in the Crimea, and Yanaev temporarily assumed power.

981. Starting on the Staten-Island side of the Verrazano Narrows Bridge, the New York City Marathon winds its way through all five boroughs of the city before ending in Central Park. Billed as 'Where the World Comes To Run', the event has grown steadily from its beginnings in 1970 to become the largest race of its kind in the US. It attracts more than 30,000 runners each year.

982. When Gorbachev was placed under house arrest an official announcement was made that he had been taken ill. Boris Yeltsin, the popular President of the Russian Republic, immediately recognized that a coup was under way. He quickly transformed the parliament in Moscow – the White House – into a centre of resistance. He denounced the hardliners and declared the coup void. During the confusion, clashes between demonstrators and troops left three people dead. The coup had already begun to collapse when troops ignored orders from Yanaev to assault the parliament building.

983. The coup failed largely because of wide support for Yeltsin among the masses and in the army. The US also played a role by providing pro-government forces with decoded communications between coup leaders which had been picked up by the CIA. Gorbachev returned to Moscow on 22 August in good health but visibly shaken. His arch political enemy Yeltsin was now a popular hero. Thirteen high-ranking Soviet officials were charged with treason. Ironically, their attempt to halt the weakening Soviet central authority by force dramatically accelerated it. The independence of the Baltic states was officially recognized in early September, followed soon after by demands for independence from the rest of the Soviet Union's constituent republics.

984. A British Court of Appeal released the 'Birmingham Six'

on 14 March 1991. The six men from Northern Ireland had been sentenced to life imprisonment in 1975 for bombings at two public houses in Birmingham in England which killed twenty-one people. In 1989 a major police-force scandal cast serious doubts on some of the key evidence and testimonies which had been used by British authorities to secure convictions. Police officers were shown to have altered notes taken from interviews during which the men had supposedly confessed to the crimes. The case of the 'Birmingham Six', who had maintained their innocence throughout their long confinement, was the latest in a series of embarrassments for the British government in which people suspected of being involved in IRA bombings were shown to have been wrongly imprisoned, resulting in their convictions being overturned.

985. The collapse of Soviet central power was complete when Gorbachev resigned on 25 December 1991. Within minutes the Soviet hammer and sickle flying over the Kremlin had been lowered and replaced with the flag of Russia. Other potent symbols of the Soviet era such as the statue of Felix Dzerzhinsky, first head of the Cheka police force – the forerunner to the hated KGB – had already fallen. The last great world empire fragmented on 31 December 1991 and a new Commonwealth of Independent States (CIS), a loose alliance of the former Soviet republics without a central governing body, was formed.

1992

986. John Major was elected to parliament for the first time in 1979. As a Conservative MP he advanced quickly through the junior government ranks before entering Margaret Thatcher's cabinet in 1987. When Thatcher resigned in November 1990 she supported Major's candidacy in the party leadership contest. Major won, surprising many observers who had noted his relative inconspicuousness in her government. Despite having had little advanced formal education, Major was considered competent, if stolid and unimaginative. However there was a general consensus among the Conservative Party that he was the least

divisive choice as leader after the tumultuous final years under Thatcher. The Conservatives were widely expected to lose power to Labour in the 1992 elections, but Major surprised the pundits and led his party to their fourth consecutive general election victory on 9 April.

987. In 1979 at the age of thirty-three Bill Clinton became the youngest state governor in US history. Arkansas-born Rhodes Scholar and Yale Law graduate, Clinton remained governor of his home state until 1992 except for a brief period between 1981 and 1983. In this year he became the Democratic Party nominee for president and on 3 November 1992 he defeated George Bush in the national election, ending a twelve-year Republican hold on the presidency. Clinton had proved himself a masterful campaigner, styling himself as the candidate of the postwar generation in the mould of the much-romanticized John F. Kennedy. Critics alleged that he was too eager to please everyone and had no coherent policy agenda. His presidency has been beset by allegations of financial misdealing and sexual improprieties.

988. In early 1991 the prospect of a humanitarian disaster in the war-torn African country of Somalia loomed after UN relief agencies were forced to pull out of the country. Inter-clan warfare which had erupted periodically throughout the 1980s intensified dramatically in the early 1990s with the mushrooming of various guerrilla groups and the establishment of a multitude of individual fiefdoms controlled by clan warlords. UN aid workers attempting to distribute food and medicine in the drought-ravaged country could no longer continue operations because of persistent looting, demands for protection money from bandits and guerrillas and the increasingly dangerous circumstances in which they were forced to work. By 1992 voluntary groups such as the International Red Cross, which had arrived in Somalia in the wake of the UN estimated that famine threatened 1.5 million Somalis.

989. Spanish designer Paco Rabanne earned his reputation for audacity and innovation in the 1960s through a series of futuristic garments made of plastic and

aluminium. His clothes challenged existing conventions in fashion and became some of the most influential designs of the decade. More than twenty years later his work was rediscovered as contemporary designers looked back with nostalgia to a more innocent period in which the high modernism of designers like Rabanne had been infused with optimism for the future. Cotton and viscose fabrics in metallic hues accompanied by formidable pieces of jewellery were typical of Rabanne's collections.

990. Parts of Los Angeles were engulfed by racial unrest following the acquittal of four local police officers for the beating of an African-American motorist Rodney King after a lengthy car chase. A shocking 81-second videotape of the incident shot by an onlooker had been broadcast on television to millions of Americans repeatedly since King's arrest more than a year earlier. Within hours of the verdict, enraged black Americans began attacking mainly white and Asian pedestrians and shopkeepers in Los Angeles. Motorists were dragged from their vehicles and beaten and hundreds of shops and buildings were looted and destroyed. In some cases looters were shot by store-owners intent on defending their businesses. The city's ill-prepared police force was paralyzed, retreating to their headquarters during the initial outbreaks of violence. Similar racial violence and disturbances occurred in other US cities in response to the Rodney King ruling. The Los Angeles race riots were brought under control by 2 May after the Governor of California declared a state of emergency. Police, the National Guard and the US army were called in to quell the unrest which had led to fifty-eight deaths and left 2,300 people wounded. Property damage exceeded a billion dollars. About 12,000 people were arrested.

991. On the initiative of US President George Bush and UN Secretary-General Boutros Boutros Ghali, Operation Restore Hope was launched in Somalia in late 1992 to safeguard the delivery of food and medicine by emergency relief teams in the country. Bush, mindful of the American public's lukewarm feelings towards the operation,

promised a speedy withdrawal of US troops as soon as the situation was stable enough for a multi-national UN force to take over. The first contingent of troops from the US and ten other countries landed in the capital Mogadishu on 9 December. The port and airport of Mogadishu and several other relief zones were secured. By early 1993 however, it became clear that the US administration had grossly underestimated the intractability and complexity of the crisis in Somalia. With no functioning government to maintain order, rival bands of heavily armed marauders continued to hijack supply vehicles and threaten aid workers. US and other nations' ground troops also became targets. In response US forces tried to disarm bandits and chase after warlords without success. After dead US soldiers were mutilated in public and dragged through the streets, America's new President Bill Clinton announced plans for a speedy withdrawal.

992. Sarajevo, the capital of Bosnia, became a focal point of the civil war which began in earnest following the declaration of independence by the country's Muslim president Alija Izetbegovic on 3 March 1992. Bosnia's orthodox Christian Serb minority rebelled and launched an armed struggle, claiming that Izetbegovic wanted to turn Bosnia into a fundamentalist Islamic state. Although Bosnia's Muslims were in the majority, the country's Serbs were better armed, receiving support from the Serb-dominated Yugoslav army. Serb militias throughout Bosnia carried out a brutal programme of 'ethnic cleansing'. Muslims and Croats were expelled and often murdered in an effort to create ethnically homogenous areas under Serb control. In response the government forces, severely weakened by an international arms embargo, exacted cruel revenge on Serb civilians and soldiers in Muslim-controlled areas. Torture, mass rapes and other atrocities were common on both sides of the conflict. Thousands of non-combatants, mostly Muslims, were forced to take refuge in Sarajevo where they joined the besieged city's remaining population in their struggle to survive. For some, daily life necessitated making

the perilous journey along a main road into the city that became known as Sniper Alley. Civilians were often shot down by Serb gunmen here as they tried to cross exposed intersections.

993. As part of a series of works focusing on child labour in many parts of the world, French photographer Marie Dorigny photographed these delinquent adolescents in a Moscow detention centre which makes products for various companies. Dirigny's moving photographs of 'children stripped of their childhood' reflected a major issue of global concern in the 1990s – the roughly 250 million child labourers who were being exploited for profit or forced to work in order to survive. The UN and numerous governmental and non-governmental organizations have urged an immediate end to hazardous and exploitative child labour which threatens to deprive millions of children of the skills and knowledge needed to build their adult lives.

994. By mid 1993 France's long-serving President François Mitterrand seemed unlikely to last the year in office. In spite of his brave visit to war-torn Sarajevo during the siege and leading efforts toward further European integration of Sarajevo, Mitterrand's support within France was falling sharply. In 1992 his Socialist Party was crushed in national elections in which right-wing parties won 484 seats to the left's ninety-two. A severe economic recession, rising unemployment and a series of scandals within the president's cabinet were mostly to blame for the left's poor performance. In May 1993 Mitterrand's appointee as Prime Minister Pierre Bérégovey, committed suicide after being implicated in a financial loan scandal. Mitterrand himself was the target of continuing allegations of corruption. He managed to hold on to power for two more years although he was suffering from prostate cancer. He was France's longest serving leader since Napoleon III.

995. The collapse of communist regimes in Eastern Europe and the impending end of the cold war led to increasing debate among the people of Yugoslavia about the nature and viability of their multi-ethnic state. The majority

of people in the constituent republics of Slovenia, Croatia and Bosnia-Herzegovina bitterly resented attempts by Serbia's communist president Slobodan Milosevic to gain control over the Yugoslav state apparatus after its collapse in 1989. His appropriation of vast amounts of the country's food reserves to buttress Serbia's ailing economy without consent from the other republics led to Slovenian and Croatian declarations of independence in 1991, followed by Bosnia the next year. By 1992 all that remained of Yugoslavia was Serbia and Montenegro, which on 29 April formed the Federal Republic of Yugoslavia. Milosevic, a fierce nationalist and devoted champion of a Greater Serbia (a reunified Serbian homeland), used the new Yugoslav army to support the rebellious Serb communities in Croatia and Bosnia-Herzegovina who rejected their incorporation into the newly-independent states.

1993

996–97. Violence between India's Muslims and Hindus flared up in January 1993 as the city of Bombay became engulfed in communal attacks following the Hindu destruction of a mosque at Ayodhya a few days earlier. More than a hundred people were killed in the violence as arson and looting swept across the city on 10 January in spite of warnings from Indian army units that rioters would be shot on sight. The mosque at Ayodhya had been the subject of conflicting claims by Hindus and Muslims as the site on which the mosque stood was sacred to both.

998. For more than twenty years Bulgarian-born artist Christo and his wife Jeanne Claude lobbied the German government for permission to 'wrap' the Reichstag in Berlin. In February 1994 their unique and controversial plan for Germany's former parliament building (which will soon be the parliament building again) was finally given the go-ahead despite Chancellor Helmut Kohl's personal dislike of the project. Bright blue rope was to be used to tie down the huge quantity of silvery fabric which would cover the structure. The entire project, including material and labour, cost $10,000,000. Spectators from around the world flocked to see the 'wrapped Reichstag' on its

completion on 25 June 1995. The Reichstag remained wrapped for fourteen days and all materials were later recycled.

999. Launched into space by a shuttle in 1990, the Hubble Space Telescope (HST) was the largest and most powerful observatory placed in Earth orbit. Equipped with a 2.4 metre (8 foot) primary mirror, the HST was designed to generate images with a resolution seven to ten times greater than those from ground-based telescopes, enabling scientists to observe and monitor cosmic objects and phenomena far more closely than before. Once in orbit however, the primary mirror proved faulty. NASA launched the space shuttle *Endeavour* on a repair mission on 2 December 1993 to intercept the HST. The *Endeavour*'s robotic arm grabbed the HST, berthed the 11,000 kilogramme (25,000 pound) telescope in the shuttle's cargo bay and began repair work. The crew made a record five space walks to repair and replace the myopic primary mirror, an obsolete camera, faulty gyroscopes and other major components. The eleven-day mission was widely regarded as NASA's toughest and most audacious since the *Apollo* landings. It was also one of its most successful as the HST has performed virtually flawlessly ever since.

1000 top. Soaring inflation and a continuing decline in living standards in Russia in the early 1990s led to widespread discontent with Boris Yeltsin's government. His dramatic economic reforms and autocratic style alienated those still present in parliament from the communist era. A stand-off between Yeltsin and the Congress of People's Deputies began in Moscow in late September 1993 after he had dissolved the Congress and announced elections for two reformed chambers and a new constitution. Parliamentarians responded by deposing the president and then occupying the Russian parliament building. Under Yeltsin's orders the army barricaded the White House and cut off all power supplies. On 3 October the newly-declared President Alexander Rutskoi appeared on the parliament's balcony to exhort anti-Yeltsin demonstrators who had gathered

below to seize the Kremlin. The following day tanks shelled the White House before Russian élite units stormed the building to crush the resistance. Yeltsin moved quickly in the aftermath of the coup attemp, which left 148 people dead, to consolidate his position. Leaders of the uprising were imprisoned, but released in early 1994 under a general amnesty.

1000 bottom. After months of secret negotiations sponsored by the Norwegian government, representatives of the PLO and Israel achieved a breakthrough in one of the world's most intractable conflicts. Israel's inability to end the Palestinian uprising in the West Bank and the Gaza Strip had damaged the country's reputation internationally and caused great disillusionment within Israel. Israel's leaders were finally convinced that a peace agreement with the PLO was necessary. The Israeli government agreed to recognize the PLO and its leader Yasser Arafat, as the legitimate representative of the Palestinian people. The PLO recognized Israeli sovereignty and renounced the use of violence in the pursuit of its goal of a Palestinian state. The agreement also provided for subsequent discussions on matters of mutual interest, including a series of principles for Palestinian autonomy in the West Bank and Gaza Strip. The peace agreement, signed in Washington on 13 September 1993, was viewed by many as the first genuine opportunity for a comprehensive peace settlement in the Middle East since the founding of the Jewish state in 1948. Attacks in Israel and the occupied territories diminished in wake of the agreement, but a rival Palestinian organization Hamas continued to incite violence against Israeli rule.

1001. By 1993 Sarajevo was completely surrounded and subjected to heavy artillery bombardment and sniper attacks by Serb rebels who established their headquarters in nearby Pale. The city managed to survive the long siege, however, thanks largely to UN peacekeepers who organized relief operations and attempted to mediate between the warring parties. Peacekeepers were restricted by a UN mandate to humanitarian tasks and were

officially impartial in the war. They could therefore do little to stop the bloodshed in the rest of the country.

1002. In 1981 medical researchers throughout the world became aware of a frightening new disease when several healthy young men in different parts of the world suddenly developed a rare and fatal pneumonia and a form of cancer which was virtually unprecedented in younger men. The following year US health officials began using the name Acquired Immune Deficiency Syndrome, or AIDS to describe the still unexplained disease which seemed to affect primarily homosexual men and intravenous drug users. By 1984 US and French scientists had discovered a link between AIDS and a virus called Human Immunodeficiency Virus or HIV. This impairs the body's immune system, leaving it vulnerable to infections which would be easily suppressed under normal circumstances. Unfounded fears that infection could occur through casual contact with AIDS sufferers caused many victims of the disease to be ostracized until research firmly established that the disease, which is transmitted by contamination of the bloodstream with HIV-infected body fluids, could essentially only be contracted through sexual intercourse, by the transfusion of virus-contaminated blood or by sharing HIV-contaminated intravenous needles.

1003. According to the World Health Organization by 1993 more than 47 million people had been infected by HIV since the epidemic began, and nearly 14 million had died of AIDS. Africa has been by far the hardest hit with 21.5 million adults and a further one million children infected with the disease. The lack of availability and use of contraceptive condoms has been the primary factor behind the alarming spread of the disease on in Africa. New combinations of anti-HIV drugs have significantly reduced the rate of AIDS deaths in North America and Western Europe. The search for a vaccine continues.

1004. The first years after the reunification of Germany saw a sinister increase in the membership of neo-Nazi groups. In August 1992 the eastern port city of Rostock witnessed a series

of attacks directed against foreigners which culminated in a refugee hostel being burnt down by young neo-Nazi thugs while hundreds of onlookers cheered them on. In May 1993 two young Turkish women and three girls died in Solingen when their house was set alight with petrol. Firebombings and other acts of terrorism against immigrants took place mostly in the former East Germany. Fortunately for the country's foreign immigrants, the attacks in Rostock and elsewhere led to large anti-racist marches in several major German cities.

1005. By August 1993, 20 per cent of Azerbaijani territory had been seized by Armenian forces. The hotly disputed region of Nagorno-Karabakh from which virtually the entire Azeri population had been driven out was effectively becoming part of Armenia. The conflict between the Muslim Azeris and the Christian Armenians, which began in earnest with the collapse of central Soviet authority in the early 1990s, had resulted in nearly 20,000 dead and created a million Azeri refugees. An estimated 300,000 Armenians had fled their homes in Baku. In 1994 a cease-fire came into effect but skirmishes between Azeris and Armenian forces, well-armed mainly with Russian weapons and supported by the Armenian diaspora in the US and France, continued along the heavily militarized border between the two countries.

1994

1006. Since Rwandan independence in 1962 tensions between the country's two main ethnic groups, the Hutus and the Tutsis, regularly erupted into tribal violence. The Hutu majority, which represented roughly 90 per cent of Rwanda's population, resented the power held by the country's Tutsi minority. On 6 April 1994 an aeroplane carrying Rwandan President Juvénal Habyarimana and Burundan President Cyprien Ntaryamira was shot down over Rwanda's Kigali airport killing everyone on board. Habyarimana, a Hutu, was returning from a regional summit meeting in Tanzania where he had reiterated his commitment to bringing about reconciliation in Rwanda. A number of prominent Rwandan politicians, most of them Tutsis

and moderate Hutus, were assassinated immediately after Habyarimana's death in retributive attacks by the presidential guard. Although it was not clear who was responsible for the shooting down of President Habyarimana's aeroplane, Hutu forces used the incident to initiate a pre-meditated genocide. Government troops had been amassing weapons for months and passing them on to Hutu killing squads, the so-called Interhamwe militia. Within a few weeks of Habyarimana's death, roughly 500,000 Rwandans, mainly Tutsis, had been slaughtered by extremist Hutu militias. Moderate Hutus who favoured reconciliation with the Tutsis were also made targets, and some reportedly forced on pain of death to murder their Tutsi neighbours. Civilians seeking refuge in schools, hospitals and churches were massacred, along with nuns, priests and hospital and relief agency workers.

1007. The 14,000-strong Tutsi-dominated Rwandan Patriotic Front (RPF) began to fight back against the Hutu onslaught and laid siege to the capital, Kigali. The UN mediated a fragile sixty-hour cease-fire during which small evacuation forces from several countries escorted foreign nationals out of the country before hostilities recommenced. The slaughter in Rwanda provoked international outrage but there was little political will for the establishment of a multinational force to halt the atrocities. With the situation in Rwanda totally out of control, a contingent of French troops crossed into the country on 23 June. Their aim was to halt the genocide by moving non-combatants to safer areas close to the border in Zaïre. Fear of reprisals from the advancing RPF led to the exodus of nearly 3 million Hutu refugees into neighbouring countries from a total Rwandan population of 7.5 million. By July 1994 the RPF controlled most of Rwanda and had established a new government in Kigali.

1008–09. Conditions in the makeshift camps in Zaïre, overflowing with refugees from the war in Rwanda, had worsened dramatically by the end of July as hunger and cholera became widespread. Non-governmental organizations working in the camps were outraged at the inadequate international response to the crisis which was claiming more than 2,000 refugees a day, adding to a death toll already in excess of 20,000. Violence between Hutu and Tutsi soldiers in the camps exacerbated the desperate situation by making the distribution of food and medicine difficult and dangerous for aid workers. At the end of 1994 the UN Security Council approved the establishment of an international court to examine charges of genocide, mostly against Hutus.

1010. In 1991 the fiercely in-dependent people of the former USSR state of Chechnya elected Dzhokhar Dudaev, a former Soviet air force commander turned national activist, as their president. Notoriously resistant to Russian rule, the Muslim Chechens rallied behind their new president as he attempted to transform the autonomous republic in the northern Caucasus region of Russia into a fully-fledged independent state. The republic soon descended into chaos however, as Dudaev became corrupt and dictatorial. Meanwhile Russian President Boris Yeltsin, firmly opposed to the republic's secession, sent military and financial support to groups opposed to Dudaev. After a series of warnings from Yeltsin to Chechen rebels threatening dire consequences if Chechnya did not rejoin the Russian Federation, Russian troops invaded on 11 December 1994.

1011. The Russian invasion of Chechnya quickly became a disaster for President Yeltsin. He had severely underestimated the potential strength of the Chechen resistors, whom he had regarded as nothing more than bandits. Despite vastly superior equipment, Russian élite troops could not crush the rebellion which Russian Defence Minister Pavel Grachev had boasted would be over in a matter of days. Dudaev's troops moved to the southern hills from where they launched damaging attacks on Russian forces. With painful collective memories of Soviet repression, ordinary Chechens also fiercely resisted the occupation. Support for President Yeltsin's actions was virtually non-existent in the international community.

1012–13. President Yeltsin met with German Chancellor Helmut Kohl during his three-day visit to Germany in May 1994 to discuss, among other things, the final withdrawal of Russian troops from East Germany. The troops' continued presence was a source of increasing concern to Kohl in view of the growing strength of nationalist extremists within Russia, and President Yeltsin's tendency to bend to the wishes of the conservatives. Nevertheless, the Russian president was well thought of by Kohl and other Western leaders following his evident commitment to reform in a country beset by grave economic problems, political instability and rapidly escalating crime. By the mid 1990s however, Yeltsin's susceptibility to diplomatic slip-ups, his recurrent health problems and reports of excessive drinking were causing many to question whether he was still capable of leading the difficult process of reform in Russia.

1014. In the summer of 1994 more than 500,000 music fans attended a three-day concert in upstate New York marking the twenty-fifth anniversary of the Woodstock festival. Several of the artists who performed at the original event in 1969, including Bob Dylan, Joe Cocker and the band Crosby, Stills and Nash, returned to the main stage at Woodstock to join the latest crop of rock musicians. Fans hoped the anniversary might rekindle the spirit of the first festival, considered the high-point of American youth counter-culture in the 1960s. However, apart from the dire condition of the grounds, the event had little in common with the original Woodstock – peace and harmony were barely in evidence in the festival's crass commercialism.

1015. American football star and television personality Orenthal James 'O.J.'Simpson was charged with the murder of his former wife Nicole Brown Simpson and her friend Ronald Goldman in June 1994. Simpson pleaded not guilty and hired a legal team made up of some of America's most prominent defence attorneys. Owing to Simpson's enormous fame and popularity, the case attracted extreme publicity particularly in the US. After a lengthy televised trial which attracted millions of viewers every day, Simpson was acquitted on 3 October 1995. The public's reaction to the verdict revealed a significant gulf between blacks and whites in America. Whites were shocked by the acquittal, contending that Simpson's high-priced lawyers and a nearly all-black jury enabled him to escape conviction despite evidence linking him to the brutal murders. However, African-Americans rejoiced at the jury's decision, believing the country's justice system – notoriously unfair to blacks – had finally worked in their favour. Simpson was free, but in 1995 relatives of the victims brought a successful civil suit against him and were awarded substantial damages.

1016 top. In April 1994 South Africa experienced the first elections in the country's history in which people of all races were eligible to vote for regional and national leaders. Despite considerable organizational difficulties in registering the millions of black South Africans for the first time and some pre-election violence, balloting went relatively smoothly and ended on 29 April. The African National Congress (ANC) gained 62.6 per cent of the popular vote while the National Party which had founded apartheid received only 20.4 per cent. The result marked the official end of three centuries of white minority rule in South Africa and the extinction of apartheid. On 10 May the ANC leader Nelson Mandela was sworn in as the country's new president at a ceremony attended by dignitaries and heads of states from more than 130 countries.

1016 bottom. The election of Jean-Bertrand Aristide as President of Haiti in December 1990 raised hopes that peace and democracy might finally take root in a country ruined by decades of corrupt and bloody dictatorships. However, he was deposed in a military coup and fled into exile the following year. Haiti sunk deeper into chaos and violence as the army and its paramilitary ally the Revolutionary Front for the Advancement and Progress of Haiti (FRAPPE) waged a brutal campaign of terror against Aristide supporters, forcing large numbers of them to flee to America. US President Clinton, eager to halt the flow of refugees and restore Aristide to power, decided in favour of a military intervention in September 1994. The Haitian military junta resisted calls to surrender and stepped up attacks against pro-democracy activists while organizing parades of 'volunteers' to fight the invasion. War was averted through skilful last-minute diplomatic efforts led by former US President Jimmy Carter. The regime stepped down before US troops landed in Haiti on 19 September. Aristide made a triumphant return as Haiti's president on 13 October, three years after having been ousted, and began the formidable tasks of reconciliation and development.

1017. On 1 January 1994 an armed uprising began in the south-eastern state of Chiapas in Mexico. The rebels were an indigenous group calling themselves the Zapatista National Liberation Army, after the great Mexican revolutionary leader Emiliano Zapata. They caught the federal authorities completely by surprise and had captured four towns before the insurrection was crushed by heavily-armed government forces whose actions were deemed to be serious human rights violations. The rebels had hoped to secure greater autonomy from Mexico City, preserve their distinctive culture and implement various social reforms. The rebels had also sought the resignation of President Carlos Salinas for alleged discrimination against the Mayan Indians of Chiapas and other indigenous peoples of Mexico. The rebellion was timed to coincide with the introduction of the North American Free Trade Agreement (NAFTA) between Canada, America and Mexico, which the Zapatistas claimed was designed to benefit Mexico's wealthy élite at the expense of the poor. The uprising attracted considerable international attention and highlighted the plight of threatened indigenous cultures around the world.

1995

1018 top. Throughout 1995 Chechnya was the scene of continued fighting between separatist rebels and Russian forces. In January 1995 Russian air and artillery attacks reduced much of the capital, Grozny, to rubble and inflicted heavy losses on the civilian population. President Yeltsin ordered a halt to the bombing of the city. This

was apparently ignored by his Defense Minister Pavel Grachev who instructed Russian forces to continue the assault. Similar disagreements and confusions over Russian strategy in Chechnya caused many to question whether President Yeltsin was losing control over the military.

1018 bottom. Russian troops eventually claimed control of two-thirds of Chechen territory, capturing all the main towns. Despite a cease-fire ordered by President Yeltsin in June 1995, Chechen rebels continued fighting from bases in the mountainous region in the south. They also penetrated southern Russia where they attacked the town of Budenovsk, killing over a hundred people. Faced with mounting international criticism, growing numbers of civilian casualties and Russian forces suffering weakened morale and effectiveness, President Yeltsin was torn over whether to take a hard line or seek a negotiated settlement. After Chechen rebels retook Grozny in a surprise offensive in early August 1996, he realized that further military occupation of the breakaway republic was no longer feasible. By the end of the month a peace agreement was signed, accompanied by a protocol stating that consideration of Chechnya's political status was to be deferred until 31 December 2001. By early 1997 it was estimated that the conflict had caused 80,000 deaths and displaced over 400,000 people. In Chechnya itself the violence continued as rival warlords fought to gain control over the republic.

1019. Shortly after 9.00 am on 16 April 1995 a truck containing home-made explosives blew up outside the Alfred P. Murrah Federal Building in Oklahoma City in the worst act of terrorism in American history. The explosion ripped the front off the nine-storey structure, killing 168 people, including nineteen small children. Timothy McVeigh, a US army veteran of the Persian Gulf War, was charged with the crime. Preliminary investigations revealed that McVeigh had been assisted in the bombing by a heavily armed militia that espoused virulently anti-government views. McVeigh was convicted and later sentenced to death on 13 June 1997. The attack exposed the activities of paramilitary organizations in

America and their support from radically disaffected Americans angered by the federal government's perceived infringement on their individual and constitutional rights, particularly their right to bear arms.

1020. A year after tribal slaughter engulfed Rwanda, refugee camps in Rwanda and neighbouring countries were still overflowing with Hutus and Tutsis who had been forced from their homes as a result of the war. The number of refugees exceeded a million in Zaïre, while an additional 80,000 languished in Burundi and Tanzania. Violence was common in the camps. The worst incident occurred on 22 April 1995 at the Kibeho refugee camp in south-western Rwanda. Over 2,000 refugees were shot, bayoneted or trampled to death by members of the Tutsi dominated RPF who feared that the Hutu Interhamwe militia was establishing control of the camp.

1021. Since the founding of the Jewish state in 1948, few - if any - Israelis have played a more significant role in its diplomatic, military, and political history than Yitzhak Rabin. He served as the Israeli army's chief of staff, ambassador to the US, and prime minister (1974-77). In 1984 Rabin was appointed Defence Minister under the Likud coalition government. In the late 1980s he earned a reputation for harshness and even brutality in dealing with Palestinian insurgents in Gaza and the West Bank after the outbreak of the *Intifadah* in 1987. Rabin was re-elected as Prime Minister in 1992 and, encouraged by his Foreign Minister Shimon Peres, courageously abandoned his hardline policies towards the Palestinians and became a peacemaker. Norwegian and American mediators brokered preliminary agreements between Rabin and the PLO leader Yasser Arafat and also with King Hussein of Jordan. The agreements were aimed at securing a lasting peace settlement in the region. In signing these agreements Rabin incurred the wrath of Jewish fundamentalists who violently opposed Israeli withdrawal from the occupied territories. On 4 November 1995 he was assassinated after addressing a peace rally of more than 100,000 supporters in Tel Aviv by a student who belonged to an extremist group.

Hours after the killing, thousands of shocked and grief-stricken Israelis across the country began lighting white candles, traditionally used by Jews to honour the dead. Rabin was buried in Mount Herzl Cemetery in Jerusalem.

1022. The award-winning film *Ulysses' Gaze* (1995) by Greek director Theo Angelopoulos centres on one man's search through the present-day for a mythical film. The quest takes him on a journey through Albania to Bulgaria, Romania and then Belgrade and Sarajevo. He struggles to find his own identity amid the shifting borders and internecine warfare which has marked the region's recent and past history. Angelopoulos' haunting and visually stunning film is filled with images that evoke nearly a century of pain and suffering in the Balkans. Among these is the absurd and still ominous image of a barge carrying the dismembered remains of a colossal statue of Lenin on the Danube River.

1023. The world's banking community was severely shaken in February 1995 when the London-based merchant bank Barings collapsed after running up losses of more than a billion dollars in futures trading on the Singapore International Monetary Exchange. The blame for the financial disaster fell on twenty-eight-year-old British trader Nicholas Leeson. According to inspectors, senior officials at the bank had permitted Leeson to use highly risky instruments without adequate supervision while trading on the Asian markets. As the bank was collapsing Leeson fled to Germany but was quickly arrested and extradited to Singapore to stand trial on charges of fraud and forgery. He was later convicted and sentenced to six and a half years in prison in Singapore. Barings was bought by the Dutch bank ING.

1024. By 1995, Serb rebels controlled roughly 70 per cent of Bosnia. The UN, desperate to halt Serb aggression, designated certain towns in Bosnia 'safe havens' where the war was off-limits and refugees could stay without fear of attack. However, on the night of 11 July 1995 Serb forces began slaughtering Muslims in the 'safe haven' of

Srebrenica, killing an estimated 8,000 people. The UN's inability to stop the massacre prompted an American-led initiative which finally brought the war to an end. In late August NATO began launching air and artillery attacks on Serb positions on the outskirts of Sarajevo, as a result of which Serbs agreed to begin peace negotiations in America. A joint agreement between the leaders of Serbia, Croatia and Bosnia was signed in late 1995 providing a new government structure for Bosnia. The country was to be reunited and pursue a common foreign and defence policy. However it would have two largely autonomous halves – a Muslim-Croat federation based in Sarajevo and a Serbian entity based in eastern Bosnia. UN peacekeepers were replaced by a 60,000 strong Implementation Force (IFOR) which would ensure all sides complied with the Dayton Peace Agreement.

1025. In autumn of 1991 the British and American media began using the term 'Gulf War Syndrome' to describe a medical condition that was affecting large numbers of soldiers who had served in the Persian Gulf War. Symptoms such as chronic fatigue, hair and weight loss, bloated joints, skin rashes and intestinal problems were being reported by thousands of war veterans. The syndrome was also thought to be the cause of an unusually high number of birth defects in the children of Gulf War veterans, including babies born with facial disfigurements, missing limbs and congestive heart failure. Initial rumours that the syndrome was caused by exposure to harmful chemicals perhaps used by Saddam Hussein during the war, and subsequently covered up by coalition leaders, were quickly dismissed. Attention turned to other possible causes including vaccines administered to soldiers before the war to protect them against chemical attacks. Although nearly 70,000 US and more than 2,000 British soldiers have complained of similar symptoms, experts remain divided over whether 'Gulf War Syndrome' really exists.

1026. Early in the morning of 17 January 1995 an earthquake centring on Awaji Island 20 kilometres (12 miles) off the coast of Japan devastated the city

of Kobe and other parts of the densely populated Hanshin region. The earthquake was Japan's worst since 1923, claiming 6,000 lives and leaving more than 300,000 people homeless. The damage to homes, buildings and infrastructure in the area was colossal, worth an estimated total of 150 billion dollars. The government was criticised for its slow response in the immediate aftermath of the earthquake and later acknowledged serious flaws in the country's emergency-management system.

1027. On 1 April 1995 the wide-field planetary camera of the Hubble Space Telescope took this extra-ordinary photograph of pillars of dense molecular hydrogen and dust in the Eagle Nebula. This is a star-forming region 7,000 light-years away from Earth in the constellation Serpens. The colours are produced by three separate images taken in the light emitted from various types of atoms, and the glow is associated with hot young stars which have recently formed.

1996

1028. Israeli warplanes and helicopter gunships had been bombarding various targets in southern Lebanon in early April 1996 as part of a military campaign against Hezbollah (party of God) guerrillas who were launching rocket attacks into northern Israel. On 18 April Israeli gunners – believing they had targeted a guerrilla hideout – shelled the Fiji Battalion Headquarters of the UN in Quana which was being used to house hundreds of refugees, including many women and children. More than 150 people were killed in the attack and a further 200 were maimed or injured. Israeli officials claimed that mapping errors had caused the mis-calculation, but this did little to appease Israeli's many opponents in the region who called for a stern international response to the attack. On 26 April Israel and Hezbollah managed to secure a cease-fire agreement prohibiting attacks against civilians, but fighting between the Israeli army and Hezbollah guerrillas continued to flare up in southern Lebanon.

1029. Two years after Israel and the Palestine Liberation

Organization (PLO) established a basis for lasting peace in the region by signing the Oslo Peace Agreement, the peace process began to unravel. In November 1995, Israel's Prime Minister Yitzhak Rabin, one of the architects of the agreement, was assassinated by a Jew opposed to his peace-making efforts with the Arabs. A few months later a prominent Palestinian terrorist Yahya Ayyash was killed, allegedly by Israeli secret agents. In retaliation, suicide bombers launched a spate of attacks on Israel in late February and early March which left more than fifty Israeli civilians dead and hundreds injured. Palestinian groups opposed to the PLO's deal with Israel claimed responsibility. Benjamin Netanyahu, head of Israel's right-wing Likud Party and bitterly opposed to the Oslo Accords, became the country's new prime minister after winning the national elections at the end of May. Netanyahu replaced Rabin's successor Peres, who was a co-architect of the Peace Agreement. Israeli voters had swung to Netanyahu in the immediate aftermath of the suicide bombings largely because of his promise to halt terrorist attacks within Israel by taking a hard line against the Palestinians and, if necessary, breaking the Peace Agreement.

1030. The war between Afghanistan's various armed groups had claimed the lives of as many as 45,000 Afghans, mostly civilians, by mid 1996. Following the withdrawal of Soviet troops in 1989 and the collapse of the country's communist government three years later, Afghanistan was bitterly divided between local warlords and their warring factions. In 1994 a previously unknown group, the *Taliban* (meaning seeker of religious knowledge) emerged as a major contender in the struggle for power. The group was composed primarily of young students recruited from fundamentalist Islamic schools established by Afghan refugees in Pakistan. Although inexperienced, the *Taliban* zealously pursued support among Afghans by offering to rid their country of the corruption and lawlessness that had devastated Afghanistan during the last fifteen years.

1031 top. The struggle for control of Afghanistan came to a climax in September 1996 during a fierce battle for its capital, Kabul. Soldiers under the command of Ahmed Shah Massoud – the man partly credited with forcing the Soviets to pull out of Afghanistan in the late 1980s – attempted to thwart the *Taliban* advance into the city. The 25,000-strong *Taliban* army was allegedly assisted by Pakistani communications and logistics, although the government of Pakistan refuted such claims.

1031 bottom. Massoud's resistance in Kabul collapsed on 27 September and his 6,000-man *Tajik* army fled to bases in the Panjshir Valley from where they continued to control part of northern Afghanistan. Upon entering the city the *Taliban* executed the country's last communist president Mohammed Najibullah, who had been living inside a UN compound in Kabul for over four years. The majority of Afghans still hoped the *Taliban* would put an end to the violence and that normal life would at last be restored. Not surprisingly, Pakistan was the first country to recognize the new *Taliban* government.

1032. Not since Richard Nixon's tumultuous second term in the White House has a US president been so relentlessly bombarded with verbal attacks from the dreaded White House press corps as President Bill Clinton. During his stint as Clinton's press secretary, Mike McCurry famously described the administration's press conferences in the White House Briefing Room as a 'feeding frenzy'. Notoriously hungry for scandal, the press corps were inundated with a number of ongoing scandals attributed to Clinton and several continuing investigations which threatened to topple his presidency. Remarkably, Clinton managed successfully to thwart the most searing attacks and maintain high public approval ratings through crisis after crisis. Several reasons have been put forward to explain this unlikely phenomenon, Clinton's consummate political skill being the most obvious factor. Since his inauguration in January 1993 Clinton has remained wary – some would say paranoid – of journalists' intentions, believing they are 'out to get him'. The

White House Press Corps have been continually frustrated by what they regard as stonewalling and lack of cooperation from the president and his staff.

1033. One of the most pernicious features of post-Soviet Russia has been the explosion of organized crime in the country. The sudden emergence of free enterprise in the late 1980s enabled powerful criminal elements to infiltrate virtually every sphere of society during a period of political and economic uncertainty. By the mid 1990s an epidemic of organized crime and mafia-linked corruption was severely undermining President Yeltsin's attempts to establish a stable democratic structure in Russia. Widespread criminal activities threatened to erode the very foundations of Russian society. By 1997 Interpol estimated that around 10,000 organized crime groups with between 50,000 and 100,000 members now operate in Russia and control roughly 40,000 firms and 550 banks.

1034. Popular enthusiasm for the *Taliban* rapidly decreased after they assumed power in Kabul. In areas of Afghanistan under their control the *Taliban* enforced a strict Islamic code. Television, alcohol and non-religious music were banned. It became compulsory for all men to grow beards and attend mosques while women were forbidden to work outside their homes and were excluded from society. Girls were not permitted to be educated beyond the age of ten nor enter any form of employment.

1035. The *Taliban* caused horror and revulsion around the world with their barbaric enforcement of their new fundamentalist laws. Punishments meted out to Afghans suspected of violating the strict Islamic code included amputations, public stonings and hangings. Friends and family of the victims were sometimes forced at gunpoint to administer the punishments themselves. The UN refused to recognize the *Taliban* as Afghanistan's legitimate government, opting to give the country's UN seat to a representative of the ousted Afghan President Burhanuddin Rabbani who had fled Kabul in September.

1036. In the first national election in the Republic of Bosnia-Herzegovina after the civil war, Alija Izetbegovic received 80 per cent of the Muslim vote. He was named chairman of the three-man leadership in September 1996. Each of the new republic's three ethnic groups – Croats, Serbs, and Slavic Muslims – voted for regional and national offices, as stipulated by the Dayton Peace Agreement which ended the vicious four-year conflict in Bosnia. They also each elected presidents to represent their interests in a collective leadership. However, despite the success of bringing together the three factions, election monitors reported that the vote was compromised by acts of intimidation, harassment and other infractions from extreme nationalists on all sides.

1037. Only 10 per cent of refugees from a total of 150,000 who were eligible to cross the border separating Bosnia's two regions cast their vote in the national election. In some cases, Muslims were intimidated by Serbs from returning to their villages to vote even though multinational Implementation Force (IFOR) troops had guaranteed their safe passage. The election results – which confirmed the *de facto* division of the country along ethnic lines – did not bode well for the future peace and stability of the republic. The Serb leader resigned himself to working within the federation, but remained hopeful that his people might someday secede and form an independent Bosnian Serb republic. Only days after the national election the three sides began arguing over basic issues such as where the presidency should meet and the wording of an official oath of office.

1038. Since 1984 thousands of flamboyant and colourful drag queens and kings have gathered at the annual Wigstock festival in New York. The success of the festival spawned a documentary *Wigstock: The Movie*, released in 1995. The event was cancelled in 1996 due to lack of sponsors and opposition from the mayor's office over its location. In its place, a spontaneous parade called Dragapalooza took place on the site of the original Wigstock festival in New York's Tompkins Square Park.

1039. The Newbury bypass in Hampshire in England was the last segment of a four-lane motorway that aimed to link the south of France with Scotland via the Channel Tunnel. Controversy over its construction was thrust into the spotlight after self-styled 'eco-warriors' began to occupy trees marked for demolition by the motorway contractors. They established a network of treehouses linked by rope walkways and refused to be moved from the area. Their demonstration raised public awareness of the potential loss of this piece of countryside and its wildlife. Meanwhile, proponents of the bypass claimed that its benefits – shorter travel times and reduced traffic congestion – outweighed the concerns of environmentalists. The 'eco-warriors' were eventually dislodged from the trees and by the end of the year 900 arrests had been made in protests related to construction of the bypass. It was completed in November 1998 but protesters continued to organize various operations designed to disrupt traffic on the bypass.

1040. The staging of traditional Protestant marches in Northern Ireland sparked social unrest and violent clashes in the summer of 1996. Earlier in the year tensions in Northern Ireland had intensified when an IRA cease-fire, which had been in effect since September 1994, came to an abrupt end with the explosion of a huge IRA bomb at Canary Wharf in London's Docklands. As a result, the run-up to the traditional Protestant marching season was fraught with tension. The marches took place yearly to commemorate events in the late seventeenth century which culminated in the Protestant victory over the Catholics at the Battle of the Boyne (1690). The major point of contention between the two communities concerned the route of the parades, some of which went directly through predominantly Catholic areas. When the Royal Ulster Constabulary (RUC) made a last minute decision to permit one such march through a Catholic neighbourhood in Dumcree contrary to an earlier decision, widespread rioting broke out, with particular ferocity in Londonderry. Barricades were set up, vehicles and property were destroyed and there were

gunfights between loyalists and republicans. Once the tensions had subsided, various parties attempted to secure a deal that would avert violence during future marches.

1041. For six years Richard Billingham photographed his parents going about their daily life at their home in Britain's West Midlands. His purpose was to accumulate reference material for his paintings which he hoped would convey the tragic lives of his unemployed, alcoholic father Ray, and his mother Liz. He soon found that photography was a medium which allowed him to understand himself and his family better. Moreover, it enabled Billingham bring low-life subject matter into the realms of 'high art'.

1997

1042. Tony Blair was elected head of the British Labour Party in 1994 following the untimely death of its leader, John Smith. Three years later Blair led the party to its biggest ever election victory, becoming the third youngest prime minister in the country's history and ousting the Conservatives from office after eighteen years in power. Blair's campaign focused on a number of ideas which together constituted what he called 'New Labour'. Gone was the party's traditional devotion to state socialism and its reluctance to embrace market competition. Blair successfully worked to portray himself as the man capable of modernizing Labour and bringing the party's economic and industrial policies up-to-date. He borrowed a number of techniques from the successful presidential campaigns of Bill Clinton, a leader with whom Blair quickly developed a strong bond.

1043 top. On 19 February 1997 China's ageing leader Deng Xiaoping died at the age of ninety-two. He had spent more than seven decades in the Chinese Communist Party, becoming its leader during the crucial period following the death of Chairman Mao. He won acclaim for liberating China from the ravages of the Cultural Revolution and for transforming the country into an economic power and a major force on the world stage. His international reputation was damaged, perhaps irreparably, after he ordered the

military action in Tiananmen Square in 1989 in which 3,000 peaceful pro-democracy demonstrators were killed. Throughout his reign and despite his long infirmities, Deng retained a tight grip on power and displayed a total intolerance of political dissent. News of his death was greeted with little sign of public mourning, in sharp contrast to the death of Chairman Mao two decades earlier. His successor Chiang Zemin gave few indications of making any significant change in China's policies.

1043 bottom. Young neo-Nazi skinheads who adopted the Nazi salute and shouted slogans such as '*Sieg Heil*' were responsible for a significant rise in extreme right-wing violence across Germany in the late 1990s, particularly in the east. In 1997 German police put the number of active neo-Nazis in the country at around 45,000. Most of their anger was directed towards Germany's generous asylum laws. Although such laws undoubtedly contributed to the rise in neo-Nazi attacks, most believed that the violence was due to unemployment and other problems associated with the difficult process of reunification. The extremists' connection to Germany's Nazi past was evident in August as more than 220 neo-Nazis were arrested when clashes erupted during demonstrations marking the tenth anniversary of the death of Hitler's deputy Rudolf Hess.

1044. On 23 February scientists at the Roslin Institute in Edinburgh in Scotland revealed that they had created the first clone of an adult animal. The team, led by Dr Ian Wilmot, extracted a single cell from the mammary gland of an adult sheep and fused it with an unfertilized egg from which all the DNA had been removed. The embryo produced was then inserted into a surrogate mother, leading to the birth of a lamb which was genetically identical to the sheep from which the DNA was originally taken. The scientists named the cloned sheep Dolly and she dominated headlines around the world for days. The cloning promised to expand the possibilities of bio-research and to foster the development of new health-care products. In addition, it was hoped that techniques used on Dolly might be developed to

assist in the treatment of cancer and other diseases if applied to humans. This possibility fuelled wide debate in many countries about the ethics of genetic research and cloning in particular. It inevitably led some to conclude that Dolly was the first step towards replicating individual human beings through cloning.

1045. In February 1997 North Korea's notoriously secretive leaders made the unprecedented admission that their country was experiencing 'temporary food problems'. In actual fact, after severe drought and a typhoon which had followed two years of destructive flooding of the country's farmland, North Korea was on the verge a major humanitarian disaster. UN representatives discovered thousands of people, particularly infants, suffering from chronic malnutrition while North Korean medical services were grossly ill-prepared to cope with the crisis. In all, 80,000 North Koreans were in immediate danger of dying while another 800,000 were suffering from malnutrition. The government was eventually forced to appeal to the UN and other international organizations for emergency food relief. South Korea agreed to send 50,000 tonnes of food to the North and America shipped 50 million dollars-worth of surplus grain to the country. In January 1998 the UN World Food Programme made the largest appeal in the organization's history requesting emergency food aid for North Korea worth nearly 400 million dollars.

1046. At midnight on 30 June 1997 the long-awaited handover of Hong Kong from British to Chinese sovereignty took place. The Chinese communist government had insisted that the treaties signed in the nineteenth century that gave Britain economic and political power over Hong Kong were invalid since the Chinese communist government had come to power in 1949 . In 1984 British Prime Minister Margaret Thatcher conceded to China's demands and agreed that in 1997, on the expiry of its lease on the New Territories, the whole of Hong Kong would revert to Chinese sovereignty. The agreement was predicated on China's commitment not to alter Hong Kong's capitalist economy or its unique social and political

character for a period of fifty years after the handover. The objective was enshrined in the slogan 'one country, two systems'.

1047. The handover of Hong Kong touched off a massive demonstration of patriotic fervour in celebrations across China. Within Hong Kong the occasion was marked by pomp and pageantry at a ceremony attended by Britain's Prince Charles, Prime Minister Tony Blair and Governor of Hong Kong Chris Patten. Shortly before midnight on 30 June the Union Jack was lowered in the city before British leaders and dignitaries boarded the Royal Yacht *Britannia* and bade farewell to the last significant colony ruled by Britain. Some 4,000 troops of the Chinese Liberation Army entered Hong Kong on 1 July, symbolizing the return to Chinese sovereignty.

1048. In 1997 Turkey undertook major military incursions into northern Iraq in pursuit of guerrillas from the Kurdish Workers' Party (PKK). The PKK is a group of Turkish Kurds attempting to carve out an independent Kurdish homeland in south-eastern Turkey. They used northern Iraq as a base for their raids. The incursions resulted in heavy losses to the PKK fighters. They were carried out with assistance from rival Turkish factions. The nearly 30 million Kurds spread between Iran, Iraq, Turkey and Syria, in an ill-defined area which the Kurds call Kurdistan, remain a deeply fractured people who have known little peace for centuries. A large and distinct group, with their own language which is not Arab, Turkish, or Persian, Kurds have historically been viewed as a political and military threat by all four of the countries in which they are concentrated. As a result, Kurds have been persecuted and subjected to untold hardships for centuries.

1049 top. On 30 July two suicide bombers blew themselves up in the Mehane Yehuda fruit and vegetable market in Jerusalem, killing eleven Israelis. The militant Palestinian group Hamas claimed responsibility for the attack which was aimed at destroying the Oslo Peace Process between the Palestinian authorities and the Israeli government. Israeli Prime

Minister Benjamin Netanyahu, presiding over a fragile coalition government, was torn between hardliners calling for an immediate end to the peace process and others demanding that he honour the commitments made by his predecessors Shimon Peres and Yitzhak Rabin. He declared that there would be no further land transfers to the Palestinians until the terrorism stopped.

1049 bottom. After the suicide bombings in July, Netanyahu eventually agreed to the handover of more towns in the West Bank to Palestinian self-rule as set down in the Oslo Agreement. This was on condition that Palestinian leader Yasser Arafat redouble efforts to crack down on Hamas extremists. On 4 September three suicide bombers set off explosions in a busy shopping area of Jerusalem killing five Israelis and wounding at least 180 others. Netanyahu responded by halting further redeployments in the West Bank and ordered the closure of certain Palestinian self-rule areas. Recrimination and mistrust escalated on both sides as foreign governments, notably the US, began frantic diplomatic attempts to rescue the floundering peace process.

1050. On 1 May 1997 British voters dispatched the Conservative Party after its candidates won only 179 seats to Labour's 418 in the general election. The Conservatives' share of the popular vote was the lowest since the early nineteenth century and its total number of seats was the lowest since 1906. Several prominent Conservatives and members of cabinet were defeated in their own local constituencies. Support for the party collapsed for a number of reasons including bitter divisions within the party over Britain's relations with the rest of Europe as well as persistent allegations of corruption and 'sleaze' among Conservative MPs. The outgoing Prime Minister John Major resigned as Conservative Party leader immediately following the defeat.

1051. Diana, Princess of Wales, and her lover Dodi Fayed were killed along with their driver when their car crashed in a Paris motorway tunnel on 31 August 1997. At the time of her death, the former wife of the British heir

to the throne Prince Charles was one of the most famous women in the world. Few details of her glamourous and tumultuous private life escaped report by the media. The paparazzi pursued her relentlessly whether she was meeting film stars or simply training at her local fitness centre. Her death provoked an extraordinary display of public grief across Britain. Hundreds of thousands of people laid floral tributes outside the gates of her Kensington Palace home while up to a million people lined the streets of London to watch the funeral cortège pass by on 7 September and as many as 2 billion worldwide watched the funeral on television. After the service the coffin was driven to the Spencer family estate at Althorp, Northamptonshire, where it was buried in a private ceremony.

1998

1052. More than 1.5 million people died in the civil war that had been devastating Sudan since 1983 when the mainly Muslim Arabic government in Sudan's capital Khartoum tried to impose Islamic law. Rebels in southern Sudan desiring autonomy for the mostly Christian and animist inhabitants in the area resisted. The ensuing war devastated the economy and caused almost unimaginable hardships for the civilian population, particularly in the south which faced relentless aerial bombardment by government forces during the 1990s. Soldiers on both sides of the conflict robbed ordinary Sudanese of their cattle, destroyed crops and sent them fleeing from their land. Unable to support themselves, millions of desperately hungry Sudanese found themselves constantly on the move looking for food. Scant rains in the late 1990s severely reduced harvests and added to their misery. By early 1998 aid agencies in the country confirmed that a major humanitarian disaster was unfolding.

1053. In June 1998 the UN officially declared famine in Sudan. Earlier in the year international relief operations were halted by a month-long government ban on all aid flights which intensified the crisis considerably. Aid agencies announced that more than 2.5 million people in the country faced starvation, as a result of the country's fifteen-year civil war. In July a cease-fire was brokered for the south-western state of Bahr al Ghazal, one of the worst hit areas, to allow humanitarian aid to be delivered. With the arrival of rains ending two years of drought in the region, relief agencies expressed hopes that the famine might be brought under control. Nevertheless, most aid workers believed that famine would continue to threaten Sudan until the conflict between the government and the rebels was resolved.

1054. On 21 May 1998 General Suharto stepped down as President of Indonesia after thirty-two years in power. His resignation came after months of student protests demanding fundamental economic and political reforms which Suharto categorically refused to consider until 2003 when his seventh presidential term was scheduled to expire. A decisive moment came on 4 May when the regime announced a sharp rise in fuel, transport and electricity prices in response to urgent calls from the International Monetary Fund to introduce austerity measures. Indonesia was already in the throes of serious economic turmoil due to the financial confusion which had spread across Asia a year earlier and the continuing decline of the national currency. Previously peaceful demonstrations turned violent as widespread riots and looting made parts of Indonesia into war zones. By mid May thousands of students had congregated outside the legislature where they demanded Suharto's resignation. Eventually 10,000 students occupied the building. When the military leadership informed Suharto that he no longer had their support he finally stepped down, sparking spontaneous celebrations across the country. Strong doubts were raised about the ability of his successor Bacharuddin Jusuf (B.J.) Habibie – Suharto's Vice-President and close friend – to revive the economy and establish a stable democracy.

1055. During more than three decades in power General Suharto amassed one of the largest financial dynasties in Asia. The former president and his family accumulated billions of dollars through an interlocking empire in property, banking, industry, telecommunications, media and transport. The extent of corruption and self-aggrandisement which had taken place during his reign shocked the world when it was exposed. His extraordinary riches stood in sharp contrast to the desperate plight of millions of Indonesians who had languished in poverty throughout his years in power.

1056. Yugoslavia's victory over Russia in the final of the World Basketball Championship on 9 August 1998 resulted in euphoric celebrations among Serbs. News of the victory covered the front pages of most newspapers, temporarily supplanting reports of the continuing violence in the southern Yugoslav territory of Kosovo. The disputed territory, roughly 90 per cent Albanian and 10 per cent Serbian, had always been held by Serbs to be central to their history and cultural identity. Yugoslav President Slobodan Milosevic had stripped Kosovo of its limited autonomy in 1989 when he was president of Serbia. Despite attacks from the separatist ethnic Albanian Kosovo Liberation Army (KLA) and popular demonstrations for autonomy, Milosevic vowed never to give Kosovo up. This was a stand backed by the vast majority of his countrymen. In February 1998 Serb forces began a bloody crackdown in the separatist province. Hundreds of thousands of ethnic Albanians were uprooted from their homes by fighting between Serbs and the KLA. Brutal ethnic cleansing operations took place, identical to those carried out during the Bosnian civil war.

1057 top. The introduction of legislation to curb the sale and possession of handguns in the US was greeted with approval by most Americans. The Brady Handgun Violence Prevention Act was named after former White House Press Secretary James Brady, who was wounded in the 1981 assassination attempt on President Ronald Reagan. The act became law in 1994 and was credited with a sharp reduction in incidents of violent crime in America during the latter half of the 1990s. The law, requiring background checks for gun purchasers and a seven-day waiting period, resulted in nearly 70,000 handgun purchases being blocked. More than half of these blocks occurred because the would-be gun owner had a criminal record.

1057 bottom. Although significant, the number of handgun purchases blocked by the Brady law represented a mere 2.7 per cent of the 2,574,000 applications for handgun sales in America during 1998. The same year there were 14,000 gun-related murders in America. Opponents of gun control, including the nearly 2 million members of the National Rifle Association, had long argued that the right to possess firearms was an intrinsic part of American identity. They ceaselessly reminded proponents of gun control that the right to bear arms is guaranteed by the second amendment to the US constitution. However, by the end of the decade, public opinion was shifting further away from this view.

1058. Throughout 1998 US President Bill Clinton was beset by a series of allegations which threatened to topple his presidency. In mid January a frenzy of media speculation surrounded reports that he had had a sexual relationship with a young White House intern, Monica Lewinsky, and then lied under oath by denying the affair, encouraging her to do the same and thus perjured herself. Lewinsky had been subpoenaed to testify in an ongoing sexual harassment civic action against the president. Meanwhile Kenneth Starr was appointed as a special prosecutor to investigate Clinton's alleged involvement in a loan and property scandal in his home state of Arkansas – the so-called Whitewater affair. Starr was asked by an American court to extend his investigation to establish whether Clinton was abusing his executive powers in matters related to this latest scandal. On 26 January 1998 in a televised statement Clinton emphatically denied any sexual relationship with Lewinsky. Starr continued to pursue his investigation over the next year. He incurred the wrath of American liberals who claimed he had lost objectivity and was merely 'out to get the president'. After admitting to the affair with Lewinsky in August, Clinton claimed his crimes were undeserving of impeachment. However, Clinton was impeached by the American House of Representatives on 19 December 1998 for 'high crimes and misdemeanors', for lying under oath and obstructing justice. He remained in office however, after the US Senate failed to confirm the impeachment decision by the House with the necessary two-thirds majority.

1059 top. The World Cup final began after a characteristically French pre-match event in which the legendary French designer and World Cup sponsor Yves St Laurent displayed four decades of his work in a parade by 300 models from around the world. The field at the national stadium in Paris was covered with blue fabric as the models strutted about to Ravel's *Bolero*.

1059 bottom. The 1998 football World Cup on 12 July was won by host-nation France in a spectacular victory over the reigning champions and tournament favourites, Brazil. The French triumph was watched by a global television audience estimated at more than 1.5 billion and provoked jubilant displays of national pride across France. In Paris alone, more than a million people gathered along the Champs Elysées in what was the largest spontaneous celebration in France since the country's liberation from the Nazis in 1944. Popular enthusiasm for the French national team, made up of players of African, Arab and European descent, raised hopes that their World Cup victory might help reduce growing racial tension within French society.

1060. By 1998 the *Taliban* had extended their brutally repressive regime over two-thirds of Afghanistan, the remainder of which was held by a northern alliance opposition force led by Ahmed Shah Massoud. Iran, America and the UN attempted to bring about peace, but the *Taliban* continued their efforts to achieve control over rebel territory in the north. Meanwhile reports emanating from the country revealed Afghan women were still being targeted by the *Taliban* in a violent campaign designed to keep them under virtual house arrest. They were prohibited from showing their faces in public, seeking medical care without a male escort and attending school. In 1997 European Humanitarian

Affairs Commissioner Emma Bonino led an international fact-finding mission to the country to investigate the plight of local women. It was rebuffed and its members threatened with violence by *Taliban* police, before they were evicted from Kabul. World leaders expressed hope that a peace agreement between Massoud's rebels and the *Taliban* might ease the terrible suffering and per-secution of women in Afghanistan.

1061 top. On 15 August 1998 a car bomb planted by a splinter group of the IRA exploded in Omagh, Northern Ireland, killing twenty-eight civilians and injuring more than 200 others. The bomb was de-tonated in the town centre among crowds of shoppers on a Saturday afternoon. The death toll made it the worst single incident in Northern Ireland since the troubles began in 1969. The 'Real IRA' – whose members had broken away from the mainstream IRA as a result their acceptance of the Good Friday Agreement – claimed responsibility for the attack three days later. The bombing outraged both nationalists and unionists alike, and was immediately condemned by the IRA and its political wing, Sinn Fein, whose leaders had traditionally refused to condemn attacks committed by nationalist terrorists.

1061 bottom. The Omagh bombing did not sabotage the Good Friday Agreement, as those responsible had hoped. Instead the attack redoubled peacemaking efforts on all sides of the conflict in Northern Ireland. In addition, the attack further marginalized groups who aimed to overturn the agreement through acts of violence. The Good Friday Agreement had been made a few months earlier after exhaustive negotiations involving represen-tatives from Britain, the Republic of Ireland, an international commission on Northern Ireland and the various parties in Northern Ireland. It enshrined the idea that the fate of Northern Ireland could only be determined through the consent of its people. The Agreement also provided for a new legislature, consultative bodies linking the Republic with Northern Ireland as with Britain, and the release of paramilitary prisoners and eventual decommissioning of arms.

1062. Exactly eighty years to the day after Russian Tsar Nicholas II and his family were executed by Bolshevik troops in 1918, their remains were buried in an official state funeral in St Petersburg, the old imperial capital. The remains of the Romanovs had been dis-covered in Yekaterinburg almost twenty years earlier, under railroad ties on a country road where they had been hidden by their assassins. Their whereabouts were kept secret until 1991 when tests were ordered to authenticate the bones. Six years of examination and DNA-testing established the remains as those of the last imperial family. The bones remained in a city morgue until January 1998 when President Boris Yeltsin ordered preparations for a funeral. Thousands of Russians paid tribute to the Romanovs in Yekaterinburg where their bones were put on display. They were then placed in wooden coffins and taken to St Petersburg. Yeltsin, who had earlier derided Nicholas II's rule and refused to be involved in the burial, changed his mind at the last minute and elevated the occasion into a major state spectacle. He claimed to be acting in the interests of history and humanity.

1063. Hurricane Mitch formed in the south-western Caribbean Sea on 22 October and grew into one of the most intense hurricanes ever recorded, with sustained winds of 290 kilometres per hour (180 miles per hour). When the full force of the hurricane hit the Central American coast a few days later the results were catastrophic. It destroyed roads and bridges, swept away electricity and telephone poles and flattened thousands of hectares of crops. As the storm winds weakened, Mitch continued to cause torrential rains throughout the region, resulting in floods and mudslides which killed more than 11,000 people. Carlos Flores Facusse, the President of Honduras, claimed that Hurricane Mitch had destroyed in less than a week what it had taken Honduras fifty years to build. Damage estimates in Honduras, which was one of the worst hit countries, reached 3 billion dollars. More than a million Hondurans were displaced from either their homes or their jobs because of the hurricane. In neighbouring Nicaragua damage was estimated at a billion dollars. Experts on the scene claimed that

lack of environmental controls and widespread poverty had exacerbated the storm's deadly effects.

1064. Work on the Millennium Dome began in June 1997. Located at Greenwich in London – the focal point of the British government's celebrations to mark the year 2000 – the dome is the largest structure of its kind in the world. Designed by a team of architects from the Richard Rogers Partnership, the spectacular 100,000 square metre (981,000 square foot) dome is clad in Teflon-coated glass fabric and tensioned to twelve principal masts a hundred metres (328 feet) high. It was conceived as a grand national pavilion which would contain exhibits and attractions on a scale never seen before in Britain. The construction of the dome has been dogged by controversy from the beginning. Religious leaders complained about the absence of a strong Christian theme in a project marking the anniversary of the birth of Christ. Others condemned the dome, the projected cost of which is 758 million pounds, as a colossal waste of money. Twelve million visitors are expected to visit the dome in its first year.

1065. On 16 December 1998 American and British aeroplanes launched a massive bombing campaign against Iraq following a report by the UN chief weapons inspector in Iraq that Saddam Hussein was not co-operating with arms inspectors. The attack, named Operation Desert Fox, was claimed to be necessary by both British and American officials. The Iraqi leader had repeatedly failed to abide by a UN agreement allowing unconditional access to UN inspectors who were trying to establish whether Iraq had dismantled its biological, chemical and nuclear weapons programme. After four days of bombings, the American and British governments called a halt, claiming that their objective of 'degrading' Saddam's Hussein's ability to make and use weapons of mass destruction had been achieved. The UN and several major world leaders expressed serious opposition to the strikes which represented a clear violation of the UN charter. It was believed that strikes would result in further suffering for the Iraqi people while doing little to weaken Saddam Hussein's grip

on power in the country. Commentators also noted that the timing of the attacks seemed to signal an attempt by President Clinton to deflect attention away from – or even postpone – a crucial vote scheduled to be held in the US Congress regarding his impeachment.

1999

1066. After months of treatment for lymph cancer in the US, Jordan's King Hussein returned to the Jordanian capital, Amman, on 19 January declaring himself fully recovered. He suffered a relapse however, and was forced to return to America a week later. Before leaving and with his health deteriorating rapidly, King Hussein made his son, Prince Abdullah, heir to the Hashemite throne instead of his brother Prince Hassan. At sixty-three Hussein was the Middle East's longest-serving leader, having ruled Jordan since 1952, and one of the region's great peace-makers. His impending death provoked fears that peace settlements between Israel and its Arab neighbours might begin to unravel without his forceful, stabilizing leadership in the region.

1067 top. King Hussein died on 7 February 1999 after forty-six years on the Hashemite throne. Thousands of Jordanians had been keeping a vigil outside King Hussein's clinic during his last hours on a life-support machine, praying for a miracle to save their leader, the only one most of them had ever known. As news of Hussein's death spread across the country, many of his subjects were overcome with grief and wept openly on the streets. Three hours after his death was announced, Prince Abdullah was officially sworn in as the new King and announced forty days of mourning.

1067 bottom. On 8 February 1999 King Hussein was laid to rest in a funeral service attended by his wife and family, dozens of world leaders and thousands of ordinary Jordanians. As a testament to the extraordinary warmth and admiration that the King had enjoyed internationally during his lifetime, avowed enemies, such as Israeli Prime Minister Benjamin Netanyahu and Syrian President Hafez al-Assad, briefly put aside their differences and gathered

together at Raghadan Palace in Amman to pay their final respects to Hussein. Hussein's successor, Abdullah, vowed to continue his father's policies even though doubts remained whether the young and inexperienced new leader would be able to steer Jordan through the various minefields of Middle Eastern politics in the way that King Hussein had successfully done for nearly five decades.

1068. In mid January inter-national peace monitors in Kosovo discovered the bodies of forty-five ethnic Albanians massacred by Serbian forces in the village of Racek, 24 kilometres (15 miles) south of the capital, Pristina. The killings were in clear violation of a ceasefire agreement brokered by American envoy Richard Holbrooke in October 1998 to halt the Serbs' brutal, year-long suppression of a KLA-led uprising by ethnic Albanians in Kosovo. Yugoslav authorities claimed that the victims had died as a result of a fight with the KLA, but members of the Kosovo Verification Mission at Racek confirmed that the dead had been executed at close range and some had been mutilated. Shortly afterwards representatives from several countries convened urgent peace talks in France to end the conflict. Yugoslavia's President Slobodan Milosevic remained intransigent, defiantly ordering his Serbian troops to continue their crackdown in Kosovo.

1069. Russian Prime Minister Yevgeny Primakov met with Yugoslav President Milosevic on 30 March in Belgrade in the first serious diplomatic effort to end the worsening conflict in Kosovo. Fearing that an escalation of the crisis and the possible intro-duction of NATO ground troops might lead to a third world war, Russian President Boris Yeltsin ordered Primakov to the Yugoslav capital in the hopes that Milosevic might be persuaded to restart negotiations over the fate of the embattled province. The commonalities shared by Slavic Russia and Yugoslavia – the Orthodox religion, long periods of communist rule and similar languages – and the closeness of the two leaders, suggested that Primakov's visit might be the last chance to diffuse a crisis which was now threatening to plunge the whole of the Balkans into a wider

war. After their meeting Milosevic agreed to a partial withdrawal of Serb forces from Kosovo if NATO would stop the bombing. NATO rejected the plan and announced that it was intensifying its aerial-bombardments on Yugoslavia to continue twenty-four hours a day.

1070. Following the Serbian massacre of ethnic Albanians at Racek, NATO warned Yugoslavia's President Milosevic that his country faced imminent air attack from NATO forces if he did not join peace talks being held in Paris. Milosevic agreed, but his continuing intransigence, particularly his refusal to accept NATO peacekeeping troops on Yugoslav territory to police a settlement, led to the collapse of the talks in mid March. Serb security forces stepped-up attacks against the KLA and on towns and villages in north-western Kosovo, forcing thousands of ethnic Albanians to flee their homes and seek refuge in nearby hills.

1071 top. After international monitors evacuated Yugoslavia and most Western diplomats and nationals pulled out of the country, NATO aircraft began attacks on various Serb targets inside the rebellious province of Kosovo and other parts of Yugoslavia on 24 March. The US-led bombardment, designed to halt the Serbian offensive in Kosovo, led immediately to Serb reprisals against ethnic Albanians and the forced exodus of civilians across the border into neighbouring countries. The NATO action, dubbed Operation Allied Force, represented the first attack on a sovereign state by NATO in the alliance's fifty-year history. The bombing was immediately condemned by Russia and concerns were raised amongst UN representatives about the legality of the air strikes. Milosevic responded by declaring a state of war and vowed never to accept NATO troops on Yugoslav soil.

1071 bottom. By early April a humani-tarian disaster loomed in the Balkans as the forced exodus of hundreds of thousands of ethnic Albanians from Kosovo over-whelmed temporary camps set up in neighbouring countries to house and feed the refugees. In Blace, Macedonia, tens of thousands were left stranded in an open field where lack of clean water and sanitary facilities

threatened to cause an epidemic. Macedonian authorities refused to cede to US authority to process the refugees. The plight of the refugees only began to improve with the arrival of British, French and Italian soldiers who set up a well-equipped NATO camp a few miles to the south.

1072. In the aftermath of the first NATO attacks on Yugoslavia, tens of thousands of ethnic Albanians began pouring over the border into neighbouring Macedonia, Albania and the Yugoslav Republic of Montenegro. Government forces bent on expelling all non-Serbs from Kosovo commenced a brutal campaign of ethnic cleansing. Although officials in the Yugoslav capital, Belgrade, blamed NATO for the flight of ethnic Albanians from Kosovo and declared that security forces were only acting against KLA rebels, refugees from the fighting reported widespread Serb atrocities against civilians and claimed they were forced to flee their homes at gunpoint.

1073. The flight of ethnic Albanians form Kosovo in the spring of 1999 created a serious dilemma for European govern-ments. Aside from disagreements over how best to handle the desperate refugee problem along Kosovo's borders, European governments were forced to make ad-hoc decisions about the future of refugees who arrived at their own borders after some managed to filter through Albania to Italy, France and elsewhere. Leaders in several countries were nervous that a sudden influx of ethnic Albanians could trigger a popular backlash and revive divisive political debates over immigration, a sensitive issue in many European countries. Moreover, governments responding to the refugee crisis were anxious not to be viewed as ignoring humanitarian ideals while simultaneously ensuring they did not become unwitting allies of Milosevic in his ethnic cleansing operation in Kosovo by granting asylum to large numbers of ethnic Albanians fleeing Serb attacks in the rebellious province.

1074. Serbs in major cities across Yugoslavia formed human shields on bridges to protect them from being destroyed by NATO bombing. In the northern city of Novi Sad, a constant target of NATO since the US-led campaign

began in late March, residents began gathering each night in early April on the Beska bridge after air strikes destroyed the city's other main bridges across the river Danube. Bridges became the scenes of intense anti-NATO demonstrations during the early stages of the conflict. Serbs waved Yugoslav flags, held lit candles in their hands, and many took to pinning paper 'targets' on their chests, a nationwide symbol of the country's defiance of NATO bombing. The American and British governments were demonized for the bombings in the Serbian press and likened to the Nazis who had terrorized Serbs during the Second World War when they fought alongside the Allies against Hitler.

1075. The refugee situation along Kosovo's borders grew increasingly strained by mid April as numbers of ethnic Albanians forced out of the province swelled to more than half a million, prompting officials in neighbouring countries to place strict limits on the number of refugees permitted to stay in their countries. Western governments scrambled to arrange flights to take some refugees from Macedonia, Albania and Montenegro to temporary shelters abroad, although they were mindful that such actions could legitimize ethnic cleansing in Kosovo if NATO failed to achieve decisive victory over the Serbian military. At the same time fears mounted over the fate of more than 800,000 ethnic Albanian refugees trapped within Kosovo after they had been driven from their homes by the Serbs. Some were forcibly turned back as they tried to escape the war-torn province after the Yugoslav government abruptly changed tack on 6 April and closed border crossings.

1076. Kosovan refugees entering Albania via the Morini border post arrived by any means of transport available – on tractors and wagons, in private cars and on foot. Nearly all reported similar stories of barbaric treatment suffered at the hands of Serbian troops to aid workers and journalists. Each new group of refugees corroborated the testimony of earlier arrivals that the bodies of hundreds of ethnic Albanians lined the routes out of Kosovo while in towns and villages Serbian soldiers were systematically raping women and

setting fire to homes. NATO's continuing reluctance to send ground troops into Kosovo meant reports of atrocities could not be confirmed independently.

1077. On 20 April 1999 the world's media abruptly switched its focus from the war in Kosovo to a suburban high school in Denver in the US, where two teenage boys armed with automatic weapons and pipe bombs went on a rampage, killing twelve fellow students and a teacher before taking their own lives. The two young killers, claiming to be members of the 'Trench-Coat Mafia', a self-styled group which wore swastikas, advocated white supremacy and fantasized about death and destruction, were apparently seeking revenge against school athletes, so-called 'jocks', who had ridiculed and humiliated them. The massacre, which took place on the anniversary of Hitler's birthday, the issue of gun control in America once again and is an example of the culture of violence which some argue is causing the moral decline of American society.

1078. *Fidelio* was Beethoven's only opera; he had great difficulty in writing it. Initially composed in 1803, the first version was performed on 20 November 1805 in Vienna, at a time when Napoleon's army was occupying the city. The final version – which was much worked on – was not completed until 1814. Beethoven took the plot from a French play which had already been made into an opera in 1798. Two other operas based on the same script were written while Beethoven was working on his version. The story is of a woman whose husband has mysteriously disappeared. As she rightly comes to suspect, he has been put into a prison governed one of his personal enemies. Disguised as a boy, she gets a job assisting Rocco, the head jailer, at the prison and soon finds Florestan, her husband, in the darkest dungeon, about to be executed by the governor Don Pizzarro. She rescues Florestan in the nick of time and their reunion leads to monumental rejoicing. It is a simple tale, but one that Beethoven tells with music of powerful grandeur combined with great human feeling. The opera was not performed in Germany during the Nazi period, although Beethoven escaped the ostracism suffered by other musicians and

artists under the Nazi regime. This was partly due to Wagner's enthusiasm for both the composer and *Fidelio*. Unless the world has changed very much for the worse, *Fidelio* will surely be in several opera repertoires in 2099, whatever form they take. In the production of *Fidelio* at the Staatsoper in 1999, Leonora was played by Deborah Polaski and Rocco by Siegfried Vogel.

Index

Photographic Acknowledgements

14 courtesy Gilman Paper Company Collection; 15 Museum of the City of New York, The Byron Collection; 16 The Photography Collection, The Carpenter Center for the Visual Arts, Harvard University; 17(t) Lafayette Studios/Victoria & Albert Museum, London; 17(b) Novosti, London; 18 Library of Congress, Washington, DC (neg no. 262-92666); 19 Library of Congress, Washington, DC (neg no. 262-13290); 20 Mary Evans Picture Library, London; 21 The Photography Collection, The Carpenter Center for the Visual Arts, Harvard University; 22 anonymous; 23 American Museum of Natural History, New York (neg. no. 336289); 24(t) courtesy Weidenfeld and Nicolson Ltd, London; 24(b) Hulton Getty; 25(t) The Royal Photographic Society Collection, Bath; 25(b) Hulton Getty; 26 William van der Weyde, courtesy George Eastman House, Rochester, New York; 27 Hulton Getty; 28-29 Roger-Viollet, Paris; 29 Harry C. Ellis/Stephen White Associates, Los Angeles; 30 Popperfoto, Northampton; 31 courtesy Merlin Holland; 32 Popperfoto, Northampton; 33 The Carnegie Library, Pittsburgh; 34 Novosti, London; 35 The State Central Theatre Museum, Moscow; 36 Brown Brothers, Sterling, PA; 37 Hulton Getty; 38-39 Corbis UK Ltd; 39 Hulton Getty; 40 Roger-Viollet, Paris; 41 Edward Steichen, courtesy Gilman Paper Company Collection (reprinted with permission of Joanna T. Steichen); 42 Harry C. Ellis/Stephen White Associates, Los Angeles; 43 Library of Congress, Washington, DC (LCUSZ62-67611); 44 Hulton Getty; 45 The Kobal Collection, London; 46-47 Palace Museum, Beijing/*The Chinese Century*, 1996, Endeavour Group UK; 48 Ullstein Bilderdienst, Berlin; 49 National Army Museum, London; 50-51 L'Illustration/Sygma; 52 Roger-Viollet, Paris; 53(t) Hulton Getty; 53(b) Wellcome Institute Library, London; 54 Brown Brothers, Sterling, PA; 55 Emile Bernard/Collection Sirot-Angel, Paris; 56 Hulton Getty; 57 Culver Pictures Inc., New York (Alexander Alland Collection); 58 Robert Hunt Library, London; 59 Hulton Getty; 60-61 Novosti, London; 62(l) The Russian State Archive of Cine Photo Documents, Moscow; 62(r) David King Collection, London; 63 Ullstein Bilderdienst, Berlin; 64 Corbis UK Ltd; 64-65 Harry C. Ellis/Stephen White Associates, Los Angeles; 66 Stephen

White Collection II; 67 Arnold Genthe, courtesy James Moores Collection; 68 courtesy The Mariners' Museum, Newport News, VA; 69 Culver Pictures Inc., New York; 70 Roger-Viollet, Paris; 71 L'Illustration/Sygma; 72(t) Roger-Viollet, Paris; 72(b) Hulton Getty; 73 Ullstein Bilderdienst, Berlin; 74 Hulton Getty; 75 Roger-Viollet, Paris; 76-77 L'Illustration/Sygma; 77 Fondo Melitón Rodríguez, Biblioteca Pública Piloto de Medellín, Colombia; 78 Institut Amatller d'Art Hispànic, Barcelona; 79 Institut Amatller d'Art Hispànic, Barcelona; 80 courtesy James Danziger Gallery, New York; 81 Pach Brothers, New York, courtesy James Moores Collection; 82 Hulton Getty; 83 Grant Brothers/John Hillelson Collection, London; 84 Beinecke Rare Book and Manuscript Library, Yale University; 85 Tony Grant/John Hillelson Collection, London; 86 Roger-Viollet, Paris; 87 Institut Amatller d'Art Hispànic, Barcelona; 88 courtesy The Mariners' Museum, Newport News, VA; 89(t) Hulton Getty; 89(b) Ullstein Bilderdienst, Berlin; 90 Grant Brothers/John Hillelson Collection, London; 91 Hulton Getty; 92(t) Roger-Viollet, Paris; 92(b) Brown Brothers, Sterling, PA; 93 Corbis UK Ltd; 94 Archivo Casasola, Hidalgo, Mexico; 95(l) Brown Brothers, Sterling, PA; 95(r) Mary Evans Picture Library, London; 96(t) David King Collection, London; 96(b) Brown Brothers, Sterling, PA; 97 David King Collection, London; 98 Culver Pictures Inc., New York (Alexander Alland Collection); 99 The Metropolitan Museum of Art, New York (The Alfred Stieglitz Collection, 1949) (49.55.205);

100 J.H. Lartigue/ © Ministère de la Culture (AAJHL), Paris; 101 Edimedia, Paris; 102 Popperfoto, Northampton; 103 Hulton Getty; 104 Roger-Viollet, Paris; 105 L'Illustration/Sygma; 106 © Museum of London; 107 Brown Brothers, Sterling, PA; 108 Hulton Getty; 109(t) Brown Brothers, Sterling, PA; 109(b) Roger-Viollet, Paris; 110-11 The Metropolitan Museum of Art, New York (The Alfred Stieglitz Collection, 1949) (49.55.327); 112 Edimedia, Paris; 113 Roger-Viollet, Paris; 114 Barnaby's Picture Library, London; 115 Archivo Casasola, Hidalgo, Mexico; 116 Archivo Casasola, Hidalgo, Mexico; 117 Ullstein Bilderdienst, Berlin; 118

Bischof/Magnum Photos; 485 Interfoto, Munich; 486 Corbis UK Ltd; 487 Corbis UK Ltd; 488 © Henri Cartier-Bresson/Magnum Photos; 489 © Henri Cartier-Bresson/Magnum Photos; 490 La Presse, Turin; 491 BFI Stills, Posters and Designs, London; 492 Hulton Getty; 493 Ullstein Bilderdienst, Berlin; 494(t) © Henri Cartier-Bresson/Magnum Photos; 494(b) The Mainchi Newspapers, Tokyo; 495 © Boris Lipnitzki/Roger-Viollet, Paris; 496 Interfoto, Munich; 497 Hulton Getty; 498 Xinhua News Agency, Beijing; 499 Corbis UK Ltd;

500 Hulton Getty; 501 © Henri Cartier-Bresson/Magnum Photos; 502-03 David King Collection, London; 504 Roger-Viollet, Paris; 505 The Photography Collection, The Carpenter Center for the Visual Arts, Harvard University; 506-07 Roger-Viollet, Paris; 508 © Robert Capa/Magnum Photos; 509 anonymous; 510 © Rudolph Burckhardt; 511 Photograph by Irving Penn. Courtesy *Vogue*. © 1950 (renewed 1978) by the Condé Nast Publications Inc.; 512 Corbis UK Ltd; 513 Hulton Getty; 514 Corbis UK Ltd; 515 Corbis UK Ltd; 516 © Robert Capa/Magnum Photos; 517 Interfoto, Munich; 518 La Presse, Turin; 519 Brown Brothers, Sterling, PA; 520 Corbis UK Ltd; 521 Corbis UK Ltd; 522 © Marc Riboud/Magnum Photos; 523 © Jan Lukas; 524 courtesy The National Archives, Washington, DC; 525 © Werner Bischof/Magnum Photos; 526 courtesy The National Archives, Washington, DC; 527 © Stanley Weston Collection/Ring Magazine; 528 Corbis UK Ltd; 529 Hulton Getty; 530 © W. Eugene Smith/Magnum Photos; 531 anonymous; 532 Corbis UK Ltd; 533 Popperfoto, Northampton; 534 © Cornell Capa/Magnum Photos; 535 Corbis UK Ltd; 536 Hulton Getty; 537 Hulton Getty; 538 Margaret Bourke-White/ © Life Magazine, Time Inc./Katz Pictures Ltd; 539 Corbis UK Ltd; 540 © Werner Bischof/Magnum Photos; 541 Hulton Getty; 542 Novosti, London; 543(t) Novosti, London; 543(b) Ullstein Bilderdienst, Berlin; 544 Süddeutscher Verlag Bilderdienst, Munich; 545 Corbis UK Ltd; 546(t) Hulton Getty; 546(b) Keystone/Sygma; 547 BFI Stills, Posters and Designs, London; 548 BFI Stills, Posters and Designs, London; 549 courtesy James Moores Collection; 550 Corbis

UK Ltd; 551 Agence France Presse/INP; 552 © George Rodger/Magnum Photos; 553 © George Rodger/Magnum Photos; 554 © Erich Lessing/Magnum Photos; 555 BFI Stills, Posters and Designs, London; 556 Keystone/Sygma; 557 L'Illustration/Sygma; 558 © Marc Riboud; 559 Interfoto, Munich; 560 Corbis UK Ltd; 561 Agence France Presse, Paris; 562 © Edward Quinn/The Edward Quinn Archive/Scalo Publishers & Gallery, Zürich; 563 © Edward Quinn/The Edward Quinn Archive/Scalo Publishers & Gallery, Zürich; 564 Hulton Getty; 565 Popperfoto, Northampton; 566 Hulton Getty; 567 © William Klein; 568 BFI Stills, Posters and Designs, London; 569 © Erich Lessing/Magnum Photos; 570 © Roger Mayne; 571 Hulton Getty; 572 Hulton Getty; 573 Hulton Getty; 574 Süddeutscher Verlag Bilderdienst, Munich; 575 John Sadovy/ © Life Magazine, Time Inc./Katz Pictures Ltd; 576 The Associated Press Ltd; 577 Agence France Presse, Paris; 578 © Cornell Capa/Magnum Photos; 579 Corbis UK Ltd; 580 Hulton Getty; 581 Corbis UK Ltd; 582 La Presse, Turin; 583 © Ian Berry/Magnum Photos; 584 © Don Craven/Black Star/Colorific!, London; 585 © Ernest Cole; 586 copyright © by Fred W. McDarrah; 587 George Silk/ © Life Magazine, Time Inc./Katz Pictures Ltd; 588 © Ed van der Elsken/The Netherlands Photo Archives, Rotterdam; 589 © Charles Moore/Black Star/Colorific!, London; 590 © Elliott Erwitt/Magnum Photos; 591 © Elliott Erwitt/Magnum Photos; 592 © Burt Glinn/Magnum Photos; 593 © Bob Henriques/Magnum Photos; 594 Hulton Getty; 595 © Burt Glinn/Magnum Photos; 596 Agence France Presse, Paris; 597 Corbis UK Ltd; 598 Rex Features Ltd, London; 599 © Rolf Gillhausen/Stern, Hamburg;

600(1) © Jan Lukas; 600-01 © Nicolas Tikhomiroff/Magnum Photos; 602(1) Corbis UK Ltd; 602-03 © Nicolas Tikhomiroff/Magnum Photos; 604 © Marc Riboud/Magnum Photos; 605 Nicolas Tikhomiroff/Magnum Photos; 606 © Raymond Depardon/Magnum Photos; 607 Hulton Getty; 608(t) © Robert Lebeck; 608(b) © Ian Berry/Magnum Photos; 609 © Robert Lebeck; 610 © Eve Arnold/Magnum Photos; 611 NASA, Washington, DC; 612 Novosti, London; 613 Novosti, London; 614 Popperfoto, Northampton; 615 Hulton Getty; 616

Hulton Getty; 617 © Burt Glinn/Magnum Photos; 618 © Ian Berry/Magnum Photos; 619 Popperfoto, Northampton; 620 © William Klein; 621 BFI Stills, Posters and Designs, London; 622 Novosti, London; 623 Hulton Getty; 624 Corbis UK Ltd; 625 Hulton Getty; 626 Corbis UK Ltd; 627 © Charles Moore/Black Star/Colorific!, London; 628 © J.P. Charbonnier/Agence Top, Paris; 629 © Marc Riboud/Magnum Photos; 630-31 © Colin Jones; 632 Corbis UK Ltd; 633 © Ernst Haas/Hulton Getty; 634 © Charles Moore/Black Star/Colorific!, London; 635 Corbis UK Ltd; 636 Corbis UK Ltd; 637 copyright © Estate of Diane Arbus 1971, courtesy of the Robert Miller Gallery, New York; 638 © The Irish Times, Dublin; 639 Zapruder/Colorific!, London; 640 Corbis UK Ltd; 641 Corbis UK Ltd; 642-43 Popperfoto, Northampton; 644 Corbis UK Ltd; 645 Jane Bown/Camera Press, London; 646 Corbis UK Ltd; 647 © Don McCullin/Contact Press Images; 648 Keystone/Sygma; 649 Hulton Getty; 650 © Cornell Capa/Magnum Photos; 651 © Don McCullin/Contact Press Images; 652 © David Goldblatt; 653 © Gerry Cranham; 654 Rue des Archives, Paris; 655 The Associated Press Ltd; 656-57 The Associated Press Ltd; 658 © Romano Cagnoni; 659 Larry Burrows/ © Life Magazine, Time Warner Inc./Katz Pictures Ltd; 660 Keystone/Sygma; 661 Hulton Getty; 682 David King Collection, London; 682-83 © Li Zhen Sheng/Contact Press Images; 684 Corbis UK Ltd; 685 Corbis UK Ltd; 686 Camera Press, London; 687 © Paolo Koch/Rapho/Network, London; 688 © Don McCullin/Contact Press Images; 689 The Associated Press Ltd; 690 Corbis UK Ltd; 691 © Philip Jones Griffiths/Magnum Photos; 692 Corbis UK Ltd; 693 © Li Zhen Sheng/Contact Press Images; 694 Corbis UK Ltd; 695 © Gilles Caron/Contact Press Images; 696 © Charles Harbutt/Rapho/Network, London; 697 © Gilles Caron/Contact Press Images; 698 © Cornell Capa/Magnum Photos; 699 © Cornell Capa/Magnum Photos;

700 Corbis UK Ltd; 701 © Josef Koudelka/Magnum Photos; 702 © Raymond Depardon/Magnum Photos; 703 Novosti, London; 704 The Ronald Grant Archive, London; 705 The Ronald Grant Archive, London; 706 Cecil Beaton, courtesy Sotheby's, London; 707 Corbis UK Ltd; 708-09 © Gilles Caron/Contact Press Images; 710 © Gilles Caron/Contact

**Editor's
Acknowledgements**

For Virginia

My first expression of gratitude must be to the distinguished graphic designer Germano Facetti, who, in 1967, when I was as good as down and out, offered me a job doing picture research for a partwork magazine he had designed, and which was called, if you please, *History of the Twentieth Century*. I succeeded in this and became its picture editor partly because I was older than my colleagues there and could recognise more of the people in the pictures. I am glad that those I have known, who were given it when quite young, really enjoyed it – and that was very much to do with Germano's generous vitality, and his young design staff being hugely enthused by the project.

Secondly (one who would have otherwise been first) I must thank someone quite indispensable – my assistant Sophie Spencer-Wood – in whose eye I very soon came to have complete trust, and whose understanding and application to the task have been phenomenal. Adrienne Corner has kept the many thousands of pictures involved beautifully in order, and Matt Corrall, who, although for personal reasons unable to stay the distance, is certainly made of the right stuff. Emily Asquith has been extraordinarily patient and industrious in fact-checking and editing both the short captions and the historical background. Terry McNamee, tireless writer of the historical background and in effect the historical editor of the book, has been of great help in correcting my own and some of the picture agencies' inevitable innaccuracies. He needed all his application, self-effacement and intelligence as well as a ready indulgence for my ignorance of so many things.

Richard Davenport-Hines' contribution has also been very welcome – his erudition and imagination providing the very illuminating asides from literature and other verbiage.

I also feel much indebted to Karl Shanahan, the designer of the book, who has taken such an interest in the photographs, and let their sense and character have a vital say in where they should go rather than trying to impose any 'designery' concept on them.

There are many others upon whom I have depended for advice, encouragement and practical assistance in varying degrees and combinations, and I beg anyone's indulgence if they feel they have been unjustly omitted. Many members of Phaidon's editorial and design staff have been extremely helpful, with Clare Manchester and Amanda Renshaw indispensably so. The Chairman of Phaidon Press, Richard Schlagman, has shown an unswerving faith in the project from the beginning.

Those to whom special thanks are due :
Pierre Apraxine, Daniel Baum, M. Blanch, Dorothy Bohm, Tara Bonakdar, Chris Boot, Gunn Brinson, Warren Butson, Cornell Capa, Judith Clarke, Hamish Crooks, James Danziger, Dominique Deschavannes, Delphine Desveaux, John Delaney, Ian Denning, Sylvia Duffin, Fiona Duncan, Jimmy Fox, Hans-Peter Frentz, Howard Greenberg, Suzanne Greenberg, Mark Haworth-Booth, Martin Heller, John Hillelson, Bob Hoare, Mike Hollingshead, Colin Jacobson, Liz Jobey, Christopher Killip, David King, Susan Kismaric, Bernhard Koppmeyer, Younes Kubota, Vaughan Melzer, Charles Merullo, Natasha Mitchell, James Moores, Rosemary Nief, Barbara Norfleet, Kelly O'Neil, Liliane Rabec, Marcella E. Ramirez, Michael Rand, Sara Rumens, Sally Ryall, Maggie Santin, Max Scheler, Margaret Schultz, Sean Sexton, Linda Sheard, Elizabeth Smith, Pat Stratherne, Sasha Tanya, Bridget Tily, Lisa Tomkins, Heather Vickers, Stephen White, Alison Whalley, Holly Whitelaw, Rebecca Wood

Bruce Bernard, 1992, by Lucian Freud

Biographies

Bruce Bernard has been a picture editor, of magazines and books on art and photography, for over thirty years.

He started working in the field of visual journalism in 1967, on a part-work publication of Purnell's *History of the Twentieth Century*, and quickly became Picture Editor of this series. He was Picture Editor of *The Sunday Times Magazine* from 1972–80. In 1980 he produced *Photodiscovery* – a highly respected account of the revolution in attitudes to photography which started in the 1960s. Bernard was visual arts editor of the Saturday *Independent Magazine* for its first four years (1988–92). He curated the exhibition 'All Human Life' at London's Barbican Centre in 1996, and is currently the curator of a private collection of photographs.

Bernard has devoted the last several years exclusively to *Century*. However this book is the culmination of his extensive knowledge and the experience he has gained during thirty years of looking at pictures.

His publications include *Photodiscovery* (1980); *The Bible and its Painters* (1983); *Vincent by Himself* (1985); *The Impressionist Revolution* (edit.) (1986) and *Lucien Freud* (edit.) (1996).

Terence McNamee studied politics and international relations at the University of British Columbia, Vancouver, and at McGill University, Montreal. He is currently completing a PhD on South Africa's foreign policy during the apartheid era at the London School of Economics. He has also worked as a researcher for two studies carried out by the Canadian High Commission in London which examined the relationship of the British government and its former colonies. McNamee is a freelance writer and editor and is researching and editing a study of the US presidential decisions made during the Vietnam War.

Richard Davenport-Hines is a Fellow of the Royal Historical Society and a Research Associate of the *New Dictionary of National Biography*. He was awarded the Wolfson Prize for History and Biograhy in 1985. Among his recent publications are: *The Macmillans* (1992), *Vice* (1993), *Auden* (1995) and *Gothic* (1998). He regularly reviews books, films and exhibitions for magazines and newspapers including *The Times*, *The Times Literary Supplement* and *The New Statesman*. Davenport-Hines is currently working on a history of narcotics and other drugs entitled *The Pursuit of Oblivion*, due for publication in 2001.

Phaidon Press Limited
Regent's Wharf
All Saints Street
London N1 9PA

First published 1999
© Phaidon Press Limited 1999

ISBN 0 7148 3848 9

A CIP catalogue record of
this book is available from
the British Library.

Printed in Singapore